2013
Artist's
& Graphic Designer's
MARKET

ArtistsMarketOnline.com

Where & How to Sell What You Create

THE ULTIMATE MARKET RESEARCH TOOL FOR ARTISTS AND DESIGNERS

To register your *2013 Artist's & Graphic Designer's Market* book and **start your FREE 1-year online subscription**, scratch off the block below to reveal your activation code*, then go to www.ArtistsMarketOnline.com. Click on "Sign Up Now" and enter your contact information and activation code. It's that easy!

Carefully scratch off the block with a coin. **Do not use a key.**

UPDATED MARKET LISTINGS

EASY-TO-USE SEARCHABLE DATABASE • RECORD-KEEPING TOOLS

INDUSTRY NEWS • PROFESSIONAL TIPS & ADVICE

*Valid through 12/31/13

ArtistsMarketOnline.com

Where & How to Sell What You Create

Activate your FREE ArtistsMarketOnline.com subscription to get instant access to:

- **UPDATED MARKET LISTINGS** — Find additional listings, updated contact information and more. ArtistsMarketOnline.com provides the most comprehensive database of verified markets available anywhere.

- **EASY-TO-USE SEARCHABLE DATABASE** — Looking for a specific magazine or book publisher? Just type in its name or other relevant keywords. Or widen your prospects with the Advanced Search. You can also receive notifications for listings that have been recently updated!

- **PERSONALIZED TOOLS** — Store your best-bet markets, and use our popular record-keeping tools to track your submissions. Plus, get new and updated market listings, query reminders, and more – every time you log in!

- **PROFESSIONAL TIPS & ADVICE** — From pay rate charts to sample query letters, and from how-to articles to Q&As, we have the resources creative freelancers need.

YOU'LL GET ALL OF THIS WITH YOUR
FREE SUBSCRIPTION TO

ArtistsMarketOnline**.com**

Where & How to Sell What You Create

13ARI0M

38TH ANNUAL EDITION

2013

Artist's

& Graphic Designer's

MARKET

Mary Burzlaff Bostic, Editor

NORTH LIGHT BOOKS
CINCINNATI, OHIO
artistsmarketonline.com

Publisher and Community Leader, Fine Art Community: Jamie Markle
Senior Content Director, North Light Books: Pam Wissman
Market Books Assistant, North Light Books: Elizabeth Coyle

Artist's Market Online website: artistsmarketonline.com
Artist's Network website: artistsnetwork.com
North Light Shop website: northlightshop.com

Distributed in Canada by Fraser Direct
100 Armstrong Avenue
Georgetown, ON, Canada L7G 5S4
Tel: (905) 877-4411

Distributed in the U.K. and Europe by F&W Media International, LTD
Brunel House, Forde Close, Newton Abbot, TQ12 4PU, UK
Tel: (+44) 1626 323200, Fax: (+44) 1626 323319
E-mail: enquiries@fwmedia.com

Distributed in Australia by Capricorn Link
P.O. Box 704, S. Windsor NSW, 2756 Australia
Tel: (02) 4577-3555

ISSN: 1075-0894
ISBN-13: 978-1-59963-614-6
ISBN-10: 1-59963-614-X

Cover design by Julie Barnett
Interior design by Claudean Wheeler
Interior layout by Angela Wilcox and Wendy Dunning
Production coordinated by Greg Nock

Attention Booksellers: This is an annual directory of F+W Media, Inc. Return deadline for this edition is December 31, 2013.

CONTENTS

ARTICLES & INTERVIEWS

FROM THE EDITOR

The economy seems to be looking up, but it's still tough out there, especially for freelancers. While being a fantastic artist or designer is a great start to turning your passion into a career, you also need a strategic plan with clear goals and the business smarts to fulfill them. That's where *Artist's & Graphic Designer's Market* can help. In addition to providing more than 1,700 individually verified market contacts, this edition of *AGDM* will show you how to set your goals and then develop the professional skills you need to achieve your dreams.

To start, you need a comprehensive plan to build your business. Check out "Do You Need an OGSM?" in the Articles & Interviews section to learn how to develop a business framework that includes your objective, goals, strategies and measurements. Then read on to learn tips for strengthening your business.

Once you have your strategic plans in place, you need the business skills to accomplish your goals. Read the special features on discovering your client's budget, negotiating contracts, applying for grants, writing professional materials, communicating with clients and hanging a solo show. Even freelancers need some rest and relaxation, so be sure to check out "Happy, Healthy and Successful" to learn more about achieving work-life balance.

You'll also find inspiring and informative interviews with successful professionals, including artist Lisa L. Cyr, illustrator Loren Long and These Are Things design duo Jen Adrion and Omar Noory. These freelancers do what they love for a living, and you can too.

Read on, keep creating and good luck!

Mary Burzlaff Bostic

Mary Burzlaff Bostic
art.design@fwmedia.com
www.artistsmarketonline.com

P.S. Don't forget to register at **Artist's Market Online, which you get FREE for a year with the purchase of this book.** Your free 1-year subscription will provide you with everything *Artist's & Graphic Designer's Market* has to offer and then some. You'll be able to search listings, track your submissions, read up on the latest market news, and much more. Use the activation code from the front insert to access your free subscription today.

HOW TO USE THIS BOOK

If you're picking up this book for the first time, you might not know quite how to start using it. Your first impulse might be to flip through and quickly make a mailing list, submitting to everyone with hopes that *someone* might like your work. Resist that urge. First you have to narrow down the names in this book to those who need your particular art style. That's what this book is all about. We provide the names and addresses of art buyers along with plenty of marketing tips. You provide the hard work, creativity, and patience necessary to hang in there until work starts coming your way.

Listings

The book is divided into market sections, from galleries to art fairs. (See the Table of Contents for a complete list.) Each section begins with an introduction containing information and advice to help you break into that specific market. Listings are the meat of this book. In a nutshell, listings are names, addresses, and contact information for places that buy or commission artwork, along with a description of the type of art they need and their submission preferences.

Articles and interviews

Throughout this book you will find helpful articles and interviews with working artists and experts from the art world. These articles give you a richer understanding of the marketplace by sharing the featured artists' personal experiences and insights. Their stories, and the lessons you can learn from other artists' feats and follies, give you an important edge over competition.

HOW ARTIST'S & GRAPHIC DESIGNER'S MARKET WORKS

Following the instructions in the listings, we suggest you send samples of your work (not originals) to a dozen (or more) targeted markets. The more companies you send to, the greater your chances of a positive response. Establish a system to keep track of who you submit your work to and send follow-up mailings to your target markets at least twice a year.

How to read listings

The first thing you'll notice about many of the listings in this book is the group of symbols that appears before the name of each company. (You'll find a quick-reference key to the symbols on the back inside cover of the book.) Here's what each symbol stands for:

⊕ Market new to this edition

☯ Canadian market

⬤ International market

⊙ Market prefers to work with local artists/designers

Each listing contains a description of the artwork and/or services the company prefers. The information often reveals how much freelance artwork is used, whether computer skills are needed, and which software programs are preferred.

In some sections, additional subheads help you identify potential markets. Magazine listings specify needs for cartoons and illustrations. Galleries specify media and style.

Editorial comments, denoted by ⊙, give you extra information about markets, such as company awards, mergers and insight into a company's staff or procedures.

It might take a while to get accustomed to the layout and language in the listings. In the beginning, you will encounter some terms and symbols that might be unfamiliar to you. Refer to the Glossary to help you with terms you don't understand.

Working with listings

1. Read the entire listing to decide whether to submit your samples. Do not use this book simply as a mailing list of names and addresses. Reading listings carefully helps you narrow your mailing list and submit appropriate material.

2. Read the description of the company or gallery in the first paragraph of the listing. Then jump to the **Needs** or **Media** heading to find out what type of artwork is preferred. Is it the type of artwork you create? This is the first step to narrowing your target market. You should send your samples only to places that need the kind of work you create.

3. Send appropriate submissions. It seems like common sense to research what kind of samples a listing wants before sending off just any artwork you have on hand. But believe it or not, some artists skip this step. Some art directors have pulled their listings from *Artist's & Graphic Designer's Market* because they've received too many inappropriate submissions. Look under the **First Contact & Terms** heading to find out how to contact the market and

FREQUENTLY ASKED QUESTIONS

1 **How do companies get listed in the book?** No company pays to be included—all listings are free. Every company has to fill out a detailed questionnaire about their art needs. All questionnaires are screened to make sure the companies meet our requirements. Each year we contact every company in the book and ask them to update their information.

2 **Why aren't other companies I know about listed in this book?** We may have sent these companies a questionnaire, but they never returned it. Or if they did return a questionnaire, we may have decided not to include them based on our requirements. If you know of a market you'd like to see in the book, send an e-mail request to art. design@fwmedia.com.

3 **I sent some samples to a company that stated they were open to reviewing the type of work I do, but I have not heard from them yet, and they have not returned my materials. What should I do?** At the time we contacted the company, they were open to receiving such submissions. However, things can change. It's a good idea to contact any company listed in this book to check on their policy before sending them anything. Perhaps they have not had time to review your submission yet. If the listing states that they respond to queries in one month, and more than a month has passed, you can send a brief e-mail to the company to inquire about the status of your submission. Some companies receive a large volume of submissions, so you must be patient. Never send originals when you are querying—always send copies. If for any reason your samples are never returned, you will not have lost forever the opportunity to sell an important image. It is a good idea to include a SASE (self-addressed, stamped envelope) with your submissions, even if the listing does not specifically request that you do so. This may facilitate getting your work back.

4 **A company says they want to publish my artwork, but first they will need a fee from me. Is this a standard business practice?** No, it is not a standard business practice. You should never have to pay to have your art reviewed or accepted for publication. If you suspect that a company may not be reputable, do some research before you submit anything or pay their fees. The exception to this rule is art fairs. Most art fairs have an application fee, and usually there is a fee for renting booth space. Some galleries may also require a fee for renting space to exhibit your work (see the gallery market section for more information).

what to send. Some companies and publishers are very picky about what kinds of samples they like to see; others are more flexible.

What's an inappropriate submission? Here's an example: Suppose you want to be a children's book illustrator. Don't send samples of your cute animal art to *Business Law Today*

magazine—they would rather see law-related subjects. Use the Niche Marketing Index to find listings that accept children's illustrations. You'd be surprised how many illustrators waste their postage sending the wrong samples—which, of course, alienates art directors. Make sure all your mailings are *appropriate ones.*

4. Consider your competition. Under the **Needs** heading, compare the number of freelancers who contact the company with the number they actually work with. You'll have a better chance with listings that use a lot of artwork or work with many artists.

5. Look for what they pay. In most sections, you can find this information under **First Contact & Terms**. In the Book Publishers section publishers list pay rates under headings pertaining to the type of work they assign, such as **Text Illustration** or **Book Design**.

At first, try not to be too picky about how much a listing pays. After you have a couple of assignments under your belt, you might decide to only send samples to medium- or high-paying markets.

6. Be sure to read the Tips. This is where art directors describe their pet peeves and give clues for how to impress them. Artists say the information within the **Tips** helps them get a feel for what a company might be like to work for.

These steps are just the beginning. As you become accustomed to reading listings, you will think of more ways to mine this book for your potential clients. Some of our readers tell us they peruse listings to find the speed at which a magazine pays its freelancers. In publishing, it's often a long wait until an edition or book is actually published, but if you are paid "on acceptance," you'll get a check soon after you complete the assignment and it is approved by the art director.

When looking for galleries, savvy artists often check to see how many square feet of space are available and what hours the gallery is open. These details all factor in when narrowing down your search for target markets.

Pay attention to copyright information

It's also important to consider what rights companies buy. It is preferable to work with companies that buy first or one-time rights. If you see a listing that buys "all rights," be aware you may be giving up the right to sell that particular artwork in the future. See the "Copyright Basics" article in this section for more information.

Look for specialties and niche markets

Read listings closely. Most describe their specialties, clients, and products within the first paragraph. If you hope to design restaurant menus, for example, target agencies that have restaurants for clients. If you prefer illustrating people, you might target ad agencies whose clients are hospitals or financial institutions. If you like to draw cars, look for agencies with clients in the automotive industry, and so on. Many book publishers specialize, too. Look

for a publisher who specializes in children's books if that's the type of work you'd like to do. The Niche Marketing Index lists possible opportunities for specialization.

Read listings for ideas

You'd be surprised how many artists found new niches they hadn't thought of by browsing the listings. One greeting card artist read about a company that produces mugs. Inspiration struck. Now this artist has added mugs to her repertoire, along with paper plates, figurines and rubber stamps—all because she browsed the listings for ideas!

Sending out samples

Once you narrow down some target markets, the next step is sending them samples of your work. As you create your samples and submission packets, be aware that your package or postcard has to look professional. It must be up to the standards art directors and gallery dealers expect. There are examples throughout this book of some great samples sent out by other artists. Make sure your samples rise to that standard of professionalism.

See you next year

Use this book for one year. Highlight listings, make notes in the margins, fill it with Post-it notes. In November of 2013, our next edition—the *2014 Artist's & Graphic Designer's Market*—starts arriving in bookstores. By then, we'll have collected hundreds of new listings and changes in contact information. It is a career investment to buy the new edition every year. (And it's deductible! See the "How to Stay on Track & Get Paid" article in this section for information on tax deductions.)

COMPLAINT PROCEDURE

If you feel you have not been treated fairly by a company listed in *Artist's & Graphic Designer's Market*, we advise you to take the following steps:

- First, try to contact the company. Sometimes one e-mail or letter can quickly clear up the matter.
- Document all your correspondence with the company. If you write to us with a complaint, provide the details of your submission, the date of your first contact with the company, and the nature of your subsequent correspondence.
- We will enter your complaint into our files.
- The number and severity of complaints will be considered in our decision whether to delete the listing from the next edition.
- We reserve the right to not list any company for any reason.

Join a professional organization

Artists who have the most success using this book are those who take the time to read the articles to learn about the bigger picture. In our interviews, you'll learn what has worked for other artists and what kind of work impresses art directors and gallery dealers.

You'll find out how joining professional organizations such as the Graphic Artists Guild (www.gag.org) or the Society of Illustrators (www.societyillustrators.org) can jump-start your career. You'll find out the importance of reading trade magazines such as *HOW* (www. howdesign.com), *PRINT* (www.printmag.com) and *Greetings etc.* (www. greetingsmag azine.com) to learn more about the industries you hope to approach. You'll learn about trade shows, art reps, shipping, billing, working with vendors, networking, self-promotion and hundreds of other details it would take years to find out about on your own. Perhaps most importantly, you'll read about how successful artists overcame rejection through persistence.

Hang in there!

Being professional doesn't happen overnight. It's a gradual process. It may take two or three years to gain enough information and experience to be a true professional in your field. So if you really want to be a professional artist, hang in there. Before long, you'll feel that heady feeling that comes from selling your work or seeing your illustrations on greeting cards or in magazines. If you really want it and you're willing to work for it, it *will* happen.

HOW TO STAY ON TRACK & GET PAID

///

As you launch your artistic career, be aware that you are actually starting a small business. It is crucial that you keep track of the details, or your business will not last very long. The most important rule of all is to find a system to keep your business organized and stick with it.

YOUR DAILY RECORD-KEEPING SYSTEM

Every artist needs to keep a daily record of art-making and marketing activities. Before you do anything else, visit an office supply store and pick out the items listed below (or your own variations of these items). Keep it simple so you can remember your system and use it on automatic pilot whenever you make a business transaction.

What you'll need:

- A packet of colorful file folders or a basic Personal Information Manager on your smartphone, computer or personal digital assistant (PDA).
- A notebook or legal pads to serve as a log or journal to keep track of your daily art-making and art-marketing activities.
- A small pocket notebook to keep in your car to track mileage and gas expenses.

How to start your system

Designate a permanent location in your studio or home office for two file folders and your notebook. Label one red file folder "Expenses." Label one green file folder "Income." Write in your daily log book each and every day.

Every time you purchase anything for your business, such as envelopes or art supplies, place the receipt in your red Expenses folder. When you receive payment for an assignment or painting, photocopy the check or place the receipt in your green Income folder.

Keep track of assignments

Whether you're an illustrator or fine artist, you should devise a system for keeping track of assignments and artworks. Most illustrators assign a job number to each assignment they receive and create a file folder for each job. Some arrange these folders by client name; others keep them in numerical order. The important thing is to keep all correspondence for each assignment in a spot where you can easily find it.

Pricing illustration and design

One of the hardest things to master is what to charge for your work. It's difficult to make blanket statements on this topic. Every slice of the market is somewhat different. Nevertheless, there is one recurring pattern: Hourly rates are generally only paid to designers working in-house on a client's equipment. Freelance illustrators working out of their own studios are almost always paid a flat fee or an advance against royalties.

If you don't know what to charge, begin by devising an hourly rate, taking into consideration the cost of materials and overhead as well as what you think your time is worth. If you're a designer, determine what the average salary would be for a full-time employee doing the same job. Then estimate how many hours the job will take and quote a flat fee based on these calculations.

There is a distinct difference between giving the client a job estimate and a job quote. An estimate is a ballpark figure of what the job will cost but is subject to change. A quote is a set fee which, once agreed upon, is pretty much carved in stone. Make sure the client understands which you are negotiating. Estimates are often used as a preliminary step in itemizing costs for a combination of design services such as concepting, typesetting and printing. Flat quotes are generally used by illustrators, as there are fewer factors involved in arriving at fees.

For recommended fees for different services, refer to the *Graphic Artists Guild Handbook of Pricing & Ethical Guidelines* (www.gag.org). Many artists' organizations have standard pay rates listed on their websites.

As you set fees, certain stipulations call for higher rates. Consider these bargaining points:

- **Usage (rights).** The more rights purchased, the more you can charge. For example, if the client asks for a "buyout" (to buy all rights), you can charge more, because by relinquishing all rights to future use of your work, you will be losing out on resale potential.

PRICING YOUR FINE ART

There are no hard-and-fast rules for pricing your fine artwork. Most artists and galleries base prices on market value—what the buying public is currently paying for similar work. Learn the market value by visiting galleries and checking prices of works similar to yours. When you're starting out, don't compare your prices to established artists but to emerging talent in your region. Consider these factors when determining price:

- **Medium.** Oils and acrylics cost more than watercolors by the same artist. Price paintings higher than drawings.
- **Expense of materials.** Charge more for work done on expensive paper than for work of a similar size on a lesser grade paper.
- **Size.** Though a large work isn't necessarily better than a small one, as a rule of thumb you can charge more for the larger work.
- **Scarcity.** Charge more for one-of-a-kind works like paintings and drawings than for limited editions such as lithographs and woodcuts.
- **Status of artist.** Established artists can charge more than lesser-known artists.
- **Status of gallery.** Prestigious galleries can charge higher prices.
- **Region.** Works usually sell for more in larger cities like New York and Chicago.
- **Gallery commission.** The gallery will charge from 30 to 50 percent commission. Your cut must cover the cost of materials, studio space, taxes, and perhaps shipping and insurance, as well as enough extra to make a profit. If materials for a painting cost $25, matting and framing cost $37, and you spent five hours working on it, make sure you get at least the cost of material and labor back before the gallery takes its share. Once you set your price, stick to the same price structure wherever you show your work. A $500 painting by you should cost $500 whether it is bought in a gallery or directly from you. To do otherwise is not fair to the gallery and devalues your work.

As you establish a reputation, begin to raise your prices—but do so cautiously. Each time you graduate to a new price level, it will be that much harder to revert to former prices.

- **Turnaround time.** If you are asked to turn the job around quickly, charge more.
- **Budget.** Don't be afraid to ask about a project's budget before offering a quote. You won't want to charge $500 for a print ad illustration if the ad agency has a budget of $40,000 for that ad. If the budget is that big, ask for higher payment.
- **Reputation.** The more well known you are, the more you can charge. As you become established, periodically raise your rates (in small steps) and see what happens.

What goes in a contract?

Contracts are simply business tools used to make sure everyone agrees on the terms of a project. Ask for one any time you enter into a business agreement. Be sure to arrange for the specifics in writing or provide your own. A letter stating the terms of agreement signed by both parties can serve as an informal contract. (See "Negotiating the Contract" in the Articles & Interviews section.) Several excellent books, such as *Legal Guide for the Visual Artist* and *Business and Legal Forms for Illustrators*, both by Tad Crawford (Allworth Press), contain negotiation checklists and tear-out forms, and provide sample contracts you can copy. The sample contracts in these books cover practically any situation you might encounter.

The items specified in your contract will vary according to the market you're dealing with and the complexity of the project. Nevertheless, here are some basic points you'll want to cover:

Commercial contracts

- **A description** of the service(s) you're providing.
- **Deadlines** for finished work.
- **Rights sold. Your fee.** Hourly rate, flat fee or royalty.
- **Kill fee.** Compensatory payment received by you if the project is cancelled.
- **Changes fees.** Penalty fees to be paid by the client for last-minute changes.
- **Advances.** Any funds paid to you before you begin working on the project.
- **Payment schedule.** When and how often you will be paid for the assignment.
- **Statement regarding return of original art.** Unless you're doing work for hire, your artwork should always be returned to you.

Gallery contracts

- **Terms of acquisition or representation.** Will the work be handled on consignment? What is the gallery's commission?
- **Nature of the show(s).** Will the work be exhibited in group or solo shows or both?
- **Timeframes.** If a work is sold, when will you be paid? At what point will the gallery return unsold works to you? When will the contract cease to be in effect?
- **Promotion.** Who will coordinate and pay for promotion? What does promotion entail? Who pays for printing and mailing of invitations? If costs are shared, what is the breakdown?
- **Insurance.** Will the gallery insure the work while it is being exhibited and/or while it is being shipped to or from the gallery?
- **Shipping.** Who will pay for shipping costs to and from the gallery?

- **Geographic restrictions.** If you sign with this gallery, will you relinquish the rights to show your work elsewhere in a specified area? If so, what are the boundaries of this area?

How to send invoices

If you're a designer or illustrator, you will be responsible for sending invoices for your services. Clients generally will not issue checks without them, so mail or fax an invoice as soon as you've completed the assignment. Illustrators are generally paid in full either upon receipt of illustration or on publication. Most graphic designers arrange to be paid in thirds, billing the first third before starting the project, the second after the client approves the initial roughs, and the third upon completion of the project.

Standard invoice forms allow you to itemize your services. The more you spell out the charges, the easier it will be for your clients to understand what they're paying for. Most freelancers charge extra for changes made after approval of the initial layout. Keep a separate form for change orders and attach it to your invoice.

If you're an illustrator, your invoice can be much simpler, as you'll generally be charging a flat fee. It's helpful, in determining your quoted fee, to itemize charges according to time, materials, and expenses. (The client need not see this itemization; it is for your own purposes.) Most businesses require your Social Security number or tax ID number before they can cut a check, so include this information in your bill. Be sure to put a due date on each invoice; include the phrase "payable within 30 days" (or other preferred time frame) directly on your invoice. Most freelancers ask for payment within ten to thirty days. Sample invoices are featured in *Business and Legal Forms for Illustrators* and *Business and Legal Forms for Graphic Designers*, both by Tad Crawford (Allworth Press).

If you're working with a gallery, you will not need to send invoices. The gallery should send you a check each time one of your pieces is sold (generally within thirty days).

To ensure that you are paid in a timely manner, call the gallery periodically to touch base. Let the director or business manager know that you are keeping an eye on your work. When selling work independently of a gallery, give receipts to buyers and keep copies for your records.

Take advantage of tax deductions

You have the right to deduct legitimate business expenses from your taxable income. Art supplies, studio rent, printing costs, and other business expenses are deductible against your gross art-related income. It is imperative to seek the help of an accountant or tax preparation service in filing your return. In the event your deductions exceed profits, the loss will lower your taxable income from other sources.

To guard against taxpayers fraudulently claiming hobby expenses as business losses, the IRS requires taxpayers to demonstrate a "profit motive." As a general rule, you must show a profit for three out of five years to retain a business status. If you are audited, the burden of proof will be on you to validate your work as a business and not a hobby. The nine criteria the IRS uses to distinguish a business from a hobby are:

- the manner in which you conduct your business
- expertise
- amount of time and effort put into your work
- expectation of future profits
- success in similar ventures
- history of profit and losses
- amount of occasional profits
- financial status
- element of personal pleasure or recreation

If the IRS rules that you paint for pure enjoyment rather than profit, they will consider you a hobbyist. Complete and accurate records will demonstrate to the IRS that you take your business seriously.

Even if you are a "hobbyist," you can deduct expenses such as supplies on a Schedule A, but you can only take art-related deductions equal to art-related income. If you sold two $500 paintings, you can deduct expenses such as art supplies, art books, and seminars only up to $1,000. Itemize deductions only if your total itemized deductions exceed your standard deduction. You will not be allowed to deduct a loss from other sources of income.

Figuring deductions

To deduct business expenses, you or your accountant will fill out a 1040 tax form (not 1040EZ) and prepare a Schedule C, which is a separate form used to calculate profit or loss from your business. The income (or loss) from Schedule C is then reported on the 1040 form. In regard to business expenses, the standard deduction does not come into play as it would for a hobbyist. The total of your business expenses need not exceed the standard deduction.

There is a shorter form called Schedule C-EZ for self-employed people in service industries. It can be applicable to illustrators and designers who have receipts of $25,000 or less and deductible expenses of $2,000 or less. Check with your accountant to see if you qualify.

Deductible expenses include advertising costs, brochures, business cards, professional group dues, subscriptions to trade journals and arts magazines, legal and professional services, leased office equipment, office supplies, business travel expenses, etc. Your accountant can give you a list of all 100-percent and 50-percent deductible expenses. Don't forget to deduct the cost of this book!

CAN I DEDUCT MY HOME STUDIO?

If you freelance full time from your home and devote a separate area to your business, you may qualify for a home office deduction. If eligible, you can deduct a percentage of your rent or mortgage as well as utilities and expenses like office supplies and business-related telephone calls.

The IRS does not allow deductions if the space is used for purposes other than business. A studio or office in your home must meet three criteria:

- The space must be used exclusively for your business.
- The space must be used regularly as a place of business.
- The space must be your principle place of business.

The IRS might question a home office deduction if you are employed full time elsewhere and freelance from home. If you do claim a home office, the area must be clearly divided from your living area. A desk in your bedroom will not qualify. To figure out the percentage of your home used for business, divide the total square footage of your home by the total square footage of your office. This will give you a percentage to work with when figuring deductions. If the home office is 10 percent of the square footage of your home, deduct 10 percent of expenses such as rent, heat, and air conditioning.

The total home office deduction cannot exceed the gross income you derive from its business use. You cannot take a net business loss resulting from a home office deduction. Your business must be profitable three out of five years; otherwise, you will be classified as a hobbyist and will not be entitled to this deduction.

Consult a tax advisor before attempting to take this deduction, as its interpretations frequently change.

For additional information, refer to IRS Publication 587, Business Use of Your Home, which can be downloaded at www.irs.gov or ordered by calling (800)829-3676.

As a self-employed "sole proprietor," there is no employer regularly taking tax out of your paycheck. Your accountant will help you put money away to meet your tax obligations and may advise you to estimate your tax and file quarterly returns.

Your accountant also will be knowledgeable about another annual tax called the Social Security Self-Employment tax. You must pay this tax if your net freelance income is $400 or more.

The fees of tax professionals are relatively low, and they are deductible. To find a good accountant, ask colleagues for recommendations, look for advertisements in trade publications, or ask your local Small Business Association.

Whenever possible, retain your independent contractor status

Some clients automatically classify freelancers as employees and require them to file Form W-4. If you are placed on employee status, you may be entitled to certain benefits, but a portion of your earnings will be withheld by the client until the end of the tax year and you could forfeit certain deductions. In short, you may end up taking home less than you would if you were classified as an independent contractor.

The IRS uses a list of twenty factors to determine whether a person should be classified as an independent contractor or an employee. This list can be found in IRS Publication 937. Note, however, that your client will be the first to decide how you'll be classified.

Report all income to Uncle Sam

Don't be tempted to sell artwork without reporting it on your income tax. You may think this saves money, but it can do real damage to your career and credibility—even if you are never audited by the IRS. Unless you report your income, the IRS will not categorize you as a professional, and you won't be able to deduct expenses. And don't think you won't get caught if you neglect to report income. If you bill any client in excess of $600, the IRS requires the client to provide you with a Form 1099 at the end of the year. Your client must send one copy to the IRS and a copy to you to attach to your income tax return. Likewise, if you pay a freelancer over $600, you must issue a 1099 form. This procedure is one way the IRS cuts down on unreported income.

Register with the state sales tax department

Most states require a 2–7 percent sales tax on artwork you sell directly from your studio or at art fairs, or on work created for a client. You must register with the state sales tax department, which will issue you a sales permit or a resale number and send you appropriate forms and instructions for collecting the tax. Getting a sales permit usually involves filling out a form and paying a small fee. Reporting sales tax is a relatively simple procedure. Record all sales taxes on invoices and in your sales journal. Every three months, total the taxes collected and send it to the state sales tax department.

In most states, if you sell to a customer outside of your sales tax area, you do not have to collect sales tax. However, this may not hold true for your state. You may also need a business license or permit. Call your state tax office to find out what is required.

Save money on art supplies

As long as you have the above sales permit number, you can buy art supplies without paying sales tax. You will probably have to fill out a tax-exempt form with your permit number at the sales desk where you buy materials. The reason you do not have to pay sales tax on art

supplies is that sales tax is only charged on the final product. However, you must then add the cost of materials into the cost of your finished painting or the final artwork for your client. Keep all receipts in case of a tax audit. If the state discovers that you have not collected sales tax, you will be liable for tax and penalties.

If you sell all your work through galleries, they will charge sales tax, but you still need a sales permit number to get a tax exemption on supplies.

Some states claim "creativity" is a non-taxable service, while others view it as a product and therefore taxable. Be certain you understand the sales tax laws to avoid being held liable for uncollected money at tax time. Contact your state auditor for sales tax information.

Save money on postage

When you send out postcard samples or invitations to openings, you can save big bucks by mailing in bulk. Fine artists should send submissions via first-class mail for quicker service and better handling. Package flat work between heavy cardboard or foam core, or roll it in a cardboard tube. Include your business card or a label with your name and address on the outside of the packaging material in case the outer wrapper becomes separated from the inner packing in transit.

Protect larger works—particularly those that are matted or framed—with a strong outer surface, such as laminated cardboard, Masonite, or light plywood. Wrap the work in polyfoam, heavy cloth, or bubble wrap, and cushion it against the outer container with spacers to keep it from moving. Whenever possible, ship work before it is glassed. If the glass breaks en route, it may destroy your original image. If shipping large framed work, contact a museum in your area for more suggestions on packaging.

The U.S. Postal Service will not automatically insure your work, but you can purchase up to $5,000 worth of coverage. Artworks exceeding this value should be sent by registered mail, which can be insured for up to $25,000. Certified packages travel a little slower but are easier to track.

Consider special services offered by the post office, such as Priority Mail, Express Mail Next Day Service, and Special Delivery. For overnight delivery, check to see which air freight services are available in your area. Federal Express automatically insures packages for $100 and will ship art valued up to $500. Their 24-hour computer tracking system enables you to locate your package at any time.

The United Parcel Service automatically insures work for $100, but you can purchase additional insurance for work valued as high as $25,000 for items shipped by air (there is no limit for items sent on the ground). UPS cannot guarantee arrival dates but will track lost packages. It also offers Two-Day Blue Label Air Service within the U.S. and Next Day Service in specific zip code zones.

Before sending any original work, make sure you have a copy (digital, photocopy, slide, or transparency) in your files. Always make a quick address check by phone before putting your package in the mail.

Send us your business tips

If you've used a business strategy we haven't covered, please e-mail us at art.design@fwmedia. com. We may feature you and your work in a future edition.

COPYRIGHT BASICS

As creator of your artwork, you have certain inherent rights over your work and can control how each one of your works is used, until you sell your rights to someone else. The legal term for these rights is called *copyright*. Technically, any original artwork you produce is automatically copyrighted as soon as you put it in tangible form.

To be automatically copyrighted, your artwork must fall within these guidelines:

- **It must be your original creation.** It cannot be a *copy* of somebody else's work.
- **It must be "pictorial, graphic, or sculptural."** Utilitarian objects, such as lamps or toasters, are not covered, although you can copyright an illustration featured on a lamp or toaster.
- **It must be fixed in "any tangible medium, now known or later developed."** Your work, or at least a representation of a planned work, must be created in or on a medium you can see or touch, such as paper, canvas, clay, a sketch pad, or even a website. It can't just be an idea in your head. An idea cannot be copyrighted.

Copyright lasts for your lifetime plus seventy years

Copyright is *exclusive*. When you create a work, the rights automatically belong to you and nobody else but you until those rights are sold to someone else.

Works of art created on or after January 1978 are protected for your lifetime plus seventy years.

The artist's bundle of rights

One of the most important things you need to know about copyright is that it is not just a *singular* right. It is a *bundle* of rights you enjoy as creator of your artwork:

- **Reproduction right.** You have the right to make copies of the original work.
- **Modification right.** You have the right to create derivative works based on the original work.
- **Distribution rights.** You have the right to sell, rent or lease copies of your work.
- **Public performance right.** You have the right to play, recite, or otherwise perform a work. (This right is more applicable to written or musical art forms than to visual art.)
- **Public display right.** You have the right to display your work in a public place. This bundle of rights can be divided up in a number of ways, so that you can sell all or part of any of those exclusive rights to one or more parties. The system of selling parts of your copyright bundle is sometimes referred to as *divisible copyright*. Just as a land owner can divide up his property and sell it to many different people, the artist can divide up his rights to an artwork and sell portions of those rights to different buyers.

Divisible copyright: divide and conquer

Why is divisible copyright so important? Because dividing up your bundle and selling parts of it to different buyers will help you get the most payment for each of your artworks. For any one of your artworks, you can sell your entire bundle of rights at one time (not advisable!) or divide each bundle pertaining to that work into smaller portions and make more money as a result. You can grant one party the right to use your work on a greeting card and sell another party the right to print that same work on T-shirts.

Divisible copyright terms

Clients tend to use legal jargon to specify the rights they want to buy. The terms below are commonly used in contracts to indicate portions of your bundle of rights. Some terms are vague or general, such as "all rights." Other terms are more specific, such as "first North American rights." Make sure you know what each term means before signing a contract.

- **One-time rights.** Your client buys the right to use or publish your artwork or illustration on a one-time basis. One fee is paid for one use. Most magazine and book cover assignments fall under this category.
- **First rights.** This is almost the same as one-time rights, except that the buyer is also paying for the privilege of being the first to use your image. He may use it only once unless the other rights are negotiated. Sometimes first rights can be further broken down geographically. The buyer might ask to buy **first North American rights**, meaning he would have the right to be the first to publish the work in North America.

- **Exclusive rights.** This guarantees the buyer's exclusive right to use the artwork in his particular market or for a particular product. Exclusive rights are frequently negotiated by greeting card and gift companies. One company might purchase the exclusive right to use your work as a greeting card, leaving you free to sell the exclusive rights to produce the image on a mug to another company.
- **Promotional rights.** These rights allow a publisher to use an artwork for promotion of a publication in which the artwork appears. For example, if *The New Yorker* bought promotional rights to your cartoon, they could also use it in a direct mail promotion.
- **Electronic rights.** These rights allow a buyer to place your work on electronic media such as websites. Often these rights are requested with print rights.
- **Work for hire.** Under the Copyright Act of 1976, section 101, a "work for hire" is defined as "(1) a work prepared by an employee within the scope of his or her employment; or (2) a work specially ordered or commissioned for use as a contribution to a collective work, as part of a motion picture or other audiovisual work . . . if the parties expressly agree in a written instrument signed by them that the work shall be considered a work made for hire." When the agreement is "work for hire," you surrender all rights to the image and can never resell that particular image again. If you agree to the terms, make sure the money you receive makes it well worth the arrangement.
- **All rights.** Again, be aware that this phrase means you will relinquish your entire copyright to a specific artwork. Before agreeing to the terms, make sure this is an arrangement you can live with. At the very least, arrange for the contract to expire after a specified date. Terms for all rights—including time period for usage and compensation—should be confirmed in a written agreement with the client.

Since legally your artwork is your property, when you create an illustration for a magazine you are, in effect, temporarily "leasing" your work to the client for publication.

Chances are you'll never hear an art director ask to lease or license your illustration, and he may not even realize he is leasing, not buying, your work. But most art directors know that once the magazine is published, the art director has no further claims to your work and the rights revert back to you. If the art director wants to use your work a second or third time, he must ask permission and negotiate with you to determine any additional fees you want to charge. You are free to take that same artwork and sell it to another buyer.

However, if the art director buys "all rights," you cannot legally offer that same image to another client. If you agree to create the artwork as "work for hire," you relinquish your rights entirely.

What licensing agents know

The practice of leasing parts or groups of an artist's bundle of rights is often referred to as *licensing*, because (legally) the artist is granting someone a "license" to use his work for a limited time for a specific reason. As licensing agents have come to realize, it is the exclusivity of the rights and the ability to divide and sell them that make them valuable. Knowing exactly what rights you own, which you can sell, and in what combinations, will help you negotiate with your clients.

Don't sell conflicting rights to different clients

You also have to make sure the rights you sell to one client don't conflict with any of the rights sold to other clients. For example, you can't sell the exclusive right to use your image on greeting cards to two separate greeting card companies. You can sell the exclusive greeting card rights to one card company and the exclusive rights to use your artwork on mugs to a separate gift company. You should always get such agreements in writing and let both companies know your work will appear on other products.

When to use the Copyright © and credit lines

A copyright notice consists of the word "Copyright" or its symbol ©, the year the work was created or first published, and the full name of the copyright owner. It should be placed where it can easily be seen, on the front or back of an illustration or artwork. It's also common to print your copyright notice on slide mounts or onto labels on the back of photographs.

Under today's laws, placing the copyright symbol on your work isn't absolutely necessary to claim copyright infringement and take a plagiarist to court if he steals your work. If you browse through magazines, you will often see the illustrator's name in small print near the illustration, *without* the Copyright ©. This is common practice in the magazine industry. Even though the © is not printed, the illustrator still owns the copyright unless

the magazine purchased all rights to the work. Just make sure the art director gives you a credit line near the illustration.

Usually you will not see the artist's name or credit line next to advertisements for products. Advertising agencies often purchase all rights to the work for a specified time. They usually pay the artist generously for this privilege and spell out the terms clearly in the artist's contract.

How to register a copyright

The process of registering your work is simple. Visit the United States Copyright Office website at www.copyright.gov to file electronically. You can still register with paper forms, but this method requires a higher filing fee. To request paper forms, call (202)707-9100 or write to the Library of Congress, Copyright Office-COPUBS, 101 Independence Ave. SE, Washington, DC 20559-6304, Attn: Information Publications, Section LM0455 and ask for package 115 and circulars 40 and 40A. Cartoonists should ask for package 111 and circular 44. They will send you a package containing Form VA (for visual artists).

You can register an entire collection of your work rather than one work at a time. That way you will only have to pay one fee for an unlimited number of works. For example, if you have created a hundred works between 2011 and 2013, you can complete a copyright form to register "the collected works of Jane Smith, 2011–2013." But you will have to upload digital files or send either slides or photocopies of each of those works.

Why register?

It seems like a lot of time and trouble to complete the forms to register copyrights for all your artworks. It may not be necessary or worth it to you to register every artwork you create. After all, a work is copyrighted the moment it's created anyway, right? The benefits of registering are basically to give you additional clout in case an infringement occurs and you decide to take the offender to court. Without a copyright registration, it probably wouldn't be economically feasible to file suit, because you'd be entitled to only your damages and the infringer's profits, which might not equal the cost of litigating the case. If the works are registered with the U.S. Copyright Office, it will be easier to prove your case and get reimbursed for your court costs.

Likewise, the big advantage of using the Copyright © also comes when and if you ever have to take an infringer to court. Since the Copyright © is the most clear warning to potential plagiarizers, it is easier to collect damages if the © is in plain sight.

Register with the U.S. Copyright Office those works you fear are likely to be plagiarized before or shortly after they have been exhibited or published. That way, if anyone uses your work without permission, you can take action.

Deal swiftly with plagiarists

If you suspect your work has been plagiarized and you have not already registered it with the Copyright Office, register it immediately. You have to wait until it is registered before you can take legal action against the infringer.

Before taking the matter to court, however, your first course of action might be a well-phrased letter from your lawyer telling the offender to "cease and desist" using your work, because you have a registered copyright. Such a warning (especially if printed on your lawyer's letterhead) is often enough to get the offender to stop using your work.

Don't sell your rights too cheaply

Recently a controversy has been raging about whether or not artists should sell the rights to their works to stock illustration agencies. Many illustrators strongly believe selling rights to stock agencies hurts the illustration profession. They say artists who deal with stock agencies, especially those who sell royalty-free art, are giving up the rights to their work too cheaply.

Another pressing copyright concern is the issue of electronic rights. As technology makes it easier to download images, it is more important than ever for artists to protect their work against infringement.

Log on to www.theispot.com and discuss copyright issues with your fellow artists. Join organizations that crusade for artists' rights, such as the Graphic Artists Guild (www.gag.org) or The American Institute of Graphic Arts (www.aiga.org). Volunteer Lawyers for the Arts (www.vlany.org) is a national network of lawyers who volunteer free legal services to artists who can't afford legal advice. A quick Internet search will help you locate a branch in your state. Most branches offer workshops and consultations.

PROMOTING YOUR WORK

So, you're ready to launch your freelance art or gallery career. How do you let people know about your talent? One way is by introducing yourself to them by sending promotional samples. Samples are your most important sales tool, so put a lot of thought into what you send. Your ultimate success depends largely on the impression they make.

We divided this article into three sections, so whether you're a fine artist, illustrator, or designer, check the appropriate heading for guidelines. Read individual listings and section introductions thoroughly for more specific instructions. As you read the listings, you'll see the term SASE, short for self-addressed, stamped envelope. Enclose an SASE with your submissions if you want your material returned. If you send postcards or tearsheets, no return envelope is necessary. Many art directors want only nonreturnable samples, because they are too busy to return materials, even with SASEs. So read listings carefully and save stamps.

ILLUSTRATORS & CARTOONISTS

You will have several choices when submitting to magazines, book publishers, and other illustration and cartoon markets. Many freelancers send a cover letter and one or two samples in initial mailings. Others prefer a simple postcard showing their illustrations. Here are a few of your options:

Postcard. Choose one (or more) of your illustrations or cartoons that represent your style, then have the image(s) printed on postcards. Have your name, address, phone number, e-mail, and website printed on the front of the postcard or in the return address corner. Somewhere on the card should be printed the word "Illustrator" or "Cartoonist." If you use one or two colors, you can keep the cost below $200. Art directors like postcards because

they are easy to file or tack on a bulletin board. If the art director likes what she sees, she can always call you for more samples.

Promotional sheet. If you want to show more of your work, you can opt for an 8½×11 color or black-and-white printed image or photocopy of your work. No matter what size sample you send, never fold the page. It is more professional to send flat sheets, in a 9×12 envelope, along with a typed query letter, preferably on your own professional stationery.

Tearsheets. After you complete assignments, acquire copies of any printed pages on which your illustrations appear. Tearsheets impress art directors because they are proof that you are experienced and have met deadlines on previous projects.

Photographs. Some illustrators have been successful sending photographs, but printed or photocopied samples are preferred by most art directors. It is not practical or effective to send slides.

Query or cover letter. A query letter is a nice way to introduce yourself to an art director for the first time. One or two paragraphs stating your desire and availability for freelance work is all you need. Include your phone number and e-mail address.

E-mail submissions. E-mail is a great way to introduce your work to potential clients. When sending e-mails, provide a link to your website or JPEGs of your best work.

DESIGNERS & DIGITAL ARTISTS

Plan and create your submission package as if it were a paying assignment from a client. Your submission piece should show your skill as a designer. Include one or both of the following:

Cover letter. This is your opportunity to show you can design a beautiful, simple logo or letterhead for your own business card, stationery, and envelopes. Have these all-important pieces printed on excellent-quality bond paper. Then write a simple cover letter stating your experience and skills.

Sample. Your sample can be a copy of an assignment you've completed for another client, or a clever self-promotional piece. Design a great piece to show off your capabilities.

Stand out from the crowd

You may have only a few seconds to grab art directors' attention as they make their way through the "slush pile" (an industry term for unsolicited submissions). Make yourself stand out in simple, effective ways:

Tie in your cover letter with your sample. When sending an initial mailing to a potential client, include a cover letter of introduction with your sample. Type it on a great-looking letterhead of your own design. Make your sample tie in with your cover letter by repeating a design element from your sample onto your letterhead. List some of your past clients within your letter.

> ## PRINT AND MAIL THROUGH THE USPS
>
> If you're looking for a convenient, time-saving and versatile service for printing and mailing promotional postcards, consider the U.S. Postal Service. USPS offers a postcard service through several partner sites. You can have promotional postcards printed in a variety of sizes and buy as many or as few as you need.
>
> One drawback of going through the USPS and its partner sites is that you can't order extra postcards to keep on hand—cards must be addressed online and are mailed out for you automatically. But you can essentially create a personal database and simply click on an address and mail a promo card whenever needed. You can upload different images and create postcards that are geared to specific companies. (When you visit the site, click on "Create Greeting Cards & Postcards!" in the Shipping & Mailing section.)

Send artful invoices. After you complete assignments, a well-designed invoice (with one of your illustrations or designs strategically placed on it, of course) will make you look professional and help art directors remember you—and hopefully, think of you for another assignment.

Follow up with seasonal promotions. Many illustrators regularly send out holiday-themed promo cards. Holiday promotions build relationships while reminding past and potential clients of your services. It's a good idea to get out your calendar at the beginning of each year and plan some special promos for the year's holidays.

Are portfolios necessary?

You do not need to send a portfolio when you first contact a market. But after buyers see your samples they may want to see more, so have a portfolio ready to show. Many successful illustrators started their careers by making appointments to show their portfolios. But it is often enough for art directors to see your samples. Some markets in this book have drop-off policies, accepting portfolios one or two days a week. You will not be present for the review and can pick up the work a few days later, after they've had a chance to look at it. Since things can get lost, include only duplicates that can be insured at a reasonable cost. Only show originals when you can be present for the review. Label your portfolio with your name, address, and phone number.

Portfolio pointers

The overall appearance of your portfolio affects your professional presentation. It need not be made of high-grade leather to leave a good impression. Neatness and careful organization are essential whether you're using a three-ring binder or a leather case. The most popular portfolios are simulated leather with puncture-proof sides that allow the inclusion of loose

samples. Choose a size that can be handled easily. Avoid the large, "student-size" books, which are too big to fit easily on an art director's desk. Most artists choose 11×14 or 18×24. If you're a fine artist and your work is too large for a portfolio, bring a digital portfolio on a smartphone or tablet or slides of your work and a few small samples.

- **Don't include everything you've done in your portfolio.** Select only your best work, and choose pieces relevant to the company you are approaching. If you're showing your book to an ad agency, for example, don't include greeting card illustrations.
- **Show progressives.** In reviewing portfolios, art directors look for consistency of style and skill. They sometimes like to see work in different stages (roughs, comps, and finished pieces) to examine the progression of ideas and how you handle certain problems.
- **Your work should speak for itself.** It's best to keep explanations to a minimum and be available for questions if asked. Prepare for the review by taking along notes on each piece. If the buyer asks a question, take the opportunity to talk a little bit about the piece in question. Mention the budget, time frame, and any problems you faced and solved. If you're a fine artist, talk about how the piece fits into the evolution of a concept and how it relates to other pieces you've shown.
- **Leave a business card.** Don't ever walk out of a portfolio review without leaving the buyer a sample to remember you by. A few weeks after your review, follow up by sending a small promo postcard or other sample as a reminder.

FINE ARTISTS

Send a 9×12 envelope containing whatever materials galleries request in their submission guidelines. Usually that means a query letter, images and résumé, but check each listing for specifics. Some galleries like to see more. Here's an overview of the various components you can include:

- **Digital images or slides.** Send eight to twelve digital images (JPEGs on a disk) or slides of similar work in a plastic slide sleeve (available at art supply stores). Slide submissions are less common these days, but, if you do submit slides, protect them by inserting slide sheets between two pieces of cardboard. Ideally, images should be taken by a professional photographer, but if you want to photograph them yourself, refer to *The Quick & Easy Guide to Photographing Your Artwork* by Roger Saddington (North Light Books). Label each image with your name, the title of the work, the medium, and the dimensions of the work. For slides, also include an arrow indicating the top of the slide. Include a list of titles and suggested prices gallery directors can refer to as they review the disk or slides. Make sure the list is in the same order as the images on the disk or the slides. Type your name, address, phone number, e-

mail, and website at the top of the list. Don't send a variety of unrelated work. Send work that shows one style or direction.

- **Query letter or cover letter.** Type one or two paragraphs expressing your interest in showing at the gallery, and include a date and time when you will follow up.
- **Résumé or bio.** Your résumé should concentrate on your art-related experience. List any shows your work has been included in, with dates. A bio is a paragraph describing where you were born, your education, the work you do, and where you have shown in the past. (See "The Art of Writing" in the Articles & Interviews section for information on writing bios.)
- **Artist's statement.** Some galleries require a short statement about your work and the themes you're exploring. Your statement should show you have a sense of vision. It should also explain what you hope to convey in your work. (See "The Art of Writing" in the Articles & Interviews section for information on writing an artist's statement.)
- **Portfolios.** Gallery directors sometimes ask to see your portfolio, but they can usually judge from your JPEGs or slides whether your work would be appropriate for their galleries. Never visit a gallery to show your portfolio without first setting up an appointment.
- **SASE.** If you need material returned to you, don't forget to include an SASE.

DO YOU NEED AN OGSM?

Use Strategic Planning to Boost Your Creative Career

by Linda Fisler

Brought from Japan to corporate America in the 1950s, the OGSM concept was used initially by car manufacturers. Today large corporations, including Fortune 500 companies, employ this framework to keep their workforces centered on goals and objectives. Ideally this tool can express in a one-page document what a traditional business plan takes 50 pages to explain. The initials in OGSM stand for *objective*, *goals*, *strategies* and *measurements*. So in what way can this concept be applied to an artist's business or artwork? Let's walk through the process of creating a sample OGSM and see.

You can compose an OGSM in any word-processing application, such as Microsoft Word, that allows for inserting a table. Or you can use spreadsheet software, such as Excel, to create an OGSM. If you aren't computer savvy, simply handwrite the plan on a sheet of paper. Whatever format you choose, you'll need four columns, labeled "Objective," "Goals," "Strategies" and "Measurements" respectively.

Identifying an objective

The first step is to identify an objective. Think of it as your mission—what you're going to focus on and work to accomplish within a year's time. The objective should be both broad and detailed enough that it encompasses all facets of your plan. An example might be: "My

Linda Fisler is an artist and a business mentor at www.artistmentorsonline.com, where she adapts her 26 years of experience as a manager at Procter & Gamble to help artists develop business skills.

Excerpted from the May 2011 issue of *The Artist's Magazine*. Used with the kind permission of *The Artist's Magazine*, a publication of F+W Media, Inc. Visit www.artistsnetwork.com to subscribe.

objective is to become a recognized and respected artist, with an increase in the number of my collectors and followers, which should increase my income."

You can flesh out this trial objective by specifying how many more collectors and followers you wish to attract and the income increase you hope to gain as a result. The statement would then look something like: "My objective is to become a recognized, respected artist, with an increase of 25 percent in the number of my collectors and followers, which in turn should increase my income by an additional 5 percent."

Now you're almost finished with this task, but you need to be certain that this objective addresses every aspect of your business. Surely you don't want to forget your established collectors and followers, so the final, adjusted statement should include them: "My objective is to become a recognized, respected artist, with an increase in my collectors and followers of 25 percent, which in turn should increase my income by an additional 5 percent, while honoring my current collectors and followers."

Setting goals

With an objective firmly stated, you can move on to setting goals. This step in the process breaks down the objective into tangible benchmarks you'll work to achieve over the year. The trial objective states that you want to increase your collectors and followers by 25 percent. One of your goals may be to grow your mailing list by 15 percent. Another goal may be to increase the number of your friends and followers at Twitter and Facebook by 10 percent.

These goals become more tangible if you throw in a little math. So to determine 15 percent of the current number on a mailing list (which we'll say is 200 people), you simply multiply 200 by .15; this gives you the number of new subscribers you must recruit to your mailing list this year—in this case, 30. According to your objective, you want to grow your income by 5 percent. In a similar way, you can calculate how much income that would be. You might also set goals determining how much of that income will come from new sales as compared to your current collector base.

Developing strategies

With your objective and goals established, it's time to list your strategies for attaining your goals and objective. Let's take the goal of increasing your mailing list by 15 percent. One strategy to achieve this could be to place a spot on your website where a visitor can register to be included in your mailing list. Another strategy could be that, at any showing of your artwork, you have a guest book where people sign in with their mailing and e-mail addresses. Yet another strategy could be this: No matter where you are, if someone takes an interest in your artwork, you will ask for his or her mailing information. To further break down your strategy into digestible bits, you may want to set a target of a certain number of new regis-

TIPS FOR DEVELOPING AN OGSM

Here are some questions to help you formulate your objective, goals, strategies and measurements:

Objective:

- What is it I want to accomplish this year? long term?
- Is my objective broad and inclusive enough to cover all facets of what I wish to achieve?

Goals:

- What markets will I need to target?
- What practices will help me meet my objective?

Strategies:

- What choices do I need to make to achieve my goals?
- Where should I focus my attention to achieve my goals?
- Can I break down my strategies into manageable parts?

Measurements:

- What benchmarks will indicate I'm on the right path?
- Is the measurement accurate and representative of its respective goal?
- Although the industry standard is somewhere between 250–600 words, there is no set rule for the perfect post length. However, a mix of short and long posts keeps your blog from getting too predictable. Use Google Analytics to measure and monitor your website and blog traffic and watch it grow! Your main goal for the blog is to convert your readers into business prospects.

trations each month. You can assign target amounts per month for each strategy. Then you can proceed to develop strategies for every goal you've listed.

Measuring progress

So at this point you have examples of an objective, goals and strategies in place, but you aren't finished yet. Unless there's a way to measure how your strategies are working, you won't have any idea how successful you are at reaching your goals. The measurements for each strategy should vary. Some may be very easy to measure, while others may take some creativity and legwork.

Looking again at the example of increasing your mailing list by 15 percent, the strategies set for that can be measured very easily. There's a number you're trying to achieve. In the measurement portion of the OGSM, you would enter that you're going to track the number of new registrations to your mailing list and check it against your projections of how many new members you need each month. You'll check this measurement each month to ensure you're working toward achieving your goal. To evaluate the success of other strategies may

require following up with clientele. For example, if your goal is to have very satisfied customers, you may need to do a customer survey to determine how satisfied they really are.

Boosting art skills

In addition to advancing an art business, the OGSM concept can also be an instrument for boosting art skills. For example, a sample of this type of objective could be to focus on improving the quality of your art by developing strong design and harmonious color in your paintings. Your sample goals could be to be accepted into two national shows and to begin your journey to becoming a signature member of an art association. Some strategies could be to attend selected workshops, study various instructional books and DVDs, seek out a mentor and practice by doing a painting a day. Measurements for this objective could be how many of the designated workshops you complete and how many of the books and DVDs you study, whether or not you find a mentor and, finally, how successful you are at completing a painting a day. Your ultimate, longer-term measurement would be whether you get into the national shows and eventually obtain signature status in a society.

Through these examples, I've shown how using an OGSM framework can help you hold yourself accountable as an artist and keep you focused and inspired to reach your objective and goals—for both the business and creative aspects of your art. By clearly stating your objective, your goals and the strategies for attaining each goal—and by measuring your progress against each goal—you can maintain a more direct and informed path to a successful and satisfying career.

STRENGTHEN YOUR BUSINESS

7 Lessons for Leading, Marketing, Using Time Wisely and More

by Marcia Hoeck

In the early days of my marketing communications firm, there was nothing I wanted more than a blueprint for what I should be doing as a business owner. I was doing well, but I had no idea how to manage my business, and didn't know if I'd be around next year—or even next month. I wanted to know what made a business work so that mine wouldn't fall apart around me, and I needed it dished out in language I could understand. I had a BFA in graphic design, not an MBA—and traditional business plans and spreadsheets made me want to run for the hills with my hair on fire.

There wasn't a resource specifically written for creative professionals available to me back then, so I had to learn on my own. Soon, people started asking me how I got my business to run so well, so solidly, for so long (more than 25 years). They asked how I got such great people to work for me and kept them so long (for 6, 14, 22 years), and how I kept my clients for so long (6, 10, 14 years).

What follows is a brief overview of the plan I created for myself—the guide I wished I'd had handed to me all those years ago.

1. Build a rock-solid vision

When I ask entrepreneurs, "What's your vision for your business?" I'm surprised by how often they answer, "Well, that's a good question."

Marcia Hoeck makes business easy and less scary for values-driven entrepreneurs with her coaching programs and products. Get her free Business Confidence Grader worksheet and tutorial. www.marciahoeck.com/confidence-grader

Excerpted from the July 2011 issue of *HOW* magazine. Used with the kind permission of *HOW* magazine, a publication of F+W Media, Inc. Visit www.howdesign.com to subscribe.

Vision is pivotal to your success. Your car won't take you where you want to go if you just drive aimlessly around. If you don't know where you're starting from, where you're headed and why you want to go there, and have an idea of how to get from here to there, it isn't going to happen. You need to steer it, and you need to think of your business in the same way. How?

Document where you are now. The first step in plotting your route involves taking a look at your business and having a good feel for where you are now. How many clients do you have? Which ones are most profitable? (That question usually yields some surprises.) How's the traffic to your firm's website? How well do you convert prospects to clients? What projects get your team in a real groove? What problems are making you crazy? Are you happy with your workload and your personal income? Simply paying attention to this brings breakthroughs for many business owners.

Then figure out where you want to go, and why. Running a business for the wrong reasons—i.e., because someone else thinks that's what you should do—can make your work much more difficult. Focus on the Big What and the Big Why: Consider the kind of work you want to do and be sure it's something you really love.

A good way to get your head around the Big What is to imagine your perfect day, step by step. Where do you go to work? (At home? To a building? What kind of atmosphere does the office have?) Who's there? (No one? A few people? Many people? Who are they?) What are they doing? How do you interact with them? What do you do first when you start your day?

For the Big Why, think about what drives you to do this kind of work. A childhood dream? A desire to save the planet or to make the world a better place? To spend more time with your kids? The stronger your Big Why, the more likely you'll get your Big What.

My Big Why was simple: I was a single mom with the wolf at my door. I had a passion and a purpose. Without that kid needing cereal in the morning, I doubt I would have had the necessary drive to get to the Big What.

2. Project steady confidence

Nothing makes you feel better about your business and look better to clients than having the right kind of confidence. It's the underpinning of everything you do.

Cultivate confidence in yourself as well as in your work. Are you as confident in your ability to communicate your contribution to the work as you are in the value of the work itself? This is where many creative people have a disconnect.

Because you hold the design work you produce in such high regard, you may downplay your own contribution to it. You might have no problem talking about the work, but a great big problem talking about yourself or taking due credit. It sounds harmless, but it shows up to clients as a lack of competence—and that can raise enough doubt in their minds to scuttle the deal. The challenge is in showing confidence without turning clients off with arrogance.

Take control of overwhelm. Ever notice how quickly you lose confidence when you're overwhelmed? At times like this, thinking more won't help. Knowing how to prioritize, focusing on your purpose and getting rid of limiting beliefs will lead to more consistent confidence in yourself as a business owner, making your business naturally stronger.

3. Communicate your difference

You need to know how to talk about what makes you different, and why yours is the perfect company for your clients to hire. Every design firm positions itself as client-oriented, results-driven, creative and fun to work with. Beyond that, what makes your studio different—really different?

Know your driving forces. The things that drive you can be very strong differentiators. No one has exactly the same reasons you have for being in business, exactly the same passion you have to serve clients, or exactly the same insights you have about how to make the world a better place. Communicate these, and they'll help shape your difference.

Talk to clients. Ask your clients what they struggle with, what they want and how you've helped them. They'll tell you what it's like to work with your firm and shed light on your capabilities from an outside point of view, giving you insight you'd never gain on your own. Throw these perspectives into the brew.

Use sneaky brain tricks. Sometimes just trying to think of what makes you different and valuable to your clients is difficult, and you have to trick your brain to get to the information. Try going on a rant about a subject you're passionate about, or imagining that you have to write a book on the topic you know the best—by next week.

4. Commit to being visible

Being visible is all about letting the right people know what you offer so they'll find you and be attracted to you. Both the methods and the message have to be a good fit for you.

Choose methods that work for your unique situation. You know you should have a consistent plan for marketing your business. There are many methods to get the word out. You don't need to do all of them, but you do need to figure out which ones work for you, and you do need to do them authentically and consistently.

Craft a clear message. You're great at this for clients, but maybe not so good at it for yourself. If you understand what makes your business different, then tap into that to express a message that's compelling, genuine, and communicated in a way that your ideal audience can hear.

5. Be effectively productive

As a creative business owner, you have lots of interests and you're easily distracted. You're free to spend your time doing what you want, and you've got so many ideas. But often, you just don't do the things you should be doing to make your business successful.

Track all of your time. If you're like most business owners, you only track time for client projects. Try tracking your internal time, as well—the hours you spend on tasks like managing your team, reaching out to prospects, answering e-mail, standing in line at the post office. Chart the personal time you take during the workday, like going to doctor's appointments. Prepare to be amazed at how much time you waste. One of my clients was so appalled after tracking her internal time that she called me to say, "Who the hell do I think I am? Mrs. Astor?" She was spending lots of time at lunch and on personal appointments.

Schedule your activities. You might also try scheduling your time. Put everything on your calendar, including time for planning, writing, calls and internal projects, as if they're appointments. What gets scheduled gets done.

Create systems. Notice repeatable activities that you can build into processes, like research calls to prospective clients. Document and schedule the tasks so they become almost automatic. Using information to design systems is an efficient way to generate more time to be creative.

6. Get the right support

In order to be excellent at the things you and only you can do, you need the right support from people both inside and outside your company.

Look for supportiveness and shared values. When looking for people to add to your team, there are two things more important than skills or experience. Many people are capable, but if you don't choose those who 1) share your values and 2) are willing and able to truly support you, they won't be a good fit for the long run.

Get direction and accountability for yourself. As the leader of your business with no one to report to, it's easy to doubt yourself and to get off track. To get an objective look at your business, you need a different kind of support, in the form of direction and accountability for yourself. Find a coach, consultant, peer group or mastermind group just for you. One of my own coaches put it this way: "Even the sharpest knife can't carve its own handle."

7. Understand your money

There's a lot of crazy thinking around money that hampers our ability to make more of it. It has to do with feelings of worth and the deep-seated fear of rejection.

Think about getting paid as an energy exchange. Let's talk about why you feel such angst about money. Think about what you put out there (your work) and what you get back in exchange (the client's money) as energy. We know from science class that every energy

exchange in the universe has to be equal—for every force in nature there is an equal and opposite force. That's why you feel uneasy when the exchange isn't equal.

Balance the scorecard. It's your job to make sure the energy is balanced and your compensation is equal to the work you do. For example, don't discount your rates in order to get a project; instead, revise your proposal with fewer services to fit the client's budget. Offer bundled packages of your services where the client gets a slightly better deal when engaging you for larger programs, and you both benefit from economies of scale. Alert the client when a project is going over budget, and get documented approval to cover additional costs.

Balance also includes keeping track of where your money is: what you have, what you owe and what's owed to you, as well as the relationship between your marketing activities and income.

That pretty much covers my business success plan. Sure, there are details to fill in, but every aspect of running your firm more or less falls under one of these seven headings.

It's the same plan I use with my clients today, and if a business isn't working, it's because one of the seven areas is out of kilter. It's an easy plan to understand, and it's creative-friendly.

And not one of my clients has ever run for the hills with her hair on fire.

THE BUDGET GAME

How to Play the Numbers Game and Win

..

by Ilise Benun

How many times have you submitted a proposal and then never heard from your prospect again? Or worse, learned that the project was awarded to someone else because your price was too high?

If either of these is a common occurrence, you're probably wasting valuable time writing proposals you will never win. The only solution is to learn how to distinguish the viable prospects from the deadbeats before you agree to write anything. And that means you have to find out what the prospect's budget is.

But that's a problem, because either you're afraid to ask, or you ask and the response you get is useless. Either way, you're back to square one. That's the moment to do something different.

Discovering a prospect's budget isn't that complicated; it just requires some creativity and persistence. It's one more business communication skill you can learn if you want to save yourself time and, more important, anxiety.

After being in business for six years, Ashleigh Hansberger and Sunny Bonnell of Myrtle Beach, South Carolina-based Motto Agency have learned that skill. "Proposal writing can be a huge waste of time," Hansberger says. "We learned to talk more and write less, and to agree on cost verbally before we put it in writing."

Ilise Benun, founder of Marketing Mentor and co-producer of the Creative Freelancer Conference (www.creativefreelancerconference.com), works with creative freelancers who are serious about building healthy businesses. Sign up for her Quick Tips at www.marketing-mentortips.com.

Excerpted from the July 2011 issue of *HOW* magazine. Used with the kind permission of *HOW* magazine, a publication of F+W Media, Inc. Visit www.howdesign.com to subscribe.

Talk about money early

Broaching the subject of money as early in the process as possible puts you in the driver's seat. It positions you as the professional you are, planting the seeds for the client to trust they're in good hands. It also allows you to weed out inappropriate candidates. Your goal in the first conversation is to determine whether you can provide what they need and, if so, whether it would be a profitable project for you.

Asking directly for the prospect's budget should be one of many basic questions you ask to achieve that goal. It's no different from "What is your timeframe?" or "What is your objective with this project?" This may seem obvious, but many people neglect to ask this basic question. (Some creative professionals don't address money at all, so when they go to bill the project, they find themselves in a bit of a pickle.)

In the best-case scenario, and especially if you're talking to a corporate professional, your prospect will simply tell you their budget. Big-company clients don't take any of this personally, as many small-business owners do. They know you need to know, and they don't want to waste their time reviewing a proposal that doesn't work within their budget.

Here are a few phrases to try:

"What budget have you allocated for this project?" The construction of this question presumes they have allocated a budget.

"What do you have in mind to spend?"

"What can you afford?"

If they reply, "I don't know"—meaning, someone else has established a budget but your contact doesn't know what it is—they may be looking for you to tell them how much the

LET'S TALK ABOUT MONEY

There are several ways to segue into the money conversation:

1. **Be matter-of-fact.** "We've talked about everything else. Now, let's talk about the cost." Note the use of "the cost" and not "our fees." This is about what it costs to do what they need done, not what you will charge. Precise language makes it more objective and professional.

2. **Take the pressure off.** "It's helpful to get the money thing rolling. We don't have to settle it this minute, but I wanted to give you some ideas about what we should be thinking." Note the use of "we," which implies a collaborative process.

3. **Give them your thinking.** "Here's how we think about the money." This approach implies you've given it thought and you've done this a lot, instilling confidence and credibility.

4. **Make a joke.** "Here's everyone's favorite part of the conversation." A little levity goes a long way.

project should cost (you are, after all, the expert here). If you sense this could be a viable project, it's worth probing to make sure you're at least in the same ballpark.

However, you should consider certain responses to be red flags, such as: "I don't have much to spend," or "We don't really have a budget." Those answers signify that you should push to get a number before the end of the conversation so you can decide whether or not to pursue the work. You can say:

"If you're looking for the most inexpensive designer, I'm not your best option. Can you give me a general idea of what you can afford?"

Float some numbers

Just because a prospect says they don't know their budget doesn't mean you can't find out what they're thinking of spending. Call on your creativity: Throw out some round numbers to see how they react. As soon as there are numbers on the table, people tend to respond, even when they claim not to know. Start with:

"I can think of several ways we could approach this depending on how much you want to invest. So tell me, are we talking about $2,000 or $20,000?"

Giving them a wide range, even if they didn't know their budget, will trigger a response such as "Well, we don't have $20,000, but somewhere in the middle could work." This gives you something to start with.

If they say, "Well, $2,000 would be ideal but we probably couldn't go higher than $5,000," then you know to outline in your proposal (if you decide to pursue the project) what they can get within that range. This alone will save you time estimating higher or proposing services they don't need or can't afford. You may worry that when you throw out numbers, the client will automatically choose your lowest. Not so. Good prospects know that the lowest price indicates low quality. If they affirm the low number, that may be your cue to walk away.

Plus, at this point you're just trying to gauge budget—you're not quoting a price—so be sure to let your prospect know that these numbers are not yet firm.

All of this back and forth should be done in real time, either on the phone or in person, so you maintain control over the conversation. Asking these questions via e-mail doesn't give you the opportunity to see or hear their reactions and respond accordingly, and is therefore much less effective. When someone e-mails you to ask for your price on a project, call them immediately or reply via e-mail with a request for a phone meeting to discuss their needs. Unless you don't want the job, don't respond via e-mail with numbers.

Try a mini-proposal first

Sometimes, no matter how you ask or how creatively you probe, the prospect won't reveal their budget. One alternative is a mini-proposal. You can say:

"OK, I understand you can't provide the budget. So I'm going to work up some numbers and a brief scope of work, and then present it to you before doing a full-fledged proposal. If the numbers work, I'll go ahead. If not, I won't."

This mini-proposal can be as short as a paragraph or as long as a page. It should include a recap of what you discussed with general price ranges. Think "executive summary," and make it easy to skim, with an emphasis on bullets and lists. The mini-proposal lays out a price that the prospect can respond to, without taking too much of your time to prepare.

This process of getting the budget isn't easy for most creative professionals, but it does get easier once you've learned the art (and it is an art) of finessing questions that will uncover the information you need. It's a worthwhile habit to develop. And it's your responsibility to yourself as a business owner, whether a solopreneur or an agency owner, not to waste time writing proposals that you never get, just because a prospect doesn't know or won't share their budget.

To run a successful practice, you have to be a clear communicator, especially when it comes to money. Some prospects may not be willing to share the numbers when you ask, and you risk annoying them if you push too far. But the more you welcome these exchanges and learn how to communicate more clearly, the stronger your financial footing will be.

Put this into practice and you'll submit fewer proposals, but all of them will be legitimate. The result: less time with tire-kickers and more time with serious opportunities.

NEGOTIATING THE CONTRACT

by Ilise Benun

"We see things in black and white: 'They either want me or they don't. I'll either get it or I won't. They will pay this price or they won't.' But between those two poles, there are many other possibilities, if only you would take the time to talk about them, address them, propose them."

—*Mikelann Valterra, certified financial recovery coach and author*

Every business book you read will tell you that you need a contract for every client and every project. But in the real world of doing business, it's easy to let this detail slip through the cracks, especially if you aren't particularly comfortable with it in the first place. Is it because you don't have a good contract? (If you read this article, you won't be able to use that excuse anymore.) Or because it's an extra step in the process to get things in writing? Or

Ilise Benun, founder of Marketing Mentor and co-producer of the Creative Freelancer Conference (www.creativefreelancerconference.com), works with creative freelancers who are serious about building healthy businesses. Sign up for her Quick Tips at www.marketing-mentortips.com.

because the job is a rush and there simply is no time to get a contract signed? (How long does it really take?)

If you've been stiffed or had to absorb a cost you couldn't afford thanks to lack of a contract, you have hopefully learned from the experience. If you haven't been lucky enough to have a bad experience yet, read on. . . .

WHAT IS A CONTRACT, AND WHY DO I NEED ONE?

You need a contract because human relationships are messy, memories are imperfect and communication is often ambiguous. A contract cannot protect you from any of this, but it can bring some clarity and consensus.

Clarity because it puts in writing what was said (and sometimes not said) so all parties can review it before embarking on a joint project. Consensus because each party must agree to what is written before proceeding further. If any problems arise afterward, the contract stands as the objective document to fall back on.

Simply put, a contract is a document that can protect all parties by avoiding misunderstandings and serving as a paper trail if things do go wrong. It outlines the terms and conditions under which you will perform your work, what you will provide to the client and what they will provide in return. Its purpose is also to anticipate problems and clarify the responsibilities of both parties should problems arise.

A contract isn't necessarily a thick document with lots of legalese. A contract can be a simple outline of the terms and conditions by which you and your client agree to work. Or it can be a complex document of several pages, depending on the intricacy of the project or the number of elements involved. Its purpose is to set forth the terms of work—deadlines, scope of work and limitations, contingencies in case of unexpected changes and potential misunderstandings. More than anything, putting these items in writing prevents miscommunication and keeps everyone's stress level low.

Many creative professionals believe that contracts are only necessary for big jobs with big fees for big clients. They often skip the paperwork on small projects. But it's actually the little stuff that has the most potential to cause time-consuming, expensive problems.

Contracts are especially important for creative professionals because when you sell your work, you essentially are selling a right to your property—in this case, your intellectual property, which is intangible. And because it's intangible, the process may be less clear than if the object in question were tangible, like a car or a house.

However, a contract is only as good as the people signing it. Business relationships are built on trust. In fact, many agreements are made on a handshake and that is enough if both parties are trustworthy. So the rule to live by is this: If you sense that your partner is not negotiating in good faith, walk away. Nothing you put in a contract will protect you.

What about a contract's ability to anticipate what might happen? In real life you can't predict everything that could possibly happen, so don't spend too much time thinking about every single "what if." If you're dealing with honorable people, you'll come up with an acceptable solution to an unanticipated problem, even if it's not in the contract.

That said, have your own contract drawn up by an attorney who understands creative services and your interests. You can customize it for each situation. If that's beyond your means, there are plenty of resources available.

SAMPLE CONTRACT

Gerry Suchy of Arlington, Virginia-based GMS Designs has generously shared his standard contract, created by his in-house legal team (his wife, who's a lawyer). "Clients love it for its simplicity," says Suchy, "and my wife would be the first to tell you that almost all legal documents are mash-ups of documents that preceded them. The law firm rule is don't waste time reinventing the wheel if there is a document that can be cut and pasted."

This contract is obviously created for a small design business, but the concepts and language are general enough that they can be adapted for other creative professions. So feel free to adjust this sample contract for your own purposes.

1. Client information

> Name:
> Organization:
> Address:
> E-mail address:
> Phone number:

2. Project information

> Artwork will be designed to enhance the body copy supplied by the client and laid out for an 8½ × 11, duplex, full-color, trifold brochure. All artwork will be done to client specifications and use client-provided graphics. GMS Designs may supplement other graphics with the approval of the client. Any custom graphics obtained from image houses will be paid for by the client. The project will be designed using some combination of Adobe Illustrator, Adobe Photoshop and Adobe InDesign. The final artwork will be output in a file format suitable for commercial printing press production. If the client does not have a commercial printer, GMS Designs will make three (3) recommendations.

Go into as much detail as possible about what you will do and how you will provide the deliverable.

3. Project price and payment terms

The project price is based upon a negotiated package price for the entire project of $_____.

The price quote does not include combined a (state) sales tax of 8.0%. Sales tax will not be applied to non-Virginia residents. Additionally if you choose PayPal as your form of payment, there is a service charge that will be computed based on the total payment. This will be itemized and added to the final invoice.

Be sure to note any details regarding state taxes that apply (or don't apply) as well as any service charges you plan to add if you use any services, such as Paypal or other merchant services that charge a fee. It is up to you whether you pass this fee on to your client or absorb it as a cost of doing business. Either way, it should be stated up front and agreed upon. Being able to offer credit card payment helps because small projects can require a very quick turnaround.

4. Final payment terms

An itemized invoice will be provided to the client within three (3) days of project completion, before the final work files are given to client. A deposit of 50% is required to commence work. Final payment is required when the work is complete. In addition to PayPal, I also accept corporate or business checks. Checks will need to clear before the final files are sent.

There are no "right" terms. What's important is that you outline your terms clearly. Always include how much you'll be paid and when, plus your policies regarding late charges. Traditionally, clients with whom you've maintained long relationships should pay "net thirty," meaning they have the standard thirty days to pay. For smaller projects and for new clients, it's customary to request 50 percent in advance and the balance on delivery.

For large projects, consider asking for "progress payments" which are payments that are not tied directly to project milestones, but instead are tied to the calendar. For example, for a project that you estimate will take you four months, propose four equal monthly payments (less the deposit) on the first of every month. This way, if the project takes longer or the client has a bottleneck, your cash flow isn't compromised. Plus it's an incentive to finish the project since they've already paid for it.

5. Revisions

The project price quoted does not include an unlimited number of revisions. I, of course, want you to be satisfied with the final look and feel of the project and I'm sure you feel the same. It has been my experience that good communication between the designer and the client can limit the revisions to just minor changes rather than complete do-overs. Minor changes and adjustments are part of the process.

Do-overs are a symptom of poor communication. Having said that, let me suggest that for the proposed cost of this project I will include two rounds of adjustments. Beyond that, the cost of further adjustments can be negotiated. This way of doing business works to your advantage as well as mine in that your project is finished in a timely manner and within your budget.

What's important here is addressing the issue of revisions and clarifying exactly what a revision is. It is not advised to provide unlimited revisions at a fixed price, especially with a new client.

6. Ownership of artwork/files

Until full payment has been made, GMS Designs retains ownership of all original artwork/files or parts contained therein, whether preliminary or final. Upon full payment, the client shall obtain ownership of the final artwork/files to use and distribute as they see fit. GMS Designs retains the right to use the completed project and any preliminary designs for the purpose of design competitions, future publications on design, educational purposes, marketing materials and portfolio. Where applicable, the client will be given any necessary credit for usage of the project elements. Any trade-sensitive information, such as product pricing or customer data, shall be redacted by the designer prior to use.

Whether you retain ownership of the files or you transfer that ownership to your client is your decision to make. It should be decided on a case-by-case basis. Here, Suchy is transferring all rights in exchange for full payment, while retaining the right to use the material for promotional purposes. If you want to retain the rights and the native files, you must make that clear because most clients do not understand that is not what they're contracting for.

7. Production schedule/delivery of project

The client will assume any shipping or insurance costs related to the project. Any alteration or deviation from the above specifications involving extra costs will be executed only upon approval with the client. The designer shall not incur any liability or penalty for delays in the completion of the project due to actions or negligence of client, unusual transportation delays, unforeseen illness, or external forces beyond the control of the designer. If such event(s) occur, it shall entitle the designer to extend the completion/delivery date, by the time equivalent to the period of such delay.

This clause is designed to avoid the all-too-common situation where a client is delayed in getting their feedback to you and you therefore have less time to implement the changes. It states up front that you will extend your time frame according to the length of their delay.

In the actual situation, that may not be possible or your choice, but at least you've provided for it as an option.

8. Third-party shipping

In the event any material necessary for the production of the project must be shipped to a third party for additional processing, typesetting, photographic work, color separation, press work or binding, the designer will incur no liability for losses incurred in transit, or due to the delay of the shipper of the third party.

9. Claims period

Claims for defects, damages and/or shortages must be made by the client in writing within a period of ten (10) days after delivery of all or any part of the order. Failure to make such claim within the stated period shall constitute irrevocable acceptance and an admission that they fully comply with terms, conditions and specifications.

10. Proofing of final project

The designer shall make every effort to ensure the final product is free of any grammatical and spelling errors, before giving the final product to the client. It is agreed that it is the client's responsibility to ensure that there are no spelling or grammatical errors contained in the final product. It is agreed that the designer is not responsible or held liable for any errors contained in the final product after the final product has been committed to print or posted in view of the public.

These clauses attempt to protect you from mistakes and minimize your liability. These mistakes will hopefully not occur often, but, when they do, it can be catastrophic if you haven't protected yourself.

11. Cancellation

In the event of cancellation of the project, ownership of all copyrights and the original artwork and disks shall be retained by GMS Designs (Gerry Suchy), and a fee for work completed, based on the contract price and expenses already incurred, shall be paid by the client.

It's a good idea to have a clause outlining what will happen and what charges will be incurred in the event of a cancellation of the project. If the cancellation is due to reasons beyond your control, a kill fee should be applied according to a percentage representing the stage of the work completed. The *Graphic Artists Guild Handbook* states, "Typical charges for services rendered can be 25–50 percent if the work is killed during the initial sketch stage, 50 percent if killed after completion of the sketch stage and 100 percent if killed after the final design is

completed." You should also allow for payment in the event that the work is rejected due to client dissatisfaction, which also depends on where in the process the project is. GAG also states, "Common cancellation fees are one-third of the total fee if canceled before completion of final art, and 50–100 percent after the final artwork is completed." This is subject to negotiation but should be provided for.

12. Confidentiality

All correspondence and documents provided will be treated as confidential between the client and the designer, unless consent has been granted by both parties involved.

13. Acceptance of Agreement

The above prices, specifications and conditions are hereby accepted. The designer is authorized to execute the project as outlined in this agreement. Payment will be made as proposed above. This agreement is not valid until signed by client and returned to the designer.

Signature:

Date:

Please print your name here:

BAD CONTRACTS/BAD DEALS AND HOW TO GET OUT OF THEM

By Jean S. Perwin

In the poem "The Hand That Signed the Paper," Dylan Thomas wrote, "Great is the hand that holds dominion over/Man by a scribbled name." All of our hands have signed papers we wish we didn't. But when it happens in business and someone holds dominion over you, figuring out your options can be difficult indeed. If every business relationship went smoothly, no one would ever need to sign or enforce a contract. One of the reasons to have a written contract is to prevent problems and to solve them. What happens if you sign a contract with a client or partner or employer or employee and you live to regret it? What do you do?

First, you have to identify what makes a contract a bad one. A bad contract usually comes down to one of two things: the deal itself is bad or the contract was badly drafted, or both. If the deal you made turned out to be a bad one, the best-drafted contract cannot turn it into a silk purse. But it should be able to help you change it. If the deal is sound, but the contract is poorly drafted, it won't be able to help you solve problems that may come up. But if the deal is bad and the contract poorly drafted, you're down that river and contemplating your lack of a paddle.

If nothing is permanent but change, a good contract anticipates change. And while it's impossible to anticipate every thing that could possibly go wrong, there are several issues that come up often enough that every "good" contract should deal with them.

Money. Money is always a problematic issue in any business relationship. While most agreements specify how much money one party is supposed to be paid by the other, a common problem is how and when. If the contract doesn't say specifically (1) when payments are supposed to be made, (2) what happens if they are not, (3) what has to be done before payments are made or (4) how long after invoices are payments due, there will be problems.

Ownership. In the creative services business, any agreement that does not spell out who owns what when will be problematic. Copyright ownership is the coin of the realm for designers. Agreements should be very clear about when and if rights transfer to the client. Also, pay close attention to work-for-hire language. Much to their chagrin, many creative professionals have discovered belatedly that they signed work-for-hire agreements.

Terms. How long a contract will last can often be the difference between a good contract and a bad one. I have never had a client who regretted signing too short an agreement. But many rue the day they signed long-term agreements. While it can appear very appealing to sign a five-year contract with a client for a monthly retainer, for example, for a specific type of work, five years is a very long time in any business. What looked like a great deal in year one can be strangling you by year three. Short term agreements—no more than one-year with the opportunity to renew—are much safer.

Termination. Every agreement should have a way out. The simpler, the better. "This contract may be terminated with 30 days written notice by either party." A bad contract may spell out the work to be done and how you will get paid … but not what happens if you are not paid or if the client rejects the work. A bad contract includes nothing about ownership of the copyright for the work that is created. It does not address how the agreement will end or specify a term after which the parties would have no obligation to each other. It may contain an attorney's fees provision, but may also include an arbitration provision, which has legal implications you may not understand.

HOW TO GET OUT OF A BAD CONTRACT

There are essentially two ways to get out of a contract—renegotiate it or break it. There are advantages and disadvantages to both.

To renegotiate a contract, you need the other side to be willing to negotiate. If the relationship is still amicable and there's an avenue to work out a new agreement, take it. Sit down. Explain your position and why you need the agreement amended and what

kind of terms you are looking for. Remember that you need the cooperation of the other side, so accusing them of bad behavior, even if it's true, is not helpful.

The advantage of breaking the contract is that you end the relationship—either in writing or orally. The disadvantage is that you may be legally liable for payments or for providing services for which the other side could sue you. From where I sit, litigation is always something to be avoided if possible. It's time consuming, expensive and rarely satisfactory. But unfortunately, sometimes it's unavoidable. If you are considering walking away from a contract, get legal advice to determine whether the cost of walking is worth the potential cost of litigation. Then at least if you decide to take the leap, you're not diving into an empty pool.

The best way to avoid bad contracts is to not get into them in the first place. It is often said that an attorney who represents himself has a fool for a client. I would add that a creative professional who drafts his or her own contracts also has a fool for a client.

Jean S. Perwin is a Miami-based intellectual-property attorney who has expertise in creative services.

GRANTING YOUR WISH

Enhance Your Résumé and Secure Funding

by Christopher Reinhardt

Even under the best economic conditions, the art market can be fickle. Today the economy is in dire straights. Therefore, you need to think outside the box to develop creative ways to introduce your work to the art-buying community. One pathway that's often overlooked is grant support. Actively seeking grant support is common practice in other disciplines, such as biology. However, artists are surprised sometimes to learn that similar programs are available for them. Many artists are equally unaware of the career benefits that winning a grant can have. A grant can provide help for you to focus on a favorite theme and can lead to publicity for your work in the local press and TV, as well as in social media channels like Facebook and Twitter. Listing an award on your curriculum vitae adds considerable weight to your accomplishments as well.

Learn the difference

Both public and private grant programs are available to fund creative and artistic activities. The requirements and qualifications for applicants will vary for each program. Grant awards generally fall into two areas. The first of these is fellowships. A fellowship provides direct financial support to an artist, and the award is often based on the artist's past record of achievement. The goal of a fellowship is to provide a stipend, freeing the artist for cre-

Christopher Reinhardt is a theoretical physicist, a portrait artist—and husband to the classically trained realist painter and grant winner **JoEllen Reinhardt**. Learn more about JoEllen's still life and portrait work at www.joellenreinhardt.com.

Excerpted from the January/February 2012 issue of *The Artist's Magazine*. Used with the kind permission of *The Artist's Magazine*, a publication of F+W Media, Inc. Visit www.artistsnetwork.com to subscribe.

ative activities. The second area is grants. A grant is typically designed to fund a specific project. These awards are often confined to the direct costs for the project, although they may provide salary support.

Check out regional programs

There are state, national and international programs that support the visual arts; however, there are also many regional programs designed to assist local artists within the communities they serve. "Spending a day on the Web is a great place to start to find programs," says Deborah McNamara, vice-chair of the Worcester Arts Council (WAC) in Massachusetts. An agent of the Massachusetts Cultural Council, which receives funding primarily from the Massachusetts Legislature and the National Endowment for the Arts, WAC distributes approximately $75,000 to Worcester-based artists in the form of two fellowships and approximately thirty grant applications each year. There are 328 additional councils servicing all 351 Massachusetts cities and towns. "WAC's website provides current information for potential applicants. We strongly encourage artists to review all posted material and call or e-mail with their questions," says McNamara.

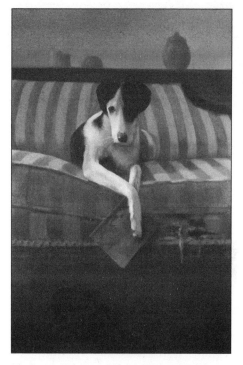

My Secret Valentine (oil, 36×24) is one of the six paintings from JoEllen Reinhardt's project celebrating the history of Worcester, Massachusetts. This piece commemorates Esther Howland, who in 1879 founded the New England Valentine Company and sold her cards in her father's Worcester stationery store. (For this painting, Reinhardt painted her dog Myles—a Puerto Rican Sato Rescue dog—holding a valentine.)

One grant recipient's story

A recent recipient of a WAC grant is JoEllen Reinhardt (www.joellenreinhardt.com). A Worcester native, Reinhardt applied for and received a small grant from WAC to support the development of six separate paintings, each relating to a specific person, company or product that has made a difference in the history of Worcester, Massachusetts. The grant was for $1,000, which helped to pay for general supplies for the project. "I've always been impressed with the many events of cultural and historical significance that have occurred in

12 TIPS FOR GETTING A GRANT

1. Search online for opportunities. The Internet provides a wealth of information (see Grant and Fellowship Websites and Newsletters sidebar).
2. Network with members of local art associations, such as city arts councils, and sign up to receive the clubs' newsletters.
3. Be conscious of the application deadline. The application process will take time, so start preparing early.
4. Be wary of application fees. Most legitimate groups that distribute grants and fellowships are nonprofit organizations and don't require fees for applicants.
5. Many programs are theme-based; therefore, your application should directly address the theme.
6. Understand all budget restrictions. For example, if the granting organization is unable to provide support for capital equipment, your budget cannot include funding to buy a camera.
7. Like the project you're proposing. Only apply to a fellowship or propose a project that you're actually interested in doing.
8. Most programs have specific requirements for applications, so make certain you understand them. For example, if you're not a sculptor, applying for a fellowship to support sculptors is not for you.
9. Follow the proposal submission directions meticulously, with attention to page limitations, font size, spacing, number of copies, and so forth.
10. Be professional. Proofread your application for typos, misspellings and grammatical errors. If images of your work are required, provide high-quality photographs or digital files.
11. Program themes and qualifications can and often do vary from year to year, so always be certain you have a current grant prospectus.
12. Don't procrastinate in requesting letters of recommendation: Asking colleagues can be intimidating, but don't put it off! Writing good letters will take your colleagues some time, so give them ample notice.

Worcester, my hometown," says Reinhardt when asked about her project. "The WAC award provided the incentive to develop a project I'd always planned to do at some point in time."

The award, which culminated in a public exhibition, generated significant local buzz in the community, including coverage on a local TV show and in newspaper articles. The signature piece of Reinhardt's show, entitled *My Secret Valentine* and commemorating Esther Howland, founder of the New England Valentine Company in Worcester, was sold on opening night. There were three portraits in the show; one of them—*Smiley Face*—depicts

GRANT AND FELLOWSHIP WEBSITES AND NEWSLETTERS

- ArtDeadline.com (artdeadline.com)
- Art Opportunities Monthly (www.artopportunitiesmonthly.com)
- Artist Trust (www.artisttrust.com)
- Creative Capital (www.artistsresourceguide.org/creative_capital_foundation)
- The Foundation Center (foundationcenter.org)
- Foundation Grants & Individuals Online (www.gtionline.fdncenter.org)
- Grants.gov (www.grants.gov/applicants/find_grant_opportunities.jsp)
- Institute of Museum and Library Services (www.imls.gov)
- National Endowment for the Arts (www.nea.gov)
- National Endowment for the Humanities (www.neh.gov)
- National Assembly of State Arts Agencies (www.nasaa-arts.org)
- New York Foundation for the Arts (www.nyfasource.org)
- WomenArts (www.womenarts.org)

Charlie Ball, son of the late Harvey Ball, who is credited with the design of the iconic Smiley Face in 1963. Reinhardt received a portrait commission based upon a referral from someone who attended the show. The client was impressed with *Smiley Face* and hired Reinhardt to paint a posthumous portrait.

"The entire grant experience greatly exceeded my expectations," says Reinhardt. "I had the privilege to meet some interesting people from Worcester who generously shared their interest and knowledge of the town's history in preparation for the show. During the opening, small groups would gather around a painting, and people began

Reinhardt's portrait *Smiley Face* (oil, 20×16) features Charlie Ball, son of Harvey Ball—the gentleman who designed the Smiley Face as a symbol to raise employee morale at the State Mutual Life Assurance Company. As a result of the showing of her six pieces, which included three portraits, Reinhardt received a portrait commission.

> ### BOOKS ON GRANTS
> - *The Artist's Guide to Grant Writing* by Gigi Rosenberg (Watson-Guptill)
> - *Guide to Getting Arts Grants* by Ellen Liberatori (Allworth Press)

to share with each other their unique memories or family stories related to the theme of the piece. It was exciting to watch!"

Benefits of winning a grant

For an artist pursuing a career in higher education, the benefits of grant and fellowship awards are obvious. Because applications often require a carefully written description of the project as well as supporting documents, such as letters of recommendation, the process itself is a demonstration of scholarship. Apart from the money awarded to the grant winner, the benefits to the entire community of artists are less apparent. Still, because these honors become permanent accolades for an artist's résumé, awards also enhance the biography of a career painter.

"Fine work will always stand on its own merit; however, artists having notable achievements will often receive a second look from potential buyers, which can lead to a sale," states Domonic Boreffi, the owner of Gallery Antonia in Chatman, Massachusetts (www.galleryantonia.com), which represents the work of nationally recognized artists, including Reinhardt. "Like juried show credits and art reviews in publications," says Boreffi, "being a grant recipient communicates that an artist is serious about his career and that his talent has been recognized by his peers. An artist's record of achievement aids dealers in efforts to promote an artist's work."

Advice to grant seekers

When applying for an award, you should note the application deadline and allow yourself plenty of time to prepare. Most programs require a written description of the proposed topic, as well as biographical information and letters of support from other artists and colleagues. As a result, a quality application will take some time to develop. Before starting work on your proposal, make sure you read and understand the program prospectus and the qualifications for applicants.

Programs are often theme-based, and a competitive application will need to clearly state how the proposed project addresses the theme. Some programs have specific qualifications that an applicant must meet, such as gender, residency status, level of education, and so forth. Feel free to contact program administrators for answers to specific questions. Most administrators welcome the opportunity to discuss their program and take pride in aiding applicants through the process. If you provide yourself ample time for preparation, applying for grant support can be fun and rewarding.

THE ART OF WRITING
Bios, Blogs and Statements

...

by Lori McNee

For many artists, facing a blank page is more intimidating than starting a new canvas! Nevertheless, besides your creative skills, writing is the primary basis upon which your work and intellect will be judged in the professional world and on the Internet. The importance of writing skills isn't limited to bios, blogs and artist's statements. It's also important for e-mails, brochures, sales materials, grants, presentations and even social media. Writing is an art form that artists can work to master, and it is necessary for a successful career.

Many of us have happily forgotten our lessons in English classes that were filled with confusing grammar terminology. Do we really need to understand intransitive verbs, dangling modifiers or even superlatives to be competent writers? Must an oil painter understand the different categories of pigment formulas and their chemical compounds? Of course not!

We can write satisfying words without the worries of whether we are being possessive about adjectives or definite about articles.

"If musicians can play by ear, so can writers, but, if they can't, it helps to know some rules."

—*Henry Ehrlich, editor*

Lori McNee is an exhibiting member of Oil Painters of America and ranks as one of the most influential artists and powerful women on Twitter. She was named a Twitter Powerhouse by *The Huffington Post*. Lori shares valuable fine art tips, art business tips and social media advice on her blog, FineArtTips.com. She has been a talk show host for Plum TV, and has been featured in and written for magazine and book publications and serves on the *Plein Air Magazine* board of advisors.

In this fast-paced world many people suffer from information overload, and understanding how to write something that gets read is more important now than ever. Read on for useful tips for writing a bio, blog and artist's statement.

Artist, blogger, writer, consultant. Paints poetic landscapes, nature, birds, and still life paintings.
http://finearttips.com
htttp://lorimcnee.com

Sun Valley, Idaho

Here is the mini bio that I use for Pinterest. I kept it very simple and clean, much like the site. I added my blogs for extra marketing potential.

HOW TO WRITE AN ATTENTION-GRABBING BIO

Gone are the days when we relied solely on our boring résumés to highlight our accomplishments. Today, you need an attention-grabbing bio to tell readers about you and your work.

A bio should contain four main factors. It should clearly explain who you are and what you do, add a dash of your personality, and then leave the reader with confidence in you.

Unlike a résumé, a bio is less formal. A bio gives you the chance to share your story, build trust and make a positive connection with the reader. Whether you are a photographer, artist, designer or entrepreneur, a good bio is an essential part of your promotional materials.

Three types of bios to consider

No matter its length, your bio is a branding opportunity, especially if you are in business for yourself. I suggest writing all three types of bios:

The mini: Do you use Facebook, Twitter or any other social networking tool? You will need a mini bio for your profile. It is only a

Terri Nakamura
@terrinakamura FOLLOWS YOU
Graphic designer & fun person; likes humor, Apple, cool, interesting, design, art, business, tech, weird, pop culture & breaking news. #BA75; (e)NAK on #EAv
Seattle · http://seattledesigner.blogspot.com/

Here's an example of a mini bio for Twitter. It's snappy and fun, and shares a bit of Terri's personality and info about her business.

few short important sentences—this is your "elevator pitch."

The short: A short bio will have all the components of a long one, but only highlights the very best. This bio will be used for your blog, newsletter, interviews, brochures, magazines and query letters. Keep the short bio at no more than one hundred words. If it is too long, people won't read it.

The long: A longer bio is generally used when you feel like you have more to say. For example, use a longer bio on your "about me" page of your blog or website. Keep the longer bio to a page in length, and add your picture for a nice touch.

Meet Lori McNee

Lori McNee is an internationally recognized professional artist who specializes in still life and landscape oil paintings. Lori shares valuable fine art tips, art business tips and social media advice on her blog. Currently, Lori ranks as one of the Top 100 Most Powerful Women on Twitter & was named a TwitterPowerhouse by The Huffington Post.

I use this short bio in the sidebar of my blog along with a smiling picture of me. This helps to personalize and humanize my content.

Key components of a bio

Use the following components to build your bio:

Name: Your name should be in the first sentence. This is the all-important introduction of you to the reader.

Tell about yourself: Assert your business with confidence. Concisely highlight your achievements and awards, and hook the reader. A little of this goes a long way—don't turn your reader off with ego-driven self-promotion.

Add a dash of personality: Personal branding is just that—your personal, virtual personality. The reason for your bio is to sell yourself by building transparency. Share a bit about your interests and what you care about.

Contact information: Include your pertinent contact information, e-mail and websites, and hyperlink the content to your social media networks.

Add a picture: For some purposes, you will want to add your picture or avatar to your bio. A friendly picture helps to humanize you to your readers. To help with branding recognition, consider using the same image across all of your social media channels.

Additional bio writing tips

Write for the reader: It is important to understand your reader or audience before you start writing. I sometimes tweak my bio for different purposes, readers or clients.

Decide on first-person or third-person: Popular opinion states that a bio is best when written in third-person (a narrative, using pronouns such as he or she). Third-person is the best option if the bio is going to be used by others.

However, there are times when a first-person bio (speaking about yourself, I) might be needed. My first-person bio has been handy for introducing myself to live audiences during keynote addresses and webinars. A first-person bio can be used to personalize your blog.

Keep it simple: Stay away from flowery language that attempts to sound too complex or grand. Write short, easy-to-read paragraphs. Remember, most people are skimmers. According to the BBC, the attention span of the average web surfer is only 9 seconds.

Proofread: Find another set of fresh eyes to proofread your bio. Use spell-check and even consider an online grammar checker if needed.

Evolve: You will grow and evolve, and your bio should reflect that. When that time comes, rewrite your bio so it can evolve with you.

TIPS FOR BETTER BLOGGING

Blogs help artists, freelancers and small businesses reach beyond the canvas or computer screen to make contact with potential collectors, customers, business prospects and like-minded individuals.

But, do we really need a blog if we use Facebook, and all the other social media networks to connect with our audience? The answer is *yes*.

With social sites, you do not own or control any of the content that has been shared on your accounts. You do not have control over the look and layout, and you cannot manage the comments.

I am a big proponent of social networking, but what if Facebook, Google+ or Twitter disappears, stops working, or is purchased and you do not like the changes? These social sites control all of your contacts, content and images. Relying solely on social networks that are owned and controlled by third parties to market your art is risky business. If you are unable to use them for any reason, you will have no way to swiftly connect to your people.

BLOGGING ADVICE

If you have trouble with writing naturally, use a voice recorder to first record your blog post verbally and then transcribe it. This allows you to find your own voice while avoiding the stiff nature of writing.

On the other hand, blogging combined with social media offers artists, freelancers, and small businesses content control, a unique opportunity for self-promotion, expanded viewership, and contact with prospective customers.

Important reasons to consider a blog

A blog strengthens your personal brand: *Branding* is who you are or what the world thinks you are. Every time a prospect or a potential customer makes contact with you they are forming an opinion of you as a brand. A blog offers you a great opportunity to share your unique perspective and creative voice, plus it will help bring the world to your art business.

Blog posts have a long shelf life: Once you submit your blog post it will be searchable via Google until you decide to take it down. A good blog post, optimized with searchable keywords, will likely bring in business down the road. With social media sites, older information is quickly replaced by the newest information. Once you update your status, the previous post is pushed down on your page. In time, it will be gone from view.

Blog posts are searchable: Your content is easily found via keywords or the search window that is in the top right-hand corner of most blogs. Blog post are also easily shared. You can categorize your content to make it easier for your readers to find. Blogs make it simple for people to search, find and spread your ideas.

Blogs create richer content: Whereas social networks are mainly for people who like to comment, blogs allow for richer content. A blog will allow you to speak your mind, and it is easy to use multiple contextual avenues such as podcasts, videos, images and MP3 files to share your ideas, portfolio and interesting stories. A blog is virtually free content marketing.

As a creative blogger, you can use this free marketing medium to receive feedback and criticism before a work is finalized, and to gain new ideas and suggestions. Posting your works-in-progress on your blog will help you see your creative process from start to finish.

LEARN FROM THE PROS

I have learned a lot from both of these blogging blogs:

Entrepreneurs-Journey.com: "Down-to-earth tips and advice for Internet entrepreneurs."

ProBlogger.com: "Blog Tips to Help You Make Money Blogging."

Consider posting tutorials, essays and experiments to reveal details about the creation process that are often overshadowed by final pieces.

Even if you decided against blogging for now, I hope you consider it in the future. Blogging is the best way to have maximum control over your content and the social technology you use to run your business.

HOW TO WRITE AN ARTIST'S STATEMENT

Writing about yourself is never an easy task. Creative people often have a difficult time formulating the right words to express their art. Most artists prefer to leave the emotional response between the viewer and the art, without the necessity for words.

EXTRA BLOGGING TIPS

- **Use thought-provoking titles:** The blog post title is the first thing to grab the reader's interest. It should highlight the main story of your post. Be creative and informative with your titles. Use keywords to help with search engine optimization (SEO). Short phrases usually rank better with search engines.

- **Post original content:** Original content will help boost your rankings in Google, allowing your blog to be found more easily. Do not plagiarize or copy someone else's work. If you do quote someone, be sure and add the link to his or her blog. Scatter your important keywords throughout the post. Use the main keyword in the opening sentence for better SEO.

- **Vary your topics:** Keep your readers coming back for more of your fresh ideas. Vary the cadence of your post topics and length. Be flexible because you never know when a hot topic might need to be your next blog post.

- **Find your voice:** Showcase your own personality in your writing. The key to a good blog post is to find your unique voice. Don't be afraid to speak your mind through your blogging.

- **Check for errors:** We are all busy, but take time to proofread your post before publishing.

- **Share the link love:** Linking to other blogs is a great way to create an information-rich post. Sharing links will also build up your relationship with other bloggers.

- **Encourage comments:** Foster a discussion by encouraging comments with your readers. Ask a question at the end of the post, and be sure to reply to your readers.

- **Use images:** Plain text is boring, and over 60 percent of your readers are visual learners. Readers want photos, graphs and illustration. Visual aides help readers memorize the ideas. Use your own images or use a site like Flickr to search for images with a creative commons license. Learn how to enter a description of the image into the alternate text field to make them searchable on the Internet.

Nevertheless, there are many times when artists are asked to provide an artist's statement. All serious creative entrepreneurs should have a well-written artist's statement ready to share with galleries, curators, grant foundations and collectors.

An artist's statement should reflect the meaning of the work to the artist. In other words, it is a short piece written for the viewer to answer questions he or she may have about you, your art and your artistic process. A good statement reveals the mystery of the work and artist to the reader.

A well-written statement is a vital marketing tool to promote you and your art. It is a bridge between the work and the viewer. The artist's statement must be informative and

written as though you were speaking in person about your work. Think of it as an introduction to yourself and your art.

The process

Statements are as individual as the artists they represent, and many aspects of an artist's statement come down to personal choice. However, there are some industry suggestions that can help you get started.

As with any writing project, begin with a rough draft. Start with the pertinent and fill in the details. Remember, you are writing for people who are interested in you and your art.

When preparing to write an artist's statement, keep a notepad with you when you are creating. Jot down simple notes that will help you recall your feelings, emotions and thoughts about your art and creative process.

Write the statement in first-person and infuse it with your unique perspective. Is your work fanciful, aggressive or solemn? Choose prose that complements and reflects your art.

Keep the language simple and clear. An artist's statement should be no more than three paragraphs. A word count of one hundred to three hundred words is optimal. Some of the finest statements are only three to five sentences. Be original, and try to begin your statement with something more creative than "My work…."

In today's world, artists are expected to do more than just create. We must stay current within the art market, and most of us don't have the luxury of a personal assistant or secretary. If writing really stumps you, hire someone to write for you. Try using a secretarial service, a college student

HELPFUL HINTS

Suggestions for writing out your ideas:
Make a list of your objectives and goals. Include your interests, influences and activities.

- Where do you live?
- What inspires you?
- Who inspires you?

Describe your creative process.

- Why do you create, and what does it mean to you?
- Is there a message?
- What are your artistic goals?

Put your art into words.

- What techniques, style, and mediums are used?
- Use language for non-artists.
- Use informal first person, "I" statements.

Read other successful artists' statements for inspiration.

or a freelance writer or journalist. Remember, good writing skills can often mean the difference between getting accepted or rejected for a show or gallery.

WHAT NOT TO DO

Don't turn the statement into a résumé.

Don't turn the statement into a biography.

Don't catalogue works.

Don't try to be funny.

Don't be pretentious.

Don't jump around from idea to idea.

Don't be afraid to ask what the event, gallery or exhibition is looking for in a statement.

COMMON GROUND
5 Tips for Bridging the Communication Gap

..

by Sunny Bonnell

Recently, I made a trip to my veterinarian because my dog was favoring his back leg. When the vet came in to discuss the X-rays, he prattled on about tibias, fibulas, tendons and a host of other anatomical terms I couldn't possibly reiterate. Forty-five seconds in, I began to glaze over. After five minutes of his doctor-speak, I craved the company of my pocket dictionary. Finally, I just asked, "Doc, is it broken?" To which he replied, "Yes." All that mumbo-jumbo for what should have been an easier conversation: "The leg is broken. We'll make a cast. It will heal in six weeks. The cost is $400." Simple. This got me thinking: How often do clients experience this frustration when communicating with designers?

Most clients don't have a deep understanding of design; that's why they hire us. From the seasoned creative professional to the newbie freelancer, communicating effectively with clients is a critical component of being or becoming a great designer. Whether you're working with a rookie client or someone who's been in a few rodeos, there will be times when you don't share a common vernacular. This can lead to simple misunderstandings—or worse, a damaged relationship.

Each client is different and requires an individual approach to communication. Joe Duffy, founder and creative director of Duffy & Partners in Minneapolis, says, "We have clients who are bold, brash and opinionated, while others are meek, mild and couldn't be

Sunny Bonnell is co-founder and creative director at Motto, a brand strategy and design firm that works with innovative and inspiring companies to help launch, grow and reinvent their brands. www.mottoagency.com

nicer—and everything in between. The best designers learn to communicate in that particular person's language."

As you learn the art of communicating with clients, you'll develop a sense of how best to connect with each individual, and you'll adjust your style and language accordingly. Here are five tips that will help you improve your communication for a higher level of interaction, more successful design solutions and much happier clients.

"How do you want to be known as an expert? For your dizzying knowledge of CS5 and the Pantone rainbow? Or for your abilities as a problem solver?"

—*Jennifer Visocky O'Grady*

1. Understand their business

For many designers, learning about the client's business and why it's different and better than those they compete with is a challenge. But that should be priority No. 1. Clients hire designers with the intellectual wherewithal to understand their business as a way of ensuring that the solutions are tied to strategies and goals. While clients might not be designers, they obviously know their brand much better than you do. Understanding the client's business is key to a solid designer/client relationship. Typical protocol includes requesting baseline information, gathering assets, conducting consumer and competitive research, interviewing key management or stakeholders, observation and so on.

Ashleigh Hansberger, my business partner at Motto, our Myrtle Beach, South Carolina-based brand strategy and design firm, recalls a recent project where understanding the client's business was a particular challenge: "We were hired by a quantitative trading firm on Wall Street to develop a college recruitment campaign. In the initial calls, the client was using industry specific terminology that was natural to them, but unfamiliar to us."

With the campaign on a tight deadline, the Motto team quickly scoured trade journals and blogs, and interviewed the company's staff to sharpen their understanding of the world of financial trading. "In order for us to get on the same page and build credibility for an effective solution, we had to walk on Wall Street and immerse ourselves in the discourse," Hansberger says. As a result, we streamlined client communication and developed a campaign strategy and design solution that delivered high-level messages that resonated with the client's audience.

2. Nix design-speak

In school, designers spend years in critique, honing both their craft and their ability to talk about design with other designers. It's wrong to expect that clients understand that specialized language. "Designers do the design business a disservice by making it sound mysterious or complicated," Duffy says.

It frustrates clients when designers speak in terms and phrases they don't understand, resulting in miscommunication and failed solutions. Using design-speak equals bad communication, and bad communicators are inherently bad designers.

Breaking down technical jargon can be equally frustrating for designers. It's not that easy to explain what a vector file is. File formats are becoming more complicated, and the programs used for design are becoming less similar to those used in a business environment, so they come with their own lingo. Explaining all the different file formats can be overwhelming for a client, especially when designers start using terms like "pixel-based" and "line art."

"The trick is to meet people where they're comfortable, while still maintaining your expert status," says Jennifer Visocky O'Grady, owner of Enspace Design in Cleveland. "How do you want to be known as an expert?" she asks, "For your dizzying knowledge of CS5 and the Pantone rainbow? (You know what PMS means to the average person, right?) Or for your abilities as a problem solver?"

Additionally, listen to the client to pick up on their vocabulary and use it whenever you can. Using the client's jargon can help reassure them your reasons for making certain design decisions are based on your understanding of their business. It will show that you're not just designing solutions that have aesthetic value, but ones that make business sense, as well.

3. Communicate visually, not verbally

Both miscommunication and misinterpretation are common problems in conversations about design. Think about all the words that clients use when they tell you what they want: Sexy, bold, sleek, bright, colorful, modern, hip, funky, simple and so on. But words like these are highly subjective; they can be interpreted any number of ways depending on who says them and who hears them.

The Duffy & Partners team averts confusion by translating those words into pictures when they begin a project. "Once we are given an assignment, we are given a verbal brief by the client. What we always do on every project is work to visualize that brief," Duffy says. "We compose a collage that in effect translates the words in the verbal brief to pictures in the visual brief. The great thing about this is we then have a filter with which we make design decisions and the client has a clear indication of where we intend to go through the design direction."

The point of providing visuals up front is to help eliminate the element of surprise—which is typically the kiss of death when it comes to presenting your design ideas. And it helps your clients, many of whom are left-brain thinkers, envision what the final solution will look like. "Most clients struggle with seeing the project all the way through, which is often a designer's gift," Hansberger says. "Make it easier for your clients to see the end result by presenting work on a tangible level. Instead of explaining to our client that we intend to use a richly textured paper such as Strathmore Grandee for their stationery system, we show them an actual sample so they can feel the tactile richness instead of imagining it."

"Leaving a meeting with confusion because we were too bashful to clarify is counterproductive. We want to create an atmosphere where asking questions is an encouraged part of the dynamic."

—*Jennifer Visocky O'Grady*

4. Explain your reasons

As you offer your expertise throughout the process, it's important that you also explain to the client why you're giving that advice. Clients will often direct you to do something that you don't think is a good idea. Rather than either doing it the way they want or doing it your way with no explanation, take the time to demonstrate to them why your recommendation is important and how either solution may affect the project's success. Designers sometimes default to explaining their choices subjectively, which can lead to an exchange of diverging or opposite views.

For example, instead of saying this: "We chose PMS 7543 because customers respond affirmatively to shades in the cool spectrum," say this: "This gray blue conveys stability and reliability and will help your customers feel confident in your brand."

Eric McNulty, a widely published business writer (*Harvard Business Review, Boston Business Journal* and online at RicherEarth.com), advises that you have data to back up statements like these and use such conversations as teachable moments. "Clients are used to having to justify their actions with evidence," he says. "So, try adding a statement like, 'A study from the Color Institute shows that female tweens gravitate toward orange but don't embrace red. Would you like a copy of the article that talked about it?' It's a great way to justify, inform and educate."

5. Ask questions

Many clients won't provide detailed information about their business or their customers unless you ask, simply because they may assume you don't need to fully understand their business to provide creative solutions. Clients who don't understand what's involved in creating a successful solution may think that a skilled designer can pick up a new project and create something special without really taking the client's specific situation into consideration. In these cases, be proactive and ask questions.

Then listen to what the client tells you—and how. "Part of being a good creative partner is learning to listen as well as you speak," Visocky O'Grady says. "When we meet with our clients, we have our ears (and eyes) open for more than just the details of their current project. We're also listening for levels of formality in their language, phrases or ideas that they're genuinely excited about, interests (perhaps personal) outside of the immediate assignment—heck, even body language and clothing choices can provide insight."

Don't be afraid to ask a client questions to clarify things you may not understand. "Leaving a meeting with confusion because we were too bashful to clarify is counterproductive," Visocky O'Grady says. "We want to create an atmosphere where asking questions is an encouraged part of the dynamic."

Your clients are busy, so they may be rushed when you're prodding them for information. But don't let that discourage you from getting what you need in order to do a great job.

HOW TO HANG YOUR SOLO SHOW

Show Your Works to Their Best Advantage

by Jonathan and Marsha Talbot

Installing a solo show of your own work is a challenging and rewarding task. A solo show is probably something you've worked toward for a year or more. You have a substantial emotional investment—and often an economic one as well—in its success. If your show is in a museum or commercial gallery, installing the show will most likely be the responsibility of the museum curator or gallery director. But if your show is in a co-op gallery, art association, alternative art space, library, bank, restaurant, office space or your own studio, part or all of the responsibility for arranging and hanging the work will probably fall on your shoulders. Exploring the installation process will help you create a cohesive exhibition that will show your work to its best advantage.

Things to consider

The first challenge is to recognize that, while the works you've created for the exhibition are the reason for the show, the exhibition is not about the works. Instead, the exhibition is a work of art unto itself. Your artworks are just one component of that larger work—the exhibition.

Creating an exhibition is a multidimensional process. Among the factors that contribute to a success or failure are the exhibition space, the lighting, the viewers and the way they will move through the space, visual distractions that are unavoidable, attention to your pri-

Jonathan and Marsha Talbot have been installing solo, group and theme exhibitions together for more than 40 years. Visit Jonathan's website at www.talbot1.com.

Photos and illustrations by Jonathan Talbot unless otherwise noted

Lisa Strazza hangs her works in her artist-owned Strazza Art Gallery in Warwick, New York.

mary purpose for the exhibition, the mechanics of how the artwork will be hung, and the arrangement of the pieces.

The space

Start by clearing the space as completely as possible. Even if there are pedestals, chairs or other furniture that you imagine you'll use in setting up your exhibition, remove them at this point so you can see the space with as few distractions as possible.

When the space is empty, examine your surroundings. Is there any natural light? How many entrances and exits are there? Are there any pillars, unmovable dividing walls or other obstructions in the space? Do the walls need to be touched up? Is the ceiling high or low? Is there sufficient lighting? Is there anything in or near the space that will compete with your work for the viewers' attention?

After you've addressed these questions and any others that occur to you, it's time to bring your works into the space—if possible, into the center of the space. Don't lean the works against the walls at this point—they'll become an impediment to envisioning the best possible layout of your show.

The works

Your art is the raw material of the show. Ideally you'll have more work than you need to fill the space because this will give you options as you create your exhibition.

TIPS

If you need to relocate a hook, using a claw hammer to pull out the nail is likely to dent the wall. Instead use pliers to carefully withdraw the nail.

Avoiding smudges on the wall is almost impossible. Use a gray kneaded eraser to remove smudges and pencil marks.

Here are a few points you may want to consider: Do you have more work than you need or not enough for this particular space? Are any of your artworks in series? If so, must the series be hung together? Are the majority of the works large or small?

The most frequent mistake that artists make when hanging their own shows is including too much work. It's a natural error. You want to share as much of your art as possible with the public. Perhaps you also think that the more you hang, the more you'll sell (not true). Quality, not quantity, should govern your decisions. Sometimes less is more. The integrity of the show itself, the success of the arrangement and the visual impact of the works, both collectively and individually, are far more important than the number of pieces on display.

The works & the space

The first step in determining what goes where is to consider how viewers will enter the space and what they'll see first. If there's a wall directly opposite the primary entrance, the visitor's gaze will likely go there first. But if there's an exit opposite the primary entrance or if the works on the opposite wall are small and far away, viewers are likely to turn to their right.

The next step is to lean works informally against the wall. By doing this, you can establish an approximate arrangement without the commitment of attaching nails or hooks in any specific locations. It's important to stay flexible during this stage of the process. Pieces initially placed in one location may be moved three, four or even more times before finding their final position.

Create an interesting arrangement. No one wants to see an uninteresting show, and such a show won't do your works justice. Try to see the exhibition from a visitor's perspective. Continuity is important, but sometimes grouping similar works together can be bor-

Lean your works informally against the wall to establish an approximate arrangement.

ing. Consider creating visual syncopation by breaking large groups into smaller blocks of unequal size and leaving space between them. Consider creating groupings of some works while displaying others singly. A group of smaller works can balance the impact of a larger work that adds power to a particular part of the exhibition. A small work resting on an easel atop a pedestal can draw viewers to a corner that they might otherwise pass by. (See photos **A** and **B**.)

Don't forget to stay flexible. Sometimes it may be necessary to move an entire group of works from one wall to another as the arrangement evolves. If you're hanging works in more than one row, lay them on the floor as you create a grouping and move the entire grouping to the wall only when you believe you're finished. Even then, be open to the possibility that last-minute changes may be needed.

If you have a friend who's experienced in hanging exhibitions, consider asking for help in hanging yours. A second opinion is as important in art as it is in medicine, and the fact that someone else sees your work objectively may help to balance your own intimate involvement with it.

A

B

In this area of Loel Barr's solo exhibition at the Woodstock Artists Association and Museum, the preliminary arrangement in picture **A** is perfectly acceptable, but interest and energy were added for the final installation by replacing some of the hanging works with three-dimensional constructions placed on shelves and a pedestal as shown in picture **B**.

The mechanics of hanging

When you're ready to hang the works on the wall, you'll need hooks or nails for hanging, a pencil, a hammer, pliers (make sure they also cut wire), a tape measure at least 8 feet long and a kneaded gray eraser. A 4- or 6-foot level and some extra picture wire for emergencies are also good to have handy. You can save considerable time if you make a "hanging gauge." (See "How to Make and Use a Hanging Gauge.")

The average human eye height is approximately 62 inches, and many galleries and museums try to position works of art with the center of the work, measured vertically, at this level. The easy way to do this is to measure the total height of the framed work, divide that

ruler portion approximately 24 inches long

62 inches from floor to beginning of ruler

HOW TO MAKE AND USE A HANGING GAUGE

To make this measuring gauge, take an 86-inch length of 1x2-inch lumber and mark a
point 62 inches from one end. Attach a 24-inch ruler to the 1x2 so that the beginning of
the ruler starts at the 62-inch mark, as shown.

To use the measuring gauge, follow these steps:

1. Measure the total height of the picture including the frame.
2. Divide the height of the picture by 2 to get ½ the total height of the picture.
3. Measure the distance from the stretched wire to the top of the frame as shown here.
4. Subtract the distance from the stretched wire to the top of the frame from ½ the total height of the picture.
5. Find the result of your calculations on the ruler. This is the height at which the hook should be placed.

Note: If you choose not to build a measuring gauge, add 62 inches to the result of your calculations in step 4, and measure that number of inches up from the floor with a ruler or tape measure. This marks the proper height at which to position the hook or rail for that particular picture.

amount by two, and subtract the distance between the wire (stretch it taught with one finger) and the top of the frame. Add the result to 62 inches and measure from the floor upwards to position the hook or nail that will hold that work. Using the gauge—where the ruler starts at 62 inches above the floor—eliminates the last calculation.

Sometimes you may want to hang a group of same-size works in a row. In this case using a level may be more effective than measuring from the floor as the floor itself may not be level. The varying length and tension of the wires on the back of the frames may also make aligning the works difficult. In this case, especially if you're using contemporary frames with space in the back, it may be useful to ignore or remove the wire and hang the same-size works with the frames themselves resting on pairs of nails driven in on a level line.

In the special case where you're hanging your works from picture rail moulding, using a continuous loop of wire helps to get the works level at the height you want. Tie the wire to one moulding hook, run it through both screw eyes on the back of the frame, and then tie

C

D

When direct lighting doesn't spread the light well enough or when there aren't enough lights (**C**), cross-lighting the works allows for better coverage and more even, pleasing lighting (**D**).

it to the other picture hook (see "Hanging From Picture Rail Moulding"). If you're on the ladder, have someone else measure the height of the work. Final leveling requires only sliding the picture up or down on one side or the other.

Lighting the work

Most exhibition spaces have track lighting of some kind. Make certain that the lights are directed so they best enhance your work. All too often there aren't as many lights as there

HANGING FROM PICTURE RAIL MOULDING

When hanging pictures from picture rail mould-ing, leveling the works will be much easier if you use a single piece of wire. Tie the wire to one hook and thread it through the screw eyes on the back of the frame, as shown. Don't wind or tie the wire to the screw eyes. Adjust the height of the picture at the other hook and then tie the wire. You'll be able to level the piece by simply pulling down gently on one side or the other. Note: For clarity, the back of the frame is shown in this illustration.

Adjust height here before tying.

are works. When this happens, lighting from an angle, or cross-lighting, enables you to light more than one work with the same fixture (see photos **C** and **D**). In general, using flood-lights—rather than spotlights that can create hot spots—is best.

Finishing up

A few things remain to be done before the opening. First, you should photograph your show. Use a tripod and turn off the flash on your camera to avoid reflections from works that have glass or are varnished. Don't include people in your photographs. What you should create is a photographic document showing the exhibition as a whole.

Second, prepare a guest book. Getting the names and e-mail addresses of the visitors to your exhibition can be a big help in growing your mailing list and your career. Most store-bought guest books don't include enough room for e-mail addresses, so we've designed pages that can be inserted in a clean loose-leaf binder that's left open, with a pen, on a table or pedestal. These printable pages, in both Microsoft Word and PDF formats, can be found at www.artistsnetwork.com/article/talbot-exhibition-guest-book-page.

Third, think about refreshments; customs vary by location and tradition. Do consider, however, that devoting too much space to food and drink may make the refreshments, rather than your works, the focus of the opening.

Lastly, take a deep breath. Forget all the effort it took to make the work and all the effort it took to hang the show. Have a good time.

HAPPY, HEALTHY AND SUCCESSFUL

Create a Positive Work-Life Balance

..

by Lori McNee

Nineteenth-century French impressionist music composer Claude Debussy stated that "extreme complication is contrary to art." Yet, in today's fast-paced world, it is becoming increasingly complicated for people to maintain a positive work-life balance.

There is lots of information on finding balance in our lives available. Nevertheless, for freelancers, small business owners, and aspiring artists, it might seem as though the only way to get ahead at work is to get behind at home. As a professional artist who juggles a busy painting career along with blogging, teaching, writing, social networking and family, I can speak on this subject with authority, because I have been guilty of imbalance myself.

It is essential for freelancers and other creatives to become skilled at organizing their time in order to reflect, design, create, market and sell their product. Striking the right balance is an individual choice, and it sometimes takes compromise. Below you will find some unique suggestions and practical tips on creating and maintaining balanced lifestyle for you and your business.

STAYING HEALTHY

The majority of my artist friends work obsessive hours without taking the proper time to eat, hydrate or exercise. Here we'll look at some of the health pitfalls of creative life and consider ways you can avoid or compensate for them.

Lori McNee is an exhibiting member of Oil Painters of America and ranks as one of the most influential artists and powerful women on Twitter. She was named a Twitter Powerhouse by *The Huffington Post*. Lori shares valuable fine art tips, art business tips and social media advice on her blog, FineArtTips.com. She has been a talk show host for Plum TV, and has been featured in and written for magazine and book publications and serves on the *Plein Air Magazine* board of advisors.

The dangers of sitting

Like many people who spend much of their day in front of a computer, artists face the same sedentary challenges. Whether you are a sitter or a stander, each pose creates different health concerns. Chances are that you are sitting down while reading this article.

According to the *British Journal of Sports Medicine*, studies show that prolonged periods of sitting and lack of whole-body movement are strongly associated with many diseases. Sitting six-plus hours per day makes you up to 40 percent likelier to die within 15 years than someone who sits less than three, even if you exercise! The once recommended 30 minutes of activity a day is not enough. Interrupt sitting whenever you can to walk around your studio, home or office.

GET MOVING!

Below, my good friend and Twitter's favorite fitness guru, Joyce Cherrier (freakingfitness.com), gives a few healthy tips to get you moving.

- **Resistance ball:** One of the best ways to get in movement throughout your day while sitting is sitting on a resistance ball. Constantly readjusting to keep balanced on the ball engages the muscles of the core, pelvis, hips and legs.
- **Set a timer:** Time flies when working. Before you know it, you've been sitting for 3 hours. Set a timer (a simple egg timer will do the trick) to make sure you get up and move around every 20 to 30 minutes. When the timer goes off, get up, move around, stand and do a reach-for-the-sky stretch.
- **Hydrate:** A good habit is to fill a large glass or water bottle before starting your day. Be sure and drink plenty of water and refill during the day.
- **Eat healthy snacks:** Keep snacks like nuts, seeds and raw veggies available. Raw veggies are also a great snack and provide fiber. Fiber is important for digestion for people who sit for long periods of time. Keep your protein intake up and it will help you stay energized and alert. Avoid sugar and you'll save yourself from a work-halting sugar crash.
- **Take a real break:** Stop eating at your desk, and physically leave the building for your lunchtime break. If you have the opportunity to add in a short stroll, that is a bonus.

Listen to music

Many people prefer listening to background music while working. Beautiful or classical music can actually help you focus and boost productivity. Slower music is known to reduce blood pressure.

However, according to Australian physician and psychiatrist Dr. John Diamond, hard rock music causes alarm to the body and lessens work performance. Also, listening to and

comprehending any talk, including the news, commercials and talk radio, is counterproductive while working.

Get on your feet

After learning about the dangers of sitting, I now stand at my easel. I also use a stand-up desk for all my blogging and computer tasks. Most artists like to stand when creating, but that poses a different set of concerns.

According to Cherrier, even though your muscles are continually at work to keep you upright, there is a lack of blood flow to the muscles being used. Lack of blood flow causes fatigue in the working muscles. It also can cause problems with vein inflammation.

Sitting on a resistance ball at a regular desk or switching to a stand-up desk are both good ways to get in movement during the work day.

Over time, long periods of standing can result in varicose veins. Joints in the feet, knees, hips and spine become locked in a prolonged standing position and this can contribute to damage of tendons and ligaments. Here are a couple of ways you can alleviate the physical stress of standing:

- **Change your workstation:** Use a small footrest to shift your weight. If working in a certain position causes you to have your arm in one position for a long period, try to use something to support your arm to help curb any fatiguing of your arm and neck.
- **Keep a stool nearby:** Have a stool that will help you stay in your favored working position but also allows you rest. Just a bit of support can help take a tremendous amount of stress off muscles and joints. Position yourself close to the working area, and face your work as straight on as possible to avoid bending and stooping.

Learn to manage stress

The American Institute of Stress has estimated that 75–90 percent of all visits to primary care physicians are for stress-related problems. According to the Stress Organization, job stress is by far the leading source of stress for adults.

Without a proper work-life balance in place, our work can easily spill over into unreasonable after hours, resulting in added stress and a lack of enthusiasm for life. Of course there are times when we are overscheduled, have important deadlines to meet, and feel behind the

Taking an exercise break outside is good for your body and your mind.

eight ball. It's also true that some of us work well under pressure, but it becomes mentally and physically exhausting to keep up.

Inspired thinkers need a sense of freedom in order to create. Exercise and breaks with space away from work help de-stress and refuel your creative engine.

"Space is the breath of art."

—*Frank Lloyd Wright*

Declutter
Did you know that clutter is a form of procrastination that causes distractions and stress? The more clutter, the less time we have to focus on working and creating.

Mess = Stress

Taking on too many projects can also be a form of clutter. In order to bring equilibrium into your daily life you must prioritize, edit and be selective. At the end of each work session, do your best to clean and clear your clutter so you are able to concentrate the next time you return to your project.

Create a healthy environment
Another major concern for artists is a healthy working environment. The U.S. Environmental Protection Agency estimates that indoor air quality is often up to ten times worse than the air outside, and the air in our studios can be even worse.

Clean the air with houseplants
Did you know that houseplants are beneficial to our lives? For only pennies a day, houseplants help beautify, purify and renew your stuffy studio, office or home. Plants filter out toxins, pollutants and the carbon dioxide we exhale, replacing it with fresh oxygen. Plus, all plants add moisture to the air and can even help prevent dry skin and sore throats in the winter.

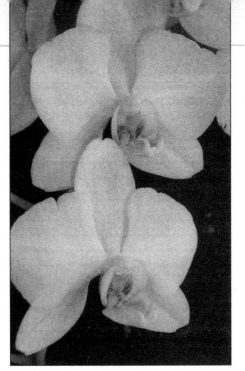

Houseplants and flowers are beautiful, and they will help purify the air in your home or studio.

Here is a list of materials that are known to cause "off-gas" pollutants in interior environments: man-made building materials, synthetic carpeting, laminated counters, plastic coated wallpaper, household cleaners, fabrics, pesticides, paints, varnishes, adhesives, printers, copiers and fax machines. Formaldehyde, a known carcinogen, is often found in new rugs and vinyl as well as cigarette smoke and even grocery bags.

Good health will allow you to keep doing what you love for many years to come. Some simple planning is all it takes to make sure you're staying healthy while accomplishing your tasks.

BALANCING PARENTHOOD

It seems a bit ironic to be writing this section on balancing parenthood, since I just officially became an "empty nester." That's right, my three kids are all out of my house and leading their own lives as young adults. I am proud of them, but it is a big transition for me, and I am grateful to have my art career.

Rearing a family and growing a business are both full-time jobs. Sometimes the lines get blurred between the two. My own art career emerged between loads of laundry, during my kids' naptimes and late at night.

Years later, what a joy it is to see my young adult children and my own art career thriving! Our children truly are our greatest works of art. Read on for tips to help you balance family life with your art career.

Become self-disciplined

Self-discipline is the ability to do what you know you should do, whether you feel like it or not. It is the most important quality for any person who is juggling parenthood and a busy career. Without it, we struggle between the forces of doing what is necessary and what is fun. Fortunately, self-discipline is a skill that can be developed:

- Create a routine and stick to it until it becomes a habit.
- Allocate a certain time each day to work on your tasks.
- Do not allow distractions to detour you.
- Focus on the task at hand, and do your best not to multitask.

Build clear boundaries

When the workplace is just a few steps away from the family space, discord with the family may become common. This is why it is especially important to build clear boundaries for the stay-at-home parent. I understand that theses tips might seem "easier said than done." Nevertheless, do your best to set work hours for creativity and stick with them.

For parents with young children, your "free time" might be limited to your child's nap-time or playpen time. If working every day is overwhelming, pick one or two days a week. Once children are school age, your schedule will allow for more work time.

It is vital to surround yourself with people who honor your boundaries and support your dreams.

GOAL GUIDELINES

Artists with clear goals achieve more. Here are a few goal-setting ideas to help you get started:

1. Know what your goals are. (For instance, let's say you are an aspiring artist who wants to become a professional artist.)
2. Write down your goals.
3. First set your long-term goals. (For example, you want to improve your art in order to be represented by galleries, self-employed and teaching workshops to others.)

 a. Set realistic long-term goals that can be achieved by completing your short-term goals.

 b. Long-term goals help us see beyond today's work and remind us of a greater purpose.

 c. It is best to keep your long-term goals to yourself in order to achieve them. Share your goals with supportive people only.
4. Prioritize your goals.
5. Now set your short-term goals. (For example, you want to improve your painting skills.)

 a. Short-term goals relate to your long-term goals, but they are more tangible (e.g., painting five small paintings a week).

 b. Short-term goals help measure your progress towards your long-term goals.

 c. Make these goals specific and add a time limit (e.g., evaluate your paintings at the end of one month).

 d. Achieving short-term goals gives a sense of satisfaction.
6. Monitor your progress.

 a. Make a checklist, review your dates and keep track of your progress.

 b. Keep your goals at the front of your consciousness.
7. Reassess and modify your goals.

 a. If you get off course, don't be afraid to modify your goals and get started again.

> b. Don't give up!
> 8. Visualize.
> a. Obviously creatives are visual people, so use your imagination to help you realize your goals.
> b. Visualization is known to result in a higher level of performance. Visualize the end result. Imagine yourself doing exactly what you want.

Limit distractions

For the home-based office, this can be difficult. Nevertheless, distractions spread our focus and reduce attention to detail, which negatively affects our work. Distractions may include phone calls, television, Internet, household tasks, social media, and even spouses, partners and children.

Staying focused and learning how to say "no" will help you cope with distractions. Set a work schedule and lay down the ground rules in the form of boundaries with your family and friends. Let your phone go to voicemail, close the laptop and shut the door to your office or studio.

Set goals

Goal setting and focusing kept me motivated when I was balancing my art career with parenthood. Back then, I was a wildlife artist, so I entered duck stamp competitions and art festivals and donated my art and illustrations to organizations such as the Nature Conservancy and the Wolf Education Research Center. All of this helped build a solid foundation for me as a professional artist. This also gave me artistic goals to achieve when motherhood suggested that I give up!

Be organized

Since work time is limited, it is imperative to stay organized. Clean up at the end of each work session so you can return to a clean workstation. Organize your projects so you are ready to work and are not fumbling around wasting time. You will become more productive and less stressed.

Stop multitasking

In the past I have proudly proclaimed myself a multitasker. The best multitasker may appear to be handling more than one task at the same time. But, studies have shown that productivity drops with multitasking because the brain cannot fully focus. People actually take longer to complete tasks and are more predisposed to error.

Photo by Andrzej Skorut

Give your kids their own art supplies to develop their creativity. This will also keep them entertained and out of your own supplies!

Experimental psychologists studying people who talk on cell phones while driving concluded that people must withdraw their attention from the road in order to formulate responses, because the brain is unable to focus on two sources of input at one time. Driving, talking and listening distract the brain and increase the likelihood of accidents.

I was so surprised to learn that simple multitasking while on the phone can cause inattention to detail, which in turn affects the quality of your work and even parenting.

Work in small increments

Have you ever told yourself, "I've only got 5 minutes" and then been amazed at just how much you were able to accomplish in those 5 minutes? When you are limited for time, get in the habit of doing your work for "just 5 minutes."

Easy cleanup

Choose pencil, charcoal, watercolor, acrylic paint and water-soluble oils, which are relatively easy to clean up and are primarily non-toxic.

Work small

While my kids were young I found that it was much easier to work on small projects. This way I was able to finish and feel a sense of accomplishment and triumph.

Involve the kids

Toddlers and pre-school aged children are naturally artistic. Consider giving your child a box filled with age-appropriate art supplies so the little budding artist can create alongside you.

I did this with my own child who eventually had his first art show when he was only ten years old. Now he is a 3D artist, working for Disney!

Take time for you

Parenting is a rewarding, but exhausting experience. The only way to maintain the energy needed to juggle parenting and your career is to create some time for yourself. This is important for replenishing your energy and creative levels.

Make an effort to give yourself at least one night off per week. Use this time to do something you enjoy. Read a book, rent a movie, go out to dinner or take a relaxing bath.

Become aware of the brief moments of quiet time in your life. Most of us spend a lot of time in our cars. Instead of filling the quiet with cell phone calls and the radio, turn everything off and enjoy the silent ride. Creating simple rituals such as these can help you find balance and help you from negatively reacting from your exhaustion.

Finding this equilibrium is particularly important to artistic individuals. Achieve balance by gaining control of your daily tasks, and by making room for some healthy habits. Then you will be rewarded with more energy to create!

LISA L. CYR

Embrace Inspiration

...

by Neely McLaughlin

Lisa L. Cyr's mixed-media fantasy-inspired work invites the viewer to participate in her imaginative vision. That vision inspires both Cyr's paintings and her desire to encourage others in creative pursuits. "Create from the heart, innovate without boundaries, strive for greatness and speak to the culture in ways that inspire and motivate," she says, explaining, "I often use this quote I wrote on my website and other materials." The desire to encourage other artists is part of Cyr's own artistic path. She pursues her work with attention to its ability to speak to viewers. She also devotes considerable energy to helping others bring their artistic endeavors into the larger culture.

Freedom for personal expression and exploration is central to Cyr's understanding of her own work and of art itself. She appreciates the voice that her art gives her. "I am very much aware that I have been given an opportunity to say something meaningful. It is my hope that my efforts will somehow make a memorable and lasting impression," she says. These efforts have come to include not only Cyr's mixed-media work, but also the books and articles she writes, and the lectures and workshops she gives.

Artistic journey

Since childhood, Cyr has been artistically inclined. She grew up with encouragement to pursue her creative tendencies using whatever materials were available. "I was always encouraged to create with what was around me: whether it was scraps of paper, pencils and paint or remnant material, yarn and thread," she says. She studied fine art and illustration

Neely McLaughlin is a writer and visiting assistant professor of English at the University of Cincinnati, Blue Ash, in Cincinnati, Ohio.

in Boston at the Massachusetts College of Art, where she earned her bachelor of fine arts degree. She later received her master of arts degree from Syracuse University. Cyr has long been committed to her own artistic vision. "I learned early on that if I was in control of my creative content, then I had something that I could build upon," she says. To Cyr, this dedication to a personal vision is an essential foundation for any artist. It is necessary for artistic success and becoming a mature artist. She explains, "To be successful, you must know who you are creatively. Allowing the market or someone else to dictate your journey only leads to a lack of authenticity and disconnection from the creative spirit that resides within."

For Cyr, this personal commitment has led to a successful and wide-ranging career. She is now an established artist, author, speaker and teacher. She has an active presence online and has exhibited in museums, galleries, universities and at industry organizations, both nationally and internationally. Her work has been featured in numerous magazines, books, and online, including features in *Spectrum: The Best in Contemporary Fantastic Art,* and is included in the permanent collection of the Museum of American Illustration in New York City. She has written seven books on art and design, including the cutting-edge, mixed-media best sellers *Experimental Painting* and *Art Revolution* (North Light Books), and she writes for many of the creative industry's leading art publications, including *Communication Arts, Applied Arts, The Artist's Magazine, HOW, Step Inside Design, ID* and *Alt Pick.*

As a speaker, Cyr hopes to inspire artists and provide practical guidance for those seeking to develop their careers and audiences. She leads workshops for a variety of groups. Her focus is on promotional strategies, marketing opportunities and entrepreneurial endeavors for those in creative fields. Cyr consistently brings a creative perspective to these undertakings. Rather than experiencing a sense of tension between her art, her marketing, and her other professional engagements, she understands all of her work as part of her artistic life.

Cyr encourages others to pursue entrepreneurial work, which is for her complementary to a commitment to an individual artistic vision. She notes that she has seen artists lose their vision due to the power of external influences. "Staying true to the soul of your work is the only way to have a rewarding career for the long term. If a market doesn't currently exist for the work that you love to do, make one." This sense of the importance of creating an audience indicates the reason for Cyr's emphasis on the benefit, even necessity, of creative entrepreneurship for an artist. Connecting with an audience in a wide variety of ways allows that audience to continue to increase and to develop in appreciation. Cyr urges artists to embrace innovation and to apply their creativity in a variety of ways, including developing new ways of discovering and building an audience. She explains, "Be willing to be entrepreneurial in your approach. Innovation often puts one first in line while others stand in the back trying to emulate. Don't ever limit yourself or be afraid to try new things. Open your mind and imagine the myriad possibilities that exist."

Juliette's Song is a sequential gatefold illustration from one of Cyr's multimedia sketchbooks.

Inspiration and imagination

Cyr always remains open to the inspirational potential of whatever she encounters or unearths. "Every day, I come across something that triggers my interests. From the mundane to the profound, I am inspired by life," she says. She approaches all that she encounters, from experiences and objects, to dreams and literature, as sources of inspiration. She maintains a persistent curiosity about how to use whatever life offers in her work. "All around, there are glimpses to something extraordinary. One only needs to be aware to discover the potential that surrounds us all."

Cyr's sources of inspiration are wide-ranging. Though she appreciates many different schools of visual art, she does not identify her work as particularly indebted to a specific artistic tradition. "Although I have artistic interests that range from the classical narratives of the Pre-Raphaelites to the abstract works of the Modern Era, my work seems to straddle the line between the poles," she explains. This all-encompassing aesthetic is evident in both Cyr's work and her approach to it.

Collaboration with other artists is one source of refreshment. "Over the years, I have collaborated with an amazing array of artists and designers, experiencing artistic expression through the eyes of some of the world's leading creative visionaries," Cyr says. She sees these interactions as mutually beneficial, a productive exchange of energy. She often turns to other art forms to maintain a sense of freshness and urgency. "Multidisciplinary exploration beyond my own creative repertoire breaks down the walls of stagnation, playing an integral part in my development as an artist," she says.

Cyr's *Voyage to Michaelania* (mixed media on clay board panel with wooden framework, 20×16×2) was inspired by a passage from one of her journals.

This habit of turning towards other creative forms and in some sense incorporating them into her life helps Cyr continually refresh her perspective. "Looking outside of my creative discipline allows for alternative ways of thinking to enter into the creative process. I love the theater, classic literature, dramatic film, instrumental music, vintage architecture and traveling." New frameworks lead to new possibilities, and engaging in a wide range of experiences facilitates the development of such frameworks. Exposure to sounds, sights and narratives, and immersion in different artistic endeavors, each with their own opportunities and particular limits, is a way to maintain an artistic life. "For me, exploring untapped territory creates the opportunity to look at the world through a different lens, creating a dynamic, multisensual smorgasbord of ideas."

Informal work provides Cyr with the opportunity for creative flexibility. *Juliette's Song* is a sequential gatefold illustration from one of Cyr's sketchbooks that employs die-cut corners, a self-leveling clear gel and acrylic insert, and a reinforced back that uses magnets to clasp the molding paste textured bookmarker to the page. Such painted pages of her sketchbook frequently lead to more finished works. The play that takes place in these informal projects is itself a process of discovery and a chance for personal artistic growth. "Things that I could not have predicted occur. I find that when I push myself creatively, I discover alternative ways in which to conceptualize and create art."

One particular source of inspiration for Cyr is the relationship between language and imagery. "I am a multidisciplinary artist and author with a content-driven approach. For me, word and image work in tandem to create a gateway to a higher consciousness," she explains. Sometimes she finds that her words shape her pictures, while, at other times, her pictures shape her words. Cyr is often inspired by the content of her journals. "To expand my visual and verbal vernacular, I experiment, explore and play almost every day. Whether I am writing in my journals, drawing and painting in my mixed-media sketchbooks or working on an alternative surface, there are happy accidents that begin to happen," she says.

For Cyr, the practice of journaling creates a space for imaginative exploration through language. In her journal, Cyr can develop a narrative and an image that might then result

in a painting. "In my painting *Voyage to Michaelania*, a passage from one of my journals was the impetus for the work," she says. The passage reads: "A humble servant by day and a traveler by night, the young peasant girl dreams of a world known only to her in books. In the silence of the dark, the mind wanders past the earthly presence to another realm of existence. Like a captain of a ship, the courageous heart braves the unknown waters to explore new ports over the horizon. Through the amazing journey, she discovers her true potential and her ultimate destiny reveals itself." The character and the world that feature in *Voyage to Michaelania* began with a word-based image, an atmosphere, and a character. Cyr then explored her idea in visual form, developing the character and world in a new way. She sees written and visual art as sharing a single imaginative source and believes that they interact productively.

The importance of texture is evident in *The Courageous* (mixed media on linen canvas over Masonite panel and board with wooden framework, 30¼×9×2½).

Texture, scale and dimension

Texture is a recurring theme in Cyr's paintings. She describes her work as "visually tactile" and has maintained a focus on mark-making as her work has developed. This emphasis suggests the value of awareness of touch for the visual artist, asking the viewer to become more fully engaged in experiencing her work. As she has developed as an artist, Cyr has become increasingly engaged in dimensionality, layering and employing a variety of formats and materials. Over time, her work has become larger in scale.

To maintain the complex texturing and dynamism central to her work on this larger scale, Cyr has incorporated tools from a variety of disciplines into her practice. "The tools that I use have evolved," she explains. Such alternative tools have enabled Cyr's mark-making to translate effectively on larger surfaces. Working large brings other practical challenges as well. For such large pieces, she often places work against a wall or even hangs it. In order to reach the entire surface of *Night Fury*, a large-scale pastel, charcoal, acrylic,

A stool allows Cyr to reach the entire surface of *Night Fury*, a large-scale mixed-media work.

In *Meditative Pathways* (mixed media on linen canvas over Masonite panel with wooden framework and inlaid boxes, 20×17×2), Cyr explores an alternative format through her use of inlaid boxes.

oil and other media work-in-progress, Cyr uses a stool.

Moving beyond two-dimensionality, Cyr reaches out into the viewer's space. "To push the picture plane into the third dimension, I insert boxes, apply imaginary windows and add sculptural assemblage accents," she explains. This aspect of her work connects with the audience spatially while also maintaining an awareness of distinction between the work of art and the viewer. Of this quality of her work, Cyr says, "The multidimensional, hybrid environment establishes a captivating pictorial stage, enticing the viewer from almost any angle."

Meditative Pathways illustrates this use of alternative formats with its use of inlaid boxes. The concept of staging, with its implication of a gap between the viewer and the work of art, productively contrasts with the fact that this work extends into the viewer's world, deliberately breaking the barrier between modes of space. Cyr also connects to the viewer through recognition. She appreciates a kind of clarity from the richly complex texture, discovers accessible imagery, and brings it forth. This aspect of her process illuminates the creative discovery process. "I love when something recognizable evolves out of layers of color, texture, and mark-making."

Art and culture

Cyr understands art to be a powerful force in the world. In reflecting on the relationship between fiction and visual art, she considers the power of the imagination. She explains, "Both fictional literature and fantastical art come from the depths of the imagi-

Masquerade of Wits (mixed media on Masonite with wooden framework, 23×26¾×1½) features a mask with delicate scrollwork.

nation, a world where everything is possible. One needs only to think it and it is so." Cyr's understanding the imaginative realm as one in which thinking constitutes being emphasizes creativity as a tremendous power. The work of art enables a connection between artist and viewer, allowing the artist to communicate an individual, internal vision to others. "The imagination serves as the great oracle to the inner world," she says. Through art, the imagination interacts with the larger culture.

Tellingly, Cyr first turns to imagery when exploring her understanding of what art means and does. "When you throw a stone into a lake, the splash creates waves and ripples that penetrate outward, altering everything in its wake," she says. That this image is not a static one suggests the importance of energy, movement, and interaction in Cyr's approach. "We leave behind a footprint in our wake."

Turning from the poetic to the practical, Cyr is attentive to the ways in which art participates in its world. "As artists, our work goes out into the culture through books, magazines, film, video, television, merchandising, websites and the walls of a public museum or gallery," she says. These various possible artistic sites, whether in virtual or physical space, context through which art is inevitably understood, and awareness of that larger context in which art exists is crucial. That awareness of context is integrally connected to the essential recognition that art is in an important way created for an audience. She explains, "It is important for artists to be mindful that their artistic works are not created to be in a vacuum but instead shared with the world." For Cyr, this awareness of audience and of the sites of interaction between art and artist results in consistent attention to the communicative potential of art. "Whether I am drawing, painting, writing, teaching or lecturing, my work is all about communicating with an audience on some level," she says.

Cyr embraces technology as a way of connecting with audiences. The role and reach of various media outlets enables artists to communicate with a larger and more geographically scattered audience than has been possible in the past. "As an artist, my presence online through websites and social media allows for instant, broad-reaching and cost-effective communications to a worldwide audience." Cyr notes that her work can be seen in portfolio-based websites, online webinars, video book trailers, e-books, syndicated artist blogs and numerous social networking sites. Each venue provides a window into her world

In *Self Awareness* (mixed media on linen canvas over Masonite panel and board with wooden framework, 30¼×21¼×2⅛), the neutral tones and quality of stillness invite the viewer to reflect.

as an artist. "The Web has opened the door for the printed page or gallery wall to be dynamic with sound, motion and interactive elements," she adds.

Cyr embraces the opportunities of the Web, which she sees as facilitating connections between people with shared artistic interests. "The Web has allowed artists to build not only artistic communities but also a following of like-minded people." Cyr embraces the expressive and communicative potential of the virtual world as central to the role of art. "The widespread penetration of web-based communications spans continents," she says. Here, the cultural conversation surrounding art, a conversation that Cyr is committed to facilitating and participating in, thrives. "The activity level is ongoing, creating a vibrant and robust exchange."

Cyr keeps up this exchange through her website, www.cyrstudio.com, her YouTube channel (www.youtube.com/user/lisalcyrstudio), her blogs at Confessions of a Mixed Media Artist (www.lisalcyr.blogspot.com) and Word + Image (www.lisalcyr.wordpress.com), as well as through Facebook and Twitter.

LOREN LONG

Soul of the Heartland

...

by Holly Davis

With a style born of America and a layering technique rooted in the Renaissance, Loren Long illustrates picture books he hopes will be shared across generations.

What do President Barack Obama, the rock star Madonna and artist Loren Long have in common? They've all written picture books. But it's Loren Long's pencil and paintbrush that truly connect the dots. He's illustrated picture books by all three authors. Before that he created illustrations for the likes of *Sports Illustrated*, *Forbes* and *Time*. Before that he worked as a greeting card artist at Gibson Greetings in Cincinnati, Ohio.

So how does a Missouri-bred artist reared in Kentucky and working in Ohio attract the attention of big New York publish-

WHAT'S A GOLDEN KITE AWARD?

Golden Kite Awards are given annually in four categories—fiction, non-fiction, picture book text and picture book illustration—by the Society of Children's Book Writers & Illustrators.

Holly Davis is senior editor of *The Artist's Magazine*.

ers and major American celebrities? The answer takes us back to the 1990s when Long got serious about becoming a professional illustrator—or to the early twentieth century, depending on how you look at it.

Breaking in

"What I did was jump out of Gibson Greetings and start working on my style," says Long. "It's one thing to get fairly accomplished in your craft, but it's another thing to set yourself apart from everybody else who's accomplished." He'd acquired his drawing and painting skills from the University of Kentucky and the American Academy of Art in Chicago, but his self-motivated, informal studies gave his work its distinctive feel. Backing away from the hierarchical distinction between illustrators and fine artists, he

Illustration (acrylic, 16×12) from *Mr. Peabody's Apples* (Callaway, 2003) by Madonna

felt drawn to N.C. Wyeth, Maxfield Parrish and J.C. Leyendecker of the American Golden Age of Illustration, as well as Edward Hopper, John Sloan and George Bellows of the Ashcan School. His greatest debt, however, is to American Regionalist painters—John Steuart Curry, Grant Wood and Thomas Hart Benton. As Long puts it, "I feel as if they gave me my career."

There's no mistaking the undercurrent of Americana in Long's work, and Long makes no bones about his affinity with Thomas Hart Benton. "He was a Missouri-born artist, and I was born in Missouri," says Long. "There were times when Benton's drawing was awkward; there are times when my drawing is awkward. His color was funky at times, and I have color

ART MOVEMENTS

American Golden Age of Illustration: (1880s through 1920s) a period when advancements in printing technologies coincided with the rapid expansion of print media, fostering creativity and experimentation in illustration

Ashcan School: (early 20th century) originally, a group of eight realists who painted scenes of the poorer districts and residents of New York City; the term eventually encompassed artists who painted the city's working class

American Regionalism: (1930s) a movement that celebrated rural America with realistic depictions of the heartland

Illustration (acrylic, 12×25) from *I Dream of Trains* (Simon & Schuster Children's Publishing, 2003) by Angela Johnson

issues. But his work had soul. It was homegrown. Whether you like it or hate it, there was a certain reality to it. I felt Benton's influence seeping into my work."

As Long developed his style, he also worked with two artist's representatives, who marketed Long's work to publishers and ad agencies, but Long feels that art directors didn't really pay attention until Long began gaining acceptance in juried exhibitions. "All of a sudden, people started identifying my name with my art." The big-name, popular magazines started calling. Then came a book cover for a HarperCollins young adult novel. Several book covers later, Simon & Schuster signed on Long to illustrate his first picture book, *I Dream of Trains*, a story about the American railroad legend Casey Jones, written by Angela Johnson. The book went on to win the 2004 Golden Kite Award for Illustration. Long had found his calling.

Big picture mentality

The art form for picture books requires a different mind-set from that for a single illustration. Long

MATERIALS

Sketching: 0.5 Pentel technical pencil—or a No. 2 pencil from school days, sketch books of no particular brand or just copy paper or tracing paper

Sketch transfer: graphite paper and ballpoint pen

Surface: Strathmore illustration board

Paint: Liquitex or Golden acrylics

Medium: water

Brushes: Winsor & Newton, Loew-Cornell and Daniel Smith synthetic: Nos. 00 to 6 rounds for details and small areas, 1- and 2½-inch for washes

CAPTURING THE ESSENCE

On the upper left of Long's drawing board is the thumbnail sketch for the Einstein spread in *Of Thee I Sing* by Barack Obama. Keeping the sketch small helps Long keep the drawing loose. Beneath the sketch, to the left and right of the painting, are figures from the left half of the sketch, blown up with a photocopier to a size larger than they'll appear in the finished book. After transferring the enlarged drawing to the illustration board, Long begins layering his acrylic colors.

"I'm a representationalist," says Loren Long, "but I'm not a photorealist. I want a train to look like a train and its wheels to connect the way train wheels really connect. But I never wanted the tractor in my book *Otis* to look like a John Deere or a Ford. I wanted it to have its own identity. That's one reason I went with a single wheel in the front. There's a tractor out there that has a single wheel on the front, but the rest of that tractor doesn't look like Otis."

That's well and good for trains and tractors, but Barack Obama's text for *Of Thee I Sing* required depictions of the president's daughters as well as historical figures such as Albert Einstein and Abraham Lincoln, both as adults and as children. Counterintuitively, regardless of his subject matter, Long always starts sketching before consulting reference material. He feels that working out the composition without worries about whether he's nailed down a likeness enables him to get a sense of life and movement in his figures. In the case of the people depicted in *Of Thee I Sing*, he says, "After my initial sketching, I consulted countless photos, narrowed them down and bluffed my way through. It wasn't a matter of doing the perfect rendition of Abraham Lincoln or Martin Luther King Jr.; it was a matter of convincing the viewer that those were the people I'd painted. I wasn't interested in painting perfect likenesses of President Obama's daughters; I was interested in showing two little girls that could represent those daughters. And I think that's the message of the book."

Such an approach takes a practical turn when reference material is scarce.

"I was never interested in showing what Albert Einstein looked like as a kid," says Long. "My figure represents what could be the young Albert Einstein looking up at the Albert Einstein we all know. It's the essence."

compares the picture book to cinema: "I'm like a director choosing moments to film, only with a certain pagination." To establish the flow, he takes technical pencil in hand and creates a series of thumbnail sketches, a two-page spread represented within a 2×6-inch space.

This is the finished art for the Einstein spread (acrylic, 16×13 each page) from *Of Thee I Sing* (Alfred A. Knopf, 2010) by Barack Obama. The three figures in the lower corner of the left page represent, from left to right, Malia Obama, Sasha Obama (President Obama's daughters) and Georgia O'Keeffe as a child. The boy standing alone represents Albert Einstein as a child. The figure on the right page is Albert Einstein as an adult. For all the figures, Long's objective was to suggest the people they represent rather than create exact likenesses.

"I'm looser when I draw small," says Long. The tiny space prevents him from including too much detail. "That's a Thomas Hart Benton thing," Long explains. "Benton called it the 'grand design.' No detail. If it works small, it will work big."

Along with the flow, Long considers the feeling each illustration must convey. Again, he compares his work to cinema: "In a film you have all these tools—light, music, props, clothing—to create mood and emotion. Quiet and active moments have different sound tracks. In the same way, I want people to feel my art, not just view it." So, when Long sketches, he considers different ways he might present the scene. Should he pull in or out? Would a bird's-eye view be better? Should the scene be hemmed with a border or bleed off the edges of the page? What effect would a black-and-white look lend as opposed to bright color? "The sketches are where all the magic occurs," says Long. "They're where the big choices are made. The final paintings are always a challenge, but all the ideas occur in that sketch phase. That's when I dream the biggest."

Classic layering technique

Once a full set of thumbnails has been approved by the editor and art director, Long blows up his sketches on a photocopier, which reveals any problems with proportions that he may

Illustration (acrylic, 17×30) from *The Little Engine That Could* (Philomel Books, 2005) by Watty Piper

Illustration (gouache and colored pencil, 11×13) from *Otis* (Philomel Books, 2009) by Loren Long

need to correct by adding or subtracting content to the sides of his sketches. He then uses graphite paper to transfer his drawings to his painting surface—illustration board.

His choice of surface reflects the evolution of his thought regarding picture book illustration. Long has come to see the final book, not the individual pages, as the artwork he's creating. He painted his first five books on canvas. He liked the archival quality this surface provided, but became more and more dissatisfied with the dominance of the canvas's texture, which he associated with paintings that viewers take in piece by piece rather than in the flowing totality of a picture book. Illustration board offered Long a smooth, archival surface. Also, the finished painting could be peeled off the illustration board and wrapped around a printer's drum for scanning, just like unmounted canvas.

Long generally paints in acrylic, using classic oil-layering techniques. "I wanted to paint like an oil painter," he says, "but in today's world of sometimes finishing a painting on the same day I ship it, oil paint didn't work for me." Following early Italian Renaissance masters, he first applies glazes of local color—up to eight layers in certain areas. Then, adopting a more modern technique, he adds thicker, opaque nuances, which are usually the lighter colors. "Go to an art museum and look at a classic nineteenth-century portrait," says Long. The paint is thin in the dark areas, and then the face is done in thicker oils. If you stand to the side, you can see it."

Artist as team player

A fine artist needs to please himself, but also potential collectors and, most likely, one or more gallery owners. A picture book illustrator deals with editors, art directors and, to some degree, marketing, publicity and sales people—all these before the book has a chance to reach a single child (not to mention the adults who buy the book for the child). To some, the situation would be a nightmare, but Long welcomes the input from members of a pub-

Illustration (acrylic, 12×25) from *Wind Flyers* (Simon & Schuster Children's Publishing, 2007) by Angela Johnson

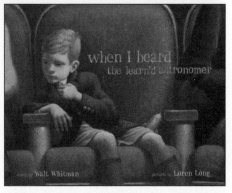

Cover (acrylic,13×18) of *When I Heard the Learn'd Astronomer* (Simon & Schuster Children's Publishing, 2004) by Walt Whitman

lishing team. "They're smart," says Long, "and I want access to their expertise in their respective fields." Long also points out, "In my experience, children's publishing offers more creative freedom than any other market for illustration I've worked in. The editor and art director want the illustrator's vision for a book. Nobody directs me as to how to illustrate a book or what to include. They just hand me a manuscript and react to the sketches I present."

Otis, the story of a tractor who befriends a calf—a book that Long both wrote and illustrated—exemplifies the artist's ability to work as a team player without sacrificing creative integrity. Loren wanted *Otis* to feel timeless, like Virginia Lee Burton's 1939 classic, *Mike Mulligan and His Steam Shovel*—something that an adult would remember loving as a child and then read to his or her own children. He felt that the story of *Otis* leant itself to a black-and-white look, quite a departure from the bright colors of his previous book for the same publisher.

He decided to paint in gouache, which allowed him to work in thin layers, almost drawing rather than painting. "I like lamp black. It has a warm, rich tone. I thought I would layer that and brush in the black outline of Otis, the tractor," says Long. But the paint fought him. "When you take those velvety washes of lamp black and throw in white to model and bring out the lights, the white becomes cool in temperature," he explains. "I started throwing in a little cream—Naples yellow." He also used a little colored pencil for outlining and texturing.

He sent the black-and-white sample illustration to his editor, who presented it to the publishing team. As Long tells it, "Half the room said, 'We love it! This is going to stand out on a bookshelf.' The other half said, 'Kids need color!' So I created the same illustration in

color. Half the room said, 'That's it!' The other half said, 'We really liked that black and white.' So I did a hybrid. I took the black-and-white scene and plopped in color, especially on the main characters. The result feels like a retro black-and-white book, but it has color." The publishing team—and Long's young readers—loved it. Long has followed up with a second Otis book, *Otis and the Tornado*.

Organic approach

Although Long's style is fully identifiable, he cultivates subtle differences in the look of his art from book to book. His illustrations for *The Little Engine That Could* by Watty Piper display rich, opaque acrylic color. Otis has a

Illustration (acrylic, 13×13) from *Of Thee I Sing* (Alfred A. Knopf, 2010) by Barack Obama

monochromatic feel with a transparent look to the paint. The book Long is working on now, *Chiro's Night Song* by Ari Berk, features illustrations that are part colorful acrylic and part charcoal. That's the current plan, anyway. The execution may change as the vision continues to come into focus. And Loren is open—to experimentation, to suggestions, to the organic development that ultimately fulfills the grand design.

MEET LOREN LONG

Illustrator and author Loren Long earned his bachelor of fine arts degree in graphic design/art studio from the University of Kentucky, followed by graduate studies in illustration at the American Academy of Art in Chicago. Before settling into a career of illustrating and writing picture books, he already had a client list that included major magazines such as *Forbes*, *Time*, *Atlantic Monthly* and *Sports Illustrated*, as well as big-name publishers like Harper Collins, Penguin, Houghton Mifflin and the National Geographic Society. Among his numerous honors are Golden Kite Awards for the books *I Dream of Trains* by Angela Johnson and *When I Heard the Learn'd Astronomer* by Walt Whitman, and his selection by Madonna to illustrate her book *Mr. Peabody's Apples* and by President Obama to illustrate his book *Of Thee I Sing*. Long's lithograph print, *The Tornado*, is part of the permanent collection of the Cincinnati Art Museum.

THESE ARE THINGS

Make What You Like

...

by Luke McLaughlin

Ohio-based design duo Jen Adrion and Omar Noory have created a design business with worldwide reach from their website These Are Things. They make colorful designs full of personality, modern lines, and sharp geometric shapes that feel more comfortable and familiar than stark. Starting with a single world map, they have built up four collections of cartographic prints. Some of their more recent designs merely hint at the shape of a city by placing stylized landmarks in a circle that represents the layout of the city.

Starting out on the Web

Adrion and Noory met while studying at the Columbus College of Art and Design, but both had started their own websites long before. They both liked computers as children, and Noory says that playing games on the computer led him to experiment with venerable graphics painting program Paint and then on into Adobe Photoshop and beyond.

Adrion remembers having fun making her own website in middle school. "It was a terrible little website, just posting 'what I did today' and things like that," she remembers. They would later realize that the experience they gained in these early days was invaluable for starting their business. "I realized that art school was a possibility and that I could do these things for a living," says Adrion. "We ended up meeting each other at art school. We were both in the graphic design program and that's really where, I think, we both seriously started doing design work."

Luke McLaughlin is an American writer based in Oxford, England. In addition to writing about art and music, he is currently working on a series of musically expressive smartphone apps.

Colorful flags enliven a monochrome map of the United States made up entirely of gray shading patterns.

Haters gonna hate

In 2008 Noory posted an image that he created of a man contentedly strolling along with the phrase "Haters gonna hate" in a thought bubble above his head. He then made it into an animation. It went viral and became a hugely popular meme. This is a concrete demonstration of the power of the Internet for distributing designs. When running These Are Things became their full-time job, they based the business in the online world.

A traditional work surface

While their marketplace is the Internet, Noory and Adrion's work surfaces are traditional and local. The centerpieces of their design studio are custom hardwood desks they commissioned to be made in Ohio Amish country. Their desks are still a little cluttered from a recent move, but their design is simple and functional. On Noory's desk is a protein

Noory's design became an Internet phenomenon. It combines humor with careful attention to design details such as lettering, lines and motion.

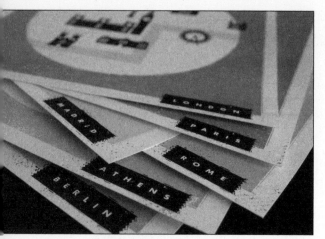

Adrion and Noory's designs are vibrant with great attention to detail. They say that they want to inspire people to travel.

bar, evidence of a recently developed interest in power lifting, and on Adrion's there is a passport.

Travel

It doesn't take a lot of detective work to discover that Adrion and Noory have a passion for travel. In addition to the passport sitting out on Adrion's desk, most of their designs for These Are Things are maps or otherwise travel related. But travel is more than a theme for their work: "Any big decision that we've ever made has been made while we were on a trip," Adrion explains. "Our decision to go full time with These Are Things was made in New York." Noory goes on to describe how they first talked about combining fine art and design and still being profitable while traveling, this time on a road trip to Chicago. They were dissatisfied with the work they were producing for their first jobs out of design school. Adrion remembers the conversation: "I was freelancing and Omar was working at an agency, and we were just driving back on this road trip and said, 'This could be cooler. We could be making better things.' I don't know what it is about travel, but we find a lot of clarity on those trips. We hope to travel more."

Making things that we want

Tired of the tedium of making "ugly business cards" for clients, Adrion and Noory decided to design for themselves. Adrion explains how they came up with their first design project: "Our rule from the beginning was that we just make things that we want. The way we got started was by making our first world map because, for a whole year, I really wanted a giant map in my apartment so that we could put pins on it and track where we'd been. I don't know why it took so long to realize that we could just make our own that's exactly like what we see in our heads. So that's really the beginning of anything that we do that's self-directed. It is just something that we want and that we would like to hang up in our home."

Noory describes the early decisions that paid off: "There were two things we did that were really good for us. We stuck with our old jobs at first. We overlapped, which meant we worked 8 to 5, then we came home and worked on These Are Things. That let us have some money coming in so there was less stress. And it showed that we were really passionate about it. Because we were working on These Are Things in our off hours, we knew we would do fine

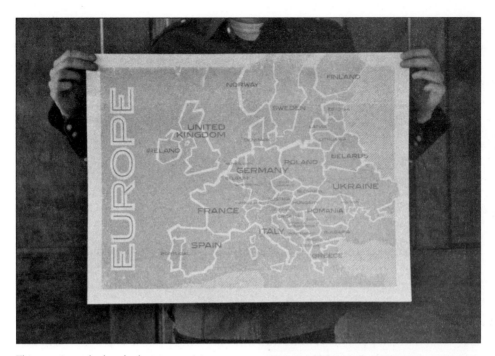

This map is on the border between contemporary and retro. The bold lettering and chunky outlines are softened by fading colors near the edges of the map.

These posters are rolled, wrapped and ready to be delivered.

when we went full time. Having the security of our freelance and agency jobs allowed us to take a few more risks than we could have if we had just quit our jobs right off the bat."

They worked 18 hours days for the first 6 months to get their business started. "Omar was working the more traditional job at an agency while I was freelancing and teaching at an art school. I would work during the day, then teach in the afternoon, and then he would come home and from work and meet at one of our apartments and roll maps or design until 4AM," says Adrion. "It was so exciting because we could see it starting to take flight, and the potential of it becoming something bigger was something that kept us going during that time."

Adrion offers some advice to others just starting out in design: "Make things you like. Have side projects and don't feel trapped by the other things going on in your life. If you are passionate about something and you make good work, chances are you will be able to sell

it to somebody. The Internet is a big place. That is another thing that we have found. Our reach compared to other giant shops is very small, but we found a really great community of people who enjoy our work and we are able to make a living from it."

Working on the Web

Adrion says that there is a reason that they are still able to enjoy the Web work that they have to do for These Are Things. They have made it a rule to never work on websites for other people. She explains, "'We've stuck to it very well and it's made our lives much better. We will do Web work all day and all night for our own projects, but we will never do it for hire. It keeps it fun for us. After working on print stuff so much, it is actually kind of refreshing to jump into the interactive world for a bit and play with all the new technologies and make something that is cool and fun."

"There is no excuse not to have a good website these days" says Noory. "We were just working on a new site, and the ability to make a website now without knowing HTML is easier than ever." Adrion could not believe the wealth of resources available to people starting out on the Web today: "We have a new product that we are testing out, and we thought we're going to make a very quick shop for it, we're going to spend a night on it, and the tools that are out there now are just so incredible how easy it is for people who don't really have the knowledge."

Adrion and Noory's familiarity with Web design has been important to their success. Noory explains, "Without the Internet, without our ability to work in the Web and make websites, we would never have gotten started. It's where we do all of our promotion, where we do all of our sales, so it's number one, absolutely the most important thing."

A local presence

Despite having a Web-based business and getting their work out to the marketplace almost entirely online, Adrion and Noory have started doing events in their local area as well. In cooperation with a local print-making studio that produces some of their prints, they let people come in and create prints based on one of their designs, a map of the state of Ohio. "We are lucky to have some really awesome friends here in Columbus. People loved it. It was great. For people who didn't go to four years of art school and spend hours and hours in the print lab it's

Visitors at a local event had the opportunity to make their own color print of one of These Are Things map designs.

It is easy to overlook the detail on the color overlays, but they add dimension and space to these flags and compass points.

kind of a magical thing to walk in and apply ink to a plate and crank this thing and out comes a print that they made. So that was fun. We hope to do that more; we got a really good response to that," says Adrion.

Working as a team

Adrion and Noory have found that they work more efficiently together than they could on their own, but they had no idea that this would be the case from the start. Adrion explains, "It's really interesting, because we each have our own individual styles and individual strengths. It sounds awful when we tell this to people, but neither of us really like working with other people. So it was funny that when we started working together on these projects that it actually came very naturally and we found that our skill sets were very complementary. I tend to be the nitpicky, detail-oriented one, aligning everything to the fraction of a pixel level, whereas Omar has this great ability to look at the bigger pictures and take things a step further than I would. Our collaboration is really great."

Noory explains how working with Adrion helps him work better: "Jen is really good at the two things that I am really bad at: starting a project and finishing a project. In the middle, I'm fine, I like that kind of work, but I really have a hard time thinking of an idea, and I have

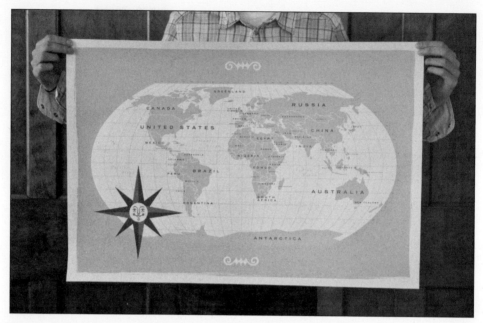

Their world map designs have a traditional look with a playful edge.

a hard time saying 'This is done.' So we help each other through these creative roadblocks. We make things that would not be possible with just one of us working on the project."

Finishing projects

They both agree that finally saying that something is finished is one of the hardest things in design. But sometimes an element from an unfinished work unexpectedly provides the missing piece for later projects. "On our dropbox for These Are Things there are probably about one hundred unfinished projects for every one finished one," says Adrion. "It's weird, sometimes while we're trying to finish one project I will remember something that I designed a year ago for something that never got made, and that will be the thing that completes the piece. We actually have one on the computer screen right now that we can't quite finish yet, but we don't know exactly what to do with it. Sometimes the project does just need to sit for a little while until you realize that it is done. Now, with client work, the sitting for a while is not really an option," Adrion laughs. "But, for the self-directed stuff, it really takes time, and I think having two of us helps because when I get completely stuck and am in a corner and can't figure out what to do, Omar can walk over and say, well, you know, it needs a third color. It's usually something simple, like 'Ah, okay, this is how we can complete this thing.' But I'm such a perfectionist that I have trouble calling anything done."

Noory says that at some point you need to just declare a project finished. "That's always the hardest thing when you are sending off something to the client or to press, to say, 'Okay, this is done.' We can sit for hours and try to make it 1 percent better, or we can just have it done." Working as a team can makes this easier for Adrion. "It's nice again to have two people because if I were on my own I would just go back and forth forever without being quite ready to call it finished. We give each other deadlines and that definitely helps with getting things done."

Don't try to do everything yourself

Noory explains that another strategy that helped them succeed was deciding not to try to do everything themselves. "If you are not really good at something, or something takes too much time, source it out. We have other people print our work and ship our work so we can just sit down and design. It costs money but the money we save from having our time back has been worth it a hundred percent."

Adrion remembers how important their first decision to outsource was to the eventual success of their company: "That was the one decision that allowed this to even happen. We both studied some printmaking in college, so we were pricing out building a silkscreen lab in my basement. We were going to print maps ourselves. We had it all priced out, we knew what we were going to buy, and we looked at each other and said 'We're not going to do this.' We would end up with a map that wouldn't even look very good because we're not professional printmakers. So we pooled together 500 dollars to get 50 maps printed. That was the smallest quantity they would let us order, so the cost per piece was really high, but that was what we started this business on."

Although it was scary to spend so much for their first run of prints, in retrospect they agree that it was a great investment. "It was probably the best money that we have ever spent. But it was a lot at that time, and we thought, 'What if we don't sell these things, we're going to have one map in his house, one map in my house,'" says Adrion.

"We were figuring we could just give them away if we had to," says Noory. "We really wanted these maps, and they looked good," Adrion explains. Noory adds, "We thought maybe someone else might like them."

GALLERIES

//

Most artists dream of seeing their work in a gallery. It's the equivalent of "making it" in the art world. That dream can be closer than you realize. The majority of galleries are actually quite approachable and open to new artists. Though there will always be a few austere establishments manned by snooty clerks, most are friendly places where people come to browse and chat with the gallery staff.

So don't let galleries intimidate you. The majority of gallery curators will be happy to take a look at your work if you make an appointment or mail your slides to them. If they feel your artwork doesn't fit their gallery, most will steer you toward a more appropriate one.

A few guidelines

- **Never walk into a gallery without an appointment** expecting to show your work to the director. When we ask gallery directors about their pet peeves, they always mention the talented newcomer walking into the gallery with paintings in hand. Most galleries prefer or even require electronic submissions. (Refer to the listings for more specific information on each gallery's preferred submission method.) Following the gallery's guidelines, send a polished package of about eight to twelve images, either by e-mail or on disk. If you prefer to work with slides and the gallery will accept them, send neatly labeled, mounted duplicate slides of your work in plastic slide sheets. Do not send original slides, as you will need them to reproduce later. Send an SASE, but realize your packet may not be returned.
- **Seek out galleries that show the type of work you create.** Most galleries have a specific "slant" or mission. A gallery that shows only abstract works will not be interested in your realistic portraits.

TYPES OF GALLERIES

As you search for the perfect gallery, it's important to understand the different types of spaces and how they operate. The route you choose depends on your needs, the type of work you do, your long-term goals, and the audience you're trying to reach.

- **Retail or commercial galleries.** The goal of the retail gallery is to sell and promote the work of artists while turning a profit. Retail galleries take a commission of 40 to 50 percent of all sales.
- **Co-op galleries.** Co-ops exist to sell and promote artists' work, but they are run by artists. Members exhibit their own work in exchange for a fee, which covers the gallery's overhead. Some co-ops also take a small commission of 20 to 30 percent to cover expenses. Members share the responsibilities of gallery-sitting, sales, housekeeping, and maintenance.
- **Rental galleries.** The rental gallery makes its profit primarily through renting space to artists and therefore may not take a commission on sales (or will take only a very small commission). Some rental spaces provide publicity for artists, while others do not. Showing in this type of gallery is risky. Rental galleries are sometimes thought of as "vanity galleries," and, consequently, do not have the credibility other galleries enjoy.
- **Nonprofit galleries.** Nonprofit spaces will provide you with an opportunity to sell your work and gain publicity, but will not market your work aggressively because their goals are not necessarily sales-oriented. Nonprofits generally take a small commission of 20 to 30 percent.
- **Museums.** Though major museums primarily show work by established artists, many small museums are open to emerging artists.
- **Art consultancies.** Consultants act as liaisons between fine artists and buyers. Most take a commission on sales (as would a gallery). Some maintain small gallery spaces and show work to clients by appointment.

- **Visit as many galleries as you can.** Browse for a while and see what type of work they sell. Do you like the work? Is it similar to yours in quality and style? What about the staff? Are they friendly and professional? Do they seem to know about the artists the gallery represents? Do they have convenient hours? If you're interested in a gallery outside your city and you can't manage a personal visit before you submit, read the listing carefully to make sure you understand what type of work is shown there. Check out the gallery's website to get a feel for what the space is like, or ask a friend or relative who lives in that city to check out the gallery for you.

- **Attend openings.** You'll have a chance to network and observe how the best galleries promote their artists. Sign each gallery's guest book or ask to be placed on galleries' mailing lists. That's also a good way to make sure the gallery sends out professional mailings to prospective collectors.

Showing in multiple galleries

Most successful artists show in several galleries. Once you've achieved representation on a local level, you might be ready to broaden your scope by querying galleries in other cities. You may decide to be a "regional" artist and concentrate on galleries in surrounding states. Some artists like to have East Coast and West Coast representation.

If you plan to sell work from your studio, or from a website or other galleries, be up front with each gallery that shows your work. Negotiate commission arrangements that will be fair to you and all involved.

Pricing your fine art

A common question of beginning artists is, "What do I charge for my paintings?" There are no hard and fast rules. The better known you become, the more collectors will pay for your work. Though you should never underprice your work, you must take into consideration what people are willing to pay. Also keep in mind that you must charge the same amount for a painting sold in a gallery as you would for work sold from your studio.

Juried shows, competitions, and other outlets

It may take months, maybe years, before you find a gallery to represent you. But don't worry; there are plenty of other venues in which to show your work. Get involved with your local art community. Attend openings and read the arts section of your local paper. You'll see there are hundreds of opportunities.

Enter group shows and competitions every chance you get. Go to the art department of your local library and check out the bulletin board, then ask the librarian to direct you to magazines that list "calls to artists" and other opportunities to exhibit your work. Subscribe to the Art Deadlines List, available online (www.artdeadlineslist.com). Join a co-op gallery and show your work in a space run by artists for artists.

Another opportunity to show your work is through local restaurants and retail shops that exhibit the work of local artists. Ask the managers how you can get your art on their walls. Become an active member in an arts group. It's important to get to know your fellow artists. And since art groups often mount exhibitions of their members' work, you'll have a way to show your work until you find a gallery to represent you.

5+5 GALLERY

620 Fort Washington Ave., Suite 3N, New York NY 10040. (718)624-6048. **E-mail:** gallery1@fodde.com. **Website:** www.5plus5gallery.com. **Contact:** Raphael Foddé, director. Online gallery only. No exhibitions. Overall price range: $300-15,000; most work sold at $1,200.

MEDIA Exhibits paper, pastel, pen & ink, watercolor.

TERMS Artwork is accepted on consignment (50% commission).

SUBMISSIONS E-mail attachments only. Finds artists through submissions.

TIPS "Submit a very simple, short and to-the-point artist's statement and CV."

⊕ 440 GALLERY

440 Sixth Ave., Brooklyn NY 11215. (718)499-3844. **E-mail:** gallery440@verizon.net. **Website:** www.440gallery.com. **Contact:** Nancy Lunsford, founder. Estab. 2005.

MEDIA Considers all media. Most frequently exhibits painting, collage/assemblage, photography

STYLE Considers all styles.

TERMS Artwork is accepted on consignment and there is a 20% commission. There is a co-op membership fee plus a donation of time. There is a 20% commission. Retail price of the art set by the artist. Gallery provides promotion. Accepted work should be framed, mounted.

SUBMISSIONS E-mail query letter with link to artist's website and JPEG samples at 72 dpi. Material cannot be returned. Responds in 1-2 months. "Files images and résumés from artists we are interested in for membership." Finds artists through word of mouth, submissions, portfolio reviews, art exhibits, referrals by other artists.

TIPS "We prefer digital submissions: a brief cover letter in the body of the e-mail, properly formatted and labeled images, a title sheet file corresponding to the image files and a brief (1-2 page) résumé. Please read about our gallery on our website and read through any calls for artists before contacting us with a question previously answered on the website."

ACADEMY GALLERY

8949 Wilshire Blvd., Beverly Hills CA 90211. (310)247-3000. **Fax:** (310)859-9619. **E-mail:** Via online contact form. **Website:** www.oscars.org. Estab. 1992. Exhibitions focus on all aspects of the film industry and the filmmaking process. Sponsors 3-5 exhibitions/year. Average display time: 3 months. Open all year; Tuesday–Friday, 10-5; weekends, 12-6. Gallery begins in building's Grand Lobby and continues on the 4th floor. Total square footage is approx. 8,000. Clients include students, senior citizens, film aficionados and tourists.

SUBMISSIONS Call or write to arrange a personal interview to show portfolio of photographs, slides and transparencies. Must be film process or history related.

ACA GALLERIES

529 W. 20th St., 5th Floor, New York NY 10011. (212)206-8080. **Fax:** (212)206-8498. **E-mail:** info@acagalleries.com. **Website:** www.acagalleries.com. Estab. 1932. For-profit gallery. "Our area of specialty is American art and American artists (ACA = American Contemporary Artists). We exhibit traditional art forms such as painting, drawing and sculpture. We do not show photography, installation, video or new media. We handle established, mid-career artists that have had solo museum exhibitions and have major books or catalogs written about them that are not self-published." Exhibited artists include Faith Ringgold (painting, drawing, soft sculpture) and Judy Chicago (painting, drawing, sculpture). Sponsors 8 exhibits/year. Average display time: 6-7 weeks. Open Tuesday–Saturday, 10:30-6. Clients include local community, tourists, upscale. 25% of sales are to corporate collectors. Overall price range: $1,000-1,000,000.

MEDIA Considers all media except photography. Most frequently exhibits acrylic, ceramics, collage, drawing, fiber, mixed media, oil, paper, pastel, pen & ink, sculpture, watercolor.

STYLE Considers all styles, all genres. Most frequently exhibits color field, expressionism, impressionism, postmodernism, surrealism.

TERMS Artwork is accepted on consignment (10-50% commission). Retail price set by both artist and gallery. Gallery provides insurance, promotion, contract. Accepted work should be framed. Requires exclusive representation locally.

SUBMISSIONS Submission guidelines available online. "If you fit the above criteria, you may submit your artwork for consideration during the months of June and July. It will take approximately 6-8 weeks to review your submission and any work received after July 31 will not be reviewed. Please do not call the gallery to follow up on your submission, to set up an appoint-

ment for a studio visit, or ask us to recommend alternate galleries. We will contact you if we are interested."

ADIRONDACK LAKES CENTER FOR THE ARTS

Route 28, P.O. Box 205, Blue Mountain Lake NY 12812. (518)352-7715. **Fax:** (518)352-7333. **E-mail:** info@adirondackarts.org. **Website:** www.adirondackarts.org. **Contact:** Stephen Svodoba, executive director. Estab. 1967. Nonprofit galleries in multi-arts center. Represents 107 emerging, mid-career and established artists/year. Sponsors 6-8 shows/year. Average display time 4-8 weeks. Open Thursday–Saturday, 10-4; July and August daily. Located on Main Street next to post office; 176 sq. ft.; "pedestals and walls are white, some wood and very versatile." Clients include tourists, summer owners and year-round residents. 90% of sales are to private collectors, 10% corporate collectors. Overall price range $100-10,000; most work sold at $100-1,000. Accepts work on consignment (30% commission). Retail price set by the artist. Gallery provides insurance, contract; shares promotion. Prefers artwork framed. Finds artists through word of mouth, art publications and artists' submissions.

MEDIA Considers all media and all types of prints. Most frequently exhibits paintings, sculpture, wood and fiber arts.

STYLE Exhibits all styles. Genres include landscapes, Americana, wildlife and portraits.

SUBMISSIONS Send query letter with slides or photos and bio. Annual submission deadline early November; selections complete by February 1. Files "slides, photos and bios on artists we're interested in." Reviews submissions once/year.

TIPS "We love to feature artists who can also teach a class in their media for us. It increases interest in both the exhibit and the class."

AGORA GALLERY

530 W. 25th St., Chelsea NY 10001. (212)226-4151. **Fax:** (212)966-4380. **E-mail:** info@agora-gallery.com. **Website:** www.agora-gallery.com. **Contact:** Angela Di Bello, director. Estab. 1984. For-profit gallery. Represents emerging, mid-career and established artists. Sponsors 19 exhibits/year. Average display time: 3 weeks. Open Tuesday–Saturday, 11-6. Closed national holidays. Located in the heart of New York City's Chelsea art galleries district, and has over 5,000 sq. ft. of exhibition space; exclusive gallery block. Clients include local, tourists, upscale collectors. Most work sold at an average of $4,000.

MEDIA Acrylic, collage, digital, drawing, mixed media, oil, pastel, photography, sculpture, watercolor.

STYLE Considers all styles.

TERMS There is a representation fee. There is a 30% commission to the gallery; 70% to the artist. Retail price set by the gallery and the artist. Gallery provides insurance and promotion. At the end of 2009, Agora Gallery opened its doors to a new exhibition space. Adjacent to the main gallery, this beautifully designed and spacious new gallery will showcase artists and their work in a significant solo exhibition environment.

SUBMISSIONS Guidelines available online (www.agora-gallery.com/artistinfo/GalleryRepresentation.aspx). Send 5-15 slides or photographs with a cover letter, artist's statement, bio and SASE; include portfolio submission form from website, or submit all materials through the online link. Responds in 3 weeks. Files bio, slides/photos and artist statement. Finds artists through word of mouth, submissions, portfolio reviews, art exhibits, online and referrals by other artists.

TIPS "Follow instructions!"

✚ AKEGO AND SAHARA GALLERY

50 Washington Ave., Endicott NY 13760. (607)821-2540. **E-mail:** info@africaresource.com. **Website:** www.africaresource.com/house. **Contact:** Azuka Nzegwu, managing director. Estab. 2007. A for-profit, alternative space, for-rent gallery, and art consultancy. Exhibits emerging, mid-career, and established artists. Represents or exhibits 3-4 artists per year. Sponsors 3 total exhibits a year. Average display time 3-4 months. Model release and property release required. Open Monday-Friday, 9-6. Clients include local community, students, tourists, and upscale. Has contests and residencies available. See website for further details.

MEDIA Considers all media, and prints.

STYLE Considers all styles and genres

TERMS Artwork is accepted on consignment and there is a 40% commission. There is a rental fee for space covering 1 month. Retail price set by the gallery and the artist. Gallery provides insurance, promotion, and contract. Does not require exclusive representation locally. Artists should call, e-mail query letter with a link to the artist's website, mail portfolio for

review, or send query letter with artist's statement, bio, résumé, and reviews. Responds in 1 week. Finds artists through word of mouth, submissions, portfolio reviews, referrals by other artists, as well as other means.

ALASKA STATE MUSEUM

395 Whittier St., Juneau AK 99801-1718. (907)465-2901. **Fax:** (907)465-2976. **E-mail:** paul.gardinier@alaska.gov. **Website:** www.museums.state.ak.us. **Contact:** Paul Gardinier, curator of exhibits. Estab. 1900. Approached by 40 artists/year; exhibits four emerging, mid-career and established artists. Sponsors 10 exhibits/year. Average display time: 6-10 weeks. Downtown location with 3 galleries exhibiting temporary exhibitions.

MEDIA Considers all media. Most frequently exhibits painting, photography and mixed media. Considers engravings, etchings, linocuts, lithographs, mezzotints, serigraphs and woodcuts.

STYLE Considers all styles.

SUBMISSIONS Finds Alaskan artists through submissions and portfolio reviews every two years. Register for e-mail notification at: http://list.state.ak.us/guest/RemoteListSummary/Museum_Exhibits_Events_Calendar.

JEAN ALBANO GALLERY

215 W. Superior St., Chicago IL 60610. (312)440-0770. **Fax:** (312)440-3103. **E-mail:** jeanalbano@aol.com. **Website:** www.jeanalbano-artgallery.com. **Contact:** Jean Albano Broday, director. Estab. 1985. Represents 24 mid-career artists. Somewhat interested in seeing the work of emerging artists. Exhibited artists include Martin Facey and Jim Waid. Average display time is 5 weeks. Open Tuesday–Friday, 10-5; Saturday, 11-5; and by appointment. Located downtown in River North gallery district; 1,600 sq. ft.; 60% of space for special exhibitions; 40% of space for gallery artists. Clientele 80% private collectors, 20% corporate collectors. Overall price range $1,000-20,000; most work sold at $2,500-6,000.

MEDIA Considers oil, acrylic, sculpture and mixed media. Most frequently exhibits mixed media, oil and acrylic. Prefers nonrepresentational, nonfigurative and abstract styles.

TERMS Accepts artwork on consignment (50% commission). Retail price set by gallery and artist; shipping costs are shared.

SUBMISSIONS Send query letter with résumé, bio, SASE and well-labeled slides (size, name, title, medium, top, etc.). Write for appointment to show portfolio. Responds in 6 weeks. If interested, gallery will file bio, résumé and selected slides.

TIPS "We look for artists whose work has a special dimension in whatever medium. We are interested in unusual materials and unique techniques."

THE ALBUQUERQUE MUSEUM OF ART & HISTORY

2000 Mountain Rd. NW, Albuquerque NM 87104. (505)243-7255. **E-mail:** aconnors@cabq.gov. **Website:** www.cabq.gov/museum. Glenn Fye, photo archivist. **Contact:** Andrew Connors, curator of art. Estab. 1967. Nonprofit municipal museum. Located in Old Town, west of downtown.

STYLE Mission is to collect, promote, and showcase art and artifacts from Albuquerque, the state of New Mexico, and the Southwest. Sponsors mainly group shows and work from the permanent collection.

SUBMISSIONS Artists may send portfolio for exhibition consideration: slides, photos, disk, artist statement, résumé, SASE.

ALEX GALLERY

2106 R St., NW, Washington DC 20008. (202)667-2599. **E-mail:** alexgallerydc@gmail.com; info@alexgalleries.com. **Website:** www.alexgalleries.com. Estab. 1985. Retail gallery and art consultancy. Represents 20 emerging and mid-career artists. Exhibited artists include Willem de Looper, Gunter Grass and Olivier Debre. Sponsors 8 shows/year. Average display time: 1 month. Open Tuesday–Saturday, 11-5; and by appointment. Located in the heart of a gallery neighborhood; two floors of beautiful turn-of-the-century townhouse; a lot of exhibit space. Clientele: diverse; international and local. 50% private collectors; 50% corporate collectors. Overall price range: $1,500-60,000.

MEDIA Considers oil, acrylic, watercolor, pastel, mixed media, collage, sculpture, photography, original handpulled prints, lithographs, linocuts and etchings. Most frequently exhibits painting, sculpture and works on paper.

STYLE Exhibits expressionism, abstraction, color field, impressionism and realism; all genres. Prefers abstract and figurative work.

TERMS Accepts artwork on consignment. Retail price set by gallery and artist. Gallery provides insurance, promotion and contract; shipping costs are shared.

SUBMISSIONS Send query letter with résumé, slides, bio, SASE and artist's statement. Write for appointment to show portfolio, which should include slides and transparencies. Responds in 2 months.

CHARLES ALLIS ART MUSEUM

1801 N. Prospect Ave., Milwaukee WI 53202. (414)278-8295. **E-mail:** mcostello@cavtmuseums. org. **Website:** www.charlesallis.org. **Contact:** Maria Costello, executive director. Estab. 1947. Approached by 20 artists/year. Represents 6 emerging, mid-career and established artists that have lived or studied in Wisconsin. Exhibited artists include Anne Miotke (watercolor); Evelyn Patricia Terry (pastel, acrylic, multi-media). Sponsors 4 exhibits/year. Average display time: 3 months. Open all year; Wednesday–Sunday, 1-5. Located in an urban area, historical home, 3 galleries. Clients include local community, students and tourists. 10% of sales are to corporate collectors. Overall price range: $200-6,000.

MEDIA Considers acrylic, collage, drawing, installation, mixed media, oil, pastel, pen & ink, sculpture, watercolor and photography. Print types include engravings, etchings, linocuts, lithographs, serigraphs and woodcuts. Most frequently exhibits acrylic, oil and watercolor.

STYLE Considers all styles and genres. Most frequently exhibits realism, impressionism and minimalism.

TERMS Artwork is accepted on consignment. Artwork can be purchased during run of an exhibition. There is a 30% commission. Retail price set by the artist. Museum provides insurance, promotion and contract. Accepted work should be framed. Does not require exclusive representation locally. Accepts only artists from or with a connection to Wisconsin.

SUBMISSIONS Send query letter with artist's statement, bio, business card, résumé, reviews, SASE and slides. Material is returned if the artist is not chosen for exhibition. Responds to queries in 1 year. Finds artists through art exhibits, referrals by other artists, submissions and word of mouth.

TIPS "All materials should be typed. Slides should be labeled and accompanied by a complete checklist."

AMERICAN PRINT ALLIANCE

302 Larkspur Turn, Peachtree City GA 30269-2210. **E-mail:** director@printalliance.org. **Website:** www. printalliance.org. **Contact:** Carol Pulin, director. Estab. 1992. Nonprofit arts organization with online gallery and exhibitions, travelling exhibitions, and journal publication; Print Bin: a place on website that is like the unframed, shrink-wrapped prints in a bricks-and-mortar gallery's "print bin." Approached by hundreds of artists/year; represents dozens of artists/year. "We only exhibit original prints, artists' books and paperworks." Usually sponsors 2 travelling exhibits/year—all prints, paperworks and artists' books. Most exhibits travel for 2 years. Hours depend on the host gallery/museum/arts center. "We travel exhibits throughout the U.S. and occasionally to Canada." Overall price range for Print Bin: $150-3,200; most work sold at $300-500.

MEDIA Considers and exhibits original prints, paperworks, artists' books. Also all original prints including any combination of printmaking techniques; no reproductions/posters.

STYLE Considers all styles, genres and subjects; the decisions are made on quality of work.

TERMS Individual subscription: $32-39. Print Bin is free with subscription. "Subscribers eligible to enter juried traveling exhibitions but must pay for framing and shipping to and from our office." Gallery provides promotion.

SUBMISSIONS Subscribe to journal, *Contemporary Impressions* (www.printalliance.org/alliance/al_sub form.html). Send one slide and signed permission form (www.printalliance.org/gallery/printbin_info. html). Returns slide if requested with SASE. Usually does not respond to queries from non-subscribers. Files slides and permission forms. Finds artists through submissions to the gallery or Print Bin, and especially portfolio reviews at printmakers conferences. "Unfortunately, we don't have the staff for individual portfolio reviews, though we may—and often do—request additional images after seeing one work, often for journal articles. Generally about 100 images are reproduced per year in the journal."

TIPS "See the Standard Forms area of our website (www.printalliance.org/library/li_forms.html) for correct labels on slides and much, much more about professional presentation."

AMERICAN SOCIETY OF ARTISTS

P.O. Box 1326, Palatine IL 60078. (847)991-4748 or (312)751-2500. **E-mail:** asoaartists@aol.com. **Website:** www.americansocietyofartists.org. **Contact:** Helen Del Valle, membership chairman. Members and nonmembers may exhibit. "Our members range

from internationally known artists to unknown artists—quality of work is the important factor."

TERMS Responds in 2 weeks.

SUBMISSIONS To jury online (only at asoaartists@aol.com) submit four images of your work (résumé/show listing helpful), or send SASE and 4 slides/photographs that represent your work; request membership information and application.

TIPS Accepted work should be framed, mounted or matted. Accepted members may participate in lecture and demonstration service. Member publication: *ASA Artisan.*

THE ANN ARBOR ART CENTER GALLERY SHOP

117 W. Liberty St., Ann Arbor MI 48104. (734)994-8004. **Fax:** (734)994-3610. **E-mail:** afarnum@annarborartcenter.org; nhogan-leftler@annarborartcenter.org. **Website:** www.annarborartcenter.org. **Contact:** Amy Farnum, gallery shop director; Niki Hogan-Lefler, exhibitions manager. Estab. 1909. Represents over 350 artists, primarily Michigan and regional. Gallery shop purchases support the Art Center's community outreach programs. "We are the only organization in Ann Arbor that offers hands-on art education, art appreciation programs and exhibitions all in one facility." Open Monday–Saturday, 11-6; Sunday, 12-5.

○ The Ann Arbor Art Center also has exhibition opportunities for Michigan artists in its exhibition gallery and art consulting program.

MEDIA Considers original work in virtually all 2D and 3D media, including jewelry, prints and etchings, ceramics, glass, fiber, wood, photography and painting.

STYLE The gallery specializes in well-crafted and accessible artwork. Many different styles are represented, including innovative contemporary.

TERMS Submission guidelines available online. Accepts work on consignment. Retail price set by artist. Offers member discounts and payment by installments. Exclusive area representation not required. Gallery provides contract; artist pays for shipping.

SUBMISSIONS "The Art Center seeks out artists through the exhibition visitation, wholesale and retail craft shows, networking with graduate and undergraduate schools, word of mouth, in addition to artist referral and submissions."

THE ANTON ART CENTER

125 Macomb Place, Mount Clemens MI 48043. (586)469-8666. **Fax:** (586)469-4529. **E-mail:** information@theartcenter.org. **Website:** www.theartcenter.org. **Contact:** Alison Wong, exhibition and education coordinator. Estab. 1969. Nonprofit gallery. Represents emerging, mid-career and established artists. 500 members. Sponsors 15-16 shows/year. Average display time 1 month. Open Tuesday–Thursday, 10-5; Friday, 10-6; Saturday, 10-5; Sunday, 12-4. Located in downtown Mount Clemens; 10,000 sq. ft. The Art Center is housed in the historic Carnegie Library Building, listed in the State of Michigan Historical Register. A 2006 addition created new classroom and exhibit space as well as a gift shop featuring handmade work. 25% of space for special exhibitions. Clients include private. Overall price range $5-1,000; most work sold at $50-200.

MEDIA Open to all media.

STYLE Exhibits all styles, all genres.

TERMS The Art Center receives a 40% commission on sales of original works.

SUBMISSIONS Send résumé, artist statement, image list, 10 images (JPEG on disk) and SASE if you want materials returned. Finds artists through word of mouth membership and in response to open calls publicized through e-mail and online. Submission guidelines available online.

TIPS "Visit our website to sign up for our e-mail list; all calls for artists are publicized via e-mail."

ARC GALLERY & EDUCATIONAL FOUNDATION

832 W. Superior St., #204, Chicago IL 60642. (312)733-2787. **E-mail:** info@arcgallery.org. **Website:** www.arcgallery.org. **President:** Iris Goldstein. Nonprofit gallery. Estab. 1973. Exhibits emerging, mid-career and established artists. 21 members review work for solo and group shows on an ongoing basis. Visit website for prospectus. Exhibited artists include Miriam Schapiro. Average display time: 1 month. Located in the West Town neighborhood; 1,600 sq. ft. Clientele: 80% private collectors, 20% corporate collectors. Overall price range: $50-40,000; most work sold at $200-4,000.

MEDIA Considers all media. Most frequently exhibits painting, sculpture (installation) and photography.

STYLE Exhibits all styles and genres. Prefers postmodern and contemporary work.

TERMS There is a rental fee for space. Rental fee covers 1 month. No commission taken on sales. Gallery provides promotion; artist pays shipping costs. Prefers framed artwork.

SUBMISSIONS See website (www.arcgallery.org/call-for-entries.aspx) for info or send e-mail query. Reviews are ongoing. Call for deadlines. Slides or digital images are accepted.

ARIZONA STATE UNIVERSITY ART MUSEUM

P.O. Box 872911, Tenth St. and Mill Ave., Tempe AZ 85287-2911. (480)965-2787. **Fax:** (480)965-5254. **Website:** asuartmuseum.asu.edu. **Contact:** Gordon Knox, director. Estab. 1950. Has 2 facilities and approximately 8 galleries of 2,500 square feet each; mounts approximately 15 exhibitions/year. Average display time 3-4 months.

MEDIA Considers all media. Greatest interests are contemporary art, crafts, video, and work by Latin American and Latin artists.

SUBMISSIONS "Interested artists should submit slides to the director or curators."

TIPS "With university cutbacks, the museum has scaled back the number of exhibitions and extended the average show's length. We are always looking for exciting exhibitions that are also inexpensive to mount."

THE ARKANSAS ARTS CENTER

501 E. Ninth St., Little Rock AR 72202. (501)372-4000. **Fax:** (501)375-8053. **E-mail:** info@arkarts.com. **Website:** www.arkarts.com. **Contact:** Brian Young, curator of art; Alan DuBois, curator of decorative arts. Museum art school, children's theater and traveling exhibition service. Estab. 1930s. Exhibits the work of emerging, mid-career and established artists. Sponsors 25 shows/year. Average display time 6 weeks. Open Tuesday–Saturday, 10-5; Sunday, 11-5. Located downtown; 10,000 sq. ft.; 60% of space for special exhibitions.

MEDIA Most frequently exhibits drawings and crafts.

STYLE Exhibits all styles and all genres.

TERMS Retail price set by the artist. "Work in the competitive exhibitions (open to artists in Arkansas and six surrounding states) is for sale; we usually charge 10% commission."

SUBMISSIONS Send query letter with samples, such as photos or slides.

TIPS "Write for information about exhibitions for emerging and regional artists, and various themed exhibitions."

ARNOLD ART

210 Thames St., Newport RI 02840. (401)847-2273; (800)352-2234. **E-mail:** info@arnoldart.com. **Website:** www.arnoldart.com. **Contact:** William Rommel, owner. Estab. 1870. Retail gallery. Represents 40 emerging, mid-career and established artists. Exhibited artists include John Mecray, Willard Bond. Sponsors 4 exhibits/year. Average display time: 1 month. Open Monday-Saturday, 9:30-5:30; Sunday, 12-5. Clientele: local community, students, tourists and Newport collectors. 1% of sales are to corporate clients. Overall price range: $100-35,000; most work sold at $600.

MEDIA Considers oil, acrylic, watercolor, pastel, pen & ink, drawings, mixed media. Most frequently exhibits oil and watercolor.

STYLE Genres include marine sailing, classic yachts, America's cup, yachting/sailing.

TERMS Accepts work on consignment (40% commission). Retail price set by artist. Exclusive area representation not required. Gallery provides promotion.

SUBMISSIONS Send e-mail. Call or e-mail for appointment to show portfolio of originals. Returns materials with SASE.

TIPS To make your submissions professional you must "frame them well."

THE ARSENAL GALLERY

The Arsenal Bldg., Room 20, Central Park, 830 Fifth Ave., New York NY 10065. (212)360-8163. **Fax:** (212)360-1329. **E-mail:** artandantiquities@parks.nyc.gov; jennifer.lantzas@parks.nyc.gov. **Website:** www.nycgovparks.org/art. Jennifer Lantzas, public art coordinator. **Contact:** Patricia Hamilton. Estab. 1971. Nonprofit gallery. Approached by 100 artists/year. Exhibits 8 emerging, mid-career and established artists. Average display time 6-7 weeks. Open all year; Monday-Friday, 9-5. Closed holidays and weekends. 100 linear feet of wall space on the 3rd floor of the Administrative Headquarters of the Parks Department located in Central Park. Clients include local community, students, tourists and upscale. Overall price range $100-30,000.

MEDIA Considers all media and all media except 3D work.

STYLE Considers all styles. Genres include florals, landscapes and wildlife.

TERMS Artwork is accepted on consignment, and there is a 15% commission. Retail price set by the artist. Gallery provides promotion. Does not require exclusive representation locally.

SUBMISSIONS Mail portfolio for review. Send query letter with artist's statement, bio, brochure, business card, photocopies, résumé, reviews and SASE. Returns material with SASE. Responds only if interested within 6 months. Files résumé and photocopies. Finds artists through word of mouth, portfolio reviews, art exhibits and referrals by other artists.

TIPS "Appear organized and professional."

ART@NET INTERNATIONAL GALLERY

E-mail: artnetg@yahoo.com. **Website:** www.design bg.com. **Contact:** Yavor Shopov, photography director. Estab. 1998. For-profit online gallery. Approached by 150 artists/year. Represents 20 emerging, mid-career and established artists. Exhibited artists include Nicolas Roerich (paintings) and Yavor Shopov (photography). Sponsors 15 exhibits/year. Average display time: permanent. Open all year; Monday-Sunday, 24 hours. "Online galleries like ours have a number of unbelievable advantages over physical galleries and work far more efficiently, so they are expanding extremely rapidly and taking over many markets held by conventional galleries for many years. Our gallery exists only online, giving us a number of advantages both for our clients and artists. Our expenses are reduced to the absolute minimum, so we charge our artists lowest commission in the branch (only 10%) and offer to our clients lowest prices for the same quality of work. Unlike physical galleries, we have over 100 million potential online clients worldwide and are able to sell in over 150 countries without need to support offices or representatives everywhere. We mount cohesive shows of our artists, which are unlimited in size and may be permanent. Each artist has individual 'exhibition space' divided to separate thematic exhibitions along with bio and statement. We are just hosted in the Internet space, otherwise our organization is the same as of a traditional gallery." Clients include collectors and business offices worldwide; 30% corporate collectors. Overall price range: $150-50,000.

MEDIA Considers ceramics, crafts, drawing, oil, pastel, pen & ink, sculpture and watercolor. Most frequently exhibits photos, oil and drawing. Considers all types of prints.

STYLE Considers expressionism, geometric abstraction, impressionism and surrealism. Most frequently exhibits impressionism, expressionism and surrealism. Also considers Americana, figurative work, florals, landscapes and wildlife.

TERMS Artwork is accepted on consignment, and there is a 10% commission and a rental fee for space of $1/image per month or $5/image per year (first 6 images are displayed free of rental fee). Retail price set by the gallery or the artist. Gallery provides promotion. Accepted work should be matted. Does not require exclusive representation locally. "Every exhibited image will contain your name and copyright as watermark and cannot be printed or illegally used, sold or distributed anywhere."

SUBMISSIONS E-mail portfolio for review. E-mail attached scans of 900×1200 pixels (300 dpi for prints or 900 dpi for 36mm slides) as JPEG files for PC computers. "We accept only computer scans; no slides, please." E-mail artist's statement, bio, résumé, and scans of the work. Cannot return material. Responds in 6 weeks. Finds artists through submissions, portfolio reviews, art exhibits, art fairs, and referrals by other artists.

TIPS "E-mail us a tightly edited selection of less than 20 scans of your best work. All work must be very appealing and interesting, and must force any person to look over it again and again. Main usage of all works exhibited in our gallery is for limited edition (photos) or original (paintings) wall decoration of offices and homes. Photos must have the quality of paintings. We like to see strong artistic sense of mood, composition, light and color, and strong graphic impact or expression of emotions. We exhibit only artistically perfect work in which value will last for decades. We would like to see any quality work facing these requirements on any media, subject or style. No distractive subjects. For us only quality of work is important, so new artists are welcome. Before you send us your work, ask yourself, 'Who and why will someone buy this work? Is it appropriate and good enough for this purpose?' During the exhibition, all photos must be available in signed limited edition museum quality 8×10 or larger matted prints."

⊕ ART 3 GALLERY

44 West Brook St., Manchester NH 03101. **E-mail:** info@art3gallery.com. **Website:** art3gallery.com. **Contact:** Joni Taube, owner. Estab. 1985. For-profit gallery and art consultancy. Exhibits emerging, mid-career, and established artists. Approached by 50+ artists a year; exhibits 180+ artists. Exhibited artists include James Aponorich (oil painting) and Stan Moeller (oil painting). Sponsors 4 exhibits/year. Average display time 2-3 months. Open Monday-Friday 9-4. Located in downtown Manchester in a two-story, 2,000 sq. ft. exhibit space. Clients include local community, tourists, and upscale clients. Overall price range $150-20,000. Most work sold at $1,000.

MEDIA Considers acrylic, ceramics, collage, drawing, fiber, glass, mixed media, oil, paper, pastel, pen & ink, sculpture, and watercolor. Most frequently exhibits oil, acrylic, and sculpture. Considers the following prints: etchings, linocuts, lithographs, serigraphs, and woodcuts.

STYLE Considers all styles and genres.

TERMS Artwork is accepted on consignment and there is a 50% commission. Retail price set by the gallery and artist. Gallery provides insurance, promotion, and contract. Accepted artwork should be framed, mounted, and matted. Does not require exclusive local representation.

SUBMISSIONS E-mail query letter with link to artist's website or JPEG samples at 72 dpi. Materials returned with SASE. Responds if interested in 4 weeks. Finds artists through word of mouth, submissions, art exhibits, art fairs, and referrals by other artists.

ART CENTER OF BATTLE CREEK

265 E. Emmett St., Battle Creek MI 49017. (269)969-9511. **Fax:** (269)969-3838. **E-mail:** artcenterofbc@yahoo.com. **Website:** www.artcenterofbattlecreek.org. Estab. 1948. Represents 150 emerging, mid-career and established artists. 90% private collectors, 10% corporate clients. Exhibition program offered in galleries, usually 3-4 solo shows each year, two artists' competitions, and a number of theme shows. Also offers Michigan Artworks Shop featuring work for sale or rent. Average display time 1-2 months. Three galleries, converted from church—handsome high-vaulted ceiling, arches lead into galleries on either side. Welcoming, open atmosphere. Overall price range $20-1,000; most work sold at $20-300. Open Tuesday–Friday, 10-5; Saturday, 11-3; closed Sunday, Monday and major holidays.

MEDIA Considers oil, acrylic, watercolor, pastel, pen & ink, drawings, mixed media, collage, works on paper, sculpture, ceramic, craft, fiber, glass, photography and original handpulled prints.

STYLE Exhibits painterly abstraction, minimalism, impressionism, photorealism, expressionism, neo-expressionism and realism. Genres include landscapes, florals, Americana, portraits and figurative work. Prefers Michigan artists.

TERMS Accepts work on consignment (40% commission). Retail price set by artist. Exclusive area representation not required. Gallery provides insurance, promotion and contract; artist pays for shipping.

SUBMISSIONS Michigan artists receive preference. Send query letter, résumé, brochure, slides and SASE. Slides returned; all other material is filed.

TIPS "Contact us before mailing materials. We are working on several theme shows with groupings of artists."

ART CENTER/SOUTH FLORIDA

924 Lincoln Rd., Suite 205, Miami Beach FL 33139. (305)674-8278. **Fax:** (305)674-8772. **Website:** www.artcentersf.org. **Contact:** Kristen Thiele, exhibitions/artist liaison. Estab. 1984. Nonprofit gallery. "The ACSF has one of the most rigorous nonprofit exhibition schedules in South Florida. A monthly exhibition schedule allows for comprehensive programming and assures that the ACSF can react to current trends. Curatorial initiatives from outside sources are the make-up of the majority of exhibits. Our exhibitions primarily focus on contemporary media, current aesthetic issues, contextual linkages and community awareness." Exhibits group shows by emerging artists. Average display time 1 month. Open Tuesday–Thursday and Sunday, 12-10; Friday and Saturday, 12-11. Clients include local community, students, tourists and upscale. Overall price range $500-5,000.

MEDIA Considers all media except craft. Most frequently exhibits painting, sculpture, drawings and installation.

STYLE Exhibits themed group shows, which challenge and advance the knowledge and practice of contemporary arts.

TERMS Retail price set by the artist. Gallery provides insurance and promotion. Gallery receives 10% commission from sales. Accepted work should be ready

to install. Does not require exclusive representation locally.

SUBMISSIONS Send query letter with SASE. Returns material with SASE. Artists apply with a proposal for an exhibition. It is then reviewed by a panel. See website for more details.

ARTEMIS, INC.

4715 Crescent St., Bethesda MD 20816. (301)229-2058. **Fax:** (301)229-2186. **E-mail:** sjtropper@aol.com. **Contact:** Sandra Tropper, owner. Art Appraisal Firm; Retail and wholesale dealership; art advisor and represents mid-career artists. Does not sponsor specific shows. Overall price range $1,000-25,000.

MEDIA Considers oil, acrylic, watercolor, mixed media, collage, works on paper, sculpture, ceramic, craft, fiber, glass, installations, woodcuts, engravings, mezzotints, etchings, lithographs, pochoir, and serigraphs. Most frequently exhibits prints, contemporary canvases and paper/collage.

STYLE Exhibits impressionism, expressionism, realism, minimalism, color field, and painterly abstraction. Genres include landscapes, florals and figurative work. "My goal is to bring together clients (buyers) with artwork they appreciate and can afford. For this reason I am interested in working with many, many artists." Interested in seeing works with a "finished" quality.

TERMS Accepts work on consignment (50% commission). Retail price set by dealer and artist. Exclusive area representation not required. Dealership provides insurance and contract; shipping costs are shared. Prefers unframed artwork.

SUBMISSIONS Send e-mail with résumé, photographs, and prices. Responds only if interested within 2 weeks.

TIPS "Many artists have overestimated the value of their work. Look at your competition's prices."

ART ENCOUNTER

5720 S. Arville St., Suite 119, Las Vegas NV 89118. (702)227-0220; (800)395-2996. **Fax:** (702)227-3353. **E-mail:** rod@artencounter.com. **Website:** www.art encounter.com. **Contact:** Rod Maly, gallery director. Estab. 1992. Retail gallery. "We have become one of the most popular destinations for locals as well as tourists. Conveniently located a short distance from the strip, we represent distinct artists, both national and international, utilizing several different art styles and mediums as well as award-winning custom fram-

ing and our certified on staff appraiser." Represents 100 emerging and established artists/year. Exhibited artists include Jennifer Main, Jan Harrison and Vance Larson. Sponsors 4 shows/year. Open Monday–Friday, 8:30-5. Clients include upscale tourists, locals, designers and casino purchasing agents. 95% of sales are to private collectors, 5% corporate collectors. Overall price range: $200-20,000; most work sold at $500-2,500.

MEDIA Considers all media and all types of prints. Most frequently exhibits watercolor, oil, acrylic, and sculpture.

STYLE Exhibits all styles and genres.

TERMS Rental fee for space; covers 6 months. Retail price set by the gallery and artist. Gallery provides promotion and contract; artist pays for shipping. Prefers artwork framed.

SUBMISSIONS E-mail JPEGs or mail photographs and SASE. Appointments will be scheduled according to selection of juried artists. Responds within 2 weeks, only if interested. Files artist bios and résumés. Finds artists by advertising in *The Artist's Magazine* and *American Artist*, art shows and word of mouth.

TIPS "Poor visuals, attempted walk-in without appointment, and no SASE are common mistakes."

ART GUILD OF BURLINGTON/THE ARTS FOR LIVING CENTER

301 Jefferson St., Burlington IA 52601. (319)754-8069. **Fax:** (319)754-4731. **E-mail:** arts4living@aol.com. **Website:** www.artguildofburlington.org. Estab. 1974. Exhibits the work of mid-career and established artists. May consider emerging artists. Sponsors 10 shows/year. Average display time 3 weeks. Open Monday–Friday, 1-5; weekends, 1-4. 15,000 sq. ft. total space; 4,500 sq. ft. for exhibitions. Overall price range $25-1,000; most work sold at $75-500.

MEDIA Considers all visual media. Most frequently exhibits two-dimensional work.

STYLE Exhibits all styles.

TERMS Accepts work on consignment (25% commission). Retail price set by artist. Gallery provides promotion and contract; artist pays for shipping. Prefers artwork framed.

SUBMISSIONS Send query letter with résumé, slides, bio, brochure, photographs, SASE and reviews.

ARTISIMO UNLIMITED

8104 East Pariso Dr., Scottsdale AZ 85255. (480)949-0433. **E-mail:** artisimo@artisimogallery.com. **Web-**

site: www.artisimogallery.com. Estab. 1988. For-profit gallery. Approached by 30 artists/year. Represents 20 emerging, mid-career and established artists. Exhibited artists include Carolyn Gareis (mixed media). Sponsors 3 exhibits/year. Average display time: 5 weeks. Clients include local community, upscale, designers, corporations, restaurants. Overall price range: $200-4,000; most work sold at $2,500.

MEDIA Considers all media and all types of prints.

STYLE Exhibits geometric abstraction and painterly abstraction. Genres include figurative work, florals, landscapes and abstract.

TERMS "Available art is displayed on the Artisimo website. Artisimo will bring desired art to the client's home or business. If art is accepted, it will be placed on the website." There is a 50% commission upon sale of art. Retail price set by the artist. Gallery provides promotion.

SUBMISSIONS Send query e-mail with artist's statement, bio, photographs, résumé or link to website. When possible, responds in 3 weeks. Files photographs and bios. Finds artists through submissions, portfolio reviews, art fairs and exhibits, word of mouth and referrals by other artists.

ARTISTS' COOPERATIVE GALLERY

405 S. 11th St., Omaha NE 68102. (402)342-9617. **E-mail:** bronzesculptor@yahoo.com; ACGomahaneb@yahoo.com. **Website:** www.artistsco-opgallery.com. Estab. 1974. Sponsors 11 exhibits/year. Average display time: 1 month. Gallery sponsors all-member exhibits and outreach exhibits; individual artists sponsor their own small group exhibits throughout the year. Overall price range: $100-500. Open Tuesday–Thursday, 11-5; Friday and Saturday, 11-10; Sunday, 12-6.

MEDIA Considers oil, acrylic, watercolor, pastel, drawings, mixed media, collage, paper, sculpture, ceramic, fiber, glass, photography, woodcuts, serigraphs. Most frequently exhibits sculpture, acrylic, oil and ceramic.

STYLE Exhibits all styles and genres.

TERMS Charges no commission. Reviews transparencies. Accepted work should be framed work only. "Artist must be willing to work 13 days per year at the gallery. We are a member-owned-and-operated cooperative. Artist must also serve on one committee."

SUBMISSIONS Send query letter with résumé, SASE. Responds in 2 months.

TIPS "Write for membership application. Membership committee screens applicants August 1-15 each year. Responds by September 1. New membership year begins October 1. Members must pay annual fee of $325. Our community outreach exhibits include local high school photographers and art from local elementary schools."

ARTISTS' GALLERY

Emerson Cultural Center, 111 S. Grand Ave., #106, Bozeman MT 59715. (406)587-2127. **E-mail:** sarah@sarahangst.com. **Website:** www.artistsgalleryboze man.com. Estab. 1992. Retail and cooperative gallery. Represents the work of 20 local emerging and mid-career artists, 20 members. Sponsors 12 shows/year. Average display time 3 months. Open all year; Monday–Friday, 10-5; open some evenings until 8. Located near downtown; 900 sq. ft.; located in Emerson Cultural Center with other galleries, studios, etc. Clients include tourists, upscale and local community. 100% of sales are to private collectors.

MEDIA Considers oil, acrylic, watercolor, pastel, pen & ink, drawing, mixed media, collage, paper, sculpture, ceramics and glass, woodcuts, engravings, linocuts and etchings. Most frequently exhibits oil, watercolor and ceramics.

STYLE Exhibits painterly abstraction, impressionism, photorealism and realism. Exhibits all genres. Prefers realism, impressionism and western.

TERMS Co-op membership fee plus donation of time (20% commission). Rental fee for space; covers 1 month. Retail price set by the artist. Gallery provides promotion; artist pays for shipping costs to gallery. Prefers artwork framed.

SUBMISSIONS Artists must be able to fulfill "sitting" time or pay someone to sit. Send query letter with résumé, slides, photographs, artist's statement or actual work. Write for appointment to show portfolio of photographs and slides. Responds in 2 weeks.

THE ART LEAGUE, INC.

105 N. Union St., Alexandria VA 22314. (703)683-1780. **Fax:** (703)683-5786. **E-mail:** gallery@theartleague.org. **Website:** www.theartleague.org. Estab. 1954. "Our engaging exhibition schedule makes the Art League Gallery an intriguing art space for gallery visitors in the D.C. metropolitan area to view original art of all media by talented artists from throughout Washington and the Mid-Atlantic region." Interested in emerging, mid-career and established artists.

1,200-1,400 members. Sponsors 7-8 solo and 14 group shows/year. Average display time 1 month. Located in the Torpedo Factory Art Center. Accepts artists from metropolitan Washington area, northern Virginia and Maryland. 75% of sales are to private collectors, 25% corporate clients. Overall price range $50-4,000; most work sold at $150-500.

MEDIA Considers all media. Most frequently exhibits watercolor, oil and photographs. Considers all types of prints.

STYLE Exhibits all styles and genres. Prefers impressionism, painted abstraction and realism. "The Art League is a membership organization open to anyone interested."

TERMS Accepts work by jury on consignment (40% commission) and co-op membership fee plus donation of time. Retail price set by artist. Offers customer discounts (designers only) and payment by installments (if requested on long term). Exclusive area representation not required.

SUBMISSIONS Work juried monthly for each new show from actual work (not slides). Work received for jurying on first Monday evening/Tuesday morning of each month; pick-up non-selected work throughout rest of week.

TIPS "Artists find us and join/exhibit as they wish within framework of our selections jurying process. It is more important that work is of artistic merit rather than saleable."

ART LEAGUE OF HOUSTON

1953 Montrose Blvd., Houston TX 77006. (713)523-9530. **Fax:** (713)523-4053. **E-mail:** jennifer@artleaguehouston.org; alh@artleaguehouston.org. **Website:** www.artleaguehouston.org. **Contact:** Jennifer Ash, exhibitions. Estab. 1948. Nonprofit gallery. Represents emerging and mid-career artists. Sponsors 12 individual and group shows/year. Each season, ALH presents contemporary art in a variety of media in its 2 gallery spaces. Average display time 3-4 weeks. Located in a contemporary metal building; 1,300 sq. ft., specially lighted; smaller inner gallery/video room. Open Monday–Friday, 9-5; Saturday, 11-5. Clientele general, artists and collectors. Overall price range $100-5,000; most artwork sold at $100-2,500.

MEDIA Considers all media.

STYLE Exhibits contemporary avant-garde, socially aware work. Features "high-quality artwork reflecting serious aesthetic investigation and innovation. Additionally the work should have a sense of personal vision."

TERMS 30% commission. Retail price set by artist. Exclusive area representation not required. Gallery provides insurance, promotion and contract; artist pays for shipping.

SUBMISSIONS Must be a Houston-area resident. Send query letter, résumé and slides that accurately portray the work. Portfolio review not required. Submissions reviewed once a year in mid-June, and exhibition agenda determined for upcoming year.

ARTPROJECTA

P.O. Box 5732, Ketchum ID 883340. (208)726-9900. **E-mail:** claudia@projecta.com. **Website:** www.artprojecta.com. **Contact:** Barbi Reed (barbi@annereedgallery.com). Estab. 1912. Represents emerging talent and established artists. Barbi Reed, Claudia Aulum, co-founders. Exhibited artists include: Kirk Anderson, Bennett Bean, Jamie Brunson, Simon Casson, Imogen Cunningham, Harold Feinstein, Josh Garber, Jenny Gummersall, Greg Gummersall, Gary Mankus, Kathryn McNeal, Owen Mortensen, Andrew Romanoff, Andrew Saftel, Sandra Sallin, Ruth Silverman, Bob Smith, Larry Stephenson, David Wharton, Lana Wilson, among others. All art retails from $65-4500. Clientele: 90% private collectors, 10% corporate collectors, art consultants, designers.

STYLE Most frequently exhibits sculpture, paintings, fine art prints, photography, fine art jewelry, ceramics, glass. Exhibits expressionism, abstraction, conceptualism, photorealism, realism. Prefers contemporary.

TERMS Retail price set by gallery and artist. Sometimes we offer client discounts. Gallery provides promotion, networking on artist's behalf, shipping costs to clients. ARTprojectA is not responsible for materials sent that are unsolicited.

SUBMISSIONS E-mail your work and include your artist website's URL. Make sure the latest work and an updated résumé are on your site.

TIPS Spend time on our website prior to contacting us.

ARTQUOTE INTERNATIONAL, LLC

4653 Chelsea Lane, Bloomfield Hills MI 48301. (248)851-6091. **Fax:** (248)851-6090. **E-mail:** artquote@comcast.net. **Contact:** M. Burnstein. Art consultancy; for-profit, wholesale gallery; corporate art and identity programs. Estab. 1985. Exhibits established artists. Exhibited artists include Andy Warhol (screenprints) and Bill Mack (sculpture). Clients in-

clude local community. Most sales are to corporate collectors. Does not sell art at retail prices. Supplier to Fortune 100 corporations (global).

SUBMISSIONS Depends on corporate client. Finds artists through "established network of channels."

THE ARTS CENTER

P.O. Box 363, 115 2nd St. SW, Jamestown ND 58401. (701)251-2496. **Fax:** (701)251-1749. **E-mail:** sjeppson@ jamestownartscenter.org. **Website:** www.jamestown artscenter.org. **Contact:** Sally Jeppson, gallery manager. Estab. 1981. Nonprofit gallery. Sponsors 8 solo and 4 group shows/year. Average display time 6 weeks. Interested in emerging artists. Overall price range $50-600; most work sold at $50-350.

STYLE Exhibits contemporary, abstraction, impressionism, primitivism, photorealism and realism. Genres include Americana, figurative and 3D work.

TERMS 20% commission on sales from regularly scheduled exhibitions. Retail price set by artist. Gallery provides insurance, promotion and contract; shipping costs are shared.

SUBMISSIONS Send query letter, résumé, brochure, slides, photograph and SASE. Write for appointment to show portfolio. Invitation to have an exhibition is extended by Arts Center gallery manager.

TIPS "We are interested in work of at least 20-30 pieces, depending on the size."

THE ARTS COMPANY

215 Fifth Ave., Nashville TN 37219. (615)254-2040; (877)694-2040. **Fax:** (615)254-9289. **E-mail:** art@ theartscompany.com. **Website:** www.theartscom pany.com. **Contact:** Anne Brown, owner. Estab. 1996. Art consultancy, for-profit gallery. Estab. 1996. Over 6,000 sq. ft. of gallery space on 2 floors. Overall price range: $10-35,000; most work sold at $300-3,000.

⚫ *We are not accepting artist submissions at this time.*

MEDIA Considers all media. Most frequently exhibits painting, photography and sculpture.

STYLE Exhibits all styles and genres. Frequently exhibits contemporary outsider art.

TERMS Artwork is accepted on consignment. Gallery provides insurance and contract. Accepted work should be framed. Requires exclusive representation locally.

SUBMISSIONS "We prefer an initial info packet via e-mail." Send query letter with artist's statement, bio, brochure, business card, photocopies, résumé, re-

views, SASE, CD. Returns material with SASE. Finds artists through word of mouth, art fairs/exhibits, submissions, referrals by other artists.

TIPS "Provide professional images on a CD along with a professional bio, résumé."

ARTS IOWA CITY

114 S. Dubuque St., Iowa City IA 52240. (319)337-7447. **E-mail:** gallery@artsiowacity.org. **Website:** www.arts iowacity.org. **Contact:** Richard Sjolund, president; Elise Kendrot, gallery director. Estab. 1975. Nonprofit gallery. Approached by 65± artists/year. Represents 45± emerging, mid-career and established artists. Sponsors 8 exhibits/year. Average display time 1-2 months. Open all year; Monday–Friday, 11-3; weekends, 11-1. Several locations include: AIC Center & Gallery (Dubuque St.); Starbucks downtown Iowa City; Melrose Meadows Retirement Community in Iowa City; Englert Civic Theatre Gallery, Iowa City and US Bank downtown Iowa City. Satellite Galleries: local storefronts, locations vary. Clients include local community, students and tourists. 10% of sales are to corporate collectors. Overall price range $100-3,000; most work sold at $500. Finds artists through referrals by other artists, submissions and word of mouth. "We are a nonprofit gallery with limited staff. Most work is done by volunteers."

MEDIA Considers all media, types of prints, and all genres. Most frequently exhibits painting, drawing and mixed media.

TERMS Artwork is accepted on consignment, and there is a 20% commission. Gallery provides insurance (in gallery, not during transit to/from gallery), promotion and contract. Accepted work should be framed, mounted and matted. "We represent artists who are members of Arts Iowa City; to be a member, one must pay a membership fee. Most members are from Iowa City and the surrounding area."

TIPS "Artists interested in submitting work should visit our website to gain a better understanding of the services we provide and to obtain membership and show proposal information. Please submit applications according to our guidelines online."

ART SOURCE L.A., INC.

2801 Ocean Park Blvd., #7, Santa Monica CA 90405. (310)452-4411. **Fax:** (310)452-0300. **E-mail:** info@art sourcela.com; bonniek@artsourcela.com. **Website:** www.artsourcela.com. **Contact:** Francine Ellman, president; Dina Dalby, artist liason. Estab. 1980. Art-

work is accepted on consignment (50% commission). No geographic restrictions. Finds artists through art fairs/exhibitions, submissions, referrals by other artists, portfolio reviews and word of mouth.

MEDIA Considers fine art in all media, including works on paper/canvas, sculpture, giclée and a broad array of accessories handmade by American artists. Considers all types of prints.

TERMS "Send minimum of 20 slides or photographs (laser copies are not acceptable) clearly labeled with your name, title and date of work, size and medium. Catalogs and brochures of your work are welcome. Also include a résumé, price list and SASE. We will not respond without a return envelope." Also accepts e-mail submissions. Responds in 30 days if interested.

SUBMISSIONS Submission guidelines available on website.

TIPS "Be professional when submitting visuals. Remember, first impressions can be critical! Submit a body of work that is consistent and of the highest quality. Work should be in excellent condition and already photographed for your records. Framing does not enhance presentation to the client."

ARTSPACE

Zero E. Fourth St., Richmond VA 23224. (804)232-6464. **Fax:** (804)232-6465. **E-mail:** artspaceorg@gmail.com. **Website:** www.artspacegallery.org. **Contact:** Michael Pierce. Nonprofit gallery. Estab. 1988. Approached by 100 artists/year. Represents approx. 50 emerging, mid-career artists. Sponsors approx. 2 exhibits/year. Average display time 1 month. Open all year; Tuesday-Sunday from 12-4. Located in the newly designated Arts District in Manchester, in Richmond VA. Brand new gallery facilities; 4 exhibition spaces; approx. 3,000 sq. ft. Clients include local community, students, tourists and upscale. 2% of sales are to corporate collectors. Overall price range $100-800; most work sold at $450.

MEDIA Considers all media and all types of prints. Most frequently exhibits photography, painting and sculpture.

STYLE Considers all styles and genres.

TERMS There are exhibition fees; 33% commission. Retail price set by the artist. Gallery provides insurance and contract. Accepted work should be framed, mounted and matted. Pedestals available for sculpture. Does not require exclusive representation locally.

SUBMISSIONS Send query letter with artist's statement, bio, résumé, SASE, slides and proposal form. Returns material with SASE. Responds to queries in 3 weeks. If accepted, all materials submitted are filed. Finds artists through referrals by other artists, submissions and word of mouth.

ARTSPACE/LIMA

65-67 Town Square, Lima OH 45801. (419)222-1721. **Fax:** (419)222-6587. **E-mail:** artspacelima@woh.rr.com. **Website:** www.artspacelima.com. **Contact:** operations manager. Nonprofit gallery. Exhibits 50-70 emerging and mid-career artists/year. Interested in seeing the work of emerging artists. Sponsors 8-10 shows/year. Average display time 6-8 weeks. Open Tuesday–Friday, 10-5; Saturday, 10-2. Located downtown; 286 running ft. 100% of space for special exhibitions. Clientele local community. 80% private collectors, 5% corporate collectors. Overall price range $300-6,000; most work sold at $500-1,000.

○ Most shows are thematic and geared toward education.

MEDIA Considers all media and all types of prints. Most frequently exhibits painting, sculpture, drawing.

STYLE Exhibits all styles of contemporary and traditional work.

TERMS Accepts work on consignment (40% commission). Retail price set by the artist. Gallery provides insurance, promotion and contract. Artwork must be ready to hang.

SUBMISSIONS Send query letter with résumé, slides, artist's statement and SASE. Portfolio should include slides. Responds only if interested within 6 weeks. Files résumé.

THE ART STORE

1013 Bridge Rd., Charleston WV 25314. (304)345-1038. **Fax:** (304)345-1858. **E-mail:** gallery@theartstorewv.com. **Website:** www.theartstorewv.com. "The Art Store is dedicated to showing original 20th-century and contemporary American art by leading local, regional and nationally recognized artists. Professional integrity, commitment and vision are the criteria for artist selection, with many artists having a history of exhibitions and museum placement. Painting, sculpture, photography, fine art prints and ceramics are among the disciplines presented. A diverse series of solo, group and invitational shows are exhibited throughout the year in the gallery." Retail gallery. Represents 50 mid-career and established artists.

Sponsors 11 shows/year. Average display time 4 weeks. Open Tuesday–Friday, 10-5:30; Saturday, 10-5; anytime by appointment. Located in a upscale shopping area; 2,000 sq. ft.; 50% of space for special exhibitions. Clientele: professionals, executives, decorators. 80% private collectors, 20% corporate collectors. Overall price range $200-8,000; most work sold at $2,000.

MEDIA Considers oil, acrylic, watercolor, pastel, mixed media, works on paper, ceramics, wood and metal.

STYLE Exhibits expressionism, painterly abstraction, color field and impressionism.

TERMS Accepts artwork on consignment (50% commission). Retail price set by gallery and artist. Gallery provides insurance, promotion and shipping costs from gallery. Prefers artwork unframed.

SUBMISSIONS Send query e-mail.

ART WITHOUT WALLS, INC.

P.O. Box 341, Sayville NY 11782. (631)567-9418. **Fax:** (631)567-9418. **E-mail:** artwithoutwalls3@webtv.net. **Website:** www.artwithoutwalls.net. **Contact:** Sharon Lippman, executive director. Estab. 1985. Nonprofit gallery. Approached by 300 artists/year. Represents 100 emerging, mid-career and established artists. Sponsors 10 exhibits/year. Average display time: 1 month. Open daily, 9-5. Closed December 22-January 5 and Easter week. Overall price range: $1,000-25,000; most work sold at $3,000-5,000. "Sponsoring the upcoming Museum Without Walls, an award-winning fine art exhibition that allows both the professional and emerging artist the opportunity to connect with the viewer in a public space. Artwork is accepted on consignment (20% commission). Retail price set by the artist. Gallery provides promotion and contract. Accepted work should be framed, mounted and matted. Finds artists through submissions, portfolio reviews and art exhibits."

MEDIA "Considers all media and all types of prints. Most frequently exhibits painting, sculpture and drawing."

STYLE Considers all styles and genres. Most frequently exhibits impressionism, expressionism, postmodernism.

SUBMISSIONS Mail portfolio for review. Send query letter with artist's statement, brochure, photographs, résumé, reviews, SASE and slides. Returns material with SASE. Responds in 1 month. Files artist résumé, slides, photos and artist's statement.

TIPS Work should be properly framed with name, year, medium, title and size.

THE ASHBY-HODGE GALLERY OF AMERICAN ART

Central Methodist University, 411 Central Methodist Square, Fayette MO 65248. (660)248-6324 (gallery) or (660)248-6304 (office). **Fax:** (660)248-2622. **E-mail:** jegeist@centralmethodist.edu. **Website:** www.centralmethodist.edu/ashbyhodge/index.php. **Contact:** Dr. Joseph E. Geist, curator. Estab. 1993. Nonprofit gallery. "The Ashby Collection of oil paintings, lithographs, drawings, and acrylics, mainly represents the work of American Regionalist artists. Although the Ashby Collection is the principal focus of the gallery, special exhibits are scheduled throughout the year." Exhibits the work of 50 artists in permanent collection. Exhibited artists include Robert MacDonald Graham, Jr. and Birger Sandzen. Sponsors 5 shows/year. Average display time 2 months. Open Sunday, Tuesday, Wednesday, Thursday, 1:30-4:30; and by appointment. Summer hours: Tuesday, Wednesday, Thursday, 1:30-4:30; and by appointment. 1,400 sq. ft.; on lower level of campus library. 100% of gallery artists for special exhibitions. Clientele local community and surrounding areas of Mid-America. Physically impaired accessible. Tours by reservation.

MEDIA Considers all media. Most frequently exhibits acrylic, lithographs, oil and fibers.

STYLE Exhibits Midwestern regionalists. Genres include portraits and landscapes. Prefers realism.

TERMS Accepts work on consignment (30% commission). Retail price set by the gallery. Gallery provides insurance and promotion; shipping costs are shared. Prefers artwork framed.

SUBMISSIONS Accepts primarily Midwestern artists. Send query letter with résumé, slides, photographs and bio. Call for appointment to show portfolio of photographs, transparencies and slides. Finds artists through recommendations and submissions.

ASIAN AMERICAN ARTS CENTRE

111 Norfolk St., New York NY 10002. (212)233-2154. **Fax:** (360)283-2154. **E-mail:** aaacinfo@artspiral.org. **Website:** www.artspiral.org. Estab. 1974. "Our mission is to promote the preservation and creative vitality of Asian American cultural growth through the arts, and its historical and aesthetic linkage to other communities." Exhibits should be Asian American or significantly influenced by Asian culture and should

be entered into the archive—a historical record of the presence of Asia in the U.S. Interested in "creative art pieces." Average display time 6 weeks. Open Monday–Friday, 12:30-6:30 (by appointment).

TERMS 30% "donation" on works sold. Sometimes buys photos outright.

SUBMISSIONS Send dupes of slides, résumé, artist's statement, bio and online form to be entered into the archive. These will be kept for users of archive to review. Recent entries are reviewed once/year for the art centre's annual exhibition.

⊕ ATELIER GALLERY

153 King St., Charleston SC 29401. **E-mail:** gabrielle@theateliergalleries.com. **Website:** theateliergalleries.com. **Contact:** Gabrielle Egan, curator and owner. Estab. 2008. For-profit gallery and art consultancy. Exhibits emerging, mid-career, and established artists. Approached by 100s of artists a year; represents or exhibits 140 artists. Exhibited artists include Nancy Jean (painting) and Marlise Newman (painting). Average display time is 6 months. Open Monday-Saturday 10-6; weekends from 10-7. Some Sundays open in the summer 12-5. Closed holidays. Clients include local community, students, tourists, upsale, and artists and designers. Overall price range $50-15,000. Most work sold in the $2,000-3,000 range.

MEDIA Accepts acrylic, ceramics, collage, drawing, fiber, glass, mixed media, oil, paper, pastel, pen & ink, sculpture, and watercolor.

STYLE Exhibits expressionism, geometric abstraction, hyper realism, minimalism, pattern painting and painterly abstraction. Interested in figurative work, and florals.

TERMS Artwork is accepted on consignment with a 50% commission. Retail price set by the gallery and artist. Gallery provides insurance, promotion, and contract. Accepted work should be framed, mounted, and matted. Atelier requires exclusive representation locally.

SUBMISSIONS E-mail query letter with link to artist's website or mail portfolio for review. Query letter should be sent with artist's statement, bio, photocopies, and photographs. Materials returned with SASE. Responds with decision in 2-4 weeks. Finds artists through word of mouth, submissions, portfolio reviews, art exhibits, art fairs, and referrals by other artists.

TIPS "Submit images that are current and be clear about your goals for your art!"

ATHENAEUM MUSIC AND ARTS LIBRARY

1008 Wall St., La Jolla CA 92037. (858)454-5872. **E-mail:** press@ljathenaeum.org. **Website:** www.ljathenaeum.org. **Contact:** Erika Torri, director. Estab. 1899. Nonprofit gallery. Represents/exhibits emerging, mid-career and established artists. "The Athenaeum Music & Arts Library, located in the heart of La Jolla, in San Diego County, is one of only 16 nonprofit membership libraries in the U.S. This rare cultural institution, an important one to the greater San Diego area, offers a depth and accessibility of resources and programs found nowhere else in the region." Exhibited artists include Ming Mur-Ray, Italo Scanga and Mauro Staccioli. Sponsors 8 exhibitions/year. Average display time 2 months. Open Tuesday, Thursday, Friday, Saturday, 10-5:30; Wednesday, 10-8:30. Located downtown La Jolla. An original 1921 building designed by architect William Templeton Johnson 12-foot high wood beam ceilings, casement windows, Spanish-Italianate architecture. 100% of space for special exhibitions. Clientele tourists, upscale, local community, students and Athenaeum members. 100% private collectors. Overall price range $100-1,000; most work sold at $100-500.

MEDIA Considers all media, all types of prints. Most frequently exhibits painting, multi-media and book art.

STYLE Exhibits all styles. Genres include florals, portraits, landscapes and figurative work.

TERMS Artwork is accepted on consignment, and there is a 25% commission. Retail price set by the artist. Gallery provides insurance and promotion; shipping costs are shared. Prefers artwork framed.

SUBMISSIONS Artists must be considered and accepted by the art committee. Send query letter with slides, bio, SASE and reviews. Write for appointment to show portfolio of photographs, slides and transparencies. Responds in 2 months. Files slide and bio only if there is initial interest in artist's work.

TIPS Finds artists through word of mouth and referrals.

ATLANTIC CENTER FOR THE ARTS, INC.

1414 Arts Center Ave., New Smyrna Beach FL 32168. (386)427-6975. **Fax:** (386)427-5669. **E-mail:** shiggins@atlanticcenterforthearts.org; program@atlanticcenterforthearts.org. **Website:** www.atlanticcen

terforthearts.org. Estab. 1977. Nonprofit interdisciplinary, international artists-in-residence program. Sponsors 5-6 residencies/year. Located on secluded bayfront 3½ miles from downtown.

○ This location accepts applications for residencies only, but they also run Harris House of Atlantic Center for the Arts, which accepts Florida artists only for exhibition opportunities. Harris House is located at 214 S. Riverside Dr., New Smyrna Beach FL 32168. (386)423-1753.

MEDIA Most frequently exhibits paintings, drawings, prints, video installations, sculpture, photographs.

STYLE Contemporary.

TERMS Call Harris House for more information.

SUBMISSIONS Call Harris House for more information.

ATLANTIC GALLERY

135 W. 29th, Suite 601, New York NY 10001. (212)219-3183. **E-mail:** contact@atlanticgallery.org. **Website:** www.atlanticgallery.org. **Contact:** Jeff Miller, president. Estab. 1974. Approached by 50 artists/year. Represents 40 emerging, mid-career and established artists. Exhibited artists include Ragnar Naess (sculptor); Sally Brody (oil, acrylic); Whitney Hansen (oil). Average display time 3 weeks. Open Tuesday-Saturday, 12-6. Closed August. Located in Chelsea. Has kitchenette. Clients include local community, tourists and upscale. 2% of sales are to corporate collectors. Overall price range $100-13,000; most work sold at $1,500-5,000.

MEDIA Considers all media. Considers all types of prints. Most frequently exhibits watercolor, acrylic and oil.

STYLE Considers all styles and genres. Most frequently exhibits impressionism, realism, imagism.

TERMS Artwork is accepted on consignment, and there is a 20% commission. There is a co-op membership fee plus a donation of time. There is a 10% commission. Rental fee for space covers 3 weeks. Retail price set by the artist. Gallery provides promotion and contract. Accepted work should be framed. Does not require exclusive representation locally. Currently accepting artists.

SUBMISSIONS Call or write to arrange a personal interview to show CD or portfolio of slides. Send query letter with artist's statement, bio, brochure, SASE and CD or slides. Returns material with SASE. Responds in 2 weeks. Files only accepted work. Finds artists through word of mouth, submissions, art exhibits and referrals by other artists.

TIPS Submit an organized folder with slides or CD, bio, and 3 pieces of actual work; if we respond with interest, we then review again.

ATLAS GALLERIES, INC.

535 N. Michigan Ave., Chicago IL 60611. (312)329-9330 and (312)649-0999. **Fax:** (312)329-9436. **E-mail:** Via online contact form. **Website:** www.atlasgalleries.com. Estab. 1967. For-profit gallery. Exhibits established artists. Sponsors 14 exhibits/year. Average display time 2 days solo/then permanently with collection. Two locations on Michigan Avenue's Magnificent Mile. See website for hours of both locations. Clients include local community, tourists, upscale. 5% of sales are to corporate collectors. Overall price range $200-100,000; most work sold at $2,000.

MEDIA Considers acrylic, ceramics, collage, drawing, glass, mixed media, oil, paper, pastel, pen & ink, sculpture and watercolor. Most frequently exhibits oil, acrylic and sculpture. Considers prints of engravings, etchings, linocuts, lithographs, serigraphs, woodcuts and giclée.

STYLE Considers all styles and genres. Most frequently exhibits impressionism, surrealism/post modern. Exhibits all genres.

TERMS Artwork is accepted on consignment or bought outright. Retail price set by the gallery. Gallery provides insurance, promotion and contract. Requires exclusive representation locally.

SUBMISSIONS Send query letter with artist's statement, bio, photocopies, photographs and slides. Returns material with SASE. Responds to queries if interested within 3 months. Does not file materials unless we are interested in artist. Finds artists through art exhibits, portfolio reviews, referrals by other artists, submissions and word of mouth.

AUROBORA PRESS

370 Brannan St., San Francisco CA 94107. (415)546-7880. **E-mail:** monotype@aurobora.com. **Website:** www.aurobora.com. **Contact:** Michael Liener, director. Estab. 1993. Retail gallery and fine arts press. Invitational Press dedicated to the monoprint and monotype medium. Represents/exhibits emerging, mid-career and established artists. Exhibited artists include William T. Wiley, David Ireland, Stephan DeStaebler, Tony Delap. Sponsors 10 shows/year. Average display time 6-8 weeks. Open Tuesday–Saturday,

10-5; and by appointment. Located south of Market (off South Park); 1,000 sq. ft.; Clientele includes collectors, individuals, and art consultants. Overall price range $1,200-16,000; most work sold at $1,500-4,000.

○ Aurobora Press invites artists each year to spend a period of time in residency working with Master Printers.

MEDIA Publishes monotypes.

TERMS Retail price set by gallery and artist. Gallery provides promotion.

SUBMISSIONS By invitation only.

AUSTIN MUSEUM OF ART

700 Congress Ave., Austin TX 78701. (512)495-9224 (downtown) or (512)458-8191 (Laguna Gloria). **E-mail:** info@amoa.org. **Website:** www.amoa.org. Estab. 1961. Downtown and Laguna Gloria locations. Interested in emerging, mid-career and established artists. Sponsors 2-3 solo and 6 group shows/year. Average display time 11/2 months. Clientele includes tourists and Austin and central Texas citizens.

MEDIA Currently exhibits 20th-21st century art of the Americas and the Caribbean with an emphasis on 2D and 3D contemporary artwork to include experimental video, mixed media and outdoor site-specific installations.

STYLE Exhibits all styles and genres. No commercial clichéd art.

TERMS Retail price set by artist. Gallery provides insurance and contract; shipping costs to be determined. Exhibitions booked 2 years in advance. "We are not a commercial gallery."

SUBMISSIONS Send query letter with résumé, slides and SASE attn: Artist Submission. Responds only if interested within 3 months. Files slides, résumé and bio. Material returned only when accompanied by SASE. Common mistakes artists make are "not enough information, poor slide quality, too much work covering too many changes in their development."

ALAN AVERY ART COMPANY

315 E. Paces Ferry Rd., Atlanta GA 30305. (404)237-0370. **Website:** www.alanaveryartcompany.com. **Contact:** Alan Avery, owner. Estab. 1983. Retail gallery and corporate sales consultants. Represents/exhibits 67 mid-career and established artists and old masters/year. Exhibited artists include Roy Lichtenstein, Jim Dine, Robert Rauschenberg, Andy Warhol, Larry Gray, Robert Kipniss, Lynn Davison and Rus-

sell Whiting. Sponsors 6-8 shows/year. Average display time: 6 weeks. Open all year; Tuesday–Friday, 10-6; Saturday, 11-5 and by appointment. Located: Buckhead; 6,700 sq. ft.; 25-year-old converted restaurant. 50-60% of space for special exhibitions; 40-50% of space for gallery artists. Clientele: upscale, local, regional, national and international. 70% private collectors, 30% corporate collectors. Overall price range: $2,500-100,000; most work sold at $2,500-5,000.

MEDIA Considers all media and all types of prints. Most frequently exhibits painting, sculpture and works on paper.

STYLE Exhibits expressionism, conceptualism, color field, painterly abstraction, postmodern works, realism, impressionism and imagism. Genres include landscapes, Americana and figurative work. Prefers realism, abstract and figurative.

TERMS Artwork is accepted on consignment (negotiable commission). Retail price set by gallery. Gallery pays promotion and contract. Shipping costs are shared. Prefers framed artwork.

SUBMISSIONS Send query letter with résumé, at least 20 images, bio, prices, medium, sizes and SASE. Reviews every 6 weeks. Finds artists through submissions, word of mouth and referrals by other artists. Submission guidelines available online.

TIPS "Be as complete and professional as possible in presentation. We provide submittal process sheets, listing all items needed for review. Following these sheets is important."

SARAH BAIN GALLERY

184 Center Street Promenade, Anaheim CA 92805. (714)758-0545. **E-mail:** info@sarahbaingallery.com. **Website:** www.sarahbaingallery.com. For-profit gallery. A commercial art gallery located in downtown Anaheim. Exhibits emerging and mid-career artists. Approached by 200 artists/year; represents or exhibits 24 artists. Sponsors 12 total exhibits/year. Average display time: 1 month. Open Tuesday–Saturday, 11-6; Sunday, 11-5; or by appointment. Clients include local community, students, tourists and upscale. Overall price range: $700-15,000; most work sold at $4,000.

MEDIA Considers acrylic, drawing, mixed media, oil. Most frequently exhibits drawing, mixed media, paintings in representational or figurative style.

STYLE Exhibits representational or figurative.

TERMS Artwork is accepted on consignment. Retail price set by the gallery. Gallery provides promotion.

Accepted work should be framed and mounted. Prefers only representational or figurative art.

SUBMISSIONS Submission guidelines available online. Mail portfolio for review. Send query letter with slides. Returns material with SASE. Responds to queries in 1 month.

TIPS "Show a consistent, comprehensive body of work as if it were its own show ready to be hung."

BAKEHOUSE ART COMPLEX

561 NW 32nd St., Miami FL 33127. (305)576-2828. **Fax:** (305)576-0316. **E-mail:** araymond@bacfl.org; lwagner@baclf.org. **Website:** www.bacfl.org. **Contact:** Arlys Ramond, executive director; Lauren Wagner, director of exhibitions. Estab. 1986. A not-for-profit organization dedicated to attracting emerging and mid-career artists in South Florida to a workplace that provides affordable studios, exhibition galleries and professional development opportunities. Represents more than 100 emerging and mid-career artists. 65 tenants, more than 50 associate artists. Sponsors numerous shows and cultural events annually. Average display time 3-5 weeks. Gallery open daily, 12-5. Located in Wynwood Art District; 3,200 sq. ft. gallery; 33,000 sq. ft. retro fitted commercial bakery, 17 ft. ceilings. Clientel: 80% private collectors, 20% corporate collectors. Overall price range $500-10,000.

MEDIA Considers all media.

STYLE Exhibits all styles, all genres.

TERMS Co-op membership fee plus donation of time. Rental fee for studio space. Retail price of art set by the artist.

SUBMISSIONS Submission guidelines available online. Accepts artists to juried membership. Send query letter for application or download online.

TIPS "Don't stop painting, sculpting, etc. while you are seeking representation. Daily work (works-in-progress, studies) evidences a commitment to the profession. Speaking to someone about your work while you are working brings an energy and an urgency that moves the art and the gallery representation relationship forward."

⊕ BAKER ARTS CENTER ·

624 N. Pershing Ave., Liberal KS 67901. (620)624-2810. **Fax:** (620)624-7726. **E-mail:** baketartscenter@sbeglobal.net. **Website:** bakerartscenter.org. **Contact:** Mike Brack, executive director. Estab. 1986. Nonprofit gallery. Exhibits emerging, mid-career, and established artists. Approached by 6-10 artists a year. Represents of exhibits 6-10 artists. Exhibited artists include J. McDonald (glass) and J. Gustafson (assorted). Sponsors 5 total exhibits/year. 1 photography exhibit/year. Model and property release are preferred. Average display time 40-50 days. Open Tuesday-Friday 9-5; weekends 2-5. Closed Christmas, Thanksgiving and New Year's Eve. Clients include local community, students, and tourists. Overall price range $10-1,000. Most work sold at $400.

MEDIA Considers all media. Most frequently exhibits glass, mixed media, and acrylic. Considers engravings, etchings, linocuts, lithographs, and woodcuts.

STYLE Considers all styles and genres

TERMS Artwork is accepted on consignment and there is a 10% commission fee. Retail price set by the artist. Gallery provides insurance, promotion, and contract. Accepted work should be framed, mounted, and matted.

SUBMISSIONS Write to arrange personal interview to show portfolio or e-mail query letter with link to artist's website or JPEG samples at 72 dpi. Returns material with SASE. Responds in 2-4 weeks. Finds artists through word of mouth, submissions, art exhibits, and referrals by other artists.

BALZEKAS MUSEUM OF LITHUANIAN CULTURE ART GALLERY

6500 S. Pulaski Rd., Chicago IL 60629. (773)582-6500. **Fax:** (773)582-5133. **E-mail:** info@balzekasmuseum.org. **Website:** www.balzekasmuseum.org. **Contact:** Stanley Balzekas, Jr., president. Estab. 1996. Museum, museum retail shop, nonprofit gallery, rental gallery. Approached by 20 artists/year. Sponsors 2 photography exhibits/year. Average display time 6 weeks. Open daily, 10-4. Closed Christmas, Easter and New Year's Day. Overall price range $150-6,000. Most work sold at $545.

MEDIA Considers all media and all types of prints.

STYLE Considers all styles and genres.

TERMS Artwork is accepted on consignment and there is a 33⅓% commission. Retail price set by the gallery. Gallery provides promotion. Accepted work should be framed.

SUBMISSIONS Write to arrange a personal interview to show portfolio. Cannot return material. Responds in 2 months. Finds artists through word of mouth, art exhibits, and referrals by other artists.

BANNISTER GALLERY

Rhode Island College, Roberts Hall, 600 Mt. Pleasant Ave., Providence RI 02908-1991. (401)456-9765. **Fax:** (401)456-9718. **E-mail:** bannistergallery@ric.edu; jmontford@ric.edu. **Website:** www.ric.edu/bannister. **Contact:** James Montford, gallery director. Estab. 1978. Nonprofit gallery. Represents emerging, mid-career and established artists. Sponsors 9 shows/year. Average display time 3 weeks. Open Tuesday–Friday, 12-8 (during academic year). Located on college campus; 1,600 sq. ft.; features spacious, well-lit gallery space with off-white walls, gloss black tile floor; two sections with 9-foot and 12-foot ceilings. 100% of space for special exhibitions. Clientele: students and public.

MEDIA Considers all media and all types of original prints. Most frequently exhibits painting, photography and sculpture.

STYLE Exhibits all styles.

TERMS Artwork is exhibited for educational purposes—gallery takes no commission. Retail price set by artist. Gallery provides insurance, promotion and limited shipping costs from gallery. Prefers artwork framed.

SUBMISSIONS Send query letter with résumé, slides, bio, brochure, SASE and reviews. Files addresses, catalogs and résumés.

KENISE BARNES FINE ART

1955 Palmer Ave., Larchmont NY 10538. (914)834-8077. **E-mail:** kenise@kbfa.com. **Website:** www.kenisebarnesfineart.com. **Contact:** Kenise Barnes, director. Estab. 1995. For-profit gallery. Works with 300 artists/year; exhibits 30 emerging and mid-career artists/year. See website for artists. Sponsors 6 exhibits/year. Average display time 5-6 weeks. Open Tuesday–Saturday, 10-5:30 and by appointment. Clients include local community and corporate collectors nationwide. 20% of sales are to corporate collectors. Overall price range $1,000-15,000; most work sold at $3,000.

STYLE Exhibits color field, representational work and painterly abstraction.

TERMS Retail price of the art set by the gallery. Gallery provides insurance and promotion. Requires exclusive representation locally.

SUBMISSIONS "Although we are not currently looking for new artists, the director does review work on a rolling basis. See gallery website for artist submission policies. If we would like to make a studio visit, we will contact you."

DAVID BARNETT GALLERY

1024 E. State St., Milwaukee WI 53202. (414)271-5058. **Fax:** (414)271-9132. **E-mail:** info@davidbarnettgallery.com. **Website:** www.davidbarnettgallery.com. Estab. 1966. Retail and rental gallery and art consultancy. "From Picasso to Rembrandt, from Old Masters to emerging Wisconsin artists, we provide a spectacular selection of art. With over 5,000 works of art in our current inventory, the gallery presents a vast variety of mediums and styles in every price range. Our gallery also brings an array of quality services that meet your art needs." Represents 300-400 emerging, mid-career and established artists. Exhibited artists include Claude Weisbuch and Carol Summers. Sponsors 12 shows/year. Average display time 1 month. Open Tuesday–Friday, 11-5:30; Saturday, 11-5. Located downtown at the corner of State and Prospect; 6,500 sq. ft.; Victorian-Italianate mansion built in 1875, three floors of artwork displayed. 25% of space for special exhibitions. Clientele: retail, corporations, interior decorators, private collectors, consultants, museums and architects. 20% private collectors, 10% corporate collectors. Overall price range $50-375,000; most work sold at $1,000-50,000.

MEDIA Considers oil, acrylic, watercolor, pastel, pen & ink, drawings, mixed media, collage, sculpture, ceramic, fiber, glass, photography, bronzes, marble, woodcuts, engravings, lithographs, wood engravings, serigraphs, linocuts, etchings and posters. Most frequently exhibits prints, drawings and oils.

STYLE Exhibits expressionism, neo-expressionism, primitivism, painterly abstraction, surrealism, imagism, conceptualism, minimalism, postmodern works, impressionism, realism and photorealism. Genres include landscapes, florals, Southwestern, Western, wildlife, portraits and figurative work. Prefers old master graphics, contemporary and impressionistic.

TERMS Accepts artwork on consignment (50% commission). Retail price set by gallery and artist. Sometimes offers customer discounts and payment by installment. Gallery provides insurance and promotion; artist pays for shipping. Prefers artwork framed.

SUBMISSIONS Send query letter with slides, bio, brochure and SASE. "We return everything if we decide not to carry the artwork." Finds artists through

agents, word of mouth, various art publications, sourcebooks, submissions and self-promotions.

BARRON ARTS CENTER

1 Main St., Woodbridge NJ 07095. (732)634-0413. **Website:** www.twp.woodbridge.nj.us/Departments/BarronArtsCenter/tabid/251/Default.aspx. **Contact:** Cynthia Knight, director. Estab. 1977. Nonprofit gallery. Interested in emerging, mid-career and established artists. Sponsors several solo and group shows/year. Average display time is 1 month. Clients include culturally minded individuals mainly from the central New Jersey region. 80% of sales are to private collectors, 20% corporate clients. Overall price range $200-5,000. Gallery hours during exhibits: Monday-Friday 11-4; Sunday 2-4; Closed holidays.

MEDIA Considers oil, acrylic, watercolor, pastel, pen & ink, drawings, mixed media, collage, works on paper, sculpture, ceramic, craft, fiber, glass, installation, photography, performance and original handpulled prints. Most frequently exhibits watercolor, oils, photography and mixed media.

STYLE Exhibits painterly abstraction, impressionism, photorealism, realism and surrealism. Genres include landscapes and figurative work. Prefers painterly abstraction, photorealism and realism.

TERMS Accepts work on consignment. Retail price set by artist. Exclusive area representation not required. Gallery provides insurance, promotion and contract; artist pays for shipping.

SUBMISSIONS Send query letter, résumé and slides. Call for appointment to show portfolio. Résumés and slides are filed.

TIPS Most common mistakes artists make in presenting their work are improper matting and framing and poor quality slides.

BATON ROUGE GALLERY, INC.

1442 City Park Ave., Baton Rouge LA 70808. (225)383-1470. **E-mail:** jandreasen@batonrougegallery.org. **Website:** batonrougegallery.org. **Contact:** Jason Andreasen, executive director. Estab. 1966. Non-profit cooperative gallery. One of the oldest professional artist cooperative galleries in the U.S. Exhibits the work of over 50 professional artists. 300 community members. Sponsors 13 exhibitions annually. Monthly exhibitions at the gallery feature the work of current artist members including photographers, painters, sculptors, stained-glass artists, printmakers, ceramists, multi-media, and installation artists. The

opening receptions are held for each exhibition on the first Wednesday of every month from 7-9 and are free and open to the public. Average display time 1 month. Open Tuesday–Sunday, 12-6. Located in BREC's historic City Park Pavilion. Overall price range $100-10,000; most work sold at $200-600.

The gallery hosts a spoken-word series featuring literary readings of all genres. We also present special performances, including dance, theater and music, Movies & Music on the lawn, Surreal Salon, and Flatscape Video Art Series.

MEDIA All media considered. Most frequently exhibits painting, sculpture and glass.

STYLE Exhibits all contemporary styles and genres.

TERMS Co-op membership fee plus donation of time. Gallery takes 40% commission on work sold.

SUBMISSIONS Membership and guest exhibitions are selected by a screening committee selected from artist members. The screening committee reviews applications in October of each year. Artist requirements and application for submissions are available online.

SETH JASON BEITLER FINE ARTS

250 NW 23rd St., Suite 202, Miami FL 33127. (305)438-0218. **Fax:** (800)952-7026. **E-mail:** info@sethjason.com. **Website:** www.sethjason.com. **Contact:** Seth Beitler, owner. Estab. 1997. For-profit gallery, art consultancy. Approached by 300 artists/year. Represents 40 mid-career, established artists. Exhibited artists include Florimond Dufoor, oil paintings; Terje Lundaas, glass sculpture. Sponsors 5 exhibits/year. Average display time: 2-3 months. Clients include local community and upscale. 5-10% of sales are to corporate collectors. Overall price range: $2,000-300,000; most work sold at $5,000.

MEDIA Considers acrylic, glass, mixed media, sculpture, drawing, oil. Most frequently exhibits sculpture, painting, photography. Considers etchings, linocuts, lithographs.

STYLE Exhibits color field, geometric abstraction and painterly abstraction. Most frequently exhibits geometric sculpture, abstract painting, photography. Genres include figurative work and landscapes.

TERMS Artwork is accepted on consignment (50% commission). Retail price set by the gallery. Gallery provides insurance, promotion and contract. Accepted work should be mounted.

SUBMISSIONS Write to arrange personal interview to show portfolio of photographs, slides, transparencies. Send query letter with artist's statement, bio, photographs, résumé, SASE. Returns material with SASE. Responds to queries in 2 months. Files photos, slides, transparencies. Finds artists through art fairs, portfolio reviews, referrals by other artists and word of mouth.

TIPS "Send easy-to-see photographs. E-mail submissions for quicker response."

CECELIA COKER BELL GALLERY

Coker College Art Dept., 300 E. College Ave., Hartsville SC 29550. (843)383-8156. **E-mail:** ccbg@coker.edu. **Website:** www.wix.com/cokerartgallery/ccgb. **Contact:** Larry Merriman. "A campus-located teaching gallery that exhibits a variety of media and styles to expose students and the community to the breadth of possibility for expression in art. Exhibits include regional, national and international artists with an emphasis on quality and originality. Shows include work from emerging, mid, and late career artists." Sponsors 5 solo shows/year, with a 4-week run for each show. Open Monday–Friday, 10-4 (when classes are in session).

MEDIA Considers all media including installation and graphic design. Most frequently exhibits painting, photography, sculpture/installation and mixed media.

STYLE Considers all styles. Not interested in conservative/commercial art.

TERMS Retail price set by artist (sales are not common). Exclusive area representation not required. Gallery provides insurance, promotion and contract; shipping costs are shared.

SUBMISSIONS Send résumé, 15-20 JPEG files on CD (or upload them to a Dropbox account) with a list of images, statement, résumé, and SASE. Reviews, web pages, and catalogues are welcome, though not required. If you would like response, but not your submission items returned, simply include an e-mail address. Visits by artists are welcome; however, the exhibition committee will review and select all shows from the JPEGs submitted by the artists.

BELL STUDIO

3428 N. Southport Ave., Chicago IL 60657. (773)281-2172. **Fax:** (773)281-2415. **E-mail:** bellstudioinc@gmail.com; paul@bellstudio.net. **Website:** www.bellstudio.net. **Contact:** Paul Therieau, director. Estab. 2001. For-profit gallery. Approached by 60 artists/year; represents or exhibits 10 artists. Sponsors 10 exhibits/year. Average display time: 6 weeks. Open all year; Monday 12-6, Tuesday 10-4, Wednesday 11-6, Thursday 11-5, Friday 12-6, Saturday 11-5, Sunday 11-5. Located in brick storefront with high traffic; 750 sq. ft. of exhibition space. Overall price range: $150-3,500; most work sold at $600.

MEDIA Considers acrylic, collage, drawing, mixed media, oil, paper, pastel, pen & ink and watercolor. Considers all types of prints except posters. Most frequently exhibits watercolor, oils and photography.

STYLE Exhibits minimalism, postmodernism and painterly abstraction. Genres include figurative work and landscapes.

TERMS Artwork is accepted on consignment (50% commission). Retail price set by the gallery. Gallery provides insurance, promotion and contract. Accepted work should be framed. Requires exclusive representation locally.

SUBMISSIONS Write to arrange a personal interview to show portfolio; include bio and résumé. Responds to queries within 3 months, only if interested. Finds artists through referrals by other artists, submissions, word of mouth.

TIPS "Type submission letter and include your show history, résumé and SASE."

BENNETT GALLERIES

5308 Kingston Pike, Knoxville TN 37919. (865)584-6791. **E-mail:** jeannieb@bennettgalleries.com. **Website:** www.bennettgalleries.com. Retail gallery. Represents emerging and established artists. "Rick Bennett has spent years traveling the world, establishing relationships with artists, craftsmen and small family-owned furniture makers, bringing to Bennett Galleries one-of-a-kind pieces for your home. Whether traveling in Italy, France or throughout the U.S., the Bennetts are constantly on the lookout for people who still do hand-made work. Every piece is unique, each with its own story. This search for unusual, top-quality merchandise has filled the gallery with unique works of art, fine furnishings, distinctive jewelry and crafts." Exhibited artists include Richard Jolley, Carl Sublett, Scott Duce, Andrew Saftel, Akira Blount, Scott Hill, Marga Hayes McBride, Grace Ann Warn, Timothy Berry and Cheryl Warrick. Sponsors 10 shows/year. Average display time: 1 month. Open all year; Monday–Thursday, 10-6; Friday–Saturday, 10-5:30. Located in West Knoxville. Clientele: 80%

private collectors, 20% corporate collectors. Overall price range: $200-20,000; most work sold at $2,000-8,000.

MEDIA Considers oil, acrylic, watercolor, pastel, drawing, mixed media, works on paper, sculpture, ceramic, craft, photography, glass, original handpulled prints. Most frequently exhibits painting, ceramic/clay, wood, glass and sculpture.

STYLE Exhibits contemporary works in abstraction, figurative, narrative, realism, contemporary landscape and still life.

TERMS Accepts artwork on consignment (50% commission). Retail price set by the gallery and the artist. Sometimes offers customer discounts and payment by installments. Gallery provides insurance on works at the gallery, promotion and contract. Prefers artwork framed. Shipping to gallery to be paid by the artist.

SUBMISSIONS Send query letter with résumé, no more than 10 slides, bio, photographs, SASE and reviews. Finds artists through agents, visiting exhibitions, word of mouth, various art publications, sourcebooks, submissions/self-promotions and referrals.

MONA BERMAN FINE ARTS

78 Lyon St., New Haven CT 06511. (203)562-4720. **E-mail:** info@monabermanfinearts.com. **Website:** www.monabermanfinearts.com. **Contact:** Mona Berman, director. Estab. 1979. Located near downtown; 1,400 sq. ft. Sells most styles, except figurative and large scale sculpture. Prefers abstract, landscape and transitional. Accepts work on consignment (50% commission; net 30 days). Retail price is set by gallery and artist. Retail prices must be consistent regardless of venue. Customer discounts and payment by installment are available. Gallery provides insurance; artist pays for shipping. Prefers artwork unframed. Finds artists through word of mouth, art publications and sourcebooks, submissions and self-promotions, and other professionals' recommendations." We will not carry artists who do not maintain consistent retail pricing. We are not a gallery, although we do a few exhibits; so please do not submit if you are looking for an exhibition venue. We are primarily art consultants. We continue to be busy selling high-quality art and related services to the corporate, architectural, design and private sectors."

◑ "Also provides professional development consulting services to individual artists. Other services include entrance and portfolio development for those seeking entry to higher-ed fine art and interior design programs and post-secondary curriculum development for fine arts and interior design programs."

TERMS Accepts digital submissions by e-mail and links to websites. Please include retail prices with all inquiries. Portfolios are reviewed only after images have been reviewed. Responds in 1 month. Include e-mail address for faster response. No phone calls please. Contact by e-mail only.

BERTONI GALLERY

1392 Kings Hwy., Sugar Loaf NY 10981. (845)469-0993. **Fax:** (845)469-6808. **E-mail:** bertoni@optonline.net. **Website:** www.bertonigallery.com. **Contact:** Rachel Bertoni, owner. For-profit gallery, rental gallery, art consultancy. Custom picture framing services available. Estab. 2000. Exhibits emerging, mid-career and established artists. Approached by 15 artists/year; represents 5 artists/year. Exhibited artists include Mae Bertoni (award winning master watercolorist); Marylyn Vanderpool (watercolors); and Mike Jarosko (oil). Sponsors 5 exhibits/year. Average display time: 2 months. Open Thursday-Sunday, 11-6. Clients include local community, tourists. 10% of sales are to corporate collectors. Overall price range: $100-1,500; most work sold at $400.

MEDIA Considers all media. Most frequently exhibits watercolor, oil, mixed media. Considers all types of prints.

STYLE Exhibits all styles and genres.

TERMS Artwork is accepted on consignment (40% commission); or artwork is bought outright for 50% of retail price. There is a rental fee for space; rental fee covers 2 months. Retail price set by the artist. Accepted work should be framed, mounted, matted.

SUBMISSIONS Send query letter with artist's statement, résumé and photographs. Returns material with SASE. Responds to queries in 2 weeks. Finds artists through word of mouth and referrals by other artists.

TIPS "Submit materials in a neat manner with SASE for easy return."

TOM BINDER FINE ARTS

825 Wilshire Blvd., #708, Santa Monica CA 90401. (800)332-4278. **E-mail:** info@artman.net. **Website:** www.artman.net. **Contact:** Tom Binder, owner. For-profit gallery. Exhibits established artists. Clients in-

clude local community, tourists and upscale. Overall price range: $200-5,000.

○ See additional listing in the Posters & Prints section.

MEDIA Considers all media; types of prints include etchings, lithographs, posters and serigraphs.

STYLE Considers all styles and genres.

TERMS Artwork is accepted on consignment or bought outright. Retail price set by the gallery. Gallery provides insurance. Accepted work should be mounted. Write to arrange a personal interview to show portfolio. Returns material with SASE. Responds in 2 weeks.

BIRMINGHAM BLOOMFIELD ART CENTER

1516 S. Cranbrook Rd., Birmingham MI 48009. (248)644-0866. **E-mail:** cindimills@bbartcenter.org. **Website:** www.bbartcenter.org. **Contact:** Cindi Mills, programs vice president. Estab. 1962. Nonprofit gallery shop. Represents emerging, mid-career and established artists. Sponsors ongoing exhibition. Open all year; Monday-Thursday, 9-6; Friday and Saturday, 9-5; second Sundays, 1-4. Suburban location. 100% of space for gallery artists. Clientele upscale, local. 100% private collectors. Overall price range $50-2,000.

MEDIA Considers all media. Most frequently exhibits glass, jewelry, ceramics and 2D work.

STYLE Exhibits all styles.

TERMS Accepts work on consignment (40% commission). Retail price set by the artist. Gallery provides promotion and contract; artist pays for shipping costs to gallery.

SUBMISSIONS Send query letter with résumé, brochure, slides, photographs, reviews, artist's statement, bio, SASE; "as much information as possible." Files résumé, bio, brochure, photos.

TIPS "We consider the presentation of the work (framing, matting, condition) and the professionalism of the artist."

○ BLACKFISH GALLERY

420 NW Ninth Ave., Portland OR 97209. (503)224-2634. **E-mail:** bf@teleport.com. **Website:** www.blackfish.com. Estab. 1979. Retail cooperative gallery. Represents 26 emerging and mid-career artists. Exhibited artists include Michael Knutson (oil paintings). Sponsors 12 shows/year. Open all year; Tuesday–Saturday, 11-5 and by appointment. Located downtown, in the Northwest Pearl District; 2,500 sq. ft.; street-level, garage-type overhead wide door, long, open space (100' deep). 70% of space for feature exhibits, 15-20% for gallery artists. 80% of sales are to private collectors, 20% corporate clients. Overall price range $250-12,000; most artwork sold at $500-2,000.

MEDIA Considers oil, acrylic, watercolor, pastel, pen & ink, drawings, mixed media, collage, sculpture, ceramic, photography, woodcuts, wood engravings, linocuts, engravings, mezzotints, etchings, lithographs, pochoir and serigraphs. Most frequently exhibits paintings, sculpture and prints.

STYLE Exhibits expressionism, neo-expressionism, painterly abstraction, surrealism, conceptualism, minimalism, color field, postmodern works, impressionism and realism. Prefers neo-expressionism, conceptualism and painterly abstraction.

TERMS Accepts work on consignment from invited artists (50% commission); co-op membership includes monthly dues plus donation of time (40% commission on sales). Retail price set by artist with assistance from gallery on request. Customer discounts and payment by installment are available. Gallery provides insurance, promotion and contract, and shipping costs from gallery. Prefers artwork framed.

SUBMISSIONS Accepts only artists from northwest Oregon and southwest Washington ("unique exceptions possible"); "must be willing to be an active cooperative member; write for details." Send query letter with résumé, slides, SASE, reviews and statement of intent. Write for appointment to show portfolio of photographs and slides. "We review throughout the year." Responds in 1 month. Files material only if exhibit invitation extended. Finds artists through agents, visiting exhibitions, word of mouth, various art publications and sourcebooks, submissions/self-promotions and art collectors' referrals.

TIPS "Understand—via research—what a cooperative gallery is. Call or write for an information packet. Do not bring work or slides to us without first having contacted us by phone, mail, or e-mail."

BLACKWELL ST. CENTER FOR THE ARTS

P.O. Box 808, Denville NJ 07834. (973)316-0857. **E-mail:** pegdartist@aol.com. **Website:** www.blackwell-st-artists.org. Estab. 1983. Nonprofit group. Exhibits the work of approximately 15 or more emerging and established artists. Sponsors 3-4 group shows/year. Average display time 1 month. Overall price range $100-5,000; most work sold at $150-350.

MEDIA Considers oil, acrylic, watercolor, pastel, pen & ink, drawings, mixed media, collage, paper, sculpture, ceramics, photography, egg tempera, woodcuts, wood engravings, linocuts, engravings, mezzotints, etchings, lithographs and serigraphs. Most frequently exhibits oil, photography and pastel.

STYLE Exhibits all styles and genres. Prefers painterly abstraction, realism and photorealism.

TERMS Membership fee plus donation of time; 20% commission. Retail price set by artist. Sometimes offers payment by installments. Exclusive area representation not required. Artist pays for shipping. Prefers artwork framed.

SUBMISSIONS Send query letter with résumé, brochure, slides, photographs, bio and SASE. Call or write for appointment to show portfolio of originals and slides. Responds in 1 month. Files slides of accepted artists. All material returned if not accepted or under consideration.

TIPS "Show one style of work and pick the best. Less is more. Slides and/or photos should be current work. Enthusiasm and organization are big pluses!"

BLOUNT-BRIDGERS HOUSE/HOBSON PITTMAN MEMORIAL GALLERY

130 Bridgers St., Tarboro NC 27886. (252)823-4159. **E-mail:** edgecombearts@embarqmail.com. **Website:** www.edgecombearts.org. Estab. 1982. Museum. Approached by 20 artists/year. Exhibits 6 emerging, mid-career and established artists. Sponsors 8 exhibits/year. Average display time 6 weeks. Open Monday-Friday, 10-4; weekends 2-4. Closed major holidays, Christmas-New Year. Located in historic house in residential area of small town; gallery on 2nd floor is accessible by passenger elevator. Room is approximately 48×20 sq. ft. Clients include local community, students and tourists. Overall price range $250-5,000; most work sold at $500.

MEDIA Considers acrylic, ceramics, collage, craft, drawing, fiber, glass, mixed media, oil, paper, pastel, pen & ink and watercolor. Most frequently exhibits oil, watercolor and ceramic. Considers all types of prints.

STYLE Considers all styles and genres.

TERMS Artwork is accepted on consignment and there is a 30% commission. Retail price set by the artist. Gallery provides insurance and limited promotion. Accepted work should be framed. Does not require exclusive representation locally. Accepts artists from southeast and Pennsylvania.

SUBMISSIONS Send portfolio of photographs, slides or transparencies. Send query letter with artist's statement, bio, SASE and slides. Returns material with SASE. Responds in 3 months. Finds artists through word of mouth, submissions, art exhibits and referrals by other artists.

⊕ BLUE GALLERY

118 Southwest Blvd., Kansas City MO 64108. (816)527-0823. **E-mail:** kellyk@bluegalleryonline.com. **Website:** www.bluegalleryonline.com. **Contact:** Kelly Kuhn, owner/director. Estab. 2000.

MEDIA Acrylic, ceramics, collage, craft, drawing, fiber, glass, installation, mixed media, oil, paper, pastel, pen & ink, sculpture, and watercolor. Considers all media, but most frequently exhibits paintings.

STYLE Considers all styles but prefers contemporary. Exhibits Americana, figurative work, florals, landscapes, portraits and Southwestern pieces among others.

TERMS Artwork is accepted on consignment. Retail price set by the artist. Gallery provides insurance, promotion, and contract. Accepted work should be framed. Requires exclusive representation locally.

SUBMISSIONS E-mail query letter with link to artist's website and JPEG samples at 72 dpi. Mail portfolio for review. Send query letter with artist's statement, bio, brochure, business card, photocopies, résumé, reviews, and SASE. Returns material with SASE. Responds in 3 months.

BLUE MOUNTAIN GALLERY

530 W. 25th St., 4th Floor, New York NY 10001. (646)486-4730. **Fax:** (646)486-4345. **E-mail:** info@bluemountaingallery.org. **Website:** www.bluemountaingallery.org. Estab. 1980. Artist-run cooperative gallery. Exhibits 32 mid-career artists. Sponsors 13 solo and 1 group shows/year. Display time is 3 weeks. "We are located on the 4th floor of a building in Chelsea. We share our floor with two other well-established cooperative galleries. Each space has white partitioning walls and an individual floor-plan." Clients include art lovers, collectors and artists. 90% of sales are to private collectors, 10% corporate clients. Open Tuesday–Saturday, 11-6. Overall price range: $100-8,000; most work sold at $100-4,000.

MEDIA Considers painting, drawing and sculpture.

STYLE "The base of the gallery is figurative but we show work that shows individuality, commitment and involvement with the medium."

TERMS Co-op membership fee plus donation of time. Retail price set by artist. Exclusive area representation not required. Gallery provides insurance, some promotion and contract; artist pays for shipping.

SUBMISSIONS Send name and address with intent of interest and sheet of 20 good slides. "We cannot be responsible for material return without SASE." Finds artists through artists' submissions and referrals.

TIPS "This is a cooperative gallery, so it is important to represent artists who can contribute actively to the gallery. We look at artists who can be termed local or in-town more than out-of-town artists and would choose the former over the latter. The work should present a consistent point of view that shows individuality. Expressive use of the medium used is important also."

⊕ BLUE SPIRAL 1

38 Biltmore Ave., Asheville NC 28801. (828)251-0202. **Fax:** (828)251-0884. **E-mail:** info@bluespiral1.com. **Website:** www.bluespiral1.com. Estab. 1991. Retail gallery. "Blue Spiral 1 presents work by exceptional Southern artists and object makers in a beautifully renovated building in the heart of downtown Asheville. The light-filled, 15,000 sq. ft. gallery spans three floors connected by an open stairway. This spacious setting allows Blue Spiral 1 to offer considerable diversity, affording accessibility to various tastes and aesthetics." Represents emerging, mid-career and established artists living in the Southeast. Over 100 exhibited artists including Julyan Davis, John Nickerson, Suzanne Stryk, Greg Decker and Will Henry Stephens. Sponsors 15-20 shows/year. Average display time: 6-8 weeks. Open Monday–Saturday, 10-6; Sunday, 12-5. Located downtown 2 blocks south of Pack Square next to the Fine Arts Theatre; historic building. 50% of space for special exhibitions; 50% of space for gallery artists. Clientele: "across the range;" 90% private collectors, 10% corporate collectors. Overall price range: less than $100-50,000; most work sold at $100-2,500.

MEDIA Considers all media. Most frequently exhibits painting, clay, sculpture and glass.

STYLE Exhibits all styles, all genres.

TERMS Accepts work on consignment (50% commission). Retail price set by the artist. Gallery provides insurance, promotion and contract; artist pays shipping costs to and from gallery. Prefers framed artwork.

SUBMISSIONS Accepts only artists from Southeast. Send query letter with résumé, slides, prices, statement and SASE. Responds in 3 months. Include SASE for items to be returned. Finds artists through word of mouth, referrals and travel. Submission guidelines available online.

TIPS "Work must be technically well executed and properly presented."

BOCA RATON MUSEUM OF ART

501 Plaza Real, Minzer Park, Boca Raton FL 33432. (561)392-2500. **Fax:** (561)391-6410. **E-mail:** iford@ bocamuseum.org; info@bocamuseum.org. **Website:** www.bocamuseum.org. Estab. 1950. Represents established artists. 5,500 members. Exhibits change every 2-3 months. Open all year; Tuesday–Friday, 10-5; Saturday and Sunday, 12-5; 1st Wednesday of every month, 10-9. Located one mile east of I-95 in Mizner Park; 44,000 sq. ft.; national and international temporary exhibitions and impressive second-floor permanent collection. Three galleries—one shows permanent collection, two are for changing exhibitions. 66% of space for special exhibitions.

MEDIA Considers all media. Exhibits modern masters including Braque, Degas, Demuth, Glackens, Klee, Matisse, Picasso and Seurat; 19th- and 20th-century photographers; Pre-Columbian and African art; contemporary sculpture.

SUBMISSIONS "Contact executive director in writing."

TIPS "Photographs of work of art should be professionally done if possible. Before approaching museums, an artist should be well-represented in solo exhibitions and museum collections. Their acceptance into a particular museum collection, however, still depends on how well their work fits into that collection's narrative and how well it fits with the goals and collecting policies of that museum."

⊕ BOEHM GALLERY

Palomar College, 1140 W. Mission Rd., San Marcos CA 92069-1487. (760)744-1150 ext. 2304. **Website:** www.palomar.edu/art/BoehmGallery.html. Estab. 1966. Nonprofit gallery. Represents/exhibits mid-career artists. May be interested in seeing the work of emerging artists in the future. Generally exhibits 30 or more artists/year in solo and group exhibitions, supplemented with faculty, student work. Exhibited artists include top illustrators, crafts people, painters and sculptors. Sponsors 6 shows/year. Average dis-

play time 4-5 weeks. Open fall and spring semester; Tuesday 10-4; Wednesday and Thursday 10-7; Friday and Saturday 10-2; closed Sunday, Monday and school holidays. Located on the Palomar College campus in San Marcos; 2,000 sq. ft.; 100% of space for special exhibitions. Clientele regional community, artists, collectors and students. "Prices range dramatically depending on exhibition type and artist; $25 for student works to $10,000 for paintings, drawings, oils and installational sculptural works."

MEDIA Considers all media; all types of prints. Most frequently exhibits installation art, painting, sculpture, glass, illustration, quilts, ceramics, furniture design and photography.

STYLE Exhibits all styles. Styles vary. Exhibits primarily group exhibits based on either a medium or theme or genre.

TERMS If artwork is sold, gallery retains 10% gallery "donation." Gallery provides insurance and promotion.

SUBMISSIONS Accepts primarily artists from Southern California. Send query letter with résumé, slides, reviews and bio. Call or write for appointment to show portfolio of photographs and slides. Responds in 2-3 months. Files artist bio and résumé. Finds artists through "artist network, other reviewed galleries, or university visits or following regional exhibitions, and referrals from other professional artists and crafts people."

TIPS Advises artists to show "clear focus for art exhibition and good slides. Lucid, direct artist statement. Be willing to take part in group exhibits—we have very few strictly 'solo' shows and then only for very prominent artists. Be professional in your contacts and presentations and prompt in meeting deadlines. Have a unified body of work which is identifiable as your expression."

BRADBURY GALLERY

P.O. Drawer 1920, State University AR 72467-1920. (870)972-3050. **Fax:** (870)972-3932. **E-mail:** dnspe@astate.edu. **Website:** www.astate.edu/bradburygallery. Estab. 1968. University Art Department Gallery. Represents/exhibits 3-4 emerging, mid-career and established artists/year. Sponsors 3-4 shows/year. Average display time 1 month. Open fall, winter and spring; Tuesday-Saturday, 12-5; Sunday 2-5. Located on university campus; 1,600 sq. ft.; 60% of time devoted to special exhibitions; 40% to faculty and student work. Clientele: students/community.

MEDIA Considers all media. Considers all types of prints. Most frequently exhibits painting, sculpture and photography.

STYLE Exhibits conceptualism, photorealism, neo-expressionism, minimalism, hard-edge geometric abstraction, painterly abstraction, postmodern works, realism, impressionism and pop. "No preference except quality and creativity."

TERMS Exhibition space only; artist responsible for sales. Retail price set by the artist. Gallery provides insurance, promotion and contract; shipping costs are shared. Prefers artwork framed.

SUBMISSIONS Send query letter with résumé, CD/DVD and SASE. Portfolio should be submitted on CD/DVD only. Responds only if interested within 2 months. Files résumé. Finds artists through call for artists published in regional and national art journals.

TIPS "Show us 20 digital images of your best work. Don't overload us with lots of collateral materials (reprints of reviews, articles, etc.). Make your vita as clear as possible."

RENA BRANSTEN GALLERY

77 Geary St., San Francisco CA 94108. (415)982-3292. **Fax:** (415)982-1807. **E-mail:** info@renabranstengallery.com; calvert@renabranstengallery.com; rena@renabranstengallery.com. **Website:** www.renabranstengallery.com. **Contact:** Rena Bransten, owner. Estab. 1974. For-profit gallery. Exhibits emerging, mid-career and established artists. Approached by 200 artists/year. Exhibits 12-15 artists/year. Average display time: 4-5 weeks. Open Tuesday–Friday, 10:30-5:30; Saturday, 11-5; usually closed the last week of August and the first week of September.

MEDIA Considers all media; all types of prints.

STYLE Considers all styles of contemporary art. Retail price set by the gallery and the artist.

TERMS Send material via JPEGs or website link via e-mail, rather than mailed submissions.

TIPS Finds artists through art fairs and exhibits, portfolio reviews, referrals by curators and other artists, studio visits and word of mouth.

BRENAU UNIVERSITY GALLERIES

500 Washington St., SE, Gainesville GA 30501. (770)534-6263. **Website:** www.brenau.edu. Estab. 1980s. Nonprofit gallery. Exhibits emerging, mid-career and established artists. Sponsors 7-9 shows/year. Average display time: 6-8 weeks. Open all year; Tuesday-Friday, 10-4; Sunday, 2-5 during exhibit

dates. "Please call for summer hours." Located near downtown; 3,958 sq. ft., 3 galleries—the main one in a renovated 1914 neoclassical building, another in an adjacent renovated Victorian building dating from the 1890s, the third in the center for performing arts. 100% of space for special exhibitions. Clientele: tourists, upscale, local community, students. "Although sales do occur as a result of our exhibits, we do not currently take any percentage, except in our invitational exhibitions. Our purpose is primarily educational."

MEDIA Considers all media.

STYLE Exhibits wide range of styles. "We intentionally try to plan a balanced variety of media and styles."

TERMS Retail price set by the artist. Gallery provides insurance and promotion; shipping costs are shared, depending on funding for exhibits. Prefers artwork framed. "Artwork must be framed or otherwise ready to exhibit."

SUBMISSIONS Send query letter with résumé, 10-20 slides, photographs and bio. Write for appointment to show portfolio of slides and transparencies. Responds within months if possible. Artist should call to follow up. Files 1 or 2 slides or photos with a short résumé or bio if interested. Remaining material returned. Finds artists through referrals, direct viewing of work and inquiries.

TIPS "Be persistent, keep working, be organized and patient. Take good slides and develop a body of work. Galleries are limited by a variety of constraints—time, budgets, location, taste—and rejection does not mean your work may not be good; it may not fit for other reasons at the time of your inquiry."

BROADHURST GALLERY

2212 Midland Rd., Pinehurst NC 28374. (910)295-4817. **E-mail:** judy@broadhurstgallery.com. **Website:** broadhurstgallery.com. Estab. 1990. Retail gallery. "Original art is displayed using 4500 sq. ft. of display area inside and outside sculpture in the garden." Represents/exhibits 25 established artists/year. Sponsors about 4 large shows and lunch and Artist Gallery Talks on most Fridays. Average display time 1-3 months. Open all year; Tuesday–Friday, 11-5; Saturday, 1-4; and by appointment. Located on the main road between Pinehurst and Southern Pines; 3,000 sq. ft.; lots of space, ample light, large outdoor sculpture garden. 50% of space for special exhibitions; 50% of space for gallery artists. Clientele: people building homes and remodeling, also collectors. 80% private collectors, 20% corporate collectors. Overall price range $5,000-40,000; most work sold at $5,000 and up.

MEDIA Considers oil, acrylic, watercolor, pastel, mixed media and collage. Most frequently exhibits oil and sculpture (stone and bronze).

STYLE Exhibits all styles, all genres.

TERMS Retail price set by the artist. Gallery provides insurance, promotion and contract; shipping costs are shared. Prefers artwork framed.

SUBMISSIONS Send query letter with résumé, slides or photographs, and bio. Write for appointment to show portfolio of originals and slides. Responds only if interested within 3 weeks. Files résumé, bio, slides or photographs. Finds artists through agents, exhibitions, word of mouth, various art publications and sourcebooks and artists' submissions.

TIPS "Talent is always the most important factor, but professionalism is very helpful."

BROOKFIELD CRAFT CENTER

286 Whisconier Rd., P.O. Box 122, Brookfield CT 06804-0122. (203)775-4526. **Fax:** (203)740-7815. **E-mail:** director@brookfieldcraft.org; info@brookfield craft. **Website:** www.brookfieldcraft.org. **Contact:** Gallery director. Estab. 1954. Exhibits emerging, mid-career and established craft artists. Approached by 100 artists/year; represents 400+ craft artists.

MEDIA Considers functional and sculptural ceramics, fiber arts, jewelry and fine metals, forged metals, glass, mixed media and wood. Most frequently exhibits clay, metal, wood, fiber.

STYLE Original, handmade work by American artisans, one-of-a-kind or very limited production.

TERMS Work is accepted on consignment (50% commission); net 30 days. Retail price of the art set by the artist. Gallery provides insurance, promotion and contract.

SUBMISSIONS E-mail photographs or website links, or send query letter with brochure. Returns material with SASE. Responds to queries in 2 weeks to 1 month. Finds artists through art fairs/exhibits, portfolio reviews, referrals by other artists, submissions and word of mouth.

BROOKLYN BOTANIC GARDEN— STEINHARDT CONSERVATORY GALLERY

1000 Washington Ave., Brooklyn NY 11225. (718)623-7200. **E-mail:** steinhardt@bbg.org. **Website:** www. bbg.org. Estab. 1988. Nonprofit botanic garden gal-

lery. Represents emerging, mid-career and established artists. 20,000 members. Sponsors 10-12 shows/year. Average display time: 4-6 weeks. Open all year; Tuesday–Friday, 8-6, Saturday and Sunday, 10-6. Located near Prospect Park and Brooklyn Museum; 1,200 sq. ft.; part of a botanic garden, gallery adjacent to the tropical, desert and temperate houses. Clients include BBG members, tourists, collectors. 100% of sales are to private collectors. Overall price range: $75-7,500; most work sold at $75-500.

MEDIA Considers all media and all types of prints. Most frequently exhibits watercolor, oil and photography.

STYLE Exhibits all styles. Genres include landscapes, florals and wildlife.

TERMS Accepts work on consignment (20% commission). Retail price set by the artist. Gallery provides insurance, promotion and contract; artist pays shipping costs to and from gallery. Artwork must be framed or ready to display unless otherwise arranged. Artists hang and remove their own shows.

SUBMISSIONS Work must reflect the natural world. Send query letter with curriculum vitae, 8 to 10 visuals indicating title, date, materials used, and dimensions of the work (if sending JPEGs of the work, please use a resolution of 300 dpi or higher), and a description of the exhibit stating why BBG is an appropriate venue. Further guidelines available online.

TIPS "Artists' groups contact me by submitting résumé and slides of artists in their group. We favor seasonal art which echoes the natural events going on in the garden. Large format, colorful works show best in our multi-use space."

BRUNNER GALLERY

215 N. Columbia St., Covington LA 70433. (985)893-0444. **Fax:** (985)893-4332. **E-mail:** sbrunner@brun nergallery.com; manager@brunnergallery.com. **Website:** www.brunnergallery.com. **Contact:** Susan Brunner, owner/director. Estab. 1997. For-profit gallery. "Over the years, Brunner Gallery has grown to be one of the most popular and recognized contemporary art galleries in the South. Located in Historic Downtown Covington on New Orleans' Northshore, and rotates exhibitions in Downtown Baton Rouge at the Hilton Baton Rouge Capitol Center." Approached by 400 artists/year. Exhibits 45 emerging, mid-career and established artists. Sponsors 10-12 exhibits/year. Average display time: 1 month. Open Wednesday–Saturday,

10-5; closed major holidays. Located 45 minutes from metropolitan New Orleans, one hour from capital of Baton Rouge and Gulf Coast; 2,500 sq. ft. Building designed by Rick Brunner, artist and sculptor, and Susan Brunner, designer. Clients include local community, tourists, upscale and professionals. 20% of sales are to corporate collectors. Overall price range: $200-10,000; most work sold at $1,500-3,000.

MEDIA Considers all media. Types of prints include etchings and monoprints.

STYLE Considers all styles and genres. Most frequently exhibits abstraction, expressionism and conceptualism.

TERMS Artwork is accepted on consignment (50% commission) or bought outright for 90-100% of retail price (net 30 days). Retail price set by the gallery and the artist. Gallery provides insurance, promotion and contract. Accepted work should be framed. Requires exclusive representation locally.

SUBMISSIONS "We welcome submissions according to certain guidelines (found online). Please read them carefully. We are not able to critique your work because of time constraints; however, we are interested in seeing the newest work from Louisiana and across the U.S. We will send a response when your submission has been reviewed. Should we wish to consider your work for a second review, we will contact you by telephone or e-mail."

TIPS "In order for us to offer representation to an artist, it is necessary for us to consider whether the artist will be a good fit for the private and corporate collectors who make up our client base. We request that each image include not only the title, dimensions and medium, but also the retail price range."

BRYAN MEMORIAL GALLERY

180 Main St., P.O. Box 340, Jeffersonville VT 05464. (802)644-5100. **Fax:** (802)644-8342. **E-mail:** info@ bryangallery.org. **Website:** www.bryangallery.org. Estab. 1984. Exhibits over 200 artists throughout the year in a schedule of revolving exhibitions. Co-op membership fee plus time donation required. "There is at least one juried exhibit per year and one open exhibit for members." Open Thursday–Sunday, 11-4 (spring and fall); daily, 11-4 (summer); by appointment at any time.

TERMS Contact the executive director through e-mail after reviewing the website. Include artist's information, such as a URL and small samples if possible.

BUSINESS OF ART CENTER

513 Manitou Ave., Manitou Springs CO 80829. (719)685-1861. **Fax:** (719)685-5276. **E-mail:** liz@the bac.org. **Website:** www.thebac.org. **Contact:** Liz Szabo, gallery curator and director. Estab. 1988. Nonprofit gallery situated in 2 renovated landmark buildings in the Manitou Springs National Historic District—Studio 513 and Venue 515. Art studios for rent. Sponsors 16 exhibits/year. Average display time 1 month. Gallery open Tuesday–Saturday, 11-6. Overall price range $50-3,000. Most work sold at $300.

MEDIA Accepts sculpture, painting, mixed media, alternative processes and photography.

TERMS Artwork is accepted on consignment, and there is a 40% commission. Gallery provides insurance, promotion, contract. Accepted work should be framed.

SUBMISSIONS Write to arrange a personal interview to show portfolio. Send query letter with artist's statement, bio, slides. Finds artists through word of mouth, submissions, portfolio reviews, art exhibits, referrals by other artists.

CADEAUX DU MONDE

26 Mary St., Newport RI 02835. (401)848-0550. **E-mail:** info@cadeauxdumonde.com. **Website:** www. cadeauxdumonde.com. **Owner:** Katie Dyer. Retail gallery. Estab. 1987. Represents emerging, mid-career and established artists. Exhibited artists include John Lyimo and A.K. Paulin. Clients include tourists, upscale, local community and students. 95% of sales are to private collectors, 5% corporate collectors. Overall price range: $20-5,000; most work sold at $100-300. Finds artists through submissions, word of mouth, referrals by other artists, visiting art fairs and exhibitions.

MEDIA Considers all media suitable for display in a stairway setting for special exhibitions. No prints.

STYLE Exhibits folk art. "Style is unimportant; quality of work is deciding factor. We look for unusual, offbeat and eclectic."

SUBMISSIONS Send query letter with résumé, 10 slides, bio, photographs and business card. Call for appointment to show portfolio of photographs or slides. Responds only if interested. Finds artists through submissions, word of mouth, referrals by other artists, visiting art fairs and exhibitions.

TIPS Artists who want gallery representation should "present themselves professionally; treat their art and the showing of it like a small business; arrive on time and be prepared; and meet deadlines promptly."

THE CANTON MUSEUM OF ART

1001 Market Ave. N., Canton OH 44702. (330)453-7666. **Fax:** (330)453-1034. **Website:** www.cantonart. org. Nonprofit gallery. Represents emerging, mid-career and established artists. "Although primarily dedicated to large-format touring and original exhibitions, the CMA occasionally sponsors solo shows by local and original artists, and one group show every 2 years featuring its own 'Artists League.'" Average display time: 6 weeks. Overall price range: $50-3,000; few sales above $300-500.

MEDIA Considers all media. Most frequently exhibits oil, watercolor and photography.

STYLE Considers all styles. Most frequently exhibits painterly abstraction, postmodernism and realism.

TERMS "While every effort is made to publicize and promote works, we cannot guarantee sales, although from time to time sales are made, at which time a 25% charge is applied." One of the most common mistakes in presenting portfolios is "sending too many materials. Send only a few slides or photos, a brief bio and a SASE."

TIPS "There seems to be a move back to realism, conservatism and support of regional artists."

CANTRELL GALLERY

8206 Cantrell Rd., Little Rock AR 72227. (501)224-1335. **E-mail:** cantrellgallery@sbcglobal.net. **Website:** www.cantrellgallery.com. **Contact:** Helen Scott or Cindy Huisman. Estab. 1970. Wholesale/retail gallery. "Cantrell Gallery is family owned and operated. In the beginning we were in a tiny storefront downtown, and our name was Art Fair. Today our business has grown to over 5,000 sq. ft. of showroom and production space. We get to know our clients and form a lasting relationship with them." Represents/exhibits 120 emerging, mid-career and established artists/year. Exhibited artists include Boulanger, Dali, G. Harvey, Warren Criswell, N. Scott and Robin Morris. Sponsors 8-12 shows/year. Average display time 1 month. Open all year; Monday–Saturday, 10-5; or by appointment. Located in the strip center; "we have several rooms and different exhibits going at one time." Clientele: collectors, retail, decorators, museums. Overall price range $100-10,000; most work sold at $250-3,000.

MEDIA Considers oil, acrylic, watercolor, pastel, pen & ink, drawing, mixed media, collage, paper, sculpture, woodcut, engraving, lithograph, wood engraving, mezzotint, serigraphs, linocut, etching. Most frequently exhibits etchings, watercolor, mixed media, oils and acrylics. Looking for outsider art.

STYLE Exhibits eclectic work, all genres.

TERMS Gallery provides insurance and promotion; shipping costs are shared. Prefers artwork unframed.

SUBMISSIONS Send query letter with résumé, 5 photos and bio. Write for appointment to show portfolio of originals. Responds in 2 months. Files all material. Finds artists through agents, by visiting exhibitions, word of mouth, art publications and sourcebooks, artists' submissions.

TIPS "Be professional. Be honest. Place a retail price on each piece, rather than only knowing what 'you need to get' for the piece. Don't spread yourself too thin in any particular area—only show in one gallery in any area."

CARNEGIE ARTS CENTER

204 W. Fourth St., Alliance NE 69301. (308)762-4571. **Fax:** (308)762-4571. **E-mail:** carnegieartscenter@bbc. net. **Website:** www.carnegieartscenter.com. **Contact:** Lynne C. Messersmith, office manager. Visual art gallery. Estab. 1993. Represents 300 emerging, mid-career and established artists/year. 350 members. Exhibited artists include Liz Enyeart (functional pottery) and Silas Kern (handblown glass). Sponsors 12 shows/year. Average display time: 6 weeks. Open all year; Tuesday-Saturday, 10-4; Sunday, 1-4. Located downtown; 2,346 sq. ft.; renovated Carnegie library built in 1911. Clients include tourists, upscale, local community and students. 90% of sales are to private collectors; 10% corporate collectors. Overall price range: $10-2,000; most work sold at $10-300.

MEDIA Considers all media and all types of prints. Most frequently exhibits pottery, blown glass, 2D, acrylics, bronze sculpture, watercolor, oil and silver jewelry.

STYLE Exhibits all styles and genres. Most frequently exhibits realism, modern realism, geometric, abstraction.

TERMS Accepts work on consignment (35% commission). Retail price set by the artist. Gallery provides promotion. Shipping costs negotiated. Prefers framed artwork.

SUBMISSIONS Accepts only quality work. Send query. Write for appointment to show portfolio of photographs, slides or transparencies. Responds within 1 month, only if interested. Files résumé and contracts. Finds artists through submissions, word of mouth, referrals by other artists, visiting art fairs and exhibitions.

TIPS "Presentations must be clean, 'new' quality—that is, ready to meet the public. Two-dimensional artwork must be nicely framed with wire attached for hanging. Unframed prints need protective wrapping in place."

CEDARHURST CENTER FOR THE ARTS

2600 Richview Rd., Mt. Vernon IL 62864. (618)242-1236. **Fax:** (618)242-9530. **E-mail:** mitchellmuseum@ cedarhurst.org. **Website:** www.cedarhurst.org. **Contact:** Rusty Freeman, director of visual arts. Estab. 1973. Museum. Exhibits emerging, mid-career and established artists. Average display time: 6 weeks. Open all year; Tuesday through Saturday, 10-5; Sunday, 1-5; closed Mondays and federal holidays.

SUBMISSIONS Call or send query letter with artist's statement, bio, résumé, and digital images.

CENTRAL MICHIGAN UNIVERSITY ART GALLERY

University Art Gallery Wightman 132, Central Michigan University, Mt. Pleasant MI 48859. (989)774-3800. **E-mail:** goche1as@cmich.edu. **Website:** www.uag. cmich.edu. **Contact:** Anne Gochenour, gallery director. Estab. 1970. Nonprofit academic gallery. Exhibits emerging, mid-career and established contemporary artists. Past artists include Sandy Skoglund, Michael Ferris, Blake Williams, John Richardson, Valerie Allen, Randal Crawford, Jane Gilmor, Denise Whitebread Fanning, Alynn Guerra, Dylan Miner. Sponsors 14 exhibits/year (2-4 curated). Average display time: 1 month. Open all year while exhibits are present; Tuesday–Friday, 11-6; Saturday, 11-3. Clients include local community, students and tourists.

MEDIA Considers all media and all types of prints. Most frequently exhibits sculpture, prints, ceramics, painting and photography.

STYLE Considers all styles.

TERMS Buyers are referred to the artist. Gallery provides insurance, promotion and contract. Accepted work should be framed. Does not require exclusive representation locally.

SUBMISSIONS Send query letter with artist's statement, bio, résumé, reviews, and images on CD. Responds within 2 months, only if interested. Finds artists through word of mouth, submissions, portfolio reviews, art exhibits, and referrals by other artists.

⊕ CHABOT FINE ART GALLERY

379 Atwells Ave., Providence RI 02909. (401)432-7783. **Fax:** (401)432-7783. **E-mail:** chris@chabot gallery.com. **Website:** www.chabotgallery.com. **Contact:** Chris Chabot, director. Estab. 2007. Rental gallery. Approached by 50 artists/year; represents 30 emerging, mid-career and established artists. Exhibited artists include Carolyn Latanision (watercolor) and Lee Chabot (oil). Sponsors 12 total exhibits/year; 1 photography exhibit/year. Average display time 30 days. Open Tuesday-Saturday, 12-6. The gallery is located on Historic Federal Hill in Providence. It has over 1,000 sq. ft. of exhibition space and a sculpture courtyard garden that is open in the warmer months. Clients include local community, tourists, upscale. 10% corporate collectors. Overall price range: $1,200-10,000. Most work sold at $3,500.

MEDIA Considers all media except craft. Most frequently exhibits oil, acrylics and watercolor.

STYLE Considers all styles and genres. Most frequently exhibits abstract, impressionism, abstract expressionism.

TERMS Artwork is accepted on consignment with a 50% commission. Retail price is set by the gallery and artist. Gallery provides insurance, promotion, and contract. Accepted work should be framed, mounted, and matted.

SUBMISSIONS Mail portfolio for review. Send query letter with artist's statement, bio, résumé, CD with images, and SASE. Returns material with SASE. Responds in 1 month. Files all submitted material. Finds artist through word of mouth, submissions, portfolio reviews, and referrals by other artists.

TIPS Be professional in your presentation, have good images in your portfolio, and submit all necessary information.

THE CHAIT GALLERIES DOWNTOWN

218 E. Washington St., Iowa City IA 52240. (319)338-4442. **Fax:** (319)338-3380. **E-mail:** info@thegalleries downtown.com; terri@thegalleriesdowntown.com; bpchait@aol.com. **Website:** www.thegalleriesdown town.com. **Contact:** Benjamin Chait, director. Estab. 2003. For-profit gallery. Approached by 100 artists/year. Represents 150 emerging, mid-career and established artists. Exhibited artists include Benjamin Chait (giclée), Corrine Smith (mixed media), Mary Merkel-Hess (fiber sculpture), Tam Bodkin Bryk (oil on canvas), Young Joo Yoo (gold and sterling silver jewelry), Nancy Lindsay (landscape paintings) and Ulfert Wilke (ink on paper). Sponsors 12 exhibits/year. Average display time: 90 days. Open all year; Monday-Friday, 11-6; Saturday, 10-5; Sunday by chance or appointment. Located in a downtown building restored to its original look (circa 1882), with 14-ft. molded ceiling and original 9-ft. front door. Professional museum lighting and scamozzi-capped columns complete the elegant gallery. Clients include local community, students, tourists, upscale. Overall price range: $50-10,000; most work sold at $250-1,000.

MEDIA Considers all media, all types of prints, all styles and all genres.

STYLE Considers all styles.

TERMS Call; mail portfolio for review. Returns material with SASE. Responds to queries in 2 weeks. Finds artists through art fairs, exhibits, portfolio reviews and referrals by other artists.

SUBMISSIONS Artwork is accepted on consignment, and there is a 50% commission. Retail price set by the gallery and the artist. Gallery provides insurance, promotion and contract. Accepted work should be framed. Requires exclusive representation locally.

CHAPMAN FRIEDMAN GALLERY

624 W. Main St., Louisville KY 40202. **E-mail:** fried man@imagesol.com; cheryl_chapman@bellsouth. net. **Website:** www.chapmanfriedmangallery.com; www.imagesol.com. **Contact:** Julius Friedman, owner. Estab. 1992. For-profit gallery. Approached by 100 or more artists/year. Represents or exhibits 25 artists. Sponsors 7 exhibits/year. Average display time: 1 month. Open by appointment only. Located downtown; approximately 3,500 sq. ft. with 15-ft. ceilings and white walls. Clients include local community and tourists. 5% of sales are to corporate collectors. Overall price range: $75-10,000; most work sold at more than $1,000.

MEDIA Considers all media except craft. Types of prints include engravings, etchings, lithographs, posters, serigraphs and woodcuts. Most frequently exhibits painting, ceramics and photography. Exhibits color field, geometric abstraction, primitivism realism, painterly abstraction. Most frequently exhibits ab-

stract, primitive and color field. Artwork is accepted on consignment (50% commission). Retail price set by the artist. Gallery provides insurance, promotion and contract. Accepted work should be framed.

TERMS Send query letter with artist's statement, bio, brochure, photographs, résumé, slides and SASE. Returns material with SASE. Responds to queries in 1 month. Finds artists through portfolio reviews and referrals by other artists.

CINCINNATI ART MUSEUM

953 Eden Park Dr., Cincinnati OH 45202. (513)639-2995. **Fax:** (513)639-2888. **E-mail:** information@cincyart.org. **Website:** www.cincinnatiartmuseum.org. **Contact:** Jéssica Flores, associate curator of contemporary art. Estab. 1881. Exhibits 6-10 emerging, mid-career and established artists/year. Sponsors 20 exhibits/year. Average display time: 3 months. Open Tuesday–Sunday, 11-5. Closed Mondays, Thanksgiving, Christmas, New Year's Day, Martin Luther King Jr. Day, Presidents Day, Memorial Day, Fourth of July and Labor Day. General art museum with a collection spanning 6,000 years of world art. Over 100,000 objects in the collection with exhibitions on view annually. Clients include local community, students, tourists and upscale.

MEDIA Considers all media and all types of prints. Most frequently exhibits paper, mixed media and oil.

STYLE Considers all styles and genres.

SUBMISSIONS Send query letter with artist's statement, photographs, reviews, SASE and slides.

⊕ CITYARTS, INC.

525 Broadway, Suite 700, New York NY 10012. (212)966-0377. **Fax:** (212)966-0551. **E-mail:** info@cityarts.org. **Website:** www.cityarts.org. Estab. 1968. Art consultancy, nonprofit public art organization. Represents 1,000 emerging, mid-career and established artists. Produces 4-8 projects/year. Average display time varies. A mural or public sculpture will last up to 15 years. Open all year; Monday–Friday, 9:30-6:30. Located in Soho; "the city is our gallery." CityArts's 200 murals are located in all 5 boroughs in NYC. Funded by foundations, corporations, government and membership ("Friends of CityArts").

MEDIA Considers oil, acrylic, drawing, sculpture, mosaic and installation. Most frequently exhibits murals (acrylic), mosaics and sculpture.

STYLE Produces all styles and all genres depending on the site.

TERMS Artist receives a flat commission for producing the mural or public art work. Retail price set by the gallery. Gallery provides insurance, promotion, contract, shipping costs.

SUBMISSIONS "We prefer New York artists due to constant needs of a public art work created in the city." Send query letter with SASE. Call for appointment to show portfolio of originals, photographs and slides. Responds in 1 month. "We reply to original query with an artist application. Then it depends on commissions." Files application form, résumé, slides, photos, reviews. Finds artists through recommendations from other art professionals.

TIPS "We look for artists who are dedicated to making a difference in people's lives through art, working in collaboration with schools and community members."

CLAMPART

521-531 W. 25th St., Ground Floor, New York NY 10001. (646)230-0020. **E-mail:** portfolioreview@clampart.com; info@clampart.com. **Website:** www.clampart.com. **Contact:** Brian Paul Clamp, director. Estab. 2000. Sponsors 8-12 exhibits/year. Average display time: 5 weeks. Open Tuesday–Saturday, 11-6; closed the last two weeks of August. Located on the ground floor on Main Street in Chelsea. Medium-sized exhibition space.

MEDIA Considers acrylic, collage, drawing, mixed media, oil, paper, pastel, pen & ink and watercolor. Considers all types of prints. Most frequently exhibits photo, oil and paper.

STYLE Exhibits conceptualism, geometric abstraction, minimalism and postmodernism. Considers genres including figurative work, florals, landscapes and portraits. Most frequently exhibits postmodernism, conceptualism and minimalism.

TERMS E-mail query letter with artist's statement, bio and JPEGs. Cannot return material. Responds to queries in 2 weeks. Clients include local community, tourists and upscale. 5% of sales are to corporate collectors. Overall price range: $300-50,000; most work sold at $2,000. Artwork is accepted on consignment (50% commission). Retail price set by the gallery. Gallery provides insurance, promotion and contract. Does not require exclusive representation locally.

SUBMISSIONS "Include a bio and well-written artist statement. Do not submit work to a gallery that does not handle the general kind of work you produce." Ac-

cepted work should be framed, mounted and matted. Finds artists through portfolio reviews, referrals by other artists and submissions.

CATHARINE CLARK GALLERY

150 Minna St., Ground Floor, San Francisco CA 94105. (415)399-1439. **Fax:** (415)543-1338. **E-mail:** info@cclarkgallery.com. **Website:** www.cclarkgallery.com. **Contact:** Catherine Clark, owner/director. Estab. 1991. Retail gallery. Represents 25+ emerging and mid-career artists. Curates 8-12 shows/year. Average display time 4-6 weeks. Open all year. Located downtown San Francisco; 3,000 sq. ft., including video project room. 90% of space for special exhibitions. Clientele: 95% private collectors, 5% corporate collectors. Overall price range $200-$300,000; most work sold at $2,000-$5,000.

MEDIA Considers painting, sculpture, installation, photography, printmaking, video and new genres. Most frequently exhibits painting, sculpture, installation and new genres.

STYLE Exhibits all styles and genres.

TERMS Accepts work on consignment (50% commission). Retail price set by gallery and artist. Offers customer payment by installments. Gallery provides insurance, promotion and contract; shipping costs are shared. Prefers artwork framed.

SUBMISSIONS Submission review is limited. Send query e-mail before sending submissions. Submissions will not be returned without SASE.

CLAY CENTER'S AVAMPATO DISCOVERY MUSEUM

One Clay Square, Charleston WV 25301. (304)561-3570. **E-mail:** lferguson@theclaycenter.org; info@theclaycenter.org. **Website:** www.theclaycenter.org. **Contact:** R. Lewis Ferguson, director of visual arts and sciences. Estab. 1974. Museum gallery. Represents emerging, mid-career and established artists. Sponsors 6 shows/year. Average display time: 2-3 months. Open all year; contact for hours. Located inside the Clay Center for the Arts & Sciences.

MEDIA Considers oil, acrylic, watercolor, pastel, pen & ink, drawings, mixed media, collage, works on paper, sculpture, installations, photography and prints.

STYLE Considers all styles and genres.

TERMS Retail price set by artist. Gallery pays shipping costs. Prefers framed artwork.

SUBMISSIONS Send query letter with bio, résumé, brochure, slides, photographs, reviews and SASE.

Write for appointment to show portfolio of slides. Responds within 2 weeks, only if interested. Files everything or returns in SASE.

THE CLAY PLACE

1 Walnut St., Carnegie PA 15106. (412)489-5240. **E-mail:** info@clayplacestandard.com. **Website:** www.clayplaceatstandard.com. Estab. 1973. Retail gallery. Represents 50 emerging, mid-career and established artists. Exhibited artists include Jack Troy and Kirk Mangus. Sponsors 7 shows/year. Open Monday–Friday, 8:30-4:30. Located in small shopping area; 1,200 sq. ft. 50% of space for special exhibitions. Overall price range: $10-2,000; most work sold at $40-100.

MEDIA Considers ceramic, sculpture, glass and pottery. Most frequently exhibits clay, glass and enamel.

TERMS Accepts artwork on consignment (50% commission) or buys outright for 50% of retail price (net 30 days). Retail price set by artist. Sometimes offers customer discounts and payment by installments. Gallery provides insurance, promotion and shipping costs from gallery. We also sell books, tools, equipment and supplies.

SUBMISSIONS Prefers only clay, some glass and enamel. Send query letter with résumé, slides, photographs, bio and SASE. Write for appointment to show portfolio. Portfolio should include actual work rather than slides. Responds in 1 month. Does not reply when busy. Files résumé. Does not return slides. Finds artists through visiting exhibitions and art collectors' referrals.

TIPS "Functional pottery sells well. Emphasis on form, surface decoration. Some clay artists have lowered quality in order to lower prices. Clientele look for quality, not price."

CLEVELAND STATE UNIVERSITY ART GALLERY

Art Building, 2307 Chester Ave., Cleveland OH 44115-2214. (216)687-2103. **Fax:** (216)687-9394. **E-mail:** t.knapp@csuohio.edu. **Website:** www.csuohio.edu/artgallery/. **Contact:** Tim Knapp, assistant director. Exhibits 50 emerging, mid-career and established artists. Exhibited artists include Joel Peter Witkin and Buzz Spector. Sponsors 6 shows/year. Average display time 6 weeks. Open Monday-Friday, 10-5; Saturday, 12-4. Closed Sunday and holidays. Call for summer hours. Located downtown 4,500 sq. ft. (250 running ft. of wall space). 100% of space for special exhibitions. Clientele: students, faculty, general pub-

lic. 85% private collectors, 15% corporate collectors. Overall price range $250-50,000; most work sold at $300-1,000.

MEDIA Considers all media.

STYLE Exhibits all styles and genres. Prefers contemporary. Looks for challenging work.

TERMS 25% commission. Sales are not a priority. Gallery provides insurance, promotion, shipping costs to and from gallery; artists handle crating. Prefers artwork framed.

SUBMISSIONS By invitation. Unsolicited inquiries may not be reviewed.

TIPS "Submissions recommended by galleries or institutions are preferred."

⌂ COAST GALLERIES

P.O. Box 223519, Carmel CA 93922. (831)625-8688. **E-mail:** gary@coastgalleries.com. **Website:** www.coast galleries.com. **Contact:** Gary Koeppel, president/CEO. Estab. 1958. Retail galleries. Represents 300 emerging, mid-career and established artists. Sponsors 3-4 shows/year. Open daily, all year. Locations in Big Sur and Carmel CA; Hana HI (Maui). No two Coast Galleries are alike. Each gallery was designed specifically for its location and clientele. The Hawaii gallery features Hawaiiana; the Big Sur gallery is constructed of redwood water tanks and is the one of the largest galleries of American crafts in the U.S. Space of each location varies from 1,500 to 3,000 sq. ft. 100% of space for special exhibitions. Clientele: 90% private collectors, 10% corporate collectors. Overall price range: $25-60,000; most work sold at $400-4,000. See website for hours and details on each gallery.

MEDIA Considers all media; engravings, lithographs, posters, etchings, wood engravings and serigraphs. Most frequently exhibits bronze sculpture, art glass limited edition prints, watercolor and oil on canvas.

STYLE Exhibits impressionism and realism. Genres include landscape, marine, abstract and wildlife.

TERMS Accepts fine art and master crafts on consignment (commission varies), or buys master crafts outright (net 30 days). Retail price set by gallery. Gallery provides insurance, promotion and contract; artist pays for shipping. Requires framed artwork.

SUBMISSIONS Accepts only artists from Hawaii for Hana gallery; coastal and wildlife imagery for California galleries; California painting for Carmel gallery and American crafts for Big Sur gallery. Send query letter with résumé, slides, bio, brochure, photographs,

business card and reviews; SASE mandatory if materials are to be returned. Write or e-mail info@coast-galleries.com for appointment. Owner responds to all inquiries.

COLEMAN FINE ART

79 Church St., Charleston SC 29401. (843)853-7000. **E-mail:** info@colemanfineart.com. **Website:** www. colemanfineart.com. Estab. 1974. Retail gallery; gilding, frame making and restoration. Represents 8 emerging, mid-career and established artists/year. Exhibited artists include John Cosby, Marc Hanson, Glenna Hartmann, Joe Paquet, Jan Pawlowski, Don Stone, George Strickland, Mary Whyte. Hosts 2 shows/year. Average display time: 1 month. Open all year; Monday, 10-4; Tuesday–Saturday, 10-6; Sunday, by chance. "Both a fine art gallery and restoration studio, Coleman Fine Art has been representing regional and national artists for over 30 years. Located on the corner of Church and Tradd streets, the gallery reinvigorates one of the country's oldest art studios." Clientele: tourists, upscale and locals. 95-98% private collectors, 2-5% corporate collectors. Overall price range: $1,000-50,000; most work sold at $3,000-8,000.

MEDIA Considers oil, watercolor, pastel, pen & ink, drawing, mixed media, sculpture. Most frequently exhibits watercolor, oil and sculpture.

STYLE Exhibits expressionism, impressionism, photorealism and realism. Genres include portraits, landscapes, still lifes and figurative work. Prefers figurative work/expressionism, realism and impressionism.

TERMS Accepts work on consignment (45% commission); net 30 days. Retail price set by the gallery and the artist. Gallery provides promotion and contract. Shipping costs are shared. Prefers artwork framed.

SUBMISSIONS Send query letter with brochure, 20 slides/digital CD of most recent work, reviews, bio and SASE. Write for appointment to show portfolio of photographs, slides and transparencies. Responds within 1 month, only if interested. Files slides. Finds artists through submissions.

TIPS "Do not approach gallery without an appointment."

COMPLEMENTS ART GALLERY

50 Lambert Lind Hwy., Warwick RI 02886. (401)739-9300; (800)841-4067. **Fax:** (401)739-7905. **E-mail:** contact@complementsartgallery.com. **Website:** www. complementsartgallery.com. Estab. 1986. Retail gallery. Represents hundreds of international and New

England emerging, mid-career and established artists. Exhibited artists include Fairchild and Hatfield. Sponsors 6 shows/year. Average display time 2-3 weeks. Open all year; Monday–Friday, 9-5; Saturday, 9-4. 3,500 sq. ft. "We have a piano and beautiful hardwood floors, also a great fireplace." 20% of space for special exhibitions; 60% of space for gallery artists. Clientele: upscale. 40% private collectors, 15% corporate collectors. Overall price range $25-$10,000; most work sold at $600-2,000.

MEDIA Considers all media except offset prints. Types of prints include engravings, lithographs, wood engravings, mezzotints, serigraphs and etchings. Most frequently exhibits serigraphs, oils.

STYLE Exhibits expressionism, painterly abstraction, impressionism, photorealism, realism and imagism. Genres include florals, portraits and landscapes. Prefers realism, impressionism and abstract.

TERMS Accepts work on consignment (30% commission) or bought outright for 50% of retail price (90 days). Retail price set by the gallery. Gallery provides insurance, promotion and contract. Shipping costs are shared. Prefers artwork unframed.

SUBMISSIONS Size limitation due to wall space. Paintings no larger than 40×60, sculpture not heavier than 150 pounds. Send query letter with résumé, bio, 6 slides or photographs. Call for appointment to show portfolio of photographs and slides. Responds in 1 month. Files all materials from artists. Finds artists through word of mouth, referrals by other artists, visiting art fairs and all exhibitions and artist's submissions.

TIPS "Artists need to have an idea of the price range of their work and provide interesting information about themselves."

CONE EDITIONS

17 Powder Spring Rd., East Topsham VT 05076. (802)439-5751. **Fax:** (802)439-6501. **E-mail:** cathy@cone-editions.com. **Website:** www.cone-editions.com. **Contact:** Cathy Cone. Gallery workshop. Printmakers, publishers and distributors of computer and digitally made works of art. Estab. 1980. Represents/exhibits 12 emerging, mid-career and established artists/year. Exhibited artists include Norman Bluhm and Wolf Kahn. Sponsors 4 shows/year. Average display time 3 months. Open all year; Monday-Friday, 7:30-5. Located downtown; 1,000 sq. ft.; post and beam, high ceilings, natural light. 50% of space for special exhibitions; 50% of space for gallery artists. Clientele: private, corporate. 40% private collectors, 60% corporate collectors. Overall price range $300-5,000; most work sold at $500-1,500.

MEDIA Considers computer and digital art and computer prints. Most frequently exhibits iris ink jet print, digital monoprint and digital gravure.

STYLE Exhibits expressionism, minimalism, color field, painterly abstraction and imagism.

TERMS Artwork is accepted on consignment (50% commission). Retail price set by the artist. Gallery provides promotion; shipping costs are shared. Prefers artwork unframed.

SUBMISSIONS Prefers computer and digital art. Contact through e-mail. Call for appointment to show portfolio on CD. Responds in 1-3 weeks. Files slides and CD.

TIPS "We find most of the artists we represent by referrals of our other artists."

CONTEMPORARY ART MUSEUM OF ST. LOUIS

3750 Washington Blvd., St. Louis MO 63108. (314)535-4660. **Fax:** (314)535-1226. **E-mail:** info@camstl.org. **Website:** www.camstl.org. Estab. 1980. Nonprofit museum. "A noncollecting museum dedicated to exhibiting contemporary art from international, national and local established and emerging artists." Open Tuesday–Saturday, 10-5; Sunday, 11-4; Thursday open until 8. Located mid-town, Grand Center; 27,200 sq. ft. building designed by Brad Cloepfil, Allied Works.

CONTEMPORARY ARTS CENTER (LAS VEGAS)

107 E. Charleston Blvd., Suite 120, Las Vegas NV 89104. (702)382-3886. **Fax:** (702)598-3886. **E-mail:** info@lasvegascac.org. **Website:** www.lasvegascac.org. Estab. 1989. Nonprofit gallery. Sponsors more than 9 exhibits/year. Average display time: 1 month. Gallery open Tuesday-Saturday, 12-5; and by appointment. Closed Thanksgiving, Christmas, New Year's Day. 1,200 sq. ft. Clients include tourists, local community and students. 75% of sales are to private collectors, 25% corporate collectors. Overall price range: $200-4,000. Most work sold at $400. Artwork is accepted through annual call for proposals of self-curated group shows. Gallery provides insurance, promotion, contract.

MEDIA Considers all media and all types of prints. Exhibits conceptualism, group shows of contempo-

rary fine art. Genres include all contemporary art/all media.

CONTEMPORARY ARTS CENTER (NEW ORLEANS)

900 Camp, New Orleans LA 70130. (504)528-3805. **Fax:** (504)528-3828. **E-mail:** amackie@cacno.org; info@cacno.org. **Website:** www.cacno.org. **Contact:** Amy Mackie, director of visual arts. Estab. 1976. Alternative space, nonprofit gallery. Exhibits emerging, mid-career and established artists. Open all year; Thursday-Sunday, 11-4; weekends 11-5. Closed Mardi Gras, Christmas and New Year's Day. Located in Arts District of New Orleans; renovated/converted warehouse. Clients include local community, students, tourists and upscale.

MEDIA Considers all media and all types of prints. Most frequently exhibits painting, sculpture, installation and photography.

STYLE Considers all styles. Exhibits anything contemporary.

TERMS Artwork is accepted on loan for curated exhibitions. Retail price set by the artist. CAC provides insurance and promotion. Accepted work should be framed. Does not require exclusive representation locally. The CAC is not a sales venue, but will refer inquiries. CAC receives 20% on items sold as a result of an exhibition.

SUBMISSIONS Send query letter with bio, SASE and slides or CDs. Responds in 4 months. Files letter and bio—slides when appropriate. Finds artists through word of mouth, submissions, art exhibits, art fairs, referrals by other artists, professional contacts and periodicals.

TIPS "Use only one slide sheet with proper labels (title, date, medium and dimensions)."

CONTRACT ART INTERNATIONAL, INC.

P.O. Box 629, Old Lyme CT 06371. (860)434-9799. **Fax:** (860)434-6240. **E-mail:** info@contractartinternational.com. **Website:** www.contractartinternational.com. In business approximately 40 years. "We contract artwork for hospitality, blue-chip, and specialized businesses." Collaborates with emerging, mid-career and established artists. Assigns site-specific commissions to artists based on project design needs, theme and client preferences. Studio is open all year to corporate art directors, architects, designers, and faculty directors. 1,600 sq. ft. studio. Clientele: 98% commercial. Overall price range $500-500,000.

MEDIA Places all types of art mediums.

TERMS Pays for design by the project, negotiable; 50% up front. Rights purchased vary according to project.

SUBMISSIONS Send letter of introduction with résumé, slides, bio, brochure, photographs, DVD/video and SASE. If local, write for appointment to present portfolio; otherwise, mail appropriate materials, which should include slides and photographs. "Show us a good range of your talent. Also, we recommend you keep us updated if you've changed styles or media." Responds in 1 week. Files all samples and information in registry library.

TIPS "We exist mainly to art direct commissioned artwork for specific projects."

⊕ COOS ART MUSEUM

235 Anderson Ave., Coos Bay OR 97420. (541)267-3901. **E-mail:** info@coosart.org. **Website:** www.coosart.org. Estab. 1950. Not-for-profit corporation; 3rd-oldest art museum in Oregon. Mounts 4 juried group exhibitions/year of 85-150 artists; 20 curated single/solo exhibits/year of established artists; and 6 exhibits/year from the permanent collection. 5 galleries allow for multiple exhibits mounted simultaneously, averaging 6 openings/year. Average display time: 6-9 weeks. Open Tuesday–Friday, 10-4; Saturday, 1-4. Closed Sunday, Monday and all major holidays. Free admission during evening of 2nd Thursday (Art Walk), 5-8. Clients include local community, students, tourists and upscale.

MEDIA For curated exhibition, considers all media including print, engraving, litho, serigraph. Posters and giclées not considered. Most frequently exhibits paintings (oil, acrylic, watercolor, pastel), sculpture (glass, metal, ceramic), drawings, etchings and prints.

STYLE Considers all styles and genres. Most frequently exhibits primitivism, realism, postmodernism and expressionism.

TERMS All inquiries are referred directly to the artist. Gallery floor sales are accepted. Retail price set by the artist. Museum provides insurance, promotion and contract. Accepted work should be framed, mounted and matted. Accepts only artists from Oregon or Western United States.

SUBMISSIONS Send query letter with artist's statement, bio, résumé, SASE, slides or digital files on CD or links to website. Responds to queries in 6 months. Never send originals of slides, résumés or portfolios.

Exhibition committee reviews 2 times/year—schedule exhibits 2 years in advance. Files proposals. Finds artists through portfolio reviews and submissions.

TIPS "Have complete files electronically on a website or CD. Have a written positioning statement and proposal of show as well as letter(s) of recommendation from a producer/curator/gallery of a previous curated exhibit. Do not expect us to produce or create the exhibition. You should have all costs figured ahead of time and submit only when you have work completed and ready. We do not develop artists. You must be professional."

☐ CORE NEW ART SPACE

900 Sante Fe Dr., Denver CO 80204. (303)297-8428. **E-mail:** corenewartspace@gmail.com. **Website:** www.corenewartspace.com. Estab. 1981. Cooperative, alternative and nonprofit gallery. Exhibits 24 emerging and mid-career artists. Sponsors 10 solo and 6 group shows/year. Average display time 3 weeks. Open Thursday-Saturday. Open Thursday, 12-6; Friday, 12-9; Saturday, 12-6; Sunday, 1-4. Located Santa Fe Arts district. Accepts mostly artists from front range Colorado. Clientele: 97% private collectors; 3% corporate clients. Overall price range $75-3,000; most work sold at $100-600.

MEDIA Considers all media. Specializes in cutting edge work. Prefers quality rather than marketability.

STYLE Exhibits expressionism, neo-expressionism, painterly abstraction, conceptualism; considers all styles and genres, but especially contemporary and alternative (non-traditional media and approach), including installations.

TERMS Co-op membership fee plus donation of time. Retail price set by artist. Exclusive area representation not required. Also rents annex space to non-members for $125-275/3 week run.

SUBMISSIONS Send query letter with SASE. Quarterly auditions to show portfolio of originals, slides and photographs. Request membership application. "Our gallery gives an opportunity for emerging artists in the metro-Denver area to show their work. We run 6 open juried shows a year. There is an entry fee charged, and a 25% commission is taken on any work sold. The member artists exhibit in a 2-person show once a year. Member artists generally work in more avant-garde formats, and the gallery encourages experimentation. Members are chosen by slide review and personal interviews. Due to time commitments

we require that they live and work in the area." Finds artists through invitations, word of mouth, art publications.

TIPS "We want to see challenging art. If your intention is to manufacture coffee-table and over-the-couch art for suburbia, we are not a good place to start."

CORNERHOUSE GALLERY AND FRAME

2753 First Ave., SE, Cedar Rapids IA 52402. (319)365-4348. **Fax:** (319)365-1707. **E-mail:** info@cornerhousegallery.com. **Website:** www.cornerhousegallery.com. Estab. 1976. For-profit gallery. "Tradition meets modern gallery services in our 1912 Midwestern house. We feature primarily local and Midwestern artists, as well as a few national and international artists." Exhibits emerging, mid-career and established artists. Approached by 75 artists/year. Sponsors 4 exhibits/year. Open Tuesday–Friday, 10-5:30; Saturday, 10-4. Located on main street through Cedar Rapids in an original 1906 building expanded to cover 3,000 sq. ft. of gallery space. Outdoor sculpture garden. Clients include local community, students, tourists, upscale, and corporate. 20% of sales are to corporate collectors. Overall price range: $500-20,000; most work sold at $1,000.

MEDIA Considers all media except craft and installation. Most frequently exhibits glass, oil and sculpture. Considers all prints except posters.

STYLE Considers all styles. Genres include figurative work, florals and landscapes.

TERMS Artwork is accepted on consignment and there is a 45% commission. Retail price is set by the artist.

SUBMISSIONS Call, e-mail or write to arrange personal interview to show portfolio of photographs, slides, transparencies or CDs, résumés and reviews with SASE. Returns material with SASE.

TIPS "Good photos of work, websites with enough work to get a feel for the overall depth and quality."

CORPORATE ART SOURCE/CAS GALLERY

2960-F Zelda Rd., Montgomery AL 36106. (334)271-3772. **Fax:** (334)271-3772. **E-mail:** casjb@mindspring.com. **Website:** www.casgallery.com. Estab. 1990. Approached by 100 artists/year; represents or exhibits 50 artists. Sponsors 1 photography exhibit/year. Average display time 6 weeks. Gallery open Monday-Friday, 10-5:30. Overall price range $200-20,000. Most work sold at $1,000.

MEDIA Considers all media and all types of prints. Most frequently exhibits paintings, glass and watercolor.

STYLE Considers all styles and genres. Most frequently exhibits painterly abstraction, impressionism and realism.

TERMS Artwork is accepted on consignment (50% commission). Retail price set by artist.

SUBMISSIONS Call, e-mail, or write to arrange a personal interview to show portfolio of photographs, slides, transparencies or CD, résumé and reviews. Returns material with SASE.

TIPS "Have good photos of work, as well as websites with enough work to get a feel for the overall depth and quality."

COURTHOUSE GALLERY, LAKE GEORGE ARTS PROJECT

1 Amherst St., Lake George NY 12845. (518)668-2616. **E-mail:** mail@lakegeorgearts.org. **Website:** www.lakegeorgearts.org. **Contact:** Laura Von Rosk, gallery director. Estab. 1986. Nonprofit gallery. Approached by 200 artists/year. Exhibits 10-15 emerging, mid-career and established artists. Sponsors 6 exhibits/year. Average display time 5-6 weeks. Open all year; Tuesday-Friday, 12-5; Saturday, 12-4. Closed mid-December to mid-January. Clients include local community, tourists and upscale. Overall price range $100-5,000; most work sold at $500.

MEDIA Considers all media and all types of prints. Most frequently exhibits painting, mixed media and sculpture.

STYLE Considers all styles and genres.

TERMS Artwork is accepted on consignment and there is a 25% commission. Retail price set by the artist. Gallery provides insurance, promotion and contract. Accepted work should be framed, mounted and matted.

SUBMISSIONS Mail portfolio for review. Deadline: January 31. Send query letter with artist's statement, bio, résumé, SASE and slides. Returns material with SASE. Finds artists through word of mouth, submissions, portfolio reviews, art exhibits, art fairs and referrals by other artists.

JAMES COX GALLERY AT WOODSTOCK

4666 Route 212, Willow NY 12495. (845)679-7608. **Fax:** (845)679-7627. **E-mail:** info@jamescoxgallery. com. **Website:** www.jamescoxgallery.com. Estab. 1990. Retail gallery. Represents 10 mid-career and established artists. Exhibited artists include Leslie Bender, Bruce North, Paola Bari and Mary Anna Goetz. Represents estates of 5 artists including James Chapin, Margery Ryerson, Joseph Garlock and Elaine Wesley. Sponsors 5 shows/year. Average display time 1 month. Open all year; Tuesday–Sunday, 10-5 (winter hours: Tuesday–Friday, 10-5, or by appointment). Elegantly restored Dutch barn. 50% of space for special exhibitions. Clients include New York City residents (within 50-mile radius) and tourists. 65% of sales are to private collectors. Overall price range $500-50,000; most work sold at $1,000-10,000.

MEDIA Considers oil, watercolor, pastel, drawing, ceramics and sculpture. Considers "historic Woodstock, art." Most frequently exhibits oil paintings, watercolors, sculpture.

STYLE Exhibits impressionism, realism. Genres include landscapes and figurative work. Prefers expressive or evocative realism, painterly landscapes and stylized figurative work.

TERMS Accepts work on consignment (50% commission). Retail price set by the artist. Gallery provides promotion; artist pays shipping costs to and from gallery. Prefers artwork framed.

SUBMISSIONS Prefer submissions by e-mail. Prefers only artists from New York region. Send query letter with résumé, bio, brochure, photographs, CD, SASE and business card. Responds in 3 months. Files material on some artists for special, theme or group shows.

TIPS "Be sure to enclose SASE and be patient for response. Also, please include information on present pricing structure."

MILDRED COX GALLERY AT WILLIAM WOODS UNIVERSITY

One University Ave., Fulton MO 65251. (573)592-4245. **E-mail:** Jennifer.Sain@williamwoods.edu. **Website:** www.williamwoods.edu. **Contact:** Jennifer Sain. Estab. 1970. Nonprofit gallery. Approached by 20 artist/year; exhibits 8 emerging, mid-career and established artists/year. Exhibited artists include Elizabeth Ginsberg and Terry Martin. Average display time 2 months. Open Monday–Friday, 9-4:00; Saturday and Sunday, 1-4. Closed Christmas-January 20. Located in the Gladys Woods Kemper Center for the Arts; within large moveable walls; 300 running feet. Clients include local community, students, upscale and foreign visitors. Overall price range $1,000-10,000; most work sold at $800-1,000. Gallery takes no commission. "Our mission is education."

MEDIA Considers all media except installation. Most frequently exhibits drawing, painting and sculpture. Considers all prints except commercial off-set.

STYLE Exhibits expressionism, geometric abstraction, impressionism, surrealism, painterly abstraction and realism. Most frequently exhibits figurative and academic. Genres include Americana, figurative work, florals, landscapes and portraits.

TERMS Artists work directly with person interested in purchase. Retail price of the art set by the artist. Gallery provides insurance and contract. Accepted work should be framed and matted. Does not require exclusive representation locally. Artists are selected by a committee from slides or original presentation to faculty committee.

SUBMISSIONS Write to arrange a personal interview to show portfolio of slides or send query letter with artist's statement, résumé and slides. Returns material with SASE. Does not reply to queries. Artist should call. Files slides, statement and résumé until exhibit concludes. Finds artists through word of mouth.

⊕ COYOTE WOMAN GALLERY

160 E. Main St., Harbor Springs MI 49740. **E-mail:** coyote@saa.net. **Website:** www.coyotewomangallery.com. **Contact:** Terru Freydenberger, owner. Estab. 1992.

MEDIA Considers acrylic, ceramics, drawing, fiber, glass, mixed media, oil, pastel, sculpture and watercolor, among others. Displays etchings, lithographs, serigraphs, woodcuts and other forms of prints.

STYLE Considers geometric abstraction, impressionism and painterly abstraction. Considers all genres.

TERMS Artwork is accepted on consignment and there is a 50% commission. Gallery provides insurance and promotion. Accepted work should be framed. Requires exclusive representation locally. Only represents American artists.

SUBMISSIONS Send query letter with artist's statement, bio, photographs, and résumé. Materials returned with SASE. Responds in 4 weeks. Finds artists through submissions, art exhibits, art fairs and referrals by other artists.

CRAFT & FOLK ART MUSEUM (CAFAM)

5814 Wilshire Blvd., Los Angeles CA 90036. (323)937-4230. **E-mail:** sasha@cafam.org; info@cafam.org. **Website:** www.cafam.org. **Contact:** Sasha Ali, exhibitions coordinator. Estab. 1973. Museum. Located on prestigious Museum Row, CAFAM acts as a catalyst for cultural understanding and unity in one of the most diverse cities in the world. Our original exhibitions and public programs are developed in close collaboration with community cultural groups to ensure authentic expression." Sponsors 3-4 shows/year. Average display time 2-3 months. Open Tuesday–Friday, 11-5; Saturday and Sunday, 12-6. Located on Miracle Mile; features design, contemporary crafts, international folk art.

MEDIA Considers all media, woodcut and wood engraving. Most frequently exhibits ceramics, found objects, wood, fiber, glass, textiles.

STYLE Exhibits all styles, all genres. Prefers culturally specific, craft and folk art.

SUBMISSIONS Submission details online. Accepts mailed submissions only. Finds artists through written submissions, word of mouth and visiting exhibits.

CRAFT ALLIANCE GALLERY

6640 Delmar, St. Louis MO 63130. (314)725-1177 ext. 322. **Fax:** (314)725-2068. **E-mail:** gallery@craftalliance.org. **Website:** www.craftalliance.org. Nonprofit arts center with exhibition and retail galleries. Estab. 1964. Represents approximately 500 emerging, mid-career and established artists. Exhibition spaces sponsor 10-12 exhibits/year. Open Tuesday-Thursday, 10-5; Friday-Saturday, 10-6; Sunday, 11-5. Located in University City in the Delmar Loop Shopping District. Clients include local community, students, tourists and upscale. Retail gallery price range $20 and up. Most work sold at $100.

MEDIA Considers ceramics, metal, fiber and glass. Most frequently exhibits jewelry, glass and clay. Doesn't consider prints.

STYLE Exhibits contemporary craft.

TERMS Exhibition artwork is sold on consignment and there is a 50% commission. Artwork is bought outright. Retail price set by the gallery and the artist. Gallery provides insurance and promotion. Requires exclusive representation locally.

SUBMISSIONS Call or write to arrange a personal interview to show portfolio of slides or call first, then send slides or photographs. Returns material with SASE.

TIPS "Call and talk. Have professional slides and attitude."

CREATIVE GROWTH ART CENTER GALLERY

355 24th St., Oakland CA 94612. (510)836-2340, ext. 15. **E-mail:** info@creativegrowth.org. **Website:** www. creativegrowth.org. Estab. 1978. Nonprofit gallery. Represents 100 emerging and established artists; 100 adults with disabilities work in our adjacent studio. Exhibited artists include Dwight Mackintosh, Nelson Tygart. Sponsors 10 shows/year. Average display time 5 weeks. Open Monday–Friday, 11-4:30. Located downtown; 1,200 sq. ft.; classic large white room with movable walls, track lights; visible from the street. 25% of space for special exhibitions; 75% of space for gallery artists. Clientele: private and corporate collectors. 90% private collectors, 10% corporate collectors. Overall price range $50-4,000; most work sold at $100-250.

This gallery concentrates mainly on the artists who work in an adjacent studio, but work from other regional or national artists may be considered for group shows. Only outsider and brut art are shown. Most of the artists have not formally studied art, but have a raw talent that is honest and real with a strong narrative quality.

MEDIA Considers oil, acrylic, watercolor, pastel, pen & ink, drawing, mixed media, collage, paper, sculpture, ceramics, fiber, woodcuts, engravings, lithographs, wood engravings, mezzotints, serigraphs, linocuts and etchings. Most frequently exhibits (2D) drawing and painting; (3D) sculpture, hooked rug/tapestries.

STYLE Exhibits expressionism, primitivism, color field, naive, folk art, brut. Genres include landscapes, florals and figurative work. Prefers brut/outsider, contemporary, expressionistic.

TERMS Accepts work on consignment (40% commission). Retail price set by the gallery. Gallery provides insurance, promotion and contract; artist pays shipping costs to and from gallery. Prefers artwork framed.

SUBMISSIONS Prefers only brut, naive, outsider; works by adult artists with disabilities. Send query letter with résumé, slides, bio. Write for appointment to show portfolio of photographs and slides. Responds only if interested. Files slides and printed material. Finds artists through agents, by visiting exhibitions, word of mouth, various art publications and sourcebooks, submissions and networking.

TIPS "Peruse publications that feature brut and expressionistic art (example *Raw Vision*)."

CUESTA COLLEGE ART GALLERY

P.O. Box 8106, San Luis Obispo CA 93403-8106. (805)546-3202 (gallery); (805)546-3201 (Fine Arts Dept.). **Website:** academic.cuesta.edu/finearts/MF_gallery.html. **Contact:** division chair. Estab. 1965. Exhibits the work of emerging, mid-career and established artists. Exhibited artists include Italo Scanga and JoAnn Callis. Sponsors 8 shows/year. Average display time: 4½ weeks. Open all year. 1,300 sq. ft.; 100% for special exhibitions. Overall price range: $250-5,000; most work sold at $400-1,200.

MEDIA Considers all media and all types of prints. Most frequently exhibits painting, sculpture and photography.

STYLE Exhibits all styles, mostly contemporary.

TERMS Accepts work on consignment (20% commission). Retail price set by artist. Customer payment by installment available. Gallery provides insurance, promotion and contract; shipping costs are shared. Prefers artwork framed.

SUBMISSIONS Gallery currently not accepting applications. Send query letter with artist statement, slides, bio, brochure, SASE and reviews. Call for appointment to show portfolio. Responds in 6 months. Finds artists mostly by reputation and referrals, sometimes through slides.

TIPS "We have a medium budget, thus cannot pay for extensive installations or shipping. Present your work legibly and simply. Include reviews or a coherent statement about the work. Don't be too slick or too sloppy."

D5 PROJECTS

2525 Michigan Ave., Santa Monica CA 90404. (310)315-9506. **Fax:** (310)315-9668. **E-mail:** info@robertbermangallery.com. **Website:** www.robertbermangallery.com. For profit gallery. Approached by 200 artists/year; exhibits 25 mid-career artists. Sponsors 12 exhibits/year. Average display time 1 month. Open Thursday-Saturday, 12-6. Closed December 24-January 1 and the last 2 weeks of August. Located in Bergamot Station Art Center in Santa Monica. Clients include local community, students, tourists and upscale. Overall price range $600-30,000; most work sold at $4,000.

MEDIA Considers all media. Most frequently exhibits oil on canvas.

STYLE Considers contemporary.

SUBMISSIONS "We currently accept submissions via e-mail *only* as URL address or no more than 3 images sent as attachments, JPEG or GIF. All three not to exceed 1.5 MB total. Images exceeding 1.5 MB will not be considered. If we receive slide submissions without a SASE, they will not be considered."

DALES GALLERY

537 Fisgard St., Victoria BC V8W 1R3, Canada. **Fax:** (250)383-1552. **E-mail:** dalesgallery@shaw.ca. **Website:** www.dalesgallery.ca. **Contact:** Alison Trembath. Estab. 1976. Art Gallery and framing studio. Approached by 50 artists/year, Sponsors 10 exhibits/year. Average display time: 4 weeks. Open all year; Monday-Friday 10-5; Saturday, 11-4. Gallery situated in Chinatown (Old Town); approximately 650 sq. ft. of space—warm and inviting with brick wall and large white display wall. Clients include local community, students, tourists and upscale. Overall price range: $100-4000; most work sold at $800.

MEDIA Considers all media including photography. Most frequently exhibits oils, photography and sculpture.

STYLE Exhibits both solo and group artists.

TERMS Accepts work on consignment (40% commission) Retail price set by both gallery and artist. Accepted work should be framed by professional picture framers. Does not require exclusive representation locally.

SUBMISSIONS Please e-mail images. Portfolio should include contact number and prices. Responds within 2 months, only if interested. Finds artists through word of mouth, art exhibits, submissions, art fairs, portfolio reviews and referral by other artists.

THE DALLAS CENTER FOR CONTEMPORARY ART

191 Glass St., Dallas TX 75204. (214)821-2522. **Fax:** (214)821-9103. **E-mail:** info@dallascontemporary.org. **Website:** www.dallascontemporary.org. **Contact:** Peter Doroshenko, director. Estab. 1981. Nonprofit gallery. Sponsors 10 exhibits/year. Average display time: 6-8 weeks. Gallery open Tuesday-Saturday, 10-5.

MEDIA Considers all media.

STYLE Exhibits all styles and genres.

TERMS Charges no commission. "Because we are nonprofit, we do not sell artwork. If someone is interested in buying art in the gallery, they get in touch with the artist. The transaction is between the artist and the buyer."

SUBMISSIONS Reviews slides/CDs. Send material by mail for consideration; include SASE. Responds October 1 annually.

TIPS "We offer a lot of information on grants, commissions and exhibitions available to Texas artists. We are gaining members as a result of our in-house resource center and non-lending library. Our 'Business of Art' seminar series provides information on marketing artwork, presentation, museum collection, tax/legal issues and other related business issues. Memberships available starting at $50. See our website for info and membership levels."

DALLAS MUSEUM OF ART

1717 Harwood St., Dallas TX 75201. (214)922-1200. **Fax:** (214)922-1350. **E-mail:** mediarelations@dallasmuseumofart.org. **Website:** www.dallasmuseumofart.org. Estab. 1903. Museum. Exhibits emerging, mid-career and established artists. Average display time: 3 months. Open Tuesday and Wednesday, 11-5; Thursday, 11-9; Friday–Sunday, 11-5; Late Night Fridays (third Friday of the month, excluding December) the museum is open until midnight. Clients include local community, students, tourists and upscale.

MEDIA Exhibits all media and all types of prints.

STYLE Exhibits all styles and genres.

SUBMISSIONS Does not accept unsolicited submissions. Call to request information.

MARY H. DANA WOMEN ARTISTS SERIES

(732)932-3726. **E-mail:** olin@rci.rutgers.edu. **Website:** www.libraries.rutgers.edu/rul/exhibits/dana_womens.shtml. **Curators:** Dr. Ferris Olin and Judith K. Brodsky. Alternative space for juried exhibitions of works by women artists. Estab. 1971. Sponsors 4 shows/year. Average display time: 5-6 weeks. Located on college campus in urban area. Clients include students, faculty and community.

MEDIA Considers all media.

STYLE Exhibits all styles and genres.

TERMS Retail price by the artist. Gallery provides insurance and promotion; arranges transportation.

SUBMISSIONS Does not accept unsolicited submissions. Write or e-mail with request to be added to mailing list.

DAVIDSON GALLERIES

313 Occidental Ave. S., Seattle WA 98104. (206)624-7684. **E-mail:** sam@davidsongalleries.com. **Website:** www.davidsongalleries.com. **Contact:** Sam Davidson, owner. Retail gallery. Estab. 1973. Represents 150

emerging, mid-career and established artists. Sponsors 36 shows/year. Average display time 3 weeks. Open all year; Tuesday-Saturday, 10-5:30. Located in old, restored part of downtown 3,200 sq. ft.; "beautiful antique space with columns and high ceilings built in 1890." 50% of space for special antique print exhibitions; 50% of space for gallery artists. Clientele: 90% private collectors, 10% corporate collectors. Overall price range $50-70,000; most work sold at $250-5,000.

MEDIA Considers oil, drawing (all types), watercolor, mixed media, pastel, woodcuts, wood engravings, linocuts, engravings, mezzotints, etchings, lithographs, limited interest in photography, digital manipulation or collage.

STYLE Exhibits expressionism, neo-expressionism, primitivism, painterly abstraction, postmodern works, realism, surrealism, impressionism.

TERMS Accepts work on consignment (50% commission). Retail price set by gallery and artist. Gallery provides insurance, promotion and contract; shipping costs are one way.

SUBMISSIONS Send query letter, e-mail a reference to a website or send a disc with appropriate descriptions and SASE. Responds in 6 weeks.

TIPS "Impressed by a simple straight-forward presentation."

THE DAYTON ART INSTITUTE

456 Belmonte Park N., Dayton OH 45405-4700. (937)223-5277. **Fax:** (937)223-3140. **E-mail:** info@ daytonart.org. **Website:** www.daytonartinstitute.org. Estab. 1919. Museum. Galleries open Wednesday, Friday, and Saturday, 10-5; Sunday, 12-5; Thursday, 10-8; closed Monday and Tuesday.

STYLE Interested in fine art.

DELAWARE CENTER FOR THE CONTEMPORARY ARTS

200 S. Madison St., Wilmington DE 19801. (302)656-6466. **E-mail:** info@thedcca.org. **Website:** www. thedcca.org. Alternative space, museum retail shop, nonprofit gallery. Approached by more than 800 artists/year; exhibits 50 artists. Sponsors 30 total exhibits/year. Average display time 6 weeks. Gallery open Tuesday, Thursday, Friday, and Saturday, 10-5; Wednesday and Sunday, 12-5. Closed on Monday and major holidays. Seven galleries located along rejuvenated Wilmington riverfront.

MEDIA Considers all media, including contemporary crafts.

STYLE Exhibits contemporary, abstract, figurative, conceptual, representational and nonrepresentational, painting, sculpture, installation and contemporary crafts.

TERMS Accepts work on consignment (35% commission). Retail price is set by the gallery and the artist. Gallery provides insurance and promotion; shipping costs are shared. Prefers contemporary art.

SUBMISSIONS Send query letter with artist's statement, bio, SASE, 10 slides. Returns material with SASE. Responds within 6 months. Finds artists through word of mouth, submissions, portfolio reviews, art exhibits, referrals by other artists.

DEL MANO GALLERY

2001 Westwood Blvd., Los Angeles CA 90025. (310)441-2001. **Website:** www.delmano.com. **Contact:** Kirsten Muenster, director of exhibitions. Estab. 1973. Retail gallery. Represents more than 300 emerging, mid-career and established artists. Interested in seeing the work of emerging artists working in wood, glass, ceramics, fiber and metals. Gallery deals heavily in turned and sculpted wood, showing work by David Ellsworth, William Hunter and Ron Kent. Gallery hosts approximately 5 exhibitions per year. Average display time 2-6 months. Open Tuesday–Saturday, 10-6. Gallery located in Brentwood (a scenic corridor); 3,000 sq. ft., 25% for special exhibitions; 75% for gallery artists. Clients include professionals and affluent collectors. 20% private collectors, 5% corporate collectors. Overall price range $50-20,000; most work sold at $250-5,000.

MEDIA Considers contemporary art in craft media, ceramics, glass, jewelry, wood, fiber. No prints. Most frequently exhibits wood, glass, ceramics, fiber, metal and jewelry.

STYLE Exhibits all styles and genres.

TERMS Accepts work on consignment (50% commission) or 30 days net. Retail price set by gallery and artist. Customer discounts and payment by installment are available. 10-mile exclusive area representation required. Gallery provides insurance, promotion and shipping costs from gallery. Prefers artwork framed.

SUBMISSIONS Send query letter with résumé, slides, bio and prices. Portfolio should include slides, price list, artist's statement and bio.

DETROIT ARTISTS MARKET

4719 Woodward Ave., Detroit MI 48201. (313)832-8540. **Fax:** (313)832-8543. **E-mail:** info@detroitart

istsmarket.org. **Website:** www.detroitartistsmarket.
org. Estab. 1932. Nonprofit gallery. Exhibits the work
of emerging, mid-career and established artists; 1,000
members. Sponsors 8-10 shows/year. Average display
time 6 weeks. Open Tuesday–Saturday, 11-6. Located
in midtown Detroit; 2,600 sq. ft.; 85% for special exhi-
bitions. Clientele: "extremely diverse client base, var-
ies from individuals to the Detroit Institute of Arts."
95% private collectors; 5% corporate collectors. Over-
all price range $200-75,000; most work sold at $100-
500.
MEDIA Considers all media. No posters. Most fre-
quently exhibits paintings, glass and multimedia.
STYLE All contemporary styles and genres.
TERMS Prefers artists from the Metro Detroit region.
Accepts artwork on consignment (33% commission).
Retail price set by artist. Gallery provides insurance.
Artist pays all shipping costs.
SUBMISSIONS "Artists and artwork shown is se-
lected by a jury (from submitted call-for-entry ap-
plications), exhibition curator or by invitation from
DAM (for the Elements gallery—our regular sales
gallery which we have in addition to the main exhi-
bition gallery)."
TIPS "Detroit Artists Market educates the Detroit
metropolitan community about the work of emerging
and established Detroit and Michigan artists through
exhibitions, sales and related programs."

DEVIN GALLERIES

507 Sherman Ave., Coeur d'Alene ID 83814. (208)667-
2898. **E-mail:** contactus@devingalleries.com. **Web-
site:** www.devingalleries.com.
MEDIA Considers all media.
STYLE Exhibits all styles from realism and impres-
sionism to contemporary and abstract. Genres in-
clude, but are not limited to, landscapes, floral, still
life, Western, and wildlife.
TERMS Accepts artwork on consignment. Retail
price set by gallery and artist. Gallery provides pro-
motion and contract; artist pays for shipping. Prefers
artwork framed.
SUBMISSIONS Submit portfolio with introduction
letter, bio, photographs/slides, SASE (for return of
materials if desired), website and other useful infor-
mation. Gallery prefers portfolio and/or website sub-
missions via e-mail. Files all material for 6-12 months.
See website for further details.

TIPS "Devin Galleries now has a complete custom
frame shop with 23 years experience in framing."

DINNERWARE ARTSPACE

425 W. Sixth St., Tucson AZ 85701. (520)869-3166.
E-mail: dinnerwareartspace@gmail.com. **Website:**
www.dinnerwarearts.com; facebook.com/dinner
ware. **Contact:** David Aguirre, director. Considers all
media. Most frequently exhibits painting and sculp-
ture. Considers all types of prints.
STYLE Most frequently exhibits group theme exhi-
bitions in all media including art installations, video,
performance art, and spoken word. Dinnerware or-
ganizes workshops in silk screen, etching press, kids
arts, ceramics, fiber arts and more.
TERMS Varied.
SUBMISSIONS E-mail query with résumé, images,
website or Facebook link.
TIPS Subscribe to e-mail list to get updates on upcom-
ing exhibition opportunities. Check Dinnerware's
Facebook page for updates.

DISTRICT OF COLUMBIA ARTS CENTER (DCAC)

2438 18th St., NW, Washington DC 20009. (202)462-
7833. **E-mail:** info@dcartscenter.org. **Website:**
dcartscenter.org. **Contact:** Deborah Anzinger, gal-
lery manager. Estab. 1989. Nonprofit gallery and per-
formance space. Exhibits emerging and mid-career
artists. Sponsors 7-8 shows/year. Average display time
1-2 months. Open Wednesday–Sunday, 2-7; and later
when there is a theater performance. Located "in Ad-
ams Morgan, a downtown neighborhood; 132 run-
ning exhibition feet in exhibition space and a 52-seat
theater." Clientele: all types. Overall price range $200-
10,000; most work sold at $600-1,400.
MEDIA Considers all media including fine and plas-
tic art. "No crafts." Most frequently exhibits painting,
sculpture and photography.
STYLE Exhibits all styles. Prefers "innovative, mature
and challenging styles."
TERMS Accepts artwork on consignment (30% com-
mission). Artwork only represented while on exhibit.
Retail price set by the gallery and artist. Offers pay-
ment by installments. Gallery provides promotion
and contract; artist pays for shipping. Prefers art-
work framed.
SUBMISSIONS Send query letter with résumé,
slides, bio and SASE. Portfolio review not required.

Responds in 4 months. More details are available on website.

TIPS "We strongly suggest the artist be familiar with the gallery's exhibitions and the kind of work we show strong, challenging pieces that demonstrate technical expertise and exceptional vision. Include SASE if requesting reply and return of slides!"

DOLPHIN GALLERIES

230 Hana Hwy., Suite 12, Kahalui HI 96732. (800)669-5051. **Fax:** (808)873-0820. **E-mail:** christianadams@dolphingalleries.com; info@dolphingalleries.com. **Website:** www.dolphingalleries.com. **Contact:** Christian Adams, director of sales and artist development. Estab. 1976. For-profit galleries. Exhibits emerging, mid-career and established artists. Exhibited artists include Alexei Butirskiy, Jia Lu and Thomas Avrid. Sponsors numerous exhibitions/year, "running at all times through 4 separate fine art or fine jewelry galleries." Average display time "varies from one-night events to a 30-day run." Open 7 days/week, 9 a.m. to 10 p.m. Located in luxury resort, high-traffic tourist locations throughout Hawaii. Gallery locations on Maui are at Whalers Village in Kaanapali and in Wailea at the Shops at Wailea. On the Big Island of Hawaii, Dolphin Galleries is located at the Kings Shops at Waikoloa. Clients include local community and upscale tourists. Overall price range: $100-100,000; most work sold at $1,000-5,000.

○ The above address is for Dolphin Galleries' corporate offices. Dolphin Galleries has 5 locations throughout the Hawaiian islands—see website for details.

MEDIA Considers all media. Most frequently exhibits oil and acrylic paintings and limited edition works of art. Considers all types of prints.

STYLE Most frequently exhibits impressionism, figurative and abstract art. Considers American landscapes, portraits and florals.

TERMS Artwork is accepted on consignment with negotiated commission, promotion and contract. Retail price set by the gallery. Gallery provides insurance, promotion and contract. Accepted work should be framed, mounted and matted. Requires exclusive representation locally.

SUBMISSIONS Submit via e-mail. Finds artists mainly through referrals by other artists, art exhibits, submissions, portfolio reviews and word of mouth.

⌂ THE DONOVAN GALLERY

3895 Main Rd., Tiverton Four Corners RI 02878. (401)624-4000. **Website:** www.donovangallery.com. **Contact:** Kris Donovan, owner. Estab. 1993. Retail gallery. Owned and operated by practicing artists. "Offers an ever-changing selection of contemporary New England art: watercolors, pastels, oil paintings, fine crafts, handcrafted jewelry, and limited-edition prints." Represents 50 emerging, mid-career and established artists/year. Average display time: 1 month. Open Wednesday–Saturday, 11-4; Sunday, 12-5. Located in a rural shopping area; 1750s historical home; 2,000 sq. ft. 100% of space for gallery artists. Clientele: tourists, upscale, local community and students. 90% private collectors, 10% corporate collectors. Overall price range: $100-6,500; most work sold at $250-800.

MEDIA Considers oil, acrylic, watercolor, pastel, mixed media, collage, paper, ceramics, some craft, fiber and glass; and limited edition prints. Most frequently exhibits watercolors, oils and pastels.

STYLE Exhibits conceptualism, impressionism, photorealism and realism. Exhibits all genres. Prefers realism, impressionism and representational.

TERMS Accepts work on consignment (45% commission). Retail price set by the artist. Gallery provides limited insurance, promotion and contract; artist pays for shipping. Prefers artwork framed.

SUBMISSIONS Only accepts artists from New England. Send query letter with résumé, 6 slides, bio, brochure, photographs, SASE, business card, reviews and artist's statement. Call or write for appointment to show portfolio of photographs or slides or transparencies. Responds in 1 week. Files material for possible future exhibition. Finds artists through networking and submissions.

TIPS "Do not appear without an appointment. Be professional, make appointments by telephone, be prepared with résumé, slides and (in my case) some originals to show. Don't give up. Join local art associations and take advantage of show opportunities there."

M.A. DORAN GALLERY

3509 S. Peoria Ave., Tulsa OK 74105. (918)748-8700. **E-mail:** Via online contact form. **Website:** madorangallery.com. Estab. 1979. Retail gallery. Represents 45 emerging, mid-career and established artists/year. Exhibited artists include P.S. Gordon and Otto Duecker. Sponsors 10 shows/year. Average display time 1 month. Open all year; Tuesday–Saturday,

10:30-6. Located central retail Tulsa; 2,000 sq. ft.; up and downstairs, Soho-like interior. 50% of space for special exhibitions; 50% of space for gallery artists. Clients include upscale. 65% of sales are to private collectors; 35% corporate collectors. Overall price range $500-40,000; most work sold at $5,000.

MEDIA Considers all media except pen & ink, paper, fiber and installation; types of prints include woodcuts, engravings, lithographs, wood engravings, mezzotints, serigraphs, linocuts and etchings. Most frequently exhibits oil paintings, watercolor and crafts.

STYLE Exhibits painterly abstraction, impressionism, photorealism, realism and imagism. Exhibits all genres. Prefers landscapes, still life and fine American crafts.

TERMS Accepts work on consignment (50% commission). Retail price set by the gallery and artist. Gallery provides insurance and promotion; shipping costs are shared. Prefers artwork framed.

SUBMISSIONS "Please submit a CD with 20 current images. Include a typed sheet with corresponding information. (If submitting slides/photos, clearly label (title, year, medium, size) images. Please include a résumé—education, one-person exhibitions distinct from group shows, awards, publications, etc., an artist statement—further explanation about your technique(s), concept, vision, etc. Please include a SASE. We appreciate your effort and a response will be sent within 30 days."

DOT FIFTYONE GALLERY

51 NW 36 St., Wynwood Arts District, Miami FL 33127. (305)573-9994, ext. 450. **Fax:** (305)573-9994. **E-mail:** dot@dotfiftyone.com. **Website:** www.dotfiftyone.com. Estab. 2003. Sponsors 12 exhibits per year. Average display time: 30 days. Clients include the local community, tourists, and upscale corporate collectors. Art sold for $1,000-20,000 (avg. $5,000) with a 50% commission. Prices are set by the gallery and the artist. Gallery provides insurance, promotion, and contract. Work should be framed, mounted and matted.

TERMS E-mail 5 JPEG samples at 72 dpi.

DUCK CLUB GALLERY

2333 N. College, Fayetteville AR 72703. (479)443-7262. **E-mail:** info@duckclubgallery.com. **Website:** www.facebook.com/duckclubgallery. Estab. 1980. Retail gallery. Represents mid-career and established artists. May be interested in seeing the work of emerging artists in the future. Exhibited artists include Terry Redlin, Jane Garrison and Linda Cullers. Displays work "until it sells." Open all year; Monday-Friday, 10-5:30; Saturday, 10-4. Located midtown; 1,200 sq. ft. 100% of space for gallery artists. Clientele: tourists, local community, students; "we are a university community." 80% private collectors, 20% corporate collectors. Overall price range $50-400; most work sold at $50-200.

MEDIA Considers all media including wood carved decoys. Considers engravings, lithographs, serigraphs, etchings, posters. Most frequently exhibits limited edition and open edition prints and poster art.

STYLE Exhibits all styles and genres. Prefers wildlife, local art and landscapes.

TERMS Buys outright for 50% of retail price (net 30 days). Retail price set by the artist. Gallery provides insurance and promotion; artist pays for shipping. Prefers artwork unframed.

SUBMISSIONS Send query letter with brochure, photographs and business card. Write for appointment to show portfolio. Finds artists through word of mouth, referrals by other artists, visiting art fairs and exhibitions, submissions, referrals from customers.

TIPS "Please call for an appointment. Don't just stop in. For a period of time, give exclusively to the gallery representing you. Permit a gallery to purchase one or two items, not large minimums."

DUCKTRAP BAY TRADING COMPANY

20 Main St., Camden ME 04843. (207)236-9568; (800)560-9568. **E-mail:** info@ducktrapbay.com. **Website:** www.ducktrapbay.com. **Contact:** Tim and Joyce Lawrence, owners. Estab. 1983. Retail gallery. "Our marine and wildlife art gallery features over 200 artists whose work spans from carving to painting, sculpture, scrimshaw, jewelry, ship models and much more!" Represents 200 emerging, mid-career and established artists/year. Exhibited artists include Sandy Scott, Stefane Bougie, Yvonne Davis, Beki Killorin, Jim O'Reilly and Gary Eigenberger. Open all year; Monday-Saturday, 9-5, Sunday, 11-4. Located downtown waterfront; 2 floors 3,000 sq. ft. 100% of space for gallery artists. Clientele: tourists, upscale. 70% private collectors, 30% corporate collectors. Overall price range $250-120,000; most work sold at $250-2,500.

MEDIA Considers watercolors, oil, acrylic, pastel, pen & ink, drawing, paper, sculpture, bronze and carvings. Types of prints include lithographs. Most

frequently exhibits woodcarvings, watercolor, acrylic and bronze.

STYLE Exhibits realism. Genres include nautical, wildlife and landscapes. Prefers marine and wildlife.

TERMS Accepts work on consignment (40% commission) or buys outright for 50% of the retail price (net 30 days). Retail price set by the artist. Gallery provides insurance and minimal promotion; artist pays for shipping. Prefers artwork framed.

SUBMISSIONS Send query letter with 10-20 slides or photographs. Call or write for appointment to show portfolio of photographs. Files all material. Finds artists through word of mouth, referrals by other artists and submissions.

TIPS "Find the right gallery and location for your subject matter. Have at least 8-10 pieces or carvings or 3-4 bronzes."

DURHAM ART GUILD

120 Morris St., Durham NC 27701. (919)560-2713. **E-mail:** board@durhamartguild.org. **Website:** www. durhamartguild.org. **Contact:** Board of Directors. Estab. 1948. Nonprofit gallery. Represents/exhibits 500 emerging, mid-career and established artists/ year. Sponsors more than 20 shows/year, including an annual juried art exhibit. Average display time: 6 weeks. Open all year; Monday-Saturday, 9-9; Sunday, 1-5. Free and open to the public. Located in center of downtown Durham in the Arts Council Building; 3,600 sq. ft.; large, open, movable walls. 100% of space for special exhibitions. Clientele: general public; 80% private collectors, 20% corporate collectors. Overall price range: $100-14,000; most work sold at $200-1,200.

MEDIA Considers all media. Most frequently exhibits painting, sculpture and photography.

STYLE Exhibits all styles, all genres.

TERMS Artwork is accepted on consignment (30-40% commission). Retail price set by the artist. Gallery provides insurance and promotion. Artist installs show. Prefers artwork framed.

SUBMISSIONS Artists must be 18 years or older. Send query letter with résumé, slides and SASE. "We accept slides for review by February 1 for consideration of a solo exhibit or special projects group show." Finds artists through word of mouth, referral by other artists, call for slides.

TIPS "Before submitting slides for consideration, be familiar with the exhibition space to make sure it can accommodate any special needs your work may require."

⊙ EAST END ARTS COUNCIL

133 E. Main St., Riverhead NY 11901. (631)727-0900. **Fax:** (631)727-0966. **E-mail:** psnyder@eastendarts. org. **Website:** www.eastendarts.org. **Contact:** Patricia Snyder, executive director. Estab. 1971. Nonprofit gallery. Located in the historic Davis-Corwin House (circa 1840). Exhibits the juried work of artists of all media. Presents 8 shows annually most of which are juried group exhibitions. Exhibits include approximately 300 artists/year, ranging from emerging to mid-career exhibitors of all ages. Average display time 4-5 weeks. Prefers regional artists. Clientele small business and private collectors. Overall price range $100-7,500; most work sold at $100-500. Open Tuesday–Saturday, 10-4.

MEDIA Considers all media including sculptures and installations. Considers matted but not framed giclées and serigraphs for gift shop but not shows.

STYLE Exhibits contemporary, abstract, naive, non-representational, photorealism, realism, post-pop works, projected installations and assemblages. "Being an organization relying strongly on community support, we aim to serve the artistic needs of our constituency and also expose them to current innovative trends within the art world. Therefore, there is not a particular genre bias; we are open to all art media."

TERMS Accepts work on consignment (30% commission). Retail price for art sold through our juried exhibits is set by the artist. Exclusive area representation not required.

SUBMISSIONS Submission guidelines available online.

TIPS "Visit, become a member ($50/year individual) and you'll be sent all the mailings that inform you of shows, lectures, workshops, grants and more! All work must be framed with clean mats and glass/plexi and wired for hanging. Artwork with clean gallery edge (no staples) is also accepted. Presentation of artwork is considered when selecting work for shows."

EASTERN SHORE ART CENTER

401 Oak St., Fairhope AL 36532. (251)928-2228. **E-mail:** kate@esartcenter.com. **Website:** www.esart center.com. **Contact:** Kate Fisher, executive director. Estab. 1957. Museum. Exhibits emerging, mid-career and established artists. Average display time 1

month. Open all year. Located downtown; 8,000 sq. ft. of galleries.

○ Artists applying to Eastern Shore should expect to wait at least a year for exhibits.

MEDIA Considers all media and prints.

STYLE Exhibits all styles and genres.

TERMS Accepts works on consignment (25% commission). Retail price set by artist. Gallery provides insurance, promotion and contract. Prefers artwork framed.

SUBMISSIONS Send query letter with résumé and slides. Write for appointment to show portfolio of originals and slides.

TIPS "Conservative, realistic art is appreciated more and sells better."

● E BRACKNELL GALLERY; MANSION SPACES

South Hill Park Arts Centre, Ringmead, Bracknell, Berkshire RG12 7PA, United Kingdom. (44)(0)1344-416240. **Website:** www.southhillpark.org.uk. Estab. 1991. Alternative space/nonprofit gallery. Approached by at least 50 artists/year; exhibits several shows of emerging, mid-career and established artists. "Very many artists approach us for the Mansion Spaces; all applications are looked at." Exhibited artists include Billy Childish (painting), Simon Roberts (photography) and Ed Piebn (digital installation/mixed media). Average display time: 2 months. Open all year; call or check website for hours. Located "within a large arts centre that includes theatre, cinema, studios, workshops and a restaurant; one large room and one smaller with high ceilings, plus more exhibiting spaces around the centre." Clients include local community and students.

MEDIA Considers all media. Most frequently exhibits painting, sculpture, live art, installations, group shows, video-digital works, craftwork (ceramics, glasswork, jewelery). Considers all types of prints.

STYLE Considers all styles and genres.

TERMS Artwork is accepted on consignment, and there is a 25% commission. Retail price set by the artist. Gallery provides insurance, promotion and contract.

SUBMISSIONS Send query letter with artist's statement, bio and photographs. Returns material with SASE. Responds to queries only if interested. Files all material "unless return of photos is requested." Finds artists through invitations, art exhibits, referrals by other artists, submissions and word of mouth.

TIPS "We have a great number of applications for exhibitions in the Mansion Spaces. Make yours stand out! Exhibitions at the Bracknell Gallery are planned 2-3 years in advance."

PETER ELLER GALLERY & APPRAISERS

206 Dartmouth NE, Albuquerque NM 87106. (505)268-7437. **E-mail:** peter@peterellerart.com. **Website:** www.peterellerart.com. Estab. 1981. Private dealer buys, sells, and does fee appraisals. Specializing in Albuquerque artists and minor New Mexico masters, 1925-1985. Overall price range $1,000-75,000.

MEDIA Considers acrylic, ceramics, drawing, mixed media, oil, pastel, pen & ink, sculpture, watercolor, engravings, etchings, linocuts, lithographs, mezzotints, serigraphs and woodcuts. Most frequently exhibits oil, sculpture and acrylic.

STYLE Considers all styles and genres. Most frequently exhibits Southwestern realism and geometric abstraction.

TERMS Primarily accepts consignments of resale works. Holds shows for contemporary artists occasionally.

SUBMISSIONS Call or write to arrange a personal interview to show portfolio or photographs. Finds artists through word of mouth and art exhibits.

EL PRADO GALLERIES, INC.

P.O. Box 1849, Sedona AZ 86339. (928)282-7390. **Website:** www.elpradogalleries.com. Estab. 1976. The gallery space is located on Hillside's Courtyard level in the heart of the complex. "The gallery enhances your experience of selecting art for your home by offering a wide array of fine contemporary art ranging from representational to impressionistic, in traditional as well as mixed media art form." Represents 60 emerging, mid-career and established artists. Exhibited artists include Guy Manning and John Cogan. Open daily, 10-6. 5,000 sq. ft. 95% private collectors, 5% corporate collectors. Accepts artists from all regions. Overall price range $75-125,000.

MEDIA Considers oil, acrylic, watercolor, pastel, mixed media, collage, works on paper, sculpture, ceramic, craft, fiber and glass. Considers woodcuts, engravings, lithographs, wood engravings, mezzotints, serigraphs, linocuts and etchings. Most frequently exhibits oil, acrylic, watercolor and sculpture.

STYLE Exhibits all styles and genres. Prefers landscapes, Southwestern and Western styles. Does not want to see avant-garde.

TERMS Accepts work on consignment (50% commission). Retail price set by the gallery and the artist. Gallery provides insurance and promotion; shipping costs are shared. Prefers framed work.

SUBMISSIONS Send query letter with photographs. Call or write to schedule an appointment to show a portfolio which should include photographs. "A common mistake artists make is presenting work not up to our standards of quality." Responds in 3 weeks. Files material only if interested.

TIPS "The artist's work must be original, not from copyrighted photos, and must include SASE. Our clients today are better art educated than before."

EMEDIALOFT.ORG

55 Bethune St., A-269, New York NY 10014-2035. (212)924-4893. **E-mail:** info@medialoft.org. **Website:** www.emedialoft.org. **Contact:** CT Rhodes, director. Estab. 1982. Alternative space. Exhibits highly original mid-career artists. Sponsors 4-6 exhibits/year. Average display time: 2 months. Open Tuesday–Saturday, 10-6 during announced shows; or by appointment. Located in the Highline/Meatpacking/West Village neighborhood of Manhattan in New York City. Overall price range: $5-50,000; most work sold at $500-2,000. Two artists studios for artists-in-residence and archives/library.

MEDIA Contemporary art, photography, mixed media, oil, watercolor, collage, prints. Frequently exhibits new media, performance, readings, sound-art video, artists' books, artist's objects, image/text and conceptual art. Most all are editions or sequences.

STYLE Themes relate to art from the subconscious, even if it looks recognizable or figurative, including landscapes or objects. No political art, no abstraction. "Art so original, it's hard to categorize."

SUBMISSIONS E-mail 250 words and 5 JPEGs (72 dpi max, 300 pixels on longest side). Or send query letter with "anything you like, but no SASE—sorry, we can't return anything. We may keep you on file, but please do not call." Responds to queries only if interested.

THOMAS ERBEN GALLERY

526 W. 26th St., Floor 4, New York NY 10001. (212)645-8701. **Fax:** (212)645-9630. **E-mail:** info@thomaserben.com. **Website:** www.thomaserben.

com. Estab. 1996. For-profit gallery. Approached by 100 artists/year. Represents 15 emerging, mid-career and established artists. Exhibited artists include Preston Scott Cohen (architecture) and Tom Wood (photography). Average display time 5-6 weeks. Open all year; Tuesday-Saturday, 10-6 (Monday–Friday in July). Closed Christmas/New Year's and August. Clients include local community, tourists and upscale.

MEDIA Considers all media. Most frequently exhibits photography, paintings and installation.

STYLE Exhibits contemporary art.

SUBMISSIONS Mail portfolio for review. Returns material with SASE. Responds in 1 month.

ETHERTON GALLERY

135 S. Sixth Ave., Tucson AZ 85701. (520)624-7370. **Fax:** (520)792-4569. **E-mail:** info@ethertongallery.com. **Website:** www.ethertongallery.com. **Contact:** Terry Etherton. Estab. 1981.

MEDIA Considers all types of photography, oil, acrylic, drawing, mixed media, collage, original hand pulled prints, woodcuts, wood engravings, linocuts, engravings, mezzotints, etchings and lithographs. Most frequently exhibits photography and painting.

STYLE Exhibits expressionism, neo-expressionism, primitivism, postmodern works. Genres include landscapes, portraits and figurative work. Prefers expressionism, primitive/folk and postmodern. Interested in seeing work that is "cutting-edge, contemporary, issue-oriented. No decorator art."

TERMS Accepts work on consignment (50% commission). Buys outright for 50% of retail price (net 30 days). Retail price set by gallery and artist. Gallery provides insurance and promotion; shipping costs are shared. Prefers framed artwork.

SUBMISSIONS A maximum of 10-20 images via CD, résumé, artist statement, bio, reviews. Materials not returned. Responds in 6 weeks only if interested.

EVENTGALLERY 910ARTS

910 Santa Fe Dr., Denver CO 80204. (303)815-1779. **E-mail:** info@910arts.com. **Website:** www.910arts.com/event-venue. Estab. 2007. Alternative space; for-profit gallery; nonprofit gallery; rental gallery; community educational outreach. Exhibits emerging, mid-career and established artists. Sponsors 6 exhibits/year in main gallery; 6/year in community; 2/year in sculpture garden. Average display time: 2 months in gallery/community; 6 months in sculpture garden. Open Tuesday, Thursday–Saturday, 10-4; 1st Fridays, 12-

9; 3rd Fridays, 12-8. "Gallery hours may vary. Hours as listed unless otherwise posted. Please check website." Located in Denver's Art District on Santa Fe at Nine10Arts, Denver's only green-built creative artist community; 1,300 sq. ft.; 105 linear ft.; additional 76 linear ft. of movable walls. Clients include local community, students, tourists, upscale.

MEDIA Considers all media, including performance art. Considers all types of prints except posters.

STYLE Considers all styles and genres.

TERMS Artwork is accepted on consignment (35% commission); or there is a rental fee for space. Retail price set by the artist. Gallery provides insurance, promotion, contract.

SUBMISSIONS See website or contact for guidelines. Responds to queries "as soon as possible." Cannot return material. Keeps all submitted materials on file if interested. Finds artists through submissions, art fairs/exhibits, portfolio reviews, art competitions, referrals by other artists, word of mouth.

TIPS "Adhere to submission guidelines. Visit website prior to submitting to ensure work fits gallery's mission."

EVERHART MUSEUM

1901 Mulberry St., Scranton PA 18510-2390. (570)346-7186. **Fax:** (570)346-0652. **E-mail:** curator@everhart-museum.org. **Website:** www.everhart-museum.org. **Contact:** Curatorial department. Estab. 1908. "The Everhart Museum is one of the oldest museums in the state and part of the early 20th-century regional museum movement." Represents established artists. 2,400 members. 15 gallery spaces providing display area for permanent and temporary exhibitions. Open Monday, Thursday, Friday, 12-4; Saturday, 10-5; Sunday, 12-5; closed in January for routine maintenance. Located in urban park; 300 linear feet. 20% of space for special exhibitions.

MEDIA Considers all media.

STYLE Prefers regional, Pennsylvania artists but also international artists that feature science and culture in their work.

TERMS Gallery provides insurance, promotion and shipping costs. 2D artwork must be framed.

SUBMISSIONS "Exhibition proposals are reviewed on an on-going basis by the curatorial department. Use the Exhibit Proposal form in order to have your proposal considered for display. If you are including work samples, slides, CDs, or other materials, please include a SASE if you would like your materials returned. Please do not send original material as the Everhart Museum accepts no responsibility for materials lost or damaged. Please note that the Everhart Museum receives many exhibition proposals each year so we would encourage you to contact a number of venues for your proposed exhibition. For additional information, or should you have difficulty downloading the online Exhibit Proposal form, please contact the curatorial department."

EVERSON MUSEUM OF ART

401 Harrison St., Syracuse NY 13202. (315)474-6064. **Fax:** (315)474-6943. **E-mail:** everson@everson.org; smassett@everson.org. **Website:** www.everson.org. **Contact:** Steven Kern, executive director; Debora Ryan, senior curator; Sarah Massett, public relations director. Estab. 1897. Museum. "In fitting with the works it houses, the Everson Museum building is a sculptural work of art in its own right. Designed by renowned architect I.M. Pei, the building itself is internationally acclaimed for its uniqueness. Within its walls, Everson houses roughly 11,000 pieces of art; American paintings, sculpture, drawings, graphics and one of the largest holdings of American ceramics in the nation." Open all year; Tuesday-Friday, 12-5; Saturday, 10-5; Sunday, 12-5. Located in a distinctive I.M. Pie-designed building in downtown Syracuse, NY. The museum features four large galleries with 24 ft. ceilings, back lighting and oak hardwood, a sculpture court, Art Zone for children, a ceramic study center and five smaller gallery spaces.

✚ EVOLVE THE GALLERY

2907 35th St., Historic Oak Park, Sacramento CA 95817. **E-mail:** info@evolvethegallery.com. **Website:** www.evolvethegallery.com. **Contact:** A. Michelle Blakeley, co-owner. Estab. 2010. For-profit and art consultancy gallery. Approached by 250+ artists/year. Represents emerging, mid-career and established artists. Exhibited artists include Richard Mayhew (master fine artist, watercolor), Corinne Whitaker (pioneer digital painter), Ben F. Jones (prominent international artist). Sponsors 12+ exhibits/year. Model and property release required. Average display time 1 month. Open Thursday-Saturday, by appointment. Clients include local community, students, tourists, upscale. 1% of sales are to corporate collectors. Overall price range $1-10,000. Most work sold at $3,000.

MEDIA Considers all media (except craft).

STYLE Exhibits conceptualism, geometric abstraction, neo-expressionism, postmodernism and painterly abstraction.

TERMS Artwork is accepted on consignment and there is a 50% commission. Retail price of the art set by the artist; reviewed by the gallery. Gallery provides insurance, promotion, contract. Accepted work should be framed, mounted.

SUBMISSIONS E-mail with link to artist's website, JPEG samples at 72 dpi. Must include artist statement and CV. Materials returned with SASE. Responds only if interested (within weeks). Finds artists through word of mouth, submissions, portfolio reviews, art exhibits, art fairs, referrals by other artists.

⌂ FALKIRK CULTURAL CENTER

1408 Mission Ave., San Rafael CA 94915-1560. (415)485-3328. **Fax:** (415)485-3404. **E-mail:** Beth. Goldberg@cityofsanrafael.org. **Website:** www. falkirkculturalcenter.org. **Contact:** Beth Goldberg, curator. Estab. 1974. Nonprofit gallery. Approached by 500 artists/year. Exhibits 350 emerging, mid-career and established artists. Sponsors 8 exhibits/year. Average display time 2 months. Open Tuesday–Friday, 1-5; Saturday, 10-1; by appointment. Three galleries located on second floor with lots of natural light (UV filtered). National historic place (1888 Victorian) converted to multi-use cultural center. Clients include local community, students, tourists and upscale.

MEDIA Considers all media and all types of prints. Most frequently exhibits painting, sculpture and works on paper.

SUBMISSIONS Marin County and San Francisco Bay Area artists only. Send artist's statement, bio, résumé and slides. Returns material with SASE. Responds within 3 months.

FARMINGTON VALLEY ARTS CENTER'S FISHER GALLERY

25 Arts Center Ln., Avon CT 06001. (860)678-1867. **Fax:** (860)674-1877. **E-mail:** online form. **Website:** www.artsfvac.org. Estab. 1972. Nonprofit gallery. Exhibits the work of 100 emerging, mid-career and established artists. Open all year; Wednesday-Saturday, 12-4; or by appointment. Located in Avon Park North just off Route 44; 850 sq. ft.; "in a beautiful 19th-century brownstone factory building once used for manufacturing." Clientele: upscale contemporary art craft buyers. Overall price range: $35-500; most work sold at $50-100.

MEDIA Considers "primarily crafts," also some mixed media, works on paper, ceramic, fiber, glass and small prints. Most frequently exhibits jewelry, ceramics and fiber.

STYLE Exhibits contemporary, handmade craft.

TERMS Accepts artwork on consignment (50% commission). Retail price set by the artist. Gallery provides promotion and contract; shipping costs are shared. Requires artwork framed where applicable.

SUBMISSIONS Send query letter with résumé, bio, digital images, SASE. Responds only if interested.

FAR WEST GALLERY

2817 Montana Ave., Billings MT 59101. (800)793-7296. **E-mail:** farwest@180com.net. **Website:** www.farwest gallery.com. **Contact:** Sondra Daly, manager. Estab. 1994. Retail gallery. Represents emerging, mid-career and established artists. Exhibited artists include Joe Beeler, Dave Powell, Kevin Red Star and Stan Natchez. Sponsors 4 shows/year. Average display time: 6-12 months. Open all year; 9-6. Located in downtown historic district in a building built in 1910. Clientele: tourists. Overall price range: $1-9,500; most work sold at $300-700.

MEDIA Considers all media and all types of prints. Most frequently exhibits Native American beadwork, oil and craft/handbuilt furniture.

STYLE Exhibits all styles. Genres include western and Americana. Prefers Native American beadwork, western bits, spurs, memorabilia, oil, watercolor and pen & ink.

TERMS Buys outright for 50% of retail price. Retail price set by the gallery and the artist. Gallery provides insurance and promotion.

FAYETTE ART MUSEUM

530 N. Temple Ave., Fayette AL 35555. (205)932-8727. **E-mail:** fayetteartmuseum@yahoo.com. **Website:** www.fayetteal.org/arts.html#museum. **Contact:** Anne Perry-Uhlman, director/curator. Estab. 1969. Exhibits the work of emerging, mid-career and established artists. Located in downtown Fayette Civic Center; 16,500 sq. ft. "Over 4,000 pieces in the permanent art collection with over 500 running feet of display space on the main floor of the Civic Center and 6 folk art galleries downstairs, as well as a gallery used for the director/curators office. Artists include internationally known and Fayette native Jimmy Lee Sudduth; Rev. Benjamin F. Perkins; Mr. Fred Webster of Berry; Sybil Gibson of Jasper; Jessi LaVon of

central Alabama; Wanda Teel of north Alabama; Lois Wilson of Fayette; Moses T and Doug Odom of south Alabama; and Margarette Scruggs of Walker County." Open all year; Monday–Friday, 9-12 and 1-4; and by appointment for group tours.

MEDIA Considers all media and all types of prints. Most frequently exhibits oil, watercolor and mixed media.

STYLE Exhibits expressionism, primitivism, painterly abstraction, minimalism, postmodern works, impressionism, realism and hard-edge geometric abstraction. Genres include landscapes, florals, Americana, wildlife, portraits and figurative work.

TERMS Shipping costs negotiable. Prefers artwork framed.

SUBMISSIONS Send query letter with résumé, brochure and photographs. Write for appointment to show portfolio of photographs. Files possible exhibit material.

TIPS "Do not send expensive mailings (slides, etc.) before calling to find out if we are interested. We want to expand collection. Top priority is folk art from established artists."

FENIX GALLERY

208A Ranchitos Road, Taos NM 87571. (575)758-9120. **Fax:** (575)776-8167. **E-mail:** jkendall@fenixgallery. com. **Website:** www.fenixgallery.com. Estab. 1989. **Director/Owner:** Judith B. Kendall. Retail gallery. Estab. 1989. Represents 18 emerging, mid-career and established artists/year. Exhibited artists include Alyce Frank and Earl Stroh. Sponsors 4 shows/year. Average display time 4-6 weeks. Open all year; daily, 10-5; Sunday, 12-5; closed Wednesday; by appointment only during winter months. Located on the main road through Taos; 2,000 sq. ft.; minimal hangings; clean, open space. 100% of space for special exhibitions during one-person shows; 50% of space for gallery artists during group exhibitions. Clientele experienced and new collectors. 90% private collectors, 10% corporate collectors. Overall price range $100-25,000; most work sold at $1,000-2,500.

MEDIA Considers all media; primarily non-representational, all types of prints except posters. Most frequently exhibits oil, sculpture and paper work/ceramics.

STYLE Exhibits expressionism, painterly abstraction, conceptualism, minimalism and postmodern works. Prefers conceptualism, expressionism and abstraction.

TERMS Accepts work on consignment (50% commission). Retail price set by the artist or a collaboration. Gallery provides insurance, promotion and contract; artist pays shipping costs to and from gallery. Prefers artwork framed.

SUBMISSIONS Prefers artists from area; "we do very little shipping of artist works." Send query letter with résumé, slides, bio, brochure, photographs, SASE, business card and reviews. Call for appointment to show portfolio of photographs. Responds in 3 weeks. Files "material I may wish to consider later—otherwise it is returned." Finds artists through personal contacts, exhibitions, studio visits, reputation regionally or nationally.

TIPS "I rely on my experience and whether I feel conviction for the art and whether sincerity is present."

FLEISHER/OLLMAN GALLERY

1616 Walnut St., Suite 100, Philadelphia PA 19103. (215)545-7562. **Fax:** (215)545-6140. **E-mail:** info@ fleisher-ollmangallery.com. **Website:** www.fleisher-ollmangallery.com. **Contact:** John Ollman, owner. Estab. 1952. Retail gallery. "In addition to our modern and contemporary interests (among them Joseph Cornell, H.C. Westermann, Ed Ruscha, and Alfred Jensen), the gallery continues to showcase the most significant American vernacular artists of the 20th-century, including the exclusive representation of Felipe Jesus Consalvos and the Philadelphia Wireman." Represents 12 emerging and established artists. Exhibited artists include James Castle and Bill Traylor. Sponsors 10 shows/year. Average display time 5 weeks. Open Monday–Friday, 10:30-5:30; Saturday, 12-5; closed Saturdays June–July; August, generally open during regular hours, but call first. Located downtown; 4,500 sq. ft. 75% of space for special exhibitions. Clientele primarily art collectors. 90% private collectors, 10% corporate collectors. Overall price range $2,500-100,000; most work sold at $2,500-30,000.

MEDIA Considers oil, acrylic, watercolor, pastel, pen & ink, drawing, mixed media and collage. Most frequently exhibits drawing, painting and sculpture.

STYLE Exhibits self-taught and contemporary works.

TERMS Accepts artwork on consignment (commission) or buys outright. Retail price set by the gallery. Gallery provides insurance and promotion; shipping costs are shared. Prefers artwork framed.

SUBMISSIONS Artists wishing to submit portfolios for review should include a CD with images, a bio or CV, and SASE if you would like your materials returned. "Due to the volume of e-mail we receive, we cannot respond to all unsolicited electronic submissions."

TIPS "Be familiar with our exhibitions and the artists we exhibit."

FLORIDA STATE UNIVERSITY MUSEUM OF FINE ARTS

530 W. Call St., Room 250, Fine Arts Bldg., Tallahassee FL 32306-1140. (850)644-6836. **Fax:** (850)644-7229. **E-mail:** apalladinocraig@fsu.edu. **Website:** www.mofa.fsu.edu. Estab. 1970. Shows work by over 100 artists/year; emerging, mid-career and established. Sponsors 12-22 shows/year. Average display time 3-4 weeks. Located on the university campus; 16,000 sq. ft. 50% for special exhibitions.

MEDIA Considers all media, including electronic imaging and performance art. Most frequently exhibits painting, sculpture and photography.

STYLE Exhibits all styles. Prefers contemporary figurative and nonobjective painting, sculpture, printmaking, photography.

TERMS "Interested collectors are placed into direct contact with the artists; the museum takes no commission." Retail price set by the artist. Museum provides promotion and shipping costs to and from the museum for invited artists.

TIPS "The museum offers a yearly international competition and catalog: The Tallahassee International. Visit website for more information."

THE FLYING PIG, LLC

N6975 State Hwy. 42, Algoma WI 54201. (920)487-9902. **Fax:** (920)487-9904. **E-mail:** info@theflyingpig.biz. **Website:** www.theflyingpig.biz. **Contact:** Susan Connor, owner/member. Estab. 2002. For-profit gallery. Located along Lake Michigan in Kewaunee County. Exhibits approximately 150 regional, national and international artists. Open daily, 9-6 (May-October); Friday-Sunday, 10-5 (November-April). Clients include local community, tourists and upscale. Overall price range: $5-2,000; most work sold at $300.

MEDIA Considers all media.

STYLE Exhibits impressionism, minimalism, painterly abstraction and primitivism realism. Most frequently exhibits primitivism realism, impressionism and minimalism. Genres include outsider and visionary.

TERMS Artwork is accepted on consignment (50% commission) or bought outright for 50% of retail price, net 15 days. Retail price set by the artist. Gallery provides insurance, promotion and contract. Accepted work should be framed. Does require exclusive representation locally.

SUBMISSIONS Send query letter with artist's statement, bio and photographs. Returns material with SASE. Responds to queries in 3 weeks. Files artist's statement, bio and photographs if interested. Finds artist's through art fairs and exhibitions, referrals by other artists, submissions, word of mouth and online.

FOCAL POINT GALLERY

321 City Island Ave., City Island NY 10464. (718)885-1403. **Fax:** (718)885-1451. **E-mail:** ronterner@gmail.com. **Contact:** Ron Terner, photographer/director. Estab. 1974. Retail gallery and alternative space. Interested in emerging and mid-career artists. Sponsors 12 group shows/year. Average display time: 3-4 weeks. Clients include locals and tourists. Overall price range: $175-750; most work sold at $300-500.

MEDIA Considers all media. Most frequently exhibits photography, watercolor, oil. Also considers etchings, giclée, color prints, silver prints.

STYLE Exhibits all styles. Most frequently exhibits painterly abstraction, conceptualism, expressionism. Genres include figurative work, florals, landscapes, portraits. Open to any use of photography.

TERMS Accepts work on consignment. Exclusive area representation required. Customer discounts and payment by installment are available. Gallery provides promotion. Artwork must be framed. There is a $20 hanging fee for each piece. Takes 30% commission.

SUBMISSIONS "Please call for submission information. Do not include résumés. The work should stand by itself. Slides should be of high quality."

TIPS "Care about your work."

TORY FOLLIARD GALLERY

233 N. Milwaukee St., Milwaukee WI 53202. (414)273-7311. **Fax:** (414)273-7313. **E-mail:** info@toryfolliard.com. **Website:** www.toryfolliard.com. Estab. 1988. Retail gallery. Represents emerging and established artists. Exhibited artists include Tom Uttech, Fred Stonehouse, TL Solien, Eric Aho, and John Wilde. Sponsors 8-9 shows/year. Average display time 4-5

weeks. Open all year; Tuesday-Friday, 11-5; Saturday, 11-4. Located downtown in historic Third Ward; 3,000 sq. ft.; 60% for special exhibitions; 40% for gallery artists. Clientele: tourists, upscale, local community and artists. 90% private collectors, 10% corporate collectors. Overall price range $500-25,000; most work sold at $1,500-8,000.

MEDIA Considers all media except installation and craft. Most frequently exhibits painting, sculpture.

STYLE Exhibits expressionism, abstraction, realism, surrealism and imagism. Prefers realism.

TERMS Accepts work on consignment. Retail price set by the gallery and the artist. Gallery provides insurance and promotion; artist pays shipping costs. Prefers artwork framed.

SUBMISSIONS Prefers artists working in midwest regional art. Accepts submissions through mail only. Send query letter with résumé, CD of images or photographs, reviews, artist's statement and SASE. Portfolio should include photographs or slides. Finds artists through referrals by other artists.

GANNON & ELSA FORDE GALLERIES

1500 Edwards Ave., Bismarck ND 58501. (701)224-5520. **Fax:** (701)224-5550. **E-mail:** Michelle_Lindblom@bsc.nodak.com. **Website:** www.bismarckstate.edu. **Gallery Director:** Michelle Lindblom. College gallery. Represents emerging, mid-career and established art exhibitions. Sponsors 6 shows/year. Average display time 6 weeks. Open all year; Monday-Thursday, 7am-9; Friday, 7:30-4; Sunday, 3-7. Summer exhibit is college student work (May-August). Located on Bismarck State College campus; high traffic areas on campus. Clientele all. 80% private collectors, 20% corporate collectors. Overall price range $50-10,000; most work sold at $50-3,000.

MEDIA Considers oil, acrylic, watercolor, pastel, drawing, mixed media, collage, paper, sculpture, ceramics, fiber, photography, woodcut, engraving, lithograph, wood engraving, mezzotint, serigraphs, linocut and etching. Most frequently exhibits painting media (all), mixed media and sculpture.

STYLE Exhibits expressionism, neo-expressionism, painterly abstraction, surrealism, impressionism, photorealism, hard-edge geometric abstraction and realism, all genres.

TERMS Accepts work on consignment (20% commission). Retail price set by the artist. Gallery provides insurance on premises, promotion, contract and shipping costs from gallery; artist pays shipping costs to gallery. Prefers artwork framed.

SUBMISSIONS Send query letter with résumé, slides, bio and SASE. Call or write for appointment to show portfolio of photographs and slides. Responds in 2 months. Files résumé, bio, photos if sent. Finds artists through word of mouth, art publications, artists' submissions, visiting exhibitions.

TIPS "Because our gallery is a university gallery, the main focus is to expose the public to art of all genres. However, we do sell work, occasionally."

FOSTER/WHITE GALLERY

220 Third Ave. S., Seattle WA 98104. (206)622-2833. **Fax:** (206)622-7606. **E-mail:** seattle@fosterwhite.com. **Website:** www.fosterwhite.com. **Contact:** Phen Huang, owner/director. Retail gallery. Estab. 1973. Represents 60 emerging, mid-career and established artists. Interested in seeing the work of local emerging artists. Exhibited artists include Mark Tobey, George Tsutakawa, Morris Graves, and William Morris. Average display time 1 month. Open all year; Tuesday-Saturday, 10-6; closed Sunday. Located in historic Pioneer Square; 7,500 sq. ft. Clientele private, corporate and public collectors. Overall price range $300-35,000; most work sold at $2,000-8,000.

MEDIA Considers oil, acrylic, watercolor, pastel, pen & ink, drawing, mixed media, collage, paper, sculpture, ceramics, craft, fiber, glass and installation.

TERMS Gallery provides insurance, promotion and contract.

SUBMISSIONS E-mail submissions are preferred. Guidelines available online. Responds in 1 month.

⏶ FOUNDRY GALLERY

1314 18th St. NW, 1st Floor, Washington DC 20036. (202)463-0203. **E-mail:** president@foundrygallery.org. **Website:** www.foundrygallery.org. **Contact:** Ron Riley and Judy Levey, co-presidents. Estab. 1971. Cooperative gallery and alternative space. "Founded to encourage and promote Washington area artists and to foster friendship with artists and arts groups outside the Washington area. The Foundry Gallery is known in the Washington area for its promotion of contemporary works of art." Interested in emerging artists. Sponsors 12 solo and 12 group (solo shows occur approximately every 1½ to 2 years. Average display time: 1 month. Open Wednesday-Friday, 1-7, Saturday-Sunday, 12-6. Clientele: 80% private collec-

tors; 20% corporate clients. Overall price range: $200-2,500; most work sold at $100-1,000.

MEDIA Considers oil, acrylic, watercolor, pastel, pen & ink, drawings, mixed media, collage, paper, sculpture, ceramic, fiber, glass, installation, photography, woodcuts, engravings, mezzotints, etchings, pochoir and serigraphs. Most frequently exhibits painting, sculpture, paper and photography.

STYLE Exhibits "serious artists in all mediums and styles." Prefers nonobjective, expressionism and neo-geometric.

TERMS Co-op membership fee plus initiation fee at time required; 30% commission. Retail price set by artist. Offers customer discounts and payment by installments. Exclusive area representation not required. Gallery provides promotion, contract and website presence. Gallery does not provide insurance.

SUBMISSIONS See website for membership application. Send query letter with 10 PDF images or slides. Local artists drop off 6 pieces of actual work. Portfolio reviews every third Wednesday of the month. Finds artists through submissions. Members are primarily local artists who pool their resources to support the gallery. A few exhibition opportunities are available for artists residing outside the Washington area and Foundry keeps a list of interested "guest artists."

TIPS "Have a coherent body of work, a minimum of 10 actual, finished works. Show your very best, strongest work. Build your résumé by submitting your artwork at juried shows. Visit gallery to ascertain whether the work fits in."

FOXHALL GALLERY

3301 New Mexico Ave. NW, Washington DC 20016. (202)966-7144. **Fax:** (202)363-2345. **E-mail:** foxhall gallery@foxhallgallery.com. **Website:** www.foxhall gallery.com. Estab. 1976. Retail gallery. "Foxhill Gallery represents a collection of fresh contemporary works of art, showing a wide variety of media and styles and focusing on fine, representational, original art. A full service gallery, Foxhall offers fine custom framing and design, museum conservation, restoration, hanging and installation." Represents emerging and established artists. Sponsors 6 solo and 6 group shows/year. Average display time 3 months. Open Monday–Saturday, 10-5. Overall price range $500-20,000; most artwork sold at $1,500-6,000.

MEDIA Considers oil, acrylic, watercolor, pastel, sculpture, mixed media, collage and original hand-pulled prints (small editions).

STYLE Exhibits contemporary, abstract, impressionistic, figurative, photorealistic and realistic works and landscapes.

TERMS Accepts work on consignment (50% commission). Retail price set by gallery and artist. Customer discounts and payment by installment are available. Exclusive area representation required. Gallery provides insurance.

SUBMISSIONS Send résumé, brochure, slides, photographs and SASE. Call or write for appointment to show portfolio. Finds artists through agents, by visiting exhibitions, word of mouth, various art publications and sourcebooks, artists' submissions, self promotions and art collectors' referrals.

TIPS To show in a gallery artists must have "a complete body of work—at least 30 pieces, participation in a juried show and commitment to their art as a profession."

FREEPORT ART MUSEUM

121 N. Harlem Ave., Freeport IL 61032. (815)235-9755. **Fax:** (815)235-6015. **E-mail:** info@freeportart museum.org. **Website:** www.freeportartmuseum.org. **Contact:** Jennifer Kirker Priest, director. Interested in emerging, mid-career and established artists. Sponsors solo and group shows. Clientele: 30% tourists; 60% local; 10% students. Average display time 7 weeks.

MEDIA Considers all media and prints.

STYLE Exhibits all styles and genres.

TERMS Gallery provides insurance and promotion; artist pays shipping costs. Prefers artwork framed.

SUBMISSIONS Send query letter with résumé, slides, SASE, brochure, photographs and bio. Files resumes.

TIPS "The exhibition committee meets quarterly each year to review the submissions."

GALERIE BONHEUR

10046 Conway Rd., St. Louis MO 63124. (314)993-9851. **Fax:** (314)993-9260. **E-mail:** gbonheur@aol.com. **Website:** www.galeriebonheur.com. **Owner:** Laurie Carmody Ahner. Private retail and wholesale gallery. Focus is on international folk art. Estab. 1980. Represents 60 emerging, mid-career and established artists/year. Exhibited artists include Milton Bond and Justin McCarthy. Sponsors 6 shows/year. Average display time: 1 year. Open all year; by appointment. Located in Ladue (a suburb of St. Louis); 3,000 sq. ft.;

art is displayed all over very large private home. 75% of sales to private collectors. Overall price range: $25-25,000; most work sold at $50-1,000.

MEDIA Considers oil, acrylic, watercolor, pastel, pen & ink, drawing, mixed media, collage, paper, sculpture, ceramics and craft. Most frequently exhibits oil, acrylic and metal sculpture.

STYLE Exhibits expressionism, primitivism, impressionism, folk art, self-taught, outsider art. Genres include landscapes, florals, Americana and figurative work. Prefers genre scenes and figurative.

TERMS Accepts work on consignment (50% commission). Retail price set by the gallery and the artist. Gallery provides promotion; artist pays shipping costs to and from gallery. Prefers artwork framed.

SUBMISSIONS Prefers only self-taught artists. Send query letter with bio, photographs and business card. Write for appointment to show portfolio of photographs. Responds within 6 weeks, only if interested. Finds artists through agents, visiting exhibitions, word of mouth, art publications, sourcebooks and submissions.

TIPS "Be true to your inspirations. Create from the heart and soul. Don't be influenced by what others are doing; do art that you believe in and love and are proud to say is an expression of yourself. Don't copy; don't get too sophisticated or you will lose your individuality!"

GALLERY 72

2709 Leavenworth St., Omaha NE 68105-2399. (402)496-4797. **E-mail:** gallery72@novia.net. **Contact:** Robert A. Rogers, director. Estab. 1972. Represents or exhibits 6 artists. Sponsors 4 solo and 4 group shows/year. Average display time: 3-4 weeks. Gallery open Tuesdays and Thursdays, by appointment and for special events. One large room, one small room.

MEDIA Considers oil, acrylic, digital, watercolor, pastel, pen & ink, drawings, mixed media, collage, sculpture, ceramic, installation, photography, original handpulled prints and posters. Most frequently exhibits paintings, prints and sculpture.

STYLE Exhibits hard-edge geometric abstraction, color field, minimalism, impressionism and realism. Genres include landscapes and figurative work. Most frequently exhibits color field/geometric, impressionism and realism.

TERMS Artwork is accepted on consignment (50% commission). Gallery provides insurance, promotion. Requires exclusive representation locally. "No Western art."

SUBMISSIONS Call, e-mail or write to arrange personal interview to show portfolio. Send query letter with artist's statement, brochure, photocopies, résumé. Accepts digital images. Finds artists through word of mouth, submissions, art exhibits.

GALLERY 110 COLLECTIVE

110 Third Ave. S., Seattle WA 98104. (206)624-9336. **E-mail:** director@gallery110.com. **Website:** www.gallery110.com. **Contact:** Paula Maratea Fuld, director. Estab. 2002. "Gallery 110 presents contemporary art in a wide variety of media in Seattle's premiere gallery district, historic Pioneer Square. Our artists are emerging and established professionals, actively engaged in their artistic careers. We aspire to present fresh exhibitions of the highest professional caliber. The exhibitions change monthly and consist of solo, group and/or thematic shows in the main gallery and solo shows in our Small Space." Open Wednesday-Saturday, 12-5; hosts receptions every first Thursday of the month, 6-8 p.m. Overall price range: $125-3,000; most work sold at $500-800.

SUBMISSIONS "Please follow directions on our website if you are interested in becoming an artist member. New members considered yearly or on a space available basis. Some membership duties apply."

TIPS "We want to know that the artist has researched us. We want to see original and creative works that shows the artist is aware of both contemporary art and art history. We seek artists who intend to actively contribute and participate as a gallery member."

GALLERY 218

207 E. Buffalo St., Suite 218, Milwaukee WI 53202. (414)643-1732. **E-mail:** info@gallery218.com. **Website:** www.gallery218.com. **Contact:** Judith Hooks, president/director. Estab. 1990. Nonprofit gallery, cooperative gallery, alternative space. "Gallery 218 is committed to providing exhibition opportunities to area artists. 218 sponsors exhibits, poetry readings, performances, recitals and other cultural events. 'The audience is the juror.'" Represents emerging, mid-career and established artists/year. Exhibited artists include Judith Hooks, Bernie Newman, Jared Plock, Daniel Fleming, Kathryn Kmet, Jean Marc Richel. Sponsors 12 shows a year. Average display time 1 month. Open all year; Thursday, 12-5; Friday, 12-5; Saturday. Located just south of downtown; 1,500

sq. ft.; warehouse-type space, wooden floor, halogen lights; includes information area. 100% of space for gallery artists. 75% private collectors, 25% corporate collectors. Overall price range $200-5,000; most work sold at $200-600.

⊙ Gallery 218 has a bricks-and-mortar gallery as well as a great website, which provides lots of links to helpful art resources.

MEDIA Considers all media except crafts. Considers linocuts, monotypes, woodcuts, mezzotints, etchings, lithographs and serigraphs. Most frequently exhibits paintings/acrylic, photography, mixed media.

STYLE Exhibits expressionism, conceptualism, photorealism, neo-expressionism, minimalism, hard-edge geometric abstraction, painterly abstraction, postmodern works, realism, and surrealism. Prefers abstract expressionism, fine art photography, personal visions.

TERMS There is a yearly co-op membership fee plus a monthly fee, and donation of time (25% commission.) Membership good for 1 year. There is a rental fee for space; covers 1 month. Group shows at least 8 times a year (small entry fee). Retail price set by the artist. Gallery provides promotion; artist pays for shipping. Prefers artwork framed.

SUBMISSIONS Prefers only adults (21 years plus), no students (grad students OK), serious artists pursuing their careers. E-mail query letter with résumé, business card, slides, photographs, bio, SASE or request for application with SASE. E-mail for appointment to show portfolio of photographs, slides, résumé, bio. Responds in 1 month. Files all. Finds artists through referrals, visiting art fairs, submissions. "We advertise for new members on a regular basis."

TIPS "Don't wait to be 'discovered.' Get your work out there not just once, but over and over again. Don't get distracted by material things, like houses, cars and real jobs. Be prepared to accept suggestions and/or criticism. Read entry forms carefully."

GALLERY 400

University of Illinois, 400 S. Peoria St., Chicago IL 60607. (312)996-6114. **Fax:** (312)355-3444. **Website:** gallery400.uic.edu. **Contact:** Lorelei Stewart, director. Estab. 1983. Nonprofit gallery. Approached by 500 artists/year; exhibits 80 artists. Sponsors 8 exhibits/year. Average display time: 6 weeks. Open Tuesday–Friday, 10-6; Saturday, 12-6. Clients include local community, students, tourists and upscale.

MEDIA Considers drawing, installation, painting, photography, design, architecture, mixed media and sculpture.

STYLE Exhibits conceptualism, minimalism and postmodernism. Most frequently exhibits contemporary conceptually based artwork.

TERMS Gallery provides insurance and promotion.

SUBMISSIONS Check info section of website for guidelines. Responds in 5 months. Finds artists through word of mouth, art exhibits, referrals by other artists.

TIPS "Check our website for guidelines for proposing an exhibition and follow those proposal guidelines. Please do not e-mail, as we do not respond to e-mails."

⊕ ⊙ GALLERY 555DC

555 12th St. NW, Washington DC 20004. (240)447-6071. **E-mail:** gallery555dc@aol.com. **Website:** www.gallery555dc.com. **Contact:** Jodi Walsh, owner. For-profit gallery. Represents or exhibits 10 emerging, mid-career and established artists. Exhibited artists include Anne Marchland, mixed medium, and Sabri ben-Achour, gas-fired ceramic. Model and property release are preferred. Average display time 30+ days. Open Tuesday-Friday, 11-5; weekends from the first Saturday of the month. Gallery is in the lobby. Located across from the Metro Station (between E&F). Gallery is a 20×20 space of glass, marble and stainless steel. Clients include local community, tourists and upscale. 5% of sales are to corporate collectors. Overall price range $250-3,000. Most work sold at $1,200.

MEDIA Considers all media.

STYLE Considers all styles.

TERMS Gallery provides insurance, promotion and contract. Accepted work should be gallery ready. Requires exclusive representation locally. Accepts only artists from DC, MD and VA.

SUBMISSIONS See website for submission guidelines. Materials returned with SASE.

TIPS Follow all instructions on our website.

GALLERY 825

Los Angeles Art Association, 825 N. La Cienega Blvd., Los Angeles CA 90069. (310)652-8272. **E-mail:** peter@laaa.org. **Website:** www.laaa.org. **Contact:** Peter Mays, executive director. Estab. 1925. Holds approximately 1 exhibition/year. Average display time 4-5 weeks. Fine art only. Exhibits all media.

MEDIA Considers all media and original handpulled prints. "Fine art only. No crafts." Most frequently exhibits mixed media, oil/acrylic and watercolor.
STYLE Exhibits all styles.
TERMS Retail price set by artist. Gallery provides promotion.
SUBMISSIONS Submit 2 pieces created during the last 3 years, 3 8×10" digital printouts of additional artwork, artist statement, membership application (available online) and non-refundable $35 application fee. See website for more details. Membership screenings are held twice a year, at the beginning and middle of each calendar year. Dates will be posted 3 months prior to screening. If accepted there is a $250 annual member fee.
TIPS "Bring work produced in the last three years. No commercial work (e.g., portraits/advertisements)."

GALLERY 1988

7020 Melrose Ave., Los Angeles CA 90038. (323)937-7088. **E-mail:** gallery1988venice@gmail.com. **Website:** www.gallery1988.com. Estab. 2004. Exhibits emerging artists. Approached by 300 artists/year; represents or exhibits 100 artists. Sponsors 15 exhibits/year. Average display time: 3 weeks. Open Tuesday-Sunday, 11-6. Closed Monday and national holidays. Located in the heart of Hollywood; 1,250 sq. ft. with 20-ft.-high walls. Clients include local community, students, upscale. Overall price range: $75-15,000; most work sold at $750.

◯ Second location: 1173 Sutter St., San Francisco CA 94109.

MEDIA Considers acrylic, drawing, oil, paper, pen & ink. Most frequently exhibits acrylic, oil, pen & ink. Types of prints include limited edition giclées.
STYLE Exhibits surrealism and illustrative work. Prefers character-based works.
TERMS Artwork is accepted on consignment. Retail price set by both the artist and gallery. Gallery provides insurance, promotion, contract. Accepted work should be framed.
SUBMISSIONS "If you are interested in submitting your work for review, please send an e-mail with 'submission' in the subject line. You can include a website link or several JPEGs of your work. Also include medium, dimensions and retail prices. If we feel your work would be a good fit for a future show at the gallery, we will contact you. Unfortunately, we cannot

respond to all submissions due to the high volume we receive."
TIPS "Keep your e-mail professional and include prices. Stay away from trying to be funny, which you'd be surprised to know happens a *lot*. We are most interested in the art."

GALLERY BERGELLI

483 Magnolia Ave., Larkspur CA 94939. (415)945-9454. **Fax:** (415)945-0311. **E-mail:** submit@bergelli.com. **Website:** www.gallerybergelli.com. Estab. 2000. For-profit gallery. "Features contemporary and original paintings and sculptures done by national and international artists. It presents work that is both exciting and technically strong in a unique and inviting art space." Approached by 200 artists/year; exhibits 15 emerging artists/year. Sponsors 8-9 exhibits/year. Average display time: 6 weeks. Open Thursday-Sunday, 10-4. "We're located in affluent Marin County, just across the Golden Gate Bridge from San Francisco. The gallery is in the center of town, on the main street of Larkspur, a charming village known for its many fine restaurants. It is spacious and open with 1,500 square feet of exhibition space with large window across the front of the building. Moveable hanging walls (see the home page of our website) give us great flexibility to customize the space to best show the current exhibition." Open Thursday and Friday, 10-4; Saturday and Sunday, 11-4; or by appointment. Clients include local community, upscale in the Marin County & Bay Area. Overall price range is $2,000-26,000; most work sold at $4,000-10,000.
MEDIA Considers acrylic, collage, mixed media, oil, pastel, sculpture. Most frequently exhibits acrylic, oil and sculpture.
STYLE Exhibits geometric abstraction, imagism, new-expressionism, painterly abstraction, postmodernism, surrealism. Most frequently exhibits painterly abstraction, imagism and neo-expressionism.
TERMS Artwork is accepted on consignment (50% commission). Retail price set by the artist with gallery input. Gallery provides insurance and promotion. Accepted work should be matted, stretched, unframed and ready to hang. Requires exclusive representation locally. Artwork evidencing geographic and cultural differences is viewed favorably.
SUBMISSIONS "We currently have a full roster of artists, but occasionally review new submissions. Artists that are interested in showing their work may e-

mail 3-5 low-res JPEGs, an artist statement and bio. Due to the volume of submissions, we are unable to respond to everyone. If we are interested, you will receive a phone call within a month."

TIPS "Please visit our website to be sure that your work is compatible with our program."

⊕ GALLERY FIFTY SIX

2256 Central Ave., Memphis TN 38104. (901)276-1251. **E-mail:** rollin@galleryfiftysix.com. **Website:** www. galleryfiftysix.com. **Contact:** Rollin Kocsis, curator. Estab. 2008. For-profit gallery. Approached by 50 artists/year; represents or exhibits 20 emerging, mid-career and established artists. Exhibited artists include John Armistead, oil on canvas, and Bryan Blankenship, painting and ceramics. Sponsors 12 exhibits/year; 1 photography exhibit/year. Model and property release are preferred. Average display time 1 month. Open Wednesday-Saturday, 12-4. Contains over 2,900 sq. ft, four galleries, upper and lower level, archives. Clients include local community, students, tourists and upscale. 5% of sales are to corporate collectors. Overall price range $200-3,000. Most work sold at $650.

MEDIA Considers acrylic, ceramics, collage, drawing, fiber, glass, mixed media, oil, pastel, pen & ink, sculpture, watercolor. Most frequently exhibits oil on canvas, acrylic on canvas, assemblages. Considers engravings, etchings, linocuts, serigraphs, woodcuts.

STYLE Considers color field, expressionism, geometric abstraction, imagism, impressionism, pattern painting, postmodernism, primitivism realism, surrealism, painterly abstraction. Most frequently exhibits realism, abstract, expressionism. Considers all genres.

TERMS Artwork is accepted on consignment and there is a 50% commission. Gallery provides promotion and contract. Accepted work should be framed, mounted, matted. Requires exclusive representation locally.

SUBMISSIONS Write to arrange personal interview to show portfolio of photographs, e-mail JPEG samples at 72 dpi or send query letter with artist's statement, bio, brochure, business card, photographs, résumé, reviews and SASE. Material returned with SASE. Responds in 2 weeks. Files JPEGs, CDs, photos. Finds artists through word of mouth, submissions, portfolio reviews, art exhibits and referrals by other artists.

TIPS "Send good quality photos, by e-mail, with all important information included."

GALLERY JOE

302 Arch St., Philadelphia PA 19106. (215)592-7752. **Fax:** (215)238-6923. **E-mail:** mail@galleryjoe.com. **Website:** galleryjoe.com. Retail and commercial exhibition gallery. Represents/exhibits 15-20 emerging, mid-career and established artists. Exhibited artists include Wes Mills and Astrid Bowlby. Sponsors 6 shows/year. Average display time 6 weeks. Open Wednesday–Saturday, 12-5:30; or by appointment. Located in Old City; 1,400 sq. ft. 100% of space for gallery artists. 80% private collectors, 20% corporate collectors. Overall price range $500-25,000; most work sold at $2,000-10,000.

MEDIA Only exhibits sculpture and drawing.

STYLE Exhibits representational/abstract.

TERMS Artwork is accepted on consignment (50% commission). Retail price set by the gallery and the artist. Gallery provides insurance and promotion. Artist pays for shipping costs. Prefers artwork framed.

SUBMISSIONS Send query letter with résumé, slides, reviews and SASE. Responds in 6 weeks. Finds artists mostly by visiting galleries and through artist referrals.

GALLERY KH

311 W. Superior St., Chicago IL 60654. (312)642-0202. **E-mail:** info@gallerykh.com. **Website:** www. gallerykh.com. Estab. 1976. Retail gallery. Represents mid-career artists. Interested in seeing the work of emerging artists. Exhibited artists include Carolyn Cole, Rick Stevens, Leslie Tejada, Peter Hoffer, and Mark Dickson. Sponsors at least 4 shows/year. Average display time: 6 weeks. Open all year. Located downtown in gallery district; 3,000 sq. ft. 25% of space for special exhibitions. Clientele: corporations, designers and individuals. 50% private collectors, 50% corporate collectors. Overall price range: $750-15,000.

MEDIA Considers oil, acrylic, pastel, mixed media, collage, paper, sculpture. Most frequently exhibits canvas and sculpture.

STYLE Exhibits expressionism, painterly abstraction, impressionism, realism and photorealism. Genres include landscapes and florals. Prefers abstract, realistic and impressionistic styles.

TERMS Accepts artwork on consignment (50% commission). Retail price set by gallery and artist. Gallery provides insurance and contract.

SUBMISSIONS E-mail query letter with images and SASE. Portfolio review requested if interested in artist's work.

GALLERY M

180 Cook St., Suite 101, Denver CO 80206. (303)331-8400. **Website:** www.gallerym.com. Estab. 1996. For-profit gallery. "Gallery M brings to Denver contemporary fine art, photography, sculpture and new media that is the quality and diversity found in New York, Los Angeles, San Francisco and Europe. Features the work of more than 30 national and international artists." Average display time: 6-12 weeks. Overall price range: $1,000-75,000. Open Monday–Saturday, 10-6.

MEDIA Considers acrylic, collage, drawing, glass, installation, mixed media, oil, paper, pastel, pen & ink, watercolor, engravings, etchings, linocuts, lithographs, mezzotints, serigraphs, woodcuts, photography and sculpture.

STYLE Exhibits color field, expressionism, geometric abstraction, neo-expressionism, postmodernism, primitivism, realism and surrealism. Considers all genres.

TERMS Retail price set by the gallery and the artist. Gallery provides insurance and promotion. Requires exclusive local and regional representation.

SUBMISSIONS "Artists interested in showing at the gallery should visit the Artist Submissions section of our website (under Site Resources). The gallery provides additional services for both collectors and artists, including our quarterly newsletter, *The Art Quarterly*."

☺ GALLERY NAGA

67 Newbury St., Boston MA 02116. (617)267-9060. **Fax:** (617)267-9040. **E-mail:** mail@gallerynaga.com. **Website:** www.gallerynaga.com. Estab. 1977. Retail gallery. "Our primary focus is painting and we represent many of the most highly regarded painters working in Boston and New England. In addition, exceptional contemporary photographers, printmakers, and sculptors exhibit with us." Represents 30 emerging, mid-career and established artists. Sponsors 9 shows/year. Average display time: 1 month. Open Tuesday–Saturday, 10-5 (September-June). Located in the neo-Gothic church building (Church of the Covenant) at the corner of Berkeley and Newbury streets. Clientele: 90% private collectors, 10% corporate collectors. Overall price range: $500-60,000; most work sold at $2,000-10,000.

MEDIA Considers oil, acrylic, mixed media, photography, studio furniture. Most frequently exhibits painting and furniture.

STYLE Exhibits expressionism, painterly abstraction, postmodern works and realism. Genres include landscapes, portraits and figurative work. Prefers expressionism, painterly abstraction and realism.

TERMS Accepts work on consignment (50% commission). Retail price set by gallery and artist. Gallery provides insurance and promotion; artist pays for shipping. Prefers artwork framed.

SUBMISSIONS "We review unsolicited material 3 times a year on a rolling schedule. We accept a maximum of 20 images (slide, hard copy, MAC-formatted JPEG), a bio and, if applicable, an SASE. If you would like to e-mail JPEGs of 3 images (include the works' sizes and materials), we'll quickly suggest whether or not we think a complete presentation is warranted."

TIPS "We focus on Boston and New England artists. We exhibit the most significant studio furniture makers in the country. Become familiar with any gallery to see if your work is appropriate before you make contact."

GALLERY NORTH

90 N. Country Rd., Setauket NY 11733. (631)751-2676. **Fax:** (516)751-0180. **E-mail:** info@gallerynorth.org. **Website:** www.gallerynorth.org. **Contact:** Judith Levy, director. Regional arts center. "Our mission is to present exhibitions of exceptional contemporary artists and artisans, especially those from Long Island and the nearby regions; to assist and encourage artists by bringing their work to the attention of the public; and to stimulate interest in the arts by presenting innovative educational programs. Exhibits the work of emerging, mid-career and established artists from Long Island and throughout the Northeast. The Gallery North community involves regional and local artists, collectors, art dealers, corporate sponsors, art consultants, businesses and schools, ranging from local elementary students to the faculty and staff at Long Island's many colleges and universities including our neighbor, Stony Brook University and the Stony Brook Medical Center. With our proximity to New York City and the East End, our region attracts a wealth of talent and interest in the arts." Located in the Historic District of Setauket, Long Island, NY, in an 1840s farm house, 1 mile from the State University

at Stony Brook. Open year-round; Tuesday–Saturday, 10-5; Sunday, 12-5; closed Monday.

STYLE "Works to be exhibited are selected by our director, Judith Levy, with input from our Artist Advisory Board. We encourage artist dialogue and participation in gallery events and community activities and many artists associated with our gallery offer ArTrips and ArTalks, as well as teaching in our education programs. Along with monthly exhibitions in our 1000-sq.-ft. space, our Gallery Shop strives to present the finest handmade jewelry and craft by local and nationally recognized artisans."

SUBMISSIONS To present work to the gallery, send an e-mail with 2-5 medium-sized images, price list (indicating title, size, medium, and date), artist's statement, biography and link to website. "We encourage artists to visit the gallery and interact with our exhibitions." Visit the website for more information.

GALLERY WEST

1213 King St., Alexandria VA 22314. (703)549-6006. **E-mail:** gallerywest@verizon.net. **Website:** www.gallery-west.com. **Contact:** Judith Smith, president. Estab. 1979. Cooperative gallery and alternative space. Exhibits the work of 24 emerging, mid-career and established artists. Sponsors 11 group shows/year and 11 solo shows/year. Holds national juried show once/year open to all artists. Average display time 1 month. Open all year. Located in Old Town; 1,000 sq. ft. 60% of space for special exhibitions. Clients include individual, corporate and decorators. 90% of sales are to private collectors, 10% corporate collectors. Overall price range $100-3,500; most work sold at $500-700.

MEDIA Considers all media except video and film.

STYLE All styles and genres.

TERMS Co-op membership fee plus a donation of time. (30% commission.) Retail price set by artist. Sometimes offers customer discounts and payment by installments. Gallery assists promotion; artist pays for shipping. Prefers artwork framed.

SUBMISSIONS Send query letter with résumé, slides, bio and SASE. Call for appointment to show portfolio of slides. Responds in 1 month. Files résumés. Holds jury shows once/year open to all artists. Memberships applications: E-mail susanlamont@cox.net to request application or visit website.

TIPS "High-quality slides are imperative."

THE FANNY GARVER GALLERY

230 State St., Madison WI 53703. (608)256-6755. **E-mail:** art@fannygarvergallery.com. **Website:** www.fannygarvergallery.com. Estab. 1972. Retail gallery. "Whether your taste is traditional or contemporary, there's something for everyone. Every month we feature a show of new artwork. One month it might be an invitational art glass show, the next it may be a watercolor show." Represents 100 emerging, mid-career and established artists/year. Exhibited artists include Lee Weiss, Jaline Pol. Sponsors 11 shows/year. Average display time: 1 month. Open Monday–Saturday, 10-5; or by appointment. Located downtown; 3,000 sq. ft.; older refurbished building in unique downtown setting. 33% of space for special exhibitions; 95% of space for gallery artists. Clientele: private collectors, gift-givers, tourists. 40% private collectors, 10% corporate collectors. Overall price range: $100-10,000; most work sold at $100-1,000.

MEDIA Considers oil, pen & ink, paper, fiber, acrylic, drawing, sculpture, glass, watercolor, mixed media, ceramics, pastel, collage, craft, woodcuts, wood engravings, linocuts, engravings, mezzotints, etchings, lithographs and serigraphs. Most frequently exhibits watercolor, oil and glass.

STYLE Exhibits all styles. Prefers landscapes, still lifes and abstraction.

TERMS Accepts work on consignment (50% commission) or buys outright for 50% of retail price (net 30 days). Retail price set by gallery. Gallery provides promotion and contract, artist pays shipping costs both ways. Prefers artwork framed.

SUBMISSIONS Send query letter with résumé, 8 photographs, bio, brochure, photographs and SASE. Write for appointment to show portfolio, which should include originals, photographs and slides. Responds within 1 month, only if interested. Files announcements and brochures.

TIPS "Don't take it personally if your work is not accepted in a gallery. Not all work is suitable for all venues. Send us an e-mail and we'll be happy to put you on our mailing list."

DAVID GARY LTD. FINE ART

Website: www.davidgaryfineart.com. Retail and wholesale gallery. Estab. 1971. Represents 17-20 mid-career and established artists. Exhibited artists include John Talbot and Theo Raucher. Sponsors 3 shows/year. Average display time 3 weeks. Open all

year. Located in the suburbs; 2,000 sq. ft.; high ceilings with sky lights. Clients include "upper income." 70% of sales are to private collectors, 30% corporate collectors. Overall price range $250-25,000; most work sold at $1,000-15,000.

MEDIA Considers oil, acrylic, watercolor, drawings, sculpture, pastel, woodcuts, engravings, lithographs, wood engravings, mezzotints, linocuts, etchings and serigraphs. Most frequently exhibits oil, original graphics and sculpture.

STYLE Exhibits primitivism, painterly abstraction, surrealism, impressionism, realism and collage. All genres. Prefers impressionism, painterly abstraction and realism.

TERMS Accepts artwork on consignment (50% commission). Retail price set by gallery and artist. Gallery services vary; artist pays for shipping. Prefers artwork unframed.

SUBMISSIONS Send query letter with résumé, photographs and reviews. Call for appointment to show portfolio of originals, photographs and transparencies. Responds in 2 weeks. Files "what is interesting to gallery."

TIPS "Have a basic knowledge of how a gallery works, and understand that the gallery is a business."

GERING & LÓPEZ GALLERY

730 Fifth Ave., New York NY 10019. (646)336-7183. **E-mail:** info@geringlopez.com. **Website:** www.geringlopez.com. **Contact:** Director. Estab. 1991. For-profit gallery. Exhibits emerging, mid-career and established artists. Open Tuesday-Saturday, 10-6 (June 22 through Labor Day: Tuesday-Friday, 10-6; Saturday and Monday by appointment). Located in the historic Crown Building.

MEDIA Considers mixed media, oil, sculpture and digital. Most frequently exhibits computer-based work, electric (light) sculpture and video/DVD.

STYLE Exhibits geometric abstraction. Most frequently exhibits cutting edge.

TERMS Artwork is accepted on consignment.

SUBMISSIONS Send e-mail query with link to website and JPEGs. Cannot return material. Responds within 6 months, only if interested. Finds artists through word of mouth, art fairs/exhibits, and referrals by other artists.

GIACOBBE-FRITZ FINE ART

702 Canyon Rd., Santa Fe NM 87501. (505)986-1156. **Fax:** (505)986-1158. **E-mail:** art@giacobbefritz.com.

Website: www.giacobbefritz.com. **Contact:** Palin Wiltshire and Sally Fritz, art consultants. Estab. 2000. For-profit gallery. Approached by 300+ artists/year. Represents 12 emerging, mid-career and established artists. Exhibits paintings, sculpture and graphics by outstanding emerging and established artists. Sponsors 12-20 exhibits/year. Average display time 2 weeks. Open all year; Monday-Saturday, 10-5; Sunday, 12-4. Located on historic Canyon Road, Santa Fe's famous street of galleries. Classic 1890 adobe with 5 exhibit rooms. Clients include local community, tourists and upscale.

MEDIA Considers acrylic, collage, mixed media, oil, pastel, sculpture, watercolor and etchings. Prints include etchings and mezzotints. Most frequently exhibits oil, sculpture and acrylic.

STYLE Exhibits impressionism, abstract and realism. Considers all styles including expressionism, impressionism, surrealism and painterly abstraction. Genres include figurative work, landscapes and figures.

TERMS Artwork is accepted on consignment and there is a 50% commission. Retail price set by the gallery. Gallery provides insurance, promotion and contract. Accepted work should be framed. Requires exclusive representation locally. No agents.

SUBMISSIONS Call, write, or e-mail to arrange a personal interview to show portfolio of photographs, transparencies and slides. Prefers to receive e-mailed portfolios. Send query letter with artist's statement, bio, photocopies, photographs, SASE, slides and CD. Returns material with SASE only. Responds to queries in 2 weeks. Finds artists through art fairs, art exhibits, portfolio reviews, referrals by other artists, submissions, word of mouth.

TIPS "Enclose SASE, brief query letter, and a few samples of your best work."

GOLD/SMITH GALLERY

41 Commercial St., BoothBay Harbor ME 04538. (207)633-6252. **E-mail:** vandor_art@myfairpoint.net. Estab. 1974. Retail gallery. Represents 30 emerging, mid-career and established artists. Exhibited artists include John Vander and John Wissemann. Sponsors 6 shows/year. Average display time 6 weeks. Open May-October; Monday-Saturday, 10-6. Located downtown across from the harbor. 1,500 sq. ft.; traditional 19th century house converted to contemporary gallery. 75% of space for special exhibitions; 25% of space for gallery artists. Clientele residents and vis-

itors. 90% private collectors, 10% corporate collectors. Overall price range $350-5,000; most work sold at $1,000-2,500.

○ One of 2 Gold/Smith Galleries. The other is in Sugar Loaf; the 2 are not affiliated with each other. Artists creating traditional and representational work should try another gallery. The work shown here is strong, self-assured and abstract.

MEDIA Considers oil, acrylic, watercolor, pastel, pen & ink, drawing, mixed media, collage, paper, sculpture, photography, woodcuts, engravings, wood engravings and etchings. Most frequently exhibits acrylic and watercolor.

STYLE Exhibits expressionism, painterly abstraction "emphasis on nontraditional work." Prefers expressionist and abstract landscape.

TERMS Commission 50%. Retail price set by the artist. Gallery provides insurance and promotion; artist pays shipping costs to and from gallery. Prefers artwork framed.

SUBMISSIONS No restrictions—emphasis on artists from Maine. Send query letter with slides, bio, photographs, SASE, reviews and retail price. Write for appointment to show portfolio of originals. Responds in 2 weeks. Artist should write the gallery.

TIPS "Present a consistent body of mature work. We need 12 to 20 works of moderate size. The sureness of the hand and the maturity interest of the vision are most important."

GRAND RAPIDS ART MUSEUM

101 Monroe Center, Grand Rapids MI 49503. (616)831-1000. **E-mail:** pr@artmuseumgr.org. **Website:** www.gramonline.org. Estab. 1910. Exhibits established artists. Sponsors 3 exhibits/year. Average display time 4 months. Open all year; Tuesday-Thursday, 10-5; Friday, 10-8:30; Sunday, 12-5. Closed Mondays and major holidays. Located in the heart of downtown Grand Rapids, the Grand Rapids Art Museum presents exhibitions of national caliber and regional distinction. The museum collection spans Renaissance to modern art, with particular strength in 19th- and 20th-century paintings, prints and drawings. Clients include local community, students, tourists, upscale.

MEDIA Considers all media and all types of prints. Most frequently exhibits paintings, prints and drawings.

STYLE Considers all styles and genres. Most frequently exhibits impressionist, modern and Renaissance.

THE GRAPHIC EYE GALLERY OF LONG ISLAND

402 Main St., Port Washington NY 11050. (516)883-9668. **Website:** www.graphiceyegallery.com. Estab. 1974. Represents 25 artists. Sponsors solo, 2-3 person and 4 group shows/year. Average display time 1 month. Interested in emerging and established artists. Overall price range $35-7,500; most artwork sold at $500-800. Open Wednesday-Sunday, 12-5.

MEDIA Considers mixed media, collage, works on paper, pastels, photography, paint on paper, woodcuts, wood engravings, linocuts, engravings, mezzotints, etchings, lithographs, serigraphs, and monoprints.

STYLE Exhibits impressionism, expressionism, realism, primitivism and painterly abstraction. Considers all genres.

TERMS Co-op membership fee plus donation of time. Retail price set by artist. Offers payment by installments. Exclusive area representation not required. Prefers framed artwork.

SUBMISSIONS Send query letter with résumé, SASE, slides and bio. Portfolio should include originals and slides. "When submitting a portfolio, the artist should have a body of work, not a 'little of this, little of that.' Finds artists through visiting exhibitions, word of mouth, artist's submissions and self-promotions.

TIPS "Artists must produce their *own* work and be actively involved. We have a competitive juried art exhibit annually. Open to all artists who work on paper."

⌂ GREATER LAFAYETTE MUSEUM OF ART

102 S. Tenth St., Lafayette IN 47905. (765)742-1128. **Fax:** (765)742-1120. **E-mail:** glenda@artlafayette.org. **Website:** artlafayette.org. **Contact:** Glenda McClatchey, administrative assistant. Estab. 1909. Museum. Temporary exhibits of American and Indiana art as well as work by emerging, mid-career and established artists from Indiana and the midwest. 1,340 members. Sponsors 5-7 shows/year. Average display time 10 weeks. Located 6 blocks from city center; 3,318 sq. ft.; 4 galleries. Open every day 11-4. Clientele includes Purdue University faculty, students and residents of Lafayette/West Lafayette and 14 county area.

STYLE Exhibits all styles. Genres include landscapes, still life, portraits, abstracts, non-objective and figurative work.

TERMS Accepts some crafts for consignment in gift shop (35% mark-up).

SUBMISSIONS Send query letter with résumé, slides, artist's statement and letter of intent.

TIPS "Indiana artists specifically encouraged to apply."

◑ GREENHUT GALLERIES

146 Middle St., Portland ME 04101. (207)772-2693; (888)772-2693. **E-mail:** greenhut@maine.com. **Website:** www.greenhutgalleries.com. **Contact:** Peggy Greenhut Golden, owner. Estab. 1990. Retail gallery. Represents/exhibits 20 emerging and mid-career artists/year. Sponsors 12 shows/year. Exhibited artists include Connie Hayes (oil/canvas), Sarah Knock (oil/canvas). Average display time 3 weeks. Open all year; Monday–Friday, 10-5:30; Saturday, 10-5. Located in downtown—Old Port; 3,000 sq. ft. with neon accents in interior space. 60% of space for special exhibitions. Clientele tourists and upscale. 55% private collectors, 10% corporate collectors. Overall price range $500-12,000; most work sold at $600-3,000.

MEDIA Considers acrylic, paper, pastel, sculpture, drawing, oil, watercolor. Most frequently exhibits oil, watercolor, pastel.

STYLE Considers all styles; etchings, lithographs, mezzotints. Genres include figurative work, landscapes, still life, seascape. Prefers landscape, seascape and abstract.

TERMS Artwork is accepted on consignment (50% commission). Retail price set by the gallery and artist. Gallery provides insurance and promotion. Artists pays for shipping costs. Prefers artwork framed (museum quality framing).

SUBMISSIONS Accepts only artists from Maine or New England area with Maine connection. Send query letter with slides, reviews, bio and SASE. Call for appointment to show portfolio of slides. Responds in 1 month. Finds artists through word of mouth, referrals by other artists, visiting art shows and exhibitions, and submissions.

TIPS "Visit the gallery and see if you feel your work fits in."

GREMILLION & CO. FINE ART, INC.

2501 Sunset Blvd., Houston TX 77005. (713)522-2701. **Fax:** (713)522-3712. **E-mail:** fineart@gremillion.com. **Website:** www.gremillion.com. Estab. 1980. Retail gallery. Represents more than 80 mid-career and established artists. May be interested in seeing the work of emerging artists in the future. Exhibited artists include John Pavlicek and Robert Rector. Sponsors 12 shows/year. Average display time 4-6 weeks. Open Tuesday–Saturday, 10-5; and by appointment. Located "West University" area; 12,000 sq. ft. 50% of space for special exhibitions. 60% private collectors; 40% corporate collectors. Overall price range $500-300,000; most work sold at $3,000-10,000.

◑ Additional gallery located in Dallas. See website for more information.

MEDIA Considers oil, acrylic, watercolor, pastel, pen & ink, drawing, mixed media, collage, works on paper, sculpture, original handpulled prints, woodcuts, engravings, lithographs, wood engravings, mezzotints, linocuts, etchings and serigraphs.

STYLE Exhibits painterly abstraction, minimalism, color field and realism. Genres include landscapes and figurative work. Prefers abstraction, realism and color field.

TERMS Accepts artwork on consignment (varying commission). Retail price set by the gallery and artist. Gallery provides insurance and promotion; shipping costs are shared. Prefers artwork unframed.

SUBMISSIONS Call for appointment to show portfolio of slides, photographs and transparencies. Responds only if interested within 3 weeks. Finds artists through submissions and word of mouth.

CARRIE HADDAD GALLERY

622 Warren St., Hudson NY 12534. (518)828-1915. **Fax:** (518)828-3341. **E-mail:** carrie.haddad@carrie haddadgallery.com; cynthia.lathrop@carriehaddad gallery.com. **Website:** www.carriehaddadgallery.com. **Contact:** Carrie Haddad, owner. Estab. 1990. Art consultancy, for-profit gallery. Hailed as the premier gallery of the Hudson Valley, the Carrie Haddad Gallery presents 8 large exhibits/year and includes all types of painting, both large and small sculpture, works on paper and a variety of techniques in photography." Approached by 50 artists/year; represents or exhibits 60 artists. Open daily, 11-5; closed Wednesday.

MEDIA Considered: paintings, work on paper, no posters or reproductions.

STYLE Exhibits expressionism, impressionism and postmodernism. Genres include figurative work, landscapes and abstract.

TERMS Artwork is accepted on consignment and there is a 50% commission. Retail price set by the

artist. Gallery provides insurance and promotion. Requires exclusive representation locally.

SUBMISSIONS The gallery is not looking to add new artists to the gallery, but artists may submit websites or CDs of their work by sending the information to the gallery.

JUDITH HALE GALLERY

P.O. Box 884, Los Olivos CA 93441. (805)688-1222. **E-mail:** info@judithhalegallery.com. **Website:** www.judithhalegallery.com. **Contact:** Judith Hale, owner. Estab. 1987. Retail gallery. Represents 70 mid-career and established artists. Exhibited artists include Dirk Foslien, Howard Carr, Kelly Donovan and Mehl Lawson. Sponsors 4 shows/year. Average display time 6 months. Open all year. Located downtown; 2,100 sq. ft.; "the gallery is eclectic and inviting, an old building with six rooms." 20% of space for special exhibitions which are regularly rotated and rehung. Clientele: homeowners, tourists, decorators, collectors. Overall price range $500-15,000; most work sold at $500-5,000.

O This gallery opened a second location and connecting sculpture garden next door at 2884 Grand Ave. Representing nationally recognized artists, including Ted Goerschner, Marilyn Simandle, Dave DeMatteo, Dick Heichberger, this old building once housed the blacksmith's shop.

MEDIA Considers oil, acrylic, watercolor, pastel, sculpture, engravings and etchings. Most frequently exhibits watercolor, oil, acrylic and sculpture.

STYLE Exhibits impressionism and realism. Genres include landscapes, florals, western and figurative work. Prefers figurative work, western, florals, landscapes, structure. No abstract or expressionistic.

TERMS Accepts work on consignment (40% commission). Retail price set by artist. Offers payment by installments. Gallery arranges reception and promotion; artist pays for shipping. Prefers artwork framed.

SUBMISSIONS "Call ahead, or e-mail a link to your website, or a couple of representative images. This saves the mailing of slides, etc., and I don't have to return them. Send query letter with 10-12 slides, bio, brochure, photographs, business card and reviews. Call for an appointment to show portfolio of photographs. Responds in 2 weeks. Files bio, brochure and business card."

TIPS "Create a nice portfolio. See if your work is comparable to what the gallery exhibits. Do not plan your visit when a show is on; make an appointment for a future time. I like genuine people who present quality work with fair pricing. Rotate artwork in a reasonable time, if unsold. Bring in your best work, not the 'seconds' after the show circuit."

HALLWALLS CONTEMPORARY ARTS CENTER

341 Delaware Ave., Buffalo NY 14202. (716)854-1694. **Fax:** (716)854-1696. **E-mail:** john@hallwalls.org; carolyn@hallwalls.org. **Website:** www.hallwalls.org. **Contact:** John Massier, visual arts curator; Carolyn Tennant, media arts director. Estab. 1974. Nonprofit multimedia organization. "Our mission is to bring the newest and most challenging work in the contemporary arts to the interested public, whether in painting and sculpture, conceptual art, experimental film, video art and activism, documentary film, performance, fiction, jazz, new music, or any number of other art forms that make up our eclectic programming mix." Sponsors 10 exhibits/year. Average display time: 6 weeks. Open Tuesday–Friday, 11-6; Saturday, 11-2.

MEDIA Considers all media including film, video, sound, multimedia, and web-based work.

STYLE Exhibits all styles and genres. "Contemporary cutting edge work which challenges traditional cultural and aesthetic boundaries."

TERMS Retail price set by artist. "Sales are not our focus. If a work does sell, we suggest a donation of 15% of the purchase price." Gallery provides insurance.

SUBMISSIONS Send material by mail for consideration. Work not returned within 3 months will be kept for up to a year for further review.

HAMPTON III GALLERY, LTD.

3110 Wade Hampton Blvd., Taylors SC 29687. (864)268-2771. **E-mail:** sandy@hamptoniiigallery.com. **Website:** www.hamptoniiigallery.com. **Contact:** Sandra Rupp, director. Estab. 1970. Rental gallery. Approached by 20 artists/year; exhibits 25 mid-career and established artists/year. Exhibited artists include Carl Blair (oil paintings) and Darell Koons (acrylic paintings). Sponsors 8 exhibits/year. Average display time: 4-6 weeks. Open all year: Tuesday–Friday, 1-5; Saturday and Sunday, 10-5. Located 3 miles outside of downtown Greenville SC; one large exhibition room in center with 7 exhibition rooms around center gallery. Clients include local community and

upscale. 5% of sales are to corporate collectors. Overall price range: $200-15,000; most work sold at $2,500.

MEDIA Considers acrylic, ceramics, collage, drawing, mixed media, oil, paper, pastel, pen & ink, sculpture and watercolor. Most frequently exhibits oil and watercolor. Also considers engravings, etchings, linocuts, lithographs, mezzotints, serigraphs and woodcuts.

STYLE Exhibits color field, expressionism, geometric abstraction, imagism, impressionism and painterly abstraction. Most frequently exhibits painterly abstraction and realism. Considers all genres.

TERMS Artwork is accepted on consignment (40% commission). Retail price of the art set by the artist. Gallery provides insurance, promotion and contract. Accepted work should be framed. Requires exclusive representation locally.

SUBMISSIONS Send query letter with artist's statement, bio, reviews, SASE and slides. Returns material with SASE. Responds to queries in 3 months. Finds artists through art exhibits, referrals by other artists and word of mouth.

HAMPTON UNIVERSITY MUSEUM

Hampton University, 11 Frissell St., Hampton VA 23663. (757)727-5308. **Fax:** (757)727-5170. **E-mail:** museum@hamptonu.edu. **Website:** www.hamptonu.edu. **Contact:** Vanessa Thaxton-Ward, curator of collections. Estab. 1868. Represents/exhibits established artists. Exhibited artists include Elizabeth Catlett and Jacob Lawrence. Sponsors 3-4 shows/year. Average display time 12-18 weeks. Open Monday–Friday, 8-5; Saturday, 12-4; closed on Sunday, major and campus holidays. Located on the campus of Hampton University.

MEDIA Considers all media and all types of prints. Most frequently exhibits oil or acrylic paintings, ceramics and mixed media.

STYLE Exhibits African-American, African and Native American art.

SUBMISSIONS Send query letter with résumé and a dozen or more slides. Portfolio should include photographs and slides.

TIPS "Familiarize yourself with the type of exhibitions the Hampton University Museum typically mounts. Do not submit an exhibition request unless you have at least 35-45 pieces available for exhibition. Call and request to be placed on the museum's mailing list so you will know what kind of exhibitions

and special events we're planning for the upcoming year(s)."

⊙ HANA COAST GALLERY

P.O. Box 565, Hana HI 96713. (808)248-8636. **Fax:** (808)248-7332. **E-mail:** info@hanacoast.com. **Website:** www.hanacoast.com. Estab. 1990. Retail gallery and art consultancy. Represents 78 established artists. Sponsors 12 group shows/year. Average display time 1 month. Open all year. Located in the Hotel Hana-Maui at Hana Ranch; 3,000 sq. ft.; "an elegant oceanview setting in one of the top small luxury resorts in the world." 20% of space for special exhibitions. Clientele ranges from very upscale to highway traffic walk-ins. 85% private collectors, 15% corporate collectors. Overall price range $150-50,000; most work sold at $1,000-6,500.

MEDIA Considers oil, acrylic, watercolor, pastel, mixed media, collage, works on paper, sculpture, ceramic, craft, fiber, glass, photography, original handpulled prints, engravings, lithographs, pochoir, wood engravings, mezzotints, serigraphs and etchings. Most frequently exhibits oil, watercolor and original prints.

STYLE Exhibits expressionism, primitivism, impressionism and realism. Genres include landscapes, florals, portraits, figurative work and Hawaiiana. Prefers landscapes, florals and figurative work. "We also display decorative art and master-level craftwork, particularly turned-wood bowls, blown glass, fiber, bronze sculpture and studio furniture.

TERMS Accepts artwork on consignment (60% commission). Retail price set by gallery and artist. Gallery provides insurance, promotion and shipping costs from gallery. Framed artwork only.

SUBMISSIONS *Accepts only full-time Hawaii resident artists.* Send query letter with résumé, slides, bio, brochure, photographs, SASE and reviews. Write for appointment to show portfolio after query and samples submitted. Portfolio should include originals, photographs, slides and reviews. Responds only if interested within 1 week. If not accepted at time of submission, all materials will be returned.

TIPS "Know the quality and price level of artwork in our gallery and know that your own art would be companionable with what's being currently shown. Be able to substantiate the prices you ask for your work. We do not offer discounts, so the mutually agreed upon price/value must stand the test of the market."

JOEL AND LILA HARNETT MUSEUM OF ART AND PRINT STUDY CENTER

University of Richmond Museums, 28 Westhampton Way, Richmond VA 23173. (804)289-8276. **Fax:** (804)287-1894. **E-mail:** rwaller@richmond.edu; museums@richmond.edu. **Website:** museums.richmond.edu. **Contact:** Richard Waller, executive director. Estab. 1968. Represents emerging, mid-career and established artists. Sponsors 6 exhibitions/year. Average display time 6 weeks. Open academic year; with limited summer hours May-August. Located on university campus; 5,000 sq. ft. 100% of space for special exhibitions.

MEDIA Considers all media and all types of prints. Most frequently exhibits painting, sculpture, prints, photography and drawing.

STYLE Exhibits all styles and genres.

TERMS Work accepted on loan for duration of special exhibition. Retail price set by the artist. Museum provides insurance, promotion, contract and shipping costs. Prefers artwork framed.

SUBMISSIONS Send query letter with résumé, 8-12 images on CD, brochure, SASE, reviews and printed material if available. Write for appointment to show portfolio of "whatever is appropriate to understanding the artist's work." Responds in 1 month. Files résumé and other materials the artist does not want returned (printed material, CD, reviews, etc.).

O.K. HARRIS WORKS OF ART

383 W. Broadway, New York NY 10012. (212)431-3600. **Fax:** (212)925-4797. **E-mail:** okharris@okharris.com. **Website:** www.okharris.com. Estab. 1969. Commercial exhibition gallery. Represents 38 emerging, mid-career and established artists. Sponsors 30 solo shows/year. Average display time 1 month. Open Tuesday–Saturday, 10-6; in July, Tuesday–Friday, 12-5; closed from mid July through August and December 24–January 1. "Four separate galleries for 4 separate one-person exhibitions. The back room features selected gallery artists which also change each month." 90% of sales are to private collectors, 10% corporate clients. Overall price range $50-250,000; most work sold at $12,500-100,000.

MEDIA Considers all media. Most frequently exhibits painting, sculpture and photography.

STYLE Exhibits realism, photorealism, minimalism, abstraction, conceptualism, photography and collectibles. Genres include landscapes, Americana

but little figurative work. "The gallery's main concern is to show the most significant artwork of our time. In its choice of works to exhibit, it demonstrates no prejudice as to style or materials employed. Its criteria demands originality of concept and maturity of technique. It believes that its exhibitions have proven the soundness of its judgment in identifying important artists and its pertinent contribution to the visual arts culture."

TERMS Accepts work on consignment (50% commission). Retail price set by gallery. Customer discounts and payment by installment are available. Exclusive area representation required. Gallery provides insurance and limited promotion. Prefers artwork ready to exhibit.

SUBMISSIONS Send query letter with 1 CD of recent work with labeled images size, medium, etc., and SASE. Responds in 1 week.

TIPS "We suggest the artist be familiar with the gallery's exhibitions and the kind of work we prefer to show. Visit us either in person or online. Always include SASE. Common mistakes artists make in presenting their work are: submissions without return envelope, inappropriate work. We affiliate about 1 out of 10,000 applicants."

JANE HASLEM GALLERY

2025 Hillyer Place NW, Washington DC 20009. (202)232-4644. **Fax:** (202)387-0679. **E-mail:** haslem@mac.com. **E-mail:** haslem@artline.com. **Website:** www.janehaslemgallery.com. Estab. 1960. For-profit gallery. Exhibited artists include Garry Trudeau (cartoonist), Mark Adams (paintings, prints, tapestry), Nancy McIntyre (prints). Sponsors 4 exhibits/year. Open by appointment. Located at DuPont Circle across from Phillips Museum; 2 floors of 1886 building; 3,000 sq. ft. Clients include local community, students, upscale and collectors worldwide. 5% of sales are to corporate collectors. Overall price range is $30-30,000; most work sold at $500-2,000.

MEDIA Exhibits prints and works on paper and paintings. Considers engravings, etchings, linocuts, lithographs, mezzotints, serigraphs, woodcuts and digital images.

STYLE Exhibits expressionism, geometric abstraction, neo-expressionism, pattern painting, painterly abstraction, postmodernism, surrealism. Most frequently exhibits abstraction, realism and geometric. Genres include figurative work, florals and landscapes.

TERMS Artwork is accepted on consignment and there is a 50% commission. Retail price set by the artist and the gallery. Gallery provides promotion and contract. Accepts only artists from the US. Prefers only prints, works on paper and paintings.

SUBMISSIONS Artists should contact via e-mail.

TIPS "100% of our sales are Internet generated. We prefer all submissions initially by e-mail."

⚲ WILLIAM HAVU GALLERY

1040 Cherokee St., Denver CO 80204. (303)893-2360. **Fax:** (303)893-2813. **E-mail:** info@williamhavugallery.com. **Website:** www.williamhavugallery.com. **Contact:** Bill Havu, owner and director; Nick Ryan, gallery administrator. For-profit gallery. "Engaged in an ongoing dialogue through its 7 exhibitions a year with regionalism as it affects and is affected by both national and international trends in realism and abstraction. Strong emphasis on mid-career and established artists." Approached by 120 artists/year; represents or exhibits 50 artists. Sponsors 1 photography exhibit/year. Average display time 6-8 weeks. Open Tuesday–Friday, 10-6; Saturday, 11-5; 1st Friday of each month, 10-9; Sundays and Mondays by appointment. Closed Christmas and New Year's Day. Overall price range $250-15,000. Most work sold at $1,000-4,000.

MEDIA Considers acrylic, ceramics, collage, drawing, mixed media, oil, paper, pastel, pen & ink, sculpture and watercolor. Most frequently exhibits painting, prints. Considers etchings, linocuts, lithographs, mezzotints, woodcuts, monotypes, monoprints and silkscreens.

STYLE Exhibits expressionism, geometric abstraction, impressionism, minimalism, postmodernism, surrealism and painterly abstraction. Most frequently exhibits painterly abstraction and expressionism.

TERMS Artwork is accepted on consignment (50% commission). Retail price set by the gallery and the artist. Gallery provides insurance, promotion and contract. Accepted work should be framed. Primarily accepts only artists from Rocky Mountain/Southwestern region.

SUBMISSIONS Mail portfolio for review. Send query letter with artist's statement, bio, brochure, résumé, SASE and slides. Returns material with SASE. Files slides and résumé, if interested in the artist. Responds within 1 month, only if interested. Finds artists through word of mouth, submissions and referrals by other artists.

TIPS "Always mail a portfolio packet. We do not accept walk-ins or phone calls to review work. Explore our website or visit gallery to make sure work would fit with the gallery's objective. Archival-quality materials play a major role in selling fine art to collectors. We only frame work with archival-quality materials and feel its inclusion in work can 'make' the sale."

⚲ HAYLEY GALLERY

270 E. Main Street, New Albany OH 43054. (614)855-4856. **Fax:** (614)855-4865. **E-mail:** hayley@hayleygallery.com. **Website:** hayleygallery.com. **Contact:** Alicia Dunlap, gallery manager. Estab. 2007.

MEDIA Considers acrylic, ceramics, fiver, glass, mixed media, oil, paper, and sculpture. Most frequently exhibits abstract art but considers all genres.

TERMS Artwork is accepted on consignment with a 50% commission. Retail price set by the gallery and the artist. Gallery provides insurance, promotion, and contract. Accepted work should be framed or gallery wrapped. Only accepts artists from Ohio and the midwest.

SUBMISSIONS E-mail query letter with link to artists website or JPEG samples at 72 dpi to alicia@hayleygallery.com or mail disc, artist's statement, and bio for review. Does not return materials. Responds in 1 week. Finds artists through word of mouth, submissions, art exhibits, art fairs and referrals by other artists.

TIPS "Do not walk in without an appointment."

◉ MARIA HENLE STUDIO

55 Company St., Christiansted, St. Croix Virgin Islands 00820. (340)718-0372. **E-mail:** info@tinahenle.com. **Website:** www.mariahenlestudio.com. Estab. 1993. For-profit gallery. Exhibits mid-career and established artists. Approached by 4 artists/year; represents or exhibits 7 artists. Sponsors 4 exhibits/year. Average display time: 1 month. Open Monday-Friday, 11-5; weekends, 11-3. Closed part of September/October. Located in an 18th-century loft space in historical Danish West Indian town; 750 sq. ft. Clients include local community, tourists, upscale. 10% of sales are to corporate collectors. Overall price range: $600-6,000; most work sold at $600.

MEDIA Considers all media. Most frequently exhibits painting, photography, printmaking. Types of prints include etchings, mezzotints.

STYLE Considers all styles. Most frequently exhibits realism, primitive realism, impressionism. Genres include figurative work, landscapes, Caribbean.

TERMS Artwork is accepted on consignment (40% commission). Retail price set by the artist. Gallery provides promotion. Accepted work should be matted. Requires exclusive representation locally.

SUBMISSIONS Send query letter with artist's statement, bio, brochure. Returns material with SASE. Responds in 4 weeks. Files promo cards, brochures, catalogues. Finds artists through art exhibits, referrals by other artists, submissions.

TIPS "Present good slides or photos neatly presented with a clear, concise bio."

THE HENRY ART GALLERY

15th Ave. NE and NE 41st St., Seattle WA 98195. (206)543-2280. **Fax:** (206)685-3123. **E-mail:** press@henryart.org. **E-mail:** info@henryart.org. **Website:** www.henryart.org. **Contact:** Betsey Brock, associate director for communications and outreach. Estab. 1927. Contemporary Art Museum. Exhibits emerging, mid-career, and established artists. Presents 18 exhibitions/year. Open Wednesday, 11-4; Thursday-Friday, 11-9; Saturday-Sunday, 11-4. Located "on the western edge of the University of Washington campus. Parking is often available in the underground Central Parking garage at NE 41st St. On Sundays, free parking is usually available. Clients include local community, students, and tourists.

MEDIA Considers all media. Most frequently exhibits photography, video, and installation work. Exhibits all types of prints.

STYLE Exhibits contemporary art.

TERMS Does not require exclusive representation locally.

SUBMISSIONS Send query letter with artist statement, résumé, SASE, 10-15 images. Returns material with SASE. Responds to queries quarterly. Finds artists through art exhibitions, exhibition announcements, individualized research, periodicals, portfolio reviews, referrals by other artists, submissions, and word of mouth.

MARTHA HENRY, INC. FINE ART

400 E. 57th St., Suite 7L, New York NY 10022. (212)308-2759. **E-mail:** mh@marthahenry.com. **Website:** www.marthahenry.com. **Contact:** Martha Henry, president. Estab. 1987. Art consultancy and appraisals. Specialist in American art from the 19th century to the present, including: African-American, American, contemporary and emerging, figurative expressionism (1950s-60s), School of Hans Hofmann, self-taught and folk. Exhibits emerging, mid-career and established artists, specializing in art by African Americans. Approached by over 200 artists/year; exhibits over 12 artists/year. Exhibited artists include Jan Muller (oil paintings), Mr. Imagination (sculpture), JAMA (acrylic paintings) and Bob Thompson (oil paintings, drawings). Sponsors 3 exhibits/year. Average display time: 4 to 6 weeks. Open all year; by appointment only. Located in a private gallery in an apartment building. 5% of sales are to corporate collectors. Overall price range: $5,000-200,000; most work sold under $50,000.

TERMS Accepts all artists, with emphasis on African-American artists.

SUBMISSIONS E-mail portfolio for review or send website link. Responds in 3 months. Finds artists through art fairs and exhibits, portfolio reviews, referrals by other artists, submissions, word of mouth, and press.

HENRY STREET SETTLEMENT/ABRONS ART CENTER

466 Grand St., New York NY 10002. (212)766-9200; (212)598-0400. **E-mail:** info@henrystreet.org. **Website:** www.abronsartscenter.org. **Contact:** Martin Dust, visual arts coordinator. Alternative space, nonprofit gallery, community center. "The Abrons Art Center brings innovative artistic excellence to Manhattan's Lower East Side through diverse performances, exhibitions, residencies, classes and workshops for all ages and arts-in-education programming at public schools. Holds 9 solo photography exhibits/year. Open Tuesday–Friday, 10-10; Saturday, 9-10; Sunday, 11-6. Closed major holidays.

MEDIA Considers all media and all types of prints. Most frequently exhibits mixed media, sculpture and painting.

STYLE Considers all styles and genres.

TERMS Artwork is accepted on consignment (20% commission). Gallery provides insurance and contract.

SUBMISSIONS Send query letter with artist's statement, résumé and SASE. Returns material with SASE. Files résumés. Finds artists through word of mouth, submissions and referrals by other artists.

HERA EDUCATIONAL FOUNDATION AND ART GALLERY

327 Main St., Wakefield RI 02879. (401)789-1488. **E-mail:** info@heragallery.org. **Website:** www.hera gallery.org. Estab. 1974. Cooperative gallery. "Hera Gallery/Hera Educational Foundation was a pioneer in the development of alternative exhibition spaces across the U.S. in the 1970s and one of the earliest women's cooperative galleries. Although many of these galleries no longer exist, Hera is proud to have not only continued, but also expanded our programs, exhibitions and events." The number of photo exhibits varies each year. Average display time: 6 weeks. Open Wednesday, Thursday, Friday, 1-5; Saturday, 10-4; or by appointment. Closed during the month of January. Sponsors openings; provides refreshments and entertainment or lectures, demonstrations and symposia for some exhibits. Call for information on exhibitions. Overall price range: $100-10,000.

MEDIA Considers all media and original handpulled prints.

STYLE Exhibits installations, conceptual art, expressionism, neo-expressionism, painterly abstraction, surrealism, conceptualism, postmodern works, realism and photorealism, basically all styles. "We are interested in innovative, conceptually strong, contemporary works that employ a wide range of styles, materials and techniques. Prefers a culturally diverse range of subject matter that explores contemporary social and artistic issues important to us all."

TERMS Co-op membership. Gallery charges 25% commission. Retail price set by artist. Sometimes offers customer discount and payment by installments. Gallery provides promotion; artist pays for shipping and shares expenses such as printing and postage for announcements. Works must fit inside a 6'6"×2'6" door.

SUBMISSIONS Inquire about membership and shows. Responds in 6 weeks. Membership guidelines and application available on website or mailed on request. Finds artists through word of mouth, advertising in art publications, and referrals from members.

TIPS "Hera exhibits a culturally diverse range of visual and emerging artists. Please follow the application procedure listed in the membership guidelines. Applications are welcome at any time of the year."

GERTRUDE HERBERT INSTITUTE OF ART

506 Telfair St., Augusta GA 30901-2310. (706)722-5495. **Fax:** (706)722-3670. **E-mail:** ghia@ghia.org. **Website:** www.ghia.org. **Contact:** Rebekah Henry, executive director. Estab. 1937. Nonprofit gallery. Exhibits 40 emerging, mid-career and established artists in 5 solo/group shows annually. Exhibited artists include John Kingerlee, Luis Cruz Azaceta, Tom Nakashima. Sponsors 5 exhibits/year. Average display time: 6-8 weeks. Open Tuesday-Friday, 10-5; Saturdays by advance appointment only; closed first week in August, December 15-31. Located in historic 1818 Ware's Folly mansion. Clients include local community, tourists and upscale. Approx. 5% of sales are to corporate collectors. Overall price range: $100-5,000; most work sold at $500.

MEDIA Considers all media except craft. Considers all types of prints.

STYLE Exhibits all styles.

TERMS Artwork is accepted on consignment (35% commission). Retail price set by the artist. Gallery provides insurance and promotion. Accepted works on paper must be framed and under Plexiglas. Does not require exclusive representation locally.

SUBMISSIONS Send query letter with artist statement, bio, brochure, résumé, reviews, SASE, slides or CD of current work. Returns material with SASE. Responds to queries quarterly after expeditions review committee meets. Finds artists through art exhibits, referrals by other artists and submissions.

THE HIGH MUSEUM OF ART

1280 Peachtree St. NE, Atlanta GA 30309. (404)733-4473. **E-mail:** highmuseum@woodruffcenter.org. **Website:** www.high.org. Estab. 1905. Exhibits emerging, mid-career and established artists. Has over 11,000 works of art in its permanent collection. The museum has an extensive anthology of 19th- and 20th-century American art; significant holdings of European paintings and decorative art; a growing collection of African-American art; and burgeoning collections of modern and contemporary art, photography and African art. Open Tuesday, Wednesday, Friday, Saturday, 10-5; Thursday, 10-8; Sunday, 12-5; closed Mondays and national holidays. Located in midtown Atlanta. The museum's building, designed by noted architect Richard Meier, opened to worldwide acclaim in 1983 and has received many design awards, including 1991 citation from the American

Institute of Architects as one of the "ten best works of American architecture of the 1980s." Meier's 135,000-sq.-ft. facility tripled the museum's space, enabling the institution to mount more comprehensive displays of its collections. In 2003, to celebrate the 20th anniversary of the building, the High unveiled enhancements to its galleries and interior, and a new chronological installation of its permanent collection. Three new buildings, designed by Italian architect Renzo Piano, more than double the museum's size to 312,000 sq. ft. This allows the High to display more of its growing collection, increase educational and exhibition programs, and offer new visitor amenities to address the needs of larger and more diverse audiences. The expansion strengthens the High's role as the premier art museum in the Southeast and allows the museum to better serve its growing audiences in Atlanta and from around the world. Clients include local community, students, tourists and upscale.

MEDIA Considers all media and prints.

STYLE Considers all styles and genres.

TERMS Retail price is set by the gallery and the artist. Gallery provides insurance, promotion and contract.

SUBMISSIONS Call, e-mail or write to arrange a personal interview to show portfolio of slides, artist's statement, bio, résumé and reviews. Returns materials with SASE.

HOCKADAY MUSEUM OF ART

302 2nd Ave. E., Kalispell MT 59901. (406)755-5268. **E-mail:** director@hockadaymuseum.org. **Website:** www.hockadaymuseum.org. **Contact:** Elizabeth Moss, executive director. Estab. 1968. Located in the historic downtown, 2,650 ft. 1906 Carnegie Library. Permanent collection includes John Fery, Russell Chatham, Charles Marion Russell, Ace Powell, O.C. Seltzer, David Shaner, Rudy Autio and more. Seeking artists for exhibition including emerging, mid-career and established artists. Artists interested in exhibiting can access all information under the artist opportunities section on the website

TERMS There is a $25 application review fee. Will consider all media, styles, and genres. Gallery provides contract, insurance, promotion and shipping one way. Submissions are reviewed twice a year in September and January.

HONOLULU ACADEMY OF ARTS

900 S. Beretania St., Honolulu HI 96814. (808)532-8700. **E-mail:** info@honoluluacademy.org. **Website:** www.honoluluacademy.org. Estab. 1927. Nonprofit museum. Exhibits emerging, mid-career and established Hawaiian artists. Interested in seeing the work of emerging artists. Sponsors 40-50 shows/year. Average display time 6-8 weeks. Open all year; Tuesday–Saturday, 10-4:30, Sunday, 1-5. Located just outside of downtown area; 40,489 sq. ft. 30% of space for special exhibition. Clientele general public and art community.

MEDIA Considers all media. Most frequently exhibits painting, works on paper, sculpture.

STYLE Exhibits all styles and genres. Prefers traditional, contemporary and ethnic.

TERMS "On occasion, artwork is for sale." Retail price set by artist. Museum provides insurance and promotion; museum pays for shipping costs. Prefers artwork framed.

SUBMISSIONS Exhibits artists of Hawaii. Send query letter with résumé, slides and bio directly to curator(s) of Western or Asian art. Curators are Jennifer Saville, Western art; Julia White, Asian art. Write for appointment to show portfolio of slides, photographs and transparencies. Responds in 3-4 weeks. Files résumé, bio.

TIPS "Be persistent but not obnoxious." Artists should have completed a body of work of 50-100 works before approaching galleries.

HOOSIER SALON PATRONS ASSOCIATION & GALLERY

714 E. 65th St., Indianapolis IN 46220. (317)253-5340. **E-mail:** info@hoosiersalon.org. **Website:** www.hoosiersalon.org. Estab. 1925. Nonprofit fine art gallery. Membership of 500 emerging, mid-career and established artists. Sponsors 7 exhibits/year (6 in gallery, 1 juried show each year at the Indiana State Museum). Average display time 5-6 weeks. Open Tuesday-Friday, 11-5; Saturday, 11-3. Closed over Christmas week. Gallery is in the Village of Broad Ripple, Indianapolis as part of a business building. Gallery occupies about 1,800 sq. ft. Clients include local community and tourists. 20% of sales are to corporate collectors. Overall price range $50-5,000; most work sold at $1,000.

This gallery opened a new location in 2001 at 507 Church St., New Harmony IN 47631; (812)682-3970.

MEDIA Considers acrylic, ceramics, collage, drawing, fiber, mixed media, oil, paper, pastel, pen & ink, sculpture, watercolor and hand-pulled prints. Most frequently exhibits oil, watercolor and pastel.

STYLE Exhibits traditional impressionism to abstract. Considers all genres.

TERMS Artwork is accepted on consignment and there is a 33% commission. Retail price set by the artist. Gallery provides insurance and contract. Accepted work must be exhibit ready. Requires membership. Criteria for membership is 1 year's residence in Indiana. Accepts only artists from Indiana (1 year residency). Gallery only shows artists who have been in one annual exhibit (show of approx. 200 artists each year).

SUBMISSIONS Call or e-mail for membership and Annual Exhibition information. Responds ASAP. We do not keep artists' materials unless they are members. Finds artists through word of mouth, art exhibits and art fairs.

TIPS While not required, all mats, glass, etc., need to be archival-quality. Because the association is widely regarded as exhibiting quality art, artists are generally careful to present their work in the most professional way possible.

EDWARD HOPPER HOUSE ART CENTER

82 N. Broadway, Nyack NY 10960. (845)358-0774. **E-mail:** info@hopperhouse.org. **Website:** hopperhouse. org. **Contact:** Kendra Yapyapan, assistant director; Carole Perry, director. Estab. 1971. Nonprofit gallery, historic house. Approached by 200 artists/year. Exhibits 100 emerging, mid-career and established artists. Sponsors 9 exhibits/year. Average display time 5 weeks. Open Thursday–Sunday, 1-5; or by appointment. The house was built in 1858. There are four gallery rooms on the first floor. Clients include local community, students, tourists, upscale. Overall price range $100-12,000; most work sold at $750.

MEDIA Considers all media and all types of prints except posters. Most frequently exhibits watercolor, photography, oil.

STYLE Considers all styles and genres. Most frequently exhibits realism, abstraction, expressionism.

TERMS Artwork is accepted on consignment and there is a 35% commission. Retail price set by the artist. Gallery provides insurance, promotion and contract. Accepted work should be framed, mounted and matted. Does not require exclusive representation locally.

SUBMISSIONS Call or check website for submission guidelines. Send query letter with artist's statement, bio, brochure, business card, photocopies, photographs, résumé, reviews, SASE and slides. Returns material with SASE. Files all materials unless return specified and paid. Finds artists through art fairs, art exhibits, portfolio reviews, referrals by other artists, submissions and word of mouth.

TIPS "When shooting slides, don't have your artwork at an angle and don't have a chair or hands in the frame. Make sure the slides look professional and are an accurate representation of your work."

⊕ HUDSON GALLERY

5621 N. Main St., Sylvania OH 43560. (419)885-8381. **Fax:** (419)885-8381. **E-mail:** info@hudsongallery.net. **Website:** www.hudsongallery.net. **Contact:** Scott Hudson, director. Estab. 2003. For-profit gallery. Approached by 30 artists a year; represents or exhibits 90 emerging, mid-career and established artists. Sponsors 10 exhibits/year. Average display time 1 month. Open Tuesday-Friday, 10-6; Saturday, 10-3. This street-level gallery has over 2,000 sq. ft. of primary exhibition space. Clients include local community, tourists and upscale. 5% of sales are to corporate collectors. Overall price range $50-10,000.

MEDIA Considers acrylic, ceramics, collage, drawing, fiber, glass, mixed media, oil, paper, pastel, sculpture, watercolor, engravings, etchings, linocuts, lithographs, mezzotints, serigraphs, woodcuts. Most frequently exhibits acrylic, oil, ceramics.

STYLE Considers all styles and genres.

TERMS Artwork is accepted on consignment and there is a 40% commission. Retail price of the art set by the gallery and artist. Gallery provides insurance, promotion and contract.

SUBMISSIONS Call, e-mail, write or send query letter with artist's statement, bio, JPEGs; include SASE. Material returned with SASE. Responds within 4 months. Finds artists through word of mouth, submissions, portfolio reviews and referrals by other artists.

TIPS Follow guidelines on our website.

HUDSON GUILD GALLERY

441 W. 26th St., New York NY 10001. (212)760-9837. **E-mail:** jfurlong@hudsonguild.org. **Contact:** Jim Furlong, director. Estab. Hudson Guild Gallery, 1948; Guild Gallery II, 2001. Represents emerging, mid-career, community-based and established artists. Sponsors 12 shows/year. Average display time 8 weeks. Open all year. Located in West Chelsea; 1,200 sq. ft.; community center galleries in a New York City neighborhood. 100% of space for special exhibitions. 100% of sales are to private collectors.

Additional gallery: Guild Gallery II, 119 Ninth Ave., New York NY 10011.

MEDIA Considers oil, acrylic, watercolor, pastel, pen & ink, drawings, mixed media, collage, paper, sculpture, original handpulled prints, woodcuts, wood engravings, linocuts, engravings, mezzotints, etchings, lithographs, pochoir and serigraphs. Most frequently exhibits paintings, sculpture and graphics. Looking for artist to do an environmental installation.

STYLE Exhibits all styles and genres.

TERMS Accepts work on consignment (20% commission). Retail price set by artist. Gallery provides insurance; artist pays for shipping. Prefers artwork framed.

SUBMISSIONS Send query letter, résumé, JPEGs by e-mail, or photos with SASE. Responds in 1 month. Finds artists through visiting exhibitions, word of mouth, various art publications and sourcebooks, artists' submissions/self-promotions, art collectors' referrals.

TIPS "Medium or small works by emerging artists are more likely to be shown in group shows than large work."

HYDE PARK ART CENTER

5020 S. Cornell Ave., Chicago IL 60615. (773)324-5520. **Fax:** (773)324-6641. **E-mail:** generalinfo@hydeparkart.org; aquinn@hydeparkart.org. **Website:** hydeparkart.org. **Contact:** Allison Peters Quinn, director of exhibitions. Estab. 1939. Nonprofit gallery. Exhibits emerging artists. Sponsors 8 group shows/year. Average display time is 4-6 weeks. Office hours Monday–Friday, 9-5. Gallery hours Monday–Thursday, 10-8; Friday-Saturday, 10-5; Sunday, 12-5. "Primary focus on Chicago area artists not currently affiliated with a retail gallery." Clientele: general public. Overall price range $100-10,000.

MEDIA Considers all media. Interested in seeing "innovative work by new artists; also interested in proposals from curators, groups of artists."

TERMS Accepts work "for exhibition only." Retail price set by artist. Sometimes offers payment by installment. Exclusive area representation not required. Gallery provides insurance and contract.

SUBMISSIONS Send cover letter, résumé, CD with 10-15 images, artist's statement of 250-400 words, and SASE attn: Allison Peters Quinn, director of exhibitions.

TIPS "Do not bring work in person."

ICEBOX QUALITY FRAMING & GALLERY

1500 Jackson St. NE, Suite #443, Minneapolis MN 55413. (612)788-1790. **E-mail:** icebox@bitstream.net. **Website:** www.iceboxminnesota.com. Estab. 1988. Exhibition, promotion and sales gallery. Represents photographers and fine artists in all media, predominantly photography. "A sole proprietorship gallery, Icebox sponsors installations and exhibits in the gallery's 2,200 sq. ft. space in the Minneapolis Arts District." Overall price range: $200-2,500; most work sold at $200-800.

MEDIA Considers mostly photography, with the door open for other fine art with some size and content limitations.

STYLE Exhibits photos of multicultural, environmental, landscapes/scenics, rural, adventure, travel and fine art photographs from artists with serious, thought-provoking work. Interested in alternative process, documentary, erotic, historical/vintage.

TERMS Charges 50% commission.

SUBMISSIONS "Send letter of interest telling why and what you would like to exhibit at Icebox. Include only materials that can be kept at the gallery and updated as needed. Check website for more details about entry and gallery history."

TIPS "Be more interested in the quality and meaning of your artwork than in a way to make money. Unique thought provoking artwork of high quality is more likely suited." Not interested in wall decor art.

ILLINOIS ARTISANS PROGRAM

James R. Thompson Center, 100 W. Randolph St., Suite 2-200, Chicago IL 60601. (312)814-5321. **E-mail:** illinoisartisans@museum.state.il.us. **Website:** www.museum.state.il.us/programs/illinois-artisans. Estab. 1985. Four retail shops operated by the nonprofit Illinois State Museum Society. Represents over 1,500 artists; emerging, mid-career and established. Average display time 6 months. "Accepts only juried artists living in Illinois." Clientele tourists, conventioneers, business people, Chicagoans. Overall price range $10-5,000; most artwork sold at $25-100.

MEDIA Considers all media. "The finest examples in all media by Illinois artists."

STYLE Exhibits all styles. "Seeks contemporary, traditional, folk and ethnic arts from all regions of Illinois."

TERMS Accepts work on consignment (50% commission). Retail price set by gallery and artist. Sometimes

offers customer discounts. Exclusive area representation not required. Gallery provides promotion and contract.

SUBMISSIONS Send résumé and slides. Accepted work is selected by a jury. Résumé and slides are filed. "The finest work can be rejected if slides are not good enough to assess." Portfolio review not required. Finds artists through word of mouth, requests by artists to be represented and by twice-yearly mailings to network of Illinois crafters announcing upcoming jury dates. Detailed guidelines are available online.

⚲ ILLINOIS STATE MUSEUM CHICAGO GALLERY

100 W. Randolph, Suite 2-100, Chicago IL 60601. (312)814-5322. **E-mail:** jstevens@museum.state.il.us. **Website:** www.museum.state.il.us./ismsites/chicago/exhibitions.html. **Contact:** Jane Stevens, assistant administrator. Estab. 1985. Museum. Exhibits emerging, mid-career and established artists. Sponsors 2-3 shows/year. Average display time: 5 months. Open all year. Located "in the Chicago loop, in the James R. Thompson Center designed by Helmut Jahn." 100% of space for special exhibitions.

MEDIA All media considered, including installations.

STYLE Exhibits all styles and genres, including contemporary and historical work.

TERMS "We exhibit work but do not handle sales." Gallery provides insurance and promotion; artist pays for shipping. Prefers artwork framed.

SUBMISSIONS Accepts only artists from Illinois. Send résumé, 12-20 JPEGs on a CD, bio and SASE.

IMPACT ARTIST GALLERY, INC.

Tri-Main Center, Suite 545, 2495 Main St., Buffalo NY 14214. (716)835-6817. **Fax:** (716)835-6817. **E-mail:** impactartistgallery@gmail.com. **Website:** www.impactartist.wordpress.com. **Contact:** Director. Estab. 1993. "A cooperative members' gallery for women artists, one of a few in the nation. We mount 10 or more exhibitions of visual art each year, including 2-4 national juried shows, a members-only show, and several community service exhibits." Approached by 500 artists/year. Represents 310 emerging, mid-career and established artists. Open all year; Tuesday–Friday, 11-4; most Saturdays, 1-4. Clients include local community, tourists and upscale.

MEDIA Considers all media except glass, installation and craft. Considers engravings, etchings, lithographs, serigraphs and woodcuts.

STYLE Considers all styles. Most frequently exhibits expressionism, painterly abstraction, surrealism. Considers all genres.

TERMS Artwork is accepted on consignment and there is a 25% commission. Retail price set by the artist. Gallery provides promotion. Accepted work should be framed, matted and ready for hanging. Does not require exclusive representation locally. Women's art except for Fall National Show and Summer Statewide Show.

SUBMISSIONS Write to arrange a personal interview to show portfolio of slides. Mail portfolio for review. Send query letter with SASE and slides. Responds in 2 months. Files artist statement and résumé.

INDIANAPOLIS ART CENTER

Marilyn K. Glick School of Art, 820 E. 67th St., Indianapolis IN 46220. (317)255-2464. **Fax:** (317)254-0486. **E-mail:** ldehayes@indplsartcenter.org. **Website:** www.indplsartcenter.org. Estab. 1934. "Started in 1934 after the Great Depression to provide employment for artists, the IAC stays true to its mission by hiring professional artists as faculty, exhibiting the work of working artists and selling artist-made gifts and art. Sponsors 1-2 photography exhibits/year. Average display time 8 weeks. Overall price range $50-5,000. Most work sold at $500.

MEDIA Considers all media and all types of original prints. Most frequently exhibits painting, sculpture installations and fine crafts.

STYLE Exhibits all styles. "In general, we do not exhibit genre works. We do maintain a referral list, though." Prefers postmodern works, installation works, conceptualism, large-scale outdoor projects.

TERMS Charges 35% commission. One-person show: $300 honorarium; 2-person show: $200 honorarium; 3-person show: $100 honorarium; plus $0.32/mile travel stipend (one way). Accepted work should be framed (or other finished-presentation formatted). Prefers artists who live within 250 miles of Indianapolis.

SUBMISSIONS Send minimum of 20 digital images with résumé, reviews, artist's statement and SASE between July 1 and December 31.

TIPS "Research galleries thoroughly; get on their mailing lists, and visit them in person at least twice before sending materials. Find out the 'power structure' of the targeted galleries and use it to your advantage. Most artists need to gain experience exhibiting

in smaller or nonprofit spaces before approaching a traditional gallery. Work needs to be of consistent, dependable quality. Have slides done by a professional if possible. Stick with one style—no scattershot approaches. Have a concrete proposal with installation sketches (if it's never been built). We book two years in advance so plan accordingly. Do not call. Put me on your mailing list 1 year before sending application so I can be familiar with your work and record. Ask to be put on my mailing list so you know the gallery's general approach. It works!"

INDIAN UPRISING GALLERY

308 E. Main St., Bozeman MT 59715. (406)586-5831. **E-mail:** info@indianuprisinggallery.com. **Website:** www.indianuprisinggallery.com. Retail gallery. "Dedicated exclusively to American Indian contemporary art featuring the unique beauty and spirit of the Plains Indians." The gallery specializes in ledger drawings, painted hides, jewelry. Artists include Linda Haukaas, Donald Montileaux, Dwayne Wilcox, Pauls Szabo, Jackie Bread. Open all year. Wednesday-Friday, 11-5:30; Saturday 11-3.
MEDIA Considers all media. Most frequently exhibits contemporary works by gallery artists.
TERMS Buys outright at wholesale price. On occasion takes consignments.
SUBMISSIONS Accepts only Native American artists of the Plains region. Send résumé, slides, bio and artist's statement. Write for appointment to show portfolio of photographs. Responds in 2 weeks. Finds artists through visiting museums and juried art shows.

INDIVIDUAL ARTISTS OF OKLAHOMA

P.O. Box 60824, Oklahoma OK 73146. (405)232-6060. **Fax:** (405)232-6060. **E-mail:** cstone@iaogallery.org. **Website:** www.iaogallery.org. **Contact:** Clint Stone, executive director. Estab. 1979. Alternative space. "IAO creates opportunities for Oklahoma artists by curating and developing socially relevant exhibitions in one of the finest gallery spaces in the region." Approached by 60 artists/year; represents or exhibits 30 artists. Sponsors 10 photography exhibits/year. Average display time 3-4 weeks. Open Tuesday–Saturday, 12-6. Gallery is located in downtown art district, 2,300 sq. ft. with 10 ft. ceilings and track lighting. Overall price range $100-2,000. Most work sold at $400.

MEDIA Considers all media. Most frequently exhibits photography, painting, installation.
STYLE Considers all styles. Most frequently exhibits "bodies of work with cohesive style and expressed in a contemporary viewpoint." Considers all genres.
SUBMISSIONS Mail portfolio for review. Send artist's statement, bio, photocopies or slides, résumé and SASE. Returns material with SASE. Responds in 3 months. Finds artists through word of mouth, art exhibits and referrals by other artists.
TIPS "IAO is committed to sustaining and encouraging emerging and established artists in all media who are intellectually and aesthetically provocative or experimental in subject matter or technique."

INTERSECTION FOR THE ARTS

925 Mission St., San Francisco CA 94103. (415)626-2787. **E-mail:** deborah@theintersection.org. **Website:** www.theintersection.org. **Contact:** Deborah Cullinan, executive director. Estab. 1965. Alternative space and nonprofit gallery. Exhibits the work of 10 emerging and mid-career artists/year. Sponsors 8 shows/year. Average display time 6 weeks. Open all year. Located in the Mission District of San Francisco; 1,000 sq. ft.; gallery has windows at one end and cement pillars between exhibition panels. 100% of space for special exhibitions. Clientele: 100% private collectors.

This gallery supports emerging and mid-career artists who explore experimental ideas and processes. Interdisciplinary, new genre, video performance and installation are encouraged.

MEDIA Considers oil, pen & ink, acrylic, drawings, watercolor, mixed media, installation, collage, photography, site-specific installation, video installation, original handpulled prints, woodcuts, lithographs, posters, wood engravings, mezzotints, linocuts and etchings.
STYLE Exhibits all styles and genres.
TERMS Retail price set by artist. Customer discounts and payment by installment are available. Gallery provides promotion; shipping costs are shared.
SUBMISSIONS Submission guidelines available online.
TIPS "Create proposals which consider the unique circumstances of this location, utilizing the availability of the theater and literary program/resources/audience."

IVANFFY-UHLER GALLERY

7668 El Camino Real, Suite 104, La Costa CA 92009. (760)730-9166. **E-mail:** info@ivanffyuhler.com. **Website:** www.ivanffyuhler.com. **Contact:** Paul Uhler, director. Estab. 1990. Retail/wholesale gallery. Represents 20 mid-career and established artists/year. May be interested in seeing the work of emerging artists in the future. Sponsors 1-2 shows/year. Average display time 1 month. Open by appointment only. Clientele: upscale, local community, tourists. 85% private collectors, 15% corporate collectors. Overall price range $1,000-20,000; most work sold at $1,500-4,000.

MEDIA Considers oil, acrylic, watercolor, pastel, pen & ink, drawing, mixed media, collage, paper, sculpture, woodcuts, engravings, lithographs, wood engravings, mezzotints, serigraphs, linocuts and etchings. Most frequently exhibits oils, mixed media, sculpture.

STYLE Exhibits neo-expressionism, painterly abstraction, surrealism, postmodern works, impressionism, hard-edge geometric abstraction, postmodern European school. Genres include florals, landscapes, figurative work.

TERMS Shipping costs are shared.

SUBMISSIONS Send query letter with résumé, photographs, bio and SASE. Write for appointment to show portfolio of photographs. Responds only if interested within 1 month.

ALICE AND WILLIAM JENKINS GALLERY

600 St. Andrews Blvd., Winter Park FL 32804. (407)671-1886. **Fax:** (407)671-0311. **E-mail:** Rberrie@ Crealde.org. **Website:** www.crealde.org. **Contact:** Rick Lang, director of photo department. Estab. 1980. The Jenkins Gallery mission is to exhibit the work of noted and established Florida artists, as well as to introduce national and international artists to the Central Florida region. Each of the 4-6 annual exhibitions are professionally curated by a member of the Crealdé Gallery Committee or a guest curator.

JESSEL GALLERY

1019 Atlas Peak Rd., Napa CA 94558. (707)257-2350. **Fax:** (707)257-2396. **E-mail:** jessel@napanet.net. **Website:** www.jesselgallery.com. **Contact:** Jessel Miller, owner. Retail gallery. Represents 5 major artists. Exhibited artists include Clark Mitchell, Timothy Dixon and Jessel Miller. Sponsors 2-6 shows/year. Average display time: 1 month. Open all year; 7 days/week, 10-5. Located 1 mile out of town; 9,000 sq. ft.

20% of space for special exhibitions; 50% of space for gallery artists. Clientele: upper income collectors. 95% private collectors, 5% corporate collectors. Overall price range: $25-10,000; most work sold at $2,000-3,500.

MEDIA Considers oil, acrylic, watercolor, pastel, collage, sculpture, ceramic and craft. Most frequently exhibits acrylic, watercolor and pastel.

STYLE Exhibits painterly abstraction, photorealism, realism and traditional. Genres include landscapes, florals and figurative work. Prefers figurative, landscape and abstract.

TERMS Accepts work on consignment (50% commission). Retail price set by gallery. Gallery provides promotion; artist pays for shipping costs. Prefers artwork framed.

SUBMISSIONS Send query letter with résumé, slides, bio, SASE and reviews. Call (after sending slides and background info) for appointment to show portfolio of photographs or slides. Responds in 1 month.

STELLA JONES GALLERY

201 St. Charles Ave., New Orleans LA 70170. (504)568-9050. **Fax:** (504)568-0840. **Website:** www.stellajones gallery.com. **Contact:** Stella Jones. Estab. 1996. For-profit gallery. "The gallery provides a venue for artists of the African diaspora to exhibit superior works of art. The gallery fulfills its educational goals through lectures, panel discussions, intimate gallery talks and exhibitions with artists in attendance." Approached by 40 artists/year; represents or exhibits 45 artists. Sponsors 1 photography exhibit/year. Average display time 6-8 weeks. Open Monday–Friday, 11-6; Saturday, 12-5; Sunday, by appointment only. Located on 1st floor of corporate 53-story office building downtown, 1 block from French Quarter. Overall price range $500-150,000. Most work sold at $5,000.

MEDIA Considers all media. Most frequently exhibits oil and acrylic. Considers all types of prints except posters.

STYLE Considers all styles. Most frequently exhibits postmodernism and geometric abstraction. Exhibits all genres.

TERMS Artwork is accepted on consignment (50% commission). Retail price set by the artist. Gallery provides insurance, promotion and contract. Accepted work should be framed. Requires exclusive representation locally.

SUBMISSIONS To show portfolio of photographs, slides and transparencies, mail for review. Send query letter with artist's statement, bio, brochure, business card, photocopies, photographs, résumé, reviews, SASE and slides. Returns material with SASE. Responds in 1 month. Finds artists through word of mouth, submissions, portfolio reviews, art exhibits, and referrals by other artists.

TIPS "Send organized, good visuals."

⊕ JRB ART AT THE ELMS

2810 North Walker, Oklahoma City OK 73103. (405)528-6336. **Fax:** (405)528-6337. **E-mail:** Jreed belt@jrbartgallery.com. **Website:** jrbartgallery.com. **Contact:** Joy Reed Belt, director. Estab. 2003. For-profit gallery. Exhibits emerging, mid-career, and established artists. Approached by 50 artists a year. Represents or exhibits 100 artists. Exhibited artists include Joe Andoe (serigraphs), Ford Beckam (mixed media), Glenna Goodacre (bronze sculpture). Average display time 1-2 months. Open Monday-Saturday 10-6; Sunday 1-5. Located in historic Paseo arts district 8,000 sq. ft. gallery. Clients include the local community, tourists, and upscale clientele. 30% of sales are to corporate collectors. Overall price range $500-50,000. Most work sold at $4,000-5,000.

MEDIA Considers all media, but most frequently exhibits oil, bronze, and mixed media. Prints considered are engravings, etchings, linocuts, lithographs, serigraphs, and woodcuts.

STYLE Considers all genres and styles but most frequently exhibits abstract, color field, surrealism.

TERMS Artwork is accepted on consignment and there is a 50% commission. Retail price set by the gallery. Gallery provides insurance, promotion, and contract. Accepted work should be framed. Requires exclusive representation locally.

SUBMISSIONS To submit, either mail portfolio for review, mail query letter with artist's statement, bio, and photographs, write to arrange personal interview to show portfolio, or e-mail query letter with link to artist's website or JPEG samples at 72 dpi. Responds in 6 weeks if interested. Finds artists through submissions, art exhibits, art fairs, and referrals by other artists.

JVA ART GROUP

4151 Taylor St., San Diego CA 92110. (619)299-3232. **Fax:** (619)299-8709. **E-mail:** Via the online contact form. **Website:** www.jvaartgroup.com. Estab. 1972.

(Formerly The Art Collector.) Retail gallery and art consultancy. Represents emerging, mid-career and established artists. Exhibited artists include Susan Singleton and Reed Cardwell. Average display time 1 month. Open Monday–Thursday, 8-5; Friday, 8:30-1. 1,000 sq. ft.; 100% of space for gallery artists. Clientele: upscale, business, decorators, health facilities, hotels, resorts, liturgical and residential artwork with interior designers, architects, landscape architects, developers and space planners. 50% private collectors, 50% corporate collectors. Overall price range $175-10,000; most work sold at $450-1,000. Other services include giclée printing, online artist resource (slide collection), custom commission work available and beginning to do governmental work.

MEDIA Considers all media and all types of prints. Most frequently exhibits paintings, sculpture, monoprints.

STYLE Exhibits all styles. Genres include all genres, especially florals, landscapes and figurative work. Prefers abstract, semi-realistic and realistic.

TERMS Artwork is accepted on consignment and there is a 50% commission. Retail price set by the artist. Gallery provides insurance. Gallery pays for shipping from gallery. Artist pays for shipping to gallery. Prefers artwork unframed.

SUBMISSIONS Send query letter with résumé and slides. Call for appointment to show portfolio of slides. Responds in 2 weeks. Files slides, biographies, information about artist's work. Finds artists through artist's submissions and referrals.

KAVANAUGH ART GALLERY

131 Fifth St., W. Des Moines IA 50265. (515)279-8682. **Fax:** (515)279-7609. **E-mail:** kagallery@gmail.com. **Website:** www.kavanaughgallery.com. **Contact:** Carole Kavanaugh, director. Estab. 1990. Retail gallery. Represents 100 mid-career and established artists/year. May be interested in seeing the work of emerging artists in the future. Exhibited artists include Kati Roberts, Don Hatfield, Dana Brown, Gregory Steele, August Holland, Ming Feng and Larry Guterson. Sponsors 3-4 shows/year. Average display time 3 months. Open all year; Monday–Saturday, 10-5. Located in Valley Junction shopping area; 10,000 sq. ft. 70% private collectors, 30% corporate collectors. Overall price range $300-20,000; most work sold at $800-3,000.

MEDIA Considers all media and all types of prints. Most frequently exhibits oil, acrylic and pastel.

STYLE Exhibits color field, impressionism, realism, florals, portraits, western, wildlife, southwestern, landscapes, Americana and figurative work. Prefers landscapes, florals and western.

TERMS Accepts work on consignment (50% commission). Retail price set by the artist. Gallery provides insurance, promotion and contract. Shipping costs are shared. Prefers artwork unframed.

SUBMISSIONS Send query letter with résumé, bio and photographs. Portfolio should include photographs. Responds in 3 weeks. Files bio and photos. Finds artists through word of mouth, referrals by other artists, visiting art fairs and exhibitions, artist's submissions.

TIPS "Get a realistic understanding of the gallery/artist relationship by visiting with directors. Be professional and persistent."

THE KENTUCK ART CENTER

503 Main Ave., Northport AL 35476. (205)758-1257. **Fax:** (205)758-1258. **E-mail:** kentuck@kentuck.org; jpruitt@kentuck.org. **Website:** www.kentuck.org. **Contact:** Executive director leads jury process. Estab. 1980. Nonprofit gallery. "The Kentuck Museum of Art presents monthly exhibitions, showcasing the work of both established artists and of up-and-comers. Sometimes traditional, sometimes visionary, always authentic, Kentuck brings art to the community and builds community with art. The annual Kentuck Festival of Art began in 1971." Approached by 400 artists/year. Represents 100 artists/year. Sponsors 24 exhibits/year. Average display time 1 month. Open Tuesday–Friday, 9-5; Saturday, 10-4:30. Closed major holidays. Clients include local community. Overall price range $150-10,000.

MEDIA Considers all media. Most frequently exhibits mixed media, natural materials, painting, pottery, and outsider art.

STYLE Considers all styles.

TERMS Artwork is accepted on consignment and there is a 40% commission on shop sales; 30% on exhibition sales. Retail price set by the artist. Gallery provides insurance, promotion and contract. For insurance purposes, artist must provide inventory manifest with photos of works, description, and value (even for not-for-sale items). Accepted work should be mounted.

SUBMISSIONS Submission instructions available online. Finds artists through word of mouth, submissions, portfolio reviews, art exhibits and referrals by other artists.

KENTUCKY MUSEUM OF ART AND CRAFT

715 West Main St., Louisville KY 40202. (502)589-0102. **E-mail:** aldy@kentuckyarts.org. **Website:** www.kentuckyarts.org. **Contact:** Aldy Milliken, executive director. Estab. 1981. Nonprofit gallery, museum. Approached by 300 artists/year. Represents 100 emerging, mid-career and established artists. Sponsors 20 exhibits/year. Average display time 4-6 weeks. Open all year; Monday–Friday, 10-5; Saturday, 11-5. Located in downtown Louisville, one block from the river; 3 galleries, one on each floor. Clients include local community, students, tourists, upscale. 10% of sales are to corporate collectors. Overall price range $50-40,000; most work sold at $200.

MEDIA Considers all media and all types of prints. Most frequently exhibits ceramics, glass, craft.

STYLE Exhibits primitivism realism.

TERMS Artwork is accepted on consignment and there is a 50% commission. Retail price set by the artist. Gallery provides insurance, promotion and contract. Accepted work should be framed and matted. Does not require exclusive representation locally.

SUBMISSIONS Send query letter with artist's statement, bio, photocopies, photographs, SASE and slides. Returns material with SASE. Responds to queries in 1 month. Files bio, artist's statement and copy of images. Finds artists through art fairs, art exhibits, portfolio reviews, referrals by other artists and submissions.

TIPS "Clearly identify reason for wanting to work with KMAC. Show a level of professionalism and a proven track record of exhibitions."

KERYGMA GALLERY

38 Oak St., Ridgewood NJ 07450. (201)444-5510. **E-mail:** KerygmaArt@aol.com. **Website:** www.kerygmagallery.com. Estab. 1988. Retail gallery. Specializes in contemporary American art. Subject matter includes the still life, landscapes, interiors, cityscapes and figurative sculpture. Represents 30 mid-career artists. Sponsors 9 shows/year. Average display time 4-6 weeks. Open Tuesday–Saturday, 10-5; Sunday, 1-5; evenings by appointment. Located in downtown business district; 2,000 sq. ft.; "professionally designed contemporary interior with classical Greek motif accents." Clientele: primarily residential, some corpo-

rate. 80-85% private collectors, 15-20% corporate collectors. Most work sold at $2,000-5,000.

MEDIA Considers oil, acrylic, watercolor, pastel, mixed media, sculpture. Prefers oil or acrylic on canvas.

STYLE Exhibits painterly abstraction, impressionism and realism. Genres include landscapes, florals, still life and figurative work. Prefers impressionism and realism.

TERMS Accepts artwork on consignment (50% commission). Retail price set by gallery and artist. Gallery provides insurance, promotion and in some cases, a contract; shipping costs are shared.

SUBMISSIONS Send query letter with résumé, slides, bio, photographs, reviews and SASE. Call for appointment to show portfolio originals, photographs and slides "only after interest is expressed by slide/photo review." Responds in 1 month. Files all written information, returns slides/photos.

TIPS "An appointment is essential—as is a slide register."

ANGELA KING GALLERY

241 Royal St., New Orleans LA 70130. (504)524-8211. **Fax:** (504)566-1944. **E-mail:** angela@angelaking gallery.com. **Website:** www.angelakinggallery.com. **Contact:** Angela King, gallery director. Estab. 1977. Formerly Hanson Gallery. For profit gallery. Represents 22 emerging, mid-career and established artists. Exhibited artists include Frederick Hart (sculptor) and Leroy Neiman (all mediums). Sponsors 6 exhibits/year. Average display time ongoing to 3 weeks. Open Monday–Saturday, 10-5; Sundays and holidays, 11-5. Clients include local community, tourists and upscale. Overall price range $650-100,000; most work sold at $4,000.

MEDIA Considers acrylic, drawing, oil, pastel, sculpture and watercolor. Most frequently exhibits oil, pastel and acrylic. Considers etchings, lithographs and serigraphs.

STYLE Exhibits impressionism, neo-expressionism and surrealism. Considers all styles. Genres include figurative work and landscapes.

TERMS Retail price set by the gallery and the artist. Gallery provides insurance. Requires exclusive representation locally.

SUBMISSIONS Write to arrange a personal interview to show portfolio of photographs and slides. Mail portfolio for review. Send query letter with artist's

statement, bio, brochure, photographs, résumé, reviews, SASE and slides. Responds in 6 weeks. Finds artists through word of mouth, submissions, art exhibits and art fairs.

TIPS "Archival-quality materials play a major role in selling fine art to collectors."

KINGSTON GALLERY

450 Harrison Ave. #43, Boston MA 02118. (617)423-4113. **E-mail:** gallerydirector@kingstongallery.com. **Website:** www.kingstongallery.com. **Contact:** Gail Erwin, director. Cooperative gallery. Estab. 1982. Exhibits the work of 20 emerging, mid-career and established artists. Sponsors 12 shows/year. Average display time 1 month. Open Wednesday-Sunday, 12-5. Closed August. Located "in downtown Boston (South End); 1,300 sq. ft.; large, open room with 12 ft. ceiling and smaller center gallery—can accommodate large installation." Overall price range $100-7,000; most work sold at $600-1,000.

MEDIA Considers all media. 20% of space for special exhibitions.

STYLE Exhibits all styles.

TERMS Co-op membership requires dues plus donation of time. 25% commission charged on sales by members. Retail price set by the artist. Sometimes offers payment by installments. Gallery provides insurance, some promotion and contract. Rental of center gallery by arrangement.

SUBMISSIONS Accepts only artists from New England for membership. Artist must fulfill monthly co-op responsibilities. Send query letter with résumé, slides, SASE and "any pertinent information. Slides are reviewed every other month. Gallery will contact artist within 1 month." Does not file material but may ask artist to re-apply in future.

TIPS "Please include thorough, specific information on slides size, price, etc."

KIRSTEN GALLERY, INC.

5320 Roosevelt Way NE, Seattle WA 98105. (206)522-2011. **E-mail:** kirstengallery@qwestoffice.net. **Website:** www.kirstengallery.com. **Contact:** Richard Kirsten, president. Estab. 1974. Retail gallery. Represents 60 emerging, mid-career and established artists. Exhibited artists include Birdsall and Daiensai. Sponsors 4 shows/year. Average display time 1 month. Open Wednesday–Sunday, 11-5. 3,500 sq. ft.; outdoor sculpture garden. 40% of space for special exhibitions; 60% of space for gallery artists. 90% private collec-

tors, 10% corporate collectors. Overall price range $75-15,000; most work sold at $75-2,000.

MEDIA Considers oil, acrylic, watercolor, mixed media, sculpture, glass and offset reproductions. Most frequently exhibits oil, watercolor and glass.

STYLE Exhibits surrealism, photorealism and realism. Genres include landscapes, florals, Americana. Prefers realism.

TERMS Accepts work on consignment (50% commission). Retail price set by artist. Offers payment by installments. Gallery provides promotion; artist pays shipping costs. "No insurance; artist responsible for own work."

SUBMISSIONS Send query letter with résumé, slides and bio. Write for appointment to show portfolio of photographs. Responds in 2 weeks. Files bio and résumé. Finds artists through visiting exhibitions and word of mouth.

TIPS "Keep prices down. Be prepared to pay shipping costs both ways. Work is not insured (send at your own risk). Send the best work—not just what you did not sell in your hometown. Do not show up without an appointment."

🌑 ⓝ MARIA ELENA KRAVETZ ART GALLERY

San Jeronimo 448, 5000 Cordoba, Argentina. (54)351 4221290. **Fax:** (54)351 4271776. **E-mail:** mek@maria elenakravetzgallery.com. **Website:** www.mariaelena kravetzgallery.com. **Contact:** Maria Elena Kravetz, director. Estab. 1998. For-profit gallery. Approached by 30 artists/year; exhibits 16 emerging and mid-career artists/year. Exhibited artists include Marina Gazulla and Tania Abrile (paintings) Anna Mazzoni (fiber arts) and Maria Moreno (jewels). Average display time: 25 days. Located in the main downtown of Cordoba city; 170 sq. meters, 50 spotlights and white walls. Overall price range: $500-10,000; most work sold at $1,500-5,000.

MEDIA Considers all media. Most frequently exhibits glass sculpture and mixed media. Considers etchings, linocuts, lithographs and woodcuts.

STYLE Considers all styles. Most frequently exhibits new-expressionism and painterly abstraction. Considers all genres.

TERMS Artwork is accepted on consignment (30% commission). Retail price set by the artist. Requires exclusive representation locally. Prefers only artists from South America and emphasizes sculptors.

SUBMISSIONS Mail portfolio for review. Cannot return material. Responds to queries in 1 month. Finds artists through art fairs and exhibits, portfolio reviews, referrals by other artists, submissions and word of mouth.

TIPS Artists "must indicate a website to make the first review of their works, then give an e-mail address to contact them if we are interested in their work."

LISA KURTS GALLERY

766 S. White Station Rd., Memphis TN 38117. (901)683-6200. **E-mail:** art@lisakurts.com. **Website:** www.lisakurts.com. Estab. 1979. For-profit gallery. Approached by 500 artists/year; exhibits 20 mid-career and established nationally and internationally known artists. Exhibited artists include Marcia Myers and Anita Huffington. Sponsors 9 total exhibitions/year. Average display time 4-6 weeks. Open all year; Tuesday–Friday, 10-5; Saturday, 11-4. "Lisa Kurts Gallery is Memphis's oldest gallery and is known to be one of the leading galleries in the USA. Exhibits nationally in International Art Fairs and is regularly reviewed in the national press. Publishes catalogues and works closely with serious collectors and museums. This gallery's sister company, Lisa Kurts, Ltd. specializes in blue chip Impressionist and Early Modern paintings and sculpture." Clients include national and international. Overall price range $5,000-100,000; most work sold at $7,500-15,000.

MEDIA Exhibits "80% oil painting, 18% sculpture, 2% photography."

STYLE Most frequently exhibits "artists with individual vision and who create works of art that are well crafted or painted." Considers all genres.

TERMS Artwork is accepted on consignment and there is a 50% commission. Retail price of the art set by the artist and the market if the artist's career is mature; set by the gallery if the artist's career is young. Gallery provides insurance, promotion and contract. Accepted work should be "professionally framed or archivally mounted as approved by gallery's standards." Requires exclusive representation in the South.

SUBMISSIONS Send query letter with artist's statement, résumé, reviews and slides. Returns materials with SASE. Responds to queries in 3 months. Files materials and complete information. Finds artists through art fairs and exhibits, portfolio reviews, referrals by other artists, submissions and word of mouth.

TIPS To make their gallery submissions professional, artists must send "clearly labeled slides and a minimum of 1 sheet, with the total résumé, artist's statement, letter why they contacted our gallery reviews, etc. Do not call. E-mail if you've not heard from us in 3 months."

THE LAB

2948 16th St., San Francisco CA 94103. (415)864-8855. **E-mail:** eilish@thelab.org. **Website:** www.thelab.org. **Contact:** Eilish Cullen, executive director. Estab. 1983. Nonprofit gallery and alternative space. Exhibits numerous emerging, mid-career artists/year. Interested in seeing the work of emerging artists. Sponsors 5-7 shows/year. Average display time 1 month. Open all year; Thursday–Saturday, 1-6 (during exhibitions). 40×55 ft.; 17 ft. height; 2,200 sq. ft.; white walls. Doubles as a performance and gallery space. Clientele: artists and Bay Area communities.

○ The LAB often curates panel discussions, performances or other special events in conjunction with exhibitions. They also sponsor an annual conference and exhibition on feminist activism and art.

MEDIA Considers all media with emphasis on interdisciplinary and experimental art. Most frequently exhibits installation art, interdisciplinary art, media art and group exhibitions.

TERMS Artists receive honorarium from the art space. Work can be sold, but that is not the emphasis.

SUBMISSIONS Submission guidelines online. Finds artists through word of mouth, submissions, calls for proposals.

TIPS Ask to be put on their mailing list to get a sense of the LAB's curatorial approach and interests.

LAKE GEORGE ARTS PROJECT/ COURTHOUSE GALLERY

Old County Courthouse, 1 Amherst St., Lake George NY 12845. (518)668-2616. **E-mail:** mail@lakegeorgearts.org. **Website:** www.lakegeorgearts.org. Estab. 1986. Alternative space; nonprofit gallery. "Presents 5-7 exhibitions yearly of regional and national contemporary visual artists in all media." Approached by 200 artists/year; exhibits 8-15 artists/year. Average display time: 5 weeks. Open Tuesday–Friday, 12-5; Saturday, 12-4 (during exhibitions); all other times by request.

MEDIA Exhibits all media.

STYLE Considers all styles.

TERMS Artwork is accepted on consignment (25% commission). Retail price set by the artist. Gallery provides insurance, promotion, contract.

SUBMISSIONS Annual deadline for open call is January 31. Send artist's statement, résumé, 10-12 images (slides or CD), image script and SASE. Guidelines available online. Returns material with SASE. Finds artists through art exhibits, portfolio reviews, referrals by other artists, submissions, word of mouth.

TIPS "Do not send e-mail submissions or links to website. Do not send original art. Review guidelines on website."

➕ LANA SANTORELLI GALLERY

628 Washington St., Hoboken NJ 07030. (201)798-9000. **Fax:** (201)798-9009. **E-mail:** info@lanasantorelli.com. **Website:** www.lanasantorelligallery.com. **Contact:** Bess Sobota, director. Estab. 2005.

MEDIA Considers all media. Most frequently exhibits painting, photography and mixed media works.

STYLE Considers all styles and genres.

TERMS Artwork is accepted on consignment and there is a 50% commission (in most cases). Retail price of the art set by the artist. Gallery provides insurance, promotion, contract. Accepted work should be framed, unless the nature of the piece prohibits it; all works on paper should be framed.

SUBMISSIONS Apply online at lanasantorelligallery.com/submissions/html and follow the guidelines. Material returned with SASE. Responds approximately one month before the start of each themed group exhibition. Responds only if interested for general submissions. Gallery will review work every 3-4 months for general submissions. Artist should follow-up with gallery after 3-4 months, but gallery will contact artist if their work is a good fit. All material kept on file for at least one year from submission date. Finds artists through word of mouth, submissions, art exhibits, art fairs, referrals by other artists.

TIPS "Visit our website and closely follow our submission guidelines."

LANCASTER MUSEUM OF ART

135 N. Lime St., Lancaster PA 17602. (717)394-3497. **E-mail:** info@lmapa.org. **Website:** www.lmapa.org. Estab. 1965. Nonprofit organization. "The Lancaster Museum of Art is recognized as one of the largest cultural organizations in the region responsible for an extensive collection of works by contemporary regional artists." Represents over 100 emerging, mid-

career and established artists/year. 900+ members. Located downtown Lancaster; 4,000 sq. ft.; neoclassical architecture. 100% of space for special exhibitions. 100% of space for gallery artists. Overall price range $100-25,000; most work sold at $100-10,000. Open Tuesday–Saturday, 10-4; 1st Friday, 5-8; Sunday, 12-4.

MEDIA Considers all media.

TERMS Accepts work on consignment. Retail price set by the artist. Gallery provides insurance; shipping costs are shared. Artwork must be ready for presentation.

SUBMISSIONS Send query letter with résumé, slides, photographs or CDs, SASE, and artist's statement for review by exhibitions committee. Annual deadline February 1.

TIPS Advises artists to submit quality slides and well-presented proposal. "No phone calls."

LANDING GALLERY

8 Elm St., Rockland ME 04841. (207)594-4544. **E-mail:** landinggallery@gmail.com. **Website:** www.landingart.com. **Contact:** Bruce Busko, president. Estab. 1985. For-profit gallery. Approached by 40 artists/year. Exhibits 35 emerging, mid-career and established artists. Exhibited artists include Bruce Busko (oil/mixed media), Irma Cerese (acrylic), Dorothy Simpsom Krause (mixed media), Roberta (photography), Michael Kahn (photography), Maria Nevelson (assemblage), Diana Godfrey (acrylic), and Bjorn Rundquist (oil). Sponsors 6 exhibits/year. Average display time: 1 month. Open 6 months, May through October; Monday-Saturday, 10-5; Sunday, 12-5. Closed Tuesdays all year, Sundays in summer. Located in mid-coast Maine next to the Farnsworth Art Museum and part of a 25 member gallery community. 2,600 sq. ft. on 2 floors with skylights, granite floors and 24-ft. ceilings. The gallery building and Landing Gallery Garden Courtyard are in the center of town. Clients include local community, tourists and upscale. 5% of sales are to corporate collectors. Overall price range: $100-12,000; most work sold at $400-1,500.

MEDIA Considers all media. Most frequently exhibits paintings, photographs and sculpture. Considers engravings, etchings, lithographs, mezzotints and serigraphs.

STYLE Considers all styles. Most frequently exhibits realism, abstract and impressionism. Considers figurative work, florals and landscapes.

TERMS Artwork is accepted on consignment (50% commission). Retail price set by the gallery. Gallery provides insurance, promotion and contract. Accepted work should be framed. Requires exclusive representation in a 100-mile radius.

SUBMISSIONS By e-mail or call to arrange a personal interview to show portfolio of photographs, slides and transparencies. Mail portfolio for review. Send query letter with artist's statement, bio, brochure, business card, photocopies, photographs, résumé, reviews, SASE and slides. Returns material with SASE. Responds in 2 weeks. Files photos, slides, photocopies and information. Finds artists through word of mouth, submissions, portfolio reviews, art exhibits, art fairs and referrals by other artists.

TIPS "Permanence denotes quality and professionalism."

ROBERT LANGE STUDIOS

2 Queen St., Charleston SC 29401. **E-mail:** info@rlsart.com. **Website:** www.robertlangestudios.com. **Contact:** Megan Lange, co-owner. Estab. 2005. For-profit gallery. Approached by 100+ artists/year. Exhibits mid-career artists. Exhibited artists include Robert Lange, Amy Lind and Nathan Durfee. Sponsors 12 exhibits/year. Average display time 6 months. Open Monday–Sunday, 11-5. Gallery located in an historic area; 3000+ sq. feet. Clients include: local community, tourists, upscale. Overall price range: $200-20,000. Most work sold at $2,000.

MEDIA Considers acrylic, collage, installation, pen & ink, mixed media, sculpture, drawing, oil. Most frequently exhibits oil.

STYLE Considers all styles. Most frequently exhibits surrealism, conceptualism. Considers all genres. Most frequently exhibits figurative work, landscapes and portraits.

TERMS Artwork accepted on consignment with a 50% commission. Retail price set by the artist. Gallery provides insurance, promotion, contract. Accepted work should be framed. Requires exclusive representation locally.

SUBMISSIONS Artists should e-mail query letter with link to website and 8 JPEG samples at 72 dpi. Responds in 1 week. Files images and contact info. Finds artists through submissions and referrals by other artists.

TIPS Have a nice website!

LATINO ARTS, INC.

1028 S. Ninth St., Milwaukee WI 53204. (414)384-3100 ext. 61. **Fax:** (414)649-4411. **E-mail:** info@latinoarts inc.org. **Website:** www.latinoartsinc.org. Nonprofit gallery. Represents emerging, mid-career and established artists. Sponsors up to 5 individual and group exhibitions/year. Average display time 2 months. Open all year; Monday-Friday, 9-8. Latino Arts, Inc. is located in the United Community center on the near southeast side of Milwaukee (gallery is in the main building on the UCC campus); 1,200 sq. ft.; one-time church. Clientele: the general Hispanic community. Overall price range $100-2,000.

MEDIA Considers all media, all types of prints. Most frequently exhibits original 2D and 3D works and photo exhibitions.

STYLE Exhibits all styles, all genres. Prefers artifacts of Hispanic cultural and educational interests.

TERMS "Our function is to promote cultural awareness (not to be a sales gallery)." Retail price set by the artist. Artist is encouraged to donate 15% of sales to help with operating costs. Gallery provides insurance, promotion, contract, shipping costs to gallery; artist pays shipping costs from gallery. Prefers artwork framed.

SUBMISSIONS Send query letter with résumé, slides, bio, business card and reviews. Call or write for appointment to show portfolio of photographs and slides. Responds in 2 weeks. Finds artists through recruiting, networking, advertising and word of mouth.

SHERRY LEEDY CONTEMPORARY ART

2004 Baltimore Ave., Kansas City MO 64108. (816)221-2626. **Fax:** (816)221-8689. **E-mail:** sherry leedy@sherryleedy.com. **Website:** www.sherryleedy. com. **Contact:** Sherry Leedy, director. Estab. 1985. Retail gallery. Represents 50 mid-career and established artists. Exhibited artists include Jun Kaneko, Mike Schultz, Vera Mercer, and more. Sponsors 6 shows/year. Average display time 6 weeks. 5,000 sq. ft. of exhibit area in 3 galleries. Clients include established and beginning collectors. 85% of sales are to private collectors, 50% corporate clients. Price range $50-100,000; most work sold at $3,500-35,000. Open Tuesday–Saturday, 11-5; and by appointment.

MEDIA Considers all media and one-of-a-kind or limited-edition prints; no posters. Most frequently exhibits painting, photography, ceramic sculpture and glass.

STYLE Considers all styles.

TERMS Accepts work on consignment (50% commission). Retail price set by gallery in consultation with the artist. Sometimes offers customer discounts and payment by installment. Exclusive area representation required. Gallery provides insurance, promotion; shipping costs are shared. Prefers artwork framed.

SUBMISSIONS E-mail query letter, résumé, artist's statement, and digital images or link to website. No work will be reviewed in person without a prior appointment. Write for appointment to show portfolio of originals, slides and transparencies. Bio, vita, slides, articles, etc. are filed if they are of potential interest.

TIPS "Please allow 3 months for gallery to review slides."

LEEPA-RATTNER MUSEUM OF ART

St. Petersburg College, 600 Klosterman Rd., Tarpon Springs FL 34689. (727)712-5762. **E-mail:** lrma@sp college.edu. **Website:** www.spcollege.edu/museum. **Contact:** R. Lynn Whitelaw, curator. The museum's 20th century collection is made up of art from Abraham Rattner's estate, donated by Allen and Isabelle Leepa, and a large donation made by the Tampa Museum of Art. The museum is filled with Rattner's retrospective works: lithographs, tapestries, sculptures, paintings and stained glass." Open Tuesday, Wednesday, Saturday, 10-5; Thursday, 10-8; Friday, 10-4, Sunday, 1-5. Closed Mondays and national holidays. Located on the Tarpon Springs campus of St. Petersburg College.

MEDIA Considers all types of media and prints. Mostly exhibits 20th-century artwork.

STYLE Considers all genres.

LEGION ARTS

1103 Third St. SE, Cedar Rapids IA 52401-2305. (319)364-1580. **Fax:** (319)362-9156. **E-mail:** info@le gionarts.org. **Website:** www.legionarts.org. **Contact:** Mel Andringa, producing director. Estab. 1991. Alternative space, nonprofit gallery. Approached by 50 artists/year. Exhibits 15 emerging artists. Exhibited artists include Bill Jordan (photographs), Paco Rosic (spray can murals). Sponsors 15 exhibits/year. Average display time 2 months. Open Wednesday–Sunday, 11-6. Closed July and August. Located in south end Cedar Rapids; old Czech meeting hall, 2 large galleries and off-site exhibits; track lights, carpet, ornamental tin ceilings. 65 events a year. Clients include

local community. Overall price range $50-500; most work sold at $200.

MEDIA Considers all media and all types of prints. Most frequently exhibits painting, mixed media and installation.

STYLE Considers all styles. Most frequently exhibits postmodernism, conceptualism and surrealism.

TERMS Artwork is accepted on consignment and there is a 30% commission. Retail price set by the artist. Gallery provides insurance and promotion. Accepted work should be framed. Requires exclusive representation locally.

SUBMISSIONS Send query letter with artist's statement, bio, SASE and slides. Responds in 6 months. Files résumé, sample slide and statement. Finds artists through word of mouth, art exhibits and art trade magazines.

LEHIGH UNIVERSITY ART GALLERIES

420 E. Packer Ave., Bethlehem PA 18015. (610)758-3619. **Fax:** (610)758-4580. **E-mail:** rv02@lehigh.edu. **Website:** www.luag.org. **Contact:** Ricardo Viera, director/curator. Sponsors 5-8 exhibits/year. Average display time 6-12 weeks. Sponsors openings. Exhibits fine art/multicultural, Latin American. Interested in all types of works.

TERMS Arrange a personal interview to show portfolio. Send query letter with SASE. Responds in 1 month.

SUBMISSIONS "Don't send more than 10 slides or a CD."

DAVID LEONARDIS GALLERY

Wicker Park, 1436 North Paulina, Chicago IL 60610. (312)863-9045; (773)278-3058. **E-mail:** david@dlg-gallery.com. **Website:** www.dlg-gallery.com. **Contact:** David Leonardis, owner. Estab. 1992. For-profit gallery. Approached by 100 artists/year. Represents 12 emerging, mid-career and established artists. Exhibited artists include Kristen Thiele and Christopher Makos. Average display time: 30 days. Open by appointment. Clients include local community, tourists, upscale. 10% of sales are to corporate collectors. Overall price range: $50-5,000; most work sold at $500.

MEDIA Most frequently exhibits painting, photography and lithography. Considers lithographs and serigraphs.

STYLE Exhibits pop. Most frequently exhibits contemporary, pop, folk, photo. Genres include figurative work and portraits.

TERMS Artwork is accepted on consignment, and there is a 50% commission. Retail price set by the gallery and the artist. Gallery provides promotion. Accepted work should be framed. Does not require local representation. Prefers artists who are professional and easy to deal with.

SUBMISSIONS E-mail. Responds only if interested. E-mails and JPEGs are filed. Finds artists through word of mouth, art exhibits, and referrals by other artists.

LEOPOLD GALLERY

324 W. 63rd St., Kansas City MO 64113. (816)333-3111. **Fax:** (816)333-3616. **E-mail:** email@leopoldgallery.com. **Website:** www.leopoldgallery.com. **Contact:** Robin Elliott, assistant director. Estab. 1991.

MEDIA Considers all media. Most frequently exhibits oils, acrylics, blown glass, ceramic, stainless steel. Some works on paper.

STYLE Considers all styles and genres. Most frequently exhibits abstraction, impressionism, conceptual.

SUBMISSIONS E-mail query letter with JPEG samples or link to website. Mail query letter with résumé, printed images, reviews, SASE and disk with images. Returns material with SASE. Responds to queries in 2 months. Finds artists through submissions, portfolio reviews, referrals by clients and artists. Only represents MO and KS artists.

RICHARD LEVY GALLERY

514 Central Ave., SW, Albuquerque NM 87102. (505)766-9888. **Fax:** (505)242-4279. **E-mail:** info@levygallery.com. **Website:** www.levygallery.com. Estab. 1991. "Comprised of contemporary art of all mediums by emerging and established regional, national and international artists. The gallery shows 6-8 exhibitions/year and participates in selected art fairs." Open Tuesday–Saturday, 11-4. Closed during art fairs (always noted on voice message). Located on Central Ave. between 5th and 6th. Clients include upscale.

MEDIA Considers all media. Most frequently exhibits paintings, prints and photography.

STYLE Contemporary art.

SUBMISSIONS Submissions by e-mail preferred. "Please include images and any other pertinent information (artist's statement, bio, etc.). When sending submissions by post, please include slides or photographs and SASE for return of materials."

TIPS "Portfolios are reviewed at the gallery by invitation or appointment only."

LIBERTY VILLAGE ARTS CENTER

410 Main St., Chester MT 59522. (406)759-5652. **E-mail:** lvac@mtintouch.net. **Website:** www.liberty villagearts.org. Estab. 1976. Nonprofit gallery. Represents 12-20 emerging, mid-career and established artists/year. Sponsors 6-12 shows/year. Average display time 6-8 weeks. Open all year; Tuesday–Friday, 12:30-4:30. Located near a school; 1,000 sq. ft.; former Catholic Church. Clients include tourists and local community. 100% of sales are to private collectors. Overall price range $100-2,500; most work sold at $250-500.

MEDIA Considers all media; types of prints include woodcuts, lithographs, mezzotints, serigraphs, linocuts and pottery. Most frequently exhibits paintings in oil, water, acrylic, b&w photos and sculpture assemblages.

STYLE Considers all styles. Prefers contemporary and historic.

TERMS Accepts work on consignment (30% commission) or buys outright for 40% of retail price. Retail price set by the gallery. Gallery provides insurance and promotion; shipping costs are shared. Prefers artwork framed or unframed.

SUBMISSIONS Send query letter with slides, bio and brochure. Portfolio should include slides. Responds only if interested within 1 year. "Artists should cross us off their list." Files everything. Finds artists through word of mouth and seeing work at shows.

TIPS "Artists make the mistake of not giving us enough information and permission to pass information on to other galleries."

LIMITED EDITIONS & COLLECTIBLES

697 Haddon Ave., Collingswood NJ 08108. (856)869-5228. **Fax:** (856)869-5228. **E-mail:** jdl697ltd@juno.com. **Website:** www.ltdeditions.net. **Contact:** John Daniel Lynch, Sr., owner. Estab. 1997. For-profit gallery. Approached by 24 artists/year. Exhibited artists include Richard Montmurro, James Allen Flood and Gino Hollander. Open all year. Located in downtown Collingswood; 700 sq. ft. Overall price range: $190-20,000; most work sold at $450.

MEDIA Considers all media and all types of prints. Most frequently exhibits acrylic, watercolors and oil.

STYLE Considers all styles and genres.

TERMS Artwork is accepted on consignment, and there is a 30% commission. Retail price set by the artist. Gallery provides insurance, promotion and contract. Accepted work should be framed, mounted and matted. Does not require exclusive representation locally.

SUBMISSIONS Call or write to arrange a personal interview to show portfolio. Send query letter with bio, business card and résumé. Responds in 1 month. Finds artists through word of mouth, portfolio reviews, art exhibits and referrals by other artists.

LIMNER GALLERY

123 Warren St., Hudson NY 12534. (518)828-2343. **E-mail:** thelimner@aol.com. **Website:** www.slowart.com. **Contact:** Tim Slowinski, director. Estab. 1987. Artist-owned alternative retail (consignment) gallery. Represents emerging and mid-career artists. Hosts periodic thematic exhibitions of emerging artists selected by competition, cash awards up to $1,000. Entry available for SASE or from website. Sponsors 6-8 shows/year. Average display time one month. Open Thursday-Sunday, 12-6; year round, by appointment. Located in storefront 400 sq. ft. 60-80% of space for special exhibitions; 20-40% of space for gallery artists. Clients include lawyers, real estate developers, doctors, architects. 95% of sales are to private collectors, 5% corporate collectors. Overall price range $300-10,000.

MEDIA Considers all media, all types of prints except posters. Most frequently exhibits painting, sculpture and works on paper.

STYLE Exhibits primitivism, surrealism, political commentary, satire, all styles, postmodern works, all genres. "Gallery exhibits all styles but emphasis is on non-traditional figurative work."

TERMS Accepts work on consignment (50% commission). Retail price set by the gallery and the artist. Gallery provides promotion and contract; artist pays shipping costs to and from gallery. Prefers artwork framed.

SUBMISSIONS Send query letter with résumé, slides, bio and SASE. Call for appointment to show portfolio of originals, photographs, slides and transparencies. Responds in 3 weeks. Files slides, résumé. Finds artists through word of mouth, art publications and sourcebooks, submissions.

LIZARDI/HARP GALLERY

P.O. Box 91895, Pasadena CA 91109. (626)791-8123. **Fax:** (626)791-8887. **E-mail:** lizardiharp@earthlink. net. **Contact:** Grady Harp, director. Estab. 1981. Retail gallery and art consultancy. Represents 15 emerging, mid-career and established artists/year. Exhibited artists include Wes Hempel, Gerard Huber, Wade Reynolds, Robert Peterson, William Fogg, and José Parra sponsors 4 shows/year. Average display time: 2 months. Open all year; Tuesday-Saturday, by appointment only. 80% private collectors, 20% corporate collectors. Overall price range: $900-80,000; most work sold at $2,000-15,000.

MEDIA Considers oil, acrylic, watercolor, pastel, pen & ink, drawing, mixed media, sculpture, installation, photography, lithographs and etchings. Most frequently exhibits works on paper and canvas, sculpture, photography.

STYLE Exhibits representational art. Genres include landscapes, figurative work (both portraiture and narrative) and still life. Prefers figurative, landscapes and experimental.

TERMS Accepts work on consignment (50% commission). Retail price set by the gallery and the artist. Gallery provides insurance, promotion, contract; artist pays shipping costs.

SUBMISSIONS Send query letter with artist's statement, résumé, 20 slides, bio, photographs, SASE and reviews. Write for appointment to show portfolio of photographs, slides and transparencies. Responds in 1 month. Files "all interesting applications." Finds artists through studio visits, group shows, submissions.

TIPS "Timelessness of message (rather than trendy) is a plus. Our emphasis is on quality or craftsmanship, evidence of originality and maturity of business relationship concept." Artists are encouraged to send an artist's statement with application and at least 10-20 JPEGs.

LOCUST PROJECTS

3852 North Miami Ave., Miami FL 33127. (305)576-8570. **E-mail:** locustprojects@yahoo.com. **Website:** www.locustprojects.org. **Contact:** Submissions. Estab. 1998. Alternative space and nonprofit gallery. 1,271 sq. ft. Exhibited artists include Kate Gilmore (video/drawing), Francesca DiMattio (mural/installation) and TM Sisters (performance/installation). Sponsors 6 exhibits/year. Average display time 4-6 weeks. Open Wednesday–Saturday, 12-5; and by appointment.

MEDIA Most frequently exhibits installation.

STYLE Exhibits postmodernism and contemporary.

TERMS Retail price set by the artist. Gallery provides promotion. Does not require exclusive representation locally.

SUBMISSIONS Submission details available online.

LONG BEACH ARTS GALLERY

5372 Long Beach Blvd., Long Beach CA 90805. (562)423-9689. **E-mail:** lba.gallery@gmail.com. **Website:** www.long-beach-arts.org. Estab. 1924. Since 1924, Long Beach Arts has been a nonprofit art organization and an on-going collaborative venture between local artists and the community. The gallery hosts a wide variety of juried, group exhibitions in most media. Open Wednesday–Sunday, 12-4 (during open exhibitions only).

STYLE Color field, conceptualism, expressionism, impressionism, minimalism, neo-expressionism, primitive realism, surrealism and painterly abstraction. Considers all genres.

TERMS Artwork is accepted on consignment with a 30% commission. Call or e-mail for further information.

LONGVIEW MUSEUM OF FINE ARTS

215 E. Tyler St., Longview TX 75606. (903)753-8103. **Fax:** (903)753-8217. **E-mail:** fineart@lmfa.org; director@lmfa.org. **Website:** www.lmfa.org. **Contact:** Renee Hawkins, director. Estab. 1967. Represents 80 emerging, mid-career and established artists/year. 600 members. Sponsors 6-9 shows/year. Average display time 6 weeks. Open all year; Tuesday–Friday, 10-4; Saturday, 12-4. Located downtown. 75% of space for special exhibitions. Clientele members, visitors (local and out-of-town) and private collectors. Overall price range $200-2,000; most work sold at $200-800.

MEDIA Considers all media, all types of prints. Most frequently exhibits oil, acrylic and photography.

STYLE Exhibits all styles and genres. Prefers contemporary American art and photography.

TERMS Accepts work on consignment (30% commission). Retail price set by the artist. Offers customer discounts to museum members. Gallery provides insurance and promotion. Prefers artwork framed.

SUBMISSIONS Send query letter with résumé and slides. Portfolio review not required. Responds in 1 month. Files slides and résumés. Finds artists through art publications and shows in other areas.

➕ LOS ANGELES MUNICIPAL ART GALLERY

4800 Hollywood Blvd., Los Angeles CA 90027. **Website:** lamag.org. **Contact:** Scott Canty, director. Estab. 1954. A nonprofit, municipally owned gallery. Exhibits emerging, mid-career, and established artists. Sponsors 8 total exhibits/year. Average display time is 8 weeks. Open Thursday-Sunday from 12-5. A 10,000 sq. ft. city-run facility located in Barnsdall Park in Hollywood CA. Clients include local community, students, tourists, and upscale clientele.

MEDIA Accepts all media.

TERMS Gallery provides insurance and promotion. Accepted artwork should be framed.

SUBMISSIONS "Visit our website for upcoming show opportunities." Responds to queries in 2 weeks. Files artists and proposals of interests. Finds artists through word of mouth, submissions, portfolio review, art exhibits, art fairs, referrals by other artists and the DCA Slide Registry.

MALTON GALLERY

3804 Edwards Rd., Cincinnati OH 45209. (513)321-8614. **E-mail:** srombis@maltonartgallery.com. **Website:** www.maltonartgallery.com. **Contact:** Sylvia Rombis, director. Estab. 1974. Retail gallery. Represents about 100 emerging, mid-career and established artists. Exhibits 20 artists/year. Exhibited artists include Carol Henry, Mark Chatterley, Terri Hallman and Esther Levy. Sponsors 7 shows/year (2-person shows alternate with display of gallery artists). Average display time: 1 month. Open all year; Tuesday-Saturday, 11-5; or by appointment. Located in high-income neighborhood shopping district; 2,500 sq. ft. Clientele: private and corporate. Overall price range: $250-10,000; most work sold at $400-2,500.

MEDIA Considers oil, acrylic, drawing, sculpture, watercolor, mixed media, pastel, collage and original handpulled prints.

STYLE Exhibits all styles. Genres include contemporary landscapes, figurative and narrative and abstractions work.

TERMS Accepts work on consignment (50% commission). Retail price set by artist (sometimes in consultation with gallery). Gallery provides insurance, promotion, contract and shipping costs from gallery; artist pays shipping costs to gallery. Prefers framed works for canvas; unframed works for paper.

SUBMISSIONS Send query letter with résumé, slides or photographs, reviews, bio and SASE. Responds in 4 months. Files résumé, review or any printed material. Slides and photographs are returned.

TIPS "Never drop in without an appointment. Be prepared and professional in presentation. This is a business. Artists themselves should be aware of what is going on, not just in the 'art world,' but with everything."

BEN MALTZ GALLERY

Otis College of Art & Design, 1st Floor, Bronya and Andy Galef Center for Fine Arts, 9045 Lincoln Blvd., Los Angeles CA 90045. (310)665-6905. **E-mail:** galleryinfo@otis.edu. **Website:** www.otis.edu/public_programs/ben_maltz_gallery/index.html. Estab. 1957. Nonprofit gallery. Represents emerging and mid-career artists. Sponsors 4-6 exhibits/year. Average display time: 1-2 months. Open Tuesday–Saturday, 10-5 (Thursday, 10-7); closed Sundays, Mondays and major holidays. Located near Los Angeles International Airport (LAX); approximately 3,520 sq. ft.; 14-ft. walls. Clients include local community, students, tourists, upscale and artists.

MEDIA Considers all media and all types of prints. Most frequently exhibits painting, mixed media.

SUBMISSIONS Submission guidelines available online. Only accepts materials digitally. Do not send 35mm slides, disks, DVDs, catalogues of artwork unless specifically requested by the gallery after your initial submission has been reviewed.

TIPS "Follow submission guidelines and be patient."

THE MARBELLA GALLERY, INC.

28 E. 72nd St., New York NY 10021. (212)288-7809. **E-mail:** marbellagallery@aol.com. Estab. 1971. Retail gallery. Represents/exhibits established artists of the 19th century. Exhibited artists include The Ten and The Eight. Sponsors 1 show/year. Average display time 6 weeks. Open all year; Tuesday-Saturday, 11-5:30. Located uptown; 750 sq. ft. 100% of space for special exhibitions. Clients include tourists and upscale. 50% of sales are to private collectors, 10% corporate collectors, 40% dealers. Overall price range $1,000-60,000; most work sold at $2,000-4,000.

STYLE Exhibits expressionism, realism and impressionism. Genres include landscapes, florals, Americana and figurative work. Prefers Hudson River, "The Eight" and genre.

TERMS Artwork is bought outright. Retail price set by the gallery. Gallery provides insurance.

⊕ MARIN MUSEUM OF CONTEMPORARY ART

500 Palm Dr., Novato CA 94949. (415)506-0137. **Fax:** (415)506-0139. **E-mail:** info@marinmoca.org. **Website:** www.marinmoca.org. **Contact:** Heather Murray, executive director. Estab. 2007. Nonprofit gallery. Exhibits emerging, mid-career and established artists. Sponsors 15+ exhibits/year; 1 photography exhibit/year. Model and property release is preferred. Average display time 5 weeks. Open Wednesday-Sunday, 11-4; closed Thanksgiving, Christmas, New Year's Day. MarinMOCA is located in historic Hamilton Field, a former Army Air Base. The Spanish-inspired architecture makes for a unique and inviting exterior and interior space. Houses two exhibition spaces—the Main Gallery (1,633 sq. ft.) and the Hamilton Gallery (750 sq. ft.). Part of the Novato Arts Center, which also contains approximately 40 artist studios and a classroom (offers adult classes and a summer camp for children). Clients include local community, students, tourists, upscale. Overall price range $200-20,000. Most work sold at $500-1,000.

MEDIA Considers all media except video. Most frequently exhibits acrylic, oil, sculpture/installation.

STYLE Considers all prints, styles and genres.

TERMS Artwork is accepted on consignment and there is a 40% commission. Retail price of the art set by the artist. Gallery provides insurance, promotion (for single exhibition only, not representation), contract (for consignment only, not representation). Accepted work should be framed (canvas can be unframed, but prints/collage/photos should be framed). "We do not have exclusive contracts with, nor do we represent artists."

SUBMISSIONS "We are currently not accepting portfolio submissions at this time. Please visit our website for updates. If you are interested in gallery rental, please visit our website and follow the instructions." Finds artists through word of mouth and portfolio reviews.

TIPS "Keep everything clean and concise. Avoid lengthy, flowery language and choose clear explanations instead. Submit only what is requested and shoot for a confident, yet humble tone. Make sure images are good quality (300 dpi) and easily identifiable regarding title, size, medium."

MARIN-PRICE GALLERIES

7022 Wisconsin Ave., Chevy Chase MD 20815. (301)718-0622. **E-mail:** fmp@marin-price.com. **Website:** www.marin-pricegalleries.com. **Contact:** Francisco Marin-Price. Estab. 1992. Retail/wholesale gallery. Represents/exhibits 25 established painters and 4 sculptors/year. Exhibited artists include Joseph Sheppard, March Avery, William Woodward, Jeremiah Stermer, Jenness Cortez and others. Sponsors 24 shows/year. Average display time 3 weeks. Open Monday–Saturday, 10:30-7; Sunday, 12-5. 1,500 sq. ft. 50% of space for special exhibitions. Clientele: upscale. 90% private collectors, 10% corporate collectors. Overall price range $5,000-75,000; most work sold at $6,000-18,000.

MEDIA Considers oil, drawing, watercolor and pastel. Most frequently exhibits oil, watercolor and pastels.

STYLE Exhibits expressionism, photorealism, neo-expressionism, primitivism, realism and impressionism. Genres include landscapes, florals, Americana and figurative work.

TERMS Retail price set by the gallery and the artist. Gallery provides insurance, promotion and contract. Artist pays for shipping costs to and from the artist. Prefers artwork framed.

SUBMISSIONS Prefers only oils. Send query letter with résumé, slides, bio and SASE. Responds in 6 weeks.

◑ MARKEIM ART CENTER

104 Walnut St., Haddonfield NJ 08033. (856)429-8585. **E-mail:** markeim@verizon.net. **Website:** www.markeimartcenter.org. **Contact:** Elizabeth H. Madden, executive director. Estab. 1956. Nonprofit gallery. Sponsors 10-11 exhibits/year. Average display time: 4 weeks. Overall price range: $75-1,000; most work sold at $350.

MEDIA Considers all media. Must be original. Most frequently exhibits paintings, photography and sculpture.

STYLE Exhibits all styles and genres.

TERMS Charges 30% commission. Accepted work should be framed, mounted or unmounted, matted or unmatted. Artists from New Jersey and Delaware Valley region are preferred. Work must be professional and high quality.

SUBMISSIONS Send slides by mail for consideration. Include SASE, résumé and letter of intent. Responds in 1 month.

TIPS "Be patient and flexible with scheduling. Look not only for one-time shows, but for opportunities to develop working relationships with a gallery. Establish yourself locally and market yourself outward."

MARLBORO GALLERY

Prince George's Community College, 301 Largo Rd., Largo MD 20772-2199. (301)322-0965. **Fax:** (301)808-0418. **E-mail:** tberault@pgcc.edu. **Website:** www.pgcc.edu. **Contact:** Tom Berault, curator-director. Estab. 1976. Interested in emerging, mid-career and established artists. Sponsors 4 solo and 4 group shows/year. Average display time: 1 month. Seasons for exhibition: September-May. 2, 100 sq. ft. with 10-ft. ceilings and 25-ft. clear story over 50% of space track lighting (incandescent) and daylight. Clientele: 100% private collectors. Overall price range: $200-10,000; most work sold at $500-700. "We are open to all serious artists and all media. We will consider all proposals without prejudice." Accepts artwork on consignment. Retail price set by artist. Exclusive area representation not required. Gallery provides insurance. Artist pays for shipping. Artwork must be ready for display.

MEDIA Considers all media. Most frequently exhibits acrylics, oils, photographs, watercolors and sculpture.

STYLE Exhibits mainly expressionism, neo-expressionism, realism, photorealism, minimalism, primitivism, painterly abstraction, conceptualism and imagism. Exhibits all genres.

TERMS Send cover letter with résumé, CD or slides, SASE, photographs, artist's statement and bio. Portfolio review requested if interested in artist's work. Portfolio should include slides and photographs.

SUBMISSIONS Responds every 6 months. Files résumé, bio and slides. Finds artists through word of mouth, visiting exhibitions and submissions. Impressed by originality. "Indicate if you prefer solo shows or will accept inclusion in group show chosen by gallery."

JAIN MARUNOUCHI GALLERY

24 W. 57th St., Suite 605, New York NY 10019. (212)969-9660. **Fax:** (212)969-9715. **E-mail:** jainmar@aol.com. **Website:** artin2000.com. Estab. 1991. Retail gallery. Represents 30 emerging artists. Exhibited artists include Fernando Pomalaza and Pauline Gagnon. Open all year; Tuesday–Saturday, 11-5; or by appointment. Located in New York Gallery Bldg., 800 sq. ft. 100% of space for special exhibitions. Clients include corporate and designer. 50% of sales are to private collectors, 50% corporate collectors. Overall price range $1,000-20,000; most work sold at $5,000-10,000.

MEDIA Considers oil, acrylic and mixed media. Most frequently exhibits oil, acrylic and collage.

STYLE Exhibits painterly abstraction. Prefers abstract and landscapes.

TERMS Accepts work on consignment (50% commission). Retail price set by artist. Offers customer discount. Gallery provides contract; artist pays for shipping costs. Prefers artwork framed.

SUBMISSIONS "If you are interested in submitting materials to our gallery, please mail a current résumé as well as a representative set of images (maximum of 20) along with an SASE if you wish to have your materials returned. You may e-mail your materials or mail them to our gallery for consideration."

MATHIAS FINE ART

10 Mathias Dr., Trevett ME 04571. (207)633-7404. **Contact:** Cordula Mathias, president. Estab. 1991. For profit gallery. Approached by 20-30 artists/year. Represents 15-20 emerging, mid-career and established artists. Exhibited artists include Brenda Bettinson and Mike Culver. Sponsors 6 exhibits/year. Average display time 2 months. Open all year; Wednesday-Sunday, 12-5; and by appointment. Mid-November through mid-May by appointment only. Located in Mid-Coast area of Maine; 400 sq. ft. combination of natural and artificial lighting. Clients include local community, tourists and upscale. Percentage of sales to corporate collectors varies. Overall price range $50-25,000; most work sold at $1,200.

MEDIA Considers acrylic, collage, drawing, original prints, mixed media, oil, paper and pen & ink. Most frequently exhibits painting, drawing and photography. Considers all types of prints except posters.

STYLE Considers all styles and genres.

TERMS Artwork is accepted on consignment and there is a 50% commission. Retail price set by the gallery and the artist. Gallery provides promotion and contract. Accepted work should be framed and matted. Requires exclusive representation locally. Prefers paintings or works on paper. Prefers artists who can deliver and pick up.

SUBMISSIONS Send query letter with bio, photographs, résumé, reviews and photographs. Returns material with SASE. Responds in 6 weeks. Files CV, artist's statement, visuals if of interest within 6-18

months. Finds artists through word of mouth, submissions, portfolio reviews, art exhibits, and referrals by other artists.

TIPS "Send clearly labeled photographs, well organized vita and an informative artist's statement. Archival-quality materials are 100% essential in selling fine art to collectors."

NEDRA MATTEUCCI GALLERIES

1075 Paseo De Peralta, Santa Fe NM 87501. (505)982-4631. **Fax:** (505)984-0199. **E-mail:** pr@matteucci.com. **Website:** www.matteucci.com. Estab. 1972. For-profit gallery. Main focus of gallery is on deceased artists of Taos, Sante Fe and the West. Approached by 20 artists/year. Represents 100 established artists. Exhibited artists include Dan Ostermiller and Glenna Goodacre. Sponsors 3-5 exhibits/year. Average display time 1 month. Open all year; Monday–Saturday, 8:30-5. Clients are upscale.

MEDIA Considers drawing, oil, pen & ink, sculpture and watercolor. Most frequently exhibits oil, watercolor and bronze sculpture.

STYLE Exhibits impressionism. Most frequently exhibits impressionism, modernism and realism. Genres include Americana, figurative work, landscapes, portraits, Southwestern, Western and wildlife.

TERMS Artwork is accepted on consignment. Retail price set by the gallery and the artist. Requires exclusive representation within New Mexico.

SUBMISSIONS Write to arrange a personal interview to show portfolio of transparencies. Send query letter with bio, photographs, résumé and SASE.

⌂ MAUI HANDS

P.O. Box 974, Makawao, HI 96768 (808)573-2021. **Fax:** (808)573-2022. **E-mail:** panna@mauihands.com. **Website:** www.mauihands.com. **Contact:** Panna Cappelli, owner. Estab. 1992. For-profit gallery. Approached by 50-60 artists/year. Continuously exhibits 300 emerging, mid-career and established artists. Exhibited artists include Linda Whittemore (abstract monotypes) and Steven Smeltzer (ceramic sculpture). Sponsors 15-20 exhibits/year; 2 photography exhibits/year. Average display time: 1 month. Open Monday-Sunday 10-7, weekends 10-6. Closed on Christmas and Thanksgiving. Three spaces: #1 on Main Highway, 1,200 sq. ft. gallery, 165 sq. ft. exhibition; #2 on Main Highway, 1,000 sq. ft. gallery, 80 sq. ft. exhibition; #3 in resort, 900 sq. ft. gallery, 50 sq. ft. exhibition. Clients include local community, tourists and upscale.

3% of sales are to corporate collectors. Overall price range: $10-7,000. Most work sold at $350.

MEDIA Considers all media. Most frequently exhibits oils, pastels, and mixed media. Considers engravings, etchings, linocuts, lithographs, and serigraphs.

STYLE Considers painterly abstraction, impressionism and primitivism realism. Most frequently exhibits impressionism and painterly abstraction. Genres include figurative work, florals, landscapes and portraits.

TERMS Artwork accepted on consignment with a 55% commission. Retail price of the art set by the gallery and artist. Gallery provides insurance and promotion. Artwork should be framed, mounted and matted, as applicable. Only accepts artists from Hawaii.

SUBMISSIONS Artists should call, write to arrange personal interview to show portfolio of original pieces, e-mail query letter with link to artist's website (JPEG samples at 72 dpi), or send query letter with artist's statement, bio, brochure, photographs, résumé, business cards and reviews. Responds in days. All materials filed. Finds artists through word of mouth, submissions, portfolio reviews, art exhibits, art fairs and referrals by other artists.

TIPS "Best to submit your work via our website."

ERNESTO MAYANS GALLERY

601 Canyon Rd., Santa Fe NM 87501. (505)983-8068. **E-mail:** arte2@aol.com. **Website:** www.ernestomayansgallery.com. **Contact:** Ernesto Mayans, Anya Maria Mayans and Pablo Mayans, directors. Estab. 1977. Publishers, retail gallery and art consultancy. Publishes books, catalogs and portfolios. Overall price range: $200-5,000.

MEDIA Considers oil, acrylic, watercolor, pastel, pen & ink, drawings, mixed media, sculpture, photography and original handpulled prints. Most frequently exhibits oil, photography, and lithographs.

STYLE Exhibits 20th-century American and Latin American art. Genres include landscapes and figurative work.

TERMS Accepts work on consignment (50% commission). Retail price set by gallery and artist. Exclusive area representation required. Size limited to 11×20 maximum.

SUBMISSIONS Arrange a personal interview to show portfolio. Send query by mail with SASE for consideration. Responds in 2 weeks. Charges 50%

commission. Consigns. Requires exclusive representation within area.

TIPS "Please call before submitting."

MCGOWAN FINE ART, INC.

10 Hills Ave., Concord NH 03301. (603)225-2515. **Fax:** (603)225-7791. **E-mail:** art@mcgowanfineart.com. **Website:** www.mcgowanfineart.com. **Contact:** Mary McGowan, owner/art consultant. Estab. 1980. Retail gallery and art consultancy. Represents emerging, mid-career and established artists. Sponsors 8 shows/year. Average display time 1 month. Located just off Main Street. 50% of space for special exhibitions. Clients include residential and corporate. Most work sold at $125-9,000. Open Tuesday–Friday, 10-6 (though frequently in store on Mondays); Saturday, 10-2; or by appointment. Closed Memorial and Labor Day weekends, Christmas (and Dec. 26), New Year's Day.

MEDIA Considers oil, acrylic, watercolor, pastel, mixed media, collage, works on paper, sculpture, woodcuts, wood engravings, linocuts, engravings, mezzotints, etchings, lithographs and serigraphs. Most frequently exhibits sculpture, watercolor and oil/acrylic.

STYLE Exhibits painterly abstraction, landscapes, etc.

TERMS Accepts work on consignment (50% commission). Retail price set by artist. Gallery provides insurance and promotion; negotiates payment of shipping costs. Prefers artwork unframed.

SUBMISSIONS Send query letter with résumé, 5-10 slides and bio. Responds in 1 month. Files materials.

TIPS "I am interested in the number of years you have been devoted to art. Are you committed? Do you show growth in your work?"

☐ MCLEAN PROJECT FOR THE ARTS

McLean Community Center, 1234 Ingleside Ave., McLean VA 22101. (703)790-1953. **Fax:** (703)790-1012. **E-mail:** nsausser@mpaart.org. **Website:** www.mpaart.org. **Contact:** Nancy Sausser, exhibitions director. Nonprofit visual arts center; alternative space. Estab. 1962. Represents emerging, mid-career and established artists from the mid-Atlantic region. Exhibited artists include Yuriko Yamaguchi and Christopher French. Sponsors 12-15 shows/year. Average display time: 5-6 weeks. Open Tuesday–Friday, 10-4; Saturday, 1-5. Luminous "white cube" type of gallery, with moveable walls; 3,000 sq. ft. 85% of space for special exhibitions. Clientele: local community, students,

artists' families. 100% private collectors. Overall price range: $200-15,000; most work sold at $800-1,800.

MEDIA Considers all media except graphic design and traditional crafts; all types of prints except posters. Most frequently exhibits painting, sculpture and installation.

STYLE Exhibits all styles, all genres.

TERMS Artwork is accepted on consignment (25% commission). Retail price set by the artist. Gallery provides insurance and promotion. Artist pays for shipping costs. Prefers framed artwork (if on paper).

SUBMISSIONS Accepts only artists from Maryland, District of Columbia, Virginia and some regional mid-Atlantic. Send query letter with résumé, slides, reviews and SASE. Responds within 4 months. Artists' bios, slides and written material kept on file for 2 years. Finds artists through referrals by other artists and curators, and by visiting exhibitions and studios.

TIPS "Visit the gallery several times before submitting proposals, so that the work you submit fits the framework of art presented."

MCMURTREY GALLERY

3508 Lake St., Houston TX 77098. (713)523-8238. **E-mail:** info@mcmurtreygallery.com. **Website:** www.mcmurtreygallery.com. Estab. 1983. Retail gallery. Primarily represents contemporary regional artists. The gallery's emphasis is on painting by both early and mid-career artists, many of whom are included in museum collections and are recognized and exhibited nationally. The gallery also represents a select group of internationally known photographers." Represents 20 emerging and mid-career artists. Exhibited artists include Robert Jessup and Jean Wetta. Sponsors 10 shows/year. Average display time: 1 month. Open Tuesday–Friday, 10:30-5; Saturday, 11-5. Located near downtown; 2,600 sq. ft. Clients include corporations. 75% of sales are to private collectors, 25% corporate collectors. Overall price range: $400-17,000; most work sold at $1,800-6,000.

MEDIA Considers oil, acrylic, pastel, drawings, mixed media, collage, works on paper, photography and sculpture. Most frequently exhibits mixed media, acrylic and oil.

STYLE Exhibits figurative, narrative, painterly abstraction and realism.

TERMS Accepts work on consignment (50% commission). Retail price set by gallery and artist. Prefers artwork framed.

SUBMISSIONS Send query letter with résumé, images and SASE. Call for appointment to show portfolio of originals and slides.

TIPS "Be aware of the work the gallery exhibits and act accordingly. Please make an appointment."

�ीं MERIDIAN MUSEUM OF ART

628 25th Ave., P.O. Box 5773, Meridian MS 39302. (601)693-1501. **E-mail:** meridianmuseum@bell south.net. **Website:** www.meridianmuseum.org. Estab. 1970. Represents emerging, mid-career and established artists. Interested in seeing the work of emerging artists. Located downtown; 3,060 sq. ft. These figures refers to exhibit spaces only. The entire museum is about 6,000 sq. ft.; housed in renovated Carnegie Library building, originally constructed 1912-13. 50% of space for special exhibitions. Clientele: general public. Overall price range: $150-2,500; most work sold at $300-1,000.

MEDIA Considers all media.

STYLE Exhibits all styles, all genres.

TERMS Work available for sale during exhibitions. Retail price set by the artist. Gallery provides insurance and promotion; shipping costs are shared. Prefers framed artwork.

SUBMISSIONS Prefers artists from Mississippi, Alabama and the Southeast. Send query letter with résumé, slides, bio and SASE. Responds in 3 months. Finds artists through submissions, referrals, work included in competitions and visiting exhibitions.

MESA CONTEMPORARY ARTS AT MESA ARTS CENTER

1 E. Main St., P.O. Box 1466, Mesa AZ 85211. (480)644-6560. **E-mail:** patty.haberman@mesaartscenter.com. **Website:** www.mesaartscenter.com. **Contact:** Patty Haberman, curator. Estab. 1980.

MEDIA Considers all media including sculpture, painting, printmaking, photography, fibers, glass, wood, metal, video, ceramics, installation and mixed.

STYLE Exhibits all styles and genres. Interested in seeing contemporary work.

TERMS Charges 25% commission. Retail price set by artist. Gallery provides insurance, promotion and contract; pays for shipping costs from gallery. Requires framed artwork.

SUBMISSIONS Send a query letter or postcard with a request for a prospectus. After you have reviewed prospectus, send slides of up to 4 works (may include details if appropriate). "We do not offer portfolio review.

Artwork is selected through national juried exhibitions." Files slides and résumés. Finds artists through gallery's placement of classified ads in various art publications, mailing news releases and word of mouth.

TIPS "Scout galleries to determine their preferences before you approach them. Have professional quality slides. Present only your very best work in a professional manner."

MICHALOPOULOS OCTAVIA'S HAZE GALLERY

498 Hayes St., San Francisco CA 94102. (415)255-6818. **Fax:** (415)255-6827. **E-mail:** info@michalopoulossf.com; lycrowder@gmail.com. **Website:** michalopoulos sf.com. Estab. 1999. For-profit gallery. Approached by 60 artists/year. Represents James Michalopoulos. Open all year; Wednesday-Saturday, 12-6; Sunday, 12-5. Closed Christmas through New Years. Clients include local community, tourists and upscale. 13% of sales are to corporate collectors. Overall price range $200-6,000; most work sold at $600.

R. MICHELSON GALLERIES

132 Main St., Northampton MA 01060. (413)586-3964. **Fax:** (413)587-9811. **E-mail:** RM@RMichelson.com. **Website:** www.rmichelson.com. **Contact:** Richard Michelson, owner and president. Estab. 1976. Retail gallery. Represents 30 emerging, mid-career and established artists/year. Exhibited artists include Barry Moser and Leonard Baskin. Sponsors 6 shows/year. Average display time 1 month. Open all year; Monday-Saturday, 10-6; Sunday, 12-5. Located downtown; Northampton gallery has 3,500 sq. ft.; Amherst gallery has 1,800 sq. ft. 50% of space for special exhibitions. Clientele 80% private collectors, 20% corporate collectors. Overall price range $100-75,000; most artwork sold at $1,000-25,000.

MEDIA Considers all media and all types of prints. Most frequently exhibits oil, egg tempera, watercolor and lithography.

STYLE Exhibits impressionism, realism and photorealism. Genres include florals, portraits, wildlife, landscapes, Americana and figurative work.

TERMS Accepts work on consignment (commission varies). Retail price set by gallery and artist. Customer discounts and payment by installment are available. Gallery provides promotion; shipping costs are shared.

SUBMISSIONS Prefers Pioneer Valley artists. Send query letter with résumé, slides, bio, brochure and

SASE. Write for appointment to show portfolio. Responds in 3 weeks. Files slides.

MILL BROOK GALLERY & SCULPTURE GARDEN

236 Hopkinton Rd., Concord NH 03301. (603)226-2046. **E-mail:** artsculpt@mindspring.com. **Website:** www.themillbrookgallery.com. Estab. 1996. Exhibits 70 artists. Sponsors 1 photography exhibit/year. Average display time 6 weeks. Gallery open Tuesday–Sunday, 11-5, April 1–December 24; open by appointment December 25–March 31. Outdoor juried sculpture exhibit. Three rooms inside for exhibitions, 1,800 sq. ft. Overall price range $8-30,000. Most work sold at $500-1,000.

MEDIA Considers acrylic, ceramics, collage, drawing, glass, mixed media, oil, pastel, sculpture, watercolor, etchings, mezzotints, serigraphs and woodcuts. Most frequently exhibits oil, acrylic and pastel.

STYLE Considers all styles. Most frequently exhibits color field/conceptualism, expressionism. Genres include landscapes. Prefers more contemporary art.

TERMS Artwork is accepted on consignment (50% commission). Retail price set by the artist. Gallery provides insurance, promotion and contract. Accepted work should be framed and matted.

SUBMISSIONS Provides insurance, promotion and contract. Accepted work should be framed and matted. Write to arrange a personal interview to show portfolio of photographs, slides. Send query letter with artist's statement, bio, photocopies, photographs, résumé, slides, SASE. Submission of art work: Accept CDs, websites, slides, and digital images. Responds to all artists within month, only if interested. Finds artists through word of mouth, submissions, art exhibits, referrals by other artists.

PETER MILLER GALLERY

118 N. Peoria St., Chicago IL 60607. (312)226-5291. **Fax:** (312)226-5441. **E-mail:** director@petermiller gallery.com. **Website:** www.petermillergallery.com. **Contact:** Peter Miller and Natalie R. Domchenko, directors. Estab. 1979. Retail gallery. Represents 15 emerging, mid-career and established artists. Sponsors 9 solo and 3 group shows/year. Average display time is 1 month. Clientele: 80% private collectors, 20% corporate clients. Overall price range $500-30,000; most artwork sold at $5,000 and up.

MEDIA Considers oil, acrylic, mixed media, collage, sculpture, installations and photography. Most frequently exhibits oil and acrylic on canvas and mixed media.

STYLE Exhibits abstraction, conceptual and realism.

TERMS Accepts work on consignment (50% commission). Retail price set by gallery and artist. Exclusive area representation required. Insurance, promotion and contract negotiable.

SUBMISSIONS Send a sheet of 20 slides of work done in the past 18 months with a SASE. Slides, show card are filed.

MILLS POND HOUSE GALLERY

Smithtown Township Arts Council, 660 Route 25 A, St. James NY 11780. **E-mail:** gallery@stacarts.org. **Website:** www.stacarts.org. **Contact:** Gallery coordinator. Nonprofit gallery. Sponsors 9 exhibits/year (1-2 photography). Average display time is 5 weeks. Hours: Monday–Friday, 10-5; weekends, 12-4. Considers all types of prints, media and styles. Prices set by the artist. Gallery provides insurance and promotion. Work should be framed. Clients: local and national community.

MOBILE MUSEUM OF ART

4850 Museum Dr., Mobile AL 36608-1917. (251)208-5200. **E-mail:** eric.gallichant@cityofmobile.org. **Website:** www.mobilemuseumofart.com. **Contact:** Tommy McPherson, director. Clientele tourists and general public. Sponsors 6 solo and 12 group shows/year. Average display time 6-8 weeks. Interested in emerging, mid-career and established artists. Overall price range $100-5,000; most artwork sold at $100-500.

MEDIA Considers all media and all types of visual art.

STYLE Exhibits all styles and genres. "We are a general fine arts museum seeking a variety of styles, media and time periods." Looking for "historical significance."

TERMS Accepts work on consignment (20% commission). Retail price set by artist. Exclusive area representation not required. Gallery provides insurance, promotion, contract; shipping costs are shared. Prefers framed artwork.

SUBMISSIONS Send query letter with résumé, brochure, business card, slides, photographs, bio and SASE. Write to schedule an appointment to show a portfolio, which should include slides, transparencies and photographs. Replies only if interested within 3 months. Files résumés and slides. All material is returned with SASE if not accepted or under consideration.

TIPS "Be persistent but friendly!"

MONTEREY MUSEUM OF ART AT LA MIRADA

720 Via Mirada, Monterey CA 93940. (408)372-5477. **Fax:** (408)372-5680. **E-mail:** mdegroat@montereyart. org. **Website:** www.montereyart.org. **Contact:** Mary De Groat, director of communications. Estab. 1959. Nonprofit museum. Exhibits the work of emerging, mid-career and established artists. Average display time is 3-4 months.

MEDIA Considers all media.

STYLE Exhibits contemporary, abstract, impressionistic, figurative, landscape, primitive, non-representational, photorealistic, western, realist, neo-expressionistic and post-pop works.

TERMS No sales. Museum provides insurance, promotion and contract; shipping costs are shared.

SUBMISSIONS Send query letter, résumé, 20 slides and SASE. Portfolio review not required. Résumé and cover letters are filed. Finds artists through agents, visiting exhibitions, word of mouth, various art publications and sourcebooks, artists' submissions/self promotions, art collectors' referrals.

THE MUNSON GALLERY

880 Main St., Chatham MA 02633. (508)945-2888. **E-mail:** art@munsongallery.net. **Website:** www.munsongallery.com. Estab. 1860. Retail gallery. "One of America's oldest art galleries." Approached by 400 artists/year; exhibits 50 emerging, mid-career and established artists/year. Exhibited artists include Elmer Schooley (oils on canvas) and Richard Segalman (oils, watercolors and monoprints). Sponsors 9 shows/year. Average display time 3 weeks. Open all year; Monday-Friday, 9:30-5; weekends, 10-5. Located in a complex that houses about 10 contemporary art galleries. 100% of space for gallery artists. Clientele upscale locals and tourists. Overall price range $450-150,000; most work sold at $2,000.

MEDIA Considers all media. Considers engravings, etchings, linocuts, lithographs, monotypes, woodcuts and aquatints. Most frequently exhibits oils watercolor, pastel.

STYLE Exhibits "contemporary representational, not too much abstract, except in sculpture." Genres include florals, southwestern, landscapes.

TERMS Accepts work on consignment (50% commission). Retail price set by the artist. Gallery provides promotion. Accepted work should be framed.

SUBMISSIONS Send query letter with artist's statement, bio, photographs, résumé, SASE and slides. Call or write for appointment to show portfolio of photographs, slides and transparencies. Responds as soon as possible. Finds artists through portfolio reviews, referrals by other artists, submissions and word of mouth. Files bios occasionally, announcements.

TIPS "At the moment, the gallery is not taking on any new artists, though portfolios will be reviewed. We will not actually be adding any new artists to our roster for at least a year. Submissions welcome, but with the understanding that this is the case."

THE CATHERINE G. MURPHY GALLERY

Visual Arts Building, St. Catherine University, 2004 Randolph Ave., St. Paul MN 55105. (651)690-6644. **E-mail:** kmdaniels@stkate.edu. **Website:** www.stkate. edu/gallery. **Contact:** Kathy Daniels, director. Estab. 1973. Nonprofit gallery. "The Catherine G. Murphy Gallery presents 5 exhibitions during each academic calendar year (September–May). These exhibitions are selected a year to a year and a half in advance of the actual show. Four of the venues are exhibitions selected from outside proposals representing local, national and international artists. The fifth exhibition, April-May, is set aside for the annual Senior Art Student Juried Show." Represents emerging, mid-career and nationally and regionally established artists. Open Monday–Friday, 8-8; Saturday and Sunday, 12-6 (see website for a list of university holidays and gallery closings). Located in the Visual Arts Building on the campus of St. Catherine University; 1,480 sq. ft.

Ｏ Gallery shows 75% women's art since it is part of an all-women's undergraduate program.

MEDIA Considers a wide range of media for exhibition.

STYLE Considers a wide range of styles.

TERMS Artwork is loaned for the period of the exhibition. Gallery provides insurance. Shipping costs are shared. Prefers artwork framed.

SUBMISSIONS Send query letter with résumé, bio, artist's statement, CDs, checklist of images (title, size, medium, etc.) and color reproductions of 2-3 images. Include SASE for return of materials. Responds in 6 weeks. Files résumé and cover letters. Serious consideration is given to artists who do group proposals under one inclusive theme. Complete submission guidelines available online.

MICHAEL MURPHY GALLERY M

2701 S. MacDill Ave., Tampa FL 33629. (813)902-1414. **Fax:** (813)835-5526. **Website:** www.michaelmurphy gallery.com. **Contact:** Michael Murphy. Estab. 1988. (Formerly Michael Murphy Gallery, Inc.) For-profit gallery. Approached by 100 artists/year; exhibits 35 artists. Sponsors 1 photography exhibit/year. Average display time 1 month. See website for current gallery hours. Overall price range $500-15,000. Most work sold at less than $1,000. "We provide elegant, timeless artwork for our clients' home and office environment as well as unique and classic framing design. We strongly believe in the preservation of art through the latest technology in archival framing."

MEDIA Considers all media. Most frequently exhibits acrylic, oil and watercolor. Considers all types of prints.

STYLE Considers all styles. Most frequently exhibits color field, impressionism and painterly abstraction. Considers all genres.

TERMS Artwork is accepted on consignment and there is a 50% commission. Retail price set by the gallery. Accepted work should be framed. Requires exclusive representation locally.

SUBMISSIONS Send query with artist's statement, bio, brochure, business card, photocopies, photographs, résumé, reviews, SASE and slides. Cannot return material. Responds to queries only if interested in 1 month. Files all materials. Finds artists through art fairs and exhibits, portfolio reviews, referrals by other artists, submissions and word of mouth.

MUSEO ITALOAMERICANO

Fort Mason Center, Bldg. C, San Francisco CA 94123. (415)673-2200. **Fax:** (415)673-2292. **E-mail:** sfmuseo@sbcglobal.net. **Website:** www.museoitalo americano.org. Estab. 1978. Museum. Approached by 80 artists/year. Exhibits 15 emerging, mid-career and established artists/year. Exhibited artists include Sam Provenzano. Sponsors 7 exhibits/year. Average display time: 3-4 months. Open all year; Tuesday-Sunday, 12-4. Closed major holidays. Located in the San Francisco Marina District with beautiful view of the Golden Gate Bridge; 3,500 sq. ft. of exhibition space. Clients include local community, students, tourists, upscale and members. Free admission.

MEDIA Considers all media and all types of prints. Most frequently exhibits mixed media, paper, photography, oil, sculpture and glass.

STYLE Considers all styles and genres. Most frequently exhibits primitivism realism, geometric abstraction, figurative and conceptualism; 20th-century and contemporary art.

TERMS "The museum sells pieces in agreement with the artist; and if it does, it takes 25% of the sale." Gallery provides insurance and promotion. Accepted work should be framed, mounted and matted. Accepts only Italian or Italian-American artists.

SUBMISSIONS Submissions accepted with artist's statement, bio, brochure, photography, résumé, reviews, SASE and slides or CDs. Returns material with SASE. Responds in 2 months. Files 2 slides, bio and artist's statement for each artist. Finds artists through word of mouth and submissions.

TIPS Looks for "good-quality slides and clarity in statements and résumés. Be concise."

THE MUSEUM OF FLORIDA ART, INC.

600 N. Woodland Blvd., Deland FL 32720. (386)734-4371. **E-mail:** fithian@museumoffloridaart.org. **Website:** www.delandmuseum.com. **Contact:** David Fithian, exhibitions coordinator. Estab. 1951. Exhibits the work of established artists. "The mission of the Museum shall be to promote and showcase Florida art, and emerging and established Florida artists, by providing a wide range of exceptional cultural experiences, exhibitions, and educational and interpretive programming made available to a diverse statewide audience of all ages." Sponsors 8-10 shows/year. Open Tuesday–Saturday, 10-4; Sunday, 1-4. Located near downtown; 5,300 sq. ft.; in the Cultural Arts Center; 18 ft. carpeted walls, two gallery areas, including a modern space. Clientele: 85% private collectors, 15% corporate collectors. Overall price range $100-30,000; most work sold at $300-5,000.

MEDIA Considers oil, acrylic, watercolor, pastel, works on paper, sculpture, ceramic, woodcuts, wood engravings, engravings and lithographs. Most frequently exhibits painting, sculpture, photographs and prints.

STYLE Exhibits contemporary art, the work of Florida artists, expressionism, surrealism, impressionism, realism and photorealism; all genres. Interested in seeing work that is finely crafted and expertly composed, with innovative concepts and professional execution and presentation. Looks for "quality, content, concept at the foundation—any style or content meeting these requirements considered."

TERMS Accepts work on consignment for exhibition period only. Retail price set by artist. Gallery provides insurance, promotion and contract; shipping costs may be shared.
SUBMISSIONS Send résumé, slides, bio, brochure, SASE and reviews. Files slides and résumé. Reviews slides twice a year.
TIPS "Artists should have a developed body of artwork and an exhibition history that reflects the artist's commitment to the fine arts. Museum contracts 2-3 years in advance. Label each slide with name, medium, size and date of execution."

NEVADA MUSEUM OF ART

160 W. Liberty St., Reno NV 89501. (775)329-3333. **Fax:** (775)329-1541. **E-mail:** wolfe@nevadaart.org. **Website:** www.nevadaart.org. **Contact:** Ann Wolfe, curator. Estab. 1931. Sponsors 12-15 exhibits/year. Average display time: 2-3 months.
MEDIA Considers all media.
STYLE Exhibits all styles and genres.
TERMS Acquires art "by committee following strict acquisition guidelines per the mission of the institution."
SUBMISSIONS Send query letter with slides. Write to schedule an appointment to show a portfolio. "No phone calls and no e-mails, please."
TIPS "The Nevada Museum of Art is a private, non-profit institution dedicated to providing a forum for the presentation of creative ideas through its collections, educational programs, exhibitions and community outreach. We specialize in art addressing the environment and the altered landscape."

NEW HARMONY GALLERY OF CONTEMPORARY ART

506 Main St., New Harmony IN 47631. (812)682-3156. **Fax:** (812)682-3870. **E-mail:** skrhoades@usi.edu. **Website:** www.nhgallery.com. **Contact:** Sara Rhodes, senior gallery associate. Estab. 1975. Nonprofit gallery. Provides an exhibition space for current Midwestern artists to promote discourse about and access to contemporary art in the southern Indiana region. Approached by 25 artists/year. Represents 8 emerging and mid-career artists. Exhibited artists include Patrick Dougherty, sculpture/installation. Sponsors 8 exhibits/year. Average display time 6 weeks. Open Tuesday–Saturday, 10-5; Sundays, 12-4 (April-December). Clients include local community, students, tourists and upscale.

MEDIA Considers all media and all types of prints. Most frequently exhibits sculpture and installation.
STYLE Considers all styles including contemporary. No genre specified.
TERMS Artwork is accepted on consignment and there is a 35% commission. Gallery provides insurance, promotion and contract. Accepted work should be framed, mounted and matted. Does not require exclusive representation locally. Prefers midwestern artists.
SUBMISSIONS Send query letter with artist's statement, bio, résumé, SASE and slides. Returns material with SASE. Finds artists through art fairs, art exhibits, portfolio reviews and submissions.

A NEW LEAF GALLERY

Cornerstone Sonoma, 23588 Arnold Dr. (Hwy. 121), Sonoma CA 95476. (707)933-1300. **E-mail:** info@sculpturesite.com. **Website:** www.sculpturesite.com. Estab. 1990. Retail gallery. Represents 100 emerging, mid-career and established artists. Sponsors 10 sculpture shows/year. Average display time: 3-4 months. Open daily, 10-5. Clients include local community, upscale. Overall price range: $1,000-100,000; most work sold at $5,000-20,000.
MEDIA Considers sculpture, mixed media, ceramic and glass. Most frequently exhibits sculpture. No crafts. "No paintings or works on paper, please."
STYLE Exhibits only contemporary abstract and abstract figurative.
TERMS Accepts artwork on consignment. Retail price set by artist in cooperation with gallery. Gallery provides insurance. Exclusive area representation required.
SUBMISSIONS Digital images are best; or send e-mail link to your website for review. Responds 2-3 times per year.
TIPS "We suggest artists visit us if possible; and, in any case, check website before submitting."

NEW VISIONS GALLERY, INC.

1000 N. Oak Ave., Marshfield WI 54449. (715)387-5562. **E-mail:** newvisions.gallery@frontier.com. **Website:** www.newvisionsgallery.org. Estab. 1975. Nonprofit educational gallery. Represents emerging, mid-career and established artists. Located in the lobby of Marshfield Clinic with additional office space and support on the lower level. The facilities are donated to the community program by Marshfield Clinic. New Visions organizes a dynamic series of changing ex-

hibitions which are displayed in a 1600 sq. ft. secure, climate controlled gallery. Exhibits change every 6-8 weeks and feature a variety of art forms including national traveling exhibitions, significant works on loan from private and public collections, and quality regional art." Does not represent artists on a continuing basis but does accept exhibition proposals. Average display time: 6 weeks. Open all year; Monday–Friday, 9-5:30. Includes a small gift shop with original jewelry, notecards and crafts at $10-50. "We do not show country crafts."

MEDIA Considers all media.

STYLE Exhibits all styles and genres.

TERMS Accepts work on consignment (35% commission). Retail price set by artist. Gallery provides insurance and promotion. Prefers artwork framed.

SUBMISSIONS Send query letter with artist's statement, résumé, SASE, image list, and a CD with 8-10 images in JPEG format. "Images should be at 72 dpi and should not exceed 250 KB. Images files should be labeled with your last name, first initial and number corresponding to the number on your image list (ex. doej-01.jpg)." The image list should include the image file name, artwork title, size of artwork and art medium.

NEXUS/FOUNDATION FOR TODAY'S ART

1400 N. American St., Philadelphia PA 19106. (215)684-1946. **E-mail:** info@nexusphiladelphia.org. **E-mail:** membership@nexusphiladelphia.org. **Website:** nexusphiladelphia.org. **Contact:** Nick Cassway, executive director. Estab. 1975. Alternative space; cooperative, nonprofit gallery. Approached by 40 artists/year; represents or exhibits 20 artists. Sponsors 2 photography exhibits/year. Average display time 1 month. Open Wednesday–Sunday, 12-6; closed July and August. Located in Fishtown, Philadelphia; 2 gallery spaces, approximately 750 sq. ft. each. Overall price range: $75-1,200. Most work sold at $200-400.

MEDIA Considers acrylic, ceramics, collage, craft, drawing, fiber, glass, installation, mixed media, oil, paper, pen & ink and sculpture. Most frequently exhibits installation and mixed media.

STYLE Exhibits conceptualism, expressionism, neo-expressionism, postmodernism and surrealism. Most frequently exhibits conceptualism, expressionism and postmodernism.

TERMS There is no commission for artwork sold by member artists; 30% commission on sales by artists outside of the organization.

SUBMISSIONS Membership reviews are held twice a year in September and February. Artists may submit an application at any time throughout the year. Incomplete applications will not be considered for review. Notification of results will be made within one week of the scheduled review. Applicants cannot be presently enrolled in school and must live within a 50-mile radius of Philadelphia. Go to www.nexus philadelphia.org/images/memberapp.pdf for an application form.

TIPS "Get great slides made by someone who knows how to take professional slides. Learn how to write a cohesive and understandable artist statement."

NICOLAYSEN ART MUSEUM & DISCOVERY CENTER

400 E. Collins Dr., Casper WY 82601. (307)235-5247. **E-mail:** info@thenic.org. **Website:** www.thenic.org. **Contact:** Connie Gibbons, executive director; Lisa Hatchadoorian, curator of exhibitions. Estab. 1967. Regional contemporary art museum. Average display time 3-4 months. Interested in emerging, mid-career and established artists. Sponsors 10 solo and 10 group shows/year. Open all year. Clientele 90% private collectors, 10% corporate clients.

MEDIA Considers all media with special attention to regional art.

STYLE Exhibits all subjects.

TERMS Accepts work on consignment (40% commission). Retail price set by artist. Exclusive area representation not required. Gallery provides insurance, promotion and shipping costs from gallery.

SUBMISSIONS Send résumé, statement and biography as well as images in digital format. "Due to the volume of correspondence we receive, we may not be able to respond directly to each and every submission and we cannot assume responsibility for or guarantee the return of any materials that are submitted."

NICOLET COLLEGE ART GALLERY

5355 College Dr., P.O. Box 518, Rhinelander WI 54501. (715)365-4556. **E-mail:** Kralph@Nicoletcollege.edu. **Website:** www.nicoletcollege.edu/community/event-sentertainment/artgallery/index.html. **Contact:** Katherine Ralph, gallery director. Exhibits 9-11 different shows each year including the Northern National Art Competition. The deadline for the annual

competition is in May. For a prospectus, or more information, contact gallery director, Katherine Ralph.
TERMS Call or e-mail for further information.

NKU GALLERY

Northern Kentucky University, Art Galleries, Nunn Dr., Highland Heights KY 41099. (859)572-5148. **Fax:** (859)572-6501. **E-mail:** knight@nku.edu. **Website:** www.nku.edu/~art/galleries/index.php. **Contact:** David Knight, director of collections and exhibitions. Estab. 1970. University galleries. Represents emerging, mid-career and established artists. Sponsors 10 shows/year. Average display time: 1 month. Open Monday-Friday, 9-9 or by appointment; closed major holidays and between Christmas and New Year's. Located 8 miles from downtown Cincinnati; 3,000 sq. ft.; 2 galleries—1 small and 1 large space with movable walls. 100% of space for special exhibitions. 90% private collectors, 10% corporate collectors. Overall price range: $25-3,000; most work sold at $500.
MEDIA Considers all media and all types of prints. Most frequently exhibits painting, printmaking and photography.
STYLE Exhibits all styles, all genres.
TERMS Retail price set by the artist. Gallery provides insurance, promotion and contract; shipping costs are shared. Prefers framed artwork, "but we are flexible." Commission rate is 20%.
SUBMISSIONS "Proposals from artists must go through our art faculty to be considered." Unsolicited submissions/proposals from outside the NKU Department of Visual Arts are not accepted. Unsolicited submissions will be returned to sender.

NO MAN'S LAND MUSEUM

207 W. Sewell, Goodwell OK 73939. (580)349-2670. **E-mail:** nmlhs@ptsi.net. **Website:** nmlhs.org. Estab. 1934. Represents emerging, mid-career and established artists. Sponsors 12 shows/year. Average display time 1 month. Open Tuesday–Saturday, 10-4 (June-August); Tuesday–Friday, 10-12 and 1-3; Saturday, 10-4 (September-May); other times by appointment. Located adjacent to university campus. 10% of space for special exhibitions. Clientele general, tourist. 100% private collectors. Overall price range $20-1,500; most work sold at $20-500.
MEDIA Considers all media and all types of prints. Most frequently exhibits oils, watercolors and pastels.
STYLE Exhibits primitivism, impressionism, photorealism and realism. Genres include landscapes, flo-

rals, Americana, southwestern, western and wildlife. Prefers realist, primitive and impressionist.
TERMS "Sales are between artist and buyer; museum does not act as middleman." Retail price set by the artist. Gallery provides promotion and shipping costs to and from gallery. Prefers artwork framed.
SUBMISSIONS Send query letter with résumé, brochure, photographs and reviews. Call or write for appointment to show portfolio of photographs. Responds only if interested within 3 weeks. Files all material. Finds artists through art publications, exhibitions, news items, word of mouth.

NORMANDALE COLLEGE CENTER GALLERY

9700 France Ave., South, Bloomington MN 55431. (952)481-8121. **Website:** www.normandale.edu/communityEvents/fineArts.cfm. **Contact:** Chris Mikkelsen. Estab. 1975. Exhibits 6 emerging, mid-career and established artists/year. Sponsors 6 shows/year. Average display time 2 months. Open all year. Suburban location; 30 running feet of exhibition space. 100% of space for special exhibitions. Clientele students, staff and community. Overall price range $25-750; most artwork sold at $100-200.
MEDIA Considers all media and all types of prints. Most frequently exhibits watercolor, photography and prints.
STYLE Exhibits all styles and genres.
TERMS "We collect 10% as donation to our foundation." Retail price set by artist. Gallery provides insurance, promotion and contract; artist pays for shipping. Prefers framed artwork.
SUBMISSIONS "Send query letter; we will send application and info." Portfolio should include slides. Responds in 2 months. Files application/résumé.

NORTHCOTE GALLERY

110 Northcote Rd., London SW11 6QP, United Kingdom. **E-mail:** info@northcotegallery.com. **Website:** www.northcotegallery.com. Estab. 1992. Art consultancy, wholesale gallery. Approached by 100 artists/year. Represents 30 emerging, mid-career and established artists. Exhibited artists include Daisy Cook and Robert McKellar. Sponsors 16 exhibits/year. Average display time 3-4 weeks. Open all year; Tuesday-Saturday, 11-7; Sunday, 11-6. Located in southwest London. 1 large exhibition space, 1 smaller space; average of 35 paintings exhibited/time. Clientele local community and upscale. 50% corporate collec-

tors. Overall price range 400-12,000; most work sold at 1,500.

MEDIA Considers acrylic, ceramics, drawing, glass, mixed media, oil, paper, photography, sculpture, watercolor, engravings, etchings and lithographs.

STYLE Exhibits conceptualism, expressionism, impressionism, painterly abstraction and postmodernism. Considers all genres.

TERMS Artwork is accepted on consignment (45% commission). Retail price set by the gallery. Gallery provides promotion. Accepted work should be framed.

SUBMISSIONS Send query letter with artist's statement, bio, brochure, photograph, résumé, reviews and SASE. Returns material with SASE. Responds in 4-6 weeks. Finds artists through word of mouth, submissions, portfolio reviews and referrals by other artists.

NORTHWEST ART CENTER

Minot State University, 500 University Ave. W., Minot ND 58707. (701)858-3264. **Fax:** (701)858-3894. **E-mail:** nac@minotstateu.edu. **Website:** www.minot stateu.edu/nac. **Contact:** Avis R. Veikley, director. Estab. 1969.

MEDIA Considers all media. Special interest in print-making, works on paper, contemporary art and drawings.

STYLE Exhibits all styles, all genres.

TERMS Accepted work should be framed and mounted. Artwork is accepted on consignment with a 30% commission. Retail price set by the artist. Gallery provides insurance, promotion and contract.

SUBMISSIONS Send query letter with artist's statement, photocopies bio, résumé and reviews. Returns material with SASE. Responds, if interested, within 3 months. Finds artists through art exhibits, submissions, referrals by other artists and entries in our juried competitions.

NOYES ART GALLERY

119 S. Ninth St., Lincoln NE 68508. (402)475-1061. **E-mail:** julianoyes@aol.com. **Website:** www.noyesart gallery.com. **Contact:** Julia Noyes, owner. Estab. 1992. For-profit gallery. "The Noyes Gallery is a co-op type art gallery, featuring approximately 24 artist members, showing their work and volunteering their time to help operate the business. The gallery features a variety of original painting, photos, pottery and jewelry. We have recently expanded the gallery adding a classroom and additional display space to our facil-

ity." Average display time: 1 month minimum. ("If mutually agreeable this may be extended or work exchanged.") Open Monday–Saturday, 10-5. Located downtown, near historic Haymarket District; 3,093 sq. ft.; renovated 128-year-old building. 25% of space for special exhibitions. Clientele: private collectors, interior designers and decorators. 90% private collectors, 10% corporate collectors. Overall price range: $100-5,000; most work sold at $200-750.

MEDIA Considers oil, acrylic, watercolor, pastel, pen & ink, drawings, mixed media, collage, paper, sculpture, ceramic, fiber, glass and photography; original handpulled prints, woodcuts, wood engravings, linocuts, engravings, mezzotints, etchings, lithographs and serigraphs. Most frequently exhibits oil, watercolor and mixed media.

STYLE Exhibits expressionism, neo-expressionism, impressionism, realism, photorealism. Genres include landscapes, florals, Americana, wildlife, figurative work. Prefers realism, expressionism, photorealism.

TERMS Accepts work on consignment (10-35% commission). Retail price set by artist (sometimes in conference with director). Gallery provides promotion and contract; artist pays for shipping. Prefers artwork framed.

SUBMISSIONS Send query letter with résumé, slides, bio, SASE; label slides concerning size, medium, price, top, etc. Submit at least 6-8 slides. Reviews submissions monthly. Responds in 1 month. Files résumé, bio and slides of work by accepted artists (unless artist requests return of slides).

NUANCE GALLERIES

804 S. Dale Mabry, Tampa FL 33609. (813)875-0511. **E-mail:** nuancegalleries@earthlink.net. **Website:** www. nuancegalleries.com. **Contact:** Robert Rowen, owner. Estab. 1981. Retail gallery. Represents 70 emerging, mid-career and established artists. Sponsors 3 shows/ year. Open all year. 3,000 sq. ft. "We've reduced the size of our gallery to give the client a more personal touch. We have a large extensive front window area." New location at 2924 Central Ave, St. Petersburg FL.

MEDIA Specializing in watercolor, original mediums and oils.

STYLE "The majority of the work we like to see are realistic landscapes, escapism pieces, bold images, bright colors and semitropical subject matter. Our

gallery handles quite a selection, and it's hard to put us into any one class."

TERMS Accepts work on consignment (50% commission). Retail price set by gallery and artist. Offers customer discounts and payment by installments. Gallery provides insurance and contract; shipping costs are shared.

SUBMISSIONS Send query letter with slides and bio, SASE if want slides/photos returned. Portfolio review requested if interested in artist's work.

TIPS "Be professional; set prices (retail) and stick with them. There are still some artists out there that are not using conservation methods of framing. As far as submissions, we would like local artists to come by to see our gallery and get the idea of what we represent. Tampa has a healthy growing art scene, and the work has been getting better and better. But as this town gets more educated, it is going to be much harder for up-and-coming artists to emerge."

THE OLD PRINT BARN—ART GALLERY

P.O. Box 978, Winona Rd., Meredith NH 03253. (603)279-6479. **Fax:** (603)279-1337. **E-mail:** oldprint barnartgallery@metrocast.net. **Website:** www.the oldprintbarn.com. **Contact:** Sophia Lane, director. Estab. 1976. Retail gallery. Represents 100-200 mid-career and established artists/year. May be interested in seeing the work of emerging artists in the future. Exhibited artists include Michael Mc-Curdy, Ryland Loos and Joop Vegter. Open daily 10-5. Closed Thanksgiving and Christmas Day. Located in the country; over 4,000 sq. ft.; remodeled antique 18th-century barn. 30% of space for special exhibitions; 70% of space for gallery artists. Clients include tourists and local. 99% of sales are to private collectors. Overall price range $10-30,000; most work sold at $200-900.

MEDIA Considers watercolor, pastel and drawing; types of prints include woodcuts, engravings, lithographs, mezzotints, serigraphs, linocuts and etchings. Most frequently exhibits etchings, engravings (antique), watercolors.

STYLE Exhibits color field, expressionism, postmodernism, realism. Most frequently exhibits color field, realism, postmodernism. Genres include florals, wildlife, landscapes and Americana.

TERMS Accepts work on consignment. Retail price set by the gallery and artist. Gallery provides promotion; shipping costs are shared.

SUBMISSIONS Prefers only works of art on paper. No abstract art. Send query letter with résumé, brochure, 10-12 slides and artist's statement. Title, medium and size of artwork must be indicated clearly on slide label. Call or write for appointment to show portfolio or photographs. Responds in a few weeks. Files query letter, statements, etc. Finds artists through word of mouth, referrals of other artists, visiting art fairs and exhibitions and submissions.

TIPS "Show your work to gallery owners in as many different regions as possible. Most gallery owners have a feeling of what will sell in their area. I certainly let artists know if I feel their images are not what will move in this area."

OPENING NIGHT GALLERY

2836 Lyndale Ave. S., Minneapolis MN 55408-2108. (612)872-2325. **Fax:** (612)872-2385. **E-mail:** deen@ onframe-art.com; info@onframe-art.com. **Website:** www.onframe-art.com. **Contact:** Deen Braathen. Estab. 1975. Rental gallery. Approached by 40 artists/year; represents or exhibits 15 artists. Sponsors 1 photography exhibit/year. Average display time 6-10 weeks. Gallery open Monday–Friday, 8:30-5; Saturday, 10:30-4. Overall price range $300-12,000. Most work sold at $2,500.

MEDIA Considers acrylic, ceramics, collage, drawing, fiber, glass, oil, paper, sculpture and watercolor.

STYLE Exhibits local and regional art.

TERMS Artwork is accepted on consignment, and there is a 50% commission. Retail price set by the gallery. Gallery provides insurance, promotion and contract.

SUBMISSIONS "E-mail Deen with cover letter, artist statement, and visuals."

⊕ ORANGE COUNTY CENTER FOR CONTEMPORARY ART

117 N. Sycamore St., Santa Ana CA 92701. (714)667-1517. **E-mail:** info.occa@gmail.com. **Website:** www. occca.org. Cooperative, nonprofit gallery. Exhibits emerging and mid-career artists. 26 members. Sponsors 12 shows/year. Average display time: 1 month. Open all year; Thursday and Sunday, 12-5; Friday and Saturday, 12-9; Monday-Wednesday by appointment. Opening receptions first Saturday of every month, 6-10 pm. Gallery space: 5,500 sq. ft. 25% of time for special exhibitions; 75% of time for gallery artists. Membership fee: $30/month.

MEDIA Considers all media-contemporary work.

TERMS Co-op membership fee plus a donation of time. Retail price set by artist.

SUBMISSIONS Accepts artists generally in and within 50 miles of Orange County. E-mail 3 images of current work format the items with "your_name_title.jpeg", include a brief description of your work, an exhibition résumé, and a website link to your work. Subject line of e-mail should read "New membership submission (your name, date)." Responds in 1 week. More information about the membership process is available online.

TIPS "This is an artist-run nonprofit. Send SASE for application prospectus. Membership involves 10 hours per month of volunteer work at the gallery or gallery-related projects."

OXFORD GALLERY

267 Oxford St., Rochester NY 14607. (585)271-5885. **E-mail:** info@oxfordgallery.com. **Website:** www.oxfordgallery.com. Estab. 1961. Retail gallery. Represents 70 emerging, mid-career and established artists. Sponsors 10 shows/year. Average display time 1 month. Open all year; Tuesday-Friday, 12-5; Saturday, 10-5; and by appointment. Located "on the edge of downtown; 1,000 sq. ft.; large gallery in a beautiful 1910 building." Overall price range $100-30,000; most work sold at $1,000-2,000.

MEDIA Considers oil, acrylic, watercolor, pastel, pen & ink, drawings, mixed media, collage, paper, sculpture, ceramic, fiber, original handpulled prints, woodcuts, engravings, lithographs, wood engravings, mezzotints, serigraphs, linocuts and etchings.

STYLE All styles.

TERMS Accepts artwork on consignment (50% commission). Retail price set by gallery and artist. Gallery provides promotion and contract.

SUBMISSIONS Send query letter with résumé, slides, bio and SASE. Responds in 3 months. Files résumés, bios and brochures.

TIPS "Have professional slides done of your artwork. Have a professional résumé and portfolio. Do not show up unannounced and expect to show your slides. Either send in your information or call to make an appointment. An artist should have enough work to have a one-person show (20-30 pieces). This allows an artist to be able to supply more than one gallery at a time, if necessary. It is important to maintain a strong body of available work."

PAINTERS ART GALLERY

30517 St. Rt. 706 E., Ashford WA 98304. (360)569-2644. **E-mail:** mtwoman2@centurytel.net. **Website:** www.paintersartgallery.com. **Contact:** Joan Painter, owner. Retail gallery. Represents 3 emerging, mid-career and established artists. Open all year. Hours are chaotic, please call ahead to be sure you will not be wasting a trip. Located 5 miles from the entrance to Mt. Rainier National Park; 1,200 sq. ft. 70% of space for work of gallery artists. Clientele collectors and tourists. Overall price range $10-7,500; most work sold at $300-2,500.

It is a very informal, outdoors atmosphere.

MEDIA Considers oil, acrylic, watercolor, pastel, mixed media. "I am seriously looking for totem poles and outdoor carvings." Most frequently exhibits oil, pastel and acrylic.

STYLE Exhibits primitivism, surrealism, imagism, impressionism, realism and photorealism. All genres. Prefers Mt. Rainier themes and wildlife. "Indians and mountain men are a strong sell."

TERMS Accepts artwork on consignment (30% commission). Retail price set by gallery and artist. Gallery provides promotion; artist pays for shipping. Prefers artwork framed.

SUBMISSIONS Send query letter or call. "I can usually tell over the phone if artwork will fit in here." Portfolio review requested if interested in artist's work. Does not file materials.

TIPS "Sell paintings and retail price items for the same price at mall and outdoor shows that you price them in galleries. I have seen artists underprice the same paintings/items, etc. when they sell at shows. Do not copy the style of other artists. To stand out, have your own style."

PARADISE CENTER FOR THE ARTS

321 Central Ave, Faribault MN 55021. (507)332-7372. **E-mail:** info@paradisecenterforthearts.org. **Website:** www.paradisecenterforthearts.org. **Contact:** Executive director. Formerly Faribault Art Center, Inc. Nonprofit gallery. Represents 26-30 emerging and mid-career artists/year. 650 members. Sponsors 8 theatre shows/year. Auditorium features regular events including comedy, live music and special events. Average display time 1 month. Open all year; Tuesday–Saturday, 12-5; Thursday, 12-8 and all events. Education classes in all mediums. Located downtown; 1,600 sq. ft. 50% of space for special exhibitions; 50% of space

for gallery artists. Clientele local and tourists. 90% private collectors.

MEDIA Considers all media and all types of prints.

STYLE Open.

TERMS Accepts work on consignment (30% commission for nonmembers). Retail price set by the artist. Artist pays for shipping. Prefers artwork framed.

SUBMISSIONS Accepts local and regional artists. Send query letter with CD with 6-10 JPEG images, artist résumé, and artist's statement. Call or write for appointment to show portfolio of photographs. Responds only if interested within 2 weeks. Artist should call. Finds artists through word of mouth, referrals by other artists, visiting art fairs and exhibitions and submissions.

TIPS "Artists should respond quickly upon receiving reply."

🌑 PARK WALK GALLERY

20 Park Walk, London SW10 0AQ United Kingdom. **E-mail:** mail@jonathancooper.co.uk. **Website:** www.jonathancooper.co.uk. **Contact:** Jonathan Cooper, gallery owner. Estab. 1988. Approached by 5 artists/year. Gallery represents 30 artists. Approached 60 artists/year. Exhibited artists include Kate Nessler. Sponsors 8 exhibits/year. Average display time 3 weeks. Open all year; Monday-Saturday, 10-6:30; Sunday, 11-4. Located in Park Walk, which runs between Fulham Rd. to Kings Rd. Clientele: upscale. 10% corporate collectors. Most work sold at £2000-20,000.

MEDIA Considers drawing, mixed media, oil, paper, pastel, pen & ink, photography, sculpture, watercolor. Most frequently exhibits watercolor, oil and sculpture.

STYLE Exhibits conceptualism, impressionism. Genres include florals, landscapes, wildlife, equestrian.

TERMS Artwork is accepted on consignment (50% commission). Retail price set by the gallery. Gallery provides promotion. Requires exclusive representation locally.

SUBMISSIONS Call to arrange a personal interview to show portfolio. Returns material with SASE. Responds in 1 week. Finds artists through submissions, portfolio reviews, art exhibits, art fairs, referrals by other artists.

TIPS "Include full curriculum vitae and photographs of work."

THE PARTHENON

Centennial Park, West End at 25th Ave. N., Nashville TN 37203. (615)862-8431. **Fax:** (615)880-2265. **E-mail:** susan.shockley@nashville.gov. **Website:** www.parthenon.org. **Contact:** Susan Shockley. Estab. 1931. Nonprofit gallery in a full-size replica of the Greek Parthenon. Exhibits the work of emerging to mid-career artists. Sponsors 3-4 shows/year. Average display time: 3-4 months. Clientele: general public, tourists. Overall price range: $300-2,000. "We also house a permanent collection of American paintings (1765-1923)."

MEDIA Considers "nearly all" media.

STYLE "Interested in both objective and non-objective work. Professional presentation is important."

TERMS "Sales request a 20% donation." Retail price set by artist. Gallery provides a contract and limited promotion. The Parthenon does not represent artists on a continuing basis.

SUBMISSIONS Send images via CD, résumé and artist's statement addressed to curator.

TIPS "We plan our gallery calendar at least one year in advance." Find us on Facebook: "The Parthenon in Nashville."

⊕ PASEO ORIGINALS ART GALLERY

2920 Pasco, Oklahoma City OK 73103. (405)604-6602. **E-mail:** info@paseooriginals.com. **Website:** www.paseooriginals.com. **Contact:** Tony Morton, director. Estab. 2010.

MEDIA Considers all except photography.

STYLE Considers all. Most frequently exhibits mixed media, printmaking, painting, Americana.

TERMS Artwork is accepted on consignment and there is a 40% commission. Retail price of the art set by the artist. Gallery provides insurance, promotion, contract. Accepted work should be framed, mounted, matted. Requires exclusive representation locally.

SUBMISSIONS E-mail query letter with link to artist's statement, bio, brochure, résumé, reviews, complete portfolio (details on website), SASE. Materials returned with SASE. Responds only if interested within 1 month. Files all materials. Finds artists through word of mouth, submissions, portfolio reviews, art exhibits, referrals by other artists.

TIPS Visit www.paseooriginals.com/submissions.html.

PENTIMENTI GALLERY

145 N. Second St., Philadelphia PA 19106. **Website:** www.pentimenti.com. **Contact:** Christine Pfister, di-

rector. Estab. 1992. Commercial gallery. Represents 20-30 emerging, mid-career and established artists. Sponsors 7-9 exhibits/year. Average display time: 4-6 weeks. Open all year; Tuesday by appointment, Wednesday-Friday, 11-5; Saturday 12-5. Closed Sundays, August, Christmas and New Year. Located in the heart of Old City cultural district in Philadelphia. Overall price range: $250-12,000; most work sold at $1,500-7,000.

MEDIA Considers all media. Most frequently exhibits paintings of all media.

STYLE Exhibits conceptualism, minimalism, postmodernism, painterly abstraction, and representational works. Most frequently exhibits postmodernism, minimalism and conceptualism.

TERMS Artwork is accepted on consignment. Retail price set by the gallery and the artist. Gallery provides insurance and promotion. Requires exclusive representation locally.

SUBMISSIONS Please review our guidelines in our website.

PETERS VALLEY CRAFT CENTER

19 Kuhn Rd., Layton NJ 07851. (973)948-5202. **Fax:** (973)948-0011. **E-mail:** store@petersvalley.org. **Website:** www.petersvalley.org. **Contact:** Brienne Rosner, gallery manager. Estab. 1970. Nonprofit gallery and store—consignment. Approached by about 200 artists/year. Represents about 400 emerging, mid-career and established artists. Exhibited artists include William Abranowitz and Clyde Butcher. Average display time for store items varies. Gallery exhibitions approx. one month duration. Open year round, call for hours. Located in northwestern New Jersey in Delaware Water Gap National Recreation Area; 2 floors; approximately 3,000 sq. ft. Clients include local community, students, tourists and upscale. 5% of sales are to corporate collectors. Overall price range $5-3,000; most work sold at $100-300.

MEDIA Considers all media and all types of prints. Also exhibits non-referential, mixed media, collage and sculpture.

STYLE Considers all styles. Most frequently exhibits contemporary fine art and craft.

TERMS Artwork is accepted on consignment and there is a 60% commission. Retail price set by the gallery in conjunction with artist. Gallery provides insurance and promotion. Accepted work should be framed, mounted and matted. Does not require exclu-

sive representation locally. Accepts only artists from North America.

SUBMISSIONS Call or write to arrange a personal interview to show portfolio. Send query letter with artist's statement, bio, résumé and images. Returns material with SASE. Responds when space is available. Files résumé and bio. Finds artists through submissions, art exhibits, art fairs, and referrals by other artists.

⊕ PHILLIPS GALLERY

444 E. 200 S., Salt Lake City UT 84111. (801)364-8284. **Fax:** (801)364-8293. **Website:** www.phillips-gallery. com. **Contact:** Meri DeCaria, director/curator. Estab. 1965. Retail gallery, art consultancy, rental gallery. Represents 80 emerging, mid-career and established artists/year. Exhibited artists include Denis Phillips, Connie Borup, Hyunmee Lee. Sponsors 10 shows/year. Average display time 1 month. Open all year; Tuesday-Friday, 11-6; Saturday, 11-4. Closed December 25-January 1. Located downtown; has 3 floors at 2,000 sq. ft. and a 2,400 sq. ft. sculpture deck on the roof. 40% private collectors, 60% corporate collectors. Overall price range $100-18,000; most work sold at $200-4,000.

MEDIA Considers all media, woodcuts, engravings, lithographs, wood engravings, linocuts, etchings. Most frequently exhibits oil, acrylic, sculpture/steel.

STYLE Exhibits expressionism, conceptualism, neo-expressionism, minimalism, pattern painting, primitivism, color field, hard-edge geometric abstraction, painterly abstraction, postmodern works, realism, surrealism, impressionism. Genres include Western, Southwestern, landscapes, figurative work, contemporary. Prefers abstract, neo-expressionism, conceptualism.

TERMS Accepts work on consignment (50% commission). Gallery does not provide insurance and promotion; shipping costs are shared. Prefers artwork framed.

SUBMISSIONS Accepts only artists from western region/Utah. Send query letter with résumé, slides, reviews, artist's statement, bio and SASE. Finds artists through word of mouth, referrals.

THE PHOENIX GALLERY

210 11th Ave., 902, New York NY 10001. (212)226-8711. **E-mail:** info@phoenix-gallery.com. **Website:** www.phoenix-gallery.com. **Contact:** Linda Handler, director. Estab. 1958. Nonprofit gallery. 32 members.

Exhibits the work of emerging, mid-career and established artists. Exhibited artists include Gretl Bauer and Jae Hi Ahn. Sponsors 10-12 shows/year. Average display time: 1 month. Open Tuesday-Saturday, 11:30-6. Located in Chelsea; 180 linear ft. "We have a movable wall that can divide the gallery into two large spaces." 100% of space for special exhibitions. 75% of sales are to private collectors, 25% corporate clients, also art consultants. Overall price range: $50-20,000; most work sold at $300-10,000.

◯ The Phoenix Gallery actively reaches out to the members of the local community, scheduling juried competitions, dance programs, poetry readings, book signings, plays, artists speaking on art panels and lectures. A special exhibition space.

MEDIA Considers oil, acrylic, watercolor, pastel, pen & ink, drawings, mixed media, collage, works on paper, sculpture, ceramic, photography, original hand-pulled prints, woodcuts, engravings, wood engravings, linocuts, etchings and photographs. Most frequently exhibits oil, acrylic and watercolor.

STYLE Exhibits painterly abstraction, minimalism, realism, photorealism, hard-edge geometric abstraction and all styles.

TERMS Co-op membership fee plus donation of time for active members, not for inactive or associate members (25% commission). Retail price set by gallery. Offers customer discounts and payment by installment. Gallery provides promotion and contract; artist pays for shipping. Prefers framed artwork.

SUBMISSIONS Send application form, 10 or more slides or JPEG images on a CD or link to website and a résumé and statement to be reviewed by the members. Responds in 1 month. Only files material of accepted artists. The most common mistakes artists make in presenting their work are "incomplete résumé, unlabeled slides and an application that is not filled out properly. We find new artists by advertising in art magazines and art newspapers, word of mouth, and inviting artists from our juried competition to be reviewed for membership."

TIPS "Come and see the gallery—meet the director."

PHOENIX GALLERY TOPEKA

2900-F Oakley Dr., Topeka KS 66614. (785)272-3999. **E-mail:** phnxgal@aol.com. **Website:** www.phnxgallery.com. Estab. 1990. Retail gallery. Represents 60 emerging, mid-career and established artists/year.

Exhibited artists include Dave Archer, Louis Copt, Nagel, Phil Starke, Robert Berkeley Green and Raymond Eastwood. Sponsors 6 shows/year. Average display time 6 weeks-3 months. Open Monday–Saturday, 10-6; Sundays by appointment; every 1st Friday, 10-9. Located downtown; 2,000 sq. ft. 100% of space for special exhibitions; 100% of space for gallery artists. Clientele: upscale. 75% private collectors, 25% corporate collectors. Overall price range $500-20,000.

MEDIA Considers all media and engravings, lithographs, woodcuts, mezzotints, serigraphs, linocuts, etchings and collage. Most frequently exhibits oil, watercolor, ceramic and artglass.

STYLE Exhibits expressionism and impressionism, all genres. Prefers regional, abstract and 3D type ceramic; national glass artists. "We find there is increased interest in original work and regional themes."

TERMS Terms negotiable. Retail price set by the gallery and the artist. Prefers artwork framed.

SUBMISSIONS Call for appointment to show portfolio of originals, photographs and slides.

PIERRO GALLERY OF SOUTH ORANGE

Baird Center, 5 Mead St., South Orange NJ 07079. (973)378-7754. **Fax:** (973)378-7833. **E-mail:** pierrogallery@southorange.org;. **Website:** www.pierrogallery.org. **Contact:** Sandy Martiny, gallery director. Estab. 1994. Nonprofit gallery. Approached by 75-185 artists/year; represents or exhibits 25-50 artists. Average display time 7 weeks. Open Friday–Sunday, 1-4 and by appointment. Closed mid-December through mid-January and the month of August. Overall price range $100-10,000. Most work sold at $800.

TERMS Artwork is accepted on consignment, and there is a 15% commission. Gallery provides insurance, promotion, contract. Accepted work should be framed.

SUBMISSIONS Mail portfolio for review. Send cover letter, biography and/or résumé, brief artist statement, up to 3 reviews/press clippings, representation of work in either CD or DVD format; no more than 10 labeled representative images. Responds in 2 months from review date. Finds artists through word of mouth, submissions, portfolio reviews, referrals by other artists.

⌂ POCATELLO ART CENTER GALLERY & SCHOOL

444 N. Main, Pocatello ID 83204. (208)232-0970. **E-mail:** pocartctr@ida.net. **Website:** pocatelloartctr.

org/gallery.html. Estab. 1970. Nonprofit gallery featuring work of artist/members. Represents approximately 60 emerging, mid-career and established artists/year. Approximately 150 members. Exhibited artists include Barbara Ruffridge, Jerry Younkin, Onita Asbury and Barbara Swanson. Sponsors 10-12 shows/year. Average display time 2 months. Open all year; Monday-Friday, 10-4 (varies occasionally). Located downtown in "Old Town." "We sponsor the 'Sagebrush Arts Fes' each year, usually in September, on the Idaho State University campus." We hold classes, feature all levels of artists and are a gathering place for artists. Clientele tourists, local community, students and artists. 100% private collectors. Overall price range $25-1,000; most work sold at $25-300.

MEDIA Considers oil, acrylic, watercolor, pastel, pen & ink, drawing, mixed media, collage, paper, sculpture, ceramics, high-end craft, fiber, glass and photography; types of prints include woodcuts, engravings, wood engravings, serigraphs, linocuts and etchings. Most frequently exhibits watercolor, oil and pastel.

STYLE Exhibits expressionism, neo-expressionism, primitivism, painterly abstraction, surrealism, minimalism, impressionism, photorealism, hard-edge geometric abstraction, realism and imagism. Exhibits all genres. Prefers impressionism, realism and painterly abstraction.

TERMS Co-op membership fee plus donation of time. Donations-monetary. Retail price set by the artist. Gallery provides promotion; hand delivered works only. Prefers artwork framed.

SUBMISSIONS Accepts only artists from Southeast Idaho. Memberships open to all artists and persons interested in the visual arts. Send query letter or visit gallery. Finds artists through word of mouth, referrals by other artists, visiting art fairs and exhibitions.

TIPS "Have work ready to hang."

POLK MUSEUM OF ART

800 E. Palmetto St., Lakeland FL 33801-5529. (863)688-7743, ext. 241. **Fax:** (863)688-2611. **E-mail:** kpope@polkmuseumofart.org. **Website:** www.polk museumofart.org. **Contact:** Adam Justice, curator of art. Estab. 1966. Approached by 75 artists/year; represents or exhibits 3 artists. Sponsors 15 exhibits/year. Open Tuesday-Saturday, 10-5; Sunday, 1-5. Closed major holidays. Reduced hours June-August. Four different galleries of various sizes and configurations. "Because we are a small institution, we do not regularly review submissions. Our Curator will be happy to look at your slides, but he may not be able to respond immediately."

MEDIA Considers all media. Most frequently exhibits prints, photos and paintings. Considers all types of prints except posters.

STYLE Considers all styles and genres, provided the artistic quality is very high.

TERMS Gallery provides insurance, promotion and contract. Accepted work should be framed.

SUBMISSIONS Mail portfolio for review. Send query letter with artist's statement, bio, résumé and SASE. Returns material with SASE. Reviews 2-3 times/year and responds shortly after each review. Files slides or CDs and résumé.

PORTFOLIO ART GALLERY

2007 Devine St., Columbia SC 29205. (803)256-2434. **E-mail:** artgal@portfolioartgal.com. **Website:** www. portfolioartgal.com. **Contact:** Judith Roberts, gallery director. Estab. 1980. Retail gallery and art consultancy. Represents 40-50 emerging, mid-career and established artists. Exhibited artists include Juko Ono Rothwell, Sigmund Abeles and Shannon Bueker. Sponsors 3 shows/year. Average display time: 3 months. Open Monday–Friday, 11-6; Saturday, 10-6. Located in a 1930s shopping village, 1 mile from downtown; 2,000 sq. ft.; features 12-ft. ceilings. 100% of space for work of gallery artists. "A unique feature is glass shelves where matted and small to medium pieces can be displayed without hanging on the wall." Clientele: professionals, collectors, corporations; 70% professionals and collectors, 30% corporate. Overall price range: $150-12,500; most work sold at $600-$3,000.

○ Gallery director Judith Roberts has a fine arts degree with an intensive in printmaking and is a former art teacher. Also named "A Top 100 Retailer of American Crafts."

MEDIA Considers oil, acrylic, watercolor, pastel, mixed media, collage, works on paper, sculpture, ceramic, glass, original handpulled prints, woodcuts, wood engravings, linocuts, engravings, mezzotints, etchings, lithographs and serigraphs. Most frequently exhibits oils, acrylics, ceramics and sculpture, and original jewelry.

STYLE Exhibits neo-expressionism, painterly abstraction, imagism, minimalism, color field, impressionism, and realism. Genres include landscapes and

figurative work. Prefers landscapes/seascapes, painterly abstraction and figurative work. "I especially like mixed media pieces, original prints and oil paintings. Pastel medium and watercolors are also favorites, as well as kinetic sculpture and whimsical clay pieces."

TERMS Accepts work on consignment (40% commission). Retail price set by gallery and artist. Offers payment by installments. Gallery provides insurance, promotion and contract; artist pays for shipping. Artwork may be framed or unframed.

SUBMISSIONS Send query letter with bio and images via e-mail, CD or slides. Write for appointment to show portfolio of originals, slides, photographs and transparencies. Responds within 1 month, only if interested. Files tearsheets, brochures and slides. Finds artists through visiting exhibitions and referrals.

TIPS "The most common mistake beginning artists make is showing all the work they have ever done. I want to see only examples of recent best work—unframed, originals (no copies)—at portfolio reviews."

PORT WASHINGTON PUBLIC LIBRARY

One Library Dr., Port Washington NY 11050. (516)883-4400. **E-mail:** library@pwpl.org. **Website:** www.pwpl.org/artgallery. Estab. 1970. Nonprofit gallery. Represents 10-12 emerging, mid-career and established artists/year. 23 members. Exhibited artists include Frank Stella, Robert Dash. Sponsors 10-12 shows/year. Average display time 1 month. Open all year; Monday, Tuesday, Thursday, Friday, 9-9; Wednesday, 11-9; Saturday, 9-5; Sunday, 1-5 (except in the summer). See website for holiday closings. 972 sq. ft. Overall price range up to $100,000.

MEDIA Considers all media and all types of prints.

STYLE Exhibits all styles.

TERMS Price set by the artist. Gallery provides insurance and promotion.

SUBMISSIONS Send query letter with résumé, slides, bio, SASE. Or contact via online submission form. Responds in 1 month. Artist should call library. Finds artists through word of mouth, referrals by other artists, visiting art fairs and exhibitions and submissions.

POSNER FINE ART

1212 S. Point View St., Los Angeles CA 90035. (323)933-3664. **Fax:** (323)934-3417. **E-mail:** info@posnerfineart.com. **Website:** www.posnerfineart.com. **Contact:** Wendy Posner, director. Estab. 1960. Private fine art dealer and art publisher. Represents 200 emerging, mid-career and established artists.

By appointment only. Clientele: upscale and collectors; 50% private collectors, 50% corporate collectors. Overall price range: $25-50,000; most work sold at $500-10,000.

See additional listing in the Posters & Prints section.

MEDIA Considers oil, acrylic, watercolor, pastel, mixed media, collage, works on paper, sculpture, ceramics, original hand-pulled prints, engravings, etchings, lithographs, posters and serigraphs. Most frequently exhibits paintings, sculpture and original prints.

STYLE Exhibits painterly abstraction, minimalism, impressionism, realism, photorealism, pattern painting and hard-edge geometric abstraction. Genres include florals and landscapes. Prefers abstract, trompe l'oeil, realistic.

TERMS Accepts work on consignment (50% commission). Retail price set by the gallery. Gallery provides insurance and promotion; shipping costs are shared. Prefers unframed artwork.

SUBMISSIONS E-mail query letter with résumé and images. Responds in 2 weeks, only if interested. Finds artists through submissions and art collectors' referrals.

TIPS Looking for artists for corporate collections.

POUDRE RIVER GALLERY

406 N. College Ave., Fort Collins CO 80524. **E-mail:** gallery@poudrestudioartists.com. **Website:** www.poudrestudioartists.com. **Contact:** Gallery administrator. Estab. 2006. Nonprofit cooperative, rental gallery with alternative space. Approached by 100+ artists/year; exhibits 200+ emerging, mid-career and established artists/year. Exhibited artists include Barbara McCulloch (watermedia) and Carol Simmons (polymer clay). Exhibits rotate monthly. Open Thursday-Saturday, 11-6 and first Fridays 11-9. Closed major holidays. Located just north of Old Town Fort Collins and participates in the city's monthly gallery walk. "Our gallery is 1,100 sq. ft., L-shaped with wood floors in a funky old building." Clients: local community, students, tourists and upscale. Overall price range: $50-10,000.

MEDIA Considers all media.

STYLE Considers all styles. Most frequently exhibits acrylics, mosaic and watercolor and painterly abstraction.

TERMS Artwork accepted on consignment with a 30% commission. Retail price of art set by the artist. Gallery provides promotion. Accepted work should be framed, mounted and matted.

SUBMISSIONS E-mail (poudrestudioartists@gmail. com) with link to artist's website and JPEG samples at 72 dpi or send query letter with artist's statement, bio, brochure and résumé. Material returned with SASE. Responds in 2-3 weeks. Brochures and printed materials filed. Finds artists through word of mouth, submissions and referrals by other artists.

TIPS "Read instructions carefully and follow them to the letter!"

THE PRINT CENTER

1614 Latimer St., Philadelphia PA 19103. (215)735-6090. **Fax:** (215)735-5511. **E-mail:** info@printcenter. org. **Website:** www.printcenter.org. **Contact:** Ashley Peel Pinkham, assistant director. Estab. 1915. Exhibits emerging, mid-career and established artists. Approached by 500 artists/year. Sponsors 11 exhibits/year. Average display time: 2 months. Open all year Tuesday-Saturday, 11-6; closed Christmas Eve to New Year's Day. Gallery houses 3 exhibit spaces as well as a separate Gallery Store. Located in historic Rittenhouse area of Philadelphia. Clients include local community, students, tourists and collectors. 30% of sales are to corporate collectors. Overall price range: $15-15,000; most work sold at $200.

MEDIA Considers all forms of printmaking and photography. Accepts original artwork only—no reproductions.

STYLE Considers all styles and genres.

TERMS Accepts artwork on consignment (50%). Retail price set by the artist. Gallery provides insurance, promotion and contract. Accepted work should be ready to hang for exhibitions; unframed for gallery store. Does not require exclusive representation locally. Only accepts prints and photos.

SUBMISSIONS Must be member to submit work—member's work is reviewed by curator and gallery store manager. See website for membership application. Finds artists through submissions, art exhibits and membership.

THE PROPOSITION

2 Extra Place, E. First St., New York NY 10003. (212)242-0035. **E-mail:** info@theproposition.com. **Website:** www.theproposition.com. Estab. 2002. For-profit gallery. Exhibits emerging and mid-career artists. Represents or exhibits 20+ artists/year. Exhibited artists include: Balint Zsako (drawing, collage, works on paper); Dane Patterson (drawing, painting, works on paper); Megan Burns (painting); Jason Gringler (mixed media, painting, work on paper); Mike Park (painting, video); Tim Evans (painting, video, works on paper); Huang Yan (sculpture); Mickalene Thomas (paintings, photos); Shinique Smith (multimedia, works on paper, installation, video, conceptual); Kyung Jeon (drawing, painting); Alfredo Martinez (sculpture, drawing, painting, performance). Average display time: 1 month. Overall price range: $0-20,000; most works on paper sold at $3,000; most paintings sold at $6,000.

PUCKER GALLERY, INC.

171 Newbury St., Boston MA 02116. (617)267-9473. **Fax:** (617)424-9759. **E-mail:** contactus@puckergallery.com; justine@puckergallery.com. **Website:** www.puckergallery.com. **Contact:** Bernard H. Pucker, director; Destiny M. Barletta. Estab. 1967. Retail gallery. Represents 50 emerging, mid-career and established artists. Exhibited artists include modern masters such as Picasso, Chagall, Braque, and Samuel Bak and Brother Thomas. Sponsors 10 shows/year. Average display time 4-5 weeks. Open all year. Located in the downtown retail district. 20% of space for special exhibitions. Clientele private clients from Boston, all over the US and Canada. 90% private collectors, 10% corporate clients. Overall price range $20-200,000; most artwork sold at $5,000-20,000.

MEDIA Considers all media. Most frequently exhibits paintings, prints and ceramics.

STYLE Exhibits all styles.

TERMS Terms of representation vary by artist, "usually it is consignment." Retail price set by gallery. Gallery provides promotion; artist pays shipping. Prefers artwork unframed.

SUBMISSIONS Send query letter with résumé, slides, bio and SASE. Write for appointment to show portfolio of originals and slides. Responds in 3 weeks. Files résumés.

PUMP HOUSE CENTER FOR THE ARTS

P.O. Box 1613, Chillicothe OH 45601. (740)772-5783. **Fax:** (740)772-5783. **E-mail:** info@pumphouseartgallery.com. **Website:** www.pumphouseartgallery.com. **Contact:** Priscilla V. Smith, director. Estab. 1991. Nonprofit gallery. Approached by 6 artists/year; represents or exhibits more than 50 artists. Sponsors 8

exhibits/year. Average display time: 6 weeks. Open Tuesday-Friday, 11-4; weekends, 1-4. Closed Mondays and major holidays. Overall price range: $150-600; most work sold at $300. Facility is also available for rent (business meetings, reunions, weddings, receptions or rehearsals, etc.).

MEDIA Considers all media and all types of prints. Most frequently exhibits oil, acrylic and watercolor.

STYLE Considers all styles and genres.

TERMS Artwork is accepted on consignment (30% commission). Gallery provides insurance and promotion. Accepted work should be framed, matted and wired for hanging. The Pump House reserves the right to reject any artwork deemed inappropriate.

SUBMISSIONS Call or stop in to show portfolio of photographs, slides, originals or prints. Send query letter with bio, photographs, SASE and slides. Returns material with SASE. Responds in 1 month. Finds artists through word of mouth, submissions, portfolio reviews, art fairs/exhibits, and referrals by other artists.

TIPS "All artwork must be original designs, framed, ready to hang (wired—no sawtooth hangers)."

QUEENS COLLEGE ART CENTER

Benjamin S. Rosenthal Library, Flushing NY 11367. (718)997-3770. **Fax:** (718)997-3753. **E-mail:** suzanna. simor@qc.cuny.edu; artcenter@qc.cuny.edu. **Website:** qcpages.qc.cuny.edu/art_library/artcenter.html. **Contact:** Suzanna Simor, director; Alexandra de Luise, associate director; Tara Tye Mathison, curator. Estab. 1955. Average display time: 6-7 weeks. Overall price range: $100-3,000.

MEDIA Considers all media.

STYLE Open to all styles and genres; decisive factors are originality and quality.

TERMS Charges 40% commission. Accepted work can be framed or unframed, mounted or unmounted, matted or unmatted. Sponsors openings.

SUBMISSIONS Online preferred or send query letter with résumé, samples and SASE. Responds in 1-2 months.

♻ MARCIA RAFELMAN FINE ARTS

10 Clarendon Ave., Toronto ON M4V 1H9, Canada. (416)920-4468. **Fax:** (416)968-6715. **E-mail:** info@ mrfinearts.com. **Website:** www.mrfinearts.com. **Contact:** Marcia Rafelman, president; Meghan Richardson, gallery director. Estab. 1984. Semi-private gallery. Average display time: 1 month. Gallery is centrally located in Toronto; 2,000 sq. ft. on 2 floors. Clients include local community, tourists and upscale. 40% of sales are to corporate collectors. Overall price range: $800-25,000; the average selling price is now $2,500.

MEDIA Considers all media. Most frequently exhibits photography, painting and graphics. Considers all types of prints.

STYLE Exhibits geometric abstraction, minimalism, neo-expressionism, primitivism and painterly abstraction. Most frequently exhibits high realism paintings. Considers all genres except Southwestern, Western and wildlife.

TERMS Artwork is accepted on consignment (50% commission); net 30 days. Retail price set by the gallery and the artist. Gallery provides insurance, promotion and contract. Requires exclusive representation locally.

SUBMISSIONS Mail or e-mail portfolio for review; include bio, photographs, reviews. Responds within 2 weeks, only if interested. Finds artists through word of mouth, submissions, art fairs, referrals by other artists.

RAHR-WEST ART MUSEUM

610 N. Eighth St., Manitowoc WI 54220. (920)686-3090. **E-mail:** rahrwest@manitowoc.org. **Website:** www.rahrwestartmuseum.org. Estab. 1950. Five thematic exhibits, preferably groups of mid-career and established artists. Sponsors 8-10 shows/year. Average display time 6-8 weeks. Open all year; Monday-Friday, 10-4; Saturday and Sunday, 11-4. Closed major holidays. Clients include local community and tourists. Overall price range $50-2,200; most work sold at $150-200.

MEDIA Considers all media and all types of original prints except posters or giclée prints. Most frequently exhibits painting, pastel and original prints.

STYLE Considers all styles. Most frequently exhibits impressionism, realism and various abstraction. Genres include figurative work, florals, landscapes and portraits.

TERMS Artwork is accepted on consignment and there is a 30% commission. Retail price set by the artist. Gallery provides insurance. Accepted work should be framed with hanging devices attached.

SUBMISSIONS Send query letter with artist's statement, bio, SASE and slides. Returns material only if requested with SASE if not considered. Otherwise slides are filed with contact info and bio. Responds only if interested.

RAIFORD GALLERY

1169 Canton St., Roswell GA 30075. (770)645-2050. **Fax:** (770)992-6197. **E-mail:** raifordgallery@mind spring.com. **Website:** www.raifordgallery.com. Estab. 1996. For-profit gallery. Approached by many artists/ year. Represents 400 mid-career and established artists. Exhibited artists include Cathryn Hayden Cooper (collage, painting and photography), Dale Rayburn (monotypes), and Richard Jacobus (metal). Average display time: 4 weeks. Open Tuesday–Saturday, 10-5. Located in historic district of Roswell; 4,500 sq. ft. in an open 2-story timber-frame space. Clients include local community, tourists and upscale. Overall price range: $10-2,000; most work sold at $200-300.

MEDIA Considers all media except installation. Most frequently exhibits painting, sculpture and glass.

STYLE Exhibits contemporary American art and craft.

TERMS Artwork is accepted on consignment, and there is a 50% commission. Retail price set by the artist. Gallery provides insurance, promotion and contract. Accepted work should be framed. Requires exclusive representation locally.

SUBMISSIONS Call or write to show to review board original work, portfolio of photographs. Send query letter with artist's statement, website, bio, brochure, photocopies, photographs, SASE. Returns material with SASE. Finds artists through submissions, portfolio reviews, art exhibits and art fairs.

THE RALLS COLLECTION, INC.

1516 31st St. NW, Washington DC 20007. (202)342-1754. **Fax:** (202)342-0141. **E-mail:** rallscollection@ gmail.com. **Website:** www.rallscollection.com. **Contact:** Marsha Ralls, owner. Estab. 1991. Approached by 125 artists/year; represents or exhibits 60 artists. Sponsors 10 exhibits/year. Average display time: 1 month. Open Tuesday-Saturday, 11-4 and by appointment. Closed Thanksgiving and Christmas. Clients include local community and tourists. 30% of sales to corporate collectors. Overall price range: $1,500-50,000; most work sold at $2,500-5,000.

MEDIA Considers acrylic, collage, drawing, mixed media, oil, sculpture and watercolor. Most frequently exhibits photography, oil and acrylic. Considers lithographs.

STYLE Exhibits geometric abstraction, neo-expressionism and painterly abstraction. Most frequently exhibits painterly abstraction.

TERMS Artwork is accepted on consignment (50% commission). Retail price set by the gallery and the artist. Gallery provides insurance, promotion and contract. Accepted work should be framed and matted. Requires exclusive representation locally. Accepts only American artists.

SUBMISSIONS Mail portfolio for review. Send query letter with artist's statement, bio, brochure, business card, photocopies, photographs, résumé, reviews, slides, SASE. Responds in 2 months. Finds artists through word of mouth, submissions, portfolio reviews, art fairs/exhibits, referrals by other artists.

RED MOUNTAIN GALLERY AND STURM GALLERY

Truckee Meadows Community College, 7000 Dandini Blvd., RDMT 334 U, Reno NV 89512. (775)673-7291. **Fax:** (775)674-4853. **Website:** www.tmcc.edu/ vparts/artgalleries. Estab. 1991. Nonprofit and college gallery. Represents emerging and mid-career artists. Sponsors 7 shows/year. Average display time 1 month. Located north of downtown Reno; 1,200 sq. ft.; "maximum access to entire college community, centrally located." 100% of space for special exhibitions. Clientele corporate art community and students/faculty. 95% private collectors, 5% corporate collectors. Overall price range $150-1,500; most work sold at $300-800.

MEDIA Considers oil, acrylic, watercolor, pastel, pen & ink, drawings, mixed media, collage, paper, sculpture, ceramic, fiber and photography. "Video is a new addition." Considers original handpulled prints, woodcuts, engravings, lithographs, wood engravings, mezzotints, serigraphs, linocuts and etchings. Most frequently exhibits painting, photography, sculpture and printmaking.

STYLE Exhibits all styles and genres. Prefers primitivism and socio-political works. Looks for "more contemporary concerns—less traditional/classical approaches. Subject matter is not the basis of the work—innovation and aesthetic exploration are primary."

TERMS Accepts work on consignment (20% commission). Retail price set by gallery and artist. Gallery provides insurance, full color announcements, promotion, contract and shipping from gallery. Prefers artwork unframed.

SUBMISSIONS Submission guidelines available online.

ANNE REED GALLERY

P.O. Box 597, Ketchum ID 83340. (208)726-3036. **Fax:** (208)726-6446. **E-mail:** barbi@annereedgallery.com. **E-mail:** info@annereedgallery.com. **Website:** www.annereedgallery.com. **Contact:** B. Anne Reed, owner. Estab. 1980. Represents mid-career and established artists. Exhibited artists include Laura Shiff Bean, Thomas Brummett, Simon Casson, Imogen Cunningham, Guy Dill, Josh Garber, Kenro Izu, Robert Kelly, Mathias Kessler, Frank Lobdell, Ricardo Mazal, John McCormick, Andrew Moore, Manuel Neri, Dan Rizzie, Andrew Saftel, Boaz Vaadia, Peter Woytuk. 50% private collectors, 50% corporate collectors, art consultants, designers.

MEDIA Most frequently exhibits sculpture, paintings, fine art prints and contemporary and vintage photography.

STYLE Exhibits expressionism, abstraction, conceptualism, photorealism, realism. Prefers contemporary.

TERMS Accepts work on consignment. Retail price set by gallery and artist. Sometimes offers client discounts and payment by installment. Gallery provides promotion, networking on artist's behalf, shipping cost to clients.

SUBMISSIONS Anne Reed Gallery is not responsible for materials sent that are unsolicited.

TIPS Best way for gallery to view work is via e-mail. Be sure to include your website's URL. Make sure the latest work and an updated résumé are on your site. Spend time on our website prior to contacting gallery.

REHOBOTH ART LEAGUE, INC.

12 Dodds Ln., Rehoboth Beach DE 19971. (302)227-8408. **Fax:** (302)227-4121. **E-mail:** galleryral@rehobothartleague.org. **Website:** www.rehobothartleague.org. **Contact:** Nick Serratore, exhibition director. Estab. 1938. Nonprofit gallery; offers education in visual arts. Exhibits the work of 1,000 emerging, mid-career and established artists. Sponsors 8-10 shows/year. Average display time 3½ weeks. Open January through November. Located in a residential area just north of town; "3½ acres, rustic gardens, built in 1743; listed in the National Register of Historic Places; excellent exhibition and studio space. Regional setting attracts artists and arts advocates." 100% of space for special exhibitions. Clientele members, artists (all media), arts advocates.

MEDIA Considers all media (except installation and photography) and all types of prints.

STYLE Exhibits all styles and all genres.

TERMS Accepts artwork on consignment (30% commission). Retail price set by the artist. Gallery provides insurance and promotion. Artist pays for shipping. Prefers artwork framed for exhibition, unframed for browser sales.

SUBMISSIONS Send query letter with résumé, slides and bio. Write to schedule an appointment to show a portfolio, which should include appropriate samples. Responds in 6 weeks. Files bios and slides in Member's Artist Registry.

RENAISSANCE GALLERY, INC.

431 Main Ave., Northport AL 35476. (205)752-4422. **E-mail:** renaissanceartga@bellsouth.net. **Website:** www.renaissanceartgallery.com. Estab. 1994. Retail gallery. Represents 25 emerging, mid-career and established artists/year. Exhibited artists include Elayne Goodman and John Kelley. Sponsors 12 shows/year. Average display time 6 months. Open Tuesday–Saturday, 11-4:30. Located in downtown historical district; 1,000 sq. ft.; historic southern building. 25% of space for special exhibitions; 75% of space for gallery artists. Clientele tourists and local community. 95% private collectors; 5% corporate collectors. Overall price range $65-3,000; most work sold at $300-900.

MEDIA Considers oil, acrylic, watercolor, pastel, pen & ink, mixed media, sculpture; types of prints include woodcuts and monoprints. No mass-produced reproductions. Most frequently exhibits oil, acrylic and watercolor.

STYLE Exhibits painterly abstraction, impressionism, photorealism, realism, imagism and folk-whimsical. Genres include florals, portraits, landscapes, Americana and figurative work. Prefers realism, imagism and abstract.

TERMS Accepts work on consignment (50% commission). Retail price set by the artist. Gallery provides promotion; shipping costs are shared. Prefers artwork framed. "We are not a frame shop."

SUBMISSIONS Prefers only painting, pottery and sculpture. Send query letter with slides or photographs. Write for appointment to show portfolio of photographs and sample work. Responds only if interested within 1 month. Files artists slides/photographs, returned if postage included. Finds artists through referrals by gallery artists.

TIPS "Do your homework. See the gallery before approaching. Make an appointment to discuss your

work. Be open to suggestions, not defensive. Send or bring decent photos. Have work that is actually available, not already given away or sold. Don't bring in your first 3 works. You should be comfortable with what you are doing, past the experimental stage. You should have already produced many works of art (zillions!) before approaching galleries."

⊕ ELLA WALTON RICHARDSON FINE ART

58 Broad St., Charleston SC 29401. (843)722-3660. **Fax:** (843)722-4330. **E-mail:** info@ellarichardson. com. **Website:** ellarichardson.com. **Contact:** Ella Richardson, owner. Estab. 2001. For-profit galley. Exhibits established artists. Approached by 100s of artists a year; represents or exhibits 28 artists. Exhibited artists include Aleksander and Lyuba Titovets, Lindsay Goodwin, the Baranovs, Jeff Jamison, and Micheal Coleman. Model and property release are required. Open Monday-Saturday 10-5. Located in historic downtown Charleston, the gallery has 3 rooms of artwork. The gallery is in the heart of the gallery district. It is an elegant and inviting space with hardwood floors, granite counters, and dual fireplaces. Clients included local community, students, tourists, and upscale. 5% of sales are to corporate collectors. Overall price range: $500-16,000.

MEDIA Considers most media. But most frequently exhibits oil, acrylic, and bronze sculptures.

STYLE Exhibits impressionism and painterly abstraction.

TERMS Artwork is accepted on consignment and there is a 50% commission. Retail price set by the gallery and artist. gallery provides insurance and promotion. Accepted artwork should be framed. Requires exclusive representation locally.

SUBMISSIONS Mail or e-mail query letter with link to artist's website, JPEG samples at 72 dpi. Include artist's statement, bio, brochure, business card, photocopies, photographs, résumé, and reviews. Materials returned with SASE.

TIPS "Address the gallery individually. Sound knowledgeable about our space and artists. Organization, and preparation."

RIVER GALLERY

400 E. Second St., Chattanooga TN 37403. (423)265-5033, ext. 5. **E-mail:** art@river-gallery.com. **Website:** river-gallery.com. **Contact:** Mary R. Portera, owner/director. Estab. 1992. Retail gallery. Represents 100 emerging, mid-career and established artists/year.

Exhibited artists include Leonard Baskin and Scott E. Hill. Sponsors 12 shows/year. Display time 1 month. Open Monday–Saturday, 10-5; Sunday, 1-5; and by appointment. Located in Bluff View Art District in downtown area; 2,500 sq. ft.; restored early New Orleans-style 1900s home; arched openings into rooms. 20% of space for special exhibitions; 80% of space for gallery artists. Clients include upscale tourists, local community. 95% of sales are to private collectors, 5% corporate collectors. Overall price range $5-10,000; most work sold at $200-2,000.

MEDIA Considers all media. Most frequently exhibits oil, original prints, photography, watercolor, mixed media, clay, jewelry, wood, glass and sculpture.

STYLE Exhibits all styles and genres. Prefers painterly abstraction, impressionism, photorealism.

TERMS Accepts work on consignment (50% commission). Retail price set by the gallery. Gallery provides insurance, promotion and contract; shipping costs are shared. Prefers artwork framed.

SUBMISSIONS Send query letter with résumé, slides, bio, photographs, SASE, reviews and artist's statement. Call or e-mail for appointment to show portfolio of photographs and slides. Files all material unless we are not interested then we return all information. Can also submit via form on website. Finds artists through word of mouth, referrals by other artists, visiting art fairs and exhibitions, submissions, ads in art publications.

ROCKPORT CENTER FOR THE ARTS

902 Navigation Circle, Rockport TX 78382. (361)729-5519. **E-mail:** info@rockportartcenter.com. **Website:** www.rockportartcenter.com. Estab. 1969. Rockport Center for the Arts is a hub of creative activity on the Texas Gulf Coast. Two parlor galleries are dedicated entirely to the works of its member artists, while the main gallery allows the center to host local, regional, national, and internationally acclaimed artists in both solo and group exhibitions. In 2000, the Garden Gallery was added, allowing the center for the first time to simultaneously feature three distinct exhibitions, at times displaying over 100 original works of art. Today, the building also houses two visual arts classrooms and an outdoor sculpture garden featuring works by internationally acclaimed artists. A well-furnished pottery studio is always active, and includes a kiln room which hosts daily firings. Visitors enjoy the exhibitions, education programs and gift shop, as well

as the Annual Rockport Art Festival every July 4th weekend. Open Tuesday-Saturday, 10-4; Sunday, 1-4; closed Monday. Call, e-mail or visit website for more information.

ROGUE GALLERY & ART CENTER

40 S. Bartlett, Medford OR 97501. (541)772-8118. E-mail: jules@roguegallery.org. Website: www.rogue gallery.org. Contact: Jules Masterjohn, executive director. Estab. 1961. Nonprofit sales rental gallery. Represents emerging, mid-career and established artists. Sponsors 8 shows/year. Average display time 6 weeks. Open all year; Tuesday–Friday, 10-5; Saturday, 11-3. Located downtown; main gallery 240 running ft. (2,000 sq. ft.); rental/sales and gallery shop, 1,800 sq. ft.; classroom facility, 1,700 sq. ft. "This is the only gallery/art center/exhibit space of its kind in the region, excellent facility, good lighting." 33% of space for special exhibitions; 33% of space for gallery artists. 95% of sales to private collectors. Overall price range $100-5,000; most work sold at $400-1,000.

MEDIA Considers all media and all types of prints. Most frequently exhibits mixed media, drawing, installation, painting, sculpture, watercolor.

STYLE Exhibits all styles and genres.

TERMS Accepts work on consignment (35% commission to members; 40% non-members). Retail price set by the artist. Gallery provides insurance, promotion and contract; in the case of main gallery exhibit.

SUBMISSIONS Send query letter with résumé, 10 slides, bio and SASE. Call or write for appointment. Responds in 1 month.

TIPS "The most important thing an artist needs to demonstrate to a prospective gallery is a cohesive, concise view of himself as a visual artist and as a person working with direction and passion."

ALICE C. SABATINI GALLERY

Topeka & Shawnee County Public Library, 1515 SW Tenth Ave., Topeka KS 66604-1374. (785)580-4400. Website: www.tscpl.org. Contact: Sherry Best, gallery director. Estab. 1976. Nonprofit gallery. Exhibits emerging, mid-career and established artists. Sponsors 6-8 shows/year. Average display time: 6 weeks. Open all year; Monday-Friday, 9-9; Saturday, 9-6; Sunday, 12-9. Located 1 mile west of downtown; 2,500 sq. ft.; security, track lighting, plex top cases; 5 moveable walls. 100% of space for special exhibitions and permanent collections. Overall price range: $150-5,000.

MEDIA Considers oil, fiber, acrylic, sculpture, glass, watercolor, mixed media, ceramic, pastel, collage, metal work, woodcuts, wood engravings, linocuts, engravings, mezzotints, etchings, lithographs, photography, and installation. Most frequently exhibits ceramic, oil and prints.

STYLE Exhibits realism, abstraction, neo-expressionism, modern and postmodern arts, functional and fine art ceramic and crafts.

TERMS Retail price set by artist. Gallery provides insurance; artist pays for shipping costs. Prefers artwork framed. Does not handle sales.

SUBMISSIONS Usually accepts regional artists. Send query letter with résumé and 12-24 images. Call or write for appointment to show portfolio. Responds in 2 months. Files résumé. Finds artists through visiting exhibitions, word of mouth and submissions.

TIPS "Research galleries to find out if your work is a good match. Send good quality images to best represent your work. Include information about yourself (bio, artist's statement), and also describe what projects you have going on. We plan 1-2 years in advance, and we look for originality."

SAINT MARY'S COLLEGE MUSEUM OF ART

P.O. Box 5110, Saint Mary's College of California, Moraga CA 94575-5110. (925)631-4379. Fax: (925)376-5128. E-mail: jarmiste@stmarys-ca.edu. Website: stmarys-ca.edu/museum. Contact: Julie Armistead, assistant curator. Estab. 1977. Nonprofit museum. Exhibits mid-career and established artists. Approached by 100 artists/year. Most large exhibitions are either historic, invitational or ethnographic. Sponsors 4 exhibits/year. Average display time 8 weeks. Open Wednesday-Sunday, 11-4:30. Admission $5. Closed major holidays. Located on college campus, 1,650 square feet exhibition space. Clients include local community, students and tourists.

MEDIA Considers all media. Considers engravings, etchings, lithographs, mezzotints, serigraphs, woodcuts.

STYLE Considers all styles and genres.

TERMS Artwork is accepted on consignment and there is a 25% commission; 10% commission if artist has an area dealer or gallery taking a separate commission. Retail price set by the artist. Gallery provides insurance, promotion and contract. Accepted work should be framed, mounted or matted as appropri-

ate to media. Does not require exclusive representation locally.

SUBMISSIONS Send query letter with bio, résumé, reviews, slides, or disks. Returns material with SASE. Responds to queries in 3 months. Finds artists through submissions, art exhibits, art fairs and word-of-mouth.

SAMEK ART GALLERY OF BUCKNELL UNIVERSITY

Elaine Langone Center, Lewisburg PA 17837. (570)577-3792. **Fax:** (570)577-3215. **E-mail:** r.rinehart@bucknell.edu. **Website:** www.bucknell.edu/x10857.xml. **Contact:** Richard Rinehart, director; Tracy Billet, assistant registrar. Estab. 1983. Nonprofit gallery. Exhibits emerging, mid-career and established international and national artists. Sponsors 6 shows/year. Average display time 6 weeks. Open all year; Monday-Friday, 11-5; Thursday 11-8; Saturday-Sunday, 1-4. Located on campus; 3,500 sq. ft. including main gallery, project room and Kress Study Collection Gallery.

MEDIA Considers all media, traditional and emerging media. Most frequently exhibits painting, sculpture, works on paper and video.

STYLE Exhibits all styles, genres and periods.

TERMS Retail price set by the artist. Gallery provides insurance, promotion (local) and contract; artist pays shipping costs to and from gallery. Prefers artwork framed or prepared for exhibition.

SUBMISSIONS Send query letter with résumé, slides and bio. Write for appointment to show portfolio of originals. Responds in 12 months. Files bio, résumé, slides. Finds artists through museum and gallery exhibits, and through studio visits.

TIPS "Most exhibitions are curated by the director or by a guest curator."

SAN DIEGO ART INSTITUTE

1439 El Prado, San Diego CA 92101. (619)236-0011. **Fax:** (619)236-1974. **E-mail:** admin@sandiego-art.org. **Website:** www.sandiego-art.org. **Contact:** Timothy Field, executive director; Kerstin Robers, executive administrator. Estab. 1941. Nonprofit gallery. Represents 600 emerging and mid-career member/artists. 2,400 artworks juried into shows each year. Sponsors 11 all-media exhibits/year. Average display time: 4-6 weeks. Open Tuesday–Saturday, 10-4; Sunday 12-4. Closed major holidays and all Mondays. 10,000 sq. ft., located in the heart of Balboa Park. Clients include local community, students and tourists. 10% of sales are to corporate collectors. Overall price range: $100-4,000; most work sold at $800.

MEDIA Considers all media and all types of prints. Most frequently exhibits oil, mixed media, pastel, digital.

STYLE Considers all styles and genres. No craft or installations.

SUBMISSIONS Request membership packet and information about juried shows. Membership not required for submission in monthly juried shows, but fee required. Returns material with SASE. Finds artists through word of mouth and referrals by other artists. Submission guidelines available online.

TIPS "All work submitted must go through jury process for each monthly exhibition. Work required to be framed in professional manner."

SANGRE DE CRISTO ARTS CENTER AND BUELL CHILDREN'S MUSEUM

210 N. Santa Fe Ave., Pueblo CO 81003. (719)295-7200. **E-mail:** mail@sdc-arts.org. **Website:** sdc-arts.org. Estab. 1972. Nonprofit gallery and museum. Exhibits emerging, mid-career and established artists. Sponsors 20 shows/year. Average display time 10 weeks. Open Tuesday–Saturday, 11-4. Closed major holidays (see website for details). Admission $4 adults; $3 children. Located "downtown, right off Interstate I-25"; 16,000 sq. ft.; 6 galleries, one showing a permanent collection of western art; changing exhibits in the other five. Also a new 12,000 sq. ft. children's museum with changing, interactive exhibits. Clientele: "We serve a 19-county region and attract 200,000 visitors yearly." Overall price range for artwork $50-100,000; most work sold at $50-2,500.

MEDIA Considers all media.

STYLE Exhibits all styles. Genres include southwestern, regional and contemporary.

TERMS Accepts work on consignment (40% commission). Retail price set by artist. Gallery provides insurance, promotion, contract and shipping costs. Prefers artwork framed.

SUBMISSIONS Send query letter with portfolio of slides. Responds in 2 months.

SAPER GALLERIES

433 Albert Ave., East Lansing MI 48823. (517)351-0815. **E-mail:** roy@sapergalleries.com. **Website:** www.sapergalleries.com. **Contact:** Roy C. Saper, director. Estab. 1978; new addition built in 1986. Displays the work of 150 artists, mostly mid-career, and artists of

significant national prominence. Exhibited artists include Picasso, Peter Max, Rembrandt. Sponsors 2 shows/year. Average display time: 2 months. Open all year. Located downtown; 5,700 sq. ft. 50% of space for special exhibitions. Clients include students, professionals, experienced and new collectors. 80% of sales are to private collectors, 20% corporate collectors. Overall price range: $100-100,000; most work sold at $1,000.

MEDIA Considers oil, acrylic, watercolor, pastel, drawings, mixed media, collage, paper, sculpture, ceramic, craft, glass and original handpulled prints. Considers all types of prints except offset reproductions. Most frequently exhibits intaglio, serigraphy and sculpture. "Must be of highest professional quality."

STYLE Exhibits expressionism, painterly abstraction, surrealism, postmodern works, impressionism, realism, photorealism and hard-edge geometric abstraction. Genres include landscapes, florals, southwestern and figurative work. Prefers abstract, landscapes and figurative. Seeking extraordinarily talented, outstanding artists who will continue to produce exceptional work.

TERMS Accepts work on consignment (negotiable commission); or buys outright for negotiated percentage of retail price. Retail price set by the artist. Offers payment by installments. Gallery provides insurance, promotion and contract; shipping costs are shared. Prefers artwork unframed (gallery frames). Best way to present your work is through website link or online portfolio.

SUBMISSIONS Prefers digital pictures e-mailed to roy@sapergalleries.com. Call for appointment to show portfolio of originals or photos of any type. Responds in 1 week. Files any material the artist does not need returned. Finds artists mostly through New York Art Expo.

TIPS "Present your very best work to galleries that display works of similar style, quality and media. Must be outstanding, professional quality. Student quality doesn't cut it. Must be great. Be sure to include prices."

⊙ SAW GALLERY, INC.

67 Nicholas St., Ottawa K1N 7B9, Canada. (613)236-6181. **Fax:** (613)238-4617. **E-mail:** sawgallery@artengine.ca. **Website:** www.galeriesawgallery.com. **Contact:** Tam-Ca Vo-Van, director. Estab. 1973. Alternative space. Approached by 100 artists/year. Represents

8-30 emerging and mid-career artists. Average display time 4-5 weeks. Open all year; Tuesday–Saturday, 11-6. Clients include local community, students, tourists and other members. Sales conducted with artist directly.

MEDIA Considers all media. Most frequently exhibits installation, mixed media, media arts (video/film/computer). Considers all types of prints.

STYLE Exhibits cutting edge contemporary art. Most frequently exhibits art attuned to contemporary issues. Considers critical and contemporary (avant-garde art).

TERMS All sales arranged between interested buyer and artist directly. Retail price set by the artist. Gallery provides insurance, promotion and contract. Does not require exclusive representation locally. Accepts only art attuned to contemporary issues.

SUBMISSIONS Send artist's statement, bio, résumé, reviews (if applicable), SASE, 10 slides. Returns material with SASE. Responds in 1-6 months. Proposals are reviewed in June and December. Files curriculum vitae. Finds artists through word of mouth, submissions, referrals by other artists, calls for proposals, advertising in Canadian art magazines.

TIPS "Have another artist offer an opinion of the proposal and build on the suggestions before submitting."

WILLIAM & FLORENCE SCHMIDT ART CENTER

Southwestern Illinois College, 2500 Carlyle Ave., Belleville IL 62221. (618) 641-5143. **Website:** schmidtart. swic.edu. Estab. 2002. Nonprofit gallery. Exhibits emerging, mid-career and established artists. Sponsors 10-12 exhibits/year. Average display time 6-8 weeks. Open Monday and Tuesday 9-3; Wednesday 9-5; Thursday 9-8; Friday and Saturday 11-5. Closed during college holidays. Clients include local community, students and tourists.

MEDIA Considers all media.

STYLE Considers all styles.

SUBMISSIONS Mail portfolio for review. Send query letter with artist's statement, bio and slides or digital images. Returns material with SASE. Finds artists through art fairs and exhibits, portfolio reviews, referrals by other artists, submissions and word of mouth.

SCOTTSDALE MUSEUM OF CONTEMPORARY ART

7380 E. Second St., Scottsdale AZ 85251. (480)874-4666. **E-mail:** smoca@sccarts.org. **Website:** www.smoca.org. Approached by 30-50 artists/year. "Arizona's only museum devoted to the art, architecture and design of our time." Sponsors 12 exhibits/year. Average display time 10 weeks. See website for summer and fall/winter hours. Located in downtown Scottsdale; more than 20,000 sq. ft. of exhibition space. Clients include local community, students and tourists.

MEDIA Considers all media.

STYLE Considers works of contemporary art, architecture and design.

SUBMISSIONS Send query letter with artist's statement, bio, photocopies, résumé, reviews and SASE. Returns material with SASE. Responds in 3 weeks.

TIPS Make your submission clear and concise. Fully identify all slides. All submission material, such as artist's statement and slide labels should be typed, not handwritten.

SCULPTURECENTER

44-19 Purves St., Long Island City NY 11101. (718)361-1750. **E-mail:** info@sculpture-center.org. **Website:** www.sculpture-center.org. **Contact:** Mary Ceruti, executive director. Estab. 1928. Alternative space, non-profit gallery. Exhibits emerging and mid-career artists. Sponsors 8-10 shows/year. Average display time 2-4 months. Open all year; Thursday–Monday, 11-6. Does not actively sell work.

MEDIA Considers drawing, mixed media, sculpture and installation. Most frequently exhibits sculpture, installations and video installations.

TERMS Not for profit museum. Does not sell work.

SUBMISSIONS "SculptureCenter is able to view work from artists with whom we are not familiar during our annual In Practice open call. If you'd like to be notified by e-mail when the next call is opened, please sign up for our e-mail list. You don't need to sign up a second time if you're already on our list. Artist materials submitted outside of the In Practice open call will be reviewed, but due to the volume of requests we receive every day, we regret that we are not able to reply to submissions. If your work appears both appropriate and timely for us to consider, we will contact you for a more formal review. Before sending materials, we ask that you first familiarize yourself with SculptureCenter by reviewing our past exhibitions and mission. We

are unable to return submitted materials. We do not accept e-mail submissions."

SECOND STREET GALLERY

115 Second St. SE, Charlottesville VA 22902. (434)977-7284. **Fax:** (434)979-9793. **E-mail:** ssg@secondstreetgallery.org. **Website:** www.secondstreetgallery.org. **Contact:** Rebecca Schoenthal, executive director. Estab. 1973. Sponsors approximately 2 photography exhibits/year. Average display time 1 month. Open Tuesday–Saturday, 11-6; 1st Friday of every month, 6-8 with artist talk at 6:30. Overall price range $300-2,000.

MEDIA Considers all media, except craft. Most frequently exhibits sculpture, paintings, prints and photographs.

STYLE Exhibits the best of contemporary artistic expression.

TERMS Artwork is accepted on consignment (40% commission).

SUBMISSIONS Reviews slides/CDs in fall; $15 processing fee. Submit 10 images in PowerPoint CD for review; include artist's statement, cover letter, bio/résumé. Responds in 4 months.

TIPS Looks for work that is "cutting edge, innovative, unexpected."

SELECT ART

1025 Levee St., Dallas TX 75207. (214)521-6833. **Fax:** (214)760-9722. **E-mail:** selart@swbell.net. **Website:** selartusa.com. **Contact:** Paul Adelson, owner. Estab. 1986. Private art gallery. Represents 25 emerging, mid-career and established artists. Open all year; Monday–Friday, 9-5 by appointment only. Located in the art/design district. By appointment only. 4,000 sq. ft. Provides art for major public spaces—corporate and healthcare. Overall price range $500-15,000.

MEDIA Considers oil, fiber, acrylic, sculpture, glass, watercolor, mixed media, ceramic, pastel, collage, photography, woodcuts, linocuts, engravings, etchings and lithographs. Prefers monoprints and paintings on paper.

STYLE No photography at this time. No impressionism or realism. Prefers abstraction and outdoor sculpture in all mediums.

TERMS Accepts work on consignment (50% commission). Retail price set by consultant and artist. Sometimes offers customer discounts. Provides contract (if the artist requests one). Consultant pays shipping costs from gallery; artist pays shipping to gallery. Prefers artwork unframed.

SUBMISSIONS "No florals or wildlife." Send query letter with résumé, bio and SASE. Responds within 1 month, only if interested. Files bio, price list. Finds artists through word of mouth and referrals from other artists.

TIPS "Be timely when you say you are going to send artwork, etc."

SILVERMINE GUILD GALLERY

1037 Silvermine Rd., New Canaan CT 06840. (203)966-5617. **Fax:** (203)972-7236. **E-mail:** nancywoodward@silvermineart.org. **Website:** silvermineart.org. **Contact:** Jeffrey Mueller, gallery director. Estab. 1922. Nonprofit gallery. Represents 300 emerging, mid-career and established artists/year. Sponsors 24 shows/year. Average display time 1 month. Open Wednesday–Saturday, 12-5; Sunday, 1-5. 5,000 sq. ft. 95% of space for gallery artists. Clientele: private collectors, corporate collectors. Overall price range $250-10,000; most work sold at $1,000-2,000.

MEDIA Considers all media and all types of prints. Most frequently exhibits paintings, sculpture and ceramics.

STYLE Exhibits all styles.

TERMS Accepts guild member work on consignment (50% commission). Co-op membership fee plus donation of time (50% commission.) Retail price set by the gallery and the artist. Gallery provides insurance, promotion and contract. Prefers artwork framed.

SUBMISSIONS Send query letter.

SIOUX CITY ART CENTER

225 Nebraska St., Sioux City IA 51101-1712. (712)279-6272. **Fax:** (712)255-2921. **E-mail:** siouxcityartcenter@sioux-city.org. **Website:** www.siouxcityartcenter.org. **Contact:** Todd Behrens, curator. Estab. 1938. Museum. Exhibits emerging, mid-career and established artists. Approached by 50 artists/year; represents or exhibits 2-3 artists. Sponsors 15 total exhibits/year. Average display time: 10-12 weeks. Gallery open Tuesday, Wednesday, Friday, Saturday 10-4; Thursday 10-9; Sunday 1-4. Closed on Mondays and municipal holidays. Located in downtown Sioux City; 2 galleries, each 40×80 ft. Clients include local community, students and tourists.

MEDIA Considers all media and types of prints. Most frequently exhibits paintings, sculpture and mixed media.

STYLE Considers all styles and genres.

TERMS Artwork is accepted on consignment with a 30% commission. "However, the purpose of our exhibitions is not sales." Retail price of the art set by the artist. Gallery provides insurance, promotion and contract.

SUBMISSIONS Artwork should be framed. Only accepts artwork from upper-Midwestern states. E-mail query letter with link to artist's website; JPEG samples at 72 dpi. Or send query letter with artist's statement, résumé and digital images. Returns materials if SASE is enclosed. Responds, only if interested, within 6 months. Files résumé, statement and images if artist is suitable. Finds artists through word of mouth, art exhibits, submissions, art fairs, portfolio reviews and referrals by other artists.

SNYDERMAN-WORKS GALLERY

303 Cherry St., Philadelphia PA 19106. (215)238-9576. **E-mail:** kat@snyderman-works.com. **Website:** www.snyderman-works.com. Estab. 1965. Retail gallery. Represents 200 emerging, mid-career and established artists. Exhibited artists include Eileen Sutton and Patricia Sannit. Sponsors 10 shows/year. Average display time 1 month. Open all year; Tuesday–Saturday, 10-6. Exhibitions usually change on a monthly basis except through the summer. Located downtown ("Old City"); 3,000 sq. ft. 65% of space for special exhibitions. Clientele designers, lawyers, businessmen and women, students. 90% private collectors, 10% corporate collectors. Overall price range $50-$10,000; most work sold at $200-$600.

MEDIA Considers ceramic, fiber, glass, photography and metal jewelry. Most frequently exhibits jewelry, ceramic and fiber.

STYLE Exhibits all styles.

TERMS Accepts artwork on consignment (50% commission); some work is bought outright. Gallery provides insurance, promotion and contract; shipping costs are shared.

SUBMISSIONS Send query letter with résumé, 5-10 photos and SASE. Files résumé and slides, if interested.

TIPS "Most work shown is one-of-a-kind. We change the gallery totally for our exhibitions. In our gallery, someone has to have a track record so that we can see the consistency of the work. We would not be pleased to see work of one quality once and have the quality differ in subsequent orders, unless it improved. Always submit slides with descriptions and prices in-

stead of walking in cold. Enclose a SASE. Follow up with a phone call. Try to have a sense of what the gallery's focus is so your work is not out of place. It would save everyone some time."

⊕ SOHN FINE ART—GALLERY & GICLÉE PRINTING

6 Elm St., 1B-C, P.O. Box 1392, Stockbridge MA 01262. (413)298-1025. **E-mail:** info@sohnfineart. com. **Website:** www.sohnfineart.com. **Contact:** Cassandra Sohn, owner. Estab. 2011. Alternative space and for-profit gallery. Approached by 50-100 artists a year; represents or exhibits 12-20 emerging, mid-career and established artists. Exhibited artists include Fran Forman, photography, and John Atchley, photography. Average display time 1-3 months. Open Thursday-Monday, 10-5. Located in the Berkshires of Western Massachusetts. The area is known for arts and culture and full of tourists. Also, 80% of the population are 2nd home owners from New York and Boston. Clients include local community, tourists and upscale. Overall price range $300-6,000. Most work sold for $500-1,500.

MEDIA Considers all media and types of prints. Most frequently exhibits photography.

STYLE Considers all styles and genres.

TERMS Artwork is accepted on consignment and there is a 50% commission. Retail price of the art set by the artist. Gallery provides insurance, promotion and contract. Accepted work should be framed, mounted and matted. Requires exclusive representation locally.

SUBMISSIONS E-mail query letter with link to artist's website and JPEG samples at 72 dpi. Material cannot be returned. Responds only if interested. Finds artists through word of mouth, art exhibits, submissions, art fairs, portfolio reviews and referrals by other artists.

SOUTH ARKANSAS ARTS CENTER

110 E. Fifth St., El Dorado AR 71730. (870)862-5474. **E-mail:** info@saac-arts.org. **Website:** www.saac-arts.org. Estab. 1963. Nonprofit gallery. Exhibits the work of 50 emerging, mid-career and established artists. Exhibited artists include George Price and Dee Ludwig. Sponsors 15 shows/year. Average display time 1 month. Open Monday–Friday, 9-5; appointments scheduled by special arrangement on weekends. Closed on major holidays (see website for details). Located "in the middle of town; 3,200 sq. ft."

60% of space for special exhibitions. 100% private collectors. Overall price range $50-1,500; most work sold at $200-300.

MEDIA Considers all media and prints. Most frequently exhibits watercolor, oil and mixed media.

STYLE Exhibits all styles.

TERMS Accepts work on consignment (25% commission). Retail price set by the artist. Gallery provides insurance and promotion; contract and shipping may be negotiated. Prefers artwork framed.

SUBMISSIONS Send query with slides, photographs, SASE and "any pertinent materials." Only after a query, call to schedule an appointment to show a portfolio. Portfolio should include originals and artist's choice of work. Responds in 2 weeks. Files materials unless artist requests return. "Keeping something on file helps us remember your style."

TIPS "We exhibit a wide variety of works by local, regional and national artists. We have facilities for 3D works."

SOUTH DAKOTA ART MUSEUM

South Dakota State University, Medary Ave. & Harvey Dunn St., P.O. Box 2250, Brookings SD 57007. (605)688-5423. **Fax:** (605)688-4445. **E-mail:** Dianne. Hawks@sdstate.edu. **Website:** www.southdakotaart museum.com. **Contact:** John Rychtarik, curator of exhibits. Estab. 1970. Sponsors 15 exhibits/year. Average display time: 4 months. Open Monday–Friday, 10-5; Saturday, 10-4; Sunday, 12-4. Closed state holidays and Sundays from January through March. Seven galleries offer 26,000 sq. ft. of exhibition space. Overall price range: $200-6,000; most work sold at $500.

MEDIA Considers all media and all types of prints. Most frequently exhibits painting, sculpture and fiber.

STYLE Considers all styles.

TERMS Artwork is accepted on consignment (30% commission). Retail price set by the artist. Gallery provides insurance and promotion. Accepted 2D work must be framed and ready to hang.

SUBMISSIONS Send query letter with artist's statement, bio, résumé, slides, SASE. Responds within 3 months, only if interested. Finds artists through word of mouth, portfolio reviews, art exhibits, referrals by other artists.

SPACES

2220 Superior Viaduct, Cleveland OH 44113. (216)621-2314. **E-mail:** clynn@spacesgallery.org; msimmons@ spacesgallery.org. **Website:** www.spacesgallery.org.

Contact: Christopher Lynn, executive director; Marilyn Ladd-Simmons, gallery manager. Estab. 1978. SPACES is the resource and public forum for artists who explore and experiment. Public projects feature artists who push boundaries by experimenting with new forms of expression and innovative uses of media, presenting work of emerging artists and established artists with new ideas. The SPACES World Artist Program is a residency program that gives national, international, and regional artists the opportunity to create new work and interact with the Northeast Ohio community. The R&D program invites artists curators and other cultural group, solo, or event-oriented." Sponsors 8-12 shows/year. Average display time: 8 weeks. Open Tuesday–Sunday, 12-5; Thursday, 12-8. Located in Cleveland; 6,000 sq. ft.; "warehouse space with row of columns."

MEDIA Considers all media. Most frequently exhibits installation, painting, video and sculpture.

STYLE "Style not relevant; presenting challenging new ideas is essential."

TERMS Artists are provided honoraria, and 25% commission is taken on work sold. Gallery provides insurance, promotion and contract.

SUBMISSIONS Contact SPACES for deadline and application.

SPAIGHTWOOD GALLERIES, INC.

P.O. Box 1193, Upton MA 01568-6193. (508)529-2511. **E-mail:** sptwd@verizon.net. **Website:** www.spaightwoodgalleries.com. **Contact:** Sonja Hansard-Weiner, president; Andy Weiner, director. Estab. 1980. Exhibits mostly established artists. Presents 2 exhibits/year. Average display time: 6 months. Open Saturday and Sunday 12-6 and by appointment. Located in a renovated former Unitarian Church; basic space is 90×46 ft.; ceilings are 25 ft. high at center, 13 ft. at walls. See website for views of the gallery. Clients include mostly Internet and visitors drawn by Internet; we are currently trying to attract visitors from Boston and vicinity via advertising and press releases." 2% of sales are to corporate collectors. Overall price range: $175-950,000; most work sold at $1,000-4,000.

MEDIA Considers all media except installations, photography, glass, craft, fiber. Most frequently exhibits original prints, drawings and ceramic sculpture, occasionally paintings.

STYLE Exhibits Old Masters to contemporary; most frequently Old Master prints and drawings, modern, contemporary, impressionist and post-impressionist. "Work shown is part of our inventory; we buy mostly at auction. In the case of some artists, we buy directly from the artist or the publisher; in a few cases we have works on consignment."

TERMS Retail price set by both artist and gallery. Accepted work should be unmatted and unframed. Requires exclusive representation locally.

SUBMISSIONS Prefers link to website with bio, exhibition history and images. Returns material with SASE. Responds to queries only if interested. Finds artists through art exhibits (particularly museum shows), referrals by other artists, books.

TIPS "Make high-quality art."

B.J. SPOKE GALLERY

299 Main St., Huntington NY 11743. (631)549-5106. **E-mail:** manager@bjspokegallery.com. **Website:** www.bjspokegallery.com. **Contact:** Marilyn Lavi, gallery manager. Estab. 1978. Cooperative and nonprofit gallery exhibiting artists on Long Island. Artists showing at the gallery are well represented in numerous public and private collections. Our artworks are for sale in the gallery and through this online exhibit space. Exhibits the work of 26 emerging, mid-career and established artists. Sponsors 2-3 invitationals and juried shows/year. Average display time 1 month. Open all year. "Located in center of town; 1,400 sq. ft.; flexible use of space; 3 separate gallery spaces." 66% of space for special exhibitions. Overall price range $300-2,500; most work sold at $900-1,600. Artist is eligible for a 2-person show every 2 years. Entire membership has ability to exhibit work 11 months of the year. Open Tuesday–Sunday, 11-5; Friday, 11-9.

○ Sponsors annual international/national juried show. Deadline: early November (see website for more details). Fee: $35. Checks made payable to b.j. spoke gallery. Send SASE for prospectives. Application is online. Send to EXPO 30 with SASE. Images are to be submitted on CD, JPEG only. File size should be between 500K and 1M. They will be viewed on a PC computer. Filenames should read: lastnamefirstname-1, lastnamefirstname-2, lastnamefirstname-3, etc. (no spaces).

MEDIA Considers all media except crafts, all types of printmaking. Most frequently exhibits paintings, prints and sculpture. Craft sold separately.

STYLE Exhibits all styles and genres. Prefers painterly abstraction, realism and expressionism.

TERMS Co-op membership fee plus donation of time. Monthly fee covers rent, other gallery expenses. Retail price set by artist. Payment by installment is available. Gallery provides promotion and publicity; artists pay for shipping. Prefers artwork framed; large format artwork can be tacked.

SUBMISSIONS For membership, send query letter with résumé, high-quality slides, bio, SASE and reviews. For national juried show send SASE for prospectus and deadline. Judge: Maura Lynch, assistant curator of drawings, Museum of Modern Art. Award: Exhibition of selected works, March 2011. Eligibility: Artists living in USA may submit up to six flat or three 3D works. Media: All fine arts media are acceptable. No crafts. Sculpture should not exceed 8 feet in any dimension.

TIPS "Call or write for appointment to show portfolio of originals and slides. Files résumés; may retain slides for awhile if needed for upcoming exhibition. Send slides that represent depth and breadth in the exploration of a theme, subject or concept. They should represent a cohesive body of work."

THE STATE MUSEUM OF PENNSYLVANIA

300 North St., Harrisburg PA 17120. (717)787-4980. **Fax:** (717)783-4558. **E-mail:** hpollman@state.pa.us. **Website:** www.statemuseumpa.org. **Contact:** N. Lee Stevens, senior curator of art collections. Offers visitors 4 floors representing Pennsylvania's story, from Earth's beginning to the present. Features archaeological artifacts, minerals, paintings, decorative arts, animal dioramas, industrial and technological innovations and military objects representing the Commonwealth's heritage. Number of exhibits varies. Average display time 2 months. Overall price range $50-3,000. Open Wednesday–Saturday, 9-5; Sunday 12-5.

MEDIA Considers all media and all types of prints.

STYLE Exhibits all styles and genres.

TERMS Work is sold in gallery, but not actively. Connects artists with interested buyers. No commission. Accepted work should be framed. Art must be created by a native or resident of Pennsylvania, or contain subject matter relevant to Pennsylvania.

SUBMISSIONS Send material by mail for consideration; include SASE. Responds in 1 month.

TIPS "Have the best visuals possible. Make appointments. Remember most curators are also overworked, underpaid and on tight schedules."

STATE OF THE ART GALLERY

120 W. State St., Ithaca NY 14850. (607)277-1626. **E-mail:** gallery@soag.org. **Website:** www.soag.org. Estab. 1989. Cooperative gallery. Sponsors 12 exhibits/year. Average display time: 1 month. Open Wednesday-Friday, 12-6; weekends, 12-5. Located in downtown Ithaca; 2 rooms; about 1,100 sq. ft. Overall price range: $100-6,000; most work sold at $200-500.

MEDIA Considers all media and all types of prints. Most frequently exhibits sculpture, paintings, mixed media.

STYLE Considers all styles and genres.

TERMS There is a co-op membership fee plus a donation of time. There is a 10% commission for members, 30% for nonmembers. Retail price set by the artist. Gallery provides promotion and contract. Accepted work must be ready to hang.

SUBMISSIONS Write for membership application. Finds artists through word of mouth, submissions, portfolio reviews, art exhibits, referrals by other artists.

PHILIP J. STEELE GALLERY AT ROCKY MOUNTAIN COLLEGE OF ART + DESIGN

1600 Pierce St., Denver CO 80214. (303)225-8575. **E-mail:** cstell@rmcad.edu. **Website:** www.rmcad.edu. **Contact:** Cortney Stell, gallery director. Estab. 1962. For-profit college gallery. Represents emerging, mid-career and established artists. Sponsors 10-12 shows/year. Exhibited artists include Christo, Herbert Bayer, Andy Warhol and others. Average display time 1 month. Open all year; Monday–Saturday, 11-4. Located in the Mary Harris Auditorium building on the southeast corner of the quad. Clientele: local community, students, faculty.

MEDIA Considers all media and all types of prints.

STYLE Exhibits all styles.

TERMS Artists sell directly to buyer; gallery takes no commission. Retail price set by the artist. Gallery provides insurance and promotion; artist pays shipping costs to and from gallery.

SUBMISSIONS Submission guidelines available online.

TIPS Impressed by "professional presentation of materials, good-quality slides or catalog."

STEVENSON UNIVERSITY ART GALLERY

1525 Greenspring Valley Rd., Stevenson MD 21153. (443)334-2163. **Fax:** (410)486-3552. **E-mail:** exhibitions@stevenson.edu. **Website:** www.stevenson.edu/explore/gallery/index.asp. **Contact:** Diane DiSalvo, director of cultural programs. Estab. 1997. College/university gallery. Approached by many artists/year. Represents numerous emerging, mid-career and established artists. Sponsors 14 exhibits/year. Average display time: 8 weeks. Open all year; Monday, Wednesday, Friday 11-5; Thursday 11-8; Saturday 1-4. Located in the Greenspring Valley, 5 miles north of downtown Baltimore; beautiful space in renovated academic center and student center. "We do not take commission; if someone is interested in an artwork we send them directly to the artist."

MEDIA Considers all media. Most frequently exhibits painting, sculpture, photography and works on paper, installation and new media.

STYLE Considers all styles and genres.

TERMS Artwork is accepted on consignment (no commission). Retail price set by the artist. Gallery provides insurance. Does not require exclusive representation locally. Has emphasis on mid-Atlantic regional artists but does not set geographic limitations.

SUBMISSIONS Write to arrange a personal interview to show portfolio of slides. Send query letter with artist's statement, bio, résumé, reviews, SASE, CD, or slides. Returns material with SASE. Responds in 3 months. Files bio, statement, reviews and letter, but will return slides or CD. Finds artists through word of mouth, submissions, portfolio reviews, art exhibits, and referrals by other artists.

TIPS "Be clear and concise, and have good visual representational of your work."

STILL POINT ART GALLERY

193 Hillside Rd., Brunswick ME 04011. (207)837-5760. **E-mail:** info@stillpointartgallery.com. **Website:** www.stillpointartgallery.com. **Contact:** Christine Cote, owner/director. Estab. 2009. For-profit online gallery. Exhibits emerging, mid-career and established artists. Approached by 750 artists/year. Represents 500 artists. Sponsors 6 exhibits/year. Model and property release preferred. Average display time: 14 months. Overall price range: $200-5,000.

MEDIA Considers all media. Most frequently exhibits oil, acrylic, and photography. Considers engravings, etchings, serigraphs, linocuts, woodcuts, lithographs and mezzotints.

STYLE Considers all styles and genres.

TERMS Retail price set by the artist. Gallery provides promotion. Responds to calls for artists posted on website.

TIPS "Follow the instructions posted on our website."

STUDIO GALLERY

2108 R St. NW, Washington DC 20008. (202)232-8734. **E-mail:** info@studiogallerydc.com. **Website:** www.studiogallerydc.com. **Contact:** Adah Rose Bitterbaum, director. Estab. 1964. Cooperative and nonprofit gallery. Exhibits the work of 30 emerging, mid-career and established local artists. Sponsors 11 shows/year. Average display time 1 month. Gallery for rent the last of August. Located downtown in the Dupont Circle area; 700 sq. ft.; "gallery backs onto a courtyard, which is a good display space for exterior sculpture and gives the gallery an open feeling." Clientele: private collectors, art consultants and corporations. 85% private collectors; 8% corporate collectors. Overall price range $300-10,000; most work sold at $500-3,000. Open Wednesday-Friday, 1-7; Saturday 1-6.

MEDIA Considers glass, oil, acrylic, watercolor, pastel, pen & ink, drawings, mixed media, collage, works on paper, sculpture, ceramic, fiber, original hand-pulled prints, woodcuts, lithographs, monotypes, linocuts and etchings. Most frequently exhibits oil, acrylic and paper.

STYLE Considers all styles. Most frequently exhibits abstract and figurative paintings, landscapes, indoor and outdoor sculpture and mixed media.

TERMS Co-op membership fee plus a donation of time (65% commission).

SUBMISSIONS Send query letter with SASE. Artists must be local or willing to drive to Washington for monthly meetings and receptions. Artist is informed as to when there is a membership opening and a selection review. Files artist's name, address, telephone.

TIPS "This is a cooperative gallery. Membership is decided by the gallery membership. Ask when the next review for membership is scheduled. An appointment for a portfolio review with the director is required before the jurying process, however. Dupont Circle is an exciting gallery scene with a variety of galleries. First Fridays from 6-8 for all galleries of DuPont Circle."

STUDIO SEVEN ARTS

400 Main St., Pleasanton CA 94566. (925)846-4322. **Fax:** (925)846-2249. **E-mail:** info@studiosevenarts. com. **Website:** www.studiosevenarts.com. Estab. 1981. Retail gallery. Represents/exhibits established artists. Sponsors 10 shows/year. Average display time 3 weeks. Open Sunday–Thursday, 10-7; Friday-Saturday, 10-9; Sunday, 11-6. Located in historic downtown Pleasanton; 2,500 sq. ft.; excellent lighting from natural and halogen sources. 30% of space for special exhibitions; 70% of space for gallery artists. Clientele "wonderful, return customers." 99% private collectors, 1% corporate designer collectors. Overall price range $100-80,000; most work sold at under $2,000-3,000.

MEDIA Considers oil, acrylic, watercolor, pastel, drawing, mixed media, collage, paper, sculpture, ceramics, fine craft, glass, woodcuts, engravings, lithographs, mezzotints, serigraphs and etchings. Most frequently exhibits oil, acrylic, etching, watercolor, handblown glass, jewelry and sculpture.

STYLE Exhibits painterly abstraction and impressionism. Genres include landscapes and figurative work. Prefers landscapes, figurative and abstract.

TERMS Work only on consignment. Retail price set by the artist. Gallery provides promotion and contract and shares in shipping costs.

SUBMISSIONS Prefers artists from the Bay Area. Send query e-mail with several examples of work representing current style. Call for appointment to show portfolio of originals. Responds only if interested within 1 month. Finds artists through word of mouth and "my own canvassing."

TIPS "Be prepared! Please come to your appointment with an artist statement, an inventory listing including prices, a résumé, and artwork that is ready for display."

SUMNER MCKNIGHT CROSBY JR. GALLERY

Arts Council of Greater New Haven, 70 Audubon St., 2nd Floor, New Haven CT 06510. (203)772-2788. **Fax:** (203)772-2262. **E-mail:** info@newhavenarts. org. **Website:** www.newhavenarts.org/programs/exhibitions/smallspace.html. Estab. 1985. Formerly Small Space Gallery. Alternative space. Interested in emerging artists. Sponsors 10 solo and group shows/year. Average display time 1-2 months. Open to Arts Council members only (Greater New Haven). Arts Council membership costs $35. Artwork price range $35-3,000.

MEDIA Considers all media.

STYLE Exhibits all styles and genres. "The Small Space Gallery was established to provide our artist members with an opportunity to show their work. Particularly those who were just starting their careers. We're not a traditional gallery, but an alternative art space." Shows are promoted through greater New Haven's only comprehensive arts and entertainment events magazine.

TERMS Arts Council requests 10% donation on sale of each piece. Retail price set by artist. Exclusive area representation not required. Gallery provides insurance (up to $10,000) and promotion.

SUBMISSIONS Send images, résumé and bio, attn: Debbie Hesse (dhesse@newhavenarts.org).

SWOPE ART MUSEUM

25 S. Seventh St., Terre Haute IN 47807. (812)238-1676. **E-mail:** info@swope.org; petrulis@swope.org. **Website:** www.swope.org. **Contact:** Lisa Petrulis, curator of collections and exhibitions. Estab. 1942. Nonprofit museum. Approached by approximately 10 artists/year. Represents 1-3 mid-career and established America artists. Average display time 6 and 12 weeks. Open all year; Tuesday–Friday, 10-5; Saturday, 12-5; first Friday of the month (September-May) 6-9. Closed national holidays. Located in downtown Terre Haute, Indiana, in an Italian Renaissance-revival building with art deco interior.

MEDIA Considers all media. Most frequently exhibits paintings, sculpture, and works on paper. Considers all types of prints except posters.

STYLE Exhibits American art of all genres. Exhibits permanent collection with a focus on mid-20th-century regionalism and Indiana artists but includes American art from all 50 states from 1800s to today.

TERMS Focuses on local and regional artists (size and weight of works are limited because we do not have a freight elevator).

SUBMISSIONS Send query letter with artist's statement, brochure, CD or slides, résumé and SASE (if need items returned). Returns material with SASE. Responds in 5 months. Files only what fits the mission statement of the museum for special exhibitions. Finds artists through word of mouth, and annual juried exhibition at the museum.

TIPS The Swope has physical limitations due to its historic interior but is willing to consider newer media, unconventional media and installations.

☮ SWORDS INTO PLOWSHARES PEACE CENTER AND GALLERY

33 E. Adams Ave., Detroit MI 48226. (313)963-7575. **E-mail:** swordsintoplowshares@prodigy.net or via online contact form. **Website:** www.swordsintoplow sharesdetroit.org. Estab. 1985. Nonprofit peace center and gallery. Presents 3-4 major shows/year. Open Tuesday, Thursday and Saturday, 11-3 or by appointment. Located in downtown Detroit in the Theater District; 2,881 sq. ft.; 1 large gallery, 3 small galleries. 100% of space for special exhibitions. Clients include walk-in, church, school and community groups. 100% of sales are to private collectors. Overall price range: $75-6,000; most work sold at $75-700.

MEDIA Considers all media and all types of prints.

TERMS Retail price set by the artist. Gallery provides insurance and promotion.

SUBMISSIONS Accepts artists primarily from Michigan and Ontario. Send query letter with statement on how work relates to theme. Responds in 2 months. Finds artists through lists from Michigan Council of the Arts and Windsor Council of the Arts.

SYNCHRONICITY FINE ARTS

106 W. 13th St., New York NY 10011. (646)230-8199. **Fax:** (646)230-8198. **E-mail:** contact@synchron cityspace.com. **Website:** www.synchronicityspace. com. **Contact:** John Amato, director. Estab. 1989. Nonprofit gallery. Approached by several hundred artists/year. Average display time: 1 month. Open Tuesday-Saturday, 12-6. Closed for 2 weeks in August. Clients include local community, students, tourists and upscale. 20% of sales are to corporate collectors. Overall price range: $1,500-10,000; most work sold at $3,000-5,000.

MEDIA Considers acrylic, collage, drawing, mixed media, oil, paper, pastel, pen & ink, sculpture, watercolor, engravings, etchings, mezzotints and woodcuts. Most frequently exhibits oil, sculpture and photography.

STYLE Exhibits color field, expressionism, impressionism, postmodernism and painterly abstraction. Most frequently exhibits semi-abstract and semi-representational abstract. Genres include figurative work, landscapes and portraits.

TERMS Retail price set by the gallery. Gallery provides insurance, promotion and contract. Accepted work should be framed, mounted and matted.

SUBMISSIONS Write or call to arrange a personal interview to show portfolio of photographs, slides and transparencies. Send query letter with photocopies, photographs, résumé, SASE and slides. Returns material with SASE. Files materials unless artist requests return. Finds artists through submissions, portfolio reviews, art exhibits and referrals by other artists.

LILLIAN & COLEMAN TAUBE MUSEUM OF ART

2 N. Main St., Minot ND 58703. (701)838-4445. **E-mail:** taube@srt.com. **Website:** www.taubemuseum. org. **Contact:** Nancy Walter, executive director. Estab. 1970. Established nonprofit organization. Sponsors 1-2 photography exhibits/year. Average display time 4-6 weeks. Museum is located in a renovated historic landmark building with room to show 2 exhibits simultaneously. Overall price range $15-225. Most work sold at $40-100.

MEDIA Considers oil, acrylic, watercolor, pastel, pen & ink, drawings, mixed media, collage, works on paper, sculpture, ceramic, fiber, glass, photograph, woodcuts, engravings, lithographs, serigraphs, linocuts and etchings. Most frequently exhibits watercolor, acrylic and mixed media.

STYLE Exhibits all styles and genres. Prefers figurative, Americana and landscapes. No "commercial-style work (unless a graphic art display)." Interested in all media.

TERMS Accepts work on consignment (30% commission, members; 40% nonmembers). Retail price set by artist. Offers discounts to gallery members and sometimes payment by installments. Gallery provides insurance, promotion and contract; pays shipping costs from gallery or shipping costs are shared. Requires artwork framed.

SUBMISSIONS Send query letter with résumé and slides. Write for appointment to show portfolio of good quality photographs and slides. "Show variety in your work." Files material interested in. Finds artists through visiting exhibitions, word of mouth, submissions of slides and members' referrals.

TIPS "We will take in a small show to fill in an exhibit. Show your best. When shipping show, be uniform on sizes and frames. Have flat backs to pieces so work does not gouge walls. Be uniform on wire placement. Avoid sawtooth hangers."

TAYLOR'S CONTEMPORANEA FINE ARTS

204 Exchange St., Hot Springs National Park AR 71901. (501)624-0516. **Fax:** (501)624-0516. **E-mail:** carolyn@taylorsarts.com. **Website:** www.taylorsarts. com. Estab. 1981. Retail gallery. Represents emerging, mid-career and established artists/year. Exhibited artists include Warren Criswell, William Dunlap, Billy De Williams, Robert Evans and David Hostetler. Sponsors 12 shows/year. Average display time 1 month. Open all year, 11-6 daily (closed Monday). Located downtown Central Ave.; 3,000 sq. ft.; 18 ft. ceiling. Outdoor sculpture garden, restored building (circa 1890). 50% of space for special exhibitions; 50-75% of space for gallery artists. Clientele: upscale, local, various. 90% private collectors, 10% corporate collectors. Overall price range $500-50,000; most work sold at $900-5,000.

MEDIA Considers all media. Considers monoprint and serigraphs. Most frequently exhibits oil, bronze and clay.

STYLE Exhibits contemporary work of all genres. Prefers surrealism, primitivism and impressionism.

TERMS Artwork is accepted on consignment and there is a 40% commission. Retail price set by gallery and artist. Gallery provides insurance, promotion and contract. Artist pays for shipping costs. Prefers artwork framed.

SUBMISSIONS Send query letter with résumé, slides and SASE. Write for appointment to show portfolio of slides. Responds in 3 months. Files work of artists currently exhibited and future exhibitors.

TEW GALLERIES, INC.

425 Peachtree Hills Ave., #24, Atlanta GA 30305. (404)869-0511. **Fax:** (404)869-0512. **E-mail:** jules@ tewgalleries.com. **E-mail:** info@tewgalleries.com. **Website:** www.tewgalleries.com. **Contact:** Jules Bekker, director. Estab. 1987. For-profit gallery. "TEW Galleries is recognized as a leading contemporary fine art institution in Atlanta. The gallery has an established reputation for its representation of national and international artists and presents a broad spectrum of works in styles ranging from traditional to contemporary, including abstract, landscape, and figurative art. The gallery also focuses on the best of the next generation of emerging talent and regularly features young artists alongside established contemporaries in exciting and stimulating exhibitions." Exhibits selected emerging and mid-career artists. Approached by 100 artists/year; represents or exhibits 20-30 artists/year in solo and group exhibitions. Exhibited artists include Brian Rutenberg (oil), Deedra Ludwig (encaustic, mixed media, oil, pastel painting) and Kimo Minton (polychrome woodcut panels and sculpture). Sponsors 7 exhibits/year. Average display time 28 days. Open Monday–Friday, 10-5; Saturday, 11-5. Located in a prestigious arts and antiques complex. Total of 3,600 sq. ft. divided over three floors. Clients include upscale and corporate. 15% of sales are to corporate collectors. Overall price range: $1,800-40,000; most work sold at $8,500 or less.

MEDIA Considers all media except craft and photography. Most frequently exhibits oil on canvas, works on paper and small to medium scale sculptures.

STYLE Considers all styles.

TERMS Artwork is accepted on consignment and there is a 50% commission. Retail price set by the gallery and the artist. Requires exclusive representation locally.

SUBMISSIONS Reviews artist submissions on an ongoing basis. Artists may send a submission by e-mail, with a maximum of 8 digital images. Links to websites are also welcome. Please be aware that we *do not* accept submissions by postal mail. With all submissions, please include a biographical history, résumé, and other material that supports your work.

TIPS "We kindly ask that artists not show up at the gallery and ask us to review their artwork. We do review everything sent to us and appreciate your attention to our submissions policy."

NATALIE AND JAMES THOMPSON ART GALLERY

School of Art Design, San Jose State University, San Jose CA 95192-0089. (408)924-4723. **Fax:** (408)924-4326. **E-mail:** thompsongallery@sjsu.edu. **Website:** www.sjsu.edu. **Contact:** Jo Farb Hernandez, director. Nonprofit gallery. Approached by 100 artists/year. Sponsors 6 exhibits/year of emerging, mid-career and established artists. Average display time: 1 month. Open during academic year; Tuesday, 11-4, 6-7:30; Monday, Wednesday-Friday, 11-4. Closed semester breaks, summer and weekends. Clients include local community, students and upscale.

MEDIA Considers all media and all types of prints.

STYLE Considers all styles and genres.

TERMS Retail price set by the artist. Gallery provides insurance, transportation and promotion. Accepted

work should be framed or ready to display. Does not require exclusive representation locally.

SUBMISSIONS Send query letter with artist's statement, bio, résumé, reviews, SASE and slides. Returns material with SASE.

THORNE-SAGENDORPH ART GALLERY

Wyman Way, Keene State College, 229 Main St., Keene NH 03435-3501. (603)358-2720. **E-mail:** thorne@keene.edu. **Website:** www.keene.edu/tsag. Estab. 1965. Nonprofit gallery. In addition to exhibitions of national and international art, the Thorne shows local artist as well as KSC faculty and student work. 600 members. Exhibited artists include Jules Olitski and Fritz Scholder. Sponsors 5 shows/year. Average display time 4-6 weeks. Open Saturday-Wednesday, 12-4; Thursday and Friday evenings till 7, summer s, Wednesday-Sunday, 12-4, closed Monday & Tuesday. Follows academic schedule. Located on campus; 4,000 sq. ft.; climate control, security. 50% of space for special exhibitions. Clients include local community and students.

MEDIA Considers all media and all types of prints.

STYLE Exhibits Considers all styles.

TERMS Gallery takes 40% commission on sales. Retail price set by the artist. Gallery provides insurance, promotion and contract; shipping costs are shared. Artwork must be framed.

SUBMISSIONS Artist's portfolio should include photographs and transparencies. Responds only if interested within 2 months. Returns all material.

THROCKMORTON FINE ART

145 E. 57th St., 3rd Floor, New York NY 10022. (212)223-1059. **Fax:** (212)223-1937. **E-mail:** info@throckmorton-nyc.com. **Website:** www.throckmorton-nyc.com. **Contact:** Kraige Block, director. Estab. 1993. For-profit gallery. A New York-based gallery specializing in vintage and contemporary photography of the Americas for over 25 years. Its primary focus is Latin American photographers. The gallery also specializes in Chinese jades and antiquities, as well as pre-Columbian art. Located in the Hammacher Schlemmer Building; 4,000 sq. ft.; 1,000 sq. ft. exhibition space. Clients include local community and upscale. Approached by 50 artists/year; represents or exhibits 20 artists. Sponsors 5 photography exhibits/year. Average display time 2 months. Overall price range $1,000-10,000. Most work sold at $2,500. Open Tuesday–Saturday, 11-5.

MEDIA Most frequently exhibits photography, antiquities. Also considers gelatin, platinum and albumen prints.

STYLE Exhibits expressionism. Genres include Latin American.

TERMS Retail price of the art set by the gallery. Gallery provides insurance and promotion. Requires exclusive representation locally. Accepts only artists from Latin America. Prefers only b&w and color photography.

SUBMISSIONS Call or write to arrange personal interview to show portfolio of photographs. Returns material with SASE. Responds to queries only if interested within 2 weeks. Files bios and résumés. Finds artists through portfolio reviews, referrals by other artists and submissions.

TIBOR DE NAGY GALLERY

724 Fifth Ave., New York NY 10019. (212)262-5050. **Fax:** (212)262-1841. **E-mail:** info@tibordenagy.com. **Website:** www.tibordenagy.com. **Contact:** Andrew Arnot and Eric Brown, owners. Estab. 1949. Retail gallery. The gallery focus is on painting within the New York School traditions, and photography. Represents emerging and mid-career artists. Sponsors 12 shows/year. Average display time: 1 month. Open Tuesday–Saturday, 10-5:30; summer hours Monday–Friday, 10-5:30; closed December 24–January 3. Located midtown; 3,500 sq. ft. 100% of space for work of gallery artists. 60% private collectors, 40% corporate collectors. Overall price range: $1,000-100,000; most work sold at $5,000-20,000.

MEDIA Considers oil, pen & ink, paper, acrylic, drawings, sculpture, watercolor, mixed media, pastel, collage, etchings, and lithographs. Most frequently exhibits oil/acrylic, watercolor and sculpture.

STYLE Exhibits representational work as well as abstract painting and sculpture. Genres include landscapes and figurative work. Prefers abstract, painterly realism and realism.

SUBMISSIONS Gallery is not looking for submissions at this time.

✚ TILT GALLERY

919 W. Filmore St., Phoenix AZ 85007. (602)716-5667. **E-mail:** info@tiltgallery.com. **Website:** www.tiltgallery.com. **Contact:** Melanie Craven, gallery owner. Estab. 2005.

MEDIA Considers fiber, installation, mixed media, paper, sculpture. Most frequently exhibits fine art

photography, mixed media, installation. Considers photogravure, collotype and bromoil prints.

STYLE Considers conceptualism and historical photographic processes. Most frequently exhibits conceptualism. Exhibits figurative work, landscapes, portraits and conceptual.

TERMS Represented artists and Tilt each receive 50% of sale. Retail price of the art set by the gallery. Gallery provides insurance, promotion, contract. Accepted work should be mounted, matted. Requires exclusive representation locally. Prefers fine art photography, historic and alternative photographic processes and mixed media.

SUBMISSIONS E-mail with link to artist's website and JPEG samples at 72 dpi, mail portfolio for review, or send query letter. Material cannot be returned. Responds in 1-3 months. Finds artists through word of mouth, submissions, portfolio reviews, art exhibits, art fairs and referrals by other artists.

TIPS "Submit a complete body of work exhibiting cohesiveness, with attention to presentation."

J. TODD GALLERIES

572 Washington St. (Route 16), Wellesley MA 02482. (781)237-3434; (888)565-6554. **Fax:** (781)237-1855. **E-mail:** fineart@jtodd.com. **Website:** www.jtodd.com. **Contact:** Jay Todd, owner. Estab. 1980. Retail gallery. "Thousands of works by living U.S. and European artists." Represents 55 emerging, mid-career and established artists. Sponsors 2-3 shows/year. Average display time: 1 month. Open Tuesday–Saturday, 10:30-5:30; Sunday (October 17-April 10), 1-5; closed Sunday, May through mid-October; open other times by appointment. Located 15 miles west of Boston; 4,000 sq. ft.; vast inventory, professionally displayed; 6 showrooms. 30% of space for special exhibitions; 70% of space for gallery artists. Clientele: residential and corporate; 75% private collectors, 25% corporate collectors. Overall price range: $500-40,000; most work sold at $1,000-15,000.

MEDIA Considers oil, acrylic, watercolor, pen & ink, drawing, mixed media, woodcuts, engravings, lithographs, wood engravings, mezzotints, serigraphs, linocuts and etchings. Most frequently exhibits oils, woodcuts and etchings. "We do not accept pastels, giclées or sculpture."

STYLE Exhibits primitivism, modern, contemporary, postmodern works, impressionism and realism. Genres include landscape, seascape, nautical, urban scenes, abstracts, interiors, florals, figurative work and still life. Prefers landscapes, abstracts, figures and still lifes.

TERMS Accepts work on consignment (negotiable commission). Retail price set by the artist. Gallery provides promotion. Prefers unframed artwork.

SUBMISSIONS Submit via e-mail. "We are mostly interested in oils on canvas. We will consider acrylics and watercolor only if you have a proven track record in the $1,000 and above price range. We are *not* currently accepting pastel, graphics or sculpture. Please allow 3 weeks to get a response." See website for complete submission instructions.

TOUCHSTONE GALLERY

901 New York Ave. NW, Washington DC 20001-2217. (202)347-2787. **E-mail:** info@touchstonegallery.com. **Website:** www.touchstonegallery.com. Estab. 1976. Cooperative member gallery. Representing 50 artists in various media uses exhibiting a new show monthly. "Our newly renovated contemporary space is available for event rental. Located near the heart of the bustling Penn Quarter district in downtown Washington DC, our large beautifully lit gallery can be found at street level and is easily accessible. Open Wednesday and Thursday, 11-6; Friday, 11-8; Saturday and Sunday, 12-5. Closed Christmas through New Year's Day. Overall price range: $400-7,000. As a functioning co-op gallery, there is a monthly membership fee, plus a donation of time. A 40% commission is taken from sold works. To become a member, visit the website for further information, or contact the gallery directly.

THE U GALLERY

221 E. Second St., New York NY 10009. (212)995-0395. **E-mail:** saccadik@gmail.com. **Website:** www.ugallery.org. **Contact:** Darius. Alternative space, for-profit gallery, art consultancy and rental gallery. Estab. 1989. Approached by 100 artists/year. Represents 3 emerging and established artists. Sponsors 2 exhibits/year. Open all year. Located in Manhattan; 500 sq. ft.

MEDIA Considers acrylic, drawing, oil, paper, pastel, sculpture and watercolor. Considers all types of prints.

STYLE Exhibits conceptualism, geometric abstraction, impressionism, minimalism and surrealism. Genres include figurative work, landscapes, portraits and wildlife.

SUBMISSIONS Write to arrange a personal interview to show portfolio of photographs and slides. Send query letter with artist's statement, photocop-

ies, photographs and slides. Cannot return material. Finds artists through word of mouth and portfolio reviews.

ULRICH MUSEUM OF ART

Wichita State University, 1845 Fairmount St., Wichita KS 67260-0046. (316)978-3664. **Fax:** (316)978-3898. **E-mail:** ulrich@wichita.edu. **Website:** www.ulrich. wichita.edu; www.facebook.com/ulrichmuseum; www.twitter.com/ulrichmuseum. **Contact:** Dr. Emily Stamey, curator of modern and contemporary art. Estab. 1974. Wichita's premier venue for modern and contemporary art. Presents 6 shows/year with emerging, mid-career and established artists. Open Tuesday–Friday, 11-5; Saturday and Sunday, 1-5; closed Mondays and major/university holidays. Located in the southwest section of the Wichita State University campus. Gallery admission and guided, group tours are free.

MEDIA "Exhibition program includes all range of media."

STYLE "Style and content of exhibitions aligns with leading contemporary trends."

UNIVERSITY ART GALLERY IN THE D.W. WILLIAMS ART CENTER

P.O. Box 30001, Las Cruces NM 88003. (575)646-2545 or (575)646-5423. **Fax:** (575)646-8036. **E-mail:** artglry@nmsu.edu. **Website:** www.nmsu.edu/~artgal. **Contact:** Preston Thayer, director. Estab. 1973. The largest visual arts facility in South Central New Mexico, the gallery presents 6-9 exhibitions annually. Overall price range $300-2,500. Features contemporary and historical art of regional, national and international importance. Focus includes the work of NMSU Art Department faculty, graduate students, undergraduates, traveling exhibitions and over 3,000 works from the university's permanent collection. The latter includes the country's largest collection of Mexican retablos (devotional paintings on tin) as well as photographs, paintings, prints and graphics, book art, and small scale sculpture and metals. Sponsors 5-6 exhibits/year. Average display time: 2 months. Overall price range: $300-2,500.

MEDIA Considers all media and all types of prints.

TERMS Send e-mail with representative images and statement.

TIPS "The gallery does mostly curated, thematic exhibitions; very few one-person exhibitions."

UNIVERSITY OF ALABAMA AT BIRMINGHAM VISUAL ARTS GALLERY

Department of Art & Art History, 113 Humanities, 900 13th St. S., Birmingham AL 35294. (205)934-4941. **Website:** www.uab.edu/art/vagallery.php. **Contact:** John Fields, interim gallery director. Estab. 1972. Nonprofit university gallery. Represents emerging, mid-career and established artists. Sponsors 10-12 exhibits/year. Average display time 3-4 weeks. Open Monday-Thursday, 11-6; Friday, 11-5; Saturday, 1-5. Closed Sundays and holidays. Located on first floor of Humanities Building, a classroom and office building, 2 rooms with a total of 2,000 sq. ft. and 222 running ft. Clients include local community, students and tourists.

MEDIA Considers all media except craft. Considers all types of prints.

STYLE Considers all styles and genres.

SUBMISSIONS Write to arrange a personal interview to show portfolio of slides. Send query letter with artist's statement, bio, brochure, photographs, résumé, reviews, SASE and slides. Returns material with SASE. The gallery does not consider unsolicited exhibition proposals.

UPSTREAM PEOPLE GALLERY

5607 Howard St., Omaha NE 68106-1257. (402)991-4741. **E-mail:** shows@upstreampeoplegallery.com. **Website:** www.upstreampeoplegallery.com. **Contact:** Laurence Bradshaw, curator. Estab. 1998. Exclusive online virtual gallery with over 40 international exhibitions in the archives section of the website. Represents mid-career and established artists. Approached by approximately 1,500 artists/year; represents or exhibits 20,000 artists. Sponsors 12 total exhibits/year and 7 photography exhibits/year. Average display time is 12 months to 4 years. Overall price range $100-60,000. Most work sold at $300. 15% of sales are to corporate collectors.

MEDIA Considers all media except video and film. Most frequently exhibits oil, acrylic and ceramics.

STYLE Considers all prints, styles and genres. Most frequently exhibits neo-expressionism, realism and surrealism.

TERMS Artwork is accepted on consignment; there is no commission if the artists sells, but a 20% commission if the gallery sells. Retail price set by the artist. Gallery provides promotion and contract.

SUBMISSIONS Accepted work should be photographed. Call or write to arrange personal interview to show portfolio, e-mail query letter with link to website and JPEG samples at 72 dpi or send query letter with artist's statement and CD/DVD. Returns material with SASE. Responds to queries within 1 week. Files résumés. Finds artists through art exhibits, referrals and online and magazine advertising.

TIPS "Make sure all photographs of works are in focus."

URBAN INSTITUTE FOR CONTEMPORARY ARTS

2 W. Fulton St., Grand Rapids MI 49503. (616)454-7000. **Fax:** (616)459-9395. **E-mail:** jteunis@uica.org. **Website:** www.uica.org. **Contact:** Janet Teunis, managing director. Estab. 1977. Alternative space and nonprofit gallery. Approached by 250 artists/year; represents or exhibits 20 artists. Sponsors 3-4 photography exhibits/year. Average display time 6 weeks. Gallery open Tuesday-Saturday, 11-9; Sunday, 12-7.

MEDIA Considers all media. Most frequently exhibits mixed media, avant garde and nontraditional.

STYLE Exhibits conceptualism and postmodernism.

TERMS Gallery provides insurance, promotion and contract.

SUBMISSIONS Check website for gallery descriptions and how to apply. Send query letter with artist's statement, bio, résumé, reviews, SASE, application fee, and slides. Returns material with SASE. Does not reply. Artist should see website, inquire about specific calls for submissions. Finds artists through submissions.

TIPS "Get submission requirements before sending materials."

VALE CRAFT GALLERY

230 W. Superior St., Chicago IL 60654. (312)337-3525. **Fax:** (312)337-3530. **E-mail:** valecraft@sbcglobal.net. **Website:** www.valecraftgallery.com. **Contact:** Peter Vale, owner. Estab. 1992. Retail gallery. "Vale Craft Gallery exhibits and sells contemporary American fine craft and sculpture including works in clay, fiber, metal, glass, wood and mixed media. Vale Craft Gallery features colorful textiles, beautiful glass objects, handcrafted furniture, innovative ceramics, whimsical sculpture, and unique jewelry." Represents 100 emerging, mid-career artists/year. Exhibited artists include Tana Acton, Mark Brown, Tina Fung Holder, John Neering and Kathyanne White. Sponsors 4 shows/year. Average display time: 3 months. Open all year; Tuesday–Friday, 10:30-5:30; Saturday, 11-5. Located in River North gallery district near downtown; 2,100 sq. ft.; lower level of prominent gallery building; corner location with street-level windows provides great visibility. Clientele: private collectors, tourists, people looking for gifts, interior designers and art consultants. Overall price range: $50-2,000; most work sold at $100-500.

MEDIA Considers paper, sculpture, ceramics, craft, fiber, glass, metal, wood and jewelry. Most frequently exhibits fiber wall pieces, jewelry, glass, ceramic sculpture and mixed media.

STYLE Exhibits contemporary craft. Prefers decorative, sculptural, colorful, whimsical, figurative, and natural or organic.

TERMS Accepts work on consignment (50% commission). Retail price set by the artist. Gallery provides insurance, promotion, contract and shipping costs from gallery; artist pays shipping costs to gallery.

SUBMISSIONS Accepts only craft media. No paintings, prints, or photographs. By mail: send query letter with résumé, bio or artist's statement, reviews if available, 10-20 slides, CD of images (in JPEG format) or photographs (including detail shots if possible), price list, record of previous sales, and SASE if you would like materials returned to you. By e-mail: include a link to your website or send JPEG images, as well as any additional information listed above. Call for appointment to show portfolio of originals and photographs. Responds in 2 months. Files résumé (if interested). Finds artists through submissions, art and craft fairs, publishing a call for entries, artists' slide registry and word of mouth.

TIPS "Call ahead to find out if the gallery is interested in showing the particular type of work that you make. Try to visit the gallery ahead of time or check out the gallery's website to find out if your work fits into the gallery's focus. I would suggest you have at least 20 pieces in a body of work before approaching galleries."

VIENNA ARTS SOCIETY ART CENTER

513 W. Maple Ave., Vienna VA 22180. (703)319-3971. **E-mail:** teresa@tlcillustration.com. **Website:** www. viennaartssociety.org. **Contact:** Director. Estab. 1969. Nonprofit gallery and work center. Art center acquired in 2005. Approached by 200-250 artists/year; represents or exhibits 50-100 artists. Average display time 3-4 weeks. Open Tuesday–Saturday, 10-

4. Closed on federal holidays, county cancellations, or delays. Historic building with spacious room with modernized hanging system. Overall price range $100-1,500. Most work sold at $250-$500.

MEDIA Considers all media except basic crafts. Most frequently exhibits watercolor, acrylic and oil.

STYLE Considers all styles.

TERMS Artwork is accepted on consignment, and there is a 25% commission. There is a rental fee that covers 1 month, "based on what we consider a 'featured artist' exhibit." Gallery handles publicity with the artist. Retail price set by the artist. Gallery provides promotion and contract. Accepted work must be framed or matted. "We do accept 'bin pieces' matted and shrink wrapped." VAS members can display at any time. Non-members will be asked for a rental fee when space is available.

SUBMISSIONS Call. Response time varies. Finds artists through art fairs and exhibits, referrals by other artists and membership.

VIRIDIAN ARTISTS, INC.

548 W. 28th St., Suite 632, New York NY 10001. (212)414-4040. **Fax:** (212)414-4040. **Website:** www.viridianartists.com. **Contact:** Vernita Nemec, director. Estab. 1968. Artist-owned gallery. Approached by 200 artists/year. Exhibits 25-30 emerging, mid-career and established artists/year. Sponsors 15 total exhibits/year; 2-4 photography exhibits/year. Average display time 3 weeks. Open Tuesday–Saturday, 12-6. Closed in August. "Classic gallery space with 3 columns, hardwood floor, white walls and track lights, approximately 1,100 sq. ft. The gallery is located in Chelsea, the prime area of contemporary art galleries in New York City." Clients include: local community, students, tourists, upscale and artists. 15% of sales are to corporate collectors. Overall price range: $100-8,000. Most work sold at $1,500.

MEDIA Considers all media except craft, traditional glass and ceramic, unless it is sculpture. Most frequently exhibits paintings, photography and sculpture. Considers engravings, etchings, linocuts, lithographs, mezzotints, serigraphs, woodcuts and monoprints/limited edition digital prints.

STYLE Mostly contemporary, but considers all styles. Most frequently exhibits painterly abstraction, imagism and neo-expressionism. "We are not interested in particular styles, but in professionally conceived and professionally executed contemporary art. Eclecti-

cism is our policy. The only unifying factor is quality. Work must be of the highest technical and aesthetic standards."

TERMS Artwork accepted on consignment with a 30% commission. There is a co-op membership fee plus a donation of time with a 30% commission. Retail price of the art is set by the gallery and artist. Gallery provides promotion and contract. "Viridian is an artist-owned gallery with a director and gallery assistant. Artists pay gallery expenses through monthly dues, but the staff takes care of running the gallery and selling the art. The director writes the press releases, helps install exhibits and advises artists on all aspects of their career. We try to take care of everything but making the art and framing it." Prefers artists who are familiar with the NYC art world and are working professionally in a contemporary mode which can range from realistic to abstract to conceptual and anything in between.

SUBMISSIONS Submitting art for consideration is a 2-step process: first through website or JPEGs, then if accepted at that level, by seeing 4-6 samples of the actual art. Artists should call, e-mail query letter with link to artist's website or JPEG samples at 72 dpi (include image list) or send query letter with artist's statement, bio, reviews, CD with images and SASE. Materials returned with SASE. Responds in 2-4 weeks. Files materials of artists who become members. Finds artists through word of mouth, submissions, art exhibits, portfolio reviews or referrals by other artists.

TIPS "Present current art completed within the last 2 years. Our submission procedure is in 2 stages: first we look at websites, JPEGs that have been e-mailed, or CDs that have been mailed to the gallery. When e-mailing JPEGs, include an image list with title, date of execution, size, media. Also, include a bio and artist's statement. Reviews about your work are helpful if you have them, but not necessary. If you make it through the first level, then you will be asked to submit 4-6 actual art works. These should be framed or matted, and similar to the work you want to show. Realize it is important to present a consistency in your vision. If you do more than one kind of art, select what you feel best represents you, for the art you show will be a reflection of who you are."

VISUAL ARTS CENTER, WASHINGTON PAVILION OF ARTS & SCIENCE

301 S. Main, Sioux Falls SD 57104. (605)367-6000. **E-mail:** info@washingtonpavilion.org. **Website:** wash

ingtonpavilion.org. Estab. 1961. Nonprofit museum. "The Visual Arts Center brings the visual arts to children and adults through exhibitions, education, collections and special events, and is devoted to building, preserving and conserving its collections for South Dakotans and worldwide audiences." Open Monday–Thursday, Saturday, 10-5; Friday, 10-8; Sunday, 12-5.

MEDIA Considers all media.

STYLE Exhibits local, regional and national artists.

SUBMISSIONS Send query letter with résumé and photographs.

◯ VOLCANO ART CENTER GALLERY

P.O. Box 129, Volcano HI 96785. (866)967-7565. **Fax:** (808)967-7511. **E-mail:** gallery@volcanoartcenter.org. **Website:** www.volcanoartcenter.org. Estab. 1974. Nonprofit gallery to benefit arts education; nonprofit organization. Represents 300 emerging, mid-career and established artists/year. 1,400 member organization. Exhibited artists include Dietrich Varez and Brad Lewis. Sponsors 8 shows/year. Average display time 6 weeks. Open Monday, Tuesday, Thursday, Friday, 8:30-5. Located in Hawaii Volcanoes National Park; 3,000 sq. ft.; in the historic 1877 Volcano House Hotel. 15% of space for special exhibitions; 85% of space for gallery artists. Clientele affluent travelers from all over the world. 95% private collectors, 5% corporate collectors. Overall price range $20-12,000; most work sold at $50-400.

MEDIA Considers all media, all types of prints. Most frequently exhibits wood, ceramics, glass and 2D.

STYLE Prefers traditional Hawaiian, contemporary Hawaiian and contemporary fine crafts.

TERMS "Artists must become Volcano Art Center members." Accepts work on consignment (50% commission). 10% discount to VAC members is absorbed by the organization. Retail price set by the gallery. Gallery provides promotion and contract; artist pays shipping costs to gallery. Submission guidelines available online.

SUBMISSIONS Prefers work relating to the area and by Hawaii resident artists. Call for appointment to show portfolio. Responds only if interested within 1 month. Files information on represented artists.

THE VON LIEBIG ART CENTER

585 Park St., Naples FL 34102. (239)262-6517. **E-mail:** info@naplesartcenter.org. **Website:** www.naplesart.org. **Contact:** Jack O'Brien, curator. Estab. 1954. The Naples Art Association at The von Liebig Art Center is located in downtown Naples and presents changing exhibitions of contemporary art by regionally, nationally and internationally recognized artists. Its education program offers professional studio art courses and workshops in painting, printmaking, drawing, photography, ceramics, sculpture and applied arts. A lecture series features visiting speakers who cover dynamic and stimulating topics in art. Five major outdoor art festivals are held annually and Art in the Park, an NAA members' outdoor art festival, is held the first Saturday of each month, November-April. Over 14 exhibitions are installed each year including *Camera USA: National Photography Award* held each summer, *National Art Encounter*, the non-juried *Show of Shows Exhibition* and many juried exhibitions. The Naples Art Association holds a collection of approximately 200 works of art created after 1950 by accomplished artists who have lived in or had a connection to Florida. Artwork is selected by a committee and accessioned through donations.

MEDIA Considers artwork in all media.

STYLE Considers all styles. Festivals feature both fine art and fine craft.

TERMS 30% commission on artwork sold during exhibitions. Artists participating in exhibitions may wish to acquire insurance to cover loss or damage.

SUBMISSIONS For more information on current exhibition opportunities visit www.naplesart.org/content/call-artists. For more information on the major outdoor art festivals, visit www.naplesart.org/content/festivals-opportunities or www.juriedartservices.com/index.php?content=home_new. For more information on Art in the Park, and to apply, visit www.naplesart.org/content/art-park-0.

TIPS Membership in the Naples Art Association offers many benefits. For more information, and to become a member, visit www.naplesart.org/content/become-member.

WAILOA CENTER

DLNR P.O. Box 936, Hilo HI 96721. (808)933-0416. **Fax:** (808)933-0417. **E-mail:** wailoa@yahoo.com. **Contact:** Codie M. King, director. Nonprofit gallery and museum. Focus is on propagation of the culture and arts of the Hawaiian Islands and their many ethnic backgrounds. Estab. 1968. Represents/exhibits 300 emerging, mid-career and established artists. Interested in seeing work of emerging artists. Sponsors 36 shows/year. Average display time: 1 month. Open all

year; Monday, Tuesday, Thursday and Friday, 8:30-4:30; Wednesday, 12-4:30; closed weekends and state holidays. Located downtown; 10,000 sq. ft.; 4 exhibition areas. Clientele: tourists, upscale, local community and students. Overall price range: $25-25,000; most work sold at $1,500.

MEDIA Considers all media and most types of prints. No giclée prints; original artwork only. Most frequently exhibits mixed media.

STYLE Exhibits all styles.

TERMS "We cannot sell, but will refer buyer to artist." Gallery provides some promotion. Artist pays for shipping, invitation, and reception costs. Artwork must be framed.

SUBMISSIONS Send query letter with résumé, slides, photographs and reviews. Call for appointment to show portfolio of photographs and slides. Responds in 3 weeks. Finds artists through word of mouth, referrals by other artists, visiting art fairs and exhibitions, submissions.

TIPS "We welcome all artists, and try to place them in the best location for the type of art they create. Drop in and let us review what you have."

WALKER'S POINT CENTER FOR THE ARTS

839 S. Fifth St., Milwaukee WI 53204. (414)672-2787. **Fax:** (414)755-1960. **E-mail:** gary@wpca-milwaukee.org; staff@wpca-milwaukee.org. **Website:** www.wpca-milwaukee.org. **Contact:** Gary Tuma, executive director. Estab. 1987. Alternative space and non-profit gallery. Represents emerging and established artists; 200+ members. Exhibited artists include Colin Dickson, Chris Silva, Josie Osborne and Shane Walsh. Sponsors 6-8 shows/year. Average display time 2 months. Open Tuesday–Saturday, 12-5. Located in the heart of the historic Walker's Point neighborhood; 6,000 sq. ft. brick building.

MEDIA Considers all media. Prefers installation, sculpture and video.

STYLE Considers all styles. Our gallery often presents work with Latino themes.

TERMS We are nonprofit and do not provide honoria. Gallery assumes a 20% commission. Retail prices set by the artist. Gallery provides insurance, contract and shipping costs. Prefers artwork framed.

SUBMISSIONS Send query letter, or e-mail, with résumé, images, bio, artist statement, SASE and reviews.

TIPS "WPCA is an alternative space, showing work for which there are not many venues. Experimental work is encouraged."

WALTON ARTS CENTER

P.O. Box 3547, Fayetteville AR 72702. (479)443-9216. **Website:** www.waltonartscenter.org. Estab. 1990. Nonprofit gallery. Approached by 50 artists/year. Represents 10 emerging, mid-career and established artists. Exhibited artists include E. Fay Jones, Judith Leiber (handbags). Average display time 2 months. Open all year; Monday-Friday, 10-6; weekends 12-4. Closed Thanksgiving, Christmas, July 4. Joy Pratt Markham Gallery is 2,500 sq. ft. with approximately 200 running wall feet. McCoy Gallery also has 200 running wall feet in the Education Building. Clients include local community and upscale. Overall price range $100-10,000. "Walton Arts Center serves as a resource to showcase a variety of thought-provoking visual media that will challenge new and traditional insights and encourage new dialogue in a museum level environment."

MEDIA Considers all media and all types of prints. Most frequently exhibits oil, installation, paper.

STYLE Considers all styles and genres.

TERMS Artwork is accepted on consignment and there is a 30% commission. Retail price set by the artist. Gallery provides insurance and contract. Accepted work should be framed. Requires exclusive representation locally.

SUBMISSIONS Mail portfolio for review. Send query letter with artist's statement, bio, business card, résumé, reviews, SASE and slides. Returns material with SASE. Responds in 3 months. Finds artists through submissions, art exhibits, referrals by other artists and travelling exhibition companies.

WASHINGTON COUNTY MUSEUM OF FINE ARTS

P.O. Box 423, 401 Museum Dr., Hagerstown MD 21741. (301)739-5727. **Fax:** (301)745-3741. **E-mail:** info@wcmfa.org. **Website:** www.wcmfa.org. **Contact:** Curator. Estab. 1929. Approached by 30 artists/year. Average display time: 6-8 weeks. Open Tuesday–Friday, 9-5; Saturday, 9-4; Sunday, 1-5. Closed legal holidays. Overall price range: $50-7,000.

MEDIA Considers all media except installation and craft. Most frequently exhibits oil, watercolor and ceramics. Considers all types of prints except posters.

STYLE Exhibits impressionism. Genres include florals, landscapes, portraits and wildlife.

TERMS Museum provides artist's contact information to potential buyers. Accepted work should not be framed.

SUBMISSIONS Write to show portfolio of photographs, slides. Mail portfolio for review. Responds in 1 month. Finds artists through word of mouth, portfolio reviews, art exhibits, referrals by other artists.

WASHINGTON PRINTMAKERS GALLERY

Pyramid Atlantic Art Center, 2nd Floor, 8230 Georgia Ave., Silver Spring MD 20910. (301)273-3660. **E-mail:** info@washingtonprintmakers.com. **Website:** www. washingtonprintmakers.com. Estab. 1985. Cooperative gallery. Exhibits 40 emerging and mid-career artists/year. Exhibited artists include Lee Newman, Max-Karl Winkler, Trudi Y. Ludwig and Margaret Adams Parker. Sponsors 12 exhibitions/year. Average display time 1 month. Open Wednesday and Thursday, 12-6; Friday, 12-7; Saturday, 10-5; Sunday, 12-5. Closed on New Year's Day, Easter, 4th of July, Thanksgiving, Christmas. Located just outside DC proper on the Red Line Metro. 100% of space for gallery artists. Clientele: varied. 90% private collectors, 10% corporate collectors. Overall price range $65-1,500; most work sold at $200-400.

MEDIA Considers all types of original prints, hand pulled by artist. No posters. Most frequently exhibits etchings, lithographs, serigraphs, relief prints.

STYLE Considers all styles and genres.

TERMS Co-op membership fee plus donation of time (40% commission). Retail price set by artist. Gallery provides promotion. Purchaser pays shipping costs of work sold.

SUBMISSIONS Send query letter. Call for appointment to show portfolio of original prints. Responds in 1 month.

TIPS "There is a monthly jury for prospective members. Call to find out how to present work. We are especially interested in artists who exhibit a strong propensity for not only the traditional conservative approaches to printmaking, but also the looser, more daring and innovative experimentation in technique."

☺ WEST END GALLERY

5425 Blossom, Houston TX 77007. (713)861-9544. **E-mail:** kpackl1346@aol.com. Estab. 1991. Retail gallery. Exhibits emerging and mid-career artists. Open all year. Located 5 minutes from downtown Houston; 800 sq. ft. "The gallery shares the building (but not the space) with West End Bicycles." 75% of space for special exhibitions; 25% of space for gallery artists. Clientele: 100% private collectors. Overall price range: $30-2,200; most work sold at $300-600.

MEDIA Considers oil, pen & ink, acrylic, drawings, watercolor, mixed media, pastel, collage, woodcuts, wood engravings, linocuts, engravings, mezzotints, etchings, lithographs and serigraphs. Prefers collage, oil and mixed media.

STYLE Exhibits conceptualism, minimalism, primitivism, postmodern works, realism and imagism. Genres include landscapes, florals, wildlife, portraits and figurative work.

TERMS Accepts work on consignment (40% commission). Retail price set by artist. Payment by installment is available. Gallery provides promotion; artist pays shipping costs. Prefers framed artwork.

SUBMISSIONS Accepts only artists from Houston area. Send query letter with slides and SASE. Portfolio review requested if interested in artist's work.

WALTER WICKISER GALLERY

210 11th Ave., Suite 303, New York NY 10001. (212)941-1817. **Fax:** (212)625-0601. **E-mail:** wwickiserg@aol.com. **Website:** www.walterwickisergallery. com. Estab. 1992. For-profit gallery. Specializing in contemporary American and Asian painting. Located in the prestigious fine art building in Chelsea. Shows only established artists. The Wickiser Gallery has received numerous reviews in *ARTnews*, *Art in America* and many other internationally recognized publications. Work by many of the gallery's artists have been exhibited at American museums including the Metropolitan Museum of Art, the Whitney Museum of American Art, the High Museum of Art in Georgia, the Dallas Museum of Art in Texas, and the New Britain Museum of American Art in Connecticut. Open Tuesday–Saturday, 11-6.

PHILIP WILLIAMS POSTERS

122 Chambers St., New York NY 10007. (212)513-0313. **E-mail:** postermuseum@gmail.com; philipwilliams posters@gmail.com. **Website:** www.postermuseum. com. **Contact:** Philip Williams. Estab. 1973. Retail and wholesale gallery. Represents/exhibits vintage posters 1870-present. "The largest vintage poster gallery in the world, with more than 12,600 sq. ft. to display the largest collection of original posters for sale. We also sell advertising ephemera, maitre de

l'affiche, poster books and other types of art, including a collection of more than 2,000 American Folk Art paintings and sculpture. Open all year; Monday–Saturday, 11-7.

TERMS Prefers artwork unframed.

SUBMISSIONS Prefers vintage posters and outsider artist. Send query letter with photographs.

WOMEN & THEIR WORK ART SPACE

1710 Lavaca St., Austin TX 78701, (512)477-1064. **Fax:** (512)477-1090. **E-mail:** info@womenandtheir work.org. **Website:** www.womenandtheirwork.org. **Contact:** Rachel Koper, director. Estab. 1978. Alternative space and nonprofit gallery. Approached by more than 200 artists/year. Sponsors 5-7 solo shows of emerging and mid-career Texas women. Average display time: 5 weeks. Open Monday-Friday, 9-6; Saturday, 12-5. Closed holidays. Located downtown; 2,000 sq. ft. Clients include local community, students, tourists and upscale. 10% of sales are to corporate collectors. Overall price range: $500-5,000; most work sold at $800-1,000.

MEDIA Considers all media. Most frequently exhibits photography, sculpture, installation and painting.

STYLE Exhibits contemporary works of art.

TERMS Selects artists through an artist advisory panel and curatorial/jury process. Pays artists to exhibit. Takes 25% commission if something is sold. Retail price set by the gallery and the artist. Gallery provides insurance, promotion and contract. Accepted work should be framed, mounted and matted. Accepts Texas women in solo shows only; all other artists, male or female, in one annual curated show. See website for more information.

SUBMISSIONS See website for current call for entries. Returns materials with SASE. Filing of material depends on artist and if he/she is a member. Online slide registry on website for members. Finds artists through submissions and annual juried process.

TIPS Send quality slides/digital images, typed résumé, and clear statement with artistic intent. 100% archival material required for framed works.

WOODWARD GALLERY

133 Eldridge St., Ground Floor, New York NY 10002. **E-mail:** art@woodwardgallery.net. **Website:** www.woodwardgallery.net. Estab. 1994.

MEDIA Considers acrylic, collage, drawing, mixed media, oil, paper, pastel, pen ink, sculpture, watercol-

or. Most frequently exhibits canvas, paper and sculpture. Considers all types of prints.

STYLE Most frequently exhibits realism/surrealism, pop, abstract and landscapes, graffiti. Genres include figurative work, florals, landscapes and portraits.

TERMS Artwork is bought outright (net 30 days) or consigned. Retail price set by the gallery.

SUBMISSIONS "Call before sending anything! Send query letter with artist's statement, bio, brochure, photocopies, photographs, reviews and SASE. Returns material with SASE. Finds artists through referrals or submissions. Policy posted on website—please adhere to directions carefully."

TIPS "Artist must follow our artist review criteria, which is available every new year (first or second week of January) with updated policy from our director."

WORCESTER CENTER FOR CRAFTS GALLERIES

25 Sagamore Rd., Worcester MA 01605. (508)753-8183. **E-mail:** ccasey@worcestercraftcenter.org. **Website:** www.worcestercraftcenter.org. **Contact:** Candace Casey, gallery director. Estab. 1856. Nonprofit rental gallery. Dedicated to promoting artisans and American crafts. Has several exhibits throughout the year, including 1 juried, catalogue show and 2 juried craft fairs in May and November. Exhibits student, faculty, visiting artists, regional, national and international artists. Open all year; Monday-Saturday, 10-5. Located at edge of downtown; 2,205 sq. ft. (main gallery); track lighting, security. Overall price range $20-400; most work sold at $65-100.

MEDIA Considers all media except paintings and drawings. Most frequently exhibits wood, metal, fiber, ceramics, glass and photography.

STYLE Exhibits all styles.

TERMS Artwork is accepted on consignment (40% commission). Retail price set by the artist. Gallery provides insurance, promotion and contract. Shipping costs are shared.

SUBMISSIONS Call for appointment to show portfolio of photographs and slides. Responds in 1 month.

WORLD FINE ART GALLERY

179 E. Third St., Suite 16, New York NY 10009-7705. (646)539-9622. **Fax:** (646)478-9361. **E-mail:** info@worldfineart.com; wfagallery@gmail.com. **Website:** www.worldfineart.com. **Contact:** O'Delle Abney, director. Estab. 1992. Online gallery since 2010. Services include online websites (www.worldfineart.com/join.

html) and personal marketing (www.worldfineart.com/navigating_the_new_york_art_scene.html). Group exhibitions around the New York City Area.

TERMS Responds to queries in 1 week. Non-exclusive agent to 12 current portfolio artists. Finds artists online.

TIPS "Have website available or send JPEG images for review."

RIVA YARES GALLERY

3625 Bishop Ln., Scottsdale AZ 85251. (480)947-3251 (Scottsdale); (505)984-0330 (Santa Fe). **Fax:** (480)947-4251 (Scottsdale); (505)986-8661 (Santa Fe). **E-mail:** art@rivayaresgallery.com. **Website:** www.rivayares gallery.com. Estab. 1963. Retail gallery. Represents 30-40 emerging, mid-career and established artists/year. Exhibited artists include Rodolfo Morales and Esteban Vicente. Sponsors 12-16 shows/year. Average display time 3-6 weeks. Call for the hours of each gallery. Scottsdale gallery located in downtown area; 8,000 sq. ft.; national design award architecture; international artists. 50% of space for special exhibitions; 50% of space for gallery artists. Clientele: collectors. 90% private collectors; 10% corporate collectors. Overall price range $1,000-1,000,000; most work sold at $20,000-50,000.

MEDIA Considers all media except craft and fiber and all types of prints. Most frequently exhibits paintings (all media), sculpture and drawings.

STYLE Exhibits expressionism, photorealism, neo-expressionism, minimalism, pattern painting, color field, hard-edge geometric abstraction, painterly abstraction, realism, surrealism and imagism. Prefers abstract expressionistic painting and sculpture, surrealistic sculpture and modern schools' painting and sculpture.

TERMS Accepts work on consignment (50% commission). Retail price set by the artist. Gallery provides insurance, promotion and contract; gallery pays for shipping from gallery; artist pays for shipping to gallery. Prefers artwork framed.

SUBMISSIONS Not accepting new artists at this time.

TIPS "Few artists take the time to understand the nature of a gallery and if their work even applies."

YEISER ART CENTER, INC.

200 Broadway St., Paducah KY 42001. (270)442-2453. **Fax:** (270)442-0828. **E-mail:** yeiser@theyeiser.org. **Website:** theyeiser.org. **Contact:** Michael Crouse, director. Estab. 1957. Nonprofit gallery. Exhibits emerging, mid-career and established artists. 450 members. Sponsors 8-10 shows/year. Average display time: 6-8 weeks. Open Tuesday–Saturday, 10-4. Located downtown; 1,800 sq. ft.; "in historic building that was farmer's market." 90% of space for special exhibitions. Clientele: professionals and collectors. 90% private collectors. Overall price range: $200-8,000; most artwork sold at $200-1,000.

MEDIA Considers all media. Prints considered include original handpulled prints, woodcuts, wood engravings, linocuts, mezzotints, etchings, lithographs and serigraphs.

STYLE Exhibits all styles and genres.

TERMS Gallery takes 40% commission on all sales (60/40 split). Expenses are negotiated.

SUBMISSIONS Send résumé, slides, bio, SASE and reviews. Responds in 3 months.

TIPS "Do not call. Give complete information about the work—media, size, date, title, price. Have good-quality slides of work, indicate availability, and include artist statement. Presentation of material is important."

YELLOWSTONE GALLERY

P.O. Box 472, 216 W. Park St., Gardiner MT 59030. (406)848-7306. **E-mail:** info@yellowstonegallery.com. **Website:** www.yellowstonegallery.com. Estab. 1983. Retail gallery. Represents 20 emerging and mid-career artists/year. Exhibited artists include Mary Blain and Nancy Glazier. Sponsors 2 shows/year. Average display time: 2 months. Located downtown; 3,000 sq. ft. 25% of space for special exhibitions; 50% of space for gallery artists. Clientele: tourist and regional. 90% private collectors, 10% corporate collectors. Overall price range: $25-8,000; most work sold at $75-600.

MEDIA Considers oil, acrylic, watercolor, ceramics, craft and photography; types of prints include wood engravings, serigraphs, etchings and posters. Most frequently exhibits watercolors, oils and limited edition, signed and numbered reproductions.

STYLE Exhibits impressionism, photorealism and realism. Genres include Western, wildlife and landscapes. Prefers wildlife realism, Western and watercolor impressionism.

TERMS Accepts work on consignment (45% commission). Retail price set by the artist. Gallery provides contract; artist pays for shipping. Prefers artwork framed.

SUBMISSIONS Send query letter with brochure or 10 slides. Write for appointment to show portfolio of photographs. Responds in 1 month. Files brochure and biography. Finds artists through word of mouth, regional fairs and exhibits, mail and periodicals.

TIPS "Don't show up unannounced without an appointment."

LEE YOUNGMAN GALLERIES

1316 Lincoln Ave., Calistoga CA 94515. (707)942-0585; (800)551-0585. **E-mail:** leeyg@sbcglobal.net. **Website:** www.leeyoungmangalleries.com. **Contact:** Ms. Lee Love Youngman, owner. Estab. 1985. Retail gallery. "We feature a broad selection of work by important national and regional artists." Represents 40 established artists. Exhibited artists include Ralph Love and Paul Youngman. Sponsors 3 shows/year. Average display time 1 month. Open Monday–Saturday, 10-5; Sunday, 11-4. Located downtown; 3,000 sq. ft.; "contemporary decor." Clientele 100% private collectors. Overall price range $500-24,000; most artwork sold at $1,000-3,500.

MEDIA Considers oil, acrylic, watercolor and sculpture. Most frequently exhibits oils, bronzes and alabaster.

STYLE Exhibits impressionism and realism. Genres include landscapes, Figurative and still life. Interested in seeing American realism. No abstract art.

TERMS Accepts work on consignment (50% commission). Retail price set by gallery. Customer discounts and payment by installment are available. Gallery provides insurance and promotion. Artist pays for shipping to and from gallery. Prefers framed artwork.

SUBMISSIONS "No unsolicited portfolios." Portfolio review requested if interested in artist's work. "The most common mistake artists make is coming on weekends, the busiest time, and expecting full attention." Finds artists through publication, submissions and owner's knowledge.

TIPS "Don't just drop in—make an appointment. No agents. While quality and eye appeal are paramount, we also select with an eye towards investment and potential appreciation for our collectors."

MIKHAIL ZAKIN GALLERY

561 Piermont Rd., Demarest NJ 07627. (201)767-7160. **Fax:** (201)767-0497. **E-mail:** gallery@tasoc.org. **Website:** www.tasoc.org. **Contact:** John J. McGurk, gallery director. Estab. 1974. Nonprofit gallery associated with the Art School at Old Church. "10-exhibition season includes contemporary, emerging, and established regional artists, NJ Annual Small Works show, student and faculty group exhibitions, among others." Gallery hours: Monday–Friday, 9:30-5:00. Call for weekend and evening hours. Exhibitions are mainly curated by invitation. However, unsolicited materials are reviewed and will be returned with the inclusion of a SASE. The gallery does not review artist websites, e-mail attachments or portfolios in the presence of the artist. Please follow the submission guidelines on our website.

MEDIA Shows work in all media.

STYLE All styles and genres are considered.

TERMS 35% commission fee charged on all gallery sales. Gallery provides promotion and contract.

SUBMISSIONS Submission guidelines are available on the gallery's website. Small works prospectus available online. Mainly finds artists through referrals by other artists and artist registries.

ZENITH GALLERY

P.O. Box 55295, Washington DC 20040. (202)783-2963. **Fax:** (202)783-0050. **E-mail:** margery@zenithgallery.com. **E-mail:** art@zenithgallery.com. **Website:** www.zenithgallery.com. **Contact:** Margery E. Goldberg, founder/owner/director. Estab. 1978. For-profit gallery. Exhibits emerging, mid-career and established artists. Open Tuesday–Friday, 11-6; Saturday, 11-7; Sunday, 12-5. Three rooms; 2,400 sq. ft. of exhibition space. Clients include local community, tourists and upscale. 50% of sales are to corporate collectors. Overall price range: $5,000-15,000.

MEDIA Considers all media.

TERMS Requires exclusive representation locally for solo exhibitions.

SUBMISSIONS Send query letter with artist's statement, bio, résumé, reviews, brochures, images on CD, SASE. Returns material with SASE. Responds to most queries if interested. Finds artists through art fairs/exhibits, portfolio reviews, referrals by other artists, submissions and word of mouth.

TIPS "The review process can take anywhere from one month to one year. Please be patient and do not call the gallery for acceptance information." Visit website for detailed submission guidelines before sending any materials.

MAGAZINES

Magazines are a major market for freelance illustrators. The best proof of this fact is as close as your nearest newsstand. The colorful publications competing for your attention are chock-full of interesting illustrations, cartoons, and caricatures. Since magazines are generally published on a monthly or bimonthly basis, art directors look for dependable artists who can deliver on deadline and produce quality artwork with a particular style and focus.

Art that illustrates a story in a magazine or newspaper is called editorial illustration. Art directors look for the best visual element to hook the reader into the story. In some cases this is a photograph, but often, especially in stories dealing with abstract ideas or difficult concepts, an illustration makes the story more compelling. A whimsical illustration can set the tone for a humorous article, or an edgy caricature of movie stars in boxing gloves might work for an article describing conflicts within a film's cast. Flip through a dozen magazines in your local drugstore and you will quickly see that each illustration conveys the tone and content of articles while fitting in with the magazine's "personality." The key to success in the magazine arena is matching your style to appropriate publications.

Target your markets

Read each listing carefully. Knowing how many artists approach each magazine will help you understand how stiff your competition is. (At first, you might do better submitting to art directors who aren't swamped with submissions.) Look at the preferred subject matter to make sure your artwork fits the magazine's needs. Note the submission requirements and develop a mailing list of markets you want to approach.

Visit newsstands and bookstores. Check the cover and interior; if illustrations are used, flip to the masthead (usually a box in one of the beginning pages) and note the art direc-

- A great source for new magazine leads is in the business section of your local library. Ask the librarian to point out the business and consumer editions of the *Standard Rate and Data Service (SRDS)* and *Bacon's Newspaper and Magazine Directory.* These huge directories list thousands of magazines and will give you an idea of the magnitude of magazines published today. Another good source is a yearly directory called *Samir Husni's Guide to New Magazines,* also available in the business section of the public library and online at www.mrmagazine.com. *Folio* magazine provides information about new magazine launches and redesigns.

- Each year the Society of Publication Designers sponsors a juried competition, the winners of which are featured in a prestigious exhibition. For information about the annual competition, contact the Society of Publication Designers at (212)223-3332 or visit their website at www.spd.org.

- Networking with fellow artists and art directors will help you find additional success strategies. The Graphic Artists Guild (www.gag.org), The American Institute of Graphic Artists (www.aiga.org), your city's Art Directors Club (www.adcglobal.org) or branch of the Society of Illustrators (www.societyillustrators.org) hold lectures and networking functions. Attend one event sponsored by each organization in your city to find a group you are comfortable with, then join and become an active member.

tor's name. The circulation figure is also relevant; the higher the circulation, the higher the art director's budget (generally). When art directors have a good budget, they tend to hire more illustrators and pay higher fees.

Look at the credit lines next to each illustration. Notice which illustrators are used often in the publications you wish to work with. You will see that each illustrator has a very definite style. After you have studied dozens of magazines, you will understand what types of illustrations are marketable.

Although many magazines can be found at a newsstand or library, some of your best markets may not be readily available. If you can't find a magazine, check the listing in *Artist's & Graphic Designer's Market* to see if sample copies are available. Keep in mind that many magazines also provide artists' guidelines on their websites.

Create a promo sample

Focus on one or two consistent styles to present to art directors in sample mailings. See if you can come up with a style that is different from every other illustrator's style, if only slightly. No matter how versatile you may be, limit the styles you market to one or two. That way, you'll be more memorable to art directors. Choose a style or two that you enjoy

and can work in relatively quickly. Art directors don't like surprises. If your sample shows a line drawing, they expect you to work in that style when they give you an assignment. It's fairly standard practice to mail nonreturnable samples: either postcard-size reproductions of your work, photocopies, or whatever is requested in the listing. Some art directors like to see a résumé, while others do not.

More marketing tips

- **Don't overlook trade magazines and regional publications.** While they may not be as glamorous as national consumer magazines, some trade and regional publications are just as lavishly produced. Most pay fairly well, and the competition is not as fierce. Until you can get some of the higher-circulation magazines to notice you, take assignments from smaller magazines. Alternative weeklies are great markets as well. Despite their modest payment, there are many advantages to working with them. You develop your signature style and learn how to communicate with art directors and to work quickly to meet deadlines. Once the assignments are done, the tearsheets become valuable samples to send to other magazines.

- **Develop a spot illustration style in addition to your regular style.** "Spots"—illustrations that are half-page or smaller—are used in magazine layouts as interesting visual cues to lead readers through large articles or to make filler articles more appealing. Though the fee for one spot is less than for a full layout, art directors often assign five or six spots within the same issue to the same artist. Because spots are small in size, they must be all the more compelling. So send art directors a sample showing a few powerful small pieces along with your regular style.

- **Be prepared to share your work electronically.** Art directors often require illustrators to fax or e-mail sketched or preliminary illustrations so layouts can be reviews and suggestion can be offered. Invest in a scanner if you aren't already working digitally.

- **Get your work into competition annuals and sourcebooks.** The term "sourcebook" refers to the creative directories published annually to showcase the work of freelancers. Art directors consult these publications when looking for new styles. Many listings mention if an art director uses sourcebooks. Some directories such as *The Black Book*, *American Showcase* and *RSVP* carry paid advertisements costing several thousand dollars per page. Other annuals, like the *PRINT Regional Design Annual* or *Communication Arts Illustration Annual*, feature award winners of various competitions.

- **Consider working with a rep.** If after working successfully on several assignments you decide to make magazine illustration your career, consider contracting with an artists' representative to market your work for you. (See the Artists' Representatives section.)

A&U MAGAZINE

25 Monroe St., Suite 205, Albany NY 12210. (518)426-9010. **Fax:** (518)436-5354. **E-mail:** mailbox@aumag.org. **Website:** www.aumag.org. Estab. 1991. Circ. 180,000. Monthly 4-color literary magazine. *A&U* is an AIDS publication. Our audience is everyone affected by the AIDS crisis. Art guidelines are free for #10 SASE with first-class postage.

CARTOONS Approached by 10 cartoonists/year. Buys 1 cartoon/year. Prefers work relating to HIV/AIDS disease. Prefers single panel, double panel or multiple panel humorous, b&w washes, color washes or line drawings.

ILLUSTRATION Approached by 15 illustrators/year. Buys 5 illustrations/issue. Features humorous illustration, realistic illustrations, charts & graphs, informational graphics, medical illustration, spot illustrations and computer illustration of all subjects affected by HIV/AIDS. Prefers all styles and media. Assigns 50% of illustrations to well-known or "name" illustrators; 25% to experienced, but not well-known illustrators; 25% to new and emerging illustrators. 50% of freelance illustration demands knowledge of Adobe Illustrator or Photoshop.

FIRST CONTACT & TERMS Submission guidelines available online.

TIPS "We would like to get cutting-edge and unique illustrations or cartoons about the HIV/AIDS crisis, they can be humorous or nonhumorous."

AARP THE MAGAZINE

601 E St. NW, Washington DC 20049. (202)434-2277. **E-mail:** aarpadsales@aarp.org. **Website:** www.aarp.org/magazine. **Contact:** Art/design director. Estab. 2002. Circ. 21 million. Bimonthly 4-color magazine emphasizing health, lifestyles, travel, sports, finance and contemporary activities for members 50 years and over.

ILLUSTRATION Approached by 200 illustrators/year. Buys 30 freelance illustrations/issue. Assigns 60% of illustrations to well-known or "name" illustrators; 30% to experienced but not well-known illustrators; 10% to new and emerging illustrators. Works on assignment only. Considers digital, watercolor, collage, oil, mixed media and pastel.

FIRST CONTACT & TERMS Samples are filed "if I can use the work." Do not send portfolio unless requested. Portfolio can include original/final art, tearsheets, slides and photocopies and samples to keep. Originals are returned after publication. Buys first rights. Pays on completion of project: $700-3,500.

TIPS "We generally use people with strong conceptual abilities. I request samples when viewing portfolios."

ABA BANKING JOURNAL

345 Hudson St., Suite 12, New York NY 10014. (212)620-7256. **E-mail:** wwilliams@sbpub.com. **Website:** www.ababj.com. Estab. 1908. Circ. 31,000+. Monthly association journal; 4-color with contemporary design. Emphasizes banking for middle and upper level banking executives and managers.

ILLUSTRATION Buys 4-5 illustrations/issue from freelancers. Features charts and graphs, computer, humorous and spot illustration. Assigns 20% of illustrations to new and emerging illustrators. Themes relate to stories, primarily financial, from the banking industry's point of view; styles vary, realistic, surreal. Uses full-color illustrations. Works on assignment only.

FIRST CONTACT & TERMS Illustrators: Send finance-related postcard sample and follow-up samples every few months. To send a portfolio, send query letter with brochure and tearsheets, promotional samples or photographs. Negotiates rights purchased. **Pays on acceptance**. Accepts previously published material. Returns original artwork after publication.

TIPS Must have experience illustrating for business or financial publications.

AD ASTRA

1155 15th St. NW, Suite 500, Washington DC 20005. (202)429-1600. **Fax:** (202)463-0659. **E-mail:** adastra.editor@nss.org. **Website:** www.nss.org. **Contact:** Gary Barnhard, editor-in-chief. Estab. 1989. Circ. 25,000. Quarterly feature magazine popularizing and advancing space exploration and development for the general public interested in all aspects of the space program.

ILLUSTRATION Illustrators: Send postcard sample or slides. "Color slides are best."

DESIGN Designers: Send query letter with brochure and photographs. Samples not filed are returned by SASE. Responds in 6 weeks. Pays $100-300 color cover; $25-100 color inside. "We do commission original art from time to time." Fees are for one-time reproduction of existing artwork. Considers rights purchased when establishing payment. Pays designers by the project.

ADVANSTAR LIFE SCIENCES

24950 Country Club Blvd., North Olmsted OH 44070. **E-mail:** pseltzer@advanstar.com. **Website:** www.advanstar.com. Estab. 1909. Publishes 15 health-related publications and special products. Uses freelance artists for "most editorial illustration in the magazines."

CARTOONS Prefers general humor topics (workspace, family, seasonal); also medically related themes. Prefers single-panel b&w drawings and washes with gagline.

ILLUSTRATION Interested in all media, including 3D, electronic and traditional illustration. Needs editorial and medical illustration that varies "but is mostly on the conservative side." Works on assignment only.

FIRST CONTACT & TERMS Cartoonists: Send unpublished cartoons only with SASE to Pete Seltzer, group art director. Buys first world publication rights. Illustrators: Send samples to Peter Seltzer. Samples are filed. Responds only if interested. Write for portfolio review. Buys nonexclusive worldwide rights. Pays $1,000-1,500 for color cover; $250-800 for color inside; $200-600 for b&w. Accepts previously published material. Originals are returned at job's completion.

ADVENTURE CYCLIST

Adventure Cycling Assn., Box 8308, Missoula MT 59807. (406)721-1776, ext. 222. **Fax:** (406)721-8754. **E-mail:** magazine@adventurecycling.org. **Website:** www.adventurecycling.org. **Contact:** Greg Siple, art director; Michael Deme, editor. Estab. 1975. Circ. 45,500. Journal of adventure travel by bicycle, published 9 times/year.

ILLUSTRATION Send digital samples. Samples are filed. Buys 1 illustration/issue. Has featured illustrations by Margie Fullmer, Ludmilla Tomova, Ed Jenne, and Anita Dufalla. Works on assignment only.

FIRST CONTACT & TERMS Will contact artist for portfolio review if interested. Pays on publication, $75-500. Buys one-time rights. Originals returned at job's completion.

THE ADVOCATE

10960 Wilshire Blvd., Suite #1050, Los Angeles CA 90024. (310)943-5858. **Fax:** (310)806-6350. **E-mail:** newsroom@advocate.com. **Website:** www.advocate.com. **Contact:** Art director. Estab. 1967. Biweekly. National gay and lesbian 4-color consumer news magazine.

FIRST CONTACT & TERMS Submission guidelines available online.

TIPS "We are happy to consider unsolicited illustration submissions to use as a reference for making possible assignments to you in the future. Before making any submissions to us, please familiarize yourself with our magazine. Keep in mind that *The Advocate* is a news magazine. As such, we publish items of interest to the gay and lesbian community based on their newsworthiness and timeliness. We do not publish unsolicited illustrations or portfolios of individual artists. Any illustration appearing in *The Advocate* was assigned by us to an artist to illustrate a specific article."

AFRICAN PILOT

Wavelengths 10 (Pty) Ltd., P.O. Box 30620, Kyalami 1684 South Africa. +27 11 466-8524. **Fax:** +27 11 466 8496. **E-mail:** Editor@Africanpilot.co.za. **Website:** www.africanpilot.co.za. **Contact:** Athol Franz, editor. Estab. 2001. Circ. 7,000+ online; 6,600+ print. "*African Pilot* is southern Africa's premier monthly aviation magazine. It publishes a high-quality magazine that is well-known and respected within the aviation community of southern Africa. The magazine offers a number of benefits to readers and advertisers, including a weekly e-mail newsletter, annual service guide, pilot training supplement, executive wall calendar and an extensive website that mirrors the paper edition. The magazine offers clean layouts with outstanding photography and reflects editorial professionalism as well as a responsible approach to journalism. The magazine offers a complete and tailored promotional solution for all aviation businesses operating in the African region."

FIRST CONTACT & TERMS Send e-mail with samples. Samples are kept on file. Portfolio not required. Credit line given.

TIPS "*African Pilot* is an African aviation specific publication and therefore preference is given to articles, illustrations and photographs that have an African theme. The entire magazine is online in exactly the same format as the printed copy for the viewing of our style and quality. Contact me for specific details on our publishing requirements for work to be submitted. Articles together with a selection of about ten thumbnail pictures to be submitted so that a decision can be made on the relevance of the article and what pictures are available to be used to illustrate the ar-

ticle. If we decide to go ahead with the article, we will request high-res images from the portfolio already submitted as thumbnails."

AGING TODAY

71 Stevenson St., Suite 1450, San Francisco CA 94105-2938. (415)974-9600. **Fax:** (415)974-0300. **E-mail:** ahood@asaging.org. **Website:** www.asaging. org. **Contact:** Alison Hood, editor. Estab. 1979. Circ. 10,000. *"Aging Today* is the bimonthly b&w newspaper of the American Society on Aging. It covers news, public policy issues, applied research and developments/trends in aging." Accepts previously published artwork. Originals returned at job's completion if requested. Sample copies available on request. "We no longer accept artwork."

ILLUSTRATION Approached by 50 illustrators/year. Works on assignment only. Drawings can be 4-color or b&w, b&w line drawings and some washes. Considers pen & ink. Needs editorial illustration.

FIRST CONTACT & TERMS Cartoonists: Send query letter with brochure and roughs. Illustrators: Send query letter with brochure, SASE and photocopies. Pays cartoonists $25, with fees for illustrations, $25-50 for b&w covers or inside drawings. Samples are not filed and are returned by SASE. Responds only if interested. To show portfolio, artist should follow up with call and/or letter after initial query. Buys one-time rights.

TIPS "Send brief letter with 2 or 3 applicable samples. Don't send hackneyed cartoons that perpetuate ageist stereotypes. We no longer accept cartoons and/or illustrations."

ALARM

Alarm Press, 205 N. Michigan Ave., Suite 3200, Chicago IL 60601. (312)341-1290. **E-mail:** info@alarm press.com. **Website:** www.alarmpress.com. *ALARM,* published 6 times/year, "does one thing, and it does it very well: it publishes the best new music and art in *ALARM* magazine and alarmpress.com. From our headquarters in a small Chicago office, along with a cast of contributing writers spread across the country, we listen to thousands of CDs, view hundreds of gallery openings, and attend lectures and live concerts in order to present inspirational artists who are fueled by an honest and contagious obsession with their art." Art event listings should be e-mailed to artlist ings@alarmpress.com.

FIRST CONTACT & TERMS Submit by e-mail with the subject line "ALARM Magazine Submissions." "Please send your work as part of the body of an e-mail; we cannot accept attachments." Alternatively, submissions may be sent by regular mail to Submissions Dept. *"ALARM* is not responsible for the return, loss of, or damage to unsolicited manuscripts, unsolicited art work, or any other unsolicited materials. Those submitting manuscripts, art work, or any other materials should not send originals."

ALASKA

301 Arctic Slope Ave., Suite 300, Anchorage AK 99518-3035. (907)272-6070. **Fax:** (907)258-5360. **E-mail:** tim.woody@alaskamagazine.com; andy.hall@ alaskamagazine.com. **Website:** www.alaskamagazine. com. **Contact:** Tim Woody, editor. Estab. 1935. Circ. 180,000. Monthly 4-color regional consumer magazine featuring Alaskan issues, stories and profiles exclusively.

ILLUSTRATION Approached by 200 illustrators/year. Buys 1-4 illustrations/issue. Has featured illustrations by Bob Crofut, Chris Ware, Victor Juhaz and Bob Parsons. Features humorous and realistic illustrations. Works on assignment only. Assigns 50% to new and emerging illustrators. 50% of freelance illustration demands knowledge of Illustrator, Photoshop and QuarkXPress.

FIRST CONTACT & TERMS Send postcard or other nonreturnable samples. Accepts Mac-compatible disk submissions. Samples are not returned. Responds only if interested. Will contact artist for portfolio review if interested. Buys first North American serial rights and electronic rights; rights purchased vary according to project. Pays on publication. Pays illustrators $125-300 for color inside; $400-600 for 2-page spreads; $125 for spots.

TIPS "We work with illustrators who grasp the visual in a story quickly and can create quality pieces on tight deadlines."

ALASKA BUSINESS MONTHLY

Alaska Business Publishing, 501 W. Northern Lights Blvd., Suite 100, Anchorage AK 99503-2577. (907)276-4373. **Fax:** (907)279-2900. **E-mail:** editor@akbizmag. com. **Website:** www.akbizmag.com. **Contact:** Susan Harrington, managing editor. Estab. 1985. Circ. 12,000-15,000. *Alaska Business Monthly,* produced in Alaska for Alaskans and other U.S. and international audiences interested in business affairs of the

49th state. Aims to provide a thorough and objective analysis of issues and trends of interest to the Alaska business community. Featuring stories about individuals, organizations and companies shaping the Alaskan economy, *Alaska Business Monthly* emphasizes the importance of enterprise and strives for statewide business coverage.

TIPS "We usually use local photographers for photos and employees for illustrations. Read the magazine before submitting anything."

ALFRED HITCHCOCK MYSTERY MAGAZINE

Dell Magazines, 267 Broadway, 4th Floor, New York NY 10007-2352. (212)686-7188. **Fax:** (212)686-7414. **E-mail:** alfredhitchcockmm@dellmagazines.com or via online contact form. **Website:** www.themystery place.com/ahmm. **Contact:** associate art director. Estab. 1956. Circ. 202,470. Monthly b&w magazine with 4-color cover emphasizing mystery fiction. Accepts previously published artwork. Original artwork returned at job's completion. Art guidelines available with #10 SASE and first-class postage.

ILLUSTRATION Approached by 300 illustrators/year. Buys 2-3 illustrations/issue. Prefers semirealistic, realistic style. Works on assignment only. Considers pen & ink. Send query letter with printed samples, photocopies or tearsheets and SASE.

FIRST CONTACT & TERMS Guidelines at: www. themysteryplace.com/ahmm/guidelines. Illustrators: Send follow-up postcard sample every 3 months. Samples are filed or returned by SASE. Responds only if interested. "No phone calls." Portfolios may be dropped off every Tuesday and should include b&w and color tearsheets. "No original art please." Rights purchased vary according to project. **Pays on acceptance**; $1,000-1,200 for color cover; $100 for b&w inside; $35-50 for spots. Finds artists through submissions drop-offs, RSVP.

TIPS "No close-up or montages. Show characters within a background environment."

ALL ANIMALS MAGAZINE

700 Professional Dr., Gaithersburg MD 20879. **Fax:** (301)721-6468. **E-mail:** jcork@humanesociety.org. **Website:** www.hsus.org. **Contact:** Jennifer Cork, creative director. Estab. 1954. Circ. 580,000. Bimonthly 4-color magazine focusing on the Humane Society of the United States news and animal protection issues.

FIRST CONTACT & TERMS Features natural history, realistic and spot illustration. Accepts previous-ly published artwork. Originals are returned at job's completion. Art guidelines not available. Work by assignment only. Themes vary. E-mail portfolio website link or mail query letter with samples. **Pays on acceptance**; $400-700 for 2-page spreads; $75-200 for spots.

ALTERNATIVE THERAPIES IN HEALTH AND MEDICINE

P.O. Box 11292, St. Paul MN 55111. **Fax:** (303)440-7446. **E-mail:** athmsubmissions@innovisionhm.com. **Website:** www.alternative-therapies.com. **Contact:** Editor. Estab. 1995. Circ. 25,000. Bimonthly trade journal. "*Alternative Therapies* is a peer-reviewed medical journal established to promote integration between alternative and cross-cultural medicine with conventional medical traditions." Sample copies available.

ILLUSTRATION Buys 6 paintings/year. Purchases fine art for the covers, not graphic art or cartoons.

FIRST CONTACT & TERMS Send e-mail with samples or link to website. Responds within 10 days. Will contact artist if interested. Samples should include subject matter consistent with impressionism, expressionism and surrealism. Buys one-time and reprint rights. Pays on publication; negotiable. Accepts previously published artwork. Originals returned at job's completion. Finds artists through websites, galleries and word of mouth.

AMERICAN AIRLINES NEXOS

American Airlines Publishing, P.O. Box 619640, DFW Airport TX 75261-9640. (817)967-1804. **E-mail:** editor@nexosmag.com. **Website:** www.nexos mag.com. **Contact:** Art Director. Circ. 270,400. Bimonthly inflight magazine published in Spanish and Portuguese that caters to "the affluent, highly-educated Latin American frequent traveler residing in the U.S. and abroad."

ILLUSTRATION Approached by 300 illustrators/year. Buys 50 illustrations/year. Features humorous and spot illustrations of business and families.

FIRST CONTACT & TERMS Send postcard sample. After introductory mailing, send follow-up postcard sample every 6 months. Pays $100-250 for color inside. Pays on publication. Buys one-time rights. Finds free-lancers through submissions.

AMERICAN FITNESS

15250 Ventura Blvd., Suite 200, Sherman Oaks CA 91403. (800)446-2322, ext. 200. **E-mail:** americanfit ness@afaa.com. **Website:** www.afaa.com. **Contact:**

Meg Jordan, editor. Estab. 1983. Circ. 42,900. Bimonthly magazine for fitness and health professionals. Official publication of the Aerobics and Fitness Association of America, the world's largest fitness educator. Send postcard promotional sample. Acquires one-time rights. Accepts previously published material. Original artwork returned after publication. Approached by 12 illustrators/month. Assigns 2 illustrations/issue. Works on assignment only.

ILLUSTRATION Prefers "very sophisticated" 4-color line drawings. Subjects include fitness, exercise, wellness, sports nutrition, innovations and trends in sports, anatomy and physiology, body composition. "Excellent source for never-before-published illustrators who are eager to supply full-page lead artwork."

THE AMERICAN LEGION MAGAZINE

P.O. Box 1055, Indianapolis IN 46206-1055. (317)630-1200. **Fax:** (317)630-1280. **E-mail:** magazine@legion.org. **E-mail:** mgrills@legion.org; hsoria@legion.org. **Website:** www.legion.org. **Contact:** Matt Grills, cartoon editor; Holly Soria, art director. Estab. 1919. Circ. 2,550,000. Emphasizes the development of the world at present and milestones of history; 4-color general-interest magazine for veterans and their families. Monthly. Original artwork not returned after publication.

CARTOONS Uses 3 freelance cartoons/issue. Receives 150 freelance submissions/month. "Experience level does not matter and does not enter into selection process." Especially needs general humor in good taste. "Generally interested in cartoons with broad appeal. Those that attract the reader and lead us to read the caption rate the highest attention. Because of tight space, we're not in the market for spread or multipanel cartoons but use both vertical and horizontal single-panel cartoons. Themes should be home life, business, sports and everyday Americana. Cartoons that pertain only to one branch of the service may be too restricted for this magazine. Service-type gags should be recognized and appreciated by any ex-service man or woman. Cartoons that may offend the reader are not accepted. Liquor, sex, religion and racial differences are taboo.

FIRST CONTACT & TERMS Cartoonists: "No roughs. Send final product for consideration." Usually responds within 1 month. Buys first rights. **Pays on acceptance**; $150.

TIPS "Artists should submit their work as we are always seeking new slant and more timely humor. Black & white submissions are acceptable, but we purchase only color cartoons. Want good, clean humor—something that might wind up on the refrigerator door. Consider the audience!"

AMERICAN LIBRARIES

50 E. Huron St., Chicago IL 60611. (800)545-2433. **Fax:** (312)440-0901. **E-mail:** americanlibraries@ala.org. **Website:** www.ala.org/alonline. **Contact:** Laurie Borman, associate editor. Estab. 1907. Circ. 58,000. Monthly professional 4-color journal of the American Library Association for its members, providing independent coverage of news and major developments in and related to the library field. Sample copy $6. Art guidelines available with SASE and first-class postage.

CARTOONS Approached by 15 cartoonists/year. Buys no more than 1 cartoon/issue. Themes related to libraries only. Average payment $50.

ILLUSTRATION Approached by 20 illustrators/year. Buys 1-2 illustrations/issue. Assigns 25% of illustrations to new and emerging illustrators. Works on assignment only.

FIRST CONTACT & TERMS Cartoonists: Send query letter with brochure and finished cartoons. Illustrators: Send query letter with brochure, tearsheets and résumé. Samples are filed. Does not respond to submissions. To show a portfolio, mail tearsheets, photographs and photocopies. Portfolio should include broad sampling of typical work with tearsheets of both b&w and color. Buys first rights. **Pays on acceptance.**

TIPS "I suggest inquirer go to a library and take a look at the magazine first." Sees trend toward "more contemporary look, simpler, more classical, returning to fewer elements."

AMERICAN LITERARY REVIEW

University of North Texas, P.O. Box 311307, Denton TX 76203-1307. (940)565-2755. **E-mail:** americanliteraryreview@gmail.com; bond@unt.edu. **Website:** www.engl.unt.edu/alr. Estab. 1990. Circ. 1,200.

○ "You may submit digital art, photography, paintings, drawings, mixed media, etc. We will keep your art on file for 1 year."

FIRST CONTACT & TERMS Artwork submitted for publication must: be on a CD in JPEG format; include the artist's contact information (name, e-mail, mailing address, and phone number), along with the title

or titles of the piece or pieces, and a brief bio in an .rtf or Microsoft Word file. Include a SASE for response, along with an appropriate mailer with correct postage for returns.

AMERICAN MEDICAL NEWS

515 N. State, Chicago IL 60610. (312)464-4432. **Fax:** (312)464-4445. **E-mail:** Jef.Capaldi@ama-assn.org; jennifer.wenger@ama-assn.org. **Website:** www.amed news.com. **Contact:** Ben Mindell, editor. Estab. 1958. Circ. 375,000. Weekly trade journal. Primarily covers the business and political side of medical current events. "We're the nation's most widely circulated publication covering socioeconomic issues in medicine." Originals returned at job's completion. Sample copies available. 10% of freelance work demands knowledge of Photoshop and FreeHand.

ILLUSTRATION Approached by 250 freelancers/year. Buys 2-3 illustrations/issue. Works on assignment only. Considers mixed media, collage, watercolor, acrylic and oil.

FIRST CONTACT & TERMS Send postcard samples. Samples are filed. Will contact for portfolio review if interested. Buys first rights. **Pays on acceptance.** Pays $300-500 for b&w, $500-850 for color inside. Pays $200-400 for spots. Finds artists through illustration contest annuals, word of mouth and submissions.

TIPS "Illustrations need to convey a strong, clever concept."

AMERICAN MUSIC TEACHER

441 Vine St., Suite 3100, Cincinnati OH 45202-3004. (513)421-1420; (888)512-5278. **Fax:** (513)421-2503. **E-mail:** bpieper@mtna.org. **Website:** www.mtna.org. **Contact:** Brian Pieper, graphic designer. Estab. 1951. Circ. 26,424. Bimonthly 4-color trade journal emphasizing music teaching. Features historical and how-to articles. "*AMT* promotes excellence in music teaching and keeps music teachers informed. It is the official journal of the Music Teachers National Association, an organization which includes concert artists, independent music teachers and faculty members of educational institutions." Accepts previously published material. Original artwork returned after publication. Sample copies available.

ILLUSTRATION Buys 1 illustration/issue. Uses freelancers mainly for diagrams and illustrations. Prefers musical theme. "No interest in cartoon illustration."

FIRST CONTACT & TERMS Illustrators: Send query letter with brochure or résumé, tearsheets, slides and photographs. Samples are filed or are returned only if requested with SASE. Responds in 3 months. To show a portfolio, mail printed samples, color and b&w tearsheets, photographs and slides. Buys one-time rights. Pays on publication; $50-150 for b&w and color, cover and inside.

AMERICAN SCHOOL BOARD JOURNAL

1680 Duke St., Alexandria VA 22314. (703)838-6739. **Fax:** (703)549-6719. **E-mail:** editorial@asbj.com. **Website:** www.asbj.com. **Contact:** Glenn Cook, editor-in-chief. Estab. 1891. Circ. 36,000. National monthly magazine for school board members and school administrators. Sample copies available.

ILLUSTRATION Buys 40-50 illustrations/year. Considers all media. Send postcard sample.

FIRST CONTACT & TERMS Illustrators: Send follow-up postcard sample every 3 months. Will not accept samples as e-mail attachment. Please send URL. Responds only if interested. Art director will contact artist for portfolio review of tearsheets if interested. Buys one-time rights. **Pays on acceptance.** Pays $1,200 maximum for color cover; $250-350 for b&w, $300-600 for color inside. Finds illustrators through agents, sourcebooks, online services, magazines, word of mouth and artist's submissions.

TIPS "We're looking for new ways of seeing old subjects—children, education, management. We also write a great deal about technology and love high-tech, very sophisticated mediums. We prefer concept over narrative styles."

ANALOG

Dell Magazines, 267 Broadway, 4th Floor, New York NY 10007-2352. (212)686-7188; (203)866-6688. **E-mail:** analog@dellmagazines.com. **Website:** www.analogsf.com. **Contact:** Victoria Green, senior art director; Stanley Schmidt, editor. Estab. 1930. Circ. 80,000. Monthly consumer magazine. Art guidelines free for #10 SASE with first-class postage or free online.

CARTOONS Prefers single panel cartoons.

ILLUSTRATION Buys 4 illustrations/issue. Prefers science fiction, hardware, robots, aliens and creatures. Considers all media.

FIRST CONTACT & TERMS Cartoonists: Send query letter with photocopies or tearsheets and SASE. Samples are not filed and are returned by SASE. Illustrators: Send query letter with printed samples or tearsheets and SASE. Send follow-up postcard sample

every 4 months. Accepts disk submissions compatible with QuarkXPress 7.5/version 3.3. Send EPS files. Files samples of interest, others are returned by SASE. Responds only if interested. "No phone calls." Portfolios may be dropped off every Tuesday and should include b&w and color tearsheets and transparencies. "No original art please, especially oversized." Buys one-time rights. **Pays on acceptance.** Pays cartoonists $35 minimum for b&w cartoons. Pays illustrators $1,200 for color cover; $125 minimum for b&w inside; $35-50 for spots. Finds illustrators through *Black Book*, *LA Workbook*, *American Showcase* and other reference books.

AQUARIUM FISH INTERNATIONAL

Bowtie, Inc., P.O. Box 6050, Mission Viejo CA 92690-6050. (949)855-8822. **Fax:** (949)855-3045. **E-mail:** aquariumfish@bowtieinc.com. **Website:** www.fishchannel.com. **Contact:** Patricia Knight, managing editor; Clay Jackson, editor. Estab. 1988. Monthly magazine covering fresh and marine aquariums. Photo guidelines available for SASE with first-class postage or on website.

CARTOONS Approached by 30 cartoonists/year.

FIRST CONTACT & TERMS Buys one-time rights. Pays $35 for b&w and color cartoons. Themes should relate to aquariums and ponds.

ARMY MAGAZINE

Association of the U.S. Army, 2425 Wilson Blvd., Arlington VA 22201. (800)336-4570. **E-mail:** armymag@ausa.org. **Website:** www.ausa.org. **Contact:** Editorial assistant. Estab. 1950. Circ. 70,000. Monthly journal dealing with current and historical military affairs. Also covers military doctrine, theory, technology and current affairs from a military perspective. Sample copies available for $3.00. Art guidelines available.

CARTOONS Buys 1 cartoon/issue.

ILLUSTRATION Prefers military, historical or political themes. "Can accept artwork done with Illustrator or Photoshop for Mac."

FIRST CONTACT & TERMS Cartoonists: Send query letter with brochure and finished cartoons. Responds to the artist only if interested. Illustrators: Send query letter with brochure, résumé, tearsheets, photocopies and photostats. Samples are filed or are returned by SASE if requested by artist. Publication will contact artist for portfolio review if interested. Portfolio should include b&w and color tearsheets, photocopies and photographs. Buys one-time rights. Pays on pub-

lication. Pays cartoonists $50 for b&w. Pays illustrators $300 minimum for b&w cover; $500 minimum for color cover; $50 for b&w inside; $75 for color inside; $35-50 for spots.

ARTHRITIS TODAY

Arthritis Foundation, 1330 W. Peachtree St., Suite 100, Atlanta GA 30309. (404)872-7100. **Fax:** (404)872-9559. **Website:** www.arthritistoday.org. Estab. 1987. Circ. 650,000. Bimonthly consumer magazine. "*Arthritis Today* is the official magazine of the Arthritis Foundation. The award-winning publication is more than the most comprehensive and reliable source of information about arthritis research, care and treatment. It is a magazine for the whole person—from their lifestyles to their relationships. It is written both for people with arthritis and those who care about them." Originals returned at job's completion. Sample copies available. 20% of freelance work demands knowledge of Illustrator, QuarkXPress or Photoshop.

ILLUSTRATION Approached by over 100 illustrators/year. Buys 5-10 illustrations/issue. Works on assignment only; stock images used in addition to original art.

FIRST CONTACT & TERMS Illustrators: Send query letter with brochure, tearsheets, photostats, slides (optional) and transparencies (optional). Samples are filed. Publication will contact artist for portfolio review if interested. Portfolio should include color tearsheets, photostats, photocopies, final art and photographs. Buys first-time North American serial rights. Other usage negotiated. **Pays on acceptance.** Finds artists through sourcebooks, Internet, other publications, word of mouth, submissions.

TIPS "No limits on areas of the magazine open to freelancers. Two to three departments in each issue use spot illustrations. Submit tearsheets for consideration. No cartoons."

THE ARTIST'S MAGAZINE

F+W Media, Inc., 10151 Carver Rd., Blue Ash OH 45242. (513)531-2690, ext. 11731. **Fax:** (513)891-7153. **Website:** www.artistsmagazine.com. **Contact:** Maureen Bloomfield, editor-in-chief; Brian Roeth, art director. Circ. 135,000. Emphasizes the techniques of working artists for the serious beginning, amateur and professional artist. Published 10 times/year. Sample copy available for $5.99 U.S., $8.99 Canadian or international; remit in U.S. funds. Sponsors 3 annual contests. Send SASE for more information. Pays illus-

trators $350-1,000 for color inside, $100-500 for spots. Occasionally accepts previously published material. Returns original artwork after publication. Must be related to art and artists.

CARTOONS Cartoonists: Contact cartoon editor. Send query letter with brochure, photocopies, photographs and tearsheets to be kept on file. Prefers photostats or tearsheets as samples. Samples not filed are returned by SASE. Buys 4-6 cartoons/year. Buys first rights. **Pays on acceptance.** Pays cartoonists $65.

ILLUSTRATION Buys 2-3 illustrations/year. Has featured illustrations by Penelope Dullaghan, A. Richard Allen, Robert Carter, Chris Sharp and Brucie Rosch. Features concept-driven illustration. Works on assignment only.

TIPS "Research past issues of publication and send samples that fit the subject matter and style of target publication."

ASIAN ENTERPRISE MAGAZINE

Asian Business Ventures, Inc., P.O. Box 1126, Walnut CA 91788. (909)896-2865; (909)319-2306. **E-mail:** alma.asianent@gmail.com;almag@asianenterprise. com. **Website:** www.asianenterprise.com. Estab. 1993. Circ. 100,000. Monthly trade publication. "The largest Asian small business focus magazine in the U.S."

CARTOONS Buys 12 cartoons/year. Prefers business-humorous, single-panel, political, b&w line drawings.

ILLUSTRATION Buys 12 illustrations/issue. Features caricatures of politicians, humorous illustration and spot illustrations of business subjects. 100% of freelance illustrations demands knowledge of Photoshop, PageMaker and QuarkXPress.

FIRST CONTACT & TERMS Cartoonists: Send query letter with samples. Illustrators: Send query letter with tearsheets. Accepts disk submissions. Send TIFF files. Samples are filed. Responds only if interested. Portfolio review not required. Buys one-time rights. Negotiates rights purchased. Pays on publication. Pays cartoonists $25-50 for b&w, $25-50 for comic strips. Pays illustrators $25-50 for b&w, $200 maximum for color cover; $25-50 for b&w inside. Finds illustrators through promo samples and word of mouth.

ASIMOV'S SCIENCE FICTION

Dell Magazine, 267 Broadway, 4th Floor, New York NY 10007-2352. (212)686-7188. **Fax:** (212)686-7414. **E-mail:** asimovssf@dellmagazines.com. **Website:** www.asimovs.com. **Contact:** Brian Bieniowski, managing editor; Sheila Williams, editor; Victoria Green,

senior art director; June Levine, associate art director. Estab. 1977. Circ. 50,000. Monthly b&w with 4-color cover magazine of science fiction and fantasy. Art guidelines available for #10 SASE with first-class postage.

CARTOONS Prefers single-panel, b&w washes or line drawings with or without gagline. "No comic book artists. Realistic work only, with science fiction/fantasy themes. Show characters with a background environment. Pays cartoonists $35 minimum. Pays illustrators $600-1,200 for color cover. Accepts previously published artwork. Original artwork returned at job's completion. Approached by 20 cartoonists/year. Buys 10 cartoons/year. Address cartoons to Brian Bieniowski.

ILLUSTRATION Accepts illustrations done with Illustrator and Photoshop. No longer buys interior illustration.

FIRST CONTACT & TERMS Now accepts submissions online. Portfolios may be dropped off every Tuesday and should include b&w and color tearsheets. Cartoonists: Send query letter with printed samples, photocopies and/or tearsheets and SASE. Accepts disk submissions compatible with QuarkXPress version 3.3. Send EPS files. Samples are filed or returned by SASE. Responds only if interested. Buys one-time and reprint rights. **Pays on acceptance.** Commissions 2 covers/year; the rest are second-time rights or stock images.

ASPEN MAGAZINE

720 E. Durant Ave., Suite E8, Aspen CO 81611. (970)920-4040. **Fax:** (970)920-4044. **E-mail:** Janran@aspenmagazine.com; jenn@aspenmagazine. com. **Website:** www.aspenmagazine.com. **Contact:** Jenn Virskus, production manager. Circ. 18,300. Bimonthly 4-color city magazine with the emphasis on Aspen and the valley. Accepts previously published artwork. Original artwork returned at job's completion. Sample copies and art guidelines available.

ILLUSTRATION Approached by 15 illustrators/year. Buys 2 illustrations/issue. Themes and styles should be appropriate for editorial content. Considers all media. Send query letter with tearsheets, photostats, photographs, slides, photocopies and transparencies. Samples are filed. Responds only if interested. Call for appointment to show a portfolio, which should include thumbnails, roughs, tearsheets, slides and

photographs. Buys first, one-time or reprint rights. Pays on publication.

ASSOCIATION OF COLLEGE UNIONS INTERNATIONAL

One City Centre, 120 W. Seventh St., Suite 200, Bloomington IN 47404. (812)245-2284. **Fax:** (812)245-6710. **E-mail:** alangeve@acui.org. **Website:** www.acui.org. **Contact:** Andrea Langerveld, marketing designer. Estab. 1914. Professional higher education association magazine covering "multicultural issues, creating community on campus, union and activities programming, managing staff, union operation, professional development and student development."

○ Also publishes hardcover and trade paperback originals. See listing in the Book Publishers section for more information.

ILLUSTRATION Works on assignment only. Considers all kinds of illustration.

DESIGN Needs designers for production.

FIRST CONTACT & TERMS Illustrators: Send query letter with résumé, photocopies, tearsheets, photographs, websites or color transparencies of college student union activities. Designers: Send query letter with résumé and samples. Samples are filed. Responds only if interested. Negotiates rights purchased. Pays by project.

TIPS "We are a volunteer-driven association. Most people submit work on that basis. We are on a limited budget."

ASTRONOMY

Kalmbach Publishing, 21027 Crossroads Circle, P.O. Box 1612, Waukesha WI 53187-1612. (800)533-6644. **Fax:** (262)796-1615. **Website:** www.astronomy.com. David J. Eicher, editor. **Contact:** LuAnn Williams Belter, art director (for art and photography). Estab. 1973. Circ. 122,000. Monthly consumer magazine emphasizing the study and hobby of astronomy. Published by Kalmbach Publishing. Also see listings for *Classic Toy Trains, Finescale Modeler, Model Railroader, Model Retailer, Bead and Button, Birder's World, Trains, The Writer,* and *Dollhouse Miniatures.*

ILLUSTRATION Send query letter with duplicate slides. Do not send originals. Accepts submissions on disk compatible with above software. Samples are filed and not returned. Buys one-time rights. Finds illustrators through word of mouth and submissions. Approached by 20 illustrators/year. Buys 2 illustrations/issue. Has featured illustrations by James Yang, Gary Baseman. Considers all media. 10% of freelance illustration demands knowledge of Photoshop, Illustrator, QuarkXPress.

FIRST CONTACT & TERMS Illustrators: Send query letter with duplicate slides. Do not send originals. Accepts submissions on disk compatible with above software. Samples are filed and not returned. Buys one-time rights. Finds illustrators through word of mouth and submissions. Approached by 20 illustrators/year. Buys 2 illustrations/issue. Has featured illustrations by James Yang, Gary Baseman. Considers all media. 10% of freelance illustration demands knowledge of Photoshop, Illustrator, QuarkXPress.

TIPS "Submitting to *Astronomy* could be tough—take a look at how technical astronomy is. But if someone is a physics teacher or an amateur astronomer, he or she might want to study the magazine for a year to see the sorts of subjects and approaches we use, and then submit a proposal. Submission guidelines available online."

A.T. JOURNEYS

Appalachian Trail Conservancy Headquarters, 799 Washington St., P.O. Box 807, Harpers Ferry WV 25425-0807. (304)535-6331. **Fax:** (304)535-2667. **E-mail:** editor@appalachiantrail.org; journeys@appalachiantrail.org. **Website:** www.appalachiantrail.org. **Contact:** Editor. Circ. 37,000. Membership publication focuses on the stories of people who experience and support the Appalachian Trail, as well as conservation-oriented stories related to the Appalachian Mountain region. Published 6 times/year. Sometimes accepts previously published material. Returns original artwork after publication. Sample copy and art guidelines available for legitimate queries.

ILLUSTRATION Buys 8-12 illustrations/issue. Accepts all styles and media; computer generated (identified as such) or manual. Original artwork should be directly related to the Appalachian Trail.

FIRST CONTACT & TERMS Illustrators: Send query letter with samples to be kept on file. Prefers nonreturnable postcards, photocopies or tearsheets as samples. Samples not filed are returned by SASE. Responds in 2 months. Negotiates rights purchased. **Pays on acceptance**; $25-$250 for b&w, color. Finds most artists through references, word of mouth and samples received through the mail.

ATLANTA MAGAZINE

260 W. Peachtree St., Suite 300, Atlanta GA 30303. (404)527-5500. **Fax:** (404)527-5575. **E-mail:** atlanta magletters@atlantamag.emmis.com. **Website:** www. atlantamagazine.com. **Contact:** Steve Fennessy, editor. Estab. 1961. Circ. 66,000. Monthly 4-color consumer magazine.

ILLUSTRATION Buys 3 illustrations/issue. Has featured illustrations by Fred Harper, Harry Campbell, Jane Sanders, various illustrators repped by Wanda Nowak, various illustrators repped by Gerald & Cullen Rapp, Inc. Features caricatures of celebrities, fashion illustration, humorous illustration and spot illustrations. Prefers a wide variety of subjects. Style and media depend on the story. Assigns 60% of illustrations to well-known or "name" illustrators; 30% to experienced but not well-known illustrators; 10% to new and emerging illustrators.

FIRST CONTACT & TERMS Illustrators: Send nonreturnable postcard sample. Samples are filed. Will contact artist for portfolio review if interested. Buys first rights. **Pays on acceptance.** Finds freelancers through promotional samples, artists' reps, *The Alternative Pick.*

AUTHORSHIP

National Writers Association, 10940 S. Parker Rd., #508, Parker CO 80134. (303)841-0246. **E-mail:** natlwritersassn@hotmail.com. **Website:** www.web masternationalwriters.com. Estab. 1950s. Circ. 4,000. Quarterly magazine. "Our publication is for our 3,000 members and is cover-to-cover about writing."

FIRST CONTACT & TERMS Cartoonists: Samples are returned. Responds in 4 months. Buys first North American serial and reprint rights. **Pays on acceptance.** Pays cartoonists $25 minimum for b&w. Illustrators: Accepts disk submissions. Send TIFF or JPEG files.

TIPS "We only take cartoons slanted to writers."

AUTOMOBILE MAGAZINE

120 E. Liberty St., 2nd Floor, Ann Arbor MI 48104-4193. **Website:** www.automobilemag.com. **Contact:** art director. Estab. 1986. Circ. 650,000. Monthly 4-color automobile magazine for upscale lifestyles. Art guidelines are specific for each project.

ILLUSTRATION Buys illustrations mainly for spots and feature spreads. Works with 5-10 illustrators/year. Buys 2-5 illustrations/issue. Works on assignment only. Considers airbrush, mixed media, colored pencil, watercolor, acrylic, oil, pastel and collage. Needs editorial and technical illustrations.

FIRST CONTACT & TERMS Send query letter with brochure showing art style, résumé, tearsheets, slides, photographs or transparencies. Show automobiles in various styles and media. "This is a full-color magazine; illustrations of cars and people must be accurate." Samples are returned only if requested. "I would like to keep something in my file." Responds to queries/submissions only if interested. Buys first rights and one-time rights. Pays $200 and up for color inside. Pays $2,000 maximum depending on size of illustration. Finds artists through mailed samples.

TIPS "Send samples that show cars drawn accurately with a unique style and imaginative use of medium."

AUTO RESTORER

Bowtie, Inc., P.O. Box 6050, Mission Viejo CA 92690. (949)855-8822. **Fax:** (949)855-3045. **E-mail:** tkade@ fancypubs.com; editors@mmminc.org. **Website:** www.autorestorermagazine.com. **Contact:** Ted Kade, editor. Estab. 1989. Circ. 60,000. Monthly b&w consumer magazine with focus on collecting, restoring and enjoying classic cars and trucks. Originals returned at job's completion. Sample copies available for $5.50.

ILLUSTRATION Technical drawings that illustrate articles in black ink are welcome. Approached by 5-10 illustrators/year. Buys 1 illustration/issue. Prefers technical illustrations and cutaways of classic/collectible automobiles through 1979. Considers pen & ink, watercolor, airbrush, acrylic, marker, colored pencil, oil, charcoal, mixed media and pastel.

FIRST CONTACT & TERMS Illustrators: Send query letter with SASE, slides, photographs and photocopies. Samples are filed or returned by SASE if requested by artist. Responds to the artist only if interested. Buys one-time rights. Pays on publication; technical illustrations negotiable. Finds artists through submissions.

TIPS Areas most open to freelance work are technical illustrations for feature articles and renderings of classic cars for various sections.

BABYBUG

Carus Publishing, 70 East Lake St., Chicago IL 60601. **E-mail:** babybug@caruspub.com. **Website:** www. cricketmag.com. **Contact:** Marianne Carus, editor-in-chief; Suzanne Beck, managing art director. Estab. 1994. Circ. 45,000. A listening and looking magazine

for infants and toddlers ages 6 months to 2 years. Published monthly except for combined May/June and July/August issues. Art guidelines available on website. Buys all rights.

○ See also listings in this section for other magazines published by the Cricket Magazine Group: *Ladybug*, *Spider*, *Cricket* and *Cicada*.

FIRST CONTACT & TERMS Send photocopies, photographs or tearsheets to be kept on file. Samples are returned by SASE if requested. Responds in 3 months. Artists should submit review samples (tearsheets/photocopies) of artwork to be kept in our illustrator files. Author-illustrators may submit a complete ms with art samples. The ms will be evaluated for quality of concept and text before the art is considered. Responds in 3 months for art samples.

TIPS "Before attempting to illustrate for *Babybug*, be sure to familiarize yourself with this age group, and read several issues of the magazine. Please do not query first."

BACKPACKER MAGAZINE

Cruz Bay Publishing, Inc., an Active Interest Media Co., 2520 55th St., Suite 210, Boulder CO 80301. **E-mail:** gfullerton@backpacker.com. **Website:** www.backpacker.com. Dennis Lewon, deputy editor (Features & People), dlewon@backpacker.com; Shannon Davis, senior editor (Destinations), sdavis@backpacker.com; Kristin Bjornsen, associate editor (Skills), kbjornsen@aimmedia.com; Kristin Hostetter, gear editor (Gear), khostetter1@gmail.com. **Contact:** Jonathan Dorn, editor-in-chief. Estab. 1973. Circ. 340,000. Approached by 200-300 illustrators/year. Buys 10 illustrations/issue. Considers all media. 60% of freelance illustration demands knowledge of FreeHand, Photoshop, Illustrator, QuarkXPress.

TIPS *Backpacker* does not buy cartoons. "Know the subject matter, and know *Backpacker Magazine*."

BALTIMORE JEWISH TIMES

1040 Park Ave., Suite 200, Baltimore MD 21201. (410)752-3504. **Fax:** (443)451-6025. **E-mail:** artdirector@jewishtimes.com. **Website:** www.jewishtimes.com. **Contact:** Lindsey Bridwell. Circ. 13,000. Weekly b&w tabloid with 4-color cover. Emphasizes special interests to the Jewish community for largely local readership. Sample copies available.

○ Alter Communications also publishes *Style*, a Baltimore lifestyle magazine; *Chesapeake Life*, which covers lifestyle topics in southern Maryland and the Eastern Shore; and *PaperDoll*, Baltimore's first magazine devoted exclusively to shopping. See www.alteryourview.com for more information on these publications.

ILLUSTRATION Approached by 50 illustrators/year. Buys 4-6 illustrations/year. Works on assignment only. Prefers high-contrast, b&w illustrations.

FIRST CONTACT & TERMS Illustrators: Send query letter with brochure showing art style or tearsheets and photocopies. Samples not filed are returned by SASE. Responds if interested. To show a portfolio, mail appropriate materials or write/call to schedule an appointment. Portfolio should include original/final art, final reproduction/product and color tearsheets and photostats. Buys first rights. Pays on publication: $500 for b&w or color cover; $50-100 for b&w inside. Accepts previously published artwork. Returns original artwork after publication, if requested.

TIPS Finds artists through word of mouth, self-promotion and sourcebooks. Sees trend toward "more freedom of design integrating visual and verbal."

BALTIMORE MAGAZINE

Inner Harbor, E. 1000 Lancaster St., Suite 400, Baltimore MD 21202. (410)752-4200. **Fax:** (410)625-0280. **E-mail:** Send correspondence to the appropriate editor. **Website:** www.baltimoremagazine.net. **Contact:** Department editors (Max Weiss—lifestyle, film, sports, general inquiries; Suzanne Loudermilk—Food; Ken Eglehart—business, special editions; John Lewis—arts and culture; Amy Mulvihill—calendar, coming events, party pages); Amanda White-Iseli, art director; Kathryn Mychailysyzn, associate art director. Estab. 1907. Circ. 70,000. Monthly city magazine featuring news, profiles and service articles. Sample copies available for $4.99 each. Considers all media, depending on assignment. 10% of freelance work demands knowledge of InDesign, FreeHand, Illustrator or Photoshop, or any other program that is saved as a TIFF or PICT file. All art is freelance-humorous front pieces, feature illustrations, etc.

CARTOONS Does not use cartoons.

ILLUSTRATION Samples are filed. Will contact for portfolio review if interested. Originals returned at job's completion. Buys one-time rights. Pays on publication: $200-1,500 for color inside; 60 days after invoice. Finds artists through sourcebooks, publications, word of mouth, submissions. Approached

by 1,000 illustrators/year. Buys 4 illustrations/issue. Works on assignment only.

FIRST CONTACT & TERMS Send postcard sample. Accepts disk submissions.

BARTENDER MAGAZINE

Foley Publishing, P.O. Box 158, Liberty Corner NJ 07938. (908)766-6006. **Fax:** (908)766-6607. **E-mail:** barmag@aol.com. **Website:** www.bartender.com. Doug Swenson, art director. **Contact:** Jackie Foley, editor. Estab. 1979. Circ. 150,000. Quarterly 4-color trade journal emphasizing restaurants, taverns, bars, bartenders, bar managers, owners, etc. Prefers bar themes; single-panel. Works on assignment only.

CARTOONS Send query letter with finished cartoons. Buys first rights. Approached by 10 cartoonists/year. Buys 3 cartoons/issue. Pays cartoonists $50 for b&w and $100 for color inside.

ILLUSTRATION Send query letter with brochure. Samples are filed. Negotiates rights purchased. Pays on publication. Approached by 5 illustrators/year. Buys 1 illustration/issue. Pays illustrators $500 for color cover.

DESIGN Considers any media.

TIPS Prefers bar themes.

BAY WINDOWS

28 Damrell St., Suite 204, Boston MA 02127. (617)464-7280. **Fax:** (617)464-7286. **E-mail:** letters.baywindows@gmail.com. **Website:** www.baywindows.com. **Contact:** Editorial design manager. Estab. 1983. Circ. 60,000. Weekly newspaper "targeted to politically-aware lesbians, gay men and other political allies publishing non-erotic news and features"; b&w with 2-color cover. Sample copies available.

CARTOONS Approached by 25 cartoonists/year. Buys 1-2 cartoons/issue. Buys 50 cartoons/year. Preferred themes include politics and lifestyles. Prefers double and multiple panel, political and editorial cartoons with gagline; b&w line drawings.

ILLUSTRATION Approached by 60 illustrators/year. Buys 1 illustration/issue. Buys 50 illustrations/year. Works on assignment only. Preferred themes include politics; "humor is a plus." Considers pen & ink and marker drawings. Needs computer illustrators familiar with Illustrator or FreeHand.

FIRST CONTACT & TERMS Cartoonists: Send query letter with roughs. Samples are returned by SASE if requested by artist. Illustrators: Send query letter with photostats and SASE. Samples are filed. Responds in 6 weeks, only if interested. Portfolio review not required. Rights purchased vary according to project. Pays on publication. Accepts previously published artwork. Original artwork returned after publication.

◯ ◑ BC OUTDOORS HUNTING AND SHOOTING

Keywest Marketing, Ltd., 202 9644 54 Ave., Edmonton AB T6E 5V1, Canada. (604)464-1876. **Fax:** (604)464-3186. **E-mail:** info@outdoorgroupmedia.com; mmitchell@outdoorgroupmedia.com; production@outdoorgroupmedia.com; sswanson@oppublishing.com; imc@outdoorgroupmedia.com. **Website:** www.bcoutdoorsmagazine.com. **Contact:** Mike Mitchell, editor. Estab. 1945. Circ. 30,000. Biannual 4-color magazine, emphasizing fishing, hunting, camping, wildlife/conservation in British Columbia. Original artwork returned after publication unless bought outright. Works on assignment only. Samples returned by SASE (nonresidents include IRC). Reports back on future assignment possibilities. Subject matter and the art's quality must fit with publication. Buys first North American serial rights or all rights on a work-for-hire basis. Interested in outdoors, wildlife (BC species only) and activities as stories require.

◒ "Send us material on fishing and hunting. We generally just send back nonrelated work."

ILLUSTRATION Approached by more than 10 illustrators/year. Buys 4-6 illustrations/year. Format b&w line drawings and washes for inside and color washes for inside. Has featured illustrations by Ian Forbes, Brad Nickason and Michael McKinell. Prefers local artists. Pays on publication; $40 minimum for spots.

FIRST CONTACT & TERMS Arrange personal appointment to show portfolio or send samples of style.

THE BEAR DELUXE MAGAZINE

Orlo, 810 SE Belmont, Studio 5, Portland OR 97214. (503)242-1047. **E-mail:** bear@orlo.org. **Website:** www.orlo.org. **Contact:** Tom Webb, editor-in-chief; Kristin Rogers Brown, art director. Estab. 1993. Circ. 19,000. "*The Bear Deluxe Magazine* is a national independent environmental arts magazine publishing significant works of reporting, creative nonfiction, literature, visual art and design. Based in the Pacific Northwest, it reaches across cultural and political divides to engage readers on vital issues effecting the environment. Published twice per year, *The Bear Deluxe* includes a wider array and a higher-percentage of visual art work and design than many other publications. Artwork is

included both as editorial support and as stand alone or independent art. It has included nationally recognized artists as well as emerging artists. As with any publication, artists are encouraged to review a sample copy for a clearer understanding of the magazine's approach. Unsolicited submissions and samples are accepted and encouraged. *The Bear Deluxe* has been recognized for both its editorial and design excellence."

CARTOONS Approached by 50 cartoonists/year. Buys 5 cartoons/issue. Prefers work related to environmental, outdoor, media, arts. Prefers single-panel, political, humorous, b&w line drawings. Buys first rights. Pays on publication. Cartoonists should continue to send us their latest and greatest, not just samples.

ILLUSTRATION Pays illustrators $200 for b&W or color cover; $15-75 for b&w or color inside; $15-75 for 2-page spreads; $20 for spots.

FIRST CONTACT & TERMS Send postcard sample and nonreturnable samples. Accepts Mac-compatible disk submissions. Send EPS or TIFF or JPEG files. Samples are filed or returned by SASE. Responds only if interested. Portfolios may be dropped off by appointment. "If you submit via e-mail, send PDF format files only, or a url address for us to visit. (Note on e-mail submissions and URL suggestions, we still prefer hard-copy work samples but will consider electronic submissions and links. We cannot, however, guarantee a response to electronic submissions.) Always include an appropriately stamped SASE for the return of materials. No faxes. *The Bear Deluxe* assumes no liability for submitted work samples."

TIPS "Most of our work (besides cartoons) is assigned out as editorial illustration or independent art. Indicate whether an assignment is possible for you. Indicate your fastest turn-around time. We sometimes need people who can work with two- to three-week turn-around or faster."

BIRD WATCHER'S DIGEST

P.O. Box 110, Marietta OH 45750. (740)373-5285; (800)879-2473. **Fax:** (740)373-8443. **E-mail:** editor@birdwatchersdigest.com. **E-mail:** submissions@birdwatchersdigest.com. **Website:** www.birdwatchersdigest.com. **Contact:** Bill Thompson III, editor. Estab. 1978. Circ. 125,000. Bimonthly magazine covering birds and bird watching for bird watchers and birders (backyard and field; veteran and novice). Sample copies available for $3.99. Art guidelines available online or free with SASE. Has featured illustrations by Julie Zickefoose, Tom Hirata, Kevin Pope and Jim Turanchik.

ILLUSTRATION Assigns 15% of illustrations to new and emerging illustrators.

FIRST CONTACT & TERMS Send samples or tearsheets. Responds in 2 months. Buys one-time rights. Pays $75 minimum for b&w, $150 minimum for color. Payment includes 2 complimentary copies of appropriate issue. Previously published material OK. Original work returned after publication. Buys 1-2 illustrations/issue.

BIRMINGHAM PARENT

Evans Publishing LLC, 700-C Southgate Dr., Pelham AL 35124. (205)739-0090. **Fax:** (205)739-0073. **E-mail:** editor@birminghamparent.com; carol@biringhamparent.com. **Website:** www.birminghamparent.com. **Contact:** Carol Muse Evans, publisher/editor; Lori Chandler Pruitt, associate editor. Estab. 2004. Circ. 40,000. Monthly magazine serving parents of families in Central Alabama/Birmingham with news pertinent to them. Art guidelines free with SASE or on website.

CARTOONS Approached by 12-20 cartoonists/year. Buys 1-2 cartoons/year. Prefers fun, humorous, parenting issues, nothing controversial. Format: single panel. Media: color washes.

ILLUSTRATION Approached by 2 illustrators/year. Assigns 5% of illustrations to new and emerging illustrators. 95% of freelance work demands computer skills. Freelancers should be familiar with InDesign, QuarkXPress, Photoshop.

FIRST CONTACT & TERMS E-mail submissions accepted with link to website. Portfolio not required. Pays cartoonists $0-25 for b&w or color cartoons. Pays on publication. Buys electronic rights, first North American serial rights. Magazine is completely digitally online, so permission must be granted for use there in the magazine.

TIPS "We do very little freelance artwork. We are still a small publication and don't have space or funds for it. Our art director provides the bulk of our needs. It would have to be outstanding for us to consider purchasing right now."

BITCH

4930 NE 29th Ave., Portland OR 97211-7034. (877)212-4824. **E-mail:** bitch@bitchmagazine.com. **Website:** www.bitchmagazine.com. **Contact:** Art di-

rector. Estab. 1996. Circ. 80,000. Quarterly b&w magazine "devoted to incisive commentary on our media-driven world. We examine popular culture in all its forms for women and feminists of all ages."

ILLUSTRATION Approached by 300 illustrators/year. Buys 3-7 illustrations/issue. Features caricatures of celebrities, conceptual, fashion and humorous illustration. Work on assignment only. Prefers b&w ink drawings and photo collage, or selective use of color. Assigns 85% of illustrations to experienced but not well-known illustrators; 12% to new and emerging illustrators; 3% to well-known or "name" illustrators.

FIRST CONTACT & TERMS Send postcard sample, non-returnable samples. Accepts Mac-compatible disk submissions. Samples are filed and are not returned. Will contact artist for portfolio review if interested. Finds illustrators through magazines and word of mouth.

TIPS "We have a couple of illustrators we work with regularly, but we are open to others. Our circulation has been doubling annually, and we are distributed internationally. Read our magazine and send something we might like. No stock submissions."

BIZTIMES MILWAUKEE

BizTimes Media, 126 N. Jefferson St., Suite 403, Milwaukee WI 53202-6120. (414)277-8181. **Fax:** (414)277-8191. **E-mail:** shelly.tabor@biztimes.com. **Website:** www.biztimes.com. **Contact:** Shelly Tabor, art director. Estab. 1994. Circ. 13,500. Biweekly business news magazine covering southeastern Wisconsin.

ILLUSTRATION Approached by 80 illustrators/year. Uses 3-5 illustrations/year. Has featured illustrations by Milan Zori, Marla Campbell, Dave Crosland. Features business concepts, charts & graphs, computer, humorous illustration, information graphics and realistic illustrations. Prefers business subjects in simpler styles that reproduce well on thin, glossy paper. Assigns 75% of work to new and emerging illustrators.

FIRST CONTACT & TERMS Illustrators: Send postcard sample and follow-up postcard every year. Accepts Mac-compatible disk submissions. Send Adobe Illustrator or Photoshop (CS5 or earlier) compatible files at 300 dpi. Will contact artist for portfolio review if interested. Buys one-time rights for print and online usage. Pays illustrators $200-400 for color cover; $80-100 for inside. **Pays on acceptance.**

TIPS "Conceptual work wanted! Audience is business men and women in southeast Wisconsin. Need

ideas relative to today's business issues/concerns (insurance, law, banking, commercial real estate, health care, manufacturing, finance, education, technology, retirement). One- to two-week turnaround."

BLACK ENTERPRISE

130 Fifth Ave., 10th Floor, New York NY 10011-4399. (212)242-8000. **E-mail:** beeditors@blackenterprise.com. **Website:** www.blackenterprise.com. Estab. 1970. Circ. 450,000. Monthly 4-color consumer magazine targeting African Americans and emphasizing personal finance, careers and entrepreneurship.

ILLUSTRATION Approached by over 100 illustrators/year. Buys 10 illustrations/issue. Has featured illustrations by Ray Alma, Cecil G. Rice, Peter Fasolino. Features humorous and spot illustrations, charts & graphs, computer illustration on business subjects. Assigns 10% of illustrations to new and emerging illustrators. 50% of freelance illustration demands knowledge of Illustrator and Photoshop.

FIRST CONTACT & TERMS Illustrators: Send postcard sample. Samples are filed. After introductory mailing, send follow-up postcard every 3 months. Responds only if interested. Portfolios may be dropped off Monday-Friday and should include color finished, original art and tearsheets. Buys first rights. **Pays on acceptance;** $200-800 for color inside; $800-1,000 for 2-page spreads. Finds illustrators through agents, artist's submissions and *Directory of Illustration*.

BLOOMBERG MARKETS MAGAZINE

731 Lexington Ave., New York NY 10022-1331. (212)318-2000. **E-mail:** stjia1@bloomberg.net. **Website:** www.bloomberg.com. **Contact:** art director. Circ. 300,000. Monthly financial/business magazine.

ILLUSTRATION Has featured Doug Ross, Steven Biver and Lisa Ferlic.

FIRST CONTACT & TERMS Illustrators: Send non-returnable postcard sample. After introductory mailing, send follow-up postcard sample every 6 months. Responds only if interested. Pays illustrators $450 for color inside. Buys one-time rights. Find freelancers through artists' submissions.

BLUELINE

120 Morey Hall, Dept. of English and Communication, Postdam NY 13676. (315)267-2043. **E-mail:** blueline@potsdam.edu. **Website:** www2.potsdam.edu/blueline. **Contact:** Donald McNutt, editor; Caroline Downing, art editor. Estab. 1979. Circ. 400. "*Blueline* seeks poems, stories, and essays relating to the

Adirondacks and regions similar in geography and spirit, or focusing on the shaping influence of nature. Payment in copies. Submission period is July through November. *Blueline* welcomes electronic submissions, either in the body of an e-mail message or in Word or html formatted files. Please avoid using compression software."

○ Open to all artists. Editors are interested in art in all media suitable for 2D b&w, or color, reproduction that addresses in some way the concerns and experiences of the Adirondacks and regions of similar spirit. There is no entry fee. The editors review all submissions from July 1 through November 30. Editorial decisions are made by mid-February. Accepted work will be retained until the publication of the journal (in May/June). Work not accepted will be returned by mid-February. *Blueline* reserves one-time publishing rights. All other rights are the property of the artist. Payment in copies.

FIRST CONTACT & TERMS Do not send original art. Submission is by slides or JPEG files only. Slides must be 35mm standard mounts and of sufficient quality for reproduction. Each slide must be labeled with the name of the artist, title of the work, medium of the work, year of creation, and top of the slide.

BOYS' QUEST

P.O. Box 227, Bluffton OH 45817-0227. (419)358-4610, ext. 101. **Fax:** (419)358-8020. **Website:** funforkidz magazines.com. **Contact:** Marilyn Edwards, editor. Estab. 1995. Circ. 10,000. Bimonthly consumer magazine "geared for elementary boys." Sample copies $6 each, Canada is $8 (includes postage) other countries is $10.50 (includes 4.50 airmail); art guidelines for SASE with first-class postage. Prefers wholesome children themes. Prefers single or double panel, humorous, b&w line drawings with gagline. Approached by 100 illustrators/year. Buys 6 illustrations/issue. Has featured illustrations by Chris Sabatino, Gail Roth and Pamela Harden. "Read our magazine. Send in a few samples of work in pen and ink. Everything revolves around a theme; the theme list is available with SASE."

CARTOONS Send finished cartoons. Illustrators: Send query letter with printed samples. Samples are filed or returned by SASE. Responds in 2 months. Buys first rights. Pays on publication. Pays cartoonists $5-25 for b&w. Buys 1-3 cartoons/issue.

ILLUSTRATION Features humorous illustration; realistic and spot illustration. Assigns 40% of illustrations to new and emerging illustrators. Prefers childhood themes. Considers all media. Pays illustrators $200-250 for color cover; $25-35 for b&w inside; $50-70 for 2-page spreads; $10-25 for spots. Finds illustrators through artist's submissions.

FIRST CONTACT & TERMS To arrange portfolio review of b&w work, artist should follow up with call or letter after initial query.

TIPS "Most art will be by assignment, in support of features used. The magazine is anxious to find artists capable of illustrating stories and features and welcomes copies of sample work, which will remain on file. Our work inside is pen and ink. We pay $35 for a full page and $25 for a partial page."

BREWERS ASSOCIATION

736 Pearl St., Boulder CO 80302. (303)447-0816. **E-mail:** allison@brewersassociation.org. **Website:** www. brewersassociation.org. **Contact:** Jill Redding, editor; Kristi Switzer, publisher; Allison Seymour, art director. Estab. 1978. "Our nonprofit organization hires illustrators for two magazines, *Zymurgy* and *The New Brewer*, each published bimonthly. *Zymurgy* is the journal of the American Homebrewers Association. The goal of the AHA division is to promote public awareness and appreciation of the quality and variety of beer through education, research and the collection and dissemination of information." Circ. 25,000. "*The New Brewer* is the journal of the Brewers Association. It offers practical insights and advice for breweries that range in size from less than 500 barrels per year to more than 800,000. Features articles on brewing technology and problem solving, pub and restaurant management, and packaged beer sales and distribution, as well as important industry news and industry sales and market share performance." Circ. 10,000.

ILLUSTRATION Approached by 50 illustrators/year. Buys 3-6 illustrations/year. Prefers beer and homebrewing themes. Considers all media.

DESIGN Prefers local design freelancers with experience in Photoshop, QuarkXPress, Illustrator.

FIRST CONTACT & TERMS Illustrators: Send postcard sample or query letter with printed samples, photocopies, tearsheets; follow-up sample every 3 months. Accepts disk submissions with EPS, TIFF or JPEG files. "We prefer samples we can keep." No originals accepted; samples are filed. Responds only

if interested. Art director will contact artist for portfolio review if interested. Buys one-time rights. Pays 60 days net on acceptance. Pays illustrators $700-800 for color cover; $200-300 for b&w inside; $200-400 for color inside. Pays $150-300 for spots. Finds artists through agents, sourcebooks and magazines (Society of Illustrators, *Graphis*, *PRINT*, *Colorado Creative*), word of mouth, submissions. Designers: Send query letter with printed samples, photocopies, tearsheets.
TIPS "Keep sending promotional material for our files. Anything beer-related for subject matter is a plus. We look at all styles."

BRIDE'S MAGAZINE
Condé Nast, 4 Times Square, New York NY 10036. **Website:** www.brides.com. Estab. 1934. Circ. 336,598. Bimonthly 4-color; "classic, clean, sophisticated design style." Original artwork is returned after publication.
ILLUSTRATION Buys illustrations mainly for spots and feature spreads. Buys 5-10 illustrations/issue. Works on assignment only. Considers pen & ink, airbrush, mixed media, colored pencil, watercolor, acrylic, collage and calligraphy. Needs editorial illustrations.
FIRST CONTACT & TERMS Illustrators: Send postcard sample. In samples or portfolio, looks for "graphic quality, conceptual skill, good 'people' style; lively, young but sophisticated work." Samples are filed. Will contact for portfolio review if interested. Portfolios may be dropped off every Monday-Thursday and should include color and b&w final art, tearsheets, photographs and transparencies. Buys one-time rights or negotiates rights purchased. Pays on publication; $250-350 for b&w or color inside; $250 minimum for spots. Finds artists through word of mouth, magazines, submissions/self-promotions, sourcebooks, artists' agents and reps, attending art exhibitions.

BUGLE
5705 Grant Creek, Missoula MT 59808. (800)Call Elk (225-5355). **E-mail:** pallen.org. **Website:** www.rmef. org. **Contact:** PJ DelHomme, hunting and human interest editor. Estab. 1984. Circ. 150,000. Bimonthly 4-color outdoor conservation and hunting magazine for a nonprofit organization.
ILLUSTRATION Approached by 10-15 illustrators/year. Buys 3-4 illustrations/issue. Has featured illustrations by Pat Daugherty, Cynthia Fisher, Joanna

Yardley and Bill Gamradt. Features natural history illustration, humorous illustration, realistic illustrations and maps. Preferred subjects wildlife and nature. "Open to all styles." Assigns 60% of illustrations to well-known or "name" illustrators; 20% to experienced but not well-known illustrators; 20% to new and emerging illustrators.
FIRST CONTACT & TERMS Illustrators: E-mail with query letter and PDF of samples or link to portfolio. Will contact artist for portfolio review if interested. **Pays on acceptance**. Finds illustrators through existing contacts and magazines.
TIPS "We are looking for elk, other wildlife and habitat. Attention to accuracy and realism."

BUILDINGS
P.O. Box 1888, Cedar Rapids IA 52406-1888. (319)364-6167. **E-mail:** jennie.morton@buildings.com, janelle. penny@buildings.com. **Website:** www.buildings.com. **Contact:** Jennie Morton or Janelle Penny, associate editors. Estab. 1906. Circ. 72,000. Monthly trade magazine featuring "information related to current approaches, technologies and products involved in large commercial facilities." Original artwork returned at job's completion.
ILLUSTRATION *Works on assignment only.* Considers all media, themes and styles.
FIRST CONTACT & TERMS Illustrators: Send postcard sample. Designers: Send query letter with brochure, photocopies and tearsheets. Accepts submissions on Mac-compatible disk. Will contact for portfolio review if interested. Portfolio should include thumbnails, b&w/color tearsheets. Rights purchased vary. **Pays on acceptance.** Pays illustrators $250-500 for b&w, $500-1,500 for color cover; $50-200 for b&w inside; $100-350 for color inside; $30-100 for spots. Pays designers by the project. Finds artists through recommendations and submissions.
TIPS "Send postcards with samples of your work printed on them. Show us a variety of work (styles), if available. Send only artwork that follows our subject matter commercial buildings, products and processes, and facility management."

BUSINESS & COMMERCIAL AVIATION
The McGraw Hill Companies, PMB 327, 54 Danbury Rd., Ridgefield CT 06877-4019. (800)525-5003. **Fax:** (888)385-1428. **E-mail:** MHIM@mcgraw-hill.com; buccustserv@cdsfulfillment.com. **Website:** www. aviationweek.com. **Contact:** William Garvey, depu-

ty managing editor. Circ. 55,000. Monthly technical publication for corporate pilots and owners of business aircraft. 4-color; "contemporary design."

ILLUSTRATION Works with 12 illustrators/year. Buys 12 editorial and technical illustrations/year. Uses artists mainly for editorials and some covers. Especially needs full-page and spot art of a business-aviation nature. "We generally only use artists with a fairly realistic style. This is a serious business publication and graphically conservative. Need artists who can work on short deadline time." 70% of freelance work demands knowledge of Photoshop, Illustrator, QuarkXPress and FreeHand.

FIRST CONTACT & TERMS Illustrators: Query with samples and SASE. Responds in 1 month. Photocopies OK. Buys all rights, but may reassign rights to artist after publication. Negotiates payment. **Pays on acceptance.**

BUSINESS LONDON

P.O. Box 7400, London ON N5Y 4X3, Canada. (519)471-2907. **Fax:** (519)473-7859. **E-mail:** editorial@businesslondon.ca. **Website:** www.businesslondon.ca. **Contact:** Gord Delamont, publisher/editor. Circ. 14,000. Monthly magazine "covering London and area businesses, entrepreneurs, building better businesses." Sample copies not available; art guidelines not available.

CARTOONS Approached by 2 cartoonists/year. Buys 1 cartoon/issue. Prefers business-related line art. Prefers single panel, humorous b&w washes and line drawings without gagline.

ILLUSTRATION Approached by 5 illustrators/year. Buys 2 illustrations/issue. Has featured illustrations by Nigel Lewis and Scott Finch. Features humorous and realistic illustration; informational graphics and spot illustration. Assigns 50% of illustrations to experienced but not well-known illustrators; 50% to new and emerging illustrators. Prefers business issues. Considers all media. 10% of freelance illustration demands knowledge of Photoshop 3, Illustrator 5.5, QuarkXPress 3.2.

FIRST CONTACT & TERMS Send query letter with roughs and printed samples. Accepts disk submissions compatible with QuarkXPress 7/version 3.3, Illustrator 5.5, Photoshop 3, TIFFs or EPS files. Samples are filed and are not returned. Responds only if interested. Art director will contact artist for portfolio review of b&w, color, final art, photographs, slides and thumbnails if interested. Pays on publication. Buys first rights. Finds illustrators through artist's submissions.

TIPS "Arrange personal meetings, provide vibrant, interesting samples, start out cheap! Quick turnaround is a must."

BUSINESS TRAVEL NEWS

116 W. 32nd St., 14th Floor, New York NY 10001. (646)380-6248. **E-mail:** jchan@thebtngroup.com. **Website:** www.businesstravelnews.com. **Contact:** Jonathan Chan, art director. Estab. 1984. Circ. 50,000. Monthly 4-color trade publication focusing on business and corporate travel news/management.

ILLUSTRATION Approached by 300 illustrators/year. Buys 4-8 illustrations/month. Features charts & graphs, computer illustration, conceptual art, informational graphics and spot illustrations. Preferred subjects: business concepts, electronic business and travel. Assigns 30% of illustrations to well-known, experienced and emerging illustrators.

FIRST CONTACT & TERMS Illustrators: Send postcard or other nonreturnable samples. Samples are filed. Buys first rights. **Pays on acceptance.** Finds illustrators through artists' promotional material and sourcebooks.

TIPS "Send your best samples. We look for interesting concepts and print a variety of styles. Please note we serve a business market."

CALIFORNIA HOME & DESIGN

680 2nd St., San Francisco CA 94107. (415)362-7797. **Fax:** (415)362-9797. **Website:** www.californiahomedesign.com/resources. **Contact:** Lisa Haines, associate publisher. Estab. 1994. Circ. 52,500. Bimonthly magazine of Northern California lifestyle. Sample copy free with 9×10 SASE and first-class postage.

ILLUSTRATION Approached by 100 illustrators/year. Buys 6 illustrations/year. Prefers financial, fashion. Considers all media. 50% of freelance illustration demands knowledge of Photoshop, Illustrator, QuarkXPress.

DESIGN Needs freelancers for design and production. Prefers local design freelancers. 100% of freelance work demands knowledge of Photoshop, Illustrator, QuarkXPress.

FIRST CONTACT & TERMS Illustrators: Send postcard sample or query letter with printed samples. Accepts disk submissions compatible with QuarkXPress (EPS files). Designers: Send printed samples. Samples

are filed. Responds only if interested. Buys one-time rights. Pays on publication. Pays illustrators $100-250 for spots. Finds illustrators through submissions.
TIPS "Read our magazine."

CALIFORNIA LAWYER

44 Montgomery St., Suite 250, San Francisco CA 94104. (415)296-2400. **Fax:** (415)296-2440. **E-mail:** jake_flaherty@dailyjournal.com. **Contact:** Jake Flaherty, design director. "Monthly magazine about groundbreaking cases, compelling controversies, and fascinating personalities. Our publication seeks to go beyond the headlines of the day with both lively writing and in-depth reporting."
ILLUSTRATION Approached by 100 illustrators/year. Buys 24-30 illustrations/year. Has featured illustrations by Dav Bordeleau, Grady McFerrin, Doug Fraser, Red Nose Studio, Richard Borge, Jack Black, Jonathan Carlson, Dan Page, Asaf Hanuka. Features caricatures of celebrities/politicians, realistic illustration, charts & graphs, humorous illustration, computer illustration, informational graphics, spot illustrations. Preferred subjects: business, politics, law.
FIRST CONTACT & TERMS Send postcard sample, URL. After introductory mailing, send follow-up postcard every 2 or 3 months.

CALYX

Calyx, Inc., P.O. Box B, Corvallis OR 97339. (541)753-9384. **Fax:** (541)753-0515. **E-mail:** editor@calyxpress.org. **Website:** www.calyxpress.org. **Contact:** Editor. Estab. 1976. Circ. 6,000. "*Calyx* exists to publish fine literature and art by women and is committed to publishing the work of all women, including women of color, older women, working class women and other voices that need to be heard. We are committed to discovering and nurturing developing writers."
○ "We publish color art inside *Calyx* now. Separate guidelines for electronic art are available."
FIRST CONTACT & TERMS Visual art should be submitted (1) electronically via CD or e-mail; or (2) 5×7 or 8×10 glossy photographs; or (3) 35mm slides. Limit of 6 images/photos/slides. All art media are considered. Please include list of all images/photos/slides with your name, titles, media, dimensions. Also mark the top of the work. Make sure all the proper information is included when sending art electronically. Include a 50-word biographical statement and a separate 50-word statement about your artwork. Submit art separately from prose and poetry.

○ CANADIAN BUSINESS

Rogers Media, One Mount Pleasant Rd., 11th Floor, Toronto ON M4Y 2Y5, Canada. (416)764-1200. **Fax:** (416)764-1255. **E-mail:** letters@canadianbusiness.com. **Website:** www.canadianbusiness.com. Circ. 85,000. Biweekly 4-color business magazine focusing on Canadian management and entrepreneurs.
ILLUSTRATION Approached by 200 illustrators/year. Buys 5-10 illustrations/issue. Has featured illustrations by Gerard Dubois, Joe Morse, Seth, Gary Taxali, Dan Page. Features conceptual illustrations, portraits, caricatures and infographics of business subjects. Assigns 70% of illustrations to well-known or "name" illustrators; 30% to new and emerging illustrators. 50% of freelance illustration demands knowledge of Illustrator and Photoshop.
FIRST CONTACT & TERMS Illustrators: Send postcard sample, printed samples and photocopies. Accepts Mac-compatible disk submissions. Responds only if interested. Will contact artist for portfolio review if interested. **Pays on acceptance**; $1,000-2,000 for color cover; $300-1,500 for color inside; $300 for spots. Finds illustrators through magazines, word of mouth and samples.

○ CANADIAN HOME WORKSHOP

Quarto Communications, 54 St. Patrick St., Toronto ON M5T 1V1, Canada. (416)599-2000. **Website:** www.canadianhomeworkshop.com. **Contact:** art director. Estab. 1977. Circ. 120,000. "The Do-it-Yourself" magazine published 10 times/year. Includes instructions and plans for woodworking projects and step-by-step home improvement articles along with tips from the pros. Sample copies available on request. Art guidelines available.
ILLUSTRATION Approached by several freelancers/year. Buys 20 illustrations/year. Has featured illustrations by Jason Schneider, Paul Perreault and Len Churchill. Features computer, humorous, realistic and spot illustration. Assigns 10% of illustrations to new and emerging illustrators. 90% of freelance illustration demands knowledge of Illustrator, Photoshop and QuarkXPress.
FIRST CONTACT & TERMS Send postcard sample or query letter with brochure, photocopies, photographs, samples and tearsheets. Send follow-up postcard every 6 months. Accepts e-mail submissions with link to website or image file. Prefers Mac-compatible TIFF, JPEG, GIF or EPS files. Samples are filed and

not returned. Responds only if interested. Will contact artist for portfolio review if interested. Portfolio should include color finished art, photographs and tearsheets. **Pays on acceptance.** Buys first rights, electronic rights. Finds freelancers through agents, submissions and word of mouth.

CATALINA

Rockefeller Center, 1230 Ave. of the Americas, 7th Floor, New York NY 10020. (212)851-3427. **Fax:** (212)202-7608. **E-mail:** cathy@catalinamagazine.com. **Website:** www.catalinamagazine.com. Estab. 2001. Bimonthly consumer magazine for Hispanic women between 24 and 54 focusing on careers, beauty, food, parenting, relationships, health and travel.

ILLUSTRATION Approached by 100 illustrators/year. Buys 10 illustrations/year. Preferred subjects: families, Hispanic women, fashion, health, career.

FIRST CONTACT & TERMS Illustrators: Send postcard sample. After introductory mailing, send follow-up postcard sample every 6 months. Responds only if interested. Buys one-time rights.

CAT FANCY

Fancy Publications, BowTie, Inc., P.O. Box 6050, Mission Viejo CA 92690. (949)855-8822. **Fax:** (949)855-3045. **E-mail:** query@catfancy.com; catsupport@catchannel.com; slogan@bowtieinc.com. **Website:** www.catfancy.com; www.catchannel.com. **Contact:** Susan Logan, editor. Estab. 1965. Circ. 290,000. Monthly 4-color consumer magazine dedicated to the love of cats. "Cat Fancy is the undisputed premier feline magazine that is dedicated to better lives for pet cats. Always a presence within the cat world, Cat Fancy and its sister website, CatChannel.com are where cat owners, lovers and rescue organizations go for education and entertainment." Sample copy available for $5.50. Needs editorial, medical and technical illustration and images of cats. Works on assignment only.

"Cat Fancy does not accept unsolicited mss and only accepts queries from January-May. Queries sent after May will be returned or discarded. Show us how you can contribute something new and unique. No phone queries."

CARTOONS Occasionally uses single-panel cartoons as filler. Cartoons must feature a cat or cats and should fit single-column width (2¼) or double-column width (4½).

FIRST CONTACT & TERMS Art guidelines available with SASE or on website. Samples will not be re-turned without a SASE. Send query letter with brochure, high-quality photocopies (preferably color), tearsheets and SASE. Responds in 6-8 weeks. Buys one-time rights. Pays on publication. Pays cartoonists $35 for b&w line drawings. Pays illustrators $35-75 for spots; $75-150 for color inside; more for packages of multiple illustrations.

CATHOLIC DIGEST

P.O. Box 6015, New London CT 06320. (800)321-0411. **Fax:** (860)457-3013. **E-mail:** queries@catholicdigest.com; cartoons@catholicdigest.com. **Website:** www.catholicdigest.com. Estab. 1936. Circ. 275,000. Publishes features and advice on topics ranging from health, psychology, humor, adventure, and family, to ethics, spirituality, and Catholics, from modern-day heroes to saints through the ages. Helpful and relevant reading culled from secular and religious periodicals.

CARTOONS Professional cartoonists may submit cartoons by e-mail or post mail. Most often uses single panel cartoons, though multi-panel cartoons occasionally are accepted. Cartoons must be family-friendly, but do not need to be religious or spiritual in nature. On average, uses 3 cartoons per issue. Pays $100, upon publication, for each cartoon (color or b&w; single or multi- panel) published in the magazine. "We do not accept political cartoons."

CATHOLIC FORESTER

Catholic Order of Foresters, 355 Shuman Blvd., P.O. Box 3012, Naperville IL 60566-7012. **Fax:** (630)983-3384. **E-mail:** magazine@catholicforester.org. **Website:** www.catholicforester.org. **Contact:** Patricia Baron, associate editor; Danielle Marsh, art director. Estab. 1883. Circ. 137,000. "Catholic Forester is the national member magazine for Catholic Order of Foresters, a not-for-profit fraternal insurance organization. We use general-interest articles, art and photos. Audience is small town and urban middle-class, patriotic, Roman Catholic and traditionally conservative." National quarterly 4-color magazine. Accepts previously published material. Sample copy free for 9½×11 SASE with 3 first-class stamps. Buys one-time rights, North American serial rights or reprint rights.

ILLUSTRATION Buys and commissions editorial illustration. No gag or panel cartoons. Will contact for portfolio review if interested. Requests work on spec before assigning job.

FIRST CONTACT & TERMS Pays on publication. Pays $30 for b&w, $75-300 for color. Turn-around time for completed artwork usually 2 weeks.

TIPS "Know the audience; always read the article and ask art director questions. Be timely."

CAVE WALL

P.O. Box 29546, Greensboro NC 27429-9546. **E-mail:** editor@cavewallpress.com. **Website:** www.cavewall press.com. Biannual magazine dedicated to publishing the best in contemporary poetry. "Visit our website to see a few images of work we have published or purchase a sample copy. We are looking for fine art in b&w. Follow the submission guidelines on our website." Sample copy $5.

O "At the moment we are accepting art submissions year-round. This issue is subject to change. Refer to our website for updates. We publish graphic works and drawings in b&w with no gray values. We do not publish photography or other work with gray tones. Response time can take up to four months. Cave Wall acquires one-time publication rights for artwork."

ILLUSTRATION Illustrators paid $3,000-$4,500. 12-15 freelance illustrators/year.

FIRST CONTACT & TERMS Send postcard sample or email with URL and samples. Send 5-10 8½"×11" reproductions (photocopies accepted) to the address above. Include artist, title of work, medium, and date on the back of each print. If the work has been published before, please let us know where. Include SASE for response. Please do not send originals or other materials that need to be returned. If your work is accepted for publication, we will send you the specifications for submitting each piece as a digital file. Follow up every 6-12 months. Samples kept on file for possible future assignments. Samples are not returned. Buys all rights. Send query letter with b&w photocopies. Samples not kept on file, returned only by SASE. Responds in 1-3 months. Guidelines free with SASE, available on website or via e-mail request.

CED (COMMUNICATIONS, ENGINEERING & DESIGN)

E-mail: traci.patterson@advantagemedia.com; brian.santo@advantagemedia.com. **Website:** www.ced magazine.com. **Contact:** Brian Santo, editor; Traci Patterson, managing editor; Don Ruth, art director. Estab. 1978. Circ. 25,000. Monthly trade journal; "the premier magazine of broadband technology." Sample copies and art guidelines available.

ILLUSTRATION Works on assignment only. Features caricatures of celebrities, realistic illustration, charts and graphs, informational graphics and computer illustrations. Prefers cable TV industry themes. Considers watercolor, airbrush, acrylic, colored pencil, oil, charcoal, mixed media, pastel, computer disk formatted in Photoshop, Illustrator or FreeHand.

FIRST CONTACT & TERMS Contact only through artist rep. Samples are filed. Portfolio should include final art, b&w/color tearsheets, photostats, photographs and slides. Rights purchased vary according to project. **Pays on acceptance.** Most illustration done in-house. Pays illustrators $400-800 for color cover; $125-400 for b&w and color inside; $250-500 for 2-page spreads; $75-175 for spots. Accepts previously published work. Original artwork not returned at job's completion.

TIPS "Be willing to change in mid course; be willing to have finished work rejected. Make sure you can draw and work fast."

CHARISMA

600 Rinehart Rd., Lake Mary FL 32746. (407)333-0600. **E-mail:** joe.deleon@strang.com. **Website:** www. charismamedia.com. **Contact:** Joe Deleon, magazine design director. Circ. 200,000. Publishes religious magazines and books for general readership. Illustrations used for text illustrations, promotional materials, book covers, children and gift books, dust jackets. Illustration guidelines free with SASE.

FIRST CONTACT & TERMS Illustrators: Send non-returnable promotional postcard, tearsheets, color copies or other appropriate promotional material. Accepts digital submissions. Send query letter with samples. Provide résumé, business card, brochure, flyer or tearsheets to be kept on file for possible future assignments. Works with freelancers on assignment only. Keeps samples on file. Simultaneous submissions and previously published work OK. Pays $5-75 for b&w; $50-550 for color spots; $100-550 for color covers. Payment negotiable. Pays on publication. Credit line given. Buys one-time, first-time, book, electronic and all rights; negotiable.

CHARLESTON MAGAZINE/CHARLESTON HOME/CHARLESTON WEDDINGS

P.O. Box 1794, Mt. Pleasant SC 29465-1794. (843)971-9811 or (888)242-7624. **E-mail:** mmonk@charleston

mag.com. **Website:** www.charlestonmag.com. **Contact:** Melinda Smith-Monk, art director. Estab. 1974. Circ. 20,000. Monthly 4-color consumer magazine. *Charleston Home* is quarterly, *Charleston Weddings* is 2 times/year with a more regional and national distribution. "Indispensable resource for information about modern-day Charleston SC, addresses issues of relevance and appeals to both visitors and residents." Art guidelines are free with #10 SASE and first-class postage.

ILLUSTRATION Approached by 35 illustrators/year. Buys 1 illustration/issue. Features realistic illustrations, informational graphics, spot illustrations, computer illustration. Prefers business subjects, children, families, men, pets, women and teens. 35% of freelance illustration demands knowledge of Illustrator, Photoshop, FreeHand, PageMaker, QuarkXPress.

FIRST CONTACT & TERMS Illustrators: Send postcard sample and follow-up postcard every month or send query letter with printed samples. Accepts Mac-compatible disk submissions. Samples are filed or returned by SASE. Responds only if interested. Rights purchased vary according to project. Finds illustrators through sourcebooks, artists' promo samples, word of mouth.

TIPS "Our magazine has won several design awards and is a good place for artists to showcase their talent in print. We welcome letters of interest from artists interested in semester-long, unpaid internships-at-large. If selected, artists would provide 4-5 illustrations for publication in return for masthead recognition and sample tearsheets. Staff internships (unpaid) also available on-site in Charleston, SC. Send letter of interest and samples of work to art director."

CHARLOTTE MAGAZINE

Morris Visitor Publications, 309 E. Morehead St., Suite 50, Charlotte NC 28202. (704)335-7181. **Fax:** (704)335-3757. **E-mail:** richard.thurmond@charlotte magazine.com. **Website:** www.charlottemagazine. com. Carrie Campbell, art director (carrie.campbell@ charlottemagazine.com). Circ. 40,000. Monthly 4-color city-based consumer magazine for Charlotte and surrounding areas. Sample copy free with #10 SASE and first-class postage.

ILLUSTRATION Approached by many illustrators/year. Buys 1-5 illustrations/issue. Features caricatures of celebrities and politicians; computer illustration; humorous illustration; natural history, realistic and spot illustration. Prefers wide range of media/conceptual styles. Assigns 20% of illustrations to new and emerging illustrators.

FIRST CONTACT & TERMS Illustrators: Send postcard sample and follow-up postcard every 6 months. Send non-returnable samples. Accepts e-mail submissions. Send EPS or TIFF files. Samples are filed. Responds only if interested. Portfolio review not required. Finds illustrators through promotional samples and sourcebooks.

TIPS "We are looking for diverse and unique approaches to illustration. Highly creative and conceptual styles are greatly needed. If you are trying to get your name out there, we are a great avenue for you."

CHATELAINE

Rogers Publishing, One Mount Pleasant Rd., Toronto ON M4Y 2Y5, Canada. (800)268-9119. **Website:** www. chatelaine.com. **Contact:** Deputy art director. Circ. 675,016. Monthly consumer magazine for contemporary Canadian woman, focusing on health, fashion, beauty, home decorating and trend.

Also publishes French edition. Address: 1200 Ave. McGill College, Bureau 800, Montreal PQ H3B 4G7 Canada. Ilana Shamir, art director. Circ: 200,000.

ILLUSTRATION Features caricatures of celebrities/politicians, fashion, humorous and spot illustrations of business, children, families and women.

FIRST CONTACT & TERMS Illustrators: Send postcard sample with link to website. After introductory mailing, send follow-up postcard sample every 6 months. Responds only if interested. Buys one-time rights.

CHEF

233 N. Michigan Ave., Suite 1780, Chicago IL 60612. (312)849-2220. **Fax:** (312)849-2174. **E-mail:** bsmith@ talcott.com. **Website:** www.chefmagazine.com. **Contact:** Brooke Smith, managing editor. Circ. 42,000. Trade publication for chefs who manage commercial and non-commercial kitchens, catering firms, restaurants, hotels/resorts/casinos, culinary schools, country clubs, universities, health care facilities. Reports on latest food service tools, food safety issues, and profiles on chefs.

CARTOONS Approached by 50 cartoonists/year. Buys 2 cartoons/year. Prefers cooking/chef related themes. Prefers single panel and humorous.

ILLUSTRATION Approached by 100 illustrators/year. Buys 5 illustrations/year. Features cooking, catering and cafeterias. Assigns 50% to new and emerging illustrators.

FIRST CONTACT & TERMS Cartoonists: Send 2-3 photocopies with link to website. Illustrators: Send postcard sample. After introductory mailing, send follow-up postcard every 6 months. Responds only if interested. At this time, no payment offered for cartoons or illustrations. Finds freelancers through artists' submissions.

TIPS "Only interested in work related to cooking, kitchens, chefs and catering."

CHEMICAL WEEK

IHS, 2 Grand Central Tower, 140 E. 45th St., 40th Floor, New York NY 10017. (212)884-9528. **Fax:** (212)884-9514. **Website:** www.chemweek.com. **Contact:** Robert Westervelt, editor-in-chief. Estab. 1908. Circ. 23,000. Bimonthly, 4-color trade publication emphasizing commercial developments in specialty chemical markets.

ILLUSTRATION Features charts and graphs, computer illustration, informational graphics, natural history illustration, realistic illustrations, medical illustration of business subjects. Prefers bright colors and clean look. Assigns 100% of illustrations to experienced but not well-known illustrators. 100% of freelance illustration demands knowledge of Illustrator, Photoshop, QuarkXPress.

FIRST CONTACT & TERMS Illustrators: Send nonreturnable postcard sample and follow-up postcard every 6 months. Accepts Mac-compatible disk submissions. Send EPS or TIFF files. Samples are filed and are not returned. Responds only if interested. Portfolio review not required. Rights purchased vary according to project. Pays on publication; $500-800 for color.

TIPS "Freelancers should be reliable and produce quality work. Promptness and the ability to meet deadlines are most important."

CHESAPEAKE BAY MAGAZINE

1819 Bay Ridge Ave., Annapolis MD 21403. (410)263-2662, ext. 32. **Fax:** (410)267-6924. **E-mail:** chesapeakeboating@gmail.com. **Website:** www.chesapeakeboating.net. **Contact:** Ann Levelle, managing editor; Karen Ashley, art director; T.F. Sayles, editor. Estab. 1972. Circ. 46,000. Monthly 4-color magazine focusing on the boating environment of the Chesa-

peake Bay, including its history, people, places, events, environmental issues and ecology. Original artwork returned after publication upon request. Sample copies free for SASE with first-class postage. Art guidelines available.

ILLUSTRATION Pays illustrators $75-200 for quarter-page or spot illustrations; up to $500-800 for spreads—four-color inside. Approached by 12 illustrators/year. Buys 2-3 technical and editorial illustrations/issue. Has featured illustrations by Jim Paterson, Kim Harroll, Jan Adkins, Tamzin B. Smith, Marcy Ramsey, Peter Bono, Stephanie Carter and James Yang. Assigns 50% of illustrations to new and emerging illustrators. Considers pen & ink, watercolor, collage, acrylic, marker, colored pencil, oil, charcoal, mixed media and pastel. Also digital. Usually prefers watercolor or acrylic for 4-color editorial illustration. "Style and tone are determined by the artist after he/she reads the story."

DESIGN "Our magazine design is relaxed, fun, oriented toward people who enjoy recreation on the water. Boating interests remain the same. But for the Chesapeake Bay boater, water quality and the environment are more important now than in the past. Colors brighter. We like to see samples that show the artist can draw boats and understands our market environment. Send tearsheets or send website information. We're always looking. Artist should have some familiarity with the appearance of different types of boats, boating gear and equipment."

FIRST CONTACT & TERMS Illustrators: Send query letter with résumé, tearsheets and photographs. Samples are filed. Make sure to include contact information on each sample. Responds only if interested. Publication will contact artist for portfolio review if interested. Portfolio should include "anything you've got." No b&w photocopies. Buys one-time rights.

TIPS "Price decided when contracted."

CHESS LIFE

P.O. Box 3967, Crossville TN 38557-3967. (931)787-1234. **Fax:** (931)787-1200. **E-mail:** dlucas@uschess.org; fbutler@uschess.org. **Website:** www.uschess.org. **Contact:** Daniel Lucas, editor; Francesca "Frankie" Butler, art director. Estab. 1939. Circ. 85,000. Official publication of the United States Chess Federation. Contains news of major chess events with special emphasis on American players, plus columns of instruction, general features, historical articles, personality

profiles, tournament reports, cartoons, quizzes, humor and short stories. Monthly b&w with 4-color cover. Design is "heavy with chess games." Accepts previously published material and simultaneous submissions. Sample copy for SASE with 6 first-class stamps; art guidelines for SASE with first-class postage. *Chess Life* commissioned cover rate $400; inside full page $100; half page $50; quarter page $25. Works on assignment, but will also consider unsolicited work.

○ Also publishes children's magazine, *Chess Life For Kids* every other month. Same submission guidelines apply.

CARTOONS Approached by 5-10 cartoonists/year. Buys 0-12 cartoons/year. All cartoons must be chess related. Prefers single panel with gagline; b&w line drawings.

ILLUSTRATION Approached by 30-50 illustrators/year. Works with 4-5 illustrators/year from freelancers. Buys 4-5 illustrations/year. Uses artists mainly for cartoons and covers.

FIRST CONTACT & TERMS Send query letter with samples or e-mail Frankie Butler at fbutler@uschess.org. Responds in 2 months. Negotiates rights purchased. Pays on publication.

CICADA®

Carus Publishing, 70 E. Lake St., Suite 300, Chicago IL 60601. **Website:** www.cicadamag.com. **Contact:** Marianne Carus, editor-in-chief; Deborah Vetter, executive editor; John Sandford, art director. Estab. 1998. Circ. 10,000. Bimonthly literary magazine for teenagers.

○ See also listings in this section for other magazines published by the Cricket Magazine Group: *Babybug, Ladybug, Spider* and *Cricket*.

FIRST CONTACT & TERMS Illustration/photography: Send 3 samples, via Cicada's website, with your information and weblink. Do *not* send printed or original art—we take *no* responsibility for their return. If you are 19 or under, label your submission "Teen Submission." We have a theme challenge every issue called Creative Endeavors: send us a piece of art, photography, story or poem on the current topic. Submit pieces to "Arbiter of Creative Endeavors," per specifications online or in the magazine.

CINCINNATI CITYBEAT

811 Race St., 5th Floor, Cincinnati OH 45202. (513)665-4700. **Fax:** (513)665-4369. **E-mail:** letters@citybeat.com. **Website:** www.citybeat.com. Estab.

1994. Circ. 50,000. Weekly alternative newspaper emphasizing Cincinnati issues, arts and events.

○ Please research alternative weeklies before contacting the art director. He reports receiving far too many inappropriate submissions.

CARTOONS Approached by 30 cartoonists/year. Buys 1 cartoon/year.

ILLUSTRATION Buys 1-3 illustrations/issue. Features caricatures of celebrities and politicians, computer and humorous illustration. Prefers work with a lot of contrast. Assigns 40% of illustrations to new and emerging illustrators. 10% of freelance illustration demands knowledge of Illustrator, Photoshop, FreeHand, QuarkXPress.

FIRST CONTACT & TERMS Cartoonists: Send query letter with samples. Illustrators: Send postcard sample or query letter with printed samples and follow-up postcard every 4 months. Accepts Mac-compatible disk submissions. Send EPS, TIFF or PDF files. Samples are filed. Responds in 2 weeks, only if interested. Buys one-time rights. Pays on publication. Finds illustrators through word of mouth and artists' samples.

CITY LIMITS

Community Service Society of New York, 105 E. 22nd St., Suite 901, New York NY 10010. (212)614-5397. **E-mail:** citylimits@citylimits.org; magazine@citylimits.org; editor@citylimits.org. **Website:** www.citylimits.org. **Contact:** Mark Anthony Thomas, director; Jarrett Murphy, editor-in-chief. Estab. 1976. Circ. 5,000. Monthly urban affairs magazine covering issues important to New York City's low- and moderate-income neighborhoods, including housing, community development, the urban environment, crime, public health and labor. Originals returned at job's completion. Sample copies for 9×12 SAE and 4 first-class stamps. "Our production schedule is tight, so publication is generally within 2 weeks of acceptance, as is payment."

CARTOONS Send query letter with finished cartoons and tearsheets. Buys 5 cartoons/year. Prefers N.Y.C. urban affairs—social policy, health care, environment and economic development. Prefers political cartoons; single, double or multiple panel b&w washes and line drawings without gaglines. Buys first rights and reprint rights. Pays cartoonists $50 for b&w.

ILLUSTRATION Send postcard sample or query letter with tearsheets, photocopies, photographs and SASE.

Buys 2-3 illustrations/issue. Has featured illustrations by Noah Scalin. Must address urban affairs and social policy issues, affecting low- and moderate-income neighborhoods, primarily in New York City. Considers pen & ink, watercolor, collage, airbrush, mixed media and anything that works in b&w. Samples are filed. Responds in 1 month. Request portfolio review in original query. Buys first rights. Pays $50-100 for b&w cover; $50 for b&w inside; $25-50 for spots. Pays on publication.

TIPS Finds artists through other publications, word of mouth and submissions. "Our niche is fairly specific. Freelancers are welcome to call and talk."

CITY SHORE MAGAZINE

200 E. Las Olas Blvd., Ft. Lauderdale FL 33301. (954)356-4685. **E-mail:** mgauert@sun-sentinel.com. **Website:** www.cityandshore.com. **Contact:** Mark Gauert, editor. Estab. 2000. Circ. 42,000. Bimonthly "luxury lifestyle magazine published for readers in South Florida." Sample copies available for $4.95.

ILLUSTRATION "We rarely use illustrations, but when we do, we prefer sophisticated, colorful styles, with lifestyle-oriented subject matter. We don't use illustration whose style is dark or very edgy."

FIRST CONTACT & TERMS Accepts e-mail submissions with image file.

CKI MAGAZINE

Circle K International, 3636 Woodview Trace, Indianapolis IN 46268. (317)217-6174. **Fax:** (317)879-0204. **E-mail:** ckimagazine@kiwanis.org. **Website:** www. circlek.org. Estab. 1968. Circ. 12,000. Digital magazine published 1-4 times/year for college-age students, emphasizing service, leadership, etc. Free sample copy with SASE and 3 first-class postage stamps.

○ Kiwanis International also publishes *Kiwanis* and *Key Club* magazines.

ILLUSTRATION Approached by more than 30 illustrators/year. Buys 1-2 illustrations/issue. Works on assignment only. Needs editorial illustration. "We look for variety."

FIRST CONTACT & TERMS Send query letter with photocopies, photographs, tearsheets and SASE. Samples are filed. Will contact for portfolio review if interested. Portfolio should include tearsheets and slides. Originals and sample copies returned to artist at job's completion. **Pays on acceptance:** $100 for b&w cover; $250 for color cover; $50 for b&w inside; $150 for color inside.

CLARETIAN PUBLICATIONS

205 W. Monroe, Chicago IL 60606. (312)236-7782. **Fax:** (312)236-8207. **E-mail:** wrightt@claretians.org. **Contact:** Tom Wright, art director. Estab. 1960. Circ. 40,000. Monthly magazine "covering the Catholic family experience and social justice." Sample copies and art guidelines available.

ILLUSTRATION Approached by 20 illustrators/year. Buys 4 illustrations/issue. Considers all media.

FIRST CONTACT & TERMS Illustrators: Send postcard sample and query letter with printed samples and photocopies or e-mail with an attached website to visit. Accepts disk submissions compatible with EPS or TIFF. Samples are filed. Responds only if interested. Art director will contact artist for portfolio review if interested. Negotiates rights purchased. **Pays on acceptance.** $100-400 for color inside.

TIPS "We like to employ humor in our illustrations and often use clichés with a twist and appreciate getting art in digital form."

CLEVELAND MAGAZINE

City Magazines, Inc., 1422 Euclid Ave., Suite 730, Cleveland OH 44115. (216)771-2833. **Fax:** (216)781-6318. **E-mail:** gleydura@clevelandmagazine.com; miller@clevelandmagazine.com; kessen@cleveland magazine.com. **Website:** www.clevelandmagazine. com. **Contact:** Kristen Miller, art director; Steve Gleydura, editor. Estab. 1972. Circ. 50,000. Monthly city magazine, with 4-color cover, emphasizing local news and information.

CARTOONS We do not publish gag cartoons, but do print editorial illustrations with a humorous twist.

ILLUSTRATION Approached by 100 illustrators/ year. Buys 3-4 editorial illustrations/issue on assigned themes. Sometimes uses humorous illustrations. 40% of freelance work demands knowledge of InDesign, Illustrator or Photoshop. "Full-page editorial illustrations usually deal with local politics, personalities and stories of general interest. Generally, we are seeing more intelligent solutions to illustration problems and better techniques."

FIRST CONTACT & TERMS Please provide self-promotions, JPEG samples or tearsheets via e-mail or mail to be kept on file for possible future assignments. Responds if interested. Illustrators: Send postcard sample with brochure or tearsheets.

TIPS "Artists are used on the basis of talent. We use many talented college graduates just starting out in

the field. The economy has drastically affected our budgets; we pick up existing work as well as commissioning illustrations."

COBBLESTONE

Carus Publishing, 30 Grove St., Suite C, Peterborough NH 03458. (800)821-0115. **Fax:** (603)924-7380. **E-mail:** customerservice@caruspub.com. **Website:** www.cobblestonepub.com. Circ. 15,000. "Our magazine emphasizes American history; features nonfiction, supplemental nonfiction, fiction, biographies, plays, activities and poetry for children ages 8-14." Accepts previously published material and simultaneous submissions. Sample copy $5.97 plus $2 shipping; art guidelines on website. Material must relate to theme of issue; subjects and topics published in guidelines for SASE. Freelance work demands knowledge of Illustrator, Photoshop and QuarkXPress. Other magazines published by Cobblestone include *Calliope* (world history), *Dig* (archaeology for kids), *Faces* (cultural anthropology), *Odyssey* (science), all for kids ages 8-15, and *Appleseeds* (social studies), for ages 7-9.
ILLUSTRATION Buys all rights. Pays on publication; $20-125 for b&w inside; $40-225 for color inside. Artists should request illustration guidelines. Buys 2-5 illustrations/issue. Prefers historical theme as it pertains to a specific feature. Works on assignment only. Has featured illustrations by Annette Cate, Beth Stover, David Kooharian. Features caricatures of celebrities and politicians, humorous, realistic illustration, informational graphics, computer and spot illustration. Assigns 15% of illustrations to new and emerging illustrators.
FIRST CONTACT & TERMS Send query letter with brochure, résumé, business card and b&w photocopies or tearsheets to be kept on file or returned by SASE. Write for appointment to show portfolio.
TIPS "Study issues of the magazine for style used. Send update samples once or twice a year to help keep your name and work fresh in our minds. Send nonreturnable samples we can keep on file; we're always interested in widening our horizons."

COLLEGE PLANNING & MANAGEMENT

Peter Li Education Group, 2621 Dryden Rd. #300, Dayton OH 45439. (800)523-4625. **E-mail:** mcole@peterli.com. **Website:** www.peterli.com. **Contact:** Matt Cole, art director. Estab. 1970. Circ. 30,000. Monthly trade publication for presidents, chief administrators and purchasing directors of junior colleges, colleges and universities.
ILLUSTRATION Prefers college students and campus.
FIRST CONTACT & TERMS Illustrators: Send postcard sample. After introductory mailing, send follow-up postcard sample every 6 months. Responds only if interested. Buys one-time rights. Find freelancers through artists' submissions.

COMMON GROUND

Common Ground Publishing Corp., #204-4381 Fraser St., Vancouver BC V5V 4G4, Canada. (604)733-2215. **Fax:** (604)733-4415. **E-mail:** editor@common ground.ca. **Website:** www.commonground.ca. Estab. 1982. Circ. 70,000. Monthly consumer magazine focusing on health and cultural activities and holistic personal resource directory. Accepts previously published artwork and cartoons. Original artwork is returned at job's completion. Sample copies for SASE with first-class Canadian postage or International Postage Certificate.
ILLUSTRATION Approached by 20-40 freelance illustrators/year. Buys 1-2 freelance illustrations/issue. Prefers all themes and styles. Considers cartoons, pen & ink, watercolor, collage and marker.
FIRST CONTACT & TERMS Illustrators: Send query letter with brochure, photographs, SASE and photocopies. Samples are filed or are returned by SASE if requested by artist. Responds only if interested. Buys one-time rights. More guidelines available online. Payment varies.
TIPS "Send photocopies of your top 1-3 inspiring works in b&w or color. Can have all 3 on one sheet of 8½×11 paper or all-in-one color copy. I can tell from that if I am interested."

COMMONWEAL

Commonweal Foundation, 475 Riverside Dr., Room 405, New York NY 10115. (212)662-4200. **Fax:** (212)662-4183. **E-mail:** editors@commonwealmaga zine.org. **Website:** www.commonwealmagazine.org. **Contact:** Paul Baumann, editor; Tiina Aleman, production editor. Estab. 1924. Circ. 20,000. Journal of opinion edited by Catholic laypeople concerning public affairs, religion, literature and the arts, full color. Biweekly. See website to order complimentary copies and for submission guidelines. Become familiar with publication before mailing submissions.
CARTOONS Send query letter with finished cartoons. Approached by 20+ cartoonists/year. Buys 1-2

cartoons/issue from freelancers. Prefers simple lines and high-contrast styles. Prefers single panel, with or without gagline. Has featured cartoons by Baloo.

ILLUSTRATION Approached by 20+ illustrators/year. Buys 1-2 illustrations/issue from freelancers. Prefers high-contrast illustrations that speak for themselves. First contact: Send query letter with tearsheets, photographs. Send SASE and photocopies to Tiina Aleman, production editor. Samples are filed or returned by SASE if requested by artist. Responds in 4 weeks. To show a portfolio, mail tearsheets, photographs and photocopies. Buys non-exclusive rights.

TIPS Pays cartoonists $15. Pays illustrators $15. Pays on publication.

CONSTRUCTION EQUIPMENT OPERATION AND MAINTENANCE

4403 First Ave. SE, Suite 400, P.O. Box 1689, Cedar Rapids IA 52403. (319)366-1597; (800)774-0438. **Fax:** (319)362-8808. **E-mail:** chuckparks@constpub.com. **Website:** www.constructionpublications.com. Estab. 1948. Circ. 67,000. Bimonthly b&w tabloid with 4-color cover. Covers heavy construction and industrial equipment for contractors, machine operators, mechanics and local government officials involved with construction. Free sample copy.

CARTOONS Buys 8-10 cartoons/issue. Interested in themes "related to heavy construction industry" or "cartoons that make contractors and their employees 'look good' and feel good about themselves"; single panel.

FIRST CONTACT & TERMS Cartoonists: Send finished cartoons and SASE. Responds in 2 weeks. Original artwork not returned after publication. Buys all rights, but may reassign rights to artist after publication. Reserves right to rewrite captions.

CONVERGENCE: AN ONLINE JOURNAL OF POETRY AND ART

E-mail: clinville@csus.edu. **E-mail:** clinville@csus.edu. **Website:** www.convergence-journal.com. **Contact:** Cynthia Linville, managing editor. Estab. 2003. "We look for well-crafted work with fresh images and a strong voice. Work from a series or with a common theme has a greater chance of being accepted. Seasonally-themed work is appreciated (spring and summer for the January deadline, fall and winter for the June deadline). Please include a 75-word bio with your work (bios may be edited for length and clarity).

A cover letter is not needed. Absolutely no simultaneous or previously published submissions."

FIRST CONTACT & TERMS Submit up to 6 JPEGs of your work, no larger than 4MB each.

DAVID C. COOK

4050 Lee Vance View, Colorado Springs CO 80918. (719)536-0100; (800)708-5550. **Website:** www.cook ministries.org. Publisher of teaching booklets, books, take-home papers for Christian market, "all age groups." Art guidelines available for SASE with first-class postage only.

ILLUSTRATION Buys about 10 full-color illustrations/month. Has featured illustrations by Richard Williams, Chuck Hamrick and Ron Diciani. Assigns 5% of illustrations to new and emerging illustrators. Features realistic illustration, Bible illustration, computer and spot illustration. Works on assignment only.

FIRST CONTACT & TERMS Illustrators: Send tearsheets, color photocopies of previously published work; include self-promo pieces. No samples returned unless requested and accompanied by SASE. **Pays on acceptance:** $400-700 for color cover; $250-400 for color inside; $150-250 for b&w inside; $500-800 for 2-page spreads; $50-75 for spots. Considers complexity of project, skill and experience of artist, and turnaround time when establishing payment. Buys all rights.

TIPS "We do not buy illustrations or cartoons on speculation. Do *not* send book proposals. We welcome those just beginning their careers, but it helps if the samples are presented in a neat and professional manner. Our deadlines are generous but must be met. Fresh, dynamic, the highest of quality is our goal; art that appeals to everyone from preschoolers to senior citizens; realistic to humorous, all media."

COPING WITH CANCER

P.O. Box 682268, Franklin TN 37068. (615)790-2400. **Fax:** (615)794-0179. **E-mail:** editor@copingmag.com. **Website:** www.copingmag.com/cwc. Estab. 1987. Circ. 90,000. "*Coping With Cancer* is a bimonthly, nationally-distributed consumer magazine dedicated to providing the latest oncology news and information of greatest interest and use to its readers. Readers are cancer survivors, their loved ones, support group leaders, oncologists, oncology nurses and other allied health professionals. The style is very conversational and, considering its sometimes technical subject matter, quite comprehensive to the layman. The

tone is upbeat and generally positive, clever and even humorous when appropriate, and very credible." Sample copy available for $3. Art guidelines for SASE with first-class postage. Guidelines are available at www.copingmag.com/author_guidelines.

COSMOPOLITAN

300 W. 57th St., 38th Floor, c/o Editorial Offices, New York NY 10019. **E-mail:** cosmo@hearst.com. **Website:** www.cosmopolitan.com. Estab. 1886. Circ. 3 million+. Monthly 4-color consumer magazine for contemporary women covering a broad range of topics including beauty, health, fitness, fashion, relationships and careers.

ILLUSTRATION Approached by 300 illustrators/year. Buys 10-12 illustrations/issue. Features beauty, humorous and spot illustration. Preferred subjects include women and couples. Prefers trendy fashion palette. Assigns 5% of illustrations to new and emerging illustrators.

FIRST CONTACT & TERMS Send postcard sample and follow-up postcard every 4 months. Samples are filed. Responds only if interested. Buys first North American serial rights. **Pays on acceptance.** Finds illustrators through sourcebooks and artists' promotional samples.

CRICKET

Carus Publishing Co., 700 E. Lake St., Suite 300, Chicago IL 60601. (312)701-1720, ext. 10. **Website:** www.cricketmag.com. **Contact:** Marianne Carus, editor-in-chief; Lonnie Plecha, executive editor; Karen Kohn, senior art director. Estab. 1973. Circ. 73,000. Monthly literary magazine for young readers, ages 9-14. Art guidelines available on website. Our "bug magazines" accept unsolicited manuscripts.

○ See also listings in this section for other magazines published by the Cricket Magazine Group: *Babybug*, *Ladybug*, *Spider* and *Cicada*.

ILLUSTRATION Works with 75 illustrators/year. Buys 600 illustrations/year. Considers pencil, pen & ink, watercolor, acrylic, oil, pastels, scratchboard, and woodcut. "While we need humorous illustration, we cannot use work that is overly caricatured or 'cartoony.' We are always looking for strong realism. Many assignments will require artist's research into a particular scientific field, world culture, or historical period." Works on assignment only.

FIRST CONTACT & TERMS Send photocopies, photographs or tearsheets to be kept on file. Samples are returned by SASE if requested. Responds in 3 months. Buys all rights. Pays 45 days after acceptance: $750 for color cover; $250 for color full page; $100 for color spots; $50 for b&w spots.

TIPS "Before attempting to write for *Cricket*, be sure to familiarize yourself with this age group, and read several issues of the magazine. Please do not query first."

DAKOTA COUNTRY

P.O. Box 2714, Bismark ND 58502. (701)255-3031. **Fax:** (701)255-5038. **E-mail:** dcmag@orbitcom.biz. **Website:** www.dakotacountrymagazine.com. **Contact:** Bill Mitzel, publisher. Estab. 1979. Circ. 14,200. Monthly hunting and fishing magazine with readership in North and South Dakota. Features stories on all game animals and fish and outdoors. Basic 3-column format, 2 and 4 columns accepted, glossy full-color throughout magazine, 4-color cover, feature layout. Accepts previously published artwork. Original artwork is returned after publication. Sample copies for $2; art guidelines with SASE and first-class postage.

CARTOONS Likes to buy cartoons in volume. Prefers outdoor themes, hunting and fishing. Prefers multiple or single panel cartoon with gagline; b&w line drawings.

ILLUSTRATION Features humorous and realistic illustration of the outdoors. Portfolio review not required.

FIRST CONTACT & TERMS Send query letter with samples of style. Samples not filed are returned by SASE. Responds to queries/submissions within 2 weeks. Negotiates rights purchased. **Pays on acceptance.** Pays cartoonists $15 per cartoon, b&w. Pays illustrators $20-25 for b&w inside; $12-30 for spots.

TIPS "Always need good-quality hunting and fishing line art and cartoons."

DC COMICS

1700 Broadway, 5th Floor, New York NY 10019. (212)636-5990. **E-mail:** DCComicsAdvertising@dccomics.com. **Website:** www.dccomics.com. Circ. 6 million+. Monthly 4-color comic books for ages 7-25. Original artwork is returned after publication.

○ See *DC Comics*'s listing in Book Publishers section. *DC Comics* does not read or accept unsolicited submissions of ideas, stories or artwork.

DELAWARE TODAY MAGAZINE

3301 Lancaster Pike, Suite 5C, Wilmington DE 19805.
(302)656-1809. **E-mail:** kcarter@delawaretoday.com.
Website: www.delawaretoday.com. **Contact:** Kelly Carter, creative director. Circ. 25,000. Monthly
4-color magazine emphasizing regional interest in
and around Delaware. Features general interest, historical, humorous, interview/profile, personal experience and travel articles. "The stories we have are about
people and happenings in and around Delaware. Our
audience is middle-aged (40-45) people with incomes
around $79,000, mostly educated. We try to be trendy
in a conservative state." Needs computer-literate freelancers for illustration.

ILLUSTRATION Buys approximately 1-2 illustrations/issue. Has featured illustrations by Nancy Harrison, Tom Deja, Wendi Koontz, Craig LaRontonda
and Jacqui Oakley. "I'm looking for different styles
and techniques of editorial illustration!" Works on
assignment only. Open to all styles.

FIRST CONTACT & TERMS Send postcard sample.
"Will accept work compatible with QuarkXPress 7.5/
version 4.0. Send EPS or TIFF files (RGB)." Send printed color promos. Samples are filed. Responds only if
interested. Publication will contact artist for portfolio
review if interested. Portfolio should include printed samples, color or b&w tearsheets and final reproduction/product. Pays on publication; $200-400 for
cover; $100-150 for inside. Buys first rights or one-time rights. Finds artists through submissions and
self-promotions.

TIPS "Be conceptual, consistent and flexible."

DERMASCOPE MAGAZINE

Aesthetics International Association, 310 E. I-30,
Suite B107, Garland TX 75043. (469)429-9300. **Fax:**
(469)429-9301. **E-mail:** amckay@dermascope.com;
press@dermascope.com. **Website:** www.dermascope.
com. **Contact:** Amy McKay. Estab. 1978. Circ. 16,000.
Monthly magazine/trade journal, 128-page magazine
for aestheticians, plastic surgeons and stylists. Articles should include quality images, graphs, or charts
when available. Sample copies and art guidelines
available.

ILLUSTRATION Approached by 5 illustrators/year.
Prefers illustrations of "how-to" demonstrations.
Considers digital media. 100% of freelance illustration demands knowledge of Photoshop, Illustrator,
InDesign, Fractil Painter.

FIRST CONTACT & TERMS Accepts disk submissions. Electronic images should be 300 dpi, CMYK,
and either JPEG, TIFF, PSD, or EPS format. Photo
credits, model releases, and identification of subjects
or techniques shown in photos are required. Samples
are not filed. Photos will not be returned; do not send
original artwork. Responds only if interested. Rights
purchased vary according to project. Pays on publication.

DUCTS

P.O. Box 3203, Grand Central Station, New York NY
10163. **E-mail:** fiction@ducts.org; essays@ducts.org.
Website: www.ducts.org/content. **Contact:** Jonathan Kravetz. Estab. 1999. Circ. 12,000. Semiannual.
DUCTS is a webzine of personal stories, fiction, essays, memoirs, poetry, humor, profiles, reviews and
art. "*DUCTS* was founded in 1999 with the intent of
giving emerging writers a venue to regularly publish their compelling, personal stories. The site has
been expanded to include art and creative works of
all genres. We believe that these genres must and do
overlap. *DUCTS* publishes the best, most compelling
stories and we hope to attract readers who are drawn
to work that rises above."

FIRST CONTACT & TERMS Submission period is
January 1 through August 31. Accepts submissions
by e-mail to art@ducts.org. Guidelines on website.

THE EAST BAY MONTHLY

The Berkeley Monthly, Inc., 1301 59th St., Emeryville
CA 94608. (510)658-9811. **Fax:** (510)658-9902. **E-mail:** editorial@themonthly.com; letters@themonthly.com. **Website:** www.eastbaymonthly.com. Estab.
1970. Circ. 81,000. Monthly consumer tabloid; b&w
with 4-color cover. Editorial features are general interests (art, entertainment, business owner profiles)
for an upscale audience. Sample copy and guidelines
available for SASE with 5-ounce first-class postage.

CARTOONS Approached by 75-100 cartoonists/year.
Buys 3 cartoons/issue. Prefers single-panel, b&w line
drawings; "any style, extreme humor."

ILLUSTRATION Approached by 150-200 illustrators/year. Buys 2 illustrations/issue. Prefers pen &
ink, watercolor, acrylic, colored pencil, oil, charcoal,
mixed media and pastel. No nature or architectural
illustrations.

DESIGN Occasionally needs freelancers for design
and production. 100% of freelance design requires

knowledge of PageMaker, Macromedia FreeHand, Photoshop, QuarkXPress, Illustrator and InDesign. **FIRST CONTACT & TERMS** Cartoonists: Send query letter with finished cartoons. Illustrators: Send postcard sample or query letter with tearsheets and photocopies. Designers: Send query letter with résumé, photocopies or tearsheets. Accepts submissions on disk, Mac-compatible with Macromedia FreeHand, Illustrator, Photoshop, PageMaker, QuarkXPress or InDesign. Samples are filed or returned by SASE. Responds only if interested. Write for appointment to show portfolio of thumbnails, roughs, b&w tearsheets and slides. Buys one-time rights. Pays 15 days after publication. Pays cartoonists $35 for b&w. Pays illustrators $100-200 for b&w inside; $25-50 for spots. Pays for design by project. Accepts previously published artwork. Originals returned at job's completion.

ELECTRICAL APPARATUS

Barks Publications, Inc., Suite 901, 500 N. Michigan Ave., Chicago IL 60611. (312)321-9440. **Fax:** (312)321-1288. **E-mail:** eamagazine@barks.com. **Website:** www.barks.com/eacurr.html. **Contact:** Elsie Dickson, associate publisher; Kevin Jones, senior editor. Estab. 1967. Circ. 16,000. Monthly 4-color trade journal emphasizing industrial electrical/mechanical maintenance. Original artwork not returned at job's completion. Sample copy $5.

CARTOONS Approached by several cartoonists/year. Buys 3-4 cartoons/issue. Has featured illustrations by Joe Buresch, Martin Filchock, James Estes, John Paine, Bernie White and Mark Ziemann. Prefers themes relevant to magazine content; with gagline. "Captions are edited in our style."

ILLUSTRATION "We have staff artists, so there is little opportunity for freelance illustrators, but we are always glad to hear from anyone who believes he or she has something relevant to contribute."

FIRST CONTACT & TERMS Cartoonists: Send query letter with roughs and finished cartoons. "Anything we don't use is returned." Responds in 3 weeks. Buys all rights. Pays $15-20 for b&w and color.

TIPS "We prefer single-panel cartoons that portray an industrial setting, ideally with an electrical bent. We also use cartoons with more generic settings and tailor the gaglines to our needs."

ELECTRONIC MUSICIAN

1111 Bayhill Dr., Suite 125, San Bruno CA 94066. **E-mail:** emeditorial@emusician.com. **Website:** www. emusician.com. **Contact:** Joe Perry, group publisher. Estab. 1986. Circ. 30,000. Monthly consumer magazine for music how-to. Sample copies and art guidelines available on request.

CARTOONS Approached by 100 cartoonist/year. Buys 12 cartoons/year. Prefers humorous.

ILLUSTRATION Approached by 500 illustrators/year. Buys 12 illustrations/year. Has featured Colin Johnson, Kitty Meek. Prefers computer and realistic illustrations of music. Assigns 80% to new and emerging illustrators. 50% of freelance illustrations demands knowledge of whatever software they do best.

FIRST CONTACT & TERMS Cartoonists/Illustrators: Send postcard sample with samples and tearsheets. After introducing mailing, send follow-up postcard sampled every 6 months. Accepts e-mail submissions with link to website. Prefers Mac-compatible, JPEG files. Samples are filed. Company will contact artist for portfolio review if interested. Portfolio should include finished art. Pays cartoonists $100-400 for b&w. Pays illustrators $800-1,200 for color cover. Pays on publication. Buys one-time rights. Finds freelancers through artists' submissions.

ELLERY QUEEN'S MYSTERY MAGAZINE

Dell Magazines, 267 Broadway, 4th Floor, New York NY 10017. (212)686-7188. **Fax:** (212)686-7414. **E-mail:** elleryqueenmm@dellmagazines.com. **Website:** www.themysteryplace.com/eqmm. Estab. 1941. Circ. 100,000. Emphasizes mystery stories and reviews of mystery books. Art guidelines available online.

○ Also publishes *Alfred Hitchcock Mystery Magazine, Analog* and *Asimov's Science Fiction*.

CARTOONS "We are looking for cartoons with an emphasis on mystery, crime and suspense."

ILLUSTRATION Prefers line drawings. All other artwork is done in house.

FIRST CONTACT & TERMS Now accepting online submissions. Cartoons should be addressed to Lauren Kuczala, editor. Illustrators: Accepts disk submissions. Responds in 3 months. **Pays on acceptance**; $1,200 for color covers; $125 for b&w interior art. Considers all media in b&w and halftones. Accepts finished art on disk.

TIPS "Please see our magazine before submitting samples."

EMERGENCY MEDICINE

7 Century Dr., Suite 302, Parsippany NJ 07054-4609. (973)206-2347. **Fax:** (973)206-9251. **E-mail:** maura.

griffin@ghc.com. **Website:** www.emedmag.com. **Contact:** Maura Griffin, editorial director. Estab. 1969. Circ. 80,000. Emphasizes emergency medicine for emergency physicians, emergency room personnel, medical students. Monthly. Returns original artwork after publication. Art guidelines not available.

ILLUSTRATION Works with 10 illustrators/year. Buys 1-2 illustrations/issue. Has featured illustrations by Scott Bodell, Craig Zuckerman and Steve Oh. Features realistic, medical and spot illustration. Assigns 70% of illustrations to well-known or "name" illustrators; 30% to experienced, but not well-known illustrators. Works on assignment only.

FIRST CONTACT & TERMS Send postcard sample or query letter with brochure, photocopies, photographs, tearsheets to be kept on file. Samples not filed are not returned. Accepts disk submissions. To show a portfolio, mail appropriate materials. Responds only if interested. Buys first rights. Pays $1,200-1,700 for color cover; $200-500 for b&w inside; $500-800 for color inside; $250-600 for spots.

⊕ EPIPHANY-EPIPHMAG.COM

E-mail: contact@epiphmag.com. **Website:** www. epiphmag.com. **Contact:** J.W. Smith, publisher. Estab. 2010. Designed as an online venue in which writers and artists can display their works. Writers, artists, photographers and other contributors retain their copyright. Publishes 6 issues/year—February, April, June, August, October and December. Features dynamically-formatted pages and strives to make each issue a visually and creatively-stimulating experience. Art/photo guidelines available on website or via e-mail request.

CARTOONS Accepts up to 30/year. Prefers humorous.

FIRST CONTACT & TERMS Send via e-mail (JPEG samples at 72 dpi). Buys one-time rights. Finds freelancers through submissions.

TIPS "Look through our publication. When submitting your work, remember to include a brief bio."

ESQUIRE

300 W. 57th St., 21st Floor, New York NY 10019. (212)649-4020. **Website:** www.esquire.com. Estab. 1933. Circ. 720,000. Contemporary culture magazine for men ages 28-40 focusing on current events, living trends, career, politics, and the media.

FIRST CONTACT & TERMS Illustrators: Send postcard mailers. Drop off portfolio on Wednesdays for review.

◯ EVENT

Douglas College, P.O. Box 2503, New Westminster BC V3L 5B2, Canada. (604)527-5293. **Fax:** (604)527-5095. **E-mail:** event@douglascollege.ca. **Website:** www.event.douglas.bc.ca. Estab. 1971. Circ. 1,250. For "those interested in literature and writing" b&w with 4-color cover. Published 3 times/year. Art guidelines available on website.

CARTOONS No cartoons or illustrations.

ILLUSTRATION Buys approximately 3 photographs/year. Has featured photographs by Mark Mushet, Lee Hutzulak and Anne de Haas. Assigns 50% of photographs to new and emerging photographers. Uses freelancers mainly for covers. "We look for art that is adaptable to a cover, particularly images that are self-sufficient and don't lead the reader to expect further artwork within the journal. Please send photography/artwork (no more than 10 images) to *EVENT*, along with SASE (Canadian postage or IRCs only) for return of your work. We also accept e-mail submissions of cover art. We recommend that you send low-res versions of your photography/art as small JPEG or PDF attachments. If we are interested, we will request high-res files. We do not buy the actual piece of art; we only pay for the use of the image." Pays $150 on publication. Credit line given. Buys one-time rights.

TIPS "On the cover of each issue we present the work of a notable or up-and-coming Canadian visual artist. It is our goal to support and encourage a thriving literary community in Canada while maintaining our international reputation for excellence."

FAMILY CIRCLE

Meredith Corporation, 375 Lexington Ave., 9th Floor, New York NY 10017. **Website:** www.familycircle.com. Lisa Kelsey, art director. Estab. 1932. Circ. 4,200,000. Supermarket-distributed publication for women/homemakers covering areas of food, home, beauty, health, child care and careers. 17 issues/year. Submissions should focus on families with children ages 8-16. Does not accept previously published material. Original artwork returned after publication.

ILLUSTRATION Buys 2-3 illustrations/issue. Works on assignment only.

FIRST CONTACT & TERMS Provide query letter with nonreturnable samples or postcard sample to

be kept on file for future assignments. Do not send original work. Prefers transparencies, postcards or tearsheets as samples. Responds only if interested. Prefers to see finished art in portfolio. Submit portfolio by appointment. All art is commissioned for specific magazine articles. Negotiates rights. **Pays on acceptance.**

FAMILY TIMES, INC.

P.O. Box 16422, St. Louis Park MN 55416. (952)922-6186. **Fax:** (952)922-3637. **E-mail:** aobrien@family timesinc.com. **Website:** www.familytimesinc.com. **Contact:** Alyssa MacDowell, art director. Estab. 1991. Circ. 60,000. Bimonthly tabloid. Sample copies available with SASE. Art guidelines available, e-mail for guidelines.

○ Publishes *Family Times, Baby Times, Grand Times* and *Best of Times.*

ILLUSTRATION Approached by 6 illustrators/year. Buys 10 illustrations/year. Has featured illustrations by primarily local illustrators. Preferred subjects: children, families, teen. Preferred all media. Assigns 2% of illustrations to new and emerging illustrators. Freelancers should be familiar with Illustrator, Photoshop. E-mail submissions accepted with link to website, accepted with image file at 72 dpi. Mac-compatible. Prefers JPEG. Samples are filed. Responds only if interested. Portfolio not required. Company will contact artist for portfolio review if interested. Pays illustrators $300 for color cover, $100 for b&w inside, $225 for color inside. Pays on publication. Buys one-time rights, electronic rights. Finds freelancers through artists' submissions, sourcebooks, online.

FIRST CONTACT & TERMS Illustrators: Send query via e-mail with samples or link to samples.

TIPS "Looking for fresh, family friendly styles and creative sense of interpretation of editorial."

FANTAGRAPHICS BOOKS, INC.

7563 Lake City Way NE, Seattle WA 98115. (800)657-1100. **Fax:** (206)524-2104. **Website:** www.fantagraph ics.com. **Contact:** c/o Submissions Editor. Circ. 8,000-30,000. Publishes comic books and graphic novels—all genres except superheroes. Recent titles: *Love and Rockets; Hate; Eightball; Black Hole; Blab; Penny Century.* Sample copy: $3; free catalog. Art submission guidelines available online.

CARTOONS Approached by 500 cartoonists/year. "Fantagraphics is looking for artists who can create

an entire product or who can work as part of an established team." Most titles are b&w.

FIRST CONTACT & TERMS Send query letter with photocopies that display storytelling capabilities, or submit a complete package. All artwork is creator-owned. Buys one-time rights. Payment terms vary.

TIPS "We prefer not to see illustration work unless there is some accompanying comics work. We also do not want to see un-illustrated scripts. Be sure to include basic information like name, address, phone number, etc. Also include SASE. In comics, I see a trend toward more personal styles. In illustration in general, I see more and more illustrators who got started in comics, appearing in national magazines."

FAST COMPANY

7 World Trade Center, New York NY 10007-2195. **E-mail:** aalves@fastcompany.com. **Website:** www.fast company.com. **Contact:** Alice Alves, deputy art director. Estab. 1996. Circ. 734,500. Monthly cutting edge business publication supplying readers with tools and strategies for business today.

ILLUSTRATION Approached by "tons" of illustrators/year. Buys approximately 20 illustrations/issue. Has used illustrations by Bill Mayer, Ward Sutton and David Cowles. Considers all media.

FIRST CONTACT & TERMS Illustrators: Send postcard sample or printed samples, photocopies. Accepts disk submissions compatible with QuarkXPress for Mac. Send EPS files. Send all samples to the attention of Julia Moburg. Samples are filed and not returned. Responds only if interested. Rights purchased vary according to project. **Pays on acceptance,** $300-1,000 for color inside; $300-500 for spots. Finds illustrators through submissions, illustration annuals, *Workbook* and *Alternative Pick.*

FAULTLINE JOURNAL OF ART & LITERATURE

Department of English, UC Irvine, Irvine CA 92697-2650. (949)824-1573. **E-mail:** faultline@uci.edu. **Website:** www.humanities.uci.edu/faultline. **Contact:** Creative director. Pushcart prize-winning journal. "We publish new poetry, fiction, translations, and artwork in an annual spring issue, and feature the work of emerging and established writers from the U.S. and abroad."

○ "Even though this is not a paying market, this high-quality literary magazine would be an excellent place for fine artists to gain exposure.

Postcard samples with a website address are the best way to show us your work."

FIRST CONTACT & TERMS Submit up to five 8×10 color or b&w prints for consideration. Slides might be required if accepted.

FEDERAL COMPUTER WEEK

3141 Fairview Park Dr., Falls Church VA 22042. (703)876-5131. **E-mail:** jeffrey_langkau@1105media. com. **Website:** www.fcw.com. **Contact:** Jeff Langkau, creative director. Estab. 1987. Circ. 120,000. Trade publication for federal, state and local government information technology professionals.

ILLUSTRATION Approached by 50-75 illustrators/ year. Buys 5-6 illustrations/month. Features charts & graphs, computer illustrations, informational graphics, spot illustrations of business subjects. Assigns 5% of illustrations to well-known or "name" illustrators; 85% to experienced but not well-known illustrators; 10% to new and emerging illustrators.

FIRST CONTACT & TERMS Send postcard or other nonreturnable samples. Accepts Mac-compatible disk submissions. Samples are filed. Will contact artist for portfolio review if interested. Rights purchased vary according to project. Pays $800-1,200 for color cover; $600-800 for color inside; $200 for spots. Finds illustrators through samples and sourcebooks.

TIPS "We look for people who understand 'concept' covers and inside art, and very often have them talk directly to writers and editors."

FILIPINAS MAGAZINE

Filipinas Publishing, Inc., GBM Building, 1580 Bryant St., Daly City CA 94015. (650)993-8943. **Website:** www.filipinasmag.com. **Contact:** Art director. Estab. 1992. Circ. 30,000. Monthly magazine "covering issues of interest to Filipino Americans and Filipino immigrants." Sample copies free for 9×12 SASE and $1.70. Contact Art Director for information.

CARTOONS Buys 1 cartoon/issue. Prefers work related to Filipino/Filipino-American experience. Prefers single panel, humorous, b&w washes and line drawings with or without gagline.

ILLUSTRATION Approached by 5 illustrators/year. Buys 1-3 illustrations/issue. Considers all media.

FIRST CONTACT & TERMS Cartoonists/illustrators: Send query letter with photocopies. Accepts disk submissions compatible with Mac, QuarkXPress 4.1, Photoshop 6, Illustrator 7; include any attached image files (TIFF or EPS) or fonts. Samples are filed. Re-

sponds only if interested. Pays on publication. Pays cartoonists $25 minimum. Pays illustrators $100 minimum for cover; $25 minimum for inside. Buys all rights.

TIPS "Read our magazine."

FIRST FOR WOMEN

Bauer Publishing, 270 Sylvan Ave., Englewood Cliffs NJ 07632. (201)569-6699. **Website:** www.first forwomen.com. Estab. 1988. Circ. 1.4 million. Mass market consumer magazine for younger women, published every 3 weeks. Sample copies and art guidelines available upon request.

Designed for the busy woman. Articles concerning health, beauty, real life stories, home and food.

CARTOONS Buys 10 cartoons/issue. Prefers humorous cartoons; single-panel b&w washes and line drawings. Prefers themes related to women's issues.

ILLUSTRATION Approached by 100 illustrators/year. Buys 1 illustration/issue. Works on assignment only. Preferred themes are humorous, sophisticated women's issues. Considers all media.

FIRST CONTACT & TERMS Cartoonists: Send query letter with photocopies. Illustrators: Send query letter with any sample or promo that can be kept on file. Samples are filed and will be returned by SASE only if requested. Responds only if interested. Will contact artist for portfolio review if interested. Buys one-time rights. **Pays on acceptance.** Pays cartoonists $150 for b&w. Pays illustrators $200 for b&w; $300 for color. Originals returned at job's completion. Finds artists through promo mailers and sourcebooks.

TIPS Uses humorous or conceptual illustrations for articles where photography won't work. "Use the mail—no phone calls, please."

FIRST HAND MAGAZINE

P.O. Box 1314, Teaneck NJ 07666. (201)836-9177. **E-mail:** editor@firsthandmag.com. Estab. 1980. Circ. 60,000. Monthly consumer magazine emphasizing gay erotica. Sample copies available for $5. Art guidelines for SASE with first-class postage.

CARTOONS Approached by 10 cartoonists/year. Buys 5 cartoons/issue. Prefers gay male themes—erotica; humorous; single panel b&w line drawings with gagline.

ILLUSTRATION Approached by 30 illustrators/year. Buys 12 illustrations/issue. Prefers gay male erotica.

Considers pen & ink, airbrush, marker, colored pencil and charcoal.

FIRST CONTACT & TERMS Cartoonists: Send query letter with finished cartoons. Illustrators: Send query letter with photostats. Samples are not filed and are returned by SASE. Responds in 6 weeks. Portfolio review not required. Buys all rights. Pays on publication. Pays cartoonists $20 for b&w. Pays illustrators $50 for b&w inside.

FLORIDA REALTOR

7025 Augusta National Dr., Orlando FL 32822-5017. (407)438-1400. **Fax:** (407)438-1411. **E-mail:** magazine@floridarealtors.org. **Website:** www.floridarealtormagazine.com. Estab. 1925. Circ. 117,572. Monthly trade publication covers news and issues of the Florida real estate industry, including sales, market trends, legislation and legal matters.

FIRST CONTACT & TERMS Approached by 100 illustrators/year. Buys 25 illustrations/year. Features homes, office of realtor and commercial building. Send postcard samples with URL. After introductory mailing, send follow-up postcard sample every 6 months. Pays illustrators $100 for color inside. Pays on publication. Buys one-time rights. Finds freelancers through artists' submissions.

FOCUS ON THE FAMILY

8605 Explorer Dr., Colorado Springs CO 80920. (719)531-5181. **Fax:** (719)531-3424. **E-mail:** help@focusonthefamily.com. **Website:** www.family.org. Estab. 1977. Circ. 2,700,000. Publishes magazines. Specializes in religious-Christian. Publishes 9 titles/year.

FIRST CONTACT & TERMS Send query letter with photocopies, printed samples, résumé, SASE and tearsheets portraying family themes. Send follow-up postcard every year. Samples are filed. Responds in 2 weeks. Will contact artist for portfolio review of photocopies of artwork portraying family themes if interested. Buys first, one-time or reprint rights. Finds freelancers through agents, sourcebooks and submissions.

FOLIATE OAK LITERARY MAGAZINE

University of Arkansas-Monticello, P.O. Box 3460, Monticello AR 71656. (870)460-1247. **E-mail:** foliateoak@uamont.edu. **Website:** www.foliateoak.uamont.edu. **Contact:** Online submission manager. Estab. 1973. Circ. 500. "We are a university general literary magazine publishing new and established artists."

Has featured Terry Wright, Brett Svelik, Lucita Peek, David Swartz and Fariel Shafee.

FIRST CONTACT & TERMS Online submission manager must be used to submit all artwork.

TIPS "We are unable to pay our contributors but we love to support freelancers. We solicit work for our online magazine and our annual print anthology. Read submission guidelines online."

FOLIO:

10 Norden Place, Norwalk CT 06855. (203)854-6730. **Fax:** (203)854-6735. **Website:** www.foliomag.com. **Contact:** Matt Kinsman, executive editor. Circ. 9,380. Trade magazine covering the magazine publishing industry. Sample copies with SASE and first-class postage.

ILLUSTRATION Approached by 200 illustrators/year. Buys 150-200 illustrations/year. Works on assignment only. Artists' online galleries welcome in lieu of portfolio.

FIRST CONTACT & TERMS Illustrators: Send postcard samples or photocopies or other appropriate samples. No originals. Samples are filed and returned by SASE if requested by artist. Responds only if interested. Call for appointment to show portfolio of tearsheets, slides, final art, photographs and transparencies. Buys one-time rights. Pays by the project.

TIPS "Art director likes to see printed 4-color and b&w sample illustrations. Do not send originals unless requested. Computer-generated illustrations are used but not always necessary. Charts and graphs must be Mac-generated."

🌀 FOLIO

10 Gate St., Lincoln's Inn Fields, London WC2A-3P, United Kingdom. +44 0207 242 9562. **Fax:** +44 0207 242 1816. **E-mail:** info@folioart.co.uk. **Website:** www.folioart.co.uk. "Folio is an illustration agency based in London. We pride ourselves on representing illustrators and artists of a particularly high quality and versatility." Exclusive representation required. Finds new talent through submissions and recommendations.

FIRST CONTACT & TERMS "Send a query letter, bio, résumé and digital images. Will respond if interested. Portfolio should include b&w, roughs, finished art and digital images."

🍴 FOODSERVICE AND HOSPITALITY

Kostuch Media, Ltd., 23 Lesmill Rd., #101, Toronto ON M3B 3P6, Canada. (416)447-0888. **Fax:** (416)447-5333. **E-mail:** web@kostuchmedia.com. **Website:**

www.foodserviceworld.com. **Contact:** Art director. Estab. 1973. Circ. 25,000. Monthly business magazine for foodservice industry/operators. Sample copies available. Art guidelines available.

○ Also publishes *Hotel Executive Magazine*.

ILLUSTRATION Approached by 30 illustrators/year. Buys 1 illustration/issue. Prefers serious/business/stylized art for *Hotel Executive Magazine*; casual free and fun style for *Foodservice and Hospitality*. Considers all media.

FIRST CONTACT & TERMS Illustrators: Send query letter with printed samples and tearsheets or postcards. Samples are filed. Responds only if interested. Art director will contact artist for portfolio review of final art and tearsheets if interested. Portfolios may be dropped off every Monday and Tuesday. Buys one-time rights. Pays on publication; $500 minimum for color cover; $300 minimum for color inside. Finds illustrators through sourcebooks, word of mouth, artist's submissions.

FORBES MAGAZINE

60 Fifth Ave., New York NY 10011. (212)620-2200. **Website:** www.forbes.com. **Contact:** Art director. Estab. 1917. Circ. 950,000. Biweekly business magazine read by company executives and those who are interested in business and investing. Art guidelines not available.

ILLUSTRATION Assigns 20% of illustrations to new and emerging illustrators.

FIRST CONTACT & TERMS "Assignments are made by one of 5 art directors. We do not use, nor are we liable for, ideas or work that a Forbes art director didn't assign. We prefer contemporary illustrations that are lucid and convey an unmistakable idea with wit and intelligence. No cartoons please. Illustration art must be rendered on a material and size that can be separated on a drum scanner or submitted digitally. We are prepared to receive art on ZIP, Scitex, CD, floppy disk, or downloaded via e-mail. Discuss the specifications and the fee before you accept the assignment. **Pays on acceptance** whether reproduced or not. Pays up to $3,000 for a cover assignment and an average of $450 to $700 for an inside illustration depending on complexity, time and the printed space rate. Dropping a portfolio off is encouraged. Deliver portfolios by 11 A.M. and plan to leave your portfolio for a few hours or overnight. Call first to make sure an art director is available. Address the label to the attention of the Forbes Art Department and the individual you want to reach. Attach your name and local phone number to the outside of the portfolio. Include a note stating when you need it. Robin Regensberg, the art traffic coordinator, will make every effort to call you to arrange for your pickup. Samples: Do not mail original artwork. Send printed samples, scanned samples or photocopies of samples. Include enough samples as you can spare in a portfolio for each person on our staff. If interested, we'll file them. Otherwise they are discarded. Samples are returned only if requested."

TIPS "Look at the magazine to determine if your style and thinking are suitable. The art director and associate art directors are listed on the masthead, located within the first ten pages of an issue. The art directors make assignments for illustration. We get a large number of requests for portfolio reviews and many mailed promotions daily. This may explain why, when you follow up with a call, we may not be able to acknowledge receipt of your samples. If the work is memorable and we think we can use your style, we'll file samples for future consideration."

FRESHLY BAKED FICTION

Isis International, P.O. Box 510232, Saint Louis MO 63151. (314)315-5200. **E-mail:** editor@freshlybakedfiction.com. **Website:** www.freshlybakedfiction.com. **Contact:** John Ferguson, editor. Estab. 2009. Circ. 8,000+ monthly. "*Freshly Baked Fiction* is a non-genre specific publication. We publish short stories, novellas, poetry, art, and more. Our audience is everyone that loves to read. Our website is free to all and updated daily with new fiction and classic works. *Freshly Baked Fiction* is a place where new and published authors can get opinions and insight from readers and other authors relating to their own work. Taking advantage of technology, we have set out goals on being the new way people read. We will be offering readers a chance to get daily fiction on eBook readers, via RSS, e-mail, iPhone, and other electronic devices that have yet to hit the market."

FIRST CONTACT & TERMS Send an e-mail with samples in zipped TIFF, GIF or JPEG format.

TIPS "We like to use technology. We look for creative artists and photographers willing to use multiple medias to create work. Also, make sure you send work as attachments. Zipped or unzipped is good. Technology is here to stay so I recommend you learn to use it."

FUGUE LITERARY MAGAZINE

200 Brink Hall, University of Idaho P.O. Box 44110, Moscow ID 83844-1102. **E-mail:** fugue@uidaho.edu. **Website:** www.uiweb.uidaho.edu/fugue. **Contact:** Jennifer Yeatts, Managing Editor. Estab. 1990. Circ. 500. Biannual literary magazine. Sample copies available for $6. Art guidelines available with SASE.

ILLUSTRATION Approached by 10 illustrators/year. Buys 1-2 illustrations/year. Has featured illustrations by Sarah Wichlucz, Cori Flowers. Features graphic art. Prefers any color scheme; preferably paintings (in slide form). Freelance illustration demands knowledge of PageMaker and Photoshop.

FIRST CONTACT & TERMS Cartoonists/illustrators: Send query letter with b&w photocopies, photographs, résumé, SASE and slides. Accepts e-mail submissions with link to website. Prefers Windows-compatible, TIFF or JPEG files. Samples are not filed but are returned by SASE. Responds in 4 months. Company will contact artist for portfolio review if interested. Portfolio should include b&w original art, photographs, slides and thumbnails. **Pays on acceptance.** Buys first North American serial rights. Submit from September-May.

TIPS "Artists send postcards to us, we browse the Web, and we always keep our eyes out for art we like in other journals, at AWP, etc."

GAME & FISH

2250 Newmarket Pkwy., Suite 110, Marietta GA 30067. (770)953-9222. **Fax:** (678)279-7512. **E-mail:** ken.dunwoody@imoutdoors.com. **Website:** www.gameandfishmag.com. **Contact:** Ken Dunwoody, editorial director; Ron Sinfelt, photo editor; Allen Hansen, graphic artist. Estab. 1975. Circ. 570,000 for 28 state-specific magazines. Publishes 29 different monthly outdoor magazines, each covering the fishing and hunting opportunities in a particular state or region (see individual titles to contact editors). Original artwork is returned after publication. Sample copies available.

ILLUSTRATION Approached by 50 illustrators/year. Buys illustrations mainly for spots and feature spreads. Buys 1-5 illustrations/issue. Considers pen & ink, watercolor, acrylic, and oil.

FIRST CONTACT & TERMS Illustrators: Send query letter with photocopies. "We look for an artist's ability to realistically depict North American game animals and game fish or hunting and fishing scenes." Samples are filed or returned only if requested. Responds only if interested. Portfolio review not required. Buys first rights. Pays 2½ months prior to publication; $25 minimum for b&w inside; $75-100 for color inside.

TIPS "We do not publish cartoons, but we do use some cartoonlike illustrations which we assign to artists to accompany specific humor stories. Send us some samples of your work, showing as broad a range as possible, and let us hold on to them for future reference. Being willing to complete an assigned illustration in a 4-6 week period and providing what we request will make you a candidate for working with us."

GEORGIA MAGAZINE

Georgia Electric Membership Corp., P.O. Box 1707, Tucker GA 30085. (770)270-6951. **Fax:** (770)270-6995. **E-mail:** aorowski@georgiaemc.com. **Website:** www.georgiamagazine.org. **Contact:** Ann Orowski, editor. Estab. 1945. Circ. 509,000. Monthly consumer magazine promoting electric co-ops. *GEORGIA Magazine* is the most widely read magazine for and about Georgians. Each issue celebrates the Georgia lifestyle in word and photo, revealing the spirit of its people and the flavor of its past in a friendly, conversational tone. Feature articles and departments focus on what's in it for the reader, bringing home the story in a useful, personal way that touches their lives directly. Copies are mailed each month to members of Georgia's Electric co-ops.

CARTOONS Approached by 20 cartoonists/year. Buys 2 cartoons/year. Prefers electric industry theme. Prefers single-panel, humorous, 4/c or b&w washes and line drawings.

ILLUSTRATION Approached by 20 illustrators/year. Prefers electric industry theme. Considers all media. 50% of freelance illustration demands knowledge of Illustrator and QuarkXPress.

DESIGN Uses freelancers for design and production. Prefers local designers with magazine experience. 80% of design demands knowledge of Photoshop, Illustrator, QuarkXPress and InDesign.

FIRST CONTACT & TERMS Cartoonists: Send query letter with photocopies. Samples are filed and not returned. Illustrators: Send postcard sample or query letter with photocopies. Designers: Send query letter with printed samples and photocopies. Accepts disk submissions compatible with QuarkXPress. Samples are filed or returned by SASE. Responds in 3 months if interested. Rights purchased vary according to proj-

ect. **Pays on acceptance.** Pays cartoonists $50 for b&w, $50-100 for color. Pays illustrators $50-100 for b&w, $50-200 for color. Finds illustrators through word of mouth and submissions.

GLAMOUR

Conde Nast Publications, Inc., 4 Times Square, 16th Floor, New York NY 10036. (212)286-2860. **Fax:** (212)286-8336. **Website:** www.glamour.com. Cynthia Leive, editor-in-chief. Estab. 1939. Circ. 2,320,325. Monthly. Covers fashion and issues concerning working women (ages 20-35). Originals returned at job's completion. Sample copies available on request. 5% of freelance work demands knowledge of Illustrator, QuarkXPress, Photoshop and FreeHand.

CARTOONS Buys 1 cartoon/issue.

ILLUSTRATION Buys 1 illustration/issue. Works on assignment only. Considers all media.

FIRST CONTACT & TERMS Illustrators: Send postcard-size sample. Samples are filed and not returned. Publication will contact artist for portfolio review if interested. Rights purchased vary according to project. Pays on publication.

GLAMOUR LATINOAMERICA

800 Brickell Ave., Suite 530, Miami FL 33131. (305)371-9393. **E-mail:** miguelgarcia@condenast.com. **Website:** www.condenast.com. **Contact:** art director. Estab. 1998. Circ. 406,760. Monthly consumer magazine for the contemporary Hispanic woman. Covers the latest trends in fashion and beauty, health, relationships, careers and entertainment.

ILLUSTRATION Approached by 100 illustrators/year. Buys 40 illustrations/year. Features fashion caricatures of celebrities, fashion illustration and spot illustrations. Assigns 10% to new and emerging illustrators. Illustrators: Send postcard sample with link to website. After introductory mailing, send follow-up postcard sample every 6 months. Responds only if interested.

FIRST CONTACT & TERMS Illustrators: $150-400 for color inside. Buys one-time rights. Finds freelancers through submissions.

THE GOLFER

59 E. 72nd St., New York NY 10021. (212)867-7070. **Fax:** (212)867-8550. **E-mail:** info@thegolferinc.com. **Website:** www.thegolfermag.com; www.thegolferinc.com. Estab. 1994. Circ. 253,000. Bimonthly "sophisticated golf magazine with an emphasis on travel and lifestyle."

ILLUSTRATION Approached by 200 illustrators/year. Buys 6 illustrations/issue. Considers all media.

FIRST CONTACT & TERMS Send postcard sample. "We will accept work compatible with QuarkXPress 3.3. Send EPS files." Samples are not filed and are not returned. Responds only if interested. Rights purchased vary according to project. Pays on publication. Payment to be negotiated.

TIPS "I like sophisticated, edgy, imaginative work. We're looking for people to interpret sport, not draw a picture of someone hitting a ball."

GOLF TIPS MAGAZINE

Werner Publishing Corp., 12121 Wilshire Blvd., 12th Floor, Los Angeles CA 90025. (310)820-1500. **Fax:** (310)820-5008. **E-mail:** editors@golftipsmag.com. **Website:** www.golftipsmag.com. Estab. 1986. Circ. 300,000. Monthly 4-color consumer magazine featuring golf instruction articles.

ILLUSTRATION Approached by 100 illustrators/year. Buys 3 illustrations/issue. Has featured illustrations by Phil Franke, Scott Matthews, Ed Wexler. Features charts and graphs, humorous illustration, informational graphics, realistic and medical illustration. Preferred subjects men and women. Prefers realism or expressive, painterly editorial style or graphic humorous style. Assigns 30% of illustrations to well-known or "name" illustrators; 50% to experienced but not well-known illustrators; 20% to new and emerging illustrators. 15% of freelance illustration demands knowledge of Illustrator, Photoshop and FreeHand.

FIRST CONTACT & TERMS Submission guidelines available online at www.golftipsmag.com/submissions.html. Illustrators: Send postcard or other nonreturnable samples. Accepts Mac-compatible disk submissions. Send EPS or TIFF files. Samples are filed. Will contact artist for portfolio review if interested. Rights purchased vary according to project. Pays on publication; $500-700 for color cover; $100-200 for b&w inside; $250-500 for color inside; $500-700 for 2-page spreads. Finds illustrators through *LA Workbook*, *Creative Black Book* and promotional samples.

TIPS "Look at our magazine and you will see straightforward, realistic illustration, but I am also open to semi-abstract, graphic humorous illustration, gritty, painterly, editorial style, or loose pen & ink and watercolor humorous style."

GOLFWEEK

1500 Park Center Dr., Orlando FL 32835. (407)563-7000. **Fax:** (407)563-7077. **E-mail:** jlusk@golfweek.com. **Website:** www.golfweek.com. Circ. 119,000. Weekly golf magazine for the accomplished golfer. Covers the latest golfing news and all levels of competitive golf from amateur and collegiate to juniors and professionals. Includes articles on golf course architecture as well as the latest equipment and apparel. **ILLUSTRATION** Approached by 200 illustrators/year. Buys 20 illustrations/year. Has featured illustrations by Roger Schillerstrom. Features caricatures of golfers and humorous illustrations of golf courses and golfers. Assigns 20% to new and emerging illustrators. 5% of freelance illustration demands knowledge of Photoshop. **FIRST CONTACT & TERMS** Send postcard sample. After introductory mailing, send follow-up postcard sample every 3-6 months. Accepts e-mail submissions with link to website. Prefers JPEG files. Samples are filed. Responds only if interested. Pays illustrators $400-1,000 for color cover; $400-500 for color inside. Pays on publication. Buys one-time rights. Finds freelancers through submissions and sourcebooks. **TIPS** "Look at our magazine. Know golf."

GOVERNING

1100 Connecticut Ave. NW, Suite 1300, Washington DC 20036. (202)862-8802. **Fax:** (202)862-0032. **E-mail:** dkidd@governing.com. **Website:** www.governing.com. **Contact:** David Kidd, design director. Estab. 1987. Circ. 86,284. Monthly. "Our readers are executives of state and local governments nationwide. They include governors, mayors, state legislators, county executives, etc." **ILLUSTRATION** Approached by hundreds of illustrators/year. Buys 2-3 illustrations/issue. Prefers conceptual editorial illustration dealing with public policy issues. Considers all media. **FIRST CONTACT & TERMS** "No phone calls please and no postcards, tearsheets or anything through the mail." Samples are filed. Responds only if interested. Art director will contact artist for portfolio review if interested. Buys one-time rights. Pays on publication; $700-1,200 for cover; $350-700 for inside; $350 for spots. Finds illustrators through *Blackbook*, *LA Workbook*, online services, magazines, word of mouth, submissions.

TIPS "We are not interested in working with artists who can't take direction. If you can collaborate with us in communicating our words visually, then we can do business. Also, please don't call asking if we have any work for you. When I'm ready to use you, I'll call you."

GRAND RAPIDS MAGAZINE

Gemini Publications, 549 Ottawa Ave. NW, Suite 201, Grand Rapids MI 49503-1444. (616)459-4545. **Fax:** (616)459-4800. **E-mail:** cvalade@geminipub.com. **Website:** www.grmag.com. Estab. 1964. Circ. 20,000. Monthly general interest life and style magazine designed for those who live in the Grand Rapids metropolitan area or desire to maintain contact with the community. Original artwork returned after publication. Local artists only. **CARTOONS** Buys 2-3 cartoons/issue. Prefers Michigan, Western Michigan, Lake Michigan, city, issue, consumer/household, fashion, lifestyle, fitness and travel themes. **ILLUSTRATION** Buys 2-3 illustrations/issue. Prefers Michigan, Western Michigan, Lake Michigan, city, issue, consumer/household, fashion, lifestyle, fitness and travel themes. **FIRST CONTACT & TERMS** Cartoonists/illustrators: Send query letter with samples. Samples not filed are returned by SASE. Responds in 1 month. To show a portfolio, mail printed samples and final reproduction/product or call for an appointment. Buys all rights. Pays on publication. Pays cartoonists $35-50 for b&w. Pays illustrators $200 minimum for color cover; $40 minimum for b&w inside; $40 minimum for color inside. **TIPS** "Particular interest in those who are able to capture the urban lifestyle."

THE GREEN MAGAZINE

260 W. 36th St., New York NY 10018. (212)629-4920. **Fax:** (212)629-4932. **E-mail:** info@thegreenmagazine.com. **Website:** www.thegreenmagazine.com. Estab. 2002. Circ. 150,000. Consumer magazine for the affluent multicultural golf enthusiast featuring articles on personalities, travel and leisure, business and etiquette. **ILLUSTRATION** Few used, but will consider solicitations. **FIRST CONTACT & TERMS** Illustrators: Send postcard sample or photocopies. After sending introductory mailing, send follow-up postcard sample every

2-3 months. Company will contact artist for portfolio review if interested. Buys one-time rights. Finds freelancers through artists submissions.

GREENPRINTS

P.O. Box 1355, Fairview NC 28730. (828)628-1902. **E-mail:** pat@greenprints.com. **Website:** www.green prints.com. **Contact:** Pat Stone, editor. Estab. 1990. Circ. 13,000. Quarterly magazine "that covers the personal, not the how-to, side of gardening." Sample copy for $5; art guidelines available on website or free with #10 SASE and first-class postage.

ILLUSTRATION Approached by 46 illustrators/year. Works with 15 illustrators/issue. Has featured illustrations by Claudia McGehee, P. Savage, Marilynne Roach and Jean Jenkins. Assigns 30% of illustrations to emerging and 5% to new illustrators. Prefers plants and people. Considers b&w only.

TIPS "Read our magazine and study the style of art we use. Can you do both plants and people? Can you interpret as well as illustrate a story?"

GROUP PUBLISHING

1515 Cascade Ave., Loveland CO 80539. (970)669-3836. **E-mail:** info@group.com. **Website:** www.group.com. **Contact:** senior designer. Publishes *Group Magazine*: Rebecca Parrott, art director (6 issues/year; circ. 50,000; 4-color); *Children's Ministry Magazine*: Rose-Anne Sather, art director (6 issues/year; circ. 65,000; 4-color), for adult leaders who work with kids from birth to 6th grade; *Rev. Magazine*: Jeff Spencer, art director (6 issues; 4-color), an interdenominational magazine which provides innovative and practical ideas for pastors. Previously published, photocopied and simultaneous submissions OK. Original artwork returned after publication. Sample copy $2 with 9×12 SAE.

◌ See additional listing in the Book Publishers section.

ILLUSTRATION Buys 2-10 illustrations/issue. Has featured illustrations by Matt Wood, Chris Dean, Dave Klug and Otto Pfandschmidt.

FIRST CONTACT & TERMS Illustrators: Send postcard samples, SASE, tearsheets to be kept on file for future assignments. Accepts disk submissions compatible with Mac. Send EPS files. Responds only if interested. **Pays on acceptance.** Pays illustrators $125-1,000, from b&w/spot illustrations (line drawings and washes) to full-page color illustrations inside. Buys first publication rights and occasional reprint rights.

TIPS "We prefer contemporary, nontraditional (not churchy), well-developed styles that are appropriate for our innovative, youth-oriented publications. We appreciate artists who can conceptualize well and approach difficult and sensitive subjects creatively."

GUERNICA

165 Bennett Ave., 4C, New York NY 10040. **E-mail:** editors@guernicamag.com; art@guernicamag.com; publisher@guernicamag.com. **Website:** www.guernicamag.com. **Contact:** Erica Wright, poetry; Dan Eckstein, art/photography. Estab. 2005. "*Guernica*, published biweekly, is one of the web's most acclaimed new magazines. 2009: *Guernica* is called a "great online literary magazine" by *Esquire*. *Guernica* contributors come from dozens of countries and write in nearly as many languages."

FIRST CONTACT & TERMS Submit by e-mail to art@guernicamag.com. In subject line (please follow this format exactly): "art/photography submission."

GUITAR PLAYER

NewBay Media, LLC, c/o Guitar World, 28 E. 28th St., 12th Floor, New York NY 10016. (650)238-0300. **E-mail:** mmolenda@musicplayer.com. **Website:** www.guitarplayer.com. **Contact:** Michael Molenda, editor-in-chief. Estab. 1975. Circ. 150,000. Monthly 4-color magazine focusing on technique, artist interviews, etc.

ILLUSTRATION Approached by 15-20 illustrators/week. Buys 5 illustrations/year. Works on assignment only. Features caricatures of celebrities; realistic, computer and spot illustration. Assigns 33% of illustrations to new and emerging illustrators. Prefers conceptual, "outside, not safe" themes and styles. Considers pen & ink, watercolor, collage, airbrush, digital, acrylic, mixed media and pastel.

FIRST CONTACT & TERMS Send query letter with brochure, tearsheets, photographs, photocopies, photostats, slides and transparencies. Accepts Mac-compatible disk submissions. Samples are filed. Responds only if interested. Will contact artist for portfolio review if interested. Buys first rights. Pays on publication.

HADASSAH MAGAZINE

50 W. 58th St., New York NY 10019. (212)688-0227. **Fax:** (212)446-9521. **E-mail:** magazine@hadassah.org. **Website:** www.hadassah.org/magazine. **Contact:** Rachel Fyman Schwartzberg. Circ. 300,000. Monthly consumer magazine chiefly of and for Jewish interests—both in the U.S. and in Israel.

ILLUSTRATION Approached by 50 freelance illustrators/year. Works on assignment only. Features humorous, realistic, computer and spot illustration. Prefers themes of news, Jewish/family, Israeli issues, holidays.

FIRST CONTACT & TERMS Cartoonists: Send postcard sample or query letter with tearsheets. Samples are filed or are returned by SASE. Write for appointment to show portfolio of original/final art, tearsheets and slides. Buys first rights. Pays on publication. Pays illustrators $400-600 for color cover; $100-200 for b&w inside; $200-250 for color inside; $75-100 for spots.

HARPER'S MAGAZINE

666 Broadway, 11th Floor, New York NY 10012. (212)420-5720. **Fax:** (212)228-5889. **E-mail:** readings@harpers.org. **Website:** www.harpers.org. Estab. 1850. Circ. 230,000. Monthly 4-color literary magazine. "The nation's oldest continually published magazine providing fiction, satire, political criticism, social criticism, essays." *Harper's Magazine* encourages national discussion on current and significant issues in a format that offers arresting facts and intelligent opinions.

ILLUSTRATION Approached by 250 illustrators/year. Buys 5-10 illustrations/issue. Has featured illustrations by Ray Bartkus, Steve Brodner, Istvan Banyai, Andrea Ventura, Hadley Hooper, Ralph Steadman, Raymond Verdaguer, Andrew Zbihlyj, Danijel Zezelj. Features intelligent concept-oriented illustration. Preferred subjects: literary, artistic, social, fiction-related. Prefers intelligent, original thought and imagery in any media. Assigns 25% of illustrations to new and emerging illustrators.

FIRST CONTACT & TERMS Approached by 250 illustrators/year. Buys 5-10 illustrations/issue. Has featured illustrations by Ray Bartkus, Steve Brodner, Istvan Banyai, Andrea Ventura, Hadley Hooper, Ralph Steadman, Raymond Verdaguer, Andrew Zbihlyj, Danijel Zezelj. Features intelligent concept-oriented illustration. Preferred subjects: literary, artistic, social, fiction-related. Prefers intelligent, original thought and imagery in any media. Assigns 25% of illustrations to new and emerging illustrators.

TIPS "Intelligence, originality, and beauty in execution are what we seek. A wide range of styles is appropriate; what counts most is content."

HEARTLAND BOATING

The Waterways Journal, Inc., 319 N. Fourth St., Suite 650, St. Louis MO 63102. (314)241-4310. **Fax:** (314)241-4207. **E-mail:** lbraff@heartlandboating.com. **Website:** www.heartlandboating.com. **Contact:** John R. Cassady, art director. Estab. 1989. Circ. 12,000. "*Heartland Boating*'s content is both informative and humorous—describing boating life as the heartland boater knows it. The content reflects the challenge, joy, and excitement of our way of life afloat. We are devoted to both power and sailboating enthusiasts throughout middle America; houseboats are included. The focus is on the freshwater inland rivers and lakes of the heartland, primarily the waters of the Arkansas, Tennessee, Cumberland, Ohio, Missouri, Illinois, and Mississippi rivers, the Tennessee-Tombigbee Waterway, The Gulf Intracoastal Waterway, and the lakes along these waterways." Samples kept on file. Portfolio not required. Credit line given.

FIRST CONTACT & TERMS Send query letter with samples or postcard sample. No follow-ups.

TIPS "Please read the magazine first. Go to the website to obtain 3 free copies. Our rates are low, but we do our best to take care of and promote our contributors. *Note: any e-mail submission will be deleted unread.* Submissions must come during our window, May 1-July 1, and be hard-copy form only. Remember to include your contact info, all of it! Please make it easy to find you."

HIGH COUNTRY NEWS

119 Grand Ave., P.O. Box 1090, Paonia CO 81428. (970)527-4898. **E-mail:** editor@hcn.org. **Website:** www.hcn.org. **Contact:** Cindy Wehling, art director. Estab. 1970. Circ. 25,000. Biweekly nonprofit newspaper. Covers environmental, public lands and community issues in the 10 western states. Art guidelines at www.hcn.org/about/guidelines.jep.

CARTOONS Buys 1 editorial cartoon/issue. Only issues affecting Western environment. Prefers single panel, political, humorous on topics currently being covered in the paper. Color or b&w. Professional quality only.

ILLUSTRATION Considers all media if reproducible.

FIRST CONTACT & TERMS Cartoonists: Send query letter with finished cartoons and photocopies. Illustrators: Send query letter with printed samples and photocopies. Accepts e-mail and disk submissions compatible with QuarkXPress and Photoshop. Sam-

ples are filed or returned by SASE. Responds only if interested. Rights purchased vary according to project. Pays on publication. Pays cartoonists $50-125 depending on size used. Pays illustrators $100-200 for color cover; $35-100 for inside. Finds illustrators through magazines, newspapers and artist's submissions. Mail photos to the attention of Cindy Wehling, art director, or via e-mail at cindy@hcn.org.

HIGHLIGHTS FOR CHILDREN

803 Church St., Honesdale PA 18431. (570)253-1080. **Fax:** (570)251-7847. **Website:** www.highlights.com. **Contact:** Christine French Clark, editor-in-chief; Cindy Faber Smith, art director. Estab. 1946. Circ. Approximately 2.5 million. Monthly 4-color magazine for children up to age 12. Art guidelines available for SASE with first-class postage.

CARTOONS Receives 20 submissions/week. Buys 2-4 cartoons/issue. Interested in upbeat, positive cartoons involving children, family life or animals; single or multiple panel. "One flaw in many submissions is that the concept or vocabulary is too adult, or that the experience necessary for its appreciation is beyond our readers. Frequently, a wordless self-explanatory cartoon is best."

ILLUSTRATION Buys 30 illustrations/issue. Works on assignment only. Prefers "realistic and stylized work; upbeat, fun, more graphic than cartoon." Pen & ink, colored pencil, watercolor, marker, cut paper and mixed media are all acceptable. Discourages work in fluorescent colors.

FIRST CONTACT & TERMS Cartoonists: Send roughs or finished cartoons and SASE. Illustrators: Send query letter with photocopies, SASE and tearsheets. Samples are kept on file. Responds in 10 weeks. Buys all rights on a work-for-hire basis. **Pays on acceptance.** Pays cartoonists $20-40 for line drawings. Pays illustrators $1,400 for color front and back covers; $50-$700 for color inside. "We are always looking for good hidden pictures. We require a picture that is interesting in itself and has the objects well-hidden. Usually an artist submits pencil sketches. In no case do we pay for any preliminaries to the final hidden pictures. Hidden pictures should be submitted to Juanita Galuska."

TIPS "We have a wide variety of needs, so I would prefer to see a representative sample of an illustrator's style."

HOME BUSINESS MAGAZINE

United Marketing & Research Co., Inc., P.O. Box 807, 20711 Holt Ave, Lakeville MN 55044. **E-mail:** editor@homebusinessmag.com; publisher@homebusinessmag.com. **Website:** www.homebusinessmag.com. Estab. 1993. Circ. 105,000. Bimonthly consumer magazine. *Home Business Magazine* covers every angle of the home-based business market including: cutting edge editorial by well-known authorities on sales and marketing, business operations, the home office, franchising, business opportunities, network marketing, mail order and other subjects to help readers choose, manage and prosper in a home-based business; display advertising, classified ads and a directory of home-based businesses; technology, the Internet, computers and the future of home-based business; home-office editorial including management advice, office set-up, and product descriptions; business opportunities, franchising and work-from-home success stories. Sample copies free for 10×13 SASE and $2.53 in first-class postage.

ILLUSTRATION Approached by 100 illustrators/year. Buys several illustrations/issue. Features natural history illustration, realistic illustrations, charts & graphs, informational graphics, spot illustrations and computer illustration of business subjects, families, men and women. Prefers pastel and bright colors. Assigns 40% of illustrations to well-known or "name" illustrators; 40% to experienced but not well-known illustrators; 20% to new and emerging illustrators. 100% of freelance illustration demands knowledge of Illustrator and QuarkXPress.

FIRST CONTACT & TERMS Illustrators: Send query letter with printed samples, photocopies and SASE. Send electronically as JPEG files. Responds only if interested. Will contact artist for portfolio review if interested. Buys reprint rights. Negotiates rights purchased. Pays on publication. Finds illustrators through magazines, word of mouth or via Internet.

HOME EDUCATION MAGAZINE

P.O. Box 1083, Tonasket WA 98855. (800)236-3278; (509)486-1351. **Fax:** (509)486-2753. **E-mail:** articles@homeedmag.com. **Website:** www.homeedmag.com. **Contact:** Jeanne Faulconer, articles editor. Estab. 1983. Circ. 120,000. "We publish one of the largest magazines available for homeschooling families." Desktop bimonthly published in full color; 4-color glossy cover. Original artwork is returned after publication

upon request. Sample copy $6.50. Guidelines available via e-mail.

CARTOONS Approached by 15-20 cartoonists/year. Buys 1-2/year. Style preferred is open, but theme must relate to home schooling. Prefers single, double or multiple panel b&w line drawings and washes with or without gagline.

FIRST CONTACT & TERMS Cartoonists: Send query letter with samples of style, roughs and finished cartoons, "any format is fine with us." Accepts disk submissions. "We're looking for originality, clarity, warmth. Children, families and parent-child situations are what we need." Samples are filed or are returned by SASE. Responds in 3 weeks. Will contact for portfolio review if interested. Buys one-time rights, reprint rights or negotiates rights purchased. **Pays on acceptance.** Pays cartoonists $10-20 for b&w. Finds artists primarily through submissions and self-promotions.

TIPS "Most of our artwork is produced by staff artists. We receive very few good cartoons. Study what we've done in the past, suggest how we might update or improve it."

HONOLULU MAGAZINE

PacificBasin Communications, 1000 Bishop St., Suite 405, Honolulu HI 96813. (808)537-9500. **Fax:** (808)537-6455. **E-mail:** akamn@honolulumagazine.com; kathrynw@honolulumagazine.com. **Website:** www.honolulumagazine.com. **Contact:** A. Kam Napier, editor; Kathryn Drury Wagner, executive editor. Estab. 1888. Circ. 30,000. Monthly 4-color city/regional magazine reporting on current affairs and issues, people profiles, lifestyle. Readership is generally upper income (based on subscription). Contemporary, clean, colorful and reader-friendly design. Original artwork is returned after publication. Sample copies for SASE with first-class postage. Art guidelines available free for SASE.

ILLUSTRATION Buys illustrations mainly for spots and feature spreads. Buys 2-6 illustrations/issue. Has featured illustrations by Rob Barber, Dean Hayashi and Charlie Pedrina. Assigns 10% of illustrations to new and emerging illustrators. Works on assignment only. Considers any media but not pencil work.

FIRST CONTACT & TERMS Illustrators: Send postcard or published sample showing art style. Looks for local subjects, conceptual abilities for abstract subjects (editorial approach) likes a variety of techniques.

Knowledge of Hawaii a must. Samples are filed or are returned only if requested with a SASE. Responds only if interested. Write to schedule an appointment to show a portfolio which should include original/final art and color and b&w tearsheets. Buys first rights or one-time rights. Pays 60 days after publication; $300-500 for cover; $100-350 for inside; $75-150 for spots. Finds artists through word of mouth, magazines, submissions, attending art exhibitions.

TIPS "Needs both feature and department illustration—best way to break in is with small spot illustration. Prefers art on ZIP disk or e-mail. Friendly and professional attitude is a must. Be a very good conceptual artist, professional, fast, and, of course, a sense of humor."

HORSE ILLUSTRATED

BowTie, Inc., P.O. Box 8237, Lexington KY 40533. (859)260-9800. **Fax:** (859)260-1154. **E-mail:** horseillustrated@bowtieinc.com. **Website:** www.horseillustrated.com. **Contact:** Elizabeth Moyer, editor. Estab. 1976. Circ. 160,660. Monthly consumer magazine providing "information for responsible horse owners." Art guidelines available on website.

○ "Readers are primarily adult horsewomen, ages 18-40, who ride and show mostly for pleasure, and who are very concerned about the well being of their horses."

HORTICULTURE

F+W Media, Inc., 10151 Carver Rd., Suite #200, Blue Ash OH 45242. (513)531-2690. **Fax:** (513)891-7153. **E-mail:** edit@hortmag.com. **Website:** www.hortmag.com. Circ. 160,000. Monthly magazine for all levels of gardeners (beginners, intermediate, highly skilled). "*Horticulture Magazine* strives to inspire and instruct avid gardeners of every level." Art guidelines available.

ILLUSTRATION Approached by 75 freelance illustrators/year. Buys up to 3 illustrations/issue. Works on assignment only. Features realistic illustration; informational graphics; spot illustration. Assigns 20% of illustrations to new and emerging illustrators. Prefers tight botanicals; garden scenes with a natural sense to the clustering of plants; people; hands and "how-to" illustrations. Considers all media.

FIRST CONTACT & TERMS Send query letter with brochure, résumé, SASE, tearsheets, slides. Samples are filed or returned by SASE. Art director will contact artist for portfolio review if interested. Buys one-time rights. Pays 1 month after project completed.

Payment depends on complexity of piece; $800-1,200 for 2-page spreads; $150-250 for spots. Finds artists through word of mouth, magazines, submissions/self-promotions, sourcebooks, agents/reps, art exhibits.

HOW MAGAZINE

F+W Media, Inc., 10151 Carver Rd., Suite 200, Blue Ash OH 45242. (513)531-2690. **E-mail:** bridgid.mccarren@fwmedia.com; editorial@howdesign.com. **Website:** www.howdesign.com. **Contact:** Bridgid McCarren, senior art director. Estab. 1985. Circ. 40,000. Bimonthly trade journal covering creativity, business and technology for graphic designers. Sample copy available for $8.50.

○ Sponsors 2 annual conferences for graphic artists, as well as annual Promotion, International, Interactive and In-House Design competitions. See website for more information.

ILLUSTRATION Approached by 100 illustrators/year. Buys 4-8 illustrations/issue. Works on assignment only. Considers all media, including photography and computer illustration.

FIRST CONTACT & TERMS Illustrators: Send non-returnable samples. Accepts disk submissions. Responds only if interested. Buys first rights or reprint rights. Pays on publication: $350-1,000 for color inside. Original artwork returned at job's completion.

TIPS "Send good samples that reflect the style and content of illustration commonly featured in the magazine. Be patient; art directors get a lot of samples."

HR MAGAZINE

1800 Duke St., Alexandria VA 22314. (703)548-3440 or (800)283-7476. **Fax:** (703)535-6490. **E-mail:** hrmag@shrm.org. **Website:** www.shrm.org. Estab. 1948. Circ. 250,000+. Monthly trade journal dedicated to the field of human resource management.

ILLUSTRATION Approached by 70 illustrators/year. Buys 6-8 illustrations/issue. Prefers people, management and stylized art. Considers all media.

FIRST CONTACT & TERMS Illustrators: Send query letter with printed samples. Accepts disk submissions. Illustrations can be attached to e-mails. *HR Magazine* is Mac-based. Samples are filed. Art director will contact artist for portfolio review if interested. Rights purchased vary according to project. Requires artist to send invoice. Pays within 30 days. Finds illustrators through sourcebooks, magazines, word of mouth and artist's submissions.

IDEALS MAGAZINE

2630 Elm Hill Pike, Suite 100, Nashville TN 37214. (615)333-0478. **Fax:** (888)815-2759. **Website:** www.idealsbooks.com. **Contact:** Melinda Rathjen Rumbaugh, editor. Estab. 1944. Circ. 25,000. Twice-yearly 4-color Christmas and Easter holiday magazine featuring poetry and text appropriate for the family. Sample copy $4. Art guidelines free with #10 SASE with first-class postage or view on website.

ILLUSTRATION Approached by 100 freelancers/year. Buys 4 or fewer illustrations/issue. Uses freelancers mainly for flowers, plant life, wildlife, realistic people illustrations and botanical (flower) and holiday-related spot art. Prefers seasonal themes. Prefers watercolors. Assigns 90% of illustrations to experienced illustrators; 10% to new and emerging illustrators. "Are not interested in computer generated art. No electronic submissions."

FIRST CONTACT & TERMS Illustrators: Send non-returnable samples or tearsheets. Samples are filed. Responds only if interested. Do not send originals. Buys artwork for hire. Pays on publication; payment negotiable.

TIPS "For submissions, target our needs as far as style is concerned, but show representative subject matter. Artists are strongly advised to be familiar with our magazine before submitting samples of work."

IEEE SPECTRUM

3 Park Ave., New York NY 10016. (212)419-7555. **E-mail:** m.montgomery@ieee.org; b.palacio@ieee.org. **Website:** www.spectrum.ieee.org. **Contact:** Mark Montgomery, senior art director. Estab. 1964. Circ. 380,000. Monthly nonprofit trade magazine serving electrical and electronics engineers worldwide.

ILLUSTRATION Buys 5 illustrations/issue. Has featured illustrations by John Hersey, David Plunkert, Mick Wiggins. Features charts, graphs, computer illustration, informational graphics, realistic illustration and spot illustration. Preferred subjects business, technology, science. Assigns 25% to new and emerging illustrators. Considers all media.

FIRST CONTACT & TERMS Illustrators: Send postcard sample or query letter with printed samples and tearsheets. Samples are filed and are not returned. Responds only if interested. Art director will contact artist for portfolio review if interested. Do *not* send samples via e-mail. Portfolio should include color, final art and tearsheets. Buys first rights and one year's

use on website. **Pays on acceptance**. Finds illustrators through *American Showcase*, *Workbook*.

TIPS "Please visit our website and review *Spectrum* before submitting samples. Most of our illustration needs are with 3-D technical diagrams and a few editorial illustrations."

IMAGE BY DESIGN LICENSING

Suite 3, 107 Bancroft, Hitchen, Herts SG4 1NB, United Kingdom. 44 0 7462 4244. **E-mail:** lucy@ibd-licensing.co.uk. **Website:** www.ibd-licensing.co.uk. **Contact:** Lucy Brenham. Agency specializing in art licensing. Serves fine artists, illustrators, and photographers. Interested in reviewing fine art, design, and photography.

FIRST CONTACT & TERMS Send a link to a website with résumé, bio, brochure of work, photocopies or digital images in low-res JPEG format.

TIPS "Be aware of current trends."

THE INDEPENDENT WEEKLY

P.O. Box 2690, Durham NC 27715. (919)286-1972. **Fax:** (919)286-4274. **E-mail:** mbshain@indyweek.com. **Website:** www.indyweek.com. **Contact:** Maria Bilinski Shain, art director. Circ. 50,000. Weekly 4-color cover tabloid; general interest alternative.

ILLUSTRATION Buys 5-10 illustrations/year. Prefers local (North Carolina) illustrators. Has featured illustrations by Tyler Bergholz, Keith Norvel, V. Cullum Rogers, Nathan Golub. Works on assignment only. Considers pen and ink; b&w, computer generated art and color.

FIRST CONTACT & TERMS Samples are filed or are returned by SASE if requested. Responds only if interested. Pays on publication; $150 for cover illustrations; $25-50 for inside illustrations.

TIPS "Have a political and alternative point of view. Understand the peculiarities of newsprint. Be easy to work with. No prima donnas."

INDUSTRYWEEK

The Penton Media Building, 1300 E. 9th St., Cleveland OH 44114. (216)931-9488. **E-mail:** Bill.Szilagyi@industryweek.com. **Website:** www.industryweek.com. **Contact:** Bill Szilagyi, art director. Estab. 1882. Circ. 200,000+. Weekly business magazine written for industry executives and key decision makers looking for insight into the latest business developments in the manufacturing world.

ILLUSTRATION Approached by 150 illustrators/year. Buys 75 illustrations/year. Has featured illustrations by Patrick Corrigan, Dave Joly, Vala Kondo. Features humorous, informational and spot illustrations of business. Assigns 10% to new and emerging illustrators. 10% of freelance illustration demands knowledge of Illustrator.

FIRST CONTACT & TERMS Illustrators: Send query letter with URL. After introductory mailing, send follow-up postcard sample every 2-3 months. Accepts e-mail submissions with link to website. Prefers JPEG files. Samples are filed. Responds only if interested. Art Director will contact artist for portfolio review if interested. Pays illustrators $250-700 for color inside. Pays on publication. Buys one-time rights. Finds freelancers through artists' submissions.

ISLANDS

460 N. Orlando Ave., Suite 200, Winter Park FL 32789. (407)628-4802. **E-mail:** editor@islands.com. **Website:** www.islands.com. **Contact:** Audrey St. Clair, managing editor. Estab. 1981. Circ. 500,000. 4-color travel magazine "exclusively about islands," published 8 times/year. Internships available for graphic artist students, photography, etc. Latest print issue has apps.

ILLUSTRATION Buys 0-1 illustrations/issue. Needs editorial illustration. Considers all media.

FIRST CONTACT & TERMS Illustrators: Send query letter with tearsheets. Samples are filed. Responds only if interested. Buys first rights or one-time rights. **Pays on acceptance:** $100-400 per image inside. Original artwork returned after publication.

JEWISH ACTION

Orthodox Union, 11 Broadway, New York NY 10004. (212)613-8146. **Fax:** (212)613-0646. **E-mail:** ja@ou.org; carmeln@ou.org. **Website:** www.ou.org/jewish_action. **Contact:** Nechama Carmel, editor; Rashel Zywica, assistant editor; Yocheved Lefkovitz, art director. Estab. 1986. Circ. 40,000. Quarterly magazine "published by Orthodox Union for members and subscribers. Orthodox Jewish contemporary issues." Sample copies can be seen on website.

CARTOONS Approached by 2 cartoonists/year. Prefers themes relevant to Jewish issues. Prefers single, double or multiple panel, political, humorous b&w washes and line drawings with or without gaglines.

ILLUSTRATION Approached by 4-5 illustrators. Considers all media. Assigns 50% of illustrations to experienced but not well-known illustrators; 50% to new and emerging illustrators. Knowledge of Photo-

shop, Illustrator and QuarkXPress "not absolutely necessary, but preferred."

DESIGN Needs freelancers for design and production. Prefers local design freelancers only.

FIRST CONTACT & TERMS Send query letter with photocopies and SASE. Accepts disk submissions. Prefer QuarkXPress TIFF or EPS files. Can send ZIP disk. Samples are not filed and are not returned. Responds only if interested. Art director will contact artist for portfolio review of photographs if interested. Buys one-time rights. Pays within 6 weeks of publication. Pays cartoonists $20-50 for b&w. Pays illustrators $25-75 for b&w, $50-300 for color cover; $50-200 for b&w, $25-150 for color inside. Finds illustrators through submissions.

TIPS Looking for "sensitivity to Orthodox Jewish traditions and symbols. Be aware that models must be clothed in keeping with Orthodox laws of modesty. Make sure to include identifying details. Don't send work depicting religion in general. We are specifically Orthodox Jewish."

JOURNAL OF ACCOUNTANCY

AICPA, 220 Leigh Farm Rd., Durham NC 27707. (919)402-4449. **E-mail:** mjohnstone@aicpa.org. **Website:** www.aicpa.org; www.journalofaccountancy.com. **Contact:** Michael Schad Johnstone. Circ. 400,000. Monthly 4-color magazine of the American Institute of Certified Public Accountants that focuses on the latest news and developments related to the field of accounting for CPAs; corporate/business format.

ILLUSTRATION Approached by 200 illustrators/year. Buys 2-6 illustrations/issue. Prefers business, finance and law themes. Accepts mixed media, pen & ink, airbrush, colored pencil, watercolor, acrylic, oil, pastel and digital. Works on assignment only. 35% of freelance work demands knowledge of Illustrator, QuarkXPress and FreeHand.

FIRST CONTACT & TERMS Send query letter with brochure showing art style. Samples not filed are returned by SASE. Portfolio should include printed samples and tearsheets. Buys first rights. Pays on publication: $1,200 for color cover; $200-600 for color inside. Accepts previously published artwork. Original artwork returned after publication. Finds artists through submissions/self-promotions, sourcebooks and magazines.

TIPS "We look for indications that an artist can turn the ordinary into something extraordinary, whether it be through concept or style. In addition to illustrators, I also hire freelancers to do charts and graphs. In portfolios, I like to see tearsheets showing how the art and editorial worked together."

JOURNAL OF ASIAN MARTIAL ARTS

Via Media Publishing Co., 941 Calle Mejia, #822, Santa Fe NM 87501. (505)983-1919. **E-mail:** info@goviamedia.com. **Website:** www.goviamedia.com. Estab. 1991. Circ. 10,000. Quarterly journal covering all historical and cultural aspects of Asian martial arts. Interdisciplinary approach. College-level audience. Accepts previously published artwork. Sample copies available for $10. Art guidelines for SASE with first-class postage.

ILLUSTRATION Buys 150 illustrations/issue. Has featured illustrations by Oscar Ratti, Jon Parr, Guy Junker, and Michael Lane. Features realistic and medical illustration. Assigns 10% of illustrations to new and emerging illustrators.

FIRST CONTACT & TERMS Illustrators: Send query letter with brochure, résumé, SASE and photocopies. Accepts disk submissions compatible with PageMaker, QuarkXPress and Illustrator. Samples are filed. Responds in 6 weeks. Publication will contact artist for portfolio review if interested. Portfolio should include b&w roughs, photocopies and final art. Buys first rights and reprint rights. Pays on publication; $100-300 for color cover; $10-100 for b&w inside; $100-150 for 2-page spreads.

TIPS "Artists should see our journal and our website for reference, because it is unlike other martial art magazines. We can be found in bookstores, libraries or in listings of publications. Areas most open to freelancers are illustrations of historic warriors, weapons, castles, battles—any subject dealing with the martial arts of Asia. If artists appreciate aspects of Asian martial arts or Asian culture, we would appreciate seeing their work and discuss the possibilities of collaboration."

JUDICATURE

2700 University Ave., Des Moines IA 50311. (773)973-0145. **Fax:** (773)338-9687. **E-mail:** bharris@ajs.org. **Website:** www.ajs.org. **Contact:** Bonnie Harris, editor. Estab. 1917. Circ. 5,000. Journal of the American Judicature Society. 4-color bimonthly publication. Accepts previously published material and computer illustration. Original artwork returned after publi-

cation. Sample copy for SASE with $1.73 postage; art guidelines not available.

CARTOONS Approached by 10 cartoonists/year. Buys 1-2 cartoons/issue. Interested in "sophisticated humor revealing a familiarity with legal issues, the courts and the administration of justice."

ILLUSTRATION Approached by 20 illustrators/year. Buys 1-2 illustrations/issue. Has featured illustrations by Estelle Carol, Mary Chaney, Jerry Warshaw and Richard Laurent. Features humorous and realistic illustration; charts & graphs; computer and spot illustration. Works on assignment only. Interested in styles from "realism to light humor." Prefers subjects related to court organization, operations and personnel. Freelance work demands knowledge of Quark and FreeHand.

DESIGN Needs freelancers for design. 100% of freelance work demands knowledge of Quark and FreeHand.

FIRST CONTACT & TERMS Cartoonists: Send query letter or e-mail with samples of style and SASE. Responds in 2 weeks. Illustrators: Send query letter, SASE, photocopies, tearsheets or brochure showing art style (can be sent electronically). Publication will contact artist for portfolio review if interested. Portfolio should include roughs and printed samples. Wants to see "b&w and color, along with the title and synopsis of editorial material the illustration accompanied." Buys one-time rights. Negotiates payment. Pays cartoonists $35 for unsolicited b&w cartoons. Pays illustrators $250-375 for 2-, 3- or 4-color cover; $250 for b&w full page, $175 for b&w half page inside; $75-100 for spots. Pays designers by the project.

TIPS "Show a variety of samples, including printed pieces and roughs."

KALEIDOSCOPE

Kaleidoscope Press, 701 S. Main St., Akron OH 44311-1019. (330)762-9755. **Fax:** (330)762-0912. **E-mail:** mshiplett@udsakron.org. **Website:** www.udsakron.org/kaleidoscope.htm. **Contact:** Mildred Shiplett. Estab. 1979. Circ. 1,000. Black & white with 4-color cover. Semiannual. "Elegant, straightforward design. Explores the experiences of disability through lens of the creative arts. Specifically seeking work by artists with disabilities. Work by artists without disabilities must have a disability focus." Accepts previously published artwork. Sample copy $6; art guidelines for SASE with first-class postage.

"Subscribers include individuals, agencies, and organizations that assist people with disabilities and many university and public libraries."

ILLUSTRATION Freelance art occasionally used with fiction pieces. More interested in publishing art that stands on its own as the focal point of an article. Approached by 15-20 artists/year. Has featured illustrations by Dennis J. Brizendine, Deborah Vidaver Cohen and Sandy Palmer. Features humorous, realistic and spot illustration.

FIRST CONTACT & TERMS Illustrators: Send query letter with résumé, photocopies, photographs, SASE and slides. 6-12 pieces maximum. Do not send originals. Prefers high contrast, b&w glossy photos, but will also review color photos or 35mm slides. Include sufficient postage for return of work. Samples are not filed. Publication will contact artist for portfolio review if interested. Acceptance or rejection may take up to a year. Pays $25-100 for color covers; $25-50 for b&w or color insides. Rights revert to artist upon publication. Finds artists through submissions/self-promotions and word of mouth.

TIPS "Inquire about future themes of upcoming issues. Considers all mediums, from pastels to acrylics to sculpture. Must be high-quality art."

KANSAS CITY MAGAZINE

7101 College Blvd., Suite 400, Overland Park KS 66210. (913)894-6923. **E-mail:** eswanson@anthempublishing.com. **Website:** www.kcmag.com. **Contact:** Leigh Elmore, editor. Estab. 1994. Circ. 31,000. Monthly lifestyle-oriented magazine, celebrating living in Kansas City. "Life's Better in KC" including: dining, shopping, home décor and local personalities." Sample copies available with SASE and first-class postage.

ILLUSTRATION Approached by 100-200 illustrators/year. Buys 3-5 illustrations/issue. Works on assignment only. Prefers conceptual editorial style. Considers all media. 25% of freelance illustration demands knowledge of Illustrator and Photoshop. Prefers local freelancers only.

DESIGN Does not need freelancers for design and production. Prefers local freelancers only. 100% of freelance work demands knowledge of Photoshop, Illustrator and QuarkXPress.

FIRST CONTACT & TERMS Illustrators: Send postcard-size sample or query letter with tearsheets, photocopies and printed samples. Accepts disk submissions compatible with Mac files (EPS, TIFF, Photo-

shop, etc.). Samples are filed. Will contact artist for portfolio review if interested. **Pays on acceptance**: rates vary by project.

TIPS "We have a high-quality, clean, cultural, creative format. Look at magazine before you submit."

KASHRUS MAGAZINE

The Kashrus Institute, P.O. Box 204, Brooklyn NY 11204. (718)336-8544. **E-mail:** editorial@kashrus magazine.com. **Website:** www.kashrusmagazine. com. **Contact:** Rabbi Wikler, editor. Estab. 1981. Circ. 10,000. "The periodical for the kosher consumer. We feature updates including mislabeled kosher products and recalls. Important for vegetarians, lactose intolerant and others with allergies."

CARTOONS Prefers food, dining, or Jewish humor cartoons.

FIRST CONTACT & TERMS Send query letter with photographs, call for follow-up. Byline given. Pays on publication. Submit seasonal materials 2 months in advance. Responds in 2 weeks.

KENTUCKY LIVING

Kentucky Association of Electric Co-Ops, P.O. Box 32170, Louisville KY 40232. (502)451-2430. **Fax:** (502)459-1611. **E-mail:** e-mail@kentuckyliving.com. **Website:** www.kentuckyliving.com. Estab. 1948. Circ. 500,000. Monthly 4-color magazine emphasizing Kentucky-related and general feature material for Kentuckians living outside metropolitan areas.

CARTOONS Approached by 10-12 cartoonists/year.

ILLUSTRATION Buys occasional illustrations. Works on assignment only. Prefers b&w line art.

FIRST CONTACT & TERMS Illustrators: Send query letter with résumé and samples. Samples not filed are returned only if requested. Buys one-time rights. **Pays on acceptance.** Pays cartoonists $30 for b&w. Pays illustrators $50 for b&w inside. Accepts previously published material. Original artwork returned after publication if requested.

KEY CLUB MAGAZINE

Kiwanis International, 3636 Woodview Trace, Indianapolis IN 46268. (317)875-8755. **E-mail:** magazine@kiwanis.org; keyclub@kiwanis.org. **Website:** www. keyclub.org. Circ. 250,000. One printed/digital and one digital-only annual magazine with "contemporary design for mature teenage audience." Free sample copy for SASE with 3 first-class postage stamps.

◯ Kiwanis International also publishes *Circle K* and *Kiwanis* magazines; see separate listings in this section.

ILLUSTRATION Buys 3 editorial illustrations/issue. Works on assignment only.

FIRST CONTACT & TERMS Include SASE. Responds in 2 weeks. Simultaneous submissions OK. Original artwork is returned after publication by request. Buys first rights. Pays on receipt of invoice: $100 for b&w cover; $250 for color cover; $50 for b&w inside; $150 for color inside.

KIPLINGER'S PERSONAL FINANCE

1729 H St. NW, Washington DC 20006. (202)887-6400. **Fax:** (202)331-1206. **E-mail:** jbodnar@kiplinger. com. **Website:** www.kiplinger.com. **Contact:** Janet Bodnar, editor; Cynthia L. Currie, art director. Estab. 1947. Circ. 800,000. Monthly 4-color magazine covering personal finance issues such as investing, saving, housing, cars, health, retirement, taxes and insurance.

ILLUSTRATION Approached by 350 illustrators/year. Buys 4-6 illustrations/issue. Works on assignment only. Has featured illustrations by Alison Sieffer, Harry Campbell, Dan Page, Mark Smith, A. Richard Allen and James O'Brien. Features computer, conceptual editorial and spot illustration. Assigns 5% of illustrations to new and emerging illustrators. Interested in editorial illustration in new styles, including computer illustration.

FIRST CONTACT & TERMS Illustration: Send postcard or e-mail samples. Accepts Mac-compatible CD submissions. Samples are filed or returned by SASE if requested by artist. Will contact artist for portfolio review if interested. Buys one-time rights. Pays on publication: $400-1,200 for color inside; $250-500 for spots. Finds illustrators through reps, online, magazines, *Workbook* and award books. Originals are returned at job's completion.

KIWANIS

Kiwanis International, 3636 Woodview Trace, Indianapolis IN 46268-3196. (317)875-8755; (800)549-2647 [dial 411] (US and Canada only). **Fax:** (317)879-0204. **E-mail:** magazine@kiwanis.org; shareyourstory@ kiwanis.org. **Website:** www.kiwanis.org. **Contact:** Jack Brockley, editor. Estab. 1917. Circ. 240,000. Bimonthly 4-color magazine emphasizing issues affecting children, organizational news and inspiring stories about Kiwanis service achievements worldwide.

Sample copy available with SASE and 5 first-class postage stamps.

ILLUSTRATION Buys 1-2 illustrations/issue. Assigns themes that correspond to themes of articles. Works on assignment only. Keeps material on file after in-person contact with artist.

FIRST CONTACT & TERMS Illustration: Include SASE. Responds in 2 weeks. To show a portfolio, mail appropriate materials (out of town/state) or call or write for appointment. Portfolio should include roughs, printed samples, final reproduction/product, color and b&w tearsheets, photostats and photographs. Original artwork returned after publication by request. Buys first rights. Pays $100-1,000 for art/illustration. Use 5% illustration. Finds artists through talent sourcebooks, references/word of mouth and portfolio reviews.

TIPS "Provide plenty of samples that show consistency."

LADYBUG

Carus Publishing Co., 700 E. Lake St., Suite 300, Chicago IL 60601. (312)701-1720. **Website:** www.cricketmag.com. **Contact:** Marianne Carus, editor-in-chief; Suzanne Beck, managing art director. Estab. 1990. Circ. 125,000. Monthly 4-color magazine emphasizing literature and activities for children ages 2-6. Our "bug magazines" accept unsolicited manuscripts. Art guidelines available on website.

○ See also listings in this section for other magazines published by the Cricket Magazine Group: *Babybug*, *Spider*, *Cricket* and *Cicada*.

ILLUSTRATION Buys 200 illustrations/year. Prefers realistic styles (animal, wildlife or human figure); occasionally accepts caricatures. Works on assignment only.

FIRST CONTACT & TERMS Send photocopies, photographs or tearsheets to be kept on file. Samples are returned by SASE if requested. Responds in 3 months. Buys all rights. **Pays 45 days after acceptance:** $750 for color cover; $250 for color full page; $100 for color spots; $50 for b&w spots.

TIPS "Before attempting to illustrate for *Ladybug*, be sure to familiarize yourself with this age group, and read several issues of the magazine. Please do not query first."

L.A. PARENT

443 E. Irving Dr., Suite A, Burbank CA 91504. (818)846-0400. **Fax:** (818)841-4380. **E-mail:** teresa. burgess@parenthood.com. **Website:** www.laparent. com. **Contact:** Terresa Burgess, graphic designer. Estab. 1979. Circ. 120,000. Monthly regional magazine for parents. 4-color throughout; "bold graphics and lots of photos of kids and families." Accepts previously published artwork. Originals are returned at job's completion.

ILLUSTRATION Buys 2 freelance illustrations/issue. Assigns 50% of illustrations to experienced but not well-known illustrators; 50% to new and emerging illustrators. Works on assignment only.

FIRST CONTACT & TERMS Send postcard sample. Accepts disk submissions compatible with Illustrator 5.0 and Photoshop 3.0. Samples are filed or returned by SASE. Responds in 2 months. To show a portfolio, mail thumbnails, tearsheets and photostats. Buys one-time rights or reprint rights. **Pays on publication:** $300 color cover; $75 for b&w inside; $50 for spots.

TIPS "Show an understanding of our publication. Since we deal with parent/child relationships, we tend to use fairly straightforward work. Also looking for images and photographs that capture an L.A. feel. Read our magazine and find out what we're all about."

LATINA

Latina Media Ventures, LLC, 625 Madison Ave, 3rd Floor, New York NY 10022. (212)642-0200. **Fax:** (212)575-3088. **E-mail:** editor@latina.com. **Website:** www.latina.com. **Contact:** Art director. Estab. 1996. Circ. 397,447. Monthly consumer magazine for Hispanic women living in the United States who have strong ties to their Latin roots. Features articles on successful Latina women, health, careers, family life, fitness, parenting, fashion, beauty and entertainment.

ILLUSTRATION Approached by 100 illustrators/year. Buys 10-15 illustrations/year. Features caricatures of Hispanic celebrities, humorous illustration and spot illustrations of families and women. Assigns 25% to new and emerging illustrators.

FIRST CONTACT & TERMS Send postcard sample with URL. After introductory mailing, send follow-up postcard sample every 4-6 months. Responds only if interested. Pays $100-400 for color inside. Buys one-time rights. Find freelancers through submissions.

LAW PRACTICE MANAGEMENT

American Bar Association Headquarters, 321 N. Clark St., Chicago IL 60654-7598. (847)550-9790. **E-mail:** releases@americanbar.org. **Website:** www. abanet.org/lpm. **Contact:** creative director. Estab.

1975. Circ. 20,833. 4-color trade journal for the practicing lawyer about "the business of practicing law." Published 8 times/year.

ILLUSTRATION Uses cover and inside feature illustrations. Uses all media, including computer graphics. Mostly 4-color artwork.

FIRST CONTACT & TERMS Illustrators: Send postcard sample or query letter with samples. Pays on publication. Very interested in high-quality, previously published works. Pay rates $200-350/illustration. Original works negotiable. Cartoons very rarely used.

TIPS "Topics focus on management, marketing, communications and technology."

LOG HOME LIVING

Home Buyer Publications, Inc., 4125 Lafayette Center Dr., Suite 100, Chantilly VA 20151. (703)222-9411; (800)826-3893. **Fax:** (703)222-3209. **E-mail:** editor@loghomeliving.com; ksmith@homebuyerpubs.com. **Website:** www.loghomeliving.com. Estab. 1989. Circ. 132,000. Monthly 4-color magazine "dealing with the aspects of buying, building and living in a log home. We emphasize upscale living (decorating, furniture, etc)." Accepts previously published artwork. Sample copies not available. Art guidelines with SASE with first-class postage. 20% of freelance work demands knowledge of QuarkXPress, Illustrator and Photoshop.

ILLUSTRATION Buys 2-4 illustrations/issue. Works on assignment only. Prefers editorial illustration with "a strong style—ability to show creative flair with not-so-creative a subject." Considers watercolor, airbrush, colored pencil, pastel and digital illustration.

DESIGN Needs freelancers for design and production occasionally. 100% of freelance work demands knowledge of Photoshop, Illustrator, QuarkXPress and InDesign.

FIRST CONTACT & TERMS Illustrators: Send postcard sample. Designers: Send query letter with brochure, résumé, and samples. Accepts disk submissions compatible with Illustrator, Photoshop and QuarkXPress. Samples are filed. Publication will contact artist for portfolio review if interested. Portfolio should include thumbnails, roughs, printed samples or color tearsheets. Buys all rights. **Pays on acceptance**. Pays illustrators $100-200 for b&w inside; $250-800 for color inside; $100-250 for spots. Pays designers by the project. Finds artists through submissions/self-promotions, sourcebooks.

THE LOOKOUT

(513)931-4050. **Fax:** (513)931-0950. **E-mail:** lookout@standardpub.com. **Website:** www.lookoutmag.com. Sheryl Overstreet, assistant editor. **Contact:** Shawn McMullen, editor. Estab. 1894. Circ. 45,000. Weekly 4-color magazine for conservative Christian adults and young adults. Sample copy available for $1.

ILLUSTRATION "We no longer publish cartoons."

TIPS "Do not send e-mail submissions. We publish strictly by theme list."

LOS ANGELES MAGAZINE

5900 Wilshire Blvd., 10th Floor, Los Angeles CA 90036. (323)801-0100. **Fax:** (323)801-0105. **E-mail:** lamagedit@lamag.com. **Website:** www.losangelesmagazine.com. Circ. 170,000. Monthly 4-color magazine with a contemporary, modern design, emphasizing lifestyles, cultural attractions, pleasures, problems and personalities of Los Angeles and the surrounding area. Especially needs very localized contributors—custom projects needing person-to-person concepting and implementation. Previously published work OK. 10% of freelance work demands knowledge of QuarkXPress, Illustrator and Photoshop.

ILLUSTRATION Buys 10 illustrations/issue on assigned themes. Prefers general interest/lifestyle illustrations with urbane and contemporary tone. To show a portfolio, send or drop off samples showing art style (tearsheets, photostats, photocopies and dupe slides).

FIRST CONTACT & TERMS Pays on publication; negotiable.

TIPS "Show work similar to that used in the magazine. Study a particular publication's content, style and format. Then proceed accordingly in submitting sample work. We initiate contact of new people per *Showcase* reference books or promo flyers sent to us. Portfolio viewing is all local."

LUCKY

Conde Nast Publications, 4 Times Square, New York NY 10036. (212)286-2860. **Fax:** (212)286-4654. **E-mail:** info@condenast.com. **Website:** www.luckymag.com. **Contact:** Art director. Estab. 2002. Circ. 1,161,200+. Monthly consumer magazine focusing on shopping, fashion, beauty and lifestyles for women. Provides upbeat, practical tips on shopping, latest fashion accessories and new items.

ILLUSTRATION Approached by hundreds of illustrators/year. Buys 35 illustrations/year. Features fashion

illustration, humorous illustration and spot illustrations of women.

FIRST CONTACT & TERMS Illustrators: Send postcard sample or e-mail with link to website. After introductory mailing, send follow-up postcard sample every 3-6 months. Samples are filed. Responds only if interested. Pays illustrators $200-500 for color inside. Buys one-time rights. Finds freelancers through sourcebooks.

LULLWATER REVIEW

Emory University, P.O. Box 122036, Atlanta GA 30322. **Fax:** (404)727-7367. **E-mail:** lullwater@lullwaterreview.com. **E-mail:** emorylullwaterreview@gmail.com. **Contact:** Rachel Wisotsky, co-editor-in-chief. Estab. 1990. Circ. 2,000. "We're a small, student-run literary magazine published out of Emory University in Atlanta, GA with two issues yearly—once in the fall and once in the spring. You can find us in the *Index of American Periodical Verse*, the *American Humanities Index* and as a member of the Council of Literary Magazines and Presses. We welcome work that brings a fresh perspective, whether through language or the visual arts."

FIRST CONTACT & TERMS Send an e-mail with photos. Samples kept on file. Portfolio should include b&w, color, photos and finished, original art. Credit line given when appropriate.

TIPS "Read our magazine. We welcome work of all different types, and we encourage submissions that bring a fresh or alternative perspective. Submit at least 5 works. We frequently accept 3-5 pieces from a single artist and like to see a selection."

THE MACGUFFIN

18600 Haggerty Rd., Livonia MI 48152-2696. (734)462-4400, ext 5327. **E-mail:** macguffin@schoolcraft.edu. **Website:** www.macguffin.org. **Contact:** Steven A. Dolgin, editor; Nicholle Cormier, managing editor; Elizabeth Kircos, fiction editor. Estab. 1984. "*The MacGuffin* is a literary magazine that publishes a range of material including poetry, creative non-fiction, fiction and art. Material ranges from traditional to experimental. Our periodical attracts a variety of people with many different interests."

FIRST CONTACT & TERMS Send an e-mail with samples. "Please submit name and contact information with your work, along with captions." Samples not kept on file. Portfolio not required. Credit line given.

TIPS "We look for colorful, interesting cover art and high-quality b&w photos for use inside each magazine. Visit www.macguffin.org for cover samples."

MAD MAGAZINE

1700 Broadway, New York NY 10019. (212)506-4850. **Fax:** (212)506-4848. **E-mail:** submissions@madmagazine.com. **Website:** www.madmag.com. Estab. 1952. Monthly magazine always on the lookout for new ways to spoof and to poke fun at hot trends.

ILLUSTRATION Approached by 300 illustrators/year. Works with 50 illustrators/year. Has featured illustrations by Mort Drucker, Al Jaffee, Sergio Aragonés, Peter Kuper, Drew Friedman, Tom Richmond and Hermann Mejia. Features humor, realism, caricature.

DESIGN Uses local freelancers for design infrequently. 100% of freelance design demands knowledge of Illustrator, Photoshop and QuarkXPress.

FIRST CONTACT & TERMS Illustrators: Send query letter with tearsheets and SASE. Samples are filed. Buys all rights. Pays $2,000 for color cover; $300-500 for inside. Finds illustrators through direct mail, sourcebooks (all).

TIPS "Know what we do! *MAD* is very specific. Everyone wants to work for *MAD*, but few are right for what *MAD* needs! Understand reproduction process, as well as give-and-take between artist and client."

MAIN LINE TODAY

4699 W. Chester Pike, Newtown Square PA 19073. (610)325-4630. **Fax:** (610)325-4636. **E-mail:** ilynch@mainlinetoday.com. **Website:** www.mainlinetoday.com. Estab. 1996. Circ. 40,000. Monthly consumer magazine providing quality information to the Main Line and western suburbs of Philadelphia. Sample copy available with #10 SASE and first-class postage.

ILLUSTRATION Approached by 100 illustrators/year. Buys 3-5 illustrations/issue. Considers acrylic, charcoal, collage, color wash, mixed media, oil, pastel and watercolor.

FIRST CONTACT & TERMS Send postcard sample or query letter with printed samples and tearsheets. Send follow-up postcard sample every 3-4 months. Samples are filed and not returned. Responds only if interested. Buys one-time and reprint rights. Pays on publication: $400 maximum for color cover; $125-250 for b&w or color inside; $125 for spots. Finds illustrators by word of mouth and submissions.

MANAGED CARE

Medimedia USA, 780 Township Line Rd., Yardley PA 19067. (267)685-2562. **Fax:** (267)775-5086. **E-mail:** pdenlinger@medimedia.com. **Website:** www.man agedcaremag.com. **Contact:** Philip Denlinger, art director. Estab. 1992. Circ. 30,000. Monthly trade publication for healthcare executives.

ILLUSTRATION Approached by 50 illustrators/ year. Buys 3 illustrations/issue. Has featured illustrations by Theo Rudnak, David Wilcox, Gary Overacre, Roger Hill. Features informational graphics, realistic and spot illustration. Prefers business subjects. Assignments for illustrations divided equally between well-known or name illustrators; experienced, but not well-known, illustrators; and new and emerging illustrators.

FIRST CONTACT & TERMS Send postcard sample. Samples are filed. Will contact artist for portfolio review if interested. Rights purchased vary according to project. **Pays on acceptance**; $1,500-2,000 for color cover; $250-750 for color inside; $450 for spots. Finds illustrators through *American Showcase* and postcards.

MANAGING AUTOMATION (MA)

Thomas Publishing Company, LLC, 5 Penn Plaza, 9th Floor, New York NY 10001. (212)629-1519. **E-mail:** pgallof@thomaspublishing.com. **E-mail:** info@man agingautomation.com. **Website:** www.managingauto mation.com. **Contact:** Phillip Gallof, art production specialist. Estab. 1986. Circ. 100,000+. Monthly business magazine written for personnel involved in computer integrated manufacturing. Covers technical, financial and organizational concerns.

ILLUSTRATION Approached by 50 illustrators/year. Buys 10 illustrations/year. Features humorous, informational and spot illustrations of computers and business. Assigns 10% to new and emerging illustrators. 20% of freelance illustration demand knowledge of Illustrator and Photoshop.

FIRST CONTACT & TERMS Illustrators: Send postcard sample with URL. After introductory mailing, send follow-up postcard sample every 6 months. Accepts e-mail submissions with link to website. Prefers TIFF files. Samples are filed. Responds only if interested. Company will contact artist for portfolio review if interested. Pays $200-500 for color inside. Pays on publication. Buys one-time rights. Finds freelancers through artists' submissions.

◐ MARKETING MAGAZINE

One Mount Pleasant Rd., 7th Floor, Toronto ON M4Y 2Y5, Canada. (416)764-1563. **E-mail:** peter.zaver@ marketingmag.rogers.com. **Website:** www.market ingmag.ca. **Contact:** Peter Zaver, art director. Estab. 1980. Circ. 13,000. Weekly trade publication featuring news, commentary and articles on advertising, promotion, direct marketing, public relations and digital marketing in Canada. Sample copies available on request. Art guidelines available on website.

ILLUSTRATION Approached by 150 illustrators/year. Buys 10 illustrations/year. Features humorous illustration and spot illustrations of business.

FIRST CONTACT & TERMS Illustrators: Send postcard sample with tearsheets. Responds only if interested. Buys one-time rights.

MEN'S HEALTH

Rodale, Inc., 400 S. Tenth St., Emmaus PA 18098-0099. (212)697-2040. **E-mail:** mhletters@rodale.com. **Website:** www.menshealth.com. **Contact:** George Karabotsos, art director. Men's fitness/lifestyle magazine. Art guidelines not available.

CARTOONS Buys 10 cartoons/year.

ILLUSTRATION Buys 100 illustrations/year. Has featured illustrations by Daniel Adel, Gary Taxali, Eboy, Mirkoilic, Jonathan Carlson. Features caricatures of celebrities/politicians, realistic illustration, charts & graphs, humorous illustration, medical illustration, computer illustration, informational graphics, spot illustrations. Prefer subjects about men. 100% of freelance work demands computer skills. Freelancers should be familiar with InDesign, Illustrator, Photoshop. E-mail submissions accepted with link to website. Samples are not filed and are not returned. Portfolio not required.

MGW NEWSMAGAZINE

Guess What Media, LLC, 1123 21st St., Suite 201, Sacramento CA 95811. (916)441-6397. **Fax:** (206)339-5864. **E-mail:** editor@momguesswhat.com. **Website:** www.mgwnews.com. **Contact:** Matthew Burlingame, editorial director. Estab. 1978. Circ. 21,000. Bimonthly publication featuring politics and commentary, interviews, local and national news, feature articles and investigative pieces. Highlighting the West Coast's progressive lifestyle are sections on automotive, gardening, home improvement, fashion, entertainment, travel and technology, as well as reviews of restaurants, theater, opera, film, art, books

and music. "With a continued focus on quality of reporting and writing, *MGW* is the place to read about the issues that affect one's local community as well as the greater society in which we live." Sample copies available with SASE and first-class postage.

CARTOONS Approached by 15 cartoonists/year. Buys 5 cartoons/issue. Prefers gay/lesbian themes. Prefers single and multiple panel, political and humorous b&w line drawings with gagline. Pays cartoonists $5-50 for b&w.

ILLUSTRATION Approached by 10 illustrators/year. Buys 3 illustrations/issue. Features caricatures of celebrities; humorous, realistic and spot illustration. Prefers gay/lesbian themes. Considers pen & ink. Assigns 50% of illustration to new and emerging illustrators. 50% of freelance illustration demands knowledge of PageMaker.

DESIGN Needs freelancers for design and production. Prefers local designers. 100% of freelance work demands knowledge of PageMaker 6.5, QuarkXPress, Photoshop, FreeHand, InDesign.

FIRST CONTACT & TERMS Cartoonists: Send query letter with photocopies and SASE. Illustrators: Send query letter with photocopies. Art director will contact artist for portfolio review of b&w photostats if interested. Rights purchased vary according to project. Pays on publication: $100 for b&w or color cover; $10-100 for b&w or color inside; $300 for 2-page spreads; $25 for spots. Finds illustrators through word of mouth and submissions.

TIPS "Send us copies of your ideas that relate to gay/lesbian issues—serious and humorous."

MICHIGAN OUT-OF-DOORS

P.O. Box 30235, Lansing MI 48909. (517)371-1041. **Fax:** (517)371-1505. **E-mail:** thansen@mucc.org; magazine@mucc.org. **Website:** www.michiganoutofdoors.com. **Contact:** Tony Hansen, editor. Estab. 1947. Circ. 40,000. Four-color magazine emphasizing hunting and fishing. Six print issues/year with 4 additional digital-only issues.

ILLUSTRATION "Following the various hunting and fishing seasons, we have a limited need for illustration material; we consider submissions 6-8 months in advance." Has featured illustrations by Ed Sutton and Nick Van Frankenhuyzen. Assigns 10% of illustrations to new and emerging illustrators.

FIRST CONTACT & TERMS Responds as soon as possible. **Pays on acceptance;** $30 for pen & ink illustrations in a vertical treatment.

MID-AMERICAN REVIEW

Bowling Green State University, Department of English, Box W, Bowling Green OH 43403. (419)372-2725. **E-mail:** mikeczy@bgsu.edu. **Website:** www.bgsu.edu/midamericanreview. **Contact:** Michael Czyzniejewski. Estab. 1981. Circ. 700. Semiannual literary magazine publishing "the best contemporary poetry, fiction, essays, and work in translation we can find. Each issue includes poems in their original language and in English." Reads all year. Originals are returned at job's completion. Sample copies available for $5.

ILLUSTRATION Approached by 10-20 illustrators/year. Buys 1 illustration/issue.

FIRST CONTACT & TERMS Send query letter with brochure, SASE, tearsheets, photographs and photocopies. Samples are filed or are returned by SASE if requested by artist. Responds in 3 months. Buys first rights. Pays on publication. Pays $50 when funding permits. Also pays in copies, up to 20.

TIPS "*MAR* only publishes artwork on its cover. We like to use the same artist for 1 volume (2 issues). We are looking for full-color artwork for a front-to-back, full bleed effect. Visit our website!"

THE MILITARY OFFICER

201 N. Washington St., Alexandria VA 22314. (703)549-2311; (800)234-6622. **E-mail:** editor@moaa.org. **Website:** www.moaa.org. Estab. 1945. 4-color magazine for retired and active duty military officers of the uniformed services; concerns current military/political affairs; recent military history, especially Vietnam, Korea and Iraq; holiday anecdotes; travel; human interest; humor; hobbies; second-career job opportunities and military family lifestyle.

ILLUSTRATION Works with 9-10 illustrators/year. Buys 15-20 illustrations/year. Buys illustrations on assigned themes. Uses freelancers mainly for features and covers.

FIRST CONTACT & TERMS Send samples.

TIPS "We look for artists who can take a concept and amplify it editorially."

MODEL RAILROADER

21027 Crossroads Circle, P.O. Box 1612, Waukesha WI 53187-1612. **E-mail:** mrmag@mrmag.com. **Website:** www.modelrailroader.com. Circ. 230,000. Monthly magazine for hobbyists, rail fans. Sample copies

available with 9×12 SASE and first-class postage. Art guidelines available.

○ Published by Kalmbach Publishing. Also publishes *Classic Toy Trains*, *Astronomy*, *Finescale Modeler*, *Model Retailer*, *Nutshell News* and *Trains*.

CARTOONS Prefers railroading themes. Prefers b&w line drawings with gagline.

ILLUSTRATION Prefers railroading, construction, how-to. Considers all media. 90% of freelance illustration demands knowledge of Photoshop 3.0, Illustrator 6.0, FreeHand 3.0, QuarkXPress 3.31 and Fractal Painter.

FIRST CONTACT & TERMS Submission guidelines available online.

MOMENT

4115 Wisconsin Ave. NW, Suite 102, Washington DC 20016. (202)363-6422. **Fax:** (202)362-2514. **E-mail:** editor@momentmag.com. **Website:** www.moment mag.com. Estab. 1973. Circ. 65,000. Bimonthly Jewish magazine, featuring articles on religion, politics, culture and Israel. Accepts previously published artwork. Originals returned at job's completion. Sample copies available for $4.50.

CARTOONS Uses reprints and originals. Prefers political themes relating to Middle East, Israel and contemporary Jewish life.

ILLUSTRATION Buys 5-10 illustrations/year. Works on assignment only.

FIRST CONTACT & TERMS Send query letter. Samples are filed. Responds only if interested. Rights purchased vary according to project. Pays cartoonists minimum of $30 for ¼ page, b&w and color. Pays illustrators $30 for b&w, $225 for color cover; $30 for color inside (¼ page or less).

TIPS "We look for specific work or style to illustrate themes in our articles. Please know the magazine—read back issues!"

MONTANA MAGAZINE

Lee Enterprises, P.O. Box 5630, Helena MT 59604-5630. **E-mail:** editor@montanamagazine.com; butch. larcombe@lee.net. **Website:** www.montanamagazine. com. **Contact:** Butch Larcombe, editor. Estab. 1970. Circ. 40,000. Bimonthly. Covers Montana recreation, history, people, wildlife. Geared to Montanans.

ILLUSTRATION Approached by 15-20 illustrators/year. Buys 1-2 illustrations/year. Prefers outdoors. Considers all media. Knowledge of QuarkXPress,

Photoshop, Illustrator helpful but not required. Send query letter with photocopies. Accepts disk submissions compatible with QuarkXPress.

FIRST CONTACT & TERMS Submission guidelines available online.

TIPS "We work with local artists usually because of convenience and turnaround." No cartoons.

⊕ MOONSHOT MAGAZINE

416 Broadway, 3rd Floor, Brooklyn NY 11211. **E-mail:** info@moonshotmagazine.org. **Website:** moonshot-magazine.org. **Contact:** JD Scott, editor. Estab. 2009. Circ. 200. "*Moonshot*, a magazine of the literary and fine arts, was conceived in 2009 to provide an equal opportunity space for writers and artists based solely on the merits of their work. Moonshot's mission is to eliminate the social challenges of publishing—encouraging all types of writers and artists to submit their work in the pursuit of exposing their creations to a wider range of audiences. It is our goal to utilize traditional printing techniques as well as new technologies and media arts to feature voices from all over the globe. Moonshot celebrates storytelling of all forms, embraces the dissemination of media, and champions diverse creators to construct an innovative and original literary magazine."

THE MORGAN HORSE

American Morgan Horse Association, 4066 Bostick Rd., Suite 5, Shelburne VT 05482-6908. (802)985-4944. **Fax:** (802)985-8897. **Website:** www.morgan horse.com. **Contact:** Publications department. Circ. 4,500. Emphasizes all aspects of Morgan horse breed including educating Morgan owners, trainers and enthusiasts on breeding and training programs; the true type of the Morgan breed; techniques on promoting the breed; how-to articles; as well as preserving the history of the breed. Monthly. Accepts previously published material, simultaneous submissions. Original artwork returned after publication. Sample copy $4.

ILLUSTRATION Approached by 10 illustrators/year. Uses artists mainly for editorial illustration and mechanical production. "Line drawings are most useful for magazine work. We also purchase art for promotional projects dealing with the Morgan horse; horses must look like Morgans."

FIRST CONTACT & TERMS Illustrators: Send query letter with samples and tearsheets. Accepts "anything that clearly shows the artist's style and craftsmanship"

as samples. Buys all rights or negotiates rights purchased. **Pays on acceptance**; $25-100 for b&w; $100-300 for color inside.

TIPS As trend sees "more of an effort on the part of art directors to use a broader style. Magazines seem to be moving toward more interesting graphic design. Our magazine design is a sophisticated blend of conservative and tasteful contemporary design. While style varies, the horses in our illustrations must be unmistakably Morgans."

⬤ MORPHEUS TALES

116 Muriel St., London N1 9QU, United Kingdom. **E-mail:** morpheustales@blueyonder.co.uk. **Website:** www.morpheustales.com. **Contact:** Adam Bradley, publisher. Estab. 2008. Circ. 1,000. Publishes experimental fiction, fantasy, horror and science fiction. Publishes 4-6 titles/year.

ILLUSTRATION "Look at magazine and website for style." Portfolio should include b&w, color, finished and original art.

FIRST CONTACT & TERMS Responds within 30 days. Model and property release are required. Publisher buys first rights, electronic rights, which may vary according to the project.

MOTHER JONES

Foundation for National Progress, 222 Sutter St., Suite 600, San Francisco CA 94108. (415)321-1700. **E-mail:** query@motherjones.com. **Website:** www. motherjones.com. **Contact:** Monika Bauerlein and Clara Jeffery, editors. Estab. 1976. Circ. 240,000. Bimonthly magazine covering politics, investigative reporting, social issues, and pop culture. Accepts previously published artwork. Originals returned at job's completion. Sample copies available.

⬤ "*Mother Jones* is a 'progressive' magazine—but the core of its editorial well is reporting (i.e., fact-based). No slant required. MotherJones. com is an online sister publication."

CARTOONS Approached by 25 cartoonists/year. Prints one cartoon/issue (6/year). Prefers full page, multiple-frame color drawings. Works on assignment only.

ILLUSTRATION "Approached by hundreds of illustrators/year. *Mother Jones* sees powerful, smart illustration as an essential part of serious journalism. Artists who have appeared in *Mother Jones* include Barry Blitt, Steve Brodner, Tomer Hanuka, Yuko Shimizu, and Ralph Steadman; and work from our pages has appeared in top illustration showcases from *American Illustration* to *Juxtapoz*. If this is where you're headed, we'd like to hear from you. It's best to give us a URL for a portfolio website. Or you can mail non-returnable samples or disks to: Carolyn Perot, art director. Please do not submit original artwork or any samples that will need to be returned. Assigns 90% of illustrations to well-known or 'name' illustrators; 5% to experienced but not well-known illustrators; 5% to new and emerging illustrators. Works on assignment only. Considers all media."

FIRST CONTACT & TERMS Cartoonists: Send query letter with postcard-size sample or finished cartoons. Illustrators: Send postcard-size sample or query letter with samples. Samples are filed or returned by SASE. Responds to the artist only if interested. Portfolio should include photographs, slides and tearsheets. Buys first rights. Pays on publication; payment varies widely. Finds artists through illustration books, other magazines, word of mouth.

MUSHING.COM MAGAZINE

P.O. Box 1195, Willow AK 99688. (907)495-2468. **E-mail:** editor@mushing.com. **Website:** www.mushing. com. **Contact:** Greg Sellentin, managing editor. Estab. 1987. Circ. 10,000. Bimonthly "year-round, international magazine for all dog-powered sports, from sledding to skijoring to weight pulling to carting to packing. We seek to educate and entertain." Photo/art originals are returned at job's completion. Sample copies available for $5. Art guidelines available upon request.

CARTOONS Approached by 20 cartoonists/year. Buys up to 1 cartoon/issue. Prefers humorous cartoons; single panel b&w line drawings with gagline.

ILLUSTRATION Approached by 20 illustrators/year. Buys 0-1 illustrations/issue. Prefers simple; healthy, happy sled dogs; some silhouettes. Considers pen & ink and charcoal. Send query letter with SASE and photocopies. Accepts disk submissions if Mac compatible.

FIRST CONTACT & TERMS Cartoonists: Send query letter with roughs. Illustrators: Send EPS or TIFF files with hardcopy. Samples are returned by SASE if requested by artist. Prefers to keep copies of possibilities on file and use as needed. Responds in 6 months. Portfolio review not required. Buys first rights and reprint rights. Pays on publication. Pays cartoonists $25 for b&w and color. Pays illustrators $150 for color cover;

$25 for b&w and color inside; $25 for spots. Finds artists through submissions.

TIPS "Be familiar with sled dogs and sled dog sports. We're most open to using freelance illustrations with articles on dog behavior, adventure stories, health and nutrition. Illustrations should be faithful and/or accurate to the sport. Cartoons should be faithful and tasteful (e.g., not inhumane to dogs)."

NA'AMAT WOMAN

350 Fifth Ave., Suite 4700, New York NY 10118. (212)563-5222. **Fax:** (212)563-5710. **E-mail:** naamat@naamat.org; judith@naamat.org. **Website:** www.naamat.org. **Contact:** Judith Sokoloff, editor. Estab. 1926. Circ. 15,000. Quarterly magazine for Jewish women, covering a wide variety of topics that are of interest to the Jewish community. Affiliated with NA'AMAT USA (a nonprofit organization). Sample copies available for $2 each.

ILLUSTRATION Approached by 30 illustrators/year. Buys 2-3 illustrations/issue. We publish in 4-color through out the issue. Has featured illustrations by Julie Delton, Ilene Winn-Lederer, Avi Katz, Marilyn Rose and Yevgenia Nayberg.

FIRST CONTACT & TERMS Illustrators: Send query letter with tearsheets, or by e-mail. Samples are filed or are returned by SASE if requested by artist. Responds only if interested. Will contact artist for portfolio review if interested. Portfolio should include tearsheets and final art. Rights purchased vary according to project. Pays on publication. Pays illustrators $150-250 for cover; $75-100 for inside. Finds artists through sourcebooks, publications, word of mouth, submissions. Originals are returned at job's completion.

TIPS "Give us a try! We're small, but nice."

NAILPRO

Creative Age Publications, 7628 Densmore Ave., Van Nuys CA 91406. (818)782-7328. **Fax:** (818)782-7450. **E-mail:** nailpro@creativeage.com. **Website:** www.nailpro.com. Estab. 1989. Circ. 65,000. Monthly trade magazine for the nail and beauty industry audience nail technicians. Sample copies available.

CARTOONS Prefers subject matter related to nail industry. Prefers humorous color washes and b&w line drawings with or without gagline.

ILLUSTRATION Approached by tons of illustrators. Buys 3-4 illustrations/issue. Has featured illustrations by Kelley Kennedy, Nick Bruel and Kathryn Adams. Assigns 20% of illustrations to well-known or "name" illustrators; 70% to experienced but not well-known illustrators; 10% to new and emerging illustrators. Prefers whimsical computer illustrations. Considers all media. 85% of freelance illustration demands knowledge of Photoshop 5.5, Illustrator 8.0 and QuarkXPress 4.04.

DESIGN Needs freelancers for design, production and multimedia projects. Prefers local design freelancers only. 100% of freelance work demands knowledge of Photoshop 5.5, Illustrator 8.0 and QuarkXPress 4.04.

FIRST CONTACT & TERMS Cartoonists: Send query letter with samples. Responds only if interested. Rights purchased vary according to project. Illustrators: Send postcard sample. Designers: Send query letter with printed samples and tearsheets. Accepts disk submissions compatible with QuarkXPress 4.04, TIFFs, EPS files submitted on ZIP, JAZ or CD (Mac format only). Send samples to Attn: Art Director. Samples are filed. Responds only if interested. Art director will contact artist for portfolio review of b&w, color, final art and tearsheets if interested. Buys first rights. Payment to cartoonists varies with projects. Pays on publication. Pays illustrators $350-400 for 2-page, full-color feature spread; $300 for 1-page; $250 for ½ page. Pays $50 for spots. Finds illustrators through *Workbook*, samples sent in the mail, magazines.

NAILS MAGAZINE

Bobit Business Media, 3520 Challenger St., Torrance CA 90503. (310)533-2400 (main); (310)533-2537 (art director). **Fax:** (310)533-2507. **E-mail:** danielle.parisi@bobit.com. **Website:** www.nailsmag.com. **Contact:** Danielle Parisi, art director. Estab. 1982. Circ. 60,000. Monthly 4-color trade journal; "seeks to educate readers on new techniques and products, nail anatomy and health, customer relations, chemical safety, salon sanitation and business." Originals can be returned at job's completion. Sample copies available. Art guidelines vary. Needs computer-literate freelancers for design, illustration and production. 100% of freelance work demands knowledge of QuarkXPress, Illustrator or Photoshop.

ILLUSTRATION Buys 3 illustrations/issue. Works on assignment only. Needs editorial and technical illustration; charts and story art. Prefers "fashion-oriented styles." Interested in all media.

FIRST CONTACT & TERMS Illustrators: Send query letter with brochure and tearsheets. Samples are filed. Responds in 1 month or artist should follow up with call. Call for an appointment to show a portfolio of tearsheets and transparencies. Buys all rights. **Pays on acceptance**. Finds artists through self-promotion and word of mouth.

THE NATION

33 Irving Place, 8th Floor, New York NY 10003. **Website:** www.thenation.com. Steven Brower, art director. **Contact:** Jordan Davis, poetry editor. Estab. 1865. Circ. 100,000. Weekly journal of "left/liberal political opinion, covering national and international affairs, literature and culture." Sample copies available.

○ *The Nation's* art director works out of his design studio at Steven Brower Design. You can send samples to *The Nation* and they will be forwarded.

ILLUSTRATION Approached by 50 illustrators/year. Buys 1-3 illustrations/issue. Works with 15 illustrators/year. Has featured illustrations by Peter O. Zierlien, Ryan Inzana, Tim Robinson and Karen Caldecott. Buys illustrations mainly for spots and feature spreads. Works on assignment only. Considers all media.

FIRST CONTACT & TERMS "Queries can be sent using our online form or sent by regular mail (the form is preferred). If sending by regular mail, please double-space and include a SASE. Our standard payment for a comment is $150; for an article $350-$500 depending on length. Payment for arts pieces is dependent on length; generally $225 and up. Samples are filed or are returned by SASE." Responds only if interested. Buys first rights. Pays $135 for color inside. Originals are returned after publication upon request.

TIPS "On top of a defined style, artist must have a strong and original political sensibility."

NATIONAL ENQUIRER

American Media, Inc., 4 New York Plaza, New York NY 10004. (561)997-7733. Circ. 2 million (readership 14 million). A weekly tabloid. Originals are returned at job's completion.

CARTOONS "We get 1,000-1,500 cartoons weekly." Buys 200 cartoons/year. Has featured cartoons by Norm Rockwell, Glenn Bernhardt, Earl Engelman, George Crenshaw, Mark Parisi, Marty Bucella and Yahan Shirvanian. Prefers animal, family, husband/wife and general themes. Nothing political or off-color. Prefers single panel b&w line drawings and washes with or without gagline. Computer-generated cartoons are not accepted. Prefers to do own coloration.

FIRST CONTACT & TERMS Cartoonists: Send query letter with good, clean, clear copies of finished cartoons. Samples are not returned. Buys first and one-time rights. Pays $200 for b&w plus $20 each additional panel. Editor will notify if cartoon is accepted.

TIPS "Study several issues to get a solid grasp of what we buy. Gear your work accordingly."

NATIONAL GEOGRAPHIC

P.O. Box 98199, Washington DC 20090-8199. **Fax:** (202)828-5460. **E-mail:** ngsforum@nationalgeographic.com. **Website:** www.nationalgeographic.com. **Contact:** Online art director; Chris Johns, editor-in-chief. Estab. 1888. Circ. 9 million. *National Geographic* receives up to 30 inquiries a day from freelancers, most of which are not appropriate to their needs. Please make sure you have studied several issues before you submit. They have a roster of artists they work with on a regular basis, and it's difficult to break in, but if they like your samples they will file them for consideration for future assignments.

ILLUSTRATION Works with 20 illustrators/year. Contracts 50 illustrations/year. Interested in "full-color renderings of historical and scientific subjects. Nothing that can be photographed is illustrated by artwork. No decorative, design material. We want scientific geological cut-aways, maps, historical paintings, prehistoric scenes." Works on assignment only.

FIRST CONTACT & TERMS Send color copies, postcards, tearsheets, proofs or other appropriate samples. Art director will contact for portfolio review if interested. Samples are returned by SASE. **Pays on acceptance**: varies according to project.

TIPS "Do your homework before submitting to any magazine. We only use historical and scientific illustrations—ones that are very informative and very accurate. No decorative, abstract or portraits."

NATIONAL LAMPOON

8228 Sunset Blvd., Los Angeles CA 90046. (310)474-5252. **Fax:** (310)474-1219. **E-mail:** feedback@nationallampoon.com. **Website:** www.nationallampoon.com. **Contact:** Art director. Estab. 1970. Online consumer magazine of humor and satire.

CARTOONS Approached by 50 cartoonists/year. Buys 6 cartoons/issue. Prefers satire, humor; b&w line drawings.

ILLUSTRATION Approached by 10 illustrators/year. Buys 30 illustrations/issue. Considers all media.

DESIGN Needs freelancers for design and production. Prefers local designers. 100% of freelance work demands knowledge of Photoshop and QuarkXPress.

FIRST CONTACT & TERMS Cartoonists: Send photocopies and SASE. E-mail submissions are preferred. Illustrators: Send e-mail with JPEG images or query letter with photocopies and SASE. Samples are filed. Responds only if interested. Rights purchased vary according to project. Payment negotiable.

TIPS "Since we are a web-based publication, I prefer artists who are experienced with JPEG images and who are familiar with e-mailing their work. I'm not going to discount some brilliant artist who sends traditional samples, but those who send e-mail samples have a better chance."

THE NATIONAL NOTARY

9350 De Soto Ave., Chatsworth CA 91311-4926. 800-876-6827. **E-mail:** publications@nationalnotary.org. **Website:** www.nationalnotary.org. Circ. 300,000. Bimonthly. Emphasizes "notaries public and notarization—goal is to impart knowledge, understanding and unity among notaries nationwide and internationally." Readers are notaries of varying primary occupations (legal, government, real estate and financial), as well as state and federal officials and foreign notaries. Original artwork not returned after publication. Sample copy $5.

Also publishes *Notary Bulletin*.

CARTOONS Approached by 5-8 cartoonists/year. Cartoons "must have a notarial angle"; single or multiple panel with gagline, b&w line drawings.

ILLUSTRATION Approached by 3-4 illustrators/year. Uses about 3 illustrations/issue; buys all from local freelancers. Works on assignment only. Themes vary, depending on subjects of articles. 100% of freelance work demands knowledge of Illustrator, QuarkXPress or FreeHand.

FIRST CONTACT & TERMS Cartoonists: Send samples of style. Illustrators: Send business card, samples and tearsheets to be kept on file. Samples not returned. Responds in 6 weeks. Call for appointment. Buys all rights. Negotiates pay.

TIPS "We are very interested in experimenting with various styles of art in illustrating the magazine. We generally work with Southern California artists, as we prefer face-to-face dealings."

NATIONAL REVIEW

215 Lexington Ave., New York NY 10016. (212)679-7330. **E-mail:** letters@nationalreview.com. **Website:** www.nationalreview.com. **Contact:** Luba Myts, art director. Circ. 150,000+. Emphasizes world events from a conservative viewpoint; bimonthly b&w with 4-color cover, design is "straight forward—the creativity comes out in the illustrations used." Originals are returned after publication. Uses freelancers mainly for illustrations of articles and book reviews, also covers.

CARTOONS Buys 6 cartoons/issue. Interested in "light political, social commentary on the conservative side."

ILLUSTRATION Buys 6-7 illustrations/issue. Especially needs b&w ink illustration, portraits of political figures and conceptual editorial art (b&w line plus halftone work). "I look for a strong graphic style; well-developed ideas and well-executed drawings." Style of Tim Bower, Jennifer Lawson, Janet Hamlin, Alan Nahigian. Works on assignment only.

FIRST CONTACT & TERMS Cartoonists: Send appropriate samples and SASE. Responds in 2 weeks. Illustrators: Send query letter with brochure showing art style or tearsheets and photocopies. No samples returned. Responds to future assignment possibilities. Call for an appointment to show portfolio of final art, final reproduction/product and b&w tearsheets. Include SASE. Buys first North American serial rights. Pays on publication. Pays cartoonists $50 for b&w. Pays illustrators $100 for b&w inside; $750 for color cover.

TIPS "Tearsheets and mailers are helpful in remembering an artist's work. Artists ought to make sure their work is professional in quality, idea and execution. Recent printed samples alongside originals help. Changes in art and design in our field include fine art influence and use of more halftone illustration." A common mistake freelancers make in presenting their work is "not having a distinct style, i.e., they have a cross sample of too many different approaches to rendering their work. This leaves me questioning what kind of artwork I am going to get when I assign a piece."

NATION'S RESTAURANT NEWS

425 Park Ave., 6th Floor, New York NY 10022-3506. (212)204-4200. **E-mail:** postoffice@nrn.com; or via online contact form. **Website:** www.nrn.com. Estab.

1967. Circ. 100,000. Weekly 4-color trade publication/ tabloid.

ILLUSTRATION Buys 2-3 illustrations/year. Features illustrations of business subjects in the food service industry. Prefers pastel and bright colors. Assigns 5% of illustrations to well-known or "name" illustrators; 70% to experienced but not well-known illustrators; 25% to new and emerging illustrators. 20% of free-lance illustration demands knowledge of Illustrator or Photoshop.

FIRST CONTACT & TERMS Illustrators: Send post-card sample or other nonreturnable samples, such as tearsheets. Accepts Mac-compatible disk submissions. Send EPS files. Samples are filed. Will contact art-ist for portfolio review if interested. Buys one-time rights. Pays on publication. Finds illustrators through *Creative Black Book* and *LA Work Book*, *Directory of Illustration* and *Contact USA*.

NATURALLY

Internaturally, LLC, P.O. Box 317, Newfoundland NJ 07435. (973)697-3552. **Fax:** (973)697-8313. **E-mail:** naturally@internaturally.com. **E-mail:** editor@inter-naturally.com. **Website:** www.internaturally.com. Es-tab. 1981. Circ. 35,000. Quarterly magazine covering family nudism/naturism and nudist resorts and travel. Sample copies available for $9.95 and $3.00 postage; art guidelines for #10 SASE with first-class postage.

CARTOONS Approached by 10 cartoonists/year. Buys approximately 3 cartoons/issue. Accepts only nudism/naturism.

ILLUSTRATION Approached by 10 illustrators/year. Buys approximately 3 illustrations/issue. Accepts only nudism/naturism. Considers all media.

FIRST CONTACT & TERMS Cartoonists: Send query letter with finished cartoons. Illustrators: Contact di-rectly. Accepts all digital formats or hard copies. Sam-ples are filed. Always responds. Buys one-time rights. Pays on publication. Pays cartoonists $20-80. Pays il-lustrators $200 for cover; $80/page inside. Fractional pages or fillers are prorated.

NECROLOGY SHORTS: TALES OF MACABRE AND HORROR

Isis International, P.O. Box 510232, St. Louis MO 63151. **E-mail:** editor@necrologyshorts.com; sub-mit@necrologyshorts.com. **Website:** www.necrolo gyshorts.com. **Contact:** John Ferguson, editor. Estab. 2009. Circ. 20,000. Consumer publication published online daily and through Amazon Kindle. Also offers an annual collection. "*Necrology Shorts* is an online publication which publishes fiction, articles, cartoons, artwork, and poetry daily. Embracing the Internet, e-book readers, and new technology, we aim to go beyond the long time standard of a regular publica-tion to bringing our readers a daily flow of entertain-ment. We will also be publishing an annual collection for each year in print, e-book reader, and Adobe PDF format. Our main genre is suspense horror similar to H.P. Lovecraft or Robert E. Howard. We also pub-lish science fiction and fantasy. We would love to see work continuing the Cthulhu Mythos, but we accept all horror. We also hold contests, judged by our read-ers, to select the top stories and artwork. Winners of contests receive various prizes, including cash."

FIRST CONTACT & TERMS Submit transparen-cies, prints, or GIF/JPEG files by e-mail at submit@ necrologyshorts.com. Requires model releases and identification of subjects.

TIPS "*Necrology Shorts* is looking to break out of the traditional publication types to use the Internet, e-book readers, and other technology. We not only pub-lish works of artists, we let them use their published works to brand themselves and further their profits of their hard work. We love to see traditional artwork, but we also look forward to those that go beyond that to create multimedia works. The best way to get to us is to let your creative side run wild and not send us the typical fare. Don't forget that we publish hor-ror, sci-fi, and fantasy. We expect deranged, warped, twisted, strange, sadistic, and things that question sanity and reality."

✪ NEO-OPSIS SCIENCE FICTION MAGAZINE

4129 Carey Rd., Victoria BC V8Z4G5, Canada. (250)811-8893. **E-mail:** neoopsis@shaw.ca. **Website:** www.neo-opsis.ca. Buys first North American serial rights, electronic rights (for the issue). Pays on pub-lication.

FIRST CONTACT & TERMS Send an e-mail with URL and JPEG samples at 72 dpi. Samples kept on file, not returned (Returned only by SASE). Responds only if interested. Pays on publication.

TIPS "Check the guidelines (on website) and the paid rate; if your work fits the genre and the rate is accept-able, then and only then, submit your work for con-sideration. It would also be nice if artists all had some examples of their work online so it is easy to see."

NERVE COWBOY

Liquid Paper Press, P.O. Box 4973, Austin TX 78765. **Website:** www.jwhagins.com/nervecowboy.html. **Contact:** Joseph Shields or Jerry Hagins. Estab. 1996. Circ. 350. Biannual b&w literary journal of poetry, short fiction and b&w artwork. Art guidelines free for #10 SASE with first-class postage.

ILLUSTRATION Approached by 400 illustrators/year. Buys work from 20 illustrators/issue. Has featured illustrations by James Dankert, Wayne Hogan and Greta Shields. Features unusual illustration and creative b&w images. Strongly prefers b&w. "Color will be considered if a b&w half-tone can reasonably be created from the piece." Assigns 60% of illustrations to new and emerging illustrators.

FIRST CONTACT & TERMS Illustrators: Send printed samples, photocopies with a SASE. Samples are returned by SASE. Responds in 3 months. Portfolio review not required. Buys first North American serial rights. Pays on publication; 3 copies of issue in which art appears on cover; or 1 copy if art appears inside.

TIPS "We are always looking for new artists with an unusual view of the world."

NEW HAMPSHIRE MAGAZINE

150 Dow St., Manchester NH 03101. (603)624-1442, ext. 128. **E-mail:** slaughlin@nhmagazine.com. **Website:** www.nhmagazine.com. Estab. 1990. Circ. 26,000. Monthly 4-color magazine emphasizing New Hampshire lifestyle and related content.

ILLUSTRATION Approached by 300 illustrators/year. Has featured illustrations by Brian Hubble and Stephen Sauer. Features lifestyle illustration, charts & graphs and spot illustration. Prefers conceptual illustrations to accompany articles. Assigns 50% to experienced but not well-known illustrators; 50% to new and emerging illustrators.

FIRST CONTACT & TERMS Send postcard sample and follow-up postcard every 3 months. Samples are filed. Portfolio review not required. Negotiates rights purchased. Pays on publication. Pays $75-250 for color inside; $150-500 for 2-page spreads; $125 for spots.

TIPS "Lifestyle magazines want 'uplifting' lifestyle messages, not dark or disturbing images."

NEW JERSEY MONTHLY

55 Park Place, P.O. Box 920, Morristown NJ 07963-0920. (973)539-8230. **Fax:** (973)538-2953. **E-mail:** dingram@njmonthly.com; dcarter@njmonthly.com. **E-mail:** research@njmonthly.com. **Website:** www.nj monthly.com. Estab. 1976. Circ. 92,000. Monthly city magazine focuses on topics related to the New Jersey regions, especially the New Jersey business community, political issues and human interest articles.

ILLUSTRATION Features New Jersey caricatures of business leaders, celebrities/politicians and humorous illustration of business, families, pets, cooking and health. Assigns 50% to new and emerging illustrators.

FIRST CONTACT & TERMS Illustrators: Send postcard sample. After introductory mailing, send follow-up postcard sample every 3-6 months. Samples are filed. Responds only if interested. Pays illustrators $100 for color inside. Buys one-time rights.

TIPS "Be familiar with New Jersey personalities and topics. Have a consistent style and professional presentation. Follow through with assignments. Be willing to take directions from art director."

NEW MEXICO MAGAZINE

Lew Wallace Bldg., 495 Old Santa Fe Trail, Santa Fe NM 87501. (505)827-7447. **E-mail:** letters@nm magazine.com. **E-mail:** queries@nmmagazine.com. **Website:** www.nmmagazine.com. Estab. 1923. Circ. 100,000. Monthly regional magazine for residents and tourists to the state of New Mexico.

Covers areas throughout the state. "We want to publish a lively editorial mix, covering both the down-home (like a diner in Tucumcari) and the upscale (a new bistro in world-class Santa Fe)." Explore the gamut of the Old West and the New Age.

ILLUSTRATION Buys 10 illustrations/year. Features spot illustrations. Assigns 5% to new and emerging illustrators.

FIRST CONTACT & TERMS Illustrators: Send postcard sample with URL. Responds only if interested. Pays illustrators $100 for color inside. Buys one-time rights. Find freelancers through artists' submissions.

NEW MOON GIRLS

New Moon Girl Media, P.O. Box 161287, Duluth MN 55816. (218)728-5507. **E-mail:** submissions@new moon.org. **Website:** www.newmoon.org. Estab. 1992. Circ. 30,000. Bimonthly 4-color cover, 4-color inside consumer magazine. Sample copies are $7.00.

ILLUSTRATION Buys 3-4 illustrations/issue. Has featured illustrations by Andrea Good, Liza Ferney-hough, Liza Wright. Features realistic illustrations, informational graphics and spot illustrations of chil-

dren, women and girls. Prefers colored work. Assigns 30% of illustrations to new and emerging illustrators. **FIRST CONTACT & TERMS** Submission guidelines available online.

TIPS "Be very familiar with the magazine and our mission. We are a magazine for girls ages 8-14 and look for illustrators who portray people of all different shapes, sizes and ethnicities in their work. Women and girl artists preferred. See cover art guidelines at www.newmoon.org.

THE NEW REPUBLIC

1331 H St. NW, Suite 700, Washington DC 20005. (202)508-4444. **E-mail:** letters@tnr.com. **Website:** www.tnr.com. **Contact:** Editor or art director. Estab. 1914. Circ. 50,000. Weekly political/literary magazine; political journalism, current events in the front section, book reviews and literary essays in the back; b&w with 4-color cover. Original artwork returned after publication. Sample copy for $4.94. 100% of freelance work demands computer skills.

CARTOONS Possible, not regular.

ILLUSTRATION Approached by 400 illustrators/year. Buys up to 5 or more illustrations/issue. Uses freelancers or photographers for cover art. Works on assignment only stand alone submissions also accepted. Prefers caricatures, portraits, and smart concepts 4-color.

FIRST CONTACT & TERMS Portfolio should include color photocopies. First-reproduction rights including web for duration of publication date unless otherwise negotiated. Pays on commission, kill fees may apply. Up to $1,200 for cover; $300-700 for b&w and color inside depending on space.

THE NEW YORKER

4 Times Square, New York NY 10036. (212) 286-5900. **E-mail:** beth_lusko@newyorker.com; toon@cartoon bank.com. **Website:** www.newyorker.com; www.cartoonbank.com. **Contact:** Bob Mankoff, cartoon; David Remnick, editor-in-chief. Estab. 1925. Circ. 938,600. A quality weekly magazine of distinct news stories, articles, essays, and poems for a literate audience. Emphasizes news analysis and lifestyle features.

CARTOONS Buys b&w cartoons. Receives 3,000 cartoons/week. Cartoon editor is Bob Mankoff, who also runs Cartoon Bank, a stock cartoon agency that features *New Yorker* cartoons.

ILLUSTRATION All illustrations are commissioned. Portfolios may be dropped off Wednesdays between 10-6 and picked up on Thursdays. Art director is Caroline Mailhot.

FIRST CONTACT & TERMS Cartoonists: Accepts unsolicited submissions only by mail. Reviews unsolicited submissions every 1-2 weeks. Photocopies only. Strict standards regarding style, technique, plausibility of drawing. Especially looks for originality. Pays $575 minimum for cartoons. Contact cartoon editor. Illustrators: Mail samples, no originals. "Because of volume of submissions we are unable to respond to all submissions." No calls please. Emphasis on portraiture. Contact illustration department.

TIPS "Familiarize yourself with *The New Yorker*."

NEW YORK MAGAZINE

75 Varick St., New York NY 10013. (212)508-0700. **E-mail:** nyletters@nymag.com. **Website:** nymag.com. **Contact:** Editorial department. Emphasizes New York City life; also covers all boroughs for New Yorkers with upper-middle income and business people interested in what's happening in the city. Weekly. Original artwork returned after publication.

ILLUSTRATION Works on assignment only.

FIRST CONTACT & TERMS Illustrators: Send query letter with tearsheets to be kept on file. Prefers photostats as samples. Samples returned if requested. Call or write for appointment to show portfolio (drop-offs). Buys first rights. Pays $1,000 for b&w and color cover; $800 for 4-color, $400 for b&w full page inside; $225 for 4-color, $150 for b&w spot inside.

NORTH AMERICAN HUNTER

12301 Whitewater Dr., #260, Minnetonka MN 55343-4103. (952)936-9333. **E-mail:** editors@huntingclub.com; gkrahn@namginc.com. **Website:** www.hunt ingclub.com. Estab. 1978. Circ. 700,000. Bimonthly consumer magazines. *North American Hunter* is the official publication of the North American Hunting Club. Accepts previously published artwork. Originals are returned at job's completion. Sample copies available. Art guidelines for SASE with first-class postage. Needs computer-literate freelancers for illustration. 20% of freelance work demands computer knowledge of Illustrator, QuarkXPress, Photoshop or FreeHand.

𝒪 This publisher also publishes *Cooking Pleasures* (circ. 300,000), *Handy* (circ. 900,000), *PGA Partners* (circ. 600,000), *Health & Wellness* (circ. 300,000), *Creative Home Arts* (circ. 300,000), *History* (circ. 300,000), *Street Thun-*

der (circ. 200,000) and *Gardening How-To* (circ. 500,000).

CARTOONS Approached by 20 cartoonists/year. Buys 3 cartoons/issue. Prefers humorous work portraying outdoorsmen in positive image; single panel b&w washes and line drawings with or without gagline.

ILLUSTRATION Approached by 40 illustrators/year. Buys 3 illustrations/issue. Prefers illustrations that portray wildlife and hunting and fishing in an accurate and positive manner. Considers pen & ink, watercolor, airbrush, acrylic, colored pencil, oil, charcoal, mixed media, pastel and electronic renderings.

FIRST CONTACT & TERMS Cartoonists: Send query letter with brochure. Illustrators: Send query letter with brochure, tearsheets, resume, photographs and slides. Samples are filed. Portfolio review not required. Rights purchased vary according to project. **Pays on acceptance.**

NORTH AMERICAN WHITETAIL

Intermedia Outdoors, P.O. Box 420235, Palm Coast FL 32142-0235. (770)953-9222. **Website:** www. northamericanwhitetail.com. Estab. 1982. Circ. 130,000. Consumer magazine "designed for serious hunters who pursue whitetailed deer." 8 issues/year. Accepts previously published artwork. Original artwork is returned at job's completion. Sample copies available for $3; art guidelines not available.

ILLUSTRATION Approached by 30 freelance illustrators/year. Buys 6-8 freelance illustrations/year. Works on assignment only. Considers pen & ink, watercolor, acrylic and oil.

FIRST CONTACT & TERMS Illustrators: Send postcard sample or query letter with brochure and photocopies. Samples are filed or are returned by SASE if requested by artist. Responds only if interested. To show a portfolio, mail appropriate materials. Rights purchased vary according to project. Pays 10 weeks prior to publication.

◎ NORTH CAROLINA LITERARY REVIEW

East Carolina University, ECU Mailstop 555 English, Greenville NC 27858-4353. (252)328-1537. **Fax:** (252)328-4889. **E-mail:** nclrsubmissions@ecu.edu; bauerm@ecu.edu; rodmand@ecu.edu. **Website:** www. nclr.ecu.edu/submissions/artists-and-photographers. html. **Contact:** Diane Rodman, art acquisitions editor. Estab. 1992. Circ. 750. Annual literary magazine of art, literature, culture having to do with NC. Samples available for $10 and $15; art guidelines on website.

ILLUSTRATION Considers all media by North Carolina artists/photographers/graphic designers.

FIRST CONTACT & TERMS Illustrators: Send postcard sample or send query letter with printed samples, SASE and tearsheets. Send website address or postcard sample every 2 months. Samples are filed and are returned by SASE. Responds if selected for inclusion. Art acquisitions editor will contact artist for portfolio review of b&w, color slides and transparencies if interested. Rights purchased vary according to projects. Pays on publication. "Artists and photographers receive a modest honorarium for reproduction rights and fees and/or some combination of copies of the issue in which their work appears, back issues, and/or subscription to *NCLR*. "

TIPS "Read our magazine. Artists, photographers, and graphic designers have to have North Carolina connections."

NOTRE DAME MAGAZINE

University of Notre Dame, 538 Grace Hall, Notre Dame IN 46556-5612. (574)631-5335. **E-mail:** ndmag@nd.edu. **Website:** magazine.nd.edu. Kerry Prugh, art director. Estab. 1972. Circ. 150,000. "We are a university magazine with a scope as broad as that found at a university, but we place our discussion in a moral, ethical, and spiritual context reflecting our Catholic heritage."

ILLUSTRATION Buys 5-8 illustrations/issue. Has featured illustrations by Ken Orvidas, Earl Keleny, Vivienne Fleshner, Darren Thompson and James O'Brien. Works on assignment only.

FIRST CONTACT & TERMS "Don't send submissions—only tearsheets or samples." Tearsheets, photographs, brochures and photocopies OK for samples. Samples are returned by SASE if requested. Buys first rights.

TIPS "Create images that can communicate ideas. Looking for noncommercial style editorial art by accomplished, experienced editorial artists. Conceptual imagery that reflects the artist's awareness of fine art ideas and methods is the kind of thing we use. Sports action illustrations not used. Cartoons not used."

NURSEWEEK

6860 Santa Teresa Blvd., San Jose CA 95119. (847)839-1700. **Website:** www.nurseweek.com. Circ. Combined circulation of all publications is over 1 million.

"*Nurseweek* is a biweekly 4-color letter size magazine mailed free to registered nurses nationwide. *Nurseweek* provides readers with nursing-related news and features that encourage and enable them to excel in their work and that enhance the profession's image by highlighting the many diverse contributions nurses make. In order to provide a complete and useful package, the publication's article mix includes late-breaking news stories, news features with analysis (including in-depth bimonthly special reports), interviews with industry leaders and achievers, continuing education articles, career option pieces and reader dialogue (Letters, Commentary, First Person)." Sample copy $3. Art guidelines not available. Needs computer-literate freelancers for production. 90% of freelance work demands knowledge of QuarkXPress, PhotoShop, Illustrator, Adobe Acrobat.

ILLUSTRATION Approached by 10 illustrators/year. Buys 1 illustration/year. Prefers pen ink, watercolor, airbrush, marker, colored pencil, mixed media and pastel. Needs medical illustration

DESIGN Needs freelancers for design. 60% of design demands knowledge of Photoshop CS2, QuarkXPress 6.1, InDesign. Prefers local freelancers. Send query letter with brochure, résumé, SASE and tear sheets. Photographs: Stock photograph used 80%.

NUTRITION HEALTH REVIEW

Box #406, Haverford PA 19041. (610)896-1853. **Fax:** (610)896-1857. Estab. 1975. **Publisher:** A. Rifkin. Estab. 1975. Quarterly newspaper covering nutrition, health and medical information for the consumer. Circ. 285,000. Sample copies available for $3. Art guidelines available.

CARTOONS Prefers single panel, humorous, b&w drawings.

ILLUSTRATION Features b&w humorous, medical and spot illustrations pertaining to health.

FIRST CONTACT & TERMS Cartoonists/illustrators: Send query letter with b&w photocopies. After introductory mailing, send follow-up postcard every 3-6 months. Samples are filed or returned by SASE. Responds in 6 months. Company will contact artist for portfolio review if interested. Pays cartoonists $20 maximum for b&w. Pays illustrators $200 maximum for b&w cover; $30 maximum for b&w inside. **Pays on acceptance.** Buys first rights, one-time rights, reprint rights. Finds freelancers through agents, artists' submissions, sourcebooks.

O&A MARKETING NEWS

KAL Publications, Inc., 559 S. Harbor Blvd., Suite A, Anaheim CA 92805-4525. (714)563-9300. **Fax:** (714)563-9310. **E-mail:** kathy@kalpub.com. **Website:** www.kalpub.com. Estab. 1966. Circ. 7,500. Bimonthly trade publication about the service station/petroleum marketing industry.

CARTOONS Approached by 10 cartoonists/year. Buys 1-2 cartoons/issue. Prefers humor that relates to service station industry. Prefers single panel, humorous, b&w line drawings.

FIRST CONTACT & TERMS Cartoonists: Send b&w photocopies, roughs, or samples and SASE. Samples are returned by SASE. Responds in 1 month. Buys one-time rights. Pays on acceptance; $10 for b&w.

TIPS "We run a cartoon (at least 1) in each issue of our trade magazine. We're looking for a humorous take on business—specifically the service station/petroleum marketing/carwash/quick lube industry that we cover."

OCEAN MAGAZINE

P.O. Box 84, Rodanthe NC 27968-0084. (252)256-2296. **Website:** www.oceanmagazine.org. Estab. 2004. Circ. 40,000. 100% Freelance written. "*OCEAN Magazine* serves to celebrate and protect the greatest, most comprehensive resource for life on earth, our world's ocean. *OCEAN* publishes articles, stories, poems, essays, and photography about the ocean—observations, experiences, scientific and environmental discussions—written with fact and feeling, illustrated with images from nature."

FIRST CONTACT & TERMS E-mail with photographs and samples. Samples kept on file. Portfolio not required.

TIPS "Purchase an issue to learn what *OCEAN* publishes."

OFFICEPRO

IAAP, 10502 NW Ambassador Dr., P.O. Box 20404, Kansas City MO 64195-0404. (816)891-6600. **E-mail:** eallen@iaap-hq.org. **Website:** www.iaap-hq.org. **Contact:** Emily Allen, managing editor. Estab. 1945. Circ. 40,000. Trade journal published 8 times/year. Official publication of the International Association of Administrative Professionals. Emphasizes workplace issues, trends and technology. Sample copies available; contact subscription office at (816)891-6600, ext. 2236.

ILLUSTRATION Approached by 50 illustrators/year. Buys 20 or fewer illustrations/year. Works on assign-

ment and purchases stock art. Prefers communication, travel, meetings and international business themes. Considers pen & ink, airbrush, colored pencil, mixed media, collage, charcoal, watercolor, acrylic, oil, pastel, marker and computer.

FIRST CONTACT & TERMS Illustrators: Send postcard-size sample or send query letter with brochure, tearsheets and photocopies. Samples are filed. Responds only if interested. Will contact artist for portfolio review if interested. Portfolio should include final art and tearsheets. Accepts previously published artwork. Originals returned at job's completion upon request only. Usually buys one-time rights, but rights purchased vary according to project. Pays $500-600 for color cover; $200-400 for color inside; $60-150 for b&w inside; $60 for b&w spots. Finds artists through word of mouth and artists' samples.

OFF THE COAST

Resolute Bear Press, P.O. Box 14, Robbinston ME 04671. (207)454-8026. **E-mail:** poetrylane2@gmail. com. **Website:** www.off-the-coast.com. **Contact:** Valerie Lawson, editor/publisher. Estab. 1994. "The mission of *Off the Coast* is to become recognized around the world as Maine's international poetry journal, a publication that prizes quality, diversity and honesty in its publications and in its dealings with poets. *Off the Coast*, a quarterly journal, publishes poetry, artwork and reviews. Arranged much like an anthology, each issue bears a title drawn from a line or phrase from one of its poems."

FIRST CONTACT & TERMS "We accept b&w graphics and photos to grace the pages of *Off the Coast*, and color or b&w for the cover. Send 3-6 images in TIFF, PNG or JPEG format, minimum 300 dpi resolution. Please use submission manager: www.offthecoast. submishmash.com/submit to send artwork.

OHIO MAGAZINE

Great Lakes Publishing Co., 1422 Euclid Ave., Suite 730, Cleveland OH 44115. (216)771-2833. **E-mail:** editorial@ohiomagazine.com. **Website:** www.ohio magazine.com. **Contact:** Lesley Blake, art director. Estab. 1978. Circ. 80,000. 2 issues/year focusing on the beauty, the adventure and the fun in Ohio. Original artwork returned after publication. Artist guidelines available online.

ILLUSTRATION Approached by 100+ illustrators/year. Use as needed. Assignment and stock illustrations used. Has featured illustrations by A.G. Ford,

Neal Aspinall, Ellyn Lusis, Doug Boehm, D. Brent Campbell, Jeff Suntala and Daniel Vasconcellos. Considers pen, ink, watercolor, acrylic, colored pencil and oil.

DESIGN Freelance work demands knowledge of InDesign, Photoshop and Illustrator CS4 or higher. Freelancers from Ohio or bordering states preferred.

TIPS "Please have a knowledge of the magazine and audience before submitting. Telephone inquiries are strongly discouraged."

OKLAHOMA TODAY

P.O. Box 1468, Oklahoma City OK 73101-1468. (405)230-8450. **Fax:** (405)230-8650. **E-mail:** steffie@ oklahomatoday.com. **Website:** www.oklahomatoday. com. **Contact:** Steffie Corcoran, editor. Estab. 1956. Circ. 45,000. Bimonthly regional, upscale consumer magazine focusing on all things that define Oklahoma and interest Oklahomans. Accepts previously published artwork. Originals are returned at job's completion. Sample copies available with SASE.

ILLUSTRATION Approached by 24 illustrators/year. Buys 5-10 illustrations/year. Has featured illustrations by Rob Silvers, Tim Jessel, Steven Walker and Cecil Adams. Features caricatures of celebrities; natural history; realistic and spot illustration. Assigns 10% of illustrations to new and emerging illustrators. Considers pen & ink, watercolor, collage, airbrush, acrylic, marker, colored pencil, oil, charcoal and pastel. 20% of freelance work demands knowledge of PageMaker, Illustrator and Photoshop.

FIRST CONTACT & TERMS Illustrators: Send query letter with brochure, résumé, SASE, tearsheets and slides. Samples are filed. Responds in days if interested; months if not. Portfolio review required if interested in artist's work. Portfolio should include b&w and color thumbnails, tearsheets and slides. Buys one-time rights. Pays $200-500 for b&w cover; $200-750 for color cover; $50-500 for b&w inside; $75-750 for color inside. Finds artists through sourcebooks, other publications, word of mouth, submissions and artist reps.

TIPS Illustrations to accompany short stories and features are most open to freelancers. "Read the magazine. Be willing to accept low fees at the beginning. We enjoy working with local artists or those with Oklahoma connections."

ON EARTH

Natural Resources Defense Council, 40 W. 20th St., New York NY 10011. (212)727-4412. **E-mail:** onearth@nrdc.org. **Website:** www.onearth.org. **Contact:** Gail Ghezzi, art director. Estab. 1979. Circ. 140,000. Quarterly "award-winning environmental magazine exploring politics, nature, wildlife, science and solutions to problems."

ILLUSTRATION Buys 4 illustrations/issue.

FIRST CONTACT & TERMS Illustrators: Send postcard sample. "We will accept work compatible with InDesign CS4, QuarkXPress, Illustrator 8.0, Photoshop 5.5 and below." Responds only if interested. Buys one-time rights. Also may ask for electronic rights. Pays $100-300 for b&w inside. Payment for spots varies. Finds artists through sourcebooks and submissions.

TIPS "We prefer 4-color. Our illustrations are often conceptual, thought-provoking, challenging. We enjoy thinking artists, and we encourage ideas and exchange."

OPEN YOUR EYES

Tlahtoani Media Group, LLC, P.O. Box 1055, Stanton CA 90680. (323)924-9728. **E-mail:** editorial@oyemag.com. **Website:** www.oyemag.com. **Contact:** Art director. Estab. 2004. Circ. 75,000. Bimonthly consumer magazine for U.S. Latino men interested in technology, fitness, women, fashion and entertainment.

ILLUSTRATION Approached by 100 illustrators/year. Buys 10 illustrations/year. Features spot illustrations of technology and fitness. Assigns 20% to new and emerging illustrators.

FIRST CONTACT & TERMS Send postcard sample. After introductory mailing, send follow-up postcard sample every 6 months. Responds only if interested. Portfolio not required. Buys one-time rights. Finds freelancers through submissions and sourcebooks.

THE OPTIMIST

4494 Lindell Blvd., St. Louis MO 63108. (314)371-6000. **Fax:** (314)371-6006. **E-mail:** magazine@optimist.org. **Website:** www.optimist.org. Circ. 100,000. Quarterly 4-color magazine with 4-color cover that emphasizes activities relating to Optimist clubs in U.S. and Canada (civic-service clubs). "Magazine is mailed to all members of Optimist clubs. Average age is 42; most are management level with some college education." Sample copy available with SASE.

CARTOONS Buys 2 cartoons/issue. Has featured cartoons by Joe Engesssei, Randy Glasbergen and Tim Oliphant. Prefers themes of general interest family-orientation, sports, kids, civic clubs. Prefers color, single-panel, with gagline. No washes.

FIRST CONTACT & TERMS Send query letter with samples. Send art on a Mac-compatible disk, if possible. Submissions returned by SASE. Buys one-time rights. **Pays on publication.**

TIPS "Send clear cartoon submissions, not poorly photocopied copies."

ORACLE MAGAZINE

Oracle Corporation, 500 Oracle Parkway, Redwood Shores CA 94065. (650)506-7000. **E-mail:** opubedit_us@oracle.com. **Website:** www.oracle.com/technetwork/oramag/magazine. **Contact:** Richard Merchan, art director. Estab. 2000. Circ. 524,000. Bimonthly trade publication for information managers, database administrators and Oracle users.

ILLUSTRATION Approached by 200 illustrators/year. Buys 50 illustrations/year. Features informational graphics and spot illustrations of business and computers. Assigns 10% to new and emerging illustrators.

FIRST CONTACT & TERMS Illustrators: Send postcard sample with URL. After introductory mailing, send follow-up postcard sample every 3 months. Responds only if interested. Pays illustrators $250-1,000 for color inside. Pays on publication. Buys one-time rights. Finds freelancers through agents, artists' submissions, sourcebooks and word-of-mouth.

ORANGE COAST MAGAZINE

(949)862-1133. **Fax:** (949)862-0133. **E-mail:** jwalters@orangecoast.com; mbenham@orangecoast.com. **Website:** www.orangecoastmagazine.com. **Contact:** Jim Walters, managing editor; Mindy Benham, art director. Estab. 1974. Circ. 52,000. Monthly 4-color local consumer magazine with celebrity covers.

ILLUSTRATION Approached by 100 illustrators/year. Has featured illustrations by Cathi Mingus, Gweyn Wong, Scott Lauman, Santiago Veeda, John Westmark, Robert Rose, Nancy Harrison. Features computer, fashion and editorial illustrations featuring children and families. Prefers serious subjects; some humorous subjects. Assigns 10% of illustrations to well-known or "name" illustrators; 40% to experienced but not well-known illustrators; 50% to new and emerging illustrators. 40% of freelance illustration demands knowledge of Illustrator or Photoshop.

FIRST CONTACT & TERMS Send postcard or other nonreturnable samples. Accepts Mac-compatible disk submissions. Send EPS files. Samples are filed. Responds in 1 month. Will contact artist for portfolio review if interested. **Pays on acceptance**: $175 for b&w or color inside; $75 for spots. Finds illustrators through artists' promotional samples.

TIPS "Looking for fresh and unique styles. We feature approximately 4 illustrators per publication. I've developed great relationships with all of them."

OREGON QUARTERLY

5228 University of Oregon, Eugene OR 97403. (541)346-5048. **Fax:** (541)346-5571. **E-mail:** quarterly@uoregon.edu. **Website:** www.oregonquarterly.com. Estab. 1919. Circ. 100,000. Quarterly 4-color alumni magazine. Emphasizes regional (Northwest) issues and events as addressed by University of Oregon faculty members and alumni. Sample copies available for SASE with first-class postage.

ILLUSTRATION Approached by 25 illustrators/year. Buys 1-2 illustrations/issue, nearly always from artists previously purchased from. Prefers story-related themes and styles. Interested in all media.

FIRST CONTACT & TERMS Illustrators: Send query letter with résumé, SASE and tearsheets. Responds only if interested. Portfolio review not required. Buys one-time rights for print and electronic versions. **Pays on acceptance**; rates negotiable. Accepts previously published artwork. Originals are returned at job's completion.

TIPS "Send postcard or URL, not portfolio. We are rarely interested in unsolicited or graphic material."

ORGANIC GARDENING

Rodale, 33 E. Minor St., Emmaus PA 18098. **E-mail:** ogdcustserv@rodale.com. **Website:** www.organicgardening.com. Estab. 1942. Circ. 300,000. Magazine emphasizing gardening; 4-color; uncluttered design. "*Organic Gardening* is for gardeners who enjoy gardening as an integral part of a healthy lifestyle. Editorial shows readers how to grow flowers, edibles, and herbs, as well as information on ecological landscaping. Also covers organic topics including soil building and pest control." Published 6 times/year.

ILLUSTRATION Buys 10 illustrations/issue. Works on assignment only.

FIRST CONTACT & TERMS Illustrators: Send tearsheets. Samples are filed or are returned by SASE only. Occasionally needs technical illustration. Buys first rights or one-time rights. Sample copies available only with SASE.

TIPS "Our emphasis is 'how-to' gardening; therefore illustrators with experience in the field will have a greater chance of being published. Detailed and fine rendering quality is essential."

ORLANDO MAGAZINE

801 N. Magnolia Ave., Suite 201, Orlando FL 32803. (407)423-0618. **Fax:** (407)237-6258. **E-mail:** jason.jones@orlandomagazine.com. **Website:** www.orlandomagazine.com. **Contact:** Jason Jones, art director. Estab. 1946. Circ. 40,000. "We are a 4-color monthly city/regional magazine covering the Central Florida area—local issues, sports, home and garden, business, entertainment and dining." Accepts previously published artwork. Originals are returned at job's completion. Sample copies available.

ILLUSTRATION Buys 2-3 illustrations/issue. Has featured illustrations by T. Sirell, Rick Martin, Mike Wright, Jon Krause. Assigns 100% of illustrations to experienced, but not necessarily well-known illustrators. Works on assignment only. Needs editorial illustration.

DESIGN Needs freelancers for design and production.

FIRST CONTACT & TERMS Illustrators: Send postcard, brochure or tearsheets. Samples are filed and are not returned. Responds only if interested with a specific job. Portfolio review not required. Buys first rights, one-time rights or all rights (rarely). Pays for design by the project.

TIPS "Send appropriate samples. Most of my illustration hiring is via direct mail. The magazine field is still a great place for illustration. Have several ideas ready after reading editorial to add to or enhance our initial concept."

OUR STATE: DOWN HOME IN NORTH CAROLINA

P.O. Box 4552, Greensboro NC 27404. (336)286-0600; (800)948-1409. **Fax:** (336)286-0100. **E-mail:** art_director@ourstate.com. **Website:** www.ourstate.com. editorial@ourstate.com. Estab. 1933. Circ. 140,000. Monthly 4-color consumer magazine featuring travel, history and culture of North Carolina. Art guidelines free with #10 SASE and first-class postage.

ILLUSTRATION Approached by 6 illustrators/year. Buys 1-10 illustrations/issue. Features representations of towns in North Carolina in every issue, plus vari-

ous illustrations for "down home" North Carolina stories. Prefers vintage/antique/literary look. Assigns 100% to new and emerging illustrators. 100% of freelance illustration demands knowledge of Illustrator. **FIRST CONTACT & TERMS** Illustrators: Send e-mail with a link to work. Send postcard sample or nonreturnable samples. Samples are not filed and are not returned. Portfolio review not required. Buys one-time rights. Pays on publication: $400-600 for color cover; $75-350 for b&w inside; $75-350 for color inside; $350 for 2-page spreads. Finds illustrators through web searches, marketing mailings, resource books.

☽ OUTDOOR CANADA MAGAZINE

25 Sheppard Ave. W, Suite 100, Toronto ON M2N 6S7, Canada. (416)733-7600. **Fax:** (416)227-8296. **E-mail:** editorial@outdoorcanada.ca. **Website:** www.outdoorcanada.ca. Estab. 1972. Circ. 90,000. 4-color magazine for Canadian anglers and hunters. Stories on fishing, hunting and conservation. Readers are 81% male. Publishes 8 regular issues/year. "We are looking for strong, attention-grabbing images that capture the love our readers have for hunting and fishing. We're interested in finding and cultivating new Canadian talent and appreciate submissions from new photographers and illustrators to add to our list."

ILLUSTRATION Approached by 12-15 illustrators/year. Buys approximately 10 drawings/issue. Has featured illustrations by Malcolm Cullen, Stephen MacEachren and Jerzy Kolatch. Features humorous, computer and spot illustration. Assigns 90% to experienced, but not well-known illustrators; 10% to new and emerging illustrators. Uses freelancers mainly for illustrating features and columns. Uses pen & ink, acrylic, oil and pastel.

DESIGN Needs freelancers for multimedia. 20% of freelance work demands knowledge of Photoshop, Illustrator and QuarkXPress.

FIRST CONTACT & TERMS Illustrators: Send postcard sample or tearsheets. Designers: Send brochure, tearsheets and postcards. Accepts disk submissions compatible with Illustrator 7.0. Send EPS, TIFF and PICT files. Buys first rights. Fees negotiated. Pays designers by the project. Artists should show a representative sampling of their work. Finds most artists through references/word of mouth.

TIPS "Meet our deadlines and our budget. Know our product. Fishing and hunting knowledge an asset."

OUTDOOR LIFE MAGAZINE

2 Park Ave., New York NY 10016-5604. (212)779-5000. **Fax:** (212)779-5366. **E-mail:** OLphotos@bonniercorp.com. **Website:** www.outdoorlife.com. **Contact:** Margaret McKenna and Jason Beckstead, assistant art directors. Estab. 1897. Circ. 900,000. Monthly magazine geared toward hunting, fishing and outdoor activities. Original artwork is returned at job's completion. Sample copies not available.

ILLUSTRATION Works on assignment only.

FIRST CONTACT & TERMS Illustrators: Send nonreturnable postcard samples, tearsheets or brochures. Samples are filed. Rights purchased vary according to project. **Pays on acceptance.**

☽ OWL

10 Lower Spadina Ave., Suite #400, Toronto ON M5V 2Z2, Canada. (416)340-2700. **Fax:** (416)340-9769. **E-mail:** owl@owlkids.com. **Website:** www.owlkids.com. Estab. 1979. Circ. 150,000 in North America. 9 issues/year. Children's discovery magazine. Also publishes *Chirp* for ages 3-6 and *chickaDEE* for ages 6-9. Each issue contains photos, illustrations, an easy-to-read animal story, a craft project, fiction, puzzles, a science experiment and a pull-out poster. Originals returned at job's completion. Sample copies available. Uses all types of conventional methods of illustration. Digital illustrators should be familiar with Illustrator or Photoshop.

Ⓞ The same company that publishes *chickaDEE* now also publishes *Chirp*, a science, nature and discovery magazine for pre-schoolers two to six years old, and *OWL*, a similar publication for children over eight years old.

ILLUSTRATION Approached by 500-750 illustrators/year. Buys 3-7 illustrations/issue. Works on assignment only. Prefers animals, children, situations and fiction. All styles, loaded with humor but not cartoons. Realistic depictions of animals and nature. Considers all media and computer art. No b&w illustrations.

FIRST CONTACT & TERMS Illustrators: Send postcard sample, photocopies and tearsheets. Accepts disk submissions compatible with Illustrator 8.0. Send EPS files. Samples are filed or returned by SASE. Will contact for portfolio review if interested. Portfolio should include final art, tearsheets and photocopies. Buys all rights. Pays within 30 days of invoice. Finds artists through sourcebooks, word of mouth, submissions

as well as looking in other magazines to see who's doing what.

TIPS "Please become familiar with the magazine before you submit. Ask yourself whether your style is appropriate before spending the money on your mailing. Magazines are ephemeral and topical. Ask yourself if your illustrations are editorial and contemporary. Some styles suit books or other forms better than magazines." Impress this art director by being "fantastic, enthusiastic and unique."

THE OXFORD AMERICAN

201 Donaghey Ave., Main 107, Conway AR 72035. (501)450-5376. **Fax:** (501)450-3490. **E-mail:** info@ oxfordamerican.org. **Website:** www.oxfordameri can.org. **Contact:** Carol Ann Fitzgerald, managing editor; Wes Enzinna, associate editor; Warwick Sabin, publisher. Circ. 20,000. Quarterly literary magazine. "The Southern magazine of good writing." Art guidelines on website.

This award-winning magazine suspended publication in July 2003, but it relaunched in the fall of 2004 as a not-for-profit publication allied with the University of Central Arkansas.

ILLUSTRATION Approached by many artists/year. Uses a varying number of illustrations/year. Considers all media.

FIRST CONTACT & TERMS Prefers digital submissions (attach JPEGs to e-mail) or include link to website. Also accepts printed tearsheets, photocopies or postcard sample of work. Samples are filed. Responds only if interested. To have materials returned, send SASE. Art director will contact artist for portfolio review of final art and roughs if interested. Buys one-time rights. Pays on publication. Finds artists through word of mouth and submissions.

TIPS "See the magazine."

OYEZ REVIEW

Roosevelt University, Dept. of Literature & Languages, 430 S. Michigan Ave., Chicago IL 60605-1394. (312)341-3500. **E-mail:** oyezreview@roosevelt.edu. **Website:** legacy.roosevelt.edu/roosevelt.edu/oyezre view. Estab. 1965. Circ. 600. Annual magazine of the Creative Writing Program at Roosevelt University, publishing fiction, creative nonfiction, poetry, and art. There are no restrictions on style, theme, or subject matter. Each issue has 100 pages: 92 pages of text and an 8-page b&w spread of one artist's work (usually drawing, painting or photography). In addition

to the 8-page spread, the front and back cover feature the artist's work as well, totaling 10 pieces.

CARTOONS "We have never received a cartoon submission before, but would be open to publishing cartoons if we liked something." Send query letter with e-mail, SASE, photographs, JPEG samples at 72 dpi, samples.

ILLUSTRATION Features realistic illustrations. "We receive about 12 contacts from illustrators each year with their work; we accept about 1. We have featured Matt Dobson and Frank Spidale."

DESIGN Be familiar with InDesign software.

PACIFIC PRESS PUBLISHING ASSOCIATION

1350 North Kings Rd., Nampa ID 83687. (208)465-2500. **Fax:** (208)465-2531. **Website:** www.pacificpress. com. **Contact:** Bonnie Laing, advertising. Estab. 1875. Book and magazine publisher. Specializes in Christian lifestyles and Christian outreach.

This association publishes magazines and books. Also see *Signs of the Times* listing for needs.

PACIFIC YACHTING

OP Publishing, Ltd., 200 West Esplanade, Suite 500, North Vancouver BC V7M 1A4, Canada. (604)998-3310. **Fax:** (604)998-3320. **E-mail:** editor@pacific yachting.com. **Website:** www.pacificyachting.com. **Contact:** Dale Miller, editor. Estab. 1968. Circ. 19,000. Monthly 4-color magazine focused on boating on the West Coast of Canada. Power/sail cruising only. Accepts previously published artwork. Original artwork returned at job's completion. Sample copies available for $6.95 cover price plus postage. Art guidelines not available.

CARTOONS Approached by 12-20 cartoonists/year. Buys 2-3 illustrations or cartoons/issue. Boating themes only; single panel b&w line drawings.

ILLUSTRATION Approached by 25 illustrators/year. Buys 10-20 illustrations/year. Has featured illustrations by Dave Alavoine, Roger Jackson and Tom Shardlow. Boating themes only. Considers pen & ink, watercolor, airbrush, acrylic, colored pencil, oil and charcoal.

FIRST CONTACT & TERMS Cartoonists and Illustrators: Send query letter with brochure and roughs. "Will keep on file and contact if interested." Illustrators: Call for appointment to show portfolio of appropriate samples related to boating on the West Coast. Buys one-time rights. Pays on publication. Pays car-

toonists $25-50 for b&w. Pays illustrators $300 for color cover; $50-100 for color inside; $25-50 for spots.

TIPS "Know boats and how to draw them correctly. Know and love my magazine."

PAINT HORSE JOURNAL

American Paint Horse Association, P.O. Box 961023, Fort Worth TX 76161-0023. (817)834-2742. **E-mail:** tonyag@apha.com; avasquez@apha.com. **Website:** www.painthorsejournal.com. **Contact:** Abigail Wilder, assistant editor. Estab. 1966. Circ. 12,000. Monthly 4-color, official publication of breed registry of the American Paint Horse for people who raise, breed and show, or just appreciate Paints. Original artwork returned after publication if requested. Sample copy for $4.50; artist's guidelines for SASE.

ILLUSTRATION Purchase a few illustrations each year.

FIRST CONTACT & TERMS Illustrators: Send business card and samples to be kept on file. Prefers snapshots of original art or photostats as samples. Samples returned by SASE if not filed. Responds in 1 month. Buys first rights but may wish to use small, filler art many times. Payment varies by project.

TIPS "No matter what style of art you use, you must include Paint Horse(s) with conformation acceptable (to the APHA). Horses of Arabian-type, Draft-type or Saddlebred-type conformation or with markings not appropriate for Paint Horses will not be considered. Please refer to our website to learn more about the breed and specifics at www.apha.com/breed."

PARABOLA MAGAZINE

20 W. 20th St., 2nd Floor, New York NY 10011. (212)822-8803. **E-mail:** editorial@parabola.org. **Website:** www.parabola.org. Estab. 1974. Circ. 40,000. Quarterly magazine of world myth, religious traditions and arts/comparative religion. Sample copies available. Art guidelines on website.

ILLUSTRATION Approached by 20 illustrators/year. Buys 4-6 illustrations/issue. Prefers traditional b&w high contrast. Considers all media.

FIRST CONTACT & TERMS Illustrators: Send postcard or query letter with printed nonreturnable samples, photocopies and SASE. Accepts disk submissions. Samples are filed. Responds only if interested. Buys one-time rights. Pays on publication (kill fee given for commissioned artwork only); $300 maximum for cover; $150 maximum for b&w inside. Pays $50-100 for spots. Finds illustrators through sourcebooks,

magazines, word of mouth and artist's submissions. "We rarely commission cover."

TIPS "Familiarity with religious traditions and symbolism a plus. Timeless or classic look is preferred over trendy."

PARADE MAGAZINE

711 Third Ave., New York NY 10017-4014. (212)450-7000. **E-mail:** mediarelations@parade.com; or via the online contact form. **Website:** www.parade.com. Circ. 36 million. Weekly emphasizing general-interest subjects. Sample copies available. Art guidelines available with SASE and first-class postage.

ILLUSTRATION Works on assignment only.

DESIGN Needs freelancers for design. 100% of freelance work demands knowledge of Photoshop, Illustrator, InDesign and QuarkXPress. Prefers local freelancers.

FIRST CONTACT & TERMS Illustrators: Send query letter with brochure, résumé, business card, postcard or tearsheets to be kept on file. Designers: Send query letter with résumé. Call or write for appointment to show portfolio. Responds only if interested. Buys first rights, occasionally all rights. Pays for design by the project, by the day or by the hour depending on assignment.

TIPS "Provide a good balance of work."

PC MAGAZINE

28 E. 28th St., 11th Floor, New York NY 10016. (212)503-3500. **Fax:** (212)503-5580. **Website:** www. pcmag.com. **Contact:** Stephanie Chang, editor. Estab. 1983. Circ. 125,000. Monthly consumer magazine featuring comparative lab-based reviews of current PC hardware and software. Sample copies available.

ILLUSTRATION Approached by 100 illustrators/year. Buys 2-3 illustrations/issue. Considers all media.

FIRST CONTACT & TERMS Send postcard sample or printed samples, photocopies, tearsheets. Accepts CD or e-mail submissions. Samples are filed. Portfolios may be dropped off and should include tearsheets and transparencies; art department keeps for one week to review. **Pays on acceptance.** Payment negotiable for cover and inside; $350 for spots.

PENNSYLVANIA LAWYER

100 South St., Harrisburg PA 17101. (717)238-6715. **E-mail:** editor@pabar.org. **Website:** www.pabar.org. Circ. 30,000. Bimonthly association magazine "featuring nuts and bolts articles and features of interest

to lawyers." Sample copies with #10 SASE and first-class postage. Art guidelines available.
ILLUSTRATION Approached by 80 illustrators/year. Buys 2-3 illustrations/year. Considers all media.
FIRST CONTACT & TERMS Illustrators: Send query letter with samples. Samples are filed or returned by SASE. Art director will contact artist for portfolio review if interested. Negotiates rights purchased. **Pays on acceptance.** Finds illustrators through word of mouth and artists' submissions.
TIPS "Artists must be able to interpret legal subjects. Art must have fresh, contemporary look. Read articles you are illustrating, provide 3 or more roughs in timely fashion."

PERSIMMON HILL

1700 NE 63rd St., Oklahoma City OK 73111. (405)478-6404. **Fax:** (405)478-4714. **E-mail:** editor@national cowboymuseum.org. **Website:** www.nationalcow boymuseum.org. **Contact:** Judy Hilovsky. Estab. 1970. Circ. 7,500. Quarterly 4-color journal of western heritage "focusing on both historical and contemporary themes. It features nonfiction articles on notable persons connected with pioneering the American West; art, rodeo, cowboys, ranching, floral and animal life; or other phenomena of the West of today or yesterday. Lively articles, well written, for a popular audience. Contemporary design follows style of *Architectural Digest, European Travel* and *Life.* Accepts no reprints. Pays on publication. Query with clips. We do not accept multiple submissions. Allow a minimum of 6 weeks for a response from the editor and editorial. Original artwork returned after publication. Sample copy for $11.
ILLUSTRATION Fine art only.
FIRST CONTACT & TERMS No phone queries are accepted. Send query letter with tearsheets, SASE, slides and transparencies. Samples are filed or returned by SASE if requested. Publication will contact artist for portfolio review if interested. Portfolio should include original/final art, photographs or slides. Buys first rights. Byline given. Requests work on spec before assigning job. Payment varies. Finds artists through word of mouth and submissions.
TIPS "We are a western museum publication. Most illustrations are used to accompany articles. Work with our writers, or suggest illustrations to the editor that can be the basis for a freelance article or a companion story. More interest in the West means we have to

provide more contemporary photographs and articles about what people in the West are doing today. Study the magazine first—at least 4 issues."

PEST CONTROL

Questex Media, 600 Superior Ave. E., Suite 1100, Cleveland OH 44114. **Website:** www.pestcontrolmag. com. Circ. 21,298. Monthly trade publication for pest control specialists focusing on crawling and flying insect control, termite control, rodent and other pest control and public health issues.
CARTOONS Approached by 50 cartoonists/year. Buys 1-2 cartoons/year. Prefer pest control, single panel and humorous.
ILLUSTRATION Approached by 50 illustrators/year. Buys 3-5 illustrations/year. Prefers pest control. Assigns 50% to new and emerging illustrators.
FIRST CONTACT & TERMS Cartoonists/illustrators: Send postcard sample with URL. After introductory mailing, send follow-up postcard sample every 6 months. Samples are filed. Responds only if interested. Buys one-time rights. Finds freelancers through artists' submissions.

PHI DELTA KAPPAN

P.O. Box 7888, Bloomington IN 47407. (800)766-1156. **Fax:** (812)339-0018. **E-mail:** memberservices@ pdkintl.org; cbucheri@pdkintl.org. **Website:** www. kappanmagazine.org. **Contact:** Carol Bucheri, design director; Terri Lawson, Kappan administrative assistant. Estab. 1915. Circ. 35,000. Journal covers issues in education, policy, research findings and opinion. Readers include members of the education organization Phi Delta Kappa as well as non-member subscribers—school administrators, teachers and policy makers. Published 8 times/year, September, October, November, December/January, February, March, April and May. Sample copy available for $15 plus shipping. Available in most university libraries.
CARTOONS Approached by over 100 cartoonists/ year. Looks for well-drawn cartoons that reflect our multi-racial, multi-ethnic, non-gender-biased world. Cartoon content MUST be related to education. Submit packages of 10-25 cartoons, 1 per 8×11 sheet, with SASE. Allow 2 months for review. Do not send submissions January 1-May 30. Does *not* accept electronic submissions of cartoons
ILLUSTRATION Approached by over 100 illustrators/ year. Relies primarily on stock illustration to supplement an increased use of photography. Send plain-

text e-mail with link to your online portfolio. Look for serious conceptual art to illustrate complex and often abstract themes. We also use humorous illustrations. Purchases royalty-free stock and one-time print and electronic rights for original work. Submission guidelines available online at www.pdkintl.org/kappan/write.htm.

PHILADELPHIA WEEKLY

1500 Sansom St., 3rd Floor, Philadelphia PA 19102. (215)563-7400. **Fax:** (215)563-0620. **E-mail:** abarbalios@philadelphiaweekly.com. **Website:** www.philadelphiaweekly.com. **Contact:** Anastasia Barbalios, managing editor. Estab. 1971. Circ. 105,500. Alternative weekly, 4-color, tabloid focusing on news and opinion and arts and culture.

CARTOONS Approached by 25 cartoonists/year. Buys 0-1 cartoon/issue. Prefers single panel, multiple panel, political, humorous, b&w washes, b&w line drawings.

ILLUSTRATION Approached by scores of illustrators/year. Buys 3-5 illustrations/issue. Has featured illustrations by Brian Biggs, Jay Bevenour, James McHugh. Features caricatures of celebrities and politicians; humorous, realistic and spot illustrations. Considers a wide range of styles.

FIRST CONTACT & TERMS Cartoonists: Send query letter with b&w photocopies. Illustrators: Send postcard sample or query letter with printed samples and photocopies. Send nonreturnable samples. Samples are filed and are not returned. Responds only if interested. Buys one-time rights. Pays on publication. Finds illustrators through promotional samples.

PHOENIX MAGAZINE

15169 N. Scottsdale Rd., Suite C310, Scottsdale AZ 85254. (480)664-3960. **E-mail:** aklawonn@citieswestpub.com. **Website:** www.phoenixmag.com. Circ. 63,000. Monthly regional magazine for residents and visitors to Phoenix, Arizona covering local personality profiles, local culture and historical articles.

ILLUSTRATION Features local caricatures of celebrities/politicians and humorous illustration of business and politics.

FIRST CONTACT & TERMS Illustrators: Send postcard sample with URL. Samples are filed. Responds only if interested. Pays illustrators $100-200 for color inside. Buys one-time rights. Finds freelancers through artists' submissions.

PLANNING

American Planning Association, 205 N. Michigan Ave., Suite 1200, Chicago IL 60601. (312)431-9100. **Fax:** (312)786-6700. **E-mail:** slewis@planning.org. **Website:** www.planning.org. **Contact:** Sylvia Lewis, editor; Richard Sessions, art director. Estab. 1972. Circ. 44,000. Monthly 4-color magazine for urban and regional planners interested in land use, housing, transportation and the environment. Free sample copy and artist's guidelines available.

CARTOONS Buys very few cartoons/year. Themes include the environment, city/regional planning, energy, garbage, transportation, housing, power plants, agriculture and land use. Prefers single-panel with gagline ("provide outside of cartoon body if possible").

ILLUSTRATION Buys very few illustrations/year. Themes include the environment, city/regional planning, energy, garbage, transportation, housing, power plants, agriculture and land use.

FIRST CONTACT & TERMS Cartoonists: Include SASE. Illustrators: We no long keep artists' promos on file. If you want a response, enclose SASE. Responds in 2 weeks. Buys all rights. Pays on publication. Pays cartoonists $50 minimum for b&w line drawings. Pays illustrators $250 maximum for b&w cover drawings; $100 minimum for b&w line drawings inside. Previously published work OK. Original artwork returned after publication, upon request.

TIPS "Don't send portfolio. No corny cartoons. Don't try to figure out what's funny to planners. All attempts seen so far are way off base. Your best chance is to send addresses for your website showing samples of any type of illustration—cartoons or other."

PLAYBOY MAGAZINE

680 N. Lake Shore Dr., Chicago IL 60611. (312)373-2700. **Fax:** (312)587-9046. **E-mail:** gcole@playboy.com. **Website:** www.playboy.com. Gary Cole, contributing editor. Estab. 1953. Monthly.

CARTOONS Playboy Enterprises, Inc., Cartoon Dept., 730 Fifth Ave., New York NY 10019.

ILLUSTRATION Approached by 700 illustrators/year. Prefers "uncommercial looking" artwork. Considers all media.

FIRST CONTACT & TERMS Illustrators: Send postcard sample or query letter with slides and photocopies or other appropriate sample. Does not accept originals. Samples are filed or returned. Responds in 2 weeks. Buys all rights. **Pays on acceptance.**

TIPS "No phone calls, only formal submissions of 5 pieces."

PLAYSTATION: THE OFFICIAL MAGAZINE

Future US, Inc., 4000 Shoreline Court, Suite 400, South San Francisco CA 94080. (650)872-1642. **Website:** www.futureus.com. **Contact:** Art director. Estab. 1997. Circ. 400,000. Monthly 4-color consumer magazine focused on PlayStation video games for youth (preteens and older). Style is "comic booky." Free sample copies available.

CARTOONS Prefers multiple-panel, humorous b&w line drawings; manga/comic book style.

ILLUSTRATION Approached by 20-30 illustrators/year. Buys 24 illustrations/issue. Has featured illustrations by Joe Madureira, Art Adams, Adam Warren, Hajeme Soroyana, Royo, J. Scott Campbell and Travis Charest. Features comic-book style, computer, humorous, realistic and spot illustration. Preferred subject: video game characters. Assigns 80% of illustrations to well-known or "name" illustrators; 10% to experienced, but not well-known, illustrators; and 10% to new and emerging illustrators. 50% of freelance illustration demands knowledge of Illustrator and Photoshop.

FIRST CONTACT & TERMS Cartoonists: Send query letter with b&w and color photocopies and samples. Illustrators: Send postcard sample or nonreturnable samples; send query letter with printed samples, photocopies and tearsheets. Accepts Mac-compatible disk submissions. E-mail JPEG or Web link (preferred method). Samples are filed. Responds only if interested. Will contact artist for portfolio review if interested. Buys all rights. Pays on publication. Finds illustrators through magazines and word of mouth.

TIPS "If you're an artist, confident that your vision is unique, your quality is the best, ever evolving, send us samples!"

PN/PARAPLEGIA NEWS

PVA Publications, 2111 E. Highland Ave., Suite 180, Phoenix AZ 85016-4702. (602)224-0500. **E-mail:** anns@pnnews.com. **Website:** www.pn-magazine.com. **Contact:** Ann Santos, article and photo submissions. Estab. 1947. Circ. 30,000. Monthly 4-color magazine emphasizing wheelchair living for wheelchair users, rehabilitation specialists. Accepts previously published artwork. Original artwork not returned after publication. Sample copy free with large-size SASE and $3 postage.

CARTOONS Buys 3 cartoons/issue. Prefers line art with wheelchair theme. Prefers single panel b&w line drawings with or without gagline.

ILLUSTRATION Prefers wheelchair living or medical and financial topics as themes. 50% of freelance work demands knowledge of QuarkXPress, Photoshop or Illustrator.

FIRST CONTACT & TERMS Submission guidelines available online.

TIPS "When sending samples, include something that shows a wheelchair user. We regularly purchase cartoons that depict wheelchair users."

POCKETS

Upper Room, P.O. Box 340004, 1908 Grand Ave., Nashville TN 37203-0004. (800)972-0433. **Fax:** (615)340-7275. **E-mail:** pockets@upperroom.org. **Website:** pockets.upperroom.org. **Contact:** Lynn W. Gilliam, editor. Estab. 1981. Devotional magazine for children 8-12. 4-color. Monthly except January/February. Accepts one-time previously published material. Original artwork returned after publication. Sample copy for 9×12 or larger SASE with 4 first-class stamps.

ILLUSTRATION Approached by 50-60 illustrators/year. Features humorous, realistic and spot illustration. Assigns 15% of illustrations to new and emerging illustrators. Uses variety of styles; 4-color, flapped traditional art or digital, appropriate for children. Realistic, fable and cartoon styles.

FIRST CONTACT & TERMS Illustrators: Send postcard sample, brochure, photocopies, and tearsheets with SASE. No fax submissions accepted. Also open to more unusual art forms cut paper, embroidery, etc. Samples not filed are returned by SASE only. No response without SASE." Buys one-time and reserves or reprint rights. **Pays on acceptance;** $600 flat fee for 4-color covers; $75-350 for color inside.

TIPS "Assignments made in consultation with out-of-house designer. Send samples to our designer Chris Schechner, Schechner & Associates, 408 Inglewood Dr., Richardson, TX 75080."

POPULAR SCIENCE

2 Park Ave. 9th Floor, New York NY 10016. (212)779-5000. **E-mail:** queries@popsci.com. **Website:** www.popsci.com. Circ. 1,500,000. "For the well-educated adult male, interested in science, technology, new products." Original artwork returned after publication. Art guidelines available.

ILLUSTRATION Uses 30-40 illustrations/issue. Has featured illustrations by Don Foley, P.J. Loughron, Andrew Grirds and Bill Duke. Assigns 50% of illustrations to well-known or "name" illustrators; 40% to experienced but not well-known illustrators; 10% to new and emerging illustrators. Works on assignment only. Interested in technical 4-color art and 2-color line art dealing with automotive or architectural subjects. Especially needs science and technological pieces as assigned per layout.

FIRST CONTACT & TERMS Illustrators: Send postcard sample, photocopies or other nonreturnable samples. Responds only if interested. Samples kept on file for future assignments. "After seeing portfolios, I photocopy or photostat those samples I feel are indicative of the art we might use." Reports whenever appropriate job is available. Buys first publishing rights.

TIPS "More and more scientific magazines have entered the field. This has provided a larger base of technical artists for us. Be sure your samples relate to our subject matter (e.g., no rose etchings) and be sure to include a tearsheet for our files. I don't really need a high end, expensive sample. All I need is something that shows the type of work you do. Look at our magazine before you send samples. Our illustration style is very specific. If you think you fit into the look of our magazine, send a sample for our files."

THE PORTLAND REVIEW

Portland State University, P.O. Box 347, Portland OR 97207-0347. (503)725-4533. **E-mail:** theportlandre view@gmail.com. **Website:** portlandreview.tumblr. com. **Contact:** Jacqueline Treiber, editor. Estab. 1956. Circ. 1,500. Triannual magazine covering short prose, poetry, photography, and art. Sample copies available for $9. Art guidelines available free with SASE or on website.

ILLUSTRATION Approached by 50 illustrators/year. We don't pay contributors. Features art illustrations and photography. Currently prefer Portland-based artists.

FIRST CONTACT & TERMS Cartoonists/illustrators: Send postcard sample or query letter with b&w photocopies and SASE. Accepts e-mail submissions with link to website or with image file. Prefers Mac-compatible. Samples are not filed and not returned. Responds with acceptance in 2 months. Portfolio not required.

PRACTICELINK

214 S. 8th St., Suite 502, Louisville KY 40202-2738. (502)589-8250. **Website:** www.uoworks.com. **Contact:** Barbara Barry, publisher and design director. Estab. 1991. Circ. 80,000. (Formerly Unique Opportunities). Quarterly trade journal. Audience is 80,000 physicians who want to stay on top of career development topics, and might be looking for a new practice. Editorial focus is on practice-related issues. Prefers files in JPEG, TIFF, or PDF format.

ILLUSTRATION Buys 1 illustrations/issue. Works on assignment or stock. Considers pen ink, mixed media, collage, pastel and computer illustration. Prefers computer illustration.

FIRST CONTACT & TERMS Views online portfolios. E-mail digital files. Buys first or one-time rights. Pays 30 days after publication; $700 for color cover; $150 for spots. Finds artists through Internet only. Do not send samples in the mail.

PRAIRIE JOURNAL OF CANADIAN LITERATURE

28 Crowfoot Terrace NW, P.0. Box 68073, Calgary AB T3G 3N8, Canada. **E-mail:** prairiejournal@yahoo. com. **Website:** www.prairiejournal.org. Estab. 1983. Circ. 600. Biannual literary magazine. Sample copies available for $6 each; art guidelines and past cover art available for viewing online.

ILLUSTRATION Approached by 25 illustrators/year. Buys 6 illustrations/year. Has featured cover art by Amanda Rehagen and John Howard, illustrations by Hubert Lacey, Rita Diebolt and Lucie Chan. Considers artistic/experimental b&w line drawings or screened prints.

FIRST CONTACT & TERMS Illustrators: Send postcard sample or query letter with b&w photocopies. Samples are filed. Responds only if interested. Portfolio review not required. Acquires one-time rights. Pays $50 maximum (Canadian) for b&w cover and $25 maximum for inside drawings. Pays on publication. Finds freelancers through unsolicited submissions and queries.

TIPS "We are looking for b&w line drawings that are high-contrast and camera-ready copy. Never send originals through the mail."

PRAIRIE MESSENGER

Benedictine Monks of St. Peter's Abbey, P.O. Box 190, Muenster SK S0K 2Y0, Canada. 1+(306)682-1772. **Fax:** 1+(306)682-5285. **E-mail:** pm.canadian@stpeter-

spress.ca. **Website:** www.prairiemessenger.ca. **Contact:** Maureen Weber, associate editor. Estab. 1904. Circ. 5,000. Weekly Catholic publication published by the Benedictine Monks of St. Peter's Abbey in Muenster, SK. Canada. Has a strong focus on ecumenism, social justice, interfaith relations, aboriginal issues, arts and culture.

FIRST CONTACT & TERMS E-mail JPEG samples at 72 dpi.

⟳ THE PRESBYTERIAN RECORD

50 Wynford Dr., Toronto ON M3C 1J7, Canada. (416)441-1111; (800)619-7301. **Fax:** (416)441-2825. **E-mail:** record@presbyterianrecord.ca. **Website:** www.presbyterianrecord.ca. Circ. 50,000. Published 11 times/year. Deals with family-oriented religious themes. Original artwork returned after publication. Simultaneous submissions and previously published work OK. Free sample copy and artists' guidelines for SASE with first-class postage.

CARTOONS Approached by 12 cartoonists/year. Buys 1-2 cartoons/issue. Interested in some theme or connection to religion.

ILLUSTRATION Approached by 6 illustrators/year. Buys 1 illustration/year on religion. Has featured illustrations by Ed Schnurr, Claudio Ghirardo and Chrissie Wysotski. Features humorous, realistic and spot illustration. Assigns 50% of illustrations to new and emerging illustrators. "We are interested in excellent color artwork for cover." Any line style acceptable—should reproduce well on newsprint. Works on assignment only.

FIRST CONTACT & TERMS Cartoonists: Send roughs and SAE (nonresidents include IRC). Illustrators: Send query letter with brochure showing art style or tearsheets, photocopies and photographs. Will accept computer illustrations compatible with QuarkXPress 4.1, Illustrator 8.0, Photoshop 6.0. Samples returned by SAE (nonresidents include IRC). Responds in 1 month. To show a portfolio, mail final art and color and b&w tearsheets. Buys all rights on a work-for-hire basis. Pays on publication. Pays cartoonists $25-50 for b&w. Pays illustrators $50-100 for b&w cover; $100-300 for color cover; $25-80 for b&w inside; $25-60 for spots.

TIPS "We don't want any 'cute' samples (in cartoons). We prefer some theological insight in cartoons; some comment on religious trends and practices."

PRESBYTERIANS TODAY

Presbyterian Church (U.S.A.), 100 Witherspoon St., Louisville KY 40202-1396. (502)569-5520. **Fax:** (502)569-8887. **E-mail:** today@pcusa.org. **Website:** www.pcusa.org/today. **Contact:** Eva Stimson, editor; Shellee Marie Layman, art director. Estab. 1867. Circ. 40,000. 4-color; official church magazine emphasizing Presbyterian news and informative and inspirational features. Publishes 10 issues year. Originals are returned after publication if requested. Sample copies for SASE with first-class postage.

ILLUSTRATION Works on assignment only. Media varies according to need.

PRINT MAGAZINE

F+W Media, 38 E. 29th St., 4th Floor, New York NY 10016. (212)447-1400. **Fax:** (212)447-5231. **E-mail:** info@printmag.com. **Website:** www.printmag.com. **Contact:** Alice Cho, art director. Estab. 1940. Circ. 55,000. Bimonthly professional magazine for "art directors, designers and anybody else interested in graphic design." Art guidelines available.

FIRST CONTACT & TERMS Illustrators/designers: Send postcard sample, printed samples and tearsheets. Samples are filed. Responds only if interested. Art director will contact artist for portfolio review if interested. Portfolios may be dropped off every Wednesday, and artists are responsible for retrieving them. Buys first rights. Pays on publication. Finds illustrators through agents, sourcebooks, word of mouth and submissions.

TIPS "Read the magazine: We showcase design, typography, illustration and photography. We're also interested in individual creative approaches to design problems. Note: We have themed issues; please ask to see our editorial calendar."

⟳ PRISM INTERNATIONAL

Department of Creative Writing, Buch E462, 1866 Main Mall, University of British Columbia, Vancouver BC V6T 1Z1, Canada. (604)822-2514. **Fax:** (604)822-3616. **Website:** www.prismmagazine.ca. Estab. 1959. Circ. 1,200. Quarterly literary magazine. "We use cover art for each issue." Sample copies available for $10 each; art guidelines free for SASE with first-class Canadian postage.

ILLUSTRATION Buys 1 cover illustration/issue. Has featured illustrations by Mark Ryden, Mark Mothersbaugh, Annette Allwood, the Clayton Brothers, Maria Capolongo, Mark Korn, Scott Bakal, Chris

Woods, Kate Collie and Angela Grossman. Features representational and nonrepresentational fine art. Assigns 50% of illustrations to experienced but not well-known illustrators; 50% to new and emerging illustrators. "Most of our covers are full color artwork and sometimes photography; on occasion we feature a black & white cover."

FIRST CONTACT & TERMS Illustrators: Send postcard sample. Accepts submissions on disk compatible with CorelDraw 5.0 (or lower) or other standard graphical formats. Most samples are filed; those not filed are returned by SASE if requested by artist. Responds in 6 months. Portfolio review not required. Buys first rights. "Image may also be used for promotional purposes related to the magazine." Pays on publication: $250 Canadian and 4 copies of magazine. Original artwork is returned to the artist at job's completion. Finds artists through word of mouth and going to local exhibits.

TIPS "We are looking for fine art suitable for the cover of a literary magazine. Your work should be polished, confident, cohesive and original. Please send postcard samples of your work. As with our literary contest, we will choose work that is exciting and which reflects the contemporary nature of the magazine."

PROCEEDINGS

U.S. Naval Institute, 291 Wood Rd., Annapolis MD 21402. (410)268-6110. **Fax:** (410)295-7940. **E-mail:** articlesubmissions@usni.org. **Website:** www.usni.org. **Contact:** Paul Merzlak, editor-in-chief; Amy Voight, photo editor. Estab. 1873. Circ. 60,000. Monthly 4-color magazine emphasizing naval and maritime subjects. "*Proceedings* is an independent forum for the sea services." Design is clean, uncluttered layout, "sophisticated." Accepts previously published material. Sample copies and art guidelines available.

CARTOONS Buys 23 cartoons/year from freelancers. Prefers cartoons assigned to tie in with editorial topics.

ILLUSTRATION Buys 1 illustration/issue. Works on assignment only. Has featured illustrations by Tom Freeman, R.G. Smith and Eric Smith. Features humorous and realistic illustration; charts & graphs; informational graphics; computer and spot illustration. Needs editorial and technical illustration. "We like a variety of styles if possible. Do excellent illustrations and meet the requirement for military appeal."

Prefers illustrations assigned to tie in with editorial topics.

FIRST CONTACT & TERMS Cartoonists: Send query letter with samples of style to be kept on file. Illustrators: send query letter with printed samples, tearsheets or photocopies. Accepts submissions on disk (call production manager for details). Samples are filed or are returned only if requested by artist. Responds only if interested. Publication will contact artist for portfolio review if interested. Negotiates rights purchased. Sometimes requests work on spec before assigning job. Pays cartoonists $25-50 for b&w, $50 for color. Pays illustrators $50 for b&w inside; $50-75 for color inside; $150-200 for color cover; $25 minimum for spots. "Contact us first to see what our needs are."

◑ PROFIT

Rogers Media, One Mount Pleasant Rd., 11th Floor, Toronto ON M4Y 2Y5, Canada. (416)764-1402. **Fax:** (416)764-1404. **E-mail:** profit@profit.rogers.com. **Website:** www.profitguide.com. **Contact:** Art director. Estab. 1982. Circ. 102,000. 4-color business magazine for Canadian entrepreneurs published 6 times/year.

ILLUSTRATION Buys 3-5 illustrations/issue. Has featured illustrations by Jerzy Kolacz, Jason Schneider, Ian Phillips. Features charts & graphs, computer, realistic and humorous illustration, informational graphics and spot illustrations of business subjects. Assigns 50% of illustrations to well-known or "name" illustrations; 50% to experienced but not well-known illustrators.

FIRST CONTACT & TERMS Illustrators: Send postcard or other nonreturnable samples. Accepts Mac-compatible disk submissions. Samples are not returned. Will contact artist for portfolio review if interested. Buys first rights. **Pays on acceptance**; $500-750 for color inside; $750-1,000 for 2-page spreads; $350 for spots. Pays in Canadian funds. Finds illustrators through promo pieces, other magazines.

THE PROGRESSIVE

409 E. Main St., Madison WI 53703. (608)257-4626. **Fax:** (608)257-3373. **E-mail:** editorial@progressive.org; mattr@progressive.org. **Website:** www.progressive.org. **Contact:** Matthew Rothschild, editor. Estab. 1909. Monthly b&w plus 4-color cover political magazine. "Grassroots publication from a left perspective, interested in foreign and domestic issues of peace and

social justice." Originals returned at job's completion. Free sample copy and art guidelines.

ILLUSTRATION Works with 50 illustrators/year. Buys 10 b&w illustrations/issue. Features humorous and political illustration. Has featured illustrations by Luba Lukova, Alex Nabaum and Seymour Chwast. Assigns 30% of illustrations to new and emerging illustrators. Needs editorial illustration that is "original, smart and bold." Works on assignment only.

FIRST CONTACT & TERMS Illustrators: Send query letter with tearsheets and/or photocopies. Samples returned by SASE. Responds in 6 weeks. Portfolio review not required. Pays $1,000 for b&w and color cover; $300 for b&w line or tone drawings/paintings/collage inside. Buys first rights. Do not send original art. Send samples, postcards or photocopies and appropriate postage for materials to be returned.

TIPS "Check out a copy of the magazine to see what kinds of art we've published in the past. A free sample copy is available by visiting our website."

PUBLIC CITIZEN NEWS

1600 20th St. NW, Washington DC 20009. (202)588-1000. **E-mail:** bblair@citizen.org. **Website:** www.citizen.org. **Contact:** Bridgette Blair, publications editor. Circ. 70,000. Bimonthly magazine emphasizing consumer issues for the membership of Public Citizen, a group founded by Ralph Nader in 1971. Accepts previously published material. Sample copy available with 9×12 SASE and first-class postage.

ILLUSTRATION Buys up to 2 illustrations/issue. Assigns 15% of illustrations to new and emerging illustrators. Prefers contemporary styles in pen & ink.

FIRST CONTACT & TERMS Illustrators: Send query letter with samples to be kept on file. Buys first rights or one-time rights. Pays on publication. Payment negotiable.

TIPS "Send several keepable samples that show a range of styles and the ability to conceptualize. We want cartoons that lampoon policies and politicians, as well as 4-color pen & ink or watercolor illustrations."

A PUBLIC SPACE

323 Dean St., Brooklyn NY 11217. (718)858-8067. **E-mail:** general@apublicspace.org. **Website:** www.apublicspace.org. **Contact:** Brigid Hughes, editor. *A Public Space*, published quarterly, "is an independent magazine of literature and culture. In an era that has relegated literature to the margins, we plan to make fiction and poetry the stars of a new conversation. We believe that stories are how we make sense of our lives and how we learn about other lives. We believe that stories matter." Single copy: $15; subscription: $36/year or $60/2 years.

FIRST CONTACT & TERMS Sample artwork, to be considered as story illustrations or as portfolios, can be sent to art@apublicspace.org. Please send no more than 4 low-res files. All artwork will be kept on file.

PUBLISHERS WEEKLY

71 W. 23rd St., #1608, New York NY 10010. (212)377-5500. **E-mail:** cchiu@publishersweekly.com. **Website:** www.publishersweekly.com. **Contact:** Clive Chiu, art director. Circ. 50,000. Weekly magazine emphasizing book publishing for "people involved in the creative or the technical side of publishing." Original artwork is returned to the artist after publication.

ILLUSTRATION Buys 75 illustrations/year. Works on assignment only. "Open to all styles."

FIRST CONTACT & TERMS Illustrators: Send postcard sample or query letter with brochure, tearsheets, photocopies. Samples are not returned. Responds only if interested. **Pays on acceptance**.

QUE ONDA!

P.O. Box 692150, Houston TX 77269-2150. (713)880-1133; (800)331-1374. **Fax:** (713)880-2322. **E-mail:** aida@queondamagazine.com. **Website:** www.queondamagazine.com. **Contact:** Aida Ulloa, art director. Estab. 1993. Circ. 160,000. Biweekly bilingual magazine providing news and entertainment sources for Latino community in and around San Antonio and Houston areas. Focusing on local politics, area celebrities, health, sports and food.

ILLUSTRATION Approached by 20 illustrators/year. Buys 10 illustrations/year. Features caricatures of local celebrities/politicians, Latino community, sports, health and local politics. Assigns 50% to new and emerging illustrators.

FIRST CONTACT & TERMS Send postcard sample. After introductory mailing, send follow-up postcard sample every 6 months. Responds only if interested. Buys one-time rights.

QUILL & QUIRE

111 Queen St. E., Suite 320, Toronto ON M5C 1S2, Canada. (416)364-3333. **Fax:** (416)595-5415. **E-mail:** astjacques@quillandquire.com. **Website:** www.quillandquire.com. **Contact:** Athena St. Jacques, art di-

rector. Estab. 1935. Monthly magazine of the Canadian book trade. Features book news and reviews for publishers, booksellers, librarians, writers, students and educators.

ILLUSTRATION Approached by 25 illustrators/year. Buys 3 visuals/issue. Assigns 1 to 2 illustrations per issue, 11 issues per year. 100% of illustrations to experienced but not necessarily well-known illustrators. Considers pen & ink and collage. 10% of freelance illustration requires knowledge of Photoshop, Illustrator, InDesign and QuarkXPress.

FIRST CONTACT & TERMS Send postcard sample. Accepts disk submissions. Samples are filed. Responds only if interested. Negotiates rights purchased. **Pays on acceptance.** Finds illustrators through word of mouth, submissions, and updated database.

RANGER RICK

1100 Wildlife Center Dr., Reston VA 20190. **E-mail:** Use online contact form. **Website:** www.nwf.org. Estab. 1967. Monthly 4-color children's magazine focusing on wildlife and conservation. Art guidelines are free with #10 SASE and first-class postage.

ILLUSTRATION Approached by 100-200 illustrators/year. Buys 4-6 illustrations/issue. Has featured illustrations by Danielle Jones, Jack Desrocher, John Dawson and Dave Clegg. Features computer, humorous, natural science and realistic illustrations. Preferred subjects children, wildlife and natural world. Assigns 1% of illustrations to new and emerging illustrators. 50% of freelance illustration demands knowledge of Illustrator, Photoshop.

FIRST CONTACT & TERMS Illustrators: Send query letter with printed samples, photocopies and SASE. Accepts Mac-compatible disk submissions. Samples are filed or returned by SASE. Responds in 3 months. Will contact artist for portfolio review if interested. Buys one-time rights. Pays on publication. Pay depends on project; $200-$2,500.

TIPS "Looking for new artists to draw animals using Illustrator, Photoshop and other computer drawing programs. Please read our magazine before submitting."

REAL ESTATE

RISMedia, Inc., 69 East Ave., Norwalk CT 06851. (800)724-6000. **Fax:** (203)855-1234. **E-mail:** christy@rismedia.com. **Website:** www.rismedia.com. **Contact:** Christy LaSalle, art director. Circ. 42,100. Monthly trade publication for real estate and relocation professionals.

ILLUSTRATION Approached by 50 illustrators/year. Buys 10 illustrations/year. Features families, houses, real estate topics and relocation. Assigns 50% to new and emerging illustrators.

FIRST CONTACT & TERMS Cartoonists: Send 2-3 photocopies of cartoons of real estate topics. Illustrators: Send postcard sample. After introductory mailing, send follow-up postcard sample every 4-6 months. Samples are filed. Responds only if interested. Buys one-time rights. Finds freelancers through artists' submissions.

REDBOOK

Hearst Magazines Division, Editorial Offices, 300 W. 57th St., 22nd Floor, New York NY 10019. (212)649-2000. **E-mail:** redbook@hearst.com. **Website:** www.redbookmag.com. **Contact:** Art director. Estab. 1903. Circ. 2 million+. Monthly magazine "written for working women ages 25-45 who want to keep a balance between career and busy home lives." Offers information on fashion, food, beauty, nutrition, health, etc.

ILLUSTRATION Buys 3-7 illustrations/issue. Illustrations can be in any medium. Accepts fashion illustrations for fashion page.

FIRST CONTACT & TERMS Send quarterly postcard. Art director will contact for more samples if interested. Portfolio drop off any day, pick up 2 days later. Buys reprint rights or negotiates rights. Accepts previously published artwork. Original artwork returned after publication with additional tearsheet if requested.

TIPS "We are absolutely open to seeing new stuff, but look at the magazine before you send anything; we might not be right for you. Generally, illustrations should look new, of the moment, fresh, intelligent and feminine. Keep in mind that our average reader is 30 years old, pretty, stylish (but not too 'fashion-y'). We do a lot of health pieces, and many times artists don't think of health when sending samples to us—so keep that in mind, too."

REFORM JUDAISM

633 Third Ave., 7th Floor, New York NY 10017-6778. (212)650-4240. **Fax:** (212)650-4249. **E-mail:** rjmagazine@urj.org. **Website:** www.reformjudaismmag.org. Estab. 1972. Circ. 310,000. Quarterly. "The official magazine of the Reform Jewish movement. It

covers developments within the movement and interprets world events and Jewish tradition from a Reform perspective." Accepts previously published artwork. Originals returned at jobs completion. Sample copies available for $3.50.

CARTOONS Prefers political themes tying into editorial coverage.

ILLUSTRATION Buys 5-8 illustrations/issue. Works on assignment. 10% of freelance work demands computer skills.

FIRST CONTACT & TERMS Cartoonists: Send query letter with copy of finished cartoons that do not have to be returned. Send with self-addressed stamped postcard offering 3 choices: "Yes, we are interested; No, unfortunately we will pass on publication; Maybe, we will consider and be back in touch with you." Illustrators: Send query letter with brochure and/or tearsheets. Samples are filed and artists are contacted when the right fit presents itself. Pays on publication; varies according to project. Finds artists' submissions.

REGISTERED REP

249 W. 17th St., 3rd Floor, New York NY 10011-5300. (212)204-4260. **Fax:** (212)206-3923. **E-mail:** sean.barrow@penton.com. **Website:** www.registeredrep.com; www.rrmag.com. **Contact:** Sean Barrow, art director. Estab. 1976. Circ. 100,000. Monthly trade publication provides stockbrokers and investment advisors with industry news and financial trends.

ILLUSTRATION Approached by 100 illustrators/year. Buys 10 illustrations/year. Features spot illustrations of business.

FIRST CONTACT & TERMS Illustrators: Send postcard sample. Send electronically or via CD as 300 dpi JPEG files. After introductory mailing, send follow-up postcard sample every 6 months. Responds only if interested. Company will contact artist for portfolio review if interested. Pays illustrators $200-500 for cover. Pays 60 days after publication. Buys one-time rights. Finds freelancers through artists' submissions.

TIPS "If you wish to contribute, please spend some time familiarizing yourself with *Registered Rep*'s various sections and features."

RELIX

104 W. 29th St., 11th Floor, New York NY 10001. (646)230-0100. **Fax:** (646)230-0200. **E-mail:** josh@relix.com. **Website:** www.relix.com. **Contact:** Josh Baron, editor. Estab. 1974. Circ. 100,000. Bimonthly consumer magazine emphasizing independent music and the jamband scene.

FIRST CONTACT & TERMS Cartoonists: Send query letter with finished cartoons. Illustrators: Send query letter with SASE and photocopies. Samples are not filed and are returned by SASE if requested by artist. Responds to the artist only if interested. Portfolio review not required. Buys first-time rights. Pays on publication. Finds artists through word of mouth.

TIPS "Not looking for any skeleton artwork."

RESTAURANT HOSPITALITY

Penton Media, 1300 E. Ninth St., Cleveland OH 44114. (216)931-9942. **Fax:** (216)696-0836. **E-mail:** chris.roberto@penton.com. **Website:** www.restaurant-hospitality.com. **Contact:** Chris Roberto, group creative director; Michael Sanson, editor-in-chief. Estab. 1919. Circ. 100,000. Monthly. Emphasizes "ideas for full-service restaurants" including business strategies and industry menu trends. Readers are restaurant owners/operators and chefs for full-service independent and chain concepts.

ILLUSTRATION Approached by 150 illustrators/year. Buys 3-5 illustrations per issue (combined assigned and stock). Prefers food- and business-related illustration in a variety of styles. Has featured illustrations by Mark Shaver, Paul Watson and Brian Raszka. Assigns 10% of illustrations to well-known or "name" illustrators; 60% to experienced but not well-known illustrators; and 30% to new and emerging illustrators. Welcomes stock submissions.

FIRST CONTACT & TERMS Illustrators: Postcard samples preferred. Follow-up card every 3-6 months. Buys one-time rights. **Pays on acceptance.** Payment range varies for full page or covers; $300-500 range for departments/features. Finished illustrations must be delivered as high-res digital. E-mail or FTP preferred.

TIPS "I am always open to new approaches—contemporary, modern visuals that explore various aspects of the restaurant industry and restaurant experience. Please include a web address on your sample so I can view an online portfolio."

RHODE ISLAND MONTHLY

The Providence Journal Co., 717 Allens Ave., Suite 105, Providence RI 02905. (401)649-4800. **E-mail:** dwelshman@rimonthly.com. **Website:** www.rimonthly.com. **Contact:** Dean Welshman, art director. Estab. 1988. Circ. 41,000. Monthly 4-color magazine focusing on life in Rhode Island. Provides in-depth reporting, ser-

vice and entertainment features as well as dining and calendar listings.

○ Also publishes a bridal magazine and tourism-related publications.

ILLUSTRATION Approached by 200 freelance illustrators/year. Buys 2-4 illustrations/issue. Works on assignment. Considers all media.

FIRST CONTACT & TERMS Illustrators: Send self-promotion postcards or samples. Accepts previously published artwork. Samples are filed and not returned. Buys one-time rights. Pays on publication; $300 minimum for color inside, depending on the job. Pays $800-1,000 for features. Finds artists through submissions/self-promotions and sourcebooks.

TIPS "Although we use a lot of photography, we are using more illustration, especially smaller, spot or quarter-page illustrations for our columns in the front of the magazine. If we see a postcard we like, we'll log on to the illustrator's website to see more work."

THE ROANOKER

Leisure Publishing Co., Leisure Publishing Co., 3424 Brambleton Ave., Roanoke VA 24018. (540)989-6138. **Fax:** (540)989-7603. **E-mail:** krheinheimer@leisure publishing.com. **Website:** www.theroanoker.com. **Contact:** Kurt Rheinheimer, editor; Austin Clark, creative director; Patty Jackson, production director. Estab. 1974. Circ. 10,000. Bimonthly general interest magazine for the city of Roanoke, VA, and the Roanoke valley. Originals are returned. Art guidelines not available.

ILLUSTRATION Approached by 20-25 freelance illustrators/year. Buys 2-5 illustrations/year.

FIRST CONTACT & TERMS Illustrators: Send query letter with brochure, tearsheets and photocopies. Samples are filed. Responds only if interested. No portfolio reviews. Buys one-time rights. Pays on publication; $100 for b&w or color cover; $75 for b&w or color inside.

TIPS "Works primarily on assignment. Welcomes a great story idea pertaining to the Roanoke Valley. Please *do not* call or send any material that needs to be returned."

ROBB REPORT

CurtCo Media Labs, 29160 Heathercliff Rd., Suite #200, Malibu CA 90265. (310)589-7700. **Fax:** (310)589-7701. **E-mail:** editorial@robbreport.com. **Website:** www.robbreport.com. **Contact:** Russ Rocknak, design director. Estab. 1976. Circ. 111,000. Monthly 4-color consumer magazine "for the luxury lifestyle, featuring exotic cars, investment, entrepreneur, boats, etc." Accepts previously published artwork. Original artwork is returned at job's completion. Sample copies not available; art guidelines for SASE with first-class postage.

ROLLING STONE

Wenner Media, 1290 Avenue of the Americas, New York NY 10104. (212)484-1616. **Fax:** (212)484-1664. **E-mail:** letters@rollingstone.com; photo@rollingstone.com. **Website:** www.rollingstone.com. **Contact:** Jann S. Wenner; John Gara, photo editor. Circ. 1,254,200. Monthly. Originals returned at job's completion. 100% of freelance design work demands knowledge of Illustrator, QuarkXPress and Photoshop. (Computer skills not necessary for illustrators.) Art guidelines on website.

ILLUSTRATION Approached by "tons" of illustrators/year. Buys approximately 4 illustrations/issue. Works on assignment only. Considers all media.

FIRST CONTACT & TERMS Illustrators: Send postcard sample and/or query letter with tearsheets, photocopies or any appropriate sample. Samples are filed. Does not reply. Portfolios may be dropped off every Tuesday before 3 p.m. and should include final art and tearsheets. Portfolios may be picked back up on Thursday after 3 p.m. "Please make sure to include your name and address on the outside of your portfolio." Publication will contact artist for portfolio review if interested. Buys first and one-time rights. **Pays on acceptance**; payment for cover and inside illustration varies; pays $300-500 for spots. Finds artists through word of mouth, *American Illustration*, *Communication Arts*, mailed samples and drop-offs.

○ ROOM

P.O. Box 46160, Station D, Vancouver BC V6J 5G5, Canada. **E-mail:** contactus@roommagazine.com. **Website:** www.roommagazine.com. **Contact:** Growing Room Collective. Estab. 1975. Circ. 1,000. Quarterly literary journal. Emphasizes feminist literature for women and libraries. Original artwork returned after publication if requested. Sample copy for $13; art guidelines for SASE (nonresidents include 3 IRCs).

ILLUSTRATION Illustrators: Send photographs, slides or original work as samples to be kept on file. Samples not kept on file are returned by SAE (nonresidents include IRC). Responds in 6 months. Buys first rights. Pays cartoonists $25 minimum for b&w

and color. Pays illustrators $25-50, b&w, color. Pays on publication. Buys 3-5 illustrations/issue from freelancers. Prefers good realistic illustrations of women and b&w line drawings. Prefers pen & ink, then charcoal/pencil and collage.

RTOHQ: THE MAGAZINE

1504 Robin Hood Trail, Austin TX 78703. (800)204-2776. **Fax:** (512)794-0097. **E-mail:** bkeese@rtohq.org. **Website:** www.rtohq.org. **Contact:** Bill Keese, executive editor. Estab. 1980. Circ. 5,500. Bimonthly publication for members of the Association of Progressive Rental Organizations, the national association of the rental-purchase industry. Sample copy free for catalog-size SASE with first-class postage.

ILLUSTRATION Buys 2-3 illustrations/issue. Has featured illustrations by Barry Fitzgerald, Aletha St. Romain, A.J. Garces, Edd Patton and Jane Marinsky. Features conceptual illustration. Assigns 15% of illustrations to new and emerging illustrators. Prefers cutting edge; nothing realistic; strong editorial qualities. Considers all media. Accepts computer-based illustrations (Photoshop, Illustrator).

FIRST CONTACT & TERMS Illustrators: Send postcard sample, query letter with printed samples, photocopies, or tearsheets. Accepts disk submissions (must be Photoshop-accessible EPS high-res at 300 dpi or Illustrator file). Samples are filed or returned by SASE. Responds in 1 month if interested. Rights purchased vary according to project. Pays on publication: $300-450 for color cover; $250-350 for color inside. Finds illustrators mostly through artist's submissions, some from other magazines.

TIPS "Must have a strong conceptual ability—that is, they must be able to illustrate for editorial articles dealing with business/management issues. We are looking for cutting-edge styles and unique approaches to illustration. I am willing to work with new, lesser-known illustrators."

RUNNER'S WORLD

Rodale, 135 N. 6th St., Emmaus PA 18098. (610)967-8441. **Fax:** (610)967-8883. **E-mail:** rwwebedit@rodale.com. **Website:** www.runnersworld.com. **Contact:** David Willey, editor-in-chief; Kory Kennedy, design director. Estab. 1966. Circ. 500,000. Monthly 4-color with a "contemporary, clean" design emphasizing serious, recreational running. Accepts previously published artwork "if appropriate." Returns original artwork after publication. Art guidelines not available.

Illustration Approached by hundreds of illustrators/year. Works with 50 illustrators/year. Buys average of 10 illustrations/issue. Has featured illustrations by Sam Hundley, Gil Eisner, Randall Enos and Katherine Adams. Features humorous and realistic illustration; charts & graphics; informational graphics; computer and spot illustration. Assigns 40% of illustrations to well-known or "name" illustrators; 40% to experienced but not well-known illustrators; 20% to new and emerging illustrators. Needs editorial, technical and medical illustrations. "Styles include tightly rendered human athletes, graphic and cerebral interpretations of running themes. Also, *RW* uses medical illustration for features on biomechanics." No special preference regarding media but appreciates electronic transmission. "No cartoons or originals larger than 11×14." Works on assignment only. 30% of freelance work demands knowledge of Illustrator, Photoshop or FreeHand.

FIRST CONTACT & TERMS Illustrators: Send postcard samples to be kept on file. Accepts submissions on disk compatible with Illustrator 5.0. Send EPS files. Publication will contact artist for portfolio review if interested. Buys one-time international rights. Pays $1,800 maximum for 2-page spreads; $400 maximum for spots. Finds artists through word of mouth, magazines, submissions/self-promotions, sourcebooks, artists' agents and reps and attending art exhibitions.

TIPS Portfolio should include "a maximum of 12 images. Show a clean presentation, lots of ideas and few samples. Don't show disorganized thinking. Portfolio samples should be uniform in size. Be patient!"

RURAL HERITAGE

P.O. Box 2067, Cedar Rapids IA 52406. (319)362-3027. **E-mail:** editor@ruralheritage.com. **Website:** www.ruralheritage.com. **Contact:** Gail Damerow, editor. Estab. 1976. Circ. 9,500. Bimonthly farm magazine "published in support of modern-day farming and logging with draft animals (horses, mules, oxen)." Sample copy for $8 postpaid; art guidelines not available.

Editor stresses the importance of submitting cartoons that deal only with farming and logging using draft animals.

CARTOONS "Approached by not nearly enough cartoonists who understand our subject." Buys 2 or more cartoons/issue. Prefers bold, clean, minimalistic draft animals and their relationship with the teamster. "No

unrelated cartoons!" Prefers single panel, humorous, b&w line drawings with or without gagline.

FIRST CONTACT & TERMS Cartoonists: Send query letter with finished cartoons and SASE. Samples accepted by U.S. mail only. Samples are not filed (unless we plan to use them—then we keep them on file until used) and are returned by SASE. Responds in 2 months. Buys first North American serial rights or all rights rarely. Pays on publication; $10 for one-time rights; $20 for all rights.

TIPS "Know draft animals (horses, mules, oxen, etc.) well enough to recognize humorous situations intrinsic to their use or that arise in their relationship to the teamster. Our best contributors read *Rural Heritage* and get their ideas from the publication's content."

SACRAMENTO MAGAZINE

706 56th St., Suite 201, Sacramento CA 95819. (916)452-6200. **Fax:** (916)452-6061. **E-mail:** debbieh@sacmag.com. **Website:** www.sacmag.com. **Contact:** Debbie Hurst, design director. Estab. 1975. Circ. 20,000. Monthly consumer lifestyle magazine with emphasis on home and garden, women, health features and stories of local interest. Accepts previously published artwork. Originals returned to artist at job's completion. Sample copies available.

ILLUSTRATION Approached by 100 illustrators/year. Buys 5 illustrations/year. Works on assignment only. Considers pen & ink, collage, airbrush, acrylic, colored pencil, oil, marker and pastel.

FIRST CONTACT & TERMS Illustrators: Send postcard sample. Accepts disk submissions. Send EPS files. Samples are filed and are not returned. Publication will contact artist for portfolio review if interested. Portfolio should include b&w and color tearsheets and final art. Buys one-time rights. Pays on publication; $300-400 for color cover; $200-500 for b&w or color inside; $100-200 for spots. Finds artists through submissions.

TIPS Sections most open to freelancers are departments and some feature stories.

SACRAMENTO NEWS & REVIEW

1124 Del Paso Blvd., Sacramento CA 95815. (916)498-1234. **Fax:** (916)498-7920. **E-mail:** sactoletters@newsreview.com. **Website:** www.newsreview.com. **Contact:** Melinda Welsh, editor. Estab. 1989. Circ. 90,000. "An award-winning b&w with 4-color cover alternative newsweekly for the Sacramento area. We combine a commitment to investigative and interpretive journalism with coverage of our area's growing arts and entertainment scene." Occasionally accepts previously published artwork. Originals returned at job's completion. Art guidelines not available.

Also publishes issues in Chico CA and Reno NV.

ILLUSTRATION Approached by 50 illustrators/year. Buys 1 illustration/issue. Works on assignment only. Features caricatures of celebrities and politicians; humorous, realistic, computer and spot illustrations. Assigns 50% of illustrations to new and emerging illustrators. For cover art, needs themes that reflect content.

FIRST CONTACT & TERMS Illustrators: Contact via online submission form with link to portfolio website. Send postcard sample or query letter with photocopies, photographs, SASE, slides and tearsheets. Samples are filed. Publication will contact artist for portfolio review if interested. Buys first rights. **Pays on acceptance.** Finds artists through submissions.

TIPS "Looking for colorful, progressive styles that jump off the page. Have a dramatic and unique style—not conventional or common."

SALT HILL LITERARY JOURNAL

Syracuse University, 401 Hall of Languages, Syracuse NY 133244. **Website:** www.salthilljournal.net. **Contact:** Art editor. Circ. 1,000. *Salt Hill* seeks unpublished 2D art-drawings, paintings, photography, mixed media, documentation of 3D art, typographic art diagrams, maps, etc. for its semiannual publication. We offer all colors, shapes, and stripes.

FIRST CONTACT & TERMS See website for specifications.

SANDY RIVER REVIEW

University of Maine at Farmington, 238 Main St., Farmington ME 04938. **E-mail:** srreview@gmail.com. **Website:** studentorgs.umf.maine.edu/~srreview. **Contact:** Kelsey Moore, editor. Biannual literary magazine. "The Sandy River Review seeks prose, poetry and art submissions twice a year for our Spring and Fall issues. Prose submissions may be either fiction or creative non-fiction and should be 15 pages or fewer in length, 12 pt., Times Roman font, double-spaced. Most of our art is published in b&w, and must be submitted as 300 dpi quality, CMYK color mode, and saved as a TIFF file. We publish a wide variety of work from students as well as professional, established writers. Your submission should be polished and imagina-

tive with strongly drawn characters and an interesting, original narrative. The review is the face of the University of Maine at Farmington's venerable BFA Creative Writing program, and we strive for the highest quality prose and poetry standard."

SANTA BARBARA MAGAZINE

2064 Almeda Padre Serra, Suite 120, Santa Barbara CA 93103. (805)965-5999. **Fax:** (805)965-7627. **E-mail:** alisa@sbmag.com. **Website:** www.sbmag.com. **Contact:** Jennifer Smith Hale, publisher; Alisa Baur, art director; Gina Tolleson, editor. Estab. 1975. Circ. 40,000. Bimonthly 4-color magazine with classic design emphasizing Santa Barbara culture and community. Original artwork returned after publication if requested.

ILLUSTRATION Approached by 20 illustrators/year. Works with 2-3 illustrators/year. Buys about 1-3 illustrations/year. Uses freelance artwork mainly for departments. Works on assignment only.

FIRST CONTACT & TERMS Send postcard, tearsheets or photocopies. To show a portfolio, mail b&w and color art, final reproduction/product and tearsheets; will contact if interested. Buys first rights. **Pays on acceptance**; approximately $275 for color cover; $175 for color inside. "Payment varies."

TIPS "Be familiar with our magazine."

THE SATURDAY EVENING POST

1100 Waterway Blvd., Indianapolis IN 46202. (317)634-1100. **Website:** www.saturdayeveningpost. com. Steve Slon, editorial director. Estab. 1728. Circ. 350,000. Bimonthly general interest, family-oriented magazine focusing on lifestyle, physical fitness, and preventive medicine.

"Ask almost any American if he or she has heard of *The Saturday Evening Post*, and you will find that many have fond recollections of the magazine from their childhood days. Many readers recall sitting with their families on Saturdays awaiting delivery of their *Post* subscription in the mail. *The Saturday Evening Post* has forged a tradition of 'forefront journalism.' *The Saturday Evening Post* continues to stand at the journalistic forefront with its coverage of health, nutrition, and preventive medicine."

CARTOONS Receives 100 batches of cartoons/week. Buys about 30 cartoons/issue. Prefers single-panel with gagline. "We look for cartoons with neat line or tone art. The content should be in good taste, suitable for a general-interest, family magazine. It must not be offensive while remaining entertaining. Review our guidelines online and then review recent issues. Political, violent or sexist cartoons are not used. We need all topics, but particularly medical, health, travel and financial."

ILLUSTRATION Buys about 3 illustrations/issue. Uses freelance illustration mainly for humorous fiction.

FIRST CONTACT & TERMS Cartoonists: Mail submissions and SASE to Post Toons, Box 567, Indianapolis IN 46202. Illustrators: Send query letter with brochure showing art style, or résumé and samples. To show a portfolio, mail final art. Buys all rights, "generally. All ideas, sketchwork and illustrative art are handled through commissions only and are thereby controlled by art direction. Do not send original material (drawings, paintings, etc.) or 'facsimiles' of material you wish returned. Cannot assume any responsibility for loss or damage." Responds in 2 months. Pays on publication. Pays cartoonists $125 for b&w line drawings and washes (no prescreened art). Pays illustrators $1,000 for color cover; $450 for color inside; $175 for b&w.

TIPS "Send samples of work published in other publications. Do not send racy or new-wave looks. Review the magazine. It's clear that 50% of the new artists submitting material have not looked at the magazine."

THE SCHOOL ADMINISTRATOR

801 N. Quincy St., Suite 700, Arlington VA 22203-1730. (703)528-0753. **Fax:** (703)841-1543. **E-mail:** lgriffin@aasa.org; info@aasa.org. **Website:** www.aasa.org. **Contact:** Liz Griffin, managing editor. Circ. 20,000. Monthly association magazine focusing on education.

CARTOONS Approached by 15 editorial cartoonists/year. Buys 11 cartoons/year. Prefers editorial/humorous, b&w line drawings only. Humor should be appropriate to a CEO of a school system, not a classroom teacher or parent."

ILLUSTRATION Approached by 60 illustrators/year. Buys 2-3 illustrations/issue. Has featured illustrations by Ralph Butler, Paul Zwolak, and Heidi Younger. Features spot and computer illustrations. Preferred subjects education K-12 and leadership. Assigns 90% of illustrations to our existing stable of illustrators. Considers all media. Requires willingness to work within tight budget.

FIRST CONTACT & TERMS Cartoonists: Send photocopies and SASE. Buys one-time rights. **Pays on acceptance.** Send nonreturnable samples. Samples are filed and not returned. Responds only if interested. Print rights purchased. Pays on publication. Pays illustrators $800 for color cover. Finds illustrators through word of mouth, stock illustration source and Creative Sourcebook.

TIPS Check out our website. Send illustration samples to: Melissa Kelly, Auras Design, 8435 Georgia Ave., Silver Spring MD 20910.

SCIENTIFIC AMERICAN

415 Madison Ave., New York NY 10017. (212)754-0550. **Fax:** (212)755-1976. **E-mail:** editors@sciam.com. **Website:** www.sciam.com. **Contact:** Emily Harrison, photography editor; Edward Bell, art director. Estab. 1845. Circ. 710,000. Monthly 4-color consumer magazine emphasizing scientific information for educated readers, covering geology, astronomy, medicine, technology and innovations.

ILLUSTRATION Approached by 100+ illustrators/year. Buys 15-30 illustrations/issue, mostly science-related, but there are opportunities for editorial art in all media. Assigns illustrations to specialized science illustrators, to well-known editorial illustrators, and to relative newcomers in both areas.

FIRST CONTACT & TERMS Illustrators: Send postcard sample or e-mail with link to website; follow up in 6 months. Responds only if interested. Portfolio reviews done as time allows. **Pays on acceptance**; $750-2,000 for color inside; $350-750 for spots.

TIPS "We use all styles of illustration and you do not have to be an expert in science although some understanding certainly helps. The art directors at *Scientific American* are highly skilled at computer programs, have a broad-based knowledge of science, and closely guide the process. Editors are experts in their field and help with technical backup material. One caveat: content is heavily vetted here for accuracy, so a huge plus on the part of our illustrators is their ability to make changes and corrections cheerfully and in a timely fashion."

SCOUTING

Boy Scouts of America, 1325 W. Walnut Hill Ln., P.O. Box 152079, Irving TX 75015-2079. **Website:** scoutingmagazine.org. **Contact:** John R. Clark, managing editor; Bryan Wendell, senior editor; Gretchen Sparling, associate editor; Linda Lawrence, assistant to the managing editor. Estab. 1913. Circ. 1 million. Magazine published 6 times/year covering Scouting activities for adult leaders of the Boy Scouts, Cub Scouts, and Venturing. "We use about 4-6 cartoons in each issue. They are normally one-panel, although we occasionally use a one-column vertical three-panel. Humor should be seen through the eyes of adults who are similar to our readers: volunteer leaders and/or parents of Cub Scouts or Boy Scouts. Avoid stereotypes such as dumb housewives, buxom blondes, lady drivers, lazy or dimwitted husbands, as well as common ethnic stereotypes. And especially avoid the stereotype of the fat Scoutmaster leading a brood of young Scouts through the woods. We emphasize more the self-reliance of the Scout and his patrol. Cartoons can feature uniformed Cub Scouts or Boy Scouts, but please be sure that you (1) know what the current uniform looks like, and (2) are familiar with the Scouting program. No smoking, hunting, or cruelty. New settings and situations are appreciated, as we get tired of deserted islands or thirsty men crawling through the desert."

CARTOONS "Size: 8×10 or 5×7. Paper: White, any weight you are comfortable with. Finish: If you send pencil roughs and we like the idea, you will be contacted to do a finish. However, we prefer finished art in case we want to use a cartoon immediately. We pay $75 per cartoon for first rights. Pays on acceptance."

SCRAP

1615 L St. NW, Suite 600, Washington DC 20036-5664. (202)662-8547. **Fax:** (202)626-0947. **E-mail:** kentkiser@scrap.org. **Website:** www.scrap.org. **Contact:** Kent Kiser, publisher. Estab. 1987. Circ. 8,451. Bimonthly 4-color trade publication that covers all aspects of the scrap recycling industry.

CARTOONS "We occasionally run single-panel cartoons that focus on the recycling theme/business."

ILLUSTRATION Approached by 100 illustrators/year. Buys 0-2 illustrations/issue. Features realistic illustrations, business/industrial/corporate illustrations and international/financial illustrations. Preferred subjects business subjects. Assigns 10% of illustrations to new and emerging illustrators.

FIRST CONTACT & TERMS Illustrators: Send postcard sample. Samples are filed. Portfolio review not required. Buys first North American serial rights. **Pays on acceptance**; $1,200-2,000 for color cover; $300-1,000 for color inside. Finds illustrators through cre-

ative sourcebook, mailed submissions, referrals from other editors, and "direct calls to artists whose work I see and like."

TIPS "We're always open to new talent and different styles. Our main requirement is the ability and willingness to take direction and make changes if necessary. No prima donnas, please. Send a postcard to let us see what you can do."

SEA MAGAZINE

Duncan McIntosh Co., 17782 Cowan, Suite A, Irvine CA 92614. (949)660-6150, ext. 253. **Fax:** (949)660-6172. **E-mail:** mike@seamag.com. **Website:** www.goboatingamerica.com. **Contact:** Mike Werling, managing editor. Estab. 1908. Circ. 55,000. Monthly 4-color magazine emphasizing recreational boating for owners or users of recreational powerboats, primarily for cruising and general recreation; some interest in boating competition; regionally oriented to 13 Western states. Accepts previously published artwork. Return of original artwork depends upon terms of purchase. Sample copy with SASE and first-class postage.

Also publishes *Go Boating* magazine.

ILLUSTRATION Approached by 20 illustrators/year. Buys 10 illustrations/year mainly for editorial. Considers airbrush, watercolor, acrylic and calligraphy.

FIRST CONTACT & TERMS Illustrators: Send query letter with brochure showing art style. Samples are returned only if requested. Publication will contact artist for portfolio review if interested. Portfolio should include tearsheets and cover letter indicating price range. Negotiates rights purchased. Pays on publication; $50 for b&w, $250 for color inside (negotiable).

TIPS "We will accept students for portfolio review with an eye to obtaining quality art at a reasonable price. We will help start career for illustrators and hope that they will remain loyal to our publication."

SEATTLE MAGAZINE

Tiger Oak Publications, Inc., 1518 First Ave. S., Suite 500, Seattle WA 98134. (206)284-1750. **Fax:** (206)284-2550. **E-mail:** rachel.hart@tigeroak.com. **Website:** www.seattlemagazine.com. **Contact:** Rachel Hart, editorial director; Kristen Russell, managing editor. Estab. 1992. Circ. 45,000. Monthly urban lifestyle magazine serving the Seattle metropolitan area. E-mail art director directly for art guidelines.

ILLUSTRATION Approached by hundreds of illustrators/year. Buys 2 illustrations/issue. Considers all media. "We can scan any type of illustration."

FIRST CONTACT & TERMS Illustrators: Prefers e-mail submissions. Samples are filed. Responds only if interested. Art director will contact artist for portfolio review of color, final art and transparencies if interested. Buys one-time rights. Sends payment on 25th of month of publication. Pays on publication; $150-1,100 for color cover; $50-400 for b $50-1,100 for color inside; $50-400 for spots. Finds illustrators through agents, sourcebooks such as *Creative Black Book*, *LA Workbook*, online services, magazines, word of mouth, artist's submissions, etc.

TIPS "Good conceptual skills are the most important quality that I look for in an illustrator as well as unique skills."

SEATTLE WEEKLY

Village Voice, 1008 Western Ave., Suite 300, Seattle WA 98104. (206)623-0500. **Fax:** (206)467-4338. **Website:** www.seattleweekly.com. Estab. 1976. Circ. 105,000. Weekly consumer magazine with emphasis on local and national issues and arts events. Accepts previously published artwork. Original artwork can be returned at job's completion if requested, "but you can come and get them if you're local." Sample copies available for SASE with first-class postage. Art guidelines not available.

ILLUSTRATION Approached by 30-50 freelance illustrators/year. Buys 3 freelance illustrations/issue. Works on assignment only. Prefers "sophisticated themes and styles."

FIRST CONTACT & TERMS Illustrators: Send query letter with tearsheets and photocopies. Samples are filed and are not returned. Does not reply, in which case the artists should "revise work and try again." To show a portfolio, mail b&w and color photocopies; "always leave us something to file." Buys first rights. Pays on publication; $200-250 for color cover; $60-75 for b&w inside.

TIPS "Give us a sample we won't forget. A really beautiful mailer might even end up on our wall, and when we assign an illustration, you won't be forgotten. All artists used must sign contract. Feel free to e-mail for a copy."

SHEEP! MAGAZINE

Countryside Publications, Ltd., 145 Industrial Dr., Medford WI 54451. (715)785-7979; (800)551-5691.

Fax: (715)785-7414. **E-mail:** sheepmag@tds.net. **Website:** www.sheepmagazine.com. Estab. 1980. Circ. 11,000. Bimonthly publication covering sheep, wool, and woolcrafts. Accepts previously published work.

CARTOONS Approached by 30 cartoonists/year. Buys 5 cartoons/year. Considers all themes and styles. Prefers single panel with gagline.

ILLUSTRATION Approached by 10 illustrators/year. Buys 5 illustrations/year; no inside color. Considers pen & ink. Features charts & graphs, computer illustration, informational graphics, realistic, medical and spot illustrations. All art should be sheep related.

FIRST CONTACT & TERMS Cartoonists: Send query letter with brochure and finished cartoons. Illustrators: Send query letter with brochure, SASE and tearsheets. To show a portfolio, mail thumbnails and b&w tearsheets. Buys first rights or all rights. **Pays on acceptance.** Pays cartoonists $5-15 for b&w. Pays illustrators $75 minimum for b&w.

TIPS "Demonstrate creativity and quality work."

SHOW-ME PUBLISHING, INC.

P.O. Box 411356, Kansas City MO 64141-1356. (816)842-9994. **Fax:** (816)474-1111. **Website:** www. ingramsonline.com. "We publish a regional business magazine (*Ingram's*) and several business-to-business publications and websites covering Kansas and Missouri. We require all freelancers to allow us full usage/copyright and resale of all work done for our publications and websites." Has occasional use for graphic designers and photographers. Prefers local talent.

FIRST CONTACT & TERMS Send cover letter, résumé, references, and samples of work to HR Department. Portfolios are not returned. Do not send original work; send digital files on CD. Pays $20/hour for Internet design and photography.

SIERRA

85 Second St., 2nd Floor, San Francisco CA 94105. (415)977-5656. **Fax:** (415)977-5799. **E-mail:** sierra. magazine@sierraclub.org. **Website:** www.sierraclub. org. **Contact:** Martha Geering, art director. Estab. 1893. Circ. 695,000. Bimonthly consumer magazine featuring environmental and general interest articles.

ILLUSTRATION Buys 8 photos/illustrations/issue. Considers all media. 10% of freelance illustration demands computer skills.

FIRST CONTACT & TERMS Send postcard samples or printed samples, SASE and tearsheets, or link to web portfolio. Samples are filed and are not returned.

Responds only if interested. Art director will contact artist for portfolio review if interested. Buys one-time rights. Finds illustrators through illustration and design annuals, illustration websites, sourcebooks, submissions, magazines, word of mouth. Submission guidelines available online.

SKIING MAGAZINE

Bonnier Corp., 5720 Flatiron Pkwy., Boulder CO 80301. (303)448-7600. **Fax:** (303)448-7638. **E-mail:** editor@skiingmag.com. **Website:** www.skinet.com/skiing. Estab. 1936. Circ. 430,000. Online publication emphasizing instruction, resorts, equipment and personality profiles. For new, intermediate and expert skiers. Published online. Previously published work OK "if we're notified." Sponsors summer internships. The internship is roughly 12 weeks long in Boulder, CO. All internships are unpaid. "Duties include working directly with the art director, photo editor and editorial staff on the development of pages from inception to final output, designing and flowing type in a number of our column and regular-section pages, and other design and production-related duties. Our staff is small and candidates will get an intimate knowledge of the day-to-day cycle of publishing a national magazine. We work with the Adobe Creative Suite 3. InDesign, Photoshop and Illustrator are all used on a daily basis. Proficiency in InDesign is critical. A passion for the sport of skiing is helpful, but not critical." Please e-mail résumé, cover letter, and portfolio or link to online portfolio to: mark@skiingmag.com.

CARTOONS Illustrators: Mail art and SASE. Responds immediately. Buys one-time rights. **Pays on acceptance;** $1,200 for color cover; $150-500 for color inside.

ILLUSTRATION Approached by 30-40 freelance illustrators/year. Buys 25 illustrations/year.

TIPS "The best way to break in is an interview and a consistent style portfolio. Then, keep us on your mailing list."

SKILLSUSA CHAMPIONS

14001 SkillsUSA Way, Leesburg VA 20176. (703)777-8810. **Fax:** (703)777-8999. **E-mail:** thall@skillsusa. org. **Website:** www.skillsusa.org/champions. **Contact:** Tom Hall, editor. Estab. 1965. Circ. 300,000. Quarterly 4-color magazine. "*SkillsUSA Champions* is primarily a features magazine that provides motivational content by focusing on successful members. SkillsUSA is an organization of more than 300,000

students and teachers in technical, skilled and service careers. Sample copies available.

ILLUSTRATION Approached by 4 illustrators/year. Works on assignment only. Prefers positive, youthful, innovative, action-oriented images. Considers pen & ink, watercolor, collage, airbrush and acrylic.

DESIGN Needs freelancers for design. 100% of freelance work demands knowledge of Adobe CS.

FIRST CONTACT & TERMS Illustrators: Send postcard sample. Designers: Send query letter with brochure. Accepts disks compatible with Illustrator CS5, and InDesign CS53. Send Illustrator and EPS files. Portfolio should include printed samples, b&w and color tearsheets and photographs. Accepts previously published artwork. Originals returned at job's completion (if requested). Rights purchased vary according to project. **Pays on acceptance.** Pays illustrators $200-300 for color; $100-300 for spots. Pays designers by the project.

TIPS "Send samples or a brochure. These will be kept on file until illustrations are needed. Don't call! Fast turnaround helpful. Due to the unique nature of our audience, most illustrations are not re-usable; we prefer to keep art."

SKIPPING STONES: A MULTICULTURAL LITERARY MAGAZINE

P.O. Box 3939, Eugene OR 97403-0939. (541)342-4956. **E-mail:** editor@skippingstones.org. **Website:** www.skippingstones.org. **Contact:** Arun Toke, editor. Estab. 1988. Circ. 2,200 print, plus web. "We promote multicultural awareness, international understanding, nature appreciation, and social responsibility. We suggest authors not make stereotypical generalizations in their articles. We like when authors include their own experiences, or base their articles on their personal immersion experiences in a culture or country." Has featured Lori Eslick, Xuan Thu Pham, Soma Han, Jon Bush, Zarouhie Abdalian, Elizabeth Zunon and Najah Clemmons.

CARTOONS Humorous cartoons. Prefers multicultural, social issues, nature/ecology themes. Requests b&w washes and line drawings. Has featured cartoons by Lindy Wojcicki of Florida. Prefers cartoons by youth under age 19.

ILLUSTRATION Approached by 100 illustrators/year. Buys 10-20 illustrations/year. Has featured illustrations by Lori Eslick, Sarah Solie, Wisconsin; Alvina Kong, California; Elizabeth Wilkinson, Vermont; Inna Svjatova, Russia; Jon Bush, Massachusetts. Features humorous illustrations, informational graphics, natural history and realistic, authentic illustrations. Preferred subjects children and teens. Prefers pen & ink. Assigns 80% of work to new and emerging illustrators. Recent issues have featured multicultural artists—their life and works.

FIRST CONTACT & TERMS Send query letter or e-mail with photographs (digital JPEGs at 72 dpi). Cartoonists: Send b&w photocopies and SASE. Illustrators: Send nonreturnable photocopies and SASE. Samples are filed or returned by SASE. Responds in 3 months if interested. Portfolio review not required. Buys first rights, reprint rights. Pays on publication 1-4 copies. No financial reimbursement. Finds illustrators through word of mouth, artists' promo samples.

TIPS "We are a multicultural magazine for youth and teens. We consider your work as a labor of love that contributes to the education of youth. We publish photoessays on various cultures and countries/regions of the world in each issue of the magazine to promote international and intercultural (and nature) understanding. Tell us a little bit about yourself, your motivation, goals, and mission."

SKYDIVING

1725 N. Lexington Ave., DeLand FL 32724. (386)736-9779. **Fax:** (386)736-9786. **E-mail:** sue@skydivingmagazine.com. **Website:** www.skydivingmagazine.com. **Contact:** Sue Clifton, editor; Mike Truffer, publisher. Estab. 1979. Circ. 14,200. *Skydiving* is a news magazine. Its purpose is to deliver timely, useful and interesting information about the equipment, techniques, events, people and places of parachuting. Our scope is national. *Skydiving*'s audience spans the entire spectrum of jumpers, from first-jump students to veterans with thousands of skydives. Some readers are riggers with a keen interest in the technical aspects of parachutes, while others are weekend "fun" jumpers who want information to help them make travel plans and equipment purchases. Originals returned at job's completion if requested. Readers are "sport parachutists worldwide, dealers and equipment manufacturers." Sample copy available for $3. Photo guidelines free with SASE or online.

CARTOONS Approached by 10 cartoonists/year. Buys 2 cartoons/issue. Has featured cartoons by Craig Robinson. Prefers skydiving themes; single panel, with gagline.

FIRST CONTACT & TERMS Cartoonists: Send query letter with roughs. Samples are filed. Responds in 2 weeks. Buys one-time rights. Pays $25 for b&w.

SMART MONEY

1211 Avenue of the Americas, New York NY 10036. **E-mail:** Jack.Hough@smartmoney.com. **Website:** www.smartmoney.com. **Contact:** Jack Hough, associate editor. Estab. 1992. Circ. 760,000. Monthly consumer magazine. Originals returned at job's completion. Sample copies available.

ILLUSTRATION Approached by 200-300 illustrators/year. Buys 10 illustrations/issue. Works on assignment only. Considers pen & ink, airbrush, colored pencil, mixed media, collage, charcoal, watercolor, acrylic, oil, pastel and digital.

FIRST CONTACT & TERMS Illustrators: Send postcard-size sample. Samples are filed. Publication will contact artist for portfolio review if interested. Portfolio should include tearsheets and photocopies. Buys first and one-time rights. Pays 30 days from invoice; $1,500 for color cover; $400-700 for spots. Finds artists through sourcebooks and submissions.

SMITHSONIAN MAGAZINE

Capital Gallery, Suite 6001, MRC 513, P.O. Box 37012, Washington DC 20013-7012. (202)275-2000. **E-mail:** smithsonianmagazine@si.edu. **Website:** www.smithsonianmag.com. **Contact:** Molly Roberts, photo editor; Jeff Campagna, art services coordinator. Circ. 2,300,000. Monthly consumer magazine exploring lifestyles, cultures, environment, travel and the arts. Smithsonian.com expands on *Smithsonian* magazine's in-depth coverage of history, science, nature, the arts, travel, world culture and technology.

Submit proposals online: www.smithsonianmag.com/contact-us.

ILLUSTRATION Approached by hundreds of illustrators/year. Buys 1-3 illustrations/issue. Illustrations are not the responsibility of authors, but it is helpful to know what photographic possibilities exist regarding your subject. Photographs published in the magazine are usually obtained through assignments, stock agencies or specialized sources. Submission guidelines: www.smithsonianmag.com/contact-us/submission-guidelines.html. Features charts and graphs, informational graphics, humorous, natural history, realistic and spot illustration.

FIRST CONTACT & TERMS Samples are filed. Responds only if interested. Will contact artist for portfolio review if interested. Buys first rights. **Pays on acceptance;** $350-$1,200 for color inside. Finds illustrators through agents and word of mouth.

SOAP OPERA DIGEST

Source Interlink Media, 261 Madison Ave., 10th Floor, New York NY 10016. **Website:** www.soapdigest.com. Estab. 1976. Circ. 2 million. Emphasizes soap opera and prime-time drama synopses and news. Weekly. Accepts previously published material. Returns original artwork after publication upon request. Sample copy available for SASE.

TIPS "Review the magazine before submitting work."

SOAP OPERA WEEKLY

261 Madison Ave., Floor 6, New York NY 10016. Estab. 1989. Circ. 700,000. Weekly 4-color consumer magazine; tabloid format. Original artwork returned at job's completion.

ILLUSTRATION Approached by 50 freelance illustrators/year. Works on assignment only.

FIRST CONTACT & TERMS Illustrators: Send query letter with brochure and soap-related samples. Samples are filed. Request portfolio review in original query. Publication will contact artist for portfolio review if interested. Portfolio should include original/final art. Buys first rights. **Pays on acceptance;** $2,000 for color cover; $750 for color, full page.

SOLIDARITY MAGAZINE

UAW Solidarity House, 8000 E. Jefferson, Detroit MI 48214. (313)926-5291. **E-mail:** uawsolidarity@uaw.net. **Website:** www.uaw.org. Published by United Auto Workers. 4-color magazine for "1.3 million member trade union representing U.S., Canadian and Puerto Rican workers in auto, aerospace, agricultural-implement, public employment and other areas." Contemporary design.

CARTOONS Carries "labor/political" cartoons. Payment varies.

ILLUSTRATION Works with 10-12 illustrators/year for posters and magazine illustrations. Interested in graphic designs of publications, topical art for magazine covers with liberal-labor political slant. Looks for "ability to grasp our editorial slant."

FIRST CONTACT & TERMS Illustrators: Send postcard sample or tearsheets and SASE. Samples are filed. Pays $500-600 for color cover; $200-300 for b&w inside; $300-450 for color inside. Graphic Artists Guild members only.

SPIDER

Carus Publishing, 70 E. Lake St., Suite 300, Chicago IL 60601. **Website:** www.cricketmag.com; www.spidermagkids.com. **Contact:** Alice Letvin, editorial director; Margaret Mincks, associate editor. Monthly literary and activity magazine for children ages 6-9. Our "bug magazines" accept unsolicited manuscripts. Art guidelines available on website.

○ See listings for other magazines published by the Cricket Magazine Group: *Babybug, Ladybug, Cricket* and *Cicada*.

ILLUSTRATION Buys 20 illustrations/issue; 240 illustrations/year. Uses color artwork only. Works on assignment only.

FIRST CONTACT & TERMS Send photocopies, photographs or tearsheets to be kept on file. Samples are returned by SASE if requested. Responds in 3 months. Buys all rights. Pays 45 days after acceptance: $750 for color cover; $250 for color full page; $100 for color spots; $50 for b&w spots.

TIPS "Before attempting to illustrate for *Spider*, be sure to familiarize yourself with this age group, and read several issues of the magazine. Please do not query first."

SPITBALL: THE LITERARY BASEBALL MAGAZINE

5560 Fox Rd., Cincinnati OH 45239. **Website:** www.spitballmag.com. **Contact:** Mike Shannon, editor-in-chief. Estab. 1981. Quarterly 2-color magazine emphasizing baseball, exclusively for "well-educated, literate baseball fans." *Spitball* has a regular column called "Brushes With Baseball" that features one artist and his/her work. Chooses artists for whom baseball is a major theme/subject. Prefers to buy at least one work from the artist to keep in its collection. Sometimes prints color material in b&w on cover. Returns original artwork after publication if the work is donated; does not return if purchased. Sample copy available for $6.

CARTOONS Prefers single-panel b&w line drawings with or without gagline. Prefers "old fashioned *Sport Magazine/New Yorker* type. Please, cartoonists, make them funny, or what's the point?"

ILLUSTRATION "We need two types of art illustration (for a story, essay or poem) and filler. All work must be baseball-related." Prefers pen & ink, airbrush, charcoal/pencil and collage. Interested artists should write to find out needs for specific illustration. Buys 3 or 4 illustrations/issue.

FIRST CONTACT & TERMS Cartoonists: Query with samples of style, roughs and finished cartoons. Illustrators: Send query letter with b&w illustrations or slides. Target samples to magazine's needs. Samples not filed are returned by SASE. Responds in 1 week. Negotiates rights purchased. **Pays on acceptance.** Pays cartoonists $10 minimum. Pays illustrators $20-40 for b&w inside.

TIPS "Usually artists contact us and if we hit it off, we form a long-lasting mutual admiration society. Please, you cartoonists out there, drag your bats up to the *Spitball* plate! We like to use a variety of artists."

SPORTS AFIELD

Field Sports Publishing, 15621 Chemical Ln., Suite B, Huntington Beach CA 92649. (714)373-4910. **E-mail:** letters@sportsafield.com. **Website:** www.sportsafield.com. **Contact:** Jerry Gutierrez, art director. Estab. 1887. Circ. 50,000. Bimonthly magazine. "*SA* is edited for hunting enthusiasts. We are the oldest outdoor magazine. We cater to the upscale hunting market, especially hunters who travel to exotic destinations like Alaska and Africa. We are not a deer hunting magazine, and we do not cover fishing."

ILLUSTRATION Hunting/wildlife themes only. Considers all media. Freelancers should be familiar with Photoshop, Illustrator, InDesign.

FIRST CONTACT & TERMS Illustrators: Send postcard sample or query letter with photocopies and tearsheets. Accepts disk submissions. Samples are filed. Responds only if interested. Will contact for portfolio of b&w or color photographs, slides, tearsheets and transparencies if interested. Buys first North American serial rights. Pays on publication; negotiable. Finds illustrators through *Black Book*, magazines, submissions.

SPORTS 'N SPOKES

PVA Publications, 2111 E. Highland Ave., Suite 180, Phoenix AZ 85016-4702. (888)888-2201. **Fax:** (602)224-0507. **E-mail:** anngarvey@pvamag.com. **Website:** www.sportsnspokes.com. **Contact:** Ann Garvey, art and production director. Circ. 15,000. Published 6 times a year. Consumer magazine with emphasis on sports and recreation for the wheelchair user. Accepts previously published artwork. Sample copies for large SASE and $3.00 postage.

CARTOONS Buys 3-5 cartoons/issue. Prefers humorous cartoons; single panel b&w line drawings with or without gagline. Must depict some aspect of wheelchair sport or recreation.

ILLUSTRATION Works on assignment only. Considers pen & ink, watercolor and computer-generated art. 50% of freelance work demands knowledge of Illustrator, QuarkXPress or Photoshop.

FIRST CONTACT & TERMS Submission guidelines available online.

TIPS "We have not purchased an illustration or used a freelance designer for many years. We regularly purchase cartoons with wheelchair sports/recreation theme."

STANFORD MAGAZINE

Frances C. Arrillaga Alumni Center, 326 Galvez St., Stanford CA 94305-6105. (650)725-0672. **E-mail:** gvirgili@stanford.edu. **Website:** www.stanford alumni.org/news/magazine/2011/julaug/. **Contact:** Giorgia Virgili, art director. Estab. 1973. Circ. 105,000. Consumer magazine, "geared toward the alumni of Stanford University. Articles vary from photo essays to fiction to academic subjects." Accepts previously published artwork. Original artwork is returned at job's completion. Sample copies available.

ILLUSTRATION Approached by 200-300 illustrators/year. Buys 4-6 illustrations/issue. Works on assignment only. Interested in all styles.

FIRST CONTACT & TERMS Send samples only. Call for appointment to show portfolio. Buys one-time rights. **Pays on acceptance.**

TIPS "We're always looking for unique styles, as well as excellent traditional work. We like to give enough time for the artist to produce the piece."

STONE SOUP

Children's Art Foundation, P.O. Box 83, Santa Cruz CA 95063-0083. (831)426-5557. **Fax:** (831)426-1161. **E-mail:** editor@stonesoup.com. **Website:** www.stone soup.com. **Contact:** Ms. Gerry Mandel, editor. Estab. 1973. Circ. 15,000. Bimonthly 4-color magazine with "simple and conservative design" emphasizing writing and art by children. Features adventure, ethnic, experimental, fantasy, humorous and science fiction articles. "We only publish writing and art by children through age 13. We look for artwork that reveals that the artist is closely observing his or her world." Sample copies available for $4 each. Art guidelines available online.

ILLUSTRATION Buys 12 illustrations/issue. Prefers complete and detailed scenes from real life. All art must be by children ages 8-13.

FIRST CONTACT & TERMS Illustrators: Send query letter with color copies. Samples are not returned. Responds in 1 month. Buys all rights. Pays on publication; $50 for color cover, $25 for color inside, $ 15 for spots.

STRATEGIC FINANCE

10 Paragon Dr., Montvale NJ 07645. (201)474-1558. **Fax:** (201)474-1603. **E-mail:** mzisk@imanet.org. **Website:** www.imanet.org and www.strategicfinancemag. com. **Contact:** Mary Zisk, art director. Estab. 1919. Circ. 58,000. Monthly 4-color emphasizing management accounting for corporate accountants, controllers, chief financial officers, and treasurers. Originals are returned after publication.

ILLUSTRATION Approached by 4 illustrators/day. Buys 3 illustrations/issue.

FIRST CONTACT & TERMS Illustrators: Send non-returnable postcard samples. Prefers financial and corporate themes. Looking for smart concepts and unique technique.

STUDENT LAWYER

ABA Publishing, Law Student Division, American Bar Association, 321 N. Clark St., Chicago IL 60654. (312)988-6049. **Fax:** (312)988-6081. **E-mail:** Student-Lawyer@americanbar.org. **Website:** www.abanet.org/lsd/studentlawyer. **Contact:** Angela Gwizdala, editor. Estab. 1972. Circ. 40,000. Trade journal, 4-color, emphasizing legal education and social/legal issues. "*Student Lawyer* is a legal affairs magazine published by the Law Student Division of the American Bar Association. It is not a legal journal. It is a features magazine, competing for a share of law students' limited spare time—so the articles we publish must be informative, lively, good reads. We have no interest whatsoever in anything that resembles a footnoted, academic article. We are interested in professional and legal education issues, sociolegal phenomena, legal career features, and profiles of lawyers who are making an impact on the profession." Monthly (September-May). Original artwork is returned to the artist after publication.

ILLUSTRATION Approached by 20 illustrators/year. Buys 8 illustrations/issue. Has featured illustrations by Sean Kane and Jim Starr. Features realistic, computer and spot illustration. Assigns 50% of illustrations to experienced but not well-known illustrators;

50% to new and emerging illustrators. Needs editorial illustration with an "innovative, intelligent style." Works on assignment only. Needs computer-literate freelancers for illustration. No cartoons please.

FIRST CONTACT & TERMS Send postcard sample, brochure, tearsheets and printed sheet with a variety of art images (include name and phone number). Samples are filed. Call for appointment to show portfolio of final art and tearsheets. Buys one-time rights. **Pays on acceptance.** $500-800 for color cover; $450-650 for color inside; $150-350 for spots.

TIPS "In your samples, show a variety of styles with an emphasis on editorial work."

☼ SUB-TERRAIN MAGAZINE

P.O. Box 3008, MPO, Vancouver BC V6B 3X5, Canada. (604)876-8710. **Fax:** (604)879-2667. **E-mail:** subter@portal.ca. **Website:** www.subterrain.ca. **Contact:** Brian Kaufman, editor-in-chief. Estab. 1988. Published 3 times a year. Full color literary magazine featuring contemporary literature of all genres. "We have changed our method of assigning illustrations. We now use a single illustrator for each issue (a 'featured' artist) and the artists are commissioned by invitation only."

CARTOONS Prefers single panel cartoons.

ILLUSTRATION Assigns 50% of illustrations to new and emerging illustrators.

FIRST CONTACT & TERMS Willing to view artist portfolios online. Send links to your website or submit a few sample JPEGs. Responds if interested. Portfolio review not required. Buys first rights, first North American serial rights, one-time rights or reprint rights. Pays $50-150 (Canadian), plus contributor copies.

TIPS "Take the time to look at an issue of the magazine to get an idea of the kind of material we publish."

SUN VALLEY MAGAZINE

Valley Publishing, LLC, 111 First Ave. N #1M, Meriwether Building, Hailey ID 83333. (208)788-0770. **Fax:** (208)788-3881. **E-mail:** michael@sunvalleymag.com; robinleahy@sunvalleymag.com. **Website:** www.sunvalleymag.com. **Contact:** Mike McKenna, editor; Robin Leahy, art director. Estab. 1973. Circ. 17,000. Consumer magazine published 3 times/year, "highlighting the activities and lifestyles of people of the Wood River Valley." Sample copies available. Art guidelines free for #10 SASE with first-class postage.

ILLUSTRATION Approached by 10 illustrators/year. Buys 3 illustrations/issue. Prefers forward, cutting edge styles. Considers all media.

FIRST CONTACT & TERMS Illustrators: Send query letter with SASE. Accepts disk submissions compatible with Macintosh, and/or InDesign. Send EPS files. Samples are filed. Does not report back. Artist should call. Art director will contact artist for portfolio review of b&w, color, final art, photostats, roughs, slides, tearsheets and thumbnails if interested. Buys first rights. Pays on publication; $350 cover; $80-240 inside.

TIPS "Read our magazine. Send ideas for illustrations and examples."

T+D

1640 King St., Box 1443, Alexandria VA 22313-2043. (800)628-2783. **E-mail:** submissions@astd.org. **Website:** www.astd.org/Publications/Magazines/TD. **Contact:** Ann Pace, associate editor. Estab. 1945. Circ. 40,000. Monthly trade journal magazine that covers training and development in all fields of business. Accepts previously published artwork. Original artwork is returned at job's completion. Art guidelines not available.

ILLUSTRATION Approached by 20 freelance illustrators/year. Buys a limited number of freelance illustrations per issue. Works on assignment only. Has featured illustrations by Alison Seiffer, James Yang and Riccardo Stampatori. Features humorous, realistic, computer and spot illustration. Assigns 10% of work to new and emerging illustrators. Prefers sophisticated business style. Considers collage, pen & ink, airbrush, acrylic, oil, mixed media, pastel.

FIRST CONTACT & TERMS Illustrators: Send postcard sample. Accepts disks compatible with Illustrator 9, FreeHand 5.0, Photoshop 5. Send EPS, JPEG or TIFF files. Use 4-color (process) settings only. Samples are filed. Responds to the artist only if interested. Write for appointment to show portfolio of tearsheets, slides. Buys one-time rights or reprint rights. Pays on publication; $700-1,200 for color cover; $350 for b&w inside; $350-800 for color inside; $800-1,000 for 2-page spreads; $100-300 for spots.

TIPS "Send more than one image if possible. Do not keep sending the same image. Try to tailor your samples to the art director's needs if possible."

TAMPA BAY MAGAZINE

2531 Landmark Dr., Suite 101, Clearwater FL 33761. (727)791-4800. **E-mail:** production@tampabaymagazine.com. **Website:** tampabaymagazine.com. Estab. 1986. Circ. 40,000. Bimonthly local lifestyle magazine with upscale readership. Accepts previously published artwork. Sample copy available for $4.50. Submission guidelines available online.

CARTOONS Approached by 30 cartoonists/year. Buys 6 cartoons/issue. Prefers single-panel color washes with gagline.

ILLUSTRATION Approached by 100 illustrators/year. Buys 5 illustrations/issue. Prefers happy, stylish themes. Considers watercolor, collage, airbrush, acrylic, marker, colored pencil, oil and mixed media.

FIRST CONTACT & TERMS Cartoonists: Send query letter with finished cartoon samples. Illustrators: Send query letter with photographs and transparencies. Samples are not filed and are returned by SASE if requested. To show a portfolio, mail color tearsheets, slides, photocopies, finished samples and photographs. Buys one-time rights. Pays on publication. Pays cartoonists $15 for b&w, $20 for color. Pays illustrators $150 for color cover; $75 for color inside.

TECHNICAL ANALYSIS OF STOCKS & COMMODITIES

4757 California Ave. SW, Seattle WA 98116. (206)938-0570. **E-mail:** editor@traders.com; jhutson@traders.com. **Website:** www.traders.com. **Contact:** Jack K. Huston, editor-in-chief; Elizabeth M.S. Flynn, managing editor. Estab. 1982. Circ. 65,000. Monthly traders' magazine for stocks, bonds, futures, commodities, options, mutual funds. Sample copies available for $5 each. Art guidelines on website.

This magazine has received several awards, including the Step by Step Design Annual, American Illustration IX, XXIII, XIV, NY Society of Illustrators Annuals 40, 46, 48, 49. separate listing for Technical Analysis, Inc., in the Book Publishers section.)

CARTOONS Approached by 10 cartoonists/year. Buys 1-4 cartoons/issue. Prefers humorous cartoons, single-panel b&w line drawings with gagline.

ILLUSTRATION Approached by 100 illustrators/year. Buys 6 illustrations/issue. Works on assignment only. Features humorous, realistic, computer (occasionally) and spot illustrations.

FIRST CONTACT & TERMS Cartoonists: Send query letter with finished cartoons (non-returnable copies only) or e-mail. Illustrators: Send e-mail JPEGs, brochure, tearsheets, photographs, photocopies, photostats, slides. Accepts disk submissions compatible with any Adobe products (TIFF or EPS files). Samples are filed and are not returned. E-mail portfolio for review if interested. Portfolio should include b&w and color art, slides, photostats, photocopies, final art and photographs. Buys one-time rights and reprint rights. Pays on publication. Pays cartoonists $35 for b&w. Pays illustrators $135-350 for color cover; $165-220 for color inside; $105-150 for b&w inside. Accepts previously published artwork.

TIPS "Looking for creative, imaginative and conceptual types of illustration that relate to articles' concepts. Also interested in caricatures with market charts and computers. If I'm interested, I will call."

TEXAS MEDICINE

401 W. 15th St., Austin TX 78701. (800)880-1300, ext. 1383. **Fax:** (512)370-1300. **E-mail:** Larry.BeSaw@texmed.org. **Website:** www.texmed.org. **Contact:** Larry BeSaw, editorial contact. Circ. 35,000. Monthly trade journal published by Texas Medical Association for the statewide Texas medical profession. Sample copies and art guidelines available.

ILLUSTRATION Approached by 30-40 illustrators/year. Buys 4-6 illustrations/issue. Prefers medical themes. Considers all media.

FIRST CONTACT & TERMS Illustrators: Send postcard sample or query letter with photocopies. Accepts disk submissions of EPS or TIFF files for QuarkXPress 3.32. Samples are filed and are not returned. Responds only if interested. Art director will contact artist for portfolio review of b&w, color, final art, photographs, photostats, tearsheets or transparencies if interested. Rights purchased vary according to project. Pays on publication. Payment varies; $350 for spots. Finds artists through agents, magazines and submissions.

TEXAS MONTHLY

Emmis Publishing LP, P.O. Box 1569, Austin TX 78767-1569. (512)320-6900. **Fax:** (512)476-9007. **E-mail:** lbaldwin@texasmonthly.com. **Website:** www.texasmonthly.com. **Contact:** Jake Silverstein, editor; Leslie Baldwin, photo editor; Scott Dadich, art director. Estab. 1973. Circ. 300,000. *Texas Monthly* is edited for the urban Texas audience and covers the

state's politics, sports, business, culture and changing lifestyles. It contains lengthy feature articles, reviews and interviews, and presents critical analysis of popular books, movies and plays. Accepts previously published artwork. Originals are returned to artist at job's completion.

ILLUSTRATION Approached by hundreds of illustrators/year. Works on assignment only. Considers all media.

FIRST CONTACT & TERMS Art/graphic design illustrators: Send postcard sample of work or an e-mail with link to your website. Appropriate samples are filed or returned by SASE if requested by artist. Fees vary based on size and complexity of illustration.

TEXAS PARKS & WILDLIFE

4200 Smith School Rd., Bldg. D, Austin TX 78744. (512)389-8793. **Fax:** (512)707-1913. **E-mail:** louie. bond@tpwd.state.tx.us; brandon.jakobeit@tpwd. state.tx.us. **Website:** www.tpwmagazine.com. **Contact:** Louie Bond, editor; Brandon Jakobeit, assistant art director. Estab. 1942. Circ. 150,000. Monthly magazine "containing information on state parks, wildlife conservation, hunting and fishing, environmental awareness." Sample copies for #10 SASE with first-class postage.

ILLUSTRATION 100% of freelance illustration.

FIRST CONTACT & TERMS Illustrators: Send postcard sample. Samples are not filed and are not returned. Responds only if interested. Buys one-time rights. Pays on publication; negotiable. Finds illustrators through magazines, word of mouth, artist's submissions.

TIPS "Read our magazine."

THRASHER

High Speed Productions, P.O. Box 884570, San Francisco CA 94188-4570. (415)822-3083. **Fax:** (415)822-8359. **E-mail:** mail@thrashermagazine.com. **Website:** www.thrashermagazine.com. Estab. 1981. Circ. 200,000. Monthly 4-color magazine. "*Thrasher* is the dominant publication devoted to the latest in extreme youth lifestyle, focusing on skateboarding, snowboarding, new music, videogames, etc." Originals returned at job's completion. Sample copies for SASE with first-class postage. Art guidelines available online. Needs computer-literate freelancers for illustration. Freelancers should be familiar with Illustrator or Photoshop.

CARTOONS Approached by 100 cartoonists/year. Has featured illustrations by Mark Gonzales and Robert Williams. Prefers skateboard, snowboard, music, youth-oriented themes. Assigns 100% of illustrations to new and emerging illustrators.

ILLUSTRATION Approached by 100 illustrators/year. Prefers themes surrounding skateboarding/skateboarders, snowboard/music (rap, hip hop, metal) and characters and commentary of an extreme nature. Prefers pen & ink, collage, airbrush, marker, charcoal, mixed media and computer media (Mac format).

FIRST CONTACT & TERMS Cartoonists: Send query letter with brochure and roughs. Illustrators: Send query letter with brochure, résumé, SASE, tearsheets, photographs and photocopies. Publication will contact artist for portfolio review if interested. Portfolio should include b&w and color tearsheets, photocopies and photographs. Rights purchased vary according to project. Negotiates payment for covers. Sometimes requests work on spec before assigning job. Pays on publication. Pays cartoonists $50 for b&w, $75 for color. Pays illustrators $75 for b&w, $100 for color inside.

TIPS "Send finished quality examples of relevant work with a bio/intro/résumé that we can keep on file and update contact info. Artists sometimes make the mistake of submitting examples of work inappropriate to the content of the magazine. Buy/borrow/steal an issue and do a little research. Read it. Desktop publishing is now sophisticated enough to replace all high-end prepress systems. Buy a Mac. Use it. Live it."

TIKKUN

2342 Shattuck Ave., Suite 1200, Berkeley CA 94704. (510)644-1200. **Fax:** (510)644-1255. **E-mail:** magazine@tikkun.org. **Website:** www.tikkun.org. **Contact:** Managing editor. Estab. 1986. Circ. 70,000. Bimonthly Jewish critique of politics, culture and society; includes articles regarding Jewish and non-Jewish issues, left-of-center politics.

ILLUSTRATION Approached by 50-100 illustrators/year. Buys 10-12 illustrations/issue. Features symbolic and figurative illustration and political cartoons in color and b&w. Assigns 90% of illustrations to experienced, but not well known illustrators; 10% to new and emerging illustrators. Prefers line drawings.

FIRST CONTACT & TERMS Prefers electronic submissions. E-mail web link or JPEGs. Do not send originals; unsolicited artwork will not be returned. Accepts previously published material. Often we hold

onto line drawings for last-minute use. Pays on publication. Buys one-time rights.

TIPS Prefers art with progressive religious and ethical themes. "We invite you to send us a sample of a *Tikkun* article we've printed, showing how you would have illustrated it."

TIME

Time/Life Building, 1271 Avenue of the Americas, New York NY 10020. **E-mail:** letters@time.com. **Website:** www.time.com. **Contact:** Art director. Estab. 1923. Circ. 4,034,000. Weekly magazine covering breaking news, national and world affairs, business news, societal and lifestyle issues, culture and entertainment.

ILLUSTRATION Considers all media.

FIRST CONTACT & TERMS Send postcard sample, printed samples, photocopies or other appropriate samples. Accepts disk submissions. Samples are filed. Responds only if interested. Buys first North American serial rights. Payment is negotiable. Finds artists through sourcebooks and illustration annuals.

THE TOASTMASTER

Toastmasters International, P.O. Box 9052, Mission Viejo CA 92690. (949)858-8255. **E-mail:** submissions@toastmasters.org. **Website:** www.toastmasters. org. **Contact:** Suzanne Frey, editor; Susan Campbell, graphic design manager. Estab. 1933. Circ. 235,000 in 11,700 clubs worldwide. Monthly trade journal for association members. "Language, public speaking, communication are our topics." Accepts previously published artwork. Originals returned at job's completion. Sample copies available.

ILLUSTRATION Buys 6 illustrations/issue. Works on assignment only. Prefers communications themes. Considers watercolor and collage.

FIRST CONTACT & TERMS Illustrators: Send postcard sample. Accepts disk submissions. Samples are filed or returned by SASE if requested by artist. Responds to the artist only if interested. Portfolio should include tearsheets and photocopies. Negotiates rights purchased. **Pays on acceptance**; $500 for color cover; $50-200 for b&w, $100-250 for color inside.

☺ TODAY'S PARENT

Rogers Media, Inc., One Mt. Pleasant Rd., 8th Floor, Toronto ON M4Y 2Y5, Canada. (416)764-2883. **Fax:** (416)764-2894. **E-mail:** editors@todaysparent.com. **Website:** www.todaysparent.com. **Contact:** Jackie

Shipley, art director. Circ. 175,000. Monthly parenting magazine. Sample copies available.

ILLUSTRATION Send query letter with printed samples, photocopies or tearsheets.

FIRST CONTACT & TERMS Illustrators: Send follow-up postcard sample every year. Accepts disk submissions. Art director will contact artist for portfolio review of b&w and color photographs, slides, tearsheets and transparencies if interested. Buys first rights. **Pays on acceptance;** $100-300 for b&w and $250-800 for color inside. Pays $400 for spots. Finds illustrators through magazines, submissions and word of mouth.

TIPS Looks for "good conceptual skills and skill at sketching children and parents."

TRAINING MAGAZINE

P.O. Box 247, Excelsior MN 55331. (516)524-3504. **E-mail:** lorri@trainingmag.com. **Website:** www.trainingmag.com. **Contact:** Lorri Freifeld, editor-in-chief. Estab. 1964. Circ. 45,000. 4-color trade journal published 6 times/year covering job-related training and education in business and industry, both theory and practice, for audience training directors, personnel managers, sales and data processing managers, general managers, etc. Sample copies available with SASE and first-class postage.

ILLUSTRATION Works on assignment only. Prefers themes that relate directly to business and training. Styles are varied. Considers pen & ink, airbrush, mixed media, watercolor, acrylic, oil, pastel and collage.

FIRST CONTACT & TERMS Send postcard sample, tearsheets or photocopies. Accepts disk submissions. Samples are filed. Responds only if interested. Buys first rights or one-time rights. **Pays on acceptance.** Pays illustrators $1,500 for color cover; $500 for color inside; $100 for spots.

TIPS "Show a wide variety of work in different media and with different subject matter."

TRAINS

Kalmbach Publishing Co., P.O. Box 1612, Waukesha WI 53187-1612. (262)796-8776. **Fax:** (262)796-1142. **E-mail:** editor@trainsmag.com; photoeditor@trainsmag.com. **Website:** www.trainsmag.com. Tom Danneman, art director. **Contact:** Jim Wrinn, editor. Estab. 1940. Circ. 934. Monthly magazine about trains, train companies, tourist RR, latest railroad news. Art guidelines available online.

Kalmbach Publishing also publishes *Classic Toy Trains*, *Astronomy*, *Finescale Modeler*, *Model Railroader*, *Model Retailer*, *Classic Trains*, *Bead and Button*, *Birder's World*.

ILLUSTRATION 100% of freelance illustration demands knowledge of Photoshop CS 5.0, Illustrator CS 8.0.

FIRST CONTACT & TERMS Illustrators: Send query letter with printed samples, photocopies and tearsheets. Accepts disk submissions (opticals) or CDs, using programs above. Samples are filed. Art director will contact artist for portfolio review of color tearsheets if interested. Buys one-time rights. Pays on publication.

TIPS "Quick turnaround and accurately built files are a must."

TRAVEL + LEISURE

1120 Avenue of the Americas, 10th Floor, New York NY 10036-6700. (212)382-5600. **Website:** www.travelandleisure.com. **Contact:** Bernard Scharf, creative director; Nora Sheehan, art director. Monthly magazine emphasizing travel, resorts, dining and entertainment. Original artwork returned after publication. Art guidelines with SASE.

ILLUSTRATION Approached by 250-350 illustrators/year. Buys 1-15 illustrations/issue. Interested in travel and leisure-related themes. "Illustrators are selected by excellence and relevance to the subject." Works on assignment only.

FIRST CONTACT & TERMS Provide samples and business card to be kept on file for future assignment. Responds only if interested. E-mail form for queries available online. In most cases these are responded to the quickest.

TIPS No cartoons.

TREASURY & RISK

475 Park Ave. S., Room 601, New York NY 10016-6901. **Website:** www.treasuryandrisk.com. Donna Miskin, editor-in-chief. Circ. 50,000. Monthly trade publication for financial/CFO-treasurers. Sample copies available on request.

ILLUSTRATION Buys 45-55 illustrations/year. Features business computer illustration, humorous illustration and spot illustrations. Prefers electronic media. Assigns 25% of illustrations to new and emerging illustrators. Freelance artists should be familiar with Illustrator and Photoshop.

FIRST CONTACT & TERMS Send postcard sample. After introductory mailing, send follow-up postcard sample every 3 months. Accepts e-mail submissions with link to website and image file. Prefers Mac-compatible JPEG files. Responds only if interested. Will contact artist for portfolio review if interested. Portfolio should include color and tearsheets. Pays illustrators $1,000-1,200 for color cover; $400 for spots; $500 for ½ page color inside; $650 for full page; $800 for spread. Buys first rights, one-time rights, reprint rights and all rights. Finds freelancers through agents, submissions, magazines and word of mouth.

TRIQUARTERLY

School of Continuing Studies, Northwestern University, 339 E. Chicago Ave., Chicago IL 60611-3008. **E-mail:** triquarterlyonline@northwestern.edu. **Website:** www.triquarterly.org. **Contact:** Editor. Estab. 1964. Circ. 5,000. *TriQuarterly* literary magazine is "dedicated to publishing writing and graphics which are fresh, adventurous, artistically challenging and never predictable." Originals returned at job's completion. Now entirely online.

ILLUSTRATION Approached by 10-20 illustrators/year. Considers only work that can be reproduced in b&w as line art or screen for pages; all media; 4-color for cover.

FIRST CONTACT & TERMS Submit online through submissions manager.

TV GUIDE

11 W. 42nd St., New York NY 10036. (212)852-7500. **Fax:** (212)852-7470. **Website:** www.tvguide.com. **Contact:** Debra Birnbaum, editor-in-chief; Catherine Suhocki, associate art director. Estab. 1953. Circ. 9,097,762. Weekly consumer magazine for television viewers. Has featured illustrations by Mike Tofanelli and Toni Persiani.

Focuses on all aspects of network, cable, and pay television programming and how it affects and reflects audiences.

ILLUSTRATION Approached by 200 illustrators/year. Buys 50 illustrations/year. Considers all media.

FIRST CONTACT & TERMS Illustrators: Send postcard sample. Samples are filed. Art director will contact artist for portfolio review of color tearsheets if interested. Negotiates rights purchased. **Pays on acceptance;** $1,500-4,000 for color cover; $1,000-2,000 for full page color inside; $200-500 for spots. Finds

artists through sourcebooks, magazines, word of mouth, submissions.

UROLOGY TIMES

24950 Country Club Blvd., North Olmsted OH 44070. (440)891-2708. **Fax:** (440)891-2643. **E-mail:** pseltzer@advanstar.com. **Website:** www.urologytimes.com. **Contact:** Peter Seltzer, group art director. Estab. 1972. Circ. 10,000. Monthly trade publication. The leading news source for urologists. Art guidelines available.

ILLUSTRATION Buys 6 illustrations/year. Has featured illustrations by DNA Illustrations, Inc. Assigns 25% of illustrations to new and emerging illustrators. 90% of freelance work demands computer skills. Freelancers should be familiar with Illustrator, Photoshop. E-mail submissions accepted with link to website. Prefers TIFF, JPEG, GIF, EPS. Samples are filed. Art director will contact artist for portfolio review if interested. Portfolio should include finished art and tearsheets. Pays on publication. Buys multiple rights. Finds freelancers through artists' submissions.

FIRST CONTACT & TERMS Illustrators: Send postcard sample with photocopies.

US AIRWAYS MAGAZINE

Pace Communications, 1301 Carolina St., Greensboro NC 27401. **E-mail:** edit@usairwaysmag.com; art@usairwaysmag.com. **Website:** www.usairwaysmag.com. **Contact:** Holly Holliday, art director. Estab. 2006. Circ. 441,000. Inflight magazine for national airline. Does not accept freelance submissions for art or editorial.

ILLUSTRATION Approached by 100 illustrators/year. Works on assignment only. Prefers editorial illustration in airbrush, mixed media, colored pencil, watercolor, acrylic, oil, pastel, collage and calligraphy. Needs computer-literate illustrators familiar with Photoshop, Illustrator, QuarkXPress and FreeHand. Assigns 95% of illustrations to experienced, but not well-known illustrators.

FIRST CONTACT & TERMS Send query letter with color brochure showing art style and tearsheets. Looks for the "ability to intelligently grasp idea behind story and illustrate it. Likes crisp, clean colorful styles." Accepts disk submissions of EPS files. Samples are filed. Will contact artist for portfolio review if interested. Sometimes requests work on spec. Buys one-time rights. Pays on publication.

TIPS "Send lots of good-looking color tearsheets that we can keep on hand for reference. If your work in-terests us we will contact you. In your portfolio, show examples of editorial illustration for other magazines, good conceptual illustrations and a variety of subject matter. Often artists don't send enough of a variety of illustrations; it's much easier to determine if an illustrator is right for an assignment if we have a complete grasp of the full range of abilities. Send high-quality illustrations and show specific interest in our publication."

UTNE READER

1503 SW 42nd St., Topeka KS 66609. (785)274-4300. **E-mail:** editor@utne.com. **Website:** www.utne.com. **Contact:** Carolyn Lang, art director. Estab. 1984. Circ. 250,000. Bimonthly digest featuring articles and reviews from the best of alternative media; independently published magazines, newsletters, books, journals and websites. Topics covered include national and international news, history, art, music, literature, science, education, economics and psychology.

Utne Reader seeks to present a lively diversity of illustration and photography "voices." We welcome artistic samples which exhibit a talent for interpreting editorial content.

FIRST CONTACT & TERMS "We are always on the lookout for skilled artists with a talent for interpreting editorial content, and welcome examples of your work for consideration. Because of our small staff, busy production schedule, and the volume of samples we receive, however, we ask that you read and keep in mind the following guidelines. We ask that you not call or e-mail seeking feedback, or to check if your package has arrived. We wish we could be more generous in this regard, but we simply don't have the staff or memory capacity to recall what has come in (SASEs and reply cards will be honored). Send samples that can be quickly viewed and tacked to a bulletin board. Single-sided postcards are preferred. Make sure to include a link to your online portfolio so we can easily view more samples of your work. DO NOT SEND cover letters, résumés, and gallery or exhibition lists. Be assured, if your art strikes us as a good fit for the magazine, we will keep you in mind for assignments. Clearly mark your full name, address, phone number, website address and e-mail address on everything you send. Please do not send original artwork or original photographs of any kind."

☯ VALLUM: NEW INTERNATIONAL POETICS

P.O. Box 598, Victoria Station, Montreal QC H3Z 2Y6, Canada. (514)937-8946. **Fax:** (514)937-8946. **E-mail:** info@vallummag.com. **Website:** www.vallummag.com. **Contact:** Joshua Auerbach and Eleni Zisimatos, editors. Estab. 2000. Circ. 3,200. Poetry/fine arts magazine published twice/year. Publishes exciting interplay of poets and artists. Sample copies available for $7 Canadian/$8 U.S. Submission guidelines available on website. Pays honorarium upon publication. Buys first North American serial rights. Seeking exciting color cover art for magazine with international distribution. Has featured illustrations by Danielle Borisoff, Allen Martian-Vandever, Barbara Legowski, Sandy Wheaton, Charles Weiss and others. Interested in b&w art for inside the magazine, though color art is also accepted.

FIRST CONTACT & TERMS Send art submissions or query letter with brochure, photographs, résumé, samples. After introductory mailing, send follow-up postcard every 6 months. Material is not filed but is returned by SASE.

VANITY FAIR

Conde Nast, 4 Times Square, 7th Floor, New York NY 10036. (212)286-2860. **Fax:** (212)286-7036. **Website:** www.vanityfair.com. **Contact:** Art director. Estab. 1983. Circ. 1.1 million. Monthly consumer magazine. Does not use previously published artwork. Original artwork returned at job's completion. 100% of freelance design work demands knowledge of QuarkXPress and Photoshop.

ILLUSTRATION Approached by "hundreds" of illustrators/year. Buys 3-4 illustrations/issue. Works on assignment only. "Mostly uses artists under contract."

VEGETARIAN JOURNAL

P.O. Box 1463, Baltimore MD 21203-1463. (410)366-8343. **E-mail:** vrg@vrg.org. **Website:** www.vrg.org. **Contact:** Debra Wasserman, editor. Estab. 1982. Circ. 20,000. Quarterly nonprofit vegetarian magazine that examines the health, ecological and ethical aspects of vegetarianism. "Highly educated audience including health professionals." Accepts previously published artwork. Originals returned at job's completion upon request. Sample copies available for $3.

CARTOONS Approached by 4 cartoonists/year. Buys 1 cartoon/issue. Prefers humorous cartoons with an obvious vegetarian theme; single panel b&w line drawings.

ILLUSTRATION Approached by 20 illustrators/year. Buys 6 illustrations/issue. Works on assignment only. Prefers strict vegetarian food scenes (no animal products). Considers pen & ink, watercolor, collage, charcoal and mixed media.

FIRST CONTACT & TERMS Cartoonists: Send query letter with roughs. Illustrators: Send query letter with photostats. Samples are not filed and are returned by SASE if requested by artist. Responds in 2 weeks. Portfolio review not required. Rights purchased vary according to project. **Pays on acceptance.** Pays cartoonists $25 for b&w. Pays illustrators $25-50 for b&w/color inside. Finds artists through word of mouth and job listings in art schools.

TIPS Areas most open to freelancers are recipe section and feature articles. "Review magazine first to learn our style. Send query letter with photocopy sample of line drawings of food."

VERMONT MAGAZINE

P.O. Box 900, Arlington VT 05250. (802)375-1366. **E-mail:** prj@vermontmagazine.com. **Website:** www.vermontmagazine.com. **Contact:** Philip Jordan, editor. Estab. 1989. Circ. 50,000. Bimonthly regional publication "aiming to explore what life in Vermont is like—its politics, social issues and scenic beauty." Delivers a blend of historic, traditional and contemporary Vermont in extraordinary words and exceptional photographs, with a new issue published every 2 months and an annual special issue, *Weddings*, that has become a definitive planning guide. Sample copies and art guidelines available with SASE and first-class postage.

ILLUSTRATION Approached by 100-150 illustrators/year. Buys 2-3 illustrations/issue. Works on assignment only. Features humorous, realistic, computer and spot illustration. "Particularly interested in creativity and uniqueness of approach." Considers pen & ink, watercolor, colored pencil, oil, charcoal, mixed media and pastel. Assigns 50% of illustrations to experienced but not well-known illustrators; 50% to new and emerging illustrators.

FIRST CONTACT & TERMS Send query letter with tearsheets, "something I can keep." Materials of interest are filed. Will contact artist for portfolio review if interested. Portfolio should include final art and tearsheets. Buys one-time rights. Considers buying

second rights (reprint rights) to previously published work. Pays $400 maximum for color cover; $75-150 for b&w inside; $75-350 for color inside; $300-500 for 2-page spreads; $50-75 for spots. Finds artists mostly through submissions/self-promos and from other art directors.

🌀 VERSAL

Postbus 3865, Amsterdam 1054 EJ, The Netherlands. **Website:** www.wordsinhere.com. **Contact:** Shayna Schapp, assistant art editor (artists); Megan Garr, editor (writers and designers). Estab. 2002. Circ. 650. "*Versal*, published each May by *wordsinhere*, is the only literary magazine of its kind in the Netherlands and publishes new poetry, prose and art from around the world. *Versal* and the writers behind it are also at the forefront of a growing translocal European literary scene, which includes exciting communities in Amsterdam, Paris and Berlin. *Versal* seeks work that is urgent, involved and unexpected."

FIRST CONTACT & TERMS Submission guidelines online. Samples not kept on file. Portfolio not required. Credit line is given. Work accepted by submission period (September–January).

TIPS "After reviewing the journal, if you are interested in what we're doing and would like to get involved, please send a query and CV to editor Megan Garr at Megan@wordsinhere.com. Artists submitting to *Versal* must follow our submission guidelines online and submit during our review period, September–January. Others interested in helping should always send an inquiry with a cover letter and CV. Please *do not* submit images of artwork via e-mail."

THE VIEW FROM HERE

E-mail: editor@viewfromheremagazine.com. **Website:** www.viewfromheremagazine.com. **Contact:** Mike French, senior editor. Estab. 2008. Circ. 8,000. "We are a print and online literary magazine with author interview, book reviews, original fiction & poetry and articles. Designed and edited by an international team we bring an entertaining mix of wit, insight and intelligence all packaged in beautifully designed pages that mix the new with the famous. We publish our fiction at *The Front View* and our poetry at *The Rear View*, where we showcase the weird, unusual, thought provoking and occasionally bizarre. We classify ourselves as 'Bohemian Eclectic'—yes, we coined the term. Our stories and poems will make you wonder, laugh, cry and generally *feel* something."

FIRST CONTACT & TERMS Send an e-mail with résumé and JPEG samples. Portfolio not required. Credit line given.

VIM & VIGOR

1010 E. Missouri Ave., Phoenix AZ 85014-2601. (602)395-5850. **Fax:** (602)395-5853. **Website:** www.comhs.org/vim_vigor/. Estab. 1985. Circ. 800,000. Quarterly consumer magazine focusing on health. Originals returned at job's completion. Sample copies available. Art guidelines available.

💬 The company publishes many other titles as well.

ILLUSTRATION Approached by 100 illustrators/year. Buys 10 illustrations/issue. Works on assignment only. Considers mixed media, collage, charcoal, acrylic, oil, pastel and computer.

FIRST CONTACT & TERMS Illustrators: Send postcard sample with tearsheets and online portfolio/website information. Accepts disk submissions. Samples are filed. Rights purchased vary according to project. **Pays on acceptance.** Finds artists through agents, Web sourcebooks, word of mouth and submissions.

VIRGINIA TOWN & CITY

P.O. Box 12164, Richmond VA 23241. (804)649-8471. **Fax:** (804)343-3758. **E-mail:** dparsons@vml.org. **Website:** www.vml.org. **Contact:** David Parsons, editor. Estab. 1965.

CARTOONS "Currently none appear, but we would use cartoons focusing on local government problems and issues."

FIRST CONTACT & TERMS Publication will contact artist for portfolio review if interested. Rights purchased vary according to project. **Pays on acceptance.** Pays $25 for b&w. Pays illustrators $50-75 for b&w and $55 for color cover; $25-45 for b&w and $35 for color inside.

TIPS "We occasionally need illustrations of local government services. For example, police, firefighters, education, transportation, public works, utilities, cable TV, meetings, personnel management, taxes, etc. Usually b&w. Illustrators who can afford to work or sell for our low fees, and who can provide rapid turnaround should send samples of their style and information on how we can contact them."

VOGUE PATTERNS

120 Broadway, 34th Floor, New York NY 10271. **E-mail:** mailbox@voguepatterns.com or via online contact form. **Website:** www.voguepatterns.com. Man-

ufacturer of clothing patterns with the *Vogue* label. Uses freelance artists mainly for fashion illustration for the *Vogue Patterns* catalog and editorial illustration for *Vogue Patterns* magazine. "The nature of catalog illustration is specialized; every button, every piece of top-stitching has to be accurately represented. Editorial illustration assigned for our magazine should have a looser editorial style. We are open to all media."

ILLUSTRATION Assigns 18 editorial illustration jobs and 100-150 fashion illustration jobs/year. Looking for "sophisticated modern fashion and intelligent creative and fresh editorial."

FIRST CONTACT & TERMS Illustrators: Send query letter with résumé, tearsheets, slides or photographs. Samples not filed are returned by SASE. Call or write for appointment to drop-off portfolio. Pays for design by the hour, illustration by the project.

TIPS "Drop off comprehensive portfolio with a current business card and sample. Make sure name is on outside of portfolio. When a job becomes available, we will call illustrator to view portfolio again."

WASHINGTON CITY PAPER

2390 Champlain St. NW, Washington DC 20009. (202)332-2100. **Fax:** (202)332-8500. **E-mail:** abaca@ washingtoncitypaper.com. **Website:** www.washing toncitypaper.com. **Contact:** Alex Baca, assistant editor. Estab. 1981. Circ. 95,000. Weekly tabloid "distributed free in DC and vicinity. We focus on investigative reportage, arts, and general interest stories with a local slant." Art guidelines not available.

CARTOONS Only accepts weekly features, no spots or op-ed style work.

ILLUSTRATION Approached by 100-200 illustrators/year. Buys 2-8 illustrations/issue. Has featured illustrations by Michael Kupperman, Peter Hoey, Greg Houston, Joe Rocco, Susie Ghahremani, and Robert Meganck. Features caricatures of politicians; humorous illustration; informational graphics; computer and spot illustration. Considers all media, if the results do well in b&w.

FIRST CONTACT & TERMS Illustrators: Send query letter with printed or e-mailed samples, photocopies or tearsheets. Art director will contact artist for more if interested. Buys first-rights. Pays on publication which is usually pretty quick. Pays cartoonists $25 minimum for b&w. Pays illustrators $110 minimum for b&w cover; $220 minimum for color cover;

$85 minimum for inside. Finds illustrators mostly through submissions.

TIPS "We are a good place for freelance illustrators, we use a wide variety of styles, and we're willing to work with beginning illustrators. We like illustrators who are good on concept and can work fast if needed. We avoid cliché D.C. imagery such as the Capitol and monuments."

WASHINGTON FAMILY MAGAZINE

485 Spring Park Pl., Suite 550, Herndon VA 20170. (877)330-1385. **Fax:** (703)318-5509. **E-mail:** Editor@ theFAMILYmagazine.com. **Website:** www.washing tonfamily.com. Estab. 1991. Circ. 100,000. Monthly consumer parenting magazine. Art guidelines available by e-mail.

ILLUSTRATION Approached by 100 illustrators/year. Features computer illustration. Preferred subjects: children, families, women. Prefers bright colors with process colors of no more than 2 color mixes. Freelancers should be familiar with PageMaker, Illustrator, Photoshop. E-mail submissions not accepted. Prefers JPEG, high-res. Samples are filed. Portfolio not required. Pays illustrators 100 for color cover. Pays on publication. Buys one-time rights. Finds freelancers through artists' submissions.

FIRST CONTACT & TERMS Illustrators: Send postcard sample, brochure, samples.

WASHINGTONIAN MAGAZINE

1828 L St. NW, Suite 200, Washington DC 20036. (202)296-3600. **E-mail:** editorial@washingtonian. com. **Website:** www.washingtonian.com. Estab. 1965. Circ. 185,000. Monthly 4-color consumer lifestyle and service magazine.

ILLUSTRATION Approached by 200 illustrators/year. Buys 2-3 illustrations/issue. Has featured illustrations by Pat Oliphant, Chris Tayne and Richard Thompson. Features caricatures of celebrities, caricatures of politicians, humorous illustration, realistic illustrations, spot illustrations, computer illustrations and photo collage. Preferred subjects: men, women and creative humorous illustration. Assigns 20% of illustrations to new and emerging illustrators. 20% of freelance illustration demands knowledge of Photoshop.

FIRST CONTACT & TERMS Illustrators: Send postcard sample and follow-up postcard every 6 months. Send nonreturnable samples. Accepts Mac-compatible submissions. Send EPS or TIFF files. Responds only if interested. Will contact artist for portfolio re-

view if interested. Buys first rights. **Pays on acceptance**. Finds illustrators through magazines, word of mouth, promotional samples, sourcebooks.

TIPS "We like caricatures that are fun, not mean and ugly. Want a well-developed sense of color, not just primaries."

WATERCOLOR ARTIST

F+W Media, Inc., 10151 Carver Rd., Suite #200, Blue Ash OH 45242. (513)531-2690. **Fax:** (513)891-7153. **Website:** www.watercolorartistmagazine.com. **Contact:** Jennifer Hoffman, art director; Kelly Kane, editor. Estab. 1984. Circ. 45,000. (Formerly *Watercolor Magic*.) Bimonthly 4-color consumer magazine for artists to explore and master watermedia. "*Watercolor Artist* is the definitive source of how-to instruction and creative inspiration for artists working in water-based media." Art guidelines free for #10 SASE with first-class postage.

FIRST CONTACT & TERMS Illustration: Pays on publication. Finds illustrators through word of mouth, visiting art exhibitions, unsolicited queries, reading books.

TIPS "We are looking for watermedia artists who are willing to teach special aspects of their work and their techniques to our readers."

WEEKLY READER

Weekly Reader Publishing, 1 Reader's Digest Rd., Pleasantville NY 10570-7000. (914)242-4000. **Website:** www.weeklyreader.com. Estab. 1928. Publishes educational periodicals, posters and books. "*Weekly Reader* teaches the news to kids pre-K through high school age. The philosophy is to connect students to the world." Publications are 4-color. Sample copies are available.

ILLUSTRATION Needs editorial and technical illustration. Style should be "contemporary and age-level appropriate for the juvenile audience." Buys more than 50 illustrations/week. *Works on assignment only*. Uses computer and reflective art.

FIRST CONTACT & TERMS Illustrators: Send brochure, tearsheets, SASE and photocopies. Samples are filed or are returned by SASE if requested by artist. Accepts previously published artwork. Original artwork is returned at job's completion. Payment is usually made within 3 weeks of receiving the invoice. Finds artists through submissions/self-promotions, sourcebooks, agents and reps. Some periodicals need quick turnarounds.

TIPS "Our primary focus is the children's and young adult marketplace. Art should reflect creativity and knowledge of audience's needs. Our budgets are tight, and we have very little flexibility in our rates. We need artists who can work with our budgets. Avoid using fluorescent dyes. Use clear, bright colors. Work on flexible board."

WESTERN DAIRYBUSINESS

Dairy Business Communications, 1200 W. Laurel Ave., Visalia CA 93277. (800)934-7872; (559)802-3743. **Fax:** (559)802-3746. **E-mail:** rgoble@dairybusiness. com. **Website:** www.dairybusiness.com. Estab. 1922. Circ. 10,051. Monthly trade journal with audience comprised of "Western-based milk producers, herd size 100 and larger, all breeds of cows, covering the 13 Western states." Accepts previously published artwork. Samples copies and art guidelines available.

ILLUSTRATION Approached by 5 illustrators/year. Buys 1-4 illustrations/issue. Works on assignment only. Preferred themes "depend on editorial need." Considers 3D and computer illustration.

FIRST CONTACT & TERMS Send query letter with brochure, tearsheets and résumé. Samples are filed or are returned by SASE if requested by artist. Responds in 2 weeks. Write for appointment to show portfolio of thumbnails, tearsheets and photographs. Buys all rights. Pays on publication; $100 for b&w, $200 for color cover; $50 for b&w, $100 for color inside.

TIPS "We have a small staff. Be patient if we don't get back immediately. A follow-up letter helps. Being familiar with dairies doesn't hurt. Quick turnaround will put you on the 'A' list."

WESTWAYS

3333 Fairview Rd., A327, Costa Mesa CA 92808. (714)885-2396. **Fax:** (714)885-2335. **E-mail:** vaneyke. eric@aaa-calif.com. **Contact:** Eric Van Eyke, art director. Estab. 1918. Circ. 3,000,000+. Bimonthly lifestyle and travel magazine.

ILLUSTRATION Approached by 20 illustrators/year. Buys 2-6 illustrations/year. Works on assignment only. Preferred style is "arty-tasteful, colorful." Considers pen & ink, watercolor, collage, airbrush, acrylic, colored pencil, oil, mixed media and pastel.

FIRST CONTACT & TERMS Illustrators: Send e-mail with link to website or query letter with brochure, tearsheets and samples. Samples are filed. Responds only if interested; "could be months after receiving samples." Buys first rights. **Pays on acceptance of fi-**

nal art: $250 minimum for color inside. Original artwork returned at job's completion.

⟳ WINDSOR REVIEW

Dept. of English, University of Windsor, Windsor ON N9B 3P4, Canada. (519)253-3000; (519) 253-4232 ext. 2290. **Fax:** (519)971-3676. **E-mail:** uwrevu@uwindsor.ca. **Website:** www.uwindsor.ca. **Contact:** Marty Gervais, art editor. Estab. 1965. Circ. 250. Biannual 4-color literary magazine featuring poetry, short fiction and art. Art guidelines free for #10 SASE with first-class postage.

ILLUSTRATION Has featured illustrations and/or fine art by Eiichi Matsuhashi, Robbert Fortin, John Pufahl, Ellen Katterbach. Features computer, humorous and realistic illustration, fine art. Prefers "anything of quality and taste, intelligent, thought-provoking."

FIRST CONTACT & TERMS Accepts Windows-compatible disk submissions. Responds in 3 months. Buys all rights. Pays on publication.

THE WITNESS

The Episcopal Divinity School, 99 Brattle St., Cambridge MA 02138. (857)225-0433. **E-mail:** editor@thewitness.org. **Website:** www.thewitness.org. Estab. 1917. Circ. 6,000. Christian journal, "focusing on faith context for addressing social justice issues. Episcopal Anglican roots content is often serious yet occasionally quirky and irreverent."

CARTOONS Buys 10-12 cartoons/year. Prefers single panel, political, b&w line drawings.

ILLUSTRATION Features humorous, realistic and spot illustration. "Themes social and economic justice, though we like to use art in unusual and surprising combination with story topics. We appreciate work that is subtle, provocative, never sentimental."

FIRST CONTACT & TERMS Cartoonists: Send query letter with finished cartoons, photographs, photocopies, roughs or tearsheets. Illustrators: Send postcard sample or query letter with printed samples, photocopies and tearsheets. Accepts CD submissions in JPEG or GIF format. Samples are filed if suitable and are not returned. "We like to keep samples of artists' work on file, with permission to use in the magazine." Responds only if interested.

WOODENBOAT MAGAZINE

WoodenBoat Publications, Inc., P.O. Box 78, 41 WoodenBoat Ln., Brooklin ME 04616. (207)359-4651. **Fax:** (207)359-8920. **E-mail:** woodenboat@wooden

boat.com. **E-mail:** matt@woodenboat.com. **Website:** www.woodenboat.com. **Contact:** Matt Murphy. Estab. 1974. Circ. 90,000. Bimonthly magazine for wooden boat owners, builders and designers. Previously published work OK. Sample copy for $6. Art guidelines free for SASE with first-class postage.

ILLUSTRATION Approached by 10-20 illustrators/year. Buys 2-10 illustrations/issue on wooden boats or related items. Uses some illustration, usually by several regularly appearing artists, but occasionally featuring others.

DESIGN Not currently using freelancers.

FIRST CONTACT & TERMS Illustrators: Send postcard sample or query letter with printed samples and tearsheets. Designers: Send query letter with tearsheets, résumé and slides. Samples are filed. Does not report back. Artist should follow up with call. Pays on publication. Pays illustrators $50-$400 for spots.

TIPS "We work with several professionals on an assignment basis, but most of the illustrative material that we use in the magazine is submitted with a feature article. When we need additional material, however, we will try to contact a good freelancer in the appropriate geographic area."

WORLD TRADE

20900 Farnsleigh Rd., Shaker Heights OH 44122. (424)634-2499; (216)991-4861. **E-mail:** hardings@worldtradewt100.com; walzm@bnpmedia.com. **Website:** www.worldtrademag.com. **Contact:** Sarah Harding, publisher; Martha L. Walz, editor-in-chief; Mike Powell, art director. Estab. 1988. Circ. 75,000. Monthly 4-color consumer journal; "read by upper management, presidents and CEOs of companies with international sales." Accepts previously published artwork. Original artwork is returned to artist at job's completion. Sample copies and art guidelines not available.

CARTOONS Prefers business/social issues.

ILLUSTRATION Approached by 15-20 illustrators/year. Buys 1-2 illustrations/issue. Works on assignment only. "We are open to all kinds of themes and styles." Considers pen & ink, colored pencil, mixed media and watercolor.

FIRST CONTACT & TERMS Illustrators: Send query letter with brochure and tearsheets to Mike Powell, art director, powellm@bnpmedia.com. Samples are filed. Responds only if interested. Portfolio review not

required. Buys first rights or reprint rights. Pays on publication; $800 for color cover; $275 for color inside.

TIPS "Send an example of your work. We prefer previous work to be in business publications. Artists need to understand we work from a budget to produce the magazine, and budget controls and deadlines are closely watched."

WRITER'S DIGEST

F+W Media, Inc., 10151 Carver Rd., Suite #200, Blue Ash OH 45242. (513)531-2690, ext. 11483. **E-mail:** wd submissions@fwmedia.com. **Website:** www.writers digest.com. Estab. 1920. Bimonthly magazine emphasizing freelance writing for freelance writers. Art guidelines free with SASE and first-class postage.

○ Submissions are also considered for inclusion in annual *Writer's Yearbook* and other one-shot publications.

ILLUSTRATION Buys 2–4 feature illustrations/issue. Theme: the writing life. Works on assignment only. Send postcard or any printed/copied samples to be kept on file (no larger than 8½×11).

FIRST CONTACT & TERMS Prefers postal mail submissions to keep on file. Final art may be sent via e-mail. Prefers EPS, TIFF or JPEG files, 300 dpi. Buys one-time rights. **Pays on acceptance:** $500–1,000 for color cover; $100–800 for color inside.

TIPS "I like having several samples to look at. Online portfolios are great."

BOOK PUBLISHERS

Walk into any bookstore and start counting the number of images you see on books and calendars. The illustrations you see on covers and within the pages of books are, for the most part, created by freelance artists. Publishers rarely have enough artists on staff to generate such a vast array of styles. If you like to read and work creatively to solve problems, the world of book publishing could be a great market for you.

The artwork appearing on a book cover must grab readers' attention and make them want to pick up the book. It must show at a glance what type of book it is and who it is meant to appeal to. In addition, the cover has to include basic information such as title, the author's name, the publisher's name, blurbs, and price.

Most assignments for freelance work are for jackets/covers. The illustration on the cover, combined with typography and the layout choices of the designer, announce to the prospective readers the style and content of a book. Suspenseful spy novels tend to feature stark, dramatic lettering and symbolic covers. Fantasy and science fiction novels, as well as murder mysteries and historical fiction, might show a scene from the story on their covers. Visit a bookstore and then decide which kinds of books interest you and would be best for your illustration style.

Book interiors are also important. The page layouts and illustrations direct readers through the text and complement the story, particularly in children's books and textbooks. Many publishing companies hire freelance designers with computer skills to design interiors on a contract basis. Look within each listing for the subheading Book Design to find the number of jobs assigned each year and how much is paid per project.

Finding your best markets

The first paragraph of each listing describes the types of books each publisher specializes in. You should submit only to publishers who specialize in the types of books you want to illustrate or design. There's no use submitting to a publisher of literary fiction if you want to illustrate children's picture books.

The publishers in this section are just the tip of the iceberg. You can find additional publishers by visiting bookstores and libraries and looking at covers and interior art. When you find covers you admire, write down the name of the books' publishers in a notebook. If the publisher is not listed in *Artist's & Graphic Designer's Market*, go to your public library and ask to look at a copy of *Literary Market Place*, also called *LMP*, published annually by Information Today, Inc. The cost of this large directory is prohibitive to most freelancers, but you should become familiar with it if you plan to work in the book publishing industry. Though it won't tell you how to submit to each publisher, it does give art directors' names. Also be sure to visit publishers' websites—many offer artist's guidelines.

How to submit

Send one to five nonreturnable samples along with a brief letter. Never send originals. Most art directors prefer samples that can fit in file drawers. Bulky submissions are considered a nuisance. After sending your initial introductory mailing, you should follow up with postcard samples every few months to keep your name in front of art directors. If you want to

e-mail TIFF or JPEG files, check the publishers' preferences to see if they will accept submissions via e-mail.

Getting paid

Payment for design and illustration varies depending on the size of the publisher, the type of project, and the rights purchased. Most publishers pay on a per-project basis, although some publishers of highly illustrated books (such as children's books) pay an advance plus royalties. Small, independent presses may pay only in copies.

Children's book illustration

Working in children's books requires a specific set of skills. You must be able to draw the same characters in a variety of poses and situations. Many publishers are expanding their product lines to include multimedia projects. While a number of children's book publishers are listed in this book, *Children's Writer's & Illustrator's Market*, published by Writer's Digest Books, is an invaluable resource if you enter this field. Visit www.writersdigestshop. com to order the most recent edition. You may also want to consider joining the Society of Children's Book Writers and Illustrators (www.scbwi.org), an international organization that offers support, information, networking opportunities, and conferences.

AACE INTERNATIONAL

209 Prairie Ave., Suite 100, Morgantown WV 26501-5934. (304)296-8444. **Fax:** (304)291-5728. **E-mail:** info@aacei.org; nkinderknecht@aacei.org. **Website:** www.aacei.org. **Contact:** Noah Kinderknecht, graphic designer/editor. Estab. 1958. Publishes trade paperback originals and reprints; textbooks. Specializes in engineering and project management books. Catalog available.

NEEDS 100% of freelance design demands knowledge of QuarkXPress. 100% of freelance illustration demands knowledge of Photoshop, Illustrator and QuarkXPress.

FIRST CONTACT & TERMS Designers: Send query letter with résumé and slides.

DESIGN Assigns 1-2 freelance design jobs/year.

TEXT ILLUSTRATION Assigns 1-2 freelance illustration jobs/year.

HARRY N. ABRAMS, INC.

Subsidiary of La Martiniere Group, 115 W. 18th St., 6th Floor, New York NY 10011. (212)206-7715. **Fax:** (212)519-1210. **E-mail:** abrams@abramsbooks.com. **Website:** www.abramsbooks.com. **Contact:** Managing editor. Estab. 1951. Publishes hardcover originals, trade paperback originals and reprints. Types of books include fine art and illustrated books. Publishes 250 titles/year. 60% require freelance design. Visit website for art submission guidelines.

NEEDS Uses freelance designers to design complete books including jackets and sales materials. Uses illustrators mainly for maps and occasional text illustration. 100% of freelance design and 50% of illustration demands knowledge of Illustrator, InDesign or QuarkXPress and Photoshop. Works on assignment only.

FIRST CONTACT & TERMS Send query letter with résumé, tearsheets, photocopies. Accepts disk submissions or Web address. Samples are filed "if work is appropriate." Samples are returned by SASE if requested by artist. Portfolio should include printed samples, tearsheets and/or photocopies. Originals are returned at job's completion, with published product. Finds artists through word of mouth, submissions, attending art exhibitions and seeing published work.

DESIGN Assigns several freelance design jobs/year. Pays by the project.

ACROPOLIS BOOKS, INC.

DeVorss and Company, 533 Constitution Ave., Camarillo CA 93012. (805)322-9010 or (800)843-5743. **Fax:** (800)843-6960. **E-mail:** service@devross.com; contact@acropolisbooks.com. **Website:** www.acropolisbooks.com. 55 Imprints include Awakening. Publishes hardcover originals and reprints; trade paperback originals and reprints. Types of books include mysticism and spiritual. Specializes in books of higher consciousness. 30% require freelance design. Catalog available.

NEEDS Approached by 7 illustrators and 5 designers/year. Works with 2-3 illustrators and 2-3 designers/year. Knowledge of Photoshop and QuarkXPress useful in freelance illustration and design.

FIRST CONTACT & TERMS Designers: Send brochure and résumé. Illustrators: Send query letter with photocopies and résumé. Samples are filed. Responds in 2 months. Will contact artist for portfolio review if interested. Buys all rights.

DESIGN Assigns 3-4 freelance design jobs/year. Pays by the project.

JACKETS/COVERS Assigns 3-4 freelance design jobs/year. Pays by the project.

TEXT ILLUSTRATION "We are looking for people who are familiar with our company and understand our focus."

⊙ ALLYN & BACON PUBLISHERS

75 Arlington St., Suite 300, Boston MA 02116. **Website:** www.allynbaconmerrill.com/index.aspx. Find local rep to submit materials via online rep locator. Publishes more than 300 hardcover and paperback college textbooks/year. 60% require freelance cover designs. Our subject areas include education, psychology and sociology, political science, theater, music and public speaking.

NEEDS Designers must be strong in book cover design and contemporary type treatment. 50% of freelance work demands knowledge of Illustrator, Photoshop and FreeHand.

JACKETS/COVERS Assigns 100 design jobs and 2-3 illustration jobs/year. Pays for design by the project, $500-1,000. Pays for illustration by the project, $500-1,000. Prefers sophisticated, abstract style in pen & ink, airbrush, charcoal/pencil, watercolor, acrylic, oil, collage and calligraphy.

TIPS "Keep stylistically and technically up to date. Learn *not* to over-design. Read instructions and ask

questions. Introductory letter must state experience and include at least photocopies of your work. If I like what I see, and you can stay on budget, you'll probably get an assignment. Being pushy closes the door. We primarily use designers based in the Boston area."

THE AMERICAN BIBLE SOCIETY

1865 Broadway, New York NY 10023. (212)408-1200. **Fax:** (212)408-1512. **E-mail:** info@americanbible. org. **Website:** www.americanbible.org. Company publishes religious products including Bibles/New Testaments, portions, leaflets, calendars and bookmarks. Additional products include religious children's books, posters, seasonal items, teaching aids, audio casettes, videos and CDs. Specializes in contemporary applications to the Bible. 90% requires freelance design. Book catalog on website.

NEEDS Approached by 50-100 freelancers/month. Works with 10 freelance illustrators and 20 designers/year. Uses freelancers for jacket/cover illustration and design, text illustration, book design and children's activity books. 90% of freelance work demands knowledge of Illustrator, QuarkXPress, Photoshop. Works on assignment only. 5% of titles require freelance art direction.

FIRST CONTACT & TERMS Send postcard samples of work or send query letter with brochure and tearsheets. Samples are filed or returned. *Please do not call.* Responds in 2 months. Product design department will contact artist for portfolio review if additional samples are needed. Portfolio should include final art and tearsheets. Buys all rights. Finds artists through artists' submissions, *The Workbook* (by Scott & Daughters Publishing) and *RSVP Illustrator.*

DESIGN Assigns 3-5 freelance interior book design jobs/year. Pays by the project.

JACKETS/COVERS Assigns 60-80 freelance design and 20 freelance illustration jobs/year. Pays by the project.

TEXT ILLUSTRATION Assigns several freelance illustration jobs/year. Pays by the project.

TIPS "Looking for contemporary, multicultural artwork/designs and good graphic designers familiar with commercial publishing standards and procedures. Have a polished and professional-looking portfolio or be prepared to show polished and professional-looking samples."

AMERICAN INSTITUTE OF CHEMICAL ENGINEERING

3 Park Ave., New York NY 10016-5991. (800)242-4363. **Fax:** (203)775-5177. **E-mail:** kares@aiche.org. **Website:** www.aiche.org. **Contact:** Karen Simpson, sales administrator. Estab. 1925. Book and magazine publisher of hardcover originals and reprints, trade paperback originals and reprints and magazines. Specializes in chemical engineering.

NEEDS Approached by 30 freelancers/year. Works with 17-20 freelance illustrators/year. Prefers freelancers with experience in technical illustration. Macintosh experience a must. Uses freelancers for concept and technical illustration. Also for multimedia projects. 100% of design and 50% of illustration demand knowledge of all standard Mac programs.

FIRST CONTACT & TERMS Send query letter with tearsheets. Accepts disk submissions. Samples are filed. Responds only if interested. Call for appointment to show portfolio of color tearsheets and electronic media. Buys first rights or one-time rights. Originals are returned at job's completion.

JACKETS/COVERS Payment depends on experience, style.

TEXT ILLUSTRATION Assigns 250 jobs/year. Pays by the hour.

AMERICAN JUDICATURE SOCIETY

2700 University Ave., Des Moines IA 50311. (515)271-2281. **Fax:** (515)279-3090. **E-mail:** manuscripts@ajs. org. **Website:** www.ajs.org. **Contact:** Michael Ream, interim editor. Estab. 1913. Publishes journals and books. Specializes in courts, judges and administration of justice. Publishes 2 titles/year; 75% require freelance illustration. Catalog available on website.

NEEDS Approached by 20 illustrators and 6 designers/year. Works with 3-4 illustrators and 1 designer/year. Prefers local designers. Uses freelancers mainly for illustration. 100% of freelance design demands knowledge of QuarkXPress, FreeHand, Photoshop and Illustrator.

FIRST CONTACT & TERMS Designers and illustrators: Submit samples electronically to drichert@ajs. org. Will contact artist for portfolio review of photocopies, roughs and tearsheets if interested. Buys one-time rights.

DESIGN Assigns 1-2 freelance design jobs/year. Pays by the project, $500-1,000.

TEXT ILLUSTRATION Assigns 10 freelance illustration jobs/year. Pays by the project, $75-375.

AMERICAN PSYCHIATRIC PRESS, INC.

1000 Wilson Blvd., Suite 1825, Arlington VA 22209. (703)907-7322 or (800)368-5777. **Fax:** (703)907-1091. **E-mail:** appi@psych.org. **E-mail:** ngray@psych.org. **Website:** www.appi.org. **Contact:** Samantha Luck, editorial support services manager. Estab. 1981. Imprint of American Psychiatric Association. Company publishes hardcover originals and textbooks. Specializes in psychiatry and its subspecialties. Publishes 60 titles/year. 10% require freelance illustration; 10% require freelance design. Book catalog free by request.

NEEDS Uses freelancers for jacket/cover design and illustration. Needs computer-literate freelancers for design. 100% of freelance work demands knowledge of QuarkXPress, Illustrator 3.0, PageMaker 5.0. Works on assignment only.

FIRST CONTACT & TERMS Designers: Send query letter with brochure, photocopies, photographs or tearsheets. Illustrators: Send postcard sample. Samples are filed. Promotions coordinator will contact artist for portfolio review if interested. Portfolio should include final art, slides and tearsheets. Rights purchased vary according to project.

DESIGN Pays by the project.

JACKETS/COVERS Pays by the project.

TIPS Finds artists through sourcebooks. "Book covers are now being done in CorelDraw 5.0 but will work with Mac happily. Book covers are for professional books with clean designs. Type treatment design are done in-house."

AMHERST MEDIA, INC.

175 Rano St., Suite 200, Buffalo NY 14207. (716)874-4450. **Fax:** (716)874-4508. **E-mail:** submissions@amherstmedia.com. **Website:** www.amherstmedia.com. **Contact:** Craig Alesse, publisher. Estab. 1974. Company publishes trade paperback originals. Types of books include instructional and reference. Specializes in photography, how-to. Publishes 30 titles/year. Recent titles include: *Portrait Photographer's Handbook; Creating World Class Photography.* 20% require freelance illustration; 80% require freelance design.

NEEDS Approached by 12 freelancers/year. Works with 3 freelance illustrators and 3 designers/year. Uses freelance artists mainly for illustration and cover design. Also for jacket/cover illustration and design and book design. 80% of freelance work demands

knowledge of QuarkXPress or Photoshop. Works on assignment only.

FIRST CONTACT & TERMS Send brochure, résumé and photographs. Samples are filed. Responds only if interested. Art director will contact artist for portfolio review if interested. Rights purchased vary according to project. Originals are returned at job's completion. Finds artists through word of mouth.

DESIGN Assigns 12 freelance design jobs/year. Pays for design by the hour $25 minimum; by the project $2,000.

JACKETS/COVERS Assigns 12 freelance design and 4 illustration jobs/year. Pays $200-1200. Prefers computer illustration (QuarkXPress/Photoshop).

TEXT ILLUSTRATION Assigns 12 freelance illustration jobs/year. Pays by the project. Only accepts computer illustration (QuarkXPress).

ANDREWS MCMEEL PUBLISHING

1130 Walnut St., Kansas City MO 64106-2109. (816)932-6700. **Fax:** (816)932-6781. **E-mail:** tlynch@amuniversal.com; marketing@amuniversal.com. **Website:** www.andrewsmcmeel.com. **Contact:** Tim Lynch, executive art director. Estab. 1972. Publishes calendars: all formats, trade hardcover and paperback originals and reprints. Category of books include humor, gift, nonfiction, reference, puzzles and games, cookbooks. Specializes in calendars and comic strip collection books. Recent titles include *Knits for Nerds, My New Orleans Cookbook, America's Best BBQ, Dilbert 2.0 Cartoon Collection* and *Posh Puzzle* book series. Publishes 200 titles/year; 10% require freelance illustration; 80% require freelance design.

NEEDS Prefers freelancers experienced in book jacket design. Freelance designers must have working knowledge of Illustrator, Photoshop, QuarkXPress, or InDesign. Food photographers experienced in cook book photography.

FIRST CONTACT & TERMS Send sample sheets and web address or contact through artist's rep. Samples are filed and not returned. Responds only if interested. Portfolio review not required. Rights purchased vary according to project.

DESIGN Assigns 60 freelance design jobs and 20 illustration jobs/year.

TIPS "We want designers who can read a manuscript and design a concept for the best possible cover. Communicate well and be flexible with design." Designer portfolio review once a year in New York City.

ANTARCTIC PRESS

7272 Wurzbach, Suite 204, San Antonio TX 78240. (210)614-0396. **E-mail:** davidjhutchison@yahoo.com; apcog1@gmail.com; rod_espinosa@antarctic-press.com. **Website:** www.antarctic-press.com. **Contact:** David Hutchison. Estab. 1985. Publishes CDs, mass market paperback originals and reprints, trade paperback originals and reprints. Types of books include adventure, comic books, fantasy, humor, juvenile fiction. Specializes in comic books. Publishes 18 titles/year. Recent titles include: *Gold Digger*; *President Evil*; *The Last Zombie*; *Time Lincoln*. 50% requires freelance illustration. Submission guidelines on website.

"Antarctic Press is among the top 10 publishers of comics in the United States. However, the difference in market shares between the top five publishers and the next five publishers is dramatic. Most of the publishers ranked above us have a far greater share of the market place. That being the case, we are an independent publisher with a small staff, and many of our employees have multiple responsibilities. Bigger companies would spread these responsibilities out among a larger staff. Additionally, we don't have the same financial power as a larger company. We cannot afford to pay high page rates; instead, we work on an advance and royalty system which is determined by sales or potential sales of a particular book. We pride ourselves on being a company that gives new talent a chance to get published and take a shot at comic stardom."

NEEDS Approached by 60-80 illustrators/year. Works with 12 illustrators/year. Prefers local illustrators. 100% of freelance illustration demands knowledge of Photoshop.

FIRST CONTACT & TERMS Digital submissions should be sent to Rod Espinosa or Douglas Dlin. Do not send originals. Send copies only. Accepts e-mail submissions from illustrators. Prefers TIFF or JPEG files. Samples are filed or returned by SASE. Portfolios may be dropped off every Monday-Friday. Portfolio should include b&w, color finished art. All submissions must include finished comic book art, 10 pages minimum. Buys first rights. Rights purchased vary according to project. Finds freelancers through anthologies published, artist's submissions, Internet, word of mouth. Payment is made on royalty basis after publication.

TEXT ILLUSTRATION Negotiated.

TIPS "You must love comics and be proficient in doing sequential art."

APPALACHIAN MOUNTAIN CLUB BOOKS

5 Joy St., Boston MA 02108. (617)523-0636. **Fax:** (617)523-0722. **E-mail:** amcpublications@outdoors.org. **Website:** www.outdoors.org. Estab. 1876. Publishes trade paperback originals and reprints. Types of books include adventure, instructional, nonfiction, travel and children's nature books. Specializes in hiking guidebooks. Publishes 7-10 titles/year. Recent titles include: *Best Day Hikes*. 5% requires freelance illustration; 100% requires freelance design. Book catalog free for #10 SASE.

NEEDS Design and typesetting work for 7-10 books per year. Prefers local freelancers experienced in book design. 100% of freelance design demands knowledge of InDesign.

FIRST CONTACT & TERMS Designers: Send link to web portfolio. Illustrators: Send link to web portfolio. Accepts Mac-compatible disk submissions. Samples are not returned. Will contact artist for portfolio review of book dummy, photocopies, photographs, tearsheets, thumbnails if interested. Negotiates rights purchased.

DESIGN Assigns 10-12 freelance design jobs/year. Pays for design by the project, $800-1,500.

JACKETS/COVERS Assigns 10-12 freelance design jobs and 1 illustration job/year.

ATHENEUM BOOKS FOR YOUNG READERS

Simon & Schuster, 1230 Avenue of the Americas, New York NY 10020. **Website:** imprints.simonandschuster.biz/atheneum; www.simonsayskids.com. **Contact:** Caitlyn Dlouhy, editorial director; Justin Chanda, vice president/publisher; Namrata Tripathi, executive editor; Emma Dryden, vice president. Estab. 1960. "Atheneum Books for Young Readers publishes books aimed at children, pre-school through high school." Publishes hardcover originals, picture books for young kids, nonfiction for ages 8-12 and novels for middle-grade and young adults. Types of books include biography, historical fiction, history, nonfiction. Publishes 60 titles/year. 100% require freelance illustration. Book catalog free by request. Approached by hundreds of freelance artists/year.

NEEDS Approached by hundreds of freelance artists/year. Works with 40-50 illustrators/year. "We are interested in artists of varying media and are try-

ing to cultivate those with a fresh look appropriate to each title." Send postcard sample of work or send query letter with tearsheets, résumé and photocopies. Samples are filed. Responds only if interested. Art director will contact artist for portfolio review if interested. Portfolio should include final art if appropriate, tearsheets, and folded and gathered sheets from any picture books you've had published. Rights purchased vary according to project. Originals are returned at job's completion. Finds artists through submissions, magazines ("I look for interesting editorial illustrators"), word of mouth.

TEXT ILLUSTRATION 100% of the books published require freelance illustration.

AUGSBURG FORTRESS PUBLISHERS

P.O. Box 1209, Minneapolis MN 55440-1209. (800)328-4648. **E-mail:** imagesub@augsburgfortress. org. **Website:** www.augsburgfortress.org. **Contact:** Senior art director. Publishes hard cover and paperback Protestant/Lutheran books (90 titles/year), religious education materials, audiovisual resources, periodicals.

NEEDS Uses freelancers for advertising layout, design, illustration and circulars and catalog cover design. Freelancers should be familiar with QuarkXPress 4.1, Photoshop 5.5 and Illustrator 8.01.

FIRST CONTACT & TERMS "Majority, but not all, of our freelancers are local." Works on assignment only. Responds on future assignment possibilities in 2 months. Call, write or send brochure, disk, flyer, tearsheet, good photocopies and 35mm transparencies; if artist is not willing to have samples filed, they are returned by SASE. Buys all rights on a work-for-hire basis. May require designers to supply overlays on color work.

JACKETS/COVERS Uses designers primarily for cover design. Pays by the project. Prefers covers on disk using QuarkXPress.

TEXT ILLUSTRATION Negotiates pay for 1-, 2- and 4-color. Generally pays by the project.

TIPS "Be knowledgeable of company product and the somewhat conservative contemporary Christian market."

BAEN BOOKS

P.O. Box 1188, Wake Forest NC 27588. (919)570-1640. **E-mail:** artdirector@baen.com. **Website:** www.baen. com. Estab. 1983. Publishes science fiction and fantasy.

Publishes 60-70 titles/year; 90% require freelance illustration/design. Book catalog free on request.

NEEDS Approached by 500 freelancers/year. Works with 10 illustrators and 3 designers/year. 50% of work demands computer skills.

FIRST CONTACT & TERMS Designers: Send query letter with résumé, color photocopies, color tearsheets and SASE. Illustrators: Send query letter with color photocopies, slides, color tearsheets and SASE. Samples are filed. Originals are returned to artist at job's completion. Buys exclusive North American book rights.

JACKETS/COVERS Pays by the project. Pays designers $200 minimum; pays illustrators $1,000 minimum.

TIPS Wants to see samples within science fiction/fantasy genre only. "Do not send b&w illustrations or surreal art. Please do not waste our time and your postage with postcards. Serious submissions only."

BANDANNA BOOKS

1212 Punta Gorda St., #13, Santa Barbara CA 93103. (805)899-2145. **E-mail:** bandanna@cox.net. **Website:** www.bandannabooks.com/bookdoc/pussy.htm. Estab. 2002. Publishes illustrated fiction trade paperback translations. Types of books include erotic or neglected classics in translation. Recent titles include *Ovid's Metamorphoses*. Open to suggestions for illustrated classics.

NEEDS Sensual art.

FIRST CONTACT & TERMS Send samples, not originals. Responds in 3 months, only if interested.

TEXT ILLUSTRATION Pays by the project. Also, subsidy publishing (you pay) or co-publishing (we split costs and rights).

BARBOUR PUBLISHING, INC.

1800 Barbour Dr., P.O. Box 719, Urichsville OH 44683. (740)922-6045. **E-mail:** editors@barbourbooks.com; aschrock@barbourbooks.com; fictionsubmit@barbourbooks.com. **Website:** www.barbourbooks.com. **Contact:** Ashley Schrock, creative director. Estab. 1981. Publishes adventure, humor, juvenile, romance, religious, young adult, coffee table, cooking and reference books. Specializes in inspirational fiction. "We're an inspirational company—no graphic or provocative images are used. Mostly scenic, non-people imagery/illustration."

Publishes hardcover, trade paperback and mass market paperback originals and reprints. Types of books include general Christian con-

temporary and Christian romance, self-help, young adult, reference and Christian children's books. Accepts Mac disk submissions compatible with Illustrator 6.0 and Photoshop. Buys all rights. Finds artists through word of mouth, recommendations, sample submissions and placing ads. Assigns 10 freelance design and 90 illustration jobs/year. Pays by the project, $450-750.

NEEDS Inspirational/traditional. Publishes more than 150 titles/year.

FIRST CONTACT & TERMS Send e-mail including digital images, samples and a URL. Follow up every 2-4 months. Responds only if interested.

TEXT ILLUSTRATION Publishes more than 150 titles/year. 60% require freelance illustration. Prefers freelancers with experience in people illustration and photorealistic styles. Uses freelancers mainly for fiction romance jacket/cover illustration. Works on assignment only. "Submit a great illustration of people suitable for a romance cover or youth cover in a photorealistic style. I am also looking for great background illustrations, such as florals and textures. As a publisher of bargain books, I am looking for top-quality art on a tight budget."

TIPS Portfolio should include b&w, color, finished and original art, photographs and tearsheets. Provide samples.

BEARMANOR MEDIA

P.O. Box 1129, Duncan OK 73534. (580)252-3547. **Fax:** (814)690-1559. **E-mail:** books@benohmart.com. **Website:** www.bearmanormedia.com. **Contact:** Ben Ohmart, publisher. Estab. 2000. Publishes 60+ titles/year. Payment negotiable. Responds only if interested. Catalog available online or free with a 9×12 SASE submission.

TIPS "Potential freelancers should be familiar with our catalog, be able to work comfortably and timely with project managers across 12 time zones, and be computer savvy. Like many modern publishing companies, different facets of our company are located in different regions from Japan to both U.S. coasts. Potential freelancers *must* be knowledgeable in the requirements of commercial printing in regards to resolution, colorspace, process printing and contrast levels. Please provide some listing of experience and payment requirements."

BECKER&MAYER!

11120 NE 33rd Place, Suite 101, Bellevue WA 98004. (425)827-7120. **Fax:** (425)828-9659. **E-mail:** infobm@beckermayer.com. **Website:** www.beckermayer.com. Estab. 1973. Publishes nonfiction biography, humor, history and coffee table books. Publishes 100+ titles/year. 10% require freelance design; 75% require freelance illustration. Book catalog available on website.

becker&mayer! is spelled in all lower case letters with an exclamation mark. Publisher requests that illustration for children's books be sent to Juvenile Submissions. All other illustration should be sent to Adult Submissions.

NEEDS Works with 6 designers and 20-30 illustrators/year. Freelance design work demands skills in FreeHand, InDesign, Illustrator, Photoshop, QuarkXPress. Freelance illustration demands skills in FreeHand, Illustrator, Photoshop.

FIRST CONTACT & TERMS Designers: Send query letter with résumé and tearsheets. Illustrators: Send query letter, nonreturnable postcard sample, résumé and tearsheets. After introductory mailing, send follow-up postcard every 6 months. Does not accept e-mail submissions. Samples are filed. Responds only if interested. Will request portfolio review of color finished art, roughs, thumbnails and tearsheets, only if interested. Rights purchased vary according to project.

TEXT ILLUSTRATION Assigns 30 freelance illustration jobs a year. Pays by the project.

TIPS "Our company is divided into adult and juvenile divisions; please send samples to the appropriate division. No phone calls!"

BLOOMSBURY CHILDREN'S BOOKS USA

175 Fifth Ave., New York NY 10010. (212)674-5151. **Fax:** (212)982-2837. **E-mail:** bloomsbury.kids@bloomsbury.com. **Website:** www.bloomsburyusa.com. Estab. 2001. Publishes hardcover and trade paperback originals and reprints. Types of books include children's picture books, fantasy, humor, juvenile and young adult fiction. Publishes 50 titles/year. 50% require freelance design; 100% require freelance illustration. Book catalog not available.

NEEDS Works with 5 designers and 20 illustrators/year. Prefers local designers. 100% of freelance design work demands knowledge of Illustrator, QuarkXPress and Photoshop.

FIRST CONTACT & TERMS Designers: Send post-card sample or query letter with brochure, résumé, tearsheets. Illustrators: Send postcard sample or query letter with brochure, photocopies and SASE. After introductory mailing, send follow-up postcard sample every 6 months. Samples are filed or returned by SASE. Responds only if interested. Will contact artist for portfolio review if interested. Buys all rights. Finds freelancers through word of mouth.

JACKETS/COVERS Assigns 5 freelance cover illustration jobs/year.

BLUE DOLPHIN PUBLISHING, INC.

P.O. Box 8, Nevada City CA 95959. (530)477-1503. **Fax:** (530)477-8342. **E-mail:** bdolphin@bluedolphin publishing.com. **Website:** www.bluedolphinpublish ing.com. **Contact:** Paul M. Clemens, president. Estab. 1985. Publishes hardcover and trade paperback originals. Types of books include biography, cookbooks, humor and self-help. Specializes in comparative spiritual traditions, lay psychology and health. Recent titles include *Vegan Inspiration, Consciousness Is All, Embracing the Miraculous, Mary's Message to the World, The Fifth Tarot,* and *The Fifth Gospel.* Publishes 20 titles/year; 25% require freelance illustration; 30% require freelance design. Books are "high quality on good paper, with laminated dust jacket and color covers." Book catalog free upon request.

NEEDS Works with 5-6 freelance illustrators and designers/year. Uses freelancers mainly for book cover design; also for jacket/cover and text illustration. "More hardcovers and mixed media are requiring box design as well." 50% of freelance work demands knowledge of PageMaker, QuarkXPress, FreeHand, Illustrator, Photoshop, CorelDraw, InDesign and other IBM-compatible programs. Works on assignment only.

FIRST CONTACT & TERMS Send postcard sample or query letter with brochure and photocopies. Samples are filed or are returned by SASE if requested. Responds "whenever work needed matches portfolio." Originals are returned to artist at job's completion. Sometimes requests work on spec before assigning job. Considers project's budget when establishing payment. Negotiates rights purchased. Considers buying second rights (reprint rights) to previously published work.

DESIGN Assigns 3-5 jobs/year. Pays by the hour, $10-15; or by the project, $300-900.

JACKETS/COVERS Assigns 5-6 design and 5-6 illustration jobs/year. Pays by the hour, $10-15; or by the project, $300-900.

TEXT ILLUSTRATION Assigns 1-2 jobs/year. Pays by the hour, $10-15; or by the project, $300-900.

TIPS "Send query letter with brief sample of style of work. We usually use local people, but are always looking for something special. Learning good design is more important than designing on the computer, but we are very computer-oriented. Basically we look for original artwork of any kind that will fit the covers for the subjects we publish. Please see our online catalog of over 250 titles to see what we have selected so far."

BLUEWOOD BOOKS

242 Aragon Blvd., San Mateo CA 94402. (650)548-0754. **Fax:** (650)548-0654. **E-mail:** bluewoodb@aol. com. Estab. 1990. Publishes trade paperback originals. Types of books include biography, history, nonfiction and young adult. Publishes 4-10 titles/year. Titles include: *True Stories of Baseball's Hall of Famers, 100 Scientists Who Shaped World History* and *American Politics in the 20th Century.* 100% require freelance illustration; 75% require freelance design. Catalog not available.

NEEDS Works with 5 illustrators and 3 designers/year. Prefers local freelancers experienced in realistic, b&w line illustration and book design. Uses freelancers mainly for illustration and design. 80-100% of freelance design demands knowledge of Photoshop, Illustrator and QuarkXPress. 80-100% of freelance illustration demands knowledge of FreeHand, Photoshop, Illustrator and QuarkXPress.

FIRST CONTACT & TERMS Designers: Send query letter with brochure, photocopies, résumé, SASE and tearsheets. Illustrators: Send query letter with photocopies, résumé, SASE and tearsheets. Samples are filed. Responds only if interested. Will contact artist for portfolio review of photocopies, photographs, roughs, slides, tearsheets, thumbnails and transparencies if interested. Buys all rights.

DESIGN Assigns 4-10 freelance design jobs/year. Pays by the hour or project.

JACKETS/COVERS Pays by the project, $150-200 for color.

TEXT ILLUSTRATION Assigns 4-10 freelance illustration jobs/year. Pays $15-30 for each b&w illustration. Finds freelancers through submissions.

NICHOLAS BREALEY PUBLISHING

20 Park Plaza, Suite 1115A, Boston MA 02116. (617)523-3801. **Fax:** (617)523-3708. **E-mail:** info@ nicholasbrealey.com. **E-mail:** submissions@nicho lasbrealey.com. **Website:** www.nicholasbrealey.com. **Contact:** Vanessa Descalzi, assistant editor and digital director. Estab. 1992. Publishes paperback and hardcover originals. Types of books include text and reference. Specializes in global business, popular psychology, travel memoir, and crossing cultures. Recent titles: *10 Career Essentials* by Donna Dunning and *Among the Iranians* by Sofia Koutlaki. Publishes 20 titles/year. 10% require freelance illustration. Book catalog free by request.
NEEDS Approached by 20 freelancers/year. Works with 2-3 freelance illustrators/year. Prefers freelancers with experience in trade books, multicultural field. Uses freelancers mainly for jacket/cover design and illustration. 100% of freelance work demands knowledge of Illustrator, Photoshop, InDesign and Quark.
FIRST CONTACT & TERMS Send query letter with brochure, tearsheets, résumé and photocopies. Samples are filed or are returned by SASE if requested by artist. Will contact artist for portfolio review if interested. Portfolio should include b&w final art. Buys all rights. Originals are not returned. Finds artists through submissions and word of mouth.
JACKETS/COVERS Assigns 6 freelance illustration jobs/year. Pays by the project, $300-500.
TEXT ILLUSTRATION Assigns 1 freelance illustration job/year. Pays "by the piece depending on complexity." Prefers b&w line art.
TIPS First-time assignments are usually book jackets only; book jackets with interiors (complete projects) are given to "proven" freelancers. "We look for artists who have flexibility with schedule and changes to artwork. We appreciate an artist who will provide artwork that doesn't need special attention by pre-press in order for it to print properly. For b&W illustrations, keep your lines crisp and bold. For color illustrations, keep your colors pure and saturated."

BROOKS/COLE PUBLISHING COMPANY

Cengage Learning, 1065 Toebben Dr., Independence KY 41051. (800)354-9706. **Fax:** (800)487-8488. **Website:** www.brookscole.com; www.cengage.com. **Contact:** Art director. Estab. 1967. Specializes in hardcover and paperback college textbooks on mathematics, chemistry, earth sciences, physics, computer science, engineering and statistics. Publishes 100 titles/year. 85% requires freelance illustration. Books are bold, contemporary textbooks for college level.
NEEDS Works with 25 freelance illustrators and 25 freelance designers/year. Uses freelance artists mainly for interior illustration. Uses illustrators for technical line art and covers. Uses designers for cover and book design and text illustration. Also uses freelance artists for jacket/cover illustration and design. Works on assignment only.
FIRST CONTACT & TERMS Send query letter with brochure, résumé, tearsheets and photographs. Samples are filed or are returned by SASE. Art director will contact artist for portfolio review if interested. Portfolio should include roughs, tearsheets, final reproduction/product, photographs, slides and transparencies. Considers complexity of project, skill and experience of artist, project's budget and turnaround time in determining payment. Negotiates rights purchased. Not interested in second rights to previously published work unless first used in totally unrelated market. Finds illustrators and designers through word of mouth, magazines, submissions/self promotion, sourcebooks, and agents.
DESIGN Assigns 70 design and many illustration jobs/year. Pays by the project.
JACKETS/COVERS Assigns 90 design and many illustration jobs/year. Pays by the project.
TEXT ILLUSTRATION Assigns 85 freelance jobs/year. Prefers ink/Macintosh. Pays by the project.
TIPS "Provide excellent package in mailing of samples and cost estimates. Follow up with phone call. Don't be pushy. Would like to see abstract and applied photography/illustration; single strong, memorable bold images."

CANDLEWICK PRESS

99 Dover St., Somerville MA 02144. (617)661-3330. **Fax:** (617)661-0565. **E-mail:** bigbear@candlewick. com. **Website:** www.candlewick.com. **Contact:** Deb Wayshak, executive editor (fiction); Joan Powers, editor-at-large (picture books); Liz Bicknell, editorial director/associate publisher (poetry, picture books, fiction); Mary Lee Donovan, executive editor (picture books, nonfiction/fiction); Hilary Van Dusen, senior editor (nonfiction/fiction); Sarah Ketchersid, senior editor (board, toddler); Joan Powers, editor-at-large. Estab. 1991. Publishes hardcover, trade paperback children's books. Publishes 200 titles/year. 100% re-

quire freelance illustration. Book catalog not available. Works with 170 illustrators and 1-2 designers/year.

FIRST CONTACT & TERMS If you think your illustration style is well-suited to our list, please send non-returnable, color samples (color copies or sample books, but no original artwork, please) to: Attn: Art resource coordinator. Please include a brief cover letter and a resume detailing relevant professional and publishing experience. If you work in more than one medium or style, or specialize in a particular subject matter (e.g., people, animals, landscapes, etc.), remember to include a representative assortment of samples. Include your name, address, and telephone number on every sample. We also appreciate knowing the date the work was created and the medium used. Please do not send original art. If you wish to submit a full portfolio or have materials returned to you, you must include detailed instructions, return packaging, and sufficient postage. We regret that materials received without these elements cannot be returned. If you would like to send an electronic file of your artwork, please send it in JPEG or PDF form to bigbear@candlewick.com where it will be forwarded to a member of the art department. We keep tear sheets and illustration samples—including updates—on file for one year and will contact you if we have or anticipate a project that suits your particular talents. *No phone calls please!*

DESIGN 100% of freelance design demands knowledge of Photoshop, Illustrator or QuarkXPress. Send non-returnable, color samples (no original artwork) a brief cover letter and a resume detailing relevant professional and publishing experience.

TEXT ILLUSTRATION Finds illustrators through agents, sourcebooks, word of mouth, submissions, art schools. "We generally use illustrators with prior trade book experience."

CANDY CANE PRESS

Guideposts Company, 2630 Elm Hill Pike, Suite 100, Nashville TN 37214. (615)333-0478. **Fax:** (615)781-1447. **E-mail:** kwest@guideposts.org. **Website:** www.idealsbooks.com. **Contact:** Peggy Schaefer, publisher. Estab. 1996. Publishes hardcover and trade paperback originals. Types of books include board books, children's picture books, educational activity books, juvenile and preschool. Publishes 10 titles/year.

CAPSTONE PRESS

151 Good Counsel Dr., P.O. Box 669, Mankato MN 56002. (800)747-4992. **Fax:** (888)262-0705. **E-mail:** Nonfiction, nf.il.sub@capstonepub.com; fiction, il.sub@capstonepub.com. **Website:** www.capstonepress.com. **Contact:** Dede Barton. Estab. 1991.

FIRST CONTACT & TERMS Send query letter with stock list. E-mail résumé, sample artwork, and a list of previous publishing credits if applicable. Accepts images in digital format for submissions as well as for use. Digital images must be at least 8×10 at 300 dpi for publishing quality (TIFF, EPS or original camera file format preferred). Keeps samples on file. Responds in 6 months. Simultaneous submissions and previously published work OK. Pays after publication. Credit line given. Looking to buy worldwide all language rights for print and digital rights. Producing online projects (interactive websites and books); printed books may be bound up into binders.

TIPS "Be flexible. Book publishing usually takes at least 6 months. Capstone does not pay holding fees. Be prompt. The first photos in are considered for covers first."

CENTERSTREAM PUBLICATION LLC

P.O. Box 17878, Anaheim CA 92807. (714)779-9390. **E-mail:** centerstrm@aol.com. **Website:** www.centerstream-usa.com. **Contact:** Ron Middlebrook, owner. Estab. 1982. "Centerstream is known for its unique publications for a variety of instruments. From instructional and reference books and biographies, to fun song collections and DVDs, our products are created by experts who offer insight and invaluable information to players and collectors." Publishes DVDs, audio tapes, and hardcover and softcover originals. Types of books include music reference, biography, music history and music instruction. Publishes 10-20 titles/year. Samples are not filed and are returned by SASE. Responds only if interested. Rights purchased vary according to project.

FIRST CONTACT & TERMS Accepts Mac-compatible submissions.

TEXT ILLUSTRATION 100% requires freelance illustration. Works with 3 illustrators/year. Approached by 12 illustrators/year.

CHELSEA HOUSE PUBLISHERS

132 W. 31st St., 17th Floor, New York NY 10001. (800) 322-8755 or (212) 967-8800. **Fax:** (800)780-7300. **E-mail:** editorial@factsonfile.com. **Website:** www.chel

seahouse.com. **Contact:** Editorial assistant. Publishes hardcover originals and reprints. Types of books include biography, history, juvenile, reference, young adult. Specializes in young adult literary books. Publishes 150 titles/year. Recent titles include: *Coretta Scott King* by Lisa Renee Rhodes. 85% requires freelance illustration; 30% requires freelance design; 10% requires freelance art direction. Book catalog not available.

NEEDS Approached by 100 illustrators and 50 designers/year. Works with 25 illustrators, 10 designers, 5 art directors/year. Prefers freelancers experienced in Mac for design. 100% of freelance design demands knowledge of Photoshop, QuarkXPress. 20% of freelance illustration demands knowledge of Illustrator, Photoshop, QuarkXPress.

FIRST CONTACT & TERMS Designers: Send query letter with nonreturnable printed samples, photocopies. Illustrators: Send postcard sample and follow-up postcard every 3 months. Accepts Mac-compatible disk submissions. Samples are filed and are not returned. Will contact artist for portfolio review if interested. Buys first rights. Finds freelancers through networking, submissions, agents and *American Showcase*.

DESIGN Assigns 25 freelance design and 5 art direction projects/year. Pays for design by the hour, $15-35; for art direction by the hour, $25-45.

JACKETS/COVERS Assigns 50 freelance design jobs and 150 illustration jobs/year. Prefers oil, acrylic. Pays for design by the hour, $25-35. Pays for illustration by the project, $650-850. Prefers portraits that capture close likeness of a person.

TIPS "Most of the illustrations we purchase involve capturing an exact likeness of a famous or historical person. Full color only, no b&w line art. Please send nonreturnable samples only."

CHURCH PUBLISHING, INC.

4775 Linglestown Rd., Harrisburg PA 17112. 800-223-6602. **Fax:** (212) 779-3392. **E-mail:** nabryan@cpg.org. **Website:** www.churchpublishing.org. **Contact:** Nancy Bryan, editorial director. Estab. 1884. Company publishes trade paperback and hardcover originals and reprints. Specializes in spirituality, Christianity/contemporary issues.

NEEDS Works with illustrators as needed.

FIRST CONTACT & TERMS Samples are filed. Usually buys one-time rights. Finds artists through freelance submissions and web.

CLARION BOOKS

Houghton Mifflin Co., 215 Park Ave. S., New York NY 10003. **Website:** www.houghtonmifflinbooks.com; www.hmco.com. **Contact:** Dinah Stevenson, vice president and publisher; Jennifer B. Greene, senior editor (contemporary fiction, picture books for all ages, nonfiction); Jennifer Wingertzahn, editor (fiction, picture books); Lynne Polvino, editor (fiction, nonfiction, picture books); Christine Kettner, art director. Estab. 1965. Imprint publishes hardcover originals and trade paperback reprints. Book catalog free with SASE. Approached by "countless" freelancers. Works with 48 freelance illustrators/year. Uses freelancers mainly for picture books and novel jackets. Also for jacket/cover and text illustration. Pays by the project. "Be familiar with the type of books we publish before submitting. Send a SASE for a catalog or look at our books in the bookstore."

NEEDS Picture books, chapter books, middle grade novels and nonfiction, including historical and animal behavior. Publishes 60 titles/year. 90% requires freelance illustration.

FIRST CONTACT & TERMS Send children's book-related samples. Send query letter with tearsheets and photocopies. Samples are filed "if suitable to our needs." Responds only if interested. Portfolios may be dropped off every Monday. Art director will contact artist for portfolio review if interested. Rights purchased vary according to project. Originals are returned at job's completion.

TEXT ILLUSTRATION Assigns 48 freelance illustration jobs/year.

CRC PROSERVICES

2850 Kalamazoo Ave. SE, Grand Rapids MI 49560. (616)224-0780. **Fax:** (616)224-0834. **E-mail:** heet derd@crcna.org. **Website:** www.crcna.org. Estab. 1866. Publishes hardcover and trade paperback originals and magazines. Types of books include instructional, religious, young adult, reference, juvenile and preschool. Specializes in religious educational materials. Publishes 8-12 titles/year. 85% require freelance illustration. 5% require freelance art direction.

NEEDS Approached by 30-45 freelancers/year. Works with 12-16 freelance illustrators/year. Prefers freelancers with religious education, cross-cultural sensitivities. Uses freelancers for jacket/cover and text illustration. Works on assignment only.

FIRST CONTACT & TERMS Send query letter with brochure, résumé, tearsheets, photographs, photocopies, slides and transparencies. Submissions will not be returned. Illustration guidelines are available on website. Samples are filed. Portfolio should include thumbnails, roughs, finished samples, color slides, tearsheets, transparencies and photographs. Buys one-time rights. Originals are returned at job's completion.

JACKETS/COVERS Assigns 2-3 freelance illustration jobs/year. Pays by the project, $200-1,000.

TEXT ILLUSTRATION Assigns 50-100 freelance illustration jobs/year. Pays by the project, $75-100. "This is high-volume work. We publish many pieces by the same artist."

TIPS "Be absolutely professional. Know how people learn and be able to communicate a concept clearly in your art."

THE CROWN PUBLISHING GROUP

Random House, Inc., 1745 Broadway, New York NY 10019. (212)782-9000. **E-mail:** crownpublicity@randomhouse.com. **Website:** www.randomhouse.com/crown. Specializes in fiction, nonfiction and illustrated nonfiction. Publishes 250 titles/year.

○ Crown is an imprint of Random House. Within that parent company, several imprints—including Clarkson Potter, Crown Arts & Letters, and Harmony—maintain separate art departments.

NEEDS Approached by several hundred freelancers/year. Works with 15-20 illustrators and 25 designers/year. Prefers local artists. 100% of design demands knowledge of QuarkXPress and Illustrator. Works on assignment only.

FIRST CONTACT & TERMS Send query letter with samples showing art style. Responds only if interested. Originals are not returned. Rights purchased vary according to project.

JACKETS/COVERS Assigns 15-20 design or illustration jobs/year. Pays by the project.

TIPS "There is no single style. We use different styles depending on nature of the book and its perceived market. Become familiar with the types of books we publish. For example, don't send juvenile, sci-fi or romance. Book design has changed to Mac-generated layout."

CYCLE PUBLICATIONS, INC.

Van der Plas Publications, 1282 Seventh Ave., San Francisco CA 94112. (415)665-8214. **Fax:** (415)753-8572. **E-mail:** rvdp@cyclepublishing.com. **Website:** www.cyclepublishing.com. Estab. 1985. Book publisher. Publishes trade paperback originals. Types of books include instructional and travel. Specializes in subjects relating to cycling and bicycles. Publishes 6 titles/year. 20% require freelance illustration. Book catalog for SASE with first-class postage.

NEEDS Approached by 5 freelance artists/year. Buys 100 freelance illustrations/year. Uses freelance artists mainly for technical (perspective) and instructions (anatomically correct hands, posture). Also uses freelance artists for text illustration; line drawings only. Also for design. 50% of freelance work demands knowledge of CorelDraw and FreeHand. Works on assignment only.

FIRST CONTACT & TERMS Send query letter with tearsheets. Accepts disk submissions. Please include print-out with EPS files. Samples are filed. Call "but only after we have responded to query." Portfolio should include photostats. Rights purchased vary according to project. Originals are not returned to the artist at the job's completion.

DESIGN Pays by the project.

TEXT ILLUSTRATION Assigns 5 freelance illustration jobs/year. Pays by the project.

TIPS "Show competence in line drawings of technical subjects and 2-color maps."

DA CAPO PRESS

Perseus Books Group, 11 Cambridge Center, Cambridge MA 02142. (617)252-5200. **Website:** www.dacapopress.com. Estab. 1975. Publishes hardcover originals, trade paperback originals, trade paperback reprints. Types of books include self-help, parenting, biography, memoir, coffee table books, history, travel, music, and film. Specializes in self-help, parenting, music and history (trade). Publishes 100 titles/year. 25% requires freelance design; 5% requires freelance illustration.

NEEDS Approached by 30+ designers and 30+ illustrators/year. Works with 10 designers and 1 illustrator/year.

FIRST CONTACT & TERMS Send query letter with résumé, URL, color prints/copies. Send follow-up postcard sample every 6 months. Prefers Mac-compatible, JPEG, and PDF files. Samples are filed. Re-

sponds only if interested. Portfolios may be dropped off every Wednesday, Thursday and Friday and should include finished, printed samples. Rights purchased vary according to project. Finds freelancers through art competitions, artist submissions, Internet and word of mouth.

JACKETS/COVERS Assigns 20 freelance cover illustration jobs/year.

TIPS "Visit our website to view work produced/assigned by Da Capo."

DARK HORSE

10956 SE Main St., Milwaukie OR 97222. (503)652-8815. **Fax:** (503)654-9440. **E-mail:** dhcomics@dark horse.com. **Website:** www.darkhorse.com. **Contact:** Submissions Dept. Estab. 1986. Publishes mass market and trade paperback originals. Types of books include comic books and graphic novels. Specializes in comic books. Book catalog available on website.

FIRST CONTACT & TERMS Send photocopies (clean, sharp, with name, address and phone number written clearly on each page). Do not submit via fax or e-mail. Samples are not filed and not returned. Responds only if interested. Company will contact artist for portfolio review if interested. Please see website for more detail guidelines.

TIPS "If you're looking for constructive criticism, show your work to industry professionals at conventions."

JONATHAN DAVID PUBLISHERS, INC.

68-22 Eliot Ave., Middle Village NY 11379. (718)456-8611. **Fax:** (718)894-2818. **E-mail:** submission@jd books.com. **Website:** www.jdbooks.com. **Contact:** David Kolatch, editorial director. Estab. 1948. Publishes hardcover and paperback originals. Types of books include biography, religious, young adult, reference, juvenile and cookbooks. Specializes in Judaica. Titles include: *Drawing a Crowd* and *The Presidents of the United States & the Jews.* Publishes 25 titles/year. 50% require freelance illustration; 75% require freelance design.

NEEDS Approached by numerous freelancers/year. Works with 5 freelance illustrators and 5 designers/year. Prefers freelancers with experience in book jacket design and jacket/cover illustration. 100% of design and 5% of illustration demand computer literacy. Works on assignment only.

FIRST CONTACT & TERMS Designers: Send query letter with résumé and photocopies. Illustrators: Send postcard sample and/or query letter with photocopies, résumé. Samples are filed. Production coordinator will contact artist for portfolio review if interested. Portfolio should include color final art and photographs. Buys all rights. Originals are not returned. Finds artists through submissions.

DESIGN Assigns 15-20 freelance design jobs/year. Pays by the project.

JACKETS/COVERS Assigns 15-20 freelance design and 4-5 illustration jobs/year. Pays by the project.

TIPS First-time assignments are usually book jackets, mechanicals and artwork.

DAW BOOKS, INC.

Penguin Group (USA), 375 Hudson St., New York NY 10014-3658. (212)366-2096. **Fax:** (212)366-2090. **Website:** www.dawbooks.com. **Contact:** Peter Stampfel, submissions editor. Estab. 1971. Publishes hardcover and mass market paperback originals and reprints. Specializes in science fiction and fantasy. Publishes 72 titles/year. All require freelance illustration. Guidelines available on website.

NEEDS Works with numerous illustrators and 1 designer/year. Buys more than 36 illustrations/year. Works with illustrators for covers. Works on assignment only.

FIRST CONTACT & TERMS Send postcard sample or query letter with brochure, résumé, tearsheets, transparencies, photocopies, photographs and SASE. "Please don't send slides." Samples are filed or are returned by SASE only if requested. Responds in 3 days. Originals returned at job's completion. Call for appointment to show portfolio of original/final art, final reproduction/product and transparencies. Considers complexity of project, skill and experience of artist and project's budget when establishing payment. Buys first rights and reprint rights.

JACKETS/COVERS Pays by the project. "Our covers illustrate the story."

TIPS "We have a drop-off policy for portfolios. We accept them on Tuesdays, Wednesdays and Thursdays and report back within a day or so. Portfolios should contain science fiction and fantasy color illustrations *only.* We do not want to see anything else. Look at several dozen of our covers."

DC COMICS

1700 Broadway, 5th Floor, New York NY 10019. (212)636-5400. **E-mail:** dccomics@cambeywest.com. **Website:** www.dccomics.com. Estab. 1948. Publishes

hardcover originals and reprints, mass market paperback originals and reprints, trade paperback originals and reprints. Types of books include adventure, comic books, fantasy, horror, humor, juvenile, science fiction. Specializes in comic books. Publishes 1,000 titles/year.

○ DC Comics does not accept unsolicited submissions.

DIAL BOOKS FOR YOUNG READERS

Imprint of Penguin Group USA, 345 Hudson St., New York NY 10014. (212)366-2000. **Website:** www. penguin.com/youngreaders. **Contact:** Lauri Hornik, president/publisher; Kathy Dawson, associate publisher; Kate Harrison, senior editor; Liz Waniewski, editor; Alisha Niehaus, editor; Jessica Garrison, editor; Lily Malcom, art director. Estab. 1961. Specializes in juvenile and young adult hardcover originals. Publishes 50 titles/year. 100% require freelance illustration. Books are "distinguished children's books."

NEEDS Approached by 400 freelancers/year. Works with 40 freelance illustrators/year. Prefers freelancers with some book experience. Works on assignment only.

FIRST CONTACT & TERMS Send query letter with photocopies, tearsheets and SASE. Samples are filed or returned by SASE. Responds only if interested. Considers complexity of project, skill and experience of artist and project's budget when establishing payment. Rights purchased vary.

JACKETS/COVERS Assigns 8 illustration jobs/year. Pays by the project.

TEXT ILLUSTRATION Assigns 40 freelance illustration jobs/year. Pays by the project.

TIPS "Never send original art. Never send art by e-mail, fax or CD. Please do not phone, fax or e-mail to inquire after your art submission."

DORCHESTER PUBLISHING

200 Madison Ave., Suite 2000, New York NY 10016. (212)725-8811. **E-mail:** submissions@dorchesterpub. com. **Website:** www.dorchesterpub.com. **Contact:** Art department. Estab. 1970. Home of Leisure Books and Love Spell. Publishes paperback originals and reprints. Specializes in mass market category fiction—romance, western, adventure, horror, thriller, chick lit. Publishes 200 titles/year. View covers on website. Art submission guidelines available online.

NEEDS Works with 24 freelance illustrators and 6 designers/year for covers. Prefers digital, oil or acrylic. Works on assignment only.

FIRST CONTACT & TERMS Send samples by mail, marked ATTN: Art Department. Send nonreturnable tearsheets. No e-mail or fax submissions. Complexity of project will determine payment. Usually buys first rights, but rights purchased vary according to project. Interested in buying second rights (reprint rights) to previously published work for romances and westerns only.

JACKETS/COVERS Pays by the project.

TIPS "Talented new artists welcome. Be familiar with the kind of artwork we use on our covers."

DREAMLAND BOOKS, INC.

P.O. Box 1714, Minnetonka MN 55345. (612)281-4704. **E-mail:** dreamlandbooks@inbox.com. **Website:** www.dreamlandbooks.inc.com. Estab. 2008. Publishes hardcover and trade paperback originals. Types of books include children's picture books, self-help and poetry journal. Specializes in children's books. Publishes 2-3 titles/year. Recent titles include *A Granny's Heart, Faces...Who Are We?, 12 Months of Baby Animals,* and *Night~A Counting Backwards Book.* 100% requires freelance design; 100% requires freelance illustration. No book catalog available.

NEEDS Approached by 10 designers and 100 illustrators a year. Works with 2 designers and 2 illustrators a year. Prefers designers to have knowledge of InDesign, Illustrator and Photoshop.

FIRST CONTACT & TERMS Designers and illustrators should send query letter with web page link. Send follow-up postcard sample every 6-12 months, if invited to do so. E-mail submissions accepted with a link to website and an image file; must be Windows-compatible. No samples kept on file. Artists must have a well-developed webpage and a professional Facebook page. Responds only if interested. Rights are negotiated. Rights purchased vary according to project. Finds freelancers through submissions, word-of-mouth and Internet.

JACKETS/COVERS Assigns 2-3 freelance illustration jobs/year. Pays by the project; combination of flat fee after books arrive in warehouse plus a royalty fee, plus a cut on all books sold at signing events the illustrator does or books sold personally by illustrator, plus some free books each 5,000 printed.

TEXT ILLUSTRATION Assigns 2 freelance illustration jobs/year. Pays by the project; combination of flat fee after books arrive in warehouse plus a royalty fee, plus a cut on all books sold at signing events the illustrator does or books sold personally by illustrator, plus some free books each 5,000 printed.

TIPS "We are a tiny publishing house, and as such we require a sense of perfection to be competitive with the large houses. We will not work with an artist who has pornographic or violent images in the portfolio. We are *very* open to working with first-time illustrators or designers. However, the illustrator must have a professional Facebook page, as well as a web page developed featuring their work. The designer, if a first-timer in children's books, must have a design degree. Art for our children's books should be vibrant, *not* vexing. Prefers hand drawn/painted art over art done on the computer in different forms."

DUTTON CHILDREN'S BOOKS

Penguin Group (USA), Inc., 375 Hudson St., New York NY 10014. **E-mail:** duttonpublicity@ us.penguingroup.com. **Website:** www.penguin.com. **Contact:** Sara Reynolds, art director. Estab. 1852. Publishes hardcover, trade picture books and illustrated middle grade. Publishes 50-75 titles/year.

NEEDS Prefers local designers.

FIRST CONTACT & TERMS Send postcard sample, printed samples, tearsheets. Samples are filed or returned by SASE. Will contact artist for portfolio review if interested. Portfolios may be dropped off every Tuesday and picked up by end of the day. Do not send samples via e-mail.

JACKETS/COVERS Pays for illustration by the project $1,800-2,500.

EDWARD ELGAR PUBLISHING, INC.

Edward Elgar Publishing, Inc., The William Pratt House, 9 Dewey Court, Northampton MA 01060. (413)584-5551. **Fax:** (413)584-9933. **E-mail:** elgarsubmissions@e-elgar.com; submissions@e-elgar.co.uk. **Website:** www.e-elgar.com. **Contact:** Alan Sturmer; Tara Gorvine. Estab. 1986. Publishes hardcover originals and textbooks. Types of books include instructional, nonfiction, reference, textbooks, academic monographs, references in economics and business and law. Publishes 200 titles/year.

❍ This publisher uses only freelance designers. Its academic books are produced in the United Kingdom. Direct marketing material is done in U.S. There is no call for illustration.

NEEDS Prefers local designers experienced in direct mail and academic publishing. 100% of freelance design demands knowledge of Photoshop, InDesign.

FIRST CONTACT & TERMS Send query letter with printed samples. Accepts Mac-compatible disk submissions. Samples are filed. Will contact artist for portfolio review if interested. Buys one-time rights or rights purchased vary according to project. Finds freelancers through word of mouth, local sources (i.e., phone book, newspaper, etc.).

FABER & FABER, INC.

Farrar, Straus & Giroux, 18 W. 18th St., New York NY 10011. (212)741-6900. **Website:** us.macmillan.com/faberandfaber.aspx. Estab. 1976. Publishes hardcover originals, trade paperback originals and reprints. Types of books include biography, cookbooks, history, mainstream fiction, nonfiction, self help and travel. Publishes 35 titles/year. 30% require freelance design.

NEEDS Approached by 60 illustrators and 40 designers/year. Uses freelancers mainly for book jacket design. 80% of freelance design demands knowledge of Photoshop and QuarkXPress.

FIRST CONTACT & TERMS Designers: Send query letter with photocopies. Illustrators: Send postcard sample or photocopies. Samples are filed or returned by SASE. Will contact artist for portfolio review if interested. Rights purchased vary according to project.

JACKETS/COVERS Assigns 20 freelance design and 4 illustration jobs/year. Pays by project.

FALCONGUIDES

246 Goose Lane, P.O. Box 480, Guilford CT 06437. (203)458-4500. **Website:** www.falcon.com; www.globepequot.com. Book publisher. The Falcon line specializes in outdoor recreation topics such as hiking, biking, climbing, surfing and other areas.

FIRST CONTACT & TERMS "We welcome solicited and unsolicited submissions from authors, agents and book packagers sent in hard copy by mail or other shipping carrier. We will not return any materials without a SASE containing sufficient postage. Never send original copies. We aren't responsible for the loss of any materials sent to us. No calls, please, unless you are a professional literary agent or have a book contract with GPP. Proposals should only be e-mailed to an editor by request." See website for complete proposal guidelines.

FANTAGRAPHICS BOOKS, INC.

7563 Lake City Way NE, Seattle WA 98115. (206)524-1967. **Fax:** (206)524-2104. **E-mail:** fbicomix@fantagraphics.com. **Website:** www.fantagraphics.com. **Contact:** Submissions editor. Estab. 1976. Publishes hardcover and trade paperback originals and reprints. Types of books include contemporary, experimental, mainstream, historical, humor and erotic. "All our books are comic books or graphic stories." Publishes 100 titles/year. 10% require freelance illustration. Book catalog free by request. Art submission guidelines available on website.

○ See additional listing in the Magazines section.

NEEDS Approached by 500 freelancers/year. Works with 25 freelance illustrators/year. Must be interested in and willing to do comics. Uses freelancers for comic book interiors and covers.

FIRST CONTACT & TERMS Send query letter addressed to Submissions Editor with résumé, SASE, photocopies and finished comics work. Samples are not filed and are returned by SASE. Responds only if interested. Call or write for appointment to show portfolio of original/final art and b&w samples. Buys one-time rights or negotiates rights purchased. Originals are returned at job's completion. Pays royalties.

TIPS "We want to see completed comics stories. We don't make assignments, but instead look for interesting material to publish that is pre-existing. We want cartoonists who have an individual style, who create stories that are personal expressions."

FARRAR, STRAUS & GIROUX

175 Fifth Ave., New York NY 10010. (212)741-6900. **Fax:** (212)633-2427. **E-mail:** childrens.editorial@fsgbooks.com. **Website:** www.fsgkidsbooks.com. **Contact:** Margaret Ferguson, editorial director; Wesley Adams, executive editor; Janine O'Malley, senior editor; Frances Foster, Frances Foster Books; Robbin Gourley, art director. Estab. 1946. Book publisher. Publishes hardcover and trade paperback originals and trade paperback reprints. Publishes nonfiction and juvenile fiction. Publishes 200 titles/year. 20% require freelance illustration; 40% freelance design.

NEEDS Works with 12 freelance designers and 3-5 illustrators/year. Uses artists for jacket/cover and book design.

FIRST CONTACT & TERMS Submission guidelines available online.

DESIGN Assigns 40 freelance design jobs/year. Pays by the project.

JACKETS/COVERS Assigns 20 freelance design jobs/year and 10-15 freelance illustration jobs/year. Pays by the project.

TIPS The best way for a freelance illustrator to get an assignment is "to have a great portfolio."

FIRST BOOKS

6750 SW Franklin St., Suite A, Portland OR 97223. (503)968-6777. **Fax:** (503)968-6779. **E-mail:** info@firstbooks.com. **Website:** www.firstbooks.com. Estab. 1988. Publishes trade paperback originals. Publishes 50 titles/year. Recent titles include: *Devine Color*, by Gretchen Schaufaer. 100% require freelance illustration.

NEEDS Works with 5 designers and 5 illustrators/year. Uses freelance designers not illustrators mainly for interiors and covers.

FIRST CONTACT & TERMS Designers: Send any samples you want to send and SASE but *no original art*. Illustrators: Send query letter with a few photocopies or slides. Samples are filed or returned by SASE. Rights purchased vary according to project.

DESIGN Payment varies per assignment.

TIPS "Small samples get looked at more than anything bulky and confusing. Little samples are better than large packets and binders. Postcards are easy. Save a tree!"

FLASHLIGHT PRESS

527 Empire Blvd., Brooklyn NY 11225. (718)288-8300. **Fax:** (718)972-6307. **E-mail:** editor@flashlightpress.com. **Website:** www.flashlightpress.com. **Contact:** Shari Dash Greenspan, editor. Estab. 2004. Publishes 2-3 picture books/year; 50% of books by first-time authors. Fiction: Picture books: contemporary, humor, multicultural. Average word length: 1,000. Recently published: *Pobble's Way* by Simon Van Booy, illustrated by Wendy Edelson (ages 4-8, picture book); *That Cat Can't Stay* by Thad Krasnesky, illustrated by David Parkins (ages 4-8, picture book); *I Always, ALWAYS Get My Way* by Thad Krasnesky, illustrated by David Parkins (ages 4-8, picture book); *I Need My Monster* by Amanda Noll, illustrated by Howard McWilliam (ages 4-8, picture book); *I'm Really Not Tired* by Lori Sunshine, illustrated by Jeffrey Ebbeler (ages 4-8, picture book).

FIRST CONTACT & TERMS E-mail with résumé and URL or low-res digital images. Submission guidelines

available at www.flashlightpress.com/submission-guidelines.html.

TIPS "Our audience is 4-8 years old. Follow our on-line submissions guide."

FORT ROSS, INC.

26 Arthur Place, Yonkers NY 10701. (914)375-6448. **E-mail:** fortross@optonline.net. **Website:** www.fortrossinc.com. **Contact:** Dr. Kartsev, executive director. Estab. 1992. "Generally, we publish Russia-related books in English or Russian. Sometimes we publish various fiction and nonfiction books in collaboration with the east European publishers in translation. We are looking mainly for well-established authors." Publishes paperback originals. Receives 100 queries received/year;100 mss received/year. Pays 6-8% royalty on wholesale price or makes outright purchase of $500-1,500; negotiable advance. Buys and sells rights for more than 500 titles per year, mostly in Russian and in Russia. Genres include children adapted classics, adventure, fantasy, horror, romance, science fiction, biography, history and self-help. Publishes more than 500 titles per year, mostly in Russian. Genres include adventure, fantasy, horror, romance, science fiction, biography, history, and self-help.

NEEDS Illustrations.

TIPS Must be proficient in Adobe Illustrator, Photoshop and QuarkXPress.

FRANKLIN WATTS

338 Euston Rd., London NW1 3BH, United Kingdom. +44 (0)20 7873 6000. **Fax:** +44 (0)20 7873 6024. **E-mail:** ad@hachettechildrens.co.uk. **Website:** www.franklinwatts.co.uk. Estab. 1942. Publishes juvenile nonfiction and specialty reference sets.

FIRST CONTACT & TERMS Submission guidelines available online.

FULCRUM PUBLISHING

4690 Table Mountain Dr., Suite 100, Golden CO 80403. **E-mail:** info@fulcrum-books.com. **Website:** www.fulcrum-books.com. **Contact:** T. Baker, acquisitions editor. Estab. 1984. Publishes hardcover originals and trade paperback originals and reprints. Types of books include biography, Native American, reference, history, self help, children's, teacher resource books, travel, humor, gardening and nature. Specializes in history, nature, teacher resource books, travel, Native American, environmental and gardening. Publishes 30 titles/year. 15% requires freelance illustration; 15% requires freelance design. Book catalog free by request.

NEEDS Uses freelancers mainly for cover and interior illustrations for gardening books. Also for other jacket/covers, text illustration and book design. Works on assignment only.

FIRST CONTACT & TERMS Send query letter with tearsheets, photographs, photocopies and photostats. Samples are filed. Responds to artist only if interested. To show portfolio, mail b&w photostats. Buys one-time rights. Originals are returned at job's completion.

DESIGN Pays by the project.

JACKETS/COVERS Pays by the project.

TEXT ILLUSTRATION Pays by the project.

TIPS Previous book design experience a plus.

GALISON/MUDPUPPY PRESS

28 W. 44th St., Suite 1411, New York NY 10036. (800)670-7441. **Fax:** (212)391-4037. **E-mail:** julia@galison.com. **Website:** www.galison.com. Publishes note cards, journals, stationery, children's products. Publishes 120 titles/year.

NEEDS Works with 20 illustrators. Assigns 5-10 freelance cover illustrations/year. Some freelance design demands knowledge of Photoshop, Illustrator and QuarkXPress.

FIRST CONTACT & TERMS "To submit your artwork for consideration, please e-mail a letter and PDF files to julia@galison.com. For Mudpuppy children's products, please submit artwork for consideration to cynthia@galison.com. We will contact you if a suitable project arises."

GALLAUDET UNIVERSITY PRESS

800 Florida Ave. NE, Washington DC 20002-3695. (202)651-5488. **Fax:** (202)651-5489. **E-mail:** gupress@gallaudet.edu. **Website:** gupress.gallaudet.edu. Estab. 1980. Publishes hardcover and trade paperback originals, hardcover and trade paperback reprints, DVDs, videotapes and textbooks. Types of books include reference, biography, coffee table books, history, instructional and textbook nonfiction. Specializes in books related to deafness. Publishes 12-15 new titles/year. 90% requires freelance design; 2% requires freelance illustration. Book catalog free on request.

NEEDS Approached by 10-20 designers and 30 illustrators/year. Works with 15 designers/year. 100% of freelance design work demands knowledge of Illustrator, PageMaker, Photoshop and QuarkXPress.

FIRST CONTACT & TERMS Send query letter with postcard sample with résumé, sample of work and URL. After introductory mailing, send follow-up postcard sample every 6 months. Accepts disk submissions. Prefers Windows-compatible, PDF files. Samples are filed. Responds only if interested. Company will contact artist for portfolio review if interested. Portfolio should include color finished art. Rights purchased vary according to project. Finds freelancers through Internet and word of mouth.

TIPS "Do not call us."

GEM GUIDES BOOK CO.

1275 W. Ninth St., Upland CA 91786. (626)855-1611. **Fax:** (626)855-1610. **E-mail:** gembooks@aol.com. **Website:** www.gemguidesbooks.com. **Contact:** Greg Warner, editor. Estab. 1965. Book publisher and wholesaler of trade paperback originals and reprints. Types of books include rocks and minerals, guide books, travel, history and regional (western U.S.). Specializes in travel and local interest (western Americana). Recent titles: *Geodes: Nature's Treasures* by Brad L. Cross and June Culp Zeitner; *Baby's Day Out in Southern California: Fun Places to Go With Babies and Toddlers* by Jobea Holt; *Fee Mining and Rockhounding Adventures in the West* by James Martin and Jeannette Hathaway Monaco; and *Moving to Arizona* by Dorothy Tegeler. Publishes 7 titles/year; 100% require freelance cover design.

NEEDS Uses freelancers mainly for covers. 100% of freelance work demands knowledge of Quark, Illustrator, Photoshop. Works on assignment only. Needs Map Makers for simple maps with minor terrain and extensive rural road network skill.

FIRST CONTACT & TERMS Send query letter with brochure, résumé and SASE; or e-mail. Samples are filed. Editor will contact artist for portfolio review if interested. Requests work on spec before assigning a job. Buys all rights. Originals are not returned. Finds artists through word of mouth and "our files."

JACKETS/COVERS Pays by the project.

GIBBS SMITH

P.O. Box 667, Layton UT 84041. (801)544-9800. **Fax:** (801)544-8853. **E-mail:** info@gibbs-smith.com. **Website:** www.gibbs-smith.com. **Contact:** Suzanne Taylor, associate publisher and creative director (children's activity books); Jennifer Grillone, art acquisitions. Estab. 1969. Imprints include Sierra Book Club for Children and Hill Street Press. Company publishes hardcover and trade paperback originals. Types of books include children's activity books, architecture and design books, cookbooks, humor, juvenile, western. Publishes 100 titles/year. 10% requires freelance illustration; 90% requires freelance design

NEEDS Approached by 250 freelance illustrators and 50 freelance designers/year. Works with 5 freelance illustrators and 15 designers/year. Designers may be located anywhere with Broadband service. Uses freelancers mainly for cover design and book layout, cartoon illustration, children's book illustration. 100% of freelance design demands knowledge of QuarkXPress or InDesign. 70% of freelance illustration demands knowledge of Photoshop, Illustrator and FreeHand.

DESIGN Assigns 90 freelance design jobs/year. Pays by the project.

JACKETS/COVERS Assigns 90 freelance design jobs and 5 illustration jobs/year. Pays for design by the project. Pays for illustration by the project.

TEXT ILLUSTRATION Pays by the project.

GLENCOE

McGraw-Hill Education, P.O. Box 182605, Columbus OH 43218. (877)833-5524. **E-mail:** mhe_cust_service@mcgraw-hill.com. **Website:** www.glencoe.com. Estab. 1965. Publishes textbooks. Types of books include marketing and career education, art and music, health, computer technology. Specializes in most el-hi (grades 7-12) subject areas, as well as post-secondary career subjects. Publishes 350 titles/year.

Glencoe also has divisions in Peoria IL and Columbus OH with separate art departments.

NEEDS Approached by 50 freelancers/year. Works with 10-20 freelance illustrators and 10-20 designers/year. Prefers experienced artists. Uses freelance artists mainly for illustration and production. Also for jacket/cover design and illustration, text illustration and book design. 100% of design and 50% of illustration demand knowledge of Adobe, InDesign, or Illustrator on Mac. Works on assignment only.

FIRST CONTACT & TERMS Send nonreturnable samples. Accepts disk submissions compatible with above program. Samples are filed. Sometimes requests work on spec before assigning a job. Negotiates rights purchased. Originals are not returned.

DESIGN Assigns 10-20 freelance design and many illustration jobs/year. Pays by the project.

JACKETS/COVERS Assigns 10-20 freelance design jobs/year. Pays by the project.

TEXT ILLUSTRATION Assigns 20-30 freelance design jobs/year. Pays by the project.

GLOBE PEQUOT PRESS

246 Goose Ln., P.O. Box 480, Guilford CT 06437. (203)458-4500. **Website:** www.globepequot.com. **Contact:** Design department. Estab. 1947. Publishes hardcover and trade paperback originals and reprints. Types of books include (mostly) travel, kayak, outdoor, cookbooks, instruction, self-help and history. Specializes in regional subjects New England, Northwest, Southeast bed-and-board country inn guides. Publishes 600 titles/year. 20% require freelance illustration; 75% require freelance design. Design of books is "classic and traditional, but fun." Book catalog available.

NEEDS Works with 10-20 freelance illustrators and 15-20 designers/year. Uses freelancers mainly for cover and text design and production. Also for jacket/cover and text illustration and direct mail design. Needs computer-literate freelancers for production. 100% of design and 75% of illustration demand knowledge of QuarkXPress 3.32, Illustrator 7.0 or Photoshop 5. Works on assignment only.

FIRST CONTACT & TERMS Send query letter with résumé, photocopies and photographs. Accepts disk submissions compatible with QuarkXPress 3.32, Illustrator 7.0 or Photoshop 5. Samples are filed and not returned. Request portfolio review in original query. "Due to the volume of inquiries, we are unable to respond individually unless suitable work is available at that time." Art director will contact artist for portfolio review if interested. Portfolio should include roughs, original/final art, photostats, tearsheets and dummies. Requests work on spec before assigning a job. Considers complexity of project, project's budget and turnaround time when establishing payment. Buys all rights. Originals are not returned. Finds artists through word of mouth, submissions, self promotion and sourcebooks.

DESIGN Pays by the hour or by the project for cover design.

JACKETS/COVERS Prefers realistic style. Pays by the hour or by the project.

TEXT ILLUSTRATION Pays by the project. Mostly b&w illustration, preferably computer-generated.

TIPS "Our books are being produced on Macintosh computers. We like designers who can use the Mac competently enough that their design looks as if it *hasn't* been done on the Mac."

GO! COMI

Go! Media Entertainment, LLC, 5737 Kanan Rd. #591, Agoura Hills CA 91301. **Website:** www.gocomi.com. "Go! Comi is not accepting submissions for original ideas or material at this time. Submissions will not be looked at and will automatically be deleted. If you ignore this policy and send us scripts, stories, artwork, ideas, or any material, either through e-mail or regular mail, your submissions become the property of Go! Media Entertainment LLC, and we will not be responsible for any use or disclosure of your material. Furthermore, by sending us unsolicited submissions without a release, you agree not to hold us liable for any similarities between your work and any work subsequently published by us."

GOLDEN BOOKS

Website: www.randomhouse.com/golden. Publishes preschool and juvenile. Specializes in picture books themed for infant to 8-year-olds. Publishes 250 titles/year, including: *Pat the Bunny*; Little Golden Books; Nickelodeon, Mattel.

NEEDS Approached by several hundred artists/year. Works with approximately 100 illustrators/year. Very little freelance design work. Most design is done in-house. Buys enough illustration for over 200 new titles, approximately 70% being licensed character books. Artists must have picture book experience; illustrations are generally full color, but b&w art is required for coloring and activity books. Uses freelancers for picture books, storybooks. Traditional illustration, as well as digital illustration is accepted, although digital is preferred.

FIRST CONTACT & TERMS Send query letter with SASE and tearsheets. Samples are filed or are returned by SASE if requested by artist. Art director will call for portfolio if interested. Will look at original artwork and/or color representations in portfolios, but please do not send original art through the mail. Royalties or work-for-hire limited according to project.

JACKETS/COVERS All design done in-house. Makes outright purchase on licensed character properties only.

TEXT ILLUSTRATION Assigns approximately 250 freelance illustration jobs/year. Payment varies.

TIPS "We are open to a wide variety of styles. Contemporary illustrations that have strong bright colors and

mass market appeal featuring appealing multicultural children will get strongest consideration."

GOOSE LANE EDITIONS, LTD.

500 Beaverbrook Ct., Suite 330, Fredericton NB E3B 5X4, Canada. (506)450-4251 or (888)926-8377. **Fax:** (506)459-4991. **E-mail:** info@gooselane.com; jscriver@gooselane.com. **Website:** www.gooselane. com. **Contact:** Julie Scriver, art director. Estab. 1954. Publishes trade paperback originals of poetry, fiction and nonfiction. Types of books include poetry, biography, cookbooks, fiction, reference and history. Publishes 10-20 titles/year. 0-5% requires freelance illustration. Books are "high quality, elegant, generally with full-color fine art reproduction on cover." Book catalog free for SASE with Canadian first-class stamp or IRC.

NEEDS Approached by 30 freelancers/year. Works with 0-1 illustrators/year. Only works with freelancers in the region. Works on assignment only.

FIRST CONTACT & TERMS Submission guidelines available online.

DESIGN Pays by the project.

JACKETS/COVERS Assigns 0-1 freelance design job and 0-1 illustration jobs/year. Pays by the project.

TEXT ILLUSTRATION Assigns 0-1 freelance illustration job/year. Pays by the project.

THE GRADUATE GROUP

P.O. Box 370351, West Hartford CT 06137-0351. (860)233-2330. **Fax:** (860)233-2330. **E-mail:** graduate group@hotmail.com. **Website:** www.graduategroup. com. **Contact:** Mara Whitman, partner; Robert Whitman, vice president. Estab. 1964. Publishes trade paperback originals. Types of books include instructional and reference. Specializes in internships and career planning. Recent title: *Create Your Ultimate Résumé, Portfolio, and Writing Samples: An Employment Guide for the Technical Communicator* by Mara W. Cohen Ioannides. Publishes 35 titles/year; 10% require freelance illustration and design. Book catalog free by request.

NEEDS Approached by 20 freelancers/year. Works with 1 freelance illustrator and 1 designer/year. Prefers local freelancers only. Uses freelancers for jacket/cover illustration and design; direct mail, book and catalog design. 5% of freelance work demands computer skills. Works on assignment only.

FIRST CONTACT & TERMS Send query letter with brochure and résumé. Samples are not filed. Re-

sponds only if interested. Write for appointment to show portfolio.

TIPS "Our goal is to provide readers with information (at no cost to them) that will help them gain a broader understanding of available opportunities and career options. It is helpful to us if you could inform us about the following: (a) your ability to obtain favorable reviews of your book, and (b) your ability to market your book. If you wish to discuss your idea for a book, call Bob Whitman at (860)232-3100."

GRAYWOLF PRESS

250 Third Ave. N., Suite 600, Minneapolis MN 55401. **E-mail:** wolves@graywolfpress.org. **Website:** www. graywolfpress.org. **Contact:** Katie Dublinski, editorial manager (nonfiction, fiction). Estab. 1974. Publishes hardcover originals, trade paperback originals and reprints. Specializes in novels, nonfiction, memoir, poetry, essays and short stories. Publishes 30 titles/year. Recent titles include: *I Curse the River of Time* by Per Petterson; *Mattaponi Queen* by Belle Boggs; *We Don't Know We Don't Know* by Nick Lantz. 100% require freelance cover design. Books use solid typography, strikingly beautiful and well-integrated artwork. Book catalog free by request.

Graywolf is recognized as one of the finest small presses in the nation.

NEEDS Approached by 100 freelance artists/year. Works with 7 designers/year. Buys 25 illustrations/year (existing art only). Uses freelancers mainly for cover design only. Works on assignment only.

FIRST CONTACT & TERMS Send query letter with résumé and photocopies. Samples are returned by SASE if requested by artist. Editorial director will contact artist for portfolio review if interested. Portfolio should include b&w, color photostats and tearsheets. Negotiates rights purchased. Originals are returned at job's completion. Pays by the project.

JACKETS/COVERS Assigns 25 design jobs/year. Pays by the project, $800-1,200.

TIPS "Have a strong portfolio of literary (fine press) design."

GREAT QUOTATIONS PUBLISHING

8102 Lemont Rd., #300, Woodridge IL 60517. (630)390-3580. **Contact:** Ringo Suek, acquisitions editor (humor, relationships, Christian); Jan Stob, acquisitions editor (children's). Estab. 1991. Imprint of Greatime Offset Printing. Publishes hardcover, trade paperback and mass market paperback origi-

nals. Types of books include humor, inspiration, motivation and books for children. Specializes in gift books. Publishes 50 titles/year. 50% require freelance illustration and design. Book catalog available for $3 with SASE.

NEEDS Approached by 100 freelancers/year. Works with 20 designers and 20 illustrators/year. Uses freelancers to illustrate and/or design books and catalogs. 50% of freelance work demands knowledge of QuarkXPress and Photoshop. Works on assignment only.

FIRST CONTACT & TERMS Send letter of introduction and sample pages. Name, address and telephone number should be clearly displayed on the front of the sample. All appropriate samples will be placed in publisher's library. Design editor will contact artist under consideration, as prospective projects become available. Rights purchased vary according to project.

JACKETS/COVERS Assigns 20 freelance cover illustration jobs/year. Pays by the project.

TEXT ILLUSTRATION Assigns 30 freelance text illustration jobs/year. Pays by the project.

TIPS "We're looking for bright, colorful cover design on a small-size book cover (around 6×6). Outstanding humor or motivational titles will be most in demand."

GREAT SOURCE EDUCATION GROUP

Houghton Mifflin Harcourt, Editorial Department, 181 Ballardvale St., Wilmington MA 01887. **Website:** www.greatsource.com. Specializes in supplemental educational materials. Publishes more than 25 titles/year. 90% requires freelance design; 80% requires freelance illustration. Book catalog free with 9×12 SASE or check website.

NEEDS Approached by more than 100 illustrators/year. Works with 25 illustrators/year. 50% of freelance illustration demands knowledge of Illustrator and Photoshop.

FIRST CONTACT & TERMS Send nonreturnable samples such as postcards, photocopies and/or tearsheets. After introductory mailing, send follow-up postcard sample every year. Accepts disk submissions from illustrators. Prefers Mac-compatible, JPEG files. Samples are filed or returned by SASE. Responds only if interested. Company will contact artist for portfolio review if interested. Portfolio should include b&w, color tearsheets. Rights purchased vary according to project. Finds freelancers through art reps, artist's submissions, Internet.

JACKETS/COVERS Assigns 10 freelance cover illustration jobs/year. Pays for illustration by the project. Prefers kid-friendly styles.

TEXT ILLUSTRATION Assigns 25 freelance illustration jobs/year. Pays by the project. Prefers professional electronic submissions.

GREENWOOD PUBLISHING

ABC-CLIO, P.O. Box 1911, Santa Barbara CA 93116-1911. (805)968-1911. **E-mail:** editorial@abc-clio.com; ccasey@abc-clio.com. **Website:** www.greenwood.com. **Contact:** Cathleen Casey, acquisitions department/Greenwood. Estab. 1964. (Formerly Libraries Unlimited/Teacher Ideas Press.) Specializes in hardcover and paperback original reference books concerning library science and school media for librarians, educators and researchers. Also publishes in resource and activity books for teachers. Publishes more than 60 titles/year. Book catalog free by request.

NEEDS Works with 4-5 freelance artists/year.

FIRST CONTACT & TERMS Designers send query letter with résumé and photocopies. Illustrators send query letter with photocopies. Samples not filed are returned only if requested. Considers complexity of project, skill and experience of artist, and project's budget when establishing payment. Buys all rights. Originals not returned.

JACKETS/COVERS Assigns 4-6 design jobs/year. Pays by the project, $500 minimum.

TEXT ILLUSTRATION Assigns 2-4 illustration jobs/year. Pays by the project.

TIPS "We look for the ability to draw or illustrate without overly loud cartoon techniques. Freelancers should have the ability to use two-color effectively, with screens and screen builds. We ignore anything sent to us that is in four-color. We also need freelancers with a good feel for typefaces."

GROSSET & DUNLAP

Penguin Group Publishers, 375 Hudson St., New York NY 10014-3657. (212)366-2000. **Website:** us.penguingroup.com. Publishes hardcover, trade paperback and mass market paperback originals and board books for preschool and juvenile audience (ages 1-10). Specializes in "very young mass market children's books." Publishes more than 200 titles/year. 100% require freelance illustration; 10% require freelance design. Grosset & Dunlap publishes children's books that examine new ways of looking at the world of children. Many books by this publisher feature

unique design components such as acetate overlays, 3D pop-up pages, or actual projects/toys that can be cut out of the book.

NEEDS Works with 100 freelance illustrators and 10 freelance designers/year. Buys 80 books' worth of illustrations/year. "Be sure your work is appropriate for our list." Uses freelance artists mainly for book illustration. Also for jacket/cover and text illustration and design. 100% of design and 50% of illustration demand knowledge of Illustrator 5.5, QuarkXPress 3.3, and Photoshop 2.5.

FIRST CONTACT & TERMS Designers: Send query letter with website address and tearsheets. Illustrators: Send postcard sample or query letter with résumé, photocopies, SASE, and tearsheets. Samples are filed. Responds to the artist only if interested. Call for appointment to show portfolio, or mail slides, color tearsheets, transparencies and dummies. Rights purchased vary according to project. Originals are returned at job's completion.

○ GROUNDWOOD BOOKS

110 Spadina Ave. Suite 801, Toronto ON M5V 2K4, Canada. (416)363-4343. **Fax:** (416)363-1071. **E-mail:** nfroman@groundwoodbooks.com. **Website:** www. groundwoodbooks.com. Publishes 10 picture books/ year; 3 young readers/year; 5 middle readers/year; 5 young adult titles/year, approximately 2 nonfiction titles/year. 10% of books by first-time authors.

GROUP PUBLISHING

1515 Cascade Ave., Loveland CO 80539. (970)669-3836 or (800)447-1070. **Fax:** (970)292-4373. **E-mail:** info@group.com. **Website:** www.group.com. Company publishes books, Bible curriculum products (including puzzles, posters, etc.), clip art resources and audiovisual materials for use in Christian education for children, youth and adults. Publishes 35-40 titles/ year. Recent titles include: *Group's Scripture Scrapbook* series; *The Dirt on Learning*; *Group's Hands-On Bible Curriculum*; *Group's Treasure Serengeti Trek Vacation Bible School*; *Faith Weaver Bible Curriculum.*

○ See additional listing in the Magazines section.

NEEDS Uses freelancers for cover illustration and design. 100% of design and 50% of illustration demand knowledge of InDesign CS2, Photoshop 7.0, Illustrator 9.0. Occasionally uses cartoons in books and teacher's guides. Uses b&w and color illustration on covers and in product interiors.

FIRST CONTACT & TERMS Send query letter with nonreturnable b&w or color photocopies, slides, tearsheets or other samples. Accepts disk submissions. Samples are filed, additional samples may be requested prior to assignment. Responds only if interested. Rights purchased vary according to project.

JACKETS/COVERS Assigns minimum 15 freelance design and 10 freelance illustration jobs/year.

TEXT ILLUSTRATION Assigns minimum 20 freelance illustration projects/year. **Pays on acceptance.** Fees for color illustration and design work vary and are negotiable. Prefers b&w line or line and wash illustrations to accompany lesson activities.

TIPS "We prefer contemporary, nontraditional styles appropriate for our innovative and upbeat products and the creative Christian teachers and students who use them. We seek experienced designers and artists who can help us achieve our goal of presenting biblical material in fresh, new and engaging ways. Submit design/illustration on disk. Self promotion pieces help get you noticed. Have book covers/jackets, brochure design, newsletter or catalog design in your portfolio. Include samples of Bible or church-related illustration."

○ GUERNICA EDITIONS

Box 117, Station P, Toronto ON M5S 2S6, Canada. (416)658-9888. **Fax:** (416)657-8885. **E-mail:** antonio dalfonso@sympatico.ca. **Website:** www.guernica editions.com. **Contact:** Antonio D'Alfonso, editor/ publisher (poetry, nonfiction, novels). Estab. 1978. Book publisher and literary press specializing in translation. Publishes trade paperback originals and reprints. Types of books include contemporary and experimental fiction, biography and history. Specializes in ethnic/multicultural writing and translation of European and Quebecois writers into English. Recent titles: *Peace Tower* by F.G. Paci (artist Hono Lulu); and *Medusa Subway* by Clara Blackwood (artist Normand Cousineau). Publishes 20-25 titles/year; 40-50% require freelance illustration. Book catalog available for SAE; include IRC if sending from outside Canada.

NEEDS Approached by 6 freelancers/year. Works with 6 freelance illustrators/year. Uses freelancers mainly for jacket/cover illustration.

FIRST CONTACT & TERMS Send e-mail. Buys one-time rights. Originals are not returned at job completion. Does not accept or respond to e-mail enquiries about manuscripts.

JACKETS/COVERS Assigns 10 freelance illustration jobs/year. Pays by the project, $150-200.

TIPS "We really believe that the author should be aware of the press they work with. Try to see what a press does and offer your own view of that look. We are looking for strong designers. We have three new series of books, so there is a lot of space for artwork."

HARLAN DAVIDSON, INC./FORUM PRESS, INC.

773 Glenn Ave., Wheeling IL 60090. (847)541-9720. **Fax:** (847)541-9830. **E-mail:** harlandavidson@harlan davidson.com. **Website:** www.harlandavidson.com. Publishes textbooks. Types of books include biography, classics in literature, drama, political science and history. Specializes in US and European history. Publishes 6-15 titles/year. 20% requires freelance illustration; 20% requires freelance design. Catalog available.

NEEDS Approached by 2 designers/year. Works with 1-2 designers/year. 100% of freelance design demands knowledge of Photoshop.

FIRST CONTACT & TERMS Designers: Send query letter with brochure and résumé. Samples are filed or are returned by SASE. Responds in 2 weeks. Portfolio review required from designers. Will contact artist for portfolio review of book dummy if interested. Buys all rights.

DESIGN Assigns 3 freelance design jobs/year. Pays by the project.

JACKETS/COVERS Assigns 3 freelance design jobs/year. Pays by the project. Finds freelancers through networking.

TIPS "Have knowledge of file preparation for electronic prepress."

◑ HARLEQUIN ENTERPRISES, LTD.

P.O. Box 5190, Buffalo NY 14240-5190. (888)432-4879. **E-mail:** customerservice@harlequin.com; public_relations@harlequin.ca. **Website:** www.ehar lequin.com. **Contact:** Art director. Publishes mass market paperbacks. Specializes in women's fiction. Publishes more than 100 titles/year. 15% requires freelance design; 100% requires freelance illustration. Book catalog not available.

NEEDS Approached by 1-3 designers and 20-50 illustrators/year. Works with 3 designers and 25 illustrators/year. 100% of freelance design work demands knowledge of Illustrator, Photoshop and InDesign.

FIRST CONTACT & TERMS Designers: Send postcard sample with brochure, photocopies, tearsheets and URL. Illustrators: Send postcard sample with brochure, photocopies, tearsheets and URL. After introductory mailing, send follow-up postcard sample every 6 months. Samples are filed and not returned. Does not reply. Company will contact artist for portfolio review if interested. Portfolio should include b&w and color tearsheets and color outputs. Buys all rights. Finds freelancers through art competitions, art exhibits/fairs, art reps, artist's submissions, competition/book credits, Internet, sourcebooks, word of mouth.

JACKETS/COVERS Assigns more than 50 freelance cover illustration jobs/year. Prefers variety of representational art—not just romance genre.

HARPERCOLLINS CHILDREN'S BOOKS/ HARPERCOLLINS PUBLISHERS

10 E. 53rd, New York NY 10022. (212)207-6901. **E-mail:** Dana.fritts@Harpercollins.com; Mischa.Rosenberg@ Harpercollins.com. **Website:** www.harpercollins.com. **Contact:** Mischa Rosenberg, assistant designer; Dana Fritts, designer. Publishes hardcover originals and reprints, trade paperback originals and reprints, mass market paperback originals and reprints, and audiobooks. 500 titles/year.

NEEDS Babies/children/teens, couples, multicultural, pets, food/drink, fashion, lifestyle. "We would be interested in seeing samples of map illustrations, chapter spots, full page pieces, etc. We are open to half-tone and line art illustrations for our interiors." Negotiates a flat payment fee upon acceptance. Will contact if interested. Catalog available online.

TIPS "Be flexible and responsive to comments and corrections. Hold to scheduled due dates for work. Show work that reflects the kinds of projects you *want* to get, be focused on your best technique and showcase the strongest, most successful examples."

◑ HARPERCOLLINS PUBLISHERS, LTD. (CANADA)

2 Bloor St. E, 20th Floor, Toronto ON M4W 1A8, Canada. (416)975-9334. **Website:** www.harpercanada. com. **Contact:** Vice president production. Publishes hardcover, trade paperback and mass market paperback originals and reprints. Types of books include adventure, biography, coffee table books, fantasy, history, humor, juvenile, mainstream fiction, New Age, nonfiction, preschool, reference, religious, self-help, travel, true crime, western and young adult. Publishes

100 titles/year. 50% require freelance illustration; 25% require freelance design.

NEEDS Prefers freelancers experienced in mixed media. Uses freelancers mainly for illustration, maps, cover design. 100% of freelance design demands knowledge of Photoshop, Illustrator, QuarkXPress. 25% of freelance illustration demands knowledge of Photoshop and Illustrator.

FIRST CONTACT & TERMS Designers: Send query letter with brochure, photocopies, tearsheets. Illustrators: Send postcard sample or query letter with photocopies, tearsheets. Accepts disk submissions compatible with QuarkXPress. Send EPS or TIFF files. Samples are filed. Will contact artist for portfolio review "only after review of samples if I have a project they might be right for." Portfolio should include book dummy, photocopies, photographs, slides, tearsheets, transparencies. Rights purchased vary according to project.

DESIGN Assigns 5 freelance design jobs/year. Pays by the project.

JACKETS/COVERS Assigns 20 freelance design and 50 illustration jobs/year. Pays by the project.

TEXT ILLUSTRATION Assigns 10 freelance illustration jobs/year. Pays by the project.

HARVEST HOUSE PUBLISHERS

990 Owen Loop N, Eugene OR 97402. (541)343-0123. **Fax:** (541)302-0731. **Website:** www.harvesthousepublishers.com. Estab. 1974. Specializes in hardcover and paperback editions of Christian evangelical adult fiction and nonfiction, children's books, gift books and youth material. Publishes 100-125 titles/year. Books are of contemporary designs that compete with the current book market.

NEEDS Works with 1-2 freelance illustrators and 4-5 freelance designers/year. Uses freelance artists mainly for cover art. Also uses freelance artists for text illustration. Works on assignment only.

FIRST CONTACT & TERMS Send query letter with brochure, résumé, tearsheets and photographs. Art director will contact artist for portfolio review if interested. Requests work on spec before assigning a job. Originals may be returned at job's completion. Buys all rights. Finds artists through word of mouth and submissions/self-promotions.

DESIGN Pays by the project.

JACKETS/COVERS Assigns 100-125 design and less than 5 illustration jobs/year. Pays by the project.

TEXT ILLUSTRATION Assigns fewer than 5 jobs/year. Pays by the project.

THE HAWORTH PRESS, INC.

Taylor & Francis Group, 270 Madison Ave., New York NY 10016. (212)216-7800. **Fax:** (212)244-1563. **E-mail:** orders@taylorandfrancis.com. **Website:** www.haworthpress.com. Estab. 1979. Imprints include Harrington Park Press, Haworth Pastoral Press, International Business Press, Food Products Press, Haworth Medical Press, Haworth Maltreatment, The Haworth Hospitality/Tourism Press and Trauma Press. Publishes hardcover originals, trade paperback originals and reprints and textbooks. Types of books include biography, new age, nonfiction, reference, religious and textbooks. Specializes in social work, library science, gerontology, gay and lesbian studies, addictions, etc. Catalog available.

NEEDS Approached by 2 illustrators and 5 designers/year. 100% of freelance design and illustration demands knowledge of PageMaker, Photoshop and Illustrator.

FIRST CONTACT & TERMS Designers: Send photocopies, SASE and slides. Illustrators: Send postcard sample or query letter with photocopies. Accepts disk submissions compatible with Illustrator and Photoshop 3.0. Samples are filed. Responds only if interested. Will contact artist for portfolio review of slides if interested. Buys reprint rights. Rights purchased vary according to project. Finds freelancers through word of mouth.

DESIGN Pay varies.

JACKETS/COVERS Pay varies. Prefers a variety as long as camera ready art can be supplied.

HAY HOUSE, INC.

P.O. Box 5100, Carlsbad CA 92018. (760)431-7695. **Fax:** (760)431-6948. **E-mail:** editorial@hayhouse.com. **Website:** www.hayhouse.com. **Contact:** Patty Gift, East Coast acquisitions (pgift@hayhouse.com); Alex Freemon, West Coast acquisitions (afreemon@hayhouse.com). Estab. 1985. Publishes hardcover originals and reprints, trade paperback originals and reprints, CDs and DVDs. Types of books include self-help, mind-body-spirit, psychology, finance, health and fitness, nutrition, astrology. Recent titles: *A Course in Miracles* by Marianne Williamson; *Getting Into the Vortex* by Esther and Jerry Hicks; *The Angel Therapy Handbook* by Doreen Virtue; *Power Up Your Brain* by David Perlmutter, M.D. and Alberto Villoldo,

Ph.D. Publishes 75 titles/year; 40% require freelance illustration; 30% require freelance design.

NEEDS Approached by 50 illustrators and 5 designers/year. Works with 20 illustrators and 2-5 designers/year. Uses freelancers mainly for cover design and illustration. 80% of freelance design demands knowledge of Photoshop, Illustrator, QuarkXPress. 20% of titles require freelance art direction.

FIRST CONTACT & TERMS Send e-mail or send non-returnable samples to the address above. Art director will contact if interested. Buys all rights. Finds freelancers through word of mouth and submissions.

TIPS "We look for freelancers with experience in graphic design, desktop publishing, printing processes, production and illustrators with strong ability to conceptualize."

HEAVY METAL

100 N. Village Rd., Rookville Center NY 11570. (516)594-2130. **E-mail:** heavymetal1@rcn.com. **Website:** www.heavymetal.com. Estab. 1977. Publishes trade paperback originals. Types of books include comic books, fantasy and erotic fiction. Specializes in fantasy. Art guidelines available on website.

FIRST CONTACT & TERMS Send contact information (mailing address, phone, fax, e-mail), photocopies, photographs, SASE, slides. Samples are returned only by SASE. Responds in 3 months.

TIPS "Please look over the kinds of work we publish carefully so you get a feel for what we are looking for."

HIPPOCRENE BOOKS, INC.

171 Madison Ave., New York NY 10016. (718)454-2366. **E-mail:** info@hippocrenebooks.com. **Website:** www.hippocrenebooks.com. Estab. 1971. Publishes hardcover originals and trade paperback reprints. Types of books include cookbooks, history, nonfiction, reference, travel, dictionaries, foreign language, bilingual. Specializes in dictionaries, cookbooks. Publishes 60 titles/year.

NEEDS Approached by 150 illustrators and 50 designers/year. Works with 2 illustrators and 3 designers/year. Prefers local freelancers experienced in line drawings.

FIRST CONTACT & TERMS Designers: Send query e-mail with small attachment or website link.

JACKETS/COVERS Assigns 4 freelance design and 2 freelance illustration jobs/year. Pays by the project.

TEXT ILLUSTRATION Assigns 4 freelance illustration jobs/year. Pays by the project.

TIPS "We prefer traditional illustrations appropriate for gift books and cookbooks."

HOLIDAY HOUSE

425 Madison Ave., New York NY 10017. (212)688-0085. **Fax:** (212)421-6134. **E-mail:** info@holiday house.com. **Website:** www.holidayhouse.com. **Contact:** Claire Counihan, director of art and design. Specializes in hardcover children's books. Recent titles: *Washington at Valley Forge* by Russell Freedman; *Tornadoes* by Gail Gibbons; and *The Carbon Diaries* by Saci Lloyd. Publishes 70 titles/year. 75% require illustration. Art submission guidelines available on website.

NEEDS Accepts art suitable for children and young adults only. Works on assignment only.

FIRST CONTACT & TERMS Send cover letter with photocopies and SASE. Submissions are not returned. Request portfolio review in original query. Responds only if interested. Originals are returned at job's completion. Finds artists through submissions and agents.

JACKETS/COVERS Assigns 5-10 freelance illustration jobs/year. Pays by the project.

TEXT ILLUSTRATION Assigns 35 freelance jobs/year (picture books). Pays royalty.

HOMESTEAD PUBLISHING

P.O. Box 193, Moose WY 83012. (307)733-6248. **Fax:** (307)733-6248. **Website:** www.homesteadpublishing. net. **Contact:** Art director. Estab. 1980. Publishes hardcover and paperback originals. Types of books include art, biography, history, guides, photography, nonfiction, natural history, and general books of interest. Publishes more than 6 print, 100 online titles/year. 75% require freelance illustration. Book catalog free for SASE with 4 first-class stamps.

NEEDS Works with 20 freelance illustrators and 10 designers/year. Prefers pen & ink, airbrush, pencil and watercolor. 25% of freelance work demands knowledge of PageMaker or FreeHand. Works on assignment only.

FIRST CONTACT & TERMS Submission guidelines available online.

DESIGN Assigns 6 freelance design jobs/year. Pays by the project.

JACKETS/COVERS Assigns 2 freelance design and 4 illustration jobs/year. Pays by the project.

TEXT ILLUSTRATION Assigns 50 freelance illustration jobs/year. Prefers technical pen illustration, maps (using airbrush, overlays, etc.), watercolor il-

lustrations for children's books, calligraphy and lettering for titles and headings. Pays by the hour or by the project.

TIPS "We are using more graphic, contemporary designs and looking for exceptional quality."

HOUGHTON MIFFLIN HARCOURT COMPANY

222 Berkeley St., Boston MA 02116. (617)351-5000. **E-mail:** corporate.communications@hmhpub.com. **Website:** www.hmco.com. Estab. 1980. Company publishes hardcover originals. Types of books include juvenile, preschool and young adult. Publishes 60-70 titles/year. 100% requires freelance illustration; 10% requires freelance design.

 Houghton Mifflin Harcourt now has a new imprint, Graphia, a high-end paperback book series for teens.

NEEDS Approached by 6-10 freelancers/year. Works with 50 freelance illustrators and 10 designers/year. Prefers artists with interest in or experience with children's books. Uses freelance illustrators mainly for jackets, picture books. Uses freelance designers primarily for photo essay books. 100% of freelance design work demands knowledge of QuarkXPress, Photoshop and Illustrator.

FIRST CONTACT & TERMS Please send samples through artist rep only. Finds artists through artist reps, sourcebooks, word of mouth.

DESIGN Assigns 10-20 freelance design jobs/year. Pays by the project.

JACKETS/COVERS Assigns 5-10 freelance illustration jobs/year. Pays by the project.

TEXT ILLUSTRATION Assigns up to 50 freelance illustration jobs/year. Pays by the project.

HOW BOOKS

F+W Media, Inc., 10151 Carver Rd., Suite 200, Blue Ash OH 45242. (513)531-2690. **E-mail:** megan.patrick@fwmedia.com. **Website:** www.howdesign.com. **Contact:** Megan Patrick, content director. Estab. 1985. "We look for material that reflects the cutting edge of trends, graphic design, and culture. Nearly all HOW Books are intensely visual, and authors must be able to create or supply art/illustration for their books."

FIRST CONTACT & TERMS Query with SASE. Submit proposal package, outline, 1 sample chapter, sample art or sample design.

HUMANICS PUBLISHING GROUP

12 S. Dixie Hwy., Suite 203, Lake Worth FL 33460. (800)874-8844. **Fax:** (888)874-8844. **E-mail:** humanics@mindspring.com. **Website:** www.humanicspub.com or www.humanicslearning.com. Estab. 1976. Publishes college textbooks, paperback trade, New Age and educational activity books. Publishes 30 titles/year. Trade paperbacks are 6×9 with 4-color covers. Book catalog for 9×12 SASE. Specify which imprint when requesting catalog. Learning or trade paperbacks.

 No longer publishes children's fiction or picture books.

FIRST CONTACT & TERMS Send query letter with résumé, SASE and photocopies. Samples are filed or are returned by SASE if requested by artist. Rights purchased vary according to project.

DESIGN Pays by the project.

TIPS "Books on self-help and spirituality emphasized under current program. A new imprint on mysteries, started in 2008, is called Sleuth Hound Books."

IDEALS PUBLICATIONS, INC.

2630 Elm Hill Pike, Suite 100, Nashville TN 37214. (615)781-1451. **E-mail:** kwest@guideposts.org. **Website:** www.idealsbooks.com. Estab. 1944. Company publishes hardcover originals and *Ideals* magazine. Specializes in nostalgia and holiday themes. Publishes 2-4 adult and 25-40 children's book titles and 2 magazine issues/year. 50% require freelance illustration. Guidelines available online.

NEEDS Approached by 100 freelancers/year. Works with 10-12 freelance illustrators/year. Prefers freelancers with experience in illustrating people, nostalgia, botanical flowers. Uses freelancers mainly for flower borders (color), people and spot art. Also for text illustration, jacket/cover and book design. Works on assignment only.

FIRST CONTACT & TERMS Art submission guidelines available online. Send to Attn: Art department.

TEXT ILLUSTRATION Assigns 75 freelance illustration jobs/year. Pays by the project. Prefers watercolor or gouache.

TIPS "Looking for illustrations with unique perspectives, perhaps some humor, that not only tells the story but draws the reader into the artist's world. We accept all styles."

IDW PUBLISHING

5080 Santa Fe, San Diego CA 92109. **E-mail:** letters@ idwpublishing.com. **Website:** www.idwpublishing. com. Estab. 1999. Publishes hardcover, mass market and trade paperback originals. Types of books include comic books, illustrated novel and art book nonfiction. Publishes 20 titles/year. Submission guidelines available on website.

FIRST CONTACT & TERMS Send proposal with cover letter, photocopies (5 fully inked and lettered 8½×11 pages showing story and art), 1-page synopsis of overall story. Samples are not returned. Responds only if interested.

TIPS "Do not send original art. Make sure photocopies are clean, sharp, and easy to read. Be sure that each page has your name, address and phone number written clearly on it. Do not call."

IGNATIUS PRESS

1348 Tenth Ave., San Francisco CA 94122. (415)387-2324. **Fax:** (415)387-0896. **E-mail:** info@ignatius.com. **Website:** www.ignatius.com/Default.aspx. **Contact:** Roxanne Lum, art director. Estab. 1978. Company publishes Catholic theology and devotional books for lay people, priests and religious readers. Publishes 30 titles/year.

NEEDS Works with 1-2 freelance illustrators/year. Works on assignment only.

FIRST CONTACT & TERMS Will send art guidelines "if we are interested in the artist's work." Accepts previously published material. Send brochure showing art style or résumé and photocopies. Samples not filed and not returned. Responds only if interested. To show a portfolio, mail appropriate materials; "we will contact you if interested." **Pays on acceptance.**

JACKETS/COVERS Buys cover art from freelance artists. Prefers Christian symbols/calligraphy and religious illustrations of Jesus, saints, etc. (used on cover or in text). "Simplicity, clarity, and elegance are the rule. We like calligraphy, occasionally incorporated with Christian symbols. We also do covers with type and photography." Pays by the project.

TEXT ILLUSTRATION Pays by the project.

TIPS "I do not want to see any schmaltzy religious art. Since we are a nonprofit Catholic press, we cannot always afford to pay the going rate for freelance art, so we are always appreciative when artists can give us a break on prices and work *ad maiorem Dei gloriam*."

IMAGE COMICS

Submissions, 2134 Allston Way, 2nd Floor, Berkeley CA 94704. **E-mail:** submissions@imagecomics.com. **Website:** www.imagecomics.com. **Contact:** Eric Stephenson, publisher. Estab. 1992. Publishes comic books, graphic novels. See this company's website for detailed guidelines.

NEEDS "We are looking for good, well-told stories and exceptional artwork that run the gamut in terms of both style and genre."

FIRST CONTACT & TERMS Send proposals only. See website for guidelines. No e-mail submissions. All comics are creator-owned. Image only wants proposals for comics, not "art submissions." Proposals/ samples not returned. Do not include SASE. Responds as soon as possible.

TIPS "Please do not try to 'impress' us with all the deals you've lined up or testimonials from your Aunt Matilda. We are only interested in the comic."

IMMEDIUM

P.O. Box 31846, San Francisco CA 94131. (415)452-8546. **Fax:** (360)937-6272. **E-mail:** submissions@ immedium.com. **Website:** www.immedium.com. **Contact:** Amy Ma, acquisitions editor. Estab. 2005. "*Immedium* focuses on publishing eye-catching children's picture books, Asian American topics, and contemporary arts, popular culture, and multicultural issues."

NEEDS Babies/children/teens, multicultural, families, parents, entertainment, lifestyle. Illustrations for text illustration, dust jackets, promotional materials and book covers.

FIRST CONTACT & TERMS Send query letter with résumé, samples and/or SASE.

TIPS "Look at our catalog, it's colorful and a little edgy. Tailor your submission to our catalog. We need responsive workers."

IMPACT BOOKS

F+W Media, Inc., 10151 Carver Road, Suite 200, Blue Ash OH 45242. (513)531-2690. **Fax:** (513)531-2686. **E-mail:** pam.wissman@fwmedia.com. **Website:** www. northlightshop.com; www.impact-books.com. **Contact:** Pamela Wissman, editorial director (art instruction for fantasy, comics, manga, anime, popular culture, graffiti, science fiction, cartooning, body art). Estab. 2004. Publishes trade paperback originals. Specializes in illustrated art instruction books. Recent titles: *Shojo Wonder Manga Art School* by Supittha

Bunyapen, *Dragonworld*, edited by Pamela Wissman, and *The Explorer's Guide to Drawing Fantasy Creatures* by Emily Fiegenschuh and *Graff 2* by Scape Martinez. Publishes 7 titles/year. Book catalog free with 9×12 SASE (6 first-class stamps).

○ IMPACT Books publishes titles that emphasize illustrated how-to-draw manga, graffiti and fantasy art instruction. Currently emphasizing fantasy art, Japanese-style (manga and anime), and graffiti. This market is for experienced artists who are willing to work with an IMPACT editor to produce a step-by-step how-to book about the artist's creative process.

NEEDS Approached by 30 author-artists/year. Works with 10 author-artists/year.

FIRST CONTACT & TERMS Send query letter or e-mail; digital art, tearsheets, photocopies; résumé, SASE and URL. Accepts Mac-compatible e-mail submissions (TIFF or JPEG). Samples may be filed but are usually returned. Responds only if interested. Company will contact artist for portfolio review of color finished art, digital art, roughs, photographs, tearsheets if interested. Buys all rights. Finds freelancers through referrals, submissions, conventions, Internet and word of mouth.

TIPS Submission guidelines available online www.artistnetwork.com/contactus and impact-books.com

INCENTIVE PUBLICATIONS, INC.

(615)385-2934. **Fax:** (615)385-2967. **Website:** www.incentivepublications.com. **Contact:** Patience Camplair, editor. Estab. 1970. Specializes in supplemental teacher resource material, workbooks for middle school and teaching strategy books for all levels. Publishes 15-30 titles/year. 40% require freelance illustration. Books are "cheerful, warm, uncomplicated and spontaneous."

NEEDS Uses freelancers for covers and text illustration. Also for promo items (occasionally). Works on assignment only, primarily with local artists.

FIRST CONTACT & TERMS Illustrators: Looks for a whimsical, warm style of illustration that respects the integrity of the child. Black and white line art is used for the inside illustrations of our books. Four-color art in any medium is used for our cover art. Good quality Xeroxes, photostats or printed pieces are acceptable for showing line art pieces through the mail. Color photographs or printed pieces are best for showing four-color work through the mail

JACKETS/COVERS Assigns 3-4 freelance illustration jobs/year. Prefers 4-color covers in any medium. Pays by the project.

TEXT ILLUSTRATION Assigns 3-4 freelance jobs/year. B&w line art only. Pays by the project.

TIPS "We look for a warm and whimsical style of art that respects the integrity of the child. We sell to parents and teachers. Art needs to reflect specific age children/topics for immediate association of parents and teachers to appropriate books."

INNER TRADITIONS/BEAR & COMPANY

1 Park St., Rochester VT 05767. (802)767-3174. **Fax:** (802)767-3726. **E-mail:** peris@innertraditions.com. **Website:** www.innertraditions.com. **Contact:** Peri Ann Swan, art director. Estab. 1975. Publishes hardcover originals and trade paperback originals and reprints. Types of books include self-help, psychology, esoteric philosophy, alternative medicine, Eastern religion, and art books. Recent titles: *Mystery of the Crystal Skulls*, *Thai Yoga Massage* and *Science and the Akashic Field*. Publishes 65 titles/year; 10% require freelance illustration; 5% require freelance design. Book catalog free by request.

NEEDS Works with 3-4 freelance illustrators and 3-4 freelance designers/year. 100% of freelance design demands knowledge of QuarkXPress, InDesign or Photoshop. Buys 10 illustrations/year. Uses freelancers for jacket/cover illustration and design. Works on assignment only.

FIRST CONTACT & TERMS Send query letter with résumé, tearsheets, photocopies, photographs, slides and SASE. Accepts disk submissions. Samples are filed if interested; returned by SASE if requested by artist. Responds only if interested. To show portfolio, mail tearsheets, photographs, slides and transparencies. Rights purchased vary according to project. Originals returned at job's completion. Pays by the project.

JACKETS/COVERS Assigns approximately 10 design and illustration jobs/year. Pays by the project.

INTERNATIONAL MARINE/RAGGED MOUNTAIN PRESS

90 Mechanic St., Camden ME 04843. **E-mail:** molly_mulhern@mcgraw-hill.com. **Website:** www.books.mcgraw-hill.com/im. **Contact:** Molly Mulhern, editing/design/production director. Estab. 1969. Imprint of McGraw-Hill. Specializes in hardcovers and paperbacks on marine (nautical) and outdoor recreation

topics. Publishes 50 titles/year. 50% require freelance illustration. Book catalog free by request.

NEEDS Works with 20 freelance illustrators and 20 designers/year. Uses freelancers mainly for interior illustration. Prefers local freelancers. Works on assignment only.

FIRST CONTACT & TERMS Submission guidelines available online.

DESIGN Assigns 20 freelance design jobs/year. Pays by the project or by the hour.

JACKETS/COVERS Assigns 20 freelance design and 3 illustration jobs/year. Pays by the project or by the hour.

TEXT ILLUSTRATION Assigns 20 jobs/year. Prefers technical drawings. Pays by the hour or by the project.

TIPS "Do your research. See if your work fits with what we publish. Write with a résumé and sample; then follow with a call; then come by to visit."

JEWISH LIGHTS PUBLISHING

LongHill Partners, Inc., Sunset Farm Offices, Rt. 4, P.O. Box 237, Woodstock VT 05091. (802)457-4000. **Fax:** (802)457-4004. **E-mail:** editorial@jewishlights. com; sales@jewishlights.com. **Website:** www.jewish lights.com. **Contact:** Tim Holtz, art acquisitions. Estab. 1990. Types of books include children's picture books, history, juvenile, nonfiction, reference, religious, self help, spirituality, life cycle, theology and philosophy, wellness. Specializes in adult nonfiction and children's picture books. Publishes 50 titles/year. 10% requires freelance illustration; 50% requires freelance design. Book catalog free on request.

◯ "People of all faiths and backgrounds yearn for books that attract, engage, educate and spiritually inspire. Our principal goal is to stimulate thought and help all people learn about who the Jewish people are, where they come from, and what the future can be made to hold."

NEEDS Approached by 75 illustrators and 20 designers/year. Prefers freelancers experienced in fine arts, children's book illustration, typesetting and design. 100% of freelance design demands knowledge of QuarkXPress. 50% of freelance design demands knowledge of Photoshop.

FIRST CONTACT & TERMS Designers: Send postcard sample, query letter with printed samples, tearsheets. Illustrators: Send postcard sample or other printed samples. Samples are filed and are not returned. Portfolio review not required. Buys all rights.

Finds freelancers through submission packets, websites, searching local galleries and shows, Graphic Artists' Guild's *Directory of Illustrators* and *Picture Book*.

DESIGN Assigns 40 freelance design jobs/year. Pays for design by the project.

JACKETS/COVERS Assigns 30 freelance design jobs and 5 illustration jobs/year. Pays for design by the project.

TIPS "We prefer a painterly, fine-art approach to our children's book illustration to achieve a quality that would intrigue both kids and adults. We do not consider cartoonish, caricature art for our children's book illustration."

KAEDEN BOOKS

P.O. Box 16190, Rocky River OH 44116. **E-mail:** lstenger@kaeden.com. **Website:** www.kaeden.com. **Contact:** Lisa Stenger, editor. Estab. 1986. Publishes children's books. Types of books include picture books and early juvenile. Specializes in elementary educational content. Publishes 8-20 titles/year; 90% require freelance illustration. Book catalog available upon request.

NEEDS Approached by 100-200 illustrators/year. Works with 5-10 illustrators/year. Prefers freelancers experienced in juvenile/humorous illustration and children's picture books. Uses freelancers mainly for story illustration.

FIRST CONTACT & TERMS Designers: Send query letter with brochure and résumé. Illustrators: Send postcard sample or query letter with photocopies, photographs, printed samples or tearsheets, no larger than 8½×11. Samples are filed and not returned. Responds only if interested. Art director will contact artist for portfolio review if interested. Buys all rights.

TEXT ILLUSTRATION Assigns 8-20 jobs/year. Pays by the project. Looks for a variety of styles.

TIPS "We look for professional-level drawing and rendering skills, plus the ability to interpret a juvenile story. There is a tight correlation between text and visual in our books, plus a need for attention to detail. Drawings of children are especially needed. Please send only samples that pertain to our market."

KALMBACH PUBLISHING CO.

21027 Crossroads Circle, P.O. Box 1612, Waukesha WI 53187. (262)796-8776. **Fax:** (262)798-6468. **E-mail:** books@kalmbach.com. **Website:** www.corporate. kalmbach.com. **Contact:** Ronald Kovach, senior edi-

tor. Estab. 1934. Types of books include reference and how-to books for serious hobbyists in the railfan, model railroading, plastic modeling, and toy train collecting/operating hobbies. Also publishes books and booklets on jewelry-making, beading and general crafts. Publishes 50+ new titles/year.

NEEDS 10-20% require freelance illustration; 10-20% require freelance design. Book catalog free upon request. Approached by 25 freelancers/year. Prefers freelancers with experience in the hobby field. Uses freelance artists mainly for book layout/design and line art illustrations. Freelancers should have the most recent versions of Adobe InDesign, Photoshop and Illustrator. Projects by assignment only.

FIRST CONTACT & TERMS Send query letter with résumé, tearsheets and photocopies. No phone calls please. Samples are filed and will not be returned. Art director will contact artist for portfolio review. Finds artists through word of mouth, submissions. Assigns 10-12 freelance design jobs/year. Pays by the project. Assigns 3-5 freelance illustration jobs/year. Pays by the project.

TIPS First-time assignments are usually illustrations or book layouts. Complex projects (e.g., track plans, 100+ page books) are given to proven freelancers. Admires freelancers who present an organized and visually strong portfolio, who meet deadlines, and follow instructions carefully.

KAR-BEN PUBLISHING

Lerner Publishing Group, 241 First Ave. N, Minneapolis MN 55401. (612)332-3344, ext. 229. **Fax:** 612-332-7615. **E-mail:** Editorial@Karben.com. **Website:** www.karben.com. Estab. 1974. "Kar-Ben publishes 12-15 new titles on Jewish themes for young children and families each year." Publishes hardcover, trade paperback and electronic originals. 12-15 titles/year.

NEEDS Need children's text illustration, book covers and dust jackets.

FIRST CONTACT & TERMS Send postcard sample or e-mail with URL and samples. Follow up every 6-12 months. Samples kept on file for possible future assignments. Samples are not returned. Buys all rights. Illustrators paid $4,000-$4,500. 12-15 freelance illustrators/year.

TIPS "Look at our catalog online for a sense of what we like—bright colors and lively composition."

KIDZUP PRODUCTIONS, INC./ TORMONT PUBLISHING INTERNATIONAL

5532 St. Patrick St., Montreal QC H4E 1A8, Canada. (888)321-5437. **Fax:** (514)931-0609. **E-mail:** Liliana.Martinez@tormont.ca. **Contact:** Liliana Martinez Szwarcberg, art director. Estab. 1986. Publisher and packager of children's activity and novelty books and educational music CDs.

NEEDS Always on the lookout for creative freelance illustrators, layout artists and graphic designers, with experience in children's book publishing. Experience using Illustrator, InDesign and Photoshop are a must.

FIRST CONTACT & TERMS Send portfolio by e-mail or postal mail. Art director will contact artist only if there is interest. We buy the rights to all art.

TIPS Kidzup/Tormont creates children's products, with a special focus on toddlers to 8-year-olds.

KIRKBRIDE BIBLE CO., INC.

335 W. 9th St., Indianapolis IN 46202. (800)428-4385. **Fax:** (317)633-1444. **E-mail:** info@kirkbride.com. **Website:** www.kirkbride.com. Estab. 1915. Publishes Thompson Chain-Reference Bible hardcover originals and quality leather bindings styles and translations of the Bible. Types of books include reference and religious. Specializes in reference and study material. Publishes 6 main titles/year. Recent titles: *The Thompson Student Bible* and *The Thompson Chain-Reference Bible Centennial Edition*. 2% require freelance illustration; 10% require freelance design. Catalog available.

NEEDS Approached by 1-2 designers/year. Works with 1-2 designers/year. Prefers freelancers experienced in layout and cover design. Uses freelancers mainly for artwork and design. 100% of freelance design and most illustration demands knowledge of PageMaker, InDesign, Photoshop, Illustrator and QuarkXPress. 5-10% of titles require freelance art direction.

FIRST CONTACT & TERMS Designers: Send query letter with portfolio of recent works, printed samples and résumé. Illustrators: Send query letter with Photostats, printed samples and résumé. Accepts disk submissions compatible with QuarkXPress or Photoshop files 4.0 or 3.1. Samples are filed. Responds only if interested. Rights purchased vary according to project.

DESIGN Assigns 1 freelance design job/year. Pays by the hour $100 minimum.

JACKETS/COVERS Assigns 1-2 freelance design jobs and 1-2 illustration jobs/year. Pays for design by the project, $100-1,000. Pays for illustration by the project, $100-1,000. Prefers modern with traditional text.

TEXT ILLUSTRATION Assigns 1 freelance illustration/year. Pays by the project, $100-1,000. Prefers traditional. Finds freelancers through sourcebooks and references.

TIPS "Quality craftsmanship is our top concern, and it should be yours, too!"

ALFRED A. KNOPF

1745 Broadway, 21st Floor, New York NY 10019. **Website:** knopf.knopfdoubleday.com. Estab. 1915. Publishes hardcover originals for adult trade. Specializes in history, fiction, art and cookbooks. Publishes 200 titles/year.

○ Random House, Inc. and its publishing entities are not accepting unsolicited submissions via e-mail at this time.

NEEDS Prefers artists with experience in b&w. Uses freelancers mainly for cookbooks and biographies. Also for text illustration and book design.

FIRST CONTACT & TERMS Send query letter with SASE. Request portfolio review in original query. Artist should follow up. Sometimes requests work on spec before assigning a job. Originals are returned at job's completion.

TEXT ILLUSTRATION Pays by the project, $100-5,000; $50-150/illustration; $300-800/maps.

TIPS Finds artists through submissions, agents and sourcebooks. "Freelancers should be aware that Macintosh/Quark is a must for design and becoming a must for maps and illustration."

PETER LANG PUBLISHING, INC.

29 Broadway, New York NY 10006. (212)647-7706; (800)770-5264. **Fax:** (212)647-7707. **E-mail:** customerservice@plang.com. **Website:** www.peterlang.com. **Contact:** Creative director. Publishes humanities textbooks and monographs. Publishes 300 titles/year. Book catalog available on request or on website.

NEEDS Works with a small pool of designers/year. Prefers local freelance designers experienced in scholarly book covers. Most covers will be CMYK. 100% of freelance design demands knowledge of Illustrator, Photoshop and QuarkXPress.

FIRST CONTACT & TERMS Send query letter with printed samples, photocopies and SASE. Accepts disk submissions. Samples are filed. Responds only if interested. Will contact artist for portfolio review if interested. Finds freelancers through referrals.

JACKETS/COVERS Assigns 100 freelance design jobs/year. Only accepts Quark electronic files. Pays for design by the project.

LAREDO PUBLISHING CO./RENAISSANCE HOUSE

465 WestView, Englewood NJ 07631. (201)408-4048. **Fax:** (201)408-5011. **E-mail:** laredo@renaissance house.net. **Website:** renaissancehouse.net. **Contact:** Sam Laredo, art director. Estab. 1991. Publishes children and juvenile books. Specializes in Spanish and bilingual texts, educational/readers. Recent titles include *Legends of the Americas* (series of 21 titles), *Extraordinary People* (series of 6 titles), *Yes, You Can Too!*, *The Life of Barack Obama* (bilingual English-Spanish). Winner of the International Latino Book Awards 2010, First Place, Young Adult Non-fiction category. Publishes 35 titles/year.

NEEDS Approached by 25 illustrators/year. Works with 10 designers/year.

FIRST CONTACT & TERMS Designers/illustrators: E-mail samples responds only if interested.

DESIGN Assigns 5 freelance design jobs/year. Pays for design by the project.

JACKETS/COVERS Pays for illustration by the project, page.

TEXT ILLUSTRATION Pays by the project, page.

LEE & LOW BOOKS

95 Madison Ave., #1205, New York NY 10016. (212)779-4400. **E-mail:** general@leeandlow.com. **Website:** www.leeandlow.com. Jennifer Fox, senior editor; Emily Hazel, assistant editor. **Contact:** Louise May, editor-in-chief (multicultural children's fiction/nonfiction). Estab. 1991. Publishes hardcover originals for the juvenile market. Specializes in multicultural children's books. Titles include: *Bird* by Zetta Elliot; *Honda: The Boy Who Dreamed of Cars* by Mark Weston; and *Hiromi's Hands* by Lynne Batasch. Publishes 12-15 titles/year. 100% require freelance illustration and design. Book catalog available.

NEEDS Approached by 100 freelancers/year. Works with 12-15 freelance illustrators and 4-5 designers/year. Uses freelancers mainly for illustration of children's picture books. 100% of design work demands computer skills. Works on assignment only.

FIRST CONTACT & TERMS Contact through artist rep or send query letter with brochure, résumé, SASE,

tearsheets or photocopies. Samples of interest are filed. Art director will contact artist for portfolio review if interested. Portfolio should include color tearsheets and dummies. Rights purchased vary according to project. Originals are returned at job's completion.

DESIGN Pays by the project.

TEXT ILLUSTRATION Pays by the project.

TIPS "We want an artist who can tell a story through pictures and who is familiar with the children's book genre. We are now also developing materials for older children, ages 8-12, so we are interested in seeing work for this age group, too. Lee & Low Books makes a special effort to work with writers and artists of color and encourages new talent. We prefer filing samples that feature children, particularly from diverse backgrounds."

LEGACY PRESS

P.O. Box 261129, San Diego CA 92196. (858)277-1167. **E-mail:** editor@rainbowpublishers.com. **Website:** www.rainbowpublishers.com; www.legacypresskids.com. Estab. 1979. Publishes trade paperback originals. Types of books include religious books, reproducible Sunday School books for children ages 2-12, and Bible teaching books for children and adults. Recent titles include *Favorite Bible Families, Instant Bible Lessons, The Christian Girl's Guides, Bill the Warthog, Gotta Have God, God and Me.* Publishes 20 titles/year. Book catalog available for SASE with 2 first-class stamps.

NEEDS Approached by hundreds of illustrators and 50 designers/year. Works with 5-10 illustrators and 5-10 designers/year. 100% of freelance design and illustration demands knowledge of Illustrator, Photoshop and InDesign.

FIRST CONTACT & TERMS Send query letter with printed samples, SASE and tearsheets. Samples are filed or returned by SASE. Responds only if interested. Will contact artist for portfolio review if interested. Finds freelancers through samples sent and personal referrals. For submission directions, go to: www.RainbowPublishers.com/submissions.apsx.

DESIGN Assigns 25 freelance design jobs/year. Pays for design by the project, $350 minimum. Pays for art direction by the project, $350 minimum.

JACKETS/COVERS Assigns 25 freelance design jobs and 25 illustration jobs/year. "Prefers computer generated-high energy style with bright colors appealing to kids." Pays for design and illustration by the project,

$350 minimum. "Prefers designers/illustrators with some Biblical knowledge."

TEXT ILLUSTRATION Assigns 20 freelance illustration jobs/year. Pays by the project, $500 minimum. "Prefers b&w line art, preferably computer generated with limited detail yet fun."

TIPS "We look for illustrators and designers who have some Biblical knowledge and excel in working with a fun, colorful, high-energy style that will appeal to kids and parents alike. Designers must be well versed in InDesign, Illustrator and Photoshop, know how to visually market to kids and have wonderful conceptual ideas!"

LERNER PUBLISHING GROUP

11430 Strand Dr. #2, Rockville MD 20852-4371. (301)984-8733. **Fax:** (301)881-9195. **E-mail:** editorial@karben.com; dwallek@igigraphics.com. **Website:** www.karben.com; www.lernerbooks.com. **Contact:** Dan Wallek, dir. of electronic content and photo research. Estab. 1959. Publishes educational books for young people. Subjects include animals, biography, history, geography, science and sports. Publishes 200 titles/year. 100% require freelance illustration. Book catalog free on request. Art submission guidelines available on website.

NEEDS Uses 10-12 freelance illustrators/year. Uses freelancers mainly for book illustration; also for jacket/cover design and illustration, book design and text illustration.

FIRST CONTACT & TERMS Submit samples that show skill specifically in children's book illustration. Do not send original art. Submit slides, JPEG, or PDF files on disk, color photocopies of full-color artwork, photocopies of b&w line work, or tear sheets.

TIPS "Send samples showing active children, not animals or still life. Don't send original art. Look at our books to see what we do."

LIPPINCOTT WILLIAMS & WILKINS

351 W. Camden St., Baltimore MD 21201. (401)528-4000; (800)638-3030. **E-mail:** orders@lww.com. **Website:** www.lww.com. Estab. 1890. Publishes audio tapes, CDs, hardcover originals and reprints, textbooks, trade paperbook originals and reprints. Types of books include instructional and textbooks. Specializes in medical publishing. 100% requires freelance design.

◯ See website for a listing of all locations.

NEEDS Approached by 20 illustrators and 20 designers/year. Works with 10 illustrators and 30 designers/year. Prefers freelancers experienced in medical publishing. 100% of freelance design demands knowledge of Illustrator, Photoshop, QuarkXPress.

FIRST CONTACT & TERMS Send query letter with printed samples and tearsheets. Accepts Mac-compatible disk submissions. Send EPS or TIFF files. Responds only if interested. Will contact artist for portfolio review if interested. Buys all rights. Finds freelancers through submission packets, word of mouth.

DESIGN Assigns 150 freelance design jobs/year. Pays by the project.

JACKETS/COVERS Assigns 150 freelance design jobs/year. Pays for design by the project. Prefers medical publishing experience.

TEXT ILLUSTRATION Assigns 150 freelance illustration jobs/year. Pays by the project. Prefers freelancers with medical publishing experience.

TIPS "We're looking for freelancers who are flexible and have extensive clinical and textbook medical publishing experience. Designers must be proficient in Quark, Illustrator and Photoshop and completely understand how design affects the printing (CMYK 4-color) process."

LITURGY TRAINING PUBLICATIONS

3949 S. Racine Ave., Chicago IL 60609-2523. (773)579-4900; (800)933-1800. **Fax:** (773)579-4929; (800)933-7094. **E-mail:** mfox@ltp.org. **Website:** www.ltp.org. **Contact:** John Thomas, director; Mary Fox, editor. Estab. 1964. Publishes hardcover originals and trade paperback originals and reprints. Types of books include religious instructional books for adults and children. Publishes 50 titles/year. 60% require freelance illustration. Book catalog free by request.

NEEDS Approached by 30-50 illustrators/year. Works with 10-15 illustrators/year. 10% of freelance illustration demands knowledge of Photoshop.

FIRST CONTACT & TERMS Illustrators: Send postcard sample or send introductory letter with printed samples, photocopies and tearsheets. Accepts Mac-compatible disk submissions. Send EPS or TIFF files. Samples are filed and are not returned. Will contact artist for portfolio review if interested. Rights purchased vary according to project.

TEXT ILLUSTRATION Assigns 15-20 freelance illustration jobs/year. Pays by the project. "There is more opportunity for illustrators who are good in b&w or

2-color, but illustrators who work exclusively in 4-color are also utilized."

TIPS "Two of our books were in the AIGA 50 Best Books of the Year show in recent years and we win numerous awards. Sometimes illustrators who have done religious topics for others have a hard time working with us because we do not use sentimental or traditional religious art. We look for sophisticated, daring, fine art-oriented illustrators and artists. Those who work in a more naturalistic manner need to be able to portray various nationalities well. We never use cartoons."

LLEWELLYN PUBLICATIONS

2143 Wooddale Dr., Woodbury MN 55125. (651)291-1970; (800)843-6666. **Fax:** (651)291-1908. **E-mail:** submissions@llewellyn.com. **Website:** www.llewellyn.com. Estab. 1909. Book publisher. Publishes trade paperback, calendars and Tarot decks. Llewllyn is not a distributor for fine art, cards or previously printed art works. Types of books include mystery/fiction, teens, New Age, astrology, alternative religion, self-help, Spanish language, metaphysical, occult, health, and women's spirituality. Publishes 135 titles/year. Books have photography, realistic painting and computer generated graphics. 60% require freelance illustration.

NEEDS Approached by 200 freelancers/year. Licenses 15-20 freelance illustrations/year. Prefers freelancers with experience in book covers, New Age material and realism. Uses freelancers mainly for realistic paintings and drawings. Works on assignment only. Negotiates "License for Use Only."

JACKETS/COVERS Assigns 50+ freelance jobs/year. Pays by the illustration. Realistic style preferred, may need to research for project, should know/have background in subject matter.

TEXT ILLUSTRATION Assigns 20 freelance jobs/year. Pays by the project. Media and style preferred are pen & ink, vector based or pencil. Style should be realistic and anatomically accurate.

LUMEN EDITIONS/BROOKLINE BOOKS

8 Trumbull Rd., Suite B-001, Northampton MA 01060. (413)584-0184. **Fax:** (413)584-6184. **E-mail:** brbooks@yahoo.com. **Website:** www.brooklinebooks.com. **Contact:** Milt Budoff, editor. Estab. 1970. Publishes hardcover originals, textbooks, trade paperback originals and reprints. Types of books include biography, experimental and mainstream fiction, instructional, nonfiction, reference, self-help, textbooks,

travel. Specializes in translations of literary works/ education books. Publishes 10 titles/year. 100% requires freelance illustration; 70% requires freelance design. Book catalog free with 6×9 SAE with 2 first-class stamps.

NEEDS Approached by 20 illustrators and 50 designers/year. Works with 5 illustrators and 20 designers/year. Prefers freelancers experienced in book jacket design. 100% of freelance design demands knowledge of Photoshop, PageMaker, QuarkXPress.

FIRST CONTACT & TERMS Send query letter with printed samples, SASE. Samples are filed. Will contact artist for portfolio review of book dummy, photocopies, tearsheets if interested. Negotiates rights purchased. Finds freelancers through agents, networking, other publishers, Book Builders.

DESIGN Assigns 30-40 freelance design/year. Pays for design by the project, varies.

JACKETS/COVERS Pays for design by the project, varies. Pays for illustration by the project, $200-2,500. Prefers innovative trade cover designs. Classic type focus.

TEXT ILLUSTRATION Assigns 5 freelance illustration jobs/year. Pays by the project, $200-2,500.

TIPS "We have a house style, and we recommend that designers look at some of our books before approaching us. We like subdued colors that still pop. Our covers tend to be very provocative, and we want to keep them that way. No 'mass market' looking books or display typefaces. All designers should be knowledgeable about the printing process and be able to see their work through production."

THE LYONS PRESS

The Globe Pequot Press, Inc., Box 480, 246 Goose Ln., Guilford CT 06437. (203)458-4500. **Fax:** (203)458-4668. **E-mail:** info@globepequot.com. **Website:** www.lyonspress.com. Estab. 1984 (Lyons & Burford), 1997 (The Lyons Press). Publishes hardcover and trade paperback originals and reprints. Types of books include adventure, humor, biography, memoir, coffee table books, cookbooks, history, military history, instructional, reference, self-help, sporting (also hunting and fishing), and travel. Publishes 180 titles/year. Book catalog available.

MADISON HOUSE PUBLISHERS

4501 Forbes Blvd., Suite 200, Lanham MD 20706. (301)459-3366. **Fax:** (301)429-5748. **E-mail:** custom ercare@rowman.com. **Website:** www.rowmanlittle

field.com. Estab. 1984. Publishes hardcover and trade paperback originals. Specializes in biography, history and popular culture. Publishes 10 titles/year. 40% require freelance illustration; 100% require freelance jacket design. Book catalog free by request.

○ Madison House is just one imprint of Rowman & Littlefield Publishing Group, which has eight imprints.

NEEDS Approached by 20 freelancers/year. Works with 4 freelance illustrators and 12 designers/year. Prefers freelancers with experience in book jacket design. Uses freelancers mainly for book jackets. Also for catalog design. 80% of freelance work demands knowledge of Illustrator, QuarkXPress, Photoshop or FreeHand. Works on assignment only.

FIRST CONTACT & TERMS Send query letter with tearsheets, photocopies and photostats. Samples are filed or are returned by SASE if requested by artist. Responds to the artist only if interested. Call for appointment to show portfolio of roughs, original/final art, tearsheets, photographs, slides and dummies. Buys all rights. Interested in buying second rights (reprint rights) to previously published work.

JACKETS/COVERS Assigns 16 freelance design and 2 illustration jobs/year. Pays by the project. Prefers typographic design, photography and line art.

TEXT ILLUSTRATION Pays by project.

TIPS "We are looking to produce trade-quality designs within a limited budget. Covers have large type, clean lines; they 'breathe.' If you have not designed jackets for a publishing house but want to break into that area, have at least five 'fake' titles designed to show ability. I would like to see more Eastern European style incorporated into American design. It seems that typography on jackets is becoming more assertive, as it competes for attention on bookstore shelf. Also, trends are richer colors, use of metallics."

MAGICAL CHILD

Shades of White, 301 Tenth Ave., Crystal City MO 63019. **E-mail:** acquisitions@magicalchildbooks.com. **Website:** www.magicalchildbooks.com. Estab. 2007. Publishes hardback originals; 1-3 titles/year. Pays royalty or small advance.

NEEDS Illustrations for text illustration and book covers. Works with 1 freelance illustrators/year.

FIRST CONTACT & TERMS Send postcard sample or query letter with a brochure, samples, photocopies and/or URL. Samples not kept on file. Buys first rights,

which may vary according to project. Paid small advance/royalties. Guidelines available online. SASE returned. Responds only if interested.

TIPS "We are a tiny niche publishing company. Our market is children's literature about the practices and people of the Earth religions. All freelancers should be familiar with our current catalog before submitting. Read our submissions guidelines before submitting any work. *Do not e-mail attachments.*"

MAPEASY, INC.

P.O. Box 80, Wainscott NY 11975. (631)537-6213. **Fax:** (631)537-4541. **E-mail:** info@mapeasy.com. **Website:** www.mapeasy.com. Estab. 1990. Publishes maps. 100% requires freelance illustration; 25% requires freelance design. Book catalog not available.

NEEDS Approached by 15 illustrators and 10 designers/year. Prefers local freelancers. 100% of freelance design and illustration demands knowledge of Illustrator, Photoshop, QuarkXPress and Painter.

FIRST CONTACT & TERMS Send query letter with photocopies. Accepts Mac-compatible disk submissions. Samples are filed. Responds only if interested. Will contact artist for portfolio review if interested. Portfolio should include photocopies. Finds freelancers through ads and referrals.

TEXT ILLUSTRATION Pays by the hour.

MCGRAW-HILL EDUCATION

P.O. Box 182604, Columbus OH 43272. (630)789-4000. **E-mail:** customerservice@mcgraw-hill.com. **Website:** www.mheducation.com. Estab. 1969. Independent book producer/packager of textbooks and reference books. Specializes in social studies, history, geography, vocational, math, science, etc. 80% require freelance design.

NEEDS Approached by 30 freelance artists/year. Works with 4-5 illustrators and 5-15 designers/year. Buys 5-10 illustrations/year. Prefers artists with experience in textbooks, especially health, medical, social studies. Works on assignment only.

FIRST CONTACT & TERMS Send query letter with tearsheets and résumé. Samples are filed. Responds to the artist only if interested. To show portfolio, mail roughs and tearsheets. Rights purchased vary according to project. Originals returned at job's completion.

DESIGN Assigns 5-15 jobs/year. Pays by the project.

JACKETS/COVERS Assigns 1-2 design jobs/year. Pays by the project.

TIPS "Designers, if you contact us with samples we will invite you to do a presentation and make assignments as suitable work arises. Graphic artists, when working assignments we review our files. Enclose typical rate structure with your samples."

MCGRAW-HILL HIGHER EDUCATION GROUP

P.O. Box 182604, Columbus OH 43272. (877)833-5524. **Fax:** (614)759-3749. **E-mail:** customer.service@mcgraw-hill.com. **Website:** www.mhhe.com or www.mcgraw-hill.com. Estab. 1944. Publishes hardbound and paperback college textbooks. Specializes in science, engineering and math. Produces more than 200 titles/year. 10% require freelance design; 70% require freelance illustration.

NEEDS Works with 15-25 freelance designers and 30-50 illustrators/year. Uses freelancers for advertising. 90% of freelance work demands knowledge of PageMaker, Illustrator, QuarkXPress, Photoshop or FreeHand. Works on assignment only.

FIRST CONTACT & TERMS Prefers color 35mm slides and color or b&w photocopies. Send query letter with brochure, résumé, slides and/or tearsheets. "Do not send samples that are not a true representation of your work quality." Responds in 1 month. Accepts disk submissions. Samples returned by SASE if requested. Responds on future assignment possibilities. Buys all rights. Pays half contract for unused assigned work.

DESIGN Assigns 100-140 freelance design jobs/year. Uses artists for all phases of process. Pays by the project. Payment varies widely according to complexity.

JACKETS/COVERS Assigns 100-140 freelance design jobs and 20-30 illustration jobs/year. Pays $1,700 for 4-color cover design and negotiates pay for special projects.

TEXT ILLUSTRATION Assigns 75-100 freelance jobs/year. Considers b&w and color work. Prefers computer-generated, continuous tone, some mechanical line drawings; ink preferred for b&w.

TIPS "In the McGraw-Hill field, there is more use of color. There is need for sophisticated color skills—the artist must be knowledgeable about the way color reproduces in the printing process. Be prepared to contribute to content as well as style. Tighter production schedules demand an awareness of overall schedules. *Must* be dependable."

MEADOWBROOK PRESS

5451 Smetana Dr., Minnetonka MN 55343. **Fax:** (952)930-1940. **E-mail:** info@meadowbrookpress. com. **Website:** www.meadowbrookpress.com. Estab. 1974. Company publishes hardcover and trade paperback originals. Types of books include: pregnancy, childbirth and parenting instruction; baby names; preschool and children's poetry; party and humor. Publishes 20 titles/year. Titles include: *Pregnancy, Childbirth and the Newborn*; *Very Best Baby Name Book*; *Mary Had a Little Jam*; *Age Happens*; *Themed Baby Showers*. 80% require freelance illustration; 10% require freelance design.

NEEDS Babies/children/teens. Receives 1,500 queries/year. No SASE returns. Responds only if interested. Guidelines available online. Book catalog for #10 SASE.

FIRST CONTACT & TERMS Designers: Send query letter with résumé and photocopies. Illustrators: Send query letter with photocopies. Samples are filed and are not returned. Responds only if interested. Art director will contact artist if interested. Finds artists through agents, sourcebooks and submissions.

DESIGN Assigns 2 freelance design jobs/year. "Pay varies with complexity of project."

JACKETS/COVERS Assigns 6 freelance jobs/year.

TIPS "Send me a new postcard at least every three months. I may not be looking for your style this month, but I may be in six months. I receive a pile of them every day, I will not reply until I need your style, but I enjoy looking at every single one, and I will keep them on file for six months. Don't worry about showing me everything, just show me what you do best."

MITCHELL LANE PUBLISHERS, INC.

P.O. Box 196, Hockessin DE 19707. (302)234-9426. **Fax:** (866)834-4164. **E-mail:** barbaramitchell@mitch elllane.com. **Website:** www.mitchelllane.com. **Contact:** Barbara Mitchell, publisher. Estab. 1993. Publishes library bound originals. Types of books include biography. Specializes in multicultural biography for young adults. Publishes 85 titles/year; none require freelance illustration; none require freelance design.

NEEDS Approached by 20 illustrators and 5 designers/year. Works with 2 illustrators/year. Prefers freelancers experienced in illustrations of people. Looks for cover designers and interior book designers.

FIRST CONTACT & TERMS Send query letter with printed samples, photocopies. Interesting samples are filed and are not returned. Will contact artist for portfolio review if interested. Buys all rights.

JACKETS/COVERS Prefers realistic portrayal of people.

MODERN PUBLISHING

155 E. 55th St., New York NY 10022. (212)826-0850. **Fax:** (212)759-9069. **Website:** www.modernpublish ing.com. Specializes in children's coloring and activity books, novelty books, hardcovers, paperbacks (both generic and based on licensed characters). Recent titles include Fisher Price books, Hello Kitty, Lisa Frank, Smurfs, Chuggington, Planet Earth, and more. Publishes approximately 200 titles/year.

NEEDS Approached by 15-30 freelancers/year. Works with 25-30 freelancers/year. Works on assignment and royalty.

FIRST CONTACT & TERMS Send query letter with résumé and samples. Samples are not filed and are returned by SASE only if requested. Responds only if interested. Originals not returned. Considers turnaround time, complexity of work and rights purchased when establishing payment.

JACKETS/COVERS Pays by the project, usually 2-4 books/series.

TEXT ILLUSTRATION Pays by the project.

MONDIAL

203 W. 107th St., Suite 6C, New York NY 10025. (212)851-3252. **Fax:** (208)361-2863. **E-mail:** contact@ mondialbooks.com. **Website:** www.mondialbooks. com; www.librejo.com. **Contact:** Andrew Moore, editor. Estab. 1996. Publishes mainstream fiction, romance, history and reference books. Specializes in linguistics. Payment on acceptance.

NEEDS Landscapes, travel and erotic. Printing rights are negotiated according to project. Illustrations are used for text illustration, promotional materials and book covers. Publishes 20 titles/year. Responds only if interested.

MORGAN KAUFMANN PUBLISHERS

Elsevier, 30 Corporate Dr., Suite 400, Burlington MA 01803-4252. (781)663-5200. **Website:** www.mkp.com. Estab. 1984. Publishes computer science books for academic and professional audiences in paperback, hardback and book/CD-ROM packages. Publishes 60 titles/year. 75% require freelance interior illustration; 100% require freelance text and cover design; 15% require freelance design and production of 4-col-

or inserts. Morgan Kaufmann is now part of Elsevier (www.elsevier.com).

NEEDS Approached by 150-200 freelancers/year. Works with 10-15 freelance illustrators and 10-15 designers/year. Uses freelancers for covers, text design and technical and editorial illustration, design and production of 4-color inserts. 100% of freelance work demands knowledge of at least one of the following Illustrator, QuarkXPress, Photoshop, Ventura, Framemaker, or laTEX (multiple software platform). Works on assignment only.

FIRST CONTACT & TERMS Send query letter with samples. Samples must be nonreturnable or with SASE. "No calls, please." Samples are filed. Production editor will contact artist for portfolio review if interested. Portfolio should include final printed pieces. Buys interior illustration on a work-for-hire basis. Buys first printing and reprint rights for text and cover design. Finds artists primarily through word of mouth and submissions.

DESIGN Pays by the project. Prefers Illustrator and Photoshop for interior illustration and QuarkXPress for 4-color inserts.

JACKETS/COVERS Pays by the project. Uses primarily stock photos. Prefers designers take cover design through production to film and MatchPrint. "We're interested in a look that is different from the typical technical publication." For covers, prefers modern, clean, spare design, with emphasis on typography and high-impact imagery.

TIPS "Although experience with book design is an advantage, sometimes artists from another field bring a fresh approach, especially to cover design."

MOUNTAIN PRESS PUBLISHING CO.

P.O. Box 2399, Missoula MT 59806. (406)728-1900 or (800)234-5308. **Fax:** (406)728-1635. **E-mail:** info@ mtnpress.com. **Website:** www.mountain-press.com. **Contact:** Jennifer Carey, editor. Estab. 1948. Company publishes trade paperback originals and reprints; some hardcover originals and reprints. Types of books include western history, geology, natural history/nature. Specializes in geology, natural history, history, horses, western topics. Publishes 20 titles/year. Book catalog free by request.

NEEDS Prefers artists with experience in book illustration and design, book cover illustration. Uses freelance artists for jacket/cover illustration, text illustration and maps. 100% of design work demands knowl-

edge of InDesign, Photoshop, Illustrator. Works on assignment only.

FIRST CONTACT & TERMS Send query letter with résumé, SASE and any samples. Samples are filed or are returned by SASE. Responds only if interested. Project editor will contact artist for portfolio review if interested. Buys one-time rights or reprint rights depending on project. Originals are returned at job's completion. Finds artists through submissions, word of mouth, sourcebooks and other publications.

DESIGN Pays by the project.

JACKETS/COVERS Pays by the project.

TEXT ILLUSTRATION Pays by the project.

TIPS "First-time assignments are usually book cover/jacket illustration or map drafting; text illustration projects are given to proven freelancers."

NBM PUBLISHING

40 Exchange Pl., Suite 1308, New York NY 10005. **E-mail:** nbmgn@nbmpub.com. **Website:** nbmpub.com. **Contact:** Terry Nantier, editor/art director. Estab. 1976. Publishes graphic novels for an audience of 18-34 year olds. Types of books include fiction, fantasy, mystery, science fiction, horror and social parodies. Not accepting submissions unless for graphic novels.

🔾 Publisher reports too many inappropriate submissions from artists who "don't pay attention." Check their website for instructions before submitting, so you're sure that your art is appropriate for them.

NEW ENGLAND COMICS (NEC PRESS)

732 Washington St., Norwood MA 02062. (781)769-3470. **Fax:** (781)769-2853. **E-mail:** support@newenglandcomics.com. **Website:** www.newenglandcomics.com. Types of books include comic books and games. Book catalog available on website.

NEEDS Seeking pencillers and inkers.

FIRST CONTACT & TERMS Send SASE and 2 pages of pencil or ink drawings derived from the submissions script posted on website. Responds in 2 weeks (with SASE only).

TIPS Visit website for submissions script. Do not submit original characters or stories. Do not call.

NORTH LIGHT BOOKS

F+W Media, Inc., 10151 Carver Rd., Suite 200, Blue Ash OH 45242. **Fax:** (513)891-7153. **E-mail:** jamie. markle@fwmedia.com; pam.wissman@fwmedia. com; vanessa.lyman@fwmedia.com; ali.meyer@fw media.com. **Website:** www.fwmedia.com. **Contact:**

Jamie Markle, fine art publisher; Ali Meyer, craft publisher; Pam Wissman, senior content director fine arts; Vanessa Lyman, editorial director craft. "North Light Books publishes art and craft books, including watercolor, drawing, mixed media and decorative painting, knitting, jewelry making, sewing, and needle arts that emphasize illustrated how-to art instruction. Currently emphasizing drawing, acrylic, creativity and inspiration." Recent titles: *Artist's Journal Workshop*, *Splash 12*, *Amazing Crayon Drawing With Lee Hammond*, *Sew Serendipity*, *Image Transfer Workshop*, and *The Farmer's Wife Sampler Quilt*.

○ This market is for experienced fine artists and crafters who are willing to work with a North Light editor to produce a step-by-step how-to book about the artist's creative process.

NEEDS Approached by 100 author-artists/year. Works with 50 artists/year.

FIRST CONTACT & TERMS Send query letter with photographs, digital images. Accepts e-mail submissions. Samples are not filed and are returned. Responds only if interested. Company will contact artist for portfolio review if interested. Buys all rights. Finds freelancers through art competitions, art exhibits, submissions, Internet and word of mouth.

TIPS "Include 30 examples of artwork, book idea, outline and a step-by-step demonstration. Submission guidelines posted on website."

OCP (OREGON CATHOLIC PRESS)

5536 NE Hassalo, Portland OR 97213. (800)LITURGY; (800)548-8749. **Fax:** (800)462-7329. **E-mail:** liturgy@ocp.org. **Website:** www.ocp.org. **Contact:** Judy Urben, art director. Nonprofit publishing company, producing music and liturgical publications used in parishes throughout the U.S., Canada, England and Australia. 30% require freelance illustration. Catalog available with 9×12 SASE with first-class postage.

TIPS "I am always looking for appropriate art for our projects. We tend to use work already created on a one-time-use basis, as opposed to commissioned pieces. I look for tasteful, not overtly religious art."

OCTAMERON PRESS

1900 Mount Vernon Ave., Alexandria VA 22301. (703)836-5480. **Fax:** (703)836-5650. **E-mail:** octameron@aol.com. **Website:** www.octameron.com. **Contact:** Anna J. Leider, publisher. Estab. 1976. Publishes paperback originals. Specializes in college financial and college admission guides. Recent titles: *College Match*; *The Winning Edge*. Publishes 9 titles/year.

NEEDS Approached by 25 freelancers/year. Works with 1-2 freelancers/year. Works on assignment only.

FIRST CONTACT & TERMS Send query letter with brochure showing art style or résumé and photocopies. Samples not filed are returned if SASE is included. Considers complexity of project and project's budget when establishing payment. Rights purchased vary according to project.

JACKETS/COVERS Works with 1-2 designers and illustrators/year on 15 different projects. Pays by the project, $500-1,000.

TEXT ILLUSTRATION Works with variable number of artists/year. Pays by the project, $35-75. Prefers line drawings to photographs.

TIPS "The look of the books we publish is friendly! We prefer humorous illustrations."

ONSTAGE PUBLISHING

190 Lime Quarry Rd., Suite 106-J, Madison AL 35758-8962. (256)461-0661. **E-mail:** onstage123@knology.net. **Website:** www.onstagepublishing.com. **Contact:** Dianne Hamilton, senior editor. Estab. 1999. Small, independent publishing house specializing in children's literature. "We currently publish chapter books, middle-grade fiction and YA. At this time, we only produce fiction books for ages 8-18. We will not do anthologies of any kind. Query first for non-fiction projects as non-fiction projects must spark our interest. See our submission guidelines for more information." See guidelines online.

NEEDS "Our chapter books need inside b&w line illustrations. All books need full color cover illustrations. Sample illustrations need to have one sample in full color to show your style and one sample in b&w to show your skill. The main characters in our books are children. We need to see how you portray children, especially children in action."

FIRST CONTACT & TERMS Please remember to include a cover letter and a SASE large enough, with sufficient postage, to safely return your work if we do not put your work on file. Never send originals! The art director requests that you send your samples by mail. *Please do not send your work by e-mail or computer disk unless specifically requested.*

◉ ORCHARD BOOKS

338 Euston Rd., London NW1 3BH, United Kingdom. +44 (0)20 7873 6000. **Fax:** +44 (0)20 7873 6024. **E-**

mail: ad@hachettechildrens.co.uk. **Website:** www. orchardbooks.co.uk. Estab. 1987. Publishes hardcover children's books. Specializes in picture books and novels for children and young adults. 100% require freelance illustration.

NEEDS Works on assignment only. 5% of titles require freelance art direction.

FIRST CONTACT & TERMS Designers: Send brochure or photocopies. Illustrators: Send samples, photocopies or tearsheets. Samples are filed or are returned by SASE only if requested. Responds to queries/submissions only if interested. Originals returned to artist at job's completion. Considers complexity of project, skill and experience of artist and project's budget when establishing payment. See website.

THE OVERLOOK PRESS

141 Wooster St., New York NY 10012. (212)673-2210. **Fax:** (212)673-2296. **E-mail:** sales@overlookny.com. **Website:** www.overlookpress.com. Estab. 1971. Publishes hardcover and paperback originals. Types of books include contemporary and experimental fiction, health/fitness, history, fine art and children's books. Recent title: *A Simple Act of Violence* by R.J. Ellory. Publishes around 100 titles/year. 60% require freelance illustration; 40% require freelance design. Book catalog free for SASE.

NEEDS Approached by 10 freelance artists/year. Works with around 4 freelance illustrators and 4 freelance designers/year. Buys around 5 freelance illustrations/year. Prefers local artists only. Uses freelance artists mainly for jackets. Works on assignment only.

FIRST CONTACT & TERMS "If you'd like your work to be considered for publication, we recommend you work with an established literary agent. Agents can be found in such literary guides as *Literary Marketplace*."

JACKETS/COVERS Assigns 10 freelance design jobs/year. Pays by the project, $500.

RICHARD C. OWEN PUBLISHERS, INC.

P.O. Box 585, Katonah NY 10536. (914)232-3903 or (800)336-5588. **Fax:** (914)232-3977. **E-mail:** richard owen@rcowen.com. **Website:** www.rcowen.com. **Contact:** Richard Owen, publisher. Estab. 1986. Company publishes children's books. Types of books include juvenile fiction and nonfiction. Specializes in books for 5-, 6- and 7-year-olds. Publishes 15-20 titles/year. 100% require freelance illustration.

"Focusing on adding nonfiction for young children on subjects such as history, biography, social studies, science and technology; with human characters, buildings, structures, machines. Realistic but appealing to a child."

NEEDS Approached by 200 freelancers/year. Works with 20-40 freelance illustrators/year. Prefers freelancers with focus on children's books who can create consistency of character from page to page in an appealing setting. Needs illustrators who can illustrate human characters, figures and architecture in an appropriate and appealing manner to young children. Uses freelancers for jacket/cover and text illustration. Works on assignment only.

FIRST CONTACT & TERMS Send samples of work (color brochure, tearsheets and photocopies). Samples are filed. Art director will contact artist if interested and has a suitable project available. Buys all rights. Original illustrations are returned at job's completion.

TEXT ILLUSTRATION Assigns 20-40 freelance illustration jobs/year.

TIPS "Show adequate number and only best samples of work. Send work in full color, but target the needs of the individual publisher. Send color copies of work—no slides. Be willing to work with the art director. All our books have a trade book look. No odd, distorted figures. Our readers are 5-8 years old. Try to create worlds that will captivate them."

OXFORD UNIVERSITY PRESS

198 Madison Ave., New York NY 10016. (212)726-6000. **E-mail:** custserv.us@oup.com. **Website:** www. oup.com/us. Chartered by Oxford University. Specializes in fully illustrated, not-for-profit, contemporary textbooks emphasizing English as a second language for children and adults. Also produces wall charts, picture cards, CDs and cassettes.

NEEDS Approached by 1,000 freelance artists/year. Works with 100 illustrators and 8 designers/year. Uses freelancers mainly for interior illustrations of exercises. Also uses freelance artists for jacket/cover illustration and design. Some need for computer-literate freelancers for illustration. 20% of freelance work demands knowledge of QuarkXPress or Illustrator. Works on assignment only.

FIRST CONTACT & TERMS Send query letter with brochure, tearsheets, photostats, slides or photographs. Samples are filed. Art buyer will contact artist for portfolio review if interested. Artists work from

detailed specs. Considers complexity of project, skill and experience of artist and project's budget when establishing payment. Artist retains copyright. Originals are returned at job's completion. Finds artists through submissions, artist catalogs such as *Showcase*, *Guild Book*, etc., occasionally from work seen in magazines and newspapers, other illustrators.

JACKETS/COVERS Pays by the project.

TEXT ILLUSTRATION Assigns 500 jobs/year. Uses black line, half-tone and 4-color work in styles ranging from cartoon to realistic. Greatest need is for natural, contemporary figures from all ethnic groups, in action and interaction. Pays for text illustration by the project, $45/spot, $2,500 maximum/full page.

TIPS "Please wait for us to call you. You may send new samples to update your file at any time. We would like to see more natural, contemporary, nonwhite people from freelance artists. Art needs to be fairly realistic and cheerful."

PALACE PRINTING AND DESIGN

80 Mark Dr., San Rafael CA 94903. (415)526-1378. **E-mail:** info@palacepress.com. **Website:** www.palacepress.com. Estab. 1987. Publishes art and photography books, calendars, journals, postcards and greeting card box sets. Types of books include pop culture, fine art, photography, spiritual, philosophy, art, biography, coffee table books, cookbooks, instructional, religious, travel, and nonfiction. Specializes in art books, spiritual. Publishes 12 titles/year. 100% requires freelance design and illustration. Book catalog free on request.

NEEDS Approached by 50 illustrators/year. Works with 12 designers and 12 illustrators/year. Location of designers/illustrators not a concern.

FIRST CONTACT & TERMS Send photographs and résumé. Accepts disk submissions from designers and illustrators. Prefers Mac-compatible, TIFF and JPEG files. Samples are filed. Responds only if interested. Company will contact artist for portfolio review if interested. Buys first, first North American serial, one-time and reprint rights. Rights purchased vary according to project. Finds freelancers through artist submissions, word of mouth.

JACKETS/COVERS Assigns 3 freelance cover illustration jobs/year. Pays for illustration by the project.

TEXT ILLUSTRATION Assigns 2 freelance illustration jobs/year. Pays by the project.

TIPS "Look at our published books and understand what we represent and how your work could fit."

PAPERCUTZ

40 Exchange Place, Suite 1308, New York NY 10005. (212)643-5407. **E-mail:** salicrup@papercutz.com. **Website:** www.papercutz.com. **Contact:** Chief editor. Estab. 2005. "Independent publisher of graphic novels based on popular existing properties aimed at all ages." Publishes hardcover and paperback originals, distributed by Holtzbrinck Publishers. Publishes 10+ titles/year. Book catalog free upon request.

NEEDS Uses licensed characters/properties aimed at all ages. "Looking for professional comics writers able to write material for teens and tweens without dumbing down the work, and comic book artists able to work in animated or manga styles." Also has a need for inkers, colorists, letterers.

FIRST CONTACT & TERMS Send low-res files of comic art samples or a link to website. Attends New York comic book conventions, as well as the San Diego Comic-Con, and will review portfolios if time allows. Will respond eventually—generally will hold work until an appropriate project comes along. Please be incredibly patient. Pays an advance against royalties.

TIPS "Be familiar with our titles—that's the best way to know what we're interested in publishing. If you are somehow attached to a successful teen or tween property and would like to adapt it into a graphic novel, we may be interested."

PARENTING PRESS, INC.

P.O. Box 75267, Seattle WA 98175. (206)364-2900 or (800)992-6657. **Fax:** (206)364-0702. **Website:** www.parentingpress.com. **Contact:** Carolyn Threadgill, publisher. Estab. 1979. Publishes trade paperback originals and hardcover originals. Types of books include nonfiction: instruction and parenting. Specializes in parenting and social skill building books for children. 100% requires freelance design; 100% requires freelance illustration. Book catalog online

NEEDS Approached by 10 designers/year and 100 illustrators/year. Works with 2 designers/year. Prefers local designers. 100% of freelance design work demands knowledge of Photoshop, QuarkXPress, and InDesign.

FIRST CONTACT & TERMS Send query letter with brochure, SASE, postcard sample with photocopies, photographs and tearsheets. After introductory mailing, send follow-up postcard sample every 6 months. Accepts e-mail submissions. Prefers Windows-compatible, TIFF, JPEG files. Samples returned by SASE if

not filed. Responds only if interested. Company will contact artist for portfolio review if interested. Portfolio should include b&w or color tearsheets. Rights purchased vary according to project.

JACKETS/COVERS Pays for illustration by the project. Prefers appealing human characters, realistic or moderately stylized.

TEXT ILLUSTRATION Pays by the project or shared royalty with author.

TIPS "Be willing to supply 2-4 roughs before finished art."

PATHWAY BOOK SERVICE

4 White Brook Rd., P.O. Box 89, Gilsum NH 03448. (800)345-6665. **Fax:** (603)357-2073. **E-mail:** pbs@pathwaybook.com. **Website:** www.pathwaybook.com. Specializes in design resource originals, children's nonfiction and nature/environmental books in series format or as individual titles. Publishes 6-8 titles/year; 10% require freelance design; 75% require freelance illustration.

NEEDS Approached by more than 200 freelancers/year. Works with 4 freelance illustrators and 1 designer/year. Works on assignment only.

FIRST CONTACT & TERMS Designers: Send query letter with brochure, tearsheets, SASE, photocopies. Illustrators: Send postcard sample or query letter with brochure, photocopies, photographs, SASE, slides and tearsheets. Do not send original work. Material not filed is returned by SASE. Call or write for appointment to show portfolio. Responds in 6 weeks. Works on assignment only. Originals are returned to artist at job's completion on request. Negotiates rights purchased.

DESIGN Assigns 1 freelance design and 2 illustration projects/year. Pays by the project.

JACKETS/COVERS Assigns 4 freelance design jobs/year. Prefers paintings. Pays by the project.

TEXT ILLUSTRATION Assigns 3 freelance jobs/year. Prefers full-color artwork for text illustrations. Pays by the project.

TIPS Looks for "draftsmanship, flexibility, realism, understanding of the printing process." Books are "rich in design quality and color, stylized while retaining realism; not airbrushed. We prefer noncomputer. Review our books. No picture book illustrations considered currently."

PAULINE BOOKS & MEDIA

50 St. Paula's Ave., Boston MA 02130. (617)522-8911. **Fax:** (617)541-9805. **E-mail:** design@paulinemedia.com; editorial@paulinemedia.com. **Website:** www.pauline.org. Estab. 1932. Publishes hardcover and trade paperback originals. Religious publishers; types of books include instructional biography/lives of the saints, reference, history, self-help, prayer, children's fiction. For Adults, teens and children. Also produces music and spoken recordings. Publishes 30-40 titles/year. Art guidelines available. Send requests and art samples with SASE using first-class postage.

NEEDS Approached by 50 freelancers/year. Works with 10-20 freelance illustrators/year. Knowledge and use of QuarkXPress, InDesign, Illustrator, Photoshop, etc., is valued.

FIRST CONTACT & TERMS Postcards, tearsheets, photocopies, include website address if you have one. Samples are filed or returned by SASE. Responds only if interested. Rights purchased; work for hire or exclusive rights.

JACKETS/COVERS Assigns 3-4 freelance illustration jobs/year. Pays by the project.

TEXT ILLUSTRATION Assigns 6-10 freelance illustration jobs/year. Pays by the project.

PAULIST PRESS

997 MacArthur Blvd., Mahwah NJ 07430. (201)825-7300. **Fax:** (201)825-8345. **E-mail:** info@paulistpress.com; dcrilly@paulistpress.com. **Website:** www.paulistpress.com. **Contact:** Donna Crilly, editorial. Estab. 1865. Publishes hardcover and trade paperback originals, textbooks. Types of books include religion, theology, and spirituality. Specializes in academic and pastoral theology. Recent titles include *The Catholic Prayer Bible*, *The Golfer's Prayer Book*, *Off to Serve*, and *Young and Catholic in America*. Publishes 80 titles/year; 5% require freelance illustration; 5% require freelance design.

NEEDS Works on assignment only.

FIRST CONTACT & TERMS Send query letter with brochure, résumé and tearsheets. Samples are filed. Portfolio review not required. Originals are returned at job's completion if requested.

JACKETS/COVERS Pays by the project.

PEACHTREE PUBLISHERS

1700 Chattahoochee Ave., Atlanta GA 30318-2112. (404)876-8761. **Fax:** (404)875-2578. **E-mail:** loraine@peachtree-online.com; hello@peachtree-online.com.

Website: www.peachtree-online.com. **Contact:** Helen Harriss, acquisitions editor; Loraine Joyner, art director. Estab. 1978. Publishes hardcover and trade paperback originals. Types of books include children's picture books, young adult fiction, early reader fiction, middle reader fiction and nonfiction, parenting, regional. Specializes in children's and young adult titles. Publishes 24-30 titles/year. 100% require freelance illustration. Call for catalog.

NEEDS Approached by 750 illustrators/year. Works with 15-20 illustrators. "We normally do not use book designers. When possible, send samples that show your ability to depict subjects or characters in a consistent manner. See our website to view styles of artwork we utilize."

JACKETS/COVERS Assigns 18-20 illustration jobs/year. Prefers acrylic, oils, watercolor, or mixed media on flexible material for scanning, or digital files. Pays for illustration by the project.

TEXT ILLUSTRATION Assigns 4-6 freelance illustration jobs/year. Pays by the project.

TIPS "We are an independent, award-winning, high-quality house with a limited number of new titles per season; therefore, each book must be a jewel. We expect the illustrator to bring creative insights which expand the readers' understanding of the storyline through visual clues not necessarily expressed within the text itself."

PELICAN PUBLISHING COMPANY

1000 Burmaster St., Gretna LA 70053. (504)368-1175. **Fax:** (504)368-1195. **E-mail:** editorial@pelicanpub.com. **Website:** www.pelicanpub.com. **Contact:** Nina Kooij, editor-in-chief. Estab. 1926. Publishes hardcover and paperback originals and reprints. Publishes 70 titles/year. Types of books include travel guides, cookbooks, business/motivational, architecture, golfing, history and children's books. Books have a "high-quality, conservative and detail-oriented" look. Recent titles include: *Finn McCool's Football Club*; *CRAZY About Cherries*; *Foods and Flavors of San Antonio*; *A Dream of Pilots*.

NEEDS Approached by 2,000 freelancers/year. Works with 20 freelance illustrators/year. Uses freelancers for illustration and photo projects. Works on assignment only. 100% of design and 50% of illustration demand knowledge of InDesign, Photoshop, Illustrator.

FIRST CONTACT & TERMS Designers: Send photocopies, photographs, SASE, slides and tearsheets. Illustrators: Send postcard sample or query letter with photocopies, SASE, slides and tearsheets. Samples are not returned. Responds on future assignment possibilities. Buys all rights. Originals are not returned.

DESIGN Pays by the project, $500 minimum.

JACKETS/COVERS Pays by the project, $150-500.

TEXT ILLUSTRATION Pays by the project, $50-250.

TIPS "Show your versatility. We want to see realistic detail and color samples."

PENGUIN GROUP (USA), INC.

375 Hudson St., New York NY 10014. (212)366-2372. **Website:** www.penguinputnam.com. **Contact:** Art director. Publishes hardcover and trade paperback originals.

NEEDS Works with 100-200 freelance illustrators and 100-200 freelance designers/year. Uses freelancers mainly for jackets, catalogs, etc.

FIRST CONTACT & TERMS Send query letter with tearsheets, photocopies and SASE. Rights purchased vary according to project.

DESIGN Pays by the project; amount varies.

JACKETS/COVERS Pays by the project; amount varies.

PENNY-FARTHING PRESS, INC.

2000 W. Sam Houston Pkwy. S, Houston TX 77042. (713)780-0300 or (800)926-2669. **Fax:** (713)780-4004. **E-mail:** submissions@pfpress.com; corp@pfpress.com. **Website:** www.pfpress.com. **Contact:** Ken White, publisher; Marlaine Maddox, editor-in-chief. Estab. 1998. Publishes hardcover and trade paperback originals. Types of books include adventure, comic books, fantasy, science fiction. Specializes in comics and graphic novels. Book catalog and art guidelines available on website.

FIRST CONTACT & TERMS Pencillers: Send 3-5 penciled pages "showing story-telling skills and versatility. Do not include dialogue or narrative boxes." Inkers: Send at least 3-5 samples (full-sized and reduced to letter-sized) showing interior work. "Include copies of the pencils." Illustrators: Send color photocopies. "Please do not send oversized copies." Samples are returned by SASE only. Submissions in the form of URLs may be e-mailed to submissions@pfpress.com with PFP Art Submission as the subject line. See website for specific instructions. Responds

in several months. Do not call to check on status of your submission.

TIPS "Do not send originals."

CLARKSON N. POTTER, INC.

Crown Publishers, a division of Random House, Inc., 1745 Broadway, New York NY 10019. (212)782-9000. **E-mail:** crownpublicity@randomhouse.com. **Website:** www.clarksonpotter.com. Publishes hardcover originals and reprints. Types of books include coffee table books, cookbooks, gardening, crafts, gift, style, decorating. Specializes in lifestyle (cookbooks, gardening, decorating). Publishes 50-60 titles/year. 20% requires freelance illustration; 25% requires freelance design.

NEEDS Works with 10-15 illustrators and 15 designers/year. Prefers freelancers experienced in illustrating food in traditional styles and mediums and designers with previous book design experience. 100% of freelance design demands knowledge of Illustrator, Photoshop, QuarkXPress, InDesign.

FIRST CONTACT & TERMS Send postcard sample or query letter with printed samples, photocopies, tearsheets. Samples are filed and are not returned. Will contact artist for portfolio review if interested or portfolios may be dropped off any day. Negotiates rights purchased. Finds freelancers through submission packets, promotional postcards, web sourcebooks, illustration annuals and previous books.

DESIGN Assigns 20 freelance design jobs/year.

JACKETS/COVERS Assigns 20 freelance design and 15 illustration jobs/year. Pays for design by the project. Jackets are designed by book designer, i.e., the whole book and jacket are viewed as a package.

TEXT ILLUSTRATION Assigns 15 freelance illustration jobs/year.

TIPS "We no longer have a juvenile books department. We do not publish books of cartoons or humor. We look at a wide variety of design styles. We look at mainly traditional illustration styles and mediums and are always looking for unique food and garden illustrations."

PRAKKEN PUBLICATIONS, INC.

P.O. Box 8623, Ann Arbor MI 48107. (734)975-2800. **Fax:** (734)975-2787. **E-mail:** pam@eddigest.com. **E-mail:** susanne@eddigest.com. **Contact:** Susanne Peckham, book editor; Sharon K. Miller, art/design/production manager. Estab. 1934. "We publish books for educators in career/vocational and technology ed-

ucation, as well as books for the machine trades and machinists' education. Currently emphasizing machine trades." Publishes 2 magazines: *The Education Digest* and *Tech Directions*; text and reference books for technology and career/technical education. Book catalog free by request.

NEEDS Rarely uses freelancers. 50% of freelance work demands knowledge of InDesign. Works on assignment only.

FIRST CONTACT & TERMS Send samples. Samples are filed or are returned by SASE if requested by artist. Responds only if interested. Art director will contact artist for portfolio review if interested. Portfolio should include b&w and color final art and tearsheets.

PRENTICE HALL COLLEGE DIVISION

Pearson Education, One Lake St., Upper Saddle River NJ 07458. (201)236-7000. **E-mail:** communications@pearsoned.com. **Website:** www.prenhall.com. Specializes in college textbooks in education and technology. Publishes 400 titles/year.

NEEDS Approached by 25-40 designers/freelancers/year. Works with 15 freelance designers/illustrators/year. Uses freelancers mainly for cover textbook design. 100% of freelance design and 70% of illustration demand knowledge of QuarkXPress 6.5, Illustrator and Photoshop CS.

FIRST CONTACT & TERMS Send query letter with résumé and tearsheets; sample text designs on CD in Mac format. Samples are filed and portfolios are returned. Responds if appropriate. Rights purchased vary according to project. Originals are returned at job's completion.

DESIGN Pays by the project.

TIPS "Send a style that works well with our particular disciplines."

PRO LINGUA ASSOCIATES

P.O. Box 1348, Brattleboro VT 05302-1348. (802)257-7779. **Fax:** (802)257-5117. **E-mail:** info@prolingua associates.com. **Website:** www.prolinguaassociates.com. **Contact:** Arthur A. Burrows, president. Estab. 1980. Publishes textbooks. Specializes in language textbooks. Recent titles: *Writing Strategies*, *Dictations for Discussion*. Publishes 3-8 titles/year. Some require freelance illustration. Book catalog free by request.

NEEDS Approached by 10 freelance artists/year. Works with up to 3 freelance illustrators/year. Uses freelance artists mainly for pedagogical illustrations

of various kinds; also for jacket/cover and text illustration. Works on assignment only.

FIRST CONTACT & TERMS Send postcard sample or query letter with brochure, photocopies and photographs. Samples are filed. Responds in 1 month. Portfolio review not required. Buys all rights. Originals are returned at job's completion if requested. Finds artists through word of mouth and submissions.

TEXT ILLUSTRATION Assigns 1-3 freelance illustration jobs/year. Pays by the project, $200-1,200.

G.P. PUTNAM'S SONS, BOOKS FOR YOUNG READERS

345 Hudson St., 14th Floor, New York NY 10014. (212)366-2000. **Website:** us.penguingroup.com. **Contact:** Annie Ericsson, art assistant. Publishes hardcover juvenile books. Publishes 84 titles/year. Free catalog available.

NEEDS Picture book illustration on assignment only.

FIRST CONTACT & TERMS Provide printed samples or color copies to be kept on file for possible future assignments. Samples are returned by SASE only. We take drop-offs on Tuesday mornings before 11 A.M. and return them to the front desk by 5 P.M. the same day. Do not send samples via e-mail, original art, or CDs. If you are interested in illustrating picture books, we will need to see at least 3-4 sequential scenes of the same children or animals interacting in different settings.

QUITE SPECIFIC MEDIA GROUP, LTD.

7373 Pyramid Place, Hollywood CA 90046. (323)851-5797. **Fax:** (323)851-5798. **E-mail:** info@quitespecific media.com. **Website:** www.quitespecificmedia.com. **Contact:** Ralph Pine, editor-in-chief. Estab. 1967. Publishes hardcover originals and reprints, trade paperback reprints and textbooks. Specializes in costume, fashion, theater and performing arts books. Recent titles: *Understanding Fashion History*; *The Medieval Tailor's Assistant*. Publishes 12 titles/year. 10% require freelance illustration; 60% require freelance design.

○ Imprints of Quite Specific Media Group, Ltd. include Drama Publishers, Costume & Fashion Press, By Design Press, EntertainmentPro, and Jade Rabbit.

NEEDS Works with 2-3 freelance designers/year. Uses freelancers mainly for jackets/covers; also for book, direct mail and catalog design and text illustration. Works on assignment only.

FIRST CONTACT & TERMS Send query letter with brochure and tearsheets. Samples are filed. Responds only if interested. Rights purchased vary according to project. Originals not returned. Pays by the project.

RAINBOW BOOKS, INC.

P.O. Box 430, Highland City FL 33846. (863)648-4420. **Fax:** (863)647-5951. **E-mail:** rbibooks@aol.com. **Website:** www.rainbowbooksinc.com. **Contact:** Betsy A. Lampe, president. Estab. 1979. Publishes hardcover and trade paperback originals. Types of books include instruction, adventure, biography, travel, self-help, mystery and reference. Specializes in nonfiction, self-help, mystery fiction, and how-to. Recent titles: *Blinding Pain, Simple Truth: Changing Your Life Through Buddhist Meditation, Hiking the Continental Divide Trail: One Woman's Journey, Falling Immortality: Casey Holden, Private Investigator, The Successful Retirement Guide; Teen Grief Relief*; and *Building Character Skills in the Out-of-Control Child*. Publishes 10-15 titles/year.

NEEDS All in house

RAINBOW PUBLISHERS

P.O. Box 261129, San Diego CA 92196. (858)277-1167. **E-mail:** editor@rainbowpublishers.com. **Website:** www.rainbowpublishers.com; www.legacypresskids. com. Estab. 1979. Publishes trade paperback originals. Types of books include religious books, reproducible Sunday School books for children ages 2-12, and Bible teaching books for children and adults. Recent titles include *Favorite Bible Families, Instant Bible Lessons, The Christian Girl's Guides, Bill the Warthog, Gotta Have God, God and Me*. Publishes 20 titles/year. Book catalog available for SASE with 2 first-class stamps.

NEEDS Approached by hundreds of illustrators and 50 designers/year. Works with 5-10 illustrators and 5-10 designers/year. 100% of freelance design and illustration demands knowledge of Illustrator, Photoshop and InDesign.

FIRST CONTACT & TERMS Send query letter with printed samples, SASE and tearsheets. Samples are filed or returned by SASE. Responds only if interested. Will contact artist for portfolio review if interested. Finds freelancers through samples sent and personal referrals. For submission directions, go to: www.RainbowPublishers.com/submissions.apsx.

DESIGN Assigns 25 freelance design jobs/year. Pays for design by the project, $350 minimum. Pays for art direction by the project, $350 minimum.

JACKETS/COVERS Assigns 25 freelance design jobs and 25 illustration jobs/year. "Prefers computer generated-high energy style with bright colors appealing to kids." Pays for design and illustration by the project, $350 minimum. "Prefers designers/illustrators with some Biblical knowledge."

TEXT ILLUSTRATION Assigns 20 freelance illustration jobs/year. Pays by the project, $500 minimum. "Prefers black & white line art, preferably computer generated with limited detail yet fun."

TIPS "We look for illustrators and designers who have some Biblical knowledge and excel in working with a fun, colorful, high-energy style that will appeal to kids and parents alike. Designers must be well versed in InDesign, Illustrator and Photoshop, know how to visually market to kids and have wonderful conceptual ideas!"

RANDOM HOUSE

1745 Broadway, New York NY 10019. (212)782-9000. **E-mail:** atrandompublicity@randomhouse.com. **Website:** www.randomhouse.com. **Contact:** Art director. Imprint publishes hardcover, trade paperback and reprints, and trade paperback originals. Types of books include adventure, coffee table books, cookbooks, children's books, fantasy, historical fiction, history, horror, humor, instructional, mainstream fiction, New Age, nonfiction, reference, religious, romance, science fiction, self-help, travel and western. Specializes in contemporary authors' work. 80% requires freelance illustration; 50% requires freelance design.

NEEDS Uses freelancers mainly for jacket/cover illustration and design for fiction and romance titles. 100% of design and 50% of illustration demands knowledge of Illustrator, QuarkXPress, Photoshop and FreeHand. Works on assignment only.

FIRST CONTACT & TERMS Designers: Send résumé and tearsheets. Illustrators: Send postcard sample, brochure, résumé and tearsheets. Samples are filed. Request portfolio review in original query. Art director will contact artist for portfolio review if interested. Portfolio should include tearsheets. Buys first rights. Originals are returned at job's completion. Finds artists through *American Showcase*, *Workbook*, *The Creative Illustration Book*, artist's reps.

DESIGN Pays by the project.

JACKETS/COVERS Assigns 50 freelance design and 20 illustration jobs/year. Pays by the project.

TIPS "Study the product to make sure styles are similar to what we have done new, fresh, etc."

RANDOM HOUSE CHILDREN'S BOOKS

1745 Broadway, New York NY 10019. (212)782-9000. **Website:** www.randomhouse.com. Estab. 1925. Largest English-language children's trade book publisher. Specializes in books for preschool children through young adult readers, in all formats from board books to activity books to picture books and novels. Recent titles: *How Many Seeds in a Pumpkin?*; *How Not to Start Third Grade*; *Spells & Sleeping Bags*; *The Power of One*. Publishes 250 titles/year. 100% require freelance illustration.

◑ The Random House publishing divisions hire their freelancers directly. To contact the appropriate person, send a cover letter and résumé to the department head at the publisher as follows: "Department Head" (e.g., Art Director, Production Director), "Publisher/Imprint" (e.g., Knopf, Doubleday, etc.), 1745 Broadway New York, NY 10019.

NEEDS Works with 100-150 freelancers/year. Works on assignment only.

FIRST CONTACT & TERMS Send query letter with résumé, tearsheets and printed samples; no originals. Samples are filed. Negotiates rights purchased.

DESIGN Assigns 5 freelance design jobs/year. Pays by the project.

TEXT ILLUSTRATION Assigns 150 illustration jobs/year. Pays by the project.

RED WHEEL/WEISER

665 Third St., Suite 400, San Francisco CA 94107. **E-mail:** info@redwheelweiser.com. **Website:** www.red wheelweiser.com. **Contact:** Donna Linden, creative director. Publishes trade hardcover and paperback originals and reprints. Imprints: Red Wheel (spunky self-help); Weiser Books (metaphysics/oriental mind-body-spirit/esoterica); Conari Press (self-help/inspirational). Publishes 50 titles/year.

NEEDS Uses freelancers for jacket/text design and illustration.

FIRST CONTACT & TERMS Designers: Send résumé, photocopies and tearsheets. Illustrators: Send photocopies, photographs, SASE and tearsheets. "We can use art or photos. I want to see samples I can keep." Samples are filed or are returned by SASE only if requested by artist. Responds only if interested. Originals are returned to artist at job's completion. To show

portfolio, mail tearsheets, color photocopies. Considers complexity of project, skill and experience of artist, project's budget, turnaround time and rights purchased when establishing payment. Buys one-time nonexclusive royalty-free rights. Finds most artists through references/word of mouth, portfolio reviews and samples received through the mail.

JACKETS/COVERS Assigns 20 design jobs/year. Must have trade book design experience in the subjects we publish.

TIPS "Send samples by mail, preferably in color. We work electronically and prefer digital artwork or scans. Do not send drawings of witches, goblins and demons for Weiser Books; we don't put those kinds of images on our covers. Please take a moment to look at our books before submitting anything; we have characteristic looks for all three imprints."

REGNERY PUBLISHING, INC.

Eagle Publishing, One Massachusetts Ave. NW, Washington DC 20001. (202)216-0600; (888)219-4747. **Fax:** (202)216-0612. **E-mail:** editorial@regnery.com. **E-mail:** submissions@regnery.com. **Website:** www.regnery.com. **Contact:** Art director. Estab. 1947. Publishes hardcover originals and reprints, trade paperback originals and reprints. Types of books include biography, history, nonfiction. Specializes in nonfiction. Publishes 30 titles/year. Recent titles include: *God, Guns and Rock & Roll* by Ted Nugent. 20-50% requires freelance design. Book catalog available for SASE.

NEEDS Approached by 20 illustrators and 20 designers/year. Works with 6 designers/year. Prefers local illustrators and designers. Prefers freelancers experienced in Mac, QuarkXPress and Photoshop. 100% of freelance design demands knowledge of QuarkXPress. 50% of freelance illustration demands knowledge of Photoshop, QuarkXPress.

FIRST CONTACT & TERMS "We will only accept proposals submitted by agents."

DESIGN Assigns 5-10 freelance design jobs/year. Pays for design by the project; negotiable.

JACKETS/COVERS Assigns 5-10 freelance design and 1-5 illustration jobs/year. Pays by the project; negotiable.

TIPS "We welcome designers with knowledge of Mac platforms and the ability to design 'bestsellers' under extremely tight guidelines and deadlines!"

RENAISSANCE HOUSE

465 Westview Ave., Englewood NJ 07631. (800)547-5113. **E-mail:** raquel@renaissancehouse.net. **Website:** www.renaissancehouse.net. Publishes biographies, folktales, coffee table books, instructional, textbooks, adventure, picture books, juvenile and young adult. Specializes in multicultural and bilingual titles, Spanish-English.

TIPS "We look for artists with quick turnaround. Submit artwork via e-mail through our website. Share with us any book project you might have written and illustrated yourself."

SCHOLASTIC, INC.

557 Broadway, New York NY 10012. (212)343-6100. **Website:** www.scholastic.com. Scholastic Trade Books is an award-winning publisher of original children's books. Scholastic publishes more than 600 new hardcover, paperback and novelty books each year. The list includes the phenomenally successful publishing properties Harry Potter®, Goosebumps®, The 39 Clues™, I Spy™, and *The Hunger Games*; best-selling and award-winning authors and illustrators, including Blue Balliett, Jim Benton, Meg Cabot, Suzanne Collins, Christopher Paul Curtis, Ann M. Martin, Dav Pilkey, J.K. Rowling, Pam Muñoz Ryan, Brian Selznick, David Shannon, Mark Teague, and Walter Wick, among others; as well as licensed properties such as Star Wars® and Rainbow Magic®.

⍟ SCHOOL GUIDE PUBLICATIONS

210 North Ave., New Rochelle NY 10801. (800)433-7771. **E-mail:** mridder@schoolguides.com. **Website:** www.schoolguides.com. **Contact:** Miles Ridder, publisher. Estab. 1935. Types of books include reference and educational directories. Specializes in college recruiting publications. 1% requires freelance illustration; 1% requires freelance design.

NEEDS Approached by 10 illustrators and 10 designers/year. Prefers local freelancers. Prefers freelancers experienced in book cover and brochure design. 100% of freelance design and illustration demands knowledge of Illustrator, Photoshop, QuarkXPress.

FIRST CONTACT & TERMS Send query letter with printed samples. Send EPS files. Samples are filed. Responds only if interested. Will contact artist for portfolio review if interested. Rights purchased vary according to project. Finds freelancers through word of mouth.

SIMON & SCHUSTER

1230 Avenue of the Americas, New York NY 10020. (212)698-7000. **Website:** www.simonsays.com. Imprints include Pocket Books and Archway. Company publishes hardcover, trade paperback and mass market paperback originals, reprints and textbooks. Types of books include juvenile, preschool, romance, self-help, young adult and many others. Specializes in young adult, romance and self-help. Publishes 125 titles/year. Recent titles include *Plan of Attack* by Bob Woodward; *The Price of Loyalty* by Ron Suskind. 95% require freelance illustration; 80% require freelance design.

NEEDS Works with 50 freelance illustrators and 5 designers/year. Prefers freelancers with experience working with models and taking direction well. Uses freelancers for hand lettering, jacket/cover illustration and design and book design. 100% of design and 75% of illustration demand knowledge of Illustrator and Photoshop. Works on assignment only.

FIRST CONTACT & TERMS Send query letter with tearsheets. Accepts disk submissions. Samples are filed and are not returned. Responds only if interested. Portfolios may be dropped off every Monday and Wednesday and should include tearsheets. Buys all rights. Originals are returned at job's completion.

TEXT ILLUSTRATION Assigns 50 freelance illustration jobs/year.

SIMON & SCHUSTER CHILDREN'S PUBLISHING

1230 Avenue of the Americas, New York NY 10020. (212)698-7000. **Website:** www.simonsayskids.com. Imprint publishes hardcover originals and reprints. Types of books include picture books, nonfiction and young adult. Publishes 500 titles/year. 100% require freelance illustration; 1% require freelance design.

NEEDS Approached by 200 freelancers/year. Works with 40 freelance illustrators and 2-3 designers/year. Uses freelancers mainly for jackets and picture books. 100% of design work demands knowledge of Illustrator, QuarkXPress and Photoshop. Works on assignment only.

FIRST CONTACT & TERMS Designers: Send query letter with résumé and photocopies. Illustrators: Send postcard sample or other nonreturnable samples. Accepts disk submissions. Art director will contact artist for portfolio review if interested. Portfolio should include original art, photographs and trans-parencies. Originals are returned at job's completion. Finds artists through submissions, agents, scouting in nontraditional juvenile areas such as painters, editorial artists.

JACKETS/COVERS Assigns 20 freelance illustration jobs/year. Pays by the project, $800-2,500. "We use full range of media collage, photo, oil, watercolor, etc."

TEXT ILLUSTRATION Assigns 30 freelance illustration jobs/year. Pays by the project.

SLACK, INC.

6900 Grove Rd., Thorofare NJ 08086. (856)848-1000. **Fax:** (856)853-5991. **E-mail:** bookspublishing@slack inc.com. **Website:** www.slackbooks.com. **Contact:** John Bond, publisher. Estab. 1960. Publishes 22 medical publications dealing with clinical and lifestyle issues for people in the medical professions. Accepts previously published artwork. Originals returned at job's completion. Art guidelines not available.

FIRST CONTACT & TERMS Send query letter with tearsheets, photographs, photocopies, slides and transparencies. Samples are filed and are returned by SASE if requested by artist. Responds to the artist only if interested. To show a portfolio, mail b&w and color tearsheets, slides, photostats, photocopies and photographs. Negotiates rights purchased. Pays on publication; $400-600 for color cover; $100-200 for b&w inside; $100-350 for color inside; $50-150 for spots.

TEXT ILLUSTRATION Approached by 50 illustrators/year. Buys 2 illustrations/issue. Works on assignment only. Features stylized and realistic illustration; charts & graphs; informational graphics; medical, computer and spot illustration. No cartoons! Assigns 5% of illustrations to well-known or "name" illustrators; 90% to experienced but not well-known illustrators; 5% to new and emerging illustrators. Prefers digital submissions.

TIPS "Send samples."

THE SPEECH BIN, INC.

P.O. Box 1579, Appleton WI 54912-1579. (888)388-3224. **Fax:** (888)388-6344. **E-mail:** customercare@ schoolspecialty.com. **Website:** www.speechbin.com. Estab. 1984. Publishes textbooks and educational games and workbooks for children and adults. Specializes in tests and materials for treatment of individuals with all communication disorders. Publishes 20-25 titles/year. 50% require freelance illustration; 50% require freelance design. Book catalog available on website.

NEEDS Works with 8-10 freelance illustrators and 2-4 designers/year. Buys 1,000 illustrations/year. Work must be suitable for handicapped children and adults. Uses freelancers mainly for instructional materials, cover designs, game boards, stickers; also for jacket/cover and text illustration. Occasionally uses freelancers for catalog design projects. Works on assignment only.

FIRST CONTACT & TERMS Send query letter with SASE, tearsheets and photocopies. Samples are filed or are returned by SASE if requested by artist. Responds only if interested. Do not send portfolio; query only. Usually buys all rights. Considers buying second rights (reprint rights) to previously published work. Finds artists through "word of mouth, our authors, and submissions by artists."

DESIGN Pays by the project.

JACKETS/COVERS Assigns 10-12 freelance design jobs and 10-12 illustration jobs/year. Pays by the project.

TEXT ILLUSTRATION Assigns 6-10 freelance illustration jobs/year. Prefers b&w line drawings. Pays by the project.

TECHNICAL ANALYSIS, INC.

4757 California Ave., SW, Seattle WA 98116-4499. (206)938-0570 or (800)832-4642. **E-mail:** cmorrison@traders.com. **Website:** www.traders.com. **Contact:** Christine Morrison, art director. Estab. 1982. Publishes trade paperback reprints, magazines and software. Types of books include instruction, reference, self-help and financial. Specializes in stocks, options, futures and mutual funds. Publishes 3 titles/year. 100% require freelance illustration; 10% require freelance design.

NEEDS Approached by 100 freelance artists/year. Works with 20 freelance illustrators/year. Buys 100 freelance illustrations/year. Uses freelance artists for magazine illustration; also for text illustration and direct mail design. Works on assignment only.

FIRST CONTACT & TERMS Send query letter with nonreturnable tearsheets, photographs or photocopies. Samples are filed. Will contact for possible assignment if interested. Buys first rights or reprint rights. Most originals are returned to artist at job's completion.

DESIGN Assigns 5 freelance design, 100 freelance illustration jobs/year. Pays by project.

JACKETS/COVERS Assigns 1 freelance design, 15 freelance illustration jobs/year. Pays by project.

TEXT ILLUSTRATION Assigns 5 freelance design and 100 freelance illustration jobs/year. Pays by the hour or by the project.

TIGHTROPE BOOKS

602 Markham St., Toronto ON M6G 2L8, Canada. (647)348-4460. **E-mail:** shirarose@tightropebooks.com. **Website:** www.tightropebooks.com. **Contact:** Shirarose Wilensky, editor. Estab. 2005. Publishes hardcover and trade paperback originals.

NEEDS Publishes 12 titles/year. SASE returned. Responds only if interested. Catalog and guidelines free upon request and online.

FIRST CONTACT & TERMS Send an e-mail with résumé, digital images and artist's website, if available.

TILBURY HOUSE

Harpswell Press, Inc., 103 Brunswick Ave., Gardiner ME 04345. (800)582-1899. **Fax:** (207)582-8227. **E-mail:** tilbury@tilburyhouse.com. **Website:** www.tilburyhouse.com. **Contact:** Karen Fisk, associate children's book editor; Jennifer Bunting, publisher. Estab. 1990. Publishes hardcover originals, trade paperback originals. 10 titles/year.

NEEDS Regional adult biography/history/maritime/nature, and children's picture books that deal with issues, such as bullying, multiculturalism, etc. Guidelines available online. Catalog available by request.

FIRST CONTACT & TERMS Send photocopies of photos/artwork.

TORAH AURA PRODUCTIONS

4423 Fruitland Ave., Los Angeles CA 90058. (323)585-7312. **Fax:** (323)585-0327. **E-mail:** misrad@torahaura.com. **Website:** www.torahaura.com. **Contact:** Jane Golub, art director. Estab. 1981. Publishes Jewish educational textbooks. Specializes in textbooks for Jewish schools. Recent titles: *Experiencing the Jewish Holidays, Experiencing the Torah*. Publishes 3-4 titles/year. 5% require freelance illustration. Book catalog free for 9×12 SASE with 10 first-class stamps.

NEEDS Approached by 50 illustrators and 20 designers/year. Works with 1-2 illustrators/year.

FIRST CONTACT & TERMS Illustrators: Send postcard sample and follow-up postcard every 6 months, printed samples, photocopies. Accepts Windows-compatible disk submissions. Samples are filed. Will contact artist for portfolio review if interested. Rights

purchased vary according to project. Finds freelancers through submission packets.

TREEHAUS COMMUNICATIONS, INC.

906 W. Loveland Ave., P.O. Box 249, Loveland OH 45140. (800)638-4287. **Fax:** (513)683-2882. **E-mail:** treehaus@treehaus1.com. **Website:** www.treehaus1. com. Estab. 1973. Publisher. Specializes in books, periodicals, texts, TV productions. Product specialties are social studies and religious education. Recent titles: *The Stray*; *Rosanna the Rainbow Angel* (for children ages 4-8).

NEEDS Approached by 12-24 freelancers/year. Works with 2 or 3 freelance illustrators/year. Prefers freelancers with experience in illustrations for children. Works on assignment only. Uses freelancers for all work. 5% of work is with print ads. Needs computer-literate freelancers for illustration.

FIRST CONTACT & TERMS Send query letter with résumé, transparencies, photocopies and SASE. Samples sometimes filed or returned by SASE if requested by artist. Responds in 1 month. Art director will contact artist for portfolio review if interested. Portfolio should include final art, tearsheets, slides, photostats and transparencies. Pays for design and illustration by the project. Rights purchased vary according to project. Finds artists through word of mouth, submissions and other publisher's materials.

TIPS "We are looking for original style that is developed and refined. Whimsy helps."

TRIUMPH BOOKS

542 Dearborn St., Suite 750, Chicago IL 60605. (312)939-3330; (800)335-5323. **Fax:** (312)663-3557. **Website:** www.triumphbooks.com. **Contact:** Tom Bast, editorial director. Estab. 1990. Publishes hardcover originals and reprints, trade paperback originals and reprints. Types of books include biography, coffee table books, humor, instructional, reference, sports. Specializes in sports titles. Publishes 100 titles/year. 5% requires freelance illustration; 60% requires freelance design. Book catalog free for SASE.

NEEDS Approached by 5 illustrators and 5 designers/year. Works with 2 illustrators and 8 designers/year. Prefers freelancers experienced in book design. 100% of freelance design demands knowledge of Photoshop, InDesign, Illustrator, QuarkXPress.

FIRST CONTACT & TERMS Send query letter with printed samples, SASE. Accepts Mac-compatible disk submissions. Send TIFF files. Samples are filed or returned by SASE. Will contact artist for portfolio review if interested. Buys all rights. Finds freelancers through word of mouth, organizations (Chicago Women in Publishing), submission packets. "Because of the workload, phone calls will not be returned."

DESIGN Assigns 20 freelance design jobs/year. Pays for design by the project.

JACKETS/COVERS Assigns 30 freelance design and 2 illustration jobs/year. Pays for design by the project. Prefers simple, easy-to-read, in-your-face cover treatment.

TIPS "Most of our interior design requires a fast turnaround. We do mostly one-color work with occasional two-color and four-color jobs. We like a simple, professional design."

TYNDALE HOUSE PUBLISHERS, INC.

351 Executive Dr., Carol Stream IL 60188. (800)323-9400. **Fax:** (800)684-0247. **Website:** www.tyndale. com. **Contact:** Katara Washington Patton, acquisitions; Talinda Iverson, art acquisitions. Estab. 1962. Estab. 1962. Publishes hardcover and trade paperback originals. Specializes in children's books on "Christian beliefs and their effect on everyday life." Publishes 150 titles/year. 15% require freelance illustration.

NEEDS Approached by 200-250 freelance artists/year. Works with 5-7 illustrators.

FIRST CONTACT & TERMS Send query letter and tearsheets only. Samples are filed or are returned by SASE. Responds only if interested. Considers complexity of project, skill and experience of artist, project's budget and rights purchased when establishing payment. Negotiates rights purchased. Originals are returned at job's completion except for series logos.

JACKETS/COVERS Assigns 5-10 illustration jobs/year. Prefers progressive but friendly style. Pays by the project, no royalties.

TEXT ILLUSTRATION Assigns 1-5 jobs/year. Prefers progressive but friendly style. Pays by the project.

TIPS "Only show your best work. We are looking for illustrators who can tell a story with their work and who can draw the human figure in action when appropriate."

THE UNIVERSITY OF ALABAMA PRESS

P.O. Box 870380, Tuscaloosa AL 35487. (205)348-5180 or (205)348-1571. **Fax:** (205)348-9201. **E-mail:** rcook@uapress.ua.edu. **Website:** www.uapress. ua.edu. **Contact:** Rick Cook, production manager; Michele Myatt Quinn, designer; Kaci Lane Hind-

man, production editor. Specializes in hardcover and paperback originals and reprints of academic titles. Publishes 60-65 titles/year. Recent titles include: *Motorcycling Alabama*, by Haynes; *Alabama Afternoons*, by Hoffman; *Butterflies of Alabama*, by Ogard. 55% requires freelance design.

NEEDS Almost exclusively with 5 freelancers/year. Requires book design experience, preferably with university press work. Works on assignment only. 100% of freelance design demands knowledge of Photoshop and InDesign.

FIRST CONTACT & TERMS Send information via e-mail and link to website. Tries to respond in a few days whenever possible. Considers project's budget when establishing payment. Buys all rights. Originals are not returned.

DESIGN Assigns 50 freelance jobs/year. Pays by the project, $600 minimum.

JACKETS/COVERS Assigns about 50 freelance design jobs/year. Pays by the project, $600 minimum.

TIPS Has a limited freelance budget. "For book design, our requirements are that they be classy. We are very rarely in the market for illustration or art work."

UNIVERSITY OF NEBRASKA PRESS

1111 Lincoln Mall, Lincoln NE 68588. (800)755-1105. **Fax:** (402)472-6214. **E-mail:** pressmail@unl.edu. **E-mail:** arold1@unl.edu. **Website:** nebraskapress.unl.edu. **Contact:** Heather Lundine, editor-in-chief; Alison Rold, production manager. Publishes hardcover originals and trade paperback originals and reprints. Types of books include history, translations. Specializes in Western history, American Indian ethnohistory, Judaica, nature, Civil War, sports history, women's studies. Publishes 180 titles/year. Recent titles include: *A World of Light* by Floyd Skloot; *Algonquian Spirit* by Bryan Swann. 5-10% require freelance illustration; 10% require freelance design. Book catalog free by request and available online.

NEEDS Approached by 10 freelancers/year. Works with 2-3 freelance illustrators/year. Prefers freelancers experienced in 4-color, action in Civil War, basketball or Western topics. "We must use Native American artists for books on that subject." Uses freelancers for jacket/cover illustration. Works on assignment only.

FIRST CONTACT & TERMS Send query letter with photocopies. Samples are filed. Responds to the artist only if interested. Buys one-time rights. Originals are returned at job's completion.

JACKETS/COVERS Assigns 2-3 illustration jobs/year. Usually prefers realistic, western, action styles. Pays by the project, $200-500.

UNIVERSITY OF PENNSYLVANIA PRESS

3905 Spruce St., Philadelphia PA 19104. (215)898-6261. **Fax:** (215)898-0404. **Website:** www.pennpress.org. **Contact:** Jerome Singerman, humanities editor; Peter Agree, editor-in-chief and social sciences editor; Jo Joslyn, art and architecture editor; Robert Lockhart, history editor; Bill Finan, politics, international relations; John Hubbard, art director. Estab. 1890. Publishes hardcover originals. Types of books include biography, history, nonfiction, landscape architecture, art history, anthropology, literature and regional history. Publishes 80 titles/year. 10% requires freelance design.

NEEDS 100% of freelance work demands knowledge of Illustrator, Photoshop and QuarkXPress.

FIRST CONTACT & TERMS Designers: Send query letter with photocopies. Illustrators: Send postcard sample. Accepts Mac-compatible disk submissions. Samples are not filed or returned. Will contact artist for portfolio review if interested. Portfolio should include book dummy and photocopies. Rights purchased vary according to project. Finds freelancers through submission packets and word of mouth.

DESIGN Assigns 2 freelance design jobs/year. Pays by the project.

JACKETS/COVERS Assigns 6 freelance design jobs/year. Pays by the project.

VOYAGEUR PRESS

Quayside Publishing Group, 400 First Ave. N., Suite 300, Minneapolis MN 55401. (800)458-0454. **Fax:** (612)344-8691. **E-mail:** mdregni@voyageurpress.com. **Website:** voyageurpress.com. **Contact:** Michael Dregni, publisher. Estab. 1972. Publishes hardcover originals and reprints. Subjects include regional history, nature, popular culture, travel, wildlife, Americana, collectibles, lighthouses, quilts, tractors, barns and farms. Specializes in natural history, travel and regional subjects. Publishes 50 titles/year. 10% require freelance illustration; 10% require freelance design. Book catalog free by request.

NEEDS Approached by 100 freelance artists/year. Works with 2-5 freelance illustrators and 2-5 freelance designers/year. Prefers artists with experience in maps and book and cover design. Uses freelance artists mainly for cover and book design; also for jack-

et/cover illustration and direct mail and catalog design. 100% of design requires computer skills. Works on assignment only.

FIRST CONTACT & TERMS Send postcard sample and query letter with brochure, photocopies, SASE and tearsheets, list of credits and nonreturnable samples of work that need not be returned. Samples are filed. Responds only if interested. "We do not review portfolios unless we have a specific project in mind. In that case, we'll contact artists for a portfolio review." Usually buys first rights. Originals returned at job's completion.

DESIGN Assigns 2-5 freelance design jobs and 2-5 freelance illustration jobs/year.

JACKETS/COVERS Assigns 2-5 freelance design and 2-5 freelance illustration jobs/year.

TEXT ILLUSTRATION Assigns 2-5 freelance design and 2-5 design illustration jobs/year.

TIPS "We use more book designers than artists or illustrators, since most of our books are illustrated with photographs."

WATERBROOK MULTNOMAH PUBLISHING GROUP

Random House, 12265 Oracle Blvd., Suite 200, Colorado Springs CO 80921. (719)590-4999. **Fax:** (719)590-8977. **Website:** www.waterbrookmultnomah.com. Estab. 1996. Publishes audio tapes, hardcover, mass market paperback and trade paperback originals. Types of books include romance, science fiction, western, young adult fiction; biography, coffee table books, religious, self-help nonfiction. Specializes in Christian titles. Publishes 60 titles/year. 30% requires freelance design; 10% requires freelance illustration. Book catalog free on request.

NEEDS Approached by 10 designers and 100 illustrators/year. 90% of freelance design work demands knowledge of Illustrator, QuarkXPress and Photoshop.

FIRST CONTACT & TERMS Designer/illustrators: Send postcard sample with brochure, tearsheets. After introductory mailing, send follow-up postcard sample every 3 months. Samples are filed and not returned. Portfolio not required. Buys one-time rights, first North American serial rights. Finds freelancers through artist's submissions, Internet.

JACKETS/COVERS Assigns 2 freelance cover illustration jobs/year. Pays for illustration by the project.

TEXT ILLUSTRATION Assigns 4 freelance illustration jobs/year. Pays by the project.

WEIGL EDUCATIONAL PUBLISHERS, LTD.

6325 10th St. SE, Calgary AB T2H 2Z9, Canada. (403)233-7747. **Fax:** (403)233-7769. **E-mail:** linda@weigl.com. **Website:** www.weigl.ca. Estab. 1979. Textbook and library series publisher catering to juvenile and young adult audience. Specializes in social studies, science-environmental, life skills, multicultural American and Canadian focus. Titles include: *Structural Wonders*; *Backyard Animals*; and *Learning to Write*. Publishes over 100 titles/year. Book catalog free by request.

NEEDS Approached by 300 freelancers/year. Uses freelancers only during peak periods. Prefers freelancers with experience in children's text illustration in line art/watercolor. Uses freelancers mainly for text illustration or design; also for direct mail design. Freelancers should be familiar with QuarkXPress 5.0, Illustrator 10.0 and Photoshop 7.0.

FIRST CONTACT & TERMS Send résumé for initial review prior to selection for interview. Limited freelance opportunities. Graphic designers required on site. Extremely limited need for illustrators. Samples are returned by SASE if requested by artist. Responds only if interested. Write for appointment to show portfolio of original/final art (small), b&w photostats, tearsheets and photographs. Rights purchased vary according to project.

TEXT ILLUSTRATION Pays on per-project basis, depending on job. Prefers line art and watercolor appropriate for elementary and secondary school students.

WHITE MANE PUBLISHING COMPANY, INC.

73 W. Burd St., P.O. Box 708, Shippensburg PA 17257. (717)532-2237; (888)948-6263. **Fax:** (717)532-6110. **E-mail:** marketing@whitemane.com. **Website:** www.whitemane.com. Estab. 1987. Publishes hardcover originals and reprints, trade paperback originals and reprints. Types of books include historical biography, biography, history, historical juvenile, historical nonfiction and historical young adult. Publishes 10 titles/year. 40% require freelance illustration. Book catalog free with SASE.

NEEDS Works with 2-3 illustrators and 2 designers/year.

FIRST CONTACT & TERMS Send query letter with printed samples. Samples are filed. Interested only in historic artwork. Responds only if interested. Will contact artist for portfolio review if interested. Rights

purchased vary according to project. Finds freelancers through submission packets and postcards.

JACKETS/COVERS Assigns 4 illustration jobs/year. Pays for design by the project.

TIPS Uses art for covers only—realistic historical scenes for young adults.

ALBERT WHITMAN & COMPANY

250 S. Northwest Hwy., Suite 320, Park Ridge IL 60068. (800)255-7675. **Fax:** (847)581-0039. **E-mail:** mail@awhitmanco.com. **Website:** www.albertwhitman.com. Estab. 1919. Publishes hardcover originals. Specializes in juvenile fiction and nonfiction—many picture books for young children. Publishes 40 titles/year; 100% require freelance illustration. Responds "if we have a project that seems right for the artist. We like to see evidence that an artist can show the same children and adults in a variety of moods, poses and environments."

NEEDS Prefers working with artists who have experience illustrating juvenile trade books. Works on assignment only. Illustrators: Send postcard sample and tearsheets. "One sample is not enough. We need at least three. Do *not* send original art through the mail." Accepts disk submissions. Samples are not returned.

FIRST CONTACT & TERMS Rights purchased vary. Original work returned at job's completion. Books need "a young look—we market to preschoolers and children in grades 1-3." Especially looks for "an artist's ability to draw people (especially children) and to set an appropriate mood for the story. Please do NOT submit cartoon art samples or flat digital illustrations."

WILLIAMSON BOOKS

2630 Elm Hill Pike, Suite 100, Nashville TN 37214. **E-mail:** pjay@guideposts.org. **Website:** www.idealspublications.com. Estab. 1983. Publishes trade paperback originals/casebound. Types of books include children's nonfiction (science, history, the arts), creative play, early learning, preschool and educational. Specializes in children's active hands-on learning. Publishes 8 titles/year. Book catalog free for 8½×11 SASE with 6 first-class stamps.

◐ This publisher is an imprint of Ideals Publications, a division of Guideposts.

NEEDS Approached by 100 illustrators and 10 designers/year. 100% of freelance design demands Quark computer skills. "We especially need illustrators whose art communicates with kids and has a vibrant style, as well as a sense of humor and quirky characterizations evident in illustrations. We are not looking for traditional or picture book styles." All illustrations must be provided in scanned, electronic form.

FIRST CONTACT & TERMS "Please do not e-mail large files to us. We prefer receiving postcards with references to your website. We really will look if we are interested." Designers: Send query letter with website or brochure, photocopies, résumé, SASE. Illustrators: Send postcard sample and/or query letter with website or photocopies, résumé and SASE. Samples are filed. Responds only if interested.

DESIGN Pays for design by the project.

TIPS "We are actively seeking freelance illustrators and book designers to support our growing team. We are looking for full color distinctive illustration, along with an 'energized' view of how-to illustrations (always drawn with personality as opposed to technical drawings). Go to the library and look up several of our books in our four series. You'll immediately see what we're all about. Then do a few samples for us. If we're excited about your work, you'll definitely hear from us. We always need designers who are interested in a non-traditional approach to kids' book design. Our books are award-winners, and design and illustration are key elements to our books' phenomenal success."

WILSHIRE BOOK COMPANY

9731 Variel Ave., Chatsworth CA 91311. (818)700-1522. **Fax:** (818)700-1527. **E-mail:** mpowers@mpowers.com. **Website:** www.mpowers.com. **Contact:** Rights Department. Estab. 1947. Publishes trade paperback originals and reprints. Types of books include Internet marketing, humor, instructional, New Age, psychology, self-help, inspirational and other types of nonfiction. Publishes 25 titles/year; 100% require freelance design.

NEEDS Uses freelancers mainly for book covers.

FIRST CONTACT & TERMS Send query letter with fee schedule, tearsheets, photostats, photocopies (copies of previous book covers).

DESIGN Assigns 25 freelance design jobs/year.

JACKETS/COVERS Assigns 25 cover jobs/year.

GREETING CARDS, GIFTS & PRODUCTS

The companies listed in this section contain some great potential clients for you. Although greeting card publishers make up the bulk of the listings, you'll also find many businesses that need images for all kinds of other products. We've included manufacturers of everyday items such as paper plates, napkins, banners, shopping bags, T-shirts, school supplies, personal checks, and calendars, as well as companies looking for fine art for limited edition collectibles.

TIPS FOR GETTING STARTED

Use the following tips as you prepare your greeting card or product submissions:

 1. Read the listings carefully to learn exactly what products each company makes and the specific styles and subject matter they use.

 2. Browse store shelves to see what's out there. Take a notebook and jot down the types of cards and products you see. If you want to illustrate greeting cards, familiarize yourself with the various categories of cards and note which images tend to appear again and again in each category.

 3. Pay attention to the larger trends in society, such as diversity, patriotism, and the need to feel connected to others. Fads such as reality TV and scrapbooking, as well as popular celebrities, often show up in images on cards and gifts. Trends can also be spotted in movies and on websites.

GUIDELINES FOR SUBMISSION

- Do *not* send originals. Companies want to see photographs, photocopies, printed samples, computer printouts, tearsheets, or slides. Many also accept digital files on disk or via e-mail.

GREETING CARD BASICS ///

- Approximately 7 billion greeting cards are purchased annually, generating more than $7.5 billion in retail sales.

- Women buy more than 80% of all greeting cards.

- Seasonal cards express greetings for more than twenty different holidays, including Christmas, Easter and Valentine's Day. Christmas cards account for 60 percent of seasonal greeting card sales.

- Everyday cards express non-holiday sentiments. The "everyday" category includes get well cards, thank you cards, sympathy cards, and a growing number of person-to-person greetings. There are cards of encouragement that say "Hang in there!" and cards to congratulate couples on staying together, or even getting divorced! There are cards from "the gang at the office" and cards to beloved pets. Check store racks for possible "everyday" occasions.

- Categories are further broken down into the following areas: traditional, humorous and alternative. "Alternative" cards feature quirky, sophisticated, or offbeat humor.

- There are more than 3,000 greeting card publishers in America, ranging from small family businesses to major corporations.

- Artwork should be upbeat, brightly colored, and appropriate to one of the major categories or niches popular in the industry.
- Make sure each sample is labeled with your name, address, phone number, e-mail address, and website.
- Send three to five appropriate samples of your work to the contact person named in the listing. Include a brief cover letter with your initial mailing.
- Enclose a self-addressed, stamped envelope (SASE) if you need your samples back.
- Within six months, follow up with another mailing to the same listings and additional card and gift companies you have researched.

Don't overlook the collectibles market

Limited edition collectibles, such as ornaments, figurines, and collector plates, appeal to a wide audience and are a lucrative niche for artists. To do well in this field, you have to be flexible enough to take suggestions. Companies test-market products to find out which images will sell the best, so they will guide you in the creative process. For a collectible plate, for example, your work must fit into a circular format or you'll be asked to extend the painting out to the edge of the plate.

Popular themes for collectibles include animals (especially kittens and puppies), children, dolls, TV nostalgia, patriotic, Native American, wildlife, religious (including madonnas and angels), gardening, culinary, and sports images.

E-cards

Electronic greeting cards are very popular. Many can be sent for free, but they drive people to websites and can, therefore, be a smart marketing tool. The most popular e-cards are animated, and there is an increasing need for artists who can animate their own designs for the Internet, using Flash animation. Search the Internet and visit sites such as www.hallmark.com, www.bluemountain.com, and www.americangreetings.com to get an idea of the variety of images that appear on e-cards. Companies often post their design needs on their websites.

PAYMENT AND ROYALTIES

Most card and product companies pay set fees or royalty rates for design and illustration. Card companies almost always purchase full rights to work, but some are willing to negotiate for other arrangements, such as greeting card rights only. If the company has ancillary plans in mind for your work (calendars, stationery, party supplies, or toys), they will probably want to buy all rights. In such cases, you may be able to bargain for higher payment. For more tips, see Copyright Basics in the Business Basics section.

KURT S. ADLER, INC.

7 W. 34th St., New York NY 10001. (212)924-0900. **E-mail:** info@kurtadler.com. **Website:** www.kurtadler.com. **Contact:** Howard Adler, president. Estab. 1946. Manufacturer and importer of Christmas ornaments and giftware products. Produces collectible figurines, decorations, gifts, ornaments.

NEEDS Prefers freelancers with experience in giftware. Considers all media. Will consider all styles appropriate for Christmas ornaments and giftware. Produces material for Christmas, Halloween.

FIRST CONTACT & TERMS Send query letter with brochure, photocopies, photographs. Responds within 1 month. Will contact for portfolio review if interested. Payment negotiable.

TIPS "We rely on freelance designers to give our line a fresh, new approach and innovative new ideas."

ALEF JUDAICA, INC.

13310 S. Figueroa St., Los Angeles CA 90061. (310)630-0024; (800)262-2533. **Fax:** (310)808-0940. **E-mail:** sales@alefjudaica.com. **Website:** www.alefjudaica.com. Estab. 1979. Manufacturer and distributor of a full line of Judaica, including menorahs, Kiddush cups, greeting cards, giftwrap, tableware, etc.

NEEDS Approached by 15 freelancers/year. Works with 10 freelancers/year. Buys 75-100 freelance designs and illustrations/year. Prefers local freelancers with experience. Works on assignment only. Uses freelancers for new designs in Judaica gifts (menorahs, etc.) and ceramic Judaica. Also for calligraphy, pasteup and mechanicals. All designs should be upper scale Judaica.

FIRST CONTACT & TERMS Mail brochure, photographs of final art samples. Art director will contact artist for portfolio review if interested, or portfolios may be dropped off every Friday. Sometimes requests work on spec before assigning a job. Pays $300 for illustration/design; pays royalties of 10%. Considers buying second rights (reprint rights) to previously published work.

ALLPORT EDITIONS

2337 NW York St., Portland OR 97210. (503)223-7268. **Fax:** (503)223-9182. **E-mail:** art@allport.com. **Website:** www.allport.com/artists_commitment.aspx. Produces greeting cards. Specializes in regional designs (American cities and states). Currently only working with hand-rendered art (pen & ink, watercolor, acrylic, etc.). Does not use any photography. Art guidelines available on website.

NEEDS Approached by 200 freelancers/year. Works with 2-3 freelancers/year. Licenses 60 freelance designs and illustrations/year. Prefers art scaleable to card size. Produces material for holidays, birthdays and everyday. Submit seasonal material 1 year in advance.

FIRST CONTACT & TERMS Send query letter with photocopies and SASE. Accepts submissions on disk compatible with PC-formatted TIFF or JPEG files. Samples are filed or returned by SASE. Responds in 4-5 months if response is requested. Rights purchased vary according to project. All contracts on royalty basis.

TIPS "Submit just enough samples for us to get a feel for your style/collection. Two is probably too few; 40 is far too many."

AMCAL, INC.

4751 Hempstead Station Dr., Kettering OH 45429. (937)495-6323; (800)958-4785. **Fax:** (937)495-3192. **Website:** www.amcalart.com; www.meadwestvaco.com. Publishes calendars, note cards, Christmas cards and other stationery items and books. Markets to a broad distribution channel, including better gifts, books, department stores and larger chains throughout U.S. Some sales to Europe, Canada and Japan. "We look for illustration and design that can be used in many ways: calendars, note cards, address books and more, so we can develop a collection. We license art that appeals to a widely female audience."

NEEDS Prefers work in horizontal format. No gag humor or cartoons. Art guidelines available for SASE with first-class postage or online.

FIRST CONTACT & TERMS Send query letter with brochure, résumé, photographs, slides, tearsheets and transparencies. Include a SASE for return of material. Responds within 6 weeks. Will contact artist for portfolio review if interested. Pays for illustration by the project, advance against royalty.

TIPS "Research what is selling and what's not. Go to gift shows and visit lots of stationery stores. Read all the trade magazines. Talk to store owners."

AMERICAN GREETINGS CORPORATION

One American Rd., Cleveland OH 44144-2398. (216)252-7300, ext. 4931. **Fax:** (216)252-6778. **Website:** www.corporate.americangreetings.com. Estab. 1906. Produces greeting cards, stationery, calendars,

paper tableware products, giftwrap and ornaments. Also recruiting for AG Interactive.

NEEDS Prefers designers with experience in illustration, graphic design, surface design and calligraphy. Also looking for skills in motion graphics, Photoshop, animation and strong drawing skills. Usually works from a list of 100 active freelancers.

FIRST CONTACT & TERMS Apply online. Submission guidelines available online.

TIPS "Get a BFA in graphic design with a strong emphasis on typography."

ANW/CREATIVITY WORKS

510 Ryerson Rd., Lincoln Park NJ 07035. (973)406-5000. **E-mail:** katey@anwcrestwood.com. **Website:** www.anwcrestwood.com. **Contact:** Katey Franceschini, creative department. Estab. 1901. Produces stationery, scrapbook and paper crafting. Specializes in stationery, patterned papers, stickers and related paper products.

NEEDS Approached by 100 freelancers/year. Works with 20 freelancers/year. Buys or licenses 150 freelance illustrations and design pieces/year. Prefers freelancers with experience in illustration/fine art, stationery design/surface design. Works on assignment only. Considers any medium that can be scanned.

FIRST CONTACT & TERMS Mail or e-mail nonreturnable color samples. Company will call if there is a current or future project that is relative. Accepts Mac-compatible disk and e-mail submissions. Samples are filed for future projects. Will contact artist for more samples and to discuss project. Pays for illustration by the project, $100 and up. Also considers licensing for complete product collections. Finds freelancers through trade shows and *Artist's & Graphic Designer's Market Book*.

TIPS "Research the craft and stationery market and send only appropriate samples for scrapbooking, cardcrafting and stationery applications. Send lots of samples, showing your best, neatest and cleanest work with a clear concept."

AR-EN PARTY PRINTERS, INC.

8225 N. Christiana Ave., Skokie IL 60076. (847)673-7390. **Fax:** (847)673-7379. **E-mail:** dori@ar-en.net; artwork@ar-en.net. **Website:** www.ar-en.com. Estab. 1978. Produces stationery and paper tableware products. Makes personalized party accessories for weddings and all other affairs and special events.

NEEDS Works with 1-2 freelancers/year. Buys 10 freelance designs and illustrations/year. Works on assignment only. Uses freelancers mainly for new designs; also for calligraphy. Looking for contemporary and stylish designs, especially b&w line art (no grayscale) to use for hot stamping dyes. Prefers small (2×2) format.

FIRST CONTACT & TERMS Send query letter with brochure, résumé and SASE. Samples are filed or returned by SASE if requested by artist. Responds in 2 weeks. Will contact artist for portfolio review if interested. Rights purchased vary according to project.

TIPS "My best new ideas always evolve from something I see that turns me on. Do you have an idea/style that you love? Market it. Someone out there needs it."

ARTFUL GREETINGS

2104 Riddle Rd., Durham NC 27713. (919)598-7599. **Fax:** (919)598-1381. **E-mail:** myw@artfulgreetings.com. **Website:** www.artfulgreetings.com. Estab. 1990. Produces bookmarks, greeting cards, T-shirts and magnetic notepads. Specializes in multicultural subject matter, all ages.

NEEDS Approached by 200 freelancers/year. Works with 10 freelancers/year. Buys 20 freelance designs and illustrations/year. No b&w art. Uses freelancers mainly for cards. Considers bright color art, no photographs. Looking for art depicting people of all races. Prefers a multiple of 2 sizes: 5×7 and 5½×8. Produces material for Christmas, Mother's Day, Father's Day, graduation, Kwanzaa, Valentine's Day, birthdays, everyday, sympathy, get well, romantic, thank you, woman-to-woman and multicultural. Submit seasonal material 1 year in advance.

FIRST CONTACT & TERMS Designers: Send photocopies, SASE, slides, transparencies (call first). Illustrators: Send photocopies (call first). May send samples and queries by e-mail. Samples are filed. Artist should follow up with call or letter after initial query. Will contact for portfolio review of color slides and transparencies if interested. Negotiates rights purchased. Pays for illustration by the project, $50-100. Finds freelancers through word of mouth, NY Stationery Show.

ARTISTS TO WATCH

1766 E. Highway 36, Studio B, Maplewood MN 55109. (651)222-8102. **E-mail:** submissions@artiststowatch.com. **Website:** www.artiststowatch.com. "Manufacturer of high-quality greeting cards featuring the

work of contemporary international artists. We have national and international distribution—great exposure for accomplished artists."

NEEDS Art submission guidelines available on the website. We encourage printmakers of all kind to submit, but also considers all types of media.

FIRST CONTACT & TERMS "E-mail small JPEG files or website URL. If you prefer, you may mail 10 samples of work. No originals please, include SASE if you'd like your work returned. We will respond within 12 weeks. We will contact you if we'd like to see more. Use of artwork is compensated with royalty payments."

ART LICENSING

450 Applejack Rd., Manchester Center VT 05255. (802)362-3662. **Fax:** (802)362-3286. **E-mail:** jack@ applejackart.com. **Website:** www.artlicensing.com. Licenses art for bookmarks, calendars, collectible figurines, decorative housewares, decorations, games, giftbags, gifts, giftwrap, greeting cards, limited edition plates, mugs, ornaments, paper tableware, party supplies, personal checks, posters, prints, school supplies, stationery, T-shirts, textiles, toys, wallpaper, etc.

NEEDS Seeking extensive artwork for use on posters and a wide cross section of product categories. Looking for variety of styles and subject matter. Art guidelines free for SASE with first-class postage. Considers all media and all styles. Produces material for all holidays.

FIRST CONTACT & TERMS Send color photocopies, photographs, tearsheets, CD. No e-mail submissions. Accepts disk submissions compatible with Mac. Samples are filed or returned by SASE only. Responds in 1 month. Will contact artist for portfolio review if interested.

ARTVISIONS™: FINE ART LICENSING

12117 SE 26th St., Bellevue WA 98005-4118. **E-mail:** See website for contact form. **Website:** www.artvisions.com. **Contact:** Neil Miller, president. Estab. 1993. Licenses fine art and professional photography. Fine art and professional photography licensing only. Review guidelines on website. "Not currently seeking new talent. However, we are always willing to view the work of top-notch established artists. If you fit this category, please contact ArtVisions via the website contact form and include a link to a website where your art can be seen."

"To gain an idea of the type of art we license, please view our website. Artist MUST be able to provide high-res, professionally made digital files of artwork on DVD. We are firmly entrenched in the digital world, if you are not, then we cannot represent you."

FIRST CONTACT & TERMS Written contract provided.

TIPS "If you need advice about marketing your art, please visit: www.artistsconsult.com."

BARTON-COTTON, INC.

3030 Waterview Ave., Baltimore MD 21230. (800)348-1102. **Fax:** (410)565-5011. **E-mail:** info@bartoncotton.com. **E-mail:** art.submission@bartoncotton.com. **Website:** www.bartoncotton.com. Produces religious greeting cards, commercial all-occasion, Christmas cards, wildlife designs and spring note cards. Licenses wildlife art, photography, traditional Christmas art for note cards, Christmas cards, calendars and all-occasion cards.

NEEDS Buys 150-200 freelance illustrations/year. Please submit no more then 15-20 pieces of your work in a neat and orderly format. When reviewing the artwork we are looking for concept, style, drawing skill, and color usage. Submit seasonal work any time. Free art guidelines for SASE with first-class postage and sample cards; specify area of interest (religious, Christmas, spring, etc.).

FIRST CONTACT & TERMS Send query letter with résumé, tearsheets, photocopies or slides. Submit full-color work only (watercolor, gouache, pastel, oil and acrylic). Previously published work and simultaneous submissions accepted. Responds in 1 month. Pays by the project. Pays on acceptance.

TIPS "Spend some time studying current market trends in the greeting card industry. There is an increased need for creative ways to paint traditional Christmas scenes with up-to-date styles and techniques." See website for more guidelines.

BEISTLE COMPANY

1 Beistle Plaza, Shippensburg PA 17257-9623. (717)532-2131. **Fax:** (717)532-7789. **E-mail:** rlbuterbaugh@beistle.com. **Website:** www.beistle.com. **Contact:** Rick Buterbaugh, art director. Estab. 1900. Manufacturer of paper and plastic decorations, party goods, gift items, tableware and greeting cards. Targets general public, home consumers through point

of purchase (P-O-P) displays, specialty advertising, school market and other party good suppliers.

NEEDS Approached by 250-300 freelancers/year. Works with 50 freelancers/year. Prefers artists with experience in designer gouache illustration. Also needs digital art (Mac platform or compatible). Art guidelines available. Looks for full-color, camera-ready artwork for separation and offset reproduction. Works on assignment only. Uses freelance artists mainly for product rendering and brochure design and layout. Prefers digital art using various styles and techniques. 50% of freelance design and 50% of illustration demand knowledge of QuarkXPress, Illustrator, Photoshop or Painter.

FIRST CONTACT & TERMS Send query letter with résumé and color reproductions with SASE. Samples are filed or returned by SASE. Art director will contact artist for portfolio review if interested. Sometimes requests work on spec before assigning a job. Pays by the project. Considers buying second rights (reprint rights) to previously published work. Finds artists through word of mouth, magazines, submissions/self-promotions, sourcebooks, agents, visiting artists' exhibitions, art fairs and artists' reps.

TIPS "Our primary interest is in illustration; often we receive freelance propositions for graphic design brochures, logos, catalogs, etc. These are not of interest to us as we are manufacturers of printed decorations. Send color samples rather than b&w."

BELLAMUSE

71 Nassau St., 2nd Floor, New York NY 10038. (212)727-0102;. **Fax:** (212)727-2102. **E-mail:** info@bellamuse.com. **Website:** www.bellamuse.com. Estab. 2003. "BellaMuse was established in 2003 by artist and typographer Alicia Peck. Alicia's work draws upon a love of writing, whimsy, humor, and antique illustrations. Little luxuries from BellaMuse are sold in upscale home stores and boutiques throughout the U.S."

NEEDS Produces conventional, formal, counter humor, alternative and cute cards and gifts. Categories include: Mother's Day, Christmas, Thanksgiving, graduation, birthday, Father's Day, Easter, Halloween, Valentine's Day, congratulations, wedding/anniversary, get-well/sympathy and everyday. Artists should be familiar with Adobe Illustrator, InDesign and Photoshop. Could use freelance Web design; designers should be familiar with Dreamweaver, Flash, GoLive and HTML. Submitted samples are kept on file. Seasonal material should be submitted 10 months in advance.

FIRST CONTACT & TERMS Send a query letter, e-mail or postcard sample including artist's URL, résumé, tearsheets and photographs. Follow up every 3 months.

BERGQUIST IMPORTS, INC.

1412 Hwy. 33 S., Cloquet MN 55720. (800)328-0853. **Fax:** (218)879-0010. **E-mail:** info@bergquistimports.com. **Website:** www.bergquistimports.com. Estab. 1948. Produces paper napkins, mugs and tile. Wholesaler of mugs, decorator tile, plates and dinnerware.

NEEDS Approached by 25 freelancers/year. Works with 5 freelancers/year. Buys 50 designs and illustrations/year. Prefers freelancers with experience in Scandinavian designs. Works on assignment only. Also uses freelancers for calligraphy. Produces material for Christmas, Valentine's Day and everyday. Submit seasonal material 6-8 months in advance.

FIRST CONTACT & TERMS Send query letter with brochure, tearsheets and photographs. Samples are returned, not filed. Responds in 2 months. Request portfolio review in original query. Artist should follow up with a letter after initial query. Portfolio should include roughs, color tearsheets and photographs. Rights purchased vary according to project. Originals are returned at job's completion. Requests work on spec before assigning a job. Pays by the project, $50-300; average flat fee of $100 for illustration/design; or royalties of 5%. Finds artists through word of mouth, submissions/self-promotions and art fairs.

BERWICK OFFRAY

350 Clark Dr., Budd Lake NJ 07828. (973)527-6137. **Contact:** Patti Jo Smith, director of creative and design. Estab. 1900. Produces ribbons, gift bags, wrapping paper, tissues and more. "We're mainly a ribbon company. For ribbon designs we look to the textile design studios and textile-oriented people; children's designs, craft motifs, fabric trend designs, floral designs, Christmas designs, bridal ideas, etc. Our range of needs is wide, so we need various looks."

NEEDS Looking for artists able to translate a trend or design idea into a 1½" to 2½" width ribbon. Produce ribbons for Fall/Christmas, Valentine's Day, Easter, bridal and everyday.

FIRST CONTACT & TERMS Send postcard sample or query letter with résumé or call.

GENE BLILEY STATIONERY

100 N. Park Ave., Peru IN 46970. (800)277-5458. **Fax:** (800)329-1669. **E-mail:** artwork@chatsworthcollect ion.com. **Website:** www.chatsworthcollection.com. **Contact:** Art director. Estab. 1967. Produces stationery, family-oriented birth announcements and invitations for most events and Christmas cards.

○ This company also owns Editions Limited and Frederick Beck Originals. One submission will be seen by both companies. See listing for Editions Limited/Frederick Beck.

BLOOMIN' FLOWER CARDS

4734 Pearl St., Boulder CO 80301. (800)894-9185, ext. 2. **E-mail:** flowers@bloomin.com. **Website:** bloomin. com. Estab. 1995. Produces greeting cards, stationery and gift tags—all embedded with seeds.

NEEDS Approached by 100 freelancers/year. Works with 5-8 freelancers/year. Buys 5-8 freelance designs and illustrations/year. Art guidelines available. Uses freelancers mainly for card images. Considers all media. Looking for florals, garden scenes, holiday florals, birds, and butterflies—bright colors, no photography. Produces material for Christmas, Easter, Mother's Day, Father's Day, Valentine's Day, Earth Day, birthdays, everyday, get well, romantic and thank you. Submit seasonal material 8 months in advance.

FIRST CONTACT & TERMS Accepts digital submissions only—show us samples of your work. Responds if interested. Finds freelancers through word of mouth, submissions, and local artists' guild.

TIPS "All submissions *must* be relevant to flowers and gardening."

BLUE MOUNTAIN ARTS, INC.

P.O. Box 4549, Boulder CO 80306. (303)449-0536; (800)525-0642. **Fax:** (800)545-8573. **E-mail:** editor ial@sps.com. **Website:** www.sps.com. Estab. 1970. Produces books, bookmarks, calendars, greeting cards, mugs and prints. Specializes in handmade-looking greeting cards, calendars and books with inspirational or whimsical messages accompanied by colorful hand-painted illustrations.

NEEDS Art guidelines via e-mail. Uses freelancers mainly for hand-painted illustrations. Considers all media. Product categories include alternative cards, alternative/humor, conventional, cute, inspirational and teen. Submit seasonal material 10 months in advance. Art size should be 5×7 vertical format for greeting cards.

FIRST CONTACT & TERMS Send query letter with photocopies, photographs, SASE and tearsheets. Send no more than 5 illustrations initially. Or e-mail with subject line "Greeting Card Submission." No phone calls or faxes. Samples are filed or are returned by SASE. Responds in 2 months. Portfolio not required. Buys all rights. Pays freelancers flat rate: $150-250/ illustration if chosen. Finds freelancers through submissions and word of mouth.

TIPS "We are an innovative company, always looking for fresh and unique art styles to accompany our sensitive or whimsical messages. We also welcome illustrated cards accompanied with your own editorial content. We strive for a handmade look. We love color! We don't want photography! We don't want slick computer art! Do in-store research to get a feel for the look and content of our products. We want illustrations for printed cards, not e-cards! We want to see illustrations that fit with our existing looks, and we also want fresh, new and exciting styles and concepts. Remember that people buy cards for what they say. The illustration is a beautiful backdrop for the message."

⊙ BLUE MOUNTAIN WALLCOVERINGS

15 Akron Rd., Toronto M8W 1T3, Canada. (800)219-2424. **Fax:** (800)741-2083. **E-mail:** info@blmtn.com. **Website:** www.blmtn.com. Produces wallpaper.

NEEDS Works with 20-50 freelancers/year. Prefers local designers/illustrators with experience in wallpaper. Art guidelines available. Product categories include conventional, country, juvenile and teen. 5% of freelance work demands knowledge of Photoshop.

FIRST CONTACT & TERMS Send brochure, photocopies and photographs. Samples are filed. Responds only if interested. Company will contact artist for portfolio review of color, finished art, original art, photographs, transparencies if interested. Buys rights for wallpaper or all rights. Pays freelancers by the project. Finds freelancers through agents, artist submissions and word of mouth.

BON ARTIQUE.COM/ART RESOURCES INTERNATIONAL, LTD.

Bon Art, 66 Fort Point St., Norwalk CT 06855. (203)845-8888. **E-mail:** info@bonartique.com. **Website:** www.bonartique.com. **Contact:** Brett Bennist, art coordinator. Estab. 1980. Art publisher, poster company, licensing and design studio. Publishes/distributes fine art prints, canvas transfers, unlimited editions, offset reproductions and posters. Clients: In-

ternet purveyors of art, picture frame manufacturers, catalog companies, distributors.

NEEDS Seeking decorative and fashionable art for the commercial and designer markets. Considers oil, acrylic, pastel, watercolor and mixed media. Artists represented include Eric Yang, Tom Butler, Mid Gordon, Martin Wiscombe, Julia Hawkins, Gloria Ericksen, Janet Stever, Louise Montillio, Maxwell Hutchinson, Bennie Diaz and Tina Chaden. Editions are created by collaborating with the artist or by working from an existing painting. Approached by 500 artists/year. Publishes/distributes the work of 30 emerging artists/year.

FIRST CONTACT & TERMS E-mail or send query letter with brochure, samples, photographs, URL. Accepts e-mail submissions with image files or link to website. Prefers JPEG or TIFF files. Samples are kept on file or returned by SASE if requested. Responds only if interested. Will contact artist for portfolio review if interested. Portfolio should include b&w, color, finished art, roughs, photographs. Pays flat fee or royalties. Offers advance when appropriate. Rights purchased vary according to project; negotiated. Requires exclusive representation. Provides insurance while work is at firm, shipping from firm, promotion and written contract. Finds artists through agents/reps, submissions, portfolio reviews, art fairs/exhibits, word of mouth, referrals by other artists, magazines, sourcebooks, Internet.

TIPS "We welcome submissions from a wide range of international artists. As leaders in the field of fine art publishing for the past 30 years, we believe in sharing our knowledge of the trends, categories and styles with our artists. Although interested in working with veterans of our industry, we actively recruit and encourage all accomplished artists to submit their portfolios—preferably by e-mail with links to images."

ASHLEIGH BRILLIANT ENTERPRISES

117 W. Valerio St., Santa Barbara CA 93101. (805)682-0531. **E-mail:** ashleigh@west.net; ashleigh@ashleighbrilliant.com. **Website:** www.ashleighbrilliant.com. **Contact:** Ashleigh Brilliant, president. Publishes postcards.

○ Prefers single-panel. Maximum size of artwork: 5½×3½, horizontal only. Samples are returned by SASE if requested by artist. Responds in 2 weeks. **Pays on acceptance:** minimum flat fee of $60. Buys all rights. Syndicate

owns original art. "Our product is so unusual that freelancers will be wasting their time and ours unless they first carefully study our catalog. Our product is so unusual that freelancers will be wasting their time and ours unless they first carefully study our catalog."

NEEDS Buys up to 300 designs/year. Freelancers may submit designs for word-and-picture postcards, illustrated with line drawings.

FIRST CONTACT & TERMS Submit 5½×3½ horizontal b&w line drawings and SASE. Responds in 2 weeks. Buys all rights. Pays $60 minimum.

BRISTOL GIFT CO., INC.

6 North St., P.O. Box 425, Washingtonville NY 10992. (845)496-2821; (800)225-8234. **E-mail:** bristol6@frontiernet.net. **Website:** www.bristolgift.net. Estab. 1988. Specializes in framed pictures for inspiration and religious markets. Art guidelines available for SASE.

NEEDS Approached by 5-10 freelancers/year. Works with 2 freelancers/year. Buys 15-30 freelance designs and illustrations/year. Works on assignment only. Uses freelancers mainly for design; also for calligraphy, P-O-P displays, Web design and mechanicals. Prefers 16×20 or smaller. 10% of design and 60% of illustration require knowledge of PageMaker or Illustrator. Produces material for Christmas, Mother's Day, Father's Day and graduation. Submit seasonal material 6 months in advance.

FIRST CONTACT & TERMS Send query letter with brochure and photocopies. Samples are filed or returned. Responds in 2 weeks. Will contact artist for portfolio review if interested. Portfolio should include roughs. Requests work on spec before assigning a job. Originals are not returned. Pays by the project, $30-50 or royalties of 5-10%. Rights purchased vary according to project. Interested in buying second rights (reprint rights) to previously published artwork.

BRUSH DANCE, INC.

165 N. Redwood Dr., Suite 200, San Rafael CA 94903. **E-mail:** art@brushdance.com. **Website:** www.brushdance.com. **Contact:** April Welches-Greenhill. Estab. 1989. Produces greeting cards, stationery, blank journals, illustrated journals, boxed notes, calendars, holiday cards and magnets. The line of Brush Dance products is inspired by the interplay of art and words. "We develop products that combine powerful and play-

ful words and images that act as daily reminders to inspire, connect, challenge and support."

NEEDS Approached by 200 freelancers/year. Works with 3-5 freelancers/year. Uses freelancers for illustration, photography and calligraphy. Looking for nontraditional work conveying emotion or message. "We are also interested in artists who are using both images and original words in their work."

FIRST CONTACT & TERMS Submission guidelines available online. Please limit custom formats to no larger than 11×14. Please do not send original artwork as we are unable to return your submissions.

TIPS "*Please* do your research, and look at our website to be sure your work will fit into our line of products."

✚ CALYPSO CARDS

DamonMill Square, Suite 6B, Concord MA 01640. (978)287-5900. **Fax:** (978)287-5902. **E-mail:** nicky@calypsocards.com. **E-mail:** submissions@calypsocards.com. **Website:** www.calypsocards.com. Estab. 2004. Produces greeting cards and fridge magnets. Specializes in greeting cards for all occasions and ages, with contemporary design.

NEEDS Works with 50-100 freelancers/year. Buys 200+ freelance design and illustrations/year. Art submission guidelines free on website. Product categories include alternative, counter humor, alternative/humor, inspirational, juvenile. Produces material for all holidays and seasons. Submit seasonal material one year in advance.

FIRST CONTACT & TERMS E-mail query letter. Samples kept on file or returned with SASE. Responds only if interested. Portfolio not required. Buys rights for cards. Freelancers paid royalties of 8%. Finds freelancers through agents/reps, submissions, word-of-mouth and online.

TIPS "Send examples of work via e-mail. We will contact you within 3-4 months if interested."

CANETTI DESIGN GROUP, INC.

P.O. Box 57, Pleasantville NY 10570. (914)238-1359. **Fax:** (914)238-0106. **E-mail:** info@canettidesigngroup.com. **Website:** www.canettidesigngroup.com. Estab. 1982. Produces photo frames, writing instruments, kitchen accessories and product design.

NEEDS Approached by 50 freelancers/year. Works with 10 freelancers/year. Works on assignment only. Uses freelancers mainly for illustration/computer. Also for calligraphy and mechanicals. Considers all media. Looking for contemporary style. Needs computer-literate freelancers for illustration and production. 80% of freelance work demands knowledge of Illustrator, Photoshop, Quark.

FIRST CONTACT & TERMS Send postcard-size sample of work and query letter with brochure. Samples are not filed. Portfolio review not required. Buys all rights. Originals are not returned. Pays by the hour. Finds artists through agents, sourcebooks, magazines, word of mouth and artists' submissions.

CAPE SHORE, INC.

86 Downeast Dr., Yarmouth ME 04096. (800)343-2424. **Fax:** (800)457-7087. **E-mail:** webmail@downeastconcepts.com. **Website:** www.downeastconcepts.com. **Contact:** Creative Director. Estab. 1947. "Cape Shore is concerned with seeking, manufacturing and distributing a quality line of gifts and stationery for the souvenir and gift market." Licenses art by noted illustrators with a track record for paper products and giftware. Guidelines available online.

NEEDS Approached by 100 freelancers/year. Works with 50 freelancers/year. Buys 400 freelance designs and illustrations/year. Prefers artists and product designers with experience in gift product, hanging ornament and stationery markets. Art guidelines available free for SASE. Uses freelance illustration for boxed note cards, Christmas cards, ornaments, home accessories, ceramics and other paper products. Considers all media. Looking for skilled wood carvers with a warm, endearing folk art style for holiday gift products.

FIRST CONTACT & TERMS "Do not call; no exceptions." Send query letter with color copies. Samples are filed or are returned by SASE. Art director will contact artist for portfolio review if interested. Portfolio should include finished samples, printed samples. Pays for design by the project, advance on royalties or negotiable flat fee. Buys varying rights according to project.

TIPS "Cape Shore is looking for realistic detail, good technique, and traditional themes or very high quality contemporary looks for coastal as well as inland markets. We will sometimes buy art for a full line of products, or we may buy art for a single note or gift item. Proven success in the giftware field a plus, but will consider new talent and exceptional unpublished illustrators."

CARDMAKERS

424 Fore St., Portland ME 04101. (207)761-4279. E-mail: info@cardmakers.com. Website: www.card makers.com. Contact: James A. Meserve. Estab. 1978. "We produce cards for special interests and greeting cards for businesses—primarily Christmas-themed. We also publish everyday cards for stockbrokers and boaters."

NEEDS Approached by more than 300 freelancers/year. Works with 5-10 freelancers/year. Buys 20-40 designs and illustrations/year. Prefers professional-caliber artists. Art guidelines available on website only. "Please do not e-mail us for same." Works on assignment only. Uses freelancers mainly for greeting card design and calligraphy. Considers all media. "We market 5×7 cards designed to appeal to individual's specific interest-boating, building, cycling, stocks and bonds, etc." Prefers an upscale look. Submit seasonal ideas 6-9 months in advance.

FIRST CONTACT & TERMS Submit via online submission form. Artists may submit 6-8 JPEGs at 72 dpi.

TIPS "We like to see new work in the early part of the year. Getting published and gaining experience should be the main objective of freelancers entering the field. We favor fresh talent (but do also feature seasoned talent). PLEASE be patient waiting to hear from us! Make sure your work is equal to or better than that which is commonly found in use presently. Go to a large greeting card store. If you think you're as good or better than the artists there, continue!"

CENTRIC CORP.

6712 Melrose Ave., Los Angeles CA 90038. (323)936-2100. **Fax:** (323)936-2101. **E-mail:** centric@juno.com. **Website:** www.centriccorp.com. Estab. 1986. Produces products such as watches, pens, T-shirts, pillows, clocks, and mugs. Specializes in products that feature nostalgic, humorous, thought-provoking images or sayings on them and some classic licensed celebrities.

NEEDS Looking for freelancers who know Photoshop, QuarkXPress and Illustrator well.

FIRST CONTACT & TERMS Send examples of your work. Pays when project is completed.

TIPS "Research the demographics of buyers who purchase Elvis, Lucy, Marilyn Monroe, James Dean, Betty Boop and Bettie Page products to know how to 'communicate a message' to the buyer."

CITY MERCHANDISE, INC.

228 40th St., Brooklyn NY 11232. (718)832-2931. **Fax:** (718)832-2939. **E-mail:** city@citymerchandise.com. **Website:** www.citymerchandise.com. Produces calendars, collectible figurines, gifts, mugs, souvenirs of New York.

NEEDS Works with 6-10 freelancers/year. Buys 50-100 freelance designs and illustrations/year. "We buy sculptures for our casting business." Prefers freelancers with experience in graphic design. Works on assignment only. Uses freelancers for most projects. Considers all media. 50% of design and 80% of illustration demand knowledge of Photoshop, QuarkXPress, Illustrator. Does not produce holiday material.

FIRST CONTACT & TERMS Designers: Send query letter with brochure, photocopies, résumé. Illustrators or cartoonists: Send postcard sample of work only. Sculptors: Send résumé and slides, photos or photocopies of their work. Samples are filed. Include SASE for return of samples. Responds in 2 weeks. Portfolios required for sculptors only if interested in artist's work. Buys all rights. Pays by project.

CLAY ART

389 Oyster Point Blvd., Suite 6, South San Francisco CA 94080. (800)252-9555. **Fax:** (650)238-1100. **E-mail:** sales@clayart.net. **Website:** www.clayart.net. **Contact:** Art director. Estab. 1979. Produces giftware and home accessory products cookie jars, salt & peppers, mugs, pitchers, platters and canisters. Line features innovative, contemporary or European tableware and hand-painted designs.

NEEDS Approached by 70 freelancers/year. Prefers freelancers with experience in 3D design of giftware and home accessory items. Works on assignment only. Uses freelancers mainly for illustrations and 3D design. Seeks humorous, whimsical, innovative work.

FIRST CONTACT & TERMS Send query letter with résumé, SASE, tearsheets and photocopies. Samples are filed. Responds only if interested. Call for appointment to show portfolio of thumbnails, roughs, final art, color photostats, tearsheets, slides and dummies. Negotiates rights purchased. Originals are returned at job's completion. Pays by project. Prefers buying artwork outright.

COMSTOCK CARDS

600 S. Rock Blvd., Suite 15, Reno NV 89502. (775)856-9400 or (800)326-7825. **Fax:** (775)856-9406 or (888)266-2610. **E-mail:** production@comstockcards.

com. **Website:** www.comstockcards.com. Estab. 1986. Produces greeting cards, giftbags and invitations. Styles include alternative and adult humor, outrageous and shocking themes. Art guidelines available for SASE with first-class postage.

NEEDS Approached by 250-350 freelancers/year. Works with 30-35 freelancers/year. "Especially seeking artists able to produce outrageous adult-oriented cartoons." Uses freelancers mainly for cartoon greeting cards. No verse or prose. Gaglines must be brief. Prefers 5×7 final art. Produces material for all occasions. Submit holiday concepts 6 months in advance.

FIRST CONTACT & TERMS Send query letter with SASE, tearsheets or photocopies. Samples are not usually filed and are returned by SASE if requested. Responds only if interested. Portfolio review not required. Originals are not returned. Pays royalties of 5%. Pays by the project, $50-150 minimum; may negotiate other arrangements. Buys all rights.

TIPS "Submit with SASE if you want material returned."

COURAGE CARDS

3915 Golden Valley Rd., Minneapolis MN 55422. (763)520-0239 or (888)413-3323. **Fax:** (763)520-0299. **E-mail:** artsearch@couragecenter.org. **Website:** www. couragecards.org. Estab. 1959. "Courage Cards is a greeting card company that produces a holiday card collection to support the programs of Courage Center, a nonprofit rehabilitation and resource center advancing the lives of people with disabilities."

NEEDS Seeking colorful holiday artwork that is appropriate for greeting cards, including traditional Christmas, city scenes, winter landscape, peace, international and fall seasonal images. Courage Cards supports the works of artists with a disability, but all artists are encouraged to enter the annual Courage Card Art Search.

FIRST CONTACT & TERMS Submit online, or call or e-mail name and address to receive Art Search guidelines, which are mailed in September for the November 30 entry deadline. Do not send original artwork! Responds within 5 months. Submissions returned with an SASE. Courage Cards pays a licensing fee of $400 per selected image chosen, which secures reprint rights for Courage Cards for 5 years. Artist retains ownership of their artwork. Artists are recognized through a nationwide distribution of more than 900,000 catalogs and promotional pieces, Internet, radio, TV and print advertising.

CREATIF LICENSING

31 Old Town Crossing, Mt. Kisco NY 10549. (914)241-6211. **E-mail:** info@creatifusa.com. **Website:** www. creatifusa.com. Estab. 1975. "Creatif is a licensing agency that represents artists and brands." Licensing art for commercial applications on consumer products in the gift, stationery and home furnishings industries.

NEEDS Looking for unique art styles or concepts that are applicable to multiple products and categories.

FIRST CONTACT & TERMS Send query letter with photocopies, photographs, SASE or tearsheets. Does not accept e-mail attachments but will review website links. Responds in 2 months. Samples are returned with SASE. Creatif will obtain licensing agreements on behalf of the artists, negotiate and manage the licensing programs and pay royalties. Artists are responsible for filing all copyright and trademark. Requires exclusive representation of artists. Also, the exclusivity is for "core" artists, meaning artists we work with day in day out. We will represent artists on a non-exclusive basis if their art has limited but specialized licensing application.

TIPS "We are looking to license talented and committed artists. It is important to understand current trends, and design with specific products in mind."

SUZANNE CRUISE CREATIVE SERVICES, INC.

7199 W. 98th Ter., #110, Overland Park KS 66212. (913)648-2190. **Fax:** (913)648-2110. **E-mail:** artagent@ cruisecreative.com. **Website:** www.cruisecreative. com. **Contact:** Suzanne Cruise, president. Estab. 1990.

NEEDS Seeks established and emerging artists, as well as product designers, with distinctive styles suitable for the ever-changing consumer market. Looking for artists that manufacturers cannot find, or artists who are looking for a well-established licensing agency to fully represent their work. We represent established licensing artists as well as artists whose work has the potential to become a classic license. "We work with artists who offer a variety of styles, and we license their work to manufacturers of goods that include, but are not limited to: gifts, home decor, greeting cards, gift wrap and bags, paper party ware and textiles. We look for work that has popular appeal and we prefer that portfolio contain both seasonal as well

as everyday images. It can be traditional, whimsical, floral, juvenile, cute or contemporary in style."

FIRST CONTACT & TERMS Send query letter with color copies, a low-res disk with color copies, samples or low-res JPEGs. Please don't send original art. Samples are returned only if accompanied by SASE. Responds only if interested. Portfolio required. Request portfolio review in original query.

CSI CHICAGO, INC.

4353 N. Lincoln Ave., Chicago IL 60618. (773)665-2226. **Fax:** (773)665-2228. **E-mail:** csichicago1@yahoo.com. **Website:** www.custom-studios.com. Estab. 1966. We specialize in designing and screen printed custom T-shirts, coffee mugs, bumper stickers, balloons and over 1,000 other products for schools, business promotions, fund-raising and for our own line of stock designs for retail sale.

NEEDS Works with 4 freelance illustrators/year. Assigns 9 freelance jobs/year. Needs b&w illustrations (some original and some from customer's sketch). Uses artists for direct mail and brochures/fliers, but mostly for custom and stock T-shirt designs. We are open to new stock design ideas the artist may have."

FIRST CONTACT & TERMS "Send query letter with résumé, e-mail black & white and color PDF, TIFF or EPS art files to be kept on file. We will not return mails originals or samples." Responds in 1 week–1 month. Pays for design and illustration by the hour, $20-35; by the project, $40-100. Considers turnaround time and rights purchased when establishing payment. For designs submitted to be used as stock T-shirt designs, pays 5-10% royalty. Stock designs should be something that the general public would buy and especially Chicago type designs for souvenir shirts. Rights purchased vary according to project.

TIPS "Send 5-10 good copies of your best work. We would like to see more PDF illustrations or copies, not originals. Do not get discouraged if your first designs sent are not accepted."

DALOIA DESIGN

100 Norwich E., West Palm Beach FL 33417. (561)452-4150. **E-mail:** daloiades@aol.com. Estab. 1983. Produces art for stationery and gift products such as magnets, photo frames, coasters, bookmarks, home decor, etc.

NEEDS Approached by 20-30 freelancers/year. Uses freelancers for original and innovative product art. Freelancers must know software appropriate for proj-

ect, including InDesign, Photoshop, QuarkXPress, Illustrator or "whatever is necessary."

FIRST CONTACT & TERMS Send samples of your work. Samples are filed and are not returned. Responds only if interested. Payment "depends on project and use." Negotiates rights purchased.

TIPS "Keep an open mind, strive for excellence, push limitations."

DELJOU ART GROUP

1616 Huber St., Atlanta GA 30318. (404)350-7190 or (800)237-4638. **Fax:** (404)350-7195. **E-mail:** submit@deljouartgroup.com. **Website:** www.deljouartgroup.com. Estab. 1980. Art publisher, distributor and gallery of limited editions (maximum 250 prints), hand-pulled originals, monoprints/monotypes, sculpture, fine art photography, fine art prints and paintings on paper and canvas. Clients: galleries, designers, corporate buyers and architects. Previous and current clients include Coca Cola, Xerox, Exxon, Marriott Hotels, General Electric, Charter Hospitals, AT&T and more than 3,000 galleries worldwide, "forming a strong network throughout the world."

NEEDS Seeking creative, fine and decorative art for the designer market and serious collectors. Considers oil, acrylic, pastel, sculpture and mixed media and photography. Artists represented include Yunessi, T.L. Lange, Michael Emani, Vincent George, Nela Soloman, Alterra, Ivan Reyes, Mindeli, Sanford Wakeman, Niro Vessali, Lee White, Alexa Kelemen, Bika, Kamy, Craig Alan, Roya Azim, Jian Chang, Elya DeChino, Antonio Dojer, Emanuel Mattini and Mia Stone. Editions are created by collaborating with the artist. Approached by 300 artists/year. Publishes the work of 10 emerging, 20 mid-career and 20 established artists/year.

FIRST CONTACT & TERMS Send query letter with photographs, slides, brochure, photocopies, tearsheets, SASE and transparencies. Prefers contact and samples via e-mail. Samples not filed are returned only by SASE. Responds in 6 months. Will contact artist for portfolio review if interested. Payment method is negotiated. Offers an advance when appropriate. Negotiates rights purchased. Requires exclusive representation. Provides promotion, a written contract and advertising. Finds artists through visiting galleries, art fairs, word of mouth, Internet, art reps, submissions, art competitions and sourcebooks. Pays highest royalties in the industry.

TIPS "We need landscape artists, 3D wall art (any media), strong figurative artists, sophisticated abstracts and soft-edge abstracts. We are also beginning to publish sculptures and are interested in seeing slides of such. We also have the largest gallery in the country. We have added a poster division and need images in different categories for our poster catalog as well."

DELTA CREATIVE, INC.

2690 Pellisier Place, City of Industry CA 90601-1507. (800)423-4135. **Fax:** (562)695-4227. **E-mail:** advisor@deltacreative.com. **Website:** www.deltacreative.com. Estab. 1978. Produces art and novelty rubber stamps, kits, glitter pens, ink pads, papers, stickers, scrapbooking products.

NEEDS Approached by 30 freelance artists/year. Works with 10-20 freelance artists/year. Buys 200-300 freelance designs and illustrations/year. Uses freelance artists for calligraphy, P-O-P displays, and original art for rubber stamps. Considers pen & ink. Looks for whimsical, feminine style and fashion trends. Produces seasonal material Christmas, Valentine's Day, Easter, Hanukkah, Thanksgiving, Halloween, birthdays and everyday (includes wedding, baby, travel, and other life events). Submit seasonal material 9 months in advance.

FIRST CONTACT & TERMS Send nonreturnable samples. Samples are filed. Responds only if interested. Rights purchased vary according to project. Originals are not returned.

DESIGN DESIGN, INC.

P.O. Box 2266, Grand Rapids MI 49501. (616)771-8359. **Fax:** (616)774-4020. **E-mail:** susan.birnbaum@designdesign.us. **Website:** www.designdesign.us. Estab. 1986. Specializes in greeting cards and paper-related product development.

NEEDS Uses freelancers for all of the above products. Considers most media. Produces cards for everyday and all holidays. Submit seasonal material 1 year in advance.

FIRST CONTACT & TERMS Send query letter with appropriate samples and SASE. Samples are not filed and are returned by SASE if requested by artist. To show portfolio, send color copies, photographs or slides. Do not send originals. Pays various royalties per product development.

🌑 DESIGNER GREETINGS

11 Executive Ave., Edison NJ 08817. (732)662-6700. **Fax:** (732)662-6701. **E-mail:** submissions@designer greetings.com. **Website:** www.designergreetings.com. **Contact:** Andy Epstein, creative director. Estab. 1982. Designer Greetings produces greeting cards for all ages for every occasion and holiday.

NEEDS Art/graphic design illustration, card design submissions: Purchases 250-500 freelance designs/illustrations per year. Considers all traditional and digital media. Seasonal materials should be submitted 9 months in advance. Prints for all holidays and occasions. Prefer 5×7 final submissions. Buys reprint rights for cards. Freelancers paid $200/project. Guidelines available online.

FIRST CONTACT & TERMS E-mail samples in JPEG format, 150 dpi. Does not accept submissions via mail. Responds only if interested. **Pays on acceptance**.

DLM STUDIO

4700 Lakeside Ave., 3rd Floor, Cleveland OH 44114. (216)881-8888. **Fax:** (216)274-9308. **E-mail:** pat@dlm studio.com. **Website:** www.dlmstudio.com. **Contact:** Pat Walker, vice president. Estab. 1984. Produces fabrics/peel and stick accents/wallpaper/borders. Specializes in wallcovering, border and mural design, self-adhesive accents, also ultra-wide "mural" borders.

NEEDS Approached by 40-80 freelancers/year. Works with 20-40 freelancers/year. Buys hundreds of freelance designs and illustrations/year. Art guidelines free for SASE with first-class postage. Works on assignment and some licensing. Uses freelancers mainly for designs, color work. Looking for traditional, country, floral, texture, woven, menswear, children's and novelty styles. 50% of freelance design work demands computer skills. Wallcovering CAD experience a plus. Produces material for everyday.

FIRST CONTACT & TERMS Illustrators: Send query letter with photocopies, examples of work, résumé and SASE. Accepts disk submissions compatible with Illustrator or Photoshop files (Mac), also accepts digital files on CD or DVD. Samples are filed or returned by SASE on request. Responds in 1 month. Request portfolio review of color photographs and slides in original query, follow-up with letter after initial query. Rights purchased vary according to project. Pays by the project, $500-1,500, "but it varies." Finds freelancers through agents and local ads, word of mouth.

TIPS "Send great samples, especially children's and novelty patterns, and also modern, organic textures and bold contemporary graphic work and digital files

are very helpful. Study the market closely; do very detailed artwork."

DODO GRAPHICS, INC.

P.O. Box 585, Plattsburgh NY 12901. (518)561-7294. **Fax:** (518)561-6720. **E-mail:** dodographics@aol.com. **Website:** www.dodographicsinc.com. **Contact:** Frank How, president. Estab. 1979. Art publisher of offset reproductions, posters and etchings for galleries and frame shops.

NEEDS Considers pastel, watercolor, tempera, mixed media, airbrush and photographs. Prefers contemporary themes and styles. Prefers individual works of art, 16×20 maximum. Publishes the work of 5 artists/year.

FIRST CONTACT & TERMS Send query letter with brochure showing art style or photographs, slides or CD. Samples are filed or are returned by SASE. Responds in 3 months. Write for appointment to show portfolio of original/final art and slides. Payment method is negotiated. Offers an advance when appropriate. Buys all rights. Requires exclusive representation of the artist. Provides written contract.

TIPS "Do not send any originals unless agreed upon by publisher."

EMERY-BURTON FINE CARDS & GIFTS

P.O. Box 31130, Seattle WA 98103. (866)617-1259. **Fax:** (866)617-8424. **E-mail:** info@emery-burton. com. **Website:** www.emery-burton.com. Produces greeting cards.

NEEDS Product categories include conventional, counter humor and cute. Produces material for Mother's Day, Valentine's Day, Christmas, birthday, cards for pets, congratulations, baby congrats, woman-to-woman, wedding/anniversary, get-well/sympathy and everyday. Seasonal material should be submitted 6 months in advance. Final art should be 5×7. 100% of freelance work demands computer skills; artists should be familiar with Illustrator, Photoshop and InDesign. No need for freelance Web design.

FIRST CONTACT & TERMS Send query letter with SASE, or e-mail digital images (TIFF at 300 dpi). Samples not kept on file; returned by SASE.

ENESCO GROUP, INC.

225 Windsor Dr., Itasca IL 60143. (630)875-5300. **E-mail:** dbernar@enesco.com. **Website:** www.enesco. com. Producer and importer of fine gifts, home decor and collectibles, such as resin, porcelain bisque and earthenware figurines, plates, hanging ornaments, bells, picture frames, decorative housewares. Clients gift stores, card shops and department stores.

NEEDS Works with multiple freelance artists/year. Prefers artists with experience in gift product and packaging development. Uses freelancers for rendering, illustration and sculpture. 50% of freelance work demands knowledge of Photoshop, QuarkXPress or Illustrator.

FIRST CONTACT & TERMS Submit via "product idea and artist submissions" form on website. Accepts .bmp, .flv, .gif, .jpg, .mov, .mpeg, .mpg, .png, .ppt, .rm, .tif or .wmv formats.

TIPS "All will be reviewed by our senior creative director, executive vice president and licensing director. If your talent is a good match to Enesco's product development, we will contact you to discuss further arrangements. Please do not send slides. Have a well-thought-out concept that relates to gift products before mailing your submissions."

EPIC PRODUCTS, INC.

2801 S. Yale St., Santa Ana CA 92704. (800)548-9791. **Fax:** (714)641-8217. **E-mail:** info@epicproductsinc. com. **Website:** www.epicproductsinc.com. Estab. 1978. Produces paper tableware products and wine and spirits accessories. "We manufacture products for the gourmet/housewares market; specifically products that are wine-related. Many have a design printed on them."

NEEDS Approached by 50-75 freelance artists/year. Works with 10-15 freelancers/year. Buys 25-50 designs and illustrations/year. Prefers artists with experience in gourmet/housewares, wine and spirits, gift and stationery.

FIRST CONTACT & TERMS Send query letter with résumé and photocopies. Samples are filed. Write for appointment to show portfolio. Portfolio should include thumbnails, roughs, final art, b&w and color. Buys all rights. Originals are not returned. Pays by the project.

FENTON ART GLASS COMPANY

700 Elizabeth St., Williamstown WV 26187. (304)375-6122. **Fax:** (304)375-7833. **E-mail:** askfenton@fenton artglass.com. **Website:** www.fentonartglass.com. Estab. 1905. Produces collectible figurines, gifts. Largest manufacturer of handmade colored glass in the U.S.

Design director Nancy Fenton says this company rarely uses freelancers because they have their own staff of artisans. "Glass molds aren't

very forgiving," says Fenton. Consequently it's a difficult medium to work with. There have been exceptions. "We were really taken with Linda Higdon's work," says Fenton, who worked with Higdon on a line of historical dresses.

NEEDS Uses freelancers mainly for sculpture and ceramic projects that can be translated into glass collectibles. Considers clay, ceramics, porcelain figurines. Looking for traditional artwork appealing to collectibles market.

FIRST CONTACT & TERMS Send query letter with brochure, photocopies, photographs, résumé and SASE. Samples are filed. Responds only if interested. Negotiates rights purchased. Pays for design by the project; negotiable.

FIDDLER'S ELBOW

101 Fiddler's Elbow Rd., Middle Falls NY 12848. (518)692-9665. **Fax:** (518)692-9186. **E-mail:** inquiries@fiddlerselbow.com. **E-mail:** licensing@fiddlerselbow.com. **Website:** www.fiddlerselbow.com. Estab. 1974. Produces decorative doormats, pillows, totes, soft sculpture, kitchen textiles, mouse pads, mugs.

NEEDS Introduces 100+ new products/year. Currently uses freelance designs and illustrations. Looking for adult contemporary, traditional, dog, cat, horse, botanical, inspirational, humorous, nature and beach themes. Main images with supporting art helpful in producing collections.

FIRST CONTACT & TERMS Send digital or hardcopy submissions by mail. Samples are filed or returned by SASE. Responds generally within 4 months if interested. "Please, no phone calls."

TIPS "Please visit website first to see if art is applicable to current lines and products."

FISHER-PRICE

636 Girard Ave., E. Aurora NY 14052. (716)687-3000. **Fax:** (716)687-3636. **Website:** www.fisher-price.com. Estab. 1931. Manufacturer of toys and other children's products.

NEEDS Approached by 10-15 freelance artists/year. Works with 25-30 freelance illustrators and sculptors and 15-20 freelance graphic designers/year. Assigns 100-150 jobs to freelancers/year. Prefers artists with experience in children's style illustration and graphics. Works on assignment only. Uses freelancers mainly for product decoration (label art). Prefers all media and styles except loose watercolor. Also uses sculptors.

25% of work demands knowledge of FreeHand, Illustrator, Photoshop and FreeForm (sculptors).

FIRST CONTACT & TERMS Send query letter with nonreturnable samples showing art style or photographs. Samples are filed. Responds only if interested. Call to schedule an appointment to show a portfolio. Portfolio should include original, final art and color photographs and transparencies. Pays for design and illustration by the hour, $25-50. Buys all rights.

FOTOFOLIO, INC.

561 Broadway, New York NY 10012. (212)226-0923. **E-mail:** contact@fotofolio.com; customerservice@fotofolio.com. **Website:** www.fotofolio.com. **Contact:** Submissions Department. Estab. 1976. Publishes art and photographic postcards, greeting cards, notecards, books, t-shirts and postcards books.

NEEDS Buys 60-120 freelance designs and illustrations/year. Reproduces existing works. Primarily interested in photography and contemporary art. Produces material for Christmas, Valentine's Day, birthday and everyday. Submit seasonal material 8 months in advance. Art guidelines for SASE with first-class postage.

FIRST CONTACT & TERMS "Fotofolio, Inc. reviews color and b&w photography for publication in postcard, notecard, poster and t-shirt formats. To submit your work, please make a well-edited selection of no more than 40 images, attn: Submissions. Fotofolio will accept photocopies, laser copies and promotional pieces only. Do not send original materials; no material will be returned. We will accept materials by mail only. Fotofolio will not accept digital images via e-mail to be downloaded or digital files submitted on disk. You may e-mail a website address where your work may be viewed. You'll be contacted if we are interested in seeing further work. Please note that Fotofolio, Inc. is not responsible for any lost or damaged submissions."

TIPS "When submitting materials, present a variety of your work (no more than 40 images) rather than one subject/genre."

THE FUNNY APRON COMPANY

P.O. Box 1780, Lake Dallas TX 75065-1780. (940)498-3308. **Fax:** (940)498-1596. **E-mail:** ellice@funnyaprons.com. **Website:** www.funnyaproncompany.com. **Contact:** Ellice Lovelady, creative director. Estab. 1992. "Our primary focus is now on our subdivision, The Funny Apron Company, that manufactures

humorous culinary-themed aprons and T-shirts for the gourmet marketplace. Do not send greeting card submissions!"

NEEDS Works with 6 freelancers/year. Artists must be fax/e-mail accessible and able to work on fast turn-around. Check website to determine if your style fits our art direction. 100% of freelance work Required knowledge of Illustrator, CorelDraw, or programs with ability to electronically send vector-based artwork for screenprinting. Do not submit text or concepts. (Photoshop alone is not sufficient.) Currently not accepting text or concepts.

FIRST CONTACT & TERMS Send query letter with brochure, photographs, SASE and photocopies. E-mail inquiries must include a link to a website to view artwork. Do not send unsolicited attachments; they are automatically deleted. Samples are filed or returned by SASE if requested by artist. Company will contact artist if interested. Negotiates rights and payment terms. Finds artists via word of mouth from other freelancers or referrals from publishers.

GALISON/MUDPUPPY PRESS

28 W. 44th St., New York NY 10036. (212)354-8840. **E-mail:** julia@galison.com; cynthia@galison.com. **Website:** www.galison.com. **Contact:** Julia Hecomovich, art director (for Galison and Holiday); Cynthia Matthews, creative director (children's illustration). Estab. 1978. Produces boxed greeting cards, stationery, puzzles, address books, specialty journals and fine paper gifts. Many projects are done in collaboration with museums around the world.

NEEDS Works with 10-15 freelancers/year. Buys 20 designs and illustrations/year. Works on assignment only. Uses freelancers mainly for illustration. Considers all media. Also produces material for holidays (Christmas, Hanukkah and New Year). Submit seasonal material 1 year in advance.

FIRST CONTACT & TERMS Send postcard sample, photocopies, résumé, tearsheets (no unsolicited original artwork) and SASE. Accepts submissions on disk compatible with Photoshop, Illustrator or QuarkXPress (but not preferred). Samples are filed. Responds only if interested. Request portfolio review in original query. Art director will contact artist for portfolio review if interested. Portfolio should include color photostats, slides, tearsheets and dummies. Originals are returned at job's completion. Pays by project. Rights purchased vary according to proj-

ect. Finds artists through word of mouth, magazines and artists' reps.

TIPS "Looking for great presentation and artwork we think will sell and be competitive within the gift market. Please visit our website to see if your style is compatible with our design aesthetic."

GALLERY GRAPHICS, INC.

20136 State Hwy. 59, P.O. Box 502, Noel MO 64854. (417)475-6191; (800)367-4370. **Fax:** (417)475-6494. **E-mail:** info@gallerygraphics.com. **Website:** www.gallerygraphics.com. Estab. 1979. Produces calendars, gifts, greeting cards, stationery, prints, notepads, notecards. Gift company specializing primarily in nostalgic, country and other traditional designs.

NEEDS Approached by 100 freelancers/year. Works with 10 freelancers/year. Buys 100 freelance illustrations/year. Art guidelines free for SASE with first-class postage. Uses freelancers mainly for illustration. Considers any 2-dimensional media. Looking for country, teddy bears, florals, traditional. Prefers 16×20 maximum. Produces material for Christmas, Valentine's Day, birthdays, sympathy, get well, thank you. Submit seasonal material 8 months in advance.

FIRST CONTACT & TERMS Accepts printed samples or Photoshop files. Send TIFF or EPS files. Samples are filed or returned by SASE. Will contact artist for portfolio review of color photographs, photostats, slides, tearsheets, transparencies if interested. Payment negotiable. Finds freelancers through submissions and word of mouth.

TIPS "Be flexible and open to suggestions."

C.R. GIBSON

404 BNA Dr., Building 200, Suite 600, Nashville TN 37217. (615)724-2900. **E-mail:** customerservice@crgibson.com. **Website:** www.crgibson.com. Producer of stationery and gift products, baby, kitchen and wedding collections. Specializes in baby, children, feminine, floral, wedding and kitchen-related subjects, as well as holiday designs. 80% require freelance illustration; 15% require freelance design. Gift catalog free by request.

NEEDS Approached by 200-300 freelance artists/year. Works with 30-50 illustrators and 10-30 designers/year. Assigns 30-50 design and 30-50 illustration jobs/year. Uses freelancers mainly for covers, borders and cards. 50% of freelance work demands knowledge of QuarkXPress, FreeHand and Illustrator. Works on assignment only.

FIRST CONTACT & TERMS Send query letter with brochure, résumé, tearsheets and photocopies. Samples are filed or are returned. Responds only if interested. Request portfolio review in original query. Portfolio should include thumbnails, finished art samples, color tearsheets and photographs. Return of original artwork contingent on contract. Sometimes requests work on spec before assigning a job. Interested in buying second rights (reprint rights) to previously published work. "Payment varies due to complexity and deadlines." Finds artists through word of mouth, magazines, artists' submissions/self-promotion, sourcebooks, agents, visiting artist's exhibitions, art fairs and artists' reps.

TIPS "The majority of our mechanical art is executed on the computer with discs and laser runouts given to the engraver. Please give a professional presentation of your work."

GLITTERWRAP, INC.

11 Executive Ave., Edison NJ 08817. (732)622-6700, ext. 741. **E-mail:** submissions@designergreetings. com. **Website:** www.glitterwrap.com. **Contact:** Andy Epstein, creative director. Estab. 1987. Produces gift-wrap, gift totes, allied accessories, photo albums, diaries and stationery items for all ages—party and special occasion market.

NEEDS Art/graphic designer submissions: Works with 10-15 artists/year. Buys 10-30 designs and illustrations/year. Art guidelines available online. Prefers artists with experience in textile design who are knowledgeable in repeat patterns or surface, or designers who have experience with the gift industry. Considers many styles and mediums. Style varies with season and year. Consider trends and designs already in line, as well as up-and-coming motifs in gift market. Produces material for baby, wedding and shower, florals, masculine, Christmas, graduation, birthdays, Valentine's Day, Hanukkah and everyday. Submit seasonal material 9 months in advance.

FIRST CONTACT & TERMS Send an e-mail with samples in JPEG format at 150 dpi. Responds only if interested. Does not accept submissions via mail. Rights purchased vary according to project. Freelancers paid $200/project.

GOES LITHOGRAPHING COMPANY

111 Hallberg St., Delavan WI 53115. (800)348-6700. **E-mail:** sales@goeslitho.com. **Website:** www.goeslitho. com. **Contact:** Eric Goes. Estab. 1879. Produces statio-

nery/letterheads, custom calendars to sell to printers and office product stores.

NEEDS Approached by 5-10 freelance artists/year. Works with 2-3 freelance artists/year. Buys 4-30 freelance designs and illustrations/year. Art guidelines for SASE with first-class postage. Uses freelance artists mainly for designing holiday letterheads. Considers pen & ink, color, acrylic, watercolor. Prefers final art 17×22, CMYK color compatible. Produces material for Christmas, Halloween and Thanksgiving.

FIRST CONTACT & TERMS "Send non-returnable examples for your ideas." Responds in 1-2 months if interested. Pays $100-200 on final acceptance. Buys first rights and reprint rights.

TIPS "Keep your art fresh and be aggressive with submissions."

GRAHAM & BROWN

3 Corporate Dr., Cranbury NJ 08512. (609)395-9200. **E-mail:** ncaucino@grahambrownusa.com; public relations@grahambrownusa.com. **Website:** www. grahambrown.com. Estab. 1946. Produces residential wall coverings and home decor products.

NEEDS Prefers freelancers for designs. Also for artwork. Produces material for everyday.

FIRST CONTACT & TERMS Designers: Send query letter with photographs. Illustrators: Send postcard sample of work only to the attention of Nicole Caucino. Samples are filed or returned. Responds only if interested. Buys all rights. For illustration pays a variable flat fee.

GREAT AMERICAN PUZZLE FACTORY

Fundex Games, Ltd., P.O. Box 421309, Indianapolis IN 46242. (800)486-9787. **Fax:** (317)248-1086. **E-mail:** thaman@fundexgames.com. **Website:** www. greatamericanpuzzle.com. **Contact:** Tracey Haman. Estab. 1986. Produces jigsaw puzzles and games for adults and children. Licenses various illustrations for puzzles (children's and adults').

NEEDS Approached by 200 freelancers/year. Works with 80 freelancers/year. Buys 70 designs and illustrations/year. Uses freelancers mainly for puzzle material. Looking for "fun, busy and colorful" work. 100% of graphic design requires knowledge of QuarkXPress, Illustrator or Photoshop.

FIRST CONTACT & TERMS Send postcard sample or 3 representative samples via e-mail. Do not send seasonal material. Also accepts e-mail submissions. Do not send originals or transparencies. Samples are

filed or are returned. Art director will contact artist for portfolio review if interested. Original artwork is returned at job's completion. Pays flat fee of $600-1,000, work for hire. Royalties of 5-6% for licensed art (existing art only). Interested in buying second rights (reprint rights) to previously published work.

TIPS "All artwork should be *bright*, cheerful and eye-catching. 'Subtle' is not an appropriate look for our market. Decorative motifs not appropriate. Visit stores and websites for appropriateness of your art. No black and white. Looking for color, detail, and emotion."

GREAT ARROW GRAPHICS

2495 Main St., Suite #457, Buffalo NY 14214. (716)836-0408. **E-mail:** info@greatarrow.com. **E-mail:** design@greatarrow.com. **Website:** www.greatarrow.com. **Contact:** Art director. Estab. 1981. Produces greeting cards and stationery. "We produce silkscreened greeting cards—seasonal and everyday—to a high-end design-conscious market."

NEEDS Approached by 150 freelancers/year. Works with 75 freelancers/year. Buys 350-500 images/year. Art guidelines can be downloaded at www.greatarrow.com/pdfs/guidelines.pdf. Prefers freelancers with experience in silkscreen printing process. Uses freelancers for greeting card design only. Considers all 2D media. Looking for sophisticated, classic, contemporary or cutting edge styles. Requires knowledge of Illustrator or Photoshop. Produces material for all holidays and seasons. Submit seasonal material 1 year in advance.

FIRST CONTACT & TERMS Send query letter with photocopies. Accepts submissions on disk compatible with Illustrator or Photoshop or e-mail JPEGs at 72 dpi. Samples will not be returned, do not send originals until the images are accepted. Limit e-mail attachment size to 5MB. Responds in 6 weeks if we are interested. Art director will contact artist for portfolio review if interested. Portfolio should include color roughs, final art, photographs and transparencies. Originals are returned at job's completion. Pays royalties of 5% of net sales. Rights purchased vary according to project.

TIPS "We are interested in artists familiar with the assets and limitations of screenprinting, but we are always looking for fun new ideas and are willing to give help and guidance in the silkscreen process. Be original, be complete with ideas. Don't be afraid to be different ... forget the trends ... do what you want. Make your work as complete as possible at first submission. The National Stationery Show in New York City is a great place to make contacts."

⊙ HAMPSHIRE PEWTER COMPANY

43 Mill St., Box 1570, Wolfeboro NH 03894-1570. (603)569-4944; (800)639-7704. **E-mail:** gifts@hampshirepewter.com. **Website:** www.hampshirepewter.com. Estab. 1974. Manufacturer of handcast pewter tableware, accessories and Christmas ornaments. Clients jewelry stores, department stores, executive gift buyers, tabletop and pewter specialty stores, churches and private consumers.

NEEDS Works with 3-4 freelance artists/year. "Prefers New England-based artists." Works on assignment only. Uses freelancers mainly for illustration and models. Also for brochure and catalog design, product design, illustration on product and model-making.

FIRST CONTACT & TERMS Send query letter with photocopies. Samples are not filed and are returned only if requested. Call for appointment to show portfolio, or mail b&w roughs and photographs. Pays for design and sculpture by the hour or project. Considers complexity of project, client's budget and rights purchased when determining payment. Buys all rights.

TIPS "Inform us of your capabilities. For artists who are seeking a manufacturing source, we will be happy to bid on manufacturing of designs under private license to the artists, all of whose design rights are protected. If we commission a project, we intend to have exclusive rights to the designs by contract as defined in the Copyright Law, and we intend to protect those rights."

HARLAND CLARKE

10931 Laureate Dr., San Antonio TX 78249. (210)694-1473. **Website:** www.clarkeamerican.com. Estab. 1874. Produces checks and other products and services sold through financial institutions. "We're a national printer seeking original works for check series, consisting of 1, 3 or 5 scenes. Looking for a variety of themes, media and subjects for a wide market appeal."

NEEDS Uses freelancers mainly for illustration and design of personal checks. Considers all media and a range of styles. Prefers to see art at twice the size of a standard check.

FIRST CONTACT & TERMS Send postcard sample or query letter with résumé and brochure (or website

if work is online). "Indicate whether the work is available; do not send original art." Samples are filed and are not returned. Responds only if interested. Rights purchased vary according to project. Payment for illustration varies by the project.

TIPS "Keep red and black in the illustration to a minimum for image processing."

HEART STEPS, INC.

P.O. Box 307, King WI 54946. (715)258-8141. **E-mail:** customerservice@heartsteps.com. **Website:** www. heartsteps.com. Estab. 1993. Produces greeting cards, marble and bronze plaques, photo frames, gift boxes, framed art, scrapbooking items and stationery. Specializes in inspirational items.

NEEDS Prefers freelancers with experience in watercolor. Works on assignment only. Uses freelancers mainly for completing the final watercolor images. Considers original art. Looking for watercolor fine art, floral, juvenile and still life. Prefers 10×14. Produces material for Christmas, Mother's Day, Father's Day, graduation, birthday, everyday, inspirational, encouragement, woman-to-woman. Submit seasonal material 8 months in advance.

FIRST CONTACT & TERMS Designers: Send query letter with brochure, photocopies, photographs, résumé and SASE. Illustrators: Send query letter with photocopies and résumé. Samples are filed. Responds in 2 months. Request portfolio review in original query. Rights purchased vary according to project. Finds freelancers through gift shows and word of mouth.

TIPS "Don't overlook opportunities with new, small companies!"

MARIAN HEATH GREETING CARDS

9 Kendrick Rd., Wareham MA 02571. (800)688-9998. **Fax:** (877)736-4738. **E-mail:** talktous@marianheath. com. **E-mail:** dreposa@marianheath.com. **Website:** www.marianheath.com. **Contact:** Diane Reposa. Estab. 1950. Greeting card company supporting independent card and gift shop retailers. Produces greeting cards, giftbags, giftwrap, stationary and ancillary products.

NEEDS Approached by 100 freelancers/year. Works with 35-45 freelancers/year. Buys 500 freelance designs and illustrations/year. Prefers freelancers with experience in social expression. Art guidelines free for SASE with first-class postage or e-mail requesting guidelines. Uses freelancers mainly for greeting cards. Considers all media and styles. Generally 5 1/4×7 1/4

unless otherwise directed. Will accept various sizes due to digital production/manipulation. 30% of freelance design and illustration work demands knowledge of Photoshop, Illustrator, QuarkXPress. Produces material for all holidays and seasons and everyday. Submit seasonal material 1 year in advance.

FIRST CONTACT & TERMS Submission guidelines available online.

HIGH RANGE DESIGNS

P.O. Box 346, Victor ID 83455-0346. (208)787-2277. **E-mail:** hmiller@highrangedesigns.com. **Website:** www.highrangedesigns.com. **Contact:** Hondo Miller, president. Estab. 1989. Produces T-shirts. "We produce screen-printed garments for recreational sport-oriented markets and resort markets, which includes national parks. Subject matter includes, but is not limited to, skiing, climbing, hiking, biking, fly fishing, mountains, out-of-doors, nature, canoeing and river rafting, Native American, wildlife and humorous sayings that are text only or a combination of text and art. Our resort market customers are men, women and kids looking to buy a souvenir of their vacation experience or activity. People want to identify with the message or art on the T-shirt."

◐ The art guidelines for this company are detailed and include suggestions on where to place design on the garment. It is easiest to break into HRD with designs related to fly fishing, downhill skiing, snowboarding or river rafting.

NEEDS Approached by 20 freelancers/year. Works with 3-8 freelancers/year. Buys 10-20 designs and illustration/year. Prefers artists with experience in screen printing. Uses freelancers mainly for T-shirt ideas, artwork and color separations.

FIRST CONTACT & TERMS Send query letter with résumé, SASE and photocopies. Accepts submissions on disk compatible with FreeHand 8.0 and Illustrator 8.0. Samples are filed or are returned by SASE if requested by artist. Responds in 6 months. Company will contact artist for portfolio review if interested. Portfolio should include b&w thumbnails, roughs and final art. Originals are returned at job's completion. Pays by the project, royalties of 5% based on actual sales. Buys garment rights.

TIPS "Familiarize yourself with screen printing and T-shirt art that sells. Must have knowledge of color separations process. We look for creative design styles

and interesting color applications. Artists need to be able to incorporate the colors of the garments as part of their design thinking, as well as utilize the screen-printing medium to produce interesting effects and textures. However, sometimes simple is best. Four-color process will be considered if highly marketable. Be willing to work with us on design changes to get the most marketable product. Know the industry. Art that works on paper will not necessarily work on garments. No cartoons please."

HOFFMASTER GROUP, INC.

2920 N. Main St., Oshkosh WI 54901. (800)327-9774. **E-mail:** marketing@hoffmaster.com. **Website:** www.hoffmaster.com. Produces decorative disposable paper tableware including: place mats, plates, table-cloths and napkins for institutional and consumer markets. Printing includes offset, letterpress and up to six color flexographic napkin printing.

NEEDS Approached by 10-15 freelancers/year. Works with 4-6 freelancers/year. Prefers freelancers with experience in paper tableware products. Art guidelines and specific design needs based on current market are available from Creative Managers. Looking for trends and traditional styles. Prefers 9" round artwork with coordinating 5" square image. Produces material for all holidays and seasons and everyday. Special need for seasonal material.

FIRST CONTACT & TERMS Send query letter with photocopies, résumé, appropriate samples by mail or fax only. Ideas may be sent in a color rough sketch. Accepts disk submissions compatible with Adobe Creative Suite 2. Samples are filed or returned by SASE if requested by artist. Responds in 90 days, only if interested. Creative manager will contact artist for portfolio review if interested. Prefers to buy artwork outright. Rights purchased vary according to project. Pays by the project. Amounts vary according to project. May work on a royalty arrangement for recognized properties. Finds freelancers through art fairs and artists' reps.

TIPS Looking for new trends and designs appropriate for plates and napkins.

◉ IGPC

161 Helen St., South Plainfield NJ 07080. (908)548-8088. **Fax:** (908)822-7379. **E-mail:** postmaster@igpc.net. **Website:** www.igpc.net. Agent to foreign governments. "We produce postage stamps and related items on behalf of 40 different foreign governments."

NEEDS Approximately 10 freelance graphic artists. Prefers artists within metropolitan New York or Tri-State area. Must have extremely sophisticated computer, design and composition and prepress skills, as well as keen research ability. Artwork must be focused and alive (4-color). Artist's pricing needs to be competitive. Works on assignment only. Uses artists for postage stamp art. Must have expert knowledge of Photoshop and Quark/InDesign. Illustrator a plus.

FIRST CONTACT & TERMS E-mail only. Send samples as PDFs or link to a web portfolio. Art Director will contact artist for portfolio review if interested. Portfolio should contain "4-color illustrations of realistic, flora, fauna, technical subjects, autos or ships." Sometimes requests work on spec before assigning a job. Pays by the project. Consider government allowance per project when establishing payment.

TIPS "Artists considering working with IGPC must have excellent drawing or rendering abilities in general or specific topics, e.g., flora, fauna, transport, famous people; typographical skills; the ability to create artwork with clarity and perfection. Familiarity with printing process and print call-outs a plus. Generally, the work we require is realistic art. In some cases, we supply the basic layout and reference material; however, we appreciate an artist who knows where to find references and can present new and interesting concepts. Initial contact should be made by appointment. "

INTERCONTINENTAL GREETINGS, LTD.

38 W. 32nd St., Suite 910, New York NY 10001. (212)683-5830. **Fax:** (212)779-8564. **E-mail:** interny@intercontinental-ltd.com. **E-mail:** art@intercontinental-ltd.com. **Website:** www.intercontinental-ltd.com. **Contact:** Jerra Parfitt, creative director. Estab. 1967. Sells reproduction rights of designs to manufacturers of multiple products around the world. Rep resents artists in 50 different countries. "Our clients specialize in greeting cards, giftware, giftwrap, calendars, postcards, prints, posters, stationery, paper goods, food tins, playing cards, tabletop, bath and service ware and much more. "

NEEDS Approached by several hundred artists/year. Seeking creative decorative art in traditional and computer media (Photoshop and Illustrator work accepted). Prefers artwork previously made with few or no rights pending. Graphics, sports, occasions (e.g., Christmas, baby, birthday, wedding), humorous, "soft touch," romantic themes, animals. Accepts seasonal/

holiday material any time. Prefers artists/designers experienced in greeting cards, paper products, table-top and giftware.

FIRST CONTACT & TERMS Please submit via e-mail, a link to your website or a sampling of your work, consisting of 6-10 designs which represent your collection as a whole. The sampling should show all range of subject matter, technique, style, and medium that may exist in your collection. Digital files should be submitted as e-mail attachments and in lo-resolution. Lo-resolution (LR) image files are typically 5×7, 72 dpi, CMYK, JPEG/TIFF/PDF format and are under 100KB. "Once your art is accepted, we require original color art—Photoshop files on disc (TIFF, 300 dpi). We will respond only if interested." Pays on publication. No credit line given. Offers advance when appropriate. Sells one-time rights and exclusive product rights. Simultaneous submissions and previously published work OK. "Please state reserved rights, if any."

TIPS Recommends the annual New York SURTEX and Licensing shows. In portfolio samples, wants to see "a neat presentation, thematic in arrangement, consisting of a series of interrelated images (at least 6). In addition to having good drawing/painting/designing skills, artists should be aware of market needs and trends."

JILLSON & ROBERTS

3300 W. Castor St., Santa Ana CA 92704-3908. (714)424-0111. **Fax:** (714)424-0054. **E-mail:** janel. kaden@jillsonroberts.com. **Website:** www.jillsonroberts.com. **Contact:** Janel Kaden, art director. Estab. 1974. Specializes in gift wrap, totes, printed tissues and accessories using recycled/recyclable products. Art guidelines available on website.

NEEDS Works with 10 freelance artists/year. Prefers artists with experience in giftwrap design. Considers all media. "We are looking for colorful graphic designs as well as humorous, sophisticated, elegant or contemporary styles." Produces material for Christmas, Valentine's Day, Hanukkah, Halloween, graduation, birthdays, baby announcements and everyday. Submit 3-6 months before holiday.

FIRST CONTACT & TERMS Send color copies or photocopies. Samples are kept on file. Responds in up to 2 months. Simultaneous submissions to other companies is acceptable. "If your work is chosen, we will contact you to discuss final art preparation, procedures and payment."

TIPS "We are particularly interested in baby shower and wedding shower designs."

JODDS

P.O. Box 353, Bicester OX27 0GS, United Kingdom. +44 1869 278550. **Fax:** +44 1869 278551. **E-mail:** info@ joddscards.com. **Website:** www.joddscards.com. **Contact:** Jill Payne, art director. Estab. 1988. "Jodds produces innovative design-led birthday cards, occasion cards and children's personalized canvas pictures. For Christmas, we have a range of charity cards, supporting the British Heart Foundation. Our full product range includes gift wrap, gift bags, gift boxes, birthday calendars and party invites with matching thank you cards. We print on the highest quality board and use the very latest finishing techniques." Rights purchased vary according to the project.

NEEDS Works with 10 freelancers/year. Need freelancers for animation in counter humor, teen, cute, religious and juvenile themes. Also produce Mother's Day, Christmas, birthday, Father's Day, Valentine's Day, congratulations, wedding/anniversary, get well/sympathy and everyday cards. Seasonal materials should be submitted 9 months in advance. Artists should be familiar with Adobe Photoshop.

FIRST CONTACT & TERMS Send an e-mail with low-resolution JPEGs. Samples kept on file. Company will contact artist for portfolio review if interested.

KALAN LP

97 S. Union Ave., Lansdowne PA 19050. (610)623-1900. **E-mail:** dumlauf@kalanlp.com. **Website:** www.kalanlp.com. **Contact:** Chris Wiemer, art director. Estab. 1973. Produces giftbags, greeting cards, school supplies, stationery and novelty items such as keyrings, mouse pads, shot glasses and magnets.

NEEDS Approached by 50-80 freelancers/year. Buys 100 freelance designs and illustrations/year. Art guidelines are available. Uses freelancers mainly for fresh ideas, illustration and design. Considers all media and styles. Some illustration demands knowledge of Photoshop 7.0 and Illustrator 10. Produces material for major holidays such as Christmas, Mother's Day, Valentine's Day; plus birthdays and everyday. Submit seasonal material 9-10 months in advance.

FIRST CONTACT & TERMS Designers: Send query letter with photocopies, photostats and résumé. Illustrators and cartoonists: Send query letter with photocopies and résumé. Accepts disk submissions compatible with Illustrator 10 or Photoshop 7.0. Send EPS

files. Samples are filed. Responds in 1 month if interested in artist's work. Will contact artist for portfolio review of final art if interested. Buys first rights. Pays by the project, $75 and up. Finds freelancers through submissions and newspaper ads.

⊙ KENZIG KARDS, INC.

2300 Julia Goldbach Ave., Ronkonkoma NY 11779-6317. (631)737-1584. **Fax:** (631)737-8341. **Contact:** Jerry Kenzig, president. Estab. 1999. Produces greeting cards and stationery. Specializes in greeting cards (seasonal and everyday) for a high-end, design-conscious market (all ages).

NEEDS Approached by 75 freelancers/year. Works with 3 freelancers/year. Prefers local designers/illustrators, but will consider freelancers working anywhere in the U.S. Art guidelines free with SAE and first-class postage. Uses freelancers mainly for greeting cards/design and calligraphy. Considers watercolor, colored pencils and most other mediums. Product categories include alternative/humor, business and cute. Produces material for baby congrats, birthday, cards for pets, Christmas, congratulations, everyday, get well, sympathy, Valentine's Day and wedding/anniversary. Submit seasonal material 6 months in advance. Art size should be 5×7 or 5¾×5¾ square. 20% of freelance work demands knowledge of Illustrator, QuarkXPress and Photoshop.

FIRST CONTACT & TERMS Send query letter with brochure, résumé and tearsheets. After introductory mailing, send follow-up postcard sample every 6 months. Samples are filed. Responds in 2 weeks. Company will contact artist for portfolio review if interested. Portfolio should include color, original art, roughs and tearsheets. Buys one-time rights and reprint rights for cards. Negotiates rights purchased. Pays freelancers by the project, $150-350; royalties (subject to negotiation). Finds freelancers through industry contacts (Kenzig Kards, Inc., is a member of the Greeting Card Association), submissions and word of mouth.

TIPS "We are open to new ideas and different approaches within our niche (e.g., dog- and cat-themed designs, watercolor florals). We look for bright colors and cute, whimsical art. Floral designs require crisp colors."

KID STUFF MARKETING

929 SW University Blvd., Suite B-1, Topeka KS 66619-0235. (785)862-3707. **E-mail:** michael@kidstuff.com.

Website: www.kidstuff.com. **Contact:** Michael Oden, senior director of creative. Estab. 1982. Produces collectible figurines, toys, kids' meal sacks, edutainment activities and cartoons for restaurants and entertainment venues worldwide.

NEEDS Approached by 50 freelancers/year. Works with 10 freelancers/year. Buys 30-50 freelance designs and illustrations/year. Works on assignment only. Uses freelancers mainly for illustration, activity or game development and sculpting toys. Looking for humorous, child-related styles. Freelance illustrators should be familiar with Photoshop, Illustrator and InDesign. Produces material for Christmas, Easter, Halloween, Thanksgiving, Valentine's Day and everyday. Submit seasonal material 6 months in advance.

FIRST CONTACT & TERMS Illustrators and Cartoonists: Send query letter with photocopies or e-mail JPEG files. Sculptors, calligraphers: Send photocopies. Samples are filed or returned by SASE. Responds only if interested. Portfolio review not required. Pays by the project, $250-5,000 for illustration or game activities. Finds freelancers through word of mouth and artists' submissions.

THE LANG COMPANY

P.O. Box 1605, Waukesha WI 53187. (800)967-3399. **Fax:** (800)279-3066. **Website:** www.lang.com. Estab. 1982. Produces high-quality linen-embossed greeting cards, stationery, calendars, boxes and gift items. Art guidelines available for SAE.

NEEDS Approached by 300 freelance artists/year. Works with 40 freelance artists/year. Uses freelancers mainly for card and calendar illustrations. Considers all media and styles. Looking for traditional and nonabstract country-inspired, folk, contemporary and fine art styles. Produces material for Christmas, birthdays and everyday. Submit seasonal material 6 months in advance.

FIRST CONTACT & TERMS Send query letter with SASE and brochure, tearsheets, photostats, photographs, slides, photocopies or transparencies. Samples are returned by SASE if requested by artist. Responds in 6 weeks. Pays royalties based on net wholesale sales. Rights purchased vary according to project.

TIPS "Research the company and submit compatible art. Be patient awaiting a response."

➕ ⊙ LANTERN COURT LLC

P.O. Box 61613, Irvine CA 92602. (800)454-4018. **Fax:** (714)798-2281. **E-mail:** art@lanterncourt.com. **Web-**

site: www.lanterncourt.com. **Contact:** Seher Zaman, creative director. Estab. 2011. Lantern Court specializes in party supplies and paper goods for the Muslim community or anyone who appreciates Islamic art and design. Produces balloons, calendars, decorations, e-cards, giftbags, giftwrap/wrapping paper, greeting cards, paper tableware, and part supplies. Buys 10-30 freelance designs/illustrations each year. Prefers freelancers with experience in stationery design. Buys stock photos and offers assignments.

NEEDS USES FREELANCERS FOR font designs and new designs. Needs Islamic themed and Muslim holiday related designs. Seasonal material should be submitted 10-12 months in advance. 100% of freelance work demands computer skills. Artists should be familiar with Illustrator, Photoshop, InDesign, and QuarkXPress.

FIRST CONTACT & TERMS Guidelines available free online. E-mail letter with digital images as TIFF files at 300 dpi. Keeps samples on file; samples not returned. Responds only if interested. Company will contact artist for portfolio review if interested. Pays by the project. Maximum payment $750.

TIPS "Please look at our website to be sure your work will fit into our line of products, or can be altered to fit in."

LEGACY PUBLISHING GROUP

75 Green St., Clinton MA 01510. (800)322-3866. **E-mail:** info@shoplegacy.com. **Website:** www.shoplegacy.com. **Contact:** Art department. Produces bookmarks, calendars, gifts, Christmas and seasonal cards and stationery pads. Specializes in journals, note cards, address and recipe books, coasters, place mats, magnets, book marks, albums, calendars and grocery pads.

NEEDS Works with 8-10 freelancers/year. Buys 25-30 freelance designs and illustrations/year. Prefers traditional art. Art guidelines available for SASE. Works on assignment only. Uses freelancers mainly for original art for product line. Considers all color media. Looking for traditional, contemporary, garden themes and Christmas. Produces material for Christmas, everyday (note cards) and cards for teachers.

FIRST CONTACT & TERMS Illustrators: Send query letter with photocopies, photographs, résumé, tearsheets, SASE and any good reproduction or color copy. We accept work compatible with Adobe or QuarkXPress plus color copies. Samples are filed.

Responds in 2 weeks. Company will contact artist for portfolio review if interested. Portfolio should include color photographs, slides, tearsheets and printed reproductions. Buys all rights. Pays by the project. Finds freelancers through word of mouth and artists' submissions.

TIPS "Get work out to as many potential buyers as possible. *Artist's & Graphic Designer's Market* is a good source. Initially, plan on spending 80% of your time on self-promotion."

◍ THE LEMON TREE STATIONERY CORP.

95 Mahan St., West Babylon NY 11704. (631)253-2840; (800)229-3710. **Fax:** (631)253-3369; (800)229-3709. **E-mail:** lucy@lemontreestationery.com. **Website:** www.lemontreestationery.com. **Contact:** Lucy Mlexzko, president. Estab. 1969. Produces birth announcements, Bar Mitzvah and Bat Mitzvah invitations and wedding invitations.

NEEDS Buys 100-200 pieces of calligraphy/year. Prefers local designers. Works on assignment only. Uses Mac designers. Also for calligraphy, mechanicals, paste-up, P-O-P. Looking for traditional, contemporary work. 50% of freelance work demands knowledge of Photoshop, QuarkXPress, Illustrator.

FIRST CONTACT & TERMS Send query letter with résumé. Calligraphers send photocopies of work. Samples are not filed and are not returned. Responds only if interested. Company will contact artist for portfolio review of final art, photostats, thumbnails if interested. Pays for design by the project. Pays flat fee for calligraphy.

TIPS "Look around at competitors' work to get a feeling of the type of art they use."

THE LOLO COMPANY

6755 Mira Mesa Blvd., Suite 123-410, San Diego, CA 92121. (800)760-9930. **Fax:** (800)234-6540. **E-mail:** products@lolofun.com. **Website:** www.lolofun.com. **Contact:** Charlie Paul, president. Estab. 1995. Publishes board games. Recent games include *Don't Make Me Laugh*, *Stackability*, *Bucket Blast* and *Run Around Fractions*.

NEEDS Approached by 1 illustrator and 1 designer/year. Works with 2 illustrators and 2 designers/year. Prefers humorous work. Uses freelancers mainly for product design and packaging. 100% of freelance design and illustration demands knowledge of Illustrator, Photoshop and QuarkXPress.

FIRST CONTACT & TERMS Preferred submission package is a self-promotional postcard sample. Send 5 printed samples or photographs. Accepts disk submissions in Windows format; send via ZIP as EPS. Samples are filed. Will contact artist for portfolio review if interested. Portfolio should include artwork of characters in sequence, color photocopies, photographs, transparencies of final art and roughs. Rights purchased vary according to project. Finds freelancers through word of mouth and Internet.

LPG GREETINGS, INC.

813 Wisconsin St., Walworth WI 53184. (262)275-5600. **Fax:** (262)275-5609. **E-mail:** judy@lpgcards.com. **Website:** www.lpgcards.com. **Contact:** Judy Cecchi, creative director. Estab. 1992. Produces greeting cards. Specializes in boxed Christmas cards.

NEEDS Approached by 50-100 freelancers/year. Works with 20 freelancers/year. Buys 70 freelance designs and illustrations/year. Art guidelines can be found on LPG's website. Uses freelancers mainly for original artwork for Christmas cards. Considers any media. Looking for Christmas only. Greeting cards can be vertical or horizontal; 5×7 or 6×8. Usually prefers 5×7. Submit seasonal material 1 year in advance.

FIRST CONTACT & TERMS Send e-mail with link to website samples. Please do not send unsolicited samples via e-mail without prior contact; they will not be considered. Will contact artist for samples if interested. Rights purchased vary according to project. Pays for design by the project. For illustration: pays flat fee. Finds freelancers through word of mouth and artists' submissions. Please do not send unsolicited samples via e-mail; they will not be considered.

MADISON PARK GREETINGS

The Madison Park Group, 1407 11th Ave., Seattle WA 98122. (206)324-5711; (800)638-9622. **Fax:** (206)324-5822. **E-mail:** info@madpark.com. **Website:** www.madisonparkgreetings.com. Estab. 1977. Produces greeting cards, stationery.

NEEDS Approached by 1,000 freelancers/year. Works with 20 freelancers/year. Buys 100 freelance designs and illustrations/year. Art guidelines available free for SASE. Works on assignment only. Uses freelancers mainly for greeting cards; also for calligraphy. Considers all paper-related media. Produces material for Christmas, Easter, Mother's Day, Father's Day, graduation, New Year, Valentine's Day, birthdays, everyday, sympathy, get well, anniversary, baby congratulations, wedding, thank you, expecting, friendship. Are interested in floral and whimsical imagery, as well as humor." Submit seasonal material 10 months in advance.

FIRST CONTACT & TERMS "We are interested in receiving art submissions that offer a fresh, unique design perspective and enhance our current product line." Guidelines available online.

MCGAW GRAPHICS, INC.

450 Applejack Road, Manchester VT 05255. (888)426-2429. **Fax:** (800)446-8230. **Website:** www.mcgawgraphics.com. **Contact:** Katy Murphy, product development manager. Estab. 1979. Clients: specialty retailers, museum shops, wholesale framers, e-tailers, poster shops, galleries, frame shops.

NEEDS Publishes the work of 30 emerging and 30 established artists/year; nearly 300 images/year.

FIRST CONTACT & TERMS Send low-res JPEGs via e-mail (no more than 10 images). Allow 4 weeks for a response. If your work is not accepted, please remember that we choose work for publication and licensing based on current market trends, and that our opinion only pertains to our market segment, not to the aesthetic value of your work. Send your portfolio to attn: Acquisitions Department.

TIPS "Simplicity is very important in today's market (yet there still needs to be 'a story' to the image). Form and palette are critical to our decision process. We have a tremendous need for decorative pieces, especially new abstracts, landscapes and florals. There are a lot of prints and posters being published these days. Market your best material! Review our website before submitting. Send your best work."

MIXEDBLESSING

P.O. Box 97212, Raleigh NC 27624. (919)847-7944; (800)947-4004. **Fax:** (919)847-6429. **Website:** www.mixedblessing.com. **Contact:** Elise Okrend, president. Estab. 1990. Produces interfaith greeting cards combining Jewish and Christian as well as multicultural images for all ages. Licenses holiday artwork for wrapping paper, tote bags, clothing, paper goods and greeting cards.

NEEDS Approached by 10 freelance artists/year. Works with 10 freelancers/year. Buys 20 designs and illustrations/year. Provides samples of preferred styles upon request. Works on assignment only. Uses freelancers mainly for card illustration. Considers watercolor, pen & ink and pastel. Prefers final art 5×7.

Produces material for Christmas and Hanukkah. Submit seasonal material 10 months in advance.

FIRST CONTACT & TERMS Send nonreturnable samples for review. Samples are filed. Responds only if interested. Originals are returned at job's completion. Sometimes requests work on spec before assigning a job. Pays flat fee of $125-500 for illustration/design. Buys all rights. Finds artists through visiting art schools.

TIPS "I see growth ahead for the industry. Go to and participate in the National Stationery Show."

NALPAC, LTD.

1111 E. Eight Mile Rd., Ferndale MI 48220. (248)541-1140. Estab. 1971. Produces coffee mugs gift bags, trendy gift and novelty items, and T-shirts for gift and mass merchandise markets. Licenses all kinds of artwork for T-shirts, mugs and gifts.

NEEDS Approached by 10-15 freelancers/year. Works with 2-3 freelancers/year. Buys 70 designs and illustrations/year. Works on assignment only. Considers all media. Needs computer-literate freelancers for design, illustration and production. 60% of freelance work demands computer skills.

FIRST CONTACT & TERMS Send query letter with brochure, résumé, SASE, photographs, photocopies, slides and transparencies. Samples are filed or are returned by SASE if requested by artist. Responds in 1 month. Call for appointment to show portfolio. Usually buys all rights, but rights purchased may vary according to project. Also needs package/product designers, pay rate varies. Pays for design and illustration by the hour $10-25; or by the project $40-500, or offers royalties of 4-10%.

NATIONAL DESIGN CORP.

12121 Scripps Summit Dr., San Diego CA 92131. (800)366-7367; (858)674-6040. **Fax:** (858)674-4166. **Website:** www.nationaldesign.com. Estab. 1985. Produces gifts, writing instruments and stationery accoutrements. Markets include gift/souvenir and premium markets.

NEEDS Works with 3-4 freelancers/year. Buys 3 freelance designs and illustrations/year. Prefers local freelancers only. Works on assignment only. Uses freelancers mainly for design illustration; also for prepress production on Mac. Considers computer renderings to mimic traditional medias. Prefers children's and contemporary styles. 100% of freelance work demands knowledge of Illustrator and InDesign, Free-hand and Photoshop. Produces material for Christmas and everyday.

FIRST CONTACT & TERMS Send query letter with photocopies, résumé, SASE. Accepts submissions on disk. "Contact by phone for instructions." Samples are filed and are returned if requested. Company will contact artist for portfolio review of color, final art, tearsheets if interested. Rights purchased vary according to project. Payments depends on complexity, extent of project(s).

TIPS "Must be well traveled to identify with gift/souvenir markets internationally. Fresh ideas always of interest."

N-M LETTERS

389 Nayatt Rd., Barrington RI 02806. (401)289-2460. **Fax:** (401)245-3182. **E-mail:** nmltrs@earthlink.net. **Website:** www.nmletters.com. Estab. 1982. Produces announcements and invitations that are "sweet and sassy, cool and sophisticated, playful and edgy."

NEEDS Approached by 2-5 freelancers/year. Works with 2 freelancers/year. Prefers local artists only. Works on assignment only. Produces material for parties, weddings and Bar/Bat Mitzvahs. Submit seasonal material 6 months in advance.

FIRST CONTACT & TERMS Send query letter with résumé. Responds in 1 month, only if interested. Call for appointment to show portfolio of b&w roughs. Original artwork is not returned. Pays by the project.

NOBLE WORKS

500 Paterson Plank Rd., Union City NJ 07087. (201)420-0095. **E-mail:** info@nobleworksinc.com; support@nobleworkscards.com. **Website:** www.nobleworkscards.com. **Contact:** Art department. Estab. 1981. Produces greeting cards, notepads, gift bags and gift products. Specializes in trend-oriented, hip urban greeting cards. "Always pushing the envelope, our cards redefine the edge of sophisticated, sassy, and downright silly fun." Art guidelines available for SASE with first-class postage.

NEEDS Looking for humorous, "off-the-wall" adult contemporary and editorial illustration. Produces material for Christmas, Mother's Day, Father's Day, graduation, Halloween, Valentine's Day, birthdays, thank you, anniversary, get well, astrology, sympathy, etc. Submit seasonal material 18 months in advance.

FIRST CONTACT & TERMS Designers: Send query as an e-mail attachment. Illustrators and Cartoonists: Send query as an e-mail attachment. Responds

in 1 month. Buys reprint rights. Pays for design and illustration by the project. Finds freelancers through sourcebooks, illustration annuals, referrals.

NORTHERN CARDS

5035 Timberlea Blvd., Unit #9, Mississauga ON L4W 2K9, Canada. (877)627-7444. **Website:** www.northerncards.com. Estab. 1992. Produces 3 brands of greeting cards.

NEEDS Approached by 200 freelancers/year. Works with 25 freelancers/year. Buys 75 freelance designs and illustrations/year. Uses freelancers for "camera-ready artwork and lettering." Art guidelines with SASE with first-class postage. Looking for traditional, sentimental, floral and humorous styles. Prefers 5½×7¾ or 5×7. Produces material for Christmas, Easter, Mother's Day, Father's Day, graduation, Valentine's Day, birthdays and everyday. Also sympathy, get well, someone special, thank you, friendship, new baby, good-bye and sorry. Submit seasonal material 6 months in advance.

FIRST CONTACT & TERMS Designers: Send query letter with brochure, photocopies, slides, résumé and SASE. Illustrators and Cartoonists: Send photocopies, tearsheets, résumé and SASE. Lettering artists send samples. Samples are filed or returned by SASE. Responds only if interested. Pays flat fee, $200 (CDN). Finds freelancers through newspaper ads, gallery shows and Internet.

NOVA MEDIA, INC.

1724 N. State St., Big Rapids MI 49307-9073. (231)796-4637. **E-mail:** trund@netonecom.net. **Website:** www.novamediainc.com. **Contact:** Thomas J. Rundquist, chairman. Estab. 1981. Specializes in CDs, CDs/cassettes, games, limited edition plates, posters, school supplies, T-shirts. Licenses e-prints.

NEEDS Seeking creative art for the serious collector. Considers oil, acrylic. Prefers expressionism, impressionism, abstract. Editions are created by collaborating with the artist or by working from an existing painting. Approached by 14 artists/year. Publishes/distributes the work of 2 emerging, 2 mid-career and 1 established artists/year. Also needs freelancers for design. Prefers local designers.

FIRST CONTACT & TERMS Send query letter with samples. Accepts e-mail submissions. Responds in 1 month. Keeps samples on file; does not return material. Simultaneous submissions and previously published work OK. Pays royalties of 10% or negotiates

payment. No advance. Rights purchased vary according to project. Provides promotion.

TIPS "The most effective way to contact us is by e-mail or regular mail. Visit our website."

NOVO CARD PUBLISHERS, INC.

100 Shepard Ave., Wheeling IL 60090. (847)947-8090. **Fax:** (847)947-8775. **E-mail:** art@novocard.net. **Website:** www.novocard.net. Produces all categories of greeting cards.

NEEDS Approached by 200 freelancers/year. Works with 30 freelancers/year. Buys 300 or 400 pieces/year from freelance artists. Art guidelines free for SASE with first-class postage. Uses freelancers mainly for illustration and text. Also for calligraphy. Considers all media. Prefers crop size 5×7¾, bleed 5¼×8. Knowledge of Photoshop, Illustrator and QuarkXPress, and InDesign helpful. Produces material for all holidays and seasons and everyday. Submit seasonal material 8 months in advance.

FIRST CONTACT & TERMS Designers: Send brochure, photocopies, photographs and SASE. Illustrators and Cartoonists: Send photocopies, photographs, tearsheets and SASE. Calligraphers: Send b&w copies. Accepts disk submissions compatible with Macintosh QuarkXPress 4.0 and Windows 95. Art samples are not filed and are returned by SASE only. Written samples retained on file for future assignment with writer's permission. Responds in 2 months. Pays for design and illustration by the project, $75-200.

OATMEAL STUDIOS

(802)767-3171. **E-mail:** dawn@oatmealstudios.com. **Website:** www.oatmealstudios.com. Publishes humorous greeting cards and notepads, creative ideas for everyday cards. Art guidelines available for SASE with first-class postage or on website.

NEEDS Approached by approximately 300 freelancers/year. Buys 100-150 freelance designs and illustrations/year. Considers all media.

FIRST CONTACT & TERMS Write for art guidelines; send query letter with SASE, roughs, printed pieces or brochure/flyer to be kept on file. "If brochure/flyer is not available, we ask to keep one sample printed piece; color or b&w photocopies also acceptable for our files." Samples are returned by SASE. Responds in 6 weeks. Negotiates payment.

TIPS "We're looking for exciting and creative, humorous (not cutesy) illustrations and single-panel cartoons. If you can write copy and have a humorous

cartoon style all your own, send us your ideas! We do accept artwork without copy, too."

OHIO WHOLESALE, INC.

5180 Greenwich Rd., Seville OH 44273. (330)769-1059. **Fax:** (330)769-1961. **E-mail:** annev@ohiowholesale. com. **Website:** www.ohiowholesale.com. **Contact:** Anne Secoy, vice president of product development. Estab. 1978. Home decor, giftware, seasonal. Produces collectible figurines, decorative housewares, decorations, gifts, mugs, ornaments and textiles.

NEEDS Prefers freelancers with experiences in home decor and giftware. Works with 6 freelancers/year. Buys 100 freelance designs/illustrations per year. Will consider wood, glass, resin, tin, canvas, acrylic, metal, fabric and paper mediums in the areas of religion, counter humor or inspirational pieces. Also produce materials for Christmas, Thanksgiving, Easter, Halloween, Grandparent's Day, St. Patrick's Day, woman-to-woman and everyday gifts. Seasonal materials should be submitted 18 months in advance. Artists should be familiar with Adobe Illustrator, Photoshop and QuarkXPress.

FIRST CONTACT & TERMS Send an e-mail query with brochure, photographs and SASE. Samples not kept on file. Company will contact artist for portfolio if interested. Pays by the project. Rights negotiated.

TIPS "Be able to work independently with your own ideas—use your 'gift' and think outside the box. *Wow me!*"

PAPERLINK

356 Kennington Rd., London SE11 4LD, United Kingdom 020 7582 8244. **Fax:** 020 7587 5212. **E-mail:** info@paperlink.co.uk. **Website:** www.paperlink. co.uk. Estab. 1985. Produces contemporary art and humorous greeting cards.

NEEDS Product categories include alternative/humor, counter humor, cute, juvenile and teen. Produces material for Mother's Day, Father's Day, Christmas, Easter, Valentine's Day, graduation, congratulations, wedding/anniversary, birthday, baby congrats, get-well/sympathy, everyday and all holidays and seasons. No specific size needed for final art. 50% of freelance work demands computer skills. Artists should be familiar with Illustrator, Photoshop and QuarkXPress. No need for freelance design.

FIRST CONTACT & TERMS Submission guidelines available online.

PAPER MAGIC GROUP, INC.

54 Glenmaura National Blvd., Suite 200, Moosic PA 18507. (800)278-4085. **E-mail:** orders@papermagic. com. **Website:** www.papermagic.com. **Contact:** Creative director. Estab. 1984. Produces greeting cards, stickers, vinyl wall decorations, 3D paper decorations. "We publish seasonal cards and decorations for the mass market. We use a wide variety of design styles."

NEEDS Works with 60 freelance artists/year. Prefers artists with experience in greeting cards. Work is by assignment; or send submissions on spec. Designs products for Christmas and Valentine's Day. Also uses freelancers for lettering and art direction.

FIRST CONTACT & TERMS Send query letter with résumé, samples (color photocopies) and SASE, Attn: Creative Director. Samples are filed or are returned by SASE if requested by artist. Originals not returned. Pays by the project. Buys all rights.

TIPS "Please, experienced illustrators only."

PAPER PRODUCTS DESIGN

60 Galli Dr., Novato CA 94949. (415)883-1888. **Fax:** (415)883-1999. **E-mail:** carol@ppd.co. **Website:** www. paperproductsdesign.com. **Contact:** Carol Florsheim. Estab. 1992. Produces paper napkins, plates, designer tissue, giftbags and giftwrap, porcelain accessories. Specializes in high-end design, fashionable designs.

NEEDS Approached by 50-100 freelancers/year. Buys multiple freelance designs and illustrations/year. Artists do not need to write for guidelines. They may send samples to the attention of Carol Florsheim at any time. Uses freelancers mainly for designer paper napkins. Looking for very stylized/clean designs and illustrations. Prefers 6½×6½. Produces seasonal and everyday material. Submit seasonal material 9 months in advance.

FIRST CONTACT & TERMS Designers: Send brochure, photocopies, photographs, tearsheets. Samples are not filed and are returned if requested with SASE. Responds in 6 weeks. Request portfolio review of color, final art, photostats in original query. Rights purchased vary according to project. Pays for design and illustration by the project in advances and royalties. Finds freelancers through agents, *Workbook*.

TIPS "Shop the stores, study decorative accessories, fashion clothing. Read European magazines. We are a design house."

PICKARD CHINA

782 Pickard Ave., Antioch IL 60002. (847)395-3800. **Fax:** (84)395-3827. **E-mail:** info@pickardchina.com. **Website:** www.pickardchina.com. Estab. 1893. Manufacturer of fine china dinnerware. Clients: Upscale specialty stores and department stores. Current clients include Gearys, Marshall Field's and Gump's.

NEEDS Assigns 2-3 jobs to freelance designers/year. Prefers designers for china pattern development with experience in home furnishings. Tabletop experience is a plus but not required.

FIRST CONTACT & TERMS Send query letter with résumé and color photographs, tearsheets, slides or transparencies showing art styles. Samples are filed or are returned if requested. Art director will contact artist for portfolio review if interested. Negotiates rights purchased. May purchase designs outright, work on royalty basis (usually 2%) or negotiate nonrefundable advance against royalties.

MARC POLISH ASSOCIATES

P.O. Box 3041, Margate NJ 08402. (609)823-7661. **E-mail:** mpolish@verizon.net. **Website:** www.just toiletpaper.com. **Contact:** Marc Polish, president. Estab. 1972. Produces T-shirts and sweatshirts. "We specialize in printed T-shirts, sweatshirts, printed bathroom tissue, paper towels and coasters. Our market is the gift and mail order industry, resort shops and college bookstores."

NEEDS Works with 6 freelancers/year. Designs must be convertible to screenprinting. Produces material for Christmas, Valentine's Day, Mother's Day, Father's Day, Hanukkah, graduation, Halloween, birthdays and everyday.

FIRST CONTACT & TERMS Send query letter with brochure, tearsheets, photographs, photocopies, photostats and slides. Samples are filed or are returned. Responds in 2 weeks. To show portfolio, mail anything to show concept. Originals returned at job's completion. Pays royalties of 6-10%. Negotiates rights purchased.

TIPS "We like to laugh. Humor sells. See what is selling in the local mall or department store. Submit anything suitable for T-shirts. Do not give up. No idea is a bad idea. It sometimes might have to be changed slightly to fit into a marketplace."

THE POPCORN FACTORY

13970 W. Laurel Dr., Lake Forest IL 60045. (847)362-0028. **Fax:** (847)362-9680. **Website:** www.thepop cornfactory.com. Estab. 1979. Manufacturer of popcorn packed in exclusive designed cans and other gift items sold via e-commerce and catalog for Christmas, Halloween, Valentine's Day, Easter and year-round gift giving needs.

NEEDS Works with 6 freelance artists/year. Assigns up to 20 freelance jobs/year. Works on assignment only. Uses freelancers mainly for popcorn can designs. Occasionally uses artists for illustration. 100% of freelance work requires knowledge of Illustrator and Photoshop.

FIRST CONTACT & TERMS Send query letter with copies, photographs or tearsheets. Samples are filed. Write for appointment to show portfolio, or mail copies of finished art samples and photographs. Pays for catalog design by the hour ($50 minimum) and by the page. Pays for illustration by project, $250-2,000. Considers complexity of project, skill and experience of artist, and turnaround time when establishing payment. Buys all rights.

TIPS *"Do not send art samples via e-mail."*

PORTERFIELD'S FINE ART LICENSING

4837 Tuttle Ave., Suite 410, Sarasota FL 34243. (800)660-8345 or (941)487-8581. **Fax:** (941)487-8582. **E-mail:** lance@porterfieldsfineart.com; art@porter fieldsfineart.com. **Website:** www.porterfieldsfineart. com. **Contact:** Lance J. Klass, president. Estab. 1994. Licenses representational, Christmas, holiday, seasonal, Americana, and many other subjects. We're a major, nationally recognized full-service licensing agency and functions as a full-service licensing representative for individual artists wishing to license their work into a wide range of consumer-oriented retail product categories. In addition to our top-rated art licensing portfolio site, we also run a major blog for artists on the business of art licensing at www. artlicensing.biz, where artists can learn the basics of how to go about licensing their work. Stop by our site for more information about how to become a Porterfield's artist and have us represent you and your work for licenses in wall and home decor, home fabrics, stationery and all paper products, crafts, giftware and many other fields. Send sample JPEGs via e-mail or direct us to a site with your artwork, for fastest response.

NEEDS Approached by more than 1,000 artists/year. Licenses many designs and illustrations/year, but only takes only 2-4 new artists each year. Prefers commercially oriented artists who can create beautiful pieces

of art that people want to look at again and again, and that will help sell products to the core consumer, that is, women over 30 who purchase 85% of all consumer goods in America." Art guidelines listed on website. Considers existing works first. Considers any media, oil, pastel, watercolor, acrylics, digital. "We are seeking artists who have exceptional artistic ability and commercial savvy, who study the market for trends and who would like to have their art and their talents introduced to the broad public. Artists must be willing to work hard to produce art for the market."

THE PRINTERY HOUSE

Conception Alley, P.O. Box 12, 37112 State Hwy. V V, Conception MO 64433. (660)944-3110. **Fax:** (660)944-3116. **E-mail:** art@printeryhouse.org. **Website:** www. printeryhouse.org. **Contact:** Steve Hess, creative director. Estab. 1950. Publishes religious greeting cards. Licenses art for greeting cards and wall prints. Specializes in religious Christmas and all-occasion themes for people interested in religious, yet contemporary, expressions of faith. Card designs are meant to speak to the heart. They feature strong graphics, calligraphy and other appropriate styles.

NEEDS Approached by 100 freelancers/year. Works with 40 freelancers/year. Art guidelines and technical specifications available on website. Uses freelancers for product illustration and lettering. Looking for dignified styles and solid religious themes. Has preference for high quality broad edged pen lettering with simple backgrounds/illustrations. Produces seasonal material for Christmas and Easter as well as the religious birthday, get well, sympathy, thank you, etc. Digital work is accepted in Photoshop or Illustrator format.

FIRST CONTACT & TERMS Send query letter with résumé, photocopies, CDs, photographs, slides or tearsheets. Calligraphers and artists can send samples of printed or finished work. Nonreturnable samples preferred or else samples with SASE. Submitted files should be compatible with Photoshop or Illustrator. Send TIFF or EPS files. Usually responds within 3-4 weeks. To show portfolio, e-mail appropriate materials only after query has been answered. "Generally, we continue to work with artists once we have accepted their work." Pays flat fee of $350-$550 for illustration/design, and $150-$250 for calligraphy. Usually buys exclusive reproduction rights for a specified format, but artist retains copyright for any other usage.

TIPS "Remember that our greeting cards need to have a definite Christian/religious dimension but not always over or overly sentimental. Artwork must be appealing and of high quality. It must be good quality artwork. We sell mostly via catalogs so artwork has to reduce well for catalog."

PRISMATIX, INC.

324 Railroad Ave., Hackensack NJ 07601. (800)222-9662. **Fax:** (201)525-2828. **E-mail:** prismatix@opt online.net. **Website:** www.prismatixinc.com. **Contact:** Miriam Salomon, vice president. Estab. 1977. Produces novelty humor programs. "We manufacture screen-printed novelties to be sold in the retail market."

NEEDS Works with 3-4 freelancers/year. Buys 100 freelance designs and illustrations/year. Works on assignment only. 90% of freelance work demands computer skills.

FIRST CONTACT & TERMS Send query letter with brochure, résumé. Samples are filed. Responds only if interested. Portfolio should include color thumbnails, roughs, final art. Payment negotiable.

PRUDENT PUBLISHING

65 Challenger Rd., Ridgefield Park NJ 07660. (201)641-7900. **Fax:** (201)641-9356. **E-mail:** mfrancesco@pru dentpublishing.com. **Website:** www.gallerycollection. com. Estab. 1928. Produces greeting cards. Specializes in business/corporate all-occasion and holiday cards. Art guidelines available.

NEEDS Buys calligraphy. Uses freelancers mainly for card design, illustrations and calligraphy. Considers traditional media. Prefers no cartoons or cute illustrations. Prefers 5½×7⅞ horizontal format (or proportionate). Produces material for Christmas, Thanksgiving, birthdays, everyday, sympathy, get well and thank you.

FIRST CONTACT & TERMS Designers, illustrators and calligraphers: Send query letter with brochure, photostats, photocopies, tearsheets. Samples are filed or returned by SASE if requested. Responds ASAP. Portfolio review not required. Buys all rights. No royalty or licensing arrangements. Payment is negotiable. Finds freelancers through submissions, magazines, sourcebooks, agents and word of mouth.

P.S. GREETINGS

5730 N. Tripp Ave., Chicago IL 60646. (773)267-6150. **Fax:** (773)267-6055. **E-mail:** artdirector@psgreetings. com. **Website:** www.psgreetings.com. Manufacturer

of boxed greeting and counter cards. Artists' guidelines are posted on website, or send SASE.

NEEDS Receives submissions from 300-400 freelance artists/year. Works with 50-100 artists/year on greeting card designs. Publishes greeting cards for everyday and holidays. 70% of work demands knowledge of InDesign, Illustrator and Photoshop.

FIRST CONTACT & TERMS Send all submissions to the attention of Design Director. All requests as well as submissions must be accompanied by SASE. "Samples will *not* be returned without SASE!" Responds in 1 month. Pays flat fee. Buys exclusive worldwide rights for greeting cards and stationery. No phone calls, please.

TIPS "Our line includes a whole spectrum from everyday needs (florals, scenics, feminine, masculine, humorous, cute) to every major holiday (from New Year's to Thanksgiving) with a very extensive Christmas line. We continue to grow every year and are always looking for innovative talent."

REALLY GOOD

Old Mast House, The Square, Abingdon Oxon 0X14 SAR, United Kingdom. +44 01235 537888. **Fax:** +44 01235 537779. **E-mail:** Online contact form. **Website:** www.reallygood.uk.com. **Contact:** David Hicks, managing director. Estab. 1987. Produces calendars, giftbags, gifts, giftwrap, greeting cards and stationary. Works with 5 freelancers/year. Purchases 100+ designs/illustrations per year. Buys cards and stationary 3-year rights. Freelancers are paid royalties.

NEEDS Trendy, fun, graphic, modern greeting cards. Seeks alternative, humor and counter humor cards. Produces material for Mother's Day, Christmas, birthdays, Father's Day, Valentine's Day, congratulations, baby congratulations, woman-to-woman, wedding/anniversary, get-well/sympathy and everyday cards. Seasonal material should be submitted 12 months in advance.

FIRST CONTACT & TERMS E-mail letter with artist's URL and small JPEG/PDF samples. Samples not kept on file, returned by SASE. Company will contact if interested.

RECO INTERNATIONAL CORPORATION

706 Woodlawn Ave., Cambridge OH 43725. (740)432-8800. **Fax:** (740)432-8811. **E-mail:** h.reich@reco.com. **Website:** www.reco.com. Manufacturer/distributor of stoneware and clay products. Sells through retail outlets, internet, and direct marketing firms. Reco represents Romertopf in the United States and Canada. Reco produces a line of clay products that offer a unique way of cooking, resulting in more tender, moister and more flavorful end results.

NEEDS Works with freelance and contract artists. Uses freelancers under contract for plate and figurine design, home decor and giftware. Prefers romantic and realistic styles.

FIRST CONTACT & TERMS Send query letter and brochure to be filed. Write for appointment to show portfolio. Art director will contact artist for portfolio review if interested. Negotiates payment. Considers buying second rights (reprint rights) to previously published work or royalties.

TIPS "Have several portfolios available. We are very interested in new artists. We go to shows and galleries, and receive recommendations from artists we work with."

RECYCLED PAPER GREETINGS, INC.

111 N. Canal St., Suite 700, Chicago IL 60606-7206. (800)777-9494. **Website:** www.recycled.com. **Contact:** Art director. Estab. 1971. Publishes greeting cards, adhesive notes and imprintable stationery.

NEEDS Buys 1,000-2,000 freelance designs and illustrations. Considers b&w line art and color—"no real restrictions." Looking for "great ideas done in your own style with messages that reflect your own slant on the world." Prefers 5×7 vertical format for cards. "Our primary interest is greeting cards." Produces seasonal material for all major and minor holidays including Jewish holidays. Submit seasonal material 18 months in advance; everyday cards are reviewed throughout the year.

FIRST CONTACT & TERMS Submission guidelines available online. The review process can take up to 2 months. Simultaneous submissions to other companies are acceptable. If your work is chosen, we will contact you to discuss final art preparation, procedures, and payment. If your work is not selected, it will be returned to you. To facilitate the return process, please be sure to include SASE that is big enough to hold your submission. Send submissions to Attn: Art Department.

TIPS "Remember that a greeting card is primarily a message sent from one person to another. The art must catch the customer's attention, and the words must deliver what the front promises. We are looking for unique points of view and manners of expression.

Our artists must be able to work with a minimum of direction and meet deadlines. There is a renewed interest in the use of recycled paper; we have been the industry leader in this for over 30 years."

THE REGAL LINE/ACME GRAPHICS

P.O. Box 2052, Cedar Rapids IA 52406. (319)364-0233. **E-mail:** info@regalline.com. **Website:** www.regalline. com. **Contact:** Jeff Scherrman, president. Estab. 1913. Produces printed merchandise used by funeral directors, such as acknowledgments, register books and prayer cards. Floral subjects, religious subjects and scenes are their most popular products. Art guidelines free for SASE.

○ Acme Graphics manufactures a line of merchandise for funeral directors. Floral subjects, religious subjects and scenes are their most popular products.

NEEDS Approached by 30 freelancers/year. Considers pen & ink, watercolor and acrylic. "We will send a copy of our catalog to show the type of work we do." Art guidelines available for SASE with first-class postage. Looking for religious, inspirational, church window, floral and nature art. Also uses freelancers for calligraphy and lettering.

FIRST CONTACT & TERMS Designers: Send query letter with résumé, photocopies, photographs, slides and transparencies. Illustrators: Send postcard sample or query letter with brochure, photocopies, photographs, slides and tearsheets. Accepts submissions on disk. Samples are not filed and are returned by SASE. Responds in 10 days. Call or write for appointment to show portfolio of roughs. Originals are returned. Requests work on spec before assigning a job. Pays by the project. Buys all rights.

TIPS "Send samples or prints of work from other companies. No modern art. Some designs are too expensive to print. Learn all you can about printing production. Please refer to website for examples of appropriate images!"

RIGHTS INTERNATIONAL GROUP, INC.

500 Paterson Plank Rd., Union City NJ 07087. (201)863-4500. **Fax:** Call for number. **Website:** www. rightsinternational.com. Estab. 1996. Agency for cross licensing. Licenses images for manufacturers/ publishers of giftware, stationery, posters and home furnishings.

○ See additional listing in the Posters & Prints section.

NEEDS Approached by 50 freelancers/year. Uses freelancers mainly for creative, decorative art for the commercial and designer market; also for textile art. Considers oil, acrylic, watercolor, mixed media, pastels and photography.

FIRST CONTACT & TERMS Submission guidelines available online.

RITE LITE, LTD.

333 Stanley Ave., Brooklyn NY 11207. (718)498-1700. **Fax:** (718)498-1251. **E-mail:** mail@ritelite.com. **Website:** www.ritelite.com. **Contact:** Baila Leiner, product development. Estab. 1948. Manufacturer and distributor of a full range of Judaica. Clients include department stores, galleries, gift shops, museum shops and jewelry stores.

NEEDS Looking for new menorahs, mezuzahs, children's Judaica, Passover and matza plates. Works on assignment only. Must be familiar with Jewish ceremonial objects or design. Also uses artists for illustration, and product design. Most of freelance work requires knowledge of Illustrator and Photoshop. Produces material for Hanukkah, Passover and other Jewish holidays. Submit seasonal material 1 year in advance.

FIRST CONTACT & TERMS Designers: Send query letter with brochure or résumé and photographs. Illustrators: Send photocopies. Do not send originals. Samples are filed. Responds in 1 month, only if interested. Art director will contact for portfolio review if interested. Portfolio should include color tear sheets, photographs and slides. Pays flat fee per design. Buys all rights. Finds artists through word of mouth.

TIPS "Be open to the desires of the consumers. Don't force your preconceived notions on them through the manufacturers. Know that there is one retail price, one wholesale price and one distributor price."

ROMAN, INC.

472 Brighton Dr., Bloomingdale IL 60108. (630)705-4600. **Website:** www.roman.com. Estab. 1963. Produces collectible figurines, decorative housewares, decorations, gifts, limited edition plates, ornaments. Specializes in collectibles and giftware to celebrate special occasions.

NEEDS Approached by 25-30 freelancers/year. Works with 3-5 freelancers/year. Uses freelancers mainly for graphic packaging design, illustration. Considers variety of media. Looking for traditional-based design. Roman also has an inspirational niche.

80% of freelance design and illustration demands knowledge of Photoshop, QuarkXPress, Illustrator. Produces material for Christmas, Mother's Day, graduation, Thanksgiving, birthdays, everyday. Submit seasonal material 1 year in advance.

FIRST CONTACT & TERMS Send query letter with photocopies. Samples are filed or returned by SASE. Responds in 2 months if artist requests a reply. Portfolio review not required. Pays by the project. Finds freelancers through submissions and word of mouth. "All submissions are submitted at your own risk and Roman cannot guarantee return of materials. Please do not send original artwork or prototypes. Allow 6-8 weeks for review. Please no phone calls. "

THE SARUT GROUP

P.O. Box 110495, Brooklyn NY 11211. (718)387-7484. **E-mail:** sarut@thesarutgroup.com. **Website:** www. thesarutgroup.com. **Contact:** Frederic Rambaud, vice president-marketing. Estab. 1979. Produces museum-quality science and nature gifts. "Marketing firm with 20 employees. 36 trade shows a year. No reps. All products are exclusive. Medium- to high-end market."

NEEDS Approached by 4-5 freelancers/year. Works with 4 freelancers/year. Uses freelancers mainly for new products. Seeks contemporary designs. Produces material for all holidays and seasons.

FIRST CONTACT & TERMS Samples are returned. Responds in 2 weeks. Write for appointment to show portfolio. Rights purchased vary according to project.

TIPS "We are looking for concepts; products, not automatically graphics."

SECOND NATURE, LTD.

10 Malton Rd., London W10 5UP, United Kingdom. +44 (0)20 8960-0212. **Fax:** +44 (0)20 8960-8700. **E-mail:** via online contact form. **Website:** www.second nature.co.uk. Greeting card publisher specializing in unique 3D/handmade cards and special finishes.

NEEDS Prefers interesting new contemporary but commercial styles. Also calligraphy and web design. Art guidelines available. Produces material for Christmas, Valentine's Day, Mother's Day and Father's Day. Submit seasonal material 19 months in advance.

FIRST CONTACT & TERMS Send query letter with samples showing art style. Samples not filed are returned only if requested by artist. Responds in 2 months. Originals are not returned at job's completion. Pays flat fee.

TIPS "We are interested in all forms of paper engineering or anything fresh and innovative."

PAULA SKENE DESIGNS

1250 45th St., Suite 240, Emeryville CA 94608. (510)654-3510. **Fax:** (510)654-3496. **E-mail:** paula skene@aol.com. **Website:** www.paulaskenedesigns. com.

NEEDS Works with 1-2 freelancers/year. Works on assignment only. Produces material for all holidays and seasons, everyday.

FIRST CONTACT & TERMS "Designers, artists, and illustrators: send tearsheets and photocopies. *Do not send more than 2 examples!* Samples are returned. Responds in 1 week. Buys all rights. Pays for design and illustration by the project."

SMART ALEX, INC.

1700 W. Irving Park Rd., #105, Chicago IL 60613. **E-mail:** submissions@smartalexinc.com. **Website:** www.smartalexinc.com. Estab. 1980. "From graphic artwork to cartooning, we employ a wide variety of artistic styles in our greeting cards. We will pay $150 for one time payment to purchase exclusive rights." Works with 5 freelancers/year. Buys 50 freelance designs/year.

NEEDS Always looking for funny lines, with a definite emphasis on humor for grown-ups. Our style of humor tends to be topical, witty, smart, ironic, or sexually suggestive. We will pay $125 for each submission we select to be published.

FIRST CONTACT & TERMS Send an e-mail with copy/samples in PDF format. Graphic submissions should be sent as an e-mail attachment, in JPEG format and at a resolution of 72 dpi. Final art should be 5×7. Artists should be familiar with Adobe Illustrator and Photoshop.

TIPS "Smart Alex welcomes submissions from artists, photographers and writers who share our philosophy of keeping greeting cards strictly funny, edgy and risquè. We do not deviate from this format. If your work obviously falls out of our parameters, please do not submit."

SOUL

Old Mast House, The Square, Oxford Oxfordshire OX14 SAR, United Kingdom. +44 1235 537816. **E-mail:** smile@souluk.com. **Website:** www.souluk. com. **Contact:** David Hicks, managing director. Estab. 1997. Produces greeting cards, notebooks, gift-wrap, and other stationary items. Works with 5 free-

lancers/year. Purchases 100+ designs/illustrations per year. Buys 3-year license. Freelancers paid royalties.

NEEDS Contemporary, modern, sentimental greeting cards. Birthdays, Mother's Day, Father's Day, Easter, Valentine's Day, congratulations baby congratulations, woman-to-woman, wedding/anniversary, get-well/sympathy, everyday.

FIRST CONTACT & TERMS E-mail query letter with URL of artist's site or small JPEG/PDF samples of work. Samples not kept on file. Will contact if interested.

TIPS "Check our website first for style."

SPARROW & JACOBS

6701 Concord Park Dr., Houston TX 77040. (713)329-9400. **Fax:** (713)744-8799. **E-mail:** sparrowart@gabp.com. **Contact:** Product merchandiser. Estab. 1986. Produces calendars, greeting cards, postcards and other products for the real estate industry.

NEEDS Buys up to 300 freelance photographs and illustrations/year including illustrations for postcards and greeting cards. Considers all media. Looking for new product ideas featuring residential front doors, homes and home-related images, flowers, landscapes, cute animals, holiday themes and much more. Emphasis on home-related photographs and illustrations. Produces material for Christmas, Easter, Mother's Day, Father's Day, Halloween, New Year, Thanksgiving, Valentine's Day, July 4th, birthdays, everyday, time change. Submit seasonal material 6 months in advance.

FIRST CONTACT & TERMS Send letter with color photocopies, photographs or tearsheets. We also accept e-mail submissions of low-resolution images. If sending slides, do not send originals. We are not responsible for slides lost or damaged in the mail. Samples are filed or returned in your SASE.

SPENCER'S

6826 Black Horse Pike, Egg Harbor Twp. NJ 08234-4197. **Website:** www.spencersonline.com. Estab. 1947. Retail gift chain located in approximately 850 stores in 43 states, including Hawaii and Canada. Includes 2 new retail chain stores named Spirit Halloween Superstores and ToyZam (toy chain).

- Products offered by store chain include: posters, T-shirts, games, mugs, novelty items, cards, 14K jewelry, neon art, novelty stationery. Spencer's offers different product lines, such as custom lava lights and Halloween costumes and

products. Visit a store if you can to get a sense of what they offer.

NEEDS Prefers artists with professional experience in advertising design. Uses artists for illustration (hard line art, fashion illustration, airbrush). Also needs product and fashion photography (primarily jewelry), as well as stock photography. Uses a lot of freelance computer art. 50% of freelance work demands knowledge of InDesign, Illustrator, Photoshop and QuarkXPress. Also uses production and packaging companies. "You don't necessarily have to be local for freelance production."

FIRST CONTACT & TERMS Send postcard sample or query letter with *nonreturnable* brochure, résumé and photocopies, including phone number where you can be reached during business hours. Accepts submissions on disk. Will contact artist for portfolio review if interested. Will contact only upon job need. Considers buying second rights (reprint rights) to previously published work. Finds artists through sourcebooks.

TIPS "Become proficient in as many computer programs as possible."

STARFISH & DREAMS

3291 Industry Way, Signal Hill CA 90755. (888)678-2734. **Fax:** (888)978-2734. **E-mail:** sales@starfishanddreams.com. **Website:** www.starfishanddreams.com. Estab. 1984. (Formerly NRN Designs, Inc.) Produces high-end invitations and announcements, photocards, and calendars.

NEEDS Looking for freelance artists with innovative ideas and formats for invitations and scrapbooking products. Works on assignment only. Produces stickers and other material for Christmas, Easter, graduation, Halloween, Hanukkah, New Year's, Thanksgiving, Valentine's Day, birthdays, everyday, (sympathy, get well, etc.). Submit seasonal material 1 year in advance.

FIRST CONTACT & TERMS E-mail query with link to your website or mail photocopies or other nonreturnable samples. Responds only if interested. Portfolios required from designers. Company will contact artist for portfolio review if interested. Rights purchased vary according to project. Pays for design by the project.

SUNSHINE ART STUDIOS, INC.

150 Kingswood Rd., P.O. Box 8465, Mankato MN 56002-8465. (800)873-7681. **Fax:** (800)232-3633. **E-mail:** cs@sunshinebusinessclass.com. **Website:** sun-

shinecards.com. Estab. 1921. Produces greeting cards, stationery and calendars that are sold in own catalog, appealing to all age groups.

NEEDS Works with 50 freelance artists/year. Buys 100 freelance designs and illustrations/year. Prefers artists with experience in greeting cards. Art guidelines available for SASE with first-class postage. Works on assignment only. Uses freelancers for greeting cards, stationery and gift items. Also for calligraphy. Considers all media. Looking for traditional or humorous look. Produces material for Christmas, birthdays and everyday. Submit seasonal material 6-8 months in advance.

FIRST CONTACT & TERMS Send query letter with brochure, résumé, SASE, tearsheets and slides. Samples are filed or are returned by SASE if requested by artist. Responds only if interested. Portfolio should include finished art samples and color tearsheets and slides. Originals not returned. Buys all rights.

SYRACUSE CULTURAL WORKERS

P.O. Box 6367, Syracuse NY 13217. (315)474-1132. **Fax:** (877)265-5399. **E-mail:** karenk@syracusecultural workers.com. **Website:** www.syracuseculturalwork ers.com. **Contact:** Karen Kerney, art director. Estab. 1982. Produces posters, note cards, postcards, greeting cards, T-shirts and calendars that are feminist, progressive, radical, multicultural, lesbian/gay allied, racially inclusive and honoring of elders and children. Publishes and distributes peace and justice resources through their Tools For Change catalog.

NEEDS Approached by many freelancers/year. Works with 50 freelancers/year. Buys 40-50 freelance fine art images and illustrations/year. Considers all media. Art guidelines available on website or free for SASE with first-class postage. Specifically seeking artwork celebrating peace-making diversity, people's history and community building. "Our mission is to help sustain a culture that honors diversity and celebrates community; that inspires and nurtures justice, equality and freedom; that respects our fragile Earth and all its beings; that encourages and supports all forms of creative expression." Themes include environment, positive parenting, positive gay and lesbian images, multiculturalism and cross-cultural adoption.

FIRST CONTACT & TERMS Send query letter with sample of work and SASE. Samples are filed or returned by SASE. Responds in 1 month with SASE. Will contact for portfolio review if interested. Buys one-time rights. Pays flat fee, $85-450; royalties of 4-6% gross sales. Finds artists through submissions and word of mouth.

TIPS "Please do *not* send original art. Rather, send photocopies, printed samples or duplicate slides. Also, one postcard sample is not enough for us to judge whether your work is right for us. Include return postage if you would like your artwork/slides returned. December and January are major art selection months." Please visit our website to get a sense of what we've chosen to publish in the past at www.syracuseculturalworkers.com.

TALICOR, INC.

901 Lincoln Pkwy., Plainwell MI 49080. (269)685-2345 or (800)433-GAME (4263). **Fax:** (269)685-6789. **E-mail:** orders@talicor.com. **Website:** www.talicor.com. Estab. 1971. Manufacturer and distributor of educational and entertainment games and toys. Clients chain toy stores, department stores, specialty stores and Christian bookstores.

NEEDS Works with 4-6 freelance illustrators and designers/year. Prefers local freelancers. Works on assignment only. Uses freelancers mainly for game design. Also for advertising, brochure and catalog design, illustration and layout; product design; illustration on product; P-O-P displays; posters and magazine design.

FIRST CONTACT & TERMS Send query letter with tearsheets, samples or postcards. Samples are not filed and are returned only if requested. Responds only if interested. Call or write for appointment to show portfolio. Pays for design and illustration by the project. Negotiates rights purchased. Accepts digital submissions via e-mail.

VAGABOND CREATIONS, INC.

2560 Lance Dr., Dayton OH 45409. (800)738-7237. **Fax:** (800)738-7237. **E-mail:** sales@vagabondcreations.net. **Website:** www.vagabondcreations.net. Publishes stationery and greeting cards with contemporary humor; also a line of coloring books. 99% of artwork used is provided by staff artists.

NEEDS Works with 3 freelancers/year. Buys 6 finished illustrations/year. Seeking line drawings, washes and color separations. Material should fit in standard-size envelope.

FIRST CONTACT & TERMS Query. Samples are returned by SASE. Responds in 2 weeks. Submit Christmas, Valentine's Day, everyday and graduation ma-

terial at any time. Originals are returned only upon request. Payment negotiated.

TIPS "Important! Currently we are *not* looking for additional freelance artists because we are very satisfied with the work submitted by those individuals working directly with us. Our current artists are very experienced and have been associated with us in some cases for over 30 years. We do not in any way wish to offer false hope to anyone, but it would be foolish on our part not to give consideration."

WANDA WALLACE ASSOCIATES

323 E. Plymouth, Suite 2, Inglewood CA 90302. (310)419-0376. **E-mail:** wandawallacefoundation@yahoo.com. **Website:** www.wandawallacefoundation.org. **Contact:** Wanda Wallace, president. Estab. 1980. Nonprofit organization produces greeting cards and posters for general public appeal. "We produce black art prints, posters, originals and other media."

○ This publisher is doing more educational programs, touring schools nationally with artists.

NEEDS Approached by 10-12 freelance artists/year. Works with varying number of freelance artists/year. Buys varying number of designs and illustrations/year from freelance artists. Prefers artists with experience in black/ethnic art subjects. Uses freelance artists mainly for production of originals and some guest appearances. Considers all media. Produces material for Christmas. Submit seasonal material 4-6 months in advance.

FIRST CONTACT & TERMS Send query letter with any visual aid. Some samples are filed. Policy varies regarding answering queries and submissions. Call or write to schedule an appointment to show a portfolio. Rights purchased vary according to project. Art education instruction is available. Pays by the project.

WARNER PRESS, INC.

1201 E. Fifth St., Anderson IN 46012. (800)741-7721. **E-mail:** krhodes@warnerpress.org. **Website:** www.warnerpress.org. **Contact:** Karen Rhodes, senior editor. Estab. 1884. Warner Press produces church bulletins, church supplies, Christian Art boxed greeting cards, activity and coloring books, picture story books, kids books and ministry teaching resources. We produce products for the Christian marketplace. Our main markets are the Church and Christian bookstores. We provide products for all ages. Art submission guidelines available online. Works on assignment only. Warner Press uses freelancers for all

products, as listed above. Considers media and photography. Work demands knowledge of Photoshop, Illustrator and InDesign.

NEEDS Approached by 50 freelancers/year. Works with 15-20 freelancers/year. Buys 200 freelance designs and illustrations/year. Works on assignment only. Uses freelancers for all products, including bulletins and coloring books. Considers all media and photography. 100% of production work demands knowledge of Photoshop, Illustrator and InDesign.

FIRST CONTACT & TERMS Send postcard or query letter with samples. Do not send originals. Creative director will contact artist for portfolio review if interested. Samples are filed or returned if SASE included. Pays by the project. Buys all rights (occasionally varies).

TIPS "Subject matter must be appropriate for Christian market. Most of our art purchases are for children's materials."

CAROL WILSON FINE ARTS, INC.

P.O. Box 17394, Portland OR 97217. (503)261-1860 or (800)473-0785. **Fax:** 503-255-6829. **E-mail:** info@carolwilsonfinearts.com. **Website:** www.carolwilsonfinearts.com. Estab. 1983. Produces greeting cards and fine stationery products.

NEEDS Romantic floral and nostalgic images. "We look for artists with high levels of training, creativity and ability."

FIRST CONTACT & TERMS Write or call for art guidelines. No original artwork on initial inquiry. Samples not filed; returned by SASE.

TIPS "We are seeing an increased interest in romantic fine arts cards and very elegant products featuring foil, embossing and die-cuts."

ZITI CARDS

601 S. Sixth St., St. Charles MO 63301. (800)497-5908. **Fax:** (636)352-2146. **E-mail:** mail@ziticards.com. **Website:** www.ziticards.com. **Contact:** Salvatore Ventura, owner. Estab. 2006. Produces greeting cards. Specializes in holiday cards for architects and construction businesses. Art guidelines available via e-mail.

NEEDS Architecture, cities/urban, interiors/decorating, industry, alternative process, avant garde, documentary, fine art, historical/vintage, lifestyle and seasonal photographs. Submit seasonal work 2 months in advance. Model releases and property releases are preferred. Captions are preferred. "We purchase ex-

clusive rights for the use of photographs on greeting cards and do not prevent photographers from using images on other non-greeting card items. Photographers retain all copyrights and can end the agreement for any reason." Pays $50 advance and 5% royalties at the end of the season. Finds freelancers through submissions.

FIRST CONTACT & TERMS Accepts e-mail submissions with windows-compatible image files or link to website. "E-mail attachments are preferred, but anything that accurately shows the work is fine." After introductory mailing, send follow-up postcard sample every 6 months. Samples are filed or returned by SASE if requested. Responds only if interested.

POSTERS & PRINTS

//

Have you ever noticed, perhaps at the opening of an exhibition or at an art fair, that though you have many paintings on display, everybody wants to buy the same one? Do friends, relatives, and co-workers ask you to paint duplicates of work you've already sold? Many artists turn to the print market because they find certain images have a wide appeal and will sell again and again. This section lists publishers and distributors who can produce and market your work as prints or posters. It is important to understand the difference between the terms "publisher" and "distributor" before you begin your research. Art publishers work with you to publish a piece of your work in print form. Art distributors assist you in marketing a pre-existing poster or print. Some companies function as both publisher and distributor. Look in the first paragraph of each listing to determine if the company is a publisher, distributor, or both.

RESEARCH THE MARKET

Some listings in this section are fine art presses, and others are more commercial. Read the listings carefully to determine which companies create editions for the fine art market or for the decorative market. Visit galleries, frame shops, furniture stores, and other retail outlets that carry prints to see where your art fits in. You may also want to visit designer showrooms and interior decoration outlets.

To further research this market, check each company's website or send for their catalog. Some publishers will not send their catalogs because they are too expensive, but you may be able to see one at a local poster shop, print gallery, upscale furniture store, or frame shop. Examine the colors in the catalogs to make sure the quality is high.

YOUR PUBLISHING OPTIONS

1. Working with a commercial poster manufacturer or art publisher. If you don't mind creating commercial images and following current trends, the decorative market can be quite lucrative. On the other hand, if you work with a fine art publisher, you will have more control over the final image.

2. Working with a fine art press. Fine art presses differ from commercial presses in that press operators work side by side with you every step of the way, sharing their experience and knowledge of the printing process. You may be charged a fee for the time your work is on the press and for the expert advice of the printer.

3. Working at a co-op press. Instead of approaching an art publisher, you can learn to make your own hand-pulled original prints—such as lithographs, monoprints, etchings, or silk-screens. If there is a co-op press in your city, you can rent time on a press and create your own editions. It can be rewarding to learn printing skills and have the hands-on experience. You also gain total control of your work. The drawback is you have to market your images yourself by approaching galleries, distributors, and other clients.

4. Self-publishing. Several national printing companies advertise heavily in artists' magazines, encouraging artists to publish their own work. If you are a savvy marketer who understands the ins and outs of trade shows and direct marketing, this is a viable option. However, it takes a large investment up front, whether you work with a printing company or choose to do everything on your own. If you contract with a printer, you could end up with a thousand prints taking up space in your basement. On the other hand, if you are a good marketer, you could end up selling them all and making a much larger profit than if you had gone through an art publisher or poster company.

 Another option is to create the prints yourself, from your computer, using a high-quality digital printer and archival paper. You can make the prints as needed, which will save money.

5. Marketing through distributors. If you choose the self-publishing route but don't have the resources to market your prints, distributors will market your work in exchange for a percentage of sales. Distributors have connections with all kinds of outlets like retail stores, print galleries, framers, college bookstores, and museum shops.

What to send

To approach a publisher, send a brief query letter, a short bio, a list of galleries that represent your work, and five to ten JPEGs, TIFFs, or slides. (Check the listing or submission guidelines to see the type of samples they prefer.) It helps to send printed pieces or tearsheets as samples,

as these show publishers that your work reproduces well and that you have some understanding of the publication process. Most publishers will accept digital submissions via e-mail or CD.

Signing and numbering your editions

Before you enter the print arena, follow the standard method of signing and numbering your editions. You can observe how this is done by visiting galleries and museums and talking to fellow artists.

If you are creating a limited edition—with a specific, set number of prints—all prints should be numbered, such as 35/100. The largest number is the total number of prints in the edition; the smaller number is the sequential number of the actual print. Some artists hold out ten percent as artist's proofs and number them separately with AP after the number (e.g., 5/100 AP). Many artists sign and number their prints in pencil.

Types of prints

Original prints. Original prints may be woodcuts, engravings, linocuts, mezzotints, etchings, lithographs, or serigraphs (see Glossary for definitions). What distinguishes them is that they are produced by hand by the artist (and consequently often referred to as hand-pulled prints). In a true original print, the work is created specifically to be a print. Each print is considered an original because the artist creates the artwork directly on the plate, woodblock, etching stone, or screen. Original prints are sold through specialized print galleries, frame shops, high-end decorating outlets, and fine art galleries.

Offset reproductions and posters. Offset reproductions, also known as posters and image prints, are reproduced by photochemical means. Since plates used in offset reproductions do not wear out, there are no physical limits on the number of prints that can be made. Quantities, however, may still be limited by the publisher in order to add value to the edition.

Giclée prints. As color-copier technology matures, inkjet fine art prints, also called giclées, are gaining popularity. Iris prints, images that are scanned into a computer and output on oversized printers, are even showing up in museum collections.

Canvas transfers. Canvas transfers are becoming increasingly popular. Instead of, and often in addition to, printing an image on paper, the publisher transfers the image onto canvas so the work has the look and feel of a painting. Some publishers market limited editions of 750 prints on paper, along with a smaller edition of 100 of the same image on canvas. The edition on paper might sell for about half the price (or a little less) than the price of the canvas transfer.

Pricing criteria for limited editions and posters

Because original prints are always sold in limited editions, they command higher prices than posters, which are not numbered. Since plates for original prints are made by hand, and as a result can only withstand a certain amount of use, the number of prints pulled is limited by the number of impressions that can be made before the plate wears out. Some publishers impose their own limits on the number of impressions to increase a print's value. These limits may be set as high as 700 to 1,000 impressions, but some prints are limited to just 250 to 500, making them highly prized by collectors.

A few publishers buy work outright for a flat fee, but most pay on a royalty basis. Royalties for hand-pulled prints are usually based on retail price and range from 5 to 20 percent, while percentages for posters and offset reproductions are lower (from 2½ to 5 percent) and are based on the wholesale price. Be aware that some publishers may hold back royalties to cover promotion and production costs; this is not uncommon.

Prices for prints vary widely depending on the quantity available; the artist's reputation; the popularity of the image; the quality of the paper, ink, and printing process. Because prices for posters are lower than for original prints, publishers tend to select images with high-volume sales potential.

Negotiating your contract

As in other business transactions, ask for a contract and make sure you understand and agree to all the terms before you sign. Make sure you approve the size, printing method, paper, number of images to be produced, and royalty terms. Other things to watch for include insurance terms, marketing plans, and a guarantee of a credit line or copyright notice.

Always retain ownership of your original work. Negotiate an arrangement in which you're selling publication rights only. You'll also want to sell rights for only a limited period of time. That way you can sell the image later as a reprint or license it for other use (e.g., as a calendar or note card). If you are a perfectionist about color, make sure your contract gives you final approval of your print. Stipulate that you'd like to inspect a press proof prior to the print run.

MORE INDUSTRY TIPS

Find a niche. Consider working within a specialized subject matter. Prints with Civil War themes, for example, are avidly collected by Civil War enthusiasts. But to appeal to Civil War buffs, every detail, from weapons and foliage in battlefields to uniform buttons, must be historically accurate. Signed limited editions are usually created in a print run of 950 or so and can average about $175–200; artist's proofs sell from between $195–250, with canvas transfers selling for $400–500. The original paintings from which images are taken often sell for thousands of dollars to avid collectors.

Sport art is another lucrative niche. There's a growing trend toward portraying sports figures from football, basketball, and racing (both sports car and horse racing) in prints that include both the artist's and the athlete's signatures. Movie stars and musicians from the 1950s (such as James Dean, Marilyn Monroe, and Elvis) are also cult favorites, but any specialized style (such as science fiction/fantasy or wildlife art) can be a marketable niche. See the Market Niche Index for more ideas.

Work in a series. It is easier to market a series of small prints exploring a single theme than to market single images. A series of similar prints works well in long hospital corridors, office meeting rooms, or restaurants. "Paired" images also are rather profitable. Hotels often purchase two similar prints for each of their rooms.

Study trends. If you hope to get published by a commercial art publisher or poster company, realize your work will have a greater chance of acceptance if you use popular colors and themes.

Attend trade shows. Many artists say it's the best way to research the market and make contacts. It's also a great way for self-published artists to market their work. DECOR Expo is held each year in four cities: Atlanta, New York, Orlando, and Los Angeles. For more information, call (888)608-5300 or visit www.decor-expo.com. Artexpo is held every spring in New York, and now also every fall in Las Vegas. The SOLO Independent Artists' Pavilion, a special section of Artexpo dedicated to showcasing the work of emerging artists, is the ultimate venue for artists to be discovered. See www.artexpos.com for more information.

ACTION IMAGES, INC.

7148 N. Ridgeway, Lincolnwood IL 60712. (847)763-9700. **Fax:** (847)763-9701. **E-mail:** info@actionimagesinc.biz. **Website:** actionimagesinc.biz. **Contact:** Tom Green, president. Estab. 1989. Art publisher of sport art. Publishes limited edition prints, open edition posters as well as direct printing on canvas. Specializes in sport art prints for events such as the Super Bowl, Final Four, Stanley Cup, etc. Clients include retailers, distributors, sales promotion agencies.

NEEDS "Ideally seeking sport artists/illustrators who are accomplished in both traditional and computer-generated artwork as our needs often include tight deadlines, exacting attention to detail and excellent quality. Primary work relates to posters and T-shirt artwork for retail and promotional material for sporting events." Considers all media. Artists represented include Cheri Wenner, Andy Wenner, Ken Call, Konrad Hack and Alan Studt. Approached by approximately 25 artists/year.

CONTACT & TERMS Send JPEG or PDF files via e-mail or mailed disk (compatible with Mac) and color printouts. Samples are filed. Responds only if interested. If interested in samples, will ask to see more of artist's work. Pays flat fee: $1,000-2,000. Buys exclusive reproduction rights. Rarely acquires original painting. Provides insurance while work is at firm and outbound in-transit insurance. Promotional services vary depending on project. Finds artists through recommendations from other artists, word of mouth and submissions.

TIPS "If you're a talented artist/illustrator and know your PhotoShop/Illustrator software, you have great prospects."

ARNOLD ART STORE & GALLERY

210 Thames St., Newport RI 02840. (401)847-2273; (800)352-2234. **Fax:** (401)848-0156. **E-mail:** info@arnoldart.com. **Website:** www.arnoldart.com. **Contact:** Bill Rommel, owner. Estab. 1870. Poster company; art publisher/distributor; gallery specializing in marine art. Publishes/distributes limited and unlimited editions, fine art prints, offset reproductions and posters.

NEEDS Seeking creative, fashionable, decorative art for the serious collector, commercial and designer markets. Considers oil, acrylic, watercolor, mixed media, pastel, pen & ink, sculpture. Prefers sailing images—America's Cup or other racing images. Artists represented include Kathy Bray, Thomas Buechner

and James DeWitt. Editions are created by working from an existing painting. Approached by 100 artists/year. Publishes/distributes the work of 10-15 established artists/year.

CONTACT & TERMS Send query letter with 4-5 photographs. Samples are filed or returned by SASE. Call to arrange portfolio review. Pays flat fee, royalties or consignment. Negotiates rights purchased; rights purchased vary according to project. Provides advertising and promotion. Finds artists through word of mouth.

HERBERT ARNOT, INC.

250 W. 57th St., New York NY 10107. (212)245-8287; after-hours (917)570-7910. **E-mail:** arnotart@aol.com. **Website:** www.arnotart.com. **Contact:** Vicki Arnot, owner/partner with Peter Arnot. Art dealer of original paintings, color Kasimir Etching, and limited edition Luigi Rocca Giclées. Clients: art galleries, design firms and collectors.

NEEDS Seeking creative and decorative art for the serious collector and designer market. Considers oil and acrylic paintings in all styles. Considers sculpture. Has wide range of themes and styles "mostly traditional/impressionistic." Artists represented include Raymond Campbell, Claudio Simonetti, Guy Dessapt, MALVA, Estate of Christian Nesvadba, Gerhard Nesvadba, Claudia Fisher, Michael Minthorn, and many others. Distributes the work of 250 artists/year.

CONTACT & TERMS Send query letter with brochure, résumé, business card—photographs are discarded or returned by SASE. Responds in 1 month. Portfolios may be mailed, or by appointment. Provides promotion.

TIPS "Artist should be professional."

ARTBEATS, INC.

129 Glover Ave., Norwalk CT 06850-1311. (800)677-6947. **Fax:** (203)846-2105. **E-mail:** donna@nygs.com. **Website:** www.nygs.com. Estab. 2002. Art publisher. Publishes and distributes open edition posters, matted prints, canvases and other wall decor formats. Clients: retailers of fine wall decor. Current clients include Bed Bath & Beyond, Homegoods, Cost Plus World Market, Hobby Lobby, Aaron Brothers, Michael's, Joann's and many others. Member of New York Graphic Society Publishing Group and Global Art Group, Ltd.

NEEDS Seeking creative, fashionable and decorative art for the home design market. Art guidelines are posted on website. Artwork should be current, ap-

propriate for home decor, professional and polished. Publishes approx. 500 new works each year.

CONTACT & TERMS Send query letter with résumé, color-correct photographs, JPEGs or transparencies. Samples are not filed and are returned by SASE if requested by artist. Responds in 3 months. Publisher will contact artist for portfolio review if interested. Do not send originals and do not call. Terms negotiated at time of contact. Provides written contract. Finds artists through art shows, licensing agents, exhibits, word of mouth and submissions.

ART BROKERS OF COLORADO

7615 Jeffrey Lane, Colorado Springs CO 80919. (719)520-9177. **E-mail:** artbrokers@aol.com. **Website:** www.artbrokers.com. Estab. 1991. Art publisher. Publishes limited and unlimited editions, posters and offset reproductions. Clients: galleries, decorators, frame shops.

NEEDS Seeking decorative art by established artists for the serious collector. Prefers oil, watercolor and acrylic. Prefers western theme. Editions created by collaborating with the artist. Approached by 20-40 artists/year. Publishes the work of 1-2 established artists/year.

CONTACT & TERMS Send query letter with photographs. Samples are not filed and are returned by SASE. Responds in 4-6 weeks. Company will contact artist for portfolio review of final art if interested. Pays royalties. Rights purchased vary according to project. Provides insurance while work is at firm.

TIPS Advises artists to attend all the trade shows and to participate as often as possible.

ART DALLAS, INC.

2325 Valdina St., Dallas TX 75207. (214)688-0244. **Fax:** (214)688-7758. **E-mail:** info@artdallas.com. **Website:** www.artdallas.com. **Contact:** Judy Martin, president. Estab. 1988. Art distributor, gallery, framing and display company. Distributes handpulled originals, offset reproductions. Clients: designers, architects. "Art Dallas, Inc. provides art and framing services to the design trade. Our goal is to provide the best, most complete service at the best possible price. The Gallery at Art Dallas, Inc. is a recently renovated 8,000 ft. showroom in the Dallas Design District. It is a commercial, working gallery with lots of table space. This allows our designers to spread out, facilitating the design of more than one project at a time."

NEEDS Seeking creative art for the commercial and designer markets. Considers mixed media. Prefers abstract, landscapes.

CONTACT & TERMS Send query letter with résumé, photocopies, slides, photographs and transparencies. Samples are filed or are returned. Call for appointment to show portfolio of slides and photographs. Pays flat fee $50-5,000. Offers advance when appropriate. Negotiates rights purchased.

ART EMOTION CORP.

1758 S. Edgar St., Palatine IL 60067. (847)397-9300. **E-mail:** gperez@artcom.com. **Contact:** Gerard V. Perez, president. Estab. 1977. Art publisher and distributor. Publishes and distributes limited editions. Clients: corporate/residential designers, consultants and retail galleries.

NEEDS Seeking decorative art. Considers oil, watercolor, acrylic, pastel and mixed media. Prefers representational, traditional and impressionistic styles. Editions are created by working from an existing painting. Approached by 50-75 artists/year. Publishes and distributes the work of 2-5 artists/year.

CONTACT & TERMS E-mail query letter with good image files. Will respond if interested. Pays royalties of 10%.

TIPS "E-mail visuals first."

ART IMPRESSIONS, INC.

23586 Calabasas Rd., Suite 210, Calabasas CA 91302. (818)591-0105, ext. 13. **Fax:** (818)591-0106. **E-mail:** info@artimpressionsinc.com. **Website:** www.artimpressionsinc.com. **Contact:** Cindy Bailey, CEO. Estab. 1990. Licensing agent. Brand development & licensing agency. Clients: major manufacturers worldwide. Current clients include Mighty Fine, Toynamik, Toynami, Hot Topic, Toys R Us, High Intencity, Ravensburger, Leanin' Tree, Lounge Fly, Random House, and Mead Westvaco.

NEEDS Seeking art for the commercial market, "especially art geared towards fashion/streetwear market." With focus on art that can be acquired outright. Considers oil, acrylic, mixed media, pastel and photography. No abstracts, watercolors, pastels or nudes. Artists represented include Skelanimals, So So Happy, Milky Way & The Galaxy Girls, and Josephine Wall. Approached by over 70 artists/year.

CONTACT & TERMS Send query letter with photocopies, photographs, slides, transparencies or tearsheets and SASE. Accepts disk submissions. Sam-

ples are not filed and are returned by SASE. Responds in 2 months. Will contact artist for portfolio review if interested. Artists are paid percentage of licensing revenues generated by their work. No advance. Requires exclusive representation of artist. Provides advertising, promotion, written contract and legal services. Finds artists through art exhibitions, word of mouth, publications and submissions.

TIPS "Artists should have at least 25 images available and be able to reproduce new collections several times a year. Artwork must be available on disk and be of reproduction quality."

THE ART PUBLISHING GROUP

165 Chubb Ave., Lyndhurst NJ 07071. (201)842-8500 or (800)760-3058. **Fax:** (201)842-8546. **E-mail:** contact@theartpublishinggroup.com. **E-mail:** submitart@theartpublishinggroup.com. **Website:** www.theartpublishinggroup.com. **Contact:** Artist submissions. Estab. 1973. Publisher and distributor of limited editions, open editions, and fine art prints and posters. Clients: galleries and custom frame shops worldwide.

○ Divisions of The Art Publishing Group include APG Collection, Front Line Art Publishing, Modernart Editions and Scafa Art. See website for details of each specific line. Submission guidelines are the same for all.

NEEDS Seeking decorative art for the commercial and designer markets. Considers oil, watercolor, mixed media, pastel and acrylic. Prefers fine art, abstract and contemporary, floral, representational, still life, decorative, collage, mixed media. Size: 16×20. Editions are created by collaborating with the artist or by working from an existing painting. Approached by 200 artists/year. Publishes the work of 10-15 emerging artists/year. Distributes the work of 100 emerging artists/year.

CONTACT & TERMS Submit no more than 4 JPEGs (maximum 300KB each) via e-mail. Also accepts CDs, color copies, photographs "or any other medium that best represents your art. Do not send original art, transparencies or slides. If you want your samples returned, be sure to include a SASE." Will contact artist for portfolio review if interested. Offers advance against royalties. Provides insurance while work is at firm, shipping to firm and written contract.

TIPS "If you want your submission to be considered for a specific line within The Art Publishing Group, please indicate that in your cover letter."

○ ART SOURCE

455 Cochrane Dr., Unit 23, Markham ON L3R 8E6, Canada. (905)475-8181. **Fax:** (905)479-4966. **E-mail:** victoria@artsource.ca. **Website:** www.artsource.ca. **Contact:** Victoria Fenninger, art director. Estab. 1979. Poster company and distributor. Publishes/distributes hand-pulled originals, limited editions, unlimited editions, canvas transfers, fine art prints, monoprints, monotypes, offset reproductions and posters. Clients: galleries, decorators, frame shops, distributors, corporate curators, museum shops and gift shops.

NEEDS Seeking creative, fashionable and decorative art for the designer market. Considers oil, acrylic, watercolor, mixed media, pastel and pen & ink. Editions are created by collaborating with the artist and by working from an existing painting. Approached by 50 artists/year. Publishes the work of 5 emerging, 5 mid-career and 10 established artists/year. Distributes the work of 5 emerging, 5 mid-career and 10 established artists/year.

CONTACT & TERMS Send query letter with brochure, photocopies, photographs, photostats, résumé, SASE, slides, tearsheets and transparencies. Accepts low-res submissions via e-mail. "Please keep e-mail submissions to a maximum of 10 images." Responds in 2 weeks. Company will contact artist for portfolio review if interested. Portfolios may be dropped off every Monday and Tuesday. Portfolio should include color photographs, photostats, roughs, slides, tearsheets, thumbnails and transparencies. Artist should follow up with letter after initial query. Pays royalties of 6-12%; flat fee is optional. Payment is negotiable. Offers advance when appropriate. Negotiates rights purchased. Rights purchased vary according to project. Sometimes requires exclusive representation of artist. Provides advertising, promotion and written contract.

TIPS "We are looking for more original art for our distribution."

ARTS TRENDS, LLC

P.O. Box 2627, Cookeville TN 38502. (800)833-0317. **Fax:** (931)528-8904. **E-mail:** info@arttrendsfineart.com. **Website:** www.arttrendsfineart.com. **Contact:** Lee Riemann. Estab. 1985. Art publisher. Publishes open editions on paper and canvas. Licenses a variety of artwork for cards, rugs, etc.

NEEDS We seek creative and decorative art for the publishing and licensing market. Considers all media.

Images created by collaborating with the artist or by working from an existing piece of art.

CONTACT & TERMS Correspond by e-mail with JPEG attachments, reference to website, etc., to info@arttrendsfineart.com with the words "art submission" in subject line. If you prefer to mail, send photos or other media type to the attention of Art Submission Department. Include SASE for return. Pays royalties quarterly. Printing and shipping done from firm.

BANKS FINE ART

1313 Slocum St., Suite 103, Dallas TX 75207. (214)352-1811. **Fax:** (214)352-6360. **E-mail:** bob@banksfineart.com. **Website:** www.banksfineart.com. **Contact:** Bob Banks, owner. Estab. 1980. Distributor; gallery of original oil paintings. Clients: galleries, decorators. Specializes in 18th- and 19th-century American and European oils. Represents 8 artists.

NEEDS Seeking decorative, traditional and impressionistic art for the serious collector and the commercial market. Considers oil, acrylic. Prefers traditional and impressionistic styles. Approached by 100 artists/year. Publishes/distributes the work of 2 emerging artists/year.

CONTACT & TERMS Send photographs. Samples are returned by SASE. Offers advance. Rights purchased vary according to project. Provides advertising, in-transit insurance, insurance while work is at firm, promotion, shipping from firm, written contract.

TIPS Needs Paris and Italy street scenes. Advises artists entering the poster and print market to attend Artexpo, the industry's largest trade event, held in New York City every spring and Las Vegas every fall. Also recommends reading *Art Business News*.

THE BENJAMAN GALLERY

419 Elmwood Ave., Buffalo NY 14222. (716)886-0898. **Fax:** (716)886-0546. **E-mail:** info@thebenjamangallery.com. **Website:** www.benartgallery.com. Estab. 1970. Art publisher, distributor, gallery, frame shop and appraiser. Publishes and distributes handpulled originals, limited and unlimited editions, posters, offset reproductions and sculpture. Clients include P&B International.

NEEDS Seeking decorative art for the serious collector. Considers oil, watercolor, acrylic and sculpture. Prefers art deco and florals. Artists represented include Peter Max, Robert Blair, Joan Miro, Charles Birchfield, J.C. Litz, Jason Barr and Eric Dates. Editions created by collaborating with the artist. Approached by 20-30 artists/year. Publishes and distributes the work of 4 emerging, 2 mid-career and 1 established artists/year.

CONTACT & TERMS Send query letter with SASE, slides, photocopies, résumé, transparencies, tearsheets or photographs. Samples are filed or returned. Responds in 2 weeks. Company will contact artist for portfolio review if interested. Pays on consignment basis. Firm receives 30-50% commission. Offers advance when appropriate. Rights purchased vary according to project. Does not require exclusive representation of artist. Provides advertising, promotion, shipping to and from firm, written contract and insurance while work is at firm.

TIPS "Keep trying to join a group of artists and try to develop a unique style."

BENTLEY GLOBAL ARTS GROUP

290 West End Ave. #2d, New York NY 10023. (212)595-6862. **E-mail:** harrietatbentley@gmail.com. **Website:** www.bentleyglobalarts.com. **Contact:** Harriet Rinehart, product development coordinator. Estab. 1986. Primary business is art publisher of open editions in both offset and digital mediums, markets art print reproductions; separate division licenses images to appear on puzzles, tapestry products, doormats, stitchery kits, giftbags, greeting cards, mugs, tiles, wall coverings, resin and porcelain figurines, waterglobes and various other gift items. Clients: framers, galleries, distributors both domestic and international framed picture manufacturers and large chain stores.

○ Divisions of this company include Bentley House, Rinehart Fine Arts, Art Folio West, Joan Cawley Galleries, Leslie Levy Publishing, and Bentley Licensing Group. See separate listing for Rinehart Fine Arts in this section.

NEEDS Seeking decorative fine art for the designer, residential and commercial markets. Considers oil, watercolor, acrylic, pastel, mixed media and photography. Artists represented include both contemporary and traditional. Open editions are created by collaborating with the artist or by working from an existing painting. Approached by 1,000 artists/year.

CONTACT & TERMS Submit JPEG images via e-mail. Responds in 6 weeks. Pays royalties of 10% net sales for prints quarterly plus 50 samples of offset prints. Pays 40% monies received from licensing. Obtains all reproduction rights. Licenses specific images. Pro-

vides written contract, requires hi-res files For repro-
duction.

TIPS "Bentley is looking for experienced artists with
images of universal appeal. Key is 'Decorative' appeal.
No art with heavy emotional, political, or sexual con-
tent."

BERNARD FINE ART

P.O. Box 1528, Manchester Center VT 05255.
(802)362-3662. **Fax:** (802)362-3286. **Website:** www.
applejackart.com. Art publisher. Publishes open edi-
tion prints and posters. Clients: picture frame manu-
facturers, distributors, manufacturers, galleries and
frame shops. This company is a division of Applejack
Art Partners, along with the high-end poster lines
Hope Street Editions and Rose Selavy of Vermont.
See separate listings for Hope Street Editions and
Rose Selavy of Vermont in this section, and Apple-
jack Art Partners in the Greeting Cards, Gifts Prod-
ucts section.

NEEDS Seeking creative, fashionable, and decora-
tive art and photography for commercial and designer
markets. Considers all media, including oil, water-
color, acrylic, pastel, and mixed media.

CONTACT & TERMS Send query letter with samples
showing art style and/or tearsheets, photocopies, pho-
tographs. "We prefer to see at least 12-15 examples of
your art. Submissions should be in JPEG or PDF file-
formats. Choose a wide variety of images that you feel
best represent your palate and style. You can also send
us a link to your website." Samples are returned by
SASE only. Pays royalties. Usually requires exclusive
representation of artist. Finds artists through submis-
sions, sourcebooks, agents, art shows, galleries and
word of mouth.

TIPS look for subjects with a universal appeal. Some
subjects that would be appropriate are florals, still
lifes, wildlife, religious themes, landscapes and con-
temporary images/abstracts. Please send enough ex-
amples of your work so it displays a true representa-
tion of your style and technique.

JOE BUCKALEW

1825 Annwicks Dr., Marietta GA 30062. (800)971-
9530. **Fax:** (770)971-6582. **E-mail:** art@joebuckalew.
com; joesart@bellsouth.net. **Website:** www.joebuck
alew.com. Estab. 1990. Distributor and publisher. Dis-
tributes limited editions, canvas transfers, fine art
prints and posters. Clients: frame shops and galleries.

NEEDS Seeking creative, fashionable, decorative art
for the serious collector. Considers oil, acrylic and
watercolor. Prefers florals, landscapes, Civil War
and sports. Approached by 25-30 artists/year. Dis-
tributes work of 10 emerging, 10 mid-career and 50
established artists/year. Art guidelines free with SASE
and first-class postage.

CONTACT & TERMS Send sample prints. Accepts
disk submissions. "Please call. Currently using a 460
commercial computer." Samples are filed or are re-
turned. Does not reply. Artist should call. To show
portfolio, artist should follow up with call after initial
query. Portfolio should include sample prints. Pays
on consignment basis. Firm receives 50% commis-
sion, paid net 30 days. Provides advertising on website,
shipping from firm and company catalog. Finds art-
ists through ABC shows, regional art & craft shows,
frame shops, other artists.

TIPS "Paint your own style."

☺ CANADIAN ART PRINTS, INC.

Unit 110, 6311 Westminster Hwy., Richmond BC V7C
4V4, Canada. (800)663-1166 or (604)276-4551. **Fax:**
(604)276-4552. **E-mail:** artsubmissions@encoreart
group.com. **Website:** www.canadianartprints.com.
Estab. 1965. Art publisher/distributor. Publishes or
distributes unlimited edition, fine art prints, posters
and art cards. Clients: galleries, decorators, frame
shops, distributors, corporate curators, museum
shops, giftshops and manufacturing framers. Licenses
all subjects of open editions for wallpaper, writing pa-
per, place mats, books, etc.

NEEDS Seeking fashionable and decorative art for
the commercial and designer markets. Considers oil,
acrylic, watercolor, mixed media, pastel. Prefers rep-
resentational florals, landscapes, marine, decorative
and street scenes. Editions created by collaborating
with the artist and working from an existing paint-
ing. Approached by 300-400 artists/year. Publishes/
distributes the work of more than 150 artists/year.

CONTACT & TERMS Send query letter with pho-
tographs, SASE, slides, tearsheets, transparencies.
Samples are not filed and are returned by SASE. Will
contact artist for portfolio review if interested. Nor-
mally takes 4-6 weeks to review submissions. Pays
range of royalties. Buys reprint rights or negotiates
rights purchased. Provides advertising, in-transit in-
surance, insurance while work is at firm, promotion,

shipping and contract. Finds artists through art exhibitions, art fairs, word of mouth, art reps, submissions.
TIPS "Keep up with trends by following decorating magazines."

CARPENTREE, INC.

2724 N. Sheridan, Tulsa OK 74115. (800)736-2787. **E-mail:** smorris@carpentree.com; jhobson@carpentree.com. **Website:** www.carpentree.com. **Contact:** Dan and Ginny Hobson, owners. Estab. 1976. Wholesale framed art manufacturer. Clients: decorators, frame shops, galleries, gift shops and museum shops.
NEEDS Seeking decorative art for the commercial market. Considers acrylic, mixed media, oil, pastel, pen & ink, sculpture, watercolor and photography. Prefers traditional, family-oriented, Biblical themes, landscapes. Editions created by collaborating with the artist and by working from an existing painting. Approached by 50 artists/year.
CONTACT & TERMS Send photographs, SASE and tearsheets. Prefers Windows-compatible, JPEG files. Samples are not filed, returned by SASE. Responds in 2 months. Portfolio not required. Negotiates payment. No advance. Negotiates rights purchased. Requires exclusive regional representation of artist. Provides advertising, promotion, and written contract. Finds artists through art exhibits/fairs and artist's submissions.

CHALK & VERMILION FINE ARTS

55 Old Post Rd., #2, Greenwich CT 06830. (800)877-2250. **Website:** www.chalk-vermilion.com. **Contact:** Artist submission department. Estab. 1976. Art publisher. Publishes original paintings, hand-pulled serigraphs and lithographs, posters, limited editions and offset reproductions. Clients: 4,000 galleries worldwide.
NEEDS Publishes decorative art for the serious collector and the commercial market. Considers oil, mixed media, acrylic and sculpture. Editions created by collaboration. Approached by 350 artists/year.
CONTACT & TERMS Submission guidelines available online.

CIRRUS EDITIONS

542 S. Alameda St., Los Angeles CA 90013-1708. (213)680-3473. **Fax:** (213)680-0930. **E-mail:** cirrus@cirrusgallery.com. **Website:** www.cirrusgallery.com. **Contact:** Jean R. Milant, director. Produces limited edition hand-pulled originals. Clients: museums, galleries and private collectors.

NEEDS Seeking fine art for the serious collector and museums. Prefers abstract, conceptual work. Publishes and distributes the work of 6 emerging, 2 mid-career and 1 established artists/year.
CONTACT & TERMS Prefers CD or low-res JPEGs. Samples are returned by SASE. No illustrators, graphic designers or commercial art submissions.

CLAY STREET PRESS, INC.

1312 Clay St., Cincinnati OH 45202. (513)241-3232. **E-mail:** mpginc@iac.net. **Website:** www.patsfall graphics.com. **Contact:** Mark Patsfall, owner. Estab. 1981. Art publisher and contract printer. Publishes fine art prints, hand-pulled originals, limited editions. Clients: architects, corporate curators, decorators, galleries and museum print curators.
NEEDS Seeking serious artists. Prefers conceptual/contemporary. Editions are created by collaborating with the artist. Publishes the work of 2-3 emerging artists/year.
CONTACT & TERMS Contact only through artist rep. Accepts e-mail submissions with image files. Prefers Mac-compatible JPEG files. Responds in 1 week. Negotiates payment. Negotiates rights purchased. Services provided depend on contract. Finds artists through reps, galleries and word of mouth.

☺ CLEARWATER PUBLISHING

161 MacEwan Ridge Circle NW, Calgary AB T3K 3W3, Canada. (403)295-8885. **Fax:** (403)295-9981. **E-mail:** clearwaterpublishing@shaw.ca. **Website:** www.clear water-publishing.com. Estab. 1989. Fine art publisher. Handles giclées, canvas transfers, fine art prints and offset reproductions. Clients: decorators, frame shops, gift shops, galleries and museum shops. "Offers a large selection of images, including those of landscapes, children, wildlife, western and equine, sports, and folk art. These images are available in different formats—limited edition offset lithographs, canvas transfers, and giclée reproductions (on both paper & canvas) as well as art cards."
NEEDS Seeking artwork for the serious collector and commercial market. Considers acrylic, watercolor, mixed media and oil. Prefers high realism or impressionistic works. Artists represented can be seen on website.
CONTACT & TERMS Accepts e-mail submissions with link to website and image file; Windows-compatible. Prefers JPEGs. Samples are not filed or returned. Responds only if interested. Company will

contact artist for portfolio review if interested. Portfolio should include slides. No advance. Requires exclusive representation of artist.

COLOR CIRCLE ART PUBLISHING, INC.

791 Tremont St., Box A, Suite N104, Boston MA 02118. (617)437-1260. **E-mail:** colorcircleart@gmail.com. **Website:** www.colorcircle.com. **Contact:** Bernice Robinson, co-founder/marketing and administration. Estab. 1991. Art publisher. Publishes limited editions, unlimited editions, fine art prints, offset reproductions, posters. Clients: galleries, art dealers, distributors, museum shops. Current clients include Deck the Walls, Things Graphics, Essence Art.

NEEDS Seeking creative, decorative art for the serious collector and the commercial market. Considers oil, acrylic, watercolor, mixed media, pastel, pen & ink. Prefers ethnic themes. Artists represented include Paul Goodnight. Editions created by collaborating with the artist or by working from an existing painting. Approached by 12-15 artists/year. Publishes the work of 2 emerging, 1 mid-career artists/year. Distributes the work of 4 emerging, 1 mid-career artists/year.

CONTACT & TERMS Send query letter with slides. Samples are filed or returned by SASE. Responds in 2 months. Negotiates payment. Rights purchased vary according to project. Provides advertising, insurance while work is at firm, promotion, shipping from our firm and written contract. Finds artists through submissions, trade shows and word of mouth.

TIPS "We like to present at least two pieces by a new artist that are similar in theme, treatment or colors."

DARE TO MOVE

6621 83rd St. E., Puyallup WA 98371. (206)380-4378. **E-mail:** daretomove@aol.com. **Website:** www.dare tomove.com. **Contact:** Steve W. Sherman, president. Estab. 1987. Art publisher, distributor. Publishes/distributes limited editions, unlimited editions, canvas transfers, fine art prints, offset reproductions. Licenses aviation and marine art for puzzles, note cards, bookmarks, coasters, etc. Clients include art galleries, aviation museums, frame shops and interior decorators.

○ This company has expanded from aviation-related artwork to work encompassing most civil service areas. Steve Sherman likes to work with artists who have been painting for 10-20 years. He usually starts off distributing self-published prints. If prints sell well, he will work with artists to publish new editions.

NEEDS Seeking naval, marine, firefighter, civil service and aviation-related art for the serious collector and commercial market. Considers oil and acrylic. Editions are created by collaborating with the artist or working from an existing painting. Approached by 15-20 artists/year.

CONTACT & TERMS Send query letter with photographs, slides, tearsheets and transparencies. Samples are filed or sometimes returned by SASE. Artist should follow up with a call. Portfolio should include color photographs, transparencies and final art. Pays royalties of 10% commission of wholesale price on limited editions; 5% commission of wholesale price on unlimited editions. Buys one-time or reprint rights. Provides advertising, in-transit insurance, insurance while work is at firm, promotion, shipping from firm, and written contract.

TIPS "Present your best work professionally."

DOLICE GRAPHICS

649 E. 9th St., New York NY 10009. (212)260-9240. **E-mail:** joe@dolice.com. **Website:** www.dolice.com. **Contact:** Joe Dolice, president. Estab. 1968. Art publisher. Publishes fine art prints, limited editions, offset reproductions, unlimited editions. Clients: architects, corporate curators, decorators, distributors, frame shops, galleries, gift shops and museum shops.

NEEDS Seeking decorative, representational, antiquarian "type" art for the commercial and designer markets. Considers acrylic, mixed media, pastel, pen & ink, prints (intaglio, etc.), and watercolor. Prefers traditional, decorative, antiquarian type. Editions are created by collaborating with the artist and working from an existing painting. Approached by 12-20 artists/year.

CONTACT & TERMS Send query letter with color photocopies, photographs, résumé, SASE, slides and transparencies. Samples are returned by SASE only. Responds only if interested. Will contact artist for portfolio review if interested. Negotiates payment. Buys all rights on contract work. Rights purchased vary according to project. Provides free website space, promotion and written contract. Finds artists through art reps and submissions.

TIPS "We publish replicas of antiquarian-type art prints for decorative arts markets and will commission artists to create 'works for hire' in the style of

pre-century artists and occasionally to color b&w engravings, etchings, etc. Artists interested should be well-schooled and accomplished in traditional painting and printmaking techniques."

EDITIONS LIMITED GALLERIES, INC.

4090 Halleck St., Emeryville CA 94608. (510)923-9770, ext. 6998. **Fax:** (510)923-9777. **E-mail:** submissions@editionslimited.com. **Website:** www.editions limited.com. **Contact:** Todd Haile, poster publishing; Christy Carleton, original art. Art publisher and distributor of limited open edition prints and fine art posters. Clients: contract framers, galleries, framing stores, art consultants and interior designers.

NEEDS Seeking art for the original and designer markets. Considers oil, acrylic and watercolor painting, monoprint, monotype, photography and mixed media. Prefers landscape, floral and abstract imagery. Editions created by collaborating with the artist or by working from existing works.

CONTACT & TERMS Send query letter with résumé, slides and photographs or JPEG files (8 inch maximum at 72 dpi) via e-mail. Samples are filed or are returned by SASE. Responds in 2 months. Publisher/distributor will contact artist for portfolio review if interested. Payment method is negotiated. Negotiates rights purchased.

TIPS "We deal both nationally and internationally, so we need art with wide appeal. When sending slides or photos, send at least six so we can get an overview of your work. We publish artists, not just images."

ENCORE GRAPHICS & FINE ART

P.O. Box 32, Huntsville AL 35804. (800)248-9240. **E-mail:** Encore@RandEnterprises.com. **Website:** www. egart.com. Estab. 1995. Poster company, art publisher, distributor. Publishes/distributes limited edition, unlimited edition, fine art prints, offset reproduction, posters. Clients: galleries, frame shops, distributors.

NEEDS Creative art for the serious collector. Considers all media. Prefers African American and abstract. Art guidelines available on company's website. Artists represented include Greg Gamble, Tod Fredericks, Tim Hinton, Mario Robinson, Lori Goodwin, Wyndall Coleman, T.H. Waldman, John Will Davis, Burl Washington, Henry Battle, Cisco Davis, Delbert Iron-Cloud, Gary Thomas and John Moore. Also Buffalo Soldier Prints and historical military themes. Editions created by working from an existing painting. Approached by 15 artists/year. Publishes the work of

3 emerging artists, 1 mid-career artist/year. Distributes the work of 3 emerging, 2 mid-career and 3 established artists/year.

CONTACT & TERMS Send photocopies, photographs, résumé, tearsheets. Samples are filed. Responds only if interested. Company will contact artist for portfolio review of color, photographs, tearsheets if interested. Negotiates payment. Offers advance when appropriate. Requires exclusive representation of artist. Provides advertising, in-transit insurance, insurance while work is at firm, promotion, shipping from firm, written contract. Finds artists through the Internet and art exhibits.

TIPS "Prints of African Americans with religious themes or children are popular now. Paint from the heart."

ELEANOR ETTINGER, INC.

24 W. 57th St., New York NY 10019. (212)925-7474 (57th St.); (212)925-7686 (Chelsea). **Fax:** (212)925-7734. **E-mail:** eegallery@aol.com or via online contact form. **Website:** www.eegallery.com. **Contact:** Eleanor Ettinger, president. Estab. 1975. Art dealer of limited edition lithographs, limited edition sculpture and unique works (oil, watercolor, drawings, etc.).

NEEDS Seeks classically inspired realistic work involving figurative, landscapes and still lifes for the serious collector. Considers oil, acrylic, mixed media. Prefers American realism.

CONTACT & TERMS Send query letter with visuals (slides, photographs, etc.), a brief biography, résumé (including a list of exhibitions and collections) and SASE for return of the materials. Responds in 3-4 weeks.

FAIRFIELD ART PUBLISHING

87 35th St., 3rd Floor, Brooklyn NY 11232. (800)835-3539. **Fax:** (718)832-8432. **E-mail:** cyclopete@aol. com. **Contact:** Peter Lowenkron, vice president. Estab. 1996. Art publisher. Publishes posters, limited editions and offset reproductions. Clients: galleries, frame shops, museum shops, decorators, corporate curators, gift shops, manufacturers and contract framers.

NEEDS Decorative art for the designer and commercial markets. Considers collage, oil, watercolor, pastel, pen & ink, acrylic. Artists represented include Daniel Pollera, Roger Vilarchao, Yves Poinsot.

CONTACT & TERMS Send query letter with slides and brochure. Samples are returned by SASE if re-

quested by artist. Responds only if interested. Pays flat fee, or royalties of 7-15%. Offers advance when appropriate. Rights purchased vary according to project. Interested in buying second rights (reprint rights) to previously published artwork.

RUSSELL FINK GALLERY

P.O. Box 250, Lorton VA 22199. (703)550-9699. **Fax:** (703)339-6150. **E-mail:** info@russellfinkgallery.com. **Website:** russellfinkgallery.com. **Contact:** Russell A. Fink. Art publisher.

NEEDS Considers oil, acrylic and watercolor. Prefers wildlife and sporting themes. Prefers individual works of art; framed. "Submit photos or slides of at least near-professional quality. Include size, price, media and other pertinent data regarding the artwork. Also send personal résumé and be courteous enough to include SASE for return of any material sent to me." Artists represented include Ray Harris-Ching, Ken Carlson, John Loren Head, Robert Abbett, Rod Crossman, Manfred Schatz and Chet Reneson.

CONTACT & TERMS Send query letter with slides or photographs to be kept on file. Call or write for appointment to show portfolio. Samples returned if not kept on file.

TIPS "Looks for composition, style and technique in samples. Also how the artist views his own art. Mistakes artists make are arrogance, overpricing, explaining their art and underrating the role of the dealer."

FORTUNE FINE ART

7825 E. Redfield Rd., Suite 105, Scottsdale AZ 85260. (480)946-1055; (800)350-1030. **E-mail:** carolv@fortunefa.com. **Website:** www.fortunefa.com. **Contact:** Carol J. Vidic, principal. Publishes fine art prints, hand-pulled serigraphs, giclées, originals, limited editions, offset reproductions, posters and unlimited editions. Clients: art galleries, dealers and designers.

NEEDS Seeking creative art for the serious collector. Considers oil on canvas, acrylic on canvas, mixed media on canvas and paper. Artists represented include John Powell, Daniel Gerhartz, Marilyn Simandle, Ming Feng, S. Burkett Kaiser and B. Nicole Klassen. Publishes and distributes the work of a varying number of emerging artists/year.

CONTACT & TERMS Send query letter with résumé, slides, photographs, biography and SASE or send digital images to carolv@fortunefa.com. Samples are not filed. Responds in 1 month. To show a portfolio, mail

appropriate materials. Prefers exclusive representation of artist. Provides in-transit insurance, insurance while work is at firm, promotion and written contract. **TIPS** "Establish a unique style, look or concept before looking to be published."

GALAXY OF GRAPHICS, LTD.

20 Murray Hill Pkwy., Suite 160, East Rutherford NJ 07073-2180. (888)464-7500. **E-mail:** buchweitz@sbcglobal.net; susan.murphy@kapgog.com. **Website:** www.galaxyofgraphics.com. **Contact:** Colleen Buchweitz, art director. Estab. 1983. Art publisher and distributor of unlimited editions. Licensor of images for retail and home decor products such as kitchen textiles, bath accessories, stationery, etc. Licensing handled by Susan Murphy. Clients: distributors and picture frame manufacturers that sell to retail stores.

NEEDS Seeking landscape, floral, and decorative artists that are excited by home decor style trends. We are seeking artists that have a unique look and decorative approach to their work. Editions are created by collaborating with the artist or by working from an existing painting. Considers any media. "Any currently popular and generally accepted themes." Art guidelines free via e-mail request. Approached by several hundred artists/year. Publishes and distributes the work of 20 emerging and 20 mid-career and established artists/year.

CONTACT & TERMS "Please e-mail submissions or send color copies or a CD (in Mac-based files or JPEG format). Include a SASE if you would like your submission returned and write 'Artist Submission' above the address. We can take anywhere from 2-4 weeks to review your work so please be patient, as we carefully review each submission we receive."

TIPS "We sell images that coordinate with changing home decor trends in style and color. Consider this the 'fashion' market for 2D Artists."

GALLERY GRAPHICS, INC.

20136 State Hwy. 59, P.O. Box 502, Noel MO 64854. (417)475-6191. **Fax:** (417)475-6494. **E-mail:** info@gallerygraphics.com. **Website:** www.gallerygraphics.com. Estab. 1979. Wholesale producer and distributor of prints, cards, sachets, stationery, calendars, framed art, stickers. Clients: frame shops, craft shops, florists, pharmacies and gift shops.

NEEDS Seeking art with nostalgic look, country, Victorian, children, angels, florals, landscapes, animals—nothing abstract or non-representational. Considers

oil, watercolor, mixed media, pastel and pen & ink. 10% of editions created by collaborating with artist. 90% created by working from an existing painting.

CONTACT & TERMS Send query letter with brochure showing art style and tearsheets. Designers send photographs, photocopies and tearsheets. Accepts disk submissions compatible with IBM or Mac. Samples are filed or returned by SASE. Responds in 2 months. To show portfolio, mail finished art samples, color tearsheets. Can buy all rights or pay royalties. Provides a written contract.

TIPS "Please submit artwork on different subjects and styles. Some artists do certain subjects particularly well, but you don't know if they can do other subjects. Don't concentrate on just one area. Don't limit yourself, or you could be missing out on some great opportunities."

GEME ART, INC.

209 W. 6th St., Vancouver WA 98660. (360)693-7772 or (800)426-4424. **Fax:** (360)695-9795. **E-mail:** geme art@hotmail.com. **Website:** www.gemeart.com. Estab. 1966. Art publisher. Publishes fine art prints and reproductions in unlimited and limited editions. Clients: galleries, frame shops, art museums, manufacturers, craft shops. Licenses designs.

NEEDS Considers oil, acrylic, watercolor and mixed media. "We use a variety of styles from realistic to whimsical, catering to 'mid-America art market.' Artists represented include Lois Thayer, Crystal Skelley, Steve Nelson.

CONTACT & TERMS Send color slides, photos or brochure. Include SASE. Publisher will contact artist for portfolio review if interested. Simultaneous submissions OK. Payment on a royalty basis. Purchases all rights. Provides promotion, shipping from publisher and contract.

GLEEDSVILLE ART PUBLISHERS

5 W. Loudoun St., Leesburg VA 20175. (703)771-8055 or (800)771-8055. **Fax:** (703)771-0225. **E-mail:** buyart@gleedsvilleart.com. **Website:** www.gleedsvilleart.com. **Contact:** Lawrence J. Thomas, president. Estab. 1999. Art publisher and gallery. Publishes and distributes fine art prints and limited edition. Clients: decorators, distributors, frame shops and galleries.

NEEDS Seeking decorative art for the serious collector, commercial and designer markets. Considers acrylic, mixed media, oil, pastel, pen & ink and watercolor. Prefers impressionist, landscapes, figuratives,

city scenes, realistic and whimsical. Editions created by collaborating with the artist.

CONTACT & TERMS Send photographs, slides, tearsheets, transparencies and URL. Accepts e-mail submissions with link to website. Prefers Windows-compatible, JPEG files. Samples are filed or returned. Responds in 3 months. Company will contact artist for portfolio review if interested. Portfolio should include original art, slides, tearsheets, thumbnails and transparencies. Pays royalties. Negotiates rights purchased. Requires exclusive representation of artist. Provides advertising, promotion, shipping from our firm and written contract. Finds artists through art competitions, art exhibits/fairs, artist's submissions and word of mouth.

HADDAD'S FINE ARTS, INC.

3855 E. Mira Loma Ave., Anaheim CA 92806. (714)996-2100 or (800)942-3323. **Fax:** (714)996-4153. **E-mail:** artmail@haddadsfinearts.com. **Website:** www.haddadsfinearts.com. **Contact:** Art director. Estab. 1953. Art publisher and distributor. Produces unlimited edition offset reproductions and posters. Clients: galleries, art stores, museum stores and manufacturers. Sells to the trade only—no retail.

NEEDS Seeking creative and decorative art for the commercial and designer markets. Seeks traditional/transitional scenes: landscapes, floral, decorative, abstract contemporary, and more—broad subject mix. Editions created by collaborating with the artist or by working from an existing painting. Approached by 200-300 artists/year. Publishes the work of 10-15 emerging artists/year. Also uses freelancers for design. 20% of projects require freelance design. Design demands knowledge of QuarkXPress and Illustrator.

CONTACT & TERMS Submission guidelines available online. "We would like to see slides, color copies, photographs or other representative examples of your artwork. Please do not send original art or transparencies as we do not want your irreplaceable items to be lost or damaged en route. We can also accept PC-readable CDs and e-mailed files, but mailed materials are preferred (attn: Art Director). We appreciate receiving a SASE for the return of your materials. We are not able to accept any posters or prints already in distribution."

HADLEY HOUSE PUBLISHING

4816 Nicollet Ave. S., Minneapolis MN 55419. (800)927-0880. **Fax:** (952)943-8098. **E-mail:** burks@

hadleyco.com. **Website:** www.hadleyhouse.com. **Contact:** Shannon Burke. Estab. 1974. Art publisher, distributor. Publishes and distributes canvas transfers, fine art prints, giclées, limited and unlimited editions, offset reproductions and posters. Licenses all types of flat art. Clients: wholesale and retail.

NEEDS Seeking artwork with creative artistic expression and decorative appeal. Considers oil, watercolor, acrylic, pastel and mixed media. Prefers florals, landscapes, figurative and nostalgic Americana themes and styles. Art guidelines free for SASE with first-class postage. Artists represented include Nancy Howe, Steve Hamrick, Sueellen Ross, Collin Bogle, Lee Bogle and Bruce Miller. Editions are created by collaborating with artist and by working from an existing painting. Approached by 200-300 artists/year. Publishes the work of 3-4 emerging, 15 mid-career and 8 established artists/year. Distributes the work of 1 emerging and 4 mid-career artists/year.

CONTACT & TERMS Send query letter with brochure showing art style or résumé and tearsheets, slides, photographs and transparencies. Samples are filed or are returned. Responds in 2 months. Call for appointment to show portfolio of slides, original final art and transparencies. Pays royalties. Requires exclusive representation of artist or art. Provides insurance while work is at firm, promotion, shipping from firm, a written contract and advertising through dealer showcase.

TIPS "Build a market for your originals by affiliating with an art gallery or two. Never give away your copyrights! When you can no longer satisfy the overwhelming demand for your originals, *that* is when you can hope for success in the reproduction market."

IMAGE CONNECTION

456 Penn St., Yeadon PA 19050. (610)626-7770. **Fax:** (610)626-2778. **E-mail:** sales@imageconnection.biz. **Website:** www.imageconnection.biz. **Contact:** Michael Markowicz, president. Estab. 1988. Publishes and distributes limited editions and posters. Represents several European publishers.

NEEDS Seeking fashionable and decorative art for the commercial market. Considers oil, pen & ink, watercolor, acrylic, pastel and mixed media. Prefers contemporary and popular themes, realistic and abstract art. Editions are created by collaborating with the artist and by working from an existing painting. Approached by 200 artists/year.

CONTACT & TERMS Send query letter with brochure showing art style or résumé, slides, photocopies, photographs, tearsheets and transparencies. Accepts e-mail submissions with link to website or Mac-compatible image file. Samples are not filed and are returned by SASE. Responds in 2 months. Will contact artist for portfolio review if interested. Portfolio should include b&w and color finished, original art, photographs, slides, tearsheets and transparencies. Payment method is negotiated. Offers advance when appropriate. Negotiates rights purchased. Requires exclusive representation of artist for product. Finds artists through art competitions, exhibits/fairs, reps, submissions, Internet, sourcebooks and word of mouth.

IMAGE CONSCIOUS

147 Tenth St., San Francisco CA 94103. (415)626-1555 or (800)532-2333. **Fax:** (415)626-2481. **E-mail:** inquiries@imageconscious.com. **E-mail:** sbecker@imageconscious.com. **Website:** www.imageconscious.com. Estab. 1980. Art publisher and domestic and international distributor of offset and poster reproductions. Now licensing images as well. Clients: poster galleries, frame shops, department stores, design consultants, interior designers and gift stores.

NEEDS Seeking creative and decorative art for the designer market. Considers oil, acrylic, pastel, watercolor, tempera, mixed media and photography. Prefers individual works of art, pairs or unframed series. Editions created by collaborating with the artist and by working from an existing painting or photograph. Approached by hundreds of artists/year. Publishes the work of 4-6 emerging, 4-6 mid-career and 8-10 established artists/year. Distributes the work of 50 emerging, 200 mid-career and 700 established artists/year.

CONTACT & TERMS Send query letter with brochure, résumé, tearsheets, photographs, slides or transparencies. Samples are filed or returned by SASE. Accepts low-res e-mail submissions. Please limit initial submissions to 10 images. Responds in 1 month. Publisher/distributor will contact artist for portfolio review if interested. No original art. Payment method is negotiated. Negotiates rights purchased. Provides promotion, shipping from firm and a written contract.

TIPS "Research the type of product currently in poster shops. Note colors, sizes and subject matter trends."

IMAGE SOURCE INTERNATIONAL

11½ Industrial Dr., Mattapoisett MA 02379. (508)758-1335. **Fax:** (508)758-4402. **E-mail:** pdownes@isiposters.com. **Website:** www.isiposters.com. **Contact:** Patrick Downes, art director/editor/licensing. Poster company, art publisher/distributor. Publishes/distributes unlimited editions, fine art prints, fine art prints, canvas and offset reproductions, posters. Clients: direct to retail chain stores, galleries, decorators, frame shops, distributors, architects, corporate curators, museum shops, gift shops, foreign distributors (Germany, Holland, Asia, South America).

Image Source International is one of America's fastest-growing publishers.

NEEDS Seeking fashionable, decorative art for the designer market. Considers oil, acrylic, pastel.

CONTACT & TERMS Send query letter with brochure, photocopies, photographs, résumé, slides, tearsheets, transparencies, postcards. Samples are filed and are not returned. Responds only if interested. Company will contact artist for portfolio review if interested. Pays flat fee or 10% royalty "that depends on artist and work and risk." Buys all rights for prints and posters. Does not require exclusive representation of artist.

TIPS Notes trends as sports art, neo-classical, nostalgic, oversize editions. "Think marketability. Watch the furniture market."

INSPIRATIONART & SCRIPTURE, INC.

P.O. Box 5550, Cedar Rapids IA 52406. (319)365-4350. **Fax:** (319)861-2103. **E-mail:** customerservice@inspirationart.com. **Website:** www.inspirationart.com. Estab. 1993. Produces Christian posters. "We create and produce jumbo-sized (24×36) posters targeted at pre-teens (10-14), teens (15-18) and young adults (18-30). A Christian message appears on every poster. Some are fine art and some are very commercial. We prefer contemporary images." Art guidelines available on website or for SASE with first-class postage.

NEEDS Approached by 150-200 freelance artists/year. Works with 10-15 freelancers/year. Buys 10-15 designs, photos, illustrations/year. Christian art only. Uses freelance artists for posters. Considers all media. Looking for "something contemporary or unusual that appeals to teens or young adults and communicates a Christian message."

CONTACT & TERMS Submission guidelines available online.

TIPS "The better the quality of the submission, the better we are able to determine if the work is suitable for our use (slides are best). The more complete the submission (i.e., design, art layout, scripture, copy), the more likely we are to see how it may fit into our poster line. We do accept traditional work but are looking for work that is more commercial and hip (think MTV with values). A poster needs to contain a Christian message that is relevant to teen and young adult issues and beliefs. Understand what we publish before submitting work. Visit our website to see what it is that we do. We are not simply looking for beautiful art, but rather we are looking for art that communicates a specific scriptural passage."

INTERNATIONAL GRAPHICS

Walmsley GmbH, Junkersring 11, Eggenstein DE-76344, Germany. (49)(721)978-0620. **Fax:** (49)(721)978-0651. **E-mail:** LW@ig-team.de. **Website:** www.international-graphics.de. **Contact:** Lawrence Walmsley, president. Estab. 1981. Poster company, art publisher/distributor. Publishes/distributes limited editions, offset reproductions, posters, and silkscreens. Clients: galleries, framers, department stores, gift shops, card shops and distributors. Current clients include Art.com, Windsor Art, etc.

NEEDS "We are seeking creative, fashionable and decorative art for the commercial and designer markets. Also seeking Americana art for gallery clients." Considers oil, acrylic, watercolor, mixed media, pastel and photos. Prefers landscapes, florals, painted still lifes. Also photography is a big theme for us lately. Art guidelines free for SASE with first-class postage. Artists represented include Christian Choisy, Benevolenza, Thiry, Magis, Marthe, Zacher-Finet, Shirin Donia, Panasenko, Valverde, Terrible, Gery Luger, and many more. Editions are created by working from an existing painting. Approached by 100-150 artists/year. Publishes the work of 10- 20 emerging artists/year. Distributes the work of 10-20 emerging artists/year.

CONTACT & TERMS Send query letter with brochure, photocopies, photographs, photostats, résumé, slides, tearsheets, or an e-mail. Accepts disk submissions for Mac or Windows. Samples are filed and returned. Responds in 2 months. Will contact artist for portfolio review if interested. Negotiates payment on basis of per-piece-sold arrangement or percentage for print-on-demand sales. Needs first rights. Provides advertising, promotion, shipping from firm, and con-

tract. Also works with freelance designers. Prefers local designers. Finds artists through exhibitions, word of mouth, submissions.

TIPS "Black and white photography, landscapes and still life pictures are good at the moment. Earthtones are popular—especially lighter shades. At the end of the day, we seek the unusual, that has not yet been published."

ISLAND ART PUBLISHERS

P.O. Box 952, Bragg Creek AB T0L 0K0, Canada. (403)949-7767. **Fax:** (403)949-3224. **E-mail:** submissions@islandart.com. **Website:** www.islandart.com. **Contact:** Graham Thomson, art director. Estab. 1985. Art publisher, distributor and printer. Publishes and distributes art cards, posters, open-edition prints, calenders, bookmarks, giclées and custom products. Clients: galleries, museums, Federal and local governments, major sporting events, department stores, distributors, gift shops, artists and photographers. Art guidelines available for SASE or on website.

NEEDS See website for current needs and requirements. Considers oil, watercolor and acrylic. Prefers themes related to the Pacific Northwest. Editions are created by working from an existing painting. Approached by 100 artists/year. Publishes the work of 2-4 emerging artists/year.

CONTACT & TERMS Send submissions to Attn: Art Director. Submit résumé/CV, tearsheets, slides, photographs, transparencies or digital files on CD/DVD (must be TIFF, EPS, PSD or JPEG files compatible with Photoshop). Please DO NOT send originals. Samples are not filed and are returned only by SASE if requested by artist. Responds in 3-6 months. Will contact artist for portfolio review if interested. Pays royalties of 5-10%. Licenses reproduction rights. Requires exclusive representation of artist for selected products only. Provides promotion, insurance while work is at firm, shipping from firm, written contract, fair trade representation and Internet service. Finds artists through art fairs, submissions and referrals.

TIPS "Provide a body of work along a certain theme to show a fully developed style that can be built upon. We are influenced by our market demands. Please review our submission guidelines before sending work on spec."

JADEI GRAPHICS, INC.

4943 McConnell Ave., Suite Y, Los Angeles CA 90066. (310)578-0082 or (800)717-1222. **Fax:** (310)823-4399.

E-mail: info@jadeigraphics.com. **Website:** www.jadeigraphics.com. **Contact:** Art director. Poster company. Publishes limited edition, unlimited edition and posters. Clients: galleries, framers. Licenses calendars, puzzles, etc.

NEEDS Seeking creative, decorative art for the commercial market. Considers oil, acrylic, watercolor and photographs. Editions created by collaborating with the artist or by working from an existing painting. Approached by 100 artists/year. Publishes work of 3-5 emerging artists each year. Also needs freelancers for design. Prefers local designers only.

CONTACT & TERMS Materials submitted may include but are not limited to slides, photos, color copies or transparencies. Please do not send originals. Include a suitable SASE if you would like your materials returned. Up to 5 JPEG files of no more than 600k per file may be submitted electronically.

LESLIE LEVY FINE ART PUBLISHING

P.O. Box 2993, Scottsdale AZ 85252. (602)952-2925. **E-mail:** art@leslielevy.com. **Website:** www.leslielevy.com. **Contact:** Leslie Levy, president. Estab. 1985. Publisher of fine art posters and open editions. Clients: frame shops, galleries, designers, framed art manufacturers, distributors and department stores.

This company is a division of Bentley Global Arts Group (see separate listing in this section).

NEEDS Seeking creative and decorative art for the residential, hospitality, health care, commercial and designer markets. Artists represented include Steve Hanks, Terry Isaac, Stephen Morath, Kent Wallis, Cyrus Afsary and Raymond Knaub. Considers oil, acrylic, pastel, watercolor, tempera, mixed media and photography. Prefers florals, landscapes, wildlife, semi-abstract, nautical, figurative works, and photography. Approached by hundreds of artists/year.

CONTACT & TERMS We prefer e-mail with link to website or digital photos. Send query letter with résumé, or photos and SASE. Samples are returned by SASE. Please do not send limited editions, transparencies or original works or disks. Pays royalties quarterly based on wholesale price. Insists on acquiring reprint rights for posters. Requires exclusive representation of artist. Provides promotion and written contract. "Please, don't call us. After we review your materials, if we are interested, we will contact you or return materials within one month."

TIPS "If you are a beginner, do not go through the time and expense of sending materials."

LOLA, LTD. LT'EE

1817 Egret St., SW, Shallotte NC 28470-5433. (910)754-8002. **E-mail:** lolaltd@yahoo.com. **Contact:** Lola Jackson, owner. Distributor of limited editions, offset reproductions, unlimited editions, hand-pulled originals, antique prints and etchings. Clients: art galleries, architects, picture frame shops, interior designers, major furniture and department stores, industry and antique gallery dealers.

◌ This distributor also carries antique prints, etchings and original art on paper and is interested in buying/selling to trade.

NEEDS Seeking creative and decorative art for the commercial and designer markets. "Hand-pulled graphics are our main area." Considers oil, acrylic, pastel, watercolor, tempera or mixed media. Prefers unframed series, up to 30×40 maximum. Artists represented include Buffet, White, Brent, Jackson, Mohn, Baily, Carlson, Coleman. Approached by 100 artists/year. Distributes the work of 5 emerging, 5 mid-career and 5 established artists/year. Distributes the work of 40 emerging, 40 mid-career and 5 established artists/year.

CONTACT & TERMS Send query letter with samples. Samples are filed or are returned only if requested. Responds in 2 weeks. Payment method is negotiated. "Our standard commission is 50%, less 50% off retail." Offers an advance when appropriate. Provides insurance while work is at firm, shipping from firm and written contract.

TIPS "We find we cannot sell black and white only. Leave wide margins on prints. Send all published print samples before end of May each year as our main sales are targeted for summer. We do a lot of business with birds, botanicals, boats and shells—anything nautical."

MAIN FLOOR EDITIONS

4943 McConnell Ave., Suite Y, Los Angeles CA 90066. (310)578.0082 or (800)717-1222. **Fax:** (310)823-4399. **E-mail:** info@mainflooreditions.com. **E-mail:** artists@mainflooreditions.com. **Website:** www.mainflooreditions.com. Estab. 1996. Poster company, art publisher and distributor. Publishes/distributes limited edition, unlimited edition and posters. Clients: distributors, retail chain stores, galleries, frame shops, O.E.M. framers.

NEEDS Seeking creative, fashionable and decorative art for the commercial and designer markets. Considers oil, acrylic, watercolor, mixed media, pastel and photography. Editions created by collaborating with the artist or by working from an existing painting. Approached by 100 artists/year. Publishes work of 30 emerging, 15 mid-career and 10 established artists/year. Distributes the work of 5 emerging, 3 mid-career and 2 established artists/year.

CONTACT & TERMS Send query letter with brochure, photocopies, photographs and tearsheets. Samples are filed and are not returned. Responds in 6 months only if interested. Company will contact artist for portfolio review if interested. Portfolio should include photographs, slides and tearsheets. Pays flat fee $300-700; royalties of 10%. Offers advance when appropriate. Negotiates rights purchased. Requires exclusive representation of artist. Finds artists through art fairs, sourcebooks and word of mouth.

TIPS "Follow catalog companies for colors and motifs."

MARCO FINE ARTS

4860 W. 147th St., Hawthorne CA 90250. (310)615-1818. **E-mail:** info@marcofinearts.com. **Website:** www.mfatalon.com. Publishes/distributes limited edition, fine art prints and posters. Clients: galleries, decorators and frame shops.

NEEDS Seeking creative and decorative art for the serious collector and design market. Considers oil, acrylic and mixed media. Prefers landscapes, florals, figurative, Southwest, contemporary, impressionist, antique posters. Accepts outside serigraph and digital printing (giclée) production work. Editions created by collaborating with the artist or working from an existing painting. Approached by 80-100 artists/year. Publishes the work of 3 emerging, 3 mid-career and 3-5 established artists/year.

CONTACT & TERMS Send query letter with brochure, photocopies, photographs, photostats, résumé, SASE, slides, tearsheets and transparencies. Accepts disk submissions. Samples are filed and are returned by SASE. Responds only if interested. Company will contact artist for portfolio review or original artwork (show range of ability) if interested. Payment to be discussed. Requires exclusive representation of artist.

MILITARY GALLERY

821 E. Ojai Ave., Ojai CA 93023. (805)640-0057. **Fax:** (805)640-0059. **E-mail:** enquiriesusa@militarygallery.

com. **Website:** www.militarygallery.com. Estab. 1967. Art publisher and distributor. Publishes/distributes limited edition, unlimited edition, canvas transfers, fine art prints, offset reproduction and posters. Clients galleries and mail order.

NEEDS Seeking creative, fashionable and decorative art. Considers oil, acrylic, watercolor and pen & ink. Prefers aviation and maritime. Editions created by collaborating with the artist or by working from an existing painting. Approached by 10 artists/year. Publishes and distributes work of 1 emerging, 1 mid-career and 1 established artist/year.

CONTACT & TERMS Send query letter with photographs, slides, tearsheets and transparencies. Samples are not filed and are returned with SASE. Prefers high-res e-mail submissions. Responds in 1 month. Company will contact artist for portfolio review if interested. Portfolio should include photographs, tearsheets and transparencies. Payment negotiable. Buys all rights. Requires exclusive representation of artist. Provides advertising, promotion and written contract. Finds artists through word of mouth.

TIPS "Get to know us via our catalogs."

MILL POND PRESS COMPANIES

250 Center Court, Unit A, Venice FL 34285. (800)535-0331 or (941)497-6020. **Fax:** (941)492-6983. **E-mail:** sales@millpond.com. **Website:** www.millpond.com. Estab. 1973. Publishes limited editions, unlimited editions, offset reproductions and giclées on paper and on canvas. Clients: galleries, frame shops and specialty shops, Christian book stores, licensees. Licenses various genres on a range of quality products.

NEEDS Seeking creative, decorative art. Open to all styles, primarily realism. Considers oil, acrylic, watercolor and mixed media. Prefers wildlife, spiritual, figurative, landscapes and nostalgic. Editions are created by collaborating with the artist or by working from an existing painting. Approached by 250-300 artists/year.

MUNSON GRAPHICS

7502 Mallard Way, Unit C, Santa Fe NM 87507. (888)686-7664. **Fax:** (505)424-6338. **E-mail:** sales@munsongraphics.com. **Website:** www.munsongraphics.com. Estab. 1997. Poster company, art publisher and distributor. Publishes/distributes limited edition, fine art prints and posters. Clients: galleries, museum shops, gift shops and frame shops.

NEEDS Seeking creative art for the serious collector and commercial market. Considers oil, acrylic, watercolor and pastel. Editions created by working from an existing painting. Approached by 75 artists/year. Publishes work of 3-5 emerging, 3-5 mid-career and 3-5 established artists/year. Distributes the work of 5-10 emerging, 5-10 mid-career and 5-10 established artists/year.

CONTACT & TERMS Send query letter with slides, SASE and transparencies. Samples are not filed and are returned by SASE. Responds in 1 month. Company will contact artist for portfolio review if interested. Negotiates payment. Offers advance. Rights purchased vary according to project. Provides written contract. Finds artists through art exhibitions, art fairs, word of mouth and artists' submissions.

MUSEUM MASTERS INTERNATIONAL

185 E. 85th St., Suite 27B, New York NY 10028. (212)360-7100. **Fax:** (212)360-7102. **E-mail:** MMI Marilyn@aol.com. **Website:** www.museummasters.com. **Contact:** Marilyn Goldberg, president. Licensing agent for international artists and art estates. Distributor of limited editions, posters, tapestry and sculpture for galleries, museums and gift boutiques.

NEEDS Seeking artwork with decorative appeal for the designer market. Considers oil, acrylic, pastel, watercolor and mixed media.

CONTACT & TERMS E-mail with sample download of artwork offered. Samples are filed or returned. Call or write for appointment to show portfolio or mail slides and transparencies. Payment method is negotiated. Offers advance when appropriate. Negotiates rights purchased. Exclusive representation is not required. Provides insurance while work is at firm, shipping to firm and a written contract.

NEW YORK GRAPHIC SOCIETY

129 Glover Ave., Norwalk CT 06850. (800)677-6947. **Fax:** (203)846-2105. **E-mail:** donna@nygs.com. **Website:** www.nygs.com. **Contact:** Donna LeVan, vice president of publishing (contact via e-mail only, no phone calls). Estab. 1925. Specializes in fine art reproductions, prints, posters, canvases.

NEEDS Buys 150 images/year; 125 are supplied by freelancers. "Looking for a variety of images."

CONTACT & TERMS Send query letter with samples to Attn: Artist Submissions. Does not keep samples on file; include SASE for return of material. Responds in 3 months. Payment negotiable. Pays on usage. Credit line given. Buys exclusive product rights. No phone calls.

OLD WORLD PRINTS, LTD.

8080 Villa Park Drive, Richmond VA 23228. (804)213-0600, ext. 634. **Fax:** (804)213-0700. **E-mail:** orders@theworldartgroup.com. **E-mail:** artists@theworldartgroup.com. **Website:** www.oldworldprintsltd.com. Estab. 1973. Art publisher and distributor of open-edition, hand-printed reproductions of antique engravings as well as all subject matter of color printed art. Clients: retail galleries, frame shops and manufacturers, hotels and fund raisers.

○ Old World Prints reports the top-selling art in their 10,000-piece collection includes botanical and decorative prints.

NEEDS Seeking traditional and decorative art for the commercial and designer markets. Specializes in handpainted prints. Considers "b&w (pen & ink or engraved) art which can stand by itself or be hand painted by our artists or originating artist." Prefers traditional, representational, decorative work. Editions created by collaborating with the artist. Distributes the work of more than 1,000 artists. "Also seeking golf, coffee, tea, and exotic floral images."

CONTACT & TERMS Send query letter with brochure showing art style or résumé and tearsheets and slides. Samples are filed. Responds in 6 weeks. Write for appointment to show portfolio of photographs, slides and transparencies. Pays flat fee of $100/piece and royalties of 10% of profit. Offers an advance when appropriate. Negotiates rights purchased. Provides in-transit insurance, insurance while work is at firm, promotion, shipping from firm and a written contract. Finds artists through word of mouth.

TIPS "We are a specialty art publisher, the largest of our kind in the world. We are actively seeking artists to publish and will consider all forms of art."

OUT OF THE BLUE LICENSING

1022 Hancock Ave., Sarasota FL 34232. (941)966-4042. **Fax:** (941)966-8914. **E-mail:** ootblicensing@gmail.com. **Website:** www.out-of-the-blue.us. **Contact:** Michael Woodward, president; Jane Mason, licensing manager. Estab. 1986. "We are looking for decorative art and photography that we can license for product categories such as mass market canvas, posters/print and high quality giclées for the home decor market as well as images for greeting cards, calendars, stationery and gift products. We specialize particularly in the home decor canvas and framed art market." We also require very high quality landscapes and panoramas for large scale murals. Must be very large quality digital files.

○ This company is a division of Art Licensing International, Inc.

NEEDS "We need series and collections of art or photography that have wide consumer appeal. E-mail presentations only. Keep files to 250K JPEGs and around 10×8 at 72 dpi."

CONTACT & TERMS Terms are 50/50 with no expense to artist. Artist/photographer needs to provide high-res digital files if we agree on representation. Submission guidelines are available on website at www.out-of-the-blue.us/submissions.html.

TIPS "Pay attention to trends and color palettes. Artists need to consider actual products when creating new art. Look at products in retail outlets and get a feel for what is selling well. Get to know the markets you want to sell your work to."

PENNY LANE PUBLISHING, INC.

1791 Dalton Dr., New Carlisle OH 45344. (937)849-1101 or (800)273-5263. **Fax:** (937)849-9666. **E-mail:** info@pennylanepublishing.com. **Website:** www.pennylanepublishing.com. Estab. 1993. Art publisher. Publishes limited editions, unlimited editions, offset reproductions. Clients: galleries, frame shops, distributors, decorators.

NEEDS Seeking creative, decorative art for the commercial market. Considers oil, acrylic, watercolor, mixed media, pastel. Editions are created by collaborating with the artist or working from an existing painting. Approached by 40 artists/year. Publishes the work of 10 emerging, 15 mid-career and 6 established artists/year.

CONTACT & TERMS Send query letter with brochure, résumé, photographs, slides, tearsheets. Samples are filed or returned by SASE. Responds in 2 months. Will contact artist for portfolio review of color, final art, photographs, slides and tearsheets if interested. Pays royalties. Buys first rights. Requires exclusive representation of artist. Provides advertising, shipping from firm, promotion, written contract. Finds artists through art fairs and exhibitions, submissions, decorating magazines.

TIPS "Be aware of current color trends, and work in a series. Please review our website to see the style of artwork we publish."

PGM ART WORLD

Dieselstrasse 28, 85748 Garching, Germany. +49 (89)3 20 02-250. **Fax:** +49 (89)3 20 02-250. **E-mail:** info@pgm.de. **Website:** www.pgm.de. Estab. 1969. International fine art publisher, distributor, gallery. Publishes/distributes limited and unlimited editions, offset reproductions, art prints, giclées, art cards and originals. Worldwide supplier to galleries, framers, distributors, decorators.

○ PGM publishes around 180 images/year and distributes more than 6,000 images. The company also operates 3 galleries in Munich.

NEEDS Seeking creative, fashionable and decorative art for the commercial and designer markets. Considers oil, acrylic, watercolor, mixed media, pastel, pen & ink, photography and digital art. Considers any accomplished work of any theme or style. Editions are created by working from an existing painting or high-resolution digital data. Approached by more than 420 artists/year.

CONTACT & TERMS Send query letter with photographs, slides, color copies, color prints or work in digital format (JPEG) on CD/DVD. Sent documentation will be returned. Responds within 1 month. Will contact artist for portfolio review if interested. Pays royalties per copies sold; negotiable. Requires exclusive representation of artist. Provides promotion of prints in catalogs and promotional material, presentation of artists (biography & photo) on website.

TIPS "Get as much worldwide exposure as possible at art shows and with own website."

PORTER DESIGN

Court Farm House, Wellow, Bath BA2 8PU, United Kingdom. (01144)1225 849153. **Fax:** (01144)1225 849156. **E-mail:** service@porter-design.com. **Website:** www.porter-design.com. **Contact:** Henry Porter and Mary Porter, partners. Estab. 1985. Publishes limited and unlimited editions and offset productions and hand-colored reproductions. Clients: international distributors, interior designers and hotel contract art suppliers. Current clients include Grand Image, Top Art, Harrods, hotels in the Caribbean and SE Asia.

NEEDS Seeking fashionable and decorative art for the designer market. Considers watercolor. Prefers

16th-19th century traditional styles. Artists represented include Victor Postolle, Joseph Hooker, Georg Ehret and Adrien Chancel. Editions are created by working from an existing painting. Approached by 10 artists/year. Publishes and distributes the work of 10-20 established artists/year.

CONTACT & TERMS Send query letter with brochure showing art style or résumé and photographs. Accepts disk submissions compatible with Quark-XPress on Mac. Samples are filed or are returned. Responds only if interested. To show portfolio, mail photographs. Pays flat fee or royalties. Offers an advance when appropriate. Negotiates rights purchased.

POSNER FINE ART

1212 S. Point View St., Los Angeles CA 90035. (323)933-3664. **Fax:** (323)933-3417. **E-mail:** info@posnerfineart.com. **Website:** www.posnerfineart.com. **Contact:** Wendy Posner, president. Estab. 1994. Art distributor and gallery. Distributes contemporary fine art prints, monoprints, sculpture and paintings. Clients: galleries, frame shops, distributors, architects, corporate curators, museum shops. Current clients include Renaissance Hollywood Hotel, Nuveen Investments, Fandango.

NEEDS Seeking creative art for the serious collector and commercial market. Considers oil, acrylic, watercolor, mixed media, sculpture. Prefers very contemporary style. Artists include David Shapiro, Chuck Arnoldi, Robert Cottingham, and Sam Francis. Editions are created by collaborating with the artist. Approached by hundreds of artists/year. Distributes the work of 5-10 emerging, 5 mid-career and 200 established artists/year. Art guidelines free with SASE (first-class postage).

CONTACT & TERMS E-mail submission. Responds in a few weeks. Pays on consignment basis; firm receives 50% commission. Buys one-time rights. Provides advertising, promotion, insurance while work is at firm. Finds artists through art fairs and exhibitions, word of mouth, submissions, art reps.

TIPS "Know color trends of design market. Look for dealer with same style in gallery. Send consistent work."

POSTERS INTERNATIONAL

1180 Caledonia Rd., North York ON M6A 2W5, Canada. (416)789-7156 or (800)363-2787. **Fax:** (416)789-7159. **E-mail:** art@picreativeart.com. **Website:** www.picreativeart.com. Estab. 1976. Poster company, art

publisher. Publishes fine art posters and giclée prints. Licenses for gift and stationery markets. Clients: galleries, designers, art consultants, framing, manufacturers, distributors, hotels, restaurants, etc., around the world.

NEEDS Seeking creative, fashionable art for the commercial market. Considers oil, acrylic, watercolor, mixed media, b&w and color photography. Prefers landscapes, florals, abstracts, photography, vintage, collage and tropical imagery. Editions are created by collaborating with the artist or by working from an existing painting. Approached by 100 artists/year.

CONTACT & TERMS Send query letter or e-mail with attachment, brochure, photographs. Responds in 2 months. Company will contact artist for portfolio review of photographs, tearsheets, thumbnails if interested. Pays flat fee or royalties of 10%. Rights purchased vary according to project. Provides advertising, promotion, shipping from firm, written contract. Finds artists through art fairs, art reps, submissions.

TIPS "Be aware of current home décor color trends and always work in a series of two or more per theme/subject. Visit home décor retailers in their wall décor area for inspiration and guidance before submitting artwork."

○ PROGRESSIVE EDITIONS

2586 Dunwin Dr., Unit 5A, Mississauga Ontario L5L 1J5, Canada. (416)860-0983 or (800)487-1273. **Fax:** (416)367-2724. **E-mail:** info@progressivefineart.com. **Website:** www.progressiveeditions.com. Estab. 1982. Art publisher. Publishes handpulled originals, limited edition fine art prints and monoprints. Clients: galleries, decorators, frame shops, distributors.

NEEDS Seeking creative and decorative art for the serious collector and designer market. Considers oil, acrylic, watercolor, mixed media, pastel. Prefers figurative, abstract, landscape and still lifes. Editions created by working from an existing painting. Approached by 100 artists/year. Publishes the work of 4 emerging artists/year. Distributes the work of 10 emerging artists/year.

CONTACT & TERMS Send query letter with photographs, slides. Samples are not filed and are returned. Responds in 1 month. Will contact artist for portfolio review if interested. Negotiates payment. Offers advance when appropriate. Negotiates rights purchased. Requires exclusive representation of artist. Provides advertising, in-transit insurance, insurance while work is at firm, promotion, shipping and contract. Finds artists through exhibition, art fairs, word of mouth, art reps, sourcebooks, submissions, competitions.

TIPS "Develop organizational skills."

RINEHART FINE ARTS

1410 Lesnick Lane, Walnut Creek CA 94597. (925)935-3186. **Fax:** (925)935-0213. **E-mail:** info@bentleypublishinggroup.com. **Website:** www.bentleypublishinggroup.com. Licenses 2D artwork for posters. Clients include large chain stores and wholesale framers, furniture stores, decorators, frame shops, museum shops, gift shops and substantial overseas distribution.

NEEDS Seeking creative, fashionable and decorative art. Considers oil, acrylic, watercolor, mixed media, pastel. Images are created by collaborating with the artist or working from an existing painting. Approached by 200-300 artists/year. Publishes the work of 50 new artists/year.

CONTACT & TERMS Send query letter with SASE, photographs, slides, tearsheets, transparencies, JPEGs or whatever represents artwork best. Samples are not filed. Responds in 3 months. Portfolio review not required. Pays royalties of 8-10%. Rights purchased vary according to project. Provides advertising, promotion, written contract and substantial overseas exposure.

TIPS "Submit work in pairs or groups of four. Work in standard sizes. Visit high-end furniture store chains for color trends."

● FELIX ROSENSTIEL'S WIDOW & SON, LTD.

33-35 Markham St., Chelsea Green London SW3 3NR, United Kingdom. (44)207-352-3551. **Fax:** (44)207-351-5300. **E-mail:** sales@felixr.com. **Website:** www.felixr.com. Estab. 1880. Publishes art prints and posters, both limited and open editions. Licenses all subjects on any quality product. Art guidelines on website.

NEEDS Seeking decorative art for the serious collector and the commercial market. Considers oil, acrylic, watercolor, mixed media and pastel. Prefers art suitable for homes or offices. Editions are created by collaborating with the artist or by working from an existing painting. Approached by 200-500 artists/year.

CONTACT & TERMS Send query letter with photographs. Samples are not filed and are returned by SASE. Responds in 2 weeks. Company will contact artist for portfolio review of final art and transparencies if interested. Negotiates payment. Offers advance

when appropriate. Rights purchased vary according to project.

TIPS "We publish decorative, attractive, contemporary art."

SAGEBRUSH FINE ART

3065 South West Temple, Salt Lake City UT 84115. (801)466-5136. **Fax:** (801)466-5048. **E-mail:** submissions@sagebrushfineart.com. **Website:** www.sagebrushfineart.com. **Contact:** Stephanie Marrott, art review coordinator. Estab. 1991. Art publisher. Publishes and licenses fine art prints and offset reproductions. Clients: frame shops, distributors, corporate curators and chain stores.

NEEDS Seeking decorative art for the commercial and designer markets. Considers all media. Open to all themes and styles. Current clients include Anita Phillips, Kim Lewis, Stephanie Marrott, Michael Humphries and Jo Moulton. Editions created by collaborating with the artist or by working from an existing painting. Publishes the work of new and emerging artists.

CONTACT & TERMS Submission guidelines available online. Send to the attention of the art review team. Prefers quality laser proofs. Accepts slides, transparencies, JPEGs or photos, as well as website information. "We see a lot of art and in order for art to be reviewed, we need something physical to pass around in our review meetings. Please do not send originals unless requested. If you would like a written response, or to have your presentation sent back to you, please include a SASE or package. Any presentation without it will not be returned. Once received, our art development team reviews submissions for print and licensing potential."

SCHLUMBERGER GALLERY

P.O. Box 2864, Santa Rosa CA 95405. (707)544-8356. **E-mail:** sande@schlumberger.org. Estab. 1986. Private art dealer, art publisher, distributor and gallery. Publishes and distributes limited editions, posters, original paintings and sculpture. Specializes in decorative and museum-quality art and photographs. Clients: collectors, designers, distributors, museums, galleries, film and television set designers.

NEEDS Seeking decorative art for the serious collector and the designer market. Prefers trompe l'oeil, realist, architectural, figure, portrait. Editions created by collaborating with the artist or by working from an existing painting. Approached by 50 artists/year.

CONTACT & TERMS Send query letter with tearsheets and photographs. Samples are not filed and are returned by SASE if requested by artist. Publisher/distributor will contact artist for portfolio review if interested. Portfolio should include color photographs and transparencies. Negotiates payment. Offers advance when appropriate. Rights purchased vary according to project. Provides advertising, in-transit insurance, insurance while work is at firm, promotion, shipping to and from firm, written contract and shows. Finds artists through exhibits, referrals, submissions and "pure blind luck."

TIPS "Strive for quality, clarity, clean lines and light, even if the style is impressionistic. Bring spirit into your images. It translates!"

SEGAL FINE ART

11955 Teller St., Unit C, Broomfield CO 80020. (800)999-1297. **Fax:** (303)926-0340. **E-mail:** poppysegal@gmail.com. **Website:** www.segalfineart.com. **Contact:** Ron Segal. Estab. 1986. Art publisher. Publishes limited edition giclées. Clients: bikers at motorcycle rallies. Artists represented include David Mann, and Michael Kneeper.

◐ SJATIN ART B.V.

P.O. Box 7201, 5980 AE Panningen, Holland, Netherlands. (31)77-475-1998. **E-mail:** art@sjatin.nl. **Website:** www.sjatin.nl. Estab. 1977. (Formerly Sjatin Publishing & Licensing BV.) Art publisher. Publishes open editions, fine art prints. Licenses decorative art to appear on place mats, calendars, greeting cards, stationery, photo albums, embroidery, posters, canvas, textile, puzzles and gifts. Clients: picture framers, wholesalers, distributors of art print. Sjatin actively promotes worldwide distribution for artists they sign.

NEEDS Seeking decorative art for the commercial market. Considers oil, acrylic, watercolor, pastel. Prefers romantic themes, florals, landscapes/garden scenes, still lifes. Editions created by collaborating with the artist or by working from an existing painting. Approached by 50 artists/year. "We publish a very wide range of art prints and we sell copyrights over the whole world."

CONTACT & TERMS Submission guidelines available online.

TIPS "Follow the trends in interior decoration; look at the furniture and colors. I receive so many artworks that are beautiful and very artistic, but are not commercial enough for reproduction. I need designs

which appeal to many people, worldwide such as flowers, gardens, interiors and kitchen scenes. I do not wish to receive graphic art."

⊕ SOHN FINE ART—GALLERY & GICLÉE PRINTING

6 Elm Street, 1C, Stockbridge MA 01230. (413)298-1025. **E-mail:** info@sohnfineart.com. **Website:** www.sohnfineart.com. Gallery and fine art archival giclée printer. Publishes and distributes canvas transfers, fine art prints, limited editions, unlimited editions and posters. Clients include architects, corporate curators, decorators, distributors, frame shops, and galleries. Current clients include Fran Forman, Schantz Gallery, and Jim Schantz. Considers mixed media, oil, pastel, pen & ink, and watercolor among others. Editions created by collaborating with the artist. Keeps sample on file. Responds in 7 days.

NEEDS Decorative art, fashionable art, for the serious collector, commercial market, or designer market.

CONTACT & TERMS Contact via query letter, postcard sample, or e-mail letter with digital images, photographs or transparencies.

SOMERSET FINE ART

29370 McKinnon Rd., Suite A, P.O. Box 869, Fulshear TX 77441. (800)444-2540. **Fax:** (713)932-7861. **E-mail:** jjenkins@somersethouse.com. **Website:** www.somersetfineart.com. **Contact:** J. Jenkins, art department. Estab. 1972. Leading publisher of fine art reproductions in limited and open editions; giclées on canvas and giclées on paper. Clients: independent galleries in the United States, Canada, Australia, Mexico, Brazil, and other countries. Artists represented: Bill Anton, Susan Blackwood, Rod Chase, Norm Clasen, Tim Cox, Kimerlee Curyl, Michael Dudash, June Dudley, Larry Dyke, Ragan Gennusa, Nancy Glazier, Bruce Green, Martin Grelle, George Hallmark, Jim Hansel, G. Harvey, Karen Kelley, David Mann, Denis Mayer, Chris Owen, Robert Peters, Phillip Philbeck, Kyle Polzin, Jim Rey, James Seward, Kyle Sims, Claude Steelman, Andy Thomas, Evan Wilson, Bob Wygant, and HongNian Zhang.

NEEDS Art is reproduced from original paintings or collaborating with the artist; considers oil, acrylic, watercolor, mixed media, pastel.

CONTACT & TERMS Send inquiry via e-mail or by letter to post office box; submissions by e-mail should include digital files in JPEG format or 10–12 slides or photos of work (include SASE) if by mail. Will review art on artist's website or submitted material; also include number/size/price of all paintings sold within last 24 months and gallery representation. Samples filed for future reference unless return is requested. Publisher will contact artist for portfolio review if interested. Pays royalties; artist retains painting and copyrights; written contract; company provides advertising, promotion, in-transit insurance for original art, and shipping.

◗ JACQUES SOUSSANA GRAPHICS

37 Pierre Koenig St., Jerusalem 91041, Israel. (972)(2)6782678. **Fax:** (972)(2)6782426. **E-mail:** jsgraphics@soussanart.com. **Website:** www.soussanart.com. Estab. 1973. Art publisher. Publishes hand-pulled originals, limited editions, sculpture. Clients: galleries, decorators, frame shops, distributors, architects.

NEEDS Seeking decorative art for the serious collector and designer market. Considers oil, watercolor and sculpture. Editions are created by collaborating with the artist. Approached by 20 artists/year. Publishes/distributes the work of 5 emerging artists/year.

CONTACT & TERMS Send query letter with brochure, slides. To show portfolio, artist should follow up with letter after initial query. Portfolio should include color photographs.

SULIER ART PUBLISHING

PMB 55, 3735 Palomar Center, Suite 150, Lexington KY 40513. (859)621-5511. **Fax:** (859)296-0650. **E-mail:** info@NeilSulier.com or via online contact form. **Website:** www.neilsulier.com. **Contact:** Neil Sulier, art director. Art publisher and distributor. Publishes and distributes handpulled originals, limited and unlimited editions, posters, offset reproductions and originals. Clients: designers.

NEEDS Seeking creative, fashionable and decorative art for the serious collector and the commercial and designer markets. Considers oil, watercolor, mixed media, pastel and acrylic. Prefers impressionist. Editions created by collaborating with the artist or by working from an existing painting. Approached by 20 artists/year. Publishes the work of 5 emerging, 30 mid-career and 6 established artists/year. Distributes the work of 5 emerging artists/year.

CONTACT & TERMS Send query letter with brochure, slides, photocopies, résumé, photostats, transparencies, tearsheets and photographs. Samples are filed or are returned. Responds only if interested. Request portfolio review in original query. Artist should

follow up with call. Publisher will contact artist for portfolio review if interested. Portfolio should include slides, tearsheets, final art and photographs. Pays royalties of 10%, on consignment basis or negotiates payment. Offers advance when appropriate. Negotiates rights purchased (usually one-time or all rights). Provides in-transit insurance, promotion, shipping to and from firm, insurance while work is at firm and written contract.

SUN DANCE GRAPHICS & NORTHWEST PUBLISHING

9580 Delegates Dr., Orlando FL 32837. (407)240-1091. **Fax:** (407)240-1951. **E-mail:** info@northwestpublishing.com. **Website:** www.northwestpublishing.com. Estab. 1996. Publishers and printers of giclée prints, fine art prints, and posters. Sun Dance Graphics provides trend-forward images to customers that manufacture for upscale hospitality, retail, and home furnishings markets. Primarily looking for images in sets/pairs with compelling color palette, subject, and style. Northwest Publishing provides fine art prints and posters in the following categories: classics, traditional, inspirational, contemporary, home and hearth, photography, motivationals, wildlife, landscapes and ethnic art.

NEEDS Approached by 300 freelancers/year. Works with 50 freelancers/year. Buys 200 freelance designs and illustrations/year. Art guidelines free for SASE with first-class postage. Works on assignment only. Looking for high-end art. 20% of freelance design work demands knowledge of Photoshop, Illustrator and QuarkXPress.

CONTACT & TERMS Art submissions may be electronic (e-mail low-res image or website link) or via mail. Please do not send original art unless specifically requested. Artists will be contacted if there is interest in further review. All submissions are reviewed for potential inclusion in either line as well as for licensing potential, and are kept on file for up to six months. Art may be purchased or signed under royalty agreement. Royalty/licensing contracts will be signed before any images can be considered for inclusion in either line.

TIPS "Focus on style. We tend to carve our own path with unique, compelling and high quality art, and as a result are not interested in 'me too' images."

SUNSET MARKETING

14301 Panama City Beach Pkwy., Panama City Beach FL 32413. (850)233-6261 or (800)749-6261. **Fax:** (850)233-9169. **E-mail:** sunsetmarketingllc@yahoo.com. **Website:** www.sunsetartprints.com. Estab. 1986. Art publisher and distributor of open edition prints. Clients: galleries, decorators, frame shops, distributors and corporate curators.

NEEDS Seeking fashionable and decorative art for the commercial and designer market. Considers oil, acrylic and watercolor art and home decor furnishings. Editions created by collaborating with the artist.

CONTACT & TERMS Mail query letter with brochure, photocopies and photographs. "You may also send submissions in low-resolution jpeg files that do not exceed the maximum of 72 dpi at 4×6. Please limit the cumulative total file size for all your images to 2 megabytes or less." Samples are filed. Company will contact artist for portfolio review of color final art, roughs and photographs if interested. Requires exclusive representation of artist.

JOHN SZOKE EDITIONS

24 W. 57th St., Suite 304, New York NY 10019. (212)219-8300. **E-mail:** info@johnszokeeditions.com. **Website:** www.johnszokeeditions.com. Estab. 1974. Located in Soho. Gallery hours: Tuesday-Saturday 10-5 or by appointment. Exhibits unique and limited edition works on paper, rare prints, limited edition multiples. Modern Masters: Pablo Picasso and Henri Matisse. Clients: art dealers and collectors. 20% of sales to private collectors.

TAKU GRAPHICS

5763 Glacier Hwy., Juneau AK 99801. (907)780-6310; (800)ART-3291. **Fax:** (907)780-6314. **E-mail:** takugraphics@gmail.com. **Website:** www.takugraphics.com. **Contact:** Adele Hamey. Estab. 1991. Distributor. Distributes handpulled originals, limited edition, unlimited edition, fine art prints, offset reproduction, posters, paper cast, bead jewelry and note cards. Clients: galleries and gift shops.

NEEDS Seeking art from Alaska and the Pacific Northwest exclusively. Considers oil, acrylic, watercolor, mixed media, pastel and pen & ink. Prefers regional styles and themes. Artists represented include JoAnn George, Barbara Lavalle, Byron Birdsall, Brenda Schwartz and Barry Herem. Editions created by working from an existing painting. Approached by

30-50 artists/year. Distributes the work of 50 emerging, 20 mid-career and 6 established artists/year.
CONTACT & TERMS Submission guidelines available online.

BRUCE TELEKY, INC.

87 35th St., 3rd Floor, Brooklyn NY 11232. (718)965-9690 or (800)835-3539. **Fax:** (718)832-8432. **E-mail:** sales@teleky.com. **Website:** www.teleky.com. **Contact:** Bruce Teleky, president. Estab. 1975. Clients include galleries, manufacturers and other distributors.
NEEDS Works from existing art to create open edition posters or works with artist to create limited editions. Visit our website to view represented artists. Also likes coastal images, music themes and Latino images. Uses photographs. Likes to see artists who can draw. Prefers depictions of African American and Caribbean scenes or African themes.
CONTACT & TERMS Send query letter with slides, transparencies, postcard or other appropriate samples and SASE. Publisher will contact artist for portfolio review if interested. Payment negotiable. Samples returned by SASE only.
TIPS "We are focusing on selling more one-of-a-kind items."

VLADIMIR ARTS USA, INC.

2504 Sprinkle Rd., Kalamazoo MI 49001. (269)383-0032 or (800)678-8523. **E-mail:** vladimir@vladimirarts.com. **Website:** www.vladimirarts.com. Art publisher, distributor and gallery. Publishes/distributes handpulled originals, limited edition, unlimited edition, canvas transfers, fine art prints, monoprints, monotypes, offset reproduction, posters and giclée. Clients: galleries, decorators, frame shops, distributors, architects, corporate curators, museum shops, gift shops and West Point military market.
NEEDS Seeking creative, fashionable and decorative art for the serious collector, commercial market and designer market. Considers oil, acrylic, watercolor, mixed media, pastel, pen & ink and sculpture. Editions created by collaborating with the artist. Approached by 30 artists/year. Publishes work of 10 emerging, 10 mid-career and 10 established artists/year. Distributes work of 1-2 emerging, 1 mid-career and 1-2 established artists/year.
CONTACT & TERMS Send query letter with brochure, photocopies, photographs and tearsheets. Samples are filed or returned with SASE. Responds only if interested. Company will contact artist for

portfolio review if interested. Portfolio should include b&w, color, fine art, photographs and roughs. Negotiates payment. No advance. Provides advertising, promotion and shipping from our firm. Finds artists through art exhibitions, art fairs, word of mouth, Internet, art reps, sourcebooks, artists' submissions and watching art competitions.
TIPS "The industry is growing in diversity of color. There are no limits."

WEBSTER FINE ART, LTD.

300 Dominion Dr., Building 650, Morrisville NC 27560. (800)543-6104. **Fax:** (919)388-9377. **E-mail:** boneill@websterfineart.com. **Website:** www.websterfineart.com. Estab. 1987. Art publisher/distributor. Publishes open editions and fine art prints. Clients: OEM framers, galleries, frame shops, distributors, gift shops.
NEEDS Considers oil, acrylic, watercolor, pastel, pen & ink, mixed media. "Seeking creative artists that can take directions; decorative, classic, traditional, fashionable, realistic, impressionistic, landscape, artists who know the latest trends." Editions created by collaborating with the artist.
CONTACT & TERMS E-mail JPEGs of art or send query letter with brochure, photocopies, photographs, slides, tearsheets, transparencies and SASE. Samples are filed or returned by SASE. Responds in 1 month. Company will contact artist for portfolio review if interested. Negotiates payment. Offers advance when appropriate. Buys all or reprint rights. Finds artists by word of mouth, attending art exhibitions and fairs, submissions and watching art competitions.
TIPS "Check decorative home magazines *Southern Accents*, *Architectural Digest*, *House Beautiful*, etc., for trends. Understand the decorative art market."

WILD APPLE GRAPHICS, LTD.

2513 W. Woodstock Rd., Woodstock VT 05091. (800)756-8359. **Fax:** (800)411-2775. **E-mail:** artsubmissions@wildapple.com. **Website:** www.wildapple.com. Estab. 1990. Wild Apple publishes, distributes and represents a diverse group of contemporary artists. Clients: manufacturers, galleries, designers, poster distributors (worldwide) and framers. Licensing: Acting as an artist's agent, we present your artwork to manufacturers for consideration.
NEEDS We are always looking for fresh talent and varied images to show. Considers oil, watercolor,

acrylic, pastel, mixed media and photography. Publishes 400+ new works each year.

CONTACT & TERMS Submission guidelines available online.

TIPS "We would love to hear from you. Use the telephone, fax machine, e-mail, post office or carrier pigeon (you must supply your own) to contact us."

WILD WINGS LLC

2101 S. Highway 61, Lake City MN 55041. (800)445-4833. **Fax:** (651)345-2981. **E-mail:** info@wildwings.com. **Website:** www.wildwings.com. Estab. 1968. Art publisher/distributor and gallery. Publishes and distributes limited editions and offset reproductions. Clients: retail and wholesale.

NEEDS Seeking artwork for the commercial market. Considers oil, watercolor, mixed media, pastel and acrylic. Prefers wildlife. Artists represented include David Maass, Lee Kromschroeder, Ron Van Gilder, Robert Abbett, Michael Sieve and Persis Clayton Weirs. Editions are created by working from an existing painting. Approached by 300 artists/year. Publishes the work of 36 artists/year. Distributes the work of numerous emerging artists/year.

CONTACT & TERMS Send query letter with digital files or color printouts and résumé. Samples are filed and held for 6 months, then returned. Responds in 3 weeks if uninterested; 6 months if interested. Will contact artist for portfolio review if interested. Pays royalties for prints. Accepts original art on consignment and takes 40% commission. No advance. Buys first rights or reprint rights. Requires exclusive representation of artist. Provides in-transit insurance, promotion, shipping to and from firm, insurance while work is at firm and a written contract. See website for further details.

WINN DEVON ART GROUP

Cap & Winn Devon, Unit 110, 6311 Westminster Hwy., Richmond BC V7C 4V4, Canada. (800)663-1166. **Fax:** (888)744-8275. **E-mail:** artsubmissions@encoreartgroup.com. **Website:** www.winndevon.com. Art publisher. Publishes open and limited editions, offset reproductions, giclées and serigraphs. Clients: mostly trade, designer, decorators, galleries, retail frame shops.

NEEDS Seeking decorative art for the designer market. Considers oil, watercolor, mixed media, pastel, pen & ink and acrylic. Editions are created by working from an existing painting. Approached by 300-400 artists/year. Publishes and distributes the work of 0-3 emerging, 3-8 mid-career and 8-10 established artists/year.

CONTACT & TERMS Send query letter with brochure, slides, photocopies, résumé, photostats, transparencies, tearsheets or photographs. Samples are returned by SASE if requested by artist. Responds in 4-6 weeks. Publisher will contact artist for portfolio review if interested. Portfolio should include "whatever is appropriate to communicate the artist's talents." Payment is based on royalties. Copyright remains with artist. Provides written contract. Finds artists through art exhibitions, agents, sourcebooks, publications, submissions.

TIPS Advises artists to attend WCAF Las Vegas and DECOR Expo Atlanta. "Attend just to see what is selling and being shown, but keep in mind that this is not a good time to approach publishers/exhibitors with your artwork."

ADVERTISING, DESIGN & RELATED MARKETS

This section offers a glimpse at one of the most lucrative markets for artists. Because of space constraints, the companies listed are just the tip of the proverbial iceberg. There are thousands of advertising agencies and public relations, design, and marketing firms across the country and around the world. All rely on freelancers. Look for additional firms in industry directories such as *The Black Book* and *Workbook*. Find local firms in the yellow pages and your city's business-to-business directory. You can also pick up leads by reading *Adweek*, *HOW*, *PRINT*, *Communication Arts*, and other design and marketing publications.

Find your best clients

Read listings carefully to identify firms whose clients and specialties are in line with the type of work you create. (You'll find clients and specialties in the first paragraph of each listing.) For example, if you create charts and graphs, contact firms whose clients include financial institutions. Fashion illustrators should approach firms whose clients include department stores and catalog publishers. Sculptors and modelmakers might find opportunities with firms specializing in exhibition design.

Payment and copyright

You will most likely be paid by the hour for work done on the firm's premises (in-house), and by the project if you take the assignment back to your studio. Most checks are issued 40–60 days after completion of assignments. Fees depend on the client's budget, but most companies are willing to negotiate, taking into consideration the experience of the freelancer, the lead time given, and the complexity of the project. Be prepared to offer an estimate for your services, and ask for a purchase order (P.O.) before you begin an assignment.

Some art directors will ask you to provide a preliminary sketch on speculation or "on spec," which, if approved by the client, can land you a plum assignment. If you are asked to create something "on spec" be aware that you may not receive payment beyond an hourly fee for your time if the project falls through. Be sure to ask upfront about payment policy before you start an assignment.

If you're hoping to retain usage rights to your work, you'll want to discuss this upfront, too. You can generally charge more if the client is requesting a buyout. If research and travel are required, make sure you find out ahead of time who will cover these expenses.

THE AD AGENCY

P.O. Box 470572, San Francisco CA 94147. **E-mail:** michaelcarden@msn.com; dgasper@theadagency. com. **Contact:** Michael Carden, creative director. Estab. 1971. Ad agency; full-service multimedia firm. Specializes in print, collateral, magazine ads. Client list available upon request.

NEEDS Approached by 120 freelancers/year. Works with 120 freelance illustrators and designers/year. Uses freelancers mainly for collateral, magazine ads, print ads; also for brochure, catalog and print ad design and illustration, mechanicals, billboards, posters, TV/film graphics, multimedia, lettering and logos. 60% of freelance work is with print ads. 50% of freelance design and 45% of illustration demand computer skills.

FIRST CONTACT & TERMS Send query letter with brochure, photocopies and SASE. Samples are filed or returned by SASE. Responds in 1 month. Portfolio should include color final art, photostats and photographs. Buys first rights or negotiates rights purchased. Finds artists through word of mouth, referrals and submissions.

TIPS "We are an eclectic agency with a variety of artistic needs."

ADVANCED DESIGNS CORPORATION

1169 W. Second St., Bloomington IN 47403. (812)333-1922. **Fax:** (812)333-2030. **E-mail:** mmcgrath@do prad.com. **Website:** www.doprad.com. **Contact:** Matt McGrath, president. Estab. 1982. AV firm. Specializes in TV news broadcasts. Product specialties are the doppler radar and display systems.

NEEDS Prefers freelancers with experience. Works on assignment only. Uses freelancers mainly for TV/film (weather) and cartographic graphics. Needs computer-literate freelancers for production. 100% of freelance work demands skills in ADC Graphics.

FIRST CONTACT & TERMS Send query letter with résumé and SASE. Samples are not filed and are returned by SASE. Pays for design and illustration by the hour, $7 minimum. Will contact artist for portfolio review if interested. Rights purchased vary according to project. Finds artists through classifieds.

⌂ AM/PM ADVERTISING, INC.

345 Claremont Ave., Suite 26, Montclair NJ 07402. (973)824-8600. **Fax:** (973)824-6631. **E-mail:** mpt4220@aol.com. **Contact:** Robert Saks, president. Estab. 1962. Number of employees: 130. Approximate annual billing: $24 million. Ad agency; full-service multimedia firm. Specializes in national TV commercials and print ads. Product specialties are health and beauty aids. Current clients include J&J, Bristol Myers, Colgate Palmolive. Client list available upon request. Professional affiliations: AIGA, Art Directors Club, Illustration Club.

NEEDS Approached by 35 freelancers/year. Works with 3 freelance illustrators and designers/month. Prefers to work with local freelancers with experience in animation, computer graphics, film/video production, multimedia, Macintosh. Works only with artists' reps. Works on assignment only. Uses freelancers mainly for illustration and design; also for brochure design and illustration, storyboards, slide illustration, animation, technical illustration, TV/film graphics, lettering and logos. 30% of work is with print ads. 50% of work demands knowledge of PageMaker, QuarkXPress, FreeHand, Illustrator or Photoshop.

FIRST CONTACT & TERMS Send postcard sample and/or query letter with brochure, résumé and photocopies. Samples are filed or returned. Responds in 10 days. Portfolios may be dropped off every Friday. Artist should follow up after initial query. Portfolio should include b&w and color thumbnails, roughs, final art, tearsheets, photographs and transparencies. Pays by the hour, $35-100; by the project, $300-5,000; or royalties, 25%. Rights purchased vary according to project.

TIPS "When showing work, give time it took to do job and costs."

ANDERSON STUDIO, INC.

2609 Grissom Dr., Nashville TN 37204. (615)255-4807. **Fax:** (615)255-4812. **E-mail:** sherry@andersonstudio inc.com. **Website:** andersonstudioinc.com. **Contact:** Sherry Anderson. Estab. 1976. Specializes in T-shirts (designing and printing of art on T-shirts for retail/wholesale promotional market). Clients business, corporate retail, gift and specialty stores.

NEEDS Approached by 20 freelancers/year. Works with 1-2 freelance illustrators and 1-2 designers/year. "We use freelancers with realistic (photorealistic) style. Works on assignment only. We need artists for automotive-themed art. Also motorcycle designs as seen in the current line of shirts produced for Orange County Choppers of the Discovery Channel. We're also in need of Hot Rod art and designs for T-shirts along with graphic work and logo designs of the same."

FIRST CONTACT & TERMS Send postcard sample or query letter with color copies, brochure, photocopies, photographs, SASE, slides, tearsheets and transparencies. Samples are filed and are returned by SASE if requested by artist. Portfolio should include slides, color tearsheets, transparencies and color copies. Sometimes requests work on spec before assigning a job. Pays for design and illustration by the project, $300-1,000 or in royalties per piece of printed art. Negotiates rights purchased. Considers buying second rights (reprint rights) to previously published work.

TIPS "Be flexible in financial/working arrangements. Most work is on a commission or flat buyout. We work on a tight budget until product is sold. Art-wise, the more professional, the better." Advises freelancers entering the field to "show as much work as you can. Even comps or ideas for problem solving. Let art directors see how you think. Don't send disks as they take too long to review. Most art directors like hard copy art."

ARIZONA CINE EQUIPMENT, INC.

2125 E. 20th St., Tucson AZ 85719. (520)623-8268. **Fax:** (520)623-1092. **E-mail:** Leejr@azcine.com. **Website:** www.arizonacine.com. Estab. 1967. Number of employees 11. Approximate annual billing $850,000. AV firm. Full-service, multimedia firm. Specializes in video. Product specialty is industrial.

NEEDS Approached by 5 freelancers/year. Works with 5 illustrators and 5 freelance designers/year. Prefers local artists. Uses freelancers mainly for graphic design. Also for brochure and slide illustration, catalog design and illustration, print ad design, storyboards, animation and retouching. 20% of work is with print ads. Also for multimedia projects. 70% of design and 80% of illustration demand knowledge of PageMaker, QuarkXPress, FreeHand, Illustrator or Photoshop.

FIRST CONTACT & TERMS Send query letter with brochure, résumé, photocopies, tearsheets, transparencies, photographs, slides and SASE. Samples are filed. Responds only if interested. Will contact artist for portfolio review if interested. Portfolio should include color thumbnails, final art, tearsheets, slides, photostats, photographs and transparencies. Pays for design by the project, $100-5,000. Pays for illustration by the project, $25-5,000. Buys first rights or negotiates rights purchased.

ASHCRAFT DESIGN

821 N. Nash St., El Segundo CA 90245. (310)640-8330. **Fax:** (310)640-8333. **E-mail:** info@ashcraftdesign.com. **Website:** www.ashcraftdesign.com. Specializes in corporate identity, display and package design and signage. Client list available upon request.

NEEDS Approached by 2 freelance artists/year. Works with 1 freelance illustrator and 2 freelance designers/year. Works on assignment only. Uses freelance illustrators mainly for technical illustration. Uses freelance designers mainly for packaging and production. Also uses freelance artists for mechanicals and model making.

FIRST CONTACT & TERMS Send query letter with tearsheets, résumé and photographs. Samples are filed and are not returned. Responds only if interested. To show a portfolio, e-mail samples or mail color copies. Pays for design and illustration by the project. Rights purchased vary according to project.

⏻ ASHER AGENCY

535 W. Wayne St., Fort Wayne IN 46802. (260)424-3373 (Ft. Wayne); (859)273-5530 (Lexington). **Fax:** (260)424-0848 (Ft. Wayne); (859)273-5484 (Lexington). **E-mail:** webelieve@asheragency.com. **Website:** www.asheragency.com. Estab. 1974. Approximate annual billing: $12 million. Full service ad agency and PR firm. Clients: automotive firms, financial/investment firms, area economic development agencies, health care providers, fast food companies, gaming companies and industrial.

NEEDS Works with 5-10 freelance artists/year. Assigns 25-50 freelance jobs/year. Prefers local artists. Works on assignment only. Uses freelance artists mainly for illustration; also for design, brochures, catalogs, consumer and trade magazines, retouching, billboards, posters, direct mail packages, logos and advertisements.

FIRST CONTACT & TERMS Send query letter with brochure showing art style or tearsheets and photocopies. Samples are filed or are returned by SASE. Responds only if interested. Will contact artist for portfolio review if interested. Portfolio should include roughs, original/final art, tearsheets and final reproduction/product. Pays for design by the hour, $40 minimum. Pays for illustration by the project, $40 minimum. Finds artists usually through word of mouth.

⊙ A.T. ASSOCIATES

63 Old Rutherford Ave., Charlestown MA 02129. (617)242-6004. **Website:** www.atadesign.net. Estab. 1976. Specializes in annual reports, industrial, interior, product and graphic design, model making, corporate identity, signage, display and packaging. Clients nonprofit companies, high tech, medical, corporate clients, small businesses and ad agencies. Client list available upon request.

NEEDS Approached by 20-25 freelance artists/year. Works with 3-4 freelance illustrators and 2-3 freelance designers/year. Prefers local artists; some experience necessary. Uses artists for posters, model making, mechanicals, logos, brochures, P-O-P display, charts/graphs and design.

FIRST CONTACT & TERMS Send résumé and nonreturnable samples. Samples are filed or are returned by SASE if requested by artist. Responds only if interested. Call to schedule an appointment to show a portfolio, which should include a "cross section of your work." Pays for design and illustration by the hour or by the project. Rights purchased vary according to project.

AURELIO & FRIENDS, INC.

14971 SW 43 Terrace, Miami FL 33185. (305)225-2434. **Fax:** (305)225-2121. **E-mail:** info@aurelioandfriends. com. **Website:** aurelioandfriends.com. **Contact:** Aurelio Sica, president; Nancy Sica, vice president. Estab. 1973. Number of employees 3. Specializes in corporate advertising and graphic design. Clients: corporations, retailers, large companies, hotels and resorts.

NEEDS Approached by 4-5 freelancers/year. Works with 1-2 freelance illustrators and 3-5 designers/year. Uses freelancers for ad design and illustration, brochure, catalog and direct mail design, and mechanicals. 50% of freelance work demands knowledge of Adobe Illustrator, Photoshop and QuarkXPress.

FIRST CONTACT & TERMS Send brochure and tearsheets. Samples are filed. Will contact artist for portfolio review if interested. Portfolio should include b&w and color final art, photographs, roughs and transparencies. Pays for design and illustration by the project. Buys all rights.

THE BAILEY GROUP, INC.

200 W. Germantown Pike, Plymouth Meeting PA 19462. (610)940-9030. **E-mail:** info@baileygp.com. **Website:** www.baileygp.com. Estab. 1985. Number of employees: 38. Specializes in package design, brand and corporate identity, sales promotion materials, corporate communications and signage systems. Clients: corporations (food, drug, health and beauty aids). Current clients include Aetna, Johnson & Johnson Consumer Products Co., Wills Eye Hospital and Welch's. Professional affiliations: AIGA, PDC, APP, AMA, ADC.

NEEDS Approached by 10 freelancers/year. Works with 3-6 freelance illustrators and 3-6 designers/year. Uses illustrators mainly for editorial, technical and medical illustration and final art, charts and airbrushing. Uses designers mainly for freelance production (*not* design), or computer only. Also uses freelancers for mechanicals, brochure and catalog design and illustration, P-O-P illustration and model-making.

FIRST CONTACT & TERMS Send query letter with brochure, résumé, tearsheets and photographs. Samples are filed. Responds only if interested. Will contact for portfolio review if interested. Portfolio should include finished art samples, color tearsheets, transparencies and artist's choice of other materials. May pay for illustration by the hour, $10-15; by the project, $300-3,000. Rights purchased vary according to project.

TIPS Finds artists through word of mouth, self-promotions and sourcebooks.

AUGUSTUS BARNETT ADVERTISING/ DESIGN

P.O. Box 197, Fox Island WA 98333. (253)549-2396. **E-mail:** charlieb@augustusbarnett.com. **Website:** www. augustusbarnett.com. **Contact:** Augustus Barnett, president; Charlie Barnett, president/creative director. Estab. 1981. Approximate annual billing: WND. Specializes in business to business, food/beverage, financial, agricultural, corporate identity, package design. Clients: large & small corporations, manufacturers, service organizations. Current clients include Martinac Shipbuilding, HaloSource, Mavada Wealth Management. Charlie Barnett, president/creative director. Works with 2-4 freelance illustrators, photographers and designers/year. Prefers production art experience in all disciplines. Works as consultant, by project, on assignment and retainer. Uses illustrators and photographers as needed. Also uses freelancers for new-media projects. Pays for design by the hour/project/budget/negotiable. Pays for illustration by project/use and buyouts. Rights purchased vary according to project.

FIRST CONTACT & TERMS Send query letter with samples, résumé and photocopies. Samples are filed. Responds in 1 month.

BASIC-BEDELL ADVERTISING & PUBLISHING

P.O. Box 6068, Ventura CA 93006. (805)650-1565. **E-mail:** barriebedell@gmail.com. **Contact:** Barrie Bedell, president. Specializes in advertisements, direct mail, how-to books, direct response websites and manuals. Clients publishers, direct response marketers, retail stores, software developers, Web entrepreneurs, plus extensive self-promotion of proprietary advertising how-to manuals.

○ This company's president is seeing "a glut of 'graphic designers,' and an acute shortage of 'direct response' designers."

NEEDS Uses artists for publication and direct mail design, book covers and dust jackets, and direct response websites. Especially interested in hearing from professionals experienced in e-commerce and in converting printed training materials to electronic media, as well as designers of direct response websites.

FIRST CONTACT & TERMS Portfolio review not required. Pays for design by the project, $100-2,500 and up or royalties based on sales.

TIPS "There has been a substantial increase in the use of freelance talent and an increasing need for true professionals with exceptional skills and responsible performance (delivery as promised and 'on target'). It is very difficult to locate freelance talent with expertise in design of advertising, advertising, direct mail and websites with heavy use of type. E-mail query with website link or contact with personal letter and photocopy of one or more samples of work that needn't be returned."

BBDO NEW YORK

1285 Avenue of the Americas, New York NY 10019. (212)459-5000. **Website:** www.bbdo.com. Estab. 1891. Number of employees: 850. Annual billing: $50,000,000. Ad agency; full-service multimedia firm. Specializes in business, consumer advertising, sports marketing and brand development. Clients include Lowe's, VW, FedEx, Pepsi, and Nike.

○ BBDO art director told our editors he is always open to new ideas and maintains an open drop-off policy. If you call and arrange to drop off your portfolio, he'll review it, and you can pick it up in a couple days.

○ BEDA DESIGN

38663 Thorndale Place, Lake Villa IL 60046. (847)245-8939. **Fax:** (847)245-8939. **E-mail:** bedadesign@earth link.net. **Contact:** Lynn Beda, president. Estab. 1971. Design firm specializing in packaging, print material, publishing, film and video documentaries. Clients: business-to-business accounts, producers to writers, directors and artists. Approximate annual billing: $300,000.

NEEDS Web page builders in Mac platforms. Use skilled Mac freelancers for retouching, technical, illustration, production, Photoshop, QuarkXPress, Illustrator, Premiere, and Go Live. Use film and editorial writers and photographers.

FIRST CONTACT & TERMS Designers: Send query letter with brochure, photocopies and résumé. Illustrators: Send postcard samples and/or photocopies. Samples are filed and are not returned. Will contact for portfolio review if interested.

BARRY DAVID BERGER & ASSOCIATES, INC.

2 Eli Circle, East Hampton NY 11937. (631)324-4484. **Fax:** (631)329-5578. **E-mail:** bergerbarry@hotmail. com. **Website:** www.bergerdesign.com. Estab. 1977. Number of employees: 5. Approximate annual billing: $500,000. Specializes in brand and corporate identity, P-O-P displays, product and interior design, exhibits and shows, corporate capability brochures, advertising graphics, packaging, publications and signage. Clients: manufacturers and distributors of consumer products, office/stationery products, art materials, chemicals, healthcare, pharmaceuticals and cosmetics. Clients: Dennison, Timex, Sheaffer, Bausch & Lomb and Kodak. Professional affiliations: IDSA, AIGA, APDF.

NEEDS Approached by 12 freelancers/year. Works with 5 freelance illustrators and 7 designers/year. Uses artists for advertising, editorial, medical, technical and fashion illustration, mechanicals, retouching, direct mail and package design, model-making, charts/graphs, photography, AV presentations and lettering. Needs computer-literate freelancers for illustration and production. 50% of freelance work demands computer skills.

FIRST CONTACT & TERMS Send query letter, then call for appointment. Works on assignment only. Send "whatever samples are necessary to demonstrate competence" including multiple roughs for a few projects. Samples are filed or returned. Responds immediate-

ly. Provide brochure/flyer, résumé, business card, tearsheets and samples to be kept on file for possible future assignments. Pays for design by the project, $1,000-10,000. Pays for illustration by the project.
TIPS Looks for creativity and confidence.

BERSON, DEAN, STEVENS

P.O. Box 3997, Westlake Village CA 91359. (877)477-0134. **E-mail:** contact@bersondeanstevens.com; info@bersondeanstevens.com. **Website:** www.bersondeanstevens.com. **Contact:** Lori Berson, owner. Estab. 1981. Specializes in annual reports, brand and corporate identity, collateral, direct mail, trade show booths, promotions, websites, packaging, and publication design. Clients: manufacturers, professional and financial service firms, ad agencies, corporations and movie studios. Professional affiliation: L.A. Ad Club.

NEEDS Approached by 50 freelancers/year. Works with 10-20 illustrators and 10 designers/year. Works on assignment only. Uses illustrators mainly for brochures, packaging, and comps. Also for catalog, P-O-P, ad and poster illustration, mechanicals retouching, airbrushing, lettering, logos and model-making. 90% of freelance work demands skills in Illustrator, QuarkXPress, Photoshop, as well as Web authoring, Dreamweaver, Flash/HTML, CGI, Java, etc.
FIRST CONTACT & TERMS Send query letter with tearsheets and photocopies. Samples are filed. Will contact artist for portfolio review if interested. Pays for design and illustration by the project. Rights purchased vary according to project. Considers buying second rights (reprint rights) to previously published work. Finds artists through word of mouth, submissions/self-promotions, sourcebooks and agents.

BFL MARKETING COMMUNICATIONS

1399 Lear Industrial Pkwy., Avon OH 44011. (216)875-8860. **Fax:** (216)875-8870. **Website:** www.bflcom.com. **Contact:** David Costin, graphic design/website design & multimedia specialist. Estab. 1955. Number of employees: 12. Approximate annual billing: $6.5 million. Marketing communications firm; full-service multimedia firm. Specializes in new product marketing, website design, interactive media. Product specialty is consumer home products. Client list available upon request. Professional affiliations: North American Advertising Agency Network, BPAA.
NEEDS Approached by 20 freelancers/year. Works with 5 freelance illustrators and 5 designers/year. Pre-

fers freelancers with experience in advertising design. Uses freelancers mainly for graphic design, illustration; also for brochure and catalog design and illustration, lettering, logos, model making, posters, retouching, TV/film graphics. 80% of work is with print ads. Needs computer-literate freelancers for design, illustration, production and presentation. 50% of freelance work demands knowledge of FreeHand, Photoshop, QuarkXPress, Illustrator.
FIRST CONTACT & TERMS Send postcard-size sample of work or send query letter with brochure, photostats, tearsheets, photocopies, résumé, slides and photographs. Samples are filed or returned by SASE. Responds in 2 weeks. Artist should follow-up with call or letter after initial query. Will contact artist for portfolio review if interested. Portfolio should include b&w and color final art, photographs, photostats, roughs, slides and thumbnails. Pays by the project, $200 minimum.
TIPS Finds artists through *Creative Black Book, Illustration Annual, Communication Arts*, local interviews. "Seeking specialist in Internet design, CD computer presentations and interactive media."

BIGGS-GILMORE

261 E. Kalamazoo Ave., Suite 300, Kalamazoo MI 49007-3990. (269)349-7711. **E-mail:** info@biggs-gilmore.com. **Website:** www.biggs-gilmore.com. **Contact:** Marino Puhalj, creative director. Estab. 1973. Ad agency; full-service multimedia firm. Specializes in traditional advertising (print, collateral, TV, radio, outdoor), branding, strategic planning, e-business development, and media planning and buying. Product specialties are consumer, business-to-business, marine and healthcare. Clients include Morningstar Farms, Pfizer, Kellogg Company, Zimmer, Beaner's Coffee, United Way.
Additional location: 65 E. Wacker Place, Suite #2410, Chicago IL 60601-7239; (312)269-5563.
NEEDS Approached by 10 artists/month. Works with 1-3 illustrators and designers/month. Works both with artist reps and directly with artist. Prefers artists with experience with client needs. Works on assignment only. Uses freelancers mainly for completion of projects needing specialties; also for brochure, catalog and print ad design and illustration, storyboards, mechanicals, retouching, billboards, posters, TV/film graphics, lettering and logos.

FIRST CONTACT & TERMS Send query letter with brochure, photocopies and résumé. Samples are filed. Responds only if interested. Call for appointment to show portfolio. Portfolio should include all samples the artist considers appropriate. Pays for design and illustration by the hour and by the project. Rights purchased vary according to project.

BLOCK & DECORSO

3 Claridge Dr., Verona NJ 07044. (973)857-3900. **Fax:** (973)857-4041. **E-mail:** bdecorso@blockdecorso.com. **Website:** www.blockdecorso.com. Estab. 1939. Approximate annual billing: $12 million. Product specialties are food and beverage, education, finance, home fashion, giftware, healthcare and industrial manufacturing. Professional affiliations: Ad Club of North Jersey.

NEEDS Approached by 100 freelancers/year. Works with 25 freelance illustrators and 25 designers/year. Prefers to work with "freelancers with at least 3-5 years experience as Mac-compatible artists and 'on premises' work as Mac artists." Uses freelancers for "consumer friendly" technical illustration, layout, lettering, mechanicals and retouching for ads, annual reports, billboards, catalogs, letterhead, brochures and corporate identity. Needs computer-literate freelancers for design and presentation. 90% of freelance work demands knowledge of QuarkXPress, Illustrator, Type-Styler and Photoshop.

FIRST CONTACT & TERMS To show portfolio, mail appropriate samples and follow up with a phone call. Pays for design by the hour; illustration by the project.

TIPS "We are fortunately busy—we use 4-6 freelancers daily. Be familiar with the latest versions of QuarkXPress, Illustrator and Photoshop. We like to see sketches of the first round of ideas. Make yourself available occasionally to work on premises. Be flexible in usage rights!"

BOOKMAKERS, LTD.

P.O. Box 1086, Taos NM 87571. (505)776-5435. **Fax:** (505)776-2762. **E-mail:** reg@bookmakersltd.com. **Website:** www.bookmakersltd.com. Estab. 1975. Full-service design and production studio. "We provide design and production services to the publishing industry. We also represent a group of the best children's book illustrators in the business. We welcome authors who are interested in self-publishing."

TIPS "The most common mistake illustrators make in presenting samples or portfolios is "too much variety, not enough focus.""

BOXER DESIGN

548 State St., Brooklyn NY 11217. (718)802-9212. **Fax:** (718)802-9213. **E-mail:** eileen@boxerdesign. com. **Website:** www.boxerdesign.com. **Contact:** Eileen Boxer. Estab. 1986. Approximate annual billing: $250,000. Design firm. Specializes in books and catalogs for art institutions; announcements and conceptual design primarily, but not exclusively, for cultural institutions. Current clients include Ubu Gallery, Guggenheim Museum, The American Federation of Arts, The Menil Collection, Dallas Museum of Fine Arts.

◑ This firm received AIGA Awards of Excellence in 1997 (Graphic Design USA: 18) and 2005 (AIGA Year in Design 26).

NEEDS Design work demands intelligent and mature approach to design; knowledge of Photoshop, Illustrator, QuarkXPress, InDesign.

FIRST CONTACT & TERMS Send e-mail with written and visual credentials. Accepts disk submissions, Mac-compatible, with Adobe PDFs, InDesign, Photoshop, Illustrator. Responds in 3 weeks if interested. Artist should follow-up with call after initial query. Pays by the project. Rights purchased vary according to project.

BOYDEN & YOUNGBLUTT ADVERTISING & MARKETING

120 W. Superior St., Fort Wayne IN 46802. (260)422-4499. **E-mail:** talk@b-y.net; info@b-y.net. **Website:** www.b-y.net. **Contact:** Jerry Youngblutt. Estab. 1990. Number of employees: 24. Ad agency. Full-service, multimedia firm. Specializes in magazine ads, collateral, web, media, television.

NEEDS Approached by 10 freelancers/year. Works with 3-4 freelance illustrators and 5-6 designers/year. Uses freelancers mainly for collateral layout and web. Also for annual reports, billboards, brochure design and illustration, logos and model-making. 25% of work is with print ads, 25% web, 25% media, and 25% TV. Needs computer-literate freelancers for design. 100% of freelance work demands knowledge of Free-Hand, Photoshop, Adobe Illustrator, Web Weaver and InDesign.

FIRST CONTACT & TERMS Send query letter with photostats and résumé. Samples are filed. Will con-

tact artist for portfolio review if interested. Portfolio should include b&w and color final art. Pays for design and illustration by the project. Buys all rights.

TIPS Finds artists through sourcebooks, word of mouth and artists' submissions. "Send a precise résumé with what you feel are your 'best' samples—less is more."

BRAINWORKS DESIGN GROUP, INC.

2460 Garden Rd., Suite G, Monterey CA 93940. (831)657-0650. **Fax:** (831)657-0750. **E-mail:** info@brainwks.com. **Website:** www.brainwks.com. Estab. 1970. Number of employees: 8. Specializes in ERC (Emotional Response Communications), graphic design, corporate identity, direct mail and publication. Clients: colleges, universities, nonprofit organizations; majority are colleges and universities. Current clients include City College of New York, Queens College, Manhattan College, Nova University, University of Rochester, Florida International University, Cleveland Chiropractic College, Art Institute of N.Y., Naval post graduate school.

Additional location: 221 W. 82nd St., Suite 8A, New York NY 10024; (201)240-5555.

NEEDS Approached by 50 freelancers/year. Works with 4 freelance illustrators and 10 designers/year. Prefers freelancers with experience in type, layout, grids, mechanicals, comps and creative visual thinking. Works on assignment only. Uses freelancers mainly for Web design; also for brochure, direct mail and poster design; lettering; and logos. 100% of design work demands knowledge of QuarkXPress, Illustrator, Photoshop and InDesign.

FIRST CONTACT & TERMS Send brochure or résumé, photocopies, photographs, tearsheets and transparencies. Samples are filed. Artist should follow up with call and/or letter after initial query. Will contact artist for portfolio review if interested. Portfolio should include thumbnails, roughs, final reproduction/product and b&w and color tearsheets, photostats, photographs and transparencies. Pays for design by the project, $100-1,000. Considers complexity of project and client's budget when establishing payment. Rights purchased vary according to project. Finds artists through sourcebooks and self-promotions.

TIPS "Creative thinking and a positive attitude are a plus." The most common mistake freelancers make in presenting samples or portfolios is that the "work does not match up to the samples they show." Would like to see more roughs and thumbnails.

BRAMSON + ASSOCIATES

7400 Beverly Blvd., Los Angeles CA 90036. (323)938-3595. **Fax:** (323)938-0852. **E-mail:** gbramson@aol.com. **Contact:** Gene Bramson, principal. Estab. 1970. Number of employees 15. Approximate annual billing more than $4 million. Advertising agency. Specializes in corporate communications, branding, magazine branding ads, collateral, ID, signage, graphic design, imaging, campaigns. Product specialties are healthcare, consumer, business to business. Clients include Johnson & Johnson, Chiron Vision, Lawry's, Sumitomo Metal/ Mining, iScience Interventionals, Afgrow division of Hair Raising Personal Care Products, Inc.

NEEDS Approached by 150 freelancers/year. Works with 10 freelance illustrators, 2 animators and 5 designers/year. Prefers local freelancers but work internationally. Works on assignment only. Uses freelancers for brochure and print ad design; brochure, technical, medical and print ad illustration, storyboards, mechanicals, retouching, lettering, logos. 30% of work is with print ads. 50% of freelance work" knowledge of Illustrator, Photoshop, Freehand or 3-D Studio and InDesign.

FIRST CONTACT & TERMS Send query letter with brochure, photocopies, résumé, photographs, tearsheets, SASE. Samples are filed. Will contact artist for portfolio review if interested. Portfolio should include roughs, color tearsheets. Sometimes requests work on spec before assigning job. Pays for design by the hour, $20-75. Pays for illustration by the project, $250-2,000. Buys all rights or negotiates rights purchased. Finds artists through sourcebooks.

TIPS "We look for very unique talent only. Price and availability are also important."

BRANDLOGIC

15 River Rd., Wilton CT 06897. (203)834-0087. **Website:** www.brandlogic.com. A brand consultancy with practice areas in corporate brand identity, website design, corporate/sustainability reports and collateral. Current clients include IBM, Sunovion, CFA Institute, PepsiCo, HSB and more.

NEEDS Works with 15 artists/year. Works on assignment only. Uses artists for editorial illustration. Needs computer-literate freelancers for illustration. 30% of freelance work demands knowledge of Illustrator.

FIRST CONTACT & TERMS *"No phone calls!"* Send query letter with tearsheets, slides, photostats or photocopies. Samples not kept on file are returned by SASE only. Responds only if interested. Pays for illustration by the project, $300-3,500 average. Considers client's budget, skill and experience of artist, and how work will be used when establishing payment.

LEO J. BRENNAN, INC.

2359 Livernois, Troy MI 48083-1692. (248)362-3131. **Fax:** (248)362-2355. **E-mail:** lbrennan@ljbrennan. com. **Website:** www.ljbrennan.com. **Contact:** Leo Brennan, president. Estab. 1969. Number of employees: 3. Ad, PR and marketing firm. Clients: industrial, electronics, robotics, automotive, chemical, tooling, B2B.

NEEDS Works with 2 illustrators and 2 designers/year. Prefers experienced artists. Uses freelancers for design, technical illustration, brochures, catalogs, retouching, lettering, keylining and typesetting; also for multimedia projects. 50% of work is with print ads. 100% of freelance work demands knowledge of IBM software graphics programs.

FIRST CONTACT & TERMS Send query letter with résumé and samples. Samples not filed are returned only if requested. Responds only if interested. Call for appointment to show portfolio of thumbnails, roughs, original/final art, final reproduction/product, color and b&w tearsheets, photostats and photographs. Payment for design and illustration varies. Buys all rights.

BRIGHT LIGHT PRODUCTIONS, INC.

602 Main St., Suite 810, Cincinnati OH 45202. (513)721-2574. **Fax:** (513)721-3329. **E-mail:** info@ brightlightusa.com. **Website:** www.brightlightusa. com. Estab. 1976. "We are a full-service film/video communications firm producing TV commercials and corporate communications."

NEEDS Works on assignment only. Uses artists for editorial, technical and medical illustration and brochure and print ad design, storyboards, slide illustration, animatics, animation, TV/film graphics and logos. Needs computer-literate freelancers for design and production. 50% of freelance work demands knowledge of Photoshop, Illustrator and After Effects.

FIRST CONTACT & TERMS Send query letter with brochure and résumé. Samples not filed are returned by SASE only if requested by artist. Request portfolio review in original query. Portfolio should include roughs and photographs. Pays for design and illustration by the project. Negotiates rights purchased. Finds artists through recommendations.

TIPS "Our need for freelance artists is growing."

⊙ BROMLEY COMMUNICATIONS

401 E. Houston St., San Antonio TX 78205-2615. (210)244-2000. **E-mail:** Ron.Landreth@bromley.biz. **Website:** www.bromley.biz. **Contact:** Ron Landreth, vice president creative director. Number of employees: 80. Approximate annual billing: $80 million. Estab. 1986. Full-service, multimedia ad agency and PR firm. Specializes in TV, radio and magazine ads, etc. Specializes in consumer service firms and Hispanic markets. Current clients include BellSouth, Burger King, Continental Airlines, Nestlé, Procter & Gamble.

NEEDS Approached by 3 artists/month. Prefers local artists only. Works on assignment only. Uses freelancers for storyboards, slide illustration, new business presentations and TV/film graphics and logos. 35% of work is with print ads. 25% of freelance work demands knowledge of PageMaker, QuarkXPress and Illustrator.

FIRST CONTACT & TERMS Send query letter with brochure and résumé. Samples are not filed and are returned by SASE only if requested by artist. Responds only if interested. Write for appointment to show portfolio.

BROWNING ADVERTISING

1 Browning Place, Morgan UT 84050. (801)876-2711. **Website:** www.browning.com. **Contact:** Senior art director. Estab. 1878. Distributor and marketer of outdoor sports products, particularly firearms. Inhouse agency for 3 main clients. Inhouse divisions include non-gun hunting products, firearms and accessories.

NEEDS Approached by 50 freelancers/year. View website for any upcoming freelance opportunities. Prefers freelancers with experience in outdoor sports, hunting, shooting, fishing. Works on assignment only. Uses freelancers occasionally for design, illustration and production. Also for advertising and brochure layout, catalogs, product rendering and design, signage, P-O-P displays, and posters.

FIRST CONTACT & TERMS Send query letter with résumé and tearsheets, slides, photographs and transparencies. Samples are not filed and are not returned. Responds only if interested. To show portfolio, mail photostats, slides, tearsheets, transparencies and photographs. Pays for design by the hour, $50-75. Pays

for illustration by the project. Buys all rights or reprint rights.

CAHAN & ASSOCIATES

171 Second St., 5th Floor, San Francisco CA 94105. (415)621-0915. **E-mail:** billc@cahanassociates.com. **Website:** www.cahanassociates.com. **Contact:** Bill Cahan, president. Estab. 1984. Specializes in annual reports, corporate identity, package design, signage, business and business collateral. Clients: public and private companies (real estate, finance and biotechnology). Client list available upon request.

NEEDS Approached by 50 freelance artists/year. Works with 5-10 freelance illustrators and 3-5 freelance designers/year. Works on assignment only. Uses freelance illustrators mainly for annual reports. Uses freelance designers mainly for overload cases. Also uses freelance artists for brochure design.

FIRST CONTACT & TERMS Send query letter with brochure, tearsheets, photostats, résumé, photographs, and photocopies. Samples are filed and are not returned. Responds only if interested. To show a portfolio, mail thumbnails, roughs, tearsheets, and transparencies. Pays for design or illustration by the hour or by the project. Negotiates rights purchased.

THE CALIBER GROUP

4007 E. Paradise Falls Dr., Suite 210, Tucson AZ 85712. (520)795-4500 (Tucson); (480)442-4505 (Tempe). **Fax:** (520)795-4565 (Tucson). **E-mail:** info@calibergroup. com. **E-mail:** freelancing@calibergroup.com. **Website:** www.calibergroup.com. Estab. 1997. Specializes in annual reports, brand identity, corporate identity, display design, direct mail design, environmental graphics, package design, publication design and signage. Client list available upon request.

The creative team has won over 500 international, national and local awards.

NEEDS Approached by 100 freelance artists/year. Works with 10 freelance illustrators and 5-10 freelance designers/year. Works on assignment only. Uses designers and illustrators for brochure, poster, catalog, P-O-P and ad illustration, mechanicals, retouching, airbrushing, charts/graphs and audiovisual materials.

FIRST CONTACT & TERMS Send query letter with PDF samples and résumé. Samples are filed. Responds only if interested. Call to schedule an appointment to show portfolio. Portfolio should include roughs, original/final art. Pays for design by the hour and by the

project. Pays for illustration by the project. Negotiates rights purchased.

TIPS When presenting samples or portfolios, designers and illustrators "sometimes mistake quantity for quality. Keep it short and show your best work."

CARNASE, INC.

300 E. Molino Rd., Palm Springs CA 92262. **E-mail:** carnase@carnase.com. **Website:** www.carnase.com. **Contact:** Tom Carnase, president. Estab. 1978. Specializes in annual reports, brand and corporate identity, display, landscape, interior, direct mail, package and publication design, signage and technical illustration. Clients: agencies, corporations, consultants. Clients: Brooks Brothers, Fortune Magazine, Calvin Klein, Saks Fifth Avenue.

NEEDS Approached by 60 freelance artists/year. Works with 2 illustrators and 1 designer/year. Prefers artists with 5 years experience. Works on assignment only. Uses artists for brochure, catalog, book, magazine and direct mail design and brochure and collateral illustration. Needs computer-literate freelancers. 50% of freelance work demands skills in QuarkXPress or Illustrator.

FIRST CONTACT & TERMS Send query letter with brochure, résumé and tearsheets. Samples are filed. Responds in 10 days. Will contact artist for portfolio review if interested. Portfolio should include photostats, slides and color tearsheets. Negotiates payment. Rights purchased vary according to project. Finds artists through word of mouth, magazines, submissions/ self-promotions, sourcebooks and agents.

CGT MARKETING

275-B Dixon Ave., Amityville NY 11701. (516)767-8182. **Fax:** (516)767-8185. **Website:** www.cgtmarketing.com. Estab. 1981. Ad agency. Product specialties are business to business and business to consumer.

NEEDS Approached by 2 freelance artists/month. Works with 1 freelance illustrator and 4 designers/month. Works on assignment only. Uses freelancers for brochure, catalog and print ad design and technical illustration, retouching, billboards, posters, TV/film graphics, lettering and logos. 25% of work is with print ads. 75% of freelance work demands knowledge of QuarkXPress, Illustrator, Photoshop, GoLive or Dreamweaver.

FIRST CONTACT & TERMS Send query letter with SASE and tearsheets. Samples are filed or are returned by SASE. Responds in 1 month. Call for appointment

to show portfolio or mail thumbnails, roughs, b&w and color tearsheets and transparencies. Pays for design by the hour. Pays for illustration by the project, $300-1,500 ($50 for spot illustrations). Negotiates rights purchased.

⊕ CHAPPELLROBERTS

1600 E. 8th Ave., Suite A-133, Tampa FL 33605. (813)281-0088. **Fax:** (813)281-0271. **E-mail:** info@chappellroberts.com. **Website:** www.chappellroberts.com. Estab. 1986. Number of employees: 20. Ad agency, PR firm, full-service multimedia firm. Specializes in integrated communications campaigns using multiple media and promotion. Professional affiliations: AIGA, PRSA, AAF, TBAF and AAAAS.

NEEDS Approached by 50 freelancers/year. Works with 15 freelance illustrators and designers/year. Prefers local artists with experience in conceptualization and production knowledge. Uses freelancers for billboards, brochure design and illustration, logos, mechanicals, posters, retouching and website production. 60% of work is with print ads. 80% of freelance work demands knowledge of Adobe Creative Suite 2, QuarkXPress 6.5.

FIRST CONTACT & TERMS E-mail query with samples in PDF files. Will contact artist for portfolio review if interested. Portfolio should include b&w and color final art, roughs and thumbnails. Pays for design by the hour, by the project, by the day. Pays for illustration by the project, negotiable. Refers to *Graphic Artists Guild Handbook* for fee structure. Rights purchased vary according to project. Finds artists through agents, sourcebooks, seeing actual work done for others, annuals (*Communication Arts*, *PRINT*, *One Show*, etc.).

TIPS Impressed by "work that demonstrates knowledge of product, willingness to work within budget, contributing to creative process, delivering on-time."

CINE DESIGN FILMS

P.O. Box 6495, Cherry Creek Station, Denver CO 80206. (303)888-0204. **E-mail:** jh@cinedesignfilms.com. **Website:** www.cinedesignfilms.com. **Contact:** Jon Husband, producer/director. AV firm. Clients documentary productions.

NEEDS Works with 3-20 freelancers/year. Works on assignment only. Uses freelancers for layout, titles, animation and still photography. Clear concept ideas that relate to the client in question are important.

FIRST CONTACT & TERMS E-mail query with website links or URL's or mail query with sample DVD/CD. "We like to see completed works as samples in DVD/CD form." Responds only if interested. Pays by the project. Considers complexity of project, client's budget and rights purchased when establishing payment. Rights purchased vary according to project.

⊕ CLIFF & ASSOCIATES

10061 Riverside Dr. #808, Toluca Lake CA 91602. (323)876-1180. **Fax:** (323)876-5484. **E-mail:** design@cliffassoc.com. **Website:** www.cliffassoc.com. **Contact:** Gregg Cliff, owner/creative director. Estab. 1984. Number of employees: 10. Approximate annual billing: $1 million. Specializes in annual reports, corporate identity, direct mail, publication design and signage. Clients: Fortune 500 corporations and performing arts companies. Current clients include BP, IXIA, WSPA, IABC, Capital Research and ING.

NEEDS Approached by 50 freelancers/year. Works with 30 illustrators and 10 designers/year. Prefers local freelancers and Art Center graduates. Uses freelancers mainly for brochures; also for technical, "fresh" editorial and medical illustration, mechanicals, lettering, logos, catalog/book/magazine design, P-O-P and poster design and illustration, and model making. Needs computer-literate freelancers for design and production. 90% of freelance work demands knowledge of QuarkXPress, FreeHand, Illustrator, Photoshop, etc.

FIRST CONTACT & TERMS Send query letter with résumé and a nonreturnable sample of work. Samples are filed. Will contact artist for portfolio review if interested. Portfolio should include thumbnails, b&w photostats and printed samples. Pays for design by the hour, $25-35. Pays for illustration by the project, $50-3,000. Buys one-time rights. Finds artists through sourcebooks.

COAKLEY HEAGERTY ADVERTISING & PUBLIC RELATIONS

1165 Lincoln Ave., Suite 208, San Jose CA 95125. (408)275-9400. **E-mail:** info@coakley-heagerty.com. **Website:** www.coakley-heagerty.com. Estab. 1961. Number of employees: 35. Full-service ad agency and PR firm. Clients: real estate, consumer, senior care, banking/financial, insurance, automotive, telcom, public service. Professional affiliation: MAGNET (Marketing and Advertising Global Network).

NEEDS Approached by 50 freelancers/year. Works with 3 freelance illustrators and 5 designers/year. "We want freelancers with digital or website experience." Works on assignment only. Uses freelancers for illustration, retouching, animation, lettering, logos and charts/graphs. Freelance work demands skills in InDesign, Illustrator, Photoshop or QuarkXPress.

FIRST CONTACT & TERMS E-mail PDF files showing art style, or e-mail link to website. Responds only if interested. Call for an appointment to show portfolio. Pays for design and illustration by the project.

COMMUNICATIONS ELECTRONICS, INC.

P.O. Box 1045, Ann Arbor MI 48106-1045. (734)996-8888. **E-mail:** ken.ascher@usascan.com. **Website:** www.usascan.com. **Contact:** Ken Ascher, editor. Estab. 1969.

NEEDS Approached by 500 freelancers/year. Works with 40 freelance illustrators and 40 designers/year. Uses freelancers for brochure and catalog design, illustration and layout, advertising, product design, illustration on product, P-O-P displays, posters and renderings. Needs editorial and technical illustration. Prefers pen & ink, airbrush, charcoal/pencil, watercolor, acrylic, marker and computer illustration. 30% of freelance work demands skills in PageMaker or QuarkXPress.

FIRST CONTACT & TERMS Send query letter with brochure, résumé, business card, samples and tearsheets to be kept on file. Samples not filed are returned by SASE. Responds in 1 month. Will contact artist for portfolio review if interested. Pays for design and illustration by the hour, $10-120; by the project, $10-15,000; by the day, $40-800.

COMPASS MEDIA, INC.

175 Northshore Place, Gulf Shores AL 36542. (251)968-4600; (800)239-9880. **E-mail:** info@compassmedia.com. **Website:** www.compassbiz.com. **Contact:** Editor. Estab. 1988. Number of employees 25-30. Approximate annual billing $4 million. Integrated marketing communications agency and publisher. Specializes in tourism products and programs. Product specialties are business and consumer tourism. Current clients include Alabama Bureau of Tourism and Alabama Gulf Coast CVB. Client list available upon request.

NEEDS Approached by 5-20 designers/year. Works with 4-6 designers/year. Prefers freelancers with experience in magazine work. Uses freelancers mainly for sales collateral, advertising collateral and illustration. 5% of work is with print ads. 100% of design demands skills in Photoshop 7.0 and InDesign.

FIRST CONTACT & TERMS Designers: Send query letter with photocopies, résumé and tearsheets. Samples are filed and are not returned. Responds in 1 month. Art director will contact artist for portfolio review of slides and tearsheets if interested. Pays by the project, $100 minimum. Rights purchased vary according to project. Finds artists through sourcebooks, networking and print.

TIPS "Be fast and flexible. Have magazine experience."

⊕ COUSINS DESIGN

330 E. 33rd St., New York NY 10016. (212)685-7190. **Fax:** (212)689-3369. **E-mail:** info@cousinsdesign.com. **Website:** www.cousinsdesign.com. **Contact:** Michael Cousins, president. Number of employees: 4. Specializes in packaging and product design. Clients: marketing and manufacturing companies. Professional affiliation: IDSA.

NEEDS Occasionally works with freelance designers. Prefers local designers. Works on assignment only.

FIRST CONTACT & TERMS Send nonreturnable postcard sample or e-mail website link. Samples are filed. Responds in 2 weeks only if interested. Write for appointment to show portfolio of roughs, final reproduction/product and photostats. Pays for design by the hour or flat fee. Considers skill and experience of artist when establishing payment. Buys all rights.

TIPS "Send great work that fits our direction."

⊕ CREATIVE COMPANY, INC.

726 NE Fourth St., McMinnville OR 97128. (866)363-4433. **Fax:** (503)883-6817. **E-mail:** jlmorrow@creativeco.com; optimize@creativeco.com. **Website:** www.creativeco.com. Specializes in branding, marketing-driven corporate identity, collateral, direct mail, packaging and ongoing marketing campaigns. Product specialties are food, financial services, colleges, manufacturing, pharmaceutical, medical, agricultural products.

NEEDS Works with 1-2 freelance designers and 1-2 illustrators/year. Prefers local artists. Works on assignment only. Uses freelancers for design, illustration, digital production (Mac), retouching and lettering. "Looking for clean, fresh designs!" 100% of design and 60% of illustration demand skills in InDesign, Illustrator and Photoshop.

FIRST CONTACT & TERMS Send query letter with brochure, résumé, online access to website, or PDF portfolio. Will contact for portfolio review if interested. "We require a portfolio review. Years of experience not important if portfolio is good. We prefer one-on-one review to discuss individual projects/time/approach." Pays for design by the hour or project, $50-90. Pays for illustration by the project. Considers complexity of project and skill and experience of artist when establishing payment.

TIPS Common mistakes freelancers make in presenting samples or portfolios are "1) poor presentation, samples not mounted or organized; 2) not knowing how long it took them to do a job to provide a budget figure; 3) not demonstrating an understanding of the audience, the problem or printing process and how their work will translate into print or online 4) just dropping in without an appointment; 5) not following up periodically to update information or a résumé that might be on file."

CREATIVE CONSULTANTS

17510 E. Montgomery Ave, Greenacres WA 99016-8541. (509)326-3604. **E-mail:** solutions@creativeconsultants.com. **Website:** www.creativeconsultants.com. **Contact:** Edmond A. Bruneau, president. Estab. 1980. Approximate annual billing $300,000. Ad agency and design firm. Specializes in collateral, logos, ads, annual reports, radio and TV spots. Product specialties are business and consumer. Client list available upon request.

NEEDS Approached by 20 illustrators and 25 designers/year. Works with 10 illustrators and 15 designers/year. Uses freelancers mainly for animation, brochure, catalog and technical illustration, model-making and TV/film graphics. 36% of work is with print ads. Designs and illustration demands skills in Photoshop, InDesign, and QuarkXPress.

FIRST CONTACT & TERMS Designers: Send query letter. Illustrators: Send postcard sample of work and e-mail. Accepts disk submissions if compatible with Photoshop, QuarkXPress, InDesign, illustrator and FreeHand. Samples are filed. Responds only if interested. Pays by the project. Buys all rights. Finds artists through Internet, word of mouth, reference books and agents.

THE CRICKET CONTRAST

(602)390-4940. **Fax:** (602)391-2199. **E-mail:** cricket@thecricketcontrast.com. **Website:** www.thecricket contrast.com. Estab. 1982. Specializes in providing solutions for branding, corporate identity, web page design, advertising, package and publication design, and traditional online printing. Clients: corporations. Professional affiliations: AIGA, Scottsdale Chamber of Commerce, Phoenix Society of Communicating Arts, Phoenix Art Museum, Phoenix Zoo.

NEEDS Approached by 25-50 freelancers/year. Works with 5 freelance illustrators and 5 designers/year. Uses freelancers for ad illustration, brochure design and illustration, lettering and logos. Needs computer-literate freelancers for design and production. 100% of freelance work demands knowledge of Illustrator, Photoshop, InDesign, and QuarkXPress.

FIRST CONTACT & TERMS Send photocopies, photographs and résumé via e-mail. Will contact artist for portfolio review if interested. Pays for design and illustration by the project. Negotiates rights purchased. Finds artists through self-promotions and sourcebooks.

TIPS "Beginning freelancers should send all info through e-mail."

CTCREATIVE

214 W. River Rd., St. Charles IL 60174. (630)587-6000. **E-mail:** newbranding@ctcreative.com. **Website:** www.ctcreative.com. Estab. 1989. Integrated marketing communications agency. Specializes in consulting, creative branding, collateral. Product specialties: healthcare, family. Current clients include Kidspeace, Cook Communications, Opportunity International.

NEEDS Works with 1-2 freelance illustrators and 2-3 designers/year. Needs freelancers for brochure design and illustration, logos, multimedia projects, posters, signage, storyboards, TV/film graphics. 20% of work is with print ads. 100% of freelance design demands skills in Illustrator and InDesign.

FIRST CONTACT & TERMS Designers: Send query letter with brochure and photocopies. Illustrators: Send postcard sample of work. Samples are filed. Responds only if interested. Portfolio review not required. Pays by the project. Buys all rights.

⊕ JO CULBERTSON DESIGN, INC.

939 Pearl St., Denver CO 80203. (303)861-9046. **E-mail:** joculdes@aol.com. **Contact:** Jo Culbertson, president. Estab. 1976. Number of employees 1. Approximate annual billing $75,000. Specializes in direct mail, packaging, publication and marketing design, annual reports, corporate identity, and signage.

Clients: corporations, not-for-profit organizations. Current clients include Love Publishing Company, Gabby Krause Foundation, Jace Management Services, Vitamin Cottage, Sun Gard Insurance Systems. Client list available upon request.

NEEDS Approached by 2 freelancers/year. Works with 1 freelance illustrator/year. Prefers local freelancers only. Works on assignment only. Uses illustrators mainly for corporate collateral pieces, illustration and ad illustration. 50% of freelance work demands knowledge of QuarkXPress, Photoshop, CorelDraw.

FIRST CONTACT & TERMS Send query letter or e-mail with résumé, tearsheets and photocopies. Samples are filed. Responds only if interested. Artist should follow up with call. Portfolio should include b&w and color thumbnails, roughs and final art. Pays for design by the project, $250 minimum. Pays for illustration by the project, $100 minimum. Finds artists through file of résumés, samples, interviews.

⌂ DAIGLE DESIGN, INC.

6606 Eagle Harbor Dr., Bainbridge Island WA 98110. (206)842-5356. **Fax:** (206)331-4222. **E-mail:** candace@daigle.com. **Website:** www.daigledesign.com. **Contact:** Candace Daigle, creative director. Estab. 1987. Number of employees: 3. Approximate annual billing $250,000. Design firm. Specializes in brochures, catalogs, logos, magazine ads, trade show displays, and websites. Product specialties are agriculture, law, nutraceuticals, furniture, real estate development, aviation, yachts, restaurant equipment, and automotive.

NEEDS Approached by 10 illustrators and 20 designers/year. Works with 5 illustrators and 5 designers/year. Prefers local designers with experience in Photoshop, Illustrator, DreamWeaver, Flash, CSS, and InDesign. Uses freelancers mainly for concept and production. Also for brochure design and illustration, lettering, logos, multimedia projects, signage, technical illustration and Web page design. 50% of work is with print. 50% of design demands skills in Photoshop, Illustrator and InDesign. 50% of illustration demands skills in Photoshop, Illustrator.

FIRST CONTACT & TERMS Designers: Send query letter with résumé. Illustrators: Send query letter with photocopies. Accepts PDF submissions. Send JPEG files. Samples are filed and are not returned. Responds only if interested. Will contact for portfolio review of b&w, color, final art, slides and tearsheets if interest-

ed. Pays for design by the hour, $35; pays for illustration by the project, $150-3,000. Buys all rights. Finds artists through submissions, reps, temp agencies and word of mouth.

DEFOREST GROUP

300 W. Lake St., Elmhurst IL 60126. (630)834-7200. **Fax:** (630)279-8410. **E-mail:** info@deforestgroup.com. **Website:** www.deforestgroup.com. Number of employees: 15. Marketing solutions, graphic design and digital photography firm.

NEEDS Approached by 50 freelance artists/year. Works with 3-5 freelance designers/year. Prefers artists with experience in Photoshop, Illustrator and InDesign.

FIRST CONTACT & TERMS Send query letter with résumé and samples. Samples are filed or returned by SASE if requested by artist. To arrange for portfolio review artist should fax or e-mail. Pays for production by the hour, $25-75. Finds designers through word of mouth and artists' submissions.

TIPS "Be hardworking, honest, and good at your craft."

DESIGN ASSOCIATES GROUP, INC.

1828 Asbury Ave., Evanston IL 60201-3504. (847)425-4800. **E-mail:** info@designassociatesinc.com. **Website:** www.designassociatesinc.com. Estab. 1986. Number of employees: 5. Specializes in text and trade book design, corporate marketing and communications: annual reports, corporate branding/identity, website development, content management systems, mobile app development. Clients: corporations, publishers and institutions. Client list available upon request.

NEEDS Approached by 10-20 freelancers/year. Works with 100 freelance illustrators and 2 designers/year. Uses freelancers for design and production. 100% of freelance work demands knowledge of Illustrator, Photoshop and InDesign.

FIRST CONTACT & TERMS Send query letter with samples that best represent work. Accepts disk submissions. Samples are filed. Will contact artist for portfolio review if interested. Portfolio should include b&w and color samples.

⌂ DESIGN COLLABORATIVE

1617 Lincoln Ave., San Rafael CA 94901. (415)456-0252. **E-mail:** mail@designco.com. **Website:** www.designco.com. **Contact:** Bob Ford, creative director. Estab. 1987. Number of employees 7. Approximate

annual billing $350,000. Ad agency/design firm. Specializes in publication design, package design, environmental graphics. Product specialty is consumer. Current clients include B of A, Lucas Film, Ltd., Broderbund Software. Client list available upon request. Professional affiliations AAGD, PINC, AAD.

NEEDS Approached by 20 freelance illustrators and 60 designers/year. Works with 15 freelance illustrators and 20 designers/year. Prefers local designers with experience in package design. Uses freelancers mainly for art direction production. Also for brochure design and illustration, mechanicals, multimedia projects, signage, web page design. 25% of work is with print ads. 80% of design and 85% of illustration demand skills in PageMaker, FreeHand, Photoshop, QuarkXPress, Illustrator, PageMill.

FIRST CONTACT & TERMS Designers: Send query letter with photocopies, résumé, color copies. Illustrators: Send postcard sample or query letter with photocopies and color copies. After introductory mailing, send follow-up postcard samples. Accepts disk submissions. Send EPS files. Samples are filed or returned. Responds in 1 week. Artist should call. Portfolio review required if interested in artist's work. Portfolios of final art and transparencies may be dropped off every Monday. Pays for design by the hour, $40-80. Pays for illustration by the hour, $40-100. Buys first rights. Rights purchased vary according to project. Finds artists through creative sourcebooks.

TIPS "Listen carefully and execute well."

DESIGN RESOURCE CENTER

424 Fort Hill Dr., Suite 118, Naperville IL 60540. (630)357-6008. **Fax:** (630)357-6040. **E-mail:** info@ drcchicago.com. **Website:** www.drcchicago.com. **Contact:** John Norman and Chuck Bokar, principals. Estab. 1990. Number of employees: 20. Approximate annual billing: $2,500,000. Specializes in strategic branding and package design. Clients: corporations, manufacturers, retailers, private labels.

NEEDS Approached by 5-10 freelancers/year. Works with 5-10 freelance designers and production artists and 5-10 designers/year. Uses designers mainly for conceptual design or production. Also uses freelancers for P-O-P design and illustration, lettering, logos and package design. Needs computer-literate freelancers for design, illustration and production. 100% of freelance work demands knowledge of Illustrator, QuarkXPress and Photoshop.

FIRST CONTACT & TERMS Send query letter with brochure, photocopies, photographs and résumé. Samples are filed. Artist should follow up. Portfolio review sometimes required. Portfolio should include b&w and color final art, photographs, roughs and thumbnails. Pays for design by the hour or per project. Pays for illustration by the project. Buys all rights. Finds artists through word of mouth and referrals.

DEVER DESIGNS

14203 Park Center Dr., Suite 308, Laurel MD 20707. (301)776-2812. **Fax:** (866)665-1196. **E-mail:** info@ deverdesigns.com. **Website:** www.deverdesigns.com. **Contact:** Holly Hagen, marketing director. Estab. 1985. Number of employees: 8. Specializes in annual reports, corporate identity and publication design. Clients: associations, nonprofit organizations, educational institutions, museums, government agencies.

NEEDS Approached by 100 freelance illustrators/ year. Works with 0-5 freelance illustrators/year. Prefers artists with experience in editorial illustration. Uses illustrators mainly for publications.

FIRST CONTACT & TERMS Send postcard, samples or query letter with photocopies, résumé and tearsheets. Accepts PDFs and disk submissions compatible with Photoshop, Illustrator or InDesign, but prefers hard copy samples which are filed. Will contact artist for portfolio review if interested. Portfolio should include b&w or color photocopies for files. Pays for illustration by the project. Rights purchased vary according to project. Finds artists through referrals and sourcebooks.

TIPS Impressed by consistent quality.

ANTHONY DI MARCO

301 Aris Ave., Metairie LA 70005. (504)833-3122. **Website:** www.anthonydimarcostudio.com. **Contact:** Anthony Di Marco, creative director. Estab. 1972. Number of employees: 1. Specializes in illustration, sculpture, costume design, art and photo restoration and retouching. Current clients include Audubon Institute, Louisiana Nature and Science Center, Fair Grounds Race Course. Client list available upon request. Professional affiliations: Art Directors Designers Association, Entergy Arts Council, Louisiana Crafts Council, Louisiana Alliance for Conservation of Arts.

NEEDS Approached by 50 or more freelancers/year. Works with 5-10 freelance illustrators and 5-10 designers/year. Seeks "local freelancers with ambition.

Freelancers should have substantial portfolios and an understanding of business requirements." Uses freelancers mainly for fill-in and finish design, illustration, mechanicals, retouching, airbrushing, posters, model-making, charts/graphs. Prefers highly polished, finished art in pen & ink, airbrush, charcoal/pencil, colored pencil, watercolor, acrylic, oil, pastel, collage and marker. 25% of freelance work demands computer skills.

FIRST CONTACT & TERMS Send query letter with résumé, business card, slides, brochure, photocopies, photographs, transparencies and tearsheets to be kept on file. Samples not filed are returned by SASE. Responds in 1 week if interested. Call or write for appointment to show portfolio. Pays for illustration by the hour or by the project, $100 minimum.

TIPS "Keep professionalism in mind at all times. Put forth your best effort. Apologizing for imperfect work is a common mistake freelancers make when presenting a portfolio. Include prices for completed works (avoid overpricing). 3D works comprise more of our total commissions than before."

DITTMANN DESIGN

P.O. Box 31387, Seattle WA 98103-1387. (206)523-4778. **E-mail:** dittdsgn@nwlink.com. **Contact:** Martha Dittmann, owner/designer. Estab. 1981. Number of employees: 2. Specializes in brand and corporate identity, display and package design and signage. Clients corporations. Client list available upon request. Professional affiliations AIGA.

NEEDS Approached by 50 freelancers/year. Works with 5 freelance illustrators and 2 designers/year. Uses illustrators mainly for corporate collateral and packaging. Uses designers mainly for color brochure layout and production. Also uses freelancers for brochure and P-O-P illustration, charts/graphs and lettering. Needs computer-literate freelancers for design, illustration, production and presentation.

FIRST CONTACT & TERMS Send postcard sample of work or brochure and photocopies. Samples are filed. Will contact artist for portfolio review if interested. Portfolio should include final art, roughs and thumbnails. Pays for design by the hour, $65-150. Pays for illustration by the project, $500-7,500. Rights purchased vary according to project. Finds artists through sourcebooks, agents and submissions.

TIPS Looks for "enthusiasm and talent."

DS+F (DON SCHAAF & FRIENDS, INC.)

1313 F St. NW, Washington DC 20004. (202)965-2600; Toll Free (866)965-1313. **Fax:** (202)965-2669. **E-mail:** don@dsfriends.com. **Website:** www.dsfriends.com. **Contact:** Matt Schaaf, Mike Raso and Ami Barker, senior executives. Estab. 1990. Number of employees: 12. Approximate annual billing $3 million. Marketing, advertising and branding firm. Clients: Kennametal, Flowserve, Dresser, Westinghouse Nuclear, National Association of Broadcasters, US Bobsled Federation, Venable, ASIS International, National Retail Federation, Ezra, NIH Foundation, NPE Show, etc. Complete client list available upon request. Professional affiliations: AIGA, Art Directors Club of Metropolitan Washington DC.

NEEDS Approached by 25 illustrators and 100 designers/year. Works with 10 illustrators/year. Uses freelance illustrators for print, multimedia and Web projects.

FIRST CONTACT & TERMS Send postcard sample or query letter with follow-up postcard every 3 months. Samples are filed. Responds only if interested. Portfolios of photographs may be dropped every Friday. Pays for illustration by the project, $1,000-10,000. Rights purchased vary according to project. Finds artists through sourcebooks and word of mouth.

DYKEMAN ASSOCIATES, INC.

4115 Rawlins St., Dallas TX 75219. (214)528-2991. **E-mail:** afo@dykemanassociates.com. **Website:** www.dykemanassociates.com. Estab. 1974. PR/marketing firm. Specializes in business, hospitality, sports, environmental, energy, health.

NEEDS Works with 5 illustrators and designers/year. Local freelancers preferred. Uses freelancers for editorial and technical illustration, brochure design, exhibits, corporate identification, POS, signs, posters, ads and all design and finished artwork for Web sites and printed materials. PC or Mac.

FIRST CONTACT & TERMS Request portfolio review in original query. Pays by the project, $300-3,000. "Artist makes an estimate; we approve or negotiate."

TIPS "Be enthusiastic. Present an organized portfolio with a variety of work. Portfolio should reflect all that an artist can do. Don't include examples of projects for which you only did a small part of the creative work. Have a price structure but be willing to negotiate per project. We prefer to use artists/designers/illustrators

who will work with barter (trade) dollars and join one of our trade exchanges. We see steady growth ahead."

⊙ EJW ASSOCIATES, INC.

1602 Abbey Court, Alpharetta GA 30004. (770)664-9322. **Fax:** (770)664-9324. **E-mail:** emilw@ejwassoc.com. **Website:** www.ejwassoc.com. **Contact:** Emil Walcek, president. Estab. 1982. Ad agency. Specializes in website design and development, advertising, corporate ID, brochures, and show graphics. Product specialty is business-to-business.

NEEDS Works with 1-2 freelance illustrators and designers/year. Prefers local freelancers with experience in Mac computer design/illustration and Photoshop expertise. Works on assignment only. Uses freelancers for brochure, website development, catalog and print ad design and illustration, editorial, technical illustration and logos. 50% of work is with print ads. 75% of freelance work demands skills in FreeHand, Photoshop, Web coding, Flash.

FIRST CONTACT & TERMS Send query letter with résumé, photostats, slides and website. Samples are filed or are returned by SASE if requested by artist. Responds only if interested. Pays for design by the hour, $40-80; by the day, $300-600; or by the project. Buys all rights.

TIPS "Have experience in non-consumer, industrial or technology account work. Visit our website first, then e-mail or call. Do not send e-mail attachments."

THE EMERY GROUP

2707 Congress St., #2M, San Diego CA 92110. (619)299-0775 (San Diego); (915)532-3636 (El Paso). **E-mail:** tome@emerygroup.com. **Website:** www.emerygroup.com. Number of employees: 18. Ad agency. Specializes in automotive and retail firms, banks and restaurants. Clients: Texas National Bank and Horizon Company, Ltd.

⊙ Second location: 1519 Montana Ave., El Paso TX 79902.

NEEDS Approached by 3-4 freelancers/year. Works with 2-3 freelance illustrators and 4-5 designers/year. Uses freelancers mainly for design, illustration and production. Needs technical illustration and cartoons.

FIRST CONTACT & TERMS Works on assignment only. Send query letter with résumé and samples to be kept on file. Prefers tearsheets as samples. Samples not filed are returned by SASE. Will contact artist for portfolio review if interested. Sometimes requests work on spec before assigning a job. Pays for design

by the hour, $15 minimum; by the project, $100 minimum; by the day, $300 minimum. Pays for illustration by the hour, $15 minimum; by the project, $100 minimum. Considers complexity of project, client's budget and turnaround time when establishing payment. Rights purchased vary according to project.

TIPS Especially looks for "consistency and dependability; high creativity; familiarity with retail, Southwestern and Southern California look."

ERICKSEN ADVERTISING & DESIGN, INC.

12 W. 37th St., 9th Floor, New York NY 10018. (212)239-3313. **Fax:** (212)239-3321. **E-mail:** magno@eadcom.com. **Website:** www.eadcom.com. **Contact:** Magno Parada, senior graphic designer/web designer. Full-service ad agency providing all promotional materials and commercial services for clients. Product specialties are promotional, commercial and advertising material. Current clients include BBC, *National Geographic*, CBSTV and Prudential.

NEEDS Works with several freelancers/year. Assigns several jobs/year. Works on assignment only. Uses freelancers mainly for advertising, packaging, brochures, catalogs, trade, P-O-P displays, posters, lettering and logos. Prefers composited and computer-generated artwork.

FIRST CONTACT & TERMS Contact through artist's agent or send query letter with brochure or tearsheets and slides. Samples are filed and are not returned unless requested with SASE; unsolicited samples are not returned. Responds in 1 week if interested or when artist is needed for a project. Does not respond to all unsolicited samples. "Only on request should a portfolio be sent." Pays for illustration by the project, up to $5,000. Buys all rights, and retains ownership of original in some situations. Finds artists through word of mouth, magazines, submissions and sourcebooks.

TIPS "Advertising artwork is becoming increasingly 'commercial' in response to very tightly targeted marketing. The artist has to respond to increased creative team input. Must be experienced in computer softwares; Quark, Photoshop, Acrobat, Illustrator, MS Office, Dreamweaver, and other design/web programs."

ERVIN ADVERTISING & DESIGN, INC.

3100 Airway Ave., Suite 132, Costa Mesa CA 92626. (714)668-1307. **E-mail:** info@ervinad.com. **Website:** www.ervinbell.com. **Contact:** Mike Ervin. Estab. 1981. (Formerly Ervin-Bell Marketing Communications.) Specializes in annual reports, branding and

brand management, corporate identity, retail, direct mail, package and publication design. Clients: corporations, malls, financial firms, industrial firms and software publishers. Current clients include Nutro Pet Foods, The First American Corporation, Toyota. Client list available upon request.

NEEDS Approached by 100 freelancers/year. Works with 10 freelance illustrators and 6 designers/year. Works on assignment only. Uses illustrators mainly for package designs, annual reports. Uses designers mainly for annual reports, special projects. Also uses freelancers for brochure design and illustration, P-O-P and ad illustration, audiovisual materials, lettering and charts/graphs. Needs computer-literate freelancers for production. 100% of freelance work demands knowledge of InDesign and Photoshop.

FIRST CONTACT & TERMS Send résumé and photocopies. Samples are filed and are not returned. Responds only if interested. Request portfolio review in original query. Portfolio should include tearsheets. Pays for design by the hour, $15-30; by the project (rate varies); by the day, $120-240. Pays for illustration by the project (rate varies). Buys all rights.

TIPS Finds artists through Internet, Creative Hotlist and submitted résumés.

EVENSON DESIGN GROUP

4445 Overland Ave., Culver City CA 90230. (310)204-1995. **Fax:** (310)204-4879. **E-mail:** sevenson@evensondesign.com. **Website:** evensondesign.com. **Contact:** Stan Evenson, principal. Estab. 1976. Specializes in annual reports, brand and corporate identity, display design, direct mail, package design, website design, and signage. Clients ad agencies, hospitals, corporations, law firms, entertainment companies, record companies, publications, PR firms. Current clients include ActiVistion, Disney, Universal Studios, NSL Properties, Co-Op Network, University of Southern California, Warner Brothers, Yokohama.

NEEDS Approached by 75-100 freelance artists/year. Works with 10 illustrators and 15 designers/year. Prefers artists with production experience as well as strong design capabilities. Works on assignment only. Uses illustrators mainly for covers for corporate brochures. Uses designers mainly for logo design, page layouts, all overflow work. Also uses freelancers for brochure, catalog, direct mail, ad, P-O-P and poster design and illustration, mechanicals, lettering, logos and charts/graphs. 100% of design work

demands skills in InDesign, FreeHand, Photoshop or Illustrator.

FIRST CONTACT & TERMS Send query letter with résumé and samples or send samples via e-mail. Responds only if interested. Portfolio should include b&w and color photostats and tearsheets and 4×5 or larger transparencies.

TIPS "Be efficient in the execution of design work, producing quality designs over the quantity of designs. Professionalism, as well as a good sense of humor, will prove you to be a favorable addition to any design team."

EVENTIV

10116 Blue Creek North, Whitehouse OH 43571. (419)877-5711. **E-mail:** jan@eventiv.com. **Website:** www.eventiv.com. **Contact:** Janice Robie, president/creative director. Agency specializing in graphics, promotions and tradeshow marketing.

NEEDS Assigns freelance jobs. Works with illustrators and designers on assignment only. Uses freelancers for brochures, P-O-P displays, AV presentations, posters and illustrations (technical or creative) electronic authoring, animation, web design. Requires computer skills.

FIRST CONTACT & TERMS E-mail samples. Responds only interested. Pays by the hour or by the project. Considers client's budget and skill and experience of artist when establishing payment. Retains rights purchased.

FLEXSTEEL INDUSTRIES, INC.

P.O. Box 877, Dubuque IA 52004. (563)585-8294. **E-mail:** jmills@flexsteel.com. **Website:** www.flexsteel.com. **Contact:** Justin Mills, Director of Advertising & PR. Estab. 1893. Full-service multimedia firm; manufacturer with full-service in-house agency. Specializes in furniture advertising layouts, price lists, etc. Product specialty is consumer-upholstered furniture. Employs two graphic designers and one compositor/pre-press person.

NEEDS Approached by 1 freelance artist/month. Works with 2-4 illustrators/month. Prefers artists who can do both wash and line illustration of upholstered furniture. Uses freelance artists for catalog and print ad illustration, retouching, billboards and posters. Works on assignment only. 25% of work is with print ads.

FIRST CONTACT & TERMS Send query letter with résumé, tearsheets and samples. Samples are filed or

are returned by SASE if requested by artist. Responds only if interested. To show a portfolio, mail thumbnails, roughs and b&w tearsheets. Pays for design and illustration by the project. Buys all rights.

FLINT COMMUNICATIONS

101 N. 10th St., Suite 300, Fargo ND 58107. (701)237-4850. **Fax:** (701)234-9680. **E-mail:** gerriL@flintcom.com, dawnk@flintcom.com. **Website:** www.flintcom.com. **Contact:** Gerri Lien, creative director; Dawn Koranda, art director. Estab. 1946. Number of employees: 60. Approximate annual billing: $14 million. Ad agency; full-service multimedia firm. Product specialties are agriculture, manufacturing, healthcare, insurance, tourism and banking. Professional affiliations: AIGA, MN Ad Fed.

NEEDS Approached by 50 freelancers/year. Works with 6-10 freelance illustrators and 3-4 designers/year. Uses freelancers for annual reports, brochure design and illustration, lettering, logos and TV/film graphics. 40% of work is with print ads. 20% of freelance work demands knowledge of InDesign, Photoshop, QuarkXPress and Illustrator.

FIRST CONTACT & TERMS Send query letter and postcard-size or larger sample of work. Samples are filed. Will contact artist for portfolio review if interested. Pays for illustration by the project, $100-2,000. Rights purchased vary according to project.

FORDESIGN GROUP

5405 South, 550 East, Ogden UT 84405. (801)479-4002. **E-mail:** steven@fordesign.net. **Website:** www.fordesign.net. **Contact:** Steven Ford, owner. Estab. 1990. Specializes in brand and corporate identity, package and website design. Clients: corporations. Current clients include Sony, IBM, Cadbury Beverage, Carrs, MasterCard. Professional affiliations: AIGA, PDC.

NEEDS Approached by 100 freelancers/year. Works with 6-10 freelance illustrators and 4-6 designers/year. Uses illustrators mainly for brochures, ads. Uses designers mainly for corporate identity, packaging, collateral. Also uses freelancers for ad and brochure design and illustration, logos. Needs bright, conceptual designers and illustrators. 90% of freelance work demands skills in Illustrator, Photoshop, FreeHand and Dreamweaver.

FIRST CONTACT & TERMS Send postcard sample of work or send photostats, slides and transparencies. Samples are filed or returned by SASE if requested by artist. Will contact artist for portfolio review if interested. Portfolio should include b&w and color samples. Pays for design by the hour or by the project. Pays for illustration by the project.

TIPS "We review *Showcase*, *Workbook*, etc. We are impressed by great work, simply presented. Save money on promotional materials by partnering with printers. Create a joint project or tie-in."

FREEASSOCIATES

2300 Westwood Blvd., Suite 105, Los Angeles CA 90064. (310)441-9950. **Fax:** (310)441-9949. **E-mail:** jfreeman@freeassoc.com. **Website:** www.freeassoc.com. **Contact:** Josh Freeman, president/creative director. Estab. 1974. Number of employees: 4. Design firm. Specializes in marketing materials for corporate clients. Client list available upon request. Professional affiliations: AIGA.

NEEDS Approached by 60 illustrators and 30 designers/year. Works with 3 illustrators and 3 designers/year. Prefers freelancers with experience in top level design and advertising. Uses freelancers mainly for design, production, illustration; also for airbrushing, brochure design and illustration, catalog design and illustration, lettering, logos, mechanicals, multimedia projects, posters, retouching, signage, storyboards, technical illustration and web page design. 30% of work is with print ads. 90% of design and 50% of illustration demand skills in Photoshop, InDesign CS, Illustrator.

FIRST CONTACT & TERMS Designers: Send query letter with photocopies, photographs, résumé, tearsheets. Illustrators: Send postcard sample of work or photographs and tearsheets. Accepts Mac-compatible disk submissions to view in current version of major software or self-running presentations—CD OK. Samples are filed or returned by SASE. Will contact for portfolio review if interested. Pays for design and illustration by the project; negotiable. Rights purchased vary according to project. Finds artists through iSpot.com and other online resources, *LA Workbook*, *CA*, *Print*, *Graphis*, submissions and samples.

TIPS "Designers should have their own computer and high speed Internet connection. Must have sensitivity to marketing requirements of projects they work on. Deadline commitments are critical."

G2 PARTNERS

6 Spring St., Medway MA 02053-2156. (508)533-1223.
E-mail: jamie@g2partners.com. **Website:** www.
g2partners.com. Estab. 1975. Ad agency. Specializes
in business-to-business marketing communications
(advertising, direct mail, branding and identity, Inter-
net presence, corporate literature, investor relations)
for a variety of regional, national and international
clients, large and small.

NEEDS Uses freelancers mainly for advertising, di-
rect mail and literature; also for brochure and print
ad illustration.

FIRST CONTACT & TERMS Samples are filed or are
returned by SASE if requested by artist. Responds
only if interested. Pays for illustration by the proj-
ect: $500-3,500. Finds artists through online sources.

GIRVIN STRATEGIC BRANDING

121 Stewart St., Suite 212, Seattle WA 98101-2414.
(206)674-7808. **Fax:** (206)674-7909. **E-mail:** info@
girvin.com. **Website:** www.girvin.com. Estab. 1977.
Design Firm. Number of employees: 20. Specializes
in corporate identity and brand strategy, naming, In-
ternet strategy, graphic design, signage and packag-
ing. Clients: Kerzner, Kraft, NaturoMedica, Nintendo,
Paramount, Procter & Gamble, Simon Golub & Sons
and Schwartz Brothers.

NEEDS Works with some freelance copy writers,
photographers, web programmers, illustrators, pro-
duction artists and designers/year.

FIRST CONTACT & TERMS Designers: Send que-
ry letter with appropriate samples. Illustrators: Send
postcard sample or other nonreturnable samples. Will
contact for portfolio review if interested. Payment ne-
gotiable.

⊕ GLOBAL FLUENCY

4151 Middlefield Rd., Palo Alto CA 94303. (650)328-
5555. **Fax:** (650)328-5016. **Website:** www.globalflu
ency.com. Estab. 1986. Strategic communications and
PR firm. Specializes in promotions, packaging, corpo-
rate identity, collateral design, annuals, graphic and
ad design. Product specialties are Internet, high-tech,
computer systems and peripherals, medical and con-
sumer packaged goods. Clients include eDiets.com,
McAfee, PGP Corporation, TOA Technologies.

NEEDS Approached by 20 freelance artists/month.
Works with 2-3 freelance illustrators and 2-3 free-
lance designers/month. Prefers local artists with expe-
rience in all areas of manual and electronic art capa-

bilities. Works on assignment only. Uses freelance art-
ists mainly for brochure design and illustration, print
ad illustration, mechanicals, posters, lettering, logos
and cartoons. Needs editorial and technical illustra-
tion for cartoons and caricatures. Needs freelancers
for design, illustration, production and presentation.

FIRST CONTACT & TERMS Send query letter with
"best work samples in the area you're best in." Samples
are filed. Responds in 2 weeks. To show a portfolio,
mail thumbnails, roughs and color slides. Pays for de-
sign by the hour. Negotiates rights purchased.

GOLD & ASSOCIATES, INC.

6000-C Sawgrass Village Circle, Ponte Vedra Beach
FL 32082. (904)285-5669. **Fax:** (904)285-1579. **E-mail:**
gold@strikegold.com. **Website:** www.strikegold.com.
Contact: Keith Gold, creative director/CEO. Estab.
1988. Full-service multimedia, marketing and com-
munications firm. Specializes in graphic design and
advertising. Product specialties are entertainment,
medical, publishing, tourism and sports.

NEEDS Approached by over 100 freelancers/year.
Works with approximately 25 freelance illustrators/
year. Works primarily with artist reps. Uses illustra-
tors for annual reports, books, brochures, editorial,
technical, print ad illustration; storyboards, animat-
ics, animation, music videos. 65% of work is in print.
50% of freelance work demands knowledge of Illustra-
tor, QuarkXPress, Photoshop or InDesign.

FIRST CONTACT & TERMS Contact through art-
ist rep or send query letter with photocopies or
tearsheets. Samples are filed. Responds *only* if inter-
ested. Will contact artists for portfolio review if inter-
ested. Follow up with letter after initial query. Portfo-
lio should include tearsheets. Pays for illustration by
the project, $200-7,500. Buys all rights. Finds artists
primarily through sourcebooks and reps. Does not
use freelance designers.

GRAPHIC DESIGN CONCEPTS

15329 Yukon Ave., El Camino Village CA 90260-2452.
(310)978-8922. **Contact:** C. Weinstein, president. Es-
tab. 1980. Specializes in package, publication and in-
dustrial design, annual reports, corporate identity,
displays and direct mail. Clients: Trust Financial Ser-
vices (marketing materials). Current projects include
new product development for electronic, hardware,
cosmetic, toy and novelty companies.

NEEDS Works with 15 illustrators and 25 designers/
year. "Looking for highly creative idea people, all lev-

els of experience." All styles considered. Uses illustrators mainly for commercial illustration. Uses designers mainly for product and graphic design. Also uses freelancers for brochure, P-O-P, poster and catalog design and illustration; book, magazine, direct mail and newspaper design; mechanicals; retouching; airbrushing; model-making; charts/graphs; lettering; logos. Also for multimedia design, program and content development. 50% of freelance work demands knowledge of PageMaker, Illustrator, QuarkXPress, Photoshop or FreeHand. **FIRST CONTACT & TERMS** Send query letter with brochure, résumé, tearsheets, photostats, photocopies, slides, photographs or transparencies. Accepts disk submissions compatible with Windows. Samples are filed or returned if accompanied by SASE. Responds in 10 days with SASE. Portfolio should include thumbnails, roughs, original/final art, final reproduction/product, tearsheets, transparencies and references from employers. Pays by the hour, $15-50. Considers complexity of project, client's budget, skill and experience of artist, how work will be used, turnaround time, and rights purchased when establishing payment. **TIPS** "Send a résumé, if available. Send samples of recent work or *high quality* copies. Everything sent to us should have a professional look. After all, it is the first impression we will have of you. Selling artwork is a business. Conduct yourself in a professional manner."

GRETEMAN GROUP

1425 E. Douglas Ave., Wichita KS 67211. (316)263-1004. **E-mail:** info@gretemangroup.com. **Website:** www.gretemangroup.com. **Contact:** Sonia Greteman, owner. Estab. 1989. Number of employees 24. Marketing communications. Specializes in corporate identity, advertising, annual reports, signage, website design, interactive media, brochures, collateral. Professional affiliations AIGA. **NEEDS** Approached by 20 illustrators and 20 designers/year. Illustration demands computer skills in Photoshop and Illustrator. **FIRST CONTACT & TERMS** Send query letter with brochure and résumé. Accepts disk submissions. Send EPS files. Samples are filed. Will contact for portfolio review of b&w and color final art and photostats if interested. Pays for illustration by the project. Rights purchased vary according to project.

GREY NEW YORK

200 Fifth Ave., New York NY 10010. (212)546-2000. **Fax:** (212)546-2001. **E-mail:** jim.heekin@grey.com. **Website:** www.grey.com. **Contact:** Jim Heekin, chairman and CEO. Professional affiliations 4A's Art Services Committee. **NEEDS** Approached by hundreds of freelancers/year. Clients include Pantene, DDF, Diagio, and 3M. Works with about 300 freelancers/year. Freelancers are needed mostly for illustration and photography, but also for model-making, fashion styling and lettering. **FIRST CONTACT & TERMS** Works on assignment only. E-mail query with website link for initial contact. No follow-up e-mails. Does not respond unless interested and an appropriate project arises. Pays by the project. Considers client's budget and rights purchased when establishing fees. **TIPS** "Show your work in a neat and organized manner. Have sample leave-behinds or website link and do not expect to leave with a job."

GRIFFIN MARKETING SERVICES, INC.

802 Wabash Ave., Suite 6, Chesterton IN 46304. (219)929-1616. **E-mail:** shannon@griffinmarketing services.com. **Website:** www.griffinmarketingservices.com. **Contact:** Shannon Luther, vice president/creative director. Estab. 1974. Number of employees 20. Approximate annual billing $4 million. Integrated marketing firm. Specializes in collateral, direct mail, multimedia. Product specialty is industrial. Current clients include Hyatt, USX, McDonald's. **NEEDS** Works with 20-30 freelance illustrators and 2-30 designers/year. Prefers artists with experience in computer graphics. Uses freelancers mainly for design and illustration. Also uses freelancers for animation, model making and TV/film graphics. 75% of work is with print ads. Needs computer-literate freelancers for design, illustration, production and presentation. 95% of freelance work demands knowledge of PageMaker, FreeHand, Photoshop, QuarkXPress and Illustrator. **FIRST CONTACT & TERMS** Send query letter with SASE or e-mail. Samples are not filed and are returned by SASE if requested by artist. Responds in 1 month. Will contact artist for portfolio review if interested. Pays for design and illustration by the hour, $20-150; or by the project. **TIPS** Finds artists through *Creative Black Book*.

HAMMOND DESIGN ASSOCIATES, INC.

824 Euclid Ave., Suite 102, Lexington KY 40502. (859)259-3639. **Fax:** (859)259-3697. **E-mail:** grady@hammonddesign.com. **Website:** www.hammonddesign.com. **Contact:** Grady Walter, vice president/publishing and new accounts. Estab. 1986. Specializes in direct mail, package and publication design and annual reports, brand and corporate identity, display and signage. Clients corporations, universities and medical facilities.

NEEDS Approached by 35-50 freelance/year. Works with 5-7 illustrators and 5-7 designers/year. Works on assignment only. Uses freelancers mainly for brochures and ads. Also for editorial, technical and medical illustration, airbrushing, lettering, P-O-P and poster illustration; and charts/graphs. 100% of design and 50% of illustration require computer skills.

FIRST CONTACT & TERMS Send postcard sample or query letter with brochure or résumé. "Sample in query letter a must." Samples are filed or returned by SASE if requested by artist. Responds only if interested. Will contact artist for portfolio review if interested. Pays by the project.

HANSEN BELYEA

225 Terry Ave. N, Suite 102, Seattle WA 98109. (206)682-4895. **E-mail:** patricia@hansenbelyea.com. **Website:** www.hansenbelyea.com. Estab. 1988. Creative agency specializes in branding, marketing and communication programs including corporate identity, websites and videos, marketing collateral. Clients: B2B and B2C-professional services, education, manufacturers. Current clients include PEMCO Insurance, University of Washington, Washington Global Health Alliance, Robbins Tunnel Boring Machines.

NEEDS Approached by 20-30 freelancers/year. Works with 1-3 freelance illustrators/photographers and no designers/year. Works on assignment only. Also uses freelancers for calligraphy.

FIRST CONTACT & TERMS Direct mail and electronic communication accepted. Responds only if interested. Pays for illustration by the project. Rights purchased vary according to project. Finds artists through submissions and referral by other professionals.

TIPS "Illustrators and photographers must deliver digital files. Illustrators must develop a style that makes them unique in the marketplace. When pursuing potential clients, send something distinctive.

Follow up. Be persistent (it can take one or two years to get noticed) but not pesky."

HANSON DODGE CREATIVE

220 E. Buffalo St., Milwaukee WI 53202. (414)347-1266. **Fax:** (414)347-0493. **E-mail:** info@hansondodge.com. **Website:** www.hansondodge.com. Estab. 1980. Number of employees 70. Approximate annual billing $78 million. Specializes in active lifestyle driven consumer marketing including brand planning, marketing communications, design, technology solutions, public relations and social media. Clients corporations, agencies. Current clients include Trek Bicycle, Wolverine, Wilson Sports. Professional affiliations AIGA, APDF, ACD.

NEEDS Approached by 30 freelancers/year. Works with 2-3 freelance illustrators, 2-3 designers and 5-8 production artists/year. Needs computer-literate freelancers for design, illustration and production. 90% of freelance work demands knowledge of Illustrator, Photoshop and InDesign.

FIRST CONTACT & TERMS Send letter of introduction and position sought with résumé and nonreturnable samples to Hanson Dodge Design, Attn: Kelly Klawonn or apply through www.hansondodge.com/About/Careers. Résumés and samples are kept on file for 6 months. Responds in 2 weeks. Artist should follow-up with call. Pays for design and illustration by the hour. Finds artists through word of mouth, submissions.

HARMON GROUP

807 Third Ave. S., Nashville TN 37210. (615)256-3393. **Fax:** (615)256-3464. **E-mail:** contact@harmongrp.com. **Website:** www.harmongrp.com. Estab. 1988. Approximate annual billing $7.2 million. Specializes in luxury consumer products, brand identity, display and direct mail design and signage. Clients: consumer product companies, corporations, mid-size businesses.

NEEDS Approached by 20 freelancers/year. Uses illustrators mainly for P-O-P. Uses designers mainly for flyers and catalogs. Also uses freelancers for ad, brochure, catalog, poster and P-O-P design and illustration, logos, magazine design, mechanicals and retouching. 85% of freelance work demands skills in Illustrator, Photoshop and QuarkXPress.

FIRST CONTACT & TERMS Send photographs, résumé, slides and transparencies. Samples are filed. Will contact artist for portfolio review if interested.

Portfolio should include color final art, roughs, slides and thumbnails. Pays for design and illustration by the project. Rights purchased vary according to project. Finds artists through sourcebooks and portfolio reviews.

HILL AND KNOWLTON STRATEGIES

909 Third Ave., 10th Floor, New York NY 10022. (212)885-0300. **Fax:** (212)885-0570. **E-mail:** allison.cohen@hkstrategies. **Website:** www.hkstrategies.com. **Contact:** Allison Cohen,. Estab. 1927. Number of employees: 1,800 (worldwide). PR firm; full-service multimedia firm. Specializes in corporate communications, marketing communications, public affairs, health care/pharmaceuticals, technology. Creative services include reports, collateral materials, corporate identity, presentation design, signage and advertisements.

NEEDS Works with 0-10 freelancers/month. Works on assignment only. Uses freelancers for editorial, technical and medical illustration; also for storyboards, slide illustration, animatics, mechanicals, presentation design, retouching. 10% of work is with print ads. Needs computer-literate freelancers for illustration. Freelancers should be familiar with Adobe Creative Suite: Photoshop, Illustrator, InDesign, and Microsoft PowerPoint.

FIRST CONTACT & TERMS Send query letter with promo and samples. Samples are filed. Does not respond, in which case the artist should "keep in touch by mail—do not call." Call and drop-off only for a portfolio review. Pays freelancers by the project, $250-5,000. Negotiates rights purchased.

TIPS Looks for "variety; unique but marketable styles are always appreciated."

BERNARD HODES GROUP

220 E. 42nd St., New York NY 10017. (212)999-9687. **Website:** www.hodes.com. **Contact:** Gregg Petermann, creative director. Estab. 1970. Ad agency. Full-service, multimedia firm. Specializes in recruitment advertising and employment communications.

NEEDS Prefers artists with strong interactive design skills. Heavy emphasis on Flash, Dreamweaver, and html. Works on assignment only. Uses freelancers for illustration. 50% of work is with print ads. Freelance work demands knowledge of QuarkXPress, Illustrator, Photoshop or InDesign.

FIRST CONTACT & TERMS Send query letter with samples, CD of best work or website link to the cre-

ative director. Write for an appointment to show a portfolio.

HORNALL ANDERSON

710 Second Ave., Suite 1300, Seattle WA 98104. (206)467-5800. **Fax:** (206)467-6411. **E-mail:** us@hornallanderson.com. **Website:** www.hornallanderson.com. Estab. 1982. Specializes in full-range integrated brand and communications strategy, corporate identity, digital and interactive experience design, packaging, corporate literature, collateral, retail and environmental graphics. Clients: Holland America Line, Redhook Brewery, Microsoft, Madison Square Garden, Starbucks, Skydeck Chicago at Willis Tower, Empire State Building, Pepsico, and HTC. Professional affiliations: AIGA, Seattle Design Association, Art Directors Club.

◯ This firm has received numerous awards and honors, including the International Mobius Awards, London International Advertising Awards, ADDY Awards, Communication Arts, AIGA, Clio Awards, Webby Awards, and Graphis Awards.

NEEDS Interested in all levels, from senior print and interactive design personnel to interns with design experience. Additional illustrators and freelancers are used on an as-needed basis in design and online media projects

FIRST CONTACT & TERMS Designers: Send query letter with photocopies and résumé or e-mail. Illustrators: Send résumé/cover letter and samples (URL link, PDF, JPEGs), If appropriate hard copies are accepted, but won't be returned. Samples are filed. Responds only if interested. Portfolios may be dropped off, but must be picked up by owner following review. Finds designers through word of mouth and submissions; illustrators through sourcebooks, reps and submissions. No unsolicited third party recruiter résumé submissions.

HOWARD DESIGN GROUP

20 Nassau St., Suite 250W, Princeton NJ 08542. (609)924-1106. **Fax:** (609)924-1165. **E-mail:** diane@howarddesign.com. **Website:** www.howarddesign.com. **Contact:** Diane Savoy, vice president. Estab. 1980. Number of employees: 10. Specializes in marketing and design for packaging websites, corporate identity, college recruitment materials and publication design. Clients: corporations, wholesalers, schools and colleges.

NEEDS Approached by 20 freelancers/year. Works with 10 freelance illustrators and 5 designers/year. Uses freelancers mainly for publication design; also for brochure design and illustration; catalog, direct mail, magazine and poster design; logos. Needs computer-literate freelancers for design and production. 100% of freelance work demands knowledge of Illustrator, Photoshop, FreeHand and QuarkXPress.

FIRST CONTACT & TERMS Send résumé. Samples are filed. Will contact artist for portfolio review if interested. Portfolio should include color final art, roughs and thumbnails. Pays for design and illustration by the project. Buys one-time rights. Finds artists through *Showcase*.

TIPS Looks for "innovative design in portfolio."

HOWARD/FROST ADVERTISING COMMUNICATIONS

2100 Westlake Ave. N, Suite #201, Seattle WA 98109-5802. (206)378-1909. **Fax:** (206)378-1910. **E-mail:** jack@hofro.com. **Website:** www.hofro.com. Estab. 1994. Number of full-time employees 4. Ad agency. Specializes in media advertising, collateral, web design, web advertising and direct mail. Client list is available upon request.

NEEDS Approached by 20-30 illustrators and 10-15 designers/year. Works with 10 illustrators and 2 designers/year. Works only with artist reps. Uses freelancers mainly for illustration, design overload. Also for airbrushing, animation, billboards, brochure, humorous and technical illustration, lettering, logos, multimedia projects, retouching, storyboards, web page design. 60% of work is with print ads. 60% of freelance design demands knowledge of PageMaker, FreeHand and Photoshop.

FIRST CONTACT & TERMS Designers: Send query letter with photocopies. Illustrators: Send postcard sample. Accepts disk submissions. Send files compatible with Acrobat, InDesign, Illustrator, Dreamweaver, Flash or Photoshop. Samples are filed and not returned. Responds only if interested. Art director will contact artist for portfolio review if interested. Pays for design and illustration by the project. Negotiates rights purchased.

TIPS "Be patient."

HOWRY DESIGN ASSOCIATES

354 Pine St., Suite 600, San Francisco CA 94104. (415)433-2035. **Fax:** (415)433-0816. **E-mail:** info@howry.com. **Website:** www.howry.com. **Contact:** Jill Howry, principal/creative director. Estab. 1988. Full service design studio. Number of employees: 10. Specializes in annual reports, corporate identity, print, advertising and multimedia. Clients: startups to Fortune 100 companies. Current clients include Del Monte, Affymetrix, Geron Corporation, McKesson Corp., First Republic Bank. Professional affiliation: AIGA.

NEEDS Works with 30 freelance illustrators, photographers and Internet and print designers/year. Works on assignment only. Uses illustrators for "anything that applies." Uses designers mainly for newsletters, brochures, corporate identity. Also uses freelancers for production, programming, retouching, photography/illustration, logos and charts/graphs. 100% of design work, 10% of illustration work demands knowledge of InDesign, Illustrator or Photoshop.

FIRST CONTACT & TERMS Samples are filed. Responds only if interested. Portfolios may be dropped off every Thursday. Pays for design/production by the hour, or by the job, $25-60. Pays for photography and illustration on a per-job basis. Rights purchased vary according to project.

TIPS Finds artists through sourcebooks, samples, representatives.

HUTCHINSON ASSOCIATES, INC.

822 Linden Ave., Suite 200, Oak Park IL 60302. (312)455-9191. **Fax:** (312)455-9190. **E-mail:** hutch@hutchinson.com, or contact via website. **Website:** www.hutchinson.com. **Contact:** Jerry Hutchinson, president. Estab. 1988. Member of American Institute of Graphic Arts. Design firm. Number of employees: 3. Firm specializes in identity development, website development, annual reports, collateral, magazine ads, publication design, marketing brochures. Types of clients: industrial, financial, real estate, retail, publishing, nonprofit and medical. Recent client: Cardinal Growth.

Work from Hutchinson Associates has been published in the following design books: *Graphis Design* (Graphis Publications); *Revival of the Fittest: Digital Versions of Classic Typefaces* (North Light Books); *Simpson Paper Show Catalog* (Simpson Paper, San Francisco); *Working With Computer Type*, Vols. 1-3 (Rotovision); *Context One* (Sappi Papers); *Logo Lounge*, Vols. 1-3 (Rockport); *1,000 Invitations* (Rockport); *Publication Design Workbook* (Rockport); *Letterhead and Logo Design 9* (Rockport).

NEEDS Approached by 5-10 freelancers/year. Works with 3-4 freelance illustrators and 5-15 designers/year. **FIRST CONTACT & TERMS** Send e-mail with link/postcard. Designers, please send letter, link and resume. Samples/links are filed/marked. Request portfolio review in original query. Artist should follow up with call. Will contact artist for portfolio review if interested. Pays by the project, $100-10,000. Rights purchased vary according to project. Finds artists through sourcebooks, submissions and Illinois reps. **TIPS** "Persistence pays off."

◉ IDEA BANK MARKETING

701 W. Second St., Hastings NE 68901. (402)463-0588. **Fax:** (402)463-2187. **E-mail:** sherma@ideabankmarketing.com or via online contact form. **Website:** www.ideabankmarketing.com. **Contact:** Sherma Jones, creative director. Estab. 1982. Number of employees: 14. Approximate annual billing: $2,500,000. Ad agency. Specializes in print materials, direct mail. Product specialty is manufacturers. Client list available upon request. Professional affiliations: Advertising Federation of Lincoln, American Marketing Association.
NEEDS Approached by 2 illustrators/year. Works with 2 illustrators and 2 designers/year. Prefers local designers only. Uses freelancers mainly for illustration; also for airbrushing, catalog and humorous illustration, lettering. 30% of work is with print ads. 75% of design demands knowledge of Photoshop, Illustrator. 60% of illustration demands knowledge of Photoshop, Illustrator.
FIRST CONTACT & TERMS Designers/Illustrators: Send query letter with brochure. Send follow-up postcard samples every 6 months. Accepts disk submissions compatible with original illustration files or Photoshop files. Samples are filed or returned by SASE. Responds only if interested. Will contact artist for portfolio review of b&w, color, final art, tearsheets if interested. Pays by the project. Rights purchased vary according to project and are negotiable. Finds artists through word of mouth.

IMAGE ASSOCIATES, INC.

5311 S. Miami Blvd., Suite G, Durham NC 27703. (919)876-6400. **Fax:** (919)876-6400. **E-mail:** info@imageassociates.com. **Website:** www.imageassociates.com. Estab. 1984. Marketing communications group offering advanced web-based solutions, multimedia and print. Visual communications firm specializing in computer graphics and AV, multi-image,

interactive multimedia, Internet development, print and photographic applications.
NEEDS Prefers freelancers with experience in Web, CD and print. Works on assignment only. Uses freelancers mainly for Web design and programming. Also for print ad design and illustration and animation. 90% of freelance work demands skills in Flash, HTML, DHTML, ASP, Photoshop and Macromind Director.
FIRST CONTACT & TERMS Send query letter with brochure, résumé and tearsheets. Samples are filed or are returned by SASE if requested by artist. Responds only if interested. To show portfolio, mail roughs, finished art samples, tearsheets, final reproduction/product and slides. Pays for assignments by the project. Considers complexity of project, client's budget and how work will be used when establishing payment. Rights purchased vary according to project.

◉ IMAGINASIUM, INC.

110 S. Washington St., Green Bay WI 54301. (920)431-7872 or (800)820-4624. **Fax:** (920)431-7875. **E-mail:** dkreft@imaginasium.com. **Website:** www.imaginasium.com. **Contact:** Denis Kreft. Estab. 1992. Approximate annual billing: $2 million. Strategic marketing communications firm. Specializes in brand development, graphic design, advertising. Product specialties are business to business retail.
NEEDS Prefers local designers. Uses freelancers mainly for overflow; also for brochure illustration and lettering. 15-20% of work is with print ads. 100% of design and 88% of illustration demands skills in Photoshop, QuarkXPress and Illustrator.
FIRST CONTACT & TERMS Designers: Send query letter with brochure, photographs and tearsheets. Illustrators: Send sample of work with follow-up every 6 months. Accepts Mac-compatible disk submissions. Samples are filed and are not returned. Will contact for portfolio review of color tearsheets, thumbnails and transparencies if interested. Pays for design by the hour; illustration by the project. Rights purchased vary according to project. Finds artists through submissions, word of mouth, Internet.

IMPACT COMMUNICATIONS GROUP

18627 Brookhurst St., #4200, Fountain Valley CA 92708. (714)963-6760. **E-mail:** web@impactgroup.com. **E-mail:** via online contact form. **Website:** www.impactgroup.com. **Contact:** Brad Vinikow, creative director. Estab. 1983. Number of employees: 15. Mar-

keting communications firm; full-service multimedia firm. Specializes in electronic media, business-to-business and print design. Current clients include Yamaha Corporation, Prudential, Isuzu. Professional affiliations: IICS, NCCC and ITVA.

NEEDS Approached by 12 freelancers/year. Works with 12 freelance illustrators and 12 designers/year. Uses freelancers mainly for illustration, design and computer production; also for brochure and catalog design and illustration, multimedia and logos. 10% of work is with print ads. 90% of design and 50% of illustration demands knowledge of Photoshop, QuarkXPress, Illustrator and Macro Mind Director.

FIRST CONTACT & TERMS Designers: Send query letter with photocopies, photographs, résumé and tearsheets. Illustrators: Send postcard sample. Samples are filed and are not returned. Will contact artist for portfolio review if interested. Portfolio should include b&w and color final art, photographs, photostats, roughs, slides, tearsheets and thumbnails. Pays for design and illustration by the project, depending on budget. Rights purchased vary according to project. Finds artists through sourcebooks and self-promotion pieces received in mail.

TIPS "Be flexible."

⌂ INNOVATIVE DESIGN & GRAPHICS

1327 Greenleaf St., Evanston IL 60202-1152. (847)475-7772. **Fax:** (847)475-7784. **E-mail:** info@idgevanston.com. **Contact:** Tim Sonder. Clients: corporate communication and marketing departments.

NEEDS Works with 1-2 freelance artists/year. Prefers local artists only. Uses artists for editorial and technical illustration and marketing, advertising and spot illustration. Illustrators should be knowledgeable in Adobe Illustrator and Photoshop.

FIRST CONTACT & TERMS Send query letter with résumé or brochure showing art style, tearsheets and photographs. Will contact artist for portfolio review if interested. Pays for illustration by the project, $200-1,000 average. Considers complexity of project, client's budget and turnaround time when establishing payment. Interested in buying second rights (reprint rights) to previously published work.

TIPS "Looking for people who can grasp complex ideas and turn them into high-quality illustrations. Ability to draw people well is a must. Do not call for an appointment to show your portfolio. Send nonreturn-able tearsheets or self-promos; we will call you when we have an appropriate project for you."

⌂ JUDE STUDIOS

8000 Research Forest, Suite 115-266, The Woodlands TX 77382. (281)364-9366. **Fax:** (281)364-9529. **E-mail:** jdollar@judestudios.com. **Contact:** Judith Dollar, art director. Estab. 1994. Number of employees: 2. Design firm. Specializes in printed material, brochure, trade show, collateral, illustration, and logodesign. Product specialties are industrial, restaurant, homebuilder, financial, high-tech business to business, non-profit, and event marketing materials.

NEEDS Uses freelancers mainly for newsletter, logo and brochures assorted print design, illustration and lettering. Use of Adobe CS required.

FIRST CONTACT & TERMS Designers and illustrators can e-mail with link to webpage or blog (no attachments). Pays by the project; varies. Negotiates rights purchased. Finds artists through directories or online.

TIPS Wants freelancers with good type usage who contribute to concept ideas. "We are open to designers and illustrators who are just starting out their careers."

⌂ KAUFMAN RYAN STRAL, INC.

820 Oakton St., Suite 3D, Evanston IL 60202-2842. (847)328-6154. **E-mail:** lak@bworld.com. **Website:** www.bworld.com. **Contact:** Laurence Kaufman, president/creative director. Estab. 1993. Number of employees 7. Ad agency. Specializes in all materials in print and website development. Product specialty is business-to-business. Client list available upon request. Professional affiliations: American Israel Chamber of Commerce.

NEEDS Approached by 30 freelancers/year. Works with 3 designers/year. Prefers local freelancers. Uses freelancers for design, production, illustration and computer work. Also for brochure, catalog and print ad design and illustration, animation, mechanicals, retouching, model-making, posters, lettering and logos. 5% of work is with print ads. 50% of freelance work demands knowledge of QuarkXPress, HTML programs FrontPage or Page Mill, Photoshop or Illustrator.

FIRST CONTACT & TERMS Send e-mail with résumé and JPEGs. Responds only if interested. Will contact artist for portfolio review if interested. Portfolio should include b&w and color roughs and final art. Pays for design by the hour, $40-120; or by the

project. Pays for illustration by the project. Buys all rights. Finds artists through sourcebooks, word of mouth, submissions.

ⓛ KETCHUM PLEON CHANGE

1285 Avenue of the Americas, New York NY 10019. (646)935-4300. **Website:** www.ketchum.com. **Contact:** Sophia Sayers, administrative assistant. (Formerly Stromberg Consulting) Specializes in direct marketing, internal and corporate communications. Clients: industrial and corporate. Produces multimedia presentations and print materials.

NEEDS Assigns 25-35 jobs/year. Prefers local designers only (Manhattan and its 5 boroughs) with experience in animation, computer graphics, multimedia and Macintosh. Uses freelancers for animation logos, posters, storyboards, training guides, Web Flash, application development, design catalogs, corporate brochures, presentations, annual reports, slide shows, layouts, mechanicals, illustrations, computer graphics and desk-top publishing web development, application development.

FIRST CONTACT & TERMS "Send note on availability and previous work." Responds only if interested. Provide materials to be kept on file for future assignments. Originals are not returned. Pays hourly or by the project.

TIPS Finds designers through word of mouth and submissions.

KIZER INCORPORATED ADVERTISING & COMMUNICATIONS

4513 N. Classen Blvd., Oklahoma City OK 73118. (405)708-4302. **E-mail:** mrkt@kizerincorporated. com. **Website:** www.kizerincorporated.com. Estab. 1998. Number of employees: 5. Creative shop specializing in campaign planning, creative development and production. 65% print, 20% web, 15% broadcast/other. 65% of work is print ads, brochures, annual reports, direct mail. InDesign is primary design software used. Professional affiliations: OKC Ad Club, AMA, AIGA.

NEEDS Approached by 30+ illustrators and designers/year. Works with varying number of illustrators and designers/year.

FIRST CONTACT & TERMS Direct mail or e-mail queries are both acceptable. For e-mail contacts, prefers link back to artist's portfolio to see samples. No large attachments, please. Responds if interested. Pays by the project. Rights purchased vary according

to project. Finds artists through agents, sourcebooks, online services, magazines, word of mouth, artist's submissions.

ⓛ LEKASMILLER

1460 Maria Lane, Suite 260, Walnut Creek CA 94596. (925)934-3971. **Fax:** (925)934-3978. **E-mail:** tina@ lekasmiller.com. **Website:** www.lekasmiller.com. Estab. 1979. Specializes in annual reports, corporate identity, advertising, direct mail and brochure design. Clients: corporate and retail. Current clients include Bank of the West, Sutter Health, Dignity Health, Dominican University of California, and Mills College.

NEEDS Approached by 80 freelance artists/year. Works with 1-3 illustrators and 5-7 designers/year. Prefers local artists only with experience in design and production. Works on assignment only. Uses artists for brochure design and illustration, mechanicals, direct mail design, logos, ad design and illustration. 100% of freelance work demands knowledge of InDesign, Photoshop and Illustrator.

FIRST CONTACT & TERMS Designers/illustrators: E-mail PDF or résumé and portfolio. Responds only if interested. Considers skill and experience of artist when establishing payment. Negotiates rights purchased.

LISA LELEU STUDIOS, INC.

187 East Court Street, Doylestown PA 18901. (215)345-1233 ext. 102. **Fax:** (610)819-0334. **E-mail:** contact@ lisaleleustudios.com. **Website:** www.fullmooncreations.com. Estab. 1986. (Formerly Fullmoon Creations, Inc.) Number of employees: 10. Specializes in new product ideas, new product concept development, product name generations, brand development, product design, packaging design, packaging structure design, packaging descriptive copy writing. Clients: Fortune 500 corporations. Current clients are top 1,000 manufacturers involved in new product and packaging development.

NEEDS Approached by 100-120 freelancers/year. Works with 5-15 freelance illustrators and 10-20 designers/year. Uses freelancers for ad, brochure and catalog design and illustration; airbrushing; audiovisual materials; book, direct mail and magazine design; logos; mechanicals; poster and P-O-P illustration. Needs computer-literate freelancers for design, illustration and production. 50% of freelance work demands knowledge of Illustrator, Photoshop, Adobe CS.

FIRST CONTACT & TERMS Send postcard sample of work, photocopies, résumé and URL. Samples are filed. E-mail links to website. Responds in 1 month with SASE. Will contact artist for portfolio review if interested. Portfolio should include b&w and color roughs, thumbnails and transparencies.

LIEBER BREWSTER DESIGN, INC.

740 Broadway, Suite 1101, New York NY 10003. (212)614-1221. **E-mail:** office@lieberbrewster.com. **Website:** www.lieberbrewster.com. **Contact:** Anna Lieber, principal. Estab. 1988. Specializes in strategic marketing. Clients: small and midsize businesses, Fortune 500s. Client list available upon request. Professional affiliations: Toastmasters, Ad Club-NY.

NEEDS Approached by more than 100 freelancers/year. Works on assignment only. Uses freelancers for HTML programming, multimedia presentations, Web development, logos, marketing programs, audiovisual materials.

FIRST CONTACT & TERMS Send query letter with résumé, tearsheets and photocopies. Will contact artist for portfolio review if interested.

LIGGETT STASHOWER

1422 Euclid Ave., Suite 400, Cleveland OH 44115. (216)348-8500. **E-mail:** info@liggett.com. **Website:** www.liggett.com. **Contact:** Tom Federico. Estab. 1932. Ad and PR agency. Full-service multimedia firm. Works in all formats. Handles all product categories. Clients: Forest City Management, Member Health, Crane Performance Siding, Henkel Consumer Adhesives and AkzoNobel.

NEEDS Approached by 120 freelancers/year. Works with freelance illustrators and designers. Prefers local freelancers. Works on assignment only. Uses freelancers mainly for brochure, catalog and print ad design and illustration, storyboards, slide illustration, animatics, animation, retouching, billboards, posters, TV/film graphics, lettering and logos. Needs computer-literate freelancers for illustration and production. 90% of freelance work demands skills in InDesign, Photoshop or Illustrator.

FIRST CONTACT & TERMS Send query letter. Samples are filed and are not returned. Responds only if interested. To show portfolio, e-mail works best. Pays for design and illustration by the project. Negotiates rights purchased.

TIPS "Please consider that art buyers and art directors are very busy and receive numerous inquiries per day from freelancers looking for work opportunities. We might have loved your promo piece, but chances of us remembering it by your name alone when you call are slim. Give us a hint 'it was red and black' or whatever. We'd love to discuss your piece, but it's uncomfortable if we don't know what you're talking about."

LINEAR CYCLE PRODUCTIONS

P.O. Box 2608, North Hills CA 91393-2608. (818)347-9880. **Fax:** (818)347-9880. **E-mail:** Lcp@Wgn.net. **Website:** www.linearcycleproductions.com. **Contact:** Mason Pandanceski, associate director. Estab. 1980. Number of employees 30. Approximate annual billing $500,000. AV firm. Specializes in display design, magazine ads, design and packaging signage. Current clients include: Katz, Inc.; Doland, Kilpatrich & Spear; Sterling Estates and United Twade, LLP. Serves industrial, publishing and retail clients. 80% of design/illustration work demands skills in Adobe Illustrator, PageMaker and Photoshop.

FIRST CONTACT & TERMS Send a query letter with a résumé, business card, artist's statement, biography, photographs/slides/SASE. Samples kept on file with résumé. Samples not returned. Responds within 90 days. Portfolio should include color, original art, photographs, slides, transparencies and tearsheets. Paid by the project, on acceptance. Buys all rights.

TIPS "Make sure all photos and multimedia elements are presented in original formats that show supreme quality of work. If originals are desired, no photocopies can be accepted. The same goes for video and related elements."

LOHRE & ASSOCIATES, INC.

126A W. 14th St., 2nd Floor, Cincinnati OH 45202-7535. (513)961-1174. **Website:** www.lohre.com. **Contact:** Chuck Lohre, president. Number of employees: 6. Approximate annual billing: $1 million. Ad agency. Specializes in industrial firms. Professional affiliation: SMPS, U.S. Green Building, Council Cincinnati, Regional Chapter.

NEEDS Approached by 24 freelancers/year. Works with 10 freelance illustrators and 10 designers/year. Works on assignment only. Uses freelance artists for trade magazines, direct mail, P-O-P displays, multimedia, brochures and catalogs. 100% of freelance work demands knowledge of PageMaker, FreeHand, Photoshop and Illustrator.

FIRST CONTACT & TERMS Send postcard sample or e-mail. Accepts submissions on disk, any Mac application. Pays for design and illustration by the hour, $10 minimum.

TIPS Looks for artists who "have experience in chemical and mining industry, can read blueprints and have worked with metal fabrication." Also needs "Mac-literate artists who are willing to work at office, day or evenings."

LOMANGINO STUDIO, INC.

1530 Key Blvd., #1309, Arlington VA 22209. **E-mail:** info@lomangino.com. **Website:** www.lomangino. com. **Contact:** Donna Lomangino, president. Estab. 1987. Specializes in annual reports, corporate identity, website and publication design. Clients: corporations, nonprofit organizations. Client list available upon request. Professional affiliations: AIGA.

NEEDS Approached by 25-50 freelancers/year. Works with 1 freelance illustrator/year. Uses illustrators and production designers occasionally for publication; also for multimedia projects. 99% of design work demands skills in Illustrator, Photoshop and QuarkXPress.

FIRST CONTACT & TERMS Send postcard sample of work or URL. Samples are filed. Accepts disk submissions, but not preferable. Will contact artist for portfolio review if interested. Pays for design and illustration by the project. Finds artists through sourcebooks, word of mouth and studio files.

TIPS "Please don't call. Send samples or URL for consideration."

⌂ LORENC & YOO DESIGN, INC.

109 Vickery St., Roswell GA 30075-4926. (770)645-2828. **Fax:** (770)998-2452. **E-mail:** jan@lorencyoo design.com. **Website:** www.lorencyoodesign.com. **Contact:** Jan Lorenc, president. Specializes in architectural signage design; exhibit design for museums and trade shows. Clients: corporate, developers, product manufacturers, architects, real estate and institutions. Current clients include Hines Interests, UPS, Georgia-Pacific, IBM, Simon Property Company, Mayo Clinic. Client list available upon request.

NEEDS Approached by 25 freelancers/year. Works with 5 illustrators and 10 designers/year. Local senior designers only. Uses freelancers for design, illustration, brochures, catalogs, books, P-O-P displays, mechanicals, retouching, airbrushing, posters, direct mail packages, model-making, charts/graphs,

AV materials, lettering and logos. Needs editorial and technical illustration. Especially needs architectural signage and exhibit designers. 95% of freelance work demands knowledge of QuarkXPress, Illustrator or FreeHand.

FIRST CONTACT & TERMS Send brochure, weblink, CD, résumé and samples to be kept on file. Prefers digital files as samples. Samples are filed or returned. Call or write for appointment to show portfolio of thumbnails, roughs, original/final art, final reproduction/product, color photostats and photographs. Pays for design by the hour, $40-100; by the project, $250-20,000; by the day, $80-400. Pays for illustration by the hour, $40-100; by the project, $100-2,000; by the day, $80-400. Considers complexity of project, client's budget, and skill and experience of artist when establishing payment.

TIPS "Sometimes it's more cost-effective to use freelancers in this economy, so we have scaled down permanent staff."

JODI LUBY & COMPANY, INC.

288 Twin Lakes Road, Salisbury CT 06068. (860)824-7039. **E-mail:** jodiluby@gmail.com. **Website:** www. jodiluby.com or jodiluby.blogspot.com. **Contact:** Jodi Luby, president. Estab. 1983. Specializes in branding, direct marketing, packaging, and web design. Clients: major magazines, startup businesses and corporate clients.

NEEDS Uses freelancers for production and web production. 100% of freelance work demands computer skills.

FIRST CONTACT & TERMS Send e-mail samples only. Samples are not filed and are not returned. Will contact artist for portfolio review if interested.

TAYLOR MACK ADVERTISING

21 W. Mountain, Suite 227, Fayetteville AR 72071. (479)444-7770. **E-mail:** greg@taylormack.com. **Website:** www.taylormack.com. **Contact:** Greg Mack, managing director. Estab. 1990. Number of employees 16. Approximate annual billing $3 million. Ad agency. Specializes in collateral. Current clients include Cobb, Jose's, Rheem-Rudd and Bikes, Blues and BBQ. Client list available upon request.

NEEDS Approached by 12 illustrators and 20 designers/year. Works with 4 illustrators and 6 designers/year. Uses freelancers mainly for brochure, catalog and technical illustration, TV/film graphics and web page design. 30% of work is with print ads. 50% of

design and illustration demands skills in Photoshop, Illustrator and InDesign.

FIRST CONTACT & TERMS Designers: E-mail website links or URLs. Samples are filed or are returned. Responds only if interested. Art director will contact artist for portfolio review of photographs if interested. Pays for design by the project or by the day; pays for illustration by the project, $10,000 maximum. Rights purchased vary according to project.

MICHAEL MAHAN GRAPHICS

P.O. Box 642, Bath ME 04530-0642. (207)443-6110. **E-mail:** ldelorme@mahangraphics.com. **Website:** www.mahangraphics.com. Estab. 1986. Number of employees: 5. Approximate annual billing $500,000. Design firm. Specializes in publication design—catalogs and direct mail. Product specialties are furniture, fine art and high tech. Clients: Bowdoin College, Bath Iron Works and Monhegan Museum. Professional affiliations G.A.G., AIGA and Art Director's Club-Portland, ME.

NEEDS Approached by 5-10 illustrators and 10-20 designers/year. Works with 2 illustrators and 2 designers/year. Uses freelancers mainly for production. Also for brochure, catalog and humorous illustration and lettering. 5% of work is with print ads. 100% of design demands skills in Photoshop, QuarkXPress and InDesign.

FIRST CONTACT & TERMS Designers: Send query letter with photocopies and résumé. Illustrators: Send query letter with photocopies. Accepts CD/DVD submissions. Samples are filed and are not returned. Responds only if interested. Art director will contact artist for portfolio review of final art roughs and thumbnails if interested. Pays for design by the hour, $15-40. Pays for illustration by the hour, $18-60. Rights purchased vary according to project. Finds artists through word of mouth and submissions.

MANGAN HOLCOMB PARTNERS

2300 Cottondale Lane, Suite 300, Little Rock AR 72202. (501)376-0321. **Fax:** (501)376-6127. **E-mail:** chip@manganholcomb.com. **Website:** www.manganholcomb.com. **Contact:** Chip Culpepper, creative director. Number of employees: 12. Approximate annual billing: $3 million. Marketing, advertising and PR firm. Clients: recreation, financial, tourism, retail, agriculture. Current clients include Citizens Bank, Farmers Bank & Trust, The Wilcox Group.

NEEDS Approached by 50 freelancers/year. Works with 8 freelance illustrators and 20 designers/year. Uses freelancers for consumer magazines, stationery design, direct mail, brochures/flyers, trade magazines and newspapers. Needs computer-literate freelancers for production and presentation. 30% of freelance work demands skills in Mac-based page layout and illustration software.

FIRST CONTACT & TERMS Query with samples, flier and business card to be kept on file. Include SASE. Responds in 2 weeks. Call or write for appointment to show portfolio of final reproduction/product. Pays by the project, $250 minimum.

MARKEFXS

449 W. 44th St., Suite 4-C, New York NY 10036. (212)581-4827. **E-mail:** mark@mfxs.com. **Website:** www.mfxs.com. **Contact:** Mark Tekushan, owner/creative director. Estab. 1985. Full-service multimedia firm. Specializes in TV, video, advertising, design and production of promos, show openings and graphics. Current clients include ESPN and HBO.

○ Los Angeles office: (323)933-3673

NEEDS Prefers freelancers with experience in television or advertising production. Works on assignment only. Uses freelancers mainly for design production. Also for animation, TV/film graphics and logos. Needs computer-literate freelancers for design, production and presentation.

FIRST CONTACT & TERMS E-mail your website link or mail DVD/CD. Coordinating Producer will contact artist for portfolio review if interested. Pays for design by the hour, $25-50. Finds artists through word of mouth.

⚘ MARKETAIDE SERVICES, INC.

P.O. Box 500, Salina KS 67402. (785)825-7161; (800)204-2433. **Fax:** (785)825-4697. **E-mail:** creative@marketaide.com. **Website:** www.marketaide.com. **Contact:** Production manager. Estab. 1975. Full-service ad/marketing/direct mail firm. Clients: financial, industrial and educational.

NEEDS Prefers artists within one-state distance who possess professional expertise. Works on assignment only. Needs computer-literate freelancers for design, illustration and web design. 90% of freelance work demands knowledge of QuarkXPress, Illustrator and Photoshop.

FIRST CONTACT & TERMS Send query letter with résumé, business card and samples to be kept on

file. Samples not filed are returned by SASE only if requested. Responds only if interested. Write for appointment to show portfolio. Pays for design by the hour, $15-75 average. "Because projects vary in size, we are forced to estimate according to each job's parameters." Pays for illustration by the project.

TIPS "Artists interested in working here should be highly polished in technical ability, have a good eye for design, and be able to meet all deadline commitments."

MARKETING BY DESIGN

2012 19th St., Suite 200, Sacramento CA 95818. (916)441-3050. **Fax:** (916)446-4641. **E-mail:** creative@mbdstudio.com. **Website:** www.mbdstudio.com. Estab. 1977. Specializes in corporate identity and brochure design, publications, direct mail, trade shows, signage, display and packaging. Clients: associations and corporations.

NEEDS Approached by 50 freelance artists/year. Works with 6-7 freelance illustrators and 1-3 freelance designers/year. Works on assignment only. Uses illustrators mainly for editorial; also for brochure and catalog design and illustration, mechanicals, retouching, lettering, ad design and charts/graphs.

FIRST CONTACT & TERMS Send query letter with brochure, résumé, tearsheets. Samples are filed and are not returned. Does not respond. Artist should follow up with call. Call for appointment to show portfolio of roughs, color tearsheets, transparencies and photographs. Rights purchased vary according to project. Finds designers through word of mouth; illustrators through sourcebooks.

MARTIN THOMAS, INC.

42 Riverside Dr., Barrington RI 02806-3612. (401)245-8500. **Fax:** (866)899-2710. **E-mail:** contact@martinthomas.com. **Website:** www.martinthomas.com. Estab. 1987. Number of employees: 12. Approximate annual billing: $7 million. Ad agency; PR firm. Specializes in industrial, business-to-business. Product specialties are plastics, medical and automotive. Professional affiliations: American Association of Advertising Agencies, Boston Ad Club.

NEEDS Approached by 10-15 freelancers/year. Works with 6 freelance illustrators and 10-15 designers/year. Prefers freelancers with experience in business-to-business/industrial. Uses freelancers mainly for design of ads, literature and direct mail; also for brochure and catalog design and illustration. 85% of work is print ads. 70% of design and 40% of illustration demands skills in QuarkXPress.

FIRST CONTACT & TERMS Send query letter with brochure and résumé. Samples are filed and are returned. Responds in 3 weeks. Will contact artist for portfolio review if interested. Portfolio should include b&w and color final art. Pays for design and illustration by the hour and by the project. Buys all rights. Finds artists through *Creative Black Book*.

TIPS Impress agency by "knowing industries we serve."

SUDI MCCOLLUM DESIGN

3244 Cornwall Dr., Glendale CA 91206. (818)243-1345. **Fax:** (818)243-2344. **E-mail:** sudimccollum@earthlink.net. **Contact:** Sudi McCollum. Specializes in home fashion design and illustration. Clients: home furnishing and giftware manufacturers, advertising agencies and graphic design studios; majority of clients are medium- to large-size businesses in home fashion and graphic design industry.

NEEDS Uses freelance production people either on computer or with painting and product design skills. Potential to develop into full-time job.

FIRST CONTACT & TERMS "Send query letter or whatever you have that's convenient. Samples are filed. Responds only if interested."

MCGRATHICS

18 Chestnut St., Marblehead MA 01945. (978)317-1172. **E-mail:** mcgrathics@aol.com. **Website:** www.mcgrathics.com. **Contact:** Art director. Estab. 1978. Number of employees 4-6. Specializes in corporate identity, annual reports, package and publication and Web design. Clients corporations and universities. Professional affiliations AIGA, VUGB.

NEEDS Approached by 30 freelancers/year. Works with 8-10 freelance illustrators/year. Uses illustrators mainly for advertising, corporate identity (both conventional and computer). Also for ad, brochure, catalog, poster and P-O-P illustration; charts/graphs. Computer and conventional art purchased.

FIRST CONTACT & TERMS Send postcard sample of work or send brochure, photocopies, photographs, résumé, slides and transparencies. Samples are filed. Responds only if interested. Portfolio review not required. Pays for illustration by the hour or by the project. Rights purchased vary according to project. Finds artists through sourcebooks and mailings.

TIPS "Annually mail us updates for our review."

MEDIA ENTERPRISES

1644 S. Clementine St., Anaheim CA 92802. (714)778-5336. **Fax:** (714)778-6367. **E-mail:** john@media-enterprises.com. **Website:** www.media-enterprises.com. **Contact:** John Lemieux Rose. Estab. 1982. Number of employees: 10. Approximate annual billing $14 million. Integrated marketing communications agency. Specializes in web, social network marketing, mobile applications, public relations, magazine publishing. Product specialty high-tech. Client list available upon request. Professional affiliations Small Business Administration, Society of North American Goldsmiths, Software Council of Southern California, Association of Internet Professionals.

NEEDS Approached by 30 freelance illustrators and 10 designers/year. Works with 8-10 freelance illustrators and 3 designers/year. Uses freelancers for animation, humorous illustration, lettering, logos, mechanicals, multimedia projects. 20% of work is with print ads, 80% digital media. 100% of freelance work demands skills in PageMaker, Photoshop, InDesign, Illustrator, Director.

FIRST CONTACT & TERMS E-mail digital samples or website pays by project; negotiated. Buys all rights.

MEDIA LOGIC INC.

One Park Place, Albany NY 12205. (518)456-3015; (866)353-3011. **Fax:** (518)456-4279. **E-mail:** cainsburg@mlinc.com. **Website:** www.mlinc.com. **Contact:** Carol Ainsburg, director of studio services. Estab. 1984. Number of employees: 75. Approximate annual billing: $50 million. Media Logic, a leader in marketing innovation, is ushering in a new era of conversation-centric marketing, putting social at the center of business to achieve better customer engagement, advocacy and revenue growth. Combining more than 25 years of experience with its breakthrough Zeitgeist & Coffee social management program, Media Logic is helping organizations harness the power of social media to drive marketing strategy and brand evolution. Prefers freelancers with experience on MAC platform. Uses freelancers for Multimedia/Rich Media full build (footage editing and element animation for video creation) using Adobe Flash (including Action Script 3.0), After Effects, Premiere, Apple Final Cut Pro, and Maxon Cinema 4D. Interactive design, and build using HTML, PHP, CSS, CMS (especially WordPress and Expression Engine). Also, high-end traditional print projects (DM, collateral, trade show panels, POP) using Photoshop, InDesign, Illustrator, QuarkXPress. Candidates must be able to work on site. Compensation via hourly rate.

DONYA MELANSON ASSOCIATES

5 Bisson Ln., Merrimac MA 01860. (978)346-9240. **Fax:** (978)346-8345. **E-mail:** dmelanson@dmelanson.com. **Website:** www.dmelanson.com. **Contact:** Donya Melanson. Advertising agency. Number of employees: 1. Clients: government, education, associations, publishers, financial services and industries. Current clients include US Geological Survey, Mannesmann, Cambridge College, American Psychological Association, Ledakka Enterprises and US Department of Agriculture.

NEEDS Approached by 30 artists/year. Works with 2-3 illustrators/year. Most work is handled by staff, but may occasionally use freelance illustrators and designers. Uses artists for stationery design, direct mail, brochures/flyers, annual reports, charts/graphs and book illustration. Needs editorial and promotional illustration. Most freelance work demands skills in Adobe Illustrator, InDesign, Photoshop, or QuarkXPress.

FIRST CONTACT & TERMS Query with brochure, résumé, photocopies, tearsheets or CD. Provide materials (no originals) to be kept on file for future assignments. Originals returned to artist after use only when specified in advance. Call or write for appointment to show portfolio or mail non-original, non-returnable materials. Pays for design and illustration by the project, $100 minimum. Considers complexity of project, client's budget, skill and experience of artist and how work will be used when establishing payment.

TIPS "Be sure your work reflects concept development."

HOWARD MERRELL & PARTNERS

8521 Six Forks Rd., 4th Floor, Raleigh NC 27615. (919)848-2400. **Fax:** (919)848-2400. **E-mail:** bibarnes@merrellgroup.com. **Website:** www.merrellgroup.com. **Contact:** Billy Barnes, creative director. Estab. 1993. Number of employees: 60. Approximate annual billing $90 million. Ad agency. Full-service, multimedia firm. Specializes in ads, collateral, full service TV, broadcast. Product specialties are industrial and high-tech. Clients include Colonial Bank, Interton, Zilla.

NEEDS Approached by 25-50 freelancers/year. Works with 10-12 freelance illustrators and 20-30 designers/year. Uses freelancers for brochure design and illustration, catalog design, logos, posters, signage and P-O-P. 40% of work is with print ads. Needs computer-literate freelancers for design, illustration, production and presentation. 100% of freelance work demands knowledge of Photoshop, InDesign and Illustrator.

FIRST CONTACT & TERMS Send postcard sample of work or query letter with photocopies. Samples are filed. Request portfolio review in original query. Will contact artist for portfolio review if interested. Portfolio should include b&w and color final art. Pays for design by the hour, $25-65. Pays for design and illustrator by the hour or project.

THE M. GROUP

2512 E. Thomas Rd., Suite 12, Phoenix AZ 85016. (480)998-0600. **Fax:** (480)998-9833. **E-mail:** gary@themgroupinc.com. **Website:** www.themgroupinc.com. **Contact:** Gary Miller. Estab. 1987. Number of employees: 7. Approximate annual billing: $2.75 million. Strategic visual communications firm. Specializes in annual reports, corporate identity, direct mail, package design, advertising. Clients: corporations and small business. Current clients include American Cancer Society, BankOne, Dole Foods, Giant Industries, Motorola, Subway.

NEEDS Approached by 50 freelancers/year. Works with 5-10 freelance illustrators/year. Uses freelancers for ad, brochure, poster and P-O-P illustration. 95% of freelance work demands skills in Illustrator, Photoshop and QuarkXPress.

FIRST CONTACT & TERMS Send postcard sample or query letter with samples. Samples are filed or returned by SASE if requested by artist. Responds only if interested. Request portfolio review in original query. Artist should follow-up. Portfolio should include b&w and color final art, photographs and transparencies. Rights purchased vary according to project. Finds artists through publications (trade) and reps.

TIPS Impressed by "good work, persistence and professionalism."

MILICI VALENTI NG PACK

999 Bishop St., 21st Floor, Honolulu HI 96813. (808)536-0881. **Fax:** (808)529-6208. **E-mail:** info@mvnp.com. **Website:** www.mvnp.com. Estab. 1946. Approximate annual billing: $40,000,000. Ad agency.

Clients: travel/tourism, food, finance, utilities, entertainment and public service. Current clients include First Hawaiian Bank, Aloha Airlines, Sheraton Hotels.

NEEDS Works with 2-3 freelance illustrators/month. Uses freelance artists mainly for illustration, retouching and lettering for newspapers, multimedia kits, magazines, radio, TV and direct mail. Artists must be familiar with advertising demands; used to working long distance through the mail and over the Internet; and familiar with Hawaii.

FIRST CONTACT & TERMS Send brochure, flyer and tearsheets or PDFs to be kept on file for future assignments.

MITCHELL STUDIOS DESIGN CONSULTANTS

1499 Sherwood Dr., East Meadow NY 11554. (516)832-6230. **Fax:** (516)832-6232. **E-mail:** msdcdesign@aol.com. Estab. 1922. Specializes in brand and corporate identity, displays, direct mail and packaging. Clients: major corporations.

NEEDS Works with 5-10 freelance designers and 20 illustrators/year. "Most work is started in our studio." Uses freelancers for design, illustration, mechanicals, retouching, airbrushing, model-making, lettering and logos. 100% of design and 50% of illustration demands skills in Illustrator, Photoshop and QuarkXPress. Needs technical illustration and illustration of food, people.

FIRST CONTACT & TERMS Send query letter with brochure, résumé, business card, photographs and photocopies to be kept on file. Accepts nonreturnable disk submissions compatible with Illustrator, QuarkXPress, FreeHand and Photoshop. Responds only if interested. Call or write for appointment to show portfolio of roughs, original/final art, final reproduction/product and color photostats and photographs. Pays for design by the hour, $25 minimum; by the project, $250 minimum. Pays for illustration by the project, $250 minimum.

TIPS "Call first. Show actual samples, not only printed samples. Don't show student work. Our need has increased--we are very busy."

MONDERER DESIGN, INC.

2067 Massachusetts Ave., 3rd Floor, Cambridge MA 02140. (617)661-6125. **Fax:** (617)661-6126. **E-mail:** info@monderer.com. **Website:** www.monderer.com. stewart@monderer.com. **Contact:** Stewart Monderer, president. Estab. 1981. Specializes in corporate iden-

tity, branding, print collateral, website, event and interactive solutions. Clients: corporations (technology, education, consulting and life science). Current clients include Solidworks, Thermo Scientific, MIT Sloan, Northeastern University, Progress Software, Kronos, Greenlight Fund, Canaccord Genuity.

NEEDS Approached by 40 freelancers/year. Works with 10-12 illustrators and photographers/year. Works on assignment only.

FIRST CONTACT & TERMS Send query letter with brochure, tearsheets, photographs, photocopies or nonreturnable postcards. Will look at links and PDF files. Samples are filed. Will contact artist for portfolio review if interested. Negotiates rights purchased. Finds artists through submissions, self-promotions and sourcebooks.

MRW COMMUNICATIONS

2 Fairfield St., Hingham MA 02043. (781)924-5282. **Fax:** (781)926-0371. **E-mail:** jim@mrwinc.com. **Website:** www.mrwinc.com. **Contact:** Jim Watts, president. Estab. 2003. Ad agency. Specializes in branding, advertising, collateral, direct marketing, website development, online marketing. Product specialties are high tech, healthcare, business to business, financial services, and consumer. Client list available upon request.

NEEDS Approached by 40-50 freelance illustrators and 40-50 designers/year. Works with 5-10 freelance illustrators and 2-5 designers/year. Prefers freelancers with experience in a variety of techniques brochure, medical and technical illustration, multimedia projects, retouching, storyboards, TV/film graphics and web page design. 75% of work is with print ads. 90% of design and 90% of illustration demands skills in FreeHand, Photoshop, QuarkXPress, Illustrator.

FIRST CONTACT & TERMS Designers: Send query letter with photocopies, photographs, résumé. Illustrators: Send postcard sample and résumé, follow-up postcard every 6 months. Accepts disk submissions compatible with QuarkXPress 7.5/version 3.3. Send EPS files. Samples are filed. Will contact for portfolio review of b&w, color final art if interested. Pays by the hour, by the project or by the day depending on experience and ability. Rights purchased vary according to project. Finds artist through sourcebooks and word of mouth.

MYERS, MYERS & ADAMS ADVERTISING, INC.

934 N. Victoria Park Rd., Fort Lauderdale FL 33304. (954)523-6262. **Fax:** (954)523-3517. **E-mail:** pete@mmanda.com. **Website:** www.mmanda.com. **Contact:** Virginia Myers, creative director. Estab. 1986. Number of employees 6. Approximate annual billing $2 million. Ad agency. Full-service, multimedia firm. Specializes in magazines and newspaper ads; radio and TV; brochures; and various collateral. Product specialties are consumer and business-to-business. Current clients include Harley-Davidson, Wendy's and Embassy Suites. Professional affiliation Advertising Federation.

NEEDS Approached by 10-15 freelancers/year. Works with 3-5 freelance illustrators and 3-5 designers/year. Uses freelancers mainly for overflow. Also for animation, brochure and catalog illustration, model-making, posters, retouching and TV/film graphics. 55% of work is with print ads. Needs computer-literate freelancers for illustration and production. 20% of freelance work demands knowledge of PageMaker, Photoshop, QuarkXPress and Illustrator.

FIRST CONTACT & TERMS Send postcard-size sample of work or send query letter with tearsheets. Samples are filed and are returned by SASE if requested by artist. Will contact artist for portfolio review if interested. Portfolio should include b&w and color final art, roughs, tearsheets and thumbnails. Pays for design and illustration by the project, $50-1,500. Buys all rights. Finds artists through *Creative Black Book*, *Workbook* and artists' submissions.

◉ THE NAPOLEON GROUP

420 Lexington Ave., Suite 3020, New York NY 10170. (212)692-9200. **Fax:** (212)692-0309. **E-mail:** scott@napny.com. **Website:** www.napny.com. **Contact:** Scott Stein, studio manager. Estab. 1985. Number of employees: 40. AV firm. Full-service, multimedia firm. Specializes in storyboards, comps, magazine ads, computer graphic art and animatics. Leading provider in the "TEST" market. Product specialty is consumer. Clients: "all major New York City ad agencies." Client list not available.

NEEDS Approached by 20 freelancers/year. Works with 15 freelance illustrators and 5 designers/year. Prefers local freelancers with experience in animation, computer graphics, film/video production and multimedia. Works on assignment only. Uses free-

lancers for storyboards, animation, direct mail, logos and retouching. 10% of work is with print ads. Needs computer-literate freelancers for design, illustration, production and presentation. 80% of freelance work demands skills in Illustrator or Photoshop.

FIRST CONTACT & TERMS Send e-mail samples with attachments of current work, query letter with photocopies, tearsheets, DVD or CD. Samples are filed. Responds only if interested. Will contact artist for portfolio review if interested. Currently seeking cutting edge contemporary artists that can produce fast clean and realistic storyboard and animatic artwork. Computer coloring and drawing skills desired in applicants. Also seeking 3D animation artists, modelers and animators for consideration. Pays for design and illustration by the project. Rights purchased vary according to project. Finds artists through word of mouth and submissions.

⚲ NEIMAN GROUP

614 N. Front St., Harrisburg PA 17101. (717)232-5554. **Fax:** (717)232-7998. **E-mail:** info@neimangroup.com. **Website:** www.neimangroup.com. Estab. 1978. Full-service ad agency specializing in print collateral and ad campaigns. Product specialties are health care, banks, retail and industry.

⚲ Second location: 1619 Walnut St., 4th Floor, Philadelphia PA 19103; (215)667-8719.

NEEDS Prefers local artists with experience in comps and roughs. Works on assignment only. Uses freelancers mainly for advertising illustration and comps. Also uses freelancers for brochure design, mechanicals, retouching, lettering and logos. 50% of work is with print ads. 3% of design and 1% of illustration demands knowledge of Illustrator and Photoshop.

FIRST CONTACT & TERMS Designers: Send query letter with résumé. Illustrators: Send postcard sample, query letter or tearsheets. Samples are filed. Will contact artist for portfolio review if interested. Portfolio should include color thumbnails, roughs, original/final art, photographs. Pays for design and illustration by the project. Finds artists through sourcebooks and workbooks.

TIPS "Try to get a potential client's attention with a novel concept. Never, ever, miss a deadline. Enjoy what you do."

LOUIS NELSON DESIGN, INC.

P.O. Box 995, New York NY 10025. (212)620-9191. **E-mail:** info@louisnelson.com. **Website:** www.louis

nelson.com. **Contact:** Louis Nelson, president. Estab. 1980. Number of employees: 2. Approximate annual billing: $1.2 million. Specializes in environmental, interior and product design and brand and corporate identity, displays, packaging, publications, signage and wayfinding, exhibitions and marketing. Clients: nonprofit organizations, corporations, associations and governments. Current clients include Stargazer Group, Rocky Mountain Productions, Wildflower Records, Port Authority of New York & New Jersey, Richter+Ratner Contracting Corporation, MTA and NYC Transit, Massachusetts Port Authority, Evelyn Hill, Inc., Km et cie. Professional affiliations: IDSA, AIGA, SEGD, APDF.

NEEDS Approached by 30-40 freelancers/year. Works with 30-40 designers/year. Works on assignment only. Uses freelancers mainly for specialty graphics and 3D design; also for design, photo-retouching, model-making and charts/graphs. 100% of design demands knowledge of PageMaker, QuarkXPress, Photoshop, Velum, Autocad, Vectorworks, Alias, Solidworks or Illustrator. Needs editorial illustration. Needs design more than illustration or photography.

FIRST CONTACT & TERMS Send postcard sample or query letter with résumé. Accepts disk submissions compatible with Illustrator 10.0 or Photoshop 7.0. Send EPS/PDF files. Samples are returned only if requested. Responds in 2 weeks. Write for appointment to show portfolio of roughs, color final reproduction/product and photographs. Pays for design by the hour, $15-25; or by the project, negotiable.

TIPS "I want to see how the artist responded to the specific design problem and to see documentation of the process–the stages of development. The artist must be versatile and able to communicate a wide range of ideas. Mostly, I want to see the artist's integrity reflected in the work."

NICE LTD-NICOSIA CREATIVE EXPRESSO, LTD.

355 W. 52nd St., 8th Floor, New York NY 10019. (212)515-6600. **Fax:** (212)265-5422. **E-mail:** info@niceltd.com. **Website:** www.niceltd.com. **Contact:** Davide Nicosia, principal/creative director. Estab. 1993. Number of employees: 70. Full-service multicultural creative agency. Specializes in brand strategy, holistic design, graphic design, corporate/brand identity, brochures, promotional material, packaging, fragrance bottles and 3D animations. Current clients

include Estée Lauder Companies, Procter & Gamble, Dunhill, Gillette, Montblanc, Old Spice and Pantene. Additional locations in Singapore, Tokyo and Bangkok (see website for details).

NEEDS Approached by 70 freelancers/year. Works with 6 illustrators and 8 designers/year. Works by assignment only. Uses illustrators, designers, 3D computer artists and computer artists familiar with Illustrator, Photoshop, After Effects, Premiere, Macromedia Director, Flash and Alias Wavefront.

FIRST CONTACT & TERMS Send query letter and résumé. Responds for portfolio review only if interested. Pays for design by the hour. Pays for illustration by the project. Rights purchased vary according to project.

TIPS Looks for "promising talent and the right attitude."

NOSTRADAMUS ADVERTISING

884 West End Ave., Suite #2, New York NY 10025. (212)581-1362. **E-mail:** nos@nostradamus.net. **Website:** www.nostradamus.net. **Contact:** B. Sher, creative director. Specializes in book design, Web design, fliers, advertising and direct mail. Clients ad agencies, book publishers, nonprofit organizations and politicians.

NEEDS Works with 5 artists/year. Needs computer-literate freelancers for design and production. Freelancers should know InDesign, Quark, Photoshop, Dreamweaver.

FIRST CONTACT & TERMS Send query letter with brochure, résumé, business card, samples and tearsheets. Do *not* send slides as samples; will accept "anything else that doesn't have to be returned." Samples not kept on file are not returned. Responds only if interested. Call for appointment to show portfolio. Pays for illustration by the project, $150 minimum. Considers skill and experience of artist when establishing payment.

NOTOVITZ COMMUNICATIONS

15 Cutter Mill Rd., Suite 212, Great Neck NY 11021. (516)467-4672. **E-mail:** joseph@notovitz.com. **Website:** www.notovitz.com. **Contact:** Joseph Notovitz, president. Number of employees: 4. Specializes in marketing communications (branding, annual reports, literature, publications, websites), corporate identity, exhibit signage, event design and writing. Clients: finance, real estate and industry. Professional affiliation: Specialty Graphic Imaging Association.

NEEDS Approached by 100 freelancers/year. Works with 10 freelance illustrators and 10 designers/year. Uses freelancers for brochure, poster, direct mail and booklet illustration; mechanicals; charts/graphs; and logo design. Needs computer-literate freelancers for design, illustration and production. 90% of freelance work demands expertise in InDesign, Illustrator and Photoshop. Needs pool of freelance Web developers with expertise in Flash, coding and design. Also collaborates on projects that writers and freelancers bring.

FIRST CONTACT & TERMS Send résumé and links to online examples of work. Responds "if there is fit and need." Pays for design and production work by the hour, $25-75. Pays for illustration by the project.

TIPS "Do a bit of research on the firm you are contacting. Send pieces that reflect the firm's style and needs. If we never produce book covers, book cover art does not interest us. Stress what you can do for the firm, not what the firm can do for you."

NOVUS VISUAL COMMUNICATIONS

59 Page Ave., Suite 300, Yonkers NY 10704. (212)473-1377. **Fax:** (212)505-3300. **E-mail:** novuscom@aol.com. **Website:** www.novuscommunications.com. **Contact:** Robert Antonik, managing director. Estab. 1988. Number of employees: 4. Specializes in multichannel online and offline publications, interactive display design, multimedia, packaging, dire developers, industrial, financial, retail, health care, entertainment and nonprofits.

NEEDS Considers oil, acrylic, watercolor, pastel, mixed media, collage, paper, sculpture, ceramics, craft, fiber, glass, photography, and all types of prints. Exhibits all styles. Genres include landscapes, abstracts, florals and figurative work. Prefers landscapes, abstract and figurative.

FIRST CONTACT & TERMS Send query letter with résumé, slides, brochure and reviews. Write for appointment to show portfolio of originals, photographs and slides. Responds only if interested within 1 month. Files CD or weblinks and bio. Finds artists through agents, visiting exhibitions, word of mouth, art publications and sourcebooks, submissions.

TIPS "Send complete information and pricing. Do not expect slides and information back. Keep the dealer updated with current work and materials."

⚙ OAKLEY DESIGN STUDIOS

Website: oakleydesign.com; oakleydesign.blogspot.com. **Contact:** Tim Oakley, creative director. Estab. 1992. Specializes in brand and corporate identity, display, package, feature film design, along with advertising. Clients: advertising agencies, record companies, motion picture studios, surf apparel manufacturers, mid-size businesses. Current clients include Patrick Lamb Productions, Metro Computerworks, Tiki Nights Entertainment, Hui Nalu Brand Surf, Stona Winery, Mt. Hood Jazz Festival, Think AV, Audient Events, Portland Center for the Media Arts, NBC, and Diablo Motor Rods. Professional affiliations: GAG, AIGA, PAF, Type Directors Club, Society of Illustrators.

NEEDS Approached by 3-5 freelancers/year. Works with 3 freelance illustrators and 2 designers/year. Prefers local artists with experience in technical & freehand illustration, airbrush. Uses illustrators mainly for advertising. Uses designers mainly for brand and corporate identity. Also uses freelancers for ad and P-O-P illustration, airbrushing, catalog illustration, lettering and retouching. 60% of design and 30% of illustration demands skills in CS2 Illustrator, CS2 Photoshop and CS2 InDesign.

FIRST CONTACT & TERMS Contact through artist rep or send query letter with brochure, photocopies, photographs, plus resume. Samples are filed or returned by SASE if requested by artist. Request portfolio review in original query. Will contact artist for portfolio review if interested. Portfolio should include b&w and color final art, photocopies, photostats, roughs and/or slides. Pays for design by the project, $200 minimum. Pays for illustration by the project. Rights purchased vary according to project. Finds artists through design workbooks.

TIPS "Just be yourself and bring coffee."

THE O'CARROLL GROUP

300 E. McNeese St., Suite 2-B, Lake Charles LA 70605. (337)478-7396. **Fax:** (337)478-0503. **E-mail:** online contact form. **Website:** www.ocarroll.com. **Contact:** Peter O'Carroll, president. Estab. 1978. Ad agency/PR firm. Specializes in newspaper, magazine, outdoor, radio and TV ads. Product specialty is consumer. Client list available upon request.

NEEDS Approached by 1 freelancer/month. Works with 1 illustrator every 3 months. Prefers freelancers with experience in computer graphics. Works on assignment only. Uses freelancers mainly for time-consuming computer graphics. Also for brochure and print ad illustration and storyboards. Needs website developers. 65% of work is with print ads. 50% of freelance work demands skills in Illustrator and Photoshop.

FIRST CONTACT & TERMS Send query e-mail with electronic samples. Responds only if interested. Will contact artist for portfolio review if interested. Pays for design by the project. Pays for illustration by the project. Rights purchased vary according to project. Find artists through viewing portfolios, submissions, word of mouth, American Advertising Federation district conferences and conventions.

ODEN MARKETING & DESIGN

119 S. Main St., Suite 300, Memphis TN 38103. (901)578-8055; (800)371-6233. **E-mail:** whubbard@oden.com. **Website:** www.oden.com. **Contact:** Design director. Estab. 1971. Specializes in annual reports, brand and corporate identity, design and package design. Clients: corporations. Current clients include International Paper, Federal Express.

NEEDS Works with 5-8 freelance illustrators and photographers/year. Works on assignment only. Uses illustrators mainly for collateral. 50% of freelance work demands knowledge of QuarkXPress, InDesign, Illustrator, or Photoshop.

FIRST CONTACT & TERMS Send query letter with brochure, photographs, slides and transparencies. Samples are filed and are not returned. Responds only if interested. Portfolio review not required. Pays for illustration by the project. Rights purchased vary according to project.

TIPS Finds artists through sourcebooks.

OMNI PRODUCTIONS

P.O. Box 302, Carmel IN 46082-0302. (317)846-2345. **E-mail:** omni@omniproductions.com. **Website:** omniproductions.com. **Contact:** Winston Long, president. Estab. 1984. AV firm. Full-service, multimedia firm. Specializes in video, Intranet, CD and Internet. Current clients include "a variety of industrial clients, government and international agencies."

NEEDS Works on assignment only. Uses freelancers for brochure design and illustration, storyboards, slide illustration, animation, and TV/film graphics. Needs computer-literate freelancers for design, illustration and production. Most of freelance work demands computer skills.

FIRST CONTACT & TERMS Send résumé. Samples are filed and are not returned. Artist should follow up with call or letter after initial query. Pays by the project. Finds artists through agents, word of mouth and submissions.

ORIGIN DESIGN

One Origin Center, 2600 Travis—Level Two, Houston TX 77006. (877)520-9544. **Website:** www.origin design.com. Design and marketing firm.

○ Recent Origin projects have been recognized in *HOW Magazine*, the national Summit Awards, the Dallas Society of Visual Communicators Annual Show, and the regional Addys.

FIRST CONTACT & TERMS Send query letter with résumé and samples.

OUTSIDE THE BOX INTERACTIVE LLC

150 Bay St., Suite 706, Jersey City NJ 07302. (201)610-0625. **Fax:** (201)610-0627. **Website:** www.outboxin. com. Estab. 1995. Number of employees: 6. Interactive design and marketing firm. "For over a decade we have been providing strategic and integrated solutions for branding, advertising, and corporate communications. Our skills lie in creating active experiences versus passive messages. We focus on the strengths of each particular delivery platform, whether multimedia, web or print, to create unique solutions that meet our client's needs. Our strategies are as diverse as our clients, but our focus is the same: to maximize the full potential of integrated marketing, combining the best in new media and traditional assets. We offer a unique blend of creativity, technology, experience and commitment." Clients include Society of Illustrators, Dereckfor Shipyards, Educational Testing Service, Nature's Best.

NEEDS Approached by 5-10 illustrators and 5-10 designers/year. Works with 2-5 freelance illustrators and 4-6 designers/year. Freelancers must be digitally fluent. Uses freelancers for airbrushing, animation, brochure and humorous illustration, logos, model-making, multimedia projects, posters, retouching, storyboards, TV/film graphics, web page design. 90% of design demands skills in Photoshop, QuarkXPress, Illustrator, Director HTML, Java Script and any 3D program. 60% of illustration demands skills in Photoshop, QuarkXPress, Illustrator, any animation and 3D program.

FIRST CONTACT & TERMS Send query letter with brochure, photocopies, photographs, résumé, SASE,
slides, tearsheets, transparencies. Send follow-up postcard every 3 months. Accepts DVD/CD submissions. Samples are filed and are returned by SASE. Will contact if interested. Pays by the project. Rights purchased vary according to project.

○ OXFORD COMMUNICATIONS, INC.

11 Music Mountain Blvd., Lambertville NJ 08530. (609)397-4242. **Fax:** (609)397-5915. **E-mail:** solu tions@oxfordcommunications.com. **Website:** www. oxfordcommunications.com. **Contact:** Steve Sharp, interactive creative director. Estab. 1986. Ad agency. Full-service, integrated multimedia firm. Specializes in branding, strategic planning, integrated marketing. Product specialties are retail, real estate, healthcare, education, and destination marketing.

NEEDS Approached by 6 freelancers/month. Works with 3 designers every 6 months. Currently all design and production handled by staff. Prefers local freelancers with experience in Illustrator, InDesign and Photoshop. Uses freelancers mainly for production and interactive development. 50% of work is with print ads.

FIRST CONTACT & TERMS E-mail résumé and PDF samples. Samples are filed. Responds only if interested. Will contact artist for portfolio review if interested. Pays for design and illustration by the project, negotiable. Rights purchased vary according to project.

PAPAGALOS STRATEGIC COMMUNICATIONS

7330 N. 16th St., Suite B-102, Phoenix AZ 85020. (602)279-2933. **Fax:** (602)277-7448. **Website:** www. papagalos.com. **Contact:** Nicholas Papagalos, creative director. Specializes in advertising, brochures, annual corporate identity, displays, packaging, publications and signage. Clients major regional, consumer and business-to-business. Clients include Perini, American Hospice Foundation, McMillan Fiberglass Stocks, Schuff Steel.

NEEDS Works with 6-20 freelance artists/year. Works on assignment only. Uses artists for illustration, retouching, design and production. Needs computer-literate freelancers, HTML programmers and Web designers for design, illustration and production. 100% of freelance work demands skills in Illustrator, QuarkXPress, InDesign or Photoshop.

FIRST CONTACT & TERMS Mail résumé and appropriate samples. Pays for design by the hour or by the project. Pays for illustration by the project. Con-

siders complexity of project, client's budget, skill and experience of artist, how work will be used, turnaround time and rights purchased when establishing payment. Rights purchased vary according to project.

TIPS In presenting samples or portfolios, "two samples of the same type/style are enough."

PHOENIX LEARNING GROUP, INC.

141 Millwell Dr. Suite A, St. Louis MO 63043. (314)569-0211; (800)221-1274. **Fax:** (314)569-2834. **E-mail:** info@phoenixlearninggroup.com. **Website:** phoenixlearninggroup.com. **Contact:** Erin Bryant, VP/operations & management. Number of employees: 50. Produces and distributes educational films. Clients: libraries, museums, religious institutions, U.S. government, schools, universities, film societies and businesses. Catalog available on website or by request.

NEEDS Works with 1-2 freelance illustrators and 2-3 designers/year. Prefers local freelancers only. Uses artists for motion picture catalog sheets, direct mail brochures, posters and study guides; also for multimedia projects. 85% of freelance work demands knowledge of PageMaker, QuarkXPress and Illustrator.

FIRST CONTACT & TERMS Send postcard sample and query letter with brochure (if applicable). Send recent samples of artwork and rates to director of promotions. "No telephone calls, please." Responds if need arises. Buys all rights. Keeps all original art "but will loan to artist for use as a sample." Pays for design and illustration by the hour or by the project. Rates negotiable.

POSNER ADVERTISING

30 Broad St., 33rd Floor, New York NY 10004. (212)867-3900. **Website:** www.posneradv.com. **Contact:** Vice president/creative director. Estab. 1959. Number of employees: 85. Full-service multimedia firm. Specializes in ads, collaterals, packaging, outdoor. Product specialties are healthcare, real estate, consumer business to business, corporate.

NEEDS Approached by 25 freelance artists/month. Works with 1-3 illustrators and 5 designers/month. Prefers local artists only with traditional background and experience in computer design. Uses freelancers mainly for graphic design, production, illustration. 80% of work is with print ads. Needs computer-literate freelancers for design, illustration and production. 90% of freelance work demands knowledge of Illustrator, QuarkXPress, InDesign, Photoshop or FreeHand.

FIRST CONTACT & TERMS Send query letter with photocopies or disk. Samples are filed. Responds only if interested. Write for appointment to show portfolio. Portfolio should include thumbnails, roughs, b&w and color tearsheets, printed pieces. Pays for design by the hour ($15-35) or by the project ($300-2,000). Pays for illustration by the project, $300-2,000. Negotiates rights purchased.

TIPS Advises freelancers starting out in advertising field to offer to intern at agencies for minimum wage.

RH POWER AND ASSOCIATES, INC.

9621 4th St. NW, Albuquerque NM 87114-2128. (505)761-3150; (800)552-1993. **Fax:** (505)761-3153. **E-mail:** info@rhpower.com. **Website:** www.rhpower. com. **Contact:** Bruce Yager, art director. Estab. 1989. Number of employees 12. Ad agency. Full-service, multimedia firm. Specializes in TV, magazine, billboard, direct mail, marriage mail, newspaper, radio. Product specialties are recreational vehicles and automotive. Current clients include Kem Lite Corporation, Albany RV, Ultra-Fab Products, Collier RV, Nichols RV, American RV and Marine. Client list available upon request.

NEEDS Approached by 10-50 freelancers/year. Works with 5-10 freelance illustrators and 5-10 designers/year. Prefers freelancers with experience in retail automotive layout and design. Uses freelancers mainly for work overload, special projects and illustrations. Also for annual reports, billboards, brochure and catalog design and illustration, logos, mechanicals, posters and TV/film graphics. 50% of work is with print ads. 100% of design demands knowledge of Photoshop 9.0, and Illustrator CS 12.

FIRST CONTACT & TERMS Send query letter with photocopies or photographs and résumé. Accepts disk submissions in PC format compatible with Illustrator 10.0 or Adobe Acrobat (PDF). Send PC EPS files. Samples are filed and are not returned. Will contact artist for portfolio review if interested. Portfolio should include b&w and color final art, roughs and thumbnails. Pays for design and illustration by the hour, $15 minimum; by the project, $100 minimum. Buys all rights.

TIPS Impressed by work ethic and quality of finished product. "Deliver on time and within budget. Do it until it's right without charging for your own corrections."

⊙ POWERS DESIGN INTERNATIONAL

828 Production Place, Newport Beach CA 92663. (949)645-2265. **Fax:** (254)364-2416. **E-mail:** sweep-info@gmail.com. **Website:** www.powersdesigninter. com. **Contact:** Ron Powers, president. Estab. 1974. Specializes in vehicle and product design, development; exterior & interior transportation design. Clients large corporations. Clients: Paccar, Inc., McDonnell Douglas, Ford Motor Co. and GM.

NEEDS Works with varying number of freelance illustrators and 5-10 freelance designers/year. Prefers local designers/artists only with experience in transportation design (such as those from Art Center College of Design), or with SYD Mead type abilities. Works on assignment only. Uses freelance designers and illustrators for brochure, ad and catalog design, logos, model making and Alias/Pro-E Computer Cad-Cam capabilities.

FIRST CONTACT & TERMS Call first for permission to submit materials and samples. Pays for design and illustration by the project.

⊙ PRECISION ARTS ADVERTISING, INC.

57 Fitchburg Rd., Ashburnham MA 01430. (978)855-7648. **E-mail:** info@precisionarts.com. **Website:** www.precisionarts.com. **Contact:** Terri Adams, president. Estab. 1985. Number of employees: 2. Full-service Web/print ad agency. Specializes in Internet marketing strategy, website/print design, graphic design.

NEEDS Approached by 5 illustrators and 5 designers/year. Works with 1 freelance illustrator and 1 designer/year. Prefers local freelancers. website design is now 75% and print marketing is 25% of the business. Freelance Web skills required in Macintosh Dream-Weaver and Photoshop; freelance print skills required in QuarkXPress, Photoshop, Illustrator and Pre-Press.

FIRST CONTACT & TERMS Send résumé with links to artwork and suggested hourly rate.

⊙ PRINCETON MARKETECH

2 Alice Rd., Princeton Junction NJ 08550. (609)936-0021. **Fax:** (609)936-0015. **E-mail:** bzyontz@prince tonmarketech.com. **E-mail:** info@princetonmar ketech.com. **Website:** www.princetonmarketech. com. **Contact:** Creative director. Estab. 1987. Ad agency. Specializes in direct mail, multimedia, websites. Product specialties are financial, computer, senior markets. Current clients include Citizens Bank, ING Direct, Diamond Tours. Client list available upon request.

NEEDS Approached by 12 freelance illustrators and 25 designers/year. Works with 2 freelance illustrators and 5 designers/year. Prefers local designers with Mac experience. Uses freelancers for airbrushing, animation, brochure design and illustration, multimedia projects, retouching, technical illustration, TV/film graphics. 10% of work is with print ads. 90% of design demands skills in Photoshop, QuarkXPress, Illustrator and Macromedia Director. 50% of illustration demands skills in Photoshop, Illustrator.

FIRST CONTACT & TERMS Send query letter with résumé, tearsheets, digital files or sample disk. Send follow-up postcard every 6 months. Accepts disk submissions compatible with QuarkXPress, Photoshop. Samples are filed. Responds only if interested. Pay negotiable. Rights purchased vary according to project.

PRO INK

2826 NE 19th Dr., Gainesville FL 32609. (352)377-8973. **Fax:** (352)373-1175. **E-mail:** info@proink.com. **Website:** www.proink.com. **Contact:** Terry Van Nortwick, president. Estab. 1979. Number of employees: 5. Specializes in publications, marketing, healthcare, engineering, development and ads. Professional affiliations: Public Relations Society of America, Society of Professional Journalists, International Association of Business Communicators, Gainesville Advertising Federation, Florida Public Relations Association.

NEEDS Works with 3-5 freelancers/year. Works on assignment only. Uses freelancers for brochure/annual report illustration and lettering. 100% of freelance work demands knowledge of Illustrator, InDesign, or Photoshop. Needs editorial, medical and technical illustration.

FIRST CONTACT & TERMS Send résumé, samples, tearsheets, photostats, photocopies, slides and photography. Samples are filed or are returned if accompanied by SASE. Responds only if interested. Call or write for appointment to show portfolio of original/final art. Pays for design and illustration by the project, $50-500. Rights purchased vary according to project.

QUALLY & COMPANY, INC.

1187 Wilmette Ave., Suite 160, Wilmette IL 60091-2719. (312)280-1898. **E-mail:** quallycompany@hot mail.com. **Website:** www.quallycompany.com. **Contact:** Michael Iva, creative director. Estab. 1979. Specializes in integrated marketing/communication, new product launches, antidotes for propaganda. Clients:

major corporations, high net worth individuals and think tanks.

NEEDS Works with 10-12 freelancers/year. "Freelancers must have talent and the right attitude." Works on assignment only. Uses freelancers for design, copywriting, illustration, retouching, and computer production.

FIRST CONTACT & TERMS Send query letter with résumé, business card and samples that we can keep on file. Call or write for appointment to show portfolio.

TIPS Looking for "people with ideas, talent, point of view, style, craftsmanship, depth and innovation." Sees "too many look-alikes, very little innovation."

QUARASAN

405 W. Superior St., Chicago IL 60654. (312)981-2500. **E-mail:** info@quarasan.com. **Website:** www.quarasan.com. **Contact:** John Linder. Estab. 1982. Full-service product developer. Specializes in educational products. Clients: educational publishers.

NEEDS Approached by 400 freelancers/year. Works with 700-900 illustrators/year. Prefers freelancers with publishing experience. Uses freelancers for illustration, books, mechanicals, charts/graphs, lettering and production. Needs computer-literate freelancers for illustration. 50% of freelance illustration work demands skills in Illustrator, QuarkXPress, Photoshop or FreeHand. Needs editorial, technical, medical and scientific illustration.

FIRST CONTACT & TERMS Send query letter with brochure or résumé and samples to be circulated and kept on file. Prefers "anything that we can retain for our files–photocopies, color tearsheets, e-mail submissions, disks or dupe slides that do not have to be returned." Responds only if interested. Pays for illustration by the piece/project, $40-750 average. Considers complexity of project, client's budget, how work will be used and turnaround time when establishing payment.

TIPS Current job openings posted on website.

QUON DESIGN

543 River Rd., Fair Haven NJ 07704-3227. (732)212-9200. **Fax:** (732)212-9217. **E-mail:** studio@quondesign.com; mike@quondesign.com. **Website:** www.quondesign.com. **Contact:** Mike Quon, president/creative director. Specializes in corporate identity, collateral, packaging, publications and Web design. Number of employees: 2. Clients: corporations (financial,

healthcare, telecommunications), non-profits (hospitals, museums), P.R. firms, and ad agencies. Current clients include Pfizer, Bristol-Myers Squibb, American Express, Hasbro, Verizon, AT&T. Professional affiliations: AIGA, Society of Illustrators, Graphic Artists Guild.

NEEDS Approached by 10 illustrators and 10 designers/year. Works with 6 designers/year. Works on assignment only. Prefers graphic style. Uses artists for brochures, design and illustration, logos, charts/graphs and lettering. Especially needs computer artists with skills in QuarkXPress, Illustrator, Photoshop and InDesign.

FIRST CONTACT & TERMS E-mail résumé with website link or mail query letter with résumé and photocopies. Samples are filed, not returned. Responds only if interested. No portfolio drop-offs. Mail only. Pays for design by the hour, depending on experience. Pays for illustration by the project, $100-500. Buys first rights.

GERALD & CULLEN RAPP

420 Lexington Ave., New York NY 10170. (212)889-3337. **Fax:** (212)889-3341. **E-mail:** info@rappart.com. **Website:** www.rappart.com. Estab. 1944. Clients: ad agencies, corporations and magazines. Client list not available. Professional affiliations: GAG, S.I.

NEEDS Approached by 500 freelance artists/year. Exclusive representations of freelance illustrators. Works on assignment only. Uses freelance illustrators for editorial advertising and corporate illustration.

FIRST CONTACT & TERMS E-mail query letter with samples or website link. Will contact artist for portfolio review if interested. Responds in 2 weeks. Pays for illustration by the project, $500-40,000. Negotiates fees and rights purchased with clients on per-project basis.

⊕ REALLY GOOD COPY CO.

92 Moseley Ter., Glastonbury CT 06033. (860)659-9487. **E-mail:** copyqueen@aol.com. **Website:** www.reallygoodcopy.com. **Contact:** Donna Donovan, president. Estab. 1982. Number of employees: 1. Ad agency; full-service multimedia firm. Specializes in direct response, brochures, catalogs and collateral. Product specialties are medical/health care, business services, consumer products and services. Current clients include Eastern Connecticut Health Network, WSHU Public Radio, Wellspring, That's Amore Gelato Cafes, Buddy's Appliance and Furniture Retail, Avid Mar-

keting, Glastonbury Chamber of Commerce. Professional affiliations: Connecticut Art Directors Club, New England Mail Order Association, Glastonbury Chamber of Commerce.

NEEDS Approached by 40-50 freelancers/year. Works with 1-2 freelance illustrators and 6-8 designers/year. Prefers local freelancers whenever possible. Works on assignment only. Uses freelancers for all projects. "There are no on-staff artists." 50% print, 50% Web. 100% of design and 50% of illustration demand knowledge of InDesign or QuarkXPress, Illustrator or Photoshop and HTML.

FIRST CONTACT & TERMS Designers: send query letter with résumé. Illustrators: send postcard samples. Accepts CD submissions, EPS or JPEG files only. Samples are filed or are returned by SASE, only if requested. Responds only if interested. Portfolio review not required, but portfolio should include roughs and original/final art. Pays for design by the hour, $50-125. Pays by the project or by the hour.

TIPS "Continue to depend upon word of mouth from other satisfied agencies and local talent. I'm fortunate to be in an area that's overflowing with good people. Send 2 or 3 good samples—not a bundle."

RIPE CREATIVE

1543 W. Apollo Rd., Phoenix AZ 85041. (602)304-0703. **Fax:** (480)247-5339. **E-mail:** mark@ripecreative.com. **Website:** www.ripecreative.com. **Contact:** Mark Anthony Munoz, principal. Estab. 2005. Number of employees: 5. Approximate annual billing: $500,000. Design firm. Specializes in branding, advertising, strategic marketing, publication design, trade-show environments. Clients: American Bar Association, Healthways, Quiznos, Superior Case Coding, PetSmart, AonConsulting, Humana. Client list available upon request. Professional affiliations: American Advertising Federation, National Organization of Women Business Owners, Greater Phoenix Chamber of Commerce, Arizona Hispanic Chamber of Commerce.

NEEDS Approached by 100 illustrators and 10 designers/year. Works with 10 illustrators and 3 designers/year. Works on assignment only. Uses freelancers mainly for illustration, graphic design, website design. Also for animation, brochure design/illustration, direct mail, industrial/structural design, logos, posters, print ads, storyboards, catalog design and technical illustration. 15% of work is assigned with print ads.

100% of design work demands skills in InDesign, Illustrator, QuarkXPress and Photoshop. 100% of illustration work demands skills in Illustrator, Photoshop and traditional illustration media.

FIRST CONTACT & TERMS Designers: Send query letter with contact information, résumé, samples, and URL if applicable. Illustrators: Send tearsheets, URL. Samples are returned if requested and SASE is provided. Designers and illustrators should attach PDF files or URL. Samples are filed or returned by SASE. Responds in 2 weeks. Company will contact artist for portfolio review if interested. Portfolio should include color finished art, photographs and tearsheets. Pays for illustration. Set rate negotiated and agreed to between RIPE and talent. Pays for design by the hour, $25-100. Rights purchased vary according to project. Finds artists through submissions, word of mouth, *Workbook*, *The Black Book*.

TIPS "Calls are discouraged. When making first contact, the preferred method is via mail or electronically. If interested, RIPE will follow up with talent electronically or by telephone. When providing samples, please ensure talent/rep contact is listed on all samples."

RIVET

555 Washington Ave., St. Louis MO 63101-2019. (314)231-2400 or (314)345-4374. **E-mail:** brad.fuller@rivetglobal.com. **Website:** www.rivetglobal.com. Number of employees: 235. Approximate annual billing: $30 million. Full service marketing agency. Specializes in branding, promotion, digital, advertising, social media, event, CRM, direct marketing. Also maintains electronic design division that designs, develops and manages client websites, develops client intranets, extranets and CDs, consults on web marketing strategies, competitive analysis, and domain name research. Product specialties are food and beverage. Current clients include McNeil, Microsoft, Levi's, Visa, Johnson & Johnson, Purina, Dreyer's, Exxon Mobil. Client list available on website.

Also has locations in Chicago, New York, San Francisco and Toronto.

NEEDS Approached by 200 illustrators and 50 designers/year. Works with 35 illustrators/year. Uses freelancers mainly for point-of-purchase displays, brochures; also for brochure design and illustration, model-making, posters and web graphics.

FIRST CONTACT & TERMS Send query letter with brochure or photocopies and résumé. Send postcard

sample of work with follow-up postcard samples every 3 months. Accepts disk submissions. Samples are filed. Pays by the project, $300-8,000. Negotiates rights purchased. Finds illustrators through *American Showcase*, *The Black Book*, *Directory of Illustration* and submissions.

⬤ SAATCHI & SAATCHI ADVERTISING WORLDWIDE

375 Hudson St., New York NY 10014. (212)463-2000. **Fax:** (212)463-9855. **E-mail:** conway.williamson@saatchiny.com. **Website:** www.saatchiny.com. **Contact:** Conway Williamson, chief creative officer. Full-service advertising agency. Clients: Delta Airlines, Eastman Kodak, General Mills and Procter & Gamble. This company has 153 offices in 83 countries. See website for specific details of each location.

NEEDS Approached by 50-100 freelancers/year. Works with 1-5 designers and 15-35 illustrators/year. Uses freelancers mainly for illustration and advertising graphics. Prefers freelancers with knowledge of electronic/digital delivery of images.

FIRST CONTACT & TERMS Send query letter and nonreturnable samples or postcard sample. Prefers illustrators' sample postcards or promotional pieces to show around a half a dozen illustrations, enough to help art buyer determine illustrator's style and visual vocabulary. Files interesting promo samples for possible future assignments. Pays for design and illustration by the project.

SAI COMMUNICATIONS

P.O. Box 743, Media PA 19063. (215)923-6466. **Fax:** (215)923-6469. **E-mail:** info@saicommunications.com. **Website:** www.saicommunications.com. Full-service multimedia firm.

NEEDS Approached by 5 freelance artists/month. Works with 3 freelance designers/month. Uses freelance artists mainly for computer-generated slides; also for brochure and print ad design, storyboards, slide illustration and logos. 1% of work is with print ads.

FIRST CONTACT & TERMS Send query letter with résumé. Samples are filed. Call to schedule an appointment to show a portfolio. Portfolio should include slides. Pays for design by the hour, $15-20. Pays for illustration by the project. Buys first rights.

ARNOLD SAKS ASSOCIATES

118 E. 28th St., Suite 401, New York NY 10016. (212)861-4300. **Fax:** (212)861-4374. **E-mail:** afioril lo@saksdesign.com. **Website:** www.saksdesign.com. **Contact:** Anita Fiorillo, vice president. Estab. 1967.

NEEDS Works with 1 or 2 computer technicians and 1 designer/year. "Technicians' accuracy and speed are important, as is a willingness to work late nights and some weekends." Uses illustrators for technical illustration and occasionally for annual reports. Uses designers mainly for in-season annual reports. Also uses artists for brochure design and illustration, mechanicals and charts/graphics. Needs computer-literate freelancers for production and presentation. All freelance work demands knowledge of InDesign, Illustrator or Photoshop.

FIRST CONTACT & TERMS Send query letter with brochure and résumé. Samples are filed. Responds only if interested. Write for appointment to show portfolio. Portfolio should include finished pieces. Pays for design by the hour, $25-60. Pays for illustration by the project, $200 minimum. Payment depends on experience and terms, and varies depending upon scope and complexity of project. Rights purchased vary according to project.

⌂ JACK SCHECTERSON ASSOCIATES

5316 251 Place, Little Neck NY 11362. (718)225-3536. **Contact:** Jack Schecterson, principal. Estab. 1967. Ad agency. Specializes in 2D and 3D visual marketing; new product introduction; product; package; graphic and corporate design.

NEEDS Works direct and with artist reps. Prefers local freelancers. Works on assignment only. Uses freelancers for package, product, and corporate design; illustration, brochures, catalogs, logos. 100% of design and 90% of graphic illustration demands skills in Illustrator, Photoshop and InDesign.

FIRST CONTACT & TERMS Send query letter with brochure, photocopies, tearsheets, résumé, photographs, slides, transparencies and SASE; "whatever best illustrates work." Samples not filed are returned by SASE only if requested by artist. Requests portfolio review in original query. Will contact artist for portfolio review if interested. Portfolio should include roughs, b&w and color—"whatever best illustrates creative abilities/work." Pays for design and illustration by the project; depends on budget. Buys all rights.

THOMAS SEBASTIAN COMPANIES

508 Bluffs Edge Dr., McHenry IL 60185. (815)578-9171. **E-mail:** sebastiancompanies@mac.com. **Website:** www.thomassebastiancompanies.com. **Con-**

tact: Pete Secker, creative director; Thomas Sebastian, owner. Estab. 1996. Number of employees: 10. Integrated marketing communications agency and Internet service. Specializes in website and graphic design for print materials. Client list available upon request.

NEEDS Approached by 12 illustrators and 12 designers/year. Works with 2-3 illustrators and 1-2 designers/year. Uses freelancers mainly for design and computer illustration; also for humorous illustration, lettering, logos and web page design. 5% of work is with print ads. 90% of design and 70% of illustration demands knowledge of Photoshop, Illustrator, QuarkXPress.

FIRST CONTACT & TERMS Send query via e-mail. Send follow-up postcard samples every 6 months. Accepts Mac-compatible submissions on CD or DVD. Samples are filed and are not returned. Responds only if interested. Will contact artist for portfolio review if interested. Pays by the project. Negotiates rights purchased. Finds freelancers through *The Black Book*, creative sourcebooks, Internet.

SELBERT-PERKINS DESIGN COLLABORATIVE

5 Water St., Arlington MA 02476. (781)574-6605. **Website:** www.selbertperkins.com. **Contact:** Linda Murphy. Estab. 1980. Number of employees 25. Specializes in annual reports, brand identity design, displays, landscape architecture and urban design, direct mail, product and package design, exhibits, interactive media and CD-ROM design and print and environmental graphic design. Clients: airports, colleges, theme parks, corporations, hospitals, computer companies, retailers, financial institutions, architects. Professional affiliations: AIGA, SEGD.

 This company has several locations throughout the world. See website for a complete listing.

NEEDS Approached by "hundreds" of freelancers/year. Works with 10 freelance illustrators and 20 designers/year. Prefers artists with "experience in all types of design and computer experience." Uses freelance artists for brochures, mechanicals, logos, P-O-P, poster and direct mail. Also for multimedia projects. 100% of freelance work demands knowledge of Photoshop, Canvas, InDesign, Illustrator.

FIRST CONTACT & TERMS Send query letter with brochure, résumé, tearsheets, photographs, photocopies, slides and transparencies. Samples are filed. Responds only if interested. Portfolios may be dropped off every Monday-Friday. Artist should follow up with call or letter after initial query. Will contact artist for portfolio review if interested. Pays for design by the hour, or by the project. Pays for illustration by the project. Rights purchased vary according to project. Finds artists through word of mouth, magazines, submissions/self-promotions, sourcebooks and agents.

STEVEN SESSIONS, INC.

5177 Richmond, Suite 500, Houston TX 77056. (713)850-8450. **E-mail:** info@sessionsgroup.com. **Website:** www.sessionsgroup.com. **Contact:** Steven Sessions, president/creative director. Estab. 1981. Number of employees 8. Approximate annual billing $2.5 million. Specializes in annual reports; brand and corporate identity; fashion, package and publication design. Clients corporations and ad agencies. Current clients are listed on website. Professional affiliations AIGA, Art Directors Club, American Ad Federation.

NEEDS Approached by 50 freelancers/year. Works with 10 illustrators and 2 designers/year. Uses freelancers for brochure, catalog and ad design and illustration; poster illustration; lettering; and logos. 100% of freelance work demands knowledge of Illustrator, InDesign, QuarkXPress, Photoshop. Needs editorial, technical and medical illustration.

FIRST CONTACT & TERMS Designers: Send query letter with brochure, tearsheets, CDs, PDF files and SASE. Illustrators: Send postcard sample or other nonreturnable samples. Samples are filed. Responds only if interested. To show portfolio, mail slides. Payment depends on project. Rights purchased vary according to project.

SIGNATURE DESIGN

727 N. First St., Suite 340, St. Louis MO 63102. (314)621-6333. **E-mail:** therese.mckee@gmail.com; therese@signatureexhibitions.com. **Website:** www.theresemckee.com. Estab. 1993. Signature Design seeks to convey the authentic story of ecological and man-made environments in a memorable and meaningful way. Specialists—Interpretive planning and design of exhibits and signage. Innovative—Design collaborative of diverse unique skills; designers, writers, illustrators interactive media producers/animators creating experiences that entertain, educate and engage visitors. Clients include Bureau of Land Management, Missouri Botanical Garden, U.S. Post Office. Client list available upon request.

○ Additional locations in Austin, Atlanta and Dublin (see website for details).

NEEDS Approached by 15 freelancers/year. Works with 1-2 illustrators and 4-6 designers/year. Prefers local freelancers. Works on assignment only. 90% of freelance work demands knowledge of InDesign, Flash animation, Illustrator or Photoshop. Helpful to have web and animation software skills.

FIRST CONTACT & TERMS Send query letter with résumé, tearsheets and photocopies. Samples are filed. Responds only if interested. Artist should follow up with letter after initial query. Portfolio should include "whatever best represents your work." Pays for design by the hour. Pays for illustration by the project.

○ SILVER FOX ADVERTISING

Silver Fox Studios, 117 Ann St., North Providence RI 02904. (401)725-2161. **Fax:** (401)726-8270. **E-mail:** sfoxstudios@earthlink.net. **Website:** www.silverfox studios.com. Estab. 1979. Specializes in package and publication design, logo design, brand and corporate identity, display, technical illustration and annual reports. Clients: corporations, retail. Client list available upon request.

NEEDS Works only with artist reps. Prefers local artists. Uses illustrators mainly for cover designs. Also for multimedia projects. 50% of freelance work demands knowledge of Illustrator, Photoshop, Page-Maker and QuarkXPress.

FIRST CONTACT & TERMS Send query letter with résumé and photocopies. Accepts disk submissions compatible with Photoshop, Illustrator. Samples are filed. Does not reply. Artist should follow up with call or letter after initial query. Portfolio should include final art, photographs, roughs and slides.

SIMMONS/FLINT ADVERTISING

33 S. Third St., Suite D, Grand Forks ND 58201. (701)746-4573. **Fax:** (701)746-8067. **Website:** www.simmonsflint.com. Estab. 1947. Number of employees 90. Approximate annual billing $5.5 million. Ad agency. Specializes in magazine ads, collateral, documentaries, web design etc. Product specialties are agriculture, gardening, fast food/restaurants, healthcare. Client list available upon request.

○ A division of Flint Communications, Fargo ND, with 5 locations in North Dakota and Minnesota. See listing for Flint Communications in this section.

NEEDS Approached by 3-6 freelancers/year. Works with 3 freelance illustrators and 2 designers/year. Works on assignment only. Uses freelancers mainly for illustration. Also for brochure, catalog and print ad design and illustration; storyboards; billboards; and logos. 10% of work is with print ads. 10% of freelance work demands knowledge of QuarkXPress, Photoshop, Illustrator.

FIRST CONTACT & TERMS Send postcard, tearsheets or digital submission. Samples are filed or are returned. Will contact artist for portfolio review if interested. Portfolio should include color thumbnails, roughs, tearsheets, and photographs. Pays for design and illustration by the hour, by the project, or by the day. Rights purchased vary according to project.

○ SMITH & DRESS, LTD.

432 W. Main St., Huntington NY 11743. (631)427-9333. **Fax:** (631)427-9334. **E-mail:** dress2@att.net. **Website:** www.smithanddress.com. Full-service ad firm. Specializes in branding, publications, websites, trade shows, and signage.

NEEDS Works with 2-3 freelance artists/year. Prefers local artists only. Works on assignment only. Uses artists for illustration, retouching, and lettering.

FIRST CONTACT & TERMS Send query letter with brochure showing art style or tearsheets to be kept on file (except for works larger than 8½×11). Pays for illustration by the project on a work for hire basis. Considers client's budget and turnaround time when establishing payment.

J. GREG SMITH

14707 California St., Suite 6, Omaha NE 68154. (402)444-1600. **Fax:** (402)444-1610. **E-mail:** jgreg@jgregsmith.com. **Contact:** Greg Smith, senior art director. Estab. 1974. Number of employees: 8. Approximate annual billing: $1.5 million. Ad agency. Clients: financial, banking, associations, agricultural, travel and tourism, insurance. Professional affiliation: AAAA.

NEEDS Approached by 1-10 freelancers/year. Works with 4-5 freelancers illustrators and 1-2 designers/year. Works on assignment only. Uses freelancers mainly for mailers, brochures and projects; also for consumer and trade magazines, catalogs and AV presentations. Needs illustrations of farming, nature, travel.

FIRST CONTACT & TERMS Send query letter with samples showing art style or photocopies. Responds

only if interested. To show portfolio, mail final re-production/product, color and b&w. Pays for design and illustration by the project: $500-5,000. Buys first, reprint or all rights.

SMITH DESIGN

P.O. Box 8278, 205 Thomas St., Glen Ridge NJ 07028. (973)429-2177. **Fax:** (973)429-7119. **E-mail:** info@ smithdesign.com. **Website:** www.smithdesign.com. **Contact:** Laraine Blauvelt, vice president. Brand design firm. Specializes in strategy-based visual solutions for leading consumer brands. Clients: grocery, mass market consumer brands, electronics, construction, automotive, toy manufacturers. Current clients include Popsicle, Bertoli, Disney, Sika Corporation. Client list available upon request.

○ West Coast office: P.O. Box 222687, Carmel CA 93922; (831)620-1198

NEEDS Approached by more than 100 freelancers/year. Works with 10-20 freelance illustrators and 3-4 designers/year. Requires experience, talent, quality work and reliability. Uses freelancers for package design, concept boards, brochure design, print ads, newsletters illustration, POP display design, retail environments, web programming. 90% of freelance work demands knowledge of Illustrator, Quark-XPress, 3D rendering programs. Design style must be current to trends, particularly when designing for kids and teens. "Our work ranges from classic brands to cutting edge."

FIRST CONTACT & TERMS Send query letter with brochure/samples showing work, style and experience. Include contact information. Samples are filed or are returned only if requested by artist. Responds in 1 week. Call for appointment to show portfolio. Pays for design by the hour, $35-100; or by the project, $175-5,000. Pays for illustration by the project, $175-5,000. Considers complexity of project and client's budget when establishing payment. Buys all rights. (For illustration work, rights may be limited to a particular use TBD). Also buys rights for use of existing non-commissioned art. Finds artists through word of mouth, self-promotions/sourcebooks and agents.

TIPS "Know who you're presenting to (visit our website to see our needs). Show work which is relevant to our business at the level and quality we require. We use more freelance designers and illustrators for diversity of style and talent."

SOFTMIRAGE

17922 Fitch, 1st Floor, Irvine CA 92614. (949)474-2002. **Fax:** (949)474-2011. **E-mail:** contact@softmirage.com. **Website:** www.softmirage.com. **Contact:** Steve Pollack, design director. Estab. 1995. Number of employees 28. Approximate annual billing $3 million. Visual communications agency. Specializes in architecture, luxury, real estate. Needs people with strong spatial design skills, modeling and ability to work with computer graphics. Current clients include Four Seasons Hotels, Ford, Richard Meier & Partners and various real estate companies.

NEEDS Approached by 15 computer freelance illustrators and 5 designers/year. Works with 6 freelance 3D modelers, and 10 graphic designers/year. Prefers West coast designers with experience in architecture, engineering, technology. Uses freelancers mainly for concept, work in process computer modeling. Also for animation, brochure design, mechanicals, multimedia projects, retouching, technical illustration, TV/film graphics. 50% of work is renderings. 100% of design and 30% of illustration demand skills in Photoshop, 3-D Studio Max, Flash and Director. Need Macromedia Flash developers.

FIRST CONTACT & TERMS Designers: Send e-mail query letter with samples. 3D modelers: Send e-mail query letter with photocopies or link to website. Accepts digital and video submissions. Samples are filed or returned by SASE. Will contact for portfolio review if interested. Pays for design by the hour, $15-85. Pays for modeling by the project, $100-2,500. Rights purchased vary according to project. Finds artists through Internet, AIGA and referrals.

TIPS "Be innovative, push the creativity, understand the business rationale and accept technology. Check our website, as we do not use traditional illustrators, all our work is now digital. Send information electronically, making sure work is progressive and emphasizing types of projects you can assist with."

SPECTRUM BOSTON CONSULTING, INC.

P.O. Box 689, Westwood MA 02090-0689. (781)320-1361. **Fax:** (781)320-1315. **E-mail:** gboesel@spectrumboston.com. **Website:** www.spectrumboston. com. **Contact:** George Boesel, president. Estab. 1985. Specializes in brand and corporate identity, display and package design and signage. Clients: consumer products manufacturers.

NEEDS Approached by 30 freelance artists/year. Works with 5 illustrators and 3 designers/year. All artists employed on work-for-hire basis. Works on assignment only. Uses illustrators mainly for package and brochure work; also for brochure design and illustration, logos, P-O-P design, illustration and model-making. 100% of design and 85% of illustration demand knowledge of Illustrator, QuarkXPress, Photoshop, 3D illustration.

FIRST CONTACT & TERMS Send query letter with résumé and photocopies. Illustrators: Send query letter with tearsheets, photographs and photocopies. Accepts Mac-formatted disk in PPT, PDF, JPEG or MS Office formats. Samples are filed. Responds only if interested. Call or write for appointment to show portfolio of roughs, original/final art and color slides.

SPIRIT CREATIVE SERVICES, INC.

3157 Rolling Rd., Edgewater MD 21037. (410)956-1117. **Fax:** (410)956-1118. **E-mail:** info@spiritcreativeser vices.com. **Website:** www.spiritcreativeservices.com. Number of employees: 2. Approximate annual billing $50,000. Specializes in publications, brochure, catalogs, signage, books, annual reports, brand and corporate identity, display, direct mail, packaging, website design, technical and general illustration, photography, copywriting, and marketing. Clients/ associations: corporations, government.

NEEDS Approached by 20 freelancers/year. Works with local MAC based designers only. Uses freelancers for ad, brochure, catalog, poster and P-O-P design, technical illustration, books, direct mail, magazine, charts/graphs, logos, multimedia and design projects. 100% of design and 10% of illustration demands knowledge of Illustrator, Photoshop, Type Manager, InDesign and IWeb.

FIRST CONTACT & TERMS Call before sending submissions. Does not accept e-mail submissions without prior contact via phone. Portfolio samples and résumé. Responds in 1-3 weeks if interested. Portfolio should include b&w and color samples of artwork. Pays by the design project, $50-6,000.

TIPS "Being responsive to all communications and due dates with attention to details, creativity, and intuition is vital."

SPLANE DESIGN ASSOCIATES

30634 Persimmon Lane, Valley Center CA 90282. (760)749-6018. **Fax:** (760)749-6388. **E-mail:** splane design@gmail.com. **Website:** www.splanedesign.

com. **Contact:** Robson Splane, president. Specializes in product design. Clients: small, medium and large companies. Current clients include Lockheed Aircraft, Western Airlines, Liz Claiborne, Max Factor, Sunkist, Universal studios. Client list available upon request.

NEEDS Approached by 25-30 freelancers/year. Works with 1-2 freelance illustrators and 6-12 designers/year. Works on assignment only. Uses illustrators mainly for logos, mailings to clients, renderings. Uses designers mainly for sourcing, drawings, prototyping, modeling; also for brochure design and illustration, ad design, mechanicals, retouching, airbrushing, model making, lettering and logos. 75% of freelance work demands skills in FreeHand, Ashlar Vellum, Solidworks and Excel.

FIRST CONTACT & TERMS Send query letter with résumé and photocopies. Samples are filed or are returned. Responds only if interested. Will contact artist for portfolio review if interested. Portfolio should include color roughs, final art, photostats, slides and photographs. Pays for design and illustration by the hour, $7-25. Rights purchased vary according to project. Finds artists through submissions and contacts.

STEVENS STRATEGIC COMMUNICATIONS, INC.

1991 Crocker Rd., Suite 500, Westlake OH 44145. (440)617-0100. **Fax:** (440)614-0529. **E-mail:** estevens@ stevensstrategic.com. **Website:** www.stevensstrategic. com. Estab. 1956. Ad agency. Specializes in public relations, advertising, corporate and crisis communications, integrated marketing, magazine ads and collateral. Product specialties are business-to-business, food, building products, technical products, industrial food service, healthcare, safety.

NEEDS Approached by 30-40 freelance artists/ month. Prefers artists with experience in food, healthcare and technical equipment. Works on assignment only. Uses freelance artists mainly for specialized projects; also for brochure, catalog and print ad illustration and retouching. Freelancers should be familiar with InDesign, Adobe Creative Suite Master Collection, QuarkXPress, Illustrator and Photoshop.

FIRST CONTACT & TERMS Send query letter with résumé and photocopies. Samples are filed and are not returned. Responds only if interested. "Artist should send only samples or copies that do not need to be returned." Will contact artist for portfolio review if interested. Portfolio should include final art and tearsheets. Pay for design depends on style. Pay

for illustration depends on technique. Buys all rights. Finds artists through agents, sourcebooks, word of mouth and submissions.

THE STRONGTYPE

P.O. Box 1520, Dover NJ 07802-1520. (973)919-4265. **E-mail:** richard@strongtype.com. **Website:** www.strongtype.com. **Contact:** Richard Puder. Estab. 1985. Approximate annual billing: $300,000. Specializes in marketing communications, direct mail and publication design, technical illustration. Client history includes Hewlett-Packard, Micron Electronics, R.R. Bowker, Scholastic, Simon & Schuster and Sony. Professional affiliation: Type Directors Club.

NEEDS Approached by 100 freelancers/year. Uses designers mainly for corporate, publishing clients; also for ad and brochure design and illustration, book, direct mail, magazine and poster design, charts/graphs, lettering, logos and retouching. 100% of freelance work demands skills in Illustrator, Photoshop, Free-Hand, Acrobat, QuarkXPress, Director, Flash, Fireworks and Dreamweaver.

FIRST CONTACT & TERMS E-mail with links and follow up with call, or send postcard sample, résumé and tearsheets. Samples are filed. Will contact artist for portfolio review if interested. Pays for design and production by the hour, depending on skills, $10-100. Pays for illustration by the job. Buys first rights or rights purchased vary according to project. Finds artists through sourcebooks (e.g., *American Showcase* and *Workbook*) and by client referral.

TIPS Impressed by "listening, problem-solving, speed, technical competency and creativity."

STUDIO WILKS

2148-A Federal Ave., Los Angeles CA 90025. (310)478-4442. **Fax:** (310)477-7888. **E-mail:** info@studiowilks.com. **Website:** www.studiowilks.com. Estab. 1990.

NEEDS Works with 6-10 freelance illustrators and 10-20 designers/year. Uses illustrators mainly for packaging illustration. Also for brochures, print ads, collateral, direct mail and promotions.

FIRST CONTACT & TERMS Designers: Send query letter with brochure, résumé, photocopies and tearsheets. Illustrators: Send postcard sample or query letter with tearsheets. Samples are returned by SASE if requested by artist. Will contact artist for portfolio review if interested. Pays for design by the project. Buys all rights. Considers buying second rights (reprint rights) to previously published work.

Finds artists through *The Workbook* and word of mouth.

SWANSON RUSSELL ASSOCIATES

1222 P St., Lincoln NE 68508. (402)437-6400. **Fax:** (402)437-6401. **E-mail:** wesn@swansonrussell.com; daveh@swansonrussell.com. **Website:** www.swansonrussell.com. **Contact:** Wes Neuhaus, executive vice president/managing director; Dave Hansen, partner/CEO. Estab. 1962. Number of employees: 120. Approximate annual billing: $80 million. Integrated marketing communications agency. Specializes in collateral, catalogs, magazine and newspaper ads, direct mail. Product specialties are healthcare, agriculture, green industry, outdoor recreation. Current clients include Mercy Hospital, Physicians Mutual, Manna Pro, OPUS Medication Systems. Professional affiliations: PRSA, AIGA, Ad Club.

○ Second location: 14301 FNB Pkwy., Suite 312, Omaha NE 68154. (402)393-4940. Fax: (402)393-6926.

NEEDS Approached by 12 illustrators and 3-4 designers/year. Works with 5 illustrators and 2 designers/year. Prefers freelancers with experience in agriculture, pharmaceuticals, human and animal health. Uses freelancers mainly for collateral, ads, direct mail, storyboards; also for brochure design and illustration, humorous and technical illustration, lettering, logos, mechanicals, posters, storyboards. 10% of work is with print ads. 90% of design demands knowledge of Photoshop 7.0, FreeHand 5.0, QuarkXPress 3.3. 30% of illustration demands knowledge of Photoshop, Illustrator, FreeHand.

FIRST CONTACT & TERMS Designers: Send query letter with photocopies, photographs, photostats, SASE, slides, tearsheets, transparencies. Illustrators: Send query letter with SASE. Send follow-up postcard samples every 3 months. Accepts Mac-compatible disk submissions. Send self-expanding archives and player for multimedia, or JPEG, EPS and TIFFs. Software Quark, FreeHand or Adobe. Samples are filed or returned by SASE. Responds only if interested within 2 weeks. Art director will contact artist for portfolio review of final art, photographs, photostats, transparencies if interested. Pays for design by the hour; pays for illustration by the project. Rights purchased vary according to project. Finds artists through agents, submissions, word of mouth, *Laughing Stock*, *American Showcase*.

⚲ TASTEFUL IDEAS, INC.

7638 Bell Dr., Shawnee KS 66217. (913)722-3769. **Fax:** (913)722-3967. **E-mail:** john@tastefulideas.com. **Website:** www.tastefulideas.com. **Contact:** John Thomsen, president. Estab. 1986. Number of employees: 4. Approximate annual billing: $500,000. Design firm. Specializes in consumer packaging. Product specialties are largely, but not limited to, food and food service.

NEEDS Approached by 15 illustrators and 15 designers/year. Works with 3 illustrators and 3 designers/year. Prefers local freelancers. Uses freelancers mainly for specialized graphics; also for airbrushing, animation, humorous and technical illustration. 10% of work is with print ads. 75% of design and illustration demand skills in Photoshop and Illustrator.

FIRST CONTACT & TERMS Designers: Send query letter with photocopies. Illustrators: Send non-returnable promotional sample. Accepts submissions compatible with Illustrator, Photoshop (Mac based). Samples are filed. Art director will contact artist for portfolio review of final art if interested. Pays by the project. Finds artists through submissions.

⚲ BRANDON TAYLOR DESIGN

5405 Morehouse Dr., Suite 280, San Diego CA 92121. (858)623-9084. **E-mail:** dennis@brandontaylor.com. **E-mail:** info@brandontaylor.com. **Website:** www.brandontaylor.com. **Contact:** Robert Hines. Estab. 1977. Specializes in corporate identity, displays, direct mail, package and publication design and signage. Clients corporations and manufacturers. Client list available upon request.

NEEDS Approached by 20 freelance artists/year. Works with 15 freelance illustrators and 10 freelance designers/year. Prefers local artists. Works on assignment only. Uses freelance illustrators mainly for technical and instructional spots. Uses freelance designers mainly for logo design, books and ad layouts. Also uses freelance artists for brochure, catalog, ad, P-O-P and poster design and illustration, retouching, airbrushing, logos, direct mail design and charts/graphs.

FIRST CONTACT & TERMS Send query letter with brochure, résumé, photocopies and photostats. Samples are filed. Responds in 2 weeks. Write to schedule an appointment to show a portfolio or mail thumbnails, roughs, photostats, tearsheets, comps and printed samples. Pays for design by the assignment. Pays for illustration by the project. Rights purchased vary according to project.

TGADESIGN

4649 Ponce De Leon Blvd., Suite 401, Coral Gables FL 33146. (305)669-2550. **Fax:** (305)669-2539. **E-mail:** info@tgadesign.com. **Website:** www.tgadesign.com. **Contact:** Tom Graboski, president. Estab. 1980. Also known as Tom Graboski Associates, Inc. Specializes in exterior/interior signage, environmental graphics, corporate identity, urban design and print graphics. Clients: corporations, cities, museums, a few ad agencies. Current clients include Universal Studios, Florida; Royal Caribbean Cruise Line; The Equity Group; Disney Development; Celebrity Cruises; Baptist Health So. Florida; City of Miami; City of Coral Gables.

NEEDS Approached by 20-30 freelance artists/year. Works with approximately 4-8 designers/draftspersons/year. Prefers artists with a background in signage and knowledge of architecture and industrial design. Freelance artists used in conjunction with signage projects, occasionally miscellaneous print graphics. 100% of design and 10% of illustration demand knowledge of Illustrator, Photoshop and QuarkXPress.

FIRST CONTACT & TERMS Send query letter with brochure and résumé. "We will contact designer/artist to arrange appointment for portfolio review. Portfolio should be representative of artist's work and skills; presentation should be in a standard portfolio format." Pays by the project. Payment varies by experience and project. Rights purchased vary by project.

TIPS "Look at what type of work the firm does. Tailor presentation to that type of work. For this firm, knowledge of environmental graphics and detailing is a plus."

J. WALTER THOMPSON COMPANY

3630 Peachtree Rd. NE, Suite 1200, Atlanta GA 30326. (404)365-7300. **Website:** www.jwt.com. Ad agency. Current clients include Domino's, Ford, HSBC, Kraft, Shell, Unilever.

⚲ JWT has offices all over the world. See website for details.

NEEDS Works on assignment only. Uses freelancers for billboards, consumer and trade magazines and newspapers. Needs computer-literate freelancers for design, production and presentation. 60% of freelance work demands skills in Illustrator, Photoshop, InDesign, Flash, and Dreamweaver.

FIRST CONTACT & TERMS *Deals with artist reps only.* Send slides, original work, stats. Samples returned by SASE. Responds only if interested. Originals not returned. Call for appointment to show portfolio.

TIPS Wants to see samples of work done for different clients. Likes to see work done in different mediums; variety and versatility. Freelancers interested in working here should "be *professional* and do topgrade work."

TOKYO DESIGN CENTER

703 Market St., Suite 252, San Francisco CA 94103-2102. (415)543-4886. **Fax:** (415)543-4956. **E-mail:** info@tokyodesign.com. **Website:** www.tokyodesign. com. Specializes in annual reports, brand identity, corporate identity, packaging and publications. Clients: consumer products, travel agencies and retailers.

NEEDS Uses artists for design and editorial illustration.

FIRST CONTACT & TERMS Send business card, slides, tearsheets and printed material to be kept on file. Samples not kept on file are returned by SASE, if requested. Will contact artist for portfolio review if interested. Pays for design and illustration by the project, $100-1,500 average. Sometimes requests work on spec before assigning job. Considers client's budget, skill and experience of artist, turnaround time and rights purchased when establishing payment. Interested in buying second rights (reprint rights) to previously published work. Finds artists through self-promotions and sourcebooks.

THE TOMBRAS GROUP

630 Concord St., Knoxville TN 37919. (865)524-5376. **E-mail:** jwelsch@tombras.com. **Website:** www.tom bras.com. Estab. 1946. Number of employees: 68. Approximate annual billing $75 million. Ad agency. Full-service multimedia firm. Specializes in full media advertising, collateral, interactive. Clients: National Highway Traffic, Safety Administration, Fred's Stores, Bristol Motor Speedway, Lowe's Motor Speedway, Atlanta Motor Speedway, and Farm Bureau Insurance. Client list available upon request. Professional affiliations AAAA, Worldwide Partners, AMA.

NEEDS Approached by 20-25 freelancers/year. Works with 20-30 freelance illustrators and 10-15 designers/year. Uses freelancers mainly for illustration and photography. Also for brochure design and illustration, model-making and retouching. 60% of work is with print ads. Needs computer-literate freelancers for design and presentation. 25% of freelance work demands skills in InDesign, Photoshop and QuarkXPress.

FIRST CONTACT & TERMS Send query letter with photocopies and résumé. Samples are filed. Will contact artist for portfolio review if interested. Portfolio should include b&w and color samples. Pays for design by the hour, $25-75; by the project, $250-2,500. Pays for illustration by the project, $100-10,000. Rights purchased vary according to project.

TIPS "Stay in touch with quality promotion. 'Service me to death' when you get a job."

A. TOMLINSON/SIMS ADVERTISING

250 S. Poplar St., P.O. Box 2530, Florence AL 35630. (256)766-4222; (800)779-4222. **Fax:** (256)766-4106. **Website:** www.atsa-usa.com. **Contact:** Allen Tomlinson, president/managing partner. Estab. 1990. Number of employees: 9. Approximate annual billing: $5 million. Ad agency. Specializes in magazine, collateral, catalog, business-to-business. Product specialties are home building products. Client list available upon request.

NEEDS Approached by 20 illustrators and 20 designers/year. Works with 5 illustrators and 5 designers/year. Uses freelancers for airbrushing, billboards, brochure and catalog design and illustration, logos and retouching. 35% of work is with print ads. 85% of design and illustration demand skills in PageMaker, Photoshop, Illustrator and QuarkXPress.

FIRST CONTACT & TERMS Designers: Send query letter with brochure and photocopies. Illustrators: Send samples of work, photocopies and résumé. Samples are filed and are not returned. Does not reply; artist should call. Artist should also call to arrange for portfolio review of color photographs, thumbnails and transparencies. Pays by the project. Rights purchased vary according to project.

T-P DESIGN, INC.

7007 Eagle Watch Court, Stone Mountain GA 30087. (770)413-8276. **Fax:** (770)413-9856. **E-mail:** tpde sign@att.net. **Website:** www.tpdesigninc.com. **Contact:** Creative Director. Estab. 1991. Number of employees 3. Approximate annual billing $500,000. Specializes in brand identity, display, package and publication design. Clients corporations. Current clients include Georgia Pacific, Cartoon Network, General Mills, KFC.

NEEDS Approached by 4 freelancers/year. Works with 2 freelance illustrators and 2 designers/year. Prefers local artists with Mac systems, traditional background. Uses illustrators and designers mainly for comps and illustration on Mac. Also uses freelancers for ad, brochure, poster and P-O-P design and illustration; book design, charts/graphs, lettering, logos, mechanicals (important) and page layout. Also for multimedia projects. 75% of freelance work demands skills in Illustrator, Photoshop, InDesign. "Knowledge of multimedia programs such as Director and Premier would also be desirable."

FIRST CONTACT & TERMS Send query letter or photocopies, résumé and tearsheets. Also accepts e-mail submissions. Samples are filed. Will contact artist for portfolio review if interested. Portfolio should include b&w and color final art, roughs (important) and thumbnails (important). Pays for design and illustration by the project. Rights purchased vary according to project. Finds artists through submissions and word of mouth. Desires freelancers with web design or web programming experience and skills.

TIPS "Be original, be creative and have a positive attitude. Need to show strength in illustration with a good design sense. A flair for typography would be desirable."

⌂ TR PRODUCTIONS

2 13th St., Floor 3, Charleston MA 02129. (508)650-3400. **E-mail:** info@trprod.com. **Website:** www.trprod.com. **Contact:** Creative director. Estab. 1947. Number of employees: 12. AV firm; full-service multimedia firm. Specializes in Flash, collateral, multimedia, Web graphics and video.

NEEDS Approached by 15 freelancers/year. Works with 5 freelance illustrators and 5 designers/year. Prefers local freelancers with experience in slides, Web, multimedia, collateral and video graphics. Works on assignment only. Uses freelancers mainly for slides, Web, multimedia, collateral and video graphics; also for brochure and print ad design and illustration, slide illustration, animation and mechanicals. 25% of work is with print ads. Needs computer-literate freelancers for design, production and presentation. 95% of work demands skills in FreeHand, Photoshop, Premier, After Effects, PowerPoint, QuarkXPress, Illustrator, Flash.

FIRST CONTACT & TERMS Send query letter. Samples are filed. Does not reply. Artist should follow up with call. Will contact artist for portfolio review if interested. Rights purchased vary according to project.

TVN—THE VIDEO NETWORK

31 Cutler Dr., Ashland MA 01721-1210. (508)881-1800. **E-mail:** info@tvnvideo.com. **Website:** www.tvnvideo.com. Estab. 1986. AV firm. Full-service multimedia firm. Specializes in video production for business, broadcast and special events. Product specialties "cover a broad range of categories." Current clients include Marriott, Digital, IBM, Waters Corp., National Park Service.

NEEDS Approached by 1 freelancer/month. Works with 1 illustrator/month. Prefers freelancers with experience in Mac/NT, 2D and 3D programs. Works on assignment only. Uses freelancers mainly for video production, technical illustration, flying logos and 3D work. Also for storyboards, animation, TV/film graphics and logos.

FIRST CONTACT & TERMS Send query letter with videotape or computer disk. Samples are filed or are returned. Responds in 2 weeks. Will contact artist for portfolio review if interested. Portfolio should include videotape and computer disk. Pays for design by the hour, $50; by the project, $1,000-5,000; by the day, $250-500. Buys all rights. Finds artists through word of mouth, magazines and submissions.

TIPS Advises freelancers starting out in the field to find a company internship or mentor program.

ULTITECH, INC.

Foot of Broad St., Stratford CT 06497. (203)375-7300. **Fax:** (203)375-6699. **E-mail:** ultitech@meds.com. **Website:** www.meds.com. Estab. 1993. Number of employees 3. Approximate annual billing $1 million. Integrated marketing communications agency. Specializes in interactive multimedia, software, online services. Product specialties are medicine, science, technology. Current clients include large pharmaceutical companies.

NEEDS Approached by 10-20 freelance illustrators and 10-20 designers/year. Works with 2-3 freelance illustrators and 6-10 designers/year. Prefers freelancers with experience in interactive media design and online design. Uses freelancers mainly for design of websites and interactive CDs/DVDs. Also for animation, brochure design, medical illustration, multimedia projects, TV/film graphics. 10% of work is with print ads. 100% of freelance design demands skills in Photoshop, QuarkXPress, Illustrator, 3D packages.

FIRST CONTACT & TERMS E-mail submission is best. Include links to online portfolio. Responds only if interested. Pays for design by the project or by the day. Pays for illustration by the project. Buys all rights. Finds artists through sourcebooks, word of mouth, submissions.

TIPS "Learn design principles for interactive media."

UNICOM

9470 N. Broadmoor Rd., Bayside WI 53217. (414)352-5070. **Fax:** (414)352-4755. **E-mail:** keichenbaum@wi.rr.com. **Contact:** Ken Eichenbaum, senior partner. Estab. 1974. Specializes in annual reports, brand and corporate identity, display, direct, package and publication design and signage. Clients: corporations, business-to-business communications, and consumer goods. Client list available upon request.

NEEDS Approached by 5-10 freelancers/year. Works with 1-2 freelance illustrators/year. Works on assignment only. Uses freelancers for brochure, book and poster illustration, pre-press composition.

FIRST CONTACT & TERMS Send query letter with brochure. Samples not filed or returned. Does not reply; send nonreturnable samples. Write for appointment to show portfolio of thumbnails, photostats, slides and tearsheets. Pays by the project, $200-3,000. Rights purchased vary according to project.

○ UNO HISPANIC ADVERTISING AND DESIGN

111 E. Franklin Ave., Suite 101, Minneapolis MN 55404. (612)874-1920. **Fax:** (612)874-1912. **E-mail:** luis@unobranding.com. **Website:** www.unobranding.com. **Contact:** Luis Fitch, creative director. Estab. 1990. Number of employees: 6. Approximate annual billing $950,000. Specializes in brand and corporate identity, display, package and retail design and signage for the US Hispanic markets. Clients: Latin American corporations, retail. Current clients include MTV Latino, Target, Mervyn's, 3M, Univision, Wilson's. Client list available upon request. Professional affiliations AIGA, GAG.

NEEDS Approached by 33 freelancers/year. Works with 40 freelance illustrators and 20 designers/year. Works only with artists' reps. Prefers local artists with experience in retail design, graphics. Uses illustrators mainly for packaging. Uses designers mainly for retail graphics. Also uses freelancers for ad and book design, brochure, catalog and P-O-P design and illustration, audiovisual materials, logos and model mak-

ing. Also for multimedia projects (Interactive Kiosk, CD-Educational for Hispanic Market). 60% of design demands computer skills in Illustrator, Photoshop, FreeHand and QuarkXPress.

FIRST CONTACT & TERMS Designers: Send postcard sample, brochure, résumé, photographs, slides, or tearsheets. Illustrators: Send postcard sample, brochure, or tearsheets. Accepts disk submissions compatible with Illustrator, Photoshop, FreeHand. Send EPS files. Samples are filed. Will contact artist for portfolio review if interested. Portfolio should include color final art, photographs and slides. Pays for design by the project, $500-6,000. Pays for illustration by the project, $200-20,000. Rights purchased vary according to project. Finds artists through artist reps, *Creative Black Book* and *Workbook*.

TIPS "It helps to be bilingual and to have an understanding of Hispanic cultures."

UTOPIAN EMPIRE CREATIVEWORKS

P.O. Box 9, Traverse City MI 49865. (231)943-5050 or (231)943-4000. **E-mail:** creativeservices@utopianempire.com; clientworks@utopianempire.com. **Website:** www.utopianempire.com. **Contact:** Ms. M'Lynn Hartwell, president. Estab. 1970. Full-service multimedia firm. Specializes in corporate and industrial products, as well as TV and radio spots.

NEEDS Works on assignment. Uses freelance talent.

FIRST CONTACT & TERMS Send query letter with brochure, SASE, and tearsheets. Samples are filed to review for project relevancy or returned by SASE if requested by artist. Responds only if interested. To show portfolio, mail samples or CD/DVD media. Pays for design and illustration by the project, negotiated rate. Rights purchased vary according to project.

THE VAN NOY GROUP

3315 Westside Rd., Healdsburg CA 95448-9453. (707)433-3944. **Fax:** (707)433-0375. **E-mail:** jim@vannoygroup.com. **Website:** www.vannoygroup.com. **Contact:** Jim Van Noy. Estab. 1972. Specializes in brand and corporate identity, displays and package design. Clients: corporations, consumer product, beverage, health and beauty, lawn and garden and decorative hardware companies. Client list available upon request.

NEEDS Approached by 1-10 freelance artists/year. Works with 2 illustrators and 3 designers/year. Prefers artists with experience in Mac design. Works on as-

signment only. Uses freelancers for packaging design and illustration, Photoshop production and lettering.
FIRST CONTACT & TERMS Send query letter with résumé and photographs. Samples are filed. Will contact artist for portfolio review if interested. If no reply, artist should follow up. Pays for design by the hour, $35-100. Pays for illustration by the hour or by the project at a TBD fee. Finds artists through sourcebooks, self-promotions and primarily agents. Also have permanent positions available.
TIPS "I think more and more clients will be setting up internal art departments and relying less and less on outside designers and talent. The computer has made design accessible to the user who is not design-trained."

VIDEO RESOURCES

1809 E. Dyer Rd., #307, Santa Ana CA 92705. (949)261-7266; (800)261-7266. **Fax:** (949)261-5908. **E-mail:** brad@videoresouces.com. **Website:** www.videore sources.com. **Contact:** Brad Hagen, producer. Number of employees: 15. Video and multimedia firm. Specializes in automotive, banks, restaurants, computer, health care, transportation and energy.

○ Additional location: 110 Campus Dr., Marlborough MA 01752; (508)485-8100.

NEEDS Approached by 10-20 freelancers/year. Works with 5-10 freelance illustrators and 5-10 designers/year. Works on assignment only. Uses freelancers for graphics, multimedia, animation, etc.
FIRST CONTACT & TERMS Send query letter with brochure showing art style or résumé, business card, photostats and tearsheets to be kept on file. Samples not filed are returned by SASE. Considers complexity of the project and client's budget when establishing payment. Buys all rights.

VISUAL HORIZONS

180 Metro Park, Rochester NY 14623. (585)424-5300; (800)424-1011. **Fax:** (585)424-5313. **E-mail:** cs@visu alhorizons.com. **Website:** www.visualhorizons.com. Estab. 1971. AV firm; full-service multimedia firm. Specializes in presentation products, digital imaging of 35mm slides. Current: U.S. government agencies, corporations and universities.
NEEDS Works on assignment only. Uses freelancers mainly for web design. 5% of work is with print ads. 100% of freelance work demands skills in Photoshop.
FIRST CONTACT & TERMS Send query letter with tearsheets. Samples are not filed and are not returned.

Responds if interested. Portfolio review not required. Pays for design and illustration by the hour or project, negotiated. Buys all rights.

WALKER DESIGN GROUP

421 Central Ave., Great Falls MT 59401. (406)727-8115. **Fax:** (406)791-9655. **E-mail:** info@walkerde signgroup.com. **Website:** www.walkerdesigngroup. com. **Contact:** Duane Walker, president. Number of employees: 6. Design firm. Specializes in annual reports and corporate identity. Professional affiliations: AIGA and Ad Federation.
NEEDS Uses freelancers for animation, annual reports, brochure, medical and technical illustration, catalog design, lettering, logos and TV/film graphics. 80% of design and 90% of illustration demand skills in PageMaker, Photoshop and Illustrator.
FIRST CONTACT & TERMS Send query letter with brochure, photocopies, post cards, résumé or tearsheets. Accepts digital submissions. Samples are filed and are not returned. Responds only if interested. To arrange portfolio review, artist should follow up with call or letter after initial query. Portfolio should include color photographs, photostats and tearsheets. Pays by the project; negotiable. Finds artists through *Workbook*.
TIPS "Stress customer service and be very aware of deadlines."

WARKULWIZ DESIGN ASSOCIATES, INC.

211 N. 13th St., Suite 702, Philadelphia PA 19107-1610. (215)988-1777. **Fax:** (215)988-1780. **E-mail:** info@ warkulwiz.com. **Website:** www.warkulwiz.com. **Contact:** Bob Warkulwiz, president. Estab. 1985. Number of employees: 6. Approximate annual billing: $1 million. Specializes in annual reports, publication design and corporate communications. Clients: corporations and universities. Client list available upon request. Professional affiliations: AIGA
NEEDS Approached by 100 freelancers/year. Works with 10 freelance illustrators and 5-10 photographers/ year. Works on assignment only. Uses freelance illustrators mainly for editorial and corporate work; also for brochure and poster illustration and mechanicals. Freelancers should be familiar with most recent versions of QuarkXPress, Illustrator, Photoshop, FreeHand and Director.
FIRST CONTACT & TERMS Send query letter with tearsheets and photostats. Samples are filed. Responds only if interested. Call for appointment to

show portfolio of "best edited work—published or unpublished." Pays for illustration by the project, "depends upon usage and complexity." Rights purchased vary according to project.

TIPS "Be creative and professional."

WAVE DESIGN WORKS

55 Elmgrove Ave., Providence RI 02906. (774)254-0946. **E-mail:** ideas@wavedesignworks.com. **Website:** www.wavedesignworks.com. **Contact:** John Buchholz, principal. Estab. 1986. Specializes in corporate identity and display, package and publication design. Clients corporations primarily biotech, medical and healthcare, B2B.

NEEDS Approached by 24 freelance graphic artists/year. Works with 1-5 freelance illustrators and 1-5 freelance designers/year. Works on assignment only. Uses freelancers for brochure, catalog, poster and ad illustration; lettering; and charts/graphs. 100% of design and 50% of illustration demand knowledge of QuarkXPress, InDesign, Illustrator or Photoshop.

FIRST CONTACT & TERMS Designers send query letter with brochure, résumé, photocopies, photographs and tearsheets. Illustrators send postcard promo. Samples are filed. Responds only if interested. Artist should follow up with call or letter after initial query. Portfolio should include b&w and color thumbnails and final art. Pays for illustration by the project. Rights purchased vary according to project. Finds artists through submissions and sourcebooks.

WEST CREATIVE, INC.

10780 S. Cedar Niles Circle, Overland Park KS 66210. (913)839-2181. **Fax:** (913)839-2176. **E-mail:** stan@westcreative.com. **Website:** www.westcreative.com. Estab. 1974. Number of employees: 8. Approximate annual billing $600,000. Design firm and agency. Full-service multimedia firm. Client list available upon request. Professional affiliation AIGA.

Additional locations in Dallas and Tucson.

NEEDS Approached by 50 freelancers/year. Works with 4-6 freelance illustrators and 1-2 designers/year. Uses freelancers mainly for illustration. Also for animation, lettering, mechanicals, model-making, retouching and TV/film graphics. 20% of work is with print ads. Needs computer-literate freelancers for design, illustration and production. 95% of freelance work demands knowledge of FreeHand, Photoshop, QuarkXPress and Illustrator. Full service web design capabilities.

FIRST CONTACT & TERMS Send postcard-size sample of work or query letter with brochure, photocopies, résumé, SASE, slides, tearsheets and transparencies. Samples are filed or returned by SASE if requested by artist. Responds only if interested. Portfolios may be dropped off Monday-Thursday. Portfolios should include color photographs, roughs, slides and tearsheets. Pays for illustration by the project; pays for design by the hour, $25-60. "Each project is bid." Rights purchased vary according to project. Finds artists through *Creative Black Book* and *Workbook*.

WEYMOUTH DESIGN, INC.

332 Congress St., Floor 6, Boston MA 02210. (617)542-2647. **Fax:** (617)451-6233. **E-mail:** info@weymouthdesign.com. **Website:** www.weymouthdesign.com. Estab. 1973. Number of employees: 16. Specializes in annual reports, corporate collateral, website design, CDs and multimedia. Clients: corporations and small businesses. Member of AIGA.

Second location: 600 Townsend St., San Francisco CA 94103. (415)487-7900. Fax: (415)431-7200.

NEEDS Works with 3-5 freelance illustrators or photographers. Needs editorial, medical and technical illustration mainly for annual reports and multimedia projects.

FIRST CONTACT & TERMS Send query letter with résumé or illustration samples/tearsheets. Samples are filed or are returned by SASE if requested by artist. Will contact artist for portfolio review if interested.

DANA WHITE PRODUCTIONS

2623 29th St., Santa Monica CA 90405. (310)450-9101. **E-mail:** dwprods@aol.com. **Contact:** Dana C. White, president. AV firm. "We are a full-service audiovisual design and production company, providing video and audio presentations for training, marketing, awards, historical and public relations uses. We have complete in-house production resources, including computer multimedia, photo digitizing, image manipulation, program assembly, slide making, soundtrack production, photography and AV multi-image programming. We serve major industries such as U.S. Forest Services; medical, such as Whittier Hospital, Florida Hospital; schools, such as University of Southern California, Pepperdine University; publishers, such as McGraw-Hill, West Publishing; and public service efforts, including fund-raising."

NEEDS Works with 8-10 freelancers/year. Prefers freelancers local to greater Los Angeles, "with timely turnaround, ability to keep elements in accurate registration, neatness, design quality, imagination and price." Uses freelancers for design, illustration, retouching, characterization/animation, lettering and charts. 50% of freelance work demands knowledge of Illustrator, FreeHand, Photoshop, Quark and Premier.

FIRST CONTACT & TERMS Send query letter with brochure or tearsheets, photostats, photocopies, slides and photographs. Samples are filed or are returned only if requested. Responds in 2 weeks, only if interested. Call or write for appointment to show portfolio. Pays by the project. Payment negotiable by job.

TIPS "Be flexible. Negotiate. Your work should show that you have spirit, enjoy what you do, and that you can deliver high-quality work on time."

L.C. WILLIAMS & ASSOCIATES

150 N. Michigan Ave., 38th Floor, Chicago IL 60601. (312)565-3900; (800)837-7123. **E-mail:** info@lcwa. com. **Website:** www.lcwa.com/. **Contact:** Monica McFadden, creative services manager. Estab. 2000. Number of employees 28. Approximate annual billing $3.5 million. PR firm. Specializes in marketing, communication, publicity, direct mail, brochures, newsletters, trade magazine ads, AV presentations. Product specialty is consumer home products. Current clients include Pergo, Ace Hardware, La-Z-Boy, Inc. and Glidden. Professional affiliations: Chicago Direct Marketing Association, Sales & Marketing Executives of Chicago, Public Relations Society of America, Publicity Club of Chicago.

◯ LCWA is among the top 15 public relations agencies in Chicago. It maintains a satellite office in New York.

NEEDS Approached by 50-100 freelancers/year. Works with 1-2 freelance illustrators and 2-5 designers/year. Works on assignment only. Uses freelancers mainly for brochures, ads, newsletters. Also for print ad design and illustration, editorial and technical illustration, mechanicals, retouching and logos. 90% of freelance work demands computer skills.

FIRST CONTACT & TERMS Send query letter with brochure and résumé. Samples are filed. Does not reply. Request portfolio review in original query. Artist should call within 1 week. Portfolio should include printed pieces. Pays for design and illustration by the project, fee varies. Rights purchased vary according to project. Finds artists through word of mouth and queries.

TIPS "Many new people are opening shop and you need to keep your name in front of your prospects."

THE WILLIAMS MCBRIDE GROUP

344 E. Main St., Lexington KY 40507. (859)253-9319. **E-mail:** tsmith@williamsmcbride.com. **Website:** www.williamsmcbride.com. Estab. 1988. Number of employees: 12. Design firm specializing in brand management, corporate identity and business-to-business marketing.

NEEDS Approached by 10-20 freelance artists/year. Works with 4 illustrators and 3 designers/year. Prefers freelancers with experience in corporate design, branding. Works on assignment only. 100% of freelance design work demands knowledge of InDesign, Photoshop and Illustrator. Will review résumés of web designers with knowledge of Director and Flash.

FIRST CONTACT & TERMS Designers: Send query letter with résumé. Will review online portfolios or hardcopy samples. Illustrators: Send website link or postcard sample of work. Samples are filed. Responds only if interested. Pays for design by the hour, $50-65. Pays for illustration by the project. Rights purchased vary according to project. Finds artists through submissions, word of mouth, *Creative Black Book*, *Workbook*, *American Showcase*, artist's representatives.

TIPS "Keep our company on your mailing list; remind us that you are out there."

WISNER CREATIVE

18200 NW Sauvie Island Rd., Portland OR 97231-1338. (503)282-3929. **Fax:** (503)282-0325. **E-mail:** wizbiz@ wisnercreative.com. **Website:** www.wisnercreative. com. **Contact:** Linda Wisner, creative director. Estab. 1979. Number of employees: 1. Specializes in brand and corporate identity, book design, publications and exhibit design. Clients: small businesses, manufacturers, restaurants, service businesses and book publishers.

NEEDS Works with 3-5 freelance illustrators/year. Prefers experienced freelancers and "fast, accurate work." Works on assignment only. Uses freelancers for technical and fashion illustration and graphic production. Knowledge of QuarkXPress, InDesign, Photoshop, Illustrator, Dreamweaver, and other software required.

FIRST CONTACT & TERMS Send query letter or e-mail with résumé and samples. Prefers "examples of completed pieces that show the fullest abilities of the artist." Samples not kept on file are returned by SASE, if requested. Will contact artist for portfolio review if interested. Pays for illustration by the by the project, by bid. Pays for graphic production by the hour, $35-50 or by project, by bid.

⊙ MICHAEL WOLK DESIGN ASSOCIATES

31 NE 28th St., Miami FL 33137. (305)576-2898. **Fax:** (305)576-2899. **E-mail:** contact@wolkdesign.com. **Website:** www.wolkdesign.com. **Contact:** Michael Wolk, chairman/creative director. Estab. 1985. Specializes in corporate identity, displays, interior design and signage. Clients: corporate and private. Client list available on website.

NEEDS Approached by 10 freelancers/year. Works with 5 illustrators and 5 freelance designers/year. Prefers local artists only. Works on assignment only. Needs editorial and technical illustration mainly for brochures. Uses designers mainly for interiors and graphics; also for brochure design, mechanicals, logos and catalog illustration. Prefers "progressive" illustration. Needs computer-literate freelancers for design, production and presentation. 75% of freelance work demands knowledge of PageMaker, QuarkXPress, FreeHand, Illustrator or other software.

FIRST CONTACT & TERMS Send query letter with slides. Samples are not filed and are returned by SASE. Responds only if interested. To show a portfolio, mail slides. Pays for design by the hour, $10-20. Rights purchased vary according to project.

ERIC WOO DESIGN, INC.

Pacific Guardian Center, 733 Bishop St., Suite 1280, Honolulu HI 96813. (808)545-7442. **Fax:** (808)545-7445. **E-mail:** info@ericwoodesign.com. **Website:** www.ericwoodesign.com. Number of employees: 3. Approximate annual billing: $500,000. Design firm. Specializes in identities and visual branding, product packaging, print and web design, environmental graphics and signage. Majority of clients are government, corporations and nonprofits. Current clients include NOAA, Paradise Water, University of Hawaii, Western Pacific Regional Fishery Management Council, Alexander & Baldwin, Inc.

NEEDS Approached by 5-10 illustrators and 10 designers/year. Works with 1-2 illustrators/year. Prefers freelancers with experience in multimedia. Uses free-lancers mainly for multimedia projects and lettering. 5% of work is with print ads. 90% of design demands skills in Photoshop, Illustrator, Quark, Flash, Dreamweaver and InDesign.

FIRST CONTACT & TERMS Designers: Send query letter with web link. Illustrators: Send postcard sample of work or web link. Pays for design by the hour, $20-50. Pays for illustration by the project. Rights purchased vary according to project.

TIPS "Have a good sense of humor and enjoy life."

YASVIN DESIGNERS

P.O. Box 116, Hancock NH 03449. (603)525-3000. **Fax:** (603)525-3300. **E-mail:** info@yasvin.com. **Website:** yasvin.com. **Contact:** Creative director. Estab. 1990. Number of employees: 3. Specializes in annual reports, brand and corporate identity, package design and advertising. Clients: corporations, colleges and institutions.

NEEDS Approached by 10-15 freelancers/year. Works with 6 freelance illustrators and 2 designers/year. Uses freelancers for book production, brochure illustration, logos. 50% of freelance work demands knowledge of Illustrator, InDesign, Photoshop or QuarkXPress.

FIRST CONTACT & TERMS Send postcard sample of work or send query letter with photocopies, SASE and tearsheets. Samples are filed. Responds only if interested. Request portfolio review in original query. Portfolio should include b&w and color photocopies, roughs and tearsheets. Pays for design by the project and by the day. Pays for work by the project. Rights purchased vary according to project. Finds artists through sourcebooks and artists' submissions.

SPENCER ZAHN & ASSOCIATES

2015 Sansom St., Philadelphia PA 19103. (215)564-5979. **Fax:** (215)564-6285. **E-mail:** szahn@erols.com. **Contact:** Spencer Zahn, CEO; Brian Zahn, business manager; J. McCarthy, art director. Estab. 1970. Member of GPCC. Three employees. Specializes in brand and corporate identity, direct mail design, marketing, retail and business to business advertising. P.O.S. Clients: corporations, manufacturers, etc. Firm specializes in direct mail, electronic collateral, print ads.

NEEDS Works with freelance illustrators and designers. Prefers artists with experience in Macintosh computers. Uses freelancers for design and illustration; direct mail design; and mechanicals. Needs computer-literate freelancers for design, illustration and produc-

tion. 80% of freelance work demands knowledge of Illustrator, Photoshop, FreeHand and QuarkXPress.

FIRST CONTACT & TERMS Send query letter with samples. Samples are not filed and are returned by SASE if requested by artist. Responds only if interested. Artist should follow up with call. Portfolio should include final art and printed samples. Buys all rights.

ZUNPARTNERS, INC.

676 N. La Salle Dr., Suite 426, Chicago IL 60654. (312)951-5533. **E-mail:** bill.ferdinand@zunpartners. com. **Website:** www.zunpartners.com. **Contact:** William Ferdinand, partner. Estab. 1991. Number of employees: 9. Specializes in annual reports, brand and corporate identity, capability brochures, package and publication design, electronic and interactive. Clients: from Fortune 500 to Internet startup companies, focusing on high impact service firms. Current clients include Deloitte, Baker and McKenzie, Bracewell and Giuliani. Client list available upon request. Professional affiliations: AIGA, ACD, LMA.

NEEDS Approached by 30 freelancers/year. Works with 10-15 freelance illustrators and 15-20 designers/year. Looks for strong personal style (local and national). Uses illustrators mainly for editorial. Uses designers mainly for design and layout. Also uses freelancers for collateral and identity design, illustration; Web, video, audiovisual materials; direct mail, magazine design and lettering; logos; and retouching. Needs computer-literate freelancers for design, illustration, production and presentation. 90% of freelance work demands knowledge of Illustrator, Photoshop, InDesign.

FIRST CONTACT & TERMS Send postcard sample of work or send query letter with brochure or résumé. Samples are filed. Responds only if interested. Portfolios may be dropped off every Friday. Artist should follow up. Portfolio should include b&w and color samples. Pays for design by the hour and by the project. Pays for illustration by the project. Rights purchased vary according to project. Finds artists through reference books and submissions.

TIPS Impressed by "to the point portfolios. Show me what you like to do and what you brought to the projects you worked on. Don't fill a book with extra items (samples) for the sake of showing quantity."

SYNDICATES & CARTOON FEATURES

Syndicates are agents who sell comic strips, panels, and editorial cartoons to newspapers and magazines. If you want to see your comic strip in the funny papers, you must first get the attention of a syndicate. They promote and distribute comic strips and other features in exchange for a cut of the profits.

The syndicate business is one of the hardest markets to break into. Newspapers are reluctant to drop long-established strips for new ones. Consequently, spaces for new strips do not open up often. When they do, syndicates look for a "sure thing," a feature they'll feel comfortable investing more than $25,000 in for promotion and marketing. Even after syndication, much of your promotion will be up to you.

To crack this market, you have to be more than a fabulous cartoonist—the art won't sell if the idea isn't there in the first place. Work worthy of syndication must be original, salable, and timely, and characters must have universal appeal to attract a diverse audience.

Although newspaper syndication is still the most popular and profitable method of getting your comic strip to a wide audience, the Internet has become an exciting new venue for comic strips and political cartoons. With the click of your mouse, you can be introduced to *The Boiling Point* by Mikhaela Reid, *Overboard* by Chip Dunham, and *Strange Brew* by John Deering. (GoComics.com provides a great list of online comics.)

Such sites may not make much money for cartoonists, but it's clear they are a great promotional tool. It is rumored that scouts for the major syndicates have been known to surf the more popular comic strip sites in search of fresh voices.

HOW TO SUBMIT TO SYNDICATES

Each syndicate has a preferred method for submissions, and most have guidelines you can send for or access online. Availability is indicated in the listings.

To submit a strip idea, send a brief cover letter (fifty words or less is ideal) summarizing your idea, along with a character sheet (the names and descriptions of your major characters), and photocopies of twenty-four of your best strip samples on 8½×11 paper, six daily strips per page. Sending at least one month of samples shows that you're capable of producing consistent artwork and a long-lasting idea. Never submit originals; always send photocopies of your work. Simultaneous submissions are usually acceptable. It is often possible to query syndicates online, by attaching art files or links to your website. Response time can take several months. Syndicates understand it would be impractical for you to wait for replies before submitting your ideas to other syndicates.

Editorial cartoons

If you're an editorial cartoonist, you'll need to start out selling your cartoons to a base newspaper (probably in your hometown) and build up some clips before approaching a syndicate. Submitting published clips proves to the syndicate that you have a following and are able to produce cartoons on a regular basis. Once you've built up a good collection of clips, submit at least twelve photocopied samples of your published work along with a brief cover letter.

Payment and contracts

If you're one of the lucky few to be picked up by a syndicate, your earnings will depend on the number of publications in which your work appears. It takes a minimum of about sixty interested newspapers to make it profitable for a syndicate to distribute a strip. A top strip such as *Garfield* may be in as many as 2,500 papers worldwide.

Newspapers pay in the area of $10–15 a week for a daily feature. If that doesn't sound like much, multiply that figure by 100 or even 1,000 newspapers. Your payment will be a percentage of gross or net receipts. Contracts usually involve a 50/50 split between the syndicate and cartoonist. Check the listings for more specific payment information.

Before signing a contract, be sure you understand the terms and are comfortable with them.

Self-syndication

Self-syndicated cartoonists retain all rights to their work and keep all profits, but they also have to act as their own salespeople, sending packets to newspapers and other likely outlets. This requires developing a mailing list, promoting the strip (or panel) periodically, and developing a pricing, billing, and collections structure. If you have a knack for business and the required time and energy, this might be the route for you. Weekly suburban or alternative newspapers are the best bet here. (Daily newspapers rarely buy from self-syndicated cartoonists.)

ARTIZANS.COM

11136 - 75A St. NW, Edmonton AB T5B 2C5, Canada. (780)471-6112. **E-mail:** submissions@artizans.com. **Website:** www.artizans.com. **Contact:** Submissions editor. Estab. 1998. Artist agency and syndicate providing commissioned artwork, stock illustrations, political cartoons, gag cartoons, global caricatures and humorous illustrations to magazines, newspapers, websites, corporate and trade publications and ad agencies. Artists represented include Jan Op De Beeck, Chris Wildt, Aaron Bacall and Dusan Petricic. **NEEDS** Works with 30-40 artists/year. Buys 30-40 features/year. Needs single-image gag cartoons, political cartoons, illustrations and graphic art. Prefers professional artists with track records who create artwork regularly, and artists who have archived work or a series of existing cartoons, caricatures or illustrations. "We are not looking for strips or panels that rely on a continuing theme."

FIRST CONTACT & TERMS Submission guidelines available online.

CITY NEWS SERVICE LLC

P.O. Box 39, Willow Springs MO 65793. (417)469-4476. **E-mail:** cns@cnsus.org. **Website:** www.cnsus.org. Estab. 1969. Editorial service providing editorial and graphic packages for magazines.

NEEDS Buys from 12 or more freelance artists/year. Considers caricatures, editorial cartoons, and tax and business subjects as themes; considers b&w line drawings and shading film.

FIRST CONTACT & TERMS Send query letter with résumé, tearsheets or photocopies. Samples should contain business subjects. "Send 5 or more b&w line drawings, color drawings, shading film or good line-drawing editorial cartoons." Does not want to see comic strips. Samples not filed are returned by SASE. Responds in 4-6 weeks. To show a portfolio, mail tearsheets or photostats. Pays 50% of net proceeds; pays flat fee of $25 minimum. "We may buy art outright or split percentage of sales."

TIPS "We have the markets for multiple sales of editorial support art. We need talented artists to supply specific projects. We will work with beginning artists. Be honest about talent and artistic ability. If it isn't there, don't beat your head against the wall."

CONTINENTAL FEATURES/CONTINENTAL NEWS SERVICE

501 W. Broadway, P.M.B #265, Plaza A, San Diego CA 92101-3802. (858)492-8696. **E-mail:** continentalnewsservice@yahoo.com. **Website:** www.continentalnewsservice.com. **Contact:** Gary P. Salamone, editor-in-chief. Estab. 1981. Syndicate serving 3 outlets—house publication, publishing business, and the general public—through the Continental Newstime general interest news magazine. Features include Portfolio, a collection of cartoon and caricature art. Guidelines available for #10 SASE with first-class postage.

NEEDS Approached by up to 200 cartoonists/year. Number of new strips introduced each year varies. Considers comic strips and gag cartoons. Does not consider highly abstract, computer-produced or stick-figure art. Prefers single-panel with gagline. Maximum size of artwork: 8×10; must be reducible to 65% of original size.

FIRST CONTACT & TERMS Sample package should include cover letter and photocopies (10-15 samples). Samples are filed or are returned by SASE if requested by artist. Responds in 1 month, if interested or if SASE is received. To show portfolio, mail photocopies and cover letter. Pays 70% of gross income on publication. Rights purchased vary according to project. Minimum length of contract is 1 year. The artist owns the original art and the characters.

TIPS "We need single-panel cartoons and comic strips appropriate for English-speaking international audience, including cartoons that communicate feelings or predicaments, without words. Do not send samples reflecting the highs and lows and different stages of your artistic development. CF/CNS wants to see consistency and quality, so you'll need to send your best samples."

CREATORS SYNDICATE, INC.

5777 W. Century Blvd., Suite 700, Los Angeles CA 90045. (310)337-7003. **Fax:** (310)337-7625. **E-mail:** info@creators.com. **Website:** www.creators.com. Estab. 1987. Serves 2,400 daily newspapers, weekly and monthly magazines worldwide.

NEEDS Syndicates 100 writers and artists/year. Considers comic strips, caricatures, editorial or political cartoons and "all types of newspaper columns." Recent introductions: *Speedbump* by Dave Coverly; *Strange Brew* by John Deering.

FIRST CONTACT & TERMS Submission guidelines available online. "No submissions via e-mail! Do not send original art!"

KING FEATURES SYNDICATE

St. Tower, 300 W. 57th St., 15th Floor, New York NY 10019. **Website:** www.kingfeatures.com. **Contact:** Submissions editor.

FIRST CONTACT & TERMS Send (1): A cover letter that briefly outlines the overall nature of your comic strip. Your letter should include your full name, address and telephone number and shouldn't be much longer than a single page. (2): 24 b&w daily comic strips. You should reduce your comics to fit onto standard 8½×11 sheets of paper. Write your name, address and phone number on each page. Do not send your original drawings! Send photocopies instead. (3): A character sheet that shows your major characters (if any) along with their names and a paragraph description of each. "We do not accept work submitted via the Internet or on disk. Due to the extremely high volume of submissions we receive, it is easiest for us to receive, track, and account for the work if everything is sent in via regular mail or courier in the format described above. King Features is one of the world's largest syndicates. Each year, it gets more than 5,000 submissions of which three are chosen for syndication."

TIPS "The single best way of improving your chances for success is to practice. Only by drawing and writing cartoons do you get better at it. Invariably, the cartoonists whose work we like best turns out to be those who draw and write cartoons regularly, whether anyone sees their work or not. Another key to success it to read a lot. Read all sorts of things—fiction, magazines and newspapers. Humor is based on real life. The more you know about life, the more you have to humorously write about. "

TRIBUNE MEDIA SERVICES, INC.

435 N. Michigan Ave., Suite 1500, Chicago IL 60611. (312)222-4444. **Fax:** (312)222-2581. **Website:** www. comicspage.com. **Contact:** Tracy Clark, associate editor. Syndicate serving daily domestic and international and Sunday newspapers as well as weeklies and new media services. Strips syndicated include *Broom-Hilda, Dick Tracy, Brenda Starr* and *Helen, Sweetheart of the Internet.* "All are original comic strips, visually appealing with excellent gags." Art guidelines available on website or for SASE with first-class postage.

Tribune Media Services is a leading provider of Internet and electronic publishing content, including the WebPoint Internet Service.

NEEDS Seeks comic strips and newspaper panels, puzzles and word games. Recent introductions include *Cats With Hands* by Joe Martin; *Dunagin's People* by Ralph Dunagin. Prefers original comic ideas, with excellent art and timely, funny gags; original art styles; inventive concepts; crisp, funny humor and dialogue.

FIRST CONTACT & TERMS Send query letter with résumé and photocopies. Sample package should include 4-6 weeks of daily strips or panels. Send 8½×11 copies of material, not originals. "Interactive submissions invited." Samples not filed are returned only if SASE is enclosed. Responds in 2 months. Pays 50% of net proceeds.

TIPS "Comics with recurring characters should include a character sheet and descriptions. If there are similar comics in the marketplace, acknowledge them and describe why yours is different."

UNITED FEATURE SYNDICATE/ NEWSPAPER ENTERPRISE ASSOCIATION

200 Madison Ave., 4th Floor, New York NY 10016. (212)293-8500. **E-mail:** upssubmissions@unitedmedia.com. **Website:** www.unitedfeatures.com. **Contact:** Submissions editor. Estab. 1902. Syndicate serving 2,500 daily and weekly newspapers.

See also listing for parent company, United Media, in this section.

NEEDS Approached by 5,000 cartoonists/year. Buys 2-3 cartoons/year. Introduces 2-3 new strips/year. Strips introduced include *Dilbert, Luann* and *Over the Hedge.* Considers comic strips, editorial/political cartoons and panel cartoons.

FIRST CONTACT & TERMS Submission guidelines available online.

TIPS "No oversize packages, please."

UNITED MEDIA

200 Madison Ave., New York NY 10016. (212)293-8500. **E-mail:** submissions@unitedmedia.com. **Website:** www.unitedfeatures.com. **Contact:** Submissions editor. Estab. 1978. Syndicate servicing U.S. and international newspapers. "United Media consists of United Feature Syndicate and Newspaper Enterprise Association. Submissions are considered for both syndicates. Duplicate submissions are not needed." Guidelines available online.

○ See also listing for United Feature Syndicate/ Newspaper Enterprise Association in this section.

NEEDS Introduces 2-4 new strips/year. Considers comic strips and single, double and multiple panels. Prefers pen & ink.

FIRST CONTACT & TERMS Send cover letter, résumé, finished cartoons and photocopies. Include 36 dailies; "Sundays not needed in first submissions." Do not send "oversize submissions or concepts without strips." Samples are not filed and are returned by SASE. Responds in 3 months. Payment varies by contract. Buys all rights.

TIPS "Send copies, but not originals. Do not send mocked-up licensing concepts." Looks for "originality, art and humor writing. Be aware of long odds; don't quit your day job. Work on developing your own style and humor writing. Worry less about 'marketability'—that's our job."

UNIVERSAL PRESS SYNDICATE

1130 Walnut St., Kansas City MO 64106. (816)581-7300. **E-mail:** jglynn@amuniversal.com. **E-mail:** upssubmissions@amuniversal.com. **Website:** www.amuniversal.com/ups. **Contact:** John Glynn, acquisition editor. Largest independent newspaper and licensed property syndicate in the world, serving 2,750 daily and weekly newspapers. Submission guidelines available on website.

○ See also listing for Uclick (Universal's digital/ online division) in this section.

NEEDS Considers single-, double- or multiple-panel cartoons and comic strips; b&w and color. Requests photocopies of b&w, pen & ink, line drawings.

FIRST CONTACT & TERMS Send query letter with 4-6 weeks of samples. Include SASE for return of material. Do not send originals. Responds in 6-8 weeks. Pays on publication. Payment and rights are negotiated.

TIPS "Be original. Don't be afraid to try some new idea or technique. Don't be discouraged by rejection letters. Universal Press receives 100-150 comic submissions a week and only takes on two or three a year, so keep plugging away. Talent has a way of rising to the top."

UNIVERSAL UCLICK

1130 Walnut St., Kansas City MO 64106. **E-mail:** upssubmissions@amuniversal.com. **Website:** universaluclick.com. **Contact:** Acquisitions. Estab. 1970. Print

and online syndicate serving over 300 online clients daily. Art guidelines available on website.

NEEDS Approached by 200 cartoonists and 50 illustrators/year. Introduces about 15 new strips/year. Recent introductions include *Thatababy, Dark Side of the Horse, Rabbits Against Magic*. Considers caricatures, single- or multi-panel cartoons, comic strips, puzzles/ games. Looking for conservative political cartoons; unique puzzles, games and quizzes.

FIRST CONTACT & TERMS Send cover letter, character sheets and finished cartoons. Prefers to see 2 weeks worth of samples. Samples are not filed and are returned by SASE if requested by artist. Responds in 6-8 weeks. Will contact artist for portfolio review if interested. Pays on publication. "Royalties are based on negotiated rates, fees or licenses depending on content and distribution channels." Rights are negotiated. Artist owns original art and characters. Minimum length of contract: 3-year term is preferred; offers automatic renewal.

WASHINGTON POST WRITERS GROUP

1150 15th St., NW, Washington DC 20071. (202)334-6375; (800)879-9794, ext. 2. **E-mail:** cartoonsubmission@washpost.com. **Website:** www.postwritersgroup.com. **Contact:** Comics editor. Estab. 1973. Syndicate serving over 1,000 daily, Sunday and weekly newspapers in U.S. and abroad. Submission guidelines available on website or for SASE with necessary postage.

NEEDS Considers comic strips, panel and editorial cartoons.

FIRST CONTACT & TERMS Send at least 24 cartoons. "You do not need to send color or Sunday cartoons in your initial submission; we will ask for those later if we require them. Of course if you do include color work, we are happy to review it." No fax submissions. Include SASE for reply only; cannot return materials. Submissions without SASE will not receive a reply. Responds in about 6 weeks whenever possible. Can submit by e-mail, but only if you can send it as a multi-page PDF with at least 2 dailies to a page.

TIPS "Use letter-sized paper for your submission. Make sure cartoons will reduce to standard sizes. Send only copies; never send originals."

ARTISTS' REPRESENTATIVES

Many artists find leaving promotion to a rep allows them more time for the creative process. In exchange for actively promoting an artist's career, the representative receives a percentage of sales (usually 25–30 percent). Reps generally focus on either the fine art market or commercial market, rarely both.

Fine art reps promote the work of fine artists, sculptors, craftspeople, and fine art photographers to galleries, museums, corporate art collectors, interior designers, and art publishers. Commercial reps help illustrators and graphic designers obtain assignments from advertising agencies, publishers, magazines, and other buyers. Some reps also act as licensing agents.

What reps do

Reps work with artists to bring their portfolios up to speed and actively promote their work to clients. Usually a rep will recommend advertising in one of the many creative directories such as *American Showcase* or *Workbook* so that your work will be seen by hundreds of art directors. (Expect to make an initial investment in costs for duplicate portfolios and mailings.) Reps also negotiate contracts, handle billing and collect payments.

Getting representation isn't as easy as you might think. Reps are choosy about who they represent—not just in terms of talent but also in terms of marketability and professionalism. Reps will only take on talent they know will sell.

What to send

Once you've gone through the listings in this section and compiled a list of art reps who handle your type and style of work, contact them with a brief query letter and nonreturnable copies of your work. Check each listing for specific guidelines and requirements.

AMERICAN ARTISTS REP., INC.

380 Lexington Ave., 17th Floor, New York NY 10168. (212)682-2462. **Fax:** (212)582-0090. **Website:** www. aareps.com. Estab. 1930. Commercial illustration representative. Member of SPAR. Represents 40 illustrators. Markets include advertising agencies, corporations/client direct, design firms, editorial/magazines, paper products/greeting cards, publishing/books, sales/promotion firms.

HANDLES Illustration, design.

TERMS Rep receives 30% commission. "All portfolio expenses billed to artist." Advertising costs are split: 70% paid by talent; 30% paid by representative. "Promotion is encouraged; portfolio must be presented in a professional manner—8×10, 4×5, tearsheets, etc." Advertises in *American Showcase*, *The Black Book*, *RSVP*, *Workbook*, medical and Graphic Artist Guild publications.

HOW TO CONTACT Send query letter, direct mail flyer/brochure, tearsheets. Responds in 1 week if interested. After initial contact, drop off or mail appropriate materials for review. Portfolio should include tearsheets, slides. Obtains new talent through recommendations from others, solicitation, conferences.

ARTINFORMS

Martha Productions, 7550 W. 82nd St., Playa Del Rey CA 90293. (310)670-5300. **Fax:** (310)670-3644. **E-mail:** contact@artinforms.com; contact@martha productions.com. **Website:** www.artinforms.com. **Contact:** Martha Spelman, president. Estab. 2000. Commercial illustration representative. Specializes in illustrators who create informational graphics and technical drawings, including maps, charts, diagrams, cutaways, flow charts and more.

◯ See listing for Martha Productions in this section.

ARTISAN CREATIVE, INC.

1633 Stanford St., 2nd Floor, Santa Monica CA 90404. (310)312-2062. **Fax:** (310)312-0670. **E-mail:** lainfo@ artisancreative.com. **Website:** www.artisancreative. com. Estab. 1996. Represents creative directors, art directors, graphic designers, illustrators, animators (3D and 2D), storyboarders, packaging designers, photographers, web designers, broadcast designers and flash developers. Markets include advertising agencies, corporations/client direct, design firms, entertainment industry.

◯ Additional locations in San Francisco, Chicago, New York and Indianapolis. See website for details.

HANDLES Web design, multimedia, illustration, photography and production. Looking for web, packaging, traditional and multimedia-based graphic designers.

TERMS 100% of advertising costs paid by the representative. For promotional purposes, talent must provide PDFs of work. Advertises in magazines for the trade, direct mail and the Internet.

HOW TO CONTACT For first contact, e-mail résumé to creative staffing department. "You will then be contacted if a portfolio review is needed." Portfolio should include roughs, tearsheets, photographs, or color photos of your best work.

TIPS "Have at least 2 years of working experience and a great portfolio."

ARTWORKS ILLUSTRATION

325 W. 38th St., New York NY 10018. (212)239-4946. **Fax:** (212)239-6106. **E-mail:** artworksillustration@ earthlink.net. **Website:** www.artworksillustration. com. Estab. 1990. Commercial illustration representative. Member of Society of Illustrators. Represents 30 illustrators. Specializes in publishing. Markets include advertising agencies, design firms, paper products/greeting cards, movie studios, publishing/books, sales/promotion firms, corporations/client direct, editorial/magazines, video games. Artists include Dan Brown, Dennis Lyall, Jerry Vanderstelt and Chris Cocozza.

HANDLES Illustration. Looking for interesting juvenile, digital sci-fi/fantasy & romance images.

TERMS Rep receives 30% commission. Exclusive area representation required. Advertising costs are split: 75% paid by artist; 25% paid by rep. Advertises in *American Showcase* and on www.theispot.com. *How to Contact* for first contact, send e-mail samples. Responds only if interested.

ASCIUTTO ART REPS, INC.

1712 E. Butler Circle, Chandler AZ 85225. (480)814-8010. **E-mail:** aartreps@cox.net. **Contact:** Mary Anne Asciutto, art agent. Estab. 1980. Children's illustration representative. Specializes in children's illustration for books, magazines, posters, packaging, etc. Markets include publishing/packaging/advertising.

HANDLES Illustration only.

TERMS Rep receives 25% commission. Advertising costs are split: 75% paid by talent; 25% paid by representative. For promotional purposes, talent should provide color prints or originals in an 8½×11 format. Electronic samples via e-mail or CD.

HOW TO CONTACT E-mail or send sample work with an SASE.

TIPS "Be sure to connect with an agent who handles the kind of accounts you *want*."

CAROL BANCROFT & FRIENDS

P.O. Box 2030, Danbury CT 06813. (203)730-8270 or (800)720-7020. **Fax:** (203)730-8275. **E-mail:** cb_friends8270@sbcglobal.net or cbfriends@sbcglobal.net; artists@carolbancroft.com. **Website:** www.carolbancroft.com. **Contact:** Joy Elton Tricarico, owner; Carol Bancroft, founder. Estab. 1972. Illustration representative for children's publishing. Member of Society of Illustrators, Graphic Artists Guild, SCBWI and National Art Education Association. Represents over 30 illustrators. Specializes in, but not limited to, representing artists who illustrate for children's publishing-text, trade and any children's-related material. Clients include Scholastic, Harcourt, HarperCollins, Random House, Penguin USA, Simon & Schuster. Artist list available upon request. Illustration for children of all ages.

○ "Internationally known for representing artists who specialize in illustrating art for all aspects of the children's market. We also represent many artists who are well known in other aspects of the field of illustration."

TERMS Rep receives 25% commission. Advertising costs are split: 75% paid by talent; 25% paid by representative.

HOW TO CONTACT For promotional purposes, artist should provide "web address in an e-mail or samples via mail (laser copies, not slides; tearsheets, promo pieces, books, good color photocopies, etc.); 6 pieces or more; narrative scenes with children or animals interacting." Advertises in *Picture Book* and *Directory of Illustration*. Send samples and SASE. "Artists may call no sooner than one month after sending samples."

TIPS "We look for artists who can draw animals and people with imagination and energy, depicting engaging characters with action in situational settings."

BERNSTEIN & ANDRIULLI

58 W. 40th St., 6th Floor, New York NY 10018. (212)682-1490. **Fax:** (212)286-1890. **E-mail:** info@ba-reps.com. **Website:** www.ba-reps.com. Estab. 1975. Commercial illustration and photography representative. Member of SPAR. Represents 100 illustrators, 52 photographers. Markets include advertising agencies, corporations/client direct, design firms, editorial/magazines, paper products/greeting cards, publishing/books, sales/promotion firms.

HANDLES Illustration, new media and photography.

TERMS Rep receives a commission. Exclusive career representation is required. No geographic restrictions. Advertises in *The Black Book, Workbook, Bernstein Andriulli International Illustration, CA Magazine, Archive, American Illustration/Photography*.

HOW TO CONTACT Send query e-mail with website or digital files. Call to schedule an appointment before dropping off portfolio.

JOANIE BERNSTEIN, ART REP

756 Eighth Ave. S., Naples FL 34102. (239)403-4393. **Fax:** (239)403-0066. **E-mail:** joanie@joaniebrep.com. **Website:** www.joaniebrep.com. Estab. 1984. Commercial illustration representative.

HANDLES Illustration. Looking for an unusual, problem-solving style. Clients include advertising, design, animation, books, music, product merchandising, developers, movie studios, films, private collectors.

TERMS Rep receives 25% commission. Exclusive representation required.

HOW TO CONTACT E-mail samples.

TIPS "I'd strongly advise an updated website. Also add 'What's New'—show off new work."

BLASCO CREATIVE ARTISTS

333 N. Michigan Ave., Suite 1330, Chicago IL 60601. (312)782-0244. **E-mail:** jean@blascocreative.com. **Website:** www.blascocreative.com. **Contact:** Jean Blasco. Estab. 1988. Commercial illustration and photography/CGI. Represents 35 internationally acclaimed illustrators and 4 celebrated photographers and CGI studio. Markets include advertising agencies; corporations; design firms; editorial/magazines; publishing/books; promotion and packaging. Clients include "every major player in the United States."

HANDLES Illustration. "We are receptive to reviewing samples by enthusiastic up-and-coming artists. E-mail samples and/or your website address."

TERMS Rep receives 25% commission. Exclusive area representation is preferred. For promotional purposes, talent must provide printed promotional pieces and a well organized, creative portfolio. "If your book is not ready to show, be willing to invest in a new one." Advertises in *Workbook*, *Directory of Illustration*, *Folio Planet*, www.theispot.com.

HOW TO CONTACT For first contact, send samples via e-mail, or printed materials that do not have to be returned. Responds only if interested. Obtains new talent through recommendations from art directors, referrals and submissions.

TIPS "You need to be focused in your direction and style. Be willing to create new samples. Be a team player. The agent and artist form a bond, and the goal is success. Don't let your ego get in the way. Be open to constructive criticism. If one agent turns you down, quickly move to the next name on your list."

BROWN INK GALLERY

222 E. Brinkerhoff Ave., Palisades Park NJ 07650. (201)265-7171. **Fax:** (201)461-6571. **E-mail:** robert 229artist@juno.com. **Website:** www.browninkgal lery.com. **Contact:** Bob Brown, president/owner. Estab. 1979. Digital fine art publisher and distributor. Represents 5 fine artists, 2 illustrators. Specializes in advertising, magazine editorials and book publishing, fine art. Markets include advertising agencies, corporations/client direct, design firms, editorial/magazines, galleries, movie studios, paper products/greeting cards, publishing/books, record companies, sales/promotion firms.

HANDLES Fine art, illustration, digital fine art, digital fine art printing, licensing material. Looking for professional artists who are interested in making a living with their art. Art samples and portfolio required.

TERMS Rep receives 25% commission on illustration assignment; 50% on publishing (digital publishing) after expenses. "The only fee we charge is for services rendered (scanning, proofing, printing, etc.). We pay for postage, labels and envelopes." Exclusive area representation required (only in the NY, NJ, CT region of the country). Advertising costs are paid by artist or split: 75% paid by artist; 25% paid by rep. Artists must pay for their own promotional material. For promotional purposes, talent must provide a full-color direct mail piece, an 8½×11 flexible portfolio, digital files and CD.

HOW TO CONTACT For first contact, send bio, direct mail flier/brochure, photocopies, photographs, résumé, SASE, tearsheets, slides, digital images/CD, query letter (optional). Responds only if interested. After initial contact, call to schedule an appointment, drop off or mail portfolio, or e-mail. Portfolio should include b&w and color finished art, original art, photographs, slides, tearsheets, transparencies (35mm, 4½ and 8×10).

TIPS "Be as professional as possible! Your presentation is paramount. The competition is fierce, therefore your presentation (portfolio) and art samples need to match or exceed that of the competition."

◐ CONTACT JUPITER, INC.

346 Ninth Ave., New York NY 10001-1604. (646)290-5405. **E-mail:** oliver@contactjupiter.com. **E-mail:** info@contactjupiter.com. **Website:** www.contactjupi ter.com. **Contact:** Oliver Mielenz, managing director. Estab. 1996. Commercial illustration representative. Represents 17 illustrators, 7 photographers. Specializes in publishing, children's books, magazines, advertising. Licenses illustrators, photographers. Markets include advertising agencies, paper products/greeting cards, record companies, publishing/books, corporations/client direct, editorial/magazines.

HANDLES Illustration, multimedia, music, photography, design.

TERMS Rep receives 15-25% and rep fee. Advertising costs are split: 90% paid by artist; 10% paid by rep. Exclusive representation required. For promotional purposes, talent must provide electronic art samples only. Advertises in *Directory of Illustration*.

HOW TO CONTACT Send query by e-mail with several low-res JPEGs, along with your information, target markets and experiences. "If we think you've got what we need, we'll be in touch."

TIPS "One specific style is easier to sell. Focus, focus, focus. Initiative, I find, is very important in an artist."

CORNELL & MCCARTHY LLC

2-D Cross Highway, Westport CT 06880. (203)454-4210. **Fax:** (203)454-4258. **E-mail:** contact@cmart reps.com. **Website:** www.cmartreps.com. **Contact:** Merial Cornell. Estab. 1989. Children's book illustration representative. Member of SCBWI and Graphic Artists Guild. Represents 30 illustrators. Specializes in children's books: trade, mass market, educational. **HANDLES** Illustration.

TERMS Agent receives 25% commission. Advertising costs are split: 75% paid by talent; 25% paid by representative. For promotional purposes, talent must provide 10-12 strong portfolio pieces relating to children's publishing.

HOW TO CONTACT For first contact, send query letter, direct mail flier/brochure, tearsheets, photocopies and SASE. Or e-mail samples. Responds in 1 month. Obtains new talent through recommendations, solicitation, conferences.

TIPS "Work hard on your portfolio."

CWC INTERNATIONAL, INC.

611 Broadway, Suite 730, New York NY 10012. (646)486-6586. **Fax:** (646)486-7622. **E-mail:** agent@cwc-i.com. **E-mail:** contact@cwc-i.com. **Website:** www.cwc-i.com. Estab. 1999. Commercial illustration representative. Represents 23 illustrators. Specializes in advertising, fashion. Markets include advertising agencies, corporations/client direct, design firms, editorial/magazines, galleries, paper products/greeting cards, publishing/books, record companies. Artists include Jeffrey Fulvimari, Stina Persson, Chris Long and Kenzo Minami.

HANDLES Fine art, illustration.

TERMS Exclusive area representation required.

HOW TO CONTACT Submission guidelines available online.

TIPS "Please do not call. When sending any image samples by e-mail, be sure the entire file will not exceed 300K."

LINDA DE MORETA REPRESENTS

1511 Union St., Alameda CA 94501. (510)769-1421. **Fax:** (419)710-8298. **E-mail:** linda@lindareps.com. **Website:** www.lindareps.com. Estab. 1988. Commercial illustration, calligraphy/handlettering and storyboards/comps representative. Represents 10 illustrators, 2 photographers. Markets include advertising agencies; design firms; corporations/client direct; editorial/magazines; paper products/greeting cards; publishing/books. Represents Chuck Pyle, Pete McDonnell, Monica Dengo, John Howell, Shannon Abbey, Craig Hannah, Shan O'Neill, Ron Miller, and Doves.

HANDLES Photography, illustration, lettering/title design, storyboards/comps.

TERMS Commission, exclusive representation requirements and advertising costs are according to individual agreements. Materials for promotional purposes vary with each artist. Advertises in *Workbook*, *Directory of Illustration*.

HOW TO CONTACT For first contact, e-mail samples or link to website; or send direct mail flier/brochure. "Please do *not* send original art. Include SASE for any items you wish returned." Responds to any inquiry in which there is an interest. Portfolios are individually developed for each artist.

TIPS Obtains new talent through client and artist referrals primarily, some solicitation. "We look for great creativity, a personal vision and style combined with professionalism, and passion."

THE DESKTOP GROUP

420 Lexington Ave., 21st Floor, New York NY 10170. (212)490-7400. **Fax:** (212)867-1759. **E-mail:** info@tempositions.com. **Website:** www.thedesktopgroup.com. Estab. 1991. Specializes in recruiting and placing creative talent on a freelance basis. Markets include advertising agencies, design firms, publishers (book and magazine), corporations, and banking/financial firms.

HANDLES Artists with Mac and Windows software and multimedia expertise—graphic designers, production artists, pre-press technicians, presentation specialists, traffickers, art directors, Web designers, content developers, project managers, copywriters, and proofreaders.

HOW TO CONTACT For first contact, e-mail résumé, cover letter and work samples.

TIPS "Our clients prefer working with talented artists who have flexible, easy-going personalities and who are very professional."

LIBBY FORD ARTIST REPRESENTATIVE

320 E. 57th St. 10B, New York NY 10022. (212)935-8068. **Website:** www.libbyford.com. Represents over 45 illustrators. Specializes in children's trade books, young adult and educational markets.

TERMS Portfolios samples should be sent electronically. Will contact you for additional materials.

ROBERT GALITZ FINE ART & ACCENT ART

166 Hilltop Court, Sleepy Hollow IL 60118. (847)426-8842. **Fax:** (847)426-8846. **E-mail:** robert@galitzfineart.com. **Website:** www.galitzfineart.com. **Contact:** Robert Galitz, owner. Estab. 1985. Fine art representative. Represents 100 fine artists (including 2 sculptors). Specializes in contemporary/abstract corporate art. Markets include architects, corporate collections, galleries, interior decorators, private col-

lections. Represents Roland Poska, Jan Pozzi, Diane Bartz and Louis De Mayo.

HANDLES Fine art.

TERMS Agent receives 25-40% commission. No geographic restrictions; sells mainly in Chicago, Wisconsin, Indiana and Kentucky. For promotional purposes, talent must provide "good photos and slides." Advertises in monthly art publications and guides.

HOW TO CONTACT Send query letter, slides, photographs. Responds in 2 weeks. After initial contact, call for appointment to show portfolio of original art. Obtains new talent through recommendations from others, solicitation, conferences.

TIPS "Be confident and persistent. Never give up or quit."

GRAHAM-CAMERON ILLUSTRATION
The Studio, 23 Holt Rd., Sheringham, Norfolk NR26 8NG, United Kingdom. +44(0)1263 821333. **Fax:** +44(0)1263 821334. **E-mail:** enquiry@gciforillustration.com. **Website:** www.gciforillustration.com. **Contact:** Helen Graham-Cameron, art director. Estab. 1985. Commercial illustration representative. Represents 45 illustrators. Agency specializes in Childrens' and Educational Illustration. Markets include designer firms and publishing/books.

HANDLES Illustration.

TERMS Rep receives 30% standard commission. Exclusive representation required. Advertising costs are 100% paid by representative. May occasionally be asked to supply an illustration to representative's brief.

HOW TO CONTACT For first contact, talent should send link to website. Responds in 3 months.

TIPS Obtains new talent through submissions.

ANITA GRIEN REPRESENTING ARTISTS
155 E. 38th St., New York NY 10016. (212)697-6170; (917)494-3826 (cell). **Fax:** (212)697-6177. **E-mail:** anita@anitagrien.com. **Website:** www.anitagrien.com. Representative not currently seeking new talent.

CAROL GUENZI AGENTS, INC.
865 Delaware St., Denver CO 80204. (303)820-2599. **E-mail:** carol@artagent.com. **Website:** www.artagent.com. **Contact:** Carol Guenzi, president. Estab. 1984. Commercial illustration, photography, new media and film/animation representative. Represents 30 illustrators, 6 photographers, 4 film/animation developers, and 3 multimedia developers, copywriter. Specializes in a "worldwide selection of talent in all areas of visual communications." Markets include advertising agencies, corporations/client direct, design firms, editorial/magazines, paper products/greeting cards, sales/promotions firms. Clients: Coors, Celestial Seasonings, Audi, Northface, Whole Foods, Western Union, Gambro, Vicorp, Miller, Coca-Cola, Bacardi, First Data, Quiznos, etc. Client list available upon request. Represents Christer Eriksson, Bruce Hutchison, Juan Alvarez, Jeff Pollard, Kelly Hume, Capstone Studios and many more; Illustration, photography. Looking for "unique style application."

TERMS Rep receives 25-30% commission. Exclusive area representation is required. Advertising costs are split: 70-75% paid by talent; 25-30% paid by rep. For promotional purposes, talent must provide "promotional material; some restrictions on portfolios." Advertises in Directory of Illustration, Workbook, social marketing.

HOW TO CONTACT For first contact, e-mail PDFs or JPEGs with link to URL, or send direct mail flier/brochure. Responds only if interested. E-mail or call for phone appointment or mail in appropriate materials for review. Portfolio should include promotional material or electronic files. Obtains new talent through solicitation, art directors' referrals, and active pursuit by individual artists.

TIPS "Show your strongest style and have at least 12 samples of that style before introducing all your capabilities. Be prepared to add additional work to your portfolio to help round out your style. Have a digital background."

PAT HACKETT/ARTIST REP
7014 N. Mercer Way, Mercer Island WA 98040-2130. (206)447-1600. **Fax:** (206)447-0739. **E-mail:** pat@pathackett.com. **Website:** www.pathackett.com. **Contact:** Pat Hacket. Estab. 1979. Commercial illustration and photography representative. Represents 12 illustrators, 1 photographer. Markets include advertising agencies; corporations/client direct; design firms; editorial/magazines.

HANDLES Illustration and photography.

TERMS Rep receives 25-33% commission. Advertising costs are split: 75% paid by talent; 25% paid by representative. For promotional purposes, talent must provide "standardized portfolio, i.e., all pieces within the book are the same format. Reprints are nice, but not absolutely required." Advertises in *Showcase*, *Workbook*, and on www.theispot.com and www.portfolios.com.

HOW TO CONTACT For first contact, send direct mail flier/brochure. Responds in 1 week, only if interested. After initial contact, drop off or mail in appropriate materials—tearsheets, slides, photographs, photostats, photocopies. Obtains new talent through "recommendations and calls/letters."

TIPS Looks for "experience in the *commercial* art world, professional presentation in both portfolio and person, cooperative attitude and enthusiasm."

HOLLY HAHN & CO.

1852 W. Greenleaf, Chicago IL 60626. (312)371-0500. **E-mail:** holly@hollyhahn.com. **Website:** www.hollyhahn.com. Estab. 1988. Commercial illustration and photography representative.

HANDLES Illustration, photography.

HOW TO CONTACT Send direct mail flier/brochure and tearsheets.

BARB HAUSER, ANOTHER GIRL REP

(415)642-4297. **E-mail:** barb@girlrep.com. **Website:** www.girlrep.com. Estab. 1980. Represents 8 illustrators. Markets include primarily advertising agencies and design firms; corporations/client direct.

HANDLES Illustration and design only. No photography.

HOW TO CONTACT *Is not accepting new talent.*

HERMAN AGENCY

350 Central Park West, New York NY 10025. (212)749-4907. **E-mail:** Ronnie@HermanAgencyInc.com. **Website:** www.hermanagencyinc.com. Estab. 1999. Represents authors and illustrators for children's book market. Member of SCBWI, Graphic Artists Guild and Authors' Guild. Some of the illustrators represented: Joy Allen, Seymour Chwast, Troy Cummings, Barry Gott, Jago, Gideon Kendall, Ana Martin Larranaga, Mike Lester, John Nez, Michael Rex, Richard Torrey, Deborah Zemke. Currently not accepting new clients unless they have been successfully published by major trade publishing houses.

HANDLES Illustration. Looking for artists with strong history of publishing in the children's market.

TERMS Artists pay 75% of costs for promotional material, about $200 a year. Offers written contract. Advertising costs are split: 75% paid by illustrator; 25% paid by rep.

HOW TO CONTACT For first contact, e-mail only. Responds in 4-6 weeks. For first contact, artists or author/artists should e-mail a link to their website with bio and list of published books as well as new picture book manuscript or dummy to Ronnie or Katia. We will contact you in a month only if your samples are right for us. For first contact, authors of middle-grade or YA should e-mail bio, list of published books and first ten pages to Jill Corcoran. Jill will contact you within a month if she is interested in seeing more of your manuscript. Finds illustrators and authors through recommendations from others, conferences, queries/solicitations.

TIPS "Check our website to see if you belong with our agency."

SCOTT HULL ASSOCIATES

1430 Clear Springs Ct., Dayton OH 45458. (937)433-8383. **Fax:** (937)433-0434. **E-mail:** scott@scotthull.com. **Website:** www.scotthull.com. **Contact:** Scott Hull. Estab. 1981. Specialized illustration representative. Represents 25+ illustrators.

HOW TO CONTACT Send e-mail samples or appropriate materials for review. No original art. Follow up with e-mail. Responds in one week.

TIPS Looks for interesting talent with a passion to grow, as well as strong in-depth portfolio.

ICON ART REPS

Martha Productions, 7550 W. 82nd St., Playa Del Rey CA 90293. (310)670-5300. **E-mail:** contact@marthaproductions.com. **Website:** www.iconartreps.com. **Contact:** Martha Spelman, president. Estab. 1998. Commercial illustration representative. "We always welcome submissions from illustrators considering representation. Please e-mail us a few small digital files of your work. We will contact you if we think we would be able to sell your work or if we'd like to see more." Specializes in artists doing character design and development for advertising, promotion, publishing and licensed products.

THE INTERMARKETING GROUP

29 Holt Rd., Amherst NH 03031. (603)672-0499. **Contact:** Linda Gerson, president. Estab. 1985. Art licensing agency. Represents 8 illustrators. Licenses fine artists, commercial artists, illustrators. Markets include paper products/greeting cards, giftware, home decor products, tabletop, housewares, needlearts and all consumer product applications of art. Artists include Tracy Flickinger, Marilee Carroll, Kate Beetle, Janet Amendola, Cheryl Welch, Loren Guttormson, Natalie Buriak Susanne Rothwell.

◯ See additional listing in the Greeting Cards, Gifts & Products section.

HANDLES Fine art, illustration.

TERMS Will discuss terms of representation directly with the artists of interest. Advertising costs are paid by the artist. For promotional purposes, talent must provide color copies, biography.

HOW TO CONTACT For first contact, send query letter with bio, direct mail flier/brochure, photocopies, SASE, tearsheets, "a good representation of your work in color." Responds in 3 weeks. Will contact artist for portfolio review if interested. Portfolio should include color tearsheets.

TIPS "Present your work in an organized way. Send the kind of work you enjoy doing and that is the most representative of your style."

VINCENT KAMIN & ASSOCIATES

(312)685-8834. **E-mail:** vincekamin@att.net. **Website:** www.vincekamin.com. Estab. 1971. Commercial photography, graphic design representative. Member of SPAR. Represents 6 illustrators, 6 photographers, 1 designer, 1 fine artist (includes 1 sculptor). Markets include advertising agencies.

HANDLES Illustration, photography.

TERMS Rep receives 30% commission. Advertising costs are split: 90% paid by talent; 10% paid by representative. Advertises in *Workbook* and *Chicago Directory*.

HOW TO CONTACT Send tearsheets. Responds in 10 days. After initial contact, call to schedule an appointment. Portfolio should include tearsheets.

CLIFF KNECHT—ARTIST REPRESENTATIVE

309 Walnut Rd., Pittsburgh PA 15202. (412)761-5666. **Fax:** (412)894-8175. **E-mail:** cliff@artrep1.com. **Website:** www.artrep1.com. **Contact:** Cliff Knecht. Estab. 1972. Commercial illustration representative. Represents more than 20 illustrators. Markets include advertising agencies, corporations/client direct, design firms, editorial/magazines, paper products/greeting cards, publishing/books, sales/promotion firms.

HANDLES Illustration.

TERMS Rep receives 25% commission. No geographic restrictions. Advertising costs are split: 75% paid by the talent; 25% paid by representative. For promotional purposes, talent must provide a direct mail piece. Advertises in *Graphic Artists Guild Directory of Illustration.*

HOW TO CONTACT Send résumé, direct mail flier/brochure, tearsheets, and send JPEG samples by e-mail. Responds in 1 week. After initial contact, call

for appointment to show portfolio of original art, tearsheets, slides, photographs. Obtains new talent directly or through recommendations from others.

SHARON KURLANSKY ASSOCIATES

192 Southville Rd., Southborough MA 01772. (508)460-6058. **Fax:** (508)480-9221. **E-mail:** sharon@laughing-stock.com. **Website:** www.laughing-stock.com. **Contact:** Sharon Kurlansky. Estab. 1978. Commercial illustration representative. Represents illustrators. Clients: advertising agencies; corporations/client direct; design firms; editorial/magazines; paper products/greeting cards; publishing/books; sales/promotion firms. Client list available upon request. Represents Tim Lewis, Blair Thornley, and Ronald Slabbers. Licenses stock illustration for 150 illustrators at www.laughing-stock.com in all markets.

HANDLES Illustration.

TERMS Rep receives 25% commission. Exclusive area representation is required. Advertising costs are split: 75% paid by talent; 25% paid by representative. "Will develop promotional materials with talent. Portfolio presentation formatted and developed with talent also."

HOW TO CONTACT For first contact, send direct mail flier/brochure, tearsheets, slides and SASE or e-mail with website address/online portfolio. Responds in 1 month if interested. After initial contact, call for appointment to show portfolio of tearsheets, photocopies.

CRISTOPHER LAPP—STILL & MOVING IMAGES

1211 Sunset Plaza Dr., Suite 413, Los Angeles CA 90069. (310)612-0040. **Fax:** (310)943-3793. **E-mail:** cristopherlapp.photo@gmail.com. **Website:** www.cristopherlapp.com. **Contact:** Cristopher Lapp. Estab. 1994. Specializes in canvas transfers, fine art prints, hand-pulled originals, limited edition.

HANDLES Decorative art, fashionable art, commercial and designer marketing. Clients include: Posner Fine Art, Gilanyi, Inc., Jordan Designs.

TERMS Keeps samples on file.

HOW TO CONTACT Send an e-mail inquiry.

MAGNET REPS

1783 S. Crescent Heights Blvd., Los Angeles CA 90035. **E-mail:** art@magnetreps.com. **Website:** www.magnetreps.com. Estab. 1998. Commercial illustration and art licensing agency. Represents 18 illustrators. Clients: advertising agencies, corporations/client di-

rect, design firms, editorial/magazines, movie studios, publishing/books, record companies, character development and art licensing across all product categories. Represents Red Nose Studio, Bella Pilar, Nate Williams, Emiliano Ponzi, and Eleanor Grosch among others.

HANDLES Illustration. "Looking for artists with the passion to illustrate every day, an awareness of cultural trends in the world we live in, and a basic understanding of the business of illustration."

TERMS Exclusive representation required. Advertising costs are split. For promotional purposes, talent must provide a well-developed, consistent portfolio. Advertises in *Workbook* and others.

HOW TO CONTACT Submit a web link to portfolio, or send 3 sample low-res JPEGs for review via e-mail only. Responds in 1 month. "We do not return unsolicited submissions." Will contact artist via e-mail if interested.

TIPS "Be realistic about how your style matches our agency. We do not represent scientific, technical, medical, sci-fi, fantasy, military, hyper-realistic, story boarding, landscape, pin-up, cartoon or cutesy styles. We do not represent graphic designers or photographers, and we will not represent illustrators that imitate the style of an existing illustrator."

MARLENA AGENCY

322 Ewing St., Princeton NJ 08540. (609)252-9405. **Fax:** (609)252-1949. **E-mail:** marlena@marlenaagency. com. **Website:** www.marlenaagency.com. Estab. 1990. Commercial illustration representative. Represents approx. 30 illustrators from France, Poland, Germany, Hungary, Italy, Spain, Canada and U.S. "We speak English, French, Spanish and Polish." Specializes in conceptual illustration. Markets include advertising agencies, corporations/client direct, design firms, editorial/magazines, publishing/books, theaters.

HANDLES Illustration, fine art and prints.

TERMS Rep receives 30% commission; 35% if translation needed. Costs are shared by all artists. Exclusive area representation is required. Advertising costs are split: 70% paid by talent; 30% paid by representative. For promotional purposes, talent must provide e-mailed and direct mail pieces, 3-4 portfolios. Advertises in *Workbook*. Many of the artists are regularly featured in *CA* annuals, The Society of Illustrators annuals, and American Illustration annuals. Agency produces promotional materials for artists, such as wrapping paper, calendars, and brochures.

HOW TO CONTACT Send tearsheets or e-mail low-resolution images. Responds in 1 week, only if interested. After initial contact, drop off or mail appropriate materials. Portfolio should include tearsheets.

TIPS Wants artists with "talent, good concepts-intelligent illustration, promptness in keeping up with projects, deadlines, etc."

MARTHA PRODUCTIONS, INC.

7550 W. 82nd St., Playa Del Rey CA 90293. (310)670-5300. **Fax:** (310)670-3644. **E-mail:** contact@martha productions.com. **Website:** www.marthaproductions. com. **Contact:** Martha Spelman, president. Estab. 1978. Commercial illustration representative. Represents 45 illustrators. Also licenses the work of illustrators. Specializes in illustration in various styles and media. Markets include advertising agencies; corporations/client direct; design firms; developers; editorial/magazines; paper products/greeting cards; publishing/books; record companies; sales/promotion firms.

HANDLES Illustration.

TERMS Rep receives 30% commission. Advertising costs are split: 70% paid by talent; 30% paid by representative. For promotional purposes, talent must be on our website. Advertises in *Workbook*.

HOW TO CONTACT For first contact, e-mail a few small JPEG files. Responds only if interested. Portfolio should include b&w and color samples. Obtains new talent through recommendations and solicitation.

TIPS "An artist seeking representation should have a strong portfolio with pieces relevant to advertising, corporate collateral or publishing markets. Check the rep's website or ads to see the other talent they represent to determine whether the artist could be an asset to that rep's group or if there may be a conflict. Reps are looking for new artists who already have a portfolio of salable pieces, a willingness to invest advertising of their own work and experience working in commercial art."

MASLOV-WEINBERG

879 Florida St., San Francisco CA 94110. (415)641-4376. **Fax:** (415)695-0921. **E-mail:** maslov@maslov. com. **Website:** www.maslov.com. Estab. 1988. Commercial illustration representative. Represents 11 artists. Markets include advertising agencies, corporations/client direct, design firms, editorial/magazines,

movie studios, paper products/greeting cards, publishing/books, record companies, sales/promotion firms. Artists include Mark Matcho, Mark Ulriksen, Pamela Hobbs.

HANDLES Illustration.

TERMS Rep receives 25% commission. Exclusive representation required. Advertises in *American Showcase*, *Workbook*.

HOW TO CONTACT Send query letter with direct mail flier/brochure. Responds only if interested. After initial contact, write to schedule an appointment.

MB ARTISTS

775 Sixth Ave., #6, New York NY 10001. (212)689-7830. **E-mail:** mela@mbartists.com. **Website:** www.mbartists.com. **Contact:** Mela Bolinao. Estab. 1986. Juvenile illustration representative. Member of SPAR, Society of Illustrators and SCBWI. Represents over 45 illustrators. Specializes in illustration for juvenile markets. Markets include advertising agencies; editorial/magazines; publishing/books; toys/games.

HANDLES Illustration.

TERMS Exclusive representation required. Rep receives 25% commission. No geographic restrictions. Advertising costs are split: 75% paid by talent; 25% paid by representative. Advertises in *Picture Book*, *Directory of Illustration*, *Play Directory*, *Workbook*, folioplanet.com, and www.theispot.com.

HOW TO CONTACT E-mail query letter with website address or send portfolio with flier/brochure, tear sheets, published books if available, and SASE. Responds in 1 week. Portfolio should include at least 10-15 images exhibiting a consistent style.

TIPS Leans toward "highly individual personal styles."

MENDOLA ARTISTS

420 Lexington Ave., New York NY 10170. (212)986-5680. **Fax:** (212)818-1246. **E-mail:** info@mendolaart.com. **Website:** www.mendolaart.com. Estab. 1961. Commercial illustration representative. Member of Society of Illustrators, Graphic Artists Guild. Represents 60 or more illustrators. Markets include advertising agencies; corporations/client direct; design firms; editorial/magazines; sales/promotion firms. "Representing the industry's leading illustration talent worldwide, we work with the top agencies, magazine corporations, and publishers. Exclusive representation is usually required. Send us an e-mail with a link to your website or JPEGs. We will contact you if interested in seeing additional work."

MHS LICENSING

11100 Wayzata Blvd., Suite 550, Minneapolis MN 55305. (952)544-1377. **Fax:** (952)544-8663. **E-mail:** marty@mhslicensing.com. **E-mail:** artreviewcommittee@mhslicensing.com. **Website:** www.mhslicensing.com. **Contact:** Marty H. Segelbaum, president. Estab. 1995. Licensing agency. Represents over 30 fine artists, photographers, illustrators and brands. Markets include paper products/greeting cards, publishing/books and other consumer products including giftware, stationery/paper, tabletop, apparel, home fashions, textiles, etc. Artists include Al Agnew, Amy Hautman, Amylee Weeks, Audrey Jeanne Roberts, Christine Adolph, Collin Bogle, Cranston Collection, Darrell Bush, H. Hargrove, Hautman Brothers, James Meger, Jennifer O'Meara, Judy Buswell, Julie Ingleman, Kathy Hatch, Louise Carey, Luis Fitch, Paper D'Art, Patrick Reid O'Brien, Robin Roderick, Ron King, Stephanie Ryan, Tim Nyberg, Tina Higgins, Victoria Schultz and Vitaly Geyman. Brands include Buck Wear, Munki Munki, Museware by Sheree, Smirk, Sparky & Marie and The Girls.

HANDLES Fine art, illustration, photography and brand concepts.

TERMS Negotiable with firm.

HOW TO CONTACT Send query letter with bio, tearsheets, approximately 10 low-res JPEGs via e-mail. See submission guidelines on website. "Keep your submission simple and affordable by leaving all the fancy packaging, wrapping and enclosures in your studio. 8½×11 tearsheets (inkjet is fine), biography, and SASE are all that we need for review." Responds in 6 weeks. "No phone calls, please." Portfolio should include color tearsheets. Send SASE for return of material.

TIPS "Our mutual success is based on providing manufacturers with trend-forward artwork. Please don't duplicate what is already on the market but think instead, 'What are consumers going to want to buy in 9 months, 1 year, or 2 years?' We want to learn how you envision your artwork being applied to a variety of product types. Artists are encouraged to submit their artwork mocked-up into potential product collections ranging from stationery to tabletop to home fashion (kitchen, bed and bath). Visit your local department store or mass retailer to learn more about the key items in these categories. And, if you have multiple artwork styles, include them with your submission."

MORGAN GAYNIN, INC.

194 Third Ave., New York NY 10003. (212)475-0440. **Fax:** (212)353-8538. **E-mail:** info@morgangaynin.com; submissions@morgangaynin.com. **Website:** www.morgangaynin.com. **Contact:** Vicki Morgan and Gail Gaynin, partners. Estab. 1974. Currently not accepting submissions. See website for updates. Illustration representatives. Markets include advertising agencies; corporations/client direct; design firms; magazines; books; sales/promotion firms.

HANDLES Illustration.

TERMS Rep receives 30% commission. Exclusive area representation is required. No geographic restrictions. Advertising costs are split: 70% paid by talent; 30% paid by representative. Advertises in directories, on the Web, direct mail.

HOW TO CONTACT Follow submission guidelines on website.

MUNRO CAMPAGNA ARTISTS REPRESENTATIVES

630 N. State St., #2109, Chicago IL 60654. (312)335-8925. **E-mail:** steve@munrocampagna.com. **Website:** www.munrocampagna.com. **Contact:** Steve Munro, president. Estab. 1987. Commercial illustration, photography representative. Member of SPAR, CAR (Chicago Artists Representatives). Represents 22 illustrators, 2 photographers. Markets include advertising agencies; corporations/client direct; design firms; publishing/books. Represents Pat Dypold and Douglas Klauba.

HANDLES Illustration.

TERMS Rep receives 25-30% commission. Exclusive area representation is required. Advertising costs are split: 75% paid by talent; 25% paid by representative. For promotional purposes, talent must provide 2 portfolios. Advertises in *The Black Book* and *Workbook*.

HOW TO CONTACT For first contact, send query letter, bio, tearsheets and SASE. Responds in 2 weeks. After initial contact, write to schedule an appointment.

THE NEWBORN GROUP, INC.

115 W. 23rd St., Suite 43A, New York NY 10011. (212)989-4600. **E-mail:** joan@newborngroup.com. **Website:** www.newborngroup.com. Estab. 1964. Commercial illustration representative. Member of Society of Illustrators; Graphic Artists Guild. Represents 12 illustrators. Markets include advertising agencies, design firms, editorial/magazines, publishing/books. Clients include Leo Burnett, Penguin Putnam, Time, Inc., Weschler, Inc.

HANDLES Illustration.

TERMS Rep receives 30% commission. Exclusive area representation is required. Advertising costs are split: 70% paid by talent; 30% paid by representative. Advertises in *Workbook* and *Directory of Illustration*.

HOW TO CONTACT "Not reviewing new talent."

PAINTED WORDS

310 W. 97th St., #24, New York NY 10025. **Fax:** (212)663-2891. **E-mail:** lori@painted-words.com. **Website:** www.painted-words.com. Estab. 1993. Represents 40 illustrators. Markets include advertising agencies; design firms; editorial/magazines; publishing/books; children's publishing.

HANDLES Illustration and author/illustrators.

TERMS Rep receives 20-25% commission. Cost for direct mail promotional pieces is paid by illustrator. Exclusive area representation is required. Advertising costs are split: 75% paid by talent; 25% paid by representative.

HOW TO CONTACT "An artist seeking representation is encouraged to send a link to his or her website. We are currently seeking illustrators to add to our children's publishing group, specifically those who have a talent for writing. Please do not e-mail manuscripts. If we are interested in the art style, we will request a writing sample. We are also looking for artists with experience in multimedia/apps. All samples and unsolicited manuscripts submitted via regular mail will be returned unopened."

TIPS Wants artists with consistent style. "We are aspiring to build a larger children's publishing division and specifically looking for author/illustrators for children's publishing."

⊕ DEBORAH PEACOCK PRODUCTIONS

P.O. Box 300127, Austin TX 78703. (512)970-9024. **E-mail:** photo@deborahpeacock.com. **Website:** www.deborahpeacock.com or www.art-n-music.com. **Contact:** Deborah Peacock. Graphic design, public relations, promotions, photography and consultancy. Deborah Peacock Photography & Public Relations caters to businesses, products, actors and musicians, performing and visual artists; product photography, special events, videography and graphic/web design.

HANDLES Considers all media and all types of prints.

MARIA PISCOPO

1684 Decoto Rd., #271, Union City CA 94587. (714)356-4260. **Fax:** (888)713-0705. **E-mail:** maria@ mpiscopo.com. **Website:** www.mpiscopo.com. **Contact:** Maria Piscopo. Estab. 1978. Commercial photography representative. Member of SPAR, Women in Photography, Society of Illustrative Photographers. Market includes: advertising agencies, corporate and designer firms. Interested in reviewing illustration, photography, fine art and design. Representatives receive 25% commission.

TERMS Send query letter and samples via PDF to maria@mpiscopo.com. Do not call. Responds within 2 weeks, only if interested. E-mail for specifications of artwork.

TIPS Obtains new talent through personal referral and photo magazine articles. "Do lots of research. Be very businesslike, organized, professional and follow the above instructions!"

CAROLYN POTTS & ASSOCIATES, INC.

P.O. Box 6214, Evanston IL 60204. (312)560-6400. **E-mail:** carolyn@cpotts.com. **Website:** www.cpotts. com. Estab. 1976. Commercial photography representative and marketing consultant for creative professionals. Thirty years experience in getting assignments for commercial photographers. Member of SPAR; CAR (Chicago Artists Reps). Specializes in contemporary advertising and design. Markets include advertising agencies, corporations/client direct, design firms, publishing/books.

HANDLES Photography.

TERMS Rep receives 30-35% commission. Artists share cost of their direct mail postage and preparation. Exclusive area representation is required. Advertising costs are split: 70% paid by artist; 30% paid by rep (after initial trial period wherein artist pays 100%). For promotional purposes, talent must provide direct mail piece.

HOW TO CONTACT For first contact, send direct mail flyer/brochure and SASE. Responds in 3 days. After initial contact, write to schedule an appointment. Portfolio should include examples of published work.

TIPS Looking for artists with high level of professionalism, awareness of current advertising market, professional presentation materials and web site and positive attitude.

CHRISTINE PRAPAS/ARTIST REPRESENTATIVE

8402 SW Woods Creek Court, Portland OR 97219. (503)245-9511. **Fax:** (503)245-9512. **E-mail:** christine@christineprapas.com. **Website:** www.christineprapas.com. Estab. 1978. Commercial illustration and photography representative. Member of AIGA and Graphic Artists Guild. "Promotional material welcome."

KERRY REILLY: REPS

1826 Asheville Place, Charlotte NC 28203. (704)372-6007. **E-mail:** kerry@reillyreps.com. **Website:** www. reillyreps.com. **Contact:** Kerry Reilly. Estab. 1990. Commercial illustration and photography representative. Represents 16 illustrators, 2 photographers and animatics. Markets include advertising agencies; corporations/client direct; design firms; editorial/magazines. Clients include GM, VW, Disney World, USPO. Kerry Reilly Reps is partnering with Steven Edsey & Sons.

HANDLES Illustration, photography. Looking for computer graphics Photoshop, Illustrator, FreeHand, etc.

TERMS Rep receives 25% commission. Exclusive area representation is required. No geographic restrictions. Advertising costs are split 75% paid by talent; 25% paid by representative. For promotional purposes, talent must provide at least 2 pages printed leave-behind samples. Preferred format is 9×12 pages, portfolio work on 4×5 transparencies. Advertises in iSpot.

HOW TO CONTACT For first contact, send direct mail flier/brochure or samples of work. Responds in 2 weeks. After initial contact, call for appointment to show portfolio or drop off or mail tearsheets, slides, 4×5 transparencies.

TIPS "Have printed samples and electronic samples (in JPEG format)."

RETRO REPS

Martha Productions, 7550 W. 82nd St., Playa Del Rey CA 90293. (310)670-5300. **Fax:** (310)670-3644. **E-mail:** contact@marthaproductions.com. **Website:** www.retroreps.com. **Contact:** Martha Spelman, president. Estab. 1998. Commercial illustration representative. Represents 22 illustrators. Specializes in artists working in vintage or retro styles from the 1920s through 1970s.

LILLA ROGERS STUDIO

(781)641-2787. **E-mail:** info@lillarogers.com or via online contact form. **Website:** www.lillarogers.com. **Contact:** Susan McCabe or Ashley Lorenze, agents. Estab. 1984. Commercial illustration representatives. Represents 30 illustrators. Markets include advertising agencies, corporations/client direct, design firms, editorial/magazines, paper products, publishing/books, prints and posters, sales/promotion firms, children's books, surface design. Artists include Lisa DeJhon, Matte Stephens, Carolyn Gavin, Bonnie Dain, Susy Pilgrim Waters.

○ Lilla provides mentoring and frequent events for the artists, including classes and guest art director lunches.

HANDLES Illustration.

TERMS Rep receives 35% commission. Exclusive representation required. Promotions include *PRINT Magazine*, Design*Sponge blog, Surtex NYC trade show, Printsource NYC trade show and other events; also runs extensive direct mail and e-mail newsletter campaigns.

HOW TO CONTACT For first contact, e-mail 3-5 JPEGs or a link to your website. Responds only if interested.

TIPS "It's good to check out the agency's website to see if you feel like it's a good fit. Explain in your e-mail why you want an agent and why you think we are a good match. No phone calls, please."

THE ROLAND GROUP

4948 St. Elmo Ave., Suite 201, Bethesda MD 20814. **E-mail:** info@therolandgroup.com. **Website:** www.therolandgroup.com. Estab. 1988. Commercial illustration and photography representative. Member of SPAR, Society of Illustrators, Ad Club, Production Club. Represents 20 illustrators and over 300 photographers. Markets include advertising agencies; corporations/client direct; design firms; editorial/magazines; paper products/greeting cards; publishing/books.

HANDLES Illustration and photography.

TERMS Rep receives 35% commission. Exclusive and non-exclusive representation available. Also works with artists on a project-by-project basis. For promotional purposes, talent must provide 8½×11 promo sheet. Advertises in *American Showcase*, *Workbook*, *International Creative Handbook*, *The Black Book* and *KLIK*.

HOW TO CONTACT For first contact, send query letter, tearsheets and photocopies. Responds only if interested. Portfolio should include nonreturnable tearsheets, photocopies.

ROSENTHAL REPRESENTS

3850 Eddingham Ave., Calabasas CA 91302. (818)222-5445. **Fax:** (818)222-5650. **E-mail:** elise@rosenthalrepresents.com. **Website:** www.rosenthalrepresents.com. **Contact:** Elise Rosenthal. Estab. 1979. Represents 25 artists and designers geared for creating products, such as: dinnerware, rugs, place mats, cutting boards, coasters, kitchen and bath textiles, bedding, wall hangings, children's and baby products, stationary, and more. Specializes in licensing, merchandising art. Markets include manufacturers of tabletop products, rugs, kitchen and bath textiles, paper products/greeting cards, and more. Handles product designers and artists. Must know Photoshop and other computer programs to help artist adapt art into product mockups.

TERMS Rep receives 50% as a licensing agent. Exclusive licensing representation is required. No geographic restrictions. Artist contributes $800 once a year to exhibit wit us at our 2 all important trade shows, Surtex and Licensing Shows. For promotional purposes, talent must provide CD of artwork designs and website link if available. We advertise in Total Art Licensing. Only contact us if you have done product design and if you are willing to work hard. Must be willing to accept critiques and make corrections.

HOW TO CONTACT Send e-mail, and computer link, or direct mail flyer/brochure, tearsheets, photocopies, and SASE. Responds in 1 week. After initial contact, call for appointment to show portfolio of tearsheets, photographs, photocopies. Obtains new talent through seeing their work in trade shows, in magazines and through referrals.

SALZMAN INTERNATIONAL

1751 Charles Ave., Arcate CA 95521. (707)822-1751; (707)822-5500. **Fax:** (707)822-1751. **E-mail:** rs@salzint.com. **Website:** www.salzint.com. Estab. 1982. Commercial illustration representative. Represents 20 illustrators. 20% of artwork is children's book illustration. Staff includes Richard Salzman. Open to illustrators seeking representation. Accepting both new and established illustrators.

LIZ SANDERS AGENCY

2415 E. Hangman Creek Ln., Spokane WA 99224-8514. (509)993-6400. **E-mail:** liz@lizsanders.com. **Website:** www.lizsanders.com. **Contact:** Liz Sanders, owner. Estab. 1985. Commercial illustration representative. Represents 10 illustrators. Specializes in marketing of individual artists "within an ever-evolving illustration world." Markets include advertising agencies, corporations/client direct, design firms, editorial/magazines, juvenile markets, paper products/greeting cards, publishing/books, record companies, sales/promotion firms.

HANDLES Interested in illustration. "Looking for fresh, unique talent committed to long-term careers whereby the agent/talent relationship is mutually respectful, responsive and measurably successful."

TERMS Rep receives 25-30% commission. Exclusive representation required. Advertises in *Picturebook*, *American Showcase*, *Workbook*, *Directory of Illustration*, direct mail material, traditional/electronic portfolio for agent's personal presentations; means to advertise—if not substantially, then consistently.

HOW TO CONTACT For first contact, send nonreturnable printed pieces or e-mailed web address. Responds only if interested. After initial contact, call to schedule an appointment, depending on geographic criteria. Portfolio should include tearsheets, photocopies and digital output.

TIPS "Concisely present a single, focused style supported by 8-12 strong samples. Only send a true portfolio upon request."

JOAN SAPIRO ART CONSULTANTS

138 W. 12th Ave., Denver CO 80204. (303)793-0792. **E-mail:** info@sapiroart.com. **Website:** www.sapiroart.com. **Contact:** Kay Brouillette, principal. Estab. 1980. Specializes in "corporate art with other emphasis on hospitality, health care and art consulting/advising to private collectors."

HANDLES All mediums of artwork.

TERMS Artist must be flexible and willing to ship work on consignment. Also must be able to provide sketches, etc., if commission piece involved. No geographic restrictions.

HOW TO CONTACT Mail JPEG images encompassing the range of your work identified with your name, title of work, medium, dimensions, and pricing contact information, pertinent information about your art and process. Optional inclusions: biography, CV or resume. Be willing to work on a commission basis. Please enclose a stamped, self-addressed envelope if you would like us to return your CD or printed images.

TIPS Obtains new talent through recommendations, publications, travel, research, university faculty.

THE SCHUNA GROUP

1503 Briarknoll Dr., Arden Hills MN 55112. (651)631-8480. **E-mail:** joanne@schunagroup.com. **Website:** www.schunagroup.com. **Contact:** JoAnne Schuna, owner/commercial illustration rep. Represents 15 illustrators. Markets include advertising, corporate/client direct, and design firms.

TERMS Rep receives 25% commission and illustrators are expected to contribute to promotional costs.

HOW TO CONTACT "Send link to your website. Will respond via e-mail within a few weeks if interested."

TIPS "Listing your website in your e-mail is helpful, so I can see more if interested. Do not send multiple images for review. Sending your website is sufficient."

FREDA SCOTT, INC.

302 Costa Rica Ave., San Mateo CA 94402. (650)548-2446. **E-mail:** freda@fredascott.com. **Website:** www.fredascott.com. **Contact:** Freda Scott, rep/president. Estab. 1980. Commercial photography, illustration or photography, commercial illustration representative and licensing agent. Represents 12 photographers, 8 illustrators. Licenses photographers and illustrators. Markets include advertising agencies, architects, corporate/client direct, designer firms, developers, direct mail firms, paper products/greeting cards.

HANDLES Illustration, photography.

TERMS Rep receives 25% as standard commission. Advertising costs paid entirely by talent. For promotional purposes, talent must provide mailers/postcards. Advertises in *Workbook* and *American Showcase/Illustrators*.

HOW TO CONTACT Send link to website. Responds, only if interested, within 2 weeks. Rep will contact the talent for portfolio review, if interested.

TIPS Obtains new talent through submissions and recommendations from other artists, art directors and designers.

S.I. INTERNATIONAL

43 E. 19th St., 2nd Floor, New York NY 10003. (212)254-4996. **Fax:** (212)995-0911. **E-mail:** information@si-i.com; hspiers@si-i.com. **Website:** www.si-i.com. **Contact:** Donald Bruckstein, artists relations.

Estab. 1983. Commercial illustration representative. Member of SPAR, Graphic Artists Guild. Represents 50 illustrators. Specializes in license characters, educational publishing and children's illustration, digital art and design, mass market paperbacks. Markets include design firms; publishing/books; sales/promotion firms; licensing firms; digital art and design firms. **HANDLES** Illustration. Looking for artists "who have the ability to do children's illustration and to do license characters either digitally or reflectively." **TERMS** Rep receives 25-30% commission. Advertising costs are split 70% paid by talent; 30% paid by representative. "Contact agency for details. Must have mailer." Advertises in *Picture Book*. **HOW TO CONTACT** For first contact, send query letter, tearsheets. Responds in 3 weeks. After initial contact, write for appointment to show portfolio of tearsheets, slides.

SUSAN AND CO.

P.O. Box 264, Leavenworth WA 98826. (206)232-7873. **E-mail:** susan@susanandco.com. **Website:** www.susanandco.com. Estab. 1979. Artist representative for illustrators, commercial illustration representative. Member of SPGA. Represents 19 illustrators. Markets include advertising agencies, corporations/client direct, design firms, publishing/books. **HANDLES** Looks for "current illustration styles." **TERMS** Rep receives 25% commission. National representation is required. Advertising costs are split: 75% paid by talent; 25% paid by representative. **HOW TO CONTACT** For first contact, send e-mail letter and samples. Responds in 2 weeks, only if interested. After initial contact, call to schedule an appointment. Portfolio should "be representative of unique style."

THOSE 3 REPS

501 Second Ave., Suite A-600, Dallas TX 75226. (214)871-1316. **Fax:** (214)880-0337. **E-mail:** more info@those3reps.com. **Website:** www.those3reps.com. Estab. 1989. Member of Dallas Society of Visual Community. Represents illustrators and photographers. Specializes in commercial art. Clients: advertising agencies, corporations/client direct, design firms, editorial/magazines. **HANDLES** Illustration, photography (including digital). **TERMS** Rep receives 30% commission. Exclusive area representation is required. Advertising costs are split 70% paid by talent; 30% paid by representative. For promotional purposes, talent must provide 2 new pieces every 2 months, national advertising in sourcebooks and at least 1 mailer. Advertises in *Workbook*, own book. **HOW TO CONTACT** For first contact, send query letter and PDFs. Responds in days or weeks only if interested. After initial contact, call to schedule an appointment, drop off or mail in appropriate materials. Portfolio should include digital prints. **TIPS** Wants artists with "strong unique consistent style."

☉ THREE IN A BOX, INC.

67 Mowat Ave., Suite 236, Toronto ON M6K 3E3, Canada. (212)643-0896. **E-mail:** info@threeinabox.com. **Website:** www.threeinabox.com. Estab. 1990. Commercial illustration representative. Member of Graphic Artists Guild. Represents 53 illustrators, 2 photographers. Specializes in illustration. Licenses illustrators and photographers. Markets include advertising agencies, corporations/client direct, design firms, editorial/magazines, paper products/greeting cards, publishing/books, record companies, sales/promotion firms. **HOW TO CONTACT** For first contact, e-mail query letter and URL. Responds in 1 week. After initial contact, rep will call if interested. Send only links to website.

CHRISTINA A. TUGEAU: ARTIST AGENT, LLC

3009 Margaret Jones Lane, Williamsburg VA 23185. **E-mail:** chris@catugeau.com. **Website:** www.catugeau.com. **Contact:** Christina Tugeau, owner. Estab. 1994. Children's publishing market illustration representative (K-12). Member of SCBWI. Represents 35 illustrators. Specializes in children's book publishing and educational market and related areas. Represents Stacey Schuett, Christine Kornacki, Patrice Barton, Roger Motzkus, Melissa Iwai, Jaimi Zollars, Jason Wolff, Jeremy Tugeau, Priscilla Burris, John Kanzler, Martha Aviles, Ana Ochoa, and Sarah Beise, among others artists of North America. **HANDLES** Illustration. Must be proficient at illustrating children and animals in a variety of interactive situations, backgrounds, full color/b&w, and with a strong narrative sense. **TERMS** Rep receives 25% commission. Exclusive U.S. representation is required. For promotional purposes, talent must provide direct mail promo(s), 8-10 good

"back up" samples (multiples). North American artists only.

HOW TO CONTACT "For first contact, e-mail a few JPEG samples and a live link to website. Responds immediately!"

TIPS "You should have a style uniquely and comfortably your own. Be a cooperative team player and be great with deadlines. Will consider young, new artists to the market with great potential and desire, and of course published, more experienced North American illustrators. Best to study and learn the market standards and expectations by representing yourself for a while when new to the market."

GWEN WALTERS ARTIST REPRESENTATIVE

1801 S. Flagler Dr.,#1202, W. Palm Beach FL 33401. (561)805-7739. **E-mail:** artincgw@aol.com. **Website:** www.gwenwaltersartrep.com. **Contact:** Gwen Walters. Estab. 1976. Commercial illustration representative. Represents 60+ illustrators. Clients: advertising agencies; corporations/client direct; editorial/magazines; paper products/greeting cards; publishing/books; sales/promotion firms. "I lean more toward book publishing." Represents Gerardo Suzan, Rosario Valderrama, Lane Gregory, Susan Spellman, Judith Pfeiffer, Yvonne Gilbert, Gary Torrisi, Larry Johnson, Pat Paris, Scott Wakefield, Tom Barrett, Linda Pierce and many more.

HANDLES Illustration.

TERMS Rep receives 30% commission. Charges for color photocopies. For promotional purposes, talent must provide direct mail pieces.

HOW TO CONTACT For first contact, send résumé, bio, direct mail flier/brochure. After initial contact, representative will call. Portfolio should include "as much as possible."

WASHINGTON ARTISTS' REPRESENTATIVE, INC.

22727 Cielo Vista, #2, San Antonio TX 78255-9501. (210)872-1409. **E-mail:** artrep@sbcglobal.net. **Website:** www.washingtonartrep.com. **Contact:** Dick Washington, commercial illustration representative. Estab. 1983. Represents 17 illustrators.

HOW TO CONTACT For first contact, e-mail website or images. Responds in 2 weeks, only if interested. Usually obtains new talent through recommendations and solicitation.

WATSON & SPIERMAN PRODUCTIONS

W+S+W Creative, 636 Broadway, Suite 708, New York NY 10012. (212)431-4480. **E-mail:** info@wswcreative. com. **Website:** www.watsonspierman.com. Estab. 1992. Commercial illustration/photography representative. Member of SPAR. Represents 9 fine artists, 8 illustrators, 10 photographers. Specializes in general illustration, photography. Markets include advertising agencies, design firms, galleries, paper products/greeting cards, record companies, publishing/books, sales/promotion firms, corporations/client direct, editorial/magazines. Artists include Kan, Monica Lind, Daniel Arsenault, Adam Brown, Bryan Helm, Paul Swen, Joseph Ilan, Frank Siteman, North Sullivan, Kim Harlow, Annabelle Verhoye, Pierre Chanteau, Kristofer Dan-Bergman, Lou Wallach, Eva Byrene, Dan Cotton, Glenn Hilario, Paula Romani, Dannielle Siegelbaum, Ty Wilson, Fulvia Zambon.

HANDLES Commercial, illustration, and photography.

TERMS Rep receives 30% commission. Exclusive representation required. Advertising costs are paid by artist. Artist must publish every year in a sourcebook with all Watson & Spierman talent. Advertises in *Blackbook* and *Workbook*.

HOW TO CONTACT For first contact, send link to website. Responds only if interested. After initial contact, drop off or mail portfolio. Portfolio should include b&w, color, finished art, original art, photographs, tearsheets.

TIPS "We love to hear if an artist has an ad out or recently booked a job. Those are the updates that are most important to us."

THE WILEY GROUP

1535 Green St., Suite 301, San Francisco CA 94123. (415)441-3055. **Fax:** (415)520-0999. **E-mail:** info@ thewileygroup.com. **Website:** www.thewileygroup. com. **Contact:** David Wiley, owner. Estab. 1984. Represents a broad spectrum of unique commercial artists. Over 28 years of experience in marketing, advertising and promotional work paired with a longtime fascination and appreciation of the arts, marketing and communication. David matches up U.S. and worldwide agencies in advertising, graphic design, publishing with illustrators who can best present their products in innovative, effective ways. Past clients have included Disney, Coca Cola, Smithsonian, Microsoft, Nike, Oracle, Google, Random House, Eli

Lilly Pharmaceuticals, National Geographic, Super Bowl XLII, Twinlab, FedEx, Nestle Corp., Apple Computers. Specialties include building working relationships between illustrators and hiring professionals through individualized problem solving and creative processes.

TERMS Rep receives 25% commission with a bonus structure. No geographical restriction.

HOW TO CONTACT Actively seeking stop-motion, animation and 3D artists with solid illustration skills. "First and foremost, we receive an extensive numbers of inquiries, so responses might be delayed. If you do not hear back within 20 days, please resubmit noting in the subject line that it is your second submission. Before submitting, please read the following: We *only* represent commercial illustrators, no photographers. It is important you familiarize yourself with our agency and the artists we represent, understanding the styles we currently manage and the work we do with our clients (also visit our blog or Facebook page). We are only interested in adding unique and well-developed styles that will fit within our portfolio of talent, so understanding our current portfolio is a big part of your submission process. Once you have done so, and feel there may be a fit, please e-mail your information. Be sure to include the following: Introduction (including who you are and your professional background), the style and medium that best describes you, a list of clients, sample images in JPEG format *only* (with a max total size of 3MB) and a link to your website, blog, Facebook page or other relevant professional information. We do not accept mailed printed samples and will not return them if sent without previous agreement."

DEBORAH WOLFE, LTD.

731 N. 24th St., Philadelphia PA 19130. (215)232-6666. **Fax:** (215)232-6585. **E-mail:** info@illustrationonline.com. **Website:** www.illustrationonline.com. **Contact:** Deborah Wolfe. Estab. 1978. Commercial illustration representative. Represents 30 illustrators. Markets include advertising agencies, corporations/client direct, design firms, editorial/magazines, publishing/books, animation.

HANDLES Illustration.

TERMS Rep receives 25% commission. Advertises in *Workbook*, *Directory of Illustration Picturebook* and *The Medical Sourcebook*.

HOW TO CONTACT For first contact, send an e-mail with samples or a web address. Responds in 3 weeks.

ART FAIRS

///

How would you like to sell your art from New York to California, showcasing it to thousands of eager art collectors? Art fairs (also called art festivals or art shows) are not only a good source of income for artists but an opportunity to see how people react to their work. If you like to travel, enjoy meeting people, and can do your own matting and framing, this could be a great market for you.

Many outdoor fairs occur during the spring, summer, and fall months to take advantage of warmer temperatures. However, depending on the region, temperatures could be hot and humid, and not all that pleasant! And, of course, there is always the chance of rain. Indoor art fairs held in November and December are popular because they capitalize on the holiday shopping season.

To start selling at art fairs, you will need an inventory of work—some framed, some unframed. Even if customers do not buy the framed paintings or prints, having some framed work displayed in your booth will give buyers an idea of how your work looks framed, which could spur sales of your unframed prints. The most successful art fair exhibitors try to show a range of sizes and prices for customers to choose from.

When looking at the art fairs listed in this section, first consider local shows and shows in your neighboring cities and states. Once you find a show you'd like to enter, visit its website or contact the appropriate person for a more detailed prospectus. A prospectus is an application that will offer additional information not provided in the art fair's listing.

Ideally, most of your prints should be matted and stored in protective wraps or bags so that customers can look through your inventory without damaging prints and mats. You will also need a canopy or tent to protect yourself and your wares from the elements as well as some bins in which to store the prints. A display wall will allow you to show off your best framed

prints. Generally, artists will have 100 square feet of space in which to set up their tents and canopies. Most listings will specify the dimensions of the exhibition space for each artist.

If you see the ☺ icon before a listing in this section, it means that the art fair is a juried event. In other words, there is a selection process artists must go through to be admitted into the fair. Many art fairs have quotas for the categories of exhibitors. For example, one art fair may accept the mediums of photography, sculpture, painting, metal work, and jewelry. Once each category fills with qualified exhibitors, no more will be admitted to the show that year. The jurying process also ensures that the artists who sell their work at the fair meet the sponsor's criteria for quality. So, overall, a juried art fair is good for artists because it means they will be exhibiting their work along with other artists of equal caliber.

Be aware there are fees associated with entering art fairs. Most fairs have an application fee or a space fee, or sometimes both. The space fee is essentially a rental fee for the space your booth will occupy for the art fair's duration. These fees can vary greatly from show to show, so be sure to check this information in each listing before you apply to any art fair.

Most art fair sponsors want to exhibit only work that is handmade by the artist, no matter what medium. Unfortunately, some people try to sell work that they purchased elsewhere as their own original artwork. In the art fair trade, this is known as "buy/sell." It is an undesirable situation because it tends to bring down the quality of the whole show. Some listings will make a point to say "no buy/sell" or "no manufactured work."

For more information on art fairs, pick up a copy of *Sunshine Artist* (www.sunshineartist.com) or *Art Calendar* (www.artcalendar.com), and consult online sources such as www.artfairsource.com.

4 BRIDGES ARTS FESTIVAL

30 Frazier Ave., Chattanooga TN 37405. (423)265-4282. **Fax:** (423)265-5233. **E-mail:** jdmcfadden@avarts.org. **Website:** www.4bridgesartsfestival.org. **Contact:** Jerry Dale McFadden, director. Estab. 2001. Fine arts & crafts show held annually in mid-April. Held in a covered, open-air pavilion. Accepts photography and 24 different mediums. Juried by 3 different art professionals each year. Awards: $10,000 in artist merit awards; the on-site jurying for merit awards will take place Saturday morning. Number of exhibitors: 150. Public attendance: 20,000. Public admission: $7/day or a 2-day pass for $10; children are free. Artists should apply at www.zapplication.org. Deadline for entry: early November (see website for details). Application fee: $40. Space fee: $425 for 10×12 ft. Exhibit space: 10×12 ft.; double: 20×12 ft. Average gross sales/exhibitor: $3,091. For more information, e-mail, visit website or call.

TIPS "Have a compelling, different body of work that stands out among so many other photographers and artists."

AKRON ARTS EXPO

Hardesty Park, 1615 W. Market, Akron OH 44313. (330)375-2836. **Fax:** (330)375-2883. **E-mail:** PBomba@akronohio.gov. **Website:** www.akronartsexpo.org. **Contact:** Penny Bomba, event planner. Estab. 1979. Held in late July (4th weekend). "The Akron Arts Expo is a nationally recognized juried fine arts & crafts show held outside with over 160 artists, ribbon and cash awards, great food, an interactive children's area, and entertainment for the entire family. Participants in this festival present quality fine arts and crafts that are offered for sale at reasonable prices. For more information, see the website." Application fee $5. Booth fee: $200.

ALDEN B. DOW MUSEUM SUMMER ART FAIR

1801 W. St. Andrews Rd., Midland MI 48640. **Fax:** (989)631-7890. **E-mail:** mills@mcfta.org. **Website:** www.mcfta.org. **Contact:** Emmy Mills, business manager/art fair coordinator. Estab. 1966. Fine art & crafts show held annually in early June. Outdoors. Accepts photography, ceramics, fibers, jewelry, mixed media 3D, painting, wood, drawing, glass, leather, sculpture, basket, furniture. Juried by a panel. Awards: $500 for 1st place, $300 for 2nd place, $100 for 3rd place. Average number of exhibitors: 150. Public attendance: 5,000-8,000. Free to public. Artists should apply at www.mcfta.org/specialevents.html. Deadline for entry: early March; see website for details. Application fee: jury $25, second medium $5/each. Space fee: $195/single booth, $365/double booth. Exhibition space: approximately 12×12 ft. Average gross sales/exhibitor: $1,500. Artists should e-mail or visit website for more information.

ALLEN PARK ARTS & CRAFTS STREET FAIR

16850 Southfield Rd., Allen Park MI 48101-2599. (313)928-1370; (313)928-0940. **Fax:** (313)382-7946. **Website:** www.allenparkstreetfair.org. **Contact:** Allen Park Festivities Commission. Estab. 1981. Arts & crafts show held annually the 1st Friday and Saturday in August. Outdoors. Accepts photography, sculpture, ceramics, jewelry, glass, wood, prints, drawings, paintings. All work must be of fine quality and original work of entrant. Such items as imports, velvet paintings, manufactured or kit jewelry and any commercially produced merchandise are not eligible for exhibit or sale. Juried by 3 photos (no slides) of work. Number of exhibitors: 400. Free to the public. Deadline: Applications must be postmarked by late February (see website for specifics). Application fee: $5. Space fee: $150. Exhibition space: 10×10 ft. Artists should call or see website for more information.

ALLENTOWN ART FESTIVAL

P.O. Box 1566, Buffalo NY 14205. (716)881-4269. **Fax:** (716)881-4269. **E-mail:** allentownartfestival@verizon.net. **Website:** www.allentownartfestival.com. **Contact:** Mary Myszkiewicz, president. Estab. 1958. Fine arts & crafts show held annually 2nd full weekend in June. Outdoors. Accepts photography, painting, watercolor, drawing, graphics, sculpture, mixed media, clay, glass, acrylic, jewelry, creative craft (hard/soft). Slides juried by hired professionals that change yearly. Awards/prizes: 41 cash prizes totaling over $20,000; includes Best of Show awarding $1,000. Number of exhibitors: 450. Public attendance: 300,000. Free to public. Artists should apply by downloading application from website. Deadline for entry: late January. Exhibition space: 10×13 ft. Application fee: $15. Booth fee $275. For more information, artists should e-mail, visit website, call or send SASE.

TIPS "Artists must have attractive booth and interact with the public."

AMERICAN ARTISAN FESTIVAL

P.O. Box 41743, Nashville TN 37204. (615)429-7708. **Fax:** (423)265-5233. **E-mail:** americanartisanfestival@gmail.com. **Website:** www.american-artisan.com. **Contact:** Jerry Dale McFadden, co-director. Estab. 1971. Fine arts & crafts show held annually mid-June, Father's Day weekend. Outdoors. Accepts photography and 21 different medium categories. Juried by 3 different art professionals each year. 3 cash awards presented. Number of exhibitors: 165. Public attendance: 30,000. No admission fee for the public. Artists should apply online at www.zapplication.org. Deadline for entry: early March (see website for details). For more information, e-mail or visit the website.

AMISH ACRES ARTS & CRAFTS FESTIVAL

1600 W. Market St., Nappanee IN 46550. (574)773-4188 or (800)800-4942. **E-mail:** amishacres@amishacres.com; jenniwysong@amishacres.com; beckymaust@amishacres.com. **Website:** www.amishacres.com. **Contact:** Jenni Pletcher Wysong and Becky Maust Cappert, contact coordinators. Estab. 1962. Arts & crafts show held annually first weekend in August. Outdoors. Accepts photography, crafts, floral, folk, jewelry, oil, acrylic, sculpture, textiles, watercolors, wearable, wood. Juried by 5 images, either 35mm slides or e-mailed digital images. Awards/prizes: $5,000 Cash including Best of Show and $1,000 Purchase Prizes. Number of exhibitors: 300. Public attendance: 60,000. Children under 12 free. Artists should apply by sending SASE or printing application from website. Deadline for entry: April 1. Exhibition space: 10×12, 15×12, 20×12 or 30×12 ft.; optional stable fee, with tent, also available. For more information, artists should e-mail, visit website, call or send SASE. **TIPS** "Create a vibrant, open display that beckons to passing customers. Interact with potential buyers. Sell the romance of the purchase."

ANACORTES ARTS FESTIVAL

505 O Ave., Anacortes WA 98221. (360)293-6211. **Fax:** 360-299-0722. **E-mail:** staff@anacortesartsfestival.com. **Website:** www.anacortesartsfestival.com. Fine arts & crafts show held annually 1st full weekend in August. Accepts photography, painting, drawings, prints, ceramics, fiber art, paper art, glass, jewelry, sculpture, yard art, woodworking. Juried by projecting 3 images on a large screen. Works are evaluated on originality, quality and marketability. Each applicant must provide high-quality digital images of 3-5 works that will be available for sale. Awards/prizes: festival matches funds with 3 sponsors to award $10,500 in cash prizes. Number of exhibitors: 250. We only accept online applications. Application fee: $35. Deadline for entry: early March. Space fee: $300. Exhibition space: 10×10 ft. For more information, artists should see website.

ANN ARBOR STREET ART FAIR

721 E. Huron, Suite 200, Ann Arbor MI 48104. (734)994-5260. **Fax:** (734)994-0504. **E-mail:** production@artfair.org. **Website:** www.artfair.org. Estab. 1958. Fine arts & crafts show held annually 3rd Saturday in July. Outdoors. Accepts photography, fiber, glass, digital art, jewelry, metals, 2D and 3D mixed media, sculpture, clay, painting, drawing, printmaking, pastels, wood. Juried based on originality, creativity, technique, craftsmanship and production. Awards/prizes: cash prizes for outstanding work in any media. Number of exhibitors: 190. Public attendance: 500,000. Free to the public. Artists should apply through www.zapplication.org. Deadline for entry: January. Application fee: $40. Space fee: $650. Exhibition space: 10×12 ft. Average gross sales/exhibitor: $7,000. For more information, artists should e-mail, visit website, call.

ANN ARBOR SUMMER ART FAIR

118 N. Fourth Ave., Ann Arbor MI 48104. (734)662-3382. **Fax:** (734)662-0339. **E-mail:** info@theguild.org. **Website:** www.annarborsummerartfair.org. Estab. 1970. Fine arts and craft show held annually on the third Wednesday through Saturday in July. Outdoors. Accepts all fine art categories. Juried. Number of exhibitors: 325. Attendance: 500,000-750,000. Free to public. Deadline for entry is January; enter online at www.juriedartservices.com. Exhibition space: 10×10, 10×13, 10×17 ft. For information, artists should visit the website, call, or e-mail.

APPLE ANNIE CRAFTS & ARTS SHOW

4905 Roswell Rd., Marietta GA 30062. (770)552-6400, ext. 6110. **Fax:** (770)552-6420. **E-mail:** appleannie@st-ann.org. **Website:** www.st-ann.org/apple_annie.php. Estab. 1981. Arts & crafts show held annually the 1st weekend in December. Indoors. Accepts photography, woodworking, ceramics, pottery, painting, fabrics, glass. Juried. Number of exhibitors: 135. Pub-

lic attendance: 5,000. Artists should apply by visiting website to print an application form, or call to have one sent to them. Deadline: late April (see website for details). Application fee: $10, nonrefundable, along with photos (1 of overall display and up to 5 of your work). Exhibition space: 72 sq. ft. For more information, artists should e-mail, call or visit website.

TIPS "Have an open, welcoming booth and be accessible and friendly to customers."

ART FAIR ON THE COURTHOUSE LAWN

P.O. Box 795, Rhinelander WI 54501. (715)365-7464. **E-mail:** info@rhinelanderchamber.com. **Website:** www.rhinelanderchamber.com. assistant@rhinelanderchamber.com. **Contact:** Events coordinator. Estab. 1985. Arts & crafts show held annually in June. Outdoors. Accepts woodworking (includes furniture), jewelry, glass items, metal, paintings and photography. Number of exhibitors: 150. Public attendance: 3,000. Free to the public. Space fee: $75-125. Exhibit space: 10×10 to 10×30 ft. For more information, artists should e-mail, call or visit website.

TIPS "We accept only items handmade by the exhibitor."

ART FESTIVAL BETH-EL

400 S. Pasadena Ave., St. Petersburg FL 33707. (727)347-6136. **Fax:** (727)343-8982. **E-mail:** administrator@templebeth-el.com. **Website:** www.templebeth-el.com. Estab. 1972. Fine arts & crafts show held annually the last weekend in January. Indoors. Accepts photography, painting, jewelry, sculpture, woodworking, glass. Juried by special committee on-site or through slides. Awards/prizes: over $7,000 prize money. Number of exhibitors: over 170. Public attendance: 8,000-10,000. Free to the public. Artists should apply by application with photos or slides; show is invitational. Deadline for entry: September. For more information, artists should call or visit website. A commission is taken.

TIPS "Don't crowd display panels with artwork. Make sure your prices are on your pictures. Speak to customers about your work."

ART IN THE PARK (AZ)

P.O. Box 247, Sierra Vista AZ 85636-0247. (520)803-1511. **E-mail:** dragnfly@theriver.com. **Website:** www.artintheparksierravista.com. Estab. 1972. Oldest longest running Arts & crafts fair in Southern AZ. Fine arts & crafts show held annually 1st full weekend in

October. Outdoors. Accepts photography, all fine arts and crafts created by vendor. No resale retail strictly applied. Juried by Huachaca Art Association Board. Artists submit 5 photos. Returnable with SASE. Number of exhibitors: 240. Public attendance: 15,000. Free to public. Artists should apply by downloading the application www.artintheparksierravista.com. Deadline for entry: postmarked by late June. Last minute/late entries always considered. No application fee. Space fee: $200-275, includes jury fee. Exhibition space: 15×30 ft. Some electrical; additional cost of $25. Some RV space available at $15/night. For more information, artists should see website, e-mail, call or send SASE.

ART IN THE PARK (GA)

P.O. Box 1540, Thomasville GA 31799. (229)227-7020. **Fax:** (229)227-3320. **E-mail:** roseshowfest@rose.net; felicia@thomasville.org. **Website:** www.downtownthomasville.com. **Contact:** Felicia Brannen, festival coordinator. Estab. 1998-1999. Art in the Park (an event of Thomasville's Rose Show and Festival) is a one-day arts & crafts show held annually in April. Outdoors. Accepts photography, handcrafted items, oils, acrylics, woodworking, stained glass, other varieties. Juried by a selection committee. Number of exhibitors: 60. Public attendance: 2,500. Free to public. Artists should apply by submitting official application. Deadline for entry: early February. Space fee varies by year. Exhibition space: 20×20 ft. For more information, artists should e-mail, call or visit website.

TIPS "Most important, be friendly to the public and have an attractive booth display."

ART IN THE PARK (HOLLAND, MI)

Holland Friends of Art, P.O. Box 1052, Holland MI 49422. (616)395-3278. **E-mail:** info@hollandfriendsofart.com. **Website:** www.hollandfriendsofart.com. **Contact:** Bonnie Lowe, art fair chairperson. This annual fine arts and crafts fair is held on the first Saturday of August in Holland. The event draws one of the largest influx of visitors to the city on a single day, second only to Tulip Time. More than 300 fine artists and artisans from 8 states will be on hand to display and sell their work. Juried. All items for sale must be original. Public attendance: 15,000+. Entry fee: $80 (HFA members $70); includes a $20 application fee. Deadline: late March. Space fee: $150 for a double-wide space; $140 for a double-deep space. Exhibition space: 12×12 ft. Details of the jury and entry process are explained on the application. Application avail-

able online. Call, e-mail or visit website for more information.

TIPS "Create an inviting and neat booth. Offer well-made quality artwork and crafts at a variety of prices."

☺ ART IN THE PARK (VA)

1 Gypsy Hill Park, Staunton VA 24401. (540)885-2028. **E-mail:** info@saartcenter.org. **Website:** www.saartcenter.org. **Contact:** Beth Hodges, exec. director; Leah Dubinski, office manager. Estab. 1966. Fine arts & crafts show held annually 3rd Saturday in May. Outdoors. Accepts photography, oil, watercolor, pastel, acrylic, clay, porcelain, pottery, glass, wood, metal, almost anything as long as it is handmade fine art/craft. Juried by submitting 4 photos or slides that are representative of the work to be sold. Award/prizes: $1,500. Number of exhibitors: 100. Public attendance: 3,000-4,000. Free to public. Artists should apply by sending in application. Application fee: $15. Space fee: $100, $90 for SAAC members. Exhibition space: 10×10 ft. For more information, artists should e-mail, call or visit website.

☺ ART IN THE PARK (WARREN, MI)

Halmich Park, Warren MI 48093. (586)795-5471. **E-mail:** MGPPhotography@gmail.com. **Website:** www.warrenfinearts.org. **Contact:** Michael Peychich, chairperson (248)259-2315. Estab. 1990. Fine arts & crafts show held annually 2nd weekend in July. Indoors and outdoors. Accepts photography, sculpture, basketry, pottery, stained glass. Juried. Awards/prizes; monetary awards. Number of exhibitors: 70. Public attendance: 7,500. Free to public. Deadline for entry: mid-May. Jury fee: $25. Space fee: $125/outdoor; $135/indoor. Exhibition space: 12×12 ft./tent; 12×10 ft./pavilion. For more information, artists should e-mail, visit website or send SASE.

☺ ART IN THE PARK FALL FOLIAGE FESTIVAL

16 S. Main St., Rutland VT 05701. (802)775-0356. **Fax:** (802)773-4401. **E-mail:** info@chaffeeartcenter.org. **Website:** www.chaffeeartcenter.org. **Contact:** Sherri Birkheimer Rooker, event coordinator. Estab. 1961. A juried and fine arts & craft festival held at main street park in rutland VT annually in october over Columbus day weekend. Accepts fine art, specialty foods, fiber, jewelry, glass, metal, wood, photography, clay, floral, etc. All applications will be juried by a panel of experts. The Art in the Park Festivals are dedicated to high quality art and craft products. Number of ex-

hibitors: 100. Public attendance: 9,000-10,000. Public admission: voluntary donation. Artists should apply online and submit a CD of three photos of work and one of booth (photos upon pre-approval). Deadline for entry: on-going but to receive discount for doing both shows, must apply by late May; $25 late fee after that date. Space fee: $200-350. Exhibit space: 10×12 or 20×12 ft. For more information, artists should e-mail, visit website, or call.

TIPS "Have a good presentation and variety, if possible (in pricing also), to appeal to a large group of people. Apply early as there may be a limited amount of accepted vendors per category. Applications will be juried on a first come, first served basis until the category is determined to be filled."

✚ ART IN THE PARK—FINE ARTS FESTIVAL

4150 Elms Rd., Swartz Creek MI 48473. (810)449-3030. **E-mail:** rpmattsoneterp@aol.com. **Website:** www.swartzcreekkiwanis.org/art. **Contact:** Richard Mattson, co-chairman. Estab. 2008. Annual outdoor fine art festival held in August. Accepts all fine art. Juried by art professionals hired by the committee, monetary prizes given. Average number of exhibitors: 50. Average number of attendees: 2,500-3,000. Free admission. Artists should apply by accessing the website. Deadline July 1, 2013. Jury fee of $20, space fee of $90. Space is 225 sq. ft. For more information artists should e-mail or visit the website.

TIPS "Bring unique products."

☺ ART IN THE PARK SUMMER FESTIVAL

16 S. Main St., Rutland VT 05701. (802)775-8836. **Fax:** (802)773-0672. **E-mail:** info@chaffeeartcenter.org. **Website:** www.chaffeeartcenter.org/art_park.html. **Contact:** Sherri Birkheimer Rooker, event coordinator. Estab. 1961. Fine arts & crafts show held at Main Street Park in Rutland VT annually in mid-August. Accepts fine art, specialty foods, fiber, jewelry, glass, metal, wood, photography, clay, floral, etc. All applications will be juried by a panel of experts. The Art in the Park Festivals are dedicated to high quality art and craft products. Number of exhibitors: 100. Public attendance: 9,000-10,000. Public admission: voluntary donation. Artists should apply online and submit a CD with 3 photos of work and 1 of booth (photos upon pre-approval). Deadline for entry: on-going but to receive discount for doing both shows, must apply by late March; $25 late fee after that date. Space fee: $200-350. Exhibit space: 10×12 or 20×12

ft. For more information, artists should e-mail, visit website, or call.

TIPS "Have a good presentation, variety if possible (in price ranges, too) to appeal to a large group of people. Apply early as there may be a limited amount of accepted vendors per category. Applications will be juried on a first come, first served basis until the category is determined to be filled."

ARTISPHERE

16 Augusta St., Greenville SC 29601. (864)271-9355. **Fax:** (864)467-3133. **E-mail:** liz@greenvillearts.com. **Website:** www.artisphere.us. **Contact:** Liz Rundorff, program director; Kerry Murphy, executive director. Fine arts & crafts show held annually in early May (see website for details). Showcases local artists and top regional galleries in a gallery row at various venues along Main Street. Free to public. E-mail, call or visit website for more information and to display your work.

ART ON THE LAWN

Village Artisans, 100 Corry St., Yellow Springs OH 45387. (937)767-1209. **E-mail:** villageartisans.email@ yahoo.com. **Website:** www.shopvillageartisans.com. **Contact:** Village Artisans. Estab. 1983. Fine arts & crafts show held annually the 2nd Saturday in August. Outdoors. Accepts photography, all hand-made media and original artwork. Juried, as received, from photos accompanying the application. Awards: "Best of Show" receives a free booth space at next year's event. Number of exhibitors: 90-100. Free to public. Request an application by calling or e-mailing, or download an application from the website. Deadline for entry: early August; however, the sooner received, the better the chances of acceptance. Jury fee: $15. Space fee: $75 before May; $85 until late July; $105 thereafter. Exhibition space: 10×10 ft. Average gross sales vary. For more information, artists should visit website, e-mail, call, send SASE or stop by Village Artisans at above address.

ARTS & CRAFTS ADVENTURE

P.O. Box 1326, Palatine IL 60078. (312)751-2500. **Fax:** (847)221-5853. **E-mail:** asoaartists@aol.com. **Website:** www.americansocietyofartists.org. **Contact:** Office personnel. Estab. 1991. Fine arts & crafts show held annually in early May and mid-September. Outdoors. Event held in Park Ridge IL. Accepts photography, pottery, paintings, sculpture, glass, wood, woodcarving, and more. Juried by 4 slides or photos of work

and 1 slide or photo of display; #10 SASE; a résumé or show listing is helpful. See our website for online jury. To jury via e-mail: asoaartists@aol.com. Number of exhibitors: 75. Free to the public. Artists should apply by submitting jury materials. If juried in, you will receive a jury/approval number. Deadline for entry: 2 months prior to show or earlier if spaces fill. Space fee: $80. Exhibition space: approximately 100 sq. ft. for single space; other sizes available. For more information, artists should send SASE, submit jury material.

TIPS "Remember that when you are at work in your studio, you are an artist. But when you are at a show, you are a business person selling your work."

AN ARTS & CRAFTS AFFAIR, AUTUMN & SPRING TOURS

P.O. Box 655, Antioch IL 60002. (402)331-2889. **Fax:** (402)445-9177. **E-mail:** hpifestivals@cox.net. **Website:** www.hpifestivals.com. **Contact:** Huffman Productions. Estab. 1983. An arts & crafts show that tours different cities and states. The Autumn Festival tours annually October-November; Spring Festival tours annually in April. Artists should visit website to see list of states and schedule. Indoors. Accepts photography, pottery, stained glass, jewelry, clothing, wood, baskets. All artwork must be handcrafted by the actual artist exhibiting at the show. Juried by sending in 2 photos of work and 1 of display. Awards/prizes: 4 $30 show gift certificates; $50, $100 and $150 certificates off future booth fees. Number of exhibitors: 300-500 depending on location. Public attendance: 15,000-35,000. Public admission: $7-8/adults; $6-7/seniors; 10 & under, free. Artists should apply by calling to request an application. Deadline for entry: varies for date and location. Space fee: $350-1,350. Exhibition space: 8×11 ft. up to 8×22 ft. For more information, artists should e-mail, call, or visit website.

TIPS "Have a nice display, make sure business name is visible, dress professionally, have different price points, and be willing to talk to your customers."

ARTS & CRAFTS FESTIVAL

Simsbury Woman's Club, P.O. Box 903, Simsbury CT 06070. (860)658-2684. **E-mail:** simsburywom ansclub@hotmail.com. **Contact:** Shirley Barsness, co-chairman. Estab. 1978. Juried arts & crafts show held annually 2nd weekend after Labor Day. Outdoors rain or shine. Accepts photography, clothing, accessories, jewelry, toys, wood objects, floral arrangements. Juried. Applicants should submit photos or JPEG

files. Number of exhibitors: 120. Public attendance: 5,000-7,000. Free to public. Artists should apply by submitting completed application, 4 photos including 1 of display booth. Deadline for entry: June 30. Space fee: $150-175. Exhibition space: 11×14 ft. or 15×14 ft. frontage. For more information, artists should e-mail or call.

TIPS "Display artwork in an attractive setting."

ARTS ADVENTURE

P.O. Box 1326, Palatine IL 60078. (312)571-2500. **Fax:** (847)221-5853. **E-mail:** asoa@webtv.net or asoaartists@aol.com. **Website:** www.americansoci etyofartists.org. Estab. 2001. American Society of Artists. Fine arts & crafts show held annually the end of July. Event held in Chicago. Outdoors. Accepts photography, paintings, pottery, sculpture, jewelry and more. Juried. Please submit 4 images representative of your work you wish to exhibit, 1 of your display set-up, your first/last name, physical address, daytime telephone number (résumé/show listing helpful). See our website for online jury. To jury via e-mail: asoaartists@aol.com. Number of exhibitors: 50. Free to the public. Artists should apply by submitting jury materials. If juried in, you will receive a jury/approval number. Deadline for entry: 2 months prior to show or earlier if spaces fill. Entry fee: $135. Exhibition space: approximately 100 sq. ft. for single space; other sizes available. For more information, artists should send SASE, submit jury material.

TIPS "Remember that when you are at work in your studio, you are an artist. But when you are at a show, you are a business person selling your work."

ART'S ALIVE

Ocean City City Hall, 301 Baltimore Ave., Ocean City MD 21842. (410)250-0125. **Fax:** (410)250-5409. **Website:** oceancitymd.gov/recreation_and_parks/special events.html. **Contact:** Brenda Moore, event coordinator. Estab. 2000. Fine art show held annually in mid-June. Outdoors. Accepts photography, ceramics, drawing, fiber, furniture, glass, printmaking, jewelry, mixed media, painting, sculpture, fine wood. Juried. Awards/prizes: $5,250 in cash prizes. Number of exhibitors: 110. Public attendance: 10,000. Free to public. Artists should apply by downloading application from website or call. Deadline for entry: February 28. Space fee: $200. Jury Fee: $25. Exhibition space: 10×10 ft. For more information, artists should visit website, call or send SASE.

TIPS Apply early.

ARTS EXPERIENCE

P.O. Box 1326, Palatine IL 60078. (312)751-2500 or (847)991-4748. **Fax:** (847)221-5853. **E-mail:** asoaartists@aol.com. **Website:** www.americansoci etyofartists.org. Estab. 1979. Fine arts & crafts show held in summer in Chicago. Outdoors. Accepts photography, paintings, graphics, sculpture, quilting, woodworking, fiber art, hand-crafted candles, glass works, jewelry and more. Juried by 4 photo representative of work being exhibited; 1 photo of display set-up, #10 SASE, résumé with show listings helpful. Number of exhibitors: 50. Free to public. Artists should apply by submitting jury material and indicate you are interested in this particular show. If you wish to jury online please see our website and follow directions given there. To jury via e-mail: submit only at asoaartists@aol.com. When you pass the jury, you will receive jury approval number and application you requested. Deadline for entry: 2 months prior to show or earlier if space is filled. Space fee: to be announced. Exhibition space: 100 sq. ft. for single space; other sizes are available. For more information, artists should send SASE to submit jury material.

TIPS "Remember that at work in your studio, you are an artist. When you are at a show, you are a business person selling your work."

ARTS IN THE PARK

302 Second Ave. E., Kalispell MT 59901. (406)755-5268. **E-mail:** information@hockadaymuseum.com. **Website:** www.hockadaymuseum.org. Estab. 1968. Fine arts & crafts show held annually 4th weekend in July (see website for details). Outdoors. Accepts photography, jewelry, clothing, paintings, pottery, glass, wood, furniture, baskets. Juried by a panel of 5 members. Artwork is evaluated for quality, creativity and originality. Jurors attempt to achieve a balance of mediums in the show. Number of exhibitors: 100. Public attendance: 10,000. Artists should apply by completing the online application form and sending 5 images in JPEG format; 4 images of work and 1 of booth. Application fee: $25. Exhibition space: 10×10 or 10×20 ft. Booth fees: $170-435 For more information, artists should e-mail, call or visit website.

ARTS ON FOOT

1250 H St. NW, Suite 1000, Washington DC 20005. (202)638-3232. **E-mail:** artsonfoot@downtowndc.

org. **Website:** www.artsonfoot.org. Fine arts & crafts show held annually in September. Outdoors. Accepts photography, painting, sculpture, fiber art, furniture, glass, jewelry, leather. Juried by 5 color images of the artwork. Send images as 35mm slides, TIFF or JPEG files on CD or DVD. Also include artist's résumé and SASE for return of materials. Free to the public. Deadline for entry: July. Exhibition space: 10×10 ft. For more information, artists should call, e-mail, visit website.

ARTS ON THE GREEN

Arts Association of Oldham County, 104 E. Main St., LaGrange KY 40031. (502)222-3822. **Fax:** (502)222-3823. **E-mail:** maryklausing@bellsouth.net. **Website:** www.aaooc.org. **Contact:** Mary Klausing, director. Estab. 2001. Fine arts & crafts show held annually 1st weekend in June. Outdoors. Accepts photography, painting, clay, sculpture, metal, wood, fabric, glass, jewelry. Juried by a panel. Awards/prizes: cash prizes for Best of Show and category awards. Number of exhibitors: 100. Public attendance: 7,500. Free to the public. Artists should apply online or call. Deadline for entry: March 15. Jury fee: $20. Space fee: $175. Electricity fee: $15. Exhibition space: 10×10 or 10×12 ft. For more information, artists should e-mail, visit website, call.
TIPS "Make potential customers feel welcome in your space. Don't overcrowd your work. Smile!"

ARTSPLOSURE

313 S. Blount St., #200B, Raleigh NC 27601. (919)832-8699. **Fax:** (919)832-0890. **E-mail:** info@artsplosure.org. **Website:** www.artsplosure.org. **Contact:** Dylan Morris, operations manager. Estab. 1979. Annual outdoor art/craft fair held the 3rd weekend of May. Accepts ceramics, glass, fiber art, jewelry, metal, painting, photography, wood, 2D and 3D artwork. Juried event. Awards: 6 totaling $3,500 cash. Number of exhibitors: 170. Public attendance: 75,000. Free admission to the public. Applications available in October, deadline is mid-January. Application fee: $32. Space fee: $225 for 12×12 ft. for a double space $450. Average sales: $2,500. For more information visit website or e-mail.
TIPS "Professional quality photos of work submitted for jurying are preferred, as well as a well executed professional booth photo. Keep artist statements concise and relevant."

BEVERLY HILLS ART SHOW

Greystone Park, 501 Doheny Rd., Beverly Hills CA 90210-2921. (310)285-6836. **E-mail:** kmclean@beverlyhills.org. **Website:** www.beverlyhills.org/artshow. Estab. 1973. Fine arts & crafts show held bi-annually 3rd weekend in May and 3rd weekend in October. Outdoors, 4 blocks in the center of Beverly Hills. Accepts photography, painting, sculpture, ceramics, jewelry, digital media. Juried. Awards/prizes: 1st place in category, cash awards, Best in Show cash award; Mayor's Purchase Award in May show. Number of exhibitors: 230-250. Public attendance: 30,000-50,000. Free to public. Deadline for entry: mid-February for the May show; mid-July for the October show. For more information, artists should e-mail, visit website, call or send SASE.
TIPS "Art fairs tend to be commercially oriented. It usually pays off to think in somewhat commercial terms—what does the public usually buy? Personally, I like risky and unusual art, but the artists who produce esoteric art sometimes go hungry! Be nice and have a clean presentation."

BLACK SWAMP ARTS FESTIVAL

P.O. Box 532, Bowling Green OH 43402. (419)354-2723. **E-mail:** info@blackswamparts.org. **Website:** www.blackswamparts.org. The Black Swamp Arts Festival (BSAF), held early September, connects art and the community by presenting an annual arts festival and by promoting the arts in the Bowling Green community. Apply online at www.zapplication.org. Call, e-mail or visit website for more information. Application fee: $35. Single booth fee: $200. Double booth fee: $400.
TIPS Offer a range of prices, from $5 to $500.

BOCA RATON FINE ART SHOW

(941)755-3088. **E-mail:** info@hotworks.org. **E-mail:** patty@hotworks.org. **Website:** www.hotworks.org. **Contact:** Patty Naronzny. Estab. 2009. The annual Boca Raton Fine Art Show brings high quality juried artists to sell their art works in the heart of downtown Boca Raton. All work is original and personally handmade by the artist. We offer awards to attract the nation's best artists. Our goal is to create an atmosphere that enhances the artwork and creates a relaxing environment for art lovers. All types of disciplines for sale including sculpture, paintings, clay, glass, printmaking, fiber, wood, jewelry, photography, and more. Art show also has artist demonstrations, live entertain-

ment, and food. Awards: two $500 Juror's Award and five $100 Awards of Excellence.

BRICK STREET MARKET

E-mail: info@zionsvillechamber.org. **Website:** www.zionsvillechamber.org. Estab. 1985. Fine art, antique & craft show held annually the Saturday after Mother's Day. Outdoors. In collaboration with area merchants, this annual event is held on the Main Street Gallery District in the Historic Village of Zionsville IN. Please submit application found on line at www.zionsvillechamber.org and up to 3 JPEG images. All mediums are welcome. Artists are encouraged to perform demonstrations of their work and talk with visitors during the event. Tents will be provided. No tents are required although artists must supply display equipment. Selection committee chooses from the following criteria: antiques, art, food, green/organic products, photography, plants/flowers, and handmade/hand crafted textiles. Committee discourages catalog or mass-produced products. Number of exhibitors: 150-160. Public attendance: 3,000-4,000. Free to public. Artists should apply by requesting application by mail or on website. Space fee: $165. Exhibition space: 10×8 ft. For more information, artists should e-mail.

TIPS "Display is very important. Be creative by making booth space interesting and appealing."

CAIN PARK ARTS FESTIVAL

40 Severance Circle, Cleveland Heights OH 44118-9988. (216)291-3669. **Fax:** (216)291-3705. **E-mail:** jhoffman@clvhts.com; ksenia@clvhts.com. **Website:** www.cainpark.com. Estab. 1976. Fine arts & crafts show held annually 2nd full week in July. Outdoors. Accepts photography, painting, clay, sculpture, wood, jewelry, leather, glass, ceramics, clothes and other fiber, paper, block printing. Juried by a panel of professional artists; submit 5 slides. Awards/prizes: cash prizes of $750, $500 and $250; also Judges' Selection, Director's Choice and Artists' Award. Number of exhibitors: 155. Public attendance: 60,000. Free to the public. Artists should apply by requesting an application by mail, visiting website to download application or by calling. Deadline for entry: early March. Application fee: $35. Space fee: $400. Exhibition space: 10×10 ft. Average gross sales/exhibitor: $4,000. For more information, artists should e-mail, call or visit website.

TIPS "Have an attractive booth to display your work. Have a variety of prices. Be available to answer questions about your work."

CALABASAS FINE ARTS FESTIVAL

100 Civic Center Way, Calabasas CA 91302. (818)224-1657. **E-mail:** artscouncil@cityofcalabasas.com. **Website:** www.calabasasartscouncil.com. Estab. 1997. Fine arts & crafts show held annually in late April/early May. Outdoors. Accepts photography, painting, sculpture, jewelry, mixed media. Juried. Number of exhibitors: 250. Public attendance: 10,000+. Free to public. Application fee: $25. Artists should apply online through www.zapplication.org; must include 3 photos of work and 1 photo of booth display. Booth fee: $275-465. For more information, artists should call, e-mail or visit website.

CAREFREE FINE ART & WINE FESTIVAL

101 Easy St., Carefree AZ 85377. (480)837-5637. **Fax:** (480)837-2355. **E-mail:** info@thunderbirdartists.com. **Website:** www.thunderbirdartists.com. **Contact:** Denise Dodson, president. Estab. 1993. Fine arts & crafts show held annually in mid-January, the first weekend in March, and the first weekend in November (see website for specifics). Outdoors. Accepts photography and paintings, bronzes, baskets, jewelry, stone and pottery. Juried; CEO blind juries by medium. Number of exhibitors: 165. Public attendance: 45,000. Public admission: $3. Applications available at www.zapplication.org. Deadline for entry: mid-August (for January festival); late November (for March festival); early June (for November festival). See website for specifics. Application fee: $30. Space fee: $410-1,230. Exhibition space: 10×10 to 10×30 ft. For more information, artists should e-mail, call or visit website.

TIPS "A clean gallery-type presentation is very important."

CEDARHURST CRAFT FAIR

P.O. Box 923, 2600 Richview Rd., Mt. Vernon IL 62864. (618)242-1236, ext. 234. **Fax:** (618)242-9530. **E-mail:** linda@cedarhurst.org. **Website:** www.cedarhurst.org. **Contact:** Linda Wheeler, staff coordinator. Estab. 1977. Arts & crafts show held annually on the first weekend after Labor Day each September. Outdoors. Accepts photography, paper, glass, metal, clay, wood, leather, jewelry, fiber, baskets, 2D art. Juried. Awards/prizes: Best of most category. Number of exhibitors: 125+. Public attendance: 12,000. Public ad-

mission: $5. Artists should apply by filling out online application form. Deadline for entry: March. Application fee: $25. Space fee: $280. Exhibition space: 10×15 ft. For more information, artists should e-mail, call or visit website.

☉ CELLULAR SOUTH GUMTREE FESTIVAL

P.O. Box 786, Tupelo MS 38802. (622)844-2787. **Fax:** (622)844-9751. **E-mail:** kstafford@gumtreemuseum.com. **Website:** www.gumtreemuseum.com. Annual fine arts & crafts festival held early May on the historic courtyard square in downtown Tupelo. "A Mother's Day weekend tradition." Considers all styles and genres. Past shows have included: graphics, photography, drawings, glass, jewelry, clay, sculpture, painting, traditional crafts, water color and mixed media. Juried; selection panel made up of 4 prominent representatives in the artist community, with one serving as an alternate. Artist attendance limited to 120 juried artists selected by a panel; the next 20 artists will be placed on a waiting list. Awards: Best in Show ($1,500 Festival Purchase Award); Merit Awards ($4,900 in 7 categories); Purchase Awards ($7,000 work selected by patrons). Public attendance: 25,000. Free admission to the public. Application form, and complete details, available online. Application fee: $35. Space fee: $200 for 10×10 ft. (double booth limited availability). For more information, e-mail or see website.

CENTERVILLE–WASHINGTON TOWNSHIP AMERICANA FESTIVAL

P.O. Box 41794, Centerville OH 45441-0794. (937)433-5898. **Fax:** (937)433-5898. **E-mail:** americanafestival@sbcglobal.net. **Website:** www.americanafestival.org. Estab. 1972. Arts & crafts show held annually on the Fourth of July, except when the 4th falls on a Sunday and then festival is held on Monday the 5th. Festival includes entertainment, parade, food, car show and other activities. Accepts photography and all mediums. "No factory-made items accepted." Awards/prizes: 1st, 2nd, 3rd places; certificates and ribbons for most attractive displays. Number of exhibitors: 275-300. Public attendance: 70,000. Free to the public. Artists should send SASE for application form, or apply online. Deadline for entry: early June (see website for details). Space fee: $50. Exhibition space: 12×10 ft. For more information, artists should e-mail, call or visit website.

TIPS "Artists should have moderately priced items, bring business cards and have an eye-catching display."

☉ CHARDON SQUARE ARTS FESTIVAL

Historic Chardon Square, 107 Center St., Chardon OH 44024. (440)285-8686. **Website:** www.tourgeauga.com/default.aspx. jgipson@aol.com; rosepointe1@roadrunner.com. **Contact:** Jan Gipson, chairman. Estab. 1980. Fine arts & crafts show held annually in early August (see website for details). Outdoors. Accepts photography, pottery, weaving, wood, paintings, jewelry. Juried. Number of exhibitors: 105. Public attendance: 3,000. Free to public. Artists should apply by calling for application. Exhibition space: 10×10 ft. For more information, artists should call or visit website.

TIPS "Make your booth attractive; be friendly and offer quality work."

☉ CHARLOTTE FINE ART & CRAFT SHOW

Hot Works, LLC, The Park Expo & Conference Center, Freedom Hall, 2500 E. Independence Blvd., Charlotte NC 28205. (248)684-2613. **E-mail:** patty@hotworks.org. **Website:** www.hotworks.org. **Contact:** Patty Narozny, show director. Estab. 2008. Annual arts & crafts show. "Approximately 150 of the highest quality juried artists from around the world will sell their art in all forms of media including paintings, clay, glass, sculpture, wood, fiber, photography, and more. All work is personally hand-made by the artist who is present at the show and happy to answer any questions about how they made the work, and why, and what inspires them." Juried, by art professionals based on technique/execution, quality and originality. Awards presented. Public admission: $8, children 12 and under are free. Artists should call, e-mail or see website for more information.

☉ CHATSWORTH CRANBERRY FESTIVAL

P.O. Box 286, Chatsworth NJ 08019. (609)726-9237. **Fax:** (609)726-1459. **E-mail:** lgiamalis@aol.com. **Website:** www.cranfest.org. Estab. 1983. Arts & crafts show held annually in mid-October (see website for details). Outdoors. The festival is a celebration of New Jersey's cranberry harvest, the 3rd largest in the country, and offers a tribute to the Pine Barrens and local culture. Accepts photography. Juried. Number of exhibitors: 200. Public attendance: 75,000-100,000. Free to public. Artists should apply by sending SASE to above address (application form online). Requires 3

pictures of products and 1 of display. Deadline: September 1. Space fee: $200 for 2 days. Exhibition space: 15×15 ft. For more information, artists should visit website.

CHUN CAPITOL HILL PEOPLE'S FAIR

1290 Williams St., Suite 102, Denver CO 80218. (303)830-1651. **Fax:** (303)830-1782. **E-mail:** andrea furness@chundenver.org; nicoleanderson@chundenver.org. **Website:** www.peoplesfair.com; www.chundenver.org. **Contact:** Andrea Furness, assistant director. Estab. 1971. Arts & crafts show held annually 1st weekend in June. Outdoors. Accepts photography, ceramics, jewelry, paintings, wearable art, glass, sculpture, wood, paper, fiber, children's items, and more. Juried by professional artisans representing a variety of mediums and selected members of fair management. The jury process is based on originality, quality and expression. Awards/prizes: Best of Show. Number of exhibitors: 300. Public attendance: 250,000. Free to public. Artists should apply by downloading application from website. Deadline for entry: March. Application fee: $35. Space fee: $300. Exhibition space: 10×10 ft. For more information, artists should e-mail, visit website or call.

CHURCH STREET ART & CRAFT SHOW

Downtown Waynesville Association, P.O. Box 1409, Waynesville NC 28786. (828)456-3517. **E-mail:** downtownwaynesville@charter.net. **Website:** www.downtownwaynesville.com. Estab. 1983. Fine arts & crafts show held annually 2nd Saturday in October. Outdoors. Accepts photography, paintings, fiber, pottery, wood, jewelry. Juried by committee: submit 4 slides or digital photos of work and 1 of booth display. Prizes: $100-400 Number of exhibitors: 100. Public attendance: 15,000-18,000. Free to public. Entry fee: $20. Space fee: $100 ($195 for two booths). Exhibition space: 10×12 ft. (option of two booths for 12×20 space). For more information and application, see website. Deadline: mid-August.
TIPS Recommends "quality in work and display."

CITY OF FAIRFAX FALL FESTIVAL

4401 Sideburn Rd., Fairfax VA 22030. (703)385-7949. **Fax:** (703)246-6321. **E-mail:** leslie.herman@fairfaxva.gov; parksrec@fairfaxva.gov. **Website:** www.fairfaxva.gov. **Contact:** Leslie Herman, special events manager. Estab. 1975. Arts & crafts show held annually the 2nd Saturday in October. Outdoors. Accepts photog-

raphy, jewelry, glass, pottery, clay, wood, mixed media. Juried by a panel of 5 independent jurors. Number of exhibitors: 500. Public attendance: 35,000. Free to the public. Deadline for entry: March 15. Application fee: $12. Space fee: $155. Exhibition space: 10×10 ft. For more information, artists should e-mail.
TIPS "Be on site during the event. Smile. Price according to what the market will bear."

CITY OF FAIRFAX HOLIDAY CRAFT SHOW

10455 Armstrong St., Fairfax VA 22030. (703)385-7949. **Fax:** (703)246-6321. **E-mail:** parksrec@fairfaxva.gov; leslie.herman@fairfaxva.gov. **Website:** www.fairfaxva.gov. **Contact:** Leslie Herman, special events coordinator. Estab. 1985. Arts & crafts show held annually 3rd weekend in November. Indoors. Accepts photography, jewelry, glass, pottery, clay, wood, mixed media. Juried by a panel of 5 independent jurors. Number of exhibitors: 247. Public attendance: 7,000. Public admission: $5 for age 18 an older. $8 for two day pass. Artists should apply by contacting Leslie Herman for an application. Deadline for entry: early March (see website for details). Application fee: $12. Space fee: 10×6 ft.: $190; 11×9 ft.: $240; 10×10 ft.: $265. For more information, artists should e-mail.
TIPS "Be on-site during the event. Smile. Price according to what the market will bear."

CODORUS SUMMER BLAST

Codorus State Park, 2600 Smith Station Rd., Hanover PA 17331. (717)434-4042. **E-mail:** freedomloghouse@comcast.net. **Website:** codorusblast.com. **Contact:** Vicki Senft. Estab. 2000. Arts & crafts show held as part of a 3-day family-friendly festival. Held annually in late June (see website for details). Outdoors. Accepts photography and all crafts. Number of exhibitors: 50. Public attendance: 45,000. Free to the public. Artists should apply on website or through the mail. Space fee: $125-325. Exhibition space: 10×12, 20×12 or 30×12 ft. For more information, artists should e-mail, visit website or call.

COLORSCAPE CHENANGO ARTS FESTIVAL

P.O. Box 624, Norwich NY 13815. (607)336-3378. **E-mail:** info@colorscape.org. **Website:** www.colorscape.org. Estab. 1995. A juried exhibition of art & fine crafts held annually the weekend after Labor Day. Outdoors. Accepts photography and all types of media. Juried. Awards/prizes: $5,000. Number of exhibi-

tors: 100. Public attendance: 12,000-14,000. Free to public. Deadline for entry: see website for details. Application fee: $15 jury fee. Space fee: $175. Exhibition space: 12×12 ft. For more information, artists should e-mail, visit website, call or send SASE.

TIPS "Interact with your audience. Talk to them about your work and how it is created. People like to be involved in the art they buy and are more likely to buy if you involve them."

CONYERS CHERRY BLOSSOM FESTIVAL

1184 Scott St., Conyers GA 30012. (770)929-4270. E-mail: harriet.gattis@conyersga.com. **Website:** www. conyerscherryblossomfest.com. Estab. 1981. Arts & crafts show held annually in late March (see website for details). Outdoors. The festival is held at the Georgia International Horse Park at the Grand Prix Plaza overlooking the Grand Prix Stadium used during the 1996 Centennial Olympic Games. Accepts photography, paintings and any other handmade or original art. Juried. Submit 5 images: One picture must represent your work as it is displayed; one must represent a workshop photo of the artist creating their work; the other three need to represent your items as an accurate representation in size, style, and quality of work. Number of exhibitors: 300. Public attendance: 40,000. Free to public. Space fee: $125. Exhibition space: 10×10 ft. Electricity fee: $30. Application fee: $10; apply online. For more information, artists should e-mail, call or visit website.

CRAFT FAIR AT THE BAY

38 Charles St., Rochester NH 03867. (603)332-2616. **Fax:** (603) 332-8413. **E-mail:** info@castleberryfairs. com. **Website:** www.castleberryfairs.com. Estab. 1988. Arts & crafts show held annually in July in Alton Bay, New Hampshire. Outdoors. Accepts photography and all other mediums. Juried by photo, slide or sample. Number of exhibitors: 85. Public attendance: 7,500. Free to the public. Artists should apply by downloading application from website. Deadline for entry: until full. Exhibition space: 100 sq. ft. For more information, artists should visit call, e-mail or visit website.

TIPS "Do not bring a book; do not bring a chair. Smile and make eye contact with everyone who enters your booth. Have them sign your guest book; get their e-mail address so you can let them know when you are in the area again. And, finally, make the sale—they are at the fair to shop, after all."

CRAFTS AT RHINEBECK

6550 Springbrook Ave., Rhinebeck NY 12572. (845)876-4001. **Fax:** (845)876-4003. **E-mail:** vimperati@dutchessfair.com. **Website:** www.craftsatrhinebeck.com. Estab. 1981. Fine arts & crafts show held biannually in late June and early October. Indoors and outdoors. Accepts photography, fine art, ceramics, wood, mixed media, leather, glass, metal, fiber, jewelry. Juried. Submit 5 high-resolution digital images of your work on a CD clearly marked with the primary artist name. Four of the images must consist of individual pieces and one of the booth display containing artwork. Sharp, accurate color reproduction is important. Images cannot be any larger the 1920×1920 pixels at 72 dpi. Photographs not accepted. Number of exhibitors: 350. Public attendance: 25,000. Public admission: $7. Artists should apply by calling for application or downloading application from website. Deadline for entry: early February. Application fee: $25. Space fee: $300-730. Exhibition space: inside: 10×10 and 10×20 ft.; outside: 15×15 ft. For more information, artists should e-mail, visit website or call.

TIPS "Presentation of work within your booth is very important. Be approachable and inviting."

CRAFTWESTPORT

P.O. Box 28, Woodstock NY 12498. (845)331-7484. **Fax:** (845)331-7484. **E-mail:** crafts@artrider.com. **Website:** www.craftwestport.com. Estab. 1975. Fine arts & craft show held annually in mid-November. Indoors. Accepts photography, wearable and nonwearable fiber, metal and nonmetal jewelry, clay, leather, wood, glass, painting, drawing, prints, mixed media. Juried by 5 images of work and 1 of booth, viewed sequentially. Number of exhibitors: 160. Public attendance: 5,000. Public admission: $9. Artists should apply by downloading application from www.artrider.com or can apply online at www.zapplication.org. Deadline for entry: early July. Application fee: $45. Space fee: $545. Exhibition space: 10×10 ft. For more information, artists should e-mail, visit website, call.

CUSTER'S LAST STAND FESTIVAL OF THE ARTS

P.O. Box 6013, Evanston IL 60202. (847)328-2204. **Fax:** (847)823-2295. **E-mail:** office@custerfair.com. **Website:** www.custerfair.com. Estab. 1972. Outdoor fine art craft show held in June. Accepts photography and all mediums. Number of exhibitors: 400. Public attendance: 70,000. Free to the public. Application

fee: $10. Booth fee: $250-700. Deadline for entry: early May. Space fee varies, e-mail, call or visit website for more details.

TIPS "Be prepared to speak with patrons; invite them to look at your work and discuss."

A DAY IN TOWNE

Boalsburg Memorial Day Committee, 117 E. Boal Ave., Boalsburg PA 16827. (814)466-6311 or (814)466-9266. **E-mail:** office@boalmuseum.com. **Website:** www.boalmuseum.com/memorialdayvillage.html. Arts & crafts show held annually the last Monday in May/Memorial Day weekend. Outdoors. Accepts photography, country fabric & wood, wool knit, soap, jewelry, dried flowers, children, pottery, blown glass. Vendor must make own work. Number of exhibitors: 125-135. Public attendance: 20,000. Artists should apply by writing an inquiry letter and sending 2-3 photos; 1 of booth and 2 of the craft. Deadline for entry: January 1–February 1. Space fee: $75. Exhibition space: 10×15 ft.

TIPS "Please do not send fees until you receive an official contract. Have a neat booth and nice smile. Have fair prices—if too high, product will not sell here."

◎ DEERFIELD FINE ARTS FESTIVAL

3417 R.F.D., Long Grove IL 60047. (847)438-4517. **E-mail:** dwevents@comcast.net. **Website:** www.dwevents.org. **Contact:** D&W Events, Inc. Estab. 2003. Fine arts & crafts show held annually during the first weekend of June; hours are 10-5. Outdoors. Accepts photography, fiber, oil, acrylic, watercolor, mixed media, jewelry, sculpture, metal, paper, ceramics, painting. Juried by 3 jurors. Awards/prizes: Best of Show; First Place, awards of excellence. Number of exhibitors: 150. Public attendance: 35,000. Free to public. Artists should apply by downloading application from website, e-mail or call. Exhibition space: 100 sq. ft. For more information artists should e-mail, visit website, call.

TIPS "Artists should display professionally and attractively, and interact positively with everyone."

◎ DELAWARE ARTS FESTIVAL

P.O. Box 589, Delaware OH 43015. (740)363-2695. **E-mail:** info@delawareartsfestival.org. **Website:** www.delawareartsfestival.org. Estab. 1973. Fine arts & crafts show held annually the Saturday and Sunday after Mother's Day. Outdoors. Accepts photography; all mediums, but no buy/sell. Juried by committee members who are also artists. Awards/prizes: Ribbons, cash awards, free booth for the following year. Number of exhibitors: 160. Public attendance: 25,000. Free to the public. Submit 3 slides or photographs that best represent your work. Your work will be juried in accordance with our guidelines. Photos will be returned only if you provide a SASE. Artists should apply by visiting website for application. Application fee: $10, payable to the Delaware Arts Festival. Space fee: $125. Exhibition space: 120 sq. ft. For more information, artists should e-mail or visit website.

TIPS "Have high-quality, original stuff. Engage the public. Applications will be screened according to originality, technique, craftsmanship and design. The Delaware Arts Festival, Inc. will exercise the right to reject items during the show that are not the quality of the media submitted with the applications. No commercial buy and resell merchandise permitted. Set up a good booth."

◎ DOWNTOWN FESTIVAL & ART SHOW

P.O. Box 490, Gainesville FL 32627. (352)393-8536. **Fax:** (352)334-2249. **E-mail:** piperlr@cityofgainesville.org. **Website:** www.gvlculturalaffairs.org. **Contact:** Linda Piper, events coordinator. Estab. 1981. Fine arts & crafts show held annually in October (see website for more details). Outdoors. Accepts photography, wood, ceramic, fiber, glass, and all mediums. Juried by 3 digital images of artwork and 1 digital image of booth. Awards/prizes: $14,000 in cash awards; $5,000 in purchase awards. Number of exhibitors: 250. Public attendance: 100,000. Free to the public. Artists should apply by mailing 4 digital images. Deadline for entry: May. Space fee: $215, competitive, $195 non-competitive. Exhibition space: 12×12 ft. Average gross sales/exhibitor: $6,000. For more information, artists should e-mail, visit website, call.

TIPS "Submit the highest quality digital images. A proper booth image is very important."

◎ DURANGO AUTUMN ARTS FESTIVAL

802 E. Second Ave., Durango CO 81301. (970)259-2606. **Fax:** (970)259-6571. **E-mail:** daaf@durangoarts.org. **Website:** www.durangoarts.org. Estab. 1993. Fine arts & crafts show. Mid-September. Outdoors. Accepts photography and all mediums. Juried. Number of exhibitors: 100. Public attendance: 8,000. Free to public. Exhibition space: 10×10 ft. Space fee $300. Application fee of $30. Apply via www.zapplication.org. For more information, artists should e-mail, visit website or send SASE.

⊙ EDENS ART FAIR

P.O. Box 1326, Palatine IL 60078. (312)2500. **Fax:** (847)5853. **E-mail:** asoa@webtv.net; asoaartists@aol.com. **Website:** www.americansocietyofartists.com. **Contact:** Office personnel. Estab. 1995 (after renovation of location; held many years prior to renovation). American Society of Artists. Fine arts & fine selected crafts show held annually in mid-July. Outdoors. Event held in Wilmette, Illinois. Accepts photography, paintings, sculpture, glass works, jewelry and more. Juried. Send 4 slides or photos of your work and 1 slide or photo of your display; #10 SASE; a résumé or show listing is helpful. Number of exhibitors: 50. Free to the public. Artists should apply by submitting jury materials. If you wish to jury online please see our website and follow directions given. To jury via e-mail: asoaartists@aol.com. If you pass jury you will receive a non-member jury approval number. If juried in, you will receive a jury/approval number. Deadline for entry: 2 months prior to show or earlier if spaces fill. Entry fee: $145. Exhibition space: approximately 100 sq. ft. for single space; other sizes available. For more information, artists should send SASE, submit jury material.

TIPS "Remember that when you are at work in your studio, you are an artist. But when you are at a show, you are a business person selling your work."

⊙ EDWARDS FINE ART & SCULPTURE FESTIVAL

27 Main St., Edwards CO 81632. (480)837-5637. **Fax:** (480)837-2355. **E-mail:** info@thunderbirdartists.com. **Website:** www.thunderbirdartists.com. **Contact:** Denise Dodson, vice president. Estab. 1999. Fine art & craft show. Held annually in mid-July (see website for specifics). Outdoors. Accepts photography, painting, bronzes, baskets, jewelry, stone, pottery. Juried; blind jury by CEO. Number of exhibitors: 75. Public attendance: 10,000. Free to public. Apply online at www.zapplication.org. Deadline for entry: see website for details. Application fee: $30. Space fee: $400-1,200. Exhibition space: 10×10 to 10×30 ft. For more information, artists should e-mail, call or visit website.

TIPS "A clean, gallery-type presentation is very important."

⊙ ELMWOOD AVENUE FESTIVAL OF THE ARTS, INC.

P.O. Box 786, Buffalo NY 14213-0786. (716)830-2484. **E-mail:** directoreafa@aol.com. **Website:** www.elm

woodartfest.org. Estab. 2000. Arts & crafts show held annually in late August, the weekend before Labor Day weekend. Outdoors. Accepts photography, metal, fiber, ceramics, glass, wood, jewelry, basketry, 2D media. Juried. Awards/prizes: to be determined. Number of exhibitors: 170. Public attendance: 80,000-120,000. Free to the public. Artists should apply by e-mailing their contact information or by downloading application from website. Deadline for entry: April. Application fee: $25. Space fee: $275. Exhibition space: 10×15 ft. Average gross sales/exhibitor: $3,000. For more information, artists should e-mail, call or visit website.

TIPS "Make sure your display is well designed, with clean lines that highlight your work. Have a variety of price points—even wealthy people don't always want to spend $500 at a booth where they may like the work."

⊙ ESTERO FINE ART SHOW

Hot Works, LLC, Miromar Outlets, 10801 Corkscrew Road, I-75 Exit 123, Estero FL 33928. (941)755-3088. **E-mail:** info@hotworks.org or patty@hotworks.org. **Website:** www.hotworks.org. **Contact:** Patty Narozny, show director. Bi-annual fine art show held for two days in early January and early November (see website for details). "This event showcases artists from around the Globe. Art includes glass, clay, wood, fiber, jewelry, sculpture, painting, photography, and metal. There is artwork for every budget. Focus is on technique/execution, quality and originality." Juried by art professionals in the industry. Awards: $1,500 distributed as follows; two $500 Juror's Award of Excellence and five $100 Awards of Excellence. Free admission and free parking. Space fee varies, see artist application on website for details. For more information, artists should e-mail, call or see website for more details.

⊙ EVERGREEN FINE ARTS FESTIVAL

Evergreen Artists Association, P.O. Box 3931, Evergreen CO 80437-3931. (303)679-1609. **E-mail:** tjaunting@aol.com. **Website:** www.evergreenartists.org/shows_festivals.htm; www.fairsandfestivals.net/events/details/evergreen-fine-arts-festival-2011. **Contact:** Lynne Milliken, marketing chair. Estab. 1966. Fine arts show held annually the last weekend in August. Outdoors in Historic Grove Venue, next to Hiwan Homestead. Accepts both 2D and 3D media, including photography, fiber, oil, acrylic, pottery, jewelry, mixed media, ceramics, wood, watercolor. Juried event with jurors that change yearly. Artists should

submit a CD with 3 views of work and 1 of booth display by digital photograph high-res. Awards/prizes: Best of Show; 1st, 2nd, 3rd places in 2D and 3D. Number of exhibitors: approximately 96. Public attendance: 3,000-6,000. Free to public. Deadline for entry: April 15. Application fee: $30. Space fee: $335, and space is limited. Exhibition space: 10×10 ft. Submissions only on www.zapplication.org begin in December and jurying completed in early May. For more information, artists should call or send SASE.

TIPS "Have a variety of work. It is difficult to sell only high-ticket items."

FAIRE ON THE SQUARE

Prescott Courthouse Plaza, 120 S. Cortez St., Prescott AZ 86303, United States. (928)445-2000, ext. 112. **E-mail:** chamber@prescott.org; scott@prescott.org. **Website:** www.visit-prescott.com/details/222-faire-on-the-square.html. Estab. 1985. Arts & crafts show held annually Labor Day weekend. Outdoors. Accepts photography, ceramics, painting, sculpture, clothing, woodworking, metal art, glass, floral, home décor. No resale. Juried. Photos of work and artist creating work are required. Number of exhibitors: 170. Public attendance: 10,000-12,000. Free to public. Application can be printed from website or obtained by phone request. Deadline: spaces are sold until show is full. Space fee: $425. Exhibition space; 10×15 ft. For more information, artist should e-mail, visit website or call.

◯ A FAIR IN THE PARK

906 Yew St., Pittsburgh PA 15224. (412)370-0695. **E-mail:** info@craftsmensguild.org. **Website:** www.craftsmensguild.org. **Contact:** Katie Horowitz, director. Estab. 1969. Contemporary fine arts & crafts show held annually the weekend after Labor Day outdoors. Accepts photography, clay, fiber, jewelry, metal, mixed media, wood, glass, 2D visual arts. Juried. Awards/prizes: 1 Best of Show and 4 Craftsmen's Guild Awards. Number of exhibitors: 115. Public attendance: 25,000+. Free to public. Submit 5 JPEG images; 4 of artwork, 1 of booth display. Application fee: $25. Booth fee: $275 or $325 for corner booth. Deadline for entry: early May. Exhibition space: 11×12 ft. Average gross sales/exhibitor: $1,000 and up. For more information artists should e-mail, visit website or call.

TIPS "It is very important for artists to present their work to the public, to concentrate on the business aspect of their artist career. They will find that they can build a strong customer/collector base by exhibiting

their work and by educating the public about their artistic process and passion for creativity."

◯ FALL FEST IN THE PARK

117 W. Goodwin St., Prescott AZ 86303. (928)445-2000 or (800)266-7534. **E-mail:** chamber@prescott.org. **Website:** www.prescott.org. Estab. 1981. Arts & crafts show held annually in mid-October. Outdoors. Accepts photography, ceramics, painting, sculpture, clothing, woodworking, metal art, glass, floral, home décor. No resale. Juried. Photos of work, booth, and artist creating work are required. Number of exhibitors: 150. Public attendance: 6,000-7,000. Free to public. Application can be printed from website or obtained by phone request. Deposit: $50, non-refundable. Booth fee: $250. Electricity is limited and has a fee of $15. Deadline: Spaces are sold until show is full. Exhibition space; 10×15 ft. For more information, artists should e-mail, visit website or call.

◯ FALL FESTIVAL OF ART AT QUEENY PARK

P.O. Box 31265, St. Louis MO 63131. (314)889-0433. **E-mail:** info@gslaa.org. **Website:** http://artfairatqueenypark.com/. Estab. 1976. Fine arts & crafts show held annually Labor Day weekend at Queeny Park. Indoors. Accepts photography, all fine art and fine craft categories. Juried by 5 jurors; 5 slides shown simultaneously. Awards/prizes: 3 levels, ribbons, $4,000+ total prizes. Number of exhibitors: 130. Public attendance: 2,000-4,000. Admission: $5. Artists should apply online. Application fee: $25. Booth fee: $200; $225 for corner booth. Deadline for entry: late May, see website for specific date. Exhibition space: 80 sq. ft. For more information, artists should e-mail or visit website.

TIPS "Excellent, professional slides; neat, interesting booth. But most important—exciting, vibrant, eye-catching art work."

◯ FALL FINE ART & CRAFTS AT BROOKDALE PARK

473 Latchung Ave., Bloomfield NJ 07003. (908)874-5247. **Fax:** (908)874-7098. **E-mail:** info@rosesquared.com. **Website:** www.rosesquared.com. **Contact:** Howard Rose, vice president. Estab. 1998. Fine arts & crafts show held annually in mid-October. Outdoors. Accepts photography and all other mediums. Juried. Number of exhibitors: 160. Public attendance: 12,000. Free to public. Artists should apply on the website. Deadline for entry: mid-September. Application fee:

$25. Space fee varies by booth size; see application form on website for details. For more information, artists should visit the website.

TIPS "Have a range of products and prices."

☺ FALL FINE ART & CRAFTS AT THE WESTFIELD ARMORY

500 Rahway Ave., Westfield NJ 07090. (908)874-5247. **Fax:** (908)874-7098. **E-mail:** info@rosesquared.com. **Website:** www.rosesquared.com. **Contact:** Howard Rose, vice president. Estab. 2010. Fine arts & crafts show held annually in mid-November. Indoors. Accepts photography and all other mediums. Juried. Number of exhibitors: 130. Public attendance: 4,000. Admission fee: $6. Artists should apply on the website. Deadline for entry: early November. Application fee: $25. Space fee varies by booth size; see application form on website for details. For more information, artists should visit the website.

TIPS "Create a unique booth."

☺ FARGO'S DOWNTOWN STREET FAIR

Downtown Community Partnership, 203 Fourth Ave. N., Fargo ND 58102. (701)241-1570; (701)451-9062. **Fax:** (701)241-8275. **E-mail:** steph@fmdowntown.com. **Website:** www.fmdowntown.com. Estab. 1975. Fine arts & crafts show held annually in July (see website for dates). Outdoors. Accepts photography, ceramics, glass, fiber, textile, jewelry, metal, paint, print/drawing, sculpture, 3D mixed media, wood. Juried by a team of artists from the Fargo-Moorehead area. Awards/prizes: Best of Show and best in each medium. Number of exhibitors: 300. Public attendance: 130,000-150,000. Free to pubic. Artists should apply online and submit 3 JPEGs (at 300 dpi) of work, 1 image of booth, and 4 images of process. Deadline for entry: mid-February. Space fee: $325-700 depending on size and location. Exhibition space: 10×10 ft. For more information, artists should e-mail, visit website or call.

☺ FAUST FINE ARTS & FOLK FESTIVAL

Greensfelder Recreation Complex, 15185 Olive St., St. Louis MO 63017. (314)615-8482. **E-mail:** toconnell@stlouisco.com. **Website:** www.stlouisco.com/parks. **Contact:** Tonya O'Connell, recreation supervisor. Fine arts & crafts show held bi-annually in May and September. Outdoors. Accepts photography, oil, acrylic, clay, fiber, sculpture, watercolor, jewelry, wood, floral, baskets, prints, drawing, mixed media, folk art. Juried by a committee. Awards/prizes: $100.

Number of exhibitors: 90-100. Public attendance: 5,000. Public admission: $3 for May show and $5 for September show—includes free hayrides and carousel rides. Deadline for entry: March for spring show and July for fall show. Application fee: $15. Space fee: $85. Exhibition space: 10×10 ft. For more information, artists should call.

☺ FESTIVAL IN THE PARK

1409 East Blvd., Charlotte NC 28203. (704)338-1060. **E-mail:** festival@festivalinthepark.org. **Website:** www.festivalinthepark.org. Estab. 1964. Fine arts & crafts show held annually the 3rd Friday after Labor Day. Outdoors. Accepts photography, decorative and wearable crafts, drawing and graphics, fiber and leather, jewelry, mixed media, painting, metal, sculpture, wood. Juried by slides or photographs. Awards/prizes: $4,000 in cash awards. Number of exhibitors: 150. Public attendance: 85,000. Free to the public. Artists should apply by visiting website for application. Application fee: $35. Space fee: $350. Exhibition space: 10×10 ft. For more information, artists should e-mail, visit website, call.

☺ FILLMORE JAZZ FESTIVAL

Steven Restivo Event Services, LLC, P.O. Box 151017, San Rafael CA 94915. (800)310-6563. **Fax:** (415)456-6436. **Website:** www.fillmorejazzfestival.com. Estab. 1984. Fine arts & crafts show and jazz festival held annually 1st weekend of July in San Francisco, between Jackson & Eddy streets. Outdoors. Accepts photography, ceramics, glass, jewelry, paintings, sculpture, metal clay, wood, clothing. Juried by prescreened panel. Number of exhibitors: 250. Public attendance: 90,000. Free to pubic. Deadline for entry: ongoing; apply online. Exhibition space: 8×10 ft. or 10×10 ft. Average gross sales/exhibitor: $800-11,000. For more information, artists should visit website or call.

☺ FINE ART & CRAFTS AT ANDERSON PARK

274 Bellevue Ave., Upper Montclair NJ 07043. (908)874-5247. **Fax:** (908)874-7098. **E-mail:** info@rosesquared.com. **Website:** www.rosesquared.com. Estab. 1984. Fine art & craft show held annually in mid-September. Outdoors. Accepts photography and all other mediums. Juried. Number of exhibitors: 160. Public attendance: 12,000. Free to the public. Artists should apply on the website. Deadline for entry: mid-August. Application fee: $25. Space fee varies by booth

size; see application form on website for details. For more information, artists should visit the website.

TIPS "Create a range of sizes and prices."

FINE ART & CRAFTS AT VERONA PARK

542 Bloomfield Ave., Verona NJ 07044. (908)874-5247. **Fax:** (908)874-7098. **E-mail:** info@rosesquared.com. **Website:** www.rosesquared.com. **Contact:** Howard Rose, vice president. Estab. 1986. Fine arts & crafts show held annually in mid-May. Outdoors. Accepts photography and all other mediums. Juried. Number of exhibitors: 140. Public attendance: 10,000. Free to public. Artists should apply on the website. Deadline for entry: mid-April. Application fee: $25. Space fee varies by booth size; see application form on website for details. For more information, artists should visit the website.

TIPS "Have a range of sizes and price ranges."

FOOTHILLS CRAFTS FAIR

2753 Lynn Rd. #A, Tryon NC 28782-7870. (828)859-7427. **E-mail:** info@blueridgebbqfestival.com. **Website:** www.blueridgebbqfestival.com. **Contact:** Tabatha Cantrell. Estab. 1994. Fine arts & crafts show and Blue Ridge BBQ Festival/Championship held annually the 2nd Friday and Saturday in June. Outdoors. Accepts photography, arts and handcrafts by artist only; nothing manufactured or imported. Juried. Number of exhibitors: 50. Public attendance: 20,000+. Public admission: $8; 12 and under free. Artists should apply by downloading application from website or sending personal information to e-mail or mailing address. See website for deadline for entry. Jury fee: $25, nonrefundable. Space fee: $160. Exhibition space: 12×12 ft. For more information, artists should e-mail or visit website.

TIPS "Have an attractive booth, unique items, and reasonable prices."

FORD CITY HERITAGE DAYS

P.O. Box 205, Ford City PA 16226-0205. (724)763-1617. **E-mail:** fcheritagedays@gmail.com. Estab. 1980. Arts & crafts show held annually over the Fourth of July weekend. Outdoors. Accepts photography, any handmade craft. Juried. Public attendance: 35,000-50,000. Free to public. Artists should apply by requesting an application by e-mail or telephone. Deadline for entry: mid-April. Application fee: $200. Space fee included with application fee. Exhibition space: 12×17

ft. For more information, artists should e-mail, call or send SASE.

TIPS "Show runs for five days. Have quality product, be able to stay for length of show, and have enough product."

FOREST HILLS FESTIVAL OF THE ARTS

P.O. Box 477, Smithtown NY 11787. (631)724-5966. **Fax:** (631)724-5967. **E-mail:** showtiques@aol.com. **Website:** www.showtiques.com. Estab. 2001. Fine arts & crafts show held annually in May/June. Outdoors. Accepts photography, all arts & crafts made by the exhibitor. Juried. Number of exhibitors: 300. Public attendance: 175,000. Free to public. Deadline for entry: until full. Exhibition space: 10×10 ft. For more information, artists should visit website or call.

FOUNTAIN HILLS FINE ART & WINE AFFAIRE

16810 E. Avenue of the Fountains, Fountain Hills AZ 85268. (480)837-5637. **Fax:** (480)837-2355. **E-mail:** info@thunderbirdartists.com. **Website:** www.thunderbirdartists.com. **Contact:** Denise Dodson, president. Estab. 2005. Fine arts & crafts show held annually in mid-March (see website for specifics). Outdoors. Accepts photography, paintings, bronzes, baskets, jewelry, stone, pottery. Juried; CEO blind juries by medium. Number of exhibitors: 125. Public attendance: 25,000. Public admission: $3. Apply online at www.zapplication.org. Deadline for entry: November (see website for specifics). Application fee: $30. Space fee: $410-1,230. Exhibition space: 10×10 to 10×30 ft. For more information, artists should e-mail, call or see website.

TIPS "A clean, gallery-type presentation is very important."

FOURTH AVENUE STREET FAIR

434 E. Ninth St., Tucson AZ 85705. (520)624-5004 or (800)933-2477. **Fax:** (520)624-5933. **E-mail:** kurt@fourthavenue.org. **Website:** www.fourthavenue.org. Estab. 1970. Arts & crafts fair held annually in late March/early April and December (see website for details). Outdoors. Accepts photography, drawing, painting, sculpture, arts & crafts. Juried by 5 jurors. Awards/prizes: Best of Show. Number of exhibitors: 400. Public attendance: 300,000. Free to the public. Artists should apply by completing the online application at www.zapplication.org. Requires 4 photos of art/craft and 1 booth photo. $35 application fee. Booth fee $470, additional $150 for corner booth. Deadline

for entry: see website for details. Exhibition space: 10×10 ft. Average gross sales/exhibitor: $3,000. For more information, artists should e-mail, visit website, call, send SASE.

FOURTH OF JULY STREET FAIR

501 Poli St., #226, Ventura CA 93002. (805)654-7749. **Fax:** (805)648-1030. **E-mail:** mgodoy@ci.ventura. ca.us. **Website:** www.venturastreetfair.com. **Contact:** Michelle Godoy. Estab. 1976. Fine arts & crafts show held annually in July. Outdoors. Accepts photography. Juried by a panel of 3 artists who specialize in various mediums; photos of work required. Number of exhibitors: 75-300. Public attendance: 30,000-50,000. Free to public. Artists should apply by downloading application from website or call to request application. Space fee: $175-225. Exhibition space: 10×10 ft. For more information, artists should e-mail, visit website or call.

TIPS "Be friendly, outgoing; know the area for pricing."

FOURTH STREET FESTIVAL FOR THE ARTS & CRAFTS

P.O. Box 1257, Bloomington IN 47402. (812)335-3814. **E-mail:** info@4thstreet.org. **Website:** www.4thstreet. org. Estab. 1976. Fine arts & crafts show held annually Labor Day weekend. Outdoors. Accepts photography, clay, glass, fiber, jewelry, painting, graphic, mixed media, wood. Juried by a 4-member panel. Awards/prizes: Best of Show ($750), 1st, 2nd, 3rd in 2D and 3D. Number of exhibitors: 105. Public attendance: 25,000. Free to public. Artists should apply by sending requests by mail, e-mail or download application from website at www.zapplication.org. Exhibition space: 10×10 ft. Average gross sales/exhibitor: $2,700. For more information, artists should e-mail, visit website, call or send for information with SASE.

TIPS Be professional.

FRANKFORT ART FAIR

P.O. Box 566, Frankfort MI 49635. (231)352-7251. **Fax:** (231)352-6750. **E-mail:** fcofc@frankfort-elberta. com. **Website:** www.frankfort-elberta.com. **Contact:** Joanne Bartley, executive director. Fine art fair held annually in August. Outdoors. Accepts photography, clay, glass, jewelry, textiles, wood, drawing/graphic arts, painting, sculpture, baskets, mixed media. Juried by 3 photos of work, 1 photo of booth display and 1 photo of work in progress. Prior exhibitors are not automatically accepted. No buy/sell allowed. Artists

should apply by downloading application from website, e-mailing or calling. Deadline for entry: May 1 ($25 late fee). Jury fee: $15. Space fee: $105 for Friday and Saturday. Exhibition space: 12×12 ft. For more information, artists should e-mail or visit website.

FREDERICK FESTIVAL OF THE ARTS

15 W. Patrick St., Frederick MD 21701. (301)662-4190. **Fax:** (301)663-3084. **E-mail:** info@frederick-artscouncil.org. **Website:** frederickartscouncil.org. Juried 2-day fine arts festival held annually the 1st weekend of June along Carroll Creek Linear Park in downtown Frederick. Features approximately 115 artists from across the country, two stages of musical performances, children's crafts and activities, artist demonstrations, as well as interactive classical theater performances. Apply online at www.zapplication.org. Application fee: $25. Space fee: starts at $395, depending on size and needs. For more information, call, e-mail or visit website.

TIPS "Pricing is key. People like to feel like they are getting a deal."

FUNKY FERNDALE ART SHOW

Integrity Shows, P.O. Box 1070, Ann Arbor MI 48106. **E-mail:** markloeb@aol.com. **Website:** www.michiganartshow.com. **Contact:** Mark Loeb, president. Estab. 2004. Fine arts & crafts show held annually in September. Outdoors. Accepts photography and all fine art and craft mediums; emphasis on fun, funky work. Juried by 3 independent jurors. Awards/prizes: purchase and merit awards. Number of exhibitors: 120. Public attendance: 30,000. Free to the public. Application fee: $25. Booth fee: $275-$625. Electricity limited; fee: $75. For more information, artists should visit our website.

TIPS "Show enthusiasm. Keep a mailing list. Develop collectors."

GARRISON ART CENTER'S JURIED FINE CRAFTS FAIR

23 Depot Square on Garrison's Landing, P.O. Box 4, Garrison NY 10524. (845)424-3960. **E-mail:** info@ garrisonartcenter.org. **Website:** www.garrisonartcenter.org. Outdoor, riverside fine crafts show held annually on the third weekend in August. 85 exhibitors are selected to exhibit and sell handmade original work. Entries are judged based on creativity, originality and quality. Annual visitors 4,000-5,000. Visit our website for information, prospectus, and application.

TIPS "Have an inviting booth and be pleasant and accessible. Don't hide behind your product—engage the audience."

🎧 GENEVA ARTS FAIR

8 S. Third St., Geneva IL 60134. (630)232-6060. **Fax:** (630)232-6083. **E-mail:** chamberinfo@genevacham ber.com. **Website:** www.genevachamber.com/festi vals. Fine arts & crafts show held annually in late-July (see website for details). Outdoors. Juried. "Victorian homes-turned-businesses in the downtown historic district serve as a backdrop for the fine arts show." Showcases over 150 artists from across the country. Accepts photography, pottery, fiber, printmaking, glass, mixed media, watercolor, oil/acrylic, wood, sculpture and jewelry. Application fee: $20. Application deadline: early February. Space fee: $280. Exhibit space: 10×10 ft. Call, e-mail or visit website for more information, and to apply.

GERMANTOWN FESTIVAL

P.O. Box 381741, Germantown TN 38183. (901)757-9212. **E-mail:** gtownfestival@aol.com. **Website:** www. germantownfest.com. **Contact:** Melba Fristick, coordinator. Estab. 1971. Arts & crafts show held annually the weekend after Labor Day. Outdoors. Accepts photography, all arts & crafts mediums. Number of exhibitors: 400+. Public attendance: 65,000. Free to public. Artists should apply by sending applications by mail. Deadline for entry: until filled. Application/space fee: $200-250. Exhibition space: 10×10 ft. For more information, artists should e-mail, call or send SASE.

TIPS "Display and promote to the public. Price attractively."

🎧 GLOUCESTER WATERFRONT FESTIVAL

38 Charles St., Rochester NH 03867. (603)332-2616. **E-mail:** terrym@worldpath.net. **Website:** www.castle-berryfairs.com. **Contact:** Terry Mullen, events coordinator. Estab. 1971. Arts & crafts show held the 3rd weekend in August in Gloucester MA. Outdoors in Stage Fort Park. Accepts photography and all other mediums. Juried by photo, slide or sample. Number of exhibitors: 225. Public attendance: 50,000. Free to the public. Artists should apply by downloading application from website. Deadline for entry: until full. Space fee: $375. Exhibition space: 10×10 ft. Average gross sales/exhibitor: "Generally, this is considered an 'excellent' show, so I would guess most exhibitors sell ten times their booth fee, or in this case, at least

$3,500 in sales." For more information, artists should visit website.

TIPS "Do not bring a book; do not bring a chair. Smile and make eye contact with everyone who enters your booth. Have them sign your guest book; get their e-mail address so you can let them know when you are in the area again. And, finally, make the sale—they are at the fair to shop, after all."

GOLD RUSH DAYS

P.O. Box 774, Dahlonega GA 30533. (706)864-7247. **E-mail:** festival@dahlonegajaycees.com. **Website:** www. dahlonegajaycees.com. Arts & crafts show held annually the 3rd full week in October. Accepts photography, paintings and homemade, handcrafted items. No digitally originated art work. Outdoors. Number of exhibitors: 300. Public attendance: 200,000. Application fee of $25. Craft booth fee of $250. Free to the public. Artists should apply online under "Gold Rush," or send SASE to request application. Deadline: March. Exhibition space: 10×10 ft. Artists should e-mail, visit website for more information.

TIPS "Talk to other artists who have done other shows and festivals. Get tips and advice from those in the same line of work."

🎧 GOOD OLD SUMMERTIME ART FAIR

P.O. Box 1753, Kenosha WI 53141. (262)654-0065. **E-mail:** kenoshaartassoc@yahoo.com. **Website:** www. kenoartassoc.tripod.com/events.html. Estab. 1975. Fine arts show held annually the 1st Sunday in June. Outdoors. Accepts photography, paintings, drawings, mosaics, ceramics, pottery, sculpture, wood, stained glass. Juried by a panel. Photos or slides required with application. Number of exhibitors: 100. Public attendance: 3,000. Free to public. Artists should apply by completing application form, and including fees and SASE. Deadline for entry: early April. Exhibition space: 12×12 ft. For more information, artists should e-mail, visit website or send SASE.

TIPS "Have a professional display, and be friendly."

GRADD ARTS & CRAFTS FESTIVAL

300 Gradd Way, Owensboro KY 42301. (270)926-4433. **Fax:** (270)684-0714. **E-mail:** bethgoetz@gradd.com. **Website:** www.gradd.com. **Contact:** Beth Goetz, festival coordinator. Estab. 1972. Arts & crafts show held annually 1st full weekend in October. Outdoors. Accepts photography taken by crafter only. Number of exhibitors: 100-150. Public attendance: 15,000+. Artists should apply by calling to be put on mailing list.

Exhibition space: 15×15 ft. For more information, artists should e-mail, visit website or call.

TIPS "Be sure that only hand-crafted items are sold. No buy/sell items will be allowed."

☺ GRAND FESTIVAL OF THE ARTS & CRAFTS

P.O. Box 429, Grand Lake CO 80447-0429. (970)627-3372. **Fax:** (970)627-8007. **E-mail:** glinfo@grandlake chamber.com. **Website:** www.grandlakechamber. com. Fine arts & crafts show held annually in June and September. Outdoors. Accepts photography, jewelry, leather, mixed media, painting, paper, sculpture, wearable art. Juried by chamber committee. Awards/prizes: Best in Show and People's Choice. Number of exhibitors: 60-75. Public attendance: 1,000+. Free to public. Artists should apply by submitting slides or photos. Deadline for entry: early June and early September. Application fee: $175; includes space fee and business license. No electricity available. Exhibition space: 10×10 ft. For more information, artists should e-mail or call.

GREAT LAKES ART FAIR

46100 Grand River Ave., Novi MI 48374. (248)348-5600. **Fax:** (248)347-7720. **E-mail:** info@greatlakesartfair.com. **Website:** www.greatlakesartfair.com. **Contact:** Kristina Jones, event manager. Estab. 2009. Held twice a year. Accepts paintings, sculptures, metal and fiber work, jewelry, 2D and 3D art, ceramics and glass. Cash prizes are given. Number of exhibitors: 150-200. Public attendance: 12,000-15,000. Application fee: $30. Space fee: $400-800. Exhibition space: 10×12 ft.

TIPS E-mail, call or visit website for more information.

☺ GREAT NECK STREET FAIR

Showtiques Crafts, Inc., P.O. Box 477, Smithtown NY 11787. (631)724-5966. **Fax:** (631)724-5967. **E-mail:** showtiques@aol.com. **Website:** www.showtiques. com. Estab. 1978. Fine arts & crafts show held annually in early May (see website for details) in the Village of Great Neck. "Welcomes professional artists, craftspeople and vendors of upscale giftware." Outdoors. Accepts photography, all arts & crafts made by the exhibitor. Juried. Number of exhibitors: 250. Public attendance: 50,000. Free to public. Deadline for entry: until full. Space fee: $150-250. Exhibition space: 10×10 ft. For more information, artists should e-mail, visit website or call.

☺ GREENWICH VILLAGE ART FAIR

711 N. Main St., Rockford IL 61103. (815)968-2787. **Fax:** (815)316-2179. **E-mail:** ldennis@rockfordartmuseum.org. **Website:** www.rockfordartmuseum.org/gvaf.html. Estab. 1948. Fine arts & crafts show held annually in September. Outdoors. Our application will open late October and close early January. Download prospectus to apply. Accepts photography and all mediums. Juried by a panel of artists and committee. Awards/prizes: Best of Show and Best of Categories. Number of exhibitors: 120. Public attendance: 7,000. Artists should apply by mail or locating prospectus on the website. Application fee $30. Booth fee: $200. Deadline for entry: April 30. Exhibition space: 10×10 ft. For more information, artists should e-mail, visit website or call.

☺ GUILFORD CRAFT EXPO

P.O. Box 28, Woodstock NY 12498. (845)331-7900. **E-mail:** crafts@artrider.com. **Website:** guilfordart center.org; artrider.com. Estab. 1957. Fine craft & art show held annually in mid-July. Outdoors. Accepts photography, wearable and nonwearable fiber, metal and nonmetal jewelry, clay, leather, wood, glass, painting, drawing, prints, mixed media. Juried by 5 images of work and 1 of booth, viewed sequentially. Number of exhibitors: 180. Public attendance: 14,000. Public admission: $7. Artists should apply by downloading application from www.artrider.com or can apply online at www.zapplication.org. Deadline for entry: early January. Application fee: $45. Space fee: $655-680. Exhibition space: 10×10 ft. For more information, artists should e-mail, visit website, call.

☺ GUNSTOCK SUMMER FESTIVAL

38 Charles St., Rochester NH 03867. (603)332-2616. **Fax:** (603)332-8413. **E-mail:** info@castleberryfairs. com. **Website:** www.castleberryfairs.com. Estab. 1971. Arts & crafts show held annually in early July in Gilford NH (see website for details). Indoors and outdoors. Accepts photography and all other mediums. Juried by photo, slide or sample. Number of exhibitors: 100. Public attendance: 10,000. Free to the public. Artists should apply by downloading application from website. Deadline for entry: until full. Space fee: $275. Exhibition space: 10×8 ft. (indoor) or 10×10 ft. (outdoor). For more information, artists should visit website.

TIPS "Do not bring a book; do not bring a chair. Smile and make eye contact with everyone who enters your

booth. Have them sign your guest book; get their e-mail address so you can let them know when you are in the area again. And, finally, make the sale-they are at the fair to shop, after all."

⊕ HIGHLAND MAPLE FESTIVAL

P.O. Box 223, Monterey VA 24465. (540)468-2550. **Fax:** (540)468-2551. **E-mail:** info@highlandcounty. org. **Website:** www.highlandcounty.org. Estab. 1958. Fine arts & crafts show held annually the 2nd and 3rd weekends in March. Indoors and outdoors. Accepts photography, pottery, weaving, jewelry, painting, wood crafts, furniture. Juried by 3 photos or slides. Number of exhibitors: 150. Public attendance: 35,000-50,000. "Vendors accepted until show is full." Exhibition space: 10×10 ft. For more information, artists should e-mail, visit website, call.

TIPS "Have quality work and good salesmanship."

⊕ HIGHLANDS ART LEAGUE'S ANNUAL FINE ARTS & CRAFTS FESTIVAL

351 West Center Ave., Sebring FL 33870. (863)385-6682. **Fax:** (863)385-6611. **E-mail:** director@high landsartleague.org. **Website:** www.highland sartleague.org. **Contact:** Martile Blackman, festival director. Estab. 1966. Fine arts & crafts show held annually first Saturday in November. Outdoors. Accepts photography, pottery, painting, jewelry, fabric. Juried based on quality of work. Awards/prizes: monetary awards. Number of exhibitors: 100+. Public attendance: more than 15,000. Free to the public. Artists should apply by calling or visiting website for application form. Deadline for entry: September 1. Exhibition space: 10×14 and 10×28 ft. Artists should e-mail for more information.

⊕ HINSDALE FINE ARTS FESTIVAL

22 E. First St., Hinsdale IL 60521. (630)323-3952. **Fax:** (630)323-3953. **E-mail:** info@hinsdalechamber.com. **Website:** www.hinsdalechamber.com. Fine arts show held annually in mid-June. Outdoors. Accepts photography, ceramics, painting, sculpture, fiber arts, mixed media, jewelry. Juried by 3 images. Awards/prizes: Best in Show, President's Award and 1st, 2nd and 3rd place in 2D and 3D categories. Number of exhibitors: 140. Public attendance: 2,000-3,000. Free to public. Artists should apply online at www.zappli cation.org. Deadline for entry: First week in March. Application fee: $30. Space fee: $250. Exhibition space: 10×10 ft. For more information, artists should e-mail or visit website.

TIPS "Original artwork sold by artist."

⊕ HOLIDAY ARTS & CRAFTS SHOW

60 Ida Lee Dr., Leesburg VA 20176. (703)777-1368. **Fax:** (703)737-7165. **E-mail:** lfountain@leesburgva. gov. **Website:** www.idalee.org. Estab. 1990. Arts & crafts show held annually the 1st weekend in December. Indoors. Accepts photography, jewelry, pottery, baskets, clothing, accessories. Juried. Number of exhibitors: 95. Public attendance: 2,500. Free to public. Artists should apply by downloading application from website. Deadline for entry: August 31. Space fee: $110-150. Exhibition space: 10×7 ft. and 10×10 ft. For more information, artists should e-mail or visit website.

⊕ HOLIDAY CRAFTMORRISTOWN

P.O. Box 28, Woodstock NY 12498. (845)331-7900. **Fax:** (845)331-7484. **E-mail:** crafts@artrider.com. **Website:** www.artrider.com. Estab. 1990. Fine arts & crafts show held annually in early December. Indoors. Accepts photography, wearable and nonwearable fiber, metal and nonmetal jewelry, clay, leather, wood, glass, painting, drawing, prints, mixed media. Juried by 5 images of work and 1 of booth, viewed sequentially. Number of exhibitors: 150. Public attendance: 5,000. Public admission: $7. Artists should apply by downloading application from www.artrider.com or can apply online at www.zapplication.org. Deadline for entry: early July. Application fee: $45. Space fee: $495. Exhibition space: 10×10 ft. For more information, artists should e-mail, visit website, call.

⊕ HOLLY ARTS & CRAFTS FESTIVAL

P.O. Box 2122, Pinehurst NC 28370. (910)295-7462. **E-mail:** sbharrison@earthlink.net. **Website:** www. pinehurstbusinessguild.com. **Contact:** Susan Harrison. Estab. 1978. Annual arts & crafts show held 3rd Saturday in October. Outdoors. Accepts quality photography, arts and crafts. Juried based on uniqueness, quality of product and overall display. Awards/prizes: plaque given to Best in Show. Number of exhibitors: 200. Public attendance: 7,000. Free to the public. Artists should apply online. Submit 3 color photos, 2 of work to be exhibited, 1 of booth. Deadline for entry: late March. Space fee: $75. Electricity fee: $5 Exhibition space: 10×10 ft. For more information, artists should call or visit website.

HOME, CONDO AND OUTDOOR ART & CRAFT FAIR

P.O. Box 486, Ocean City MD 21843. (410)213-8090. **Fax:** (410)213-8092. **E-mail:** oceanpromotions@ beachin.net. **Website:** www.oceanpromotions.info. Estab. 1984. Fine arts & crafts show held annually in March. Indoors. Accepts photography, carvings, pottery, ceramics, glass work, floral, watercolor, sculpture, prints, oils, pen and ink. Number of exhibitors: 50. Public attendance: 9,000. Public admission: $5/ adults; $5/seniors & students; 13 and under free. Artists should apply by e-mailing request for info and application. Deadline for entry: until full. Space fee: $250. Exhibition space: 10×10 ft. For more information, artists should e-mail, visit website or call.

HOME DECORATING & REMODELING SHOW

P.O. Box 230699, Las Vegas NV 89105-0699. (702)450-7984; (800)343-8344. **Fax:** (702)451-7305. **E-mail:** spvandy@cox.net. **Website:** www.nashvillehome show.com. Estab. 1983. Home show held annually in early September (see website for details). Indoors. Accepts photography, sculpture, watercolor, oils, mixed media, pottery. Awards/prizes: Outstanding Booth Award. Number of exhibitors: 300-350. Public attendance: 25,000. Public admission: $8. Artists should apply by calling. Marketing is directed to middle and above income brackets. Deadline for entry: open until filled. Space fee: $925. Exhibition space: 9×10 ft. or complements of 9×10 ft. For more information, artists should call or visit website.

⊙ HOT SPRINGS ARTS & CRAFTS FAIR

308 Pullman, Hot Springs AR 71901. (501)623-9592. **E-mail:** sephpipkin@aol.com. **Website:** www. hotspringsartsandcraftsfair.com. **Contact:** Peggy Barnett. Estab. 1968. Fine arts & crafts show held annually the 1st full weekend in October at the Garland County Fairgrounds. Indoors and outdoors. Accepts photography and varied mediums ranging from heritage, crafts, jewelry, furniture. Juried by a committee of 12 volunteers. Number of exhibitors: 350+. Public attendance: 50,000+. Free to public. Deadline for entry: August. Space fee: $100-200. Exhibition space: 10×10 or 10×20 ft. For more information, and to apply, artists should e-mail, call or visit website.

⊙ HYDE PARK ARTS & CRAFTS ADVENTURE

P.O. Box 1326, Palatine IL 60078. (312)751-2500, (847)991-4748. **Fax:** (847)21-5853. **E-mail:** asoaartists@aol.com. **Website:** www.americansoci etyofartists.org. Estab. 2006. Arts & crafts show held once a year in late September. Event held in Chicago, Illinois. Outdoors. Accepts photography, painting, glass, wood, fiber arts, hand-crafted candles, quilts, sculpture and more. Juried. Please submit 4 images representative of your work you wish to exhibit, 1 of your display set-up, your first/last name, physical address, daytime telephone number - resume/show listing helpful. Number of exhibitors: 50. Free to the public. Artists should apply by submitting jury materials. To jury via e-mail: asoaartists@aol.com. If juried in, you will receive a jury/approval number. See website for jurying online. Deadline for entry: 2 months prior to show or earlier if spaces fill. Entry fee: $165. Exhibition space: approximately 100 sq. ft. for single space; other sizes are available. For more information, artists should send SASE, submit jury material.

TIPS "Remember that when you are at work in your studio, you are an artist. But when you are at a show, you are a business person selling your work."

⊙ STAN HYWET HALL & GARDENS WONDERFUL WORLD OF OHIO MART

714 N. Portage Path, Akron OH 44303. (330)836-5533 or (888)836-5533. **E-mail:** info@stanhywet.org. **Website:** www.stanhywet.org. Estab. 1966. Arts & crafts show held annually 1st full weekend in October. Outdoors. Accepts photography and all mediums. Juried 2 Saturdays in January and via mail application. Awards/prizes: Best Booth Display. Number of exhibitors: 150. Public attendance: 15,000-20,000. Deadline: June 1. Application fee: $25, nonrefundable. Application available online. Exhibition space: 10×10 or 10×15 ft. For more information, artists should visit website or call.

⊙ INDIANA ART FAIR

650 W. Washington St., Indianapolis IN 46204. (317)232-8293. **Fax:** (317)233-8268. **E-mail:** jhahn@ dnr.in.gov. **Website:** www.indianamuseum.org. Estab. 2004. Annual art/craft show held the third weekend of February. Indoors. Juried event; 5-6 judges award points in 3 categories. 80 exhibitors; 3,000 attendees. $10 admission for the public. Application fee $25. Space fee $165; 80 square feet. Accepts ceramics,

glass, fiber, jewelry, painting, sculpture, mixed media, drawing/pastels, garden, leather, surface decoration, wood, metal, printmaking, and photography.

TIPS "Make sure that your booth space complements your product and presents well. Good photography can be key for juried shows."

⊙ INDIAN WELLS ARTS FESTIVAL

78-200 Miles Ave., Indian Wells CA 92210. (760)346-0042. **Fax:** (760)346-0042. **E-mail:** info@indianwells artsfestival.com. **Website:** www.indianwellsartsfesti val.com. **Contact:** Dianne Funk, producer. "A premier fine arts festival attracting thousands annually. The Indian Wells Arts Festival brings a splash of color to the beautiful grass concourse of the Indian Wells Tennis Garden. This spectacular venue transforms into an artisan village featuring 200 judged and juried artists and hundreds of pieces of one-of-a-kind artwork available for sale. Watch glass blowing, monumental rock sculpting, wood carving, pottery wheel demonstrations, weaving and mural painting. Wine tasting, gourmet market, children's activities, entertainment and refreshments add to the festival atmosphere." See Website for information and an application.

TIPS "Have a professional display of work. Be approachable and engage in conversation. Don't give up—people sometimes need to see you a couple of times before they buy."

⊙ INTERNATIONAL FOLK FESTIVAL

301 Hay St., Fayetteville NC 28302. (910)323-1776. **Fax:** (910)323-1727. **E-mail:** bobp@theartscouncil. com. **Website:** www.theartscouncil.com. Estab. 1978. Fine arts & crafts show held annually the last weekend in September. Outdoors. Accepts photography, painting of all mediums, pottery, woodworking, sculptures. Work must be original. Number of exhibitors: 120+. Public attendance: 85,000-100,000 over two days. Free to public. Artists should apply on the website. Exhibition space: 10×10 ft. For more information, artists should e-mail or visit website.

TIPS "Have reasonable prices."

⊙ ISLE OF EIGHT FLAGS SHRIMP FESTIVAL

18 N. Second St., Fernandina Beach FL 32034. (904)271-7020. **Fax:** (904)261-1074. **E-mail:** mail box@islandart.org. **Website:** www.islandart.org. Estab. 1963. Fine arts & crafts show and community celebration held annually the 1st weekend in May. Outdoors. Accepts all mediums. Juried. Awards: $9,700

in cash prizes. Number of exhibitors: 300. Public attendance: 150,000. Free to public. Artists should apply by downloading application from website. Deadline for entry: late January. Application fee: $30. Space fee: $200. Exhibition space: 10×12 ft. Average gross sales/exhibitor: $1,500+. For more information, artists should visit website.

TIPS "Quality product and attractive display."

⊙ JOHNS HOPKINS UNIVERSITY SPRING FAIR

3400 N. Charles St., Mattin Suite 210, Baltimore MD 21218. (410)513-7692. **Fax:** (410)516-6185. **E-mail:** springfair.artscrafts@gmail.com. **Website:** www. jhuspringfair.com. Estab. 1972. Fine arts & crafts, campus-wide festival held annually in April. Outdoors. Accepts photography and all mediums. Juried. Number of exhibitors: 80. Public attendance: 20,000+. Free to public. Artists should apply via website. Deadline for entry: early March. Application fee: $200. Space fee: $200. Exhibition space: 10×10 ft. For more information, artists should e-mail, visit website or call.

TIPS "Artists should have fun displays, good prices, good variety and quality pieces."

⊙ JUBILEE FESTIVAL

Eastern Shore Chamber of Commerce, P.O. Drawer 310, Daphne AL 36526. (251)621-8222 or (251)928-6387. **Fax:** (251)621-8001. **E-mail:** specialevents@es chamber.com. **Website:** www.eschamber.com. Estab. 1952. Fine arts & crafts show held in late September in Olde Towne of Daphne AL. Outdoors. Accepts photography and fine arts and crafts. Juried. Awards/prizes: ribbons and cash prizes totaling $4,300 with Best of Show awarding $750. Number of exhibitors: 258. Free to the public. Space fee: $100. Exhibition space: 10×10 ft. For more information, and application form, artists should e-mail, call, see website.

⊙ KENTUCK FESTIVAL OF THE ARTS

503 Main Ave., Northport AL 35476. (205)758-1257. **Fax:** (205)758-1258. **E-mail:** kentuck@kentuck.org. **Website:** www.kentuck.org. Call or e-mail for more information. General information about the festival available on the Website. "Celebrates a variety of artistic styles ranging from folk to contemporary arts as well as traditional crafts. Each of the 250+ artists participating in the festival is either invited as a guest artist or is juried based on the quality and originality of their work. The guest artists are nationally recog-

nized folk and visionary artists whose powerful visual images continue to capture national and international acclaim."

KETNER'S MILL COUNTY ARTS FAIR

P.O. Box 322, Lookout Mountain TN 37350. (423)267-5702. **E-mail:** contact@ketnersmill.org. **Website:** www.ketnersmill.org. **Contact:** Dee Nash, event coordinator. Estab. 1977. Arts & crafts show held annually the 3rd weekend in October held on the grounds of the historic Ketner's Mills, in Whitwell TN, and the banks of the Sequatchie River. Outdoors. Accepts photography, painting, prints, dolls, fiber arts, baskets, folk art, wood crafts, jewelry, musical instruments, sculpture, pottery, glass. Juried. Number of exhibitors: 170. Number of attendees: 10,000/day, depending on weather. Artists should apply online. Space fee: $125. Electricity: $10 limited to light use. Exhibition space: 15×15 ft. Average gross sales/exhibitor: $1,500.

TIPS "Display your best and most expensive work, framed. But also have smaller unframed items to sell. Never underestimate a show: Someone may come forward and buy a large item."

KIA ART FAIR

Kalamazoo Institute of Arts, 314 S. Park St., Kalamazoo MI 49007. (269)349-7775. **Fax:** (269)349-9313. **E-mail:** museum@kiarts.org. **Website:** www.kiarts.org/artfair. Estab. 1951. Fine arts & crafts show held annually the 1st Friday and Saturday in June. Outdoors. "The KIA's annual art fair has been going strong for 60 years. Still staged in shady, historic Bronson Park, the fair boasts more hours, more artists and more activities. It now spans 2 full days. The art fair provides patrons with more time to visit and artists with an insurance day in case of rain. Some 190 artists will be invited to set up colorful booths. Numerous festivities are planned, including picnics in the park, public art activities, street performers and an artist dinner. For more information, visit www.kiarts.org/artfair." Apply via zapplication. Application fee: $30. Booth fee: $225.

KINGS DRIVE ART WALK

1409 E. Blvd., Charlotte NC 28203. (704)338-1060. **E-mail:** festival@festivalinthepark.org. **Website:** www.festivalinthepark.org. **Contact:** Julie Whitney Austin, executive director. Estab. 1964. Fine art & craft show held annually in late April. Indoors. Accepts photography. Juried. Number of exhibitors: 70. Public attendance: 10,000. Free to public. Artists should apply online at www.festivalinthepark.org/kingsdrive.htm. Deadline for entry: February. Application fee: $25. Space fee: $250. Exhibition space: 10×10 ft. For more information, artists should e-mail, call or visit website.

KINGS MOUNTAIN ART FAIR

13106 Skyline Blvd., Woodside CA 94062. (650)851-2710. **E-mail:** kmafsecty@aol.com. **Website:** www.kingsmountainartfair.org. **Contact:** Carrie German, administrative assistant. Estab. 1963. Fine arts & crafts show held annually Labor Day weekend. Fundraiser for volunteer fire dept. Accepts photography, ceramics, clothing, 2D, painting, glass, jewelry, leather, sculpture, textile/fiber, wood. Juried. Number of exhibitors: 138. Public attendance: 10,000. Free to public. Deadline for entry: late January. Application fee: $10 (online). Exhibition space: 10×10 ft. Average gross sales/exhibitor: $3,500. For more information, artists should e-mail or visit website.

TIPS "Read and follow the instructions. Keep an open mind and be flexible."

KRASL ART FAIR ON THE BLUFF

707 Lake Blvd., St. Joseph MI 49085. (269)983-0271. **Fax:** (269)983-0275. **E-mail:** info1@krasl.org. **Website:** www.krasl.org. Estab. 1962. Fine arts & fine craft show held annually in early July (see website for details). Outdoors. Accepts photography, painting, digital art, drawing, pastels, wearable and nonwearable fiber art, glass, jewelry, sculpture, printmaking, metals and woods. Number of exhibitors: 216. Number of attendees: more than 70,000. Free to public. Application fee: $30. Applications are available online through www.zapplication.org. Deadline for entry: approximately mid-January. There is on-site jurying the same day of the fair and approximately 35% are invited back without having to pay the $30 application fee. Space fee: $275. Exhibition space: 15×15 ft. or $300 for 20×20 ft. (limited). Average gross sales/exhibitor: $4,700 (gross according to AFSB). For more information, artists should e-mail or visit website.

TIPS "Be willing to talk to people in your booth. You are your own best asset!"

LAKE CITY ARTS & CRAFTS FESTIVAL

P.O. Box 1147, Lake City CO 81235. **E-mail:** info@lakecityarts.org. **Website:** www.lakecityarts.org. Es-

tab. 1975. Fine arts/arts & craft show held annually 3rd Tuesday in July. One-day event. Outdoors. Accepts photography, jewelry, metal work, woodworking, painting, handmade items. Juried by 3-5 undisclosed jurors. Prize: Winners are entered in a drawing for a free booth space in the following year's show. Number of exhibitors: 85. Public Attendance: 500. Free to the public. Space fee: $75. Jury fee: $10. Exhibition space: 12×12 ft. Average gross sales/exhibitor: $500-$1,000. For more information, and application form, artists should visit website.

TIPS "Repeat vendors draw repeat customers. People like to see their favorite vendors each year or every other year. If you come every year, have new things as well as your best-selling products."

☺ LEEPER PARK ART FAIR

22180 Sundancer Court, Villa 504, Estero FL 33928. (239)495-1783. **E-mail:** Studio266@aol.com. **Website:** www.leeperparkartfair.org. **Contact:** Judy Ladd, director. Estab. 1967. Fine arts & crafts show held annually in June. Indoors. Accepts photography and all areas of fine art. Juried by slides. Awards/prizes: $3,700. Number of exhibitors: 120. Public attendance: 10,000. Free to public. Artists should apply by going to the website and clicking on "To Apply." Deadline for entry: early March. Booth fee: $285. Exhibition space: 12×12 ft. Average gross sales/exhibitor: $5,000. For more information, artists should e-mail or send SASE.

TIPS "Make sure your booth display is well presented and, when applying, slides are top notch!"

☺ LES CHENEAUX FESTIVAL OF ARTS

Les Cheneaux Islands Chamber of Commerce, P.O. Box 301, Cedarville MI 49719. (906)484-3935; (888)364-7526. **Fax:** (906)484-6107. **Website:** www.lescheneaux.net/?annualevents. Estab. 1976. Fine arts & crafts show held annually 2nd Saturday in August. Outdoors. Accepts photography and all other media; original work and design only; no kits or commercially manufactured goods. Juried by a committee of 10. Submit 4 slides (3 of the artwork; 1 of booth display). Awards: monetary prizes for excellent and original work. Number of exhibitors: 70. Public attendance: 8,000. Public admission: $7. Artists should fill out application form to apply. Deadline for entry: April 1. Booth fee: $75; Jury fee: $5. Exhibition space: 10×10 ft. Average gross sales/exhibitor: $5-500. For more information, artists should call, send SASE, or visit website.

☺ LIBERTY ARTS SQUARED

P.O. Box 302, Liberty MO 64069. **E-mail:** staff@libertyartssquared.org. **Website:** www.libertyartssquared.org. Estab. 2010. Outdoor fine art/craft show held annually. Accepts all mediums. Awards: prizes totaling $4,000; Literary Arts for Awards–$500; Visual Arts for Awards–$1,500; Folk Art for Awards–$1,500; Overall Best of Show Award–$500. Free admission to the public; free parking. Application fee: $25. Space fee: $200. Exhibition space: 10×10 ft. For more information, e-mail or visit website.

☺ LILAC FESTIVAL ARTS & CRAFTS SHOW

E-mail: lilacfestival@gmail.com. **Website:** www.lilacfestival.com. Estab. 1985. Arts & crafts show held annually in mid-May (see website for details). Outdoors. Accepts photography, painting, ceramics, woodworking, metal sculpture, fiber. Juried by a panel. Number of exhibitors: 150. Public attendance: 25,000. Free to public. Exhibition space: 10×10 ft. Space fee: $200. For more information, and to apply, artists should e-mail or visit website.

☺ LOMPOC FLOWER FESTIVAL

Sponsored by Cyprus Gallery, 119 E. Cypress Ave., Lompoc CA 93436. (805)737-1129. **E-mail:** m.weyandt@verizon.net. **Website:** www.lompocvalleyartassociation.com. **Contact:** Becky Jazo. Estab. 1942. Sponsored by Lompoc Valley Art Association, Cyprus Gallery. Show held annually last week in June. Festival event includes a parade, food booths, entertainment, beer garden and commercial center, which is not located near arts & crafts area. Outdoors. Accepts photography, fine art, woodworking, pottery, stained glass, fine jewelry. Juried by 5 members of the LVAA. Vendor must submit 5 photos of their craft and a description on how to make the craft. Free to public. Artists should apply by calling for application or download application from website. Deadline for entry: early May. Application fee: $200, plus insurance. Exhibition space: 12×16 ft. For more information, artists should visit website, call the gallery or send SASE.

TIPS "Artists should have prices that are under $100 to succeed."

MADISON CHAUTAUQUA FESTIVAL OF ART

601 W. First St., Madison IN 47250. (812)265-6100. **Fax:** (812)273-3694. **E-mail:** georgie@madisonchau

tauqua.com. **Website:** www.madisonchautauqua.com. **Contact:** Georgie Kelly, coordinator. Estab. 1971. Enjoy this juried fine arts & crafts show, featuring painting, sculpture, stained glass, textiles, pottery, wood, wearables, jewelry, and more amid the tree-lined streets of Madison's historic district. The number of artists in each category is limited to protect the integrity of the show. Stop by the Riverfront FoodFest for delicious treats. Relax and listen to the live performances on the Lanier Mansion lawn on the riverfront, and enjoy strolling performers. Takes place in late September. No buy-sell, imports or kits.

TIPS "Be honest with products. Communicate with organizers. Fair market price for area."

MASON ARTS FESTIVAL

Mason-Deerfield Arts Alliance, P.O. Box 381, Mason OH 45040. (513)309-8585. **E-mail:** masonarts@gmail.com. **Website:** www.masonarts.org. Fine arts & crafts show held annually in mid-September (see website for details). Indoors and outdoors. Accepts photography, graphics, printmaking, mixed media; painting and drawing; ceramics, metal sculpture; fiber, glass, jewelry, wood, leather. Juried. Awards/prizes: $3,000+. Number of exhibitors: 75-100. Public attendance: 3,000-5,000. Free to the public. Artists should apply by visiting website for application, e-mailing or calling. Deadline for entry: April 1. Jury fee: $25. Space fee: $75. Exhibition space: 12×12 ft.; artist must provide 10×10 ft. pop-up tent.

City Gallery show is held indoors; these artists are not permitted to participate outdoors and vice versa. City Gallery is a juried show featuring approximately 30-50 artists who may show up to 2 pieces.

MEMORIAL WEEKEND ARTS & CRAFTS FESTIVAL

38 Charles St., Rochester NH 03867. (603)332-2616. **Fax:** (603) 332-8413. **E-mail:** info@castleberryfairs.com. **Website:** www.castleberryfairs.com. Estab. 1989. Arts & crafts show held annually on Memorial Day weekend in Meredith NH. Outdoors. Accepts photography and all other mediums. Juried by photo, slide or sample. Number of exhibitors: 85. Public attendance: 7,500. Free to the public. Artists should apply by downloading application from website. Deadline for entry: until full. Space fee: $325. Exhibition space: 10×10 ft. For more information, artists should visit website.

TIPS "Do not bring a book; do not bring a chair. Smile and make eye contact with everyone who enters your booth. Have them sign your guest book; get their e-mail address so you can let them know when you are in the area again. And, finally, make the sale—they are at the fair to shop, after all."

MICHIGAN STATE UNIVERSITY HOLIDAY ARTS & CRAFTS SHOW

319 MSU Union, East Lansing MI 48824. (517)355-3354. **E-mail:** uab@hfs.msu.edu. **Website:** www.uabevents.com. Estab. 1963. Arts & crafts show held annually the 1st weekend in December. Indoors. Accepts photography, basketry, candles, ceramics, clothing, sculpture, soaps, drawings, floral, fibers, glass, jewelry, metals, painting, graphics, pottery, wood. Juried by a panel of judges using the photographs submitted by each vendor to eliminate commercial products. They will evaluate on quality, creativity and crowd appeal. Number of exhibitors: 220. Public attendance: 15,000. Free to public. Artists should apply online. Exhibition space: 8×5 ft. For more information, artists should visit website or call.

MICHIGAN STATE UNIVERSITY SPRING ARTS & CRAFTS SHOW

319 MSU Union, East Lansing MI 48824. (517)355-3354. **Fax:** (517)432-2448. **E-mail:** artsandcrafts@uabevents.com. **Website:** www.uabevents.com. Estab. 1963. Arts & crafts show held annually the weekend before Memorial Day Weekend in mid-May in conjunction with the East Lansing Art Festival. Both shows are free for the public to attend. Outdoors. Accepts photography, basketry, candles, ceramics, clothing, sculpture, soaps, drawings, floral, fibers, glass, jewelry, metals, painting, graphics, pottery, wood. Juried by a panel of judges using the photographs submitted by each vendor to eliminate commercial products. They will evaluate on quality, creativity and crowd appeal. Number of exhibitors: 329. Public attendance: 60,000. Free to public. Artists can apply online beginning in February. Online applications will be accepted until show is filled. Application fee: $260 ($240 if apply online). Exhibition space: 10×10 ft. (double booth available, $500 or $480 online). For more information, artists should visit website or call.

MID-MISSOURI ARTISTS CHRISTMAS ARTS & CRAFTS SALE

P.O. Box 116, Warrensburg MO 64093. (660)747-6092. **E-mail:** rlimback@iland.net. Estab. 1970. Holiday

arts & crafts show held annually in November. Indoors. Accepts photography and all original arts and crafts. Juried by 3 good-quality color photos (2 of the artwork, 1 of the display). Number of exhibitors: 50. Public attendance: 1,200. Free to the public. Artists should apply by e-mailing or calling for an application form. Deadline for entry: early November. Space fee: $50. Exhibition space: 10×10 ft. For more information, artists should e-mail or call.

TIPS "Items under $100 are most popular."

MONTAUK POINT LIONS CLUB

P.O. Box 683, Montauk NY 11954. (631)668-2428. **E-mail:** info@onmontauk.com. **Website:** www.onmontauk.com. Estab. 1970. Arts & crafts show held annually Labor Day weekend. Outdoors. Accepts photography, arts & crafts. Number of exhibitors: 100. Public attendance: 1,000. Free to public. Exhibition space: 100 sq. ft. For more information, artists should call or visit website.

MOUNTAIN STATE FOREST FESTIVAL

P.O. Box 388, 101 Lough St., Elkins WV 26241. (304)636-1824. **Fax:** (304)636-4020. **E-mail:** msff@forestfestival.com; djudy@forestfestival.com. **Website:** www.forestfestival.com. **Contact:** Renee Heckel, executive director. Estab. 1930. Arts, crafts & photography show held annually in early October. Accepts photography and homemade crafts. Awards/prizes: cash awards for photography only. Number of exhibitors: 50. Public attendance: 50,000. Free to the public. Artists should apply by requesting an application form. For more information, artists should visit website, call, or visit Facebook page (search "Mountain State Forest Festival").

MOUNT GRETNA OUTDOOR ART SHOW

P.O. Box 637, Mount Gretna PA 17064. (717)964-3270. **Fax:** (717)964-3054. **E-mail:** mtgretnaart@comcast.net. **Website:** www.mtgretnaarts.com. Estab. 1974. Fine arts & crafts show held annually 3rd full weekend in August. Outdoors. Accepts photography, oils, acrylics, watercolors, mixed media, jewelry, wood, paper, graphics, sculpture, leather, clay/porcelain. Juried by 4 professional artists who assign each applicant a numeric score. The highest scores in each medium are accepted. Awards/prizes: Judges' Choice Awards: 30 artists are invited to return the following year, jury exempt; the top 10 are given a monetary award of $250. Number of exhibitors: 250. Public attendance: 15,000-19,000. Public admission: $8; children under

12 free. Artists should apply via www.zapplication.org. Deadline for entry: early April. Application fee: $25. Space fee: $350 per 10×12 ft. space; $700 per 10×24 ft. double space. For more information, artists should e-mail, visit website, call.

NAPA RIVER WINE & CRAFTS FAIR

After the Gold Rush, P.O. Box 5171, Walnut Creek CA 94596. (707)257-0322. **E-mail:** julie@donapa.com. **Website:** www.napadowntown.com; www.afterthegoldrushfestivals.com. Wine and crafts show held annually in early September (see website for details). Outdoors. Accepts photography, jewelry, clothing, woodworking, glass, dolls, candles and soaps, garden art. Juried based on quality, uniqueness, and overall craft mix of applicants. Number of exhibitors: over 200. Public attendance: 20,000-30,000. Artists should apply online. Jury fee: $20. Space fee: $200. Exhibition space: 10×10 ft. For more information, artists should e-mail, visit website or call.

TIPS "Electricity is available, but limited. There is a $40 processing fee for cancellations."

NEW ENGLAND ARTS & CRAFTS FESTIVAL

38 Charles St., Rochester NH 03867. (603)322-2616. **Fax:** (603)332-8413. **E-mail:** info@castleberryfairs.com. **Website:** www.castleberryfairs.com. Estab. 1988. Arts & crafts show held annually on Labor Day weekend in Topsfield, Massachusetts. Indoors and outdoors. Accepts photography and all other mediums. Juried by photo, slide or sample. Number of exhibitors: 250. Public attendance: 25,000. Artists should apply by downloading application from website. Deadline for entry: until full. Exhibition space: 100 sq. ft. Booth fee: $335. Average gross sales/exhibitor: "Generally, this is considered an 'excellent' show, so I would guess most exhibitors sell ten times their booth fee, or in this case, at least $3,500 in sales." For more information, artists should visit website.

TIPS "Do not bring a book; do not bring a chair. Smile and make eye contact with everyone who enters your booth. Have them sign your guest book; get their e-mail address so you can let them know when you are in the area again. And, finally, make the sale—they are at the fair to shop, after all."

NEW ENGLAND CRAFT & SPECIALTY FOOD FAIR

38 Charles St., Rochester NH 03867. (603)332-2616. **Fax:** (603) 332-8413. **E-mail:** info@castleberryfairs.

com. **Website:** www.castleberryfairs.com. Estab. 1995. Arts & crafts show held annually on Veteran's Day weekend in Salem NH. Indoors. Accepts photography and all other mediums. Juried by photo, slide or sample. Number of exhibitors: 200. Public attendance: 15,000. Artists should apply by downloading application from website. Deadline for entry: until full. Space fee: $350-450. Exhibition space: 10×6 or 10×10 ft. Average gross sales/exhibitor: "Generally, this is considered an 'excellent' show, so I would guess most exhibitors sell ten times their booth fee, or in this case, at least $3,000 in sales." For more information, artists should visit website.

TIPS "Do not bring a book; do not bring a chair. Smile and make eye contact with everyone who enters your booth. Have them sign your guest book; get their e-mail address so you can let them know when you are in the area again. And, finally, make the sale—they are at the fair to shop, after all."

○ ○ NEW MEXICO ARTS AND CRAFTS FAIR

2501 San Pedro St. NE, Suite 110, Albuquerque NM 87110. (505)884-9043. **Fax:** (505)884-9084. **E-mail:** info@nmartsandcraftsfair.org. **Website:** www. nmartsandcraftsfair.org. Estab. 1962. Fine arts & craft show held annually in June. Indoors. Accepts decorative and functional ceramics, digital art, drawing, precious and nonprecious jewelry, photography, paintings, printmaking, mixed media, metal, sculpture and wood. *Only New Mexico residents 18 years and older are eligible.* See website for more details.

NEW ORLEANS JAZZ & HERITAGE FESTIVAL

336 Camp St., Suite 250, New Orleans LA 70130. (504)410-4100. **Fax:** (504)410-4122. **Website:** www. nojazzfest.com. Estab. 1970. This festival showcases music, cuisine, arts and crafts from the region and around the world. The Louisiana Heritage Fair is held at the Fair Grounds Race Course over the course of 2 weekends (late April/early May; see website for details). Apply online via www.zapplication.org. Must submit 5 images, 4 of artwork, 1 of booth. Application fee: $30. Deadline: late December (see website for details). Call or visit website for more information.

NEW SMYRNA BEACH ART FIESTA

New Smyrna Beach Visitors Bureau, 2238 State Road 44, New Smyrna Beach FL 32168. (386)424-2175; (800)541-9621. **Fax:** (386)424-2177. **E-mail:** kshel

ton@cityofnsb.com. **Website:** www.cityofnsb.com; nsbfla.com/index.cfm. Estab. 1952. Arts & crafts show held annually the last full weekend in February. Outdoors. Accepts photography, oil, acrylics, pastel, drawings, graphics, sculpture, crafts, watercolor. Awards/prizes: $15,000 prize money; $1,600/category; Best of Show. Number of exhibitors: 250. Public attendance: 14,000. Free to public. Artists should apply by calling to get on mailing list. Applications are always mailed out the day before Thanksgiving. Deadline for entry: until full. Exhibition space: 10×10 ft. For more information, artists should call.

○ NEW WORLD FESTIVAL OF THE ARTS

P.O. Box 994, Manteo NC 27954. (252)473-2838. **Fax:** (252)473-6044. **E-mail:** edward@outerbankschristmas.com. **Website:** www.townofmanteo.com. **Contact:** Edward Greene. Estab. 1963. Fine arts & crafts show held annually in mid-August (see website for details). Outdoors. Juried. Location is the Waterfront in downtown Manteo. Features 80 selected artists from Vermont to Florida exhibiting and selling their works.

NORTH CONGREGATIONAL PEACH & CRAFT FAIR

17 Church St., New Hartford CT 06057. (860)379-2466. Estab. 1966. Arts & crafts show held annually in mid-August. Outdoors on the Green at Pine Meadow. Accepts photography, most arts and crafts. Number of exhibitors: 50. Public attendance: 500-2,000. Free to public. Artists should call for application form. Deadline for entry: August. Application fee: $60. Exhibition space: 11×11 ft.

TIPS "Be prepared for all kinds of weather."

○ OAK PARK AVENUE-LAKE ARTS & CRAFTS SHOW

P.O. Box 1326, Palatine IL 60078. (312)751-2500, (847)991-4748. **Fax:** (847)221-5853. **E-mail:** asoa@ webtv.net or asoaartists@aol.com. **Website:** www. americansocietyofartists.org. Estab. 1974. Fine arts & crafts show held annually in mid-August. Event held in Oak Park IL. Outdoors. Accepts photography, painting, graphics, sculpture, glass, wood, paper, fiber arts, mosaics and more. Juried. Please submit 4 images representative of your work you wish to exhibit, 1 of your display set-up, your first/last name, physical address, daytime telephone number—résumé/show listing helpful. Number of exhibitors: 150. Free to the public. Artists should apply by submitting jury materials. If you want to jury online please see

our website and follow directions given there. To jury via e-mail: asoaartists@aol.com. If juried in, you will receive a jury/approval number. Deadline for entry: 2 months prior to show or earlier if spaces fill. Entry fee: $170. Exhibition space: approximately 100 sq. ft. for single space; other sizes available. For more information, artists should send SASE, submit jury material. **TIPS** "Remember that when you are at work in your studio, you are an artist. But when you are at a show, you are a business person selling your work."

OLD TOWN ART FAIR

1763 N. North Park Ave., Chicago IL 60614. (312)337-1938. **E-mail:** info@oldtowntriangle.com. **Website:** www.oldtownartfair.com. Fine art festival held annually in early June (see website for details). Located in the city's historic Old Town Triangle District. Artists featured are chosen by an independent jury of professional artists, gallery owners and museum curators. Features a wide-range of art mediums, including 2D and 3D mixed media, drawing, painting, photography, printmaking, ceramics, fiber, glass, jewelry and works in metal, stone and wood. Apply online at www.zapplication.org. For more information, call, e-mail or visit website.

➕ ۞ ON THE GREEN FINE ART & CRAFT SHOW

Hubbard Green, Corner of Hubbard & Main St., Glastonbury CT 06033. (860)659-1196. **Fax:** (860)633-4301. **E-mail:** info@glastonburyartguild.org. **Website:** www.glastonburyartguild.org. **Contact:** Jane Fox, administrator. Estab. 1961. Fine art & craft show held annually 2nd week of September. Outdoors. Accepts photography, pastel, prints, pottery, jewelry, drawing, sculpture, mixed media, oil, acrylic, glass, watercolor, graphic, wood, fiber, etc. Juried (with 3 photos of work, 1 photo of booth). Awards/prizes: $3,000 total prize money in different categories. Number of exhibitors: 200. Public attendance: 15,000. Free to public. Artists should apply online. Deadline for entry: early June. Jury fee: $15. Space fee: $275. Exhibition space: 12×15 ft. Average gross sales/exhibitor varies. For more information, artists should visit website.

۞ ORCHARD LAKE FINE ART SHOW

P.O. Box 79, Milford MI 48381-0079. (248)684-2613; (248)685-3748. **Fax:** (248)684-0195. **E-mail:** info@hotworks.org. **Website:** www.hotworks.org. **Contact:** Patty Narozny, show director. Estab. 2003. Fine arts & crafts show held annually late July (see website for details). Outdoors. Accepts photography, clay, glass, fiber, wood, jewelry, painting, prints, drawing, sculpture, metal, multimedia. Artist applications available via Zapplication, Juried Art Services, or via "manual" application. Also home to the Chadwick Group PC's Youth Art competition for grades K-8. Admission $5; 12 & under free; free parking. Deadline: early March (see website for details). Space fee: $200. Exhibition space: 10×10, 10×15 or 10×20 ft. For more information, call, e-mail or visit website.

TIPS "Be attentive to your customers. Do not ignore anyone."

۞ PANOPLY ARTS FESTIVAL

The Arts Council, Inc., 700 Monroe St., SW, Suite 2, Huntsville AL 35801. (256)519-2787. **E-mail:** tac@artshuntsville.org; vhinton@artshuntsville.org. **Website:** www.panoply.org. Estab. 1982. Fine arts show held annually the last weekend in April. Also features music and dance. Outdoors. Accepts photography, painting, sculpture, drawing, printmaking, mixed media, glass, fiber. Juried by a panel of judges chosen for their in-depth knowledge and experience in multiple mediums, and who jury from slides or disks in January. During the festival 1 judge awards various prizes. Number of exhibitors: 60-80. Public attendance: 140,000+. Public admission: $5/day or $10/weekend (children 12 and under free). Artists should e-mail, call, or go online for an application form. Deadline for entry: January. Space fee: $185. Exhibition space: 10×10 ft. (tent available, space fee $390). Average gross sales/exhibitor: $2,500. For more information, artists should e-mail or visit website.

۞ PARADISE CITY ARTS FESTIVALS

30 Industrial Dr. E., Northampton MA 01060. (800)511-9725. **Fax:** (413)587-0966. **E-mail:** artist@paradisecityarts.com. **Website:** www.paradisecityarts.com. Estab. 1995. 5 fine arts & crafts shows held annually in March, April, May, October and November. Indoors. Accepts photography, all original art and fine craft media. Juried by 5 slides or digital images of work and an independent board of jury advisors. Number of exhibitors: 150-275. Public attendance: 5,000-20,000. Public admission: $12. Artists should apply by submitting name and address to be added to mailing list or print application from website. Deadline for entry: September 9. Application fee: $30-45. Space fee: $855-1,365. Exhibition space vary

by show, see website for more details . For more information, artists should e-mail, visit website or call.

PATTERSON APRICOT FIESTA

P.O. Box 442, Patterson CA 95363. (209)892-3118. **Fax:** (209)892-3388. **E-mail:** patterson_apricot_fiesta@hotmail.com. **Website:** www.apricotfiesta.com. **Contact:** Sandra Stobb, chairperson. Estab. 1984. Arts & crafts show held annually in May/June. Outdoors. Accepts photography, oils, leather, various handcrafts. Juried by type of product. Number of exhibitors: 140-150. Public attendance: 30,000. Free to the public. Deadline for entry: mid-April. Application fee/space fee: $225/craft, $325/commercial. Exhibition space: 12×12 ft. For more information, artists should call, send SASE.

TIPS "Please get your applications in early!"

PEND OREILLE ARTS COUNCIL

P.O. Box 1694, Sandpoint ID 83864. (208)263-6139. **E-mail:** art@sandpoint.net. **Website:** www.artinsandpoint.org. Estab. 1978. Arts & crafts show held annually, second week in August. Outdoors. Accepts photography and all handmade, noncommercial works. Juried by 8-member jury. Number of exhibitors: 120. Public attendance: 5,000. Free to public. Artists should apply by sending in application, available in February, along with 4 images (3 of your work, 1 of your booth space). Deadline for entry: May 1. Application fee: $15. Space fee: $185-280, no commission taken. Electricity: $50. Exhibition space: 10×10 ft. or 10×15 ft. (shared booths available). For more information, artists should e-mail, call or visit website.

PETERS VALLEY ANNUAL CRAFT FAIR

19 Kuhn Rd., Layton NJ 07851. (973)948-5200. **Fax:** (973)948-0011. **E-mail:** craftfair@petersvalley.org, or via online contact form. **Website:** www.petersvalley. org. Estab. 1970. Arts & crafts show held annually in late September at the Sussex County Fairgrounds in Augusta. Indoors. Accepts photography, ceramics, fiber, glass, basketry, metal, jewelry, sculpture, printmaking, paper book art, drawing, painting. Juried. Awards/prizes: cash awards. Number of exhibitors: 185. Public attendance: 7,000-8,000. Public admission: $8. Artists should apply at www.zapplication.org. Deadline for entry: June 1. Application fee: $35. Space fee: $415. Exhibition space: 10×10 ft. Average gross sales/exhibitor: $2,000-5,000. For more information artists should e-mail, visit website or call.

PRAIRIE ARTS FESTIVAL

201 Schaumburg Court, Schaumburg IL 60193. (847)923-3605. **Fax:** (847)923-2458. **E-mail:** rbenvenuti@ci.schaumburg.il.us. **Website:** www.prairiecenter. org. **Contact:** Roxane Benvenuti, special events coordinator. Outdoor fine art show & sale featuring artists, food vendors, live entertainment and children's activities. Held in late May. Located in the Robert O. Atcher Municipal Center grounds, adjacent to the Schaumburg Prairie Center for the Arts. Artist applications available in mid-January; due online or postmarked by March 1. 155 spaces available. Application fee: $110 (for 15×10 space); $220 (30×10 space). No jury fee. "With thousands of patrons in attendance, an ad in the Prairie Arts Festival program is a great way to get your business noticed. Rates are reasonable, and an ad in the program gives you access to a select regional market. Sponsorship opportunities are also available." For more information, call, e-mail or visit the website.

TIPS "Submit your best work for the jury since these images are selling your work."

PUNGO STRAWBERRY FESTIVAL

P.O. Box 6158, Virginia Beach VA 23456. (757)721-6001. **Fax:** (757)721-9335. **E-mail:** pungofestival@aol.com. **Website:** www.pungostrawberryfestival. info. Estab. 1983. Arts & crafts show held annually on Memorial Day Weekend. Outdoors. Accepts photography and all media. Number of exhibitors: 60. Public attendance: 120,000. Free to public; $5 parking fee. Artists should apply by calling for application or downloading a copy from the website and mail in. Deadline for entry: early March; applications accepted from that point until all spaces are full. Notice of acceptance or denial by early April. Application fee: $50 refundable deposit. Space fee: $200 (off road location); $450 (on road location). Exhibition space: 10×10 ft. For more information, artists should e-mail, visit website or call.

PYRAMID HILL ANNUAL ART FAIR

1763 Hamilton Cleves Rd., Hamilton OH 45013. (513)868-8336. **Fax:** (513)868-3585. **E-mail:** pyramid@pyramidhill.org. **Website:** www.pyramidhill. org. Art fair held the last Saturday and Sunday of September. Application fee: $25. Booth fee: $100 for a single, $200 for a double. Call, e-mail or visit website for more information.

TIPS "Make items affordable! Quality work at affordable prices will produce profit."

♻ QUAKER ARTS FESTIVAL

P.O. Box 202, Orchard Park NJ 14127. (716)667-2787. **E-mail:** opjaycees@aol.com. **Website:** www.opjaycees.com. Estab. 1961. Fine arts & crafts show held annually in mid-September (see website for details). Outdoors. Accepts photography, painting, graphics; sculpture, crafts. Juried by 4 panelists during event. Awards/prizes: over $10,000 total cash prizes. Number of exhibitors: 330. Public attendance: 75,000. Free to the public. Artists should apply online, or by sending SASE. Deadline for entry: late August (see website for details). Space fee: $185 ($370 for double space). Exhibition space: 10×12 ft. (outdoor), 10×6 ft. (indoor). For more information, artists should call or visit website.

TIPS "Have an inviting booth and be pleasant and accessible. Don't hide behind your product—engage the audience."

RATTLESNAKE ROUNDUP

P.O. Box 292, Claxton GA 30417. (912)739-3820. **Fax:** (912)739-3827. **E-mail:** thall@claxtonevanschamber.com. **Website:** www.claxtonevanschamber.com. Estab. 1968. Arts & crafts show held annually 2nd weekend in March. Outdoors. Accepts photography and various mediums. Number of exhibitors: 150-200. Public attendance: 15,000-20,000. Artists should apply by filling out an application. Click on the "Registration Tab" located on the Rattlesnake Roundup home page. Deadline for entry: late February/early March (see website for details). Space fee: $85. Exhibition space: 10×16 ft. For more information, artists should e-mail, visit website or call.

TIPS "Your display is a major factor in whether people will stop to browse when passing by. Offer a variety."

♻ RILEY FESTIVAL

312 E. Main St., Suite C, Greenfield IN 46140. (317)462-2141. **Fax:** (317)467-1449. **E-mail:** info@rileyfestival.com. **Website:** www.rileyfestival.com. **Contact:** Sarah Kesterson, public relations. Estab. 1970. Fine arts & crafts festival held in October. Outdoors. Accepts photography, fine arts, home arts, quilts. Juried. Awards/prizes: small monetary awards and ribbons. Number of exhibitors: 450. Public attendance: 75,000. Free to public. Artists should apply by downloading application on website. Deadline for entry: mid-September. Space fee: $185. Exhibition space: 10×10 ft. For more information, artists should visit website.

TIPS "Keep arts priced for middle-class viewers."

♻ RIVERBANK CHEESE & WINE EXPOSITION

6618 3rd St., Riverbank CA 95367-2317. (209)863-9600. **Fax:** (209)863-9601. **E-mail:** events@riverbankcheeseandwine.org. **Website:** www.riverbankcheeseandwine.org. **Contact:** Chris Elswick, event coordinator. Estab. 1977. Arts & crafts show and food show held annually 2nd weekend in October. Outdoors. Accepts photography, other mediums depends on the product. Juried by pictures and information about the artists. Number of exhibitors: 250. Public attendance: 60,000. Free to public. Artists should apply by calling and requesting an application. Applications also available on website. Deadline for entry: early September. Space fee: $345/arts & crafts; $465/commercial. Exhibition space: 12×12 ft. For more information, artists should e-mail, visit website, call or send SASE.

TIPS Make sure your display is pleasing to the eye.

RIVERFRONT MARKET

The Riverfront Market Authority, P.O. Box 565, Selma AL 36702-0565. (334)874-6683. **E-mail:** info@selmaalabama.com. **Website:** www.selmaalabama.com. Estab. 1972. Arts & crafts show held annually the 2nd Saturday in October. Outdoors. Accepts photography, painting, sculpture. Number of exhibitors: 200. Public attendance: 8,000. Public admission: $2. Artists should apply by calling or mailing to request application. Deadline for entry: September 1. Space fee: $50; limited covered space available at $60; electrical hookups $25. Exhibition space: 10×10 ft. For more information, artists should call or visit website.

♻ ROYAL OAK OUTDOOR ART FAIR

Recreation Dept., P.O. Box 1453, Royal Oak MI 48068. (248)246-3180. **E-mail:** mail@royaloakarts council.com. **Website:** www.royaloakarts.com. **Contact:** Recreation Office Staff. Estab. 1970. Fine arts & crafts show held annually in July. Outdoors. Accepts photography, collage, jewelry, clay, drawing, painting, glass, wood, metal, leather, soft sculpture. Juried. Number of exhibitors: 110. Public attendance: 25,000. Free to pubic. Artists should apply with online application form and 3 slides of current work. Space fee: $250 (plus a $20 non-refundable processing fee per medium and a $25 exhibit fee for all accepted artists). Exhibition space: 15×15 ft. For more information, artists should e-mail, call or visit website.

TIPS "Be sure to label your slides on the front with name, size of work and 'top'."

⊕ SACO SIDEWALK ART FESTIVAL

P.O. Box 336, 12½ Pepperell Square, Suite 2A, Saco ME 04072. (207)286-3546. **E-mail:** sacospirit@hot mail.com. **Website:** www.sacospirit.com. Estab. 1970. Event held in late June. Annual event organized and managed by Saco Spirit, Inc., a nonprofit organization committed to making Saco a better place to live and work by enhancing the vitality of our downtown. Dedicated to promoting art and culture in our community. Space fee: $75. Exhibition space: 10×10 ft. See website for more details.

TIPS "Offer a variety of pieces priced at various levels."

⊕ SANDY SPRINGS FESTIVAL

P.O. Box 422571, Atlanta GA 30342. (404)851-9111; (404)845-0793. **Fax:** (404)851-9807. **E-mail:** info@ sandyspringsfestival.org; patrick@affps.com; ran dall@affps.com. **Website:** www.sandyspringsfestival. com. Estab. 1985. Annual arts & crafts show held annually in mid-September. See website for details. Outdoors. Accepts photography, painting, sculpture, jewelry, furniture, clothing. Juried by artist committee. Awards/prizes: ribbons for Best in Show, 2nd Place, 3rd Place and Best Booth. Number of exhibitors: 135 maximum. Public attendance: 20,000. Public admission $5. Artists may apply via application on website or online at www.zapplication.org. Application fee: $25. Space fee: $200 for 10×10, $350 for 10×20. Average gross sales per exhibitor: $1,000. For more information, artists should e-mail or visit website.

TIPS "Many of the purchases made at Sandy Springs Festival are priced under $100. The look of the booth and its general attractiveness are very important, especially to those who might not know art."

⊕ SANTA CALI GON DAYS FESTIVAL

210 W. Truman Rd., Independence MO 64050. (816)252-4745. **E-mail:** tsingleton@independence chamber.org; tfreeland@independencechamber.org. **Website:** www.santacaligon.com. **Contact:** Terri Singleton or Teresa Freeland. Estab. 1973. Market vendors show held annually Labor Day weekend. Outdoors. Accepts photography, all other mediums. Juried by committee. Number of exhibitors: 240. Public attendance: 225,000. Free to public. Artists should apply by requesting application. Application requirements include completed application, application fee, 4 photos of product/art and 1 photo of display. Exhibition space: 8×8 ft. and 10×10 ft. For more information, artists should e-mail, visit website or call.

SANTA FE COLLEGE SPRING ARTS FESTIVAL

3000 NW 83rd St., Gainesville FL 32606. (352)395-5355. **Fax:** (352)336-2715. **E-mail:** kathryn.lehman@ sfcollege.edu. **Website:** springartsfestival.com. **Contact:** Kathryn Lehman, cultural programs coordinator. Fine arts festival held in mid-April (see website for details). "The festival is one of the 3 largest annual events in Gainesville and is known for its high quality, unique artwork." Held in the downtown historic district. Public attendance: 130,000+. Call, e-mail or visit website for more information.

⊕ SAUSALITO ART FESTIVAL

P.O. Box 10, Sausalito CA 94966. (415)332-3555. **Fax:** (415)331-1340. **E-mail:** apply@sausalitoartfestival.org. **Website:** www.sausalitoartfestival.org. Estab. 1952. Fine arts & crafts show held annually Labor Day weekend. Outdoors. Accepts painting, photography, 2D and 3D mixed media, ceramics, drawing, fiber, functional art, glass, jewelry, printmaking, sculpture, watercolor, woodwork. Juried. Jurors are elected by their peers from the previous year's show (1 from each category). They meet for a weekend at the end of March and give scores of 1, 2, 4 or 5 to each applicant (5 being the highest). 5 images must be submitted, 4 of art and 1 of booth. Number of exhibitors: 280. Public attendance: 40,000. Artists should apply by visiting website for instructions and application. Applications are through Juried Art Services. Deadline for entry: March. Exhibition space: 100 or 200 sq. ft. Booth fees range from $1,200-2,900. Average gross sales/exhibitor: $7,700. For more information, artists should visit website.

⊕ SCOTTSDALE ARTS FESTIVAL

7380 E. Second St., Scottsdale AZ 85251. (480)874-2787. **Fax:** 480-874-4699. **Website:** www.scottsdale artsfestival.org. Estab. 1970. Fine arts & crafts show held annually in March. Outdoors. Accepts photography, jewelry, ceramics, sculpture, metal, glass, drawings, fiber, paintings, printmaking, mixed media, wood. Juried. Awards/prizes: 1st, 2nd, 3rd Places in each category and Best of Show. Number of exhibitors: 200. Public attendance: 40,000. Public admission: $7. Artists should apply through www.zapplication.org. Deadline for entry: October. Exhibition space: 100 sq. ft. For more information, artists should visit website.

SIDEWALK ART MART

Downtown Helena, Inc., Mount Helena Music Festival, 225 Cruse Ave., Suite B, Helena MT 59601. (406)447-1535. **Fax:** (406)447-1533. **E-mail:** jmchugh@mt.net. **Website:** www.downtownhelena.com. jmchuch@mt.net. Estab. 1974. Arts, crafts and music festival held annually in June. Outdoors. Accepts photography. No restrictions except to display appropriate work for all ages. Number of exhibitors: 50+. Public attendance: 5,000. Free to public. Artists should apply by visiting website to download application. Space fee: $100-125. Exhibition space: 10×10 ft. For more information, artists should e-mail, visit website or call.

TIPS "Greet people walking by and have an eye-catching product in front of booth. We have found that high-end artists or expensively priced art booths that had business cards with e-mail or website information received many contacts after the festival."

◉ SIERRA MADRE WISTARIA FESTIVAL

37 Auburn Ave., Suite 1, Sierra Madre CA 91024. (626)355-5111. **Fax:** (626)306-1150. **E-mail:** info@sierramadrechamber.com. **Website:** www.sierramadrechamber.com/wistaria/photos.htm. Fine arts, crafts and garden show held annually in March. Outdoors. Accepts photography, anything handcrafted. Juried. Craft vendors send in application and photos to be juried. Most appropriate are selected. Awards/prizes: Number of exhibitors: 175. Public attendance: 12,000. Free to public. Artists should apply by sending completed and signed application, 3-5 photographs of their work, application fee, license application, space fee and 2 SASEs. Deadline for entry: late December. Application fee: $25. Public Safety Fee (non-refundable) $25. Space fee: $185 and a $25 admin fee. Exhibition space: 10×10 ft. For more information, artists should e-mail, visit website or call. Applications can be found on chamber website.

TIPS "Have a clear and simple application. Be nice."

SKOKIE ART GUILD'S ART FAIR

5211 W. Oakton, Skokie IL 60076. (847)677-8163. **E-mail:** skokieart@aol.com. **Website:** www.skokieartguild.org. **Contact:** B. Willerman, chairperson. Outdoor fine art/craft show open to all artists (18+). Held on second weekend of July. Space fee: $150 for 10×10 ft. space. Awards: Guild awards, a Mayor's award and community business gift certificates are rallied. Deadline for application: mid-May.

TIPS Display your work in a professional manner: matted, framed, etc.

◉ SMITHVILLE FIDDLERS' JAMBOREE AND CRAFT FESTIVAL

P.O. Box 83, Smithville TN 37166. (615)597-8500. **Website:** www.smithvillejamboree.com. Estab. 1971. Arts & crafts show held annually the weekend nearest the Fourth of July holiday. Indoors. Juried by photos and personally talking with crafters. Awards/prizes: ribbons and free booth for following year for Best of Show, Best of Appalachian Craft, Best Display, Best New Comer. Number of exhibitors: 235. Public attendance: 130,000. Free to public. Artists should apply online. Deadline: June 1. Space fee: $125. Exhibition space: 12×12 ft. Average gross sales/exhibitors: $1,200+. For more information, artists should call or visit website.

◉ SOLANO AVENUE STROLL

1563 Solano Ave., #PMB 101, Berkeley CA 94707. (510)527-5358. **E-mail:** SAA@solanoavenueassn.org. **Website:** www.solanoave.org. Estab. 1974. Fine arts & crafts show held annually 2nd Sunday in September. Outdoors. "Since 1974, the merchants, restaurants, and professionals, as well as the twin cities of Albany and Berkeley have hosted the Solano Avenue Stroll, the East Bay's largest street festival." Accepts photography and all other mediums. Juried by board of directors. Number of exhibitors: 140 spaces for crafts; 600 spaces total. Public attendance: 300,000. Free to the public. Artists should apply online in April, or send SASE. Space fee: $150. Exhibition space: 10×10 ft. For more information, artists should e-mail, visit website, send SASE.

TIPS "Artists should have a clean presentation; small-ticket items as well as large-ticket items; great customer service; enjoy themselves."

THE SOUTHWEST ARTS FESTIVAL

Indio Chamber of Commerce, 82921 Indio Blvd., Indio CA 92201. (760)347-0676. **Fax:** (763)3476069. **E-mail:** swaf@indiochamber.org. **Website:** www.southwestartsfest.com. Estab. 1986. Featuring over 275 acclaimed artists showing traditional, contemporary and abstract fine works of art and quality crafts, the festival is a major, internationally recognized cultural event attended by nearly 10,000 people. The event features a wide selection of clay, crafts, drawings, glass work, jewelry, metal works, paintings, photographs, printmaking, sculpture and textiles. Application fee:

$50. Easy check-in and check-out procedures with safe and secure access to festival grounds for setup and breakdown. Allow advance set-up for artists with special requirements (very large art requiring the use of cranes, forklifts, etc., or artists with special needs). Artist parking is free. Disabled artist parking is available. Apply online. For more information, artists should call, e-mail or visit website.

SPRING CRAFTMORRISTOWN

P.O. Box 28, Woodstock NY 12498. (845)331-7900. **Fax:** (845)331-7484. **E-mail:** crafts@artrider.com. **Website:** www.artrider.com. Estab. 1990. Fine arts & crafts show held annually in March or April. Indoors. Accepts photography, wearable and nonwearable fiber, metal and nonmetal jewelry, clay, leather, wood, glass, painting, drawing, prints, mixed media. Juried by 5 images of work and 1 of booth, viewed sequentially. Number of exhibitors: 150. Public attendance: 5,000. Public admission: $7. Artists should apply by downloading application from www.artrider.com or apply online at www.zapplication.org. Deadline for entry: January 1. Application fee: $45. Space fee: $495. Exhibition space: 10×10 ft. For more information, artists should e-mail, visit website, call.

SPRING CRAFTS AT LYNDHURST

P.O. Box 28, Woodstock NY 12498. (845)331-7900. **Fax:** (845)331-7484. **E-mail:** crafts@artrider.com. **Website:** www.artrider.com. Estab. 1984. Fine arts & crafts show held annually in early May. Outdoors. Accepts photography, wearable and nonwearable fiber, metal and nonmetal jewelry, clay, leather, wood, glass, painting, drawing, prints, mixed media. Juried by 5 images of work and 1 of booth, viewed sequentially. Number of exhibitors: 250. Public attendance: 14,000. Public admission: $10. Artists should apply by downloading application from www.artrider.com or can apply online at www.zapplication.org. Deadline for entry: January 1. Application fee: $45. Space fee: $755-855. Exhibition space: 10×10 ft. For more information, artists should e-mail, visit website, call.

SPRINGFEST

Southern Pines Business Association, P.O. Box 831, Southern Pines NC 28388. (910)315-6508. **E-mail:** spbainfo@southernpines.biz. **Website:** www.south ernpines.biz. Estab. 1979. Arts & crafts show held annually last Saturday in April. Outdoors. Accepts photography and crafts. We host over 160 vendors from all around North Carolina and the country. En-

joy beautiful artwork and crafts including paintings, jewelry, metal art, photography, woodwork, designs from nature and other amazing creations. Event is held in conjunction with Tour de Moore, an annual bicycle race in Moore County, and is cosponsored by the town of Southern Pines. Public attendance: 8,000. Free to the public. Deadline: March (see website for more details). Space fee: $75. Exhibition space: 10×12 ft. For more information, artists should e-mail, visit website, call, send SASE. Apply online.

SPRING FESTIVAL, AN ARTS & CRAFTS AFFAIR

P.O. Box 184, Boys Town NE 68010. (402)331-2889. **Fax:** (402)445-9177. **E-mail:** hpifestivals@cox.net. **Website:** www.hpifestivals.com. 30th annual tour takes place in Omaha (April 13-15), Minneapolis (April 20-22) and Chicago (April 27-29). Application available online. Artists should e-mail or see website for specifics on each location and exhibitor information.

SPRING FINE ART & CRAFTS AT BROOKDALE PARK (BLOOMFIELD, NJ)

473 Latchung Ave., Bloomfield NJ 07003. (908)874-5247. **Fax:** (908)874-7098. **E-mail:** info@rosesquared. com. **Website:** www.rosesquared.com. **Contact:** Howard Rose, vice president. Estab. 1988. Fine arts & crafts show held annually in mid-June. Outdoors. Accepts photography and all other mediums. Juried. Number of exhibitors: 160. Public attendance: 12,000. Free to public. Artists should apply on the website. Deadline for entry: mid-May. Application fee: $25. Space fee varies by booth size; see application form on website for details. For more information, artists should visit the website.

TIPS "Have a range of priced items."

SPRING FINE ART & CRAFTS AT BROOKDALE PARK (MONTCLAIR, NJ)

12 Galaxy Court, Montclair NJ (908)874-5247. **Fax:** (908)874-7098. **E-mail:** info@rosesquared.com. **Website:** www.rosesquared.com. Estab. 1988. Fine arts & craft show held annually in mid-June Father's Day weekend. Outdoors. Accepts photography and all other mediums. Juried. Number of exhibitors: 180. Public attendance: 16,000. Free to the public. Artists should apply by downloading application from website or call for application. Deadline: 1 month before show date. Application fee: $25. Space fee: $340. Exhi-

bition space: 120 sq. ft. For more information, artists should e-mail, visit website, call.

TIPS "Create a professional booth that is comfortable for the customer to enter. Be informative, friendly and outgoing. People come to meet the artist."

SPRING FINE ART & CRAFTS AT THE WESTFIELD ARMORY

500 Rahway Ave., Westfield NJ 07090. (908)874-5247. **Fax:** (908)874-7098. **E-mail:** info@rosesquared.com. **Website:** www.rosesquared.com. **Contact:** Howard Rose, vice president. Estab. 2010. Fine arts & crafts show held annually in early April. Indoors. Accepts photography and all other mediums. Juried by 4 images of your work. Number of exhibitors: 130. Public attendance: 4,000. Admission fee: $6. Artists should apply on the website. Deadline for entry: early March. Application fee: $25. Space fee varies by booth size; see application form on website for details. For more information, artists should visit the website.

TIPS "Create a unique booth."

ST. CHARLES FINE ART SHOW

213 Walnut St., St. Charles IL 60174. (630)513-5386. **E-mail:** jennifer@dtown.org; adorsch@dtown.org; info@dtown.org. **Website:** www.dtown.org. Fine art fair held annually in late May. Outdoors. Accepts photography, painting, sculpture, glass, ceramics, jewelry, nonwearable fiber art. Juried by committee: submit 4 slides of art and 1 slide of booth/display. Awards/prizes: Cash awards of $3,500 awarded in several categories. $14,000 of art has been purchased through this program since its inception in 2005. Number of exhibitors: 100. Free to the public. Artists should apply by downloading application from website or call for application. Deadline for entry: February. Jury fee: $35. Space fee: $350. Exhibition space: 12×12 ft. For more information, artists should e-mail, or visit website.

ST. GEORGE ART FESTIVAL

86 S. Main St., George UT 84770. (435)627-4500. **E-mail:** leisure@sgcity.org. **Website:** www.sgcity.org/artfestival. Estab. 1979. Fine arts & crafts show held annually Easter weekend in either March or April. Outdoors. Accepts photography, painting, wood, jewelry, ceramics, sculpture, drawing, 3D mixed media, glass. Juried from digital submissions, CDs and slides. Awards/prizes: $5,000 Purchase Awards. Art pieces selected will be placed in the city's permanent collections. Number of exhibitors: 110. Public attendance: 20,000/day. Free to public. Artists should apply by completing application form, nonrefundable application fee, slides or digital format of 4 current works in each category and 1 of booth, and SASE. Deadline for entry: January. Exhibition space: 10×11 ft. For more information, artists should check website or e-mail.

TIPS "Artists should have more than 50% originals. Have quality booths and set-up to display art in best possible manner. Be outgoing and friendly with buyers."

ST. JAMES COURT ART SHOW

P.O. Box 3804, Louisville KY 40201. (502)635-1842. **Fax:** (502)635-1296. **E-mail:** mesrock@stjamescourtartshow.com. **Website:** www.stjamesartshow.com. Estab. 1957. Annual fine arts & crafts show held the first full weekend in October. Accepts photography; has 17 medium categories. Juried in April; there is also a street jury held during the art show. Number of exhibitors: 300. Public attendance: 210,000. Free to the public. Artists should apply by visiting website and printing out an application or via www.zapplication.org. Deadline for entry: late March (see website for details). Application fee: $30. Space fee: $500. Exhibition space: 10×12 ft. For more information, artists should e-mail or visit website.

TIPS "Have a variety of price points. Don't sit in the back of the booth and expect sales."

ST. PATRICK'S DAY CRAFT SALE & FALL CRAFT SALE

P.O. Box 461, Maple Lake MN 55358-0461. **Website:** www.maplelakechamber.com. **Contact:** Kathy. Estab. 1988. Arts & crafts show held bi-annually in March and early November. Indoors. Number of exhibitors: 40-50. Public attendance: 300-600. Free to public. Deadline for entry: 1 month-2 weeks before the event. Exhibition space: 10×10 ft. For more information or an application, artists should visit website.

TIPS "Don't charge an arm and a leg for the items. Don't over crowd your items. Be helpful, but not pushy."

STEPPIN' OUT

Downtown Blacksburg, Inc., P.O. Box 233, Blacksburg VA 24063. (540)951-0454. **E-mail:** dbi@downtownblacksburg.com. **Website:** www.blacksburgsteppinout.com. Estab. 1981. Arts & crafts show held annually 1st Friday and Saturday in August. Outdoors. Accepts photography, pottery, painting, drawing, fiber arts, jewelry, general crafts. All arts and crafts must

be handmade. Number of exhibitors: 170. Public attendance: 45,000. Free to public. Space fee: $150. An additional $10 is required for electricity. Exhibition space: 10×16 ft. Artists should apply by e-mailing, calling or downloading an application on website. Deadline: early May.

TIPS "Visit shows and consider the booth aesthetic—what appeals to you. Put the time, thought, energy and money into your booth to draw people in to see your work."

STILLWATER ARTS FESTIVAL

P.O. Box 1449, Stillwater OK 74074. (405)533-8539. **Fax:** (405)533-3097. **E-mail:** jnovak@stillwater.org. **Website:** stillwater.org/content/arts-festival/artists.php. Estab. 1977. Fine arts & crafts show held annually in April. Outdoors. Accepts photography, oil, acrylic, watercolor and multimedia paintings, pottery, pastel work, fiber arts, jewelry, sculpture, glass art. Juried. Awards are based on entry acceptance on quality, distribution and various media entries. Awards/prizes: Best of Show, $500; 1st Place, $200; 2nd Place, $150 and 3rd Place, $100. Number of exhibitors: 80. Public attendance: 7,500-10,000. Free to public. Artists should apply online at the website. Deadline for entry: early spring (visit website for details). Jury fee: $20. Booth fee $130. Exhibition space: 10×10 ft. Average gross sales/exhibitor: $700. For more information, artists should e-mail.

STOCKLEY GARDENS FALL ARTS FESTIVAL

801 Boush St., Suite 302, Norfolk VA 23510. (757)625-6161. **Fax:** (757)625-7775. **E-mail:** aknox@hope-house.org. **Website:** www.hope-house.org. **Contact:** Anne Knox, development coordinator. Estab. 1984. Fine arts & crafts show held bi-annually in the 3rd weekend in May and October. Outdoors. Accepts photography and all major fine art mediums. Juried. Number of exhibitors: 150. Public attendance: 25,000. Free to the public. Artists should apply by submitting application, jury and booth fees, 5 slides. Deadline for entry: February and July. Exhibition space: 10×10 ft. For more information, artists should visit the website.

STONE ARCH FESTIVAL OF THE ARTS

(763)438-9978. **E-mail:** mplsriverfront@msn.com; heatherwmpls@gmail.com. **Website:** www.stonearchfestival.com. **Contact:** Sara Collins, manager. Estab. 1994. Fine arts & crafts show and culinary arts show held annually Father's Day weekend in the Riverfront District of Minneapolis. Outdoors. Accepts drawing/pastels, printmaking, ceramics, jewelry (metals/stone), mixed media, painting, photography, sculpture metal works, bead work (jewelry or sculpture), glass, fine craft, special consideration. Juried by committee. Awards/prizes: free booth the following year; $100 cash prize. Number of exhibitors: 230. Public attendance: 80,000. Free to public. Artists should apply by application found on website or through www.zapplication.org. Application fee: $25. Deadline for entry: mid-March. Space fee: depends on booth location (see website for details). Exhibition space: 10×10 ft. For more information, artists should call, e-mail or visit website.

TIPS "Have an attractive display and variety of prices."

STRAWBERRY FESTIVAL

2815 Second Ave. N., Billings MT 59101. (406)294-5060. **Fax:** (406)294-5061. **E-mail:** info@strawberryfun.com; mikaly@downtownbillings.com. **Website:** www.strawberryfun.com. Estab. 1991. Fine arts & crafts show held annually 2nd Saturday in June. Outdoors. Accepts photography and only finely crafted work. Hand crafted works by the selling artist will be given priority. Requires photographs of booth set up and 2-3 of work. Juried. Public attendance: 15,000. Free to public. Artists should apply online. Deadline for entry: April. Space fee: $150. Exhibition space: 10×10 ft. For more information, artists should e-mail or visit website.

SUMMER ARTS & CRAFTS FESTIVAL

38 Charles St., Rochester NH 03867. (603)332-2616. **Fax:** (603)332-8413. **E-mail:** info@castleberryfairs.com. **Website:** www.castleberryfairs.com. Estab. 1992. Arts & crafts show held annually 2nd weekend in August in Lincoln NH. Outdoors. Accepts photography and all other mediums. Juried by photo, slide or sample. Number of exhibitors: 100. Public attendance: 7,500. Free to the public. Artists should apply by downloading application from website. Application fee: $50. Space fee: $225. Exhibition space: 10×10 ft. For more information, artists should visit website.

TIPS "Do not bring a book; do not bring a chair. Smile and make eye contact with everyone who enters your booth. Have them sign your guest book; get their e-mail address so you can let them know when you are in the area again. And, finally, make the sale—they are at the fair to shop, after all."

SUMMERFAIR

7850 Five Mile Rd., Cincinnati OH 45230. (513)531-0050. **Fax:** (513)531-0377. **E-mail:** exhibitors@summerfair.org. **Website:** www.summerfair.org. Estab. 1968. Fine arts & crafts show held annually the weekend after Memorial Day. Outdoors. Accepts photography, ceramics, drawing, printmaking, fiber, leather, glass, jewelry, painting, sculpture, metal, wood and mixed media. Juried by a panel of judges selected by Summerfair, including artists and art educators with expertise in the categories offered at Summerfair. Submit application with 5 digital images (no booth image) through www.zapplication.org. Awards/prizes: $11,000 in cash awards. Number of exhibitors: 300. Public attendance: 20,000. Public admission: $10. Deadline: February. Application fee: $30. Space fee: $375, single; $750, double space; $75 canopy fee (optional—exhibitors can rent a canopy for all days of the fair). Exhibition space: 10×10 ft. for single space; 10×20 ft. for double space. For more information, artists should e-mail, visit website, call.

SUN FEST, INC.

P.O. Box 2404, Bartlesville OK 74005. (918)331-0456. **Fax:** (918)331-3217. **E-mail:** wcfd90@sbcglobal.net. **Website:** www.bartlesvillesunfest.org. Estab. 1982. Fine arts & crafts show held annually in early June. Outdoors. Accepts photography, painting and other arts and crafts. Juried. Awards: $2,000 in cash awards along with a ribbon/award to be displayed. Number of exhibitors: 95-100. Number of attendees: 25,000-30,000. Free to the public. Artists should apply by e-mailing or calling for an entry form, or completing online, along with 3-5 photos showing your work and booth display. Deadline: early May. Space fee: $125. An extra $20 is charged for use of electricity. Exhibition space: 10×10 ft. For more information, artists should e-mail, call or visit website.

SYRACUSE ARTS & CRAFTS FESTIVAL

572 S. Salina St., Syracuse NY 13202. (315)422-8284. **Fax:** (315)471-4503. **E-mail:** mail@downtownsyracuse.com. **Website:** www.syracuseartsandcraftsfestival.com. **Contact:** Laurie Reed, director. Estab. 1970. Fine arts & crafts show held annually in late July. Outdoors. Accepts photography, ceramics, fabric/fiber, glass, jewelry, leather, metal, wood, computer art, drawing, printmaking, painting. Juried by 4 independent jurors. Jurors review 4 slides of work and 1 slide of booth display. Number of exhibitors:

170. Public attendance: 50,000. Free to public. Artists should through www.zapplication.org. Application fee: $25. Space fee: $260. Exhibition space: 10×10 ft. For more information, artists should e-mail, visit website or call.

TALKING STICK FINE ART & WINE FESTIVAL

7555 North Pima Rd., Scottsdale AZ 85258. (480)837-5637. **Fax:** (480)837-2355. **E-mail:** info@thunderbirdartists.com. **Website:** www.thunderbirdartists.com. **Contact:** Denise Dodson, president. Estab. 2011. Fine arts & crafts show. Held annually over Thanksgiving weekend. Outdoors. Accepts photography, paintings, bronzes, baskets, jewelry, stone, pottery. Juried; CEO blind juries by medium. Number of exhibitors: 175. Public attendance: 50,000. Public admission: $3. Applications available online at www.zapplication.org. Deadline for entry: mid-June (see website for specifics). Application fee: $30. Space fee: $410-1,230. Exhibition space: 10×10 to 10×30 ft. For more information, artists should e-mail, call or see website.
TIPS "A clean, gallery-type presentation is very important."

TARPON SPRINGS FINE ARTS FESTIVAL

111 E. Tarpon Ave., Tarpon Springs FL 34689. (727)937-6109. **Fax:** (727)937-2879. **E-mail:** scottie@tarponspringschamber.org. **Website:** www.tarponspringschamber.com. Estab. 1974. Fine arts & crafts show held annually in early April. Outdoors. Accepts photography, acrylic, oil, ceramics, fiber, glass, graphics, drawings, pastels, jewelry, leather, metal, mixed media, sculpture, watercolor, wood. Juried by CD. Awards/prizes: cash and ribbons. Number of exhibitors: 225. Public attendance: 20,000. Public admission: $3; free age 12 and under and active duty military in uniform. Artists should apply by submitting signed application, CD, slides, fees and SASE. Deadline for entry: early December. Jury fee: $25. Space fee: $225. Exhibition space: 10×12 ft. For more information, artists should e-mail, call or send SASE.
TIPS "Produce good CDs for jurors."

TEXAS STATE ARTS & CRAFTS FAIR

4000 Riverside Dr. East, Kerrville TX 78028. (830)896-5711; (888)835-1455. **Fax:** (830)896-5569. **E-mail:** fair@tacef.org. **Website:** www.tacef.org. Fine arts & crafts show held annually Memorial Day weekend on the grounds of the River Star Arts & Event Park. One of the top ranked arts & crafts events in the na-

tion. Outdoors. Public admission: $5 adult, Children 12 and under free with ticket holding adult. Application fee: $25. Space fee: $300-650. Exhibition space: 10×10 or 10×20 ft. Outdoor fair tent or open air spaces available. Application form online at zapplication.org. Deadline: early December. For more information, artists should call, e-mail or visit website.

TIPS "Market and advertise."

THREE RIVERS ARTS FESTIVAL

803 Liberty Ave., Pittsburgh PA 15222. (412)471-3191. **Fax:** (412)471-6917. **Website:** www.artsfestival.net. **Contact:** Sonja Sweterlitsch, director. Estab. 1960. "Three Rivers Arts Festival has presented, during its vast and varied history, more than 10,000 visual and performing artists and entertained millions of residents and visitors. Three Rivers Arts Festival faces a new turning point in its history as a division of The Pittsburgh Cultural Trust, further advancing the shared mission of each organization to foster economic development through the arts and to enhance the quality of life in the region." Application fee: $35. Booth fee: $410. See website for more information.

TUBAC FESTIVAL OF THE ARTS

P.O. Box 1866, Tubac AZ 85646. (52)398-2704. **Fax:** (520)398-1704. **E-mail:** assistance@tubacaz.com. **Website:** www.tubacaz.com. Estab. 1959. Fine arts & crafts show held annually in early February (see website for details). Outdoors. Accepts photography and considers all fine arts and crafts. Juried. A 7-member panel reviews digital images and artist statement. Names are withheld from the jurists. Number of exhibitors: 170. Public attendance: 65,000. Free to the public; parking: $6. Deadline for entry: late October (see website for details). Application fee: $30. Artists should apply online and provide images on a labeled CD (see website for requirements). Space fee: $575. Electrical fee: $50. Exhibition space: 10×10 ft. (a limited number of double booths are available). For more information, artists should e-mail, call or visit website.

TULIP FESTIVAL STREET FAIR

P.O. Box 1801, Mt. Vernon WA 98273. (360)336-3801. **E-mail:** edmvdt@gmail.com. **Website:** www.mount vernondowntown.org. Estab. 1984. Arts & crafts show held annually 3rd weekend in April. Outdoors. Accepts photography and original artists' work only. No manufactured work. Juried by a board. Jury fee: $10 with application and prospectus. Number of exhibi-

tors: 220. Public attendance: 30,000-35,000. Free to public. Artists should apply by calling or e-mailing. Deadline for entry: late January. Application fee: $10. Space fee: $300. Exhibition space: 10×10 ft. Average gross sales/exhibitor: $2,500-4,000. For more information, artists should e-mail, visit website, call or send SASE.

TIPS "Keep records of your street fair attendance and sales for your résumé. Network with other artists about which street fairs are better to return to or apply for."

TULSA INTERNATIONAL MAYFEST

One W. Third St., Suite 109, Tulsa OK 74103. (918)582-6435. **Fax:** (918)517-3518. **E-mail:** comments@tulsa mayfest.org. **Website:** www.tulsamayfest.org. Estab. 1972. Fine arts & crafts show annually held in May. Outdoors. Accepts photography, clay, leather/fiber, mixed media, drawing, pastels, graphics, printmaking, jewelry, glass, metal, wood, painting. Juried by a blind jurying process. Artists should apply online at www.zapplication.org and submit 4 images of work and one photo of booth set-up. Awards/prizes: Best in Category and Best in Show. Number of exhibitors: 125. Public attendance: 350,000. Free to public. Artists should apply by downloading application in the fall. See website for deadline entry. Application fee: $35. Space fee: $300. Exhibition space: 10×10 ft. For more information, artists should e-mail or visit website.

UPTOWN ART FAIR

1406 W. Lake St., Lower Level C, Minneapolis MN 55408. (612)823-4581. **Fax:** (612)823-3158. **E-mail:** maude@uptownminneapolis.com; info@uptown minneapolis.com. **Website:** www.uptownartfair. com. Estab. 1963. Fine arts & crafts show held annually 1st full weekend in August. Outdoors. Accepts photography, painting, printmaking, drawing, 2D and 3D mixed media, ceramics, fiber, sculpture, jewelry, wood and glass. Juried by 4 images of artwork and 1 of booth display. Awards/prizes: Best in Show in each category; Best Artist. Number of exhibitors: 350. Public attendance: 375,000. Free to the public. The Uptown Art Fair uses www.zapplication. org. Each artist must submit 5 images of his or her work. All artwork must be in a high-quality digital format. Five highly qualified artists, instructors, and critics handpick Uptown Art Fair exhibitors after previewing projections of the images on 6-foot screens. The identities of the artists remain anonymous dur-

ing the entire review process. All submitted images must be free of signatures, headshots or other identifying marks. Three rounds of scoring determine the final selection and waitlist for the show. Artists will be notified shortly after of their acceptance. For additional information, see the links on website. Deadline for entry: early March. Application fee: $40. Space fee: $525 for 10×10 space; $1050 for 10×20 space. For more information, artists should call or visit website.

🎧 A VICTORIAN CHAUTAUQUA

P.O. Box 606, Jeffersonville IN 47131-0606. (812)283-3728 or (888)472-0606. **Fax:** (812)283-6049. **E-mail:** hsmsteam@aol.com. **Website:** www.steamboatmuseum.org. Estab. 1993. Fine arts & crafts show held annually 3rd weekend in May. Outdoors. Accepts photography, all mediums. Juried by a committee of 5. Number of exhibitors: 80. Public attendance: 3,000. Exhibition space: 12×12 ft. For more information, artists should e-mail, call or visit website.

VILLAGE SQUARE ARTS & CRAFTS FAIR

P.O. Box 1105, Saugatuck MI 49453. (269)857-2677. **Fax:** (269)857-7717. **E-mail:** artclub@saugatuckdouglasartclub.org. **Website:** www.saugatuckdouglasartclub.org. **Contact:** Bonnie Lowe, art fair co-chairperson. Estab. 2004. The art club offers two fairs each summer. See website for upcoming dates. This fair has some fine artists as well as crafters. Both fairs take place on the two busiest weekends in the resort town of Saugatuck's summer season. Both are extremely well attended. Generally the vendors do very well. Booth fee: $95-130.

TIPS "Create an inviting booth. Offer well-made artwork and crafts for a variety of prices."

VIRGINIA CHRISTMAS MARKET

The Farm Bureau Center at Meadow Event Park, 13111 Dawn Blvd., Doswell VA 23047. (804) 253-6284. **Fax:** (804) 253-6285. **E-mail:** vashowsinc@comcast.net. **Website:** www.vashowsinc.com. Indoors. Virginia Christmas Market is held the 2nd weekend in November at Farm Bureau Center at Meadow Event Park. Virginia Christmas Market will showcase over 300 quality artisans, crafters, boutiques and specialty food shops. Features porcelain, pottery, quilts, folk art, fine art, reproduction furniture, flags, ironwork, carvings, leather, toys, tinware, candles, dollcraft, wovenwares, book authors, musicians, jewelry, basketry, gourmet foods—all set amid festive Christmas displays. Accepts photography and other arts and crafts.

Juried by 3 photos of artwork and 1 of display. Attendance: 12,000. Public admission: $7; $1.50 children (2-12). Artists should apply by calling, e-mailing or downloading application from website. Space fee: $335. Exhibit spaces: 10×10 ft. For more information, artists should call, e-mail or contact through website.

🎧 VIRGINIA CHRISTMAS SHOW

P.O. Box 305, Chase City VA 23924. (434) 372-3996. **Fax:** (434) 372-3410. **E-mail:** vashowsinc@aol.com. **Website:** www.vashowsinc.com. **Contact:** Patricia Wagstaff. Estab. 1986. Arts and crafts show held annually in November in Richmond, Virginia. Accepts photography and other arts and crafts. Juried by 3 slides of artwork and 1 of display. Attendance: 30,000. Public admission: $7 adults; $1.50 children (2-12). Artists should apply by calling or e-mailing for application or downloading online application. Space fee: $435. Exhibition space: 10×10 ft. Included in this fee are booth curtains, 24-hour security in the show exhibit area, signage, a complimentary listing in the show directory and an extensive multi-media advertising campaign—radio, television, billboards, direct mail, magazines and newspapers—we do it all! Set-up is always easy, organized and convenient. The building is climate-controlled and many RVs may park on the premises for a nominal fee.

TIPS "If possible, attend the shows before you apply."

🎧 VIRGINIA SPRING SHOW

11050 Branch Rd., Glen Allen VA 23059. (804)253-6284. **Fax:** (804)253-6285. **E-mail:** vashowsinc@comcast.net. **Website:** www.vashowsinc.com. Estab. 1988. Holiday arts & crafts show held annually 2nd weekend in March in Richmond, Virginia. Indoors at the Showplace Exhibition Center. Accepts photography and other arts and crafts. Juried by 3 slides of artwork and 1 of display. Awards/prizes: Best Display. Number of exhibitors: 300. Public attendance: 20,000. Public admission: $7; $1.50 children (2-12). Exhibitor application is online at website. Artists can also apply by writing or e-mailing for an application. Space fee: $335. Exhibition space: 10×10 ft. For more information, artists should e-mail or visit website.

TIPS "If possible, attend the show before you apply."

🎧 WASHINGTON SQUARE OUTDOOR ART EXHIBIT

P.O. Box 1045, New York NY 10276. (212)982-6255. **Fax:** (212)982-6256. **E-mail:** jrm.wsoae@gmail.com. **Website:** www.wsoae.org. Estab. 1931. Fine arts &

crafts show held semiannually Memorial Day weekend and Labor Day weekend. Outdoors. Accepts photography, oil, watercolor, graphics, mixed media, sculpture, crafts. Juried by submitting 5 slides of work and 1 of booth. Awards/prizes: certificates, ribbons and cash prizes. Number of exhibitors: 150. Public attendance: 100,000. Free to public. Artists should apply by sending a SASE or downloading application from website. Deadline for entry: March, Spring Show; July, Fall Show. Exhibition space: 5×10 ft. up to 10×10 ft., double spaces available. Jury fee of $20. First show weekend (3 days) fee of $380. Second show weekend (2 days) $285. Both shows (all 5 days) fee of $485. For more information, artists should call or send SASE. **TIPS** "Price work sensibly."

WATERFRONT FINE ART & WINE FESTIVAL

7135 E. Camelback Rd., Scottsdale AZ 85251. (480)837-5637. **Fax:** (480)837-2355. **Website:** www.thunderbirdartists.com/waterfront. **Contact:** Denise Dodson, vice president. Estab. 2011. Fine art/craft show held annually over Valentine's Day weekend. Outdoors. Accepts photography, paintings, bronzes, baskets, jewelry, stone, pottery. Juried; blind jury by CEO. Number of exhibitors: 150. Public attendance: 40,000. Public admission: $3. Apply online at www.zapplication.org. Deadline for entry: late August (see website for specifics). Application fee: $30. Space fee: $410-1,230. Exhibition space: 10×10 to 10×30 ft. For more information, artists should e-mail, call or visit website.
TIPS "A clean, gallery-type presentation is very important."

WATERFRONT FINE ART FAIR

P.O. Box 1105, Saugatuck MI 49453. (269)857-2677. **Fax:** (269)857-7717. **E-mail:** artclub@saugatuckdouglasartclub.org. **Website:** www.saugatuckdouglassartclub.org. **Contact:** Bonnie Lowe and Jim Hanson, art fair co-chairs. Fee is $120. This includes application fee, booth fee, and city license. Applications juried in early April. For information, e-mail, call or visit the website.
TIPS "Create a pleasing, inviting booth. Offer well-made, top-quality fine art."

WESTMORELAND ART NATIONALS

252 Twin Lakes Rd., Latrobe PA 15650-3554. (724)834-7474. **E-mail:** info@artsandheritage.com. **Website:** www.artsandheritage.com. **Contact:** Adam Shaffer, executive director. Estab. 1975. Juried fine art exhibition & crafts show held annually in early July (see website for details). Juried art exhibition is indoors. Photography displays are indoors. Accepts photography, all handmade mediums. Juried by 2 jurors. Awards/prizes: $7,000 in prizes. Number of exhibitors: 190. Public attendance: 160,000. Free to public. Artists should apply by downloading application from website. Application fee: $25/craft show vendors; $35/art nationals exhibitors. Deadline: early March. Space fee: $375-750. Exhibition space: 10×10 or 10×20 ft. For more information, artists should visit e-mail, call or visit website. Please direct questions to our executive director.

WHITEFISH ARTS FESTIVAL

P.O. Box 131, Whitefish MT 59937. (406)862-5875. **Website:** www.whitefishartsfestival.org. Estab. 1979. Fine arts & crafts show held annually 1st full weekend in July. Outdoors. Accepts photography, pottery, jewelry, sculpture, paintings, woodworking. Juried. Art must be original and handcrafted. Work is evaluated for creativity, quality and originality. Awards/prizes: Best of Show awarded half-price booth fee for following year with no application fee. Number of exhibitors: 100. Public attendance: 3,000. Free to public. Entry fee: $29. Deadline: see website for details. Space fee: $215. Exhibition space: 10×10 ft. For more information, and to apply, artists should visit website.
TIPS Recommends "variety of price range, professional display, early application for special requests."

WHITE OAK CRAFTS FAIR

P.O. Box 111, Woodbury TN 37190. (615) 563-2787 or (800)235-9073. **E-mail:** mary@artscenterofcc.com. **Website:** www.artscenterofcc.com. Estab. 1985. Arts & crafts show held annually in early September (see website for details) featuring the traditional and contemporary craft arts of Cannon County and Middle Tennessee. Outdoors. Accepts photography; all handmade crafts, traditional and contemporary. Must be handcrafted displaying excellence in concept and technique. Juried by committee. Send 3 slides or photos. Awards/prizes: more than $1,000 cash in merit awards. Number of exhibitors: 80. Public attendance: 6,000. Free to public. Applications can be downloaded from website. Deadline: early July. Space fee: $100 ($70 for Artisan member) for a 10×10 ft. under tent; $80 ($50 for Artisan member) for a 12×12 ft. outside. For more information, artists should e-mail, call or visit website.

○ WILD WIND FOLK ART & CRAFT FESTIVAL

P.O. Box 719, Long Lake NY 12847. (814)723-0707; (814)688-1516. **E-mail:** wildwindcraftshow@yahoo. com. **Website:** www.wildwindfestival.com. **Contact:** Liz Allen and Carol Jilk, directors. Estab. 1979. Traditional crafts show held annually the weekend after Labor Day at the Warren County Fairgrounds in Pittsfield, Pennsylvania. Barn locations and outdoors. Accepts traditional country crafts, photography, paintings, pottery, jewelry, traditional crafts, prints, stained glass. Juried by promoters. Three photos or slides of work plus one of booth, if available. Number of exhibitors: 160. Public attendance: 9,000. Artists should apply by visiting website and filling out application request, calling or sending a written request.

○ WINNEBAGOLAND ART FAIR

South Park Ave., Oshkosh WI 54902. **E-mail:** oshkoshfaa@gmail.com. Estab. 1957. Fine arts show held annually the second Sunday in June. Outdoors. Accepts painting, wood or stone, ceramics, metal sculpture, jewelry, glass, fabric, drawing, photography, wall hangings, basketry. Artwork must be the original work of the artist in concept and execution. Juried. Applicants send in photographs to be reviewed. Awards/prizes: monetary awards, purchase, merit and Best of Show awards. Number of exhibitors: 125-160. Public attendance: 5,000-8,000. Free to public. Deadline for entry: Previous exhibitors due mid-March. New exhibitors due late March. $25 late entry fee after March. Exhibition space: 20×20 ft. For more information, artists should e-mail or see website. The updated entry form will be added to the website in early January.

TIPS "Artists should send clear, uncluttered photos of their current work which they intend to show in their booth as well as a photo of their booth setup."

○ WYANDOTTE STREET ART FAIR

3131 Biddle Ave., Wyandotte MI 48192. (734)324-4502. **Fax:** (734)324-7296. **E-mail:** info@wyan.org. **Website:** www.wyandottestreetartfair.org. **Contact:** Heather Thiede, special events coordinator. Estab. 1961. Fine arts & crafts show held annually 2nd week in July. Outdoors. Accepts photography, 2D mixed media, 3D mixed media, painting, pottery, basketry, sculpture, fiber, leather, digital cartoons, clothing, stitchery, metal, glass, wood, toys, prints, drawing. Juried. Awards/prizes: Best New Artist: $500; Best Booth Design Award: $500; Best of Show: $1,200. Number of exhibitors: 300. Public attendance: 200,000. Free to the public. Artists may apply online or request application. Deadline for entry: early February. Application fee: $20 jury fee. Space fee: $175/single space; $350/double space. Exhibition space: 10×10 ft. Average gross sales/exhibitor: $2,000-$4,000. For more information, and to apply, artists should e-mail, visit website, call, send SASE.

CONTESTS

//

Whether you're a seasoned veteran or a newcomer still cutting your teeth, you should consider entering contests to see how your work compares to that of other artists or graphic designers. The contests in this section range in scope from tiny juried county fairs to massive international competitions. When possible, we've included entry fees and other pertinent information in our limited space. Contact sponsors for entry forms and more details.

Once you receive rules and entry forms, pay particular attention to the sections describing rights. Some sponsors retain all rights to winning entries or even *submitted* images. Be wary of these. While you can benefit from the publicity and awards connected with winning prestigious competitions, you shouldn't unknowingly forfeit copyright. Granting limited rights for publicity is reasonable, but you should never assign rights of any kind without adequate financial compensation or a written agreement. If such terms are not stated in contest rules, ask sponsors for clarification.

If you're satisfied with the contest's copyright rules, check with contest officials to see what types of images won in previous years. By scrutinizing former winners, you might notice a trend in judging that could help when choosing your entries. If you can't view the images, ask what styles and subject matters have been popular.

⊕ 440 GALLERY ANNUAL SMALL WORKS SHOW

440 Sixth Ave., Brooklyn NY 11215. (718)499-3844. **E-mail:** gallery440@verizon.net. **Website:** www.440gallery.com. **Contact:** Nancy Lunsford. Annual contest. An exhibition opportunity for artists outside our collective. Open to all 2D and 3D media. All work, including frames and mounting materials must be under 12" in all directions. Videos are considered if the monitor provided is also under 12". Three prizes awarded: The Curator's Choice Award (decided by the juror), the 440 Award (decided by the 14 members of the collective), the People's Choice Award (decided by "liking" images posted on our Facebook page). The prize, apart from bragging rights and a line on your résumé, is a small cash award. Open to all skill levels. **Deadline: Early November.** Contestants should see website for more information.

⊕ 440 GALLERY ANNUAL THEMED SHOW

440 Sixth Ave., Brooklyn NY 11215. (718)449-3844. **E-mail:** gallery440@verizon.net. **Website:** www.440gallery.com. **Contact:** Nancy Lunsford. Annual contest. This is a themed show and the subject varies from year to year. Past themes have been: animals, Brooklyn, text. All media and styles welcome. There is no size limitation, but our gallery space is only about 400 sq. ft., so extremely large work is unlikely to be chosen. There are no prizes awarded for this show. Open to all skill levels. **Deadline: mid-May.** Contestants should see website for more information.

⟢ AESTHETICA CREATIVE WORKS COMPETITION

P.O. Box 371, York YO23 1WL, United Kingdom. **E-mail:** pauline@aestheticamagazine.com. **E-mail:** submissions@aestheticamagazine.com. **Website:** www.aestheticamagazine.com. The Aesthetica Creative Works Competition represents the scope of creative activity today, and provides an opportunity for both new and established artists to nurture their reputations on an international scale. There are three categories: Artwork & Photography, Fiction, and Poetry. See guidelines online.

AMERICAN SOCIETY OF AVIATION ARTISTS INTERNATIONAL AEROSPACE ART EXHIBITION

13330 W. Gelding Dr., Surprise AZ 85379-6487. (623)556-9630. **E-mail:** johnwclark@cox.net. **Website:** www.asaa-avart.org. **Contact:** John W. Clark, exhibition chairman. Entry fee: $40/entry for non-ASAA members. This annual contest is held to promote aerospace art. Several prizes will be awarded. Open to all skill levels. See website for more information including deadlines for submission.

ARTISTS ALPINE HOLIDAY

Ouray County Arts Association, P.O. Box 167, Ouray CO 81427. (970)626-3212. **E-mail:** ouraybelle@yahoo.com. **Website:** www.ourayarts.org. **Contact:** DeAnn McDaniel, president. Cost: $25, includes up to 2 entries. Annual fine arts show. Juried. Cash awards for 1st, 2nd and 3rd prizes in all categories total $7,200. Best of Show: $750; People's Choice Award: $50. Open to all skill levels. Photographers and artists should call or see website for more information.

THE ARTIST'S MAGAZINE ALL-MEDIA

F+W Media, Inc., Competition Dept., 10151 Carver Rd., Suite 200, Blue Ash OH 45242. (715)445-4621, ext. 13430. **E-mail:** art-competition@fwmedia.com. **Website:** www.artistsnetwork.com/allmedia. **Contact:** Nicole Florence, customer service specialist. Cost: $20/entry. Annual contest held to recognize the best work being done in various mediums. Awards: the grand prize winner receives a $500 prize, as well as a subscription to *The Artist's Magazine* and $100 worth of North Light Books. All 7 first place winners receive $100, complimentary subscriptions to *The Artist's Magazine* and $100 worth of North Light Books. Honorable mentions receive complimentary subscriptions to *The Artist's Magazine* and $50 worth of North Light Books. Open to all skill levels. E-mail or see website for more information.

THE ARTIST'S MAGAZINE'S ANNUAL ART COMPETITION

F+W Media, Inc., Competition Dept., 10151 Carver Rd., Suite 200, Blue Ash OH 45242. (715)445-4621, ext. 13430. **E-mail:** art-competition@fwmedia.com. **Website:** www.artistsnetwork.com/annualcompetition. **Contact:** Nicole Florence, customer service specialist. Cost: All entries in the Student/Beginner Division (for artists age 16 and over who (1) have been enrolled in a post-high school art program for no more than four years OR (2) have pursued art on their own or in workshops/lessons for no more than four years) are $15 per image. All others are $25 per image. Held annually. "You may enter work in any and all categories; there is no limit to the number of images you may enter. Enter online or mail all your entries in on one

CD. If entering by mail, please include a separate sheet that gives the title, medium (oil, watercolor, etc.) and dimensions of each image. The titles of the images on the CD must match the titles on the sheet. All entries should be accompanied by an entry form. Incomplete entry forms and information sheets, and improperly named image files will be disqualified. Image files cannot exceed 2MB. The file must be saved as a JPEG in RGB color mode (not CMYK). File names should include only letters, numbers and spaces. See website for complete submission details; and a list of eligible categories. Awards: More than $25,000 in cash prizes; 5 1st Place awards: $2,500 each; 5 2nd Place awards: $1,250 each; 5 3rd Place awards: $750 each; 15 Honorable Mentions: $100 each. Winners will be featured and finalists' names will be published in an upcoming issue of *The Artist's Magazine*. Nine finalists will be featured in the "Competition Spotlight" in *The Artist's Magazine*, 12 finalists will be featured as "Artist of the Month" on our website and the works of 12 finalists will be offered on our website as desktop wallpaper. All winners and finalists will receive a certificate suitable for framing. All award winners and Honorable Mentions receive a 1-year membership to the North Light VIP Program. See website for prizes to be won in the Student/Beginner Division category. Open to all skill levels. **Deadline: mid-April.** E-mail or see website for more information.

THE ARTIST'S MAGAZINE OVER 60 COMPETITION

F+W Media, Inc., Competition Dept., 10151 Carver Rd., Blue Ash OH 45242. (715)445-4621, ext. 13430. **E-mail:** art-competition@fwmedia.com. **Website:** www.artistsnetwork.com/over60. **Contact:** Nicole Florence, customer service specialist. Cost: $15/slide or image. Annual contest for artists age 60+ working in all traditional art media. Entries can be submitted online using the online entry form. There is no limit to the number of images you may enter. You may mail all your entries in on one CD. You *must* include a cover sheet that lists the title, medium/media, and dimensions of each image. The titles of the images on the CD must match the titles on the sheet. Image files cannot exceed 2MG. The file format must be JPEG. If your work is selected for the top 10, we will contact you at a later date and ask that you provide a high-res replacement file. Incomplete entry forms and information sheets, and improperly marked CDs will be disqualified. See website for complete submission

details. Awards: $1,000 in prizes; 10 winners each receive $100. Winners will be published in the March issue of *The Artist's Magazine* and on the website. All winners will receive a certificate suitable for framing. Open to all skill levels; however, participants must be 60 years of age or older. **Deadline: October.** E-mail or see website for more information.

⌂ ARTIST TRUST FELLOWSHIP AWARD

1835 12th Ave., Seattle WA 98122. (209)467-8734 ext. 9. **Fax:** (206)467-9633. **E-mail:** miguel@artisttrust.org. **Website:** artisttrust.org. **Contact:** Miguel Guillen, Program Manager. "The fellowship is a merit-based award of $7,500 to practicing professional Washington State artists of exceptional talent and demonstrated ability. The award is made on the basis of work of the past 5 years. Applicants must be individual artists; Washington State residents; not matriculated students; and generative artists. Offered every 2 years in even years. Guidelines and application online."

⬤ ARTSLINK PROJECTS AWARD

CEC Artslink, 435 Hudson St., 8th Floor, New York NY 10014. (212)643-1985, ext. 23. **Fax:** (212)643-1996. **E-mail:** tmiller@cecartslink.org. **Website:** www.cecartslink.org. **Contact:** Tamalyn Miller, program director. Estab. 1962. "CEC ArtsLink is an international arts organization. Our programs encourage and support exchange of artists and cultural managers in the United States and abroad. We believe that the arts are a society's most deliberate and complex means of communication, and that artists and arts administrators can help nations overcome long histories of reciprocal distrust, insularity and conflict. CEC ArtsLink promotes communication and understanding through innovative, mutually beneficial collaborative projects. CEC was founded in 1962 to enable citizens of the United States and the Soviet Union to accomplish what their governments could not by opening doors, sharing ideas and building mutual trust. In today's transformed and complex world, citizen diplomacy is still urgently needed."

CREATIVE QUARTERLY CALL FOR ENTRIES

244 Fifth Ave., Suite F269, New York NY 10001-7604. (212)591-2566. **Fax:** (212)537-6201. **E-mail:** shows@cqjournal.com. **Website:** www.cqjournal.com. Entry fee: $10/entry. Quarterly contest. "Our publication is all about inspiration." Open to all art directors, graphic designers, photographers, illustrators

and fine artists in all countries. Separate categories for professionals and students. We accept both commissioned and uncommissioned entries. Work is judged on the uniqueness of the image and how it best solves a marketing problem. Winners will be requested to submit an image of a person, place or thing that inspires their work. We will reprint these in the issue and select one for our cover image. *Creative Quarterly* has the rights to promote the work through our publications and website. Complete rights and copyright belong to the individual artist, designer or photographer who enters their work. Enter online or by sending a disc. Winners will be featured in the next issue of *Creative Quarterly* corresponding with the call for entries and will be displayed in our online gallery. Runners-up will be displayed online only. Winners and runners-up both receive a complimentary copy of the publication. Open to all skill levels. **Deadline: Last Friday of January, April, July and October.** See website for more information.

DIRECT ART MAGAZINE PUBLICATION COMPETITION

123 Warren St., Hudson NY 12534. (845)688-7129. **E-mail:** slowart@aol.com. **Website:** www.slowart.com. **Contact:** Tim Slowinski, director. Cost: $35. Annual contest. National magazine publication of new and emerging art in all medias. Cover and feature article awards. Open to all skill levels. Send SASE or see website for more information. SlowArt Productions presents the annual group thematic exhibition. Open to all artists, national and international, working in all media. All forms of art are eligible. *Entrants must be 18 years of age or older to apply.* 96 inch maximum for wall hung work, 72 inch for free-standing sculpture.

HOW INTERACTIVE DESIGN AWARDS

F+W Media, Inc., Competition Dept., 10151 Carver Road, Suite 200, Blue Ash OH 45242. (715)445-4612, ext. 13430. **Website:** www.howdesign.com/interactivedesignawards. **Contact:** Nicole Florence, customer service. Annual contest to recognize the best in digital design. See website for complete submission details and a list of categories. Awards: All winning entries will be featured in HOW's March Design Annual and receive a $100 discount to the HOW Design Conference. One "Best of Show" winner will get a free trip to the HOW Conference (round-trip airfare, hotel and registration). Open to all skill levels. **Deadline: early July.** E-mail or see website for more information.

HOW INTERNATIONAL DESIGN AWARDS

F+W Media, Inc., Competition Dept., 10151 Carver Rd., Suite 200, Blue Ash OH 45242. (715)445-4612, ext. 13430. **E-mail:** HOW-competition@fwmedia.com. **Website:** www.howdesign.com/international designawards. **Contact:** Nicole Florence, customer service. Annual contest to recognize the best graphic design work from around the world. Awards: All winning entry winners will be featured in HOW's April International Design Annual and get a $100 discount to the HOW Design Conference. One "Best of Show" winner will get a free trip to the HOW Design Conference (round-trip airfare, hotel and registration) and an award to be presented at the conference. Open to all skill levels. **Deadline: mid-August.** E-mail or see website for more information.

HOW LOGO DESIGN AWARDS

F+W Media, Inc., Competition Dept., 10151 Carver Rd., Suite 200, Blue Ash OH 45242. (715)445-4612, ext. 13430. **E-mail:** HOW-competition@fwmedia.com. **Website:** www.howdesign.com/logodesign awards. **Contact:** Nicole Florence, customer service specialist. Annual contest. "There are no categories, and it doesn't matter if your logo was created for yourself, for work or just for fun…we want to see what you can do! So take this wide-open media and run with it! All logos must be submitted online at howdesign.com. The image size must not exceed 1280×1024 pixels. The image can be saved at a resolution that will enable us to zoom in to see details during judging, but the file size must not exceed 2MB." Awards: 10 winners will be featured on the HOW website, get $150 worth of HOW books, a 1-year subscription to *HOW* magazine and receive a graphic to post on your website announcing your winning status. Open to all skill levels. **Deadline: early June.** E-mail or see website for more information.

HOW POSTER DESIGN AWARDS

F+W Media, Inc., Competition Dept., 10151 Carver Rd., Suite 200, Blue Ash OH 45242. (715)445-4612, ext. 13430. **E-mail:** HOW-competition@fwmedia.com. **Website:** www.howdesign.com/posterdesign awards. **Contact:** Nicole Florence, customer service specialist. Annual contest. "There are no categories, and it doesn't matter if your poster was created for yourself, for work or just for fun…we want to see what you can do! So take this wide-open media and run with it! All posters must be submitted online

at howdesign.com. The image size must not exceed 1280×1024 pixels. The image can be saved at a resolution that will enable us to zoom in to see details during judging, but the file size must not exceed 2MB." Awards: 10 winners will be featured on the HOW website, get $150 worth of HOW books and a 1-year subscription to *HOW* magazine, and receive a graphic to post on your website announcing your winning status. Open to all skill levels. **Deadline: early June.** E-mail or see website for more information.

HOW PROMOTION DESIGN AWARDS

F+W Media, Inc., Competition Dept., 10151 Carver Rd., Suite 200, Blue Ash OH 45242. (715)445-4612, ext. 13430. **E-mail:** self-promo-competition@fwme dia.com. **Website:** www.howdesign.com/promotion designawards. **Contact:** Nicole Florence, customer service specialist. Annual contest. HOW's longest-running design competition (launched in 1988). This is the only awards program to specifically recognize outstanding promotional work—whether it's a self-promo to showcase a design firm's capabilities, a project for a client's goods or services, an announcement or a student résumé or portfolio. HOW's Promotion Design Awards celebrates design work that's engaging, memorable and effective at moving the viewer toward action. See website for complete submission details and a list of categories. Accepts actual samples of annual reports, brochures, catalogs, direct mail, book and magazine covers and interior pages, invitations, announcements, greeting cards, letterhead, logos, packaging, posters, print advertising, calendars, wearables, 3D objects and other print projects. Also accepts color print-outs of workspaces, signage and other environmental graphic design. Does not accept videos, CDs, DVDs, websites or other interactive work, or digital images or slides of print work. Digital work is eligible in our Interactive Design Awards. Designs may be entered in more than one category. Submit a separate entry and fee for each category. Awards: All winning entries will be featured in HOW's Self-Promotion Design Annual and winners will get a $100 discount to the HOW Design Conference. Best of Show awarded a free trip to the annual HOW Design Conference (round-trip airfare, hotel and registration) and an award to be presented at the conference. Open to all skill levels. **Deadline: March.** E-mail or see website for more information.

IN-HOWSE DESIGN AWARDS

F+W Media, Inc., Competition Dept., 10151 Carver Rd., Blue Ash OH 45242. (715)445-4612, ext. 13430. **E-mail:** HOW-competition@fwmedia.com. **Website:** www.howdesign.com/in-howsedesignawards. **Contact:** Nicole Florence, customer service specialist. Cost: Single entry—$65 (stationery systems count as single entries); campaign—$90 (3 or more pieces that function as a system or series). Make checks payable to F+W Media, Inc. Payment must accompany entries. Entries received without payment will be disqualified. Entry fees are nonrefundable. Annual contest held to recognize the best creative work produced by designers working in corporations, associations and organizations. Submissions are evaluated by business category to ensure that a broad range of design work is represented. Accepts actual samples of annual reports, brochures, catalogs, direct mail, book and magazine covers and interior pages, invitations, announcements, greeting cards, letterhead, logos, packaging, posters, print advertising, calendars, wearables, 3D objects and other print projects. Also accepts color print-outs of workspaces, signage and other environmental graphic design. Does not accept videos, CDs, DVDs, websites or other interactive work, or digital images or slides of print work. Digital work is eligible in our Interactive Design Awards. Designs may be entered in more than one category (see website for category listing). See website for complete submission details; and a list of eligible categories. Awards: Best of Show winner will receive: two-page spread in *HOW*'s February issue; 3 HOW design conference registrations to be used at the event; $500 HOW Books gift certificate to be redeemed at the HOW design conference bookstore; 1-year HOW subscription; frameable certificate for winner and one for the company CEO, along with a letter from HOW celebrating work and a press release to the design community promoting your win. Merit winners will receive publication in *HOW* magazine and a $100 gift certificate toward the HOW Design Conference. Open to all skill levels. **Deadline: April.** Call, e-mail or see website for more information.

LOS ANGELES CENTER FOR DIGITAL JURIED COMPETITION

107 W. Fifth St., Los Angeles CA 90013. (323)646-9427. **E-mail:** rexbruce@lacda.com. **Website:** www.lacda. com. LACDA is dedicated to the propagation of all

forms of digital art, supporting local, international, emerging and established artists in our gallery. Entry fee: $30. Its juried competition is open to digital artists around the world. It also sponsors other competitions throughout the year. Visit website, e-mail, call for more information, including deadline dates.

LOVE UNLIMITED FILM FESTIVAL & ART EXHIBITION

100 Cooper Point Rd., Suite 140-136, Olympia WA 98502. (503)482-8568. **Fax:** (888)LOVE-304 (568-3304). **E-mail:** volunteers@loveanddiversity.org. **Website:** www.loveanddiversity.org. **Contact:** Submissions administrator. Accepts art (ceramics, drawings, fiber, functional, furniture, jewelry, metal, painting, printmaking, digital or graphics, mixed media 2D, mixed media 3D, sculpture, watercolor, wood, other or beyond categorization (specify), photography, music, writing, photos and all types of designs, as well as film and scripts. Accepts poetry, hip-hop, spoken word and zine excerpts, autobiography/memoir, children's, fiction, horror, humor, journalism, mystery, nature, novels, short stories, non-fiction, poetry, romance, science fiction/fantasy, screenwriting, travel, young adult and other topic areas. We accept writing in all these topic areas provided these topic areas are directly, indirectly, literally or symbolically related to love. Awards: over $30,000 in cash and prizes and 120 given out during a red carpet gala event in Los Angeles CA and Austin TX. Photos and videos of past events are online. Open to all skill levels. **Deadlines: October for art, November for all other categories.** See website for more information.

PASTEL 100

F+W Media, Inc., Competitions Dept., 10151 Carver Rd., Suite 200, Blue Ash OH 45242. (715)445-4621, ext. 13430. **E-mail:** pjcompetitions@fwmedia.com. **Website:** www.artistsnetwork.com/pasteljournal competition. **Contact:** Nicole Florence, customer service specialist. Cost: $20/image. Annual contest sponsored by *The Pastel Journal*. Offers cash, prizes and publicity to winners. Enter files online or via regular mail. All digital files submitted via regular mail must be accompanied by an Official Entry Form or facsimile. There is no limit to the number of images you may enter. If you mail all your entries in on one CD, please include a separate sheet that gives the title and dimensions of each image. Image files cannot exceed 2MB. The file format must be JPEG. If your work is selected for the top 100, we will contact you about sending a high-res replacement. Incomplete entry forms and information sheets, and improperly marked CDs will be disqualified. *Slides will not be accepted.* CDs will not be returned. See website for a listing of categories. Awards: More than $13,000 in cash prizes, including Best in Show award, worth $5,000, and the Grand Prize award, worth $2,500. All top prizewinners and placewinners will receive features in *The Pastel Journal*. Honorable mentions (70 awarded) will be featured in *The Pastel Journal*. See website for a complete list of awards. Open to all skill levels. Artists must be 16 or older. Work must be at least 80% soft pastel; no oil pastel. NuPastels and other "harder" pastels are considered soft pastels. The contest is open to artists in the U.S. and abroad. All works must be original. Compositions based on published material or other artists' work are *not* considered original and are not eligible. See website for complete eligibility details. **Deadline: mid-August.** E-mail or see website for more information.

PRINT'S CREATIVITY + COMMERCE

F+W Media, Inc., Competitions Dept., 10151 Carver Rd., Suite 200, Blue Ash OH 45242. (715)445-4612, ext. 13430. **E-mail:** printcomp@fwmedia.com. **Website:** www.printmag.com/article/creativity-and-commerce. **Contact:** Nicole Florence, customer service specialist. Cost: "An entry fee of $65 must be submitted with each single entry. Projects in which multiple pieces are part of a single program will require a $90 fee." Annual contest showcasing outstanding business-focused print and interactive design from around the world. Features the best branding campaigns, websites, advertising, corporate brochures, annual reports, identity systems, packaging, catalogs, motion graphics, and signage produced to communicate with a company's audience, investors, employees, or the public. Submit up to 10 digital photos per entry (2 MB per photo). If your work is selected as a finalist you may be asked to send a sample. Enter by mail using the downloadable entry form. If you enter via this method, attach a completed form to the back of each item submitted. Make 2 copies of each completed entry coupon, so that you have three in all—1 original and 2 copies—for each entry. Include the 2 copies with your payment, if you are not paying online. Please indicate what the entry is, or its purpose, in a few sentences, on the form. For all entries, state

the nature of the client's business. Entries cannot be returned. See website for complete submission details and a listing of categories. Awards: all winning entries will be showcased in *Print* and also a special online gallery. Open to all skill levels. **Deadline: September.** Call, e-mail or see website for more information.

PRINT'S HAND DRAWN COMPETITION

F+W Media, Inc., Competition Dept., 10151 Carver Rd., Suite 200, Blue Ash OH 45242. (715)445-4612, ext. 13430. **E-mail:** printcomp@fwmedia.com. **Website:** www.printmag.com/article/hand-drawn. **Contact:** Nicole Florence, customer service specialist. Cost: $40/entry; $60/campaign or series; $20/students, $30/student campaign or series. Annual contest devoted solely to illustration. Open to all participants and all illustrations styles. There are no restrictions and all entries will be judged equally. All files must be submitted electronically and be 2MB in size or smaller. Awards: $500 for best in show; $250 for two runner-ups and placement in the magazine and on printmag.com. Open to all skill levels. September deadline. Call, e-mail or see website for more information.

PRINT'S REGIONAL DESIGN ANNUAL

F+W Media, Inc., Competition Dept., 10151 Carver Rd., Suite 200, Blue Ash OH 45242. (715)445-4612, ext. 13430. **Fax:** (715)445-4087. **E-mail:** printcomp@ fwmedia.com. **Website:** regionaldesignannual.print mag.com/competition-details. **Contact:** Nicole Florence, customer service specialist. Cost: Single entries: $65 each piece; campaigns and series: $90 (3 or more pieces in each submission). Ad campaigns, book cover series, corporate brochure series, or poster series will all be considered campaigns. Any packaging entry, whether a single package or a family of packages, will be considered a single entry (fee: $65). Any letterhead entry that consists of stationery, envelope, and business card will be considered a single entry. Held annually. "The *Regional Design Annual* is more than just a catalog of the best American design created over the year. For thirty years, this highly-anticipated collection of art and design has displayed the considerable breadth and depth of high-quality work being generated in every corner of the country. For many designers, the *RDA* symbolizes the pinnacle of design accomplishment, while at the same time directly reflecting the aesthetics and zeitgeist of the regions included." Enter online or send a physical copy using the entry form. If entering online, you may submit up to 10 digital photos per entry (2MB per photo). If your work is selected as a finalist you may be asked to send a sample. See website for complete submission details; and a listing of categories. Awards: Winners will be published in the December issue of *Print,* as well as featured in an online gallery. Open to all skill levels. **Deadline: early March** (see website for details). E-mail or see website for more information.

SPLASH: THE BEST OF WATERCOLOR

F+W Media, Inc., Competition Dept., 10151 Carver Rd., Blue Ash OH 45242. (715)445-4612, ext. 13430. **E-mail:** bestofnorthlight@fwmedia.com; splashcon test@fwmedia.com. **Website:** www.splashwatercolor. com; www.artistsnetwork.com/competitions. **Contact:** Nicole Florence, customer service specialist. Cost: $30 for the first painting and $25 for each additional painting. Annual contest showcasing the finest watercolor paintings being created today. A new book in the series is published every year by North Light Books and features nearly 140 paintings by a wide variety of artists from around the world, each with instructive information about how it was achieved—including inspiration, tips and techniques. "We look for excellence in a variety of styles and subjects. The dominant medium must be transparent watercolor, though minor uses of other media are acceptable." Your digital images may be submitted online or on CD/DVD (please label the disks with your name and address). Mailed entries must be accompanied by a color printout and an entry form. Disks will not be returned. For judging purposes, these images must be high-quality, in RGB color mode, TIFF or JPEG format, and 72 dpi. All digital files must be smaller than 2MB. Digital files submitted by mail must be labeled with your last name, first name, the entry number (should correspond to the number on the entry form), with no punctuation marks until the file extension (example: Wolf Rachel 3.jpg). Awards: winning paintings will be published in a beautiful hardcover book. Open to all skill levels. **Deadline: December.** E-mail or see website for more information.

STROKES OF GENIUS: THE BEST OF DRAWING

F+W Media, Inc., Competition Dept., 10151 Carver Rd., Blue Ash OH 45242. (715)445-4612, ext. 13430. **E-mail:** bestofnorthlight@fwmedia.com; art-com petition@fwmedia.com. **Website:** www.splashwater color.com; www.artistsnetwork.com/competitions.

Contact: Nicole Florence, customer service specialist. Cost: $30 for the first drawing and $25 for each additional drawing. Annual contest showcasing the finest drawings being created today. A new book in the series is published every year by North Light Books and features nearly 140 drawings by a wide variety of artists from around the world, each with instructive information about how it was achieved—including inspiration, tips and techniques. Artwork can be in any dry medium, or wet medium applied in a linear fashion that would be traditionally considered drawing. Final judgment on whether a work of art fits into the "drawing" category will be determined by the editors. All submissions will be reviewed by Rachel Wolf and the editorial staff of North Light Books. Art will be selected on the basis of general quality as well as suitability for this publication. Your digital images may be submitted online or on CD/DVD (please label the disks with your name and address). Mailed entries must be accompanied by a color printout and an entry form. Disks will not be returned. For judging purposes, these images must be high- quality, in RGB color mode, TIFF or JPEG format, and 72 dpi. All digital files must be smaller than 2MB. Digital files submitted by mail must be labeled with your last name, first name, the entry number (should correspond to the number on the entry form), with no punctuation marks until the file extension (example: Wolf Rachel 3.jpg). Awards: winning drawings will be published in a beautiful hardcover book. Open to all skill levels. **Deadline: April.** E-mail or see website for more information.

WATERCOLOR ARTIST'S WATERMEDIA SHOWCASE

F+W Media, Inc., Competition Dept., 10151 Carver Rd., Blue Ash OH 45242. (715)445-4621, ext. 13430. **E-mail:** watermediashowcase@fwmedia.com. **Website:** www.artistsnetwork.com/watermediashowcase. **Contact:** Nicole Florence, customer service specialist. Cost: $20/image. Annual contest. You may enter online or you may mail all your entries in on one CD. All entries must be submitted as digital files. You may enter work in any and all categories; there is no limit to the number of images you may enter. If entering via regular mail, you must include an entry form. Please include a cover sheet with your disk. Indicate the file name, title and dimensions of each entry. Please include the title of the entry in the corresponding file name on disk. File names should include only letters, numbers and spaces. Image files cannot exceed 2MB. The file must be saved as a JPEG in RGB color mode (not CMYK). If your work is selected as a winner, we may contact you about sending a high-res replacement. Incomplete entry forms and information sheets, and improperly named image files will be disqualified. See website for complete submission details. Award: Best of Show: $500; 2nd Place: $250; 3rd Place: $100; 4th Place: $50. Award winners will be published and Honorable Mentions' names will be listed in the February issue of *Watercolor Artist*. All winners and honorable mentions will receive a certificate suitable for framing. Open to all skill levels. **Deadline: July.** E-mail or see website for more information.

⟳ FRED WHITEHEAD AWARD FOR DESIGN OF A TRADE BOOK

E-mail: tilsecretary@yahoo.com. **Website:** texasinstituteofletters.org. Offered annually for the best design for a trade book. Open to Texas residents or those who have lived in Texas for 2 consecutive years. See website for guidelines. **Deadline: Early January**; see website for exact date.

WORKSHOPS & ART TOURS

Taking an art or design workshop or tour is one of the best ways to improve your creative skills. There is no substitute for the hands-on experience and one-on-one instruction you can receive at a workshop. Besides, where else can you go and spend several days with people who share your passion for art or design?

Plein air drawing and painting are perennial workshop favorites. Creativity is another popular workshop topic. You'll also find highly specialized workshops, such as Celtic design and forensic art. Many tours specialize in a specific location and the great artistic opportunities that location affords.

As you peruse these pages, take a good look at the quality of workshops and the skill level the sponsors want to attract. It is important to know if a workshop is for beginners, advanced amateurs, or professionals. Information from a workshop organizer can help you make that determination.

These workshop listings contain only the basic information needed to make contact with sponsors, and a brief description of the styles or media covered in the programs. We also include information on costs when possible. Write, call, or e-mail the workshop/tour sponsors for complete information. Most have websites with extensive information about their programs, when they're offered, and how much they cost.

A workshop or tour can be whatever the artist or designer wishes—a holiday from the normal working routine, or an exciting introduction to new skills and perspectives on the craft. Whatever you desire, you're sure to find in these pages a workshop or tour that fulfills your expectations.

⊕ 3 DAY COLOR INTENSIVE

10915 SW 37 Ave., Portland OR 97219. (800)760-7870. **Fax:** (503)244-4998. **E-mail:** walliscorp@yahoo.com. **Contact:** Kitty Wallis, artist and teacher. Students will learn about color as a tool for the artist. How to achieve light, and life in their work. Designed for pastel artists. Open to all skill levels. Four workshops held summer of 2013. $225 including Wallis Archival Sanded Pastel Paper and some materials. Lodging and meals not included. Please write with SASE, call, or e-mail for more information.

⊕ ACADIA WORKSHOP CENTER

7 Bernard Rd., Bernard ME 04612. **E-mail:** awc maine@gmail.com. **Website:** www.acadiaworkshop. com. **Contact:** Gail Ribas, director/owner. Four to five day workshops with top instructors in all media. Open to all skill levels. Workshops are held seasonally throughout the summer/early fall. Interested parties should call or see website for more information.

⊙ AON CELTIC ART WORKSHOP

P.O. Box 23178, Connaught PO, Calgary AB T2S 3B1, Canada. **E-mail:** artstuff@aon-celtic.com. **Website:** www.aon-celtic.com/aon-workshops.html. **Contact:** Emily Broder. Learn the intricate art of Celtic design. "Topics covered will be the basic Celtic knot, complex knotting patterns, trefoil knots and freehand knotting, as well as the double, triple and quadruple spiral and an introduction to celtic animals. Within these patterns, we'll experiment with traditional embellishments and colors, easy gilding techniques, and the various ways Celtic design can be incorporated into any creative work. We will also brainstorm how to take the designs covered and begin creating your own unique works of Celtic art. All techniques will be covered, no experience in Celtic art or painting required. Just a sense of fun and a willingness to explore." Registration is open to members and public; see website at www.bvcg.ca for more information. To book this workshop for your local group or calligraphy guild, please visit Aon's website. Please book at least 6 months in advance. Open to beginners and intermediate creatives. Cost: Typically $800 USD for bookings in the USA; $700 CAD for Canadian bookings. Transportation and lodging costs extra. E-mail or see website for more information.

ARROWMONT SCHOOL OF ARTS AND CRAFTS

556 Parkway, Gatlinburg TN 37738. (865)436-5860. **Fax:** (865)430-4101. **E-mail:** info@arrowmont.org. **Website:** www.arrowmont.org. Offers weekend, 1- and 2-week workshops in photography, drawing, painting, clay, metals/enamels, kiln glass, fibers, surface design, wood turning and furniture. Residencies, studio assistantships, work-study, and scholarships are available. See individual course descriptions for pricing.

ART ESCAPES WORKSHOPS WITH DORY KANTER

3142 SW Fairview Blvd., Portland OR 97205. (503)224-3331. **E-mail:** dory@dorykanter.com. **Website:** www.dorykanter.com. **Contact:** Dory Kanter, artist and workshop organizer. Next workshop: January 2013 (Maui HI). "Chronicling impressions with quick sketches and visual storytelling is an everyday practice for Dory Kanter, whose bestselling book *Art Escapes* provides daily exercises and inspirations for artists, to help them build confidence and cultivate creativity. Join Dory as she makes it easy to create art every day with original Art Escape projects designed to spark your creativity and capture the sights and scenes around you. Learn enlivening observational art projects to record your wanderings—at home or on the road. Dory will demonstrate how to create luminous watercolor mixes with her four color triads. All skill levels will experience both inspiration and success." E-mail and see website for more information.

ART REVOLUTION: REINTERPRET, REINVENT AND REDEFINE

E-mail: lisa@cyrstudio.com. **Website:** www.cyrstu dio.com. **Contact:** Lisa L. Cyr. "This highly visual presentation by multi-disciplinary artist and author Lisa L. Cyr will provide valuable knowledge and insight into the ideology behind groundbreaking, multi-media work. A behind-the-scenes look at many of today's leading artists and illustrators will shed light on signature processes and techniques. 2D, 3D, digital and new media work will be shown in inventive combinations. The lecture will also include a survey of the historical influences behind contemporary thinking and approaches, unfolding the origins of unconventional picture making throughout the decades. This traveling lecture is open to all skill levels." E-mail or see the website for more information.

ART WORKSHOPS IN GUATEMALA

4758 Lyndale Ave. S., Minneapolis MN 55419-5304. (612)825-0747. **E-mail:** info@artguat.org. **Website:** www.artguat.org. **Contact:** Liza Fourre, director. Estab. 1995. Annual workshops held in Antigua, Guatemala. See website for a list of upcoming workshops.

BIG ART, SMALL CANVAS

E-mail: joycewashor@yahoo.com. **Website:** www.joycewashor.com. **Contact:** Sally Lamson. Three-day oil workshop at the Creative Arts Center in Chatham MA. "BIG ART, small canvas gives you the guidance you need to create small paintings. You will learn all about mixing colors, composing, creating depth and textures in a small format. Smaller canvases allow you to enjoy everything about painting with less expense, less mess and less time!" Open to all skill levels. See www.capecodcreativearts.org or www.joycewashor.com for more information, including cost.

CAPTURING RADIANT LIGHT & COLOR

10030 Fair Oaks Blvd., Fair Oaks CA 95628. (916)966-7517. **E-mail:** sarback@lightandcolor.com. **Website:** www.lightandcolor.com. **Contact:** Susan Sarback, artist/instructor. Cost varies depending on location and number of days. See website for specific dates and pricing. Workshops offer instruction on painting with oils or pastels. Open to all skill levels. Call, e-mail or see website for more information.

COASTAL MAINE ART WORKSHOPS/ ROCKLAND

P.O. Box 845, Camden ME 04843. (207)594-4813. **E-mail:** info@coastalmaineartworkshops.com. **Website:** www.coastalmaineartworkshops.com. **Contact:** Lyn Donovan, director. Annual. Art workshops held weekly mid-July through mid-October. Nationally and internationally known master painting instructors come to teach 5-day classes: plein air landscape, still life and composition/values/color in a variety of mediums. "We have glorious scenery, a fine large studio and a reputation for lavish personal attention. Rockland is halfway up the coast of Maine and full of great art, places to stay and terrific food. And this year, we're also going offshore! Contact us for details." Open to all skill levels. Artists should write, call, e-mail or see website for more information.

⊕ COLOR INTENSIVE, LIGHT & COLOR LANDSCAPE WORKSHOPS

10030 Fair Oaks Blvd., Fair Oaks CA 95628. (916)966-7517. **E-mail:** sarback@lightandcolor.com. **Website:** www.lightandcolor.com. **Contact:** Susan Sarback. These in-depth workshops focus on specific seeing and painting techniques based on the light and color of the Impressionists. Through painting a variety of still-life subjects, the students learns the foundation needed to paint any subject—landscape, still life, portraiture, etc. A slide presentation and painting demonstration are included in each workshop. Open to all skill levels. Interested parties should write, call, or e-mail for more information.

⊕ EILEEN CORSE—PALETTE KNIFE APPLICATION

4144 Herschel St., Jacksonville FL 32210. (877)386-8205. **E-mail:** corsegalleryatelier@comcast.net. **Website:** corsegalleryatelier.com. **Contact:** Eileen Corse, owner. Eileen Corse teaches how to apply oil paint with a palette knife to create lively and colorful paintings. Each day, Corse will demonstrate her technique. Open to all skill levels. Workshop held May 18-20, 2013. $330 for all 3 days. Interested parties should e-mail or see website for more information.

CREATIVE ARTS WORKSHOP

80 Audubon St., New Haven CT 06511. (203)562-4927. **E-mail:** haroldshapirophoto@gmail.com. **Website:** www.creativeartsworkshop.org. **Contact:** Harold Shapiro, photography department head. A nonprofit regional center for education in the visual arts that has served the Greater New Haven area since 1961. Located in the heart of the award-winning Audubon Arts District, CAW offers a wide-range of classes in the visual arts in its own three-story building with fully equipped studios and an active exhibition schedule in its well-known Hilles Gallery. Offers exciting classes and advanced workshops. Digital and traditional b&w darkroom. See website for more information and upcoming workshops.

◑ DAWSON COLLEGE CENTRE FOR TRAINING AND DEVELOPMENT

4001 de Maisonneuve Blvd. W., Suite 2G.1, Montreal QC H3Z 3G4, Canada. (514)933-0047. **Fax:** (514)937-3832. **E-mail:** ctd@dawsoncollege.qc.ca. **Website:** www.dawsoncollege.qc.ca/ciait. Workshop subjects include imaging arts and technologies, computer animation, photography, digital imaging, desktop pub-

lishing, multimedia, and web publishing and design. See website for course and workshop information.

DRAWING FOR THE ABSOLUTE BEGINNER

Cincinnati OH (513)671-6525. **E-mail:** willenbrink1@fuse.net. **Website:** www.shadowblaze.com. **Contact:** Mark or Mary Willenbrink. Held annually in June and September. Learn basic drawing and art principles and techniques with step-by-step demonstrations and personal instruction. Each student will complete a drawing during their workshop. "Mark is known for his encouragement and for being able to bring out the best in his students." Open to beginners and intermediate creatives. Cost determined by the specific workshop and location. Call or e-mail for more information.

DYNAMICS OF LIGHT-FILLED LANDSCAPE PAINTING

(808)873-0597. **E-mail:** julie@pleinairjourneys.com. **Website:** www.pleinairjourneys.com. **Contact:** Julie Houck. Cost: $350, instruction only. Annual workshop teaching the fundamentals of light on the landscape. See website for 2013 dates. Open to all skill levels. Artists should call, e-mail or see website for more information.

● ETRUSCAN PLACES LANDSCAPE PAINTING IN ITALY

10 Ashland St., Newburyport MA 01950. (212)780-3216. **E-mail:** info@landscapepainting.com. **Website:** www.landscapepainting.com. **Contact:** Maddine Insalaco, director. Annual workshop held May through October. "Intensive one-week open-air landscape painting workshops in Tuscany and the Roman Campagna." Cost: from $2,150-2,950 depending on class and occupancy. Fees include everything except travel, paints and brushes. Open to all skill levels. Call, e-mail or see website for more information.

EXPERIMENTAL PAINTING: INSPIRATIONAL APPROACHES IN MIXED MEDIA

E-mail: lisa@cyrstudio.com. **Website:** www.cyrstudio.com. **Contact:** Lisa L. Cyr. "This highly visual, hands-on workshop will investigate exploratory methodologies, techniques and approaches in mixed-media art. Throughout the workshop, many exciting in-depth demonstrations will be shown, providing an extensive array of visually-stimulating possibilities for artists to explore. Both 2D and 3D mixed-media techniques will be covered, including employing al-ternative working grounds, using custom tools, toning the painting surface in imaginative ways, creating a tactile ground, building the visual architecture and utilizing innovative mixed-media techniques to create intriguing effects. To assist artists in their own creative path, topics on nurturing the creative spirit, developing personal content through journalism, embracing a multidisciplinary mindset and creating message-driven art will also be discussed. For artists that are looking to push their work to a new level, this workshop will be a valuable resource and an ongoing source for creative inspiration. You can view the book that the workshop is based upon at www.cyrstudio.com/workasplay.html." See website for more information including dates and locations.

FINE ARTS WORK CENTER

24 Pearl St., Provincetown MA 02657. (508)487-9960 ext. 103. **Fax:** (508)487-8873. **E-mail:** workshops@fawc.org. **Website:** www.fawc.org. **Contact:** Dorothy Antczak, summer program director. Estab. 1968. Faculty includes Kimiko Hahn, Howard Norman, Roberto Juarez, Nona Hershey, Julia Glass, Alan Shapiro, Amy Arbus, James Everett Stanley, Ariel Levy, Nick Flynn, Dani Shapiro, and Constantine Manos.

○ FIRESIGN ART & DESIGN STUDIO

P.O. Box 265, 730 Smiths Road, Quathiaski Cove, BC V0P 1N0, Canada. (877)285-3390 (toll free) or (250)285-3390. **Fax:** (250)285-3105. **E-mail:** info@firesignartanddesign.com. **Website:** www.firesignartanddesign.com. **Contact:** Nanci Cook, owner. Annual. Customized workshops held from March through October. Artists teach workshops in small classes (5-7 students) in watercolor, oil, acrylic, and mixed media. Location is the beautiful Quadra Island. Spring workshops are held in the studio; summer and fall workshops held outside. Open to all skill levels. Costs vary. Artists should write, call, e-mail or see website for information.

HORIZONS: ARTISTIC TRAVEL

P.O. Box 634, Leverett MA 01054. (413)367-9200. **Fax:** (413)367-9522. **E-mail:** horizons@horizons-art.com. **Website:** www.horizons-art.com. **Contact:** Jane Sinauer, director. One-of-a-kind small-group travel adventures: 1 and 2-week programs in the American Southwest, Mexico, Ecuador, Peru, Burma, Laos, Vietnam, Cambodia, Southern Africa, Morocco, Northern India. See website for more information, including pricing and registration.

⊕ KRISTY KUTCH COLORED PENCIL WORKSHOPS

11555 West Earl Rd., Michigan City IN 46360. (219)874-4688. **E-mail:** kakutch@earthlink.net. **Website:** www.artshow.com/kutch. Instruction focuses on using "traditional," watercolor, and water-soluble wax pastels to create painting-like works of art. Multiple workshops throughout the year/ Prices vary. See website for more details.

LANDSCAPE PAINTING IN SOUTHERN FRANCE

(808)873-0597. **E-mail:** julie@pleinairjourneys.com. **Website:** www.pleinairjourneys.com. **Contact:** Julie Houck. Annual; upcoming workshop is September 20-30, 2012. Learn the dynamics of light-filled landscape painting, based on the study and application of fundamentals of light on form. Open to all skill levels. Artists should call, e-mail or see website for more information.

LETTING GO! ADVENTURES IN WATERMEDIA

(623)487-4031. **Fax:** (623)487-4031. **E-mail:** ncjm@earthlink.net. **Website:** www.nchristy.com. **Contact:** Nancy Christy-Moore, artist/instructor. Expanding your creativity and knowledge of mixed water media techniques is this workshop's main focus. Contact Eileen Dudley at (520)623-7475 for more information. Cost: fees range from $75-85 per day and $115-200 for 2 or more days. No lodging or food is included. Open to all skill levels. Artists should call, e-mail or see website for more information.

THE MACDOWELL COLONY

100 High St., Peterborough NH 03458. (603)924-3886. **Fax:** (603)924-9142. **E-mail:** admissions@macdowellcolony.org. **Website:** www.macdowellcolony.org. Estab. 1907. Provides creative artists with uninterrupted time and seclusion to work and enjoy the experience of living in a community of gifted artists. Residencies of up to 8 weeks for writers, playwrights, composers, film/video makers, visual artists, architects and interdisciplinary artists. Artists in residence receive room, board and exclusive use of a studio. Average length of residency is 5 weeks. Ability to pay for residency is not a factor; there are no residency fees. Limited funds available for travel reimbursement and artist grants based on need. Application deadlines: January 15: summer (June-September); April 15: fall/winter (October-January); September 15: winter/spring

(February-May). Photographers should see website for application and guidelines. Questions should be directed to the admissions director.

MAINE MEDIA WORKSHOPS

70 Camden St., P.O. Box 200, Rockport ME 04856. (207)236-8581 or (877)577-7700. **Fax:** (207)236-2558. **E-mail:** info@mainemedia.edu. **Website:** www.mainemedia.edu. "Maine Media Workshops is a nonprofit educational organization offering year-round workshops for photographers, filmmakers and media artists. Students from across the country and around the world attend courses at all levels, from absolute beginner and serious amateur to working professional; also high school and college students. Professional certificate and low-residency MFA degree programs are available through Maine Media College." See website for the fall calendar.

⊕ PAINTING IN PROVENCE

P.O. Box 1082, Fairfield IA 52556. (888)333-4541. **E-mail:** contactian@ianroberts.us. **Website:** ianroberts.us. **Contact:** Ian Roberts. Workshops focuses on painting. Two 4 hour sessions daily. The emphasis is on strong design and composition. All media and levels of experience welcome. Spectacular landscape. Gourmet food and wine. Double or single occupancy $3,390-3,990. Covers all costs from time picked up in Avignon until dropped off again 10 days later. Workshops held annually. Dates for 2013: May 19-28 and June 1-10. Interested parties should e-mail or visit website for more information.

⊕ PENINSULA SCHOOL OF ART

P.O. Box 304, 3900 County Road F, Fish Creek WI 54212. (920)868-3455. **Website:** www.peninsulaschoolofart.com. **Contact:** Tori Daubner. "With instruction in all media, and for every skill level, we've brought excellence to art education for 50 years. Within the inspirational setting of Door County WI, nationally-recognized artist educators lead 1 to 5-day workshops throughout the year. Themed gallery exhibitions of master artists' works, including the annual Door County Plein Air Festival, enhance the School's curriculum." Cost per workshop varies. Nearby lodging and meals not included in cost.

PETERS VALLEY CRAFT CENTER

19 Kuhn Rd., Layton NJ 07851. (973)948-5200. **Fax:** (973)948-0011. **E-mail:** info@petersvalley.org. **Website:** www.petersvalley.org. Offers workshops May,

June, July, August and September; 3-6 days long. Offers instruction by talented photographers in a wide range of photographic disciplines—from daguerreotypes to digital and everything in between. Also offers classes in blacksmithing/metals, ceramics, fibers, fine metals, weaving and woodworking. Located in northwest New Jersey in the Delaware Water Gap National Recreation Area, 70 miles west of New York City. Artists and photographers should call for catalog or visit website or more information.

💧 PLEIN AIR PAINTING WORKSHOPS (FRANCE, SPAIN, BELGIUM, SWITZERLAND)

2389 Blackpool Pl., San Leandro CA 94577. (510)483-5713. **E-mail:** Frenchescapade@yahoo.com. **Website:** www.frenchescapade.com. **Contact:** Jackie Grandchamps. Cost: $3,190 for France, Spain and Switzerland; $2,890 for Belgium—includes lodging, all meals except two dinners, painting and cultural visits. Held annually, 5 times a year between May and September. See website for all upcoming workshops. "American teachers are running the art aspect of the workshop. Since the tours are limited to 7 guests, each participant will receive private consult from the teacher in addition the demos and daily critiques. We stay in one accommodation for the 8 days and paint different sceneries, villages and flower fields each day. A bilingual guide will be accompanying you at all times so that you not only get the best experience in painting, but also in experiencing the fine cuisine and culture of the country." Open to all skill levels. See website for more information.

JULIE GILBERT POLLARD WATERCOLOR AND OIL WORKSHOPS

(623)849-2504. **E-mail:** JulieGilbertPollard@cox.net. **Website:** www.juliegilbertpollard.com. **Contact:** Julie Gilbert Pollard. See website for upcoming dates. "Julie Gilbert Pollard has taught watercolor and oil classes for over 25 years. While glowing, brilliant color in a format of painterly realism is her personal painting objective, her goal when teaching is to assist in the search for the individual artistic personality of each student, leaning heavily on the fundamentals of art as the gateway to fulfilling personal expression and intuitive painting." Most classes and workshops are open to all skill levels. Recurring theme: the components of a landscape with rocks, water and flowers figuring prominently—both studio and plein air. See

website for listings. Many venues with varying costs are available including: Cynthia's Art Asylum, Phoenix AZ; Dillman's Creative Arts Foundation, Lac de Flambeau WI; Cheap Joe's Art Workshops, Boone NC; La Romita School of Art, Umbria, Italy; Scottsdale Artists' School, Scottsdale AZ; Shemer Art Center, Phoenix AZ; West Valley Arts Council, Surprise AZ. Costs vary with venue and length of program. Artists should call, e-mail or see website for more information.

PORTRAIT AND STILL-LIFE WORKSHOPS WITH BEV LEE

645½ 30 Rd., Grand Junction CO 81504. **E-mail:** bleefinearts@gmail.com. **Website:** www.bevlee.com. **Contact:** Bev Lee. Held annually. See website for upcoming schedule. Emphasis for each workshop will be placed on drawing shapes and values to model form. For the portrait workshops, students will learn to map the face to capture a likeness. Color, composition, and pastel technique will also be explored. Work will be from live models with demos each morning. In the still-life workshops, students will work from various live set-ups as they experiment with color composition and design. Challenging objects will be used to help get past that "I can't paint" feeling. Cost: $270 for 3-day plus model fee; $450 for 5-day plus model fee. Open to all skill levels. Artists should e-mail or see website for more information.

RICE PAPER COLLAGE & MIXED MEDIA

(623)487-4031. **Fax:** (623)487-4031. **E-mail:** ncjm@earthlink.net. **Website:** www.nchristy.com. **Contact:** Nancy Christy-Moore, artist/instructor. This workshop is an excellent venue for both beginners and advanced watercolorists, offering creative play with delicate rice papers combined with mixed media techniques with inks, enamels, oil pastels and more. After this workshop you will never again consider a failed watercolor anything but a new beginning. Taught locally at various venues throughout Arizona; scheduled at various times for art groups and art centers. Listings are updated frequently on website. Cost: fees range from $75-85 per day and $115-200 for 2 or more days. No lodging or food is included. Open to all skill levels. Artists should call, e-mail or see website for more information.

SOHN FINE ART—MASTER ARTIST WORKSHOPS

6 Elm Street, 1C, Stockbridge MA 01230. (413)298-1025. **E-mail:** info@sohnfineart.com. **Website:** www.sohnfineart.com. **Contact:** Cassandra Sohn, owner. Workshops held every 1-3 months, usually during the artist's exhibition at our gallery. Most workshops relate to the current exhibition. Cost $100-500 depending on the workshop (meals and lodging not included). Frequent areas of concentration are unique workshops within the photographic field. This includes all levels of students: beginner, intermediate and advanced, as well as Photoshop courses, alternative process courses and many varieties of traditional and digital photography courses. Interested parties should call, e-mail, or see the website for more information.

SOUTH SHORE ART CENTER

119 Ripley Rd., Cohasset MA 02025. (781)383-2787. **Fax:** (781)383-2964. **E-mail:** info@ssac.org. **Website:** www.ssac.org. South Shore Art Center is a nonprofit organization based in the coastal area south of Boston. The facility features appealing galleries and teaching studios. Offers exhibitions and gallery programs, sales of fine art and studio crafts, courses and workshops, school outreach and special events. See website for more information and a list of upcoming workshops and events.

CARRIE STUART PARKS DRAWING WORKSHOPS

P.O. Box 73, Cataldo ID 83810. (208)682-4564. **Fax:** (208)682-2771. **E-mail:** carrie@stuartparks.com. **Website:** www.stuartparks.com. **Contact:** Carrie Stuart Parks. These workshops teach basic drawing skills, focusing on portrait drawing. As classes are constantly being added, artists should see website for information on upcoming workshops. Cost varies with each workshop, but averages $450, depending on the location. Open to all skill levels. Artists should call, e-mail or see website for more information.

CARRIE STUART PARKS FORENSIC ART WORKSHOPS

P.O. Box 73, Cataldo ID 83810. (208)682-4564. **Fax:** (208)682-2771. **E-mail:** carrie@stuartparks.com. **Website:** www.stuartparks.com. **Contact:** Carrie Stuart Parks. Held monthly in various locations across the country. A variety of classes are offered to civilian and law enforcement. Each class is 40 hours (1 week) in length. As classes are constantly being added, art-

ists should see website for information on upcoming workshops and a helpful FAQ section. Cost varies with each workshop, but averages $695. Open to all skill levels. Artists should call, e-mail or see website for more information.

CARRIE STUART PARKS WATERCOLOR WORKSHOPS

P.O. Box 73, Cataldo ID 83810. (208)682-4564. **Fax:** (208)682-2771. **E-mail:** carrie@stuartparks.com. **Website:** www.stuartparks.com. **Contact:** Carrie Stuart Parks. These workshops focus on general subjects and portraits. Cost varies with each workshop, but averages $450, depending on the location. Open to all skill levels. Artists should call, e-mail or see website for more information.

TETON ARTS COUNCIL SUMMER ART WORKSHOP SERIES

P.O. Box 627, Driggs ID 83422. (208)354-4ART (4278). **E-mail:** info@tetonartscouncil.com. **Website:** www.TetonArtsCouncil.com. **Contact:** Jennifer Moreland. Annual. Teton Arts Council hosts several art workshops in Teton Valley for painters and digital photographers. The west side of the Bridger-Teton mountain range provides warm and high-quality sunlight during the long summer days. The workshop schedule varies each summer based on the teaching artists and grants available; see the website for scheduled workshops. All workshops include a welcome social, instruction and demonstration, and a salon at the end of the workshop. Most workshops include guided excursions on conservation lands or back country. We work with local hotels and B&Bs to offer discounts to participants. Open to all skill levels. Cost: Ranges $350-500 per workshop; lodging and travel expenses are separate. Artists should see website for more information.

✚ TRIPLE D GAME FARM

P.O. Box 5072, Kalispell MT 59903. (406)755-9653. **Fax:** (406)755-9021. **E-mail:** info@tripledgamefarm.com. **Website:** tripledgamefarm.com. **Contact:** Kathleen O'Neil, assistant manager. We raise wildlife and train our species for photographers, artists, and cinema. Wolves, bears, mountain lions, bobcats, lynx, tigers, snow leopards, coyotes, fox, fisher, otter, porcupine and more are available. Open to all skill levels. Interested parties should write, call, e-mail, or see website for more information.

TUCSON ART ACADEMY, GABOR SVAGRIK

2930 N. Swan Rd., Suite 127, Tucson AZ 85751. (520)903-4588. **E-mail:** svagrikart@gmail.com. **Website:** www.svagrikfineart.com. **Contact:** Christine Svagrik, co-owner Tucson Art Academy. Refer to website for workshop dates destinations. Gabor will guide all levels of landscape painters (oil, pastels or acrylics) to further their understanding of color, value and light in their outdoor and studio paintings. Each student will be taught the importance of composition through concise drawing and editing. Daily demonstrations are in oil, and critiques are given every day. Cost: $395 for a 3-day workshop; $525 for a 4-day workshop. Transportation is not included. Note: For some workshops, lodging and meals are included at a discounted price. See website for details. Call, e-mail or see the website for more information.

WHIDBEY ISLAND FINE ART STUDIO

813 Edge Cliff Dr., Langley WA 98260. (360)637-4690. **E-mail:** info@whidbeyislandfas.com. **Website:** www.whidbeyislandfas.com. **Contact:** Cary Jurriaans, director. Cost varies by workshop; see website for details. Annual. Drawing and painting workshops from the still life, figure and landscape in studio and plein air. Individual attention and a personalized approach. Location: Langley; a shuttle will be provided, if needed, to pick up students from the ferry in Clinton. See website for dates. Open to all skill levels. Artists should call, e-mail or see website for more information.

THE HELENE WURLITZER FOUNDATION

P.O. Box 1891, Taos NM 87571. (575)758-2413. **Fax:** (575)758-2559. **E-mail:** hwf@taosnet.com. **Website:** www.wurlitzerfoundation.org. **Contact:** Michael A. Knight, executive director. Estab. 1953. The foundation offers residencies to artists in the creative fields-visual, literary and music composition. There are three thirteen week sessions from mid-January through November annually. Application deadline: January 18 for following year. For application, request by e-mail or visit website to download.

YADDO

The Corporation of Yaddo Residencies, Box 395, 312 Union Ave., Saratoga Springs NY 12866-0395. (518)584-0746. **Fax:** (518)584-1312. **E-mail:** chwait@yaddo.org; Lleduc@yaddo.org. **Website:** www.yaddo.org. **Contact:** Candace Wait, program director. Estab. 1900. Two seasons: large season is May-August; small season is October-May (stays from 2 weeks to 2 months; average stay is 5 weeks). Accepts 230 artists/year. Accommodates approximately 35 artists in large season. Those qualified for invitations to Yaddo are highly qualified writers, visual artists (including photographers), composers, choreographers, performance artists and film and video artists who are working at the professional level in their fields. Artists who wish to work collaboratively are encouraged to apply. An abiding principle at Yaddo is that applications for residencies are judged on the quality of the artists' work and professional promise. Site includes four small lakes, a rose garden, woodland, swimming pool, tennis courts. Yaddo's non-refundable application fee is $30, to which is added a fee for media uploads ranging from $5-10 depending on the discipline. Application fees must be paid by credit card. Two letters of recommendation are requested. Applications are considered by the Admissions Committee and invitations are issued by March 15 (deadline: January 1) and October 1 (deadline: August 1). Information available on website.

GRANTS

State & Provincial

///

Arts councils in the United States and Canada provide assistance to artists in the form of fellowships or grants. These grants can be substantial and confer prestige upon recipients; however, only state or province residents are eligible. Because deadlines and available support vary annually, query first (with an SASE) or check websites for guidelines.

UNITED STATES ARTS AGENCIES

Alabama State Council on the Arts, 201 Monroe St., Montgomery AL 36130-1800. (334)242-4076. E-mail: staff@arts.alabama.gov. Website: www.arts.state.al.us.

Alaska State Council on the Arts, 161 S. Klevin St., Suite 102, Anchorage AK 99508-1506. (907)269-6610 or (888)278-7424. E-mail: aksca.info@alaska.gov. Website: www.eed.state.ak.us/aksca.

Arizona Commission on the Arts, 417 W. Roosevelt St., Phoenix AZ 85003-1326. (602)771-6501. E-mail: info@azarts.gov. Website: www.azarts.gov.

Arkansas Arts Council, 1500 Tower Bldg., 323 Center St., Little Rock AR 72201-2606. (501)324-9766. E-mail: info@arkansasarts.com. Website: www.arkansasarts.org.

California Arts Council, 1300 I St., Suite 930, Sacramento CA 95814. (916)322-6555 or (800)201-6201. E-mail: info@caartscouncil.com. Website: www.cac.ca.gov.

Colorado Creative Industries, 1625 Broadway, Suite 2700, Denver CO 80202. (303)892-3802. E-mail: online form. Website: www.coloarts.state.co.us.

Connecticut Commission on Culture & Tourism, One Constitution Plaza, 2nd Floor, Hartford CT 06103. (860)256-2800. Website: www.cultureandtourism.org.

Delaware Division of the Arts, Carvel State Office Bldg., 4th Floor, 820 N. French St., Wilmington DE 19801. (302)577-8278 (New Castle County) or (302)739-5304 (Kent or Sussex counties). E-mail: delarts@state.de.us. Website: www.artsdel.org.

District of Columbia Commission on the Arts & Humanities, 1371 Harvard St. NW, Washington DC 20009. (202)724-5613. E-mail: cah@dc.gov. Website: www.dcarts. dc.gov.

Florida Division of Cultural Affairs, R.A. Gray Bldg., 3rd Floor, 500 S. Bronough St., Tallahassee FL 32399-0250. (850)245-6470. E-mail: info@florida-arts.org. Website: www.florida-arts.org.

Georgia Council for the Arts, 260 14th St. NW, Atlanta GA 30318-5360. (404)685-2787. E-mail: gaarts@gaarts.org. Website: www.gaarts.org.

Guam Council on the Arts & Humanities, P.O. Box 2950, Hagatna GU 96932. (671)475-2781/2782/3661. E-mail: info@caha.guam.gov. Website: www.guamcaha.org.

Hawai'i State Foundation on Culture & the Arts, 250 S. Hotel St., 2nd Floor Honolulu HI 96813. (808)586-0300. E-mail: vivien.lee@hawaii.gov. Website: www.state.hi.us/sfca.

Idaho Commission on the Arts, P.O. Box 83720, Boise ID 83720-0008. (208)334-2119 or (800)278-3863. E-mail: info@arts.idaho.gov. Website: www.arts.idaho.gov.

Illinois Arts Council, James R. Thompson Center, 100 W. Randolph, Suite 10-500, Chicago IL 60601-3230. (312)814-6750 or (800)237-6994. E-mail: iac.info@illinois.gov. Website: www.arts.illinois.gov.

Indiana Arts Commission, 100 N. Senate Ave., Room N505, Indianapolis IN 46204. (317)232-1268. E-mail: IndianaArtsCommission@iac.in.gov. Website: www.in.gov/arts.

Iowa Arts Council, 600 E. Locust, Des Moines IA 50319-0290. (515)242-6194. Website: www.iowaartscouncil.org.

Kansas Arts Commission, 700 SW Jackson, Suite 1004, Topeka KS 66603-3774. (785)296-3335 or (866)433-0688. E-mail: kac@arts.ks.gov. Website: arts.ks.gov.

Kentucky Arts Council, Capital Plaza Tower, 21st Floor, 500 Mero St., Frankfort KY 40601-1987. (502)564-3757 or (888)833-2787. E-mail: kyarts@ky.gov. Website: www.artscouncil.ky.gov.

Louisiana Division of the Arts, P.O. Box 44247, Baton Rouge LA 70804-4247. (225)342-8180. E-mail: arts@crt.state.la.us. Website: www.crt.state.la.us/arts.

Maine Arts Commission, 193 State St., 25 State House Station, Augusta ME 04333-0025. (207)287-2724. E-mail: MaineArts.info@maine.gov. Website: mainearts.maine.gov.

Maryland State Arts Council, 175 W. Ostend St., Suite E, Baltimore MD 21230. (410)767-6555. E-mail: msac@msac.org. Website: www.msac.org.

Massachusetts Cultural Council, 10 St. James Ave., 3rd Floor, Boston MA 02116-3803. (617)727-3668. E-mail: mcc@art.state.ma.us. Website: www.massculturalcouncil.org.

Michigan Council for Arts & Cultural Affairs, 300 N. Washington Square, Lansing MI 48913. (517)241-4011. E-mail: artsinfo@michigan.org. Website: www.themedc.org/arts.

Minnesota State Arts Board, Park Square Court, Suite 200, 400 Sibley St., St. Paul MN 55101-1928. (651)215-1600 or (800)866-2787. E-mail: msab@arts.state.mn.us. Website: www.arts.state.mn.us.

Mississippi Arts Commission, 501 N. West St., Suite 1101A, Woolfolk Bldg., Jackson MS 39201. (601)359-6030 or (800)582-2233. Website: www.arts.state.ms.us.

Missouri Arts Council, 815 Olive St., Suite 16, St. Louis MO 63101-1503. (314)340-6845 or (866)407-4752. E-mail: moarts@ded.mo.gov. Website: www.missouriartscouncil.org.

Montana Arts Council, P.O. Box 202201, Helena MT 59620-2201. (406)444-6430. E-mail: mac@mt.gov. Website: art.mt.gov.

National Assembly of State Arts Agencies, 1029 Vermont Ave. NW, 2nd Floor, Washington DC 20005. (202)347-6352. E-mail: nasaa@nasaa-arts.org. Website: www.nasaa-arts.org.

Nebraska Arts Council, Burlington Bldg., 1004 Farnam St., Plaza Level, Omaha NE 68102. (402)595-2122 or (800)341-4067. Website: www.nebraskaartscouncil.org.

Nevada Arts Council, 716 N. Carson St., Suite A, Carson City NV 89701. (775)687-6680. E-mail: online form. Website: nac.nevadaculture.org.

New Hampshire State Council on the Arts, 2½ Beacon St., Suite 225, Concord NH 03301-4447. (603)271-3584 or (800)735-2964. Website: www.nh.gov/nharts.

New Jersey State Council on the Arts, 225 W. State St., 4th Floor, P.O. Box 306, Trenton NJ 08625. (609)292-6130. E-mail: online form. Website: www.njartscouncil.org.

New Mexico Arts, Dept. of Cultural Affairs, P.O. Box 1450, Santa Fe NM 87504-1450. (505)827-6490 or (800)879-4278. Website: www.nmarts.org.

New York State Council on the Arts, 175 Varick St., New York NY 10014. (212)627-4455 or (800)895-9838. Website: www.nysca.org.

North Carolina Arts Council, Cultural Resources Bldg., 109 E. Jones St., Raleigh NC 27601. (919)807-6500. E-mail: ncarts@ncdcr.gov. Website: www.ncarts.org.

North Dakota Council on the Arts, 1600 E. Century Ave., Suite 6, Bismarck ND 58503-0649. (701)328-7590. E-mail: comserv@nd.gov. Website: www.state.nd.us/arts.

Ohio Arts Council, 727 E. Main St., Columbus OH 43205-1796. (614)466-2613. Website: www.oac.state.oh.us.

Oklahoma Arts Council, Jim Thorpe Bldg., 2101 N. Lincoln Blvd., Suite 640, Oklahoma City OK 73152-2001. (405)521-2931. E-mail: okarts@arts.ok.gov. Website: www.arts.state.ok.us.

Oregon Arts Commission, 775 Summer St. NE, Suite 200, Salem OR 97301-1280. (503)986-0082. E-mail: oregon.artscomm@state.or.us. Website: www.oregonartscommission.org.

Pennsylvania Council on the Arts, 216 Finance Bldg., Harrisburg PA 17120. (717)787-6883. Website: www.pacouncilonthearts.org.

Institute of Puerto Rican Culture, P.O. Box 9024184, San Juan PR 00902-4184. (787)724-0700. E-mail: webicp@icp.gobierno.pr. Website: www.icp.gobierno.pr.

Rhode Island State Council on the Arts, One Capitol Hill, 3rd Floor, Providence RI 02908. (401)222-3880. E-mail: info@arts.ri.gov. Website: www.arts.ri.gov.

American Samoa Council on Culture, P.O. Box 1995, Pago Pago AS 96799. (684)633-4347. E-mail: amssc@prel.org. Website: www.prel.org/programs/pcahe/ptg/terr-asamoa1.html.

South Carolina Arts Commission, 1800 Gervais St., Columbia SC 29201. (803)734-8696. E-mail: info@arts.state.sc.us. Website: www.southcarolinaarts.com.

South Dakota Arts Council, 711 E. Wells Ave., Pierre SD 57501-3369. (605)773-3301. E-mail: sdac@state.sd.us. Website: www.artscouncil.sd.gov.

Tennessee Arts Commission, 401 Charlotte Ave., Nashville TN 37243-0780. (615)741-1701. Website: www.arts.state.tn.us.

Texas Commission on the Arts, E.O. Thompson Office Bldg., 920 Colorado, Suite 501, Austin TX 78701. (512)463-5535. E-mail: front.desk@arts.state.tx.us. Website: www.arts.state.tx.us.

Utah Arts Council, 617 E. South Temple, Salt Lake City UT 84102-1177. (801)236-7555. Website: arts.utah.gov.

Vermont Arts Council, 136 State St., Montpelier VT 05633-6001. (802)828-3291. E-mail: online form. Website: www.vermontartscouncil.org.

Virginia Commission for the Arts, Lewis House, 223 Governor St., 2nd Floor, Richmond VA 23219. (804)225-3132. E-mail: arts@arts.virginia.gov. Website: www.arts.state.va.us.

Virgin Islands Council on the Arts, 5070 Norre Gade, St. Thomas VI 00802-6876. (340)774-5984. Website: vicouncilonarts.org.

Washington State Arts Commission, 711 Capitol Way S., Suite 600, P.O. Box 42675, Olympia WA 98504-2675. (360)753-3860. E-mail: info@arts.wa.gov. Website: www.arts.wa.gov.

West Virginia Commission on the Arts, The Cultural Center, Capitol Complex, 1900 Kanawha Blvd. E., Charleston WV 25305-0300. (304)558-0220. Website: www.wvculture.org/arts.

Wisconsin Arts Board, 101 E. Wilson St., 1st Floor, Madison WI 53702. (608)266-0190. E-mail: artsboard@wisconsin.gov. Website: artsboard.wisconsin.gov.

Wyoming Arts Council, 2320 Capitol Ave., Cheyenne WY 82002. (307) 777-7742. E-mail: online form. Website: wyoarts.state.wy.us.

CANADIAN PROVINCES ARTS AGENCIES

Alberta Foundation for the Arts, 10708 - 105 Ave., Edmonton AB T5H 0A1. (780)427-9968. Website: www.affta.ab.ca.

British Columbia Arts Council, P.O. Box 9819, Stn. Prov. Govt., Victoria BC V8W 9W3. (250)356-1718. E-mail: BCArtsCouncil@gov.bc.ca. Website: www.bcartscouncil.ca.

The Canada Council for the Arts, 350 Albert St., P.O. Box 1047, Ottawa ON K1P 5V8. (613)566-4414 or (800)263-5588 (within Canada). E-mail: online form. Website: www.canadacouncil.ca.

Manitoba Arts Council, 525-93 Lombard Ave., Winnipeg MB R3B 3B1. (204)945-2237 or (866)994-2787 (within Manitoba). E-mail: info@artscouncil.mb.ca. Website: www.artscouncil.mb.ca.

New Brunswick Arts Board (NBAB), 61 Carleton St., Fredericton NB E3B 3T2. (506)444-4444 or (866)460-2787. E-mail: online form. Website: www.artsnb.ca.

Newfoundland & Labrador Arts Council, P.O. Box 98, St. John's NL A1C 5H5. (709)726-2212 or (866)726-2212 (within Newfoundland). E-mail: nlacmail@nfld.net. Website: www.nlac.nf.ca.

Nova Scotia Department of Tourism, Culture, and Heritage, Culture Division, World Trade Center, 6th Floor, 1800 Argyle St., P.O. Box 456, Halifax NS B3J 2R5. (902)424-4510. E-mail: culture@gov.ns.ca. Website: www.gov.ns.ca/tch.

Ontario Arts Council, 151 Bloor St. W., 5th Floor, Toronto ON M5S 1T6. (416)961-1660 or (800)387-0058 (within Ontario). E-mail: info@arts.on.ca. Website: www.arts.on.ca.

Prince Edward Island Council of the Arts, 115 Richmond St., Charlottetown PE C1A 1H7. (902)368-4410 or (888)734-2784. E-mail: info@peica.ca. Website: www.peiartscouncil.com.

Québec Council for Arts & Literature, 79 boul. René-Lévesque Est, 3e étage, Québec QC G1R 5N5. (418)643-1707 or (800)897-1707. E-mail: info@calq.gouv.qc.ca. Website: www.calq.gouv.qc.ca.

The Saskatchewan Arts Board, 1355 Broad St., Regina SK S4P 7V1. (306)787-4056 or (800)667-7526 (within Saskatchewan). E-mail: info@artsboard.sk.ca. Website: www.artsboard.sk.ca.

Yukon Arts Section, Cultural Services Branch, Dept. of Tourism & Culture, Government of Yukon, Box 2703, Whitehorse YT Y1A 2C6. (867)667-8589 or (800)661-0408 (within Yukon). E-mail: arts@gov.yk.ca. Website: www.tc.gov.yk.ca/138.html.

REGIONAL GRANTS & AWARDS

The following opportunities are arranged by state since most of them grant money to artists in a particular geographic region. Because deadlines vary annually, check websites or call for the most up-to-date information.

California

Flintridge Foundation Awards for Visual Artists, 1040 Lincoln Ave., Suite 100, Pasadena CA 91103. (626)449-0839 or (800)303-2139. Fax: (626)585-0011. Website: www. flintridge.org. For artists in California, Oregon, and Washington only.

James D. Phelan Art Awards, Kala Art Institute, Don Porcella, 1060 Heinz Ave., Berkeley CA 94710. (510)549-2977. Website: www.kala.org. For artists born in California only.

Connecticut

Martha Boschen Porter Fund, Inc., 145 White Hallow Rd., Sharon CT 06064. For artists in northwestern Connecticut, western Massachusetts, and adjacent areas of New York (except New York City).

Idaho

See Betty Bowen Memorial Award, under Washington.

Illinois

Illinois Arts Council, Individual Artists Support Initiative, James R. Thompson Center, 100 W. Randolph, Suite 10-500, Chicago IL 60601. (312)814-6750. Website: www. arts.illinois.gov/grants-programs/funding-programs/individual-artist-support. For Illinois artists only.

Kentucky

Kentucky Foundation for Women Grants Program, 1215 Heyburn Bldg., 332 W. Broadway, Louisville KY 40202. (502)562-0045 or (866)654-7564. E-mail: info@kfw.org. Website: www.kfw.org/grants.html. For female artists living in Kentucky only.

Massachusetts

See Martha Boschen Porter Fund, Inc., under Connecticut.

Minnesota

McKnight Artist Fellowships for Photogographers, University of Minnesota Dept. of Art, Regis Center for Art, E-201, 405 21st Ave. S., Minneapolis MN 55455. (612)626-

9640. E-mail: info@mnartists.org. Website: www.mcknightphoto.umn.edu. For Minnesota artists only.

New York

A.I.R. Gallery Fellowship Program, 111 Front St., #228, Brooklyn NY 11201. (212)255-6651. E-mail: info@airgallery.org. Website: www.airgallery.org. For female artists from New York City metro area only.

Arts & Cultural Council for Greater Rochester, 277 N. Goodman St., Rochester NY 14607. (585)473-4000. Website: www.artsrochester.org.

Constance Saltonstall Foundation for the Arts Grants and Fellowships, 435 Ellis Hollow Creek Rd., Ithaca NY 14850 (include SASE). (607)539-3146. E-mail: artscolony@saltonstall.org. Website: www.saltonstall.org. For artists in the central and western counties of New York.

New York Foundation for the Arts: Artists' Fellowships, 20 Jay St., 7th Floor, Brooklyn NY 11201. (212)366-6900. E-mail: fellowships@nyfa.org. Website: www.nyfa.org. For New York artists only.

See Martha Boschen Porter Fund, Inc., under Connecticut.

Oregon

See Betty Bowen Memorial Award, under Washington.

See Flintridge Foundation Awards for Visual Artists, under California.

Pennsylvania

Leeway Foundation—Philadelphia, Pennsylvania Region, The Philadelphia Bldg., 1315 Walnut St., Suite 832, Philadelphia PA 19107. (215)545-4078. E-mail: online form. Website: www.leeway.org. For female artists in Philadelphia only.

Texas

Individual Artist Grant Program—Houston, Texas, Houston Arts Alliance, 3201 Allen Pkwy., Suite 250, Houston TX 77019-1800. (713)527-9330. E-mail: online form. Website: www.houstonartsalliance.com. For Houston artists only.

Washington

Betty Bowen Memorial Award, c/o Seattle Art Museum, 100 University St., Seattle WA 98101. (206)654-3131. E-mail: bettybowen@seattleartmuseum.org. Website: www.seattleartmuseum.org/bettybowen/. For artists in Washington, Oregon and Idaho only.

See Flintridge Foundation Awards for Visual Artists, under California.

RESIDENCIES & ORGANIZATIONS

RESIDENCIES

Artists' residencies (also known as communities, colonies, or retreats) are programs that support artists by providing time and space for the creation of new work. There are over 500 residency programs in the United States, and approximately 1,000 worldwide. These programs provide an estimated $40 million in support to independent artists each year.

Many offer not only the resources to do artwork, but also to have it seen by the public. While some communities are isolated in rural areas, others are located near urban centers and may provide public programming such as workshops and exhibitions. Spending time as a resident at an artists' community is a great way to network and cultivate relationships with other artists.

Alliance of Artists Communities: www.artistcommunities.org
> Offers an extensive list of international artists' communities and residencies.

Anderson Ranch Arts Center: www.andersonranch.org
> Nonprofit visual arts community located in Snowmass Village CO.

Arrowmont School of Arts & Crafts: www.arrowmont.org
> Nationally renowned center of contemporary arts and crafts education located in Gatlinburg TN.

The Bogliasco Foundation/Liguria Study Center for the Arts & Humanities: www.liguriastudycenter.org
> Located on the Italian Riviera in the village of Bogliasco, the Liguria Study Center provides residential fellowships for creative or scholarly projects in the arts and humanities.

Fine Arts Work Center: www.fawc.org

Nonprofit institution devoted to encouraging and supporting young artists, located in Provincetown MA.

Hall Farm Center: clients.digitalemily.com/hallfarm/wp

A 221-acre retreat in Townshend VT, that offers residencies, workshops, and other resources for emerging and established artists.

Kala Art Institute: www.kala.org

Located in the former Heinz ketchup factory in Berkeley CA, Kala provides exceptional facilities to professional artists working in all forms of printmaking, photography, digital media, and book arts.

Lower Manhattan Cultural Council: www.lmcc.net

Creative hub for connecting residents, tourists, and workers to Lower Manhattan's vast and vibrant arts community. Provides residencies, studio space, grants, and professional development programming to artists.

The MacDowell Colony: www.macdowellcolony.org

A 100-year-old artists' community consisting of thirty-two studios located on a 450-acre farm in Peterborough NH.

Santa Fe Art Institute: www.sfai.org

Located on the College of Santa Fe campus in Santa Fe NM, SFAI is a nonprofit organization offering a wide range of programs to serve artists at various stages of their careers.

Vermont Studio Center: www.vermontstudiocenter.org

The largest international artists' and writers' residency program in the United States, located in Johnson VT.

Women's Studio Workshop: www.wsworkshop.org

Visual arts organization in Rosendale NY, with specialized studios in printmaking, hand papermaking, ceramics, letterpress printing, photography, and book arts.

Yaddo: www.yaddo.org

Artists' community located on a 400-acre estate in Saratoga Springs NY, offering residencies to professional creative artists from all nations and backgrounds.

ORGANIZATIONS

There are numerous organizations for artists that provide resources and information about everything from industry standards and marketing tips to contest announcements and legal advice. Included here are just a handful of groups that we at *Artist's & Graphic Designer's Market* have found useful.

American Institute of Graphic Arts: www.aiga.org

AIGA is the oldest and largest membership association for professionals engaged in the discipline, practice, and culture of designing.

Art Dealers Association of America: www.artdealers.org

> Nonprofit membership organization of the nation's leading galleries in the fine arts.

The Art Directors Club: www.adcglobal.org

> The ADC is the premier organization for integrated media and the first international creative collective of its kind. Founded in New York in 1920, the ADC is a self-funding, not-for-profit membership organization that celebrates and inspires creative excellence by connecting visual communications professionals from around the world.

Artists Unite: www.artistsunite-ny.org

> Nonprofit organization dedicated to providing quality arts programming and to helping artists of all genres collaborate on projects.

The Association of American Editorial Cartoonists: editorialcartoonists.com

> Professional association concerned with promoting the interests of staff, freelance, and student editorial cartoonists in the United States.

The Association of Medical Illustrators: www.ami.org

> International organization for anyone interested in the highly specialized niche of medical illustration.

The Association of Science Fiction and Fantasy Artists: www.asfa-art.org

> Nonprofit association organized for artistic, literary, educational, and charitable purposes concerning the visual arts of science fiction, fantasy, mythology, and related topics.

Association International du Film d'Animation (International Animated Film Association): www.asifa.net

> International organization dedicated to the art of animation, providing worldwide news and information on chapters of the group, as well as conferences, contests, and workshops.

Association Typographique Internationale: www.atypi.org

> Not-for-profit organization run by an elected board of type designers, type publishers, and graphic and typographic designers.

Canadian Association of Photographers and Illustrators in Communications: www.capic.org

> Not-for-profit association dedicated to safeguarding and promoting the rights and interests of photographers, illustrators, and digital artists working in the communications industry.

Canadian Society of Children's Authors, Illustrators, and Performers: www.canscaip.org

> This organization supports and promotes all aspects of children's literature, illustration, and performance.

College Art Association: www.collegeart.org

CAA promotes excellence in scholarship and teaching in the history and criticism of the visual arts and in creativity and technical skill in the teaching and practices of art. Membership is open to all individuals with an interest in art, art history, or a related discipline.

The Comic Book Legal Defense Fund: www.cbldf.org

Nonprofit organization dedicated to the preservation of First Amendment rights for members of the comics community.

Friends of Lulu: www.friends-lulu.org

National organization whose main purpose is to promote and encourage female readership and participation in the comic book industry.

Graphic Artists Guild: www.gag.org

National union of illustrators, designers, production artists, and other creatives who have come together to pursue common goals, share experiences, and raise industry standards.

Greeting Card Association: www.greetingcard.org

Trade organization representing greeting card and stationery publishers, and allied members of the industry.

National Cartoonists Society: www.reuben.org

Home of the famed Reuben Awards, this organization offers news and resources for cartoonists interested in everything from caricature to animation.

New York Foundation for the Arts: www.nyfa.org

NYFA offers information and financial assistance to artists and organizations that directly serve artists, by supporting arts programming in the community, and by building collaborative relationships with others who advocate for the arts in New York State and throughout the country.

Society of Children's Book Writers and Illustrators: www.scbwi.org

With chapters all over the world, SCBWI is the premier organization for professionals in children's publishing.

Society of Graphic Designers of Canada: www.gdc.net

Member-based organization of design professionals, educators, administrators, students, and associates in communications, marketing, media, and design-related fields.

The Society of Illustrators: www.societyillustrators.org

Since 1901, this nonprofit organization has been working to promote the interests of professional illustrators through exhibitions, lectures, and education, and by fostering a sense of community and open discussion.

Type Directors Club: www.tdc.org

Organization dedicated to raising the standards of typography and related fields of the graphic arts through research, education, competitions, and publications.

United States Artists: www.unitedstatesartists.org

Provides direct financial support to artists across all disciplines. Currently offers one grant program: USA Fellows.

US Regional Arts Organizations: www.usregionalarts.org

Six nonprofit entities created to encourage development of the arts and to support arts programs on a regional basis. Funded by the NEA, these organizations—Arts Midwest, Mid-America Arts Alliance, Mid Atlantic Arts Foundation, New England Foundation for the Arts, Southern Arts Federation, and Western States Arts Federation—provide technical assistance to their member state arts agencies, support and promote artists and arts organizations, and develop and manage arts initiatives on local, regional, national, and international levels.

GEOGRAPHIC INDEX

Colorado

Connecticut

Michigan

Minnesota

North Carolina

INTERNATIONAL INDEX

NICHE MARKETING INDEX

Religious/Spiritual

Science Fiction/Fantasy

Sports Art

GENERAL INDEX

Ideas. Instruction. Inspiration.

Receive **FREE** downloadable bonus materials when you sign up for our free newsletter at artistsnetwork.com/Newsletter_Thanks.

Get published and get paid with Artist's Market Online!

Go to ArtistsMarketOnline.com for up-to-date market news, contacts and articles. Use the activation code at the front of this book to access your FREE subscription.

Follow Artist's Market Online for the latest market news and chances to win FREE BOOKS!